THE ROMAN VILLA IN THE MEDITERRANEAN BASIN

This book offers a comprehensive survey of Roman villas in Italy and the Mediterranean provinces of the Roman Empire, from their origins to the collapse of the Empire. The architecture of villas could be humble or grand, and sometimes luxurious. Villas were most often farms where wine, olive oil, cereals, and manufactured goods, among other products, were produced. They were also venues for hospitality, conversation, and thinking on pagan, and ultimately Christian, themes. Villas spread as the Empire grew. Like towns and cities, they became the means of power and assimilation, just as infrastructure, such as aqueducts and bridges, was transforming the Mediterranean into a Roman sea. The distinctive Roman/Italian villa type was transferred to the provinces, resulting in a Mediterranean-wide culture of rural dwelling and work that further unified the Empire.

Annalisa Marzano (PhD 2004, Columbia University, New York) is Professor of Ancient History at the University of Reading, and is Fellow of the Royal Historical Society and the Society of Antiquaries of London. She has published on a wide range of topics related to the social and economic history of the Roman world and has participated in numerous archaeological projects. She is the author of two monographs, *Roman Villas in Central Italy: A Social and Economic History* (2007), which won the Silver Medal and Honorable Mention at the VIII Premio Romanistico Internazionale Gerard Boulvert, and *Harvesting the Sea: The Exploitation of Marine Resources in the Roman Mediterranean* (2013).

Guy P. R. Métraux is Professor Emeritus of Visual Arts at York University, Toronto, and a member of the Collaborative Program in Ancient History (University of Toronto/York University). He has participated in archaeological excavations in Italy, Turkey, and Tunisia, coauthoring *The San*

Rocco Villa at Francolise (with M. Aylwin Cotton, 1985). His 1995 book *Sculptors and Physicians in Fifth Century Greece* won the Raymond Klibansky Prize from the Social Science and Humanities Research Council. A Guggenheim Fellow, his current work focuses on villas in their literary and physical aspects.

THE
ROMAN VILLA
IN THE
MEDITERRANEAN
BASIN

Late Republic to Late Antiquity

Edited by

ANNALISA MARZANO
University of Reading

GUY P. R. MÉTRAUX
York University, Toronto

CAMBRIDGE
UNIVERSITY PRESS

CAMBRIDGE
UNIVERSITY PRESS

University Printing House, Cambridge CB2 8BS, United Kingdom

One Liberty Plaza, 20th Floor, New York, NY 10006, USA

477 Williamstown Road, Port Melbourne, VIC 3207, Australia

314–321, 3rd Floor, Plot 3, Splendor Forum, Jasola District Centre, New Delhi – 110025, India

79 Anson Road, #06–04/06, Singapore 079906

Cambridge University Press is part of the University of Cambridge.

It furthers the University's mission by disseminating knowledge in the pursuit of
education, learning, and research at the highest international levels of excellence.

www.cambridge.org
Information on this title: www.cambridge.org/9781107164314
DOI: 10.1017/9781316687147

First published 2018

Printed in the United States of America by Sheridan Books, Inc.

A catalogue record for this publication is available from the British Library.

ISBN 978-1-107-16431-4 Hardback
ISBN 978-1-316-61594-2 Paperback

Cambridge University Press has no responsibility for the persistence or accuracy of
URLs for external or third-party internet websites referred to in this publication
and does not guarantee that any content on such websites is, or will remain,
accurate or appropriate.

Publication of this book has been aided by a grant from the von Bothmer Publication Fund
of the Archaeological Institute of America.

Ehud Netzer (1934–2010)
in memoriam

CONTENTS

ILLUSTRATIONS AND MAPS

Figures

Maps

COLOR PLATES

I Painting of villa from Pompeii, Third Style, 40-45 CE. Museo Archeologico Nazionale, Naples, inv. 9406.

II Torre Annunziata, Villa A (Oplontis), view of enfilade of windows from *oecus* 74.

III Torre Annunziata, Villa A (Oplontis), view from the north. The large propylon to the right marks room 21 (photo M. Zarmakoupi).

IV (Color image appears elsewhere in this volume) Stabiae, site plan: Blue: areas currently visible; red: areas excavated in the eighteenth century and currently reburied. (©RAS/Editrice Longobardi/Parco Archeologico di Pompei. From P.G. Guzzo, A.M. Sodo, and G. Bonifacio 2009).

V Positano, villa, north wall of *triclinium*, composite image (GEOMED).

VI Room 7, painted apse with pavilion decoration and frieze with Nereids and Tritons, view from the east; on the left, upper part of door in the north side of the apse leading to Rooms 9 and 10.

VII Sirmione (Brescia), "Grotte di Catullo" villa (Roffia 2013).

VIII Casale di Piazza Armerina, wall painting in the *apodyterium* (8) of the West Baths, and part of its floor mosaic showing a scene of a chariot race in the Circus Maximus (photo R.J.A. Wilson).

IX Casale di Piazza Armerina, *triconchos*, detail of the mosaic showing the aftermath of the Labours of Hercules (room 46) (photo R.J.A. Wilson).

X Caddeddi on the Tellaro, the Hunt mosaic (room 10). Photo L. Rubino, reproduced by permission of the Regione Sicilia, Assessorato Beni Culturali e Identità Siciliana.

XI Oued-Athménia, villa, *frigidarium* mosaic, nineteenth-century lithograph after the watercolor of Jules Chabassière (Paris, Bibliothèque nationale).

XII Wadi Lebda (near Lepcis), villa baths: mosaic panel depicting an exhausted gladiator and his dead opponent, c. 200/25 CE (?) (Lepcis Magna, Mosaic Museum: photo R.J.A. Wilson).

XIII Zliten (Dar Buk Amméra), villa, room 7, detail of the mosaic: central field of square panels, mosaics depicting fish alternating with *opus sectile* designs; border with mosaic of amphitheater scenes – musicians with their instruments, and gladiatorial contests (Tripoli Museum: photo R.J.A. Wilson).

XIV Diaporit (Butrint vicinity), Roman villa and Christian complex at Diaporit near Butrint: large apsidal fountain (*nymphaeum*) of the villa (photo W. Bowden).

XV Hinton St. Mary, villa: mosaic.

XVI C. Pember's scale model of Pliny's Laurentine villa (1947). Ashmolean Museum, Oxford.

Colour plates follow page 140.

CONTRIBUTORS

Annalisa Marzano is Professor of Ancient History at the University of Reading, UK. She has participated in excavations in Italy, Libya, and Egypt and published widely on the socioeconomic history of the Roman world, including the monographs *Roman Villas in Central Italy: A Social and Economic History* (2007) and *Harvesting the Sea: The Exploitation of Marine Resources in the Roman Mediterranean* (2013). She is Fellow of the Royal Historical Society, of the Society of Antiquaries of London, and recipient of a Leverhulme Major Research Fellowship.

Guy P.R. Métraux is Professor emeritus at York University, Toronto, Canada. He has participated in excavations in Italy, Turkey, and Tunisia and coauthored *The San Rocco Villa at Francolise* (1985) and books of the *Corpus des mosaïques antiques de Tunisie*. His *Sculptors and Physicians in Fifth Century Greece* (1995) received the Raymond Klibansky Prize. He coedited and contributed to the *BAR-IS* book *The Art of Citizens, Soldiers, and Freedmen in the Roman World* (with Eve D'Ambra, 2006). He has been a Guggenheim Fellow.

Masanori Aoyagi is Professor Emeritus at the University of Tokyo, Japan. He studied the Casa della Nave Europa in Pompeii and directed the excavations of the Roman villas at Realmonte (Agrigento), Cazzanello (Tarquinia), and Somma Vesuviana (Naples). He has been Commissioner of Heritage for the Japanese Government and Director of the National Museum of Western Art, Tokyo.

Alexandra Chavarría Arnau is Associate Professor at the Università degli Studi di Padova, Italy, where she teaches post-classical archaeology and archaeology of buildings. Her main research focuses on the study of the late-Roman and early medieval western Mediterranean (settlements, churches, cemeteries, and landscapes). She codirects the *European Journal of Post-Classical Archaeologies*.

Gian Pietro Brogiolo is Professor of Medieval Archaeology at the Università degli Studi di Padova, Italy. He has directed dozens of archaeological excavations in northern Italy and Croatia, including investigation of Roman villas and settlements, churches, fortifications, and urban contexts. He has been president of the Society of Italian Medieval Archaeologists, cofounder of the journal *Archeologia Medievale*, chief editor of *Archeologia delle Architetture*, and codirector of the *European Journal of Post-Classical Archaeologies*.

Anthony Bonanno is Professor of Archaeology at the University of Malta. He has participated in excavations in Italy (Himera), Libya (Sidi Khrebish), and Malta (various sites). He published widely, mostly on Roman sculpture and the archaeology of Malta, including *Portraits and Other Heads on Roman Historical Relief up to the Age of Septimius Severus* (1976) and *Malta: Phoenician, Punic and Roman* (2005). He is Fellow of the Society of Antiquaries of London, and Corresponding Member of the Institutum Archaeologicum Germanicum and the Archaeological Institute of America.

William Bowden is Associate Professor in Roman Archaeology at the University of Nottingham, UK. He has participated in excavations in Italy, Albania, Jordan, and the UK. His publications include *Epirus Vetus: The Archaeology of a Late Antique Province* (2003), *Byzantine Butrint: Excavations and Surveys 1994–99* (with R. Hodges and K. Lako, 2004), and *Butrint 3: Excavations at the Triconch Palace* (with R. Hodges, 2011). He also coedited three books in Brill's *Late Antique Archaeology* series and in 2015 was awarded a British Academy Mid-Career Fellowship.

Kimberly Bowes is Associate Professor of Classical Studies at the University of Pennsylvania, Philadelphia, USA. She has directed archaeological projects in Israel and Albania, and recently completed a National Science Foundation Project on the Roman rural poor in Tuscany. Author of several monographs and edited books on late Roman religion, domestic architecture, and landscape, she has also served as the twenty-second Director of the American Academy in Rome.

Loïc Buffat is Director of the *Mosaïques Archéologie* research center (France). He has directed several excavations in southern France, in the regions of Nîmes, Béziers, and Valence. His monograph on the villas of the *ager Nemausensis, L'économie domaniale en Gaule Narbonnaise* (Monographies d'archéolgie méditerranéenne), appeared in 2011.

Adele Campanelli has been archaeological manager for the Italian Ministry for Cultural Heritage since 1980. From 2010 to 2014 she was superintendent for the Office of Antiquity (Soprintendenza Archeologica) for the provinces of Salerno, Avellino, Benevento, and Caserta. From 2015 to 2016 she has been Archaeological Superintendent for the Campania region and, in 2016, Superintendent for Archeology, Fine Arts, and Landscape for Naples Metropolitan area. Currently, she is Director of the Phlegraean Fields Archaeological Park.

John R. Clarke is Annie Laurie Howard Regents Professor of Art History at the University of Texas, Austin, United States. He has published nine books and over eighty articles and chapters on ancient Roman art, architecture, and visual culture. Since 2005 he has codirected the Oplontis Project, a collaboration among forty-six scholars worldwide aimed at publishing two contiguous archaeological sites near Pompeii. The first book of the Oplontis Series, entitled *Oplontis Villa A ("of Poppaea") at Torre Annunziata, Italy. The Ancient Setting and Modern Rediscovery*, appeared in 2014 as an Open-Access, born-digital e-book.

Antonio De Simone is Professor Emeritus of Roman Architecture at the Università degli Studi Suor Orsola Benincasa, Naples, Italy. He excavated and restored several sites on the Bay of Naples, including the Villa of the Papyrii in Herculaneum, the House of the Menander and the Suburban Baths in Pompeii, and Villa Arianna at Stabiae. He has been Commissioner for the Comitato Nazionale Beni Archeologici and is currently member of the board of directors at the National Archaeological Museum of Naples.

Girolamo F. De Simone is Contract Professor of Conservation at the Accademia di Belle Arti di Napoli, Italy, and Director of the Apolline Project. He leads the excavations of the Roman villa of Pollena Trocchia (Naples) and the ancient town of Aeclanum (Avellino). His research mostly focuses on Roman economy and ancient landscapes. He has published on late-antique Campania and the environment of the Vesuvian region. In 2011 the European Association of Archaeologists awarded him the European Archaeological Heritage Prize.

Pierre de la Ruffinière du Prey is Professor Emeritus and Queen's Research Chair at Queen's University, Kingston, Canada. His villa publications include *The Villas of Pliny from Antiquity to Posterity* (1994) and a book forthcoming in *Ex Horto: Dumbarton Oaks Texts in Garden and Landscape Studies*, produced while a Visiting Scholar at Dumbarton Oaks. He is Fellow of the Royal Society of Canada, of the Society of Antiquaries of London, and was James S. Ackerman Resident in the History of Art at the American Academy in Rome.

Giovanni Di Maio is a geologist and expert in geoarchaeology of the Pompeii region. He has

often collaborated with the archaeological superintendences in several Italian regions, as well as with research institutes and universities, both in Italy and abroad, including a project by the German Archaeological Institute investigating the ancient landscape of the Sarno River and the Oplontis Project. He has authored or coauthored many publications on the ancient Sarno River Plain and on the Bronze Age tsunami that affected the Bay of Salerno.

Maurizio Gualtieri is Professor emeritus of Classical Archaeology at the University of Alberta, Canada. He has coordinated and directed several archaeological projects, including work at the Etruscan site of Artimino, the pre-Roman settlement at Roccagloriosa in Southern Italy, and the Roman villa at Ossaia/Cortona. He has received major grants from the Social Sciences and Humanities Research Council of Canada. His publications include, as editor, the two-volume study on Roccagloriosa and a book on the Ossaia villa, and the monograph *Lucania Romana* (2003). Current work includes the final publication of the excavations and survey (with H. Fracchia, University of Alberta) in the Upper Bradano Valley (Potenza).

Thomas Noble Howe is Professor of Art and Art History at Southwestern University Georgetown, USA and Coordinator General/Scientific Director of the Restoring Ancient Stabiae Foundation, Italy. His dissertation is *The Invention of the Doric Order* (1985) and he has authored commentary and illustrations for a translation of Vitruvius' *Ten Books on Architecture* (Cambridge University Press, 1999). He is currently the excavation director and the author/editor of the report on the discovery of the Prima Porta-style Garden of the Villa Arianna at Stabiae. His current work involves the development of political spaces in the Hellenistic world and the later Roman Republic.

Riccardo Iaccarino holds degrees in management of cultural heritage and in medieval archaeology from the Federico II and Suor Orsola Benincasa universities in Naples, Italy. He took part in archaeological projects run by the universities of Naples, Siena, L'Aquila, and Nice. Since 2008, he has worked as a freelance professional archaeologist and has published various articles online and in journals.

Maria Antonietta Iannelli is an officer at the Soprintendenza Archeologica, Salerno, Italy. She holds degrees in classical archaeology from the Università degli Studi di Salerno (1977) and Università degli Studi di Pisa (1983). Since 1985 she has been in charge of cultural archaeological heritage for the Sarno Valley and, from 1995, also for the Salerno area, Irno Valley, and Amalfi Coast. She is the director of the Minori Roman villa museum and site and of the National Archaeological Museum of Pontecagnano. She has been the scientific director for the investigations of the Roman villa of Positano since 2003.

Luciana Jacobelli is associate researcher of the Istituto per le Tecnologie Applicate ai Beni Culturali (CNR, Italy). She has participated in many excavations, mostly in the Vesuvian area, and has published over fifty scholarly articles and monographs on pictorial decorations, architecture, and daily life in Pompeii and Stabiae. Most cited works are *Le pitture erotiche delle Terme Suburbane di Pompei* (1995), *Gladiators at Pompeii* (2003), and *Nascere, Vivere, Morire a Pompei* (with Eva Cantarella, 2011).

Kenneth Lapatin is Curator of Antiquities at the J. Paul Getty Museum, Los Angeles, California. He has excavated in Italy, Greece, and Israel and curated exhibitions on Greek vases, polychrome sculpture, ancient gems, Roman silver, Hellenistic bronzes, and the reception of antiquity in diverse periods. Among his many publications are *Mysteries of the Snake Goddess: Art, Desire, and the Forging of History* (2002); *Luxus: The Sumptuous Arts of Greece and Rome* (2015); and *Power and Pathos: Bronze Sculpture of the Hellenistic World* (2015 – awarded the London Hellenic Prize).

Maria Papaioannou is Associate Professor in Classical Archaeology and Director of the Centre for Hellenic Studies at the University of New Brunswick, Fredrickton, Canada. Her work centers on domestic architecture in Roman Greece and as

a junior Fellow of the Getty Foundation Arts of Rome's Provinces Seminar, she has contributed to the book *Beyond Boundaries: Connecting Visual Cultures in the Provinces of Ancient Rome* (2016). Recipient of a Social Sciences and Humanities Research Council of Canada grant, she is conducting laser scanning of an *insula* at Abdera and a basilica on Kalymnos.

Gisela Ripoll is Associate Professor in Archaeology at the Universitat de Barcelona, Spain, and former member of the Institute for Advanced Study, Princeton (2001). Her *Toréutica de la Bética* (1998) received the Raoul Duseigneur Prize (Institut de France, 2001). She coedited *Sedes regiae (ann. 400–800)* (with J.M. Gurt, 2000), *Mélanges d'Antiquité Tardive. Studiola in honorem Noël Duval* (with C. Balmelle and P. Chevalier, 2004), *Elites and Architecture in Late Antiquity and the Middle Ages* (with M. Jurković, 2007), and *Arqueologia funerària al nord-est peninsular (segles VI-XII)* (with N. Molist, 2012).

Israel Roll (1937–2010) was Professor emeritus at Tel Aviv University, Israel, Director of the Apollonia-Arsuf excavations (1977–2006), and Codirector of the excavations of the Roman Temple at Kedesh, Upper Galilee (1981–1983). He has also conducted surveys and excavations of Roman road stations and sections of paved roads (including their building techniques) in order to map the Imperial Roman road network in Judaea, defining its chronology on the basis of inscribed milestones and written sources, and aiming at the reconstruction of the communication system in Roman and Byzantine Palestine.

Ursula Rothe is Baron Thyssen Lecturer in Classical Studies at the Open University, UK. She has been involved in excavation projects in Italy, Portugal, and the Netherlands, and was project lead at the Roman-Byzantine site at Tall Zira'a in northern Jordan. She is on the Archaeology Committee of the Roman Society and is Fellow of the Society of Antiquaries of Scotland. Her research focuses on cultural processes in the Roman provinces, and her publications include *Dress and Cultural Identity in the Rhine-Moselle Region of the Roman Empire* (2009).

Oren Tal is Professor of Archaeology at Tel Aviv University, Israel, and, since 2007, Director of the Apollonia-Arsuf Excavation Project. He specializes in the material culture of the classical- and medieval-period Near East and its social, political, and economic implications. Tal's scientific work reflects his efforts to improve thematic interests and to develop new methods and approaches, interdisciplinary in nature, using archaeological evidence for historical analysis in order to gain a better understanding of ancient societies.

Felix Teichner is Professor of Roman and Early Medieval Archaeology at Philipps-Universität Marburg, Germany. He has directed excavations in Germany, Hungary, Kosovo, Croatia, Scotland, Portugal, and Spain. His research focuses on geoarchaeology, Roman provincial archaeology, the early Middle Ages, and Al-Andalus. His publications include the monograph *Entre tierra y mar* (2011) on Lusitanian villas and studies on Roman cities of the Iberian Peninsula. He was Humboldt Research Fellow and is Fellow of the German Archaeological Institute. He is currently directing a geoarchaeological project on the "Roman Maritime Economy" funded by the German Science Foundation.

Andrew Wallace-Hadrill is Professor of Roman Studies and Director of Research of the Faculty of Classics, University of Cambridge. He is also Director of the Herculaneum Conservation Project and has served as Director of the British School at Rome (1995–2009). Among his most cited publications are *Houses and Society in Pompeii and Herculaneum* (1994) and *Rome's Cultural Revolution* (2008).

Zeev Weiss is Eleazar L. Sukenik Professor of Archaeology at the Hebrew University of Jerusalem, Israel, and has been Director of the Sepphoris excavation project since 1991. Trained in classical archaeology, he specializes in Roman and late-antique art and architecture in the provinces of Syria-Palestine. His publications include many articles as well as two major books: *The Sepphoris Synagogue: Deciphering an Ancient Message through Its*

Archaeological and Socio-Historical Contexts (Israel Exploration Society 2005) and *Public Spectacles in Roman and Late Antique Palestine* (2014).

R. J. A. Wilson is Director of the Centre for the Study of Ancient Sicily at the University of British Columbia (Vancouver), Canada. In 2013 he won the UBC Killam Research Prize in recognition of his contributions to scholarship. A graduate of Oxford University, he has been Charles Eliot Norton Lecturer of the AIA, Fellow at the Getty Research Institute, and Dalrymple Lecturer in Archaeology at Glasgow University. He is the author of five books, most recently *Caddeddi on the Tellaro: A Late Roman Villa in Sicily and Its Mosaics* (2016).

Mantha Zarmakoupi is Birmingham Fellow in Visual and Material Culture of Classical Antiquity at the University of Birmingham, UK. She has participated in excavations in Italy, Turkey, and Greece and has codirected an underwater survey around Delos and Rheneia. She has published widely on Roman luxury villas, including the monograph *Designing for Luxury on the Bay of Naples (c.100 BCE–79 CE): Villas and Landscapes* (2014), as well as on the urban development of late Hellenistic Delos. She has been Fellow at Freie Universität in Berlin, New York University (Institute for the Study of the Ancient World), the University of Cologne (Humboldt Stipendium), the Getty Research Institute, the Harvard Center for Hellenic Studies, and the National Hellenic Research Foundation.

ACKNOWLEDGMENTS

This book began at an international conference "The Roman villa in the Mediterranean basin," cosponsored by the Mishkenot Sha'ananim Konrad Adenauer Conference Center, Jerusalem, and the Restoring Ancient Stabiae (RAS) Foundation of Castellamare di Stabia, and their directors, Mr. Uri Dromi and Professor Thomas Noble Howe, respectively. We wish to express mighty thanks to them and their sponsoring institutions, and to convey our gratitude and that of all the conference participants to the dedicatee of this book, Professor Ehud Netzer (1934–2010), for a memorable day's visit to Herodium, where he was a gracious host.

The editors were able to include some of the conference participants, but more contributors were sought to ensure Mediterranean-wide coverage of Roman villas and the many historical issues they present. It was clear that a mere conference-proceedings publication would be inadequate to the ambitious program of the conference. A small editorial committee (Professors Wilson, Weiss, Howe, du Prey, and Mr. Dromi) was formed to make suggestions. Contributions began to come in by late 2010 and continued as solicitation for contributions and requests to participate continued.

The former Archaeology and Renaissance Studies editor of Cambridge University Press in New York, Asya Graf, is owed a debt of gratitude for her advice and encouraging attitude. She found the right anonymous assessors whose helpful insights much improved the manuscript and whom we thank; she also shepherded the manuscript and illustrations through the process of approval for publication. This was successful, and we are grateful to the Syndics of Cambridge University Press for accepting our proposal. It is to Beatrice Rehl, Publisher of Archaeology, Art History, and Religious studies, editor *par excellence*, that our most enthusiastic thanks must go for her patience, timely warnings, and fine insights.

The book has benefited greatly from a subvention of the Publication Subvention Program of the Archaeological Institute of America. Early and welcome financial support from the Queen's Research Chairs Program of Queen's University (via a contributor to the book) for photographs is gratefully acknowledged.

As editors, our greatest gratitude goes to Mehmet Deniz Öz, as much for his instinct for structuring the book as for voluntarily undertaking the editorial work for the illustrations and maps. In an international endeavor of this size, illustrations were inevitably received in various formats; Mr. Öz has brought them into uniformity and order, which has served the contributors and the book well. They, and we, are fortunate to have secured his considerable skills and talents.

Finally, the contributors are the main object of our thanks, not only for the quality of their texts but for their patience with our many questions and editorial interventions, their wide view of the purpose of the book, and their responsiveness in communicating with us.

ABBREVIATIONS

AA	Archäologische Anzeiger
AAA	Αρχαιολογικά Ανάλεκτα εξ Αθηνών – Archaiologika Analectka ex Athenon (Athens Annals of Archaeology)
AE	L'Année épigraphique
ActaArchHung	Acta archaeologica Academiae Scientiarum Hungaricae
AErgoMak	Αρχαιολογικό Έργο στη Μακεδονία και Θράκη - Archaiologiko Ergo ste Makedonia kai Thrake
AfrRom	L'Africa romana
AISCOM	Associazione italiana per lo studio e la conservazione del mosaico
Amoenitas	Amoenitas. Rivista Internazionale di Studi Miscellanei sulla Villa Romana Antica
AnalRom	Analecta romana Instituti Danici
AnnESC	Annales: économies, sociétés, cultures
AnMurcia	Anales de Prehistoria y Arqueología
ANRW	Aufstieg und Niedergang der römischen Welt
AnTard	Antiquité Tardive
AntAfr	Antiquités africaines
Antiquity	Antiquity. A Quarterly Review of Archaeology
AntW	Antike Welt. Zeitschrift für die Alterumswissenschaft
Aquitania	Aquitania. Une revue inter-régionale d'archéologie
ArchDelt	Archaiologikon Deltion
ArchEspArq	Archivo Español de Arqueología
ArqPort	O arqueólogo português
Athenaeum	Athenaeum. Studi di letteratura e storia dell'antichità
AttiTaranto	Atti del Convegno di studi sulla Magna Grecia, Taranto
BaBesch	Bulletin antieke Beschavung
BAMaroc	Bulletin d'archéologie marocaine
BAProv	Bulletin archéologique de Provence
BARev	Biblical Archaeology Review
BAR-BS	British Archaeological Reports – British Series
BAR-IS	British Archaeological Reports – International Series
BASOR	Bulletin of the American Schools of Oriental Research
BCH	Bulletin de correspondance hellénique
BCTH	Bulletin du Comité des travaux historiques
BdA	Bolletino d'arte
BÉFAR	Bibliothèque de l'École française d'Athènes de Rome
BICS	Bulletin of the Institute of Classical Studies
BJb	Bonner Jahrbücher des rheinischen Landesmuseums in Bonn und des Vereins von Altertumsfreunden im Rheinlande
BMon	Bulletin monumental. Société française d'archéologie

Britannia	Britannia. A Journal of Romano-British and Kindred Studies		Deutschen Archäologischen Instituts
BTCGI	Bibliografia topografica della colonnizazzione greca in Italia e nelle isole tirreniche, edited by G. Nenci and G. Vallet. Pisa: Scuola Normale Superiore di Pisa, and Rome: ÉFR, 1977	*GZM*	Glasnik zemaljskog muzeja u Sarajevu, Sarajevo
		HAD	Hrvatsko arheološko društvo, Zagreb
		Histria Antiqua	Histria antiqua. Casopis Međunarodnog Istraživač kog Centra za Arheologiju – Journal of the International Research Centre for Archeology
CAG	Carte archéologique de la Gaule		
CahÉtAnc	Cahiers des études anciennes		
CBI ANUBiH	Centar za balkanološka ispitivanja Akademije nauka I umjetnosti Sarajevo	*IEJ*	Israel Exploration Journal
		IJNA	International Journal of Nautical Archaeology
CÉFR	Collection de l'École française de Rome	*ILS*	Dessau, H. 1892–1916. Iscriptiones Latinae Selectae, 3 vols. Berlin: Weidmann
CIL	Corpus Inscriptionum Latinarum (1863–)		
CMT I,1	Corpus des mosaïques antiques de Tunisie I,1. Utique, edited by M.A. Alexander et al. 1973. Tunis and Washington, DC: Institut National d'archéologie and Dumbarton Oaks Center for Byzantine Studies	*InsFulc*	Insula Fulcheria
		Italia Meridionale Tardoantica	"L'Italia Meridionale in età Tardoantica." Atti Taranto 38, Naples 1999
		JdI	Jahrbuch des Deutschen Archäologischen Instituts
CP	Classical Philology	*JECS*	Journal of Early Christian Studies
CQ	The Classical Quarterly	*JEH*	Journal of Ecclesiastical History
CRAI	Comptes rendus des séances de l'Académie des inscriptions et belles-lettres (Paris)	*JRA*	Journal of Roman Archaeology
		JRS	Journal of Roman Studies
		JSAH	Journal of the Society of Architectural Historians
CSEL	Corpus Scriptorum Ecclesiasticorum Latinorum. Vienna: Kommission zur Herausgabe des Corpus der lateinischen Kirchenväter	*LibAnt*	Libya antiqua
		LibSt	Libyan Studies
		LTUR	Lexicon topographicum urbis Romae, edited by Steinby, E.M., 6 vols. Rome: Quasar
CuPAUM	*Cuadernos* de Prehistoria y Arqueología de la Universidad Autónoma de Madrid	*MAAR*	Memoirs of the American Academy in Rome
		MÉFR	Mélanges de l'École française de Rome
DHA	Dialogues d'histoire ancienne	*MÉFRA*	Mélanges de l'École française de Rome, Antiquité
DOP	Dumbarton Oaks Papers		
DossArch	Dossier d'archéologie	*MémAcInscr*	Mémoires présentés par divers savants à l'Académie des inscriptions et belles lettres
Ergon	To Ergon tes Archaeologikes Etaireias		
Gallia	Gallia. Archéologie de la France antique.	*Migne, PG*	Migne, J.P. (ed.)1857-1866. *Patrologiae cursus completus. Series*
Germania	Germania: Anzeiger der Römisch-Germanischen Komission des		

	graeca. Paris: Imprimerie Catholique
Migne, PL	Migne, J.P. (ed.) 1844-. Patrologiae cursus completus. Series latina. Paris: Apud Garnier Fratres
MM	Madrider Mitteilungen
MonAnt	Monumenti antichi pubblicati per cura della Reale Accademia dei Lincei
Mouseion	Mouseion. Journal of the Classical Association of Canada
NAHisp	Noticiario arqueológico hispánico
NEAEHL	The New Encyclopedia of Archaeological Excavations in the Holy Land (1993–)
NSc	Atti dell'Accademia Nazionale dei Lincei. Notizie degli scavi di antichità
NSAL	Soprintendenza Archeologica della Lombardia. Notiziario
ÖAW	Österreichische Akademie der Wissenschaften
Oebalus	Oebalus. Studi sulla Campania nell'Antichità
OJA	Oxford Journal of Archaeology
Opus	Rivista internazionale per la storia economica e sociale dell'antichità
PBSR	Papers of the British School at Rome
PIR2	Prosopographia Imperii Romani Saeculi I, II, III, 2nd edn. Berlin: W. de Gruyter (1933–2015)
PLRE	Jones, A.H.M., J. R. Martindale and J. Morris 1971–1992. The Prosopography of the Later Roman Empire. 4 vols.

	Cambridge, UK: Cambridge University Press
Prakt	Praktika tes en Athenais Archaiologikes Etaireias
RAC	Reallexikon für Antike und Christentum. Stuttgart: A. Hiersmann
RANarb	Revue archéologique de Narbonnaise
RendNap	Rendiconti della Accademia di Archeologia, Lettere e Belle Arti, Napoli
RendPontAcc	Atti della Pontificia Accademia romana di archeologia. Rendiconti
RM	Mitteilungen des Deutschen Archäologischen Instituts, Römische Abteilung
RStPomp	Rivista di studi pompeiani
S.H.A.	Scriptores Historiae Augustae with an English translation by David Magie. 3 vols. 1921–1932. Cambridge, MA: Harvard University Press (Loeb Classical Library)
TCCG	Topographie chrétienne des cités de la Gaule des origines au milieu du VIIIe siècle, edited by N. Gauthier. Paris: De Boccard
Topoi	Topoi. Orient-Occident
Vesuviana	Vesuviana. An International Journal of Archaeological and Historical Studies on Pompeii and Herculaneum
YCS	Yale Classical Studies
ZPE	Zeitschrift für Papyrologie und Epigrafik

INTRODUCTION

ANNALISA MARZANO
AND GUY P.R. MÉTRAUX

The expansion and proliferation of villas into the Mediterranean under Roman hegemony is the topic of this book. In addition, the historical trajectory of the villa as a formula and phenomenon is outlined for different parts of the empire. Villas – extra-urban, suburban, or seaside country houses, many with productive estates or facilities contiguous or nonadjacent to them, others purely residential – were unmistakable signs of Roman social and economic presence. Roman villas expanded into Italy and the coasts and inland areas of the *mare nostrum* (and ultimately into the northwestern provinces of the empire) along with other agricultural, physical, institutional, and sociocultural phenomena of the new hegemony.[1] There were exceptions, most notably in the eastern empire, where a widespread residential tradition and culture on agricultural estates did not develop. However, villas were signs of Roman economic organization and signifiers of Roman cultural presence in annexed lands and coastlines, and they became both normal and normalizing by the late second century BCE in central and southern Italy and a little later in the northern peninsula. Elsewhere, landscapes readily receptive to the implantation of villas and their proliferation in the imperial period further assured Roman presence in terms of architecture, agricultural practices, decorative expectations, and social *mores* throughout the Mediterranean. Roman villas were still in use and under construction well into the fifth century CE and even later; they were sustainable propositions, adaptable and attractive in many different climes and conditions, and, in Western culture, a permanent ideal of life.[2]

Roman villas spread ineluctably both geographically and over time. As with many other phenomena, villas were exportable items that came to be indispensable – though with regional variations. Villas had become naturalized in Sicily as of the Roman conquests on the island in the mid-third century, and so entrenched had they become that rich proprietors of villas were being harassed by Gaius Verres, the proconsul (governor) of Sicily, in 73–71 BCE.[3] The landscapes of the new provinces of Africa, Spain, and Greece came to be populated – some densely, others thinly – with villas in the Roman style. With the exception of the Roman east – Asia Minor, Syria-Palestine, and Egypt, where alternative methods of agricultural exploitation were used – the villa with an agricultural estate was a conspicuous phenomenon of the Roman Empire from its inception in the Republic and Empire, as of the first century CE through late antiquity.[4]

The Mediterranean-wide diffusion of villas came in part from their effectiveness as formulae for rural organization and agricultural exploitation. It also came from their most distinguished examples: villas of refined rural and sea-side living, meaningful enjoyment, and fashionable and up-to-date decoration that were developed in the late Republic and early empire, especially around Rome and most

impressively on the Bay of Naples.[5] The glamour and allure of these villas was permanent and exemplary – their memory was still current as late as the sixth century CE – and they constituted an ideal that, in various ways, was often manifested in provincial venues.[6] There were geographical and chronological variations, but the model of Roman villas in Italy, while strongly developed and changed as needed, was vigorously maintained throughout the empire from the late Republic through late antiquity.

This book is intended to outline some of the varieties of Roman villas and the various ways they interacted among themselves, with the landscape and larger economic picture, and within the late Republican and imperial hegemonies through late antiquity. This is a timeframe of some six to seven hundred years, so not all aspects of the phenomenon can be broached. Still, we – and most especially the other contributors to this book – have sought to situate villas in their settings and landscapes both geographically and socially, without claiming to be either complete or definitive. Our introductory chapter presents certain themes about villas that are prompted by issues raised in the chapters of this book.

The Roman hegemony in its administrative guises was effected by "hard" devices: land division (*centuratio*) needed to stabilize the extent of an annexation, distribute agricultural property (sometimes to demobilized soldiers as citizens of new colonies) in newly annexed regions, and determine taxation for territories outside Italy. There was even a scheme (*alimenta*) to make loans to owners of agricultural estates to provide for local charities for orphans and possibly poor families.[7]

Writers on agriculture over some six centuries in Latin literature are, in a way, the least helpful for the architectural documentation of Roman villas and even their physical spread. There are many reasons for this: The agricultural treatises stay "on message" pretty strictly, preferring to discuss how to set up a facility for pig husbandry or build a strong terrace wall for a raised garden rather than matters of taste and decoration. Their writers eschew much specific discussion of the villa's architecture itself.

Another "hard" aspect of villas – in fact, of all farms and rural residences anywhere and at any time – was equipment (*instrumentum*, pl. *instrumenta*), namely hardware and animals and also, in Roman contexts, a slave agricultural workforce. *Instrumentum*, particularly the case of equipment such as presses, is a theme tangential to several of the chapters in this book, but some considerations on how the interpretation of slavery relates to the interpretation of certain villas can be found in the introductory chapter.

Are social and cultural issues merely "soft" issues about Roman villas? We think not. Our introduction presents, in very brief outline, certain aspects of behavior among villa owners that reoccur with fair regularity in the record: clustering. Geographically, villas tended to group themselves near cities or towns, famous beauty-spots and places of resort, and in areas of particular interest in the way of markets or other advantages. A second aspect of clustering is social: the homogenization of Roman élites (social, military and financial upper strata) in the way of certain aspects of plan, types of rooms denoting systems of hierarchy and hospitality, and a certain uniformity of taste in iconography and decoration throughout the Roman Empire. What it meant to be Roman at various times was to commission craftsmen to make something "like" what others had commissioned. Of course, individuality in theme and decoration of villas was not infrequent, but a certain predictable repertory of themes and uniformity of styles were also repeated from villa to villa, and the media of mosaic floors and wall painting were almost universally adopted.

Of course, the topics about Roman villas outlined above and presented in the introductory chapter are by no means mutually exclusive or separable; they overlap in theme and content, and the contributions in subsequent pages take up many and expand them.

This book, which presents Roman villas in a Mediterranean-wide perspective, is divided into sections that correspond to current and future research in the field of Roman villas.[8] Defining so capacious and, at times, so slippery a historical and architectural category as the Roman villa with its

physical phenomena is difficult, especially in the very wide geographical scope we have proposed.

This book's aims are essentially twofold. First, to present very recent discoveries and ideas about villas, both where the scholarly attention to the archaeology of the Roman period (such as Greece and even southern Italy) is a relatively recent phenomenon and to current innovative interpretive work of sites already well-known or in the process of discovery (such as the villas of the Bay of Naples). Second, to investigate the diffusion and the social and economic function of villas in the various provinces and the types of production activities they embodied. This book is only a starting point in the much needed interpretative work of the large archaeological datasets that have become available in recent years and in the dialogue and exchange of information that needs to occur among scholars working in different geographic areas. In addition, we address an important question: How did the villa – its architecture, decoration, contents, estates, and activities – fulfill the need for certain types of social interactions and certain kinds of agricultural and resource exploitation to make the many different landscapes of the Mediterranean recognizably *Roman*?

PRESENTATION OF THIS BOOK

The topic of this book is villas, but we have limited it to the villas that belonged to private owners (*privati*) or to villa estates that became imperially owned as a matter of bequest or confiscation. We have excluded (except for passing mention, especially for instances of emulation) rural or maritime palaces attributable to imperial patronage and ownership such as the Villa of Hadrian at Tibur, the retirement palace of Diocletian at Spalatum (mod. Split), and many others. An exception also includes the large buildings termed *palatia* built in northern Italy by royal but non-Roman occupiers who fancied emulating Roman imperial villas on a smaller scale. The decisions about houses in the countryside taken by persons of ordinary fortune, some wealth, or even great wealth – but not owners with imperial responsibilities and requirements in terms of

iconography, space, and amenities – are what we have chosen to emphasize.

In addition, further investigation of the *origins* of the type of rural residence and agricultural exploitation in the environs of Rome and its nearby districts must await greater elaboration than we have offered here: The question is still open to archaeological discovery. Instead, this book covers the Mediterranean-wide spread of villas rather than their Roman origins.

This preface has outlined the scope, but not the details, of the project, so we have organized the chapters into the following broad sections. Of course, there are overlaps and unusual juxtapositions.

CHAPTERS 1 AND 2: OVERVIEWS AND INTRODUCTION

Chapter 1 covers several general key themes connected to villas, both in ancient literary texts and in modern scholarship. It also places the villa in the broader context of the Roman countryside, with its various determining features (e.g., centuriation). This general thematic treatment is followed by the contribution by Ursula Rothe (Chapter 2). Her chapter outlines the parameters of Roman villas in legal and historical scope and also provides a brief view of Roman villas away from the Mediterranean basin, namely those in the northern provinces of Gaul, Germany, Britain, and the Roman East.

ROMAN VILLAS ON THE BAY OF NAPLES AND ITS HINTERLAND: CURRENT RESEARCH

Villas in Italy were the exemplars for many Roman villas in the provinces, so current research in this area is the first to be considered. The emphasis is on Italian villas on the Bay of Naples and in central Italy.

The famous Villa of the Mysteries just outside Pompeii is freshly presented by Andrew Wallace-Hadrill (Chapter 3). His analysis embeds this very well-known dwelling in two new contexts, as a venue for a new kind of hospitality enjoined on villa-owners by the new empire of the late Republic,

and as the architectural artifact of an adaptation of *local* (Oscan) building and measuring methods to new Roman needs. Local building practices and the urgency of social demands profoundly shaped the dwelling and make it much less archetypal of the "classic" villa than it has been regarded heretofore. The equally famous Villa A at Oplontis (Torre Annunziata), currently under active reinvestigation and publication by the University of Texas at Austin and the *Soprintendenza Speciale per i Beni archeologici di Napoli e Pompei*,[9] is treated in two ways: by John R. Clarke (Chapter 4) in light of the discoveries of the Oplontis Project after several seasons of work, and by Mantha Zarmakoupi (Chapter 5) in terms of her recently published work on architectural and natural design of major villas on the Bay of Naples.[10] Together, their contributions outline new concepts of how dwellings in settings can be analyzed, and Clarke's demonstration that the site of the Oplontis Villa A was high on a cliff-like bluff overlooking the Bay (instead of its present geologically inland site) gives the villa a quite different character than that which the modern visitor experiences.

The settings of villas and how gardens were incorporated within them is the topic of Thomas Noble Howe's contribution on the very grand villas at Stabiae (Chapter 6). These had elevated settings on the south coast of the Bay and panoramic views to the north but hardly any space among themselves, in a crowded juxtaposition that is the mark of social clustering. Howe outlines how aristocratic *domus* in Rome and grand villas in Stabiae were part of the same instinct among the élites of family and/or finance. Location (the premier value-maker of real estate in any age) may have been more important than either space in a setting or adjacent productive land for such villas.

Grandest of all instances of conspicuous consumption in country houses were the villas known as *villae maritimae*, coastal dwellings often of dazzling luxury in the way of contents, decoration, and architectural elaboration. Chapter 7 presents an overview of the discoveries from the recent excavations of such a luxury maritime villa in Positano (Amalfi Coast). In that these villas were often without adjacent agricultural land, they could be characterized as "useless" (*inutilis*), a term of serious moral reproach. However, were they unproductive just because they presented a face of pleasurable ease (*amoenitas*)? Annalisa Marzano, in her contribution here (Chapter 8) and in a recent book-length study on the Roman maritime economy in all its aspects, shows that pisciculture, essential in the "Mediterranean diet" of Roman times, could be a lucrative business for owners of coastal villas who had the cash for the very high upfront investment in the technical equipment and construction required for effective farmed fishery. Their investment could also result in some unusual and charming seaside architecture, combining pleasure and profit in equal measure.

The Bay of Naples was famous for its villas, but its hinterlands (to the north, the *ager Campanus* and the *ager Falernus*, to the northwest, the territories of Nola and other Campanian towns) were areas of intense cultivation and habitation. The abrupt termination of the villas on the Bay in the eruption of Vesuvius in 79 CE has disfigured what was, in fact, an ongoing history of agricultural exploitation in the region. In areas not immediately affected by the catastrophe, villas flourished; an instance is to be found at Somma Vesuviana, a large and importantly decorated villa still under excavation by the authors of the contribution on it, Professors Antonio De Simone, Masanori Aoyagi, and Girolamo F. De Simone (Chapter 9). The villa had a long history with varied phases of alternately refined and architecturally innovative construction and reconversion to agricultural uses.

ROMAN VILLAS IN THE MEDITERRANEAN: CURRENT RESEARCH

This section, the longest of the book, provides a geographical coverage of Roman villas in the Mediterranean basin. It begins with villas in southern Italy, where Roman implantation of villas began early and intensively, as Maurizio Gualtieri shows (Chapter 10); together with cultivation and

habitation, water resources and transportation infrastructures (by river, sea, and roads) went hand-in-hand with villas. Villas were long-lived in southern Italy, lasting well into the fifth century CE.

The same was the case for northern Italy. The presence of villas began later than in the southern part of the peninsula, but the importance of the area north of the Po as the gateway to and from Italy made for an even longer tradition of villas and villa-building. This is shown in the contribution of Gian Pietro Brogiolo and Alexandra Chavarría Arnau (Chapter 11): the royal but non-Roman occupiers of the area in the newly dismembered Roman hegemony delighted in villas and grand rural dwellings sometimes called palaces.

The agricultural estates of Sicily were of diamond importance to the alimentation of the Roman *metropoleis* of the Western Empire: Together with Africa, they assured both the private market and the public system of food supply and dole. Roger J.A. Wilson's contribution (Chapter 12) reviews the legendary wealth of the province in the late Republic and its rich villas into late antiquity. The culture of late antique villas in the way of mosaic floors made by superior craftsmen called to Sicily from North Africa is among their notable features, as Wilson shows here and in other publications.

While villas were among the first implantation of Roman presence in southern and northern Italy, in general they appear rather late – only in Augustan times or later in the first century CE – in the great Republican conquests, namely southern Gaul (Gallia Narbonensis) and Aquitania, and Hispania and Lusitania. Indeed, between the eastern part of southern Gaul and Aquitania to the west, there were significant differences between the two regions both in implantation and longevity of villas, as Loïc Buffat shows (Chapter 13). The extreme abundance and brilliance of the late antique aristocratic villas of Aquitania, as famous for their mosaics as for, in the case of the Chiragan villa, their sculptural contents, emphasizes the flourishing of Roman culture in the far west, a late blossoming that went along with a strong intellectual and literary culture.[11]

Like southern Gaul and other parts of the western Roman empire, Hispania and Lusitania (modern Spain and Portugal) had some early implantation of villas (for the east coast of Hispania, already in the late Republic and Augustan times), but integration of these provinces into the Roman Mediterranean-wide economy as well as a strong urban culture prompted a mighty spread of villas. Felix Teichner (Chapter 14) shows how an architecturally timid beginning for villas, based in an existing Hispanic tradition of farms and farming, does not prepare us for the inventive designs and ideas of the villas beginning already in the later second and into the third century (see also Gisela Ripoll's contribution in Chapter 22).

Existing Mediterranean traditions of farm dwellings and methods of farming outside of Italy are difficult to apprehend archaeologically: Roman implantations often overlaid them. However, Anthony Bonanno's study (Chapter 15) of villas on Malta reveals that preexisting methods of Phoenician/Carthaginian farming sometimes continued into Roman times. This is especially significant because Roman agricultural writers paid fulsome tribute to Carthaginian agricultural writers – in particular the so-called Mago – as the basis of rational agriculture, and Malta, a possession of Carthage before the third-century BCE conquest, may have presented a source of practical knowledge about agricultural exploitation, if not of villas.

When Carthage was defeated for good in the Third Punic War (149–146 BCE), a vast Roman land-grab took place in North Africa, which was strongly to affect politics and social relations in both Italy and Rome itself. The new province was widely invested with new or refounded towns and agricultural estates of proverbial productivity. In consequence, numerous villas developed in the early imperial period but increased in size and clout from the second century CE to late antiquity. Roger J.A. Wilson's contribution (Chapter 16) synoptically reorganizes the scattered scholarship on African villas to give a one-stop view of both the monuments and the interpretive problems about their development, and he does so as he carefully distinguishes the

various categories of *villae* as well as their geographical distribution. As far as we are aware, no other study has broached the topic with this panoramic view.

Of course, Romans and Italians posted abroad in military units or traveling for business or cultural purposes needed environments that, in their familiarity, may have done something to mitigate their longing for home. Oren Tal and the late Israel Roll (Chapter 17) show how a Roman villa with a plan neatly adapted from Italian prototypes and accessories such as *lararia*, both quite foreign to their setting, found their place on the coast of Palestine during the early years of the Roman reoccupation in the later first century CE. The villa may have been more villa-like than a permanent dwelling: Tal interprets it as a *mansio* or guesthouse on a military road, intended to house official personnel and others on business in a temporary way. The Roman villa recalling familiar spaces and domestic arrangements was an exportable commodity.

Exportability is also a major issue for Roman villas. The imagery of villas, as we discuss briefly in the introductory chapter, was internally exported to the decoration of urban houses in Pompeii and elsewhere. This also occurred externally, a radiation of villa-like ideas to urban houses outside Italy. In the Roman east, villas in the Italian mode do not exist, or do so as exceptions. However, people in the Roman provinces who were willing, even anxious, to participate in the new hegemony could adapt the plan of their urban houses, their decoration, and the spatial sequences of rooms to Roman villa ideas. Zeev Weiss's contribution (Chapter 18) shows how the Jewish elites of Galilee adopted villa-like ideas to their *domus*; he broaches the much larger and very important (and as yet unexplored) topic of *provincial* adoptions of Roman/Italian villa ideals in urban houses.

Villas expanded into the Mediterranean and became naturalized in the newly annexed provinces. While the conquest of Africa in the mid-second century CE was Rome's great military achievement, the almost-simultaneous annexation of Greece (with the defeat of the Greek Confederacy and the destruction of Corinth in 146 BCE) was a cultural triumph. Works of art in vast quantities went from Greece to

Rome as spoils of war, but despite its relatively small economic importance, Greece lodged in Roman conceptions as the capital of culture, art, and the sciences. The Greek countryside was easily adaptable to Roman villas, and Maria Papaioannou's contribution (Chapter 19) shows how the existing infrastructure of roads and towns incubated, then supported, a new spread of villas. Her district-by-district account of Roman villas in the Greek peninsula provides a survey comparable to Wilson's account of North African villas, to our knowledge not heretofore available. In addition, with ingenious generosity, she presents the main outlines of the villas of Herodes Atticus, a grandee of the later second century CE and a friend of emperors: He imported to Greece the contexts and even some of the contents of imperial and grand private dwellings more familiar in Rome and Italy.

The Adriatic or Dalmatian coast opposite Italy, from Istria to Epirus, was brought into the Roman hegemony in the late Republic; unsurprisingly, Roman villas there became numerous. Their development and history is presented by William Bowden (Chapter 20), in what is also a valuable synoptic account of very scattered publications that are difficult, in some cases, to access.

ROMAN VILLAS: LATE ANTIQUITY

Late antique villas from the third through the sixth centuries CE have become important historical and cultural evidence for both the continuous traditions of Roman economic and social structures and their persistence. A contribution by Guy P.R. Métraux (Chapter 21) on various aspects of late antique villas, based in part on literary and archaeological sources and on the structure of sculptural ensembles in Aquitania (Chiragan portraits) and Gallia Belgica (Welschbillig portraits), outlines how they summed up the cultural context they sought to embody.

Along with villas in Aquitania, the most spectacular construction and decoration of Roman villas occurred in late antique Hispania: special consideration is given to that province in Gisela Ripoll's contribution (Chapter 22), which provides the

history of villas in the peninsula as well as report of recent and very important discoveries and interpretations. Besides emulating the Roman prototypes or making variations on them, late antique villas were often iconographically steeped in the classical culture of gods, myths, history, and personalities (mosaic floors and sculptural contents).

As the concentration of estates and the growing grandeur of villas in late antiquity built by competitive patrons willing to deploy money and energy on inventive designs, decoration, and contents, so too did they take on new ideas. At the time, the most widespread new idea was Christianity, and by the fourth century and with the stamp of imperial approval, owners were prompted to add architectural amenities of the Christian cult (*mausolea* with special symbols, chapels) as well as explicit symbols in the mosaic floors of their villas. The Christianization of villas, a notable late development of the Roman form, is the topic of Kimberly Bowes' contribution (Chapter 22): Her examples range throughout the Western Empire, emphasizing both the singularity of regional expressions and their pervasiveness.

ROMAN VILLAS: LATER MANIFESTATIONS

The emulation of the Roman villa in western architectural traditions is a vast topic that cannot be effectively summarized in this book. However, its importance is such that two contributions touching on both mental and material manifestations of villas have been included.

Managing private and public aspects of life is a perennial issue in domestic design: How the king's bedroom generates the *enfilade* of public spaces is a problem for palaces, and it is also a problem for villas and *domus* of *privati*. In fact, the relation of public and private modes was a concern in Roman domestic architecture; even more important, they became and still are design issues. Is a dwelling intended to incubate the private person or to represent him or her? Pierre du Prey's contribution (Chapter 24) shows how Pliny the Younger's preoccupation with procuring privacy in two of his villas

in the face of his *persona* as a public figure was realized both in Pliny's intentions and in much later reconstructions of his privacy and the private/public dilemma. The Roman villa as an instrument of combined private delectation and public instruction is given an archetype in J. Paul Getty's reconstruction of the Villa of the Papyri in a canyon in Malibu, California. Kenneth Lapatin shows us how it worked (Chapter 25). The original villa near Herculaneum, possibly owned by L. Calpurnius Piso Caesoninus, Julius Caesar's father-in-law, was emblematic of the luxury of late Republican Roman elites as well as the repository of a philosophical library. Its emulation, the Getty Villa at Malibu, has developed from being the personal project of a wealthy man into an international, well-funded, and established center for learning about the ancient world, in part on the basis of a repository of Greek and Roman art that was, after all, one of the purposes of Roman villas: great cultural tradition, viability (agricultural in the case of Roman villas, financial in the case of the Getty Villa), and a vigorous exponent of knowledge. Roman villas and their culture are exportable beyond the Mediterranean to the Pacific coast of the United States.

NOTES

1. For definitions, see Leveau 1983, the articles in Magnou-Nortier 1993, and Ursula Rothe in this book (Chapter 2).
2. General histories of Roman villas are few in number. Notable among them are McKay 1975, 100–35, 156–200, 210–37, Percival 1976, Mielsch 1987, 1999, Ackerman 1990, 35–62, Smith 1997, and vol. 2 of Gros 1996; useful compendium of articles in Reutti 1990; Ayoagi and Steingräber 1999; most recently, articles in Ciardiello 2007. Some Roman villas and their tradition are discussed in Bentmann and Müller 1970. Surveys of large geographical regions are also few in number: for the Bay of Naples, D'Arms 1970 (reprint 2003); for central Italy, Marzano 2007; for environs of Rome, De Franceschini 2005 and individual articles in Santillo Frizell and Klynne 2005; for Tibur and Tusculum, Tombrägel 2012 and Castillo Ramírez 2005, respectively; for maritime villas, especially in Italy, Lafon 1981b and 2001. For the Iberian

Peninsula, Gorges 1979; for Aquitania, Balmelle 2001; for Republican villas near Rome, articles and introduction in Becker and Terrenato 2012; for late antique Italy, Sfameni 2006. Rescue excavations in the countryside have also become important: for Gaul, the *Institut national de recherches archéologiques préventives* in its volume for 2005 has accounts of its activities for Roman villas. For villas in northern Gaul, Germania, and Britain see most recently the articles in Roymans and Derks 2011.

3. The evidence of Sicilian villa owners was used by Cicero in his speeches *In Verrem* to document Verres' abuse of his official position.

4. Rossiter 1989; Foss 1976, 47–8, 73–4.

5. D'Arms 1970, 2003; Zarmakoupi 2013.

6. The copying of metropolitan styles in provinces is a theme of empire discussed in Maier 2006, 78–111.

7. The extent to which the alimentary scheme implemented by Trajan was targeted to poor families is controversial; see Jongmann 2002.

8. The impetus for this book came from an international conference in 2008 organized by Thomas Noble Howe (Southwestern University) and Uri Dromi; the latter, director of the Mishkenot Sha'ananim Center in Jerusalem, kindly made the resources and hospitality of the Center and the Konrad Adenauer Conference Center available to the participants; the conference was conceived by Professor Howe in the context of the *Fondazione Restoring Ancient Stabiae* (RAS) project. This book includes contributions from many of the 2008 participants, but since then, the editors have asked numerous others to contribute in order to assure geographical, thematic, and chronological coverage of villas throughout the Roman world in the Mediterranean.

9. The first book on the Oplontis Project has been published as an e-book (Clarke and Muntasser eds. 2014). For other publications generated by the Project see list on the official webpage: www.oplontisproject .org/bibliography/.

10. Zarmakoupi 2014.

11. The sculptures of the Chiragan villa are part of Guy P.R. Métraux's contribution (Chapter 21).

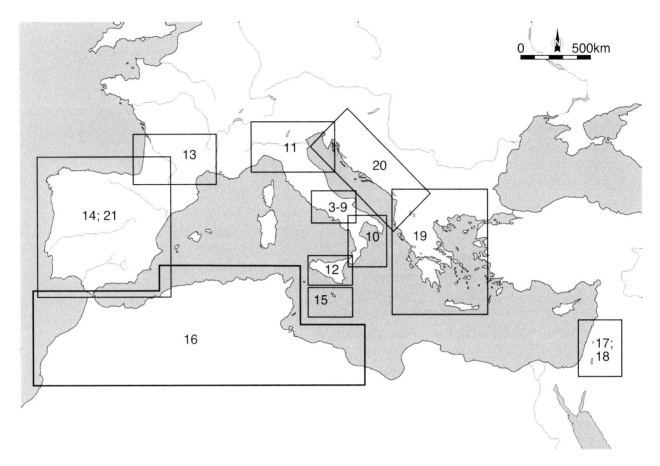

Map 1. Overview of the geographic areas covered in the book, with reference to the maps.

THE ROMAN VILLA: AN OVERVIEW

ANNALISA MARZANO AND GUY P. R. MÉTRAUX

THIS INTRODUCTORY CHAPTER DISCUSSES SOME of the themes pertaining to Roman villas: their relation to urban and rural infrastructures, their relation to urban houses, and how they contributed to Roman imperial expansion economically and socially. Many of the themes we have broached here are taken up in specific detail in the book's contributions. The reader will find further areas of interest for more intensive investigation: prompting such further research is a purpose of this book. The Romans themselves were conscious of villas and commented on them frequently, most especially with regard to their relation to the biographies of great, noble, ignoble, or notable persons, or else their own villas in relation to themselves. For that reason, this introductory chapter includes a very brief section on villas and biographies.

The work of the agronomists is invaluable to understand elite ideology, attitudes toward agriculture and villas, types of production, and so forth, but it is not so helpful when it comes to precise descriptions of the architecture of the villa. Our discussion of the treatises on agriculture in this section is general and limited to how these may have impacted villas and their interpretation.

Another important aspect of villas is their prominence in literature, where they are the venues of praise (*encomia*), subjects of description in poetry and prose (*ekphrasis*), or a means to self-expression and friendly invitation (especially in letters). Again, a very brief section on these topics is included here.

Because this book deals mainly with villa architecture, we have omitted discussion of hardware inventories (tools and farm or transport vehicles), husbandry (herds, flocks, transport animals), and other agricultural methods and techniques. However, slavery in antiquity, especially agricultural slavery, is of great historical importance and a matter of ongoing discussion, so we have outlined some of its historiography. We have had to limit ourselves to discussion of how the interpretation of slavery relates to the interpretation of certain villas and certain architectural features: The issue is broad and not completely resolved, and while villas certainly housed slaves, discerning their presence and determining with precision the role played by slave labor and free labor on agricultural estates continue to be challenges.

Finally, because this book includes – as it must – some aspects of the later history of Roman villas, we have summarized in a rapid fire way the main characteristics of the persistence of the phenomenon as it inflected villa architecture, life, and culture in later Western architectural and social history; the topic is vast and is merely outlined by us with a few references.

ROMAN VILLAS AND RURAL AND COASTAL INFRASTRUCTURES

Amenities such as roads, aqueducts, bridges, warehouses (*horrea*, sing. *horreum*), jetties, and port facilities

on rivers or the sea passed through rural landscapes and along coasts to connect urban centers with one another: They also connected villas with other villas and villas with towns and markets overseas. Shipbuilding itself in various shapes and tonnage (from rowboats to sea-going vessels) was strongly developed in antiquity.[1] These physical expressions of Roman infrastructure were accompanied by spatial organization: regions in which land was surveyed and subdivided into agricultural units (centuriation) in different ranges of size or local practices, often with standardized definitions of property types (farm, forest, pasturage) and valuation for taxation or other purposes, had been effected by Greek colonial *poleis* but became a distinctively Roman practice.[2] In its origins, the intention of such building activity and spatial arrangements may well have been military, namely as means to establish a sustainable Roman hegemony over great distances and to provide viable plots of agricultural land for veteran soldiers, the citizens of newly established towns, or newly colonized existing urban centers, some in Italy, many overseas. The new infrastructures ultimately allowed several cities to grow beyond the constraints of their immediate hinterland; facilitated travel of all kinds; bolstered private, official, and commercial communications; enhanced transport of agricultural and manufactured goods, including raw or partially prepared materials such as timber and marble; and, ideally, fostered stable rural and urban populations. As a result, cities flourished wherever Rome laid down its solid and spatial manifestations, in a seemingly never-ending process of conquest and, later, of continual expansion of colonial and municipal rights and responsibilities to new provinces. Conquest, construction, and coordination of urban centers with rural space and production were the means by which the Republican empire grew beyond Italy in the second century BCE, and these were the premier devices of the expanding imperial system later on. Proud cities and towns came to be no less a Roman phenomenon than they had been for the Greeks, and the success of urban centers in turn prompted further expansion of infrastructures by municipal, provincial, and imperial authorities.

VILLAS, URBAN ARCHITECTURAL TYPOLOGIES, AND ROMAN ECONOMIC EXPANSION

Roman architectural forms – the most famous ones, at least – are associated with towns and cities. Their components were for specific institutions: *fana* or temples, big and small, in various architectural orders and plans, for local or Latin gods and later for the imperial cult; *fora* for commerce and assembly; *basilicae* for law-courts and places for the exchange of commercial information; *curiae* for the meetings of city-councils; *macella* (sing. *macellum*) or market-buildings for shopping and goods-exchange; fountains, sewers, and latrines for urban hygiene; large or small (public or private) baths (*balnea, thermae*) for sociable relaxation and personal hygiene in grand or intimate venues; theaters, amphitheaters, and music buildings (*odea*, sing. *odeon*) for entertainment; paved roadways for urban convenience; ceremonial streets for processions and semi-sheltered pedestrian traffic; arches for commemoration; and fortifications and camps for military deployment. The architectural forms could be very specific (*basilicae*, for example, usually required a dais for the magistrate to set up his chair and *macella* might have a fountain for washing goods for sale, building clean-up, and hygiene). However, the architectural language used – columns in various orders, porticoes, pilasters, ceremoniously decorated doors, and so on – could be readily swapped among different kinds of buildings. Such buildings and the institutional entities they housed and promoted were essential to Roman presence: places of assembly, points of trade and commerce, government officialdom, bureaucracy, some standardization of languages and laws, permanent or periodic military presence, universal taxation, and civic and business organizations. These physical and institutional components were among the distinctive contributions of the later Roman Republic when, starting in the second century BCE, Rome established an empire in the Mediterranean basin in Hispania, North Africa, Greece, and Asia Minor and, later, in Gaul, Germany, and Britain. All were intensified, multiplied, and expanded geographically

and architecturally with the unification of powers in the imperial period, which began with the principate of Augustus (after 29 BCE) and continued for some five centuries through the late antique period (later third through the fifth century) until the ultimate and definitive "loss" of the Latin-speaking Western provinces of the empire, namely in the late sixth century CE.

Urban houses – *domus* – were also essential components of Roman architectural forms, in part because houses themselves became bearers of meaning and movement, a signifier of and for the family and its inhabitants. Their importance was not reserved for the elites. The urban houses of Pompeii, Herculaneum, Cosa, and Ostia could be grand or very simple, but even the simplest ones had touches of amenities: one room with a pretty mosaic floor, a decorated door, a small garden. For the upper classes, the *domus* (pl. *domus*) was, throughout the empire, the main shelter for private citizens within a *familia* (an immediate family and its extensions together with servants, slaves, and *liberti*, these last being manumitted slaves under continuing obligation to their former masters). As such, *domus* could be very grand affairs, sometimes in sober old-fashioned décors and honorific objects (wreaths, statues, inscriptions) proclaiming the antiquity of a family, at other times in up-to-date modern styles advertising wealth and fashionability. *Domus* were venues of public representation and political transaction between an incumbent head of the family (*paterfamilias*) and/or his wife (*matrona, domina*) and the incumbent's supporters and adherents (*clientes*) in a strong system of social relations known as clientage as it developed in the mid- and late Republic and was maintained, in varying ways, during the empire.[3]

Villas were also bearers of distinctively Roman meaning. They were venues of social interaction as well as centers of profitable activity – in all its meanings – in the countryside or the littorals. Like the *domus*, they were sites of personal and political hospitality of all kinds, places of retreat, pleasure, and even learning, but most often justified by their productive capacity in the way of agriculture or other lucrative endeavors. Pliny the Younger commented that he had a full granary (*horreum plenum*) at one villa

and a full bookcase (*scrinium*) at another, the villas being profitable agriculturally and productive intellectually.[4] The expansion of villas into the Mediterranean was an important aspect of Roman economic presence and organization to supply food for cities, government, and armies, but with their proliferation came a social and cultural sharing of values that bound the elites of the empire into a recognizably Roman society. And while villas could be expressions of sophisticated wealth and cultural achievement, they could also provide a backdrop of rustic wholesomeness (either real or affected) and traditional values based in ancient morality.

With these assets and advantages, villas unsurprisingly came to dominate the Roman countryside and coasts. Strabo (late first century BCE) noticed that villas were increasing in number and changing the aspect of the landscape: of the coastline on the Bay of Naples, he said that their solid walls made it look like a city.[5] A century later, Pliny remarked on the view of villas from his own villa at Laurentum, just south of Ostia, that it had "the aspect of many cities."[6] This repletion of the coasts and the countryside of Italy with villas corresponded to the fully domesticated environment of the peninsula by Varro's day in the 30s BCE: Varro comments that all Italy resembled a huge single orchard.[7]

What was good for urban centers was good for villas. The Roman Mediterranean was largely an agricultural entity of villas and their estates with strong physical, transportation, and monetary infrastructures that facilitated seaborne and land transport commerce for several centuries and over fairly long distances.[8] Villas depended on this. Consistent, diverse, quickly transportable production of food on well-capitalized and prudently developed farms is the normal expectation of all manuals describing villas and their agricultural estates, from Cato in the second century BCE to that of Palladius in the late fourth to early fifth century CE. Producing raw agricultural materials (mainly wheat or other grains) to satisfy merely local subsistence needs had long been bypassed: Instead, villas shipped ready-to-store grains for local milling or processing elsewhere as well as other produce, in addition to providing commercial

brokers with processed agricultural goods with a longer shelf-life – notably wine, olive oil, table-ready olives, various preserved or pickled fruits and vegetables, salted fish and fish sauces (*garum, allec/hallec, liquamen*) – which could be graded and traded, often through middlemen, off the agricultural estates themselves and away from the villas. Pliny the Younger, for instance, sold his grapes on the vine in advance of harvest time, thus leaving to the buyers (*negotiatores*) the harvesting, processing, transport, and the risk of possible crop failure due to bad weather or pests.[9]

Villa owners needed a place to sell their produce, either in fixed town or urban locations equipped, in some cases, with convenient, sometimes impressive permanent market buildings or in periodic market days organized regionally called *nundinae*.[10] Known cases of villa owners organizing periodic markets on their villa estates included the future emperor Claudius himself, the ex-praetor Bellicius Sollers (a contemporary of Pliny the Younger), and the senator Lucilius Africanus, this last authorized by decree of the senate, in 138 CE, to have a market on his African estate.[11] Significantly, Lucilius Africanus' property was in *regione / Beguensi territorio Musulumianorum* in Byzacena (el-Bejar), that is to say, in the modern Kasserine region of Tunisia, where abundant archaeological evidence for intensive olive cultivation, and possibly wine production, exists in the form of many Roman rural sites equipped with multiple presses.[12] This was one of the regions whence olive oil was exported to Rome and other areas of the empire, and the trade in these staples was important to the food supply in both the open market and the government-subsidized distribution systems. Earlier, Sollers may have been organizing a market on his estate to attract brokers or government agents and thereby establish a price for his product.[13] In any case, owners of villas and farms were at all times in competition with one another and anxious to get their produce off the villa estate and on its way to get the best possible prices at markets, auctions, and/or from brokers.

Fresh and longer shelf-life produce were also concerns. Assuring food supplies both locally and in Mediterranean-wide markets animated the productivity of rural estates for fresh comestibles of all kinds, storable commodities such as grains and flax, meat (mammalian, avian, and piscatorial, fresh and salted) from husbandry, hunting, fishing, and finished products like olive oil, wine, fish/fish-sauce, and tanned or untanned hides. If they were in a good locations near cities or towns, villas produced seasonal goods with a short shelf-life called *pastiones villaticae* (sing. *pastio villatica*) for choosy urban gourmets or great private or public feasts, but also for ordinary but demanding urban consumers. *Pastio villatica* included perishable fruits, meats, game-birds, fish and shellfish, honey, even flowers and plants. Such goods could be a source of considerable revenue from villa agriculture.[14]

Other urban needs were fulfilled by villas and estates. Depending on their location and what the estate offered (clay beds, stone quarries, woods), villas often produced bricks and roof-tiles, amphorae, timber, charcoal, barrels for transporting goods, bins, and other useful things essential to the local economies and the new Roman economy of the Mediterranean. These products required all the infrastructures that cities and towns – and for that matter, the military – also required: roads, bridges, and so on, as well as such special interventions (often imperial) as irrigation systems and draining of marshes. Assuring, implanting, and expanding the productivity and animation of inland and coastal landscapes were important economic functions in the Roman Mediterranean, and villas were one of their means. Villas and their estates also dominated and came to clarify the countryside, making it comprehensible and meaningful – these are issues to which we will return in several different ways.

VILLAS IN OFFICIAL LANDSCAPES: CENTURIATION, DISTRIBUTION, AND THE *ALIMENTA*

Villas existed in landscapes, and Roman landscapes were conditioned by being subjected to official organization. Such supervision most often took two forms: the first was centuriation, a series of physical

and legal acts that defined agricultural land in terms of measurable standard units and in view of its character (marginal, hilly, marsh-land, woods, and so on) and catalogued it in recordable form for administration by local authorities. A second specific measure was the *alimenta Italiae*, a scheme apparently devised by the emperor Nerva but implemented by his successor Trajan in the second century CE. This was a means of local charity, paid for with a perpetual obligation incurred by (or on) local owners of estates in Italy. The scheme was as follows: to local municipal authorities, the imperial *fiscus* sent a certain sum to be disbursed as loans to Italian proprietors, with the annual interest payments on the loan principals used for the monthly maintenance of local children, especially boys. Various similar private schemes, which took their cue from this imperial initiative, are attested epigraphically in Italy and the provinces.[15] One such famous case is the scheme devised by Pliny the Younger in support of freeborn children in his hometown, Comum.[16] Because the *alimenta* were limited to Italy (perhaps not in all regions of the peninsula) and the length of their existence is uncertain, we omit discussion here.

A third condition of the landscape affecting villas and estates was certainly the distribution of settlement and habitation in relation to the local topography, proximity to rivers, roads, sources of water and irrigation, towns and cities, and many other variables. Modern exploration in the form of aerial and field surveys – for the most part noninvasive – have contributed mightily to our knowledge of villas and the rural landscape, and below we give a very brief account of ongoing Mediterranean-wide projects.

CENTURIATION

Agricultural production of all kinds was the principal generator of wealth – small, middling, and large – in Greek and Roman antiquity. In consequence, the structure of the productive landscape came to be a matter of official cognizance and technical intervention, associated with the *ager publicus* or "public land" made available to Roman citizens in annexed regions beyond the City itself or its immediate territory.[17] These lands were reorganized with new surveying, along Roman lines, of territories adjacent to, and administratively dependent on, newly conquered old towns or else newly founded urban centers. In part, the purpose of such surveying was to define parcels to be awarded to soldiers upon demobilization or to attract settlers to newly formed colonies or new drafts of citizens to existing towns, both in Italy and elsewhere. The award of agricultural land became an important aspect of late Republican politics.

The acts of mensuration were very well developed technically, capable of both universal uniformity of application and flexibility vis-à-vis special circumstances of topography and local land practices. It was applied in Italy, Gaul, Hispania, Greece, and Africa; its application elsewhere is less certain, and it may have been flexibly applied, or not applied at all, to respect and accommodate local practices. Trained personnel called *agrimensores* ("land-measurers") were developed together with specialized handbooks and mechanical devices for sighting, finding true north, and estimating heights.[18] The result was a system of physical divisions of agricultural land in more-or-less equal, measurable, cataloguable, and registerable units reducible to valuation for tax estimates (for land outside Italy) or commercial sale prices. Once established, the divisions could be assembled in municipal lists of properties called cadasters for administrative purposes. The act of divisioning itself was termed *centuratio* (sometimes also *limitatio*), from an original delimiting into square "centuries" corresponding to an old assemblage of 100 individual properties (*heredia*, sing. *heredium*), each *heredium* (consisting of 2 *iugera* or c. ½ ha or 1.3 acres) capable, in theory and antique tradition, of sustaining a nuclear farming family. In practice even quite small farms were much larger (18–20 *iugera* or more = 4½ –5 ha = 12–14 acres), and medium-sized farms at some 100–250 *iugera* (50–125 ha = 130–325 acres).[19] The centuriation units developed in size and layout according to local needs, but usually toward larger defined plots of agricultural land. Ultimately, by the late second century BCE, official grants in

units of 500 *iugera* (250 ha or 650 acres, quite ample at any historical period) were offered to Roman citizens willing to take up residence overseas in the environs of Carthage.[20]

How centuriation related to villas is not certain, because by the second century BCE or later, when villas clearly surface in the archaeological and written historical record, the amalgamation of originally separate smaller properties may already have occurred, and the neat divisions of agricultural land intended for distribution to farming families had been bypassed. It may well be that the proliferation of villas actually disturbed or overthrew the original intention and purpose of the *centuriatio*. For that reason, the technical issues of centuriation need not occupy us here. Rather, their discovery in quite disparate parts of the empire is part of the recordable expansion of Roman hegemony and thus of the villas that eventually occupied the surveyed territories.

Archaeologists become enthusiastic when traditional and new disciplines coincide and mutually confirm one another: the discovery of centuriation is an example. Its existence and processes had been known from the texts of the *agrimensores* and from certain inscriptions that seemed to be lists of local properties; historical land divisions could also be inferred as the underpinnings of existing divisions from modern large-scale maps that seemed to show a ghostly divisioning underlying visible land features and delimitations of more recent date.[21]

However, the discovery of centuriation is one of the most exciting stories of modern archaeological investigation by technical means. In the late 1940s and 1950s, aerial photography from low-flying military, map-making, or tourist aircrafts began to register what seemed to be man-made interventions on natural or agriculturally developed land in rural or suburban areas.[22] Among many others, these could be in the form of topographical discontinuities (buried remains of walls and terraces invisible at ground level), hydrological anomalies (e.g., ruined cisterns retaining some water), and color or height variations in modern monocultural planting due to subsurface structures. For centuriation, the foot-worn tracks between surveyed fields could appear strikingly

visible, as could the low earth ridges and/or ditches defining units of the divisions. Substantial structures including villas, but also rural temples and other buildings, could be revealed. The results of aerial photography were clinched early on by epigraphic evidence, most specifically in the cadastral lists, inscribed in 77 CE on marble slabs, of properties in the region of Arausio (mod. Orange) in Gallia Narbonensis.[23] This had been a *colonia* or newly founded town set up for veterans of the *Legio* II *Gallica*, and the regular divisioning and apportionment described in the inscriptions coincided with the design of field boundaries revealed by aerial photography.

The discovery of centuriation patterns has resulted in significant new understandings of Roman territorial expansion – and therefore proliferation of villas – in the western provinces and Africa. The analysis of rural space as *Roman* space has proved fruitful for both local phenomena and for imperial history; Monique Clavel-Lévêque is a significant exponent, as is Emilio Gabba.[24] Methodological considerations began early and are ongoing.[25] Other noninvasive geophysical methods for archaeology were developed in early form around the same time as aerial photography, also to the advantage of documenting Roman villas and with ongoing refinements of technique and results.[26] In recent years, the most notable new noninvasive techniques that are greatly contributing to archaeological mapping and planning of field campaigns are LIDAR (= light detection and ranging) and remotely operated cameras on drones.[27] The former has the ability to detect man-made structures (or micro-topographical features) even under very dense forest canopy; the latter allows the capture of low altitude images (even using a heat-sensing camera) much more quickly and cheaply than in traditional aerial photography.

FIELD SURVEYS: DISTRIBUTION OF VILLAS IN LANDSCAPES

Where are villas in their landscapes? What kind were they? How were they related geographically to other rural structures such as villas (clustering for reasons

beyond the impetus for social proximity), means of irrigation, and means of transport and access (roads, rivers, and coastlines)? What did they replace, and what replaced them? These are the questions that can often be addressed (if not completely answered) by modern techniques of field survey. Like centuriation in aerial photographs, field surveys can be large scale. They can be reduced to maps keyed with symbols for the various man-made and natural phenomena to reveal patterns not fully visible on the ground. However, centuriation maps and field survey maps differ: Centuriation maps show the traces of administrative structures over large areas, while field-survey maps show how ancient societies distributed themselves – people, structures, and resources – in the landscape, sometimes in territories, sometimes in minute areas. Field surveys have contributed greatly to the knowledge of the ancient territory and gathered a large amount of archaeological data on rural settlement patterns and chronological trends. Over large areas, the landscape presents itself as a palimpsest, natural, then by man-made elements written on it, erased, and overwritten many times with interventions of all kinds. In consequence, field-survey results can be presented both in historical layers and as types of presences (farms, villas, cisterns, roads, and so on) when the visible remains are datable or identifiable. The effectiveness of field survey as an investigative tool depends on the type of terrain: Relying on teams of people walking through transects at regular intervals and noting what is visible on the ground, it is most effective in plowed fields and less so in areas with dense vegetation. The ability to date the use of a given location with some degree of precision depends on the recovery of diagnostic finds, most notably pottery sherds, which are both durable and common in the archaeological record.

Of course, villas are by no means the principal topic of field surveys, because the landscape is a chronological overlay of phenomena: Surveys can go from prehistoric times to the present. Still, the first case of an intensive and large-scale survey conducted in the Mediterranean regions did, in fact, prioritize villas in its results, mainly because it was undertaken in the *ager Veientanus* north and east of Rome, a region rife with ancient farms and villas.

The South Etruria Survey, directed by J.B. Ward-Perkins from the 1950s to the 1970s, was and became a milestone in Mediterranean archaeology.[28] In field surveys, tell-tale signs can both reveal villa sites and differentiate them as to type, date, and even social status. For example, a spread of *tesserae* for mosaic floors in association with certain types of fine pottery can denote a villa of some decorative pretension and therefore higher status, whereas fragments of lesser-quality floors and crude pottery may indicate a farm and even a date.[29] In combination, a residential part (*pars urbana*), namely a residence with some claim to comfort or even luxury, and a service quarter (*pars rustica*), namely an agricultural section devoted to farm processes, can be inferred. In turn, even small traces of masonry are datable and give evidence of Roman rural presences at various times; sporadic finds of inscriptions or hardened tracks and road pavements can make connections among settlements both chronologically and geographically. The reach of such material in relation to the hydrography and proximity of villas to landscape and habitation centers can establish when and why villas were built and what their sustainable existence might have been. The processes of field survey are, in principle, non-invasive, but they can also locate important sites for excavation or preservation.[30]

VILLAS IN AGRICULTURAL TREATISES AND IN VITRUVIUS

In discussing rural domestic architecture, writers on agriculture as well as Vitruvius had something to say about villas, but only something. Agricultural treatises were an important literary and practical genre in Latin literature, and its practitioners (except for Cato) combined the authority of previous Greek and Punic writers as well as earlier or contemporary authors with their own knowledge. For that reason, Latin agricultural treatises preserve, in ways that often seem adapted to Italy or, at least, to the southern parts of the northern Mediterranean coasts, an international culture of agriculture from at least the time of Theophrastus, the successor to Aristotle in the philosophical school of the Lyceum at Athens in

the fourth century BCE. Most of the very numerous works on agriculture (some very specialized as to geography and topic) from Greek, Punic, and even Roman antiquity have not survived, but four Latin treatises spanning some six centuries are extant, namely:[31]

1. The *De Agricultura* of Cato (Marcus Porcius Cato, 234–149 BCE, whose treatise appeared in the mid-second century BCE),
2. The *De Re Rustica* of Varro (Marcus Terentius Varro, 116–27 BCE, who published his treatise in 37 BCE when he was in his 81st year),
3. The *De Re Rustica* of Columella (Lucius Junius Moderatus Columella, c. 4–70 CE, whose book was written mid-first century CE and published with an earlier treatise on trees, *De Arboribus*), and
4. The *De Re Rustica* (also called the *Opus Agriculturae*) of Palladius (Rutilius Taurus Aemilianus Palladius, *fl.* Late fourth–early fifth century CE, with a similar date for his treatise; the treatise includes a book on veterinary medicine in sheep and a book [*De Insitione*], in verse, on grafting for stable product and optimum harvest).

To the agricultural treatises can be added:

5. The *De Architectura* (book 6.6–7) of Vitruvius (Vitruvius Pollio, *fl.* late first century BCE, with a dedication to Augustus as emperor, therefore after 27 BCE), in which the author, a military and civil architect, discussed some characteristics of rural dwellings in relation to urban *domus* in very abbreviated form, with a longer section on the *villa rustica* and its utilitarian buildings.

The authors of the Latin agricultural treatises borrowed from earlier ones or from other sources, except for Cato, who cited no earlier or contemporary authorities and appears to have relied on his own experience. Still, Cato became the touchstone for later agricultural writers and apparently an impetus for others whose works have not survived.[32] The advice he gave to an owner (whom he calls *pater familias* and whom he assumes is an absentee landlord but one intimately involved with the operation of the property) was continuously cited for six centuries by later authors despite his haphazard and disorganized presentation in twelve books and some

162 sections. The authority of Cato's text may come from the fact that his is a very early example of a prose book in Latin as well as his reputation, long after his death, as the cynosure of traditional values and antique achievement, the embodiment of the *mos maiorum*. Cato speaks at some length about crops, vine- and olive-cultivation and processing, as well as giving contract language, prayers, and recipes. Other topics – specifically about the villa itself – are telegraphically conveyed: selection of soil types, general location of the farm (at the foot of a hill and facing south, near a town for markets, nearby water for irrigation, available manpower, and close to a river, the sea, or a reliable road for transport).[33] A tabulation of building costs (whether for the residential part or the farm is not certain) is also included.[34] That's about it. Almost nothing is said about the villa itself, neither the dwelling for the *pater familias*, his relatives, and guests, nor the facilities for the personnel, beyond two economical but cursory prescriptions: "When you build, seek not [to build] the villa less than the farm, nor the farm less than the villa,"[35] and a vague recommendation to build a good *villa urbana* so the owner will want to visit it and keep an eye on the farm, thereby mitigating absenteeism.[36] The recommendation may be sarcastically intended, a rebuke to town-dwelling owners of rural properties.

In fact, despite the generosity of their insights, the clarity of their writing, and their evident experience, agricultural writers are quite laconic as regards the architecture of residential villas, and apart from moralistic judgments, there is nothing specific about decoration or contents, either physical or in terms of meaning. Their silence must have been intentional, because by contrast they wrote at length on how *horrea*, stalls for livestock, and presses of various kinds are to be built, and Vitruvius – similarly brief on villas – included detailed instructions on the construction of foundations, *cryptoporticus* (covered or below-grade passages and rooms), terraces, and terrace walls, the architectural elements of the platforms of *basis villae* and other villa structures, but not much on the villas themselves.[37]

The silence is understandable: Treatises on agriculture focus on agriculture, agricultural processes,

and nonresidential farm buildings. Still, Cato, Varro, Columella, and Palladius all assumed that a residential villa for the owner was an essential part of the estate even though their comments on the topic are very limited. Indeed, there may have been a commonplace in elite morality that regarded villas – and especially luxury in villas – as indecent and typical of vile modern attitudes: Tremellius Scrofa, who wrote on agriculture and husbandry in the late first century BCE, remarked sarcastically that present-day owners were more concerned with the orientation and temperature of their summer and winter *dining rooms* than with the best placement of windows in their wine and oil *warehouses*.[38] Scrofa's remark at least shows that owners of villas were concerned – if obtusely and epicenely – with the architecture and comfort of their residences. However, because the agricultural activity at villas was held in the respect that tradition deserved and that recalled ancient simplicity, describing modern grandeur or even comforts such as baths or rooms with pretentious Greek names was avoided, except to mock or excoriate them.

In addition, with very few exceptions, actual financial return on capital or agricultural investment is lacking in much detail in these authors,[39] possibly because talk of money was regarded as vulgar among the elites and thought of as the distinctive mark of freedmen (*liberti*, former slaves liberated by their masters but still considered socially inferior no matter how wealthy or high up in administrative hierarchies).

AGRICULTURAL WRITERS AND ROMAN OR ITALIAN "ANTIQUITIES"

The success of Roman military ventures and the expansion of Rome's Mediterranean power had an effect on both Hellenistic Greek and Latin writers: they began, with some complacency, to define Rome's identity. In the aftermath of the victory over Carthage in the Second Punic War (218–201 BCE), Romans began to ruminate their own history and cultural phenomena (both ancient and contemporary), in part prompted by Greek

historians – notably Timaeus of Tauromenium and Polybius – who had included what we might call anthropological or ethnographic material in their accounts of the expansion of Roman power. Cato, besides his *De Agricultura* and other writings, wrote a long account called *Origines* on the antiquities and traditions of Italian cities with special regard for Rome itself.[40] Cato's treatise on farming was a self-contained compendium combining his experience with what he claimed was traditional practice as well as good tips and recipes for his fellow villa owners, but it came from the same impulse that prompted his recording of antique lore.

A little more than a century later, Varro's *Antiquitates* dealt mainly with Roman lore and ancient curiosities. Its publication was followed by his three books on contemporary agriculture, *De Re Rustica*, written, he tells us, in his 81st year of life (c. 34 BCE). The association between picturesque antiquities of Rome and Italy and current Italian agriculture formed a strong bond. According to these authors, the frugal and moral exemplars of the past found their prolongation into the present by means of farming methods and the morality of farmers themselves, Romans of the old stripe. The connection between farming and the nearly mythical social and moral vigor of the past – in Latin, the *mos maiorum* (literally, the custom of the ancestors) – seemed obvious to them. Cato gives a list: men who are good farmers are brave men and eager soldiers, they are held in respect and make a good livelihood; they are rarely dispirited. The list is, for all practical purposes, the personal characteristics of those who embodied the *mores maiorum* (including Cato himself).

Latin itself – its locutions associated with farming that were still in use – could also be cited as living instance of antique tradition. Varro wrote extensively on the Latin language, the etymology of its words and the derivations of its grammar and syntax. Not a few of his topics concerned the derivation of words from agriculture, and it was no accident that for the word *villa* he claimed an origin in the *movement of produce from and to the production-site*, as follows: the word for the manager of an estate was *vilicus*, related whence and to the place agricultural goods

were transported (*convehuntur fructus et evehuntur*). Simple workers (*rustici*) called cartage roads for produce *veha*, and the place whence and to which produce was conveyed *vella* rather than *villa*, and "to haul produce" was "to do *vela*" (*facere velaturam*). In another passage, Varro bases the family names of the most ancient Romans in the quaint traditions of husbandry (*Porcius* [pig], *Equitius* [horse]) and the branch designations of families from the same: He cites the Annii *Caprae* [goats], Statilii *Tauri* [bulls], Pomponii *Vituli* [oxen].[41] History, agricultural language (ancient and in current usage), and famous ancient names were proof of the antique prestige of agricultural pursuits and, by implication, villas. The priority and superiority of life in the country over city dwelling was a commonplace in Latin literature, and villas were venues to smoothly recreate antique *mores* in modern times.[42]

VILLAS AND THEORY IN THE AGRICULTURAL WRITERS AND VITRUVIUS

Cato's lead in agricultural writing had assumed that owning a villa was a *sine qua non*, a necessity at a certain social status: any discussion of its theory and/or morality except the fact of proprietorship was so obvious as to be otiose. However, later authors targeting different, perhaps more educated but more dispersed readers at other social levels sought to provide a mild theoretical and moral framework with which to give meaning to the agricultural and villa-owning activity.[43]

Setting aside the specifics of its discourses on agriculture, Varro's agricultural manual *De Re Rustica* urges a balanced approach: the usefulness of a villa and its estate (*utilitas*) is primary, but its pleasurable aspect (*voluptas*) is important as well, as much for its own sake as for discouraging absenteeism by the owner (the anxiety about owners' indifference and absenteeism was universally present in Latin agricultural treatises). Then again, frugality in management (*diligentia*) trumps mere luxury (*luxuria*) in villas.[44] Indeed, Varro is critical of excessively lavish villas (*villae urbanae*, mostly located in the immediate

environs of Rome, also called *villae perpolitae*) whose owners disdained agriculture: He considered that their negligence drove up prices of food staples.[45] In his work, which takes the form of an imaginary dialogue between various characters, Varro juxtaposes the "unproductive" (*inutilis* in Latin) villa of Appius Claudius Pulcher, crammed with works of art and not much else, with Quintus Axius' villa, which, while elegant, retained its original function as a unit of agricultural production, including breeding of pigs and horses.[46]

Varro's treatise had the advantage of clarity in describing the deployment of the discrete parts of villas: He distinguishes the categories of space and use, though he does not fully describe them. Thus, his term, like Cato before him, for the residential villa is *pars urbana*). Other buildings devoted to agricultural processes of all kinds are termed the *pars rustica*, and storage facilities, larders, grain bins, and so on are the *pars fructuaria*. These designations entered the language of agricultural manuals and became permanent.

Of course, there were exceptions to frugality in villas: interest by owners in the architecture, decoration, and pleasure of villas was endemic. Freed from the constraints of confined urban real estate and the traditions of *domus*, space and imagination could be fully deployed at villas. Varro himself – the proponent of *utilitas* – is his own prime example. In the third book of his agricultural treatise, he describes a special aviary-dining room connected to the peristyle of his own villa at Casinum (mod. Cassino), south of Rome. Here, the owner and author combined literary *ekphrasis* with design ingenuity and simplicity: With some delight, he describes a garden with two long pools framed by wooden columns on three sides. Netting enclosed the spaces both between the columns and facing the garden to form cages for his collection of birds, and the colonnade continued in a semicircle (also netted for more birds) at the end of the garden. The semicircle framed a circular pool surrounding a ring of columns enclosing a round *triclinium*, the whole complex having devices for convenience and diversion without pretension.[47] Villas could make for originality within a tradition of plain elements (the wooden structures)

and arrangements for hospitality, and the avian collection itself was a sign of both *otium* and the learned pursuits (in this case, zoological) appropriate to villas and their owners.

Columella, picking up and further developing the concepts of Varro's work and repeating the *partes urbanae, rusticae,* and *fructuariae* division, wrote in his agricultural treatise *De Re Rustica* of the importance of equipping the villa with comfortable and well-appointed residential quarters in order to lure the absent landlord to visit his estates on a regular basis. Like Cato and Varro before him, the estate's operations could be entrusted to a trustworthy manager (either a freedman or a slave) to assure the villa's productivity and relieve the absent owner of irksome duties.[48] That is virtually the whole of Columella's remarks on the architecture of rural residences. Such generalities also characterized Palladius' treatise in the late fourth or early fifth century, though his names and analogies for villas and their parts are partially borrowed from military terminology or civic architecture: The *pars urbana* of an estate is called a *praetorium* as if it were the chief officer's headquarters and residence in an army camp, and the disposition of the *cella vinaria* is described by reference to a civil basilica or law court.[49]

Vitruvius, in his *De Architectura*, urged that elegant residential quarters ought not to impede the functionality of the service and production quarters of the agricultural estates themselves.[50] As for all houses, the Vitruvian principle of *decor* (suitability) was applied: The size, decoration, and architectural deployment (including the number and character of rooms) was to be congruent with the social status of their owners and inhabitants. Otherwise, he refers his readers to his preceding account of urban *domus* as a clue to the organization of houses in the country (he calls them *aedificia pseudourbana* or pseudo-urban buildings). The only variation is that, unlike town houses wherein *atria* are in the front of the dwelling, peristyles were the first main space encountered in country houses, with the atrium set to the back of the house amid porticoes and walkways in or overlooking gardens.

The writers on agriculture as well as Vitruvius were providing a framework for thinking about villa *ownership*: Cato's insistence on its traditions, Varro's on its useful antimonies (*utilitas/voluptas*), and all the writers offering vague prescriptions for balance and sobriety in architecture and some disdain for modern luxury and pretension. Actual architecture hardly appears at all in these writers, so the Roman account of villas must depend on other sources.

Villae Rusticae

The relation of the agricultural treatises to actual villas, or at least to the *partes rusticae* of villas, is an important part of how agricultural knowledge and practices were distributed in the Roman economy, both in Italy and throughout the Mediterranean. The most complete account of how one villa embodied (or did not embody) the practices that ultimately came to be outlined in Varro's notion of the *villa perfecta* is that by Andrea Carandini.[51] His account of the Settefinestre villa near Cosa in Etruria, excavated under his direction in the 1970s and 1980s and published in 1985, was strongly supplemented by his outline of how the archaeological discoveries jibed with the agricultural treatises, particularly that of Varro.

However, before the publication of the Settefinestre villa, evidence for *partes rusticae*, at least for Italian villas, in their working, personnel, and practical aspects had already begun with the excavation (1895–9) and publication (1897), by A. Pasqui, of the Villa della Pisanella at Boscoreale, approximately a kilometer north of Pompeii.[52] This was by no means the first villa in Italy to be excavated, nor was it the largest or most luxurious. Rather, it was among the first discovered to comprise a relatively small number of residential rooms (an atrium, a *triclinium*, and a little three-room heated bath building), which comprised only about 20 percent of the area of the villa. The rest of the villa was an impressively large and complete *villa rustica*, containing a wine-making facility with two presses, an olive oil facility, also with pressing equipment and a mill to separate the olive flesh from the pits, a bakery with a grinding machine, stabling for animals, and a *cella vinaria* (a large room with, in this case, eighty-four

large *dolia defossa* or clay jars set into the ground to maintain even temperature), besides other rooms and areas related to the products of the villa.[53] The Villa della Pisanella served as a counterweight, in the way of evidence of agricultural activities, to the more glamorous assemblage of paintings and decorated rooms being excavated in the same years (1894–5) at the villa of P. Fannius Synistor nearby, which had a very small *pars rustica* but a big *pars urbana*. Ultimately, the discovery of other villas with important remains of *partes rusticae* in the vicinity of Pompeii and elsewhere led to an early, prescient, and magisterial study of the Italian productive landscape of villas by M.I. Rostovtzeff (1911) and studies of the Pompeian *villae rusticae* by R.C. Carrington (1931) and J. Day (1932).[54] The first volume (1933) of T. Frank's *An Economic Survey of Ancient Rome* included brief discussions of agricultural economy, and M.I. Rostovtzeff, in his *Social and Economic History of the Roman Empire* of 1926, took up the theme of villas and their productive capacities that he had surveyed in 1911.[55] A broader study for Italy was that of B. Crova, published in 1942, and the original articles (1914–25) of M. Della Corte's account of *domus* and villas of Pompeii.[56] Finally, the connection among agricultural techniques of all kinds (planting, grafting, pressing, and so on), the agricultural writers, and regional landscape histories can be said to culminate with the work of K. D. White, whose prolific studies were summed up in his *Roman Farming* of 1970.[57]

LATIN AGRICULTURAL TREATISES IN LATER MANIFESTATIONS

The persistence of the agricultural treatises (see above, pp. 7–9) in Roman readership through late antiquity presaged their continuation and revival in later times, and while the tenth-century encyclopedia known as *Geoponika*[58] is a compilation of both known and now lost agricultural treatises without specific citation, it attests the continuity of interest in earlier practices. Later, the European rediscovery of the agricultural treatises came to be published in

printed form in the later fifteenth and early sixteenth centuries (e.g., Venice 1472, Bologna 1494, Paris 1512, Venice 1515), in editions more Latinate than practical. Some texts were published singly, but most were groupings of Cato, Varro, Columella, and Palladius with added material from Virgil and other writers, sometimes also with modern treatises on special subjects.[59] Translations followed in the eighteenth century, though these were in French and English, so to whom they were addressed (in view of their impracticality in northern agricultural lands) is not certain.[60]

INSTRUMENTA: EQUIPMENT AND PERSONNEL

Varro, in his book on agriculture, outlines the three categories of *instrumenta* or essential equipment of agricultural estates as follows: *instrumentum mutum* ("non-speaking" tools, by which he means rope, carts, hoes, ploughs, and so on), *instrumentum semivocalis* ("sound-making" tools, meaning animals, both beasts of burden and herded animals), and *instrumentum genus vocale* ("talking hardware" or tools capable of speech, namely slaves or other personnel).[61] His categorization is useful in our discussion of villas because, quite obviously, villas and farms need on-hand inventory and good husbandry techniques. Of course, on-site personnel of all kinds – whether free and hired, bonded in some way, or enslaved – were important as well. Such social differentiation may have inflected the plan of villas, but slavery in agriculture has also inflected the modern interpretation of evidence – archaeological and literary – about them (see pp. 51–2).

To be viable, villas required substantial capital outlay for specialized equipment, animals and their maintenance, and servants and slaves, including managers and household slaves, not just agricultural laborers.[62] Even ships (in the case of maritime villas), together with wagons, mules, skins, and barrels, and all the items needed to transport the produce from the villa by land or sea, were categorized as belonging to an estate; in cases of the sale of properties, they

were by law and precedent included in the transaction.[63] Although agrarian legislation was enacted throughout the late Republic and empire,[64] villas are not addressed directly in the late Roman compilations of laws and legal glosses (the *Theodosian Code*, issued in 438 CE and the *Digest* of Justinian of 530–3 CE) beyond definition of the types of property and ownership conditions to which land was subject. However, the *Digest* contains an impressively long list of legal opinions in the matter of farm equipment (including slaves) at villas and houses undergoing probate for inheritance as well as lists of "servitudes" (obligations permanently attached to certain properties). There was evidently lively litigation about farm equipment and personnel, implying that villas were a matter of jealous attention by litigants and serious concern for judges and legal experts.[65]

Because wealth was, for the most part throughout antiquity, generated from growing and processing agricultural goods, supervision of the villa and its estate was essential – whether by the owner, members of his (or her) family, and associates (including freedmen or slaves).[66] The architectural result of this need for oversight was that some of the social differentiation of urban dwellings came to be reproduced in villas. The superior status of an owner could be reinforced by the villa's *pars urbana* – the residential sector with traditional or innovative plans, fine views and gardens, ancient or up-to-date decorations on floors and walls, and so on – and the inferior status of agricultural workers could be architecturally underscored in the same villa by the *partes rusticae* – separate courtyards, storage facilities, work areas, and simplicity in the spaces and surfaces of the living quarters. In turn, within the villa building itself, the superior and subordinate distinction among the owner, his or her family members, and the *familia* – the assemblage of minor relatives, clients, hangers-on, servants with special functions, outside personnel, and slaves – might well be made. Roman designers were good at making such differentiations both spatially and decoratively, to give order and clear social signage in the house.[67] For very luxurious villas, the transposition of plan and decorative environment from city to country was easy. For lesser ones, the suavities of

the great villas might be harder to achieve. For villas whose owners were ambitious but did not have the means or the command of sophisticated craftsmen to produce the ideal of the perfect villa, their proprietors did as well as they could.

In addition, villas and their economic impact gave structure to the countryside and clarified its political meanings. In 138 or 137 BCE, Tiberius Sempronius Gracchus, a young nobleman in his twenties at the beginning of his career, passed through Etruria north of Rome on his way to take up a military appointment in Hispania. His journey most probably took him along the *via Aurelia Vetus*, the main coastal road begun in 241 BCE to assure military movement north of Rome along the Tyrrhenian Sea. The road had also opened the district to Roman agricultural investors. Perhaps near Cosa in the *ager Cosanus*, where there were many large villas within eyeshot of the road,[68] Tiberius Gracchus observed a relatively new phenomenon: a territory supposedly depopulated of local farmers and free workers, with "barbarian" slaves replacing them to till the soil or tend the flocks on estates perhaps of a size to be called "big farms" (*latifundia*, sing. *latifundium*).[69] Estates like these, it was alleged, had dispossessed and driven out normal farmers (*agricolae*), the owners of small holdings of land settled in the territory as colonists when the town was founded in 273 BCE, some 130 years before. Such men were, it was said, the sturdy backbone of Italian agriculture and also supplied the army with strong recruits.[70] This vision of harsh, rich, arrogant villa owners replacing hardy, independent *agricolae* with slaves – in other words, of innovative but cruel economic efficiency in estate management *versus* old-fashioned family-based farming by citizen-soldiers – gave graphic clarity to Tiberius Gracchus's later political views, a clear example of how to combine a simplifying social narrative with nostalgia for an agrarian past of "simple" farmers, which, though well bypassed, remained dear to the Roman elite. Two centuries later, Pliny the Elder was repeating the same view: "*latifundia* ruined Italy and are doing so now in the provinces."[71] The events of Tiberius Gracchus's career as a politician upholding the rights of poor citizens strongly shaped the later history of

Rome.[72] His political populism was prompted by seeing newly profitable slavery replacing traditional farmers on agricultural estates, but his insight was part of a larger Roman theme: the antinomy between the new and the traditional.

INSTRUMENTA: "TALKING HARDWARE" IN VILLAS

Agricultural labor and its conditions are complex, delicate topics that elicit strong and sharply differing opinions. In Western history and intellectual development, not to say social and political conflict and even hatred, the structures of work in agriculture are matters of very long standing.[73] Discussion had begun already in Greece,[74] and for Roman agricultural personnel, the modern discussions have been large and wide-ranging as well as disputatious (see pp. 15–17).

Slavery, both agricultural and nonagricultural, and the relationship of enslaved personnel to non-slave servants were at all times issues of discussion and contention in Roman history. While general histories of Roman slavery in modern scholarship have not been lacking, and contemporary discussions are ongoing, slavery as an institution is subject to competing theories of society and economic structure that seek to explain important questions of outcomes. None of the questions about slavery in the Roman economy are abstract ones: the issues they address must have manifested themselves tangibly and even day-by-day in Roman villas. We can formulate some of these questions (among many others and more subtle ones) as follows:

Was slavery inevitable in the expanding Roman economy, especially in the agricultural economy in the second century BCE? Was it optimally efficient? Who were its main beneficiaries? Was it the cause of economic vulnerability and thus later decline? Is slavery a form of capital and thus subject to Marxist interpretations? What are the reciprocal effects of slavery on slaves themselves and their owners?

To be sure, different but often overlapping answers to these questions have been proposed in a scholarly literature that is very extensive; discussions begun already in the 1890s, 1960s, and 1970s are under lively revision and analysis.

ROMAN SLAVERY IN MODERN AND CONTEMPORARY SCHOLARSHIP

Simplistic contrasts between ideologies and views – for example, Marxist or non-Marxist, or emphasis on cruel exploitation *versus* melioristic interpretation of the evidence – are not adequate to summarize the contemporary scholarship on Roman slavery.[75] However, within a broad spectrum, antinomy between, on the one hand, the work of Joseph Vogt and that of his students and colleagues and, on the other, the insights of Moses I. Finley have resulted in somewhat clearer classification of some of the issues.[76] The focus of this book is on material evidence of Roman villas, not on how slaves were incorporated in them. While the means by which agricultural work was effected on estates remains an important topic, there are continuing developments in interpretation that are outlined in this section. Identifying slaves both spatially in architecture and in figural representation remains a task for ongoing scholarship.

An internationally based and periodically extended bibliography on slavery begun by Joseph Vogt in the *Akademie der Wissenschaften und der Literatur* of Mainz University is ongoing,[77] and an image archive of slaves with protocols for identifying them has also been established.[78] The more recent publication edited by H. Heinen of a glossary – literary, legal, epigraphic – on slavery is now essential to the topic.[79]

Following Rostovtzeff's lead in illustrating what might well have been the activities of slaves (see pp. 15–18), many scholars have bravely attempted to identify slaves, in some cases as types in terms of figural representation, in other cases in terms of their spatial presence in domestic and/or urban architecture. A bank of images has been put in train. However, on the topic of identifying images of slaves and servile spaces, few scholars have been as

assiduous or successful as Michele George, Sandra Joshel, and Lauren Petersen, who have undertaken an archaeological detection of slave spaces in Roman villas and houses.[80]

ROMAN AGRICULTURAL PERSONNEL IN MODERN INTERPRETATION

Villas were also farms, and farming is work. Work is subject to theories in larger social and economic contexts. The conditions of agricultural work were and are a real, persistent problem as well as a fundamental element in Western social thought from Greek times to the present. Agrarian legislation has been exhaustively studied.[81] The issues are numerous and important, both in real situations and in interpretive contexts, perhaps none so fraught as that of the relation between slavery and free labor, as the example of Tiberius Gracchus and his observation of slave gangs and the dispossession of traditional farmers in the *ager Cosanus* illustrates (see p. 13). Even the account of what Tiberius Gracchus actually saw and how he interpreted it has been challenged.[82] Though the historiography of this topic began much earlier, modern discussion of slave and free personnel in Roman agriculture began about a century ago, in the 1920s.

For our purposes regarding villas, there are numerous themes. Respected traditions of work and social usefulness were enshrined in Roman consciousness about the citizen-farmer, but there was another tradition: that of concern about the asymmetries of deployment of manpower in its many forms (slavery, free citizen farmers, various types of tenancy). Modern interpretations of these asymmetries have been even more subject to discussion. In addition, issues of ownership – in its crudest form, attributing a specific property to a specific owner, but in its more refined form establishing the class, family affiliation and history, and income-level of a villa's owner and thus his relation to the workers on his properties – have also come into play. In these matters, the evidence about villas, either in literary or historical forms or from archaeological investigation, has colored

interpretations in ways that have been congruent or conflicting.[83]

As in the decades before and after the French Revolution, problems of agricultural exploitation and personnel became a concern in history writing just before and after the First World War. Why this should have been so may have been due to various pressures: The causes and effects of the 1914–1918 conflicts in Europe and its political repercussions were certainly a factor, in that a new understanding of historical causation (beyond dynastic and national analyses or ideological analyses on the political right or left) was needed. Socialist/Marxist or socially based analyses of historical phenomena came into play for Roman history. Inevitably, such studies revolved around the working personnel of rural estates, slave and citizen, and the discussion continues to this day.

Decisive in this area of study is that of M.I. Rostovtzeff, in his article of 1911 but especially in his *Social and Economic History of the Roman Empire* of 1926. This study dramatized the coexistence and conflict of social classes (including slaves) from the late Republic to late antiquity, using a language that specified the competitive and incompatible interests of the classes as an impetus for change in Roman history. Rostovtzeff's achievement was decisive in another way for villas: He *illustrated*, and later editions of his work illustrated even more abundantly, in attractive black-and-white photographs that gave authenticity and actuality to the text. His was also among the first books to show pictures of ordinary and "daily life" objects (admittedly only a few from villa sites) to enhance and extend the discussion of historical texts and inscriptions and thus to make a marriage of literary, epigraphical, and archaeological resources. His lead gave rise to a whole genre of later "daily life" presentations that have become commonplace in history writing both professional and popular.[84] The distinctly contemporary language and lively presentation in Rostovtzeff's study gave it authority and immediate appeal, attested by its numerous translations and updated revisions. Previous to Rostovtzeff's work, the issue of personnel (in agricultural enterprise, in the army,

and elsewhere) had been a subject (in 1927) of Ferdinand Lot's speculation on the "decline" of the Roman Empire.[85] Both Lot and Rostovtzeff were following, specifying, and questioning the tradition of documenting "decline" begun by Edward Gibbon's *The History of the Decline and Fall of the Roman Empire* (1776–1788).

W.E. Heitland's *Agricola* of 1921 benefitted from Rostovtzeff's earlier study (1911) of the colonate or agricultural tenants (*coloni*, sing. *colonus*, which could mean farmer in a general way or tenant-farmer) who enjoyed free status but might be bound by various obligations and restrictions and whose fortunes and conditions changed considerably from the late Republic through late antiquity.[86] Heitland set up the issue of slave and free personnel in agriculture directly, noting that, despite the contradictory claims in Latin written sources, the parallel and overlapping existence of both forms of working personnel were the norm, though the relative proportions of free to slave labor could vary. To what degree they varied at specific times and places, he could not accurately tell except to note that there must have been adaptation of the proportion of working personnel (free to slave) to different landscapes and different historical conditions (competition from overseas, concentration of estates, new forms of tenancy).[87]

The sensitivities of scholars about the use of slaves in agriculture was perhaps exacerbated by eighteenth- and nineteenth-century anti-slavery movements, namely when, especially in the Americas, slavery had become in large part agricultural and breeding slaves to produce more slaves had been normalized as a social practice and in legislation upheld by the courts. For the ancient world, slavery was a far more nuanced proposition, and M.I. Finley's essay outlining the individuals, notable for their variety of occupations and status, who were slaves, had recent slave ancestors, or were freedmen is but one example of scholars emphasizing these subtleties.[88] For villas and agricultural estates, the extremely varied status and training of specialized slaves has been usefully tabulated with literary and legal references by K.D. White as well as the complex issues surrounding the money that slaves could amass

toward paying for their freedom (*peculium*; there were other paths toward manumission).[89]

SLAVES IN VILLAS

Issues about slavery have entered the interpretation of archaeologically excavated villas, for the most part Italian villas because they are best known, and villas of the late Republic and early empire because they are abundant and, in some cases, well-preserved. While slaves, as we have seen in the Latin agricultural treatises, were essential components in the operation of agricultural estates, slavery has sometimes been used as a lens by which to interpret archaeological data, thus reinforcing images of social oppression and economic cruelty (including the dispossession of free farmers) in excavated villa sites.

The tradition of slave-based agricultural work on *latifundia* and the consequent dispossession of free farmers has a distinguished and nuanced historiography; it forms the basis of analyses by L. Perelli (1982) who discounts an extreme view, and earlier by A.H. Bernstein (1978) and D. Stockton (1979), with the issue of army recruitment from age-pools [17–25 years] in the free rural population studied by Y. Shochat (1980).[90] These studies in general assume that big slave-based farms with villas came to dominate Italian agriculture in the second century BCE and after. As we will see (pp. 17–18), the tradition colored the interpretation of the Settefinestre villa by Carandini.[91]

However, the assumptions of these studies have been modified toward a much less drastic interpretation (which also drastically minimizes the physical incidence of *latifundia* and emphasizes the continuation of small farms owned and operated by free farmers). Among others, K. Bringmann (1985) challenged the assumption that small farms operated by free personnel had been ousted by big enterprises; his view has been taken up most recently by A. Marzano (2007), S.T. Roselaar (2010), and A. Launaro (2011), in part following the view taken by D.W. Rathbone (1981 and 1983) favoring a *parallel* existence of smaller/free and larger/slave agricultural enterprises in central Italy rather than

a violent social opposition between them.[92] In that respect, the interpretation of free and slave labor in villas has returned to Heitland's views of 1921, of their parallel and overlapping structures.[93]

SLAVES IN VILLA SPACES

As regards the interpretation of villas, agricultural workers (no matter what their status) who lived outside the architectural confines of villa compounds are, of course, hard to discern. In luxurious villas with large spaces specifically allocated to household slaves or servants, servile quarters and passageways can sometimes be marked visually with certain patterns and colors to provide social signage, and such signage may have been for nonagricultural domestic personnel (janitors, cooks, personal servants, in-house and visiting slaves, and so on) or for outside suppliers or menials (messengers and deliverymen, estate managers, suppliers, and the like).[94]

A problem of some long standing since the 1980s concerns the interpretation of certain architectural spaces in the villas at Settefinestre and Lucus Feroniae. The Anglo-Italian excavators of the Settefinestre villa, understandably excited by the achievement at discovering and publishing, in very favorable circumstances, the first completely excavated villa in Italy, regarded the site as having an exemplary character and "test case" for finding the strangely invisible presence of agricultural slaves, so often referred to in the treatises of the Latin agronomists. Settefinestre is famous, as much for its importance in the history of Roman villas as for the exhaustive detail of its publication, which set a standard for the presentation of such projects.

By contrast, and quite unlike Settefinestre, the investigation of the Lucus Feroniae villa was a rescue excavation, which had to deal with definite time constraints, after a good portion of the villa had been bulldozed away in the construction works of the Rome-Florence highway *Autostrada del Sole*. The part of the villa that could be saved had to be excavated in haste, often with the use of mechanical machinery, and consequently little stratigraphic data, particularly for the later phases, exist. However, this villa, which had belonged to the senatorial family of the Volusii Saturnini, presented to the excavators an architectural feature, a courtyard with modular rooms on at least two, but probably three, sides, which was distinctly comparable to the two courtyards with modular rooms excavated at Settefinestre. At Settefinestre, these courtyards had clearly been part of the service or utilitarian part of the villa, separated from the elegant residential quarter and the access routes reserved to the owners. The interpretation given by the excavators of Settefinestre was that these courtyards with rooms (*cellae*) were the slave quarters for the agricultural manpower needed on the large estate, thus finding archaeological confirmation that slave labor, especially the fettered slaves (*vincti*) referred to in the context of villas by the agricultural writers, was the key element of the "villa system" that had displaced the small and medium free farmers of Republican central Italy. The sociopolitical history of Rome in the second century BCE reinforced such interpretation, as the appearance of large villas employing slave labor in the area of Cosa was linked to the story of Tiberius Gracchus who, while traveling to Spain along the coastal *via Aurelia Vetus*, would have seen only imported slaves in the fields (see pp. 13–14). Both the villa of Settefinestre and that of Lucus Feroniae became instances of a larger interpretation of Roman villas in Italy, offering a model by which a specific architectural feature (a courtyard with modular rooms) became the signifier of the type of labor and exploitation of the villa, a model that would then have been exported to some of the provinces.[95] While at Settefinestre the excavators had reached the conclusion that the rooms were all slave-*cellae* by excluding other functions (such as storerooms or stables), at Lucus Feroniae the interpretation relied heavily on the architectural parallel with Settefinestre.

However, the two villas were actually quite different. The Settefinestre villa was relatively far from its nearest town and port (Cosa), while the Lucus Feroniae villa was only 500 m from the forum of the nearby small town. They were also quite

different architecturally. Although about half of the
Lucus Feroniae villa is missing due to the circum-
stances of its discovery, the courtyard with its *cellae*
was not clearly separated from the *pars urbana*, as in
the case of Settefinestre. Rather, it was part of it,
and it included a central room (the so-called
Lararium) with a monumental inscription detailing
the political career of a member of the family.[96]
Even in the case of the Settefinestre courtyards,
attributing all the rooms to slaves is a very grand-
iose hypothesis, as it involves attempting
a calculation of the number of hands, and from
this datum the size of the estate. Roman historians
and archaeologists working at other sites in central
Italy have taken Settefinestre as the undisputable
archaeological proof that slave quarters housing up
to hundreds of slaves were typical of rural elite
villas. However, other interpretations of the
rooms are possible, as some of the claims made by
the excavators do not stand up to close scrutiny.[97]
The courtyard rooms at Settefinestre could have
been multipurpose, with some used for slaves,
others for storage (of tools and equipment, for
instance), others used as stables for the pack animals
(mules and donkeys) that were part of the *instru-
mentum* of a villa and that a site like this must have
needed in order to transport the agricultural pro-
duce to the port of Cosa.[98] Therefore, both these
villas, which have greatly influenced villa studies,
cannot be taken as general models to guide the
interpretation of other sites in Tyrrhenian Italy
whenever a courtyard surrounded by modular
rooms is present. Recent studies, most notably
that of Launaro (2011), have shown that, with
few, localized exceptions, there is no correlation
in Italy between the appearance of villas and the
disappearance of farms; on the contrary, the num-
ber of villas and farms increase and decrease in
tandem. The very concept of extremely large, *con-
tiguous*, estates is not really applicable to most of
peninsular Italy. Wealthy landowners as a matter of
habit amassed a number of geographically scattered
properties, and this had a clear effect on the man-
agement, organization, and size of agricultural pro-
cessing facilities of the villa estates.[99]

ORIGINS OF ROMAN VILLAS

The origins of villas, both the villas as architectural
form and villas as units of agricultural exploitation,
are matters of continuing debate. Three main
hypotheses or lines of interpretation have emerged
from the many discussions.

The first hypothesis is based on external histor-
ical origins: because farms and larger rural man-
sions that could be called "villas" were present in
the Greek classical and Hellenistic world, the villa
came to the Roman world from Greece and was
naturalized in Italy via the Greek colonies of south-
ern Italy in the third century BCE.[100] In this con-
text, both in ancient Greece and Rome, social and
political structures were based on census: landed
wealth was the criterion by which membership in
one or another class was determined. For this rea-
son, ownership of land, i.e., farms and villas, was
linked with the social and political history of
ancient states. The Greek classical period and, to
a greater extent, the Hellenistic period were
certainly defining moments in terms of the
delineation of clearer architectural typologies and
a more regular diffusion of dispersed settlements in
the countryside. In the Hellenistic period, the
number of villas and farms populating the country-
side of areas such as mainland Greece, peninsular
Italy, and Sicily greatly increased. In certain geo-
graphic areas there was a clear connection with
Greek cities' territorial expansion. Rome's expan-
sion in Italy during the third century BCE was also
accompanied by the appearance, in the conquered
territories, of farms in greater densities than here-
tofore, as revealed by the thousands of rural settle-
ments comprising farmsteads, farms, and villas
identified in the South Etruria Survey. A similar
process has been noted in northern Greece, where
the growth of the Macedonian kingdom in the
Hellenistic period prompted the appearance of
large estates that seem to have promoted the intro-
duction of new technologies in order to process
crops more efficiently.[101] However, farms and
what some have labeled "proto-villas" did not
appear out of nowhere in the Greek classical

period. They were present in the archaic period too, and in the Etruscan and Carthaginian worlds.

The second hypothesis about the origin of the Roman villa is in a link with the Punic world of North Africa. Carthage, before its destruction in 146 BCE, was surrounded by many farms and villas, her wealth deriving as much from her agricultural hinterland as from her extensive Mediterranean commercial networks. Although archaeological excavations of Hellenistic Punic farms around Carthage are scant, it is known that courtyard villas fortified by corner towers were in use both in Sicily and in North Africa as early as the third century BCE.[102] Discoveries on the island of Djerba, off the cost of Tunisia, have highlighted the great diffusion in the Hellenistic period of villas producing sweet wine, which was widely exported around the Mediterranean.[103] In addition, arboriculture and certain cultivations that were later taken up in Roman villas seem to have been developed in the farms of Carthage. The agricultural treatise by the Carthaginian Mago was judged by the Roman Senate in 146 BCE to be the only noteworthy Carthaginian writing deserving of translation into Latin, and agricultural manuals written later by Latin authors, in particular Varro's and Columella's, often quote Mago's work as an authoritative source.[104]

The third hypothesis as to the origins of Roman villas breaks away from the evolutionist model (from small farm to large villa) that both the "Greek origins" and the "Carthaginian origins" hypotheses imply. Whether positing an origin from the Greek or Carthaginian worlds, the "standard history" of the evolution of farms and villas in Roman central Italy put forward in the historiography of the 1970s and 1980s has been characterized by an evolutionist model inflected by external phenomena.[105] Small farms appeared in the third century BCE as the result of the Roman annexations in the peninsula, and in the aftermath of the Hannibalic war, which opened the way to Rome's interventions in the East after the mid-second century BCE, some developed into villas. The availability of manpower (slaves) and riches that the eastern conquests brought about allowed the elite to create slave-staffed villas producing cash crops. The landed estates of the wealthy grew in size, incorporating former small- and medium-sized properties and large tracts of ager publicus.

However, both this evolutionist model and the two "external" origins proposed for the Roman villa (Greek and Punic) have been questioned in consequence of an important archaeological discovery made in Rome in the 1990s: the Auditorium Villa. The site, now engulfed in the modern city, was well outside the north limits of the ancient City, at least as it had developed before the second century BCE. A substantial villa existed on the site already in the years 500–300 BCE; further enlargement of the complex occurred in 300–225 BCE. The name "villa" for this archaic and very early Republican complex is justified primarily by its size, so far unparalleled in these more than 250 years; by its décor, which included figurative architectural terracottas similar to those known from Etruscan religious buildings; by its plan, featuring a central open court; and by the presence of an oil press.[106] The complex had a long occupation history (nearly 650 years), going out of use only after the mid-second century CE. The discovery of the Auditorium Villa has led to the reconsideration of finds at other later villa sites, where the recovery of archaic architectural terracottas had been explained by hypothesizing the presence of nearby archaic rural sanctuaries obliterated by later farms and villas rather than a well-developed decorative culture in early villas like those found in the Auditorium Villa. In fact, the Roman villa could well have evolved from palatial rural structures of the Etruscan world.[107]

The Auditorium Villa has had reverberations throughout the discussion of "origins" of the Roman villa. While emphasizing its "Italic" character and archaic date, one of its excavators, N. Terrenato, has also highlighted the discrepancy that exists between the villa described in Cato's mid-second-century treatise (a modest, functional farm, with no signs of grandeur or luxury) and the villas in the archeological record of this time, which are larger and much more extravagant than the "Catonian villa."[108] In his agricultural treatise, the striving homo novus Cato was not describing the "new" capitalistic farm as a relatively recent phenomenon of Latium,

namely the large terraced villas in locales (Tusculum, Tibur) at easy distance from Rome. Instead, as a *novus homo*, he was promoting himself by opportunistically idealizing the villa, ignoring the realities of the villas of the elite of his time in order to appeal to the core values (e.g., frugality) of Rome's aristocracy with the aim of being fully accepted by it socially. Villas could certainly be part of self-promotion and social upward mobility in the case of luxurious rural dwellings, but in Cato's case, the ostentatiously simple villa of his agricultural treatise was at once a rebuke to foolish, showy, contemporary *mores* and a claim to prestigious old-fashioned morality.

Villas and cities go together. As a city, the growth of Rome as a large-scale consuming entity did not wait for Rome's territorial expansion in the third century BCE. There were clear and earlier indications of intensifying agricultural exploitation in its environs. At various sites in the south-eastern *suburbium* near modern Centocelle, where in the late Republic and empire luxurious villas were built, archaeological investigation has revealed numerous trenches dug in the tufa plateau in order to plant vines, dated on the basis of associated ceramic material to the fourth and third centuries BCE.[109] R. Volpe's work in the *suburbium* of Rome places the discoveries at the Auditorium Villa within the wider context of land use at the time. She reconstructs a far more extensive landscape of villas within a highly productive network of agricultural systems, a landscape that developed much earlier than has been postulated up to now. The evolutionist model for villas, namely the traditional narrative of an evolution from small farms to large villas in the second century BCE, needs reassessment in the light of the new information on the growth of Rome and agricultural exploitation of its territory at much earlier dates than have heretofore been known.[110]

DEMISE AND DECLINE OF ROMAN VILLAS

Decline and demise of villas can be observed in various ways, but the definition of these terms is difficult. Indeed, the processes may not be fully separable, and while the words themselves may prevent nuanced analysis, still, how phenomena and institutions change in a downward direction is a permanent topic in historical studies. With villas, their *decline* – or, perhaps better, the variations of their successful sustainability – within the Roman hegemony has become a topic of some dispute regarding the interpretation of the material remains. The *demise* of villas, its processes and causes were not uniform: villas in many cases outlasted, even flourished, in the face of severe social change, invasions, usurpations, changes of régime, interrupted communications, and abandonment by central authorities. The resilience of some villas as sustainable entities can be discerned, while others were more fragile, easily subject to immediate or long-term pressures. The passage from success to another, perhaps lesser, manifestation is an element in our understanding of the trajectories of the Roman Empire.

For Italy, the widespread rise of villas in the Republic, namely as of the mid- to late second century BCE and intensifying through the first century CE, cannot be doubted. In addition, the villas that were built in those two and a half centuries – with special exceptions and variations for maritime villas[111] – were usually *both* agricultural affairs in productive rural areas *and* residences with some degree of comfort both in the countryside and on coasts. Agriculture for expanded profit and agreeable, newly sophisticated lifestyle were not incompatible in Rome and Italy of the late Republic and early empire, and the association came to be a permanent and successful feature of villa life.

For modern historians and archaeologists, there is a problem with the villas' success: How can the decline of any one villa or a group of villas be interpreted? Foolish individual owners and idiosyncratic management may not be sufficient to explain simultaneous negative changes in any conglomeration of dwellings, be they *domus* in cities or villas in the countryside. In addition, decline described as a general downward trend over several centuries coarsens and may well distort both local situations

and preclude instances of variations against the perceived norm, because seeming decline of one villa site may actually be an advantage to another.

The demise and decline of Roman rule has been a perennial topic of historical research and speculation since late antiquity itself.[112] However, for Roman villas, their demise is not in doubt. By the late sixth century CE, villas as a rural settlement type had, with very rare exceptions, lost much semblance to their original economic and residential functioning, even though the incidence of the end of villas was unequal in different areas of the western empire.[113] Villa sites were gradually abandoned, suddenly abandoned, or bear traces of only seasonal or sporadic occupation. The economies that had sustained villas may have substantially changed and perhaps become merely local rather than regional or Mediterranean-wide, though a newly local agricultural economy may be successful and viable no matter the seeming degradation of residential standards.[114]

Easier to observe, but perhaps more difficult to interpret, is decline. How to define it, and where to draw the line between mere change of use and actual degradation, is hard. Sometimes grand rooms could be subdivided or changed for new uses when the villas themselves were still dignified residences.[115] In certain villas in their late phases, beaten earth floors appeared in rooms once floored in mosaic, kilns were built in formerly residential rooms, bath suites went out of use, often new agricultural activities replaced earlier ones, and burials appear in rooms no longer conventionally habitable. While the evidence has been principally collected from Italian villa sites, similar patterns of "ignoble" re-use can be registered in the historical record elsewhere in the empire: in Greece, Gaul, and Hispania as well as North Africa. As in Italy, it is difficult to draw the line between change of use and actual abandonment.

A letter written by Pliny the Younger in the late first or early second century CE is instructive in this respect.[116] Pliny needed the advice of a friend about a business decision concerning villas; the letter itself outlines the pros, cons, and variables about how to come to a decision about real estate.

A property adjacent to his estate and villa at Tifernum Tiberinum had come up for sale.[117] The proposition was tempting because its current asking price was *HS* 3,000,000, down from a previous asking price of *HS* 5,000,000, a 40 percent drop.[118] Pliny outlines three considerations, two on the positive side, another on the negative:

1. On the positive side, buying the property would attractively aggrandize his own, make for less traveling time, and would concentrate moveable goods (*sumptus supellectilis*, meaning furniture and household equipment) as well as human personnel (gardeners, blacksmiths, gamekeepers). This would lower the maintenance costs of the amalgamated estates and increase the productivity of his existing personnel (their workload would be increased with the purchase of the adjacent property).[119] Greater efficiency and streamlining would result.
2. A second positive was that he could focus on enhancing and improving only one villa (*unam villam colere et ornare*), while the *other* villa, the one on the adjacent property, could be left in "as is" state (*alteram tantum tueri*). This would make everything as convenient as it would be agreeable (*non minus utile quam voluptuosum*).
3. The downside was the risk to expose so large a property to the same uncertainties of weather (and possible crop failure) and general risks as the other estate (*sit incautum, rem tam magnam isdem tempestatibus isdem casibus subdere*).

Other considerations in the letter concern the manpower and cost, involving both slaves and what he (Pliny) would have to do for the existing tenants on the other property. This was a real difficulty. To re-establish and increase the tenants' productivity, he would have to buy new slaves for them, as he did not have any chain-gangs (*vincti*). The tenants' lack of resources and the costs associated with restoring the productivity to its earlier levels were the key elements that had depreciated the value of the property.[120]

We do not know what Pliny's final decision might have been or if he went through with the deal and effectively let the other villa stay "as is."

However, the alternatives that Pliny outlined to his friend raise two issues about how to perceive the historical trajectory of Roman villas in Italy and elsewhere: decline and ultimate demise. The first issue is as follows: If modern archaeologists visited Pliny's amalgamated estates and their villas, one enhanced and improved, the other left "as is" and perhaps converted to practical farm uses as workshop, warehouse, or even cemetery, they might well conclude that half the villas in the area had fallen on hard times, had become degraded, and were in decline. In fact, such an interpretation would be incorrect as describing the process: Pliny was making a business decision aimed at greater efficiency in use and productivity of personnel, and no actual decline occurred. The villa on his estate would be enhanced and improved (as far as the residential part was concerned), the "other" villa not. Were the latter to have been altogether abandoned in archaeological perception, that would not mean any end to villas in general or to the agricultural exploitation of the land. Instead, it could point to concentration of resources and wealth and a streamlining of agricultural production rather than to any decline in the viability of villas as such.[121]

The second issue is one of demise. Pliny's difficulty in allocating his own slaves to his potential new tenants and not having chain-gangs of slaves of his own to work the newly acquired estate were potentially deal-breaking. This raises an important historical issue in Roman history, in Italy and elsewhere: manpower. As we have seen (pp. 15–17 and 19–20), slaves and free labor were already viewed as a problem in the late Republic and later. The positing of a chronic manpower dearth throughout the Roman imperial hegemony began in the 1950s and is a continuing topic of discussion. In the most extreme interpretation, shortage of manpower has been seen as an ultimate cause of the fall of Rome;[122] more fruitfully, sporadic labor shortages have been seen as the origins of intermittent ups and downs of villa development (especially in Italy).[123] However, manpower shortage – whether long term or occasional – has not, as far as we are aware, been satisfactorily recordable for Roman villas, so we have omitted its consideration in this book.

SOCIAL GROUPS AND CLUSTERS OF VILLAS: FASHIONS IN DINING AND DECORATION

If identifying slaves as a social group in the spaces of actual villas is hard, identifying where members of Roman elites (of status or wealth or both) distributed themselves is easier: they clustered in order to congregate, interact socially, and identify themselves, both in urban *domus* in Rome (e.g., on the Palatine Hill) and in villas in the Roman environs and elsewhere in Italy. The political life of the Roman Republic in the late second and during the first century BCE and into the early empire prompted members of the elites (with some exceptions) to congregate spatially, and the results were nodes of Republican villas, first in the *suburbium* of Rome and in its southern proximate area of Latium, then in Campania and the Bay of Naples, then elsewhere. Latin authors noticed these conglomerations and commented on them as a phenomenon in the history of Roman social landscape and habits.[124] The hilly countryside to the south and east of the City was noted for groups of villas. The locales of Lanuvium, Tusculum, Tibur (mod. Tivoli), and Praeneste (mod. Palestrina) had, by the second half of the second century BCE, been thoroughly taken over as venues for villas, as had the coast around Antium (mod. Anzio) to the south (about a day's journey) and Laurentum (where Pliny the Younger had a villa that he could reach in a few hours ride from downtown Rome). Roman high society – be it of the senatorial nobility, the equestrian order, or the elite of money that might include freedmen and their descendants – tended to cluster and thus to homogenize in the way of architectural and decorative taste as well as lifestyle. Cicero tells us that the great general, *triumphator*, and consul L. Licinius Lucullus (c. 115–50 BCE, consul in 74 BCE), the scion of several ancient noble families, when living in retirement at his luxurious villa at Tusculum, answered a charge of excessive *luxuria* by remarking that he had to live *up* to the standards of his next-door neighbors, one a knight, the other a mere freedman.[125] Villas smoothed the differences

among disparate social classes where the urban *domus* might not.

The clustering of villas and the proximity of a sociable elite continued down the generations: Cicero, who built his villa at Tusculum, sets an affable chat about books in the library of a villa there. The villa was owned by Lucius Licinius Lucullus, the son of the *triumphator* and consul mentioned above, and the villa and its books were presumably inherited from his father. Cicero was looking to borrow some volumes from Lucullus but found the young M. Porcius Cato, son of the famous Cato the Younger (Cato "of Utica," a descendant of Cato the Elder) surrounded with piles of books he was perusing. Cato exclaims that, had he known Cicero was at Tusculum, he would have dropped in on him at his villa nearby. The elder *homo novus* (Cicero) was chatting about philosophy with the young descendants of high *nobiles* of the patrician and plebeian orders: Their backgrounds, ages, and even political affiliations were different, but they *all* had villas at Tusculum.[126]

Such spatial proximity of the elite despite the social differences among them prompted a certain uniformity of architectural choices: throughout the late Republic and early empire, hillside suburban villas around Rome most often were built on *basis villae*, that is, on substructures creating one or more levels of artificial terraces to dramatize the views and catch the breezes. In the *ager Cosanus*, where the Settefinestre villa discussed on p. 17 was located, there was a fashion for terraced villas to look like fortified towns with amusing little towers along their garden terrace walls – the villas referenced military architecture without really resembling it. More impressive, apparently, in the way of military aspect, were the villas of the great political figures of the late Republic: Marius, Pompey the Great, and Julius Caesar, grouped on the promontory of Misenum in the Bay of Naples.[127] Villa owners could also cluster in affinity groups: Tibur came to be favored by villa owners of senatorial rank from Hispania.[128] Outside of central Italy and the Bay of Naples, villas also tended to cluster: the Larian lake (Lacus Larius, mod. Lake Como) was replete with them, as was the Istrian peninsula, and major towns and cities

throughout the empire often developed villas in close proximity.

The relative homogeneity of architectural ideas in villas was matched by modifications in social arrangement for dining and reception. Beginning in the second century CE, the older form of *triclinium*, in which a square U-shaped arrangement of separate dining couches (each holding two diners) set on three sides, went somewhat, but not completely, out of fashion. It was replaced, in both *domus* and villas, with the *stibadium*, a continuous semicircular platform for reclining which had the advantage of greater visibility, both for the diners among themselves and for the feasting group as a whole to be on view for observers, social inferiors who were invited to observe but not to dine.[129] Of course, to be observed while feasting implies social superiority for the feasters, so the *stibadium* enhanced social difference. This difference would have been all the more marked when the *stibadium* had a splendid decorated architectural backdrop (an apse or *exedra*, quite often expanded to a tri-lobed absidal room for three *stibadia*) and/or was set off and above the other spaces with steps. These new arrangements, which became virtually obligatory in villas throughout the empire into late antiquity, denote the increasing social prestige of villa owners.

Owners of estates may well have been apt to display themselves as more powerful socially in late antiquity than they had been in earlier times. In addition, ceremonies of hospitality may have become less affable, more formal and ritualized in view of increasingly greater claims of status and self-regard by owners. Such changes in villas were marked by the frequent construction of domestic *basilicae*, that is, square or (most often) oblong rooms with an apse (semicircular, partially semicircular, or angular) on axis at one end, sometimes with the floor of the apsed area raised with a low platform or shallow steps. The architectural arrangement marks and enhances the villa owner, giving him spatial authority and presenting him as the principal actor in situations of reception and adjudication. Because the new dining arrangements and the construction of *basilicae* can be registered in villas from Gaul to Greece and from Britannia to Africa, it is

clear that their architectural prevalence came from a shared uniformity of social habit among the elites of the empire.

This uniformity can also be seen in religion: in the fourth century CE and subsequently, the spread of Christian iconography evidenced in the building of chapels and/or *mausolea* with Christian content. Themes of decoration in floors and wall paintings in villas throughout the empire likewise attest the fraternities of taste in decorative and ultimately pious practice among the elites.

With very few exceptions, notably in the Bay of Naples and some literary instances that describe real or imaginary mural decorations, most of the decorated plaster, mural mosaic, or painted walls and ceilings of villas have not survived. However, what has survived in some abundance are their floors, from very humble (beaten earth) to utilitarian in brick (*opus spicatum* in various patterns) or terrazzo (*opus signinum*, sometimes decorated with *tesserae*), to mosaic (*opus tesselatum, opus musivum*) made of grouted quadrangular elements (*tesserae*, sing. *tessera*, commonly in a c. 1 cm² cube), to very grand floors in multicolored cut marble or other stones (*opus sectile*, mainly geometric but also floral and even figural). Mosaic floors could have geometric, floral, and/or figural compositions, often rather prosaic but others enhanced with separately manufactured special elements (*emblemata*), some very detailed in tiny cubes (*opus vermiculatum*). The different techniques could coexist within houses to differentiate the social importance of their rooms, with the simpler techniques applied to ordinary rooms such as bedrooms (*cubicula*) or corridors and the grander, special-order jobs for *tablina* and *triclinia*. The techniques and different patterns could also be used in combination in a single floor. The business of mosaics for villas was evidently a lively one for craftsmen as well as a source of cultural and aesthetic engagement for their commissioners.

While *stibadia* and *basilicae* were frequent, mosaic floors were virtually universal in *domus* and villas from the first century CE through late antiquity, and they were virtually universal geographically as well. Mosaic workshops worked both locally and much further afield, in particular the African

companies that supplied the craftsmen and decorative ideas for villas in Sicily and elsewhere. The phenomenon itself is not surprising: good workmanship is, after all, its own advertisement in a socially homogenized elite. Roman owners, no matter where they lived, regarded mosaic floors as the premier and virtually obligatory embellishment of their villas, fully worth the trouble and expense of hiring local or mobile companies of craftsmen to come and work in often isolated places. This devotion to mosaic floors resulted in both a certain uniformity of decorative and iconographic ideas shared among several villas (the Four Seasons, Provinces, Dionysiac themes) but also in certain splendid, clearly original, and creative ensembles (particularly figural but also stylistic) that were quite obviously custom-made and may denote competition among elite villa owners in parading their literary culture and often abstruse mythological knowledge.[130]

VILLAS AND BIOGRAPHIES

As early as the second century BCE, investigation of their own origins and how the past conditioned their present came to be normalized in Roman self-consciousness. Families used the actions and achievements of ancestors to enhance or revive their prestige, and political factions resorted to historical exemplars to justify present policies. Historical allusion was firmly incorporated into Latin rhetoric, inscriptions, and literary production, and the presence of the past in Roman mental life constituted an impressive historiographical tradition. The past and its ancestral moral habits and traditions (*mos maiorum*, pl. *mores maiorum*) were irrefutably prestigious.[131] Villas often articulated the themes of families and recalled their history.

Among the Roman elites, competition of all kinds was the norm, in cultural achievements as well as in politics and military prowess. In that competitive milieu, owning villas became obligatory at the upper levels of society, and biographical notices of political grandees often included some facts of their owning a villa or (most often) many villas, and where they were situated: Scipio Africanus (Publius

Cornelius Scipio Africanus Maior, 236–184/3 BCE) retired from military and civil life to a villa at Liternum, using its simplicity as a standing rebuke to the malice and arrogance of his political enemies.[132] Coquettishly or grimly retiring to villas came to be a biographical theme: The future emperor Tiberius, during his short self-exile to Rhodes (6 BCE–2 CE), coyly and virtuously made do with a small house in town and another in the suburbs (a villa) not much better. Later, as emperor, he grimly self-exiled himself, from 26 CE to his death in 37, to a villa or villas on Capreae (mod. Capri), of which the depraved luxury were proverbial.[133]

As we have seen, the villas of Marius, Pompey, and Julius Caesar at Misenum were worthy of mention,[134] and the habits of the Republican grandees were smoothly transmitted to imperial ownership of multiple villas, from Augustus to emperors in late antiquity. In addition, villas became actors in emperors' biographies: The emperor Augustus was brought up on a family estate near Velitrae in the Alban Hills south of Rome, and in its villa the room that had been his nursery was still shown almost a century later.[135] In addition, Augustus died (14 CE) in the same room of a villa at Nola in which his father had passed away seventy-two years before: such magical and fated coincidences about houses included villas, and the rooms in which these events took place were held in reverence.[136] Augustus's and his successors' villas became part of their biographies,[137] and Augustus's wife Livia had a villa at Primaporta north of Rome that derived its name *ad gallinas albas* or *ad gallinas* ("At the White Hens" or "At the Hens") from a famous, highly numinous event in her life.[138] Accounts of the emperor Galba's villa birthplace and his subsequent installation of a statue of Fortuna in his villa at Tusculum were incorporated into his biography.[139] Even invitations to villas reflected notably on guests and hosts: Pliny the Younger, summoned on legal business by the emperor Trajan to the villa at Centum Cellae (mod. Civitavecchia) on the coast north of Rome, described (a little smugly) both his duties as imperial official and the perfection of the emperor's hospitality as well as the architecture and arrangements of the villa itself.[140] Imperial patron and host, honored

guest, and the hospitality at the villa and its aspect all went together. Such anecdotes emphasized villas as extensions of the *persona* or public personality of famous individuals: biography and villas went hand-in-hand.[141]

At lesser (nonimperial but still elite) social levels, villas could also express *persona*, sometimes negatively, sometimes positively. The villa of Publius Servilius Vatia (c. 65–25 BCE) near Cumae was, according to Seneca the Younger (c. 4 BCE–65 CE), superbly beautiful as to its site, planting, natural and artificial elements, and architecture, but its useless beauty was merely an epitaph on the man himself. The son and grandson of consuls and a descendant of *triumphatores*, Servilius Vatia himself had advanced to the relatively low elective post of praetor, then retired to a cowardly life of ease, gluttony, and lust and was called a "rich praetorian" (*praetorius dives*, an insult). The villa was the man's epitaph: "Here lies Vatia!"[142] Later, Pliny the Younger infused villas with emotion: When he visited his aunt's villa at Alsium (on the coast north of Rome), which had once been the retirement home of his patron, Lucius Verginius Rufus (15–97 CE), he was sad because the great man's cenotaph had never been finished.[143] The theme of self-expression through villas in the matter of family pride or personal conviction persisted throughout the presence of villas into late antiquity: in the fifth century CE, the name of the founder of a villa was inscribed in stone at the entrance to the dwelling in the case of the "castle" (*burgus*) of the Pontius family in Aquitania.[144] An entire family estate could be given over to new, Christian purposes, as Sulpicius Severus did with his estate called *Primulacium*, also in Aquitania, soon after 400 CE.[145]

Otium

What were villas for? Not in practice, but in theory? The practice of villas, namely agricultural production of some kind, even in villas described as productively *inutiles*, was more or less enshrined. But in an ideal world, what was the intellectual underpinning of villas? By the late Republic, it was *otium*,

a portmanteau term for leisure, but one that traveled along a broad spectrum from epicene material pleasure to high intellectual and literary endeavor. While *otium* could be engaged in anywhere, villas were its venue of choice in all its forms. Villas often signified leisure or its variants, ideal places of refuge and respite from work (which could be anything that was termed *negotium* or nonleisure, including political involvement).[146] *Otium* had various definitions and many components among the Romans, and it was an important social value as a mark of status, wealth, personal disposition, and even the pretense of seeming *not* to engage in *negotium* when, in fact, business in some form was being done.[147]

By the later Roman Republic (second to first centuries BCE), owning villas had become a connective tie among the graded classes of the Roman elites, but mainly as to rural residence. Within the City, the patrician aristocracy of consular distinction, the plebeian families that had arrived at senatorial or consular status, the *equites* or knights (members of the *ordo equestris*), new members of high society recruited for their talents (*homines novi*), wealthy ordinary citizens, or even rich former slaves (freedmen or *liberti*) were differentiated – sometimes subtly, mostly crudely – as to privileges, social access, and political prestige at Rome itself. As is almost always the case in earlier and later cities, this social differentiation came to be reinforced (with variations and exceptions) by spatial and neighborhood distinctions within the City. For example, urban real estate on the Palatine Hill was almost exclusively an aristocratic preserve for at least two centuries, but by the first century BCE, grand and pricey dwellings came to be bought by plebeians such as Cicero, who had grafted himself onto high society by his conspicuous gifts as a lawyer and politician and became noble upon election to the consulship.[148] Such urban houses were venues for the businesses of finance, law, politics, and patronage of client-citizens (sometimes in their thousands) – what in Latin was known as *negotium*.

By contrast, at least theoretically, villas provided for *otium*: pleasure, privacy, agreeable hospitality, walking, hunting, the pleasant supervision of the farm personnel, the cultivation of friendships and

the mind, and the deployment of literary talents – in sum, the relative democracy of leisure. As the rural villa was the center of agricultural production, so also the leisure time spent there had to be productive, devoted to the exercise of the mind, and this explains why some owners were known to keep well-stocked libraries at their villas.[149] A famous example of a villa library comes from the so-called Villa dei Papyri just outside Herculaneum, which may have belonged to Caesar's father-in-law Lucius Calpurnius Piso Caesoninus: many papyri scrolls carbonized during the eruption of 79 CE (recovered starting in the eighteenth century and continuing in conservation) appear to have been a library of Greek works of philosophy of some particular meaning to the villa's owner.[150] There are many instances of villas as intellectual retreats: after a visit to the knight Terentius Iunior, who had abandoned public honors to retire to his villa and pursue literary and philosophical studies, Pliny the Younger commented in a letter that "one would think that the man lives in Athens, not in a villa," to stress the great knowledge acquired by the knight, undoubtedly from studying the works that his library contained.[151]

No doubt villa owners enjoyed these relaxations, but the theory of *otium* in villa settings should not be exaggerated: the social engagement and competition characteristic of wealthy, well-connected members of a status-inflected society did not cease at the City's limits, and Romans were competitive. We have already seen the instance of L. Licinius Lucullus, a member of the highest social class, competing in rural luxury and outward display with two social inferiors – a knight and a freedman – who owned adjacent villas (p. 22 and n. 125). Cicero wrote pleasant essays and friendly letters from his villa at Tusculum, but he also had at least three villas in the Bay of Naples, at Pompeii, Puteoli, and Cumae, and busily extended invitations to his friends to spend their holidays there.[152] One of the villas – that at Cumae – was acquired by purchase, and that at Puteoli was a testamentary gift from a friend who had obligations to the great man: A villa – the supposed site of *otium* – could be a gift of political gratitude, thus a repayment for *negotium*.[153] Villas were also places to carry out the business of

administrating the associated estates and receiving visits of clients, local or from Rome. It is not by chance that in one of his letters Cicero calls Cumae a "small Rome" (*pusilla Roma*) and refers to his villa there as a *domus*, the urban house where business was conducted and political deals struck.[154]

Such social obligations were strongly felt, not merely devices of advancement or repayment of favors, and sometimes they involved villas. Pliny the Younger, in the early years of the second century CE, gave the income of a small property (*agellus*) with a villa worth *HS* 100,000 to his elderly nurse (*nutrix*) who had taken care of him in childhood.[155] His gift was generous, but it was also a conventional act of obligation from a patron to a dependent member of his *familia*, an act expressive of the social morality of his class. Ultimately, villas could also be matters of morality and memory: In the early years of the fifth century CE, a young Christian noblewoman, Melania the Younger, had vowed to preserve her virginity by refusing to bathe, but later she claimed that a demon had tempted her to forsake her vow by reminding her of the luxurious *balneum* of lustrous marble at her villa in Sicily.[156]

Returning to Cicero and his journeys to his villas, when he got to them, what did he find? Inevitably for an important person, he was caught up in a whirl of activities – discussions with farm managers and tenants as well as suppliers and brokers, complaints and decisions-to-be-taken – and the social and political discussions that made his life at his villas as busy with business and decision-making as it was in town.[157] Seeking *otium* at his villas, he found himself – like many others – immersed in businesses that he had thought he was leaving. Villas were an agricultural proposition, but they were also social and political venues, spaces of *negotium*.

Negotium in towns and cities, *otium* at villas: The antinomy may provide a neat contrast, but it is simplistic. The role of villas as social and business venues became even more pronounced in the imperial period, when many villa owners were also the patrons and benefactors of the local communities in whose territories their properties were located. In the first two centuries CE, and during the second century in particular, the villa operated, from an ideological perspective, on two different levels. On one level, it was still the escape from the usual duties and business of the city, therefore the place of *otium*; but on another level, the villa was where local communities had contact with the powerful owners elected as their patrons (which put the honored villa owner under obligation of being a significant benefactor). For example, the senatorial Volusii Saturnini, owners of a villa near Lucus Feroniae (see pp. 17–18), were patrons and benefactors of the nearby town.[158] The villa and its architecture marked the status of the owner in the eyes of the local communities as a *patronus* and the villa was the seat of visits on the part of clients, local notables, and tenants; it was, in other words, as much a place of local business as for personal leisure.[159]

DESCRIPTIONS OF VILLAS IN PROSE AND POETRY

Villas were subjects of ancient prose writing (often in letters) and in verse, and to the extent that such literary sources indicate how country dwellings impinged on Roman consciousness of the phenomenon, a brief account of them can be included here, though it is by no means exhaustive.[160] Villas appeared in Latin literature as the objects of satire, praise, verbal description (*ekphrasis*), moral uplift, and as centers of agricultural work. The Latin origins of such manifestations were Greek: Hesiod's poem on farm activities, the early seventh century BCE *Works and Days*, written like the Homeric poems in heroic meter (dactylic hexameter), gave authority to both agriculture and the traditional morality – claimed or real – of rural life as the basis of the good life.[161] *Ekphrasis* – encompassing the description of architecture and works of art in words – originated in Greek literature as early as Homeric descriptions of palaces and places in the Shield of Achilles and Telemachos' praise of the palace of Menelaos. The continuum from the

description of a house, its estate, and its agricultural activities as well as the life and morality of its owners and inhabitants finds an early example in Xenophon's account, in dialogue form, of the rural property and country *oikos* of a certain Ischomachos in the fourth century BCE.[162] Even though Ischomachos owned a house in Athens, the account of his country house formed the core of Xenophon's beliefs concerning the sobriety, utility, and superiority of rural pursuits. The theme quickly became an important, versatile, and multifaceted commonplace of Western thought and literature and has continued ever since in many forms.

In Latin literature, the celebration of a villa, often with its setting, inhabitants, and activities, in *ekphrasis* form (either versified or in prose) was most often the celebration of the writer's own property, in a continuation of the theme of a dwelling as expression of self. In the late Republic and early empire, Horace (Quintus Horatius Flaccus, 65–8 BCE) wrote of his favorite country house in verse, sometimes as graceful invitations to his friends to come and visit.[163] Some fifty years later, Seneca the Younger wrote three letters framing villas he had seen or visited in moral terms.[164] Toward the end of the first century CE, themes of quiet repose and learned reflection infused the very famous letters written by Pliny the Younger on two of the many villas that he owned or had inherited, the Tuscan or *Tuscanum* villa (villa *in Tuscis* at Tifernum Tiberinum, mod. Città del Castello) and the *Laurentinum* on the coast at Laurentum near Rome.[165]

Perhaps the most elevated and elaborate description of a villa, its site and contents, is that contained in a long poem by Statius (Publius Papinius Statius, c. 45–96 CE). The villa belonged to a certain Pollius Felix, a banker, and his wife Polla; the couple owned two other villas.[166] The villa, of which the site is known, was a *villa maritima* near Surrentum (mod. Sorrento) in the Bay of Naples; the poem is a description of the successive terraces, varied views, gardens, and grand rooms that the poet, a protégé of the owner, enjoyed after arriving by boat on the villa's jetty (he had embarked from the north coast

of the Bay after a dusty trip from Rome down the via Appia). From afar, the villa's silhouette beckoned the visitor with steam rising from the double-domed bath building (hospitality often began with a bath).[167] The villa was crammed with works of art (vague attributions are made to the Greek artists Phidias, Myron, and Polyclitus) and rich surfaces (marbles from Italy, Greece, Asia, and Africa are laboriously mentioned), and they, together with the site itself, were ornamented by the poet with glittering mythological allusions, both Greek and Latin. The beauty of the villa and its contents offset the questionable occupation that its owner, a money lender, may have exercised, and the mythological allusions as well as the authority of its art validated the villa's luxury.[168] Natural beauty, art, and learned allusion gave cultured glamour and possibly topics of table-talk to Pollius' villa and its feasts. The subjects of wall decoration, statues, and floor mosaics in *domus* and villas may well embody the experience of conversation – either in reality or in aspiration – in Roman dwellings.

Statius' poem had some successors in Latin literature, particularly (but less vigorously) in the way of classical allusions, but the forms of *ekphrasis* adopted by Pliny strongly influenced later letter-writers and poets who described their villas, among them Sidonius Apollinaris (Gaius Sollius Modestus Apollinaris Sidonius, c. 430–89 CE) who described his *Avitacum* near Augustonemetum (mod. Clermond-Ferrand in the Auvergne) and wrote a letter-poem about it intended to persuade a friend to visit to escape the summer heat.[169] Like Pliny (whom he sought to emulate), Sidonius in his letters and poems about his *Avitacum* and other villas combined description of architecture, amenities (the bathing facilities are important to emphasize the hospitable promise of villas), unusual features (special waterworks, the wall paintings in a lady's boudoir), pleasant inhabitants (*familia* and servants), and excursions to and from the villa. In his long poem called *Burgus Pontii Leontii*, written about the castellated villa of an Aquitanian friend and fellow nobleman, classical allusions abound, supplemented with descriptions of wall paintings showing events in Roman and Old Testament history, the whole

confection supposedly described in prophesy by the god Apollo, no less, to a drunken Dionysus, no less, as the residence of the gods and the Leontii when Rome will have expanded to the far west![170] The expansive spread of villas was not only a historical phenomenon in Roman consciousness: It was an export that came freighted with godly presence and historical inevitability, profitable agricultural work, beauty, art and mythology, hospitality and family history, pleasant friendship, and strong morality. The continuity of values is the more notable in that, by the time of composition of the poem, the Leontii and Sidonius himself were Christian. Nonetheless, for Sidonius, the Roman villa could be loaded up with the entire baggage of antiquity and readily shipped from Italy and recreated to wherever Rome ruled.

ROMAN VILLAS AS A VISUAL IDEAL

Villas and their reputation had a radiance well beyond themselves, their owners, and their locations. Seneca the Younger, who always noticed the logic or illogic by which people conducted themselves, comments on the topic: Wealth without moral principles, he tells us, begets foolish luxury in individuals. Then such individuals develop fads: among others, preoccupations with personal appearance, obsessions with furniture, and alimentary crazes in the way of cooking and menus. Conspicuous among the fads is the desire to make town houses (*domus*) look like the size of country dwellings, presumably extended physically and/or fictively to suggest the environment and perspectives of villas.[171] In Seneca's day, and to his certain eyewitness, the greatest of all imperial urban dwellings was the apex of such a fad: the *Domus Aurea*. This palace was built next to the Roman Forum by Seneca's pupil and patron, the emperor Nero; it was the culmination of the ideal of *rus in urbe* (the country in the city). From the villa-like porticoes of the palace, there was a view toward an artificial lake surrounded by buildings resembling cities seen from afar as well as an entire pastoral landscape with herds of wild and domestic animals and an agricultural setting with ploughed fields and

vineyards.[172] The palace itself was set in gardens as if in the countryside. At about the same time, real *villas* (notably that of Villa A at Oplontis, which may have been owned by Nero's wife) developed painted extensions in perspectival wall paintings depicting spaces even grander, in the way of gardens and architecture, than their already grand real ones.[173]

The architectural and decorative influence of villas on *domus* in Pompeii and Herculaneum has been studied in detail by Paul Zanker; he has shown that, both in terms of architectural adaptations and arrangements, as well as decorative motifs, owners of urban houses delighted in villa imagery.[174] Villas were prestigious no matter how or where they were evoked.

For owners, villas may have been a normal part of their visual vocabulary. For others, possibly those who did not own villas but merely aspired to do so, the glamor of villas in visual representation was a topic of frequent choice among other genre subjects (still-lives, theater scenes, and so on). It was not unusual, even in quite modest urban houses in Pompeii and Herculaneum, for visions of villas to be depicted. Villas were sometimes part of landscape subjects that included visual shibboleths such as shepherds, cows and sheep, ruined buildings, vaguely-perceived rustic-looking passersby, distant mountains, trees, and so on: these were the universal ingredients of pastorales in Roman art. Sometimes villas in landscapes might be the sole theme of such paintings: Suggestions of porticoes, towers, entrances, and the other baggage of villas in landscapes or by the sea were the subject, nothing clearly defined architecturally but everything suggested. With the addition of a ruined building suggesting a temple or a cenotaph or mausoleum, the scene became numinous and evocative of death and memory, a type often called "sacral-idyllic."[175] Vignettes such as these were usually presented, with exceptions, in minor parts of larger and more robustly depicted decorative structures, most often represented as small moveable pictures (*pinakes*) at eye level or else as framed drawings below formal, classically painted images with elevated subject-matter. The style of these vignettes is invariably fresh and sketchy with high contrast of light and

dark, atmospheric effects suggesting moist, smoky air, and unusual, often aerial, points of view.[176] Other depictions of villas in Pompeian wall painting are more decidedly perspectival, with sharp delineation of architectural elements and articulation of parts, as if the rigid formal elements were noble in themselves.

The visual genre of such representations of villas may well have been a taste among patrons who owned a villa or merely aspired to doing so. However, decorators or interior design companies may well have had such images as part of their usual baggage of choices for their customers: Villas in lovely landscapes would, with certain other mythological scenes and others in a standardized repertory, always be saleable merchandise and very charming.

Later, in North Africa, in the very late second and through the fourth centuries CE, another genre of representation developed: grand villas in the countryside or on the sea depicted in mosaic floors.[177] These are usually (with exceptions) found in *domus* in Carthage and other urban venues, as decorations in houses tightly woven into confined spaces. For city dwellers in their *domus*, the vision of the villa (and its activities) was often combined with images of deities or, occasionally and significantly, with images of their owners, the *dominus* and *domina*, sometimes as themselves, sometimes equipped with divine attributes.[178] Agricultural work and seasonal activity such as hunting at villas were also shown. Architecturally, some of the villas in mosaic representation have colonnades (often on the upper story) or towers or both. The colonnades may have struck an imperial theme, as in the upper-level colonnade of the Palace of Diocletian at Spalatum, and the towers certainly alluded to both real and described towers in actual villas of the second through the fifth centuries. For the North African villas represented in mosaics, domed buildings within the perimeter signify bath buildings: They convey the promise of the hospitality of bathing that was a part of noble reception at villas, very much as Statius described

the steam rising from his host's villa at Surrentum (see p. 28).

The representation of villas worked visually on several different levels. *Domus* could be slightly transformed into villas with allusions to them, and the representation of villas in landscapes, either for their architectural effects or as part of numinous scenes, was one of the many types of paintings in the repertory preserved at Campanian sites such as Pompeii. In the North African representations in mosaics, the villa and the activities around it appear to have been freighted with a grander iconography: The frequent presence of the *dominus* and *domina* clinch the relationship between the *personae* of the owners and the villa and estate they owned.

ROMAN VILLAS: POST-ANTIQUE MANIFESTATIONS

In modern consciousness of Roman architectural forms since the fifteenth century, villas are latecomers. Their components were often more fragile and certainly more physically dispersed than solid urban constructions, and the distribution of villas in the Roman landscape made them differently vulnerable to the depredations on the marble, masonry, brick, and concrete structures of towns and cities. While late antique,[179] medieval, and later transformations of both urban centers and rural organization were profound, the Roman infrastructures of the countryside – which would have included villas – were especially subject to the influx of populations with different methods of work and different expectations of dwelling conditions and social life. Isolation in the countryside had its dangers. While some villas – and the notion of villa life and some of the words and even ideas associated with such dwellings – certainly continued after the disappearance of the Roman hegemony, villas were for the most part abandoned, destroyed, reused for purposes other than residential and/or agricultural production, and quarried for building materials.[180] Such equipment, artifacts, and works of art as happened to have remained in

them were taken away, either to be reused or for collecting elsewhere. Villas became invisible.

The literary sources about villas were much less fragile, or, rather, their rediscovery and publication made villas visible once more. Despite the loss of continuity of Roman villas in modern consciousness, their elements from literary sources and from primitive archaeology (certainly since the eighteenth century, in some cases even earlier) have constituted a lively source of information and interpretation for archaeologists and historians of ancient culture, society, and economics. Roman rural residences have been objects of thought for many different kinds of public: owners and builders of rural property, antiquarians searching for agricultural lore, practical farmers, professional architects, as well as classically inflected poets, letter writers, and even biographers, architects or architectural amateurs, and writers of fiction. Villas have served as exemplars of what is possible in the way of a *Roman* form with *contemporary* relevance; the ideals of educated and elite *otium* were part of their attraction.[181]

In choices for contemporary cultural information, learned tourism, and entertainment, and very much like extant country houses of later date and place that are "open to the public," Roman villas in France, Italy, Spain, Portugal, and elsewhere are among the most visited sites by an educated and interested public, because they give immediacy and meaning to ordinary experience that temples, amphitheaters, and palaces do not always do. Villas provide contemporary visitors a voyeur's view into the homely life of a supposedly glamorous past that is profoundly compelling.

Latin agricultural treatises were consulted, in the Renaissance and later, for their practical information, but such antiquarianism was as nothing compared to the architectural and cultural emulation of Roman villas. They were a living font of inspiration in Western culture and architectural history, as potent as archetypes from the *suburbia* of Renaissance Rome and Florence, the *terraferma* of Venice, and many other places beginning in the fifteenth century to the *suburbia* of contemporary cities. Country houses on the supposed Roman model were built almost everywhere in Europe

and ultimately in the Americas: They are, in their Lilliputian, emulative, or grandiose versions, an almost universal phenomenon in the built environment. That many, if not most, of these later versions are imaginary does not detract from the power of the Roman prototypes that they emulated.

In this history of emulation, the rediscovery of Vitruvius' text (in 1416 by Poggio Bracciolini)[182] and Pliny's letters (in 1419 by Guarino Veronese)[183] were crucial to the modern historiography of Roman villas. In the case of Vitruvius, the dissemination and illustration of his treatise on architecture were as influential – if obtusely so – on domestic architecture as on the correct design of the columnar orders and their proportions (Doric, Tuscan, Ionic, and so forth) as on public building and *domus*, though not on villas. Editions of Vitruvius followed those of the authors on agriculture, even though his *De Architectura* had been discovered earlier. Printings of his Latin text were numerous, and one of the earliest was an illustrated one; translations followed.[184]

No less important for the history of villas in the Renaissance was the almost simultaneous discovery of the letters of Pliny the Younger. The descriptions of the *Laurentinum* and *Tuscanum* as well as other letters about villas strongly inflected owners and architects of rural residences, first in Italy, then throughout Europe. While local traditions of farmsteads with residences, some quite substantial, continued,[185] the combination of Vitruvian classical form in architectural orders, proportions, and details with a new and utterly up-to-date appreciation of nature and leisure as well as the authority of Plinian *otium* gave villas and country houses the allure of antique justification. The results were notable in actual buildings and on drawn reconstructions as well as in numerous books of "how to" live the villa life correctly. The tradition begat its own ambiguities: The double themes of pride of house and natural and architectural beauty, as well as the house as a symbol of oppressive privilege, form the bittersweet bases of William Butler Yeats' poem *Ancestral Houses*, the first section of his *Meditations in Time of Civil War* (1923).[186]

NOTES

1. For a general survey, Greene 1986.

2. For Varro's considerations on agricultural mensuration, *Rust* 1.10.1–2. See also Dilke 1971; idem 1992; texts and critical edition in *Corpus agrimensorum romanorum* 1993-1996 (French).

3. In general, Wallace-Hadrill (ed.) 1989. For large-scale patronage overseas, Badian 1958; see also articles in Wallace-Hadrill (ed.) 1990. For discussion of the *domus* as "public image" of its aristocratic owner, Wiseman 1986.

4. Plin., *Ep*. 4.6.2. The discussion of what villas were for was a long one: More than a century before Pliny, Varro had dedicated the third book of his treatise on agriculture (*Rust*. 3) to a friend, Pinnius, who owned a richly decorated villa but who also wished it to be adorned with the products of his literary pursuits. Varro wished his friend's villa to be also adorned with produce of the estate, to make the *villa perfecta* comprising beauty, intellection, and productivity.

5. Strabo 5.4.8.

6. Plin., *Ep*. 2.17.27: *multarum urbium facies*; Marzano 2007, 13.

7. Varro, *Rust*. 1.2.6: *Non arboribus consita Italia, ut tota pomarium videatur?*

8. For transport and exchange in general, the articles in D'Arms and Kopff 1980 remain seminal. The long-distance and seaborne commerce in agricultural goods is attested by the Mediterranean-wide distribution of amphorae containing foodstuffs of all kinds (olive oil, wine, fish sauces and salted fish, preserved fruit, etc.). The amphorae, generally shaped with narrow bodies and pointed bases for space-saving packing on ships and easy tipping of contents, were often stamped with the names of their makers and other information; for a general account, Peacock and Williams 1986 and two websites: Bibliography of Amphora Studies (Amphoras project) at www.projects.chass.utoronto.ca/amphoras/bib/amph-bib.htm and the University of Southampton project *Roman Amphorae: a digital resource* at www.archaeologydataservice.ac.uk/archives/view/amphora_ahrb_2005/index.cfm. For amphorae for Hispania/Lusitania see also the "Amphorae ex Hispania" webpage: www.amphorae.icac.cat/tipol/geo/map.

Amphorae were eminently recyclable by other producers and shippers for other goods. They were produced in vast quantities, often at villas themselves as a secondary activity of estates that had clay beds, and the clay could also be used for the commercial production of construction materials – roof tiles and bricks, also often stamped with the names of their owner-manufacturers. For example, the large villa called "Gara delle Nereide" at Tagiura near Tripoli in Tripolitania (modern Libya; see Wilson [Chapter 16] in this book) was built with many stamped bricks of the 150s–160s CE made in Rome or elsewhere in Italy. This villa's owner may have been shipping agricultural produce from his estate to Italy in amphorae and getting his vessels back loaded with building materials as ship ballast, for use as the villa was being built – thus satisfying a two-way commerce; see Di Vita 1966a, 133; 1966b, 16–20.

9. Plin., *Ep*. 8.2; damage due to hail was common: *Ep*. 4.6.1.

10. On market buildings (*macella*), De Ruyt 1983; for a calendar of *nundinae* from Rome to Nola covering the market days of Latium and Campania, MacMullen 1970. On permanent and periodic markets see also the papers in Lo Cascio (ed.) 2000.

11. Suet., *Claud*. 12; Plin., *Ep*. 5.4 & 5.13; *CIL* 8.270.

12. Hitchner 1990; Mattingly 1988c. Some sites, believed to have been for oil production, have been reinterpreted as wine-producing centers after excavations recovered grape pips.

13. On Roman North African periodic markets: Fentress 2007; Meloni 2008.

14. Varro devoted the entire third book of his treatise to the discussion of the *villaticae pastiones*. He gives several examples: the villa of M. Seius near Ostia where, among other fauna, wild boars, pigeons, and honey bees were raised, and a villa on Planasia island (mod. Pianosa), which specialized in peacocks (*Rust*. 3.6.2). His aunt's villa just north of Rome was equipped with an aviary for breeding thrushes, which she successfully sold for a triumphal banquet to be staged in Rome (5,000 birds for *HS* 60,000). For discussion of *pastio villatica* and villas, see Marzano 2007, 47–62; 73; 88–91; Marzano and Brizzi 2009 for the productivity of fishponds at seaside villas.

15. For the attribution of the scheme to Nerva: Aur. Victor, *Caes*. 12.4; this author stresses the aim was to help needy families but this may be the writer's own interpretation based on his Christian beliefs.

A general history of the *alimenta* and other schemes in the Italian peninsula for the public good in Pagé 2012. Scholars differ as to what the real aim of the *alimenta* was; for some, the real concern was to promote investment in the productivity of the estates of Italy (by forcing owners to take loans, with a moderate interest rate, against the property pledged as security); see Duncan-Jones 1964; Garnsey 1968. More recently, Lo Cascio 2000. Others believe the concern was demographic decline in Italy or, considering that the beneficiaries were for the most part boys, military recruitment; see Jongman 2002; Hemelrijk 2015, 46-80, n. 127. The texts of the *alimenta* in Italy are in Criniti 1991 and Cao 2010.

16. *Ep.* 1.8.10 and *ILS* 2927. For an example of a private alimentary scheme outside of Italy, *CIL* 8.1641, from Sicca in Numidia (169/180 CE).

17. On the *ager publicus* to 89 BCE, Roselaar 2010.

18. Dilke 1971; idem 1992; Campbell 2000.

19. Bringmann 1985, 13.

20. On colonization and centuriation in northern Italy, a phenomenon well-attested in Veneto and in the area of Modena and Mantua, see Gabba et al. (eds.) 2003. On the important and problematic source for the foundation of Roman colonies, the *Libri coloniarium*, see articles in Gonzalès and Guillaumin (eds.) 2006. Specific studies on land and property in the articles included in Lo Cascio (ed.) 1997. For types of land under survey and its designation, Clavel-Lévêque 2008.

21. Caillemer and Chevallier 1954; Piganiol et al. (eds.) 1960 (2nd edn. of 1954 Atlas); Chevallier 1959.

22. The early times of aerial photography to study the ancient landscape in the work of Jean Baradez in North Africa is reviewed in Boyancé 1969 (obituary of Baradez) and early techniques in Chevallier 1959. For popular accounts, Chevallier 1964; idem 1965; the techniques as developed through the 1970s and still valid today are outlined in Dassié 1978. A general overview for the Roman West: Chouquer and Favory 1991. The principal exponent of the techniques was Raymond Chevallier for Gaul and northern and central Italy: Caillemer and Chevallier 1954; Chevallier 1980; idem 1983; Chouquer et al. 1987; Chevallier 1988a. For the Spanish Peninsula: summary in Ariño et al. 2004. Chevallier 1988b for account of travel in relation to the aerial documentation of roads.

23. Piganiol 1962; Chastagnol 1965; excavated confirmation Bellet and Mefre 1991. Most recently Decramer et al. 2006.

24. Clavel-Lévêque's initial study in 1979 was for the town of Baeterrae (mod. Béziers) in Gallia Narbonensis: see analysis and extension of her work in Mauné 1998. Numerous international conferences round out the study of centuriation in Roman times, and they have been published in edited volumes: Clavel-Lévêque (ed.) 1983; Clavel-Lévêque, Jouffroy and Vignot (eds.) 1994; Clavel-Lévêque and Plana-Mallart (eds.) 1995; Clavel-Lévêque and Vignot (eds.) 1998; Clavel-Lévêque and Tirologos (eds.) 2004. See also Gabba et al. 2003. A summary of work for the western empire to 1990 is in Chouquer and Favory 1991.

25. Chouquer et al. 1982; Chouquer 1993; idem 2008.

26. The methods of electromagnetic investigation by R. J. C. Atkinson (1952) coincided with early aerial photography. Since then, magnetometry and other techniques have expanded enormously: see Clark 1996; Gaffney and Gater 2003; Witten 2006. For contemporary techniques, useful articles in Campana and Piro (eds.) 2009.

27. LIDAR is a remote sensing technology that measures distance by illuminating a target with a laser and analyzing the reflected light; it can reveal microtopography or buried structures hidden by vegetation where aerial photography cannot. Its application in archaeology is becoming more common as its cost decreases. English Heritage published in 2010 a freely downloadable document containing guidelines for the application of LIDAR to archaeological investigations/ heritage management: see www.english-heritage.org.uk/publications/light-fantastic/ (accessed December 5, 2014). Drones or UAVs (Unmanned Aerial Vehicles) have found archaeological applications recently (see, e.g., article by C. Klein published in April 2014 on History.com: www.history.com/news/can-drones-revolutionize-archaeology (accessed December 5, 2014). JISC has produced an online guide for the best use of UAVs in archaeology: www.jiscdigitalmedia.ac.uk/infokit/3d/uav-survey (accessed December 5, 2014).

28. Ward-Perkins 1955 is the preliminary article on the project and outlines its structure; Kahane, Threipland, and Ward-Perkins 1968 present the results of more than 12 years' work, and Potter 1979; idem 1980 and idem 1992 for synthesis of

these data. Pottery studies have now developed more sophisticated chronological classifications, and the South Etruria Survey data, never fully published, have been revaluated by the Tiber Valley Project. Preliminary results can be found in Patterson et al. 2004 and Patterson and Coarelli 2008. Since then, field surveys have become a norm of archaeological research. They are too numerous to list here, but notable finds of Roman villas have resulted from the surveys published in the series *Carta archeologica e ricerche in Campania*, the *Carta archeologica del Veneto*, the *Carta archeologica della Lombardia*, and many others, some online. Further afield, beginning in 1988, the numerous volumes of the *Carte archéologique de la Gaule* have added immeasurably to the knowledge of Rome and other civilizations in Gaul, and, in Greece, the Minnesota Messenia project and that of the Pylos Regional Archaeological Project have included documentation of Roman habitation sites. Renfrew and Bahn 2012 for a general account of methods.

29. Because the distinction, in a field survey, between classifying a site as a "farm" or a "villa" depends on the size of the scatter of the material that has been attributed to each category *a priori*, there are serious methodological problems in the comparison of data from different surveys; see Osborne 2004; Patterson et al. 2004; Patterson 2006, 17–24. Witcher 2006 challenges practices in field survey studies, which are seen as limited to a too narrowly defined range of historical questions.

30. Comparative studies can also be useful to reveal problems of method: for Roman Britain compared to Hispania, Millet 1992.

31. The titles of the treatises are mostly modern conventions. Translations and critical commentary on the texts in *Corpus agrimensorum romanorum* 1993–1996, trans. Clavel-Lévêque et al. (French) and in the Loeb Classical Library (English).

32. White 1970, 18–41 for a succinct and helpful list of agricultural writers in the gaps of extant texts between Cato and Varro, Varro and Columella, and Columella and Palladius, as well as consideration of other sources.

33. Cato, *Agr.* 1.3.

34. Cato, *Agr.* 14.1–5.

35. Cato, *Agr.* 1.3.

36. Cato, *Agr.* 4.1.

37. Vitr., *De arch.* 6.8.1–10.

38. Cn. Tremellius Scrofa in Varro, *Rust.* 1.13.6–7.

39. For example, while Cato gives recommendations on the size of the land one should buy and its characteristics (e.g., with varied soil and certain equipment and personnel, *Rust.* 1.7), he does not give figures as to the revenue that could be expected. Varro, in his third book, cites several instances of revenue from agriculture and husbandry (including raising of birds for special banquets), but these are almost all exceptions intended to illustrate the superiority of farming to other pursuits. The revenue from wine produced on villa estates is discussed in Étienne 1980 *contra* Duncan-Jones 1982 (in the latter's first edition of 1974). Some idea of the (owner-reported) value of estates and therefore a very rough estimate of their revenue might be derived from the lists of taxable farms in the *alimenta* system established for Italy under Nerva and Trajan: for texts and commentary of the Veleia and Ligures Baebiani inscriptions, see Pachetère 1920; Veyne 1957; idem 1958: Criniti 1991; Cao 2010. See also Duncan-Jones 1964; idem 1982.

40. On Cato's *Origines*, Chassignet 1986.

41. Varro, *Rust.* 2.1.10.

42. Varro, *Rust.* 3.1.1–6. The priority and superiority of rural dwelling versus city life had a history in Greek literature beginning in the eighth century BCE.

43. For the social thought and economic notions of the Roman agricultural writers, Martin 1971.

44. Varro, *Rust.* 1.4.

45. Varro, *Rust.* 1.13.6.

46. Varro, *Rust.* 3.2.4–5; cf. also 1.2.10: The highly productive villa-estate of Cn. Tremellius Scrofa, with its storerooms filled with agricultural produce, is a more pleasing spectacle than mansions built like palaces and adorned only with art collections. Purcell 1995.

47. Varro, *Rust.* 3.5. The aviary has often been reconstructed visually from Varro's description: see Stierlin 1996, 180–1.

48. Columella, *Rust.* 1.4.

49. *Praetorium*: 1.11; *cella vinaria* as *basilica*: 1.18. See also MacMullen 1963, 23–48 on militarization of civil architecture, and that of villas, 41–44; Ripoll and Arce 2000, 64–5.

50. Vitr., *De arch*, 6.6.5.

51. Carandini and Ricci (eds.) 1985, vol. 1, 107–37.

52. This villa is also called Villa alla Pisanella or Villa Pisanella.

53. Pasqui 1897. See also Carrington 1931, 111–19, 126–9; Day 1932, 170–83; Della Corte 1965,

433–7. The fame of the Villa della Pisanella was reinforced by the discovery, hidden in a cistern, of 108 items of silver tableware and exhibition pieces as well as coins valued at *HS* 100,000. For the silver objects, Baratte 1986; Casalis and Scarfoglio 1988; Cirillo and Casale 2004.

54. Rostovtzeff 1911; Carrington 1931; Day 1932.

55. Frank 1933; Rostovtzeff 1926, 3rd rev. edn. 1957.

56. Crova 1942; Della Corte 1965.

57. White 1970; see also White 1967.

58. Edition in Beckh 1895, repr. 1995; translation in Dalby 2011; White 1970, 32.

59. For an account of Columella translations, Forster and Heffner 1955. For Palladius, lists of some early editions in Bartoldus 2012; Rodgers 1975 and Rodgers (ed.) 1975. Early editions of the Latin texts and translations of the Roman agricultural writers in Brunet (ed.) 1965–1966 (reprint of 5th edition of 1860–1865) under their names or s.v. *Scriptores. Rei rusticae veteres latini* and *Rei rusticae scriptores*.

60. For example, a French translation was published by Saboureux de la Bonnetrie 1771–5, 6 vols. Paris: Silvestre. For the improvement of husbandry in Scotland, in 1788 Adam Dickson excerpted Latin agricultural writers in his *The Husbandry of the Ancients*.

61. *Rust.*1.17.1. Lewis 2013 for the view that the *genus vocale instrumenti* comprised both slave and free workers within an economic unit and did not mean "tool," but what is needed to run a farmstead, including the human workforce.

62. The first treatise on agriculture in Latin, that of Cato in the mid-second century BCE, gives a list of the supply yards and hardware stores where good equipment might be bought for fair prices in the environs of Rome and southward, as far as Naples and Pompeii, and he always lists what is needed for olive processing or wine making in great detail. Purcell 1995 on the prestige of the *instrumentum mutum*, which he terms "the romance of equipment."

63. *Dig.* 33.7.12.1.

64. For agrarian legislation, Max Weber was among the first to emphasize its importance in ancient social history: Weber 1891 (2008), especially chapters 2 and 4. For commentary: Winterling 2001, 603–12 on Weber's analysis and historical projection of Roman Republican social and economic changes on later Roman and medieval structures. Useful

analyses in Buck 1983, but the scholarship on agrarian legislation is too vast to detail here.

65. Some examples: *Dig.* 33.8.3 and 4 on servitudes; *Dig.* 33.7.8.12 on the right to inhabit a villa; *Dig.* 33.7.12.6 on personnel (also listed in other sections); *Dig.* 33.7.12.8 on sheep and sheep folds; *Dig.* 33.7.12.23 on plaster paintings and statues attached to walls, with a following section on libraries in houses or at villas.

66. Women could certainly own villas and estates in their own right: Varro dedicated the first book of his *De Re Rustica* to his wife, whom he calls Fundania (her name means "she who owns an estate/s"), and he mentions several women in ownership and supervisory positions at villas, including female relatives. The position of *vilicus* (manager) is described in all Latin manuals. On the *vilicus*, Carlsen 1995.

67. Vitruvius distinguished the public rooms in a house to which anyone had access from private rooms entered by invitation only: *De arch.* 6.5.1. The public-private organization of Roman domestic space: Grahame 1997; Wallace-Hadrill 1988; see Clarke and Howe in this book (Chapters 4 and 6).

68. This is a modern hypothesis based on the route of the *via Aurelia* and what is known of the type of rural settlements in the territories touched by the road: Wilson 2004.

69. Plut. *Ti.Gracch* 8.7; *cf.* also App. *B Civ.* 1.1.7–9. Plutarch relates this story as coming from a pamphlet by Tiberius Gracchus's younger brother, Gaius Sempronius Gracchus (c. 154–121 BCE), whose political career was even more radical, so the younger Gracchus may have been simplifying a more complex observation by his elder brother, or making it up. In any case, the story does not empathize with the slaves, only with the former citizen-farmers who, supposedly dispossessed of their farms and gravitating to Rome, may well have made up a body of supporters of the Gracchi along with the urban proletariat.

70. The issue of formation of large estates in the hands of the rich to the detriment of small and medium landholdings, with the displaced owners swelling the ranks of Rome's urban proletariat, is centered on another important issue that occupied much of Rome's sociopolitical debates throughout the mid- and late Republican periods: the distribution of public lands and their illegal occupation: see Roselaar 2010. For a review of the evidence, White 1967.

71. Plin., *HN* 18.11.

72. Lintott 1994, 62–103; Badian 1972.

73. They have been the backdrop for social conflict from the thirteenth century in England (the Peasants' War of 1381), the sixteenth century in Germany (the Peasants' War of 1524–5), the French Revolution, and the American Civil War. The literature is extensive on all facets of agricultural work in relation to political violence, and virtually all make reference to Roman agricultural practices. For England in 1381, Butcher 1987; Justice 1994; for Germany in 1524–5, the classic study is Frederick Engels' 1850 "Der deutsche Bauernkrieg." *Neue Rheinische Zeitung. Politisch-ökonomische Revue* 5 and 6 (Engels 1850 and see also Blickle 1981); for Roman and American use of slaves, Yeo 1951/1952; for slavery and abolition, Eckert 2010.

74. On Greek farms both in Greece and in Hellenic colonies, the relation between farmers who owned their own land (or leased it) and other forms of agricultural personnel (tenants, colonists, aboriginal workers, slaves) had come into question. Xenophon in his *Oikonomikos*, or household manual, written in the mid-fourth century CE, identifies Ischomachos' agricultural personnel as slaves, for the most part, and the ten workers in his wife's weaving factory as slaves as well. The scholarly literature on Greek agricultural slavery is large: see, in general, Alföldy 1988 and most recently, Kyrtatas 2011; for Hellenistic slavery, Thompson 2011; archaeological considerations in Morris 2011.

75. Finley 1980; Vogt 1972 and 1974; Vogt and Bellen 1983; Deissler 2010; Bradley 2010. The continuation of Vogt's work is outlined in Herrmann-Otto 2010. Previous discussions in Andreau and Descat 2006; Andreau 1999. On the varying views of ancient slavery, the chapters in Heinen (ed.) 2010 are particularly useful, especially Bradley 2010 for an overview.

76. Bradley 2010 and especially McKeown 2010.

77. Herrmann-Otto 2010.

78. Binsfeld 2010.

79. White 1970, 377–83; on free and slave laborers, 332–76.

80. George 1997, 14 and n. 3; idem 2010; and "Introduction" in George (ed.) 2013; Lenski 2013; Joshel and Petersen 2014 with preceding bibliography; Joshel and Petersen 2016. In particular, Joshel's work has added much to the study of Roman slavery: Joshel 1992 and 2010, as has the articles collected in Joshel and Murnaghan 1998.

81. Though we are omitting in this chapter consideration of agrarian legislation, the famous early study by Max Weber set out the themes that were taken up by later scholars: see n. 64.

82. Bringmann 1985.

83. An extreme thesis on the authoritarian nature of villas can be found in Bentmann and Müller 1970 (1992); for villas in landscapes, Cosgrove 1998.

84. Momigliano 1994; articles on specific aspects of Rostovtzeff's work in Andreau and Berelowitch 2008. "Daily life" literature, both scholarly and popular, is vast; the most famous and still available is that of Carcopino 1939 (1975), translated into numerous languages and editions.

85. Lot 1927, 72–75, 90–92 on slaves; ibid. 124–31 on the colonate.

86. Rostovtzeff 1911.

87. Heitland 1921, 2011, 7–14, 151–64, 203–12, 296–305. For a review of the evidence for agricultural workforce, especially its legal aspects, Lo Cascio 1999 and articles in Lo Cascio (ed.) 1997; see also White 1965 for questions of slave productivity.

88. Finley 1980, 62–94.

89. White 1970, 332–76. See also Eckert 2010.

90. Perelli 1982, 73–96; Bernstein 1978, 77–78; 82–101; Stockton 1979, 6–22; Shochat 1980, 47–76.

91. Carandini et al. 1982, vol. 1, 18–20 and vol. 3, 505–9; see also Celuzza and Regoli 1982, 31–62).

92. Marzano 2007, 123–48; Roselaar 2010, 147–220; Launaro 2011, 149–89; Rathbone 1981, 12–15; idem 1983.

93. For a review of *latifundia* stressing their parallel existence with other forms of farm properties, White 1967. Discussion in Andreau 1994; Lo Cascio 1999; Zannier 2007.

94. Goulet 2001; Laken 2003 on the application of "zebra-stripe" patterns on certain corridors or rooms evidently allocated to in-house slaves, visiting slaves, or other servants in Campanian villa decorations. The analysis, by Carandini, of the spatial arrangements of the plan of the Settefinestre villa, both its residential and service parts, into lines of movement was significant: It allowed the analysis of the villa to be subdivided into socially specific movements, lines of sight, and spatial experiences: for the late Republican villa: Carandini and Filippi 1985, vol. I, 152–6 and figs. 151–4; for the late first–early second century villa, vol. I, 171–5 and figs. 162–6. The proprietors' lines of movement through the

building were different from those of a slave. In the Phase II (Augustan) San Rocco villa at Francolise, in the *ager Falernus* north of Capua, an extra corridor (room 15) connected the *pars rustica* to the *pars urbana* to avoid servants using the representational axis from the entrance hall (*vestibulum*, room 1) to the peristyle: Cotton and Métraux 1985, 48. In Villa A at Oplontis, at the bend of a door just outside a *triclinium* (room 16; Figure 4.1 in this book), there was a special open closet or "cubby" in which a servant could stand, out of sight, but within earshot in case something was needed in the dining room; a similar "cubby" may have existed in the Villa San Marco at Stabiae, just off the atrium (Figure 6.2 in this book). We are grateful to Lea Cline for pointing out these spaces and their special uses.

Elaborate construction of social relations by means of a system termed *Relative Asymmetry* (Hillier and Hanson 1984, applied by them to large urban patterns) is occasionally used for houses but is no substitute for less cumbersome analyses of ground plans and decorations; for an example, Grahame 1997.

95. For instance, it is significant that in Spanish scholarship when noting the appearance in the archaeological record of Roman-style rural villas these are automatically linked to the presence of agricultural slaves, because of the so-called "slave mode of production" that would have been exported from Italy.

96. Marzano 2007, 139–48.

97. For instance, their use as stable boxes was ruled out by the excavators because of the size of the doorway, but stable boxes from Villa Arianna at Stabiae have a narrower doorway than at Settefinestre; see Marzano 2007, 125–38.

98. As was noted by Purcell in his review (1988) of the 1985 Settefinestre publication, the interpretation of the courtyard as slave quarters rested entirely on literary sources, namely the texts of Varro and Columella. That estates such as this relied on a *combination* of slave and hired seasonal labor had been suggested by Rathbone as early as 1981. Further discussion on this important issue in Carandini 2002, which can be read with Terrenato 2001; see also Fentress 2003, 553–6 and Rosafio 2009.

99. For instance, unlike examples of olive oil facilities with many presses found in the Roman villas of Istria or on agricultural estates in North Africa, villas in central Italy had (with three or four exceptions, including Settefinestre) only *one* wine press and *one* olive press. This indicates not only what the land was

used for but also – and very importantly – the fact that each villa needed its own processing facilities and that these could not be centralized in larger facilities serving more than one estate. The inference is that properties belonging to the same owner were not contiguous but the facilities to produce oil and wine were standalone entities; see Marzano 2013c.

100. For this interpretation, Lafon 2001; Torelli 2012.

101. Foxhall 2007.

102. Ancient authors such as Appian (*Pun.* 101; 107) normally refer to Punic farms as *turres* (towers) or *castella* (fortified buildings), emphasizing their fortified nature.

103. Fentress 2001.

104. Heurgon 1976.

105. Terrenato 2001.

106. Carandini et al. 2006.

107. Terrenato 2001.

108. Terrenato 2012.

109. Volpe 2000, 198; Volpe 2009.

110. Volpe 2012.

111. Even closely built maritime villas could derive substantial revenue from pisciculture: Marzano and Brizzi 2009; Marzano 2013b, 213–26; 252–64.

112. They are central themes in St. Augustine's *De Civitate Dei* (*City of God*) and its sequel, the *Historiae Adversus Paganos* (*Histories against the pagans*) by Orosius.

113. Ripoll and Arce 2000 for a succinct overview; Lewit 2003 for further analyses and articles in Vera (ed.) 1999.

114. For a general review, Christie 2011.

115. An example of apparent degradation can be found in the San Rocco villa at Francolise. Certain residential rooms of the older villa had been carefully preserved when the structure was enlarged in the late first century BCE, and in one case an older floor was extended with a copy of the old pattern (room A/A1 = room 29). However, around the mid-first century CE, the new room (29) with a very fine floor (*Op.mus.* 2 and 27) was remodeled to accommodate a new little bath building, a seeming degradation of a handsome older feature but motivated by a desire for modern comfort. Cotton and Métraux 1985, 59–61, 85–90, 120–1.

116. *Ep.* 3.19.

117. On the location of this estate, see Sherwin-White 1966, 254.

118. The property was an excellent one, with fertile earth and abundant good water as well as varied land

(fields, vineyards, woodlots), but it was for sale at this depressed price because the previous owner had, essentially, deprived the tenants of the necessary means to exploit the land. His tenants (*coloni*) had pledged their slaves as security, but these were confiscated when they were unable to pay their debts. Consequently, the tenants lost even more productivity and the owner had had to lower the tenancy rates. See De Neeve 1984, 165–7; Métraux 1998, 2–3; Kehoe 1988, 120–1.

119. On increasing the workload of slaves, Hopkins 1983, i–xxvii.

120. On interpreting the expression *hac penuria colonorum* at *Ep.* 3.19.7 as referring to the lack of means of the tenants in that specific case and not to difficulties in finding suitable tenants, Lo Cascio 2003 (with previous bibliography).

121. See Marzano 2007, 199–222.

122. Boak's thesis (1955) was hotly and variously criticized soon after its publication: reviews in Jones 1956, Finley 1958.

123. Jones 1964, vol. 2, 1040–5. Brunt (1971, 91–112 and his chapter 7) discusses population and manpower in relation to his analyses of the census figures through the *Res Gestae* of the emperor Augustus. See Lapyrionok 2013 for a critique. Manpower issues have become widely discussed: Rich 2007 for Italy in the late second century BCE, Dyson 2003 for late Republic and early empire, Francovich and Hodges 2003, 11–60, for the second century CE through late antiquity.

124. Analysis of literary sources in Mayer 2005.

125. Cic., *Leg.* 3.30. For Lucullus's villa, McCracken 1942.

126. Cic. *Fin.* 3.1.7–9.

127. For examples at Tibur, most recently Trombrägel 2012. For villas in the *ager Cosanus* with towers, Quilici and Quilici Gigli 1978. For the Misenum villas of Marius, Pompey, and Julius Caesar, Sen., *Ep.* 51. Later villas could also have a military look, as much for threatening aspect as for defense: examples are the "Castellum" of Nador (Anselmino 1989) and the towered villa called the "Burgus" of Pontius Leontius described by Sidonius Apollinaris (*Carm.* 22). Villas represented on North African mosaics often had high walls and towers, see e.g., the *Dominus Julius* mosaic from Carthage: Dunbabin 1978, 119–21; Duval 1985; Dunbabin 1999, 118–19.

128. For Tibur as a Spanish summer colony: Syme 1982–3; Birley 1997, 13–14, 192. Emperor Hadrian's parents (from Spanish families) may have had a country house there, thus possibly prompting his choice of the area for his own very grandiose villa: Métraux 2015a, 140–1.

129. Such visibility of the diners may have its origins in imperial dining arrangements: An early example of the *stibadium* can be found in the dining room at the far (SE) end of the Scenic Canal at Hadrian's villa at Tibur. See MacDonald and Pinto 1995, 108–9. For the issues of *stibadia* and visibility, Dunbabin 1991; 1996; Ellis 1991, 1997, and 2007.

130. On these issues, see Balmelle 2001, 238–42. Mosaics and villas did not have an accidental relationship: They presupposed one another. On mosaics in general, Ling 1998 and Dunbabin 1999. The biannual bibliography published by *AIEMA* (*Association internationale pour l'étude de la mosaïque antique*) is an essential guide.

131. For the visualization of the *mos maiorum* in families in the late Republic, see Flower 1996. The theme is widely treated: Gruen 1992; Linke and Stemmler 2000; Miano 2011.

132. Sen., *Ep.* 86; D'Arms 2003, 5–16 and n. 11, 25–6.

133. Suet., *Tib.* 11.1 (Rhodes) and 60.1 (Capreae); also Tac., *Ann.* 6.1.

134. See above, p. 00 and n. 14.

135. Suet. *Aug.* 6.1; Livy 6.5.12–13. See Syme 1979 (1959). The nursery at Velitrae appears to have had a particularly strong numinous quality, inducing strange feelings of awe in those who approached it and even having poltergeist effects.

136. Suet., *Aug.* 100.1.

137. Suet., *Aug.* 92.1; Tac., *Ann.* 4.67.

138. Plin., *HN* 15.136–7. Carrara 2005a and 2005b with preceding bibliography; De Franceschini 2005, cat. no. 7; Marzano 2007, 519.

139. Suet., *Galb.* 4.3.

140. Plin., *Ep.* 6.31. Marzano 2007, 164 and n. 39.

141. Suet., *Galb.* 1.1; 4.3; Bodel 1997; Agache 2008.

142. "*Vatia hic situs est*": Sen., *Ep.* 55.4.

143. Plin., *Ep.* 6.30. For tombs at villas, Bodel 1997; Griesbach 2005.

144. Sid. Apoll., *Carm.* 22, 142–44.

145. Paulinus of Nola. *Ep.* 29–32: Trout 1999, 128–32, 239–43; Hanson 1970. A little later than Sulpicius Severus in Aquitania, Cassiodorus (Flavius Magnus Aurelius Cassiodorus Senator, c. 490–585 BCE), an Italian nobleman in the service of the Ostrogothic

kings of Italy, converted his family estate, *Vivarium* (near Squillace in southern Italy) into a monastery, a coenobitic facility, and Christian learning center. See Bowes in this book (Chapter 23).

146. *Otium* is defined by Cicero in the third book of his *De Officiis*. The sources for, and the many different ideas of, *otium* are detailed in a large literature of scholarship: André 1962; 1966; Dosi 2006. In his letters, Pliny often alluded to it (e.g., *Ep.* 1.9.6; 9.36): Méthy 2007, 353–413.

147. The business of seeming *not* to work or being any kind of professional expert is an endemic social theme: being an *amateur* in the businesses of life was a mode of bearing for the elites recommended by Aristotle and followed, one way or another, from antiquity to the present. Except for engagement in public and political affairs or in military commands, being a dilettante was the proper stance for members of the upper classes.

148. Carandini 2010, 128–37. Cicero purchased the house from a M. Crassus (presumably the Triumvir) in 62 BCE for the grand sum of 3.5 million sesterces: He had to borrow 2 million in order to do this (Cic., *Fam.* 2.6.2; Gell., *NA* 12.12).

149. Cicero kept libraries in four of his villas; L. Licinius Lucullus had a famous library in his villa at Tusculum, largely derived from booty from his military campaigns in Asia Minor; Sulla had a library in his villa at Cumae: Casson 2001, 69–75.

150. Modern technology is allowing the reading of these texts without need to attempt to unroll the delicate and brittle carbonized scrolls: use of computer tomography and multispectral imaging are the most successful techniques currently being used, see, e.g., the Herculaneum Project of Brigham Young University: www.guides.lib.byu.edu/content.php?pid=82036&sid=609011 (accessed May 25, 2013). On works in this library not by the philosopher Philodemus: Houston 2013.

151. Plin., *Ep.* 7.25.4.

152. The wife and daughter of Cicero's great friend Atticus spent their holidays at the villa in Cumae, but invitations were not always accepted: Cicero had also invited Brutus, but he declined: Cic., *Att.* 12.36.

153. Cic., *Att.* 13.45.3. The villa at Puteoli had been inherited, together with shops and rental properties, from a businessman, a certain Cluvius.

154. Cic., *Att.* 5.2.2.

155. Plin., *Ep.* 6.3. If the woman had been a slave and then freed, she could have owned the property outright, but Pliny did not transfer the freehold to her, only its income to provide for her maintenance.

156. Gerontius mentions this in his life of the saint: *vita sanctae Melaniae* 2, in Clark 1984, 28.

157. Cic., *Att.* 2.14; 5.2, *cf.* Plin., *Ep.* 5.6.

158. On the Volusii Saturnini and Lucus Feroniae: Marzano 2007, 140–5; 176–98. A possible connection between prominent villa owners and local towns concerns the Calpurnii Pisones, possible owners of the Villa dei Papyri as patrons of the nearby town of Herculaneum. The attribution of the villa to the Calpurnii Pisones was first proposed by Comparetti in 1879 and strongly refuted by Mommsen in 1880; in current scholarship some accept the attribution and others reject it. For a discussion of the issue (with earlier bibliographical references), see Capasso 2010, 92–113.

159. Pliny had been elected by the local decurions to be patron of Tifernum Tiberinum when he was just an adolescent, probably when he inherited his villa there from his uncle (*Ep.* 4.1.4). He had several obligations when in residence at this villa: hearing complaints of his tenants, arbitrating disputes, performing his various duties as patron and even as local magistrate of the town (*Ep.* 7.30, 9.15, 9.36).

160. Zerbini 2006. Villas generated a certain number of inscriptions as well, though this has never received a separate treatment. For comment, see Marzano 2007, 92–3.

161. Hesiod was motivated to write an agricultural manual because his brother Perses had abandoned the family farm to go and live in the city (Thebes) as a hanger-on of rich urban dwellers.

162. For *ekphrasis*, Kennedy 2003; Morgan 1998, 190–8; Webb 1999. Shield of Achilles: Hom., *Il.* 18. 478–608; Palace of Menelaos: Hom., *Od.* 4.17; houses of Ischomachos: Xen. *Oec.* 6.12–11,18, especially 8.2–9 and 9 (farm), and 11. Ischomachos also had a house in Athens.

163. Hor., *Sat.*2.7.118 and *Ep.*1.14.2–3. For the Sabine farm, commentary and bibliography in Marzano 2007, 393. For discussion of Horace's second *Epode*, D'Ambra and Métraux 2006; see Métraux in this book (Chapter 21). To Horace must be added the *Georgics* and other poetic evocations of rural activity and the landscape by Virgil, who does not, however, speak of villas in any specific way.

164. Sen., *Ep.* letter 51 (on Baiae and its villas), 55 (villa of Servilius Vatia near Cumae) and 86 (villa of Scipio Africanus at Liternum), to which can be added *Ep.*

114 on villas and *domus*. For a general account, Métraux 2015b, 33–8. For an idiosyncratic presentation of Seneca's villa letters, Henderson 2004.

165. Plin., *Ep.* 2.17 (*Laurentinum*) and 5.6 (*in Tuscis*); Marzano 2007; McEwen 1995. The bibliography on Pliny's villas and other villas in his letters is vast: see Sirago 1987, Förtsch 1993 and du Prey 1994; thematic analysis in Leach 2003. On *ekphrasis* in Pliny, most recently Chinn 2007; Métraux 2015b. Pliny's letters, based in part on Cicero's (Marchesi 2008, 207–40) including those on villas, were models followed well into late antiquity: Cameron 1965; idem 1967.

166. Stat., *Silv.* 2.2. The other villas were at Bauli across the Bay of Naples and on the Ionian coast near Tarentum (mod. Taranto): Stat., *Silv.* 2.2.91–113. Other poems in the *Silvae* were devoted to villas, e.g., 1.3 on Manlius Vopiscus' villa at Tibur. Leach 2003 compares Statius on the villa of Pollius Felix with those of Pliny.

167. For private bath buildings in Italy, De Haan 2010.

168. For analysis of Statius's poem and the villa, Bergmann 1991. For an analysis of *luxuria*, Dubois-Pélerin 2008.

169. Sid. Apoll., *Ep.* 2.2.3 and *Carm.* 16. Sidonius wrote other poems on villas: *Ep.* 2.9; on baths at his villa, *Carm.* 18 and 19; on what he called the "Baiae," namely the hot springs near Augusonomentum, *Ep.*5.14; on villas and baths he enjoyed at two friends' villas, *Ep.*2.9; a long poem accompanying a prose letter called *Burgus Pontii Leontii* (*Carm.* 22). On the "Castle" of Pontius Leontius, Balmelle 2001, 144–5. General commentary in Dark 2004; Métraux 2015b, 38–41.

170. Sid. Apoll., *Carm.* 22.

171. Sen., *Ep.* 114.9. For other issues of wealth and *luxuria*, Dubois-Pélerin 2008.

172. The bibliography on the *Domus Aurea* of Nero is extensive: see Ball 2003 for preceding bibliography. In Suetonius' description of the *Domus Aurea*, the gardens and the park with its structures and landscapes seem to emphasize the views from the palace in a series of pictures. This aspect is similar to the pleasures of viewing the property, animals, and human activities of the villa estate owned by one Alphius, a moneylender, as described by Horace (*Epod.* 2.61–66) 60 or 70 years before the Neronian park; see D'Ambra and Métraux 2006, viii. Framed landscapes set out as paintings with open shutters were incorporated into the wall decorations of the so-called Palazzo Imperiale at Pompeii and the "royal box" at Herodium: Netzer et al. 2010, 98–101, color figs. D, K, and L.

173. For Villa A at Oplontis, the perspectival extensions of the spaces depicted in the wall painting are reconstructed in ingenious and convincing isometric views in Mazzoleni 2004, 133–9 (including Villa A at Oplontis; many other examples, e.g., House of the Labyrinth at Pompeii, 29 and 170–1.

174. Zanker 1979 (1990). Zanker's article introduced a fundamentally new procedure in the study of Roman domestic architecture, namely how houses are repositories of reference to idealized situations, longings, and the prestige of country living. For a villa-*domus* theme in Pompeian houses, with modest *atria* taking on the grand look of villa-like peristyles, George 1998. The larger theme of country in town, town in country is treated in Purcell 1987.

175. Bianchi-Bandinelli 1963, 819–28. The distinction between the architectural views of landscapes with or without villas and the "sacral-idyllic" scenes is analyzed in detail in Leach 1988, in literary context. See also Leach 2004.

176. The style of these paintings is extremely appealing to modern taste; for Roman viewers, their placement on the walls within larger contexts indicates that they were regarded as charming rather than important.

177. Sarnowski 1978; Dunbabin 1978, 119–23; Duval 1980; 1985; Rind 2009, 35–46; Spanish and other examples in Blázquez Martínez 1994.

178. Métraux 2008, 276–9.

179. For how changes in late antique cityscapes were perceived, Frye 2003.

180. An exception is the development, in the Roman environs and in central Italy, of agricultural enterprises called *domuscultae* under the supervision and to the profit of the papal fisc. The topic of *domuscultae* is beyond the scope of this book, but see Noble 1984, 241–53; De Francesco 1998; Milella 2007.

181. In Italian and French, respectively, the locutions *villegiatura* and *villégiature* mean holidays or vacations, specifically out of town.

182. Bigi 1971, s.v. Bracciolini, Poggio.

183. Johnson 1912.

184. Rome 1486, Venice [illustrated by Fra Giovanni Giocondo], Florence 1513 [with Frontinus's *De Aquis*], Amsterdam 1649), and translations were later produced (Italian by Caesare Caesariano, Como 1521 and another translation, Naples 1758; French translation, Paris 1547, Spanish translation, Madrid 1787; French by M. Perrault, Paris 1684). The text of Vitruvius and the writings of the Italian architect Vignola (1507–73) appeared together in London in 1703 and 1729, and translations in many other languages have followed since the early nineteenth century. For accounts of the editions of Vitruvius: Plommer 1973; Ebhardt 1865, 1962; Koch 1951; Cervera Vera 1978; Gros 2006.

185. The typologies of plans, certain features such as porticoes and raised attics (for storage of produce), and spatial organization of the enclosures of farm houses indigenous to the Veneto were the basis, with some adjustments, some application of the classical language of architectural forms, and some proportional modifications, for the very famous villas of the sixteenth century, notably those of Sebastiano Serlio and Andrea Palladio. There was thus a smooth transition from familiar farms to modern "classical" villas: see Kubelik 1977, vol. 1, 38–52.

186. In W.B. Yeats, *Meditations in Time of Civil War* (*London Mercury* 7 [January 1923] 232–8).

THE ROMAN VILLA
Definitions and Variations

URSULA ROTHE

INTRODUCTION

The term *villa* had multiple meanings in Latin and many manifestations in Roman history as well as Mediterranean-wide variations in the archaeological record. In fact, the establishment of a precise definition already preoccupied ancient authors such as Cato and Varro, and modern scholars continue to debate how it can be applied to what kinds of buildings. While we may still be far from finding a universal definition, both the written and the archaeological record can point us in the right direction.[1]

As is well known, the original meaning of the Latin term *villa* is "farm," but if we limit investigation of the phenomenon to this narrow definition, the central role of the villa in the cultural ideologies and aspirations of the Roman cultural elite is missed. In his *De Agricultura* in the 160s BCE, Cato gave us a morally pleasing image of an austere *villa rustica* with a simple agricultural routine, but while the term *villa* could describe a simple farm, it was also appropriate to describe the very grand country retreats of the great men of Rome; Scipio Africanus, one such personage of late Republican times, retired to both an elaborate country mansion and a rural estate, which, in combination, were both called *villa*,[2] and the term continued to be used for both even when they began to develop in very different directions. While apparently antithetical to one another, Cato's small estate with its modest edifice and the huge, very luxurious *villae maritimae* on the Bay of Naples had a basic common denominator: the Roman elite ideology of landedness and the improvement of the mind by natural surroundings.

The differing criteria for the use of the term *villa* among both ancient and modern writers and from Italy to the Roman provinces, with their array of cultural and climatic conditions, multiplies almost *ad infinitum* the range of possible meanings of the term and its many manifestations. Nonetheless, certain tendencies and groups of meaning can be identified, both thematically and geographically. These can only be touched on in the discussion that follows, but it is hoped that it will provide a good starting point for the rich variety of material and interpretation collected in this volume.

ANCIENT MEANINGS

Cato's farming handbook *De Agricultura* provides us with our earliest comprehensive insight into the role of villas in Roman culture. The work begins with a brief discussion of the sources of income available to a Roman citizen, dismissing both trade and money-lending as dangerous and dishonorable respectively; only land provided income that was both dependable and honorable, and, what's more, land was the very essence of Roman stock: "it is the farming community that brings forth the most

courageous men and the most capable soldiers."[3] His brief introduction reveals two of the most important elements of the Roman villa: its function as a financial investment of a city-based elite and its role as a manifestation of the idealization of country life. Cato uses the term *praedium* for the farm as a whole, and the term *villa* for its main building, but he distinguishes between the *villa rustica* (farm buildings) and the *villa urbana* (master's residence), saying that the latter should be comfortable enough for the owner to enjoy visiting as much as possible, and thus benefit the running of the farm; extravagance beyond this financial consideration is to be abhorred.[4]

Varro's more ample *De Re Rustica* of about a century later follows Cato's lead: It is a manual in three books of how to run an agricultural establishment. It is noted that the more comfortable the residence is, the more time the owner will wish to spend at the property. Maximization of profit is the overriding consideration, right down to the optimization of position near a road or port to minimize transport costs. Income derived from the land is considered desirable because not only is it more ancient but it is also more noble. In the same vein, Varro deplores the apparent prevalence of luxury fittings in the villas of his day. Today, he says, people do not think they have a real villa unless it has peristyles, palaestras, and other frivolous architectural features known by their trendy Greek names.[5] Particularly interesting is the discussion in book 3. 1–2 between the author and two men by the name of Quintus Axius and Appius Claudius. Sitting in the shade of the *Villa Publica*, a civic building in the Campus Martius in Rome used for the census among other things,[6] the men get to ponder on the true nature of a villa. Due to its architectural simplicity, the *Villa Publica*, Appius claims, is more a villa than Axius' luxury retreat at Reate with its mosaics and citrus-wood furniture. Axius, however, retorts that the fact that a building lies outside the city walls does not make it a villa. What really makes a villa is its *fundus* – its land – something the *Villa Publica* lacked. He may be half-joking when he claims that a building is not a villa unless it contains a donkey, but his point is well-taken. What this discussion

shows is that, already in Varro's time, the term *villa* had become hard to define, reaching from the simple farm to the luxury estate, with its economic basis not necessarily a determining feature. The fact that he chose to record this conversation at all – or invent and publish it as typical – highlights the importance of this ambivalence.

Despite a distinct shift toward luxury villas, a generation later, chapter 6.6 of Vitruvius' *De Architectura* still advises on the practicalities of how to build farm buildings. He states that if the owner wants the main building of the villa (for him this term equates to "farm") to have some opulence, the way it is built should nonetheless avoid impinging on the effectiveness of the work buildings.[7] Otherwise, the residential part of the complex is expected to conform to the same architectural plan as townhouses, except that instead of the urban convention that the *atrium* be situated immediately after the entrance into the house, followed further back by a peristyle, in countryside residences that are built to urban standards (*pseudourbanae*), these two features should be reversed.[8] In other words, for Vitruvius a villa was a farm, but the farmstead could be a simple house or a sumptuous residence with all the trappings of urban life. By the mid-first century CE, the demand for practical farming manuals had not abated, and Columella's *De Re Rustica* divides more clearly the different parts of the villa: the *villa rustica* (farm buildings with slave dwellings), the *villa fructuaria* (storerooms and silos for the produce), and the *villa urbana* (the owner's residence). His description of the optimal positioning of different parts of the latter now assumes the existence of summer and winter apartments, baths, dining rooms, and promenades (*Rust.* 1.6).

Subsequent literary insights into the Roman understanding of the villa are dominated by incidental but sometimes detailed descriptions of sumptuous country retreats in Roman epistography and ekphrastic literature, revealing the position and function of key elements such as the atrium, the library, the gardens, and the *triclinium*, preferably with a view of the sea or the surrounding countryside, and the intellectual and aesthetic properties of the artwork on display. Examples of this are Pliny the Younger's

affectionate step-by-step accounts of his villas in let-
ters 2.17 and 5.6, and Philostratus' (probably real)
descriptions of various picture scenes on display in
a Neapolitan villa in his *Imagines*. The emphasis in
these depictions is on these villas providing healthy
country or sea air and panoramic views for physical
and mental well-being, an intellectually stimulating
aesthetic environment, and the peace and quiet to
engage in thought and writing. While orchards and
stables are mentioned, it is clear that the main pur-
pose of these villas was their role as country retreats
and not as agricultural businesses.

Many other sources could be cited: Roman
literature abounds in descriptions of villas visited
or owned by authors whose work has come down
to us. The aristocratic preoccupation with ever
more numerous and costly villas did not, for exam-
ple, escape the satirical humor of Martial and
Juvenal,[9] while Statius delighted in the fine archi-
tectural details and landscape settings of his friends'
villas.[10] In fact, by the first century CE, as John
Bodel has put it, "the domestic environment in
which a gentleman cultivated his leisure was itself
worthy of poetic commemoration."[11] However,
having now gained an image of the "literary
villa," let us now turn to the "archaeological
villa":[12] that which remains as material evidence
for modern scholars to interpret.

MODERN INTERPRETATIONS:
THE ECONOMIC DIMENSION

Given the apparent conflict in the written sources
between sterile economic reckoning and gushing
descriptions of architectural extravagance, to what
extent do the existing remains reveal the Roman
villa as an economic establishment? Some scholars
have chosen to focus on this aspect as the deciding
factor, and, indeed, legislative measures such as the
Lex Claudia of 218 BCE saw agricultural production
as the only appropriate economic activity of
senators,[13] meaning that in order to obtain the
resources necessary for a lifestyle befitting rank, the
Roman nobility had, in theory, to invest their capital
in lucrative rural enterprises.[14] By the time of
the Second Punic War (218–201 BCE), there was
a great amount of such capital, a growing amount of
available land, and an overabundance of slaves who
could work it. Small-scale farmers, many of whom
had spent long periods away from their land fighting
in the wars, had little chance to compete with these
enterprises on the market, and many headed for the
cities, securing this change by selling their properties
to large-scale landowners. Although some still pro-
duced in small quantities the full range of basic food-
stuffs for domestic use, the new, larger agricultural
properties for the most part specialized in financially
rewarding animal breeding or cash crops such as wine
and olives for trade,[15] leaving the increasingly urba-
nized population of Italy reliant on imports from
Sicily and Sardinia, and later Egypt and the Black
Sea, for the more essential but less profitable grain.[16]
Over time, even the transport to, and storage of,
agricultural produce in cities was subcontracted to
brokers and agents.[17] Ironically, as Hans Drerup says,
"it is precisely this marked distancing from agricul-
ture that created the circumstances for the develop-
ment of villas."[18]

One of the first substantial studies to view
Italian villas in economic, rather than artistic or
architectural, terms has been Andrea Carandini's
and M. Rossella Filippi's influential report on the
excavations at Settefinestre in Etruria, and indeed,
large storage facilities and what have been inter-
preted by the excavators as slave quarters show
that this villa, at least, was a sleek money-making
machine.[19] For many, not only the production of
a significant agricultural surplus but also the
employment of large teams of slaves to work
the land was one of the distinctive features of the
Roman villa as a phenomenon.[20] In this respect,
the villa was no longer simply a "farm" but an
enterprise, and one inextricably linked to the
city:[21] The city required large agricultural sur-
pluses and solvent buyers for its manufactured
goods to remain viable, while the villa owner
needed a market for his produce, a source for the
things he needed to maintain his lifestyle, and an
urban *pied-à-terre* to conduct his political life.

In this light, the link between the villa as "capitalistic farming"[22] and the villa as lavish country retreat is not one of paradox but of correlation: In order to be able to *afford* the fountains and *palaestrae*, the villa owner had to derive from the estate as much wealth as possible. Nicholas Purcell has put the case in the following way:

> [W]hat gave the landscape of the villa, the landscape of production, a coherence from Britain to Syria, was patterns in the attitudes of producers and consumers to what was to be produced and how and by whom it was to be consumed. For my "landscape of production" is indissolubly embedded in that landscape of consumption which is formed by stratification, patronage and euergetism in the Roman city. If there is a coherence in the estates of the ancient countryside, it derives only secondarily from architecture and much more from the effect that ancient society had on producing coherence in the patterns of exploitation.[23]

As the "the visible place where wealth was produced,"[24] the villa's fields and barns were thus just as much a symbol of economic power as its architectural extravagance.

MODERN INTERPRETATIONS: THE MORPHOLOGICAL DIMENSION

But what of this architectural extravagance? A large portion of villa scholarship not only for Italy but throughout the empire has focused on distinctive architectural and decorative features that are considered to constitute a Roman villa: peristyles, baths, fountains, fishponds, gardens, libraries, small rooms for quiet activity, *triclinia* and garden dining areas, mosaic floors, frescoed walls, hypocaust heating, and such follies as towers and artificial grottoes. The outlook and layout of these constituent parts were often designed to link the structure with the surrounding countryside by the use of slope locations, ambulatory structures, and the positioning of

windows and terraces to enable the enjoyment of panoramic views.[25] Far from being a cosmetic consideration, these features were the manifestation in bricks and mortar of elite *Romanitas*, the ideology of land-based wealth and the salutary qualities of the countryside expounded by authors such as Cato and Varro.[26] Having developed out of the increasingly comfortable residence of a working farm, the Roman villa soon developed offshoots that focused more on the lifestyle aspect of this ideology. The compact, inward-looking ground plans taken from elite residences in the city were gradually adapted to be outward-looking, with porticos and gardens surrounding the building, instead of *vice versa*, and windows and terraces inviting the landscape in.[27] Special features of some villas were the *cryptoporticus* and terraces that enabled the villa to sit up high and straddle uneven terrain. What modern scholarship has termed "*otium* villas" were often built in locations chosen for their commanding views and healthy air, such as the Campanian coastline or the northern Italian lakes. It is into this type of villa that we get such a detailed insight through Pliny's letters and the excellent state of preservation of estates in the Bay of Naples that were covered by the explosion of Vesuvius in 79 CE.

The architectural characteristics described above were also a demonstration of a certain level of education for villa owners. Under the influence of newly conquered Hellenistic Greece, which for many Romans was synonymous with intellectual refinement, the elite of the middle and late Republic developed a taste for eastern architecture and cultural pursuits. While the monarchical and effeminate undertones of Greek culture rendered excessive philhellenism inappropriate to the ideally stern and pragmatic men of the Roman republic, such fancies could nonetheless be enjoyed in the greater seclusion of the countryside.[28] Many of the architectural features associated with the Roman villa were lifted directly from Hellenistic architecture, along with the fashionable Greek names that Varro found so pretentious: *procoetion* (anteroom), *palaestra* (exercise room), *apodyterion* (dressing room), *peristylon* (colonnade), *ornithon* (aviary), *peripteros* (pergola), and *oporotheca* (fruit room).[29] In these "Bildungslandschaften,"[30] or "intellectual

landscapes," both the natural and the cultural could be combined, great collections of books and art could be displayed and used in bucolic surroundings, and the mind could be free to ponder the large questions of life.[31]

However, while traditional villa scholarship has (rightly) focused on the high level of sophistication in layout and furnishings as a particular achievement of Rome's ruling class, more recent studies have called for a greater acknowledgment of the production elements in these very same villas.[32] Annalisa Marzano has shown, for example, that the large, and undoubtedly picturesque, *piscinae* in some of the coastal villas were used first and foremost as highly lucrative fish farms, and this is certainly in keeping with the information related by Varro that there was more money to be made in aquaculture than in agriculture.[33] Even if they consumed more wealth than they produced, the most urbane seaside villas still usually included at least apiaries, dovecotes, orchards, and vineyards, and it was a source of great pride to villa owners to serve their guests produce derived exclusively from their estates. In the case of suburban villas, the conspicuously large wine-pressing room in the Villa dei Misteri at Pompeii was not, as earlier interpretations held, a transformation of a reception room by boorish later owners, but an original feature of which the owner was obviously proud, given its prominence in the complex.[34] The Roman villa was the manifestation of this twofold value system: A Roman gentleman had to be both urban and rural.

MODERN INTERPRETATIONS: THE TOPOGRAPHICAL DIMENSION

If the Roman gentleman had to be both urban and rural, did it follow that his urban dwelling should have rural elements? One of the most difficult problems in considering the nature of the Roman villa is the question as to where to draw the architectural line between the villa of the country and the *domus* of the town.

Of course, in many ways the geography is straightforward; we are easily able to distinguish among *villae maritimae* next to the sea, such as the Villa San Marco at Stabiae, *villae suburbanae* in the outskirts of cities, like the Villa dei Misteri at Pompeii, and what Pierre Gros has called "villas lacustres" on the shores of lakes.[35] We can even mark the difference among thoroughly rustic villas like the Villa Regina at Boscoreale (Figure 2.1) and those with very clearly divided *villae rusticae* and *villae urbanae*, like the Villa San Rocco in Francolise.[36] But what of the *horti* within the *urbs* on the Aventine and the Palatine in Rome itself, pleasure gardens that were developed into pseudo-country retreats by their elite owners? Paul Zanker and Andrew Wallace-Hadrill have suggested these be considered together with villas because they belonged to the same people and provided the same "suitable moral alibi"[37] as quiet and aesthetically pleasing places to entertain and engage in *otium* (as well as to grow apples).[38] On the other hand, although it seems logical to follow Roman legal texts[39] and the great

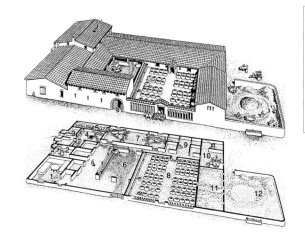

Figure 2.1. Boscoreale, Villa Regina, reconstruction drawing (from Helen and Richard Leacroft 1969 [www.the-romans.co.uk/domestic_architecture .htm accessed April 4, 2014]).

1. Triclinium
2. Bakery
3. Baths
4. Kitchen
5. Cow shed
6. Yard
7. Wine press room
8. Fermenting yard
9. Servants' rooms
10. Oil-pressing rooms
11. Barn
12. Treshing floor

Upper floor over 2-5.

many scholars[40] who let location within or outside city walls decide what is a villa and what is a *domus*, in actual fact the situation is rather complicated. The agglomerations of *villae maritimae* at places like Stabiae took on the appearance of towns, and almost identical houses were built either side of the town grid boundary.[41] At Pompeii and Herculaneum, seaside residences were even built over the top of former city walls that faced the sea,[42] and Sallust claimed that some villas were even the size of towns in their own right.[43] For many, *villae suburbanae* occupy a transitional category between *domus* and villa in that they were primarily residential without the room to command vast estates, but with the typical ground plan of the country house.[44]

Because, for the most part, the same social class owned both *domus* and villas, similar architectural and decorative elements emerged in both. As we have seen, Vitruvius held that an ideal country house should reverse the order of rooms of a *domus*: Instead of entering into the austere *atrium*, and only later proceeding into the more ornate and airy peristyle garden in the rear, the visitor to a country house should be immediately met by the greenery and space of the peristyle (perhaps a relic of the large farmyard that had been at the heart of the Roman farm), and only later proceed to the *atrium*.[45] As Wallace-Hadrill has put it, "Vitruvius turns the villa into the mirror image of the town house ... To "urbanise" the country is to stand the town on its head."[46] On the other hand, archaeological remains show us that this rule was not strictly observed: Pseudo-urban villas at Herculaneum and even the "model villa" at Settefinestre were outside the city walls and boasted extensive grounds but started with an *atrium* and moved on to a peristyle.[47]

By the same token, while the *domus* of an elite family in town needed "business" rooms for *negotium* (public and political life) together with a residential part, in rural houses the *negotium* quarters were to an extent replaced by those given over to *otium*, although rural villas could also have "public" areas, and *otium* was not necessarily confined to the countryside.[48] There was also a correspondence in substance: Although city houses were mostly built to shut the outside out and rural villas often brought the outside in, both have been shown to have been designed with an eye for visual

angles and a keen sense of symmetry, space, and perspective. Moreover, with time many of the "rural" features associated with country estates started to creep into townhouses, largely as a result of being the products of the same social group, but perhaps also to an extent due to middle class emulation of elite tastes, bringing into more modest urban dwellings luxurious elements such as peristyle gardens, landscape paintings, and mosaic scenes. This congruence of features was not confined to ornament: Caputo's "*domus-villa urbana*" at Cumae in Campania was situated within the city walls but had extensive orchards and terraces,[49] and in Pompeii, agriculture and horticulture were conducted within the city walls, both in private gardens and in separate vineyards and olive groves.[50] Jashemski has shown that gardens were standard features of houses even in more densely settled quarters, and the second-century BCE House of Pansa, one of the oldest dwellings in the city, had an *atrium*, a peristyle, and a back garden, which by its size (it took up a third of a city block) and structure (maximization of space and water use) was clearly meant to turn out a significant quantity of produce.[51] At the extreme end of the scale, the term *domus* for Nero's *Domus Aurea* in Rome was, in fact, a gaudy irony: Although it was in the center of town, it boasted vineyards, fields, woodland, and even flocks of sheep.[52]

MODERN INTERPRETATIONS: THE GEOGRAPHICAL DIMENSION

The discussion has hitherto focused quite intentionally on Italy: The question as to the definition of a villa is difficult enough in this core area. Italy itself was a patchwork of different villa landscapes: *Otium* villas tended to concentrate in the areas with the most fertile land (Etruria, Campania, the Tiber, Arno, Volturno, and Po valleys), while in other regions smaller estates and those worked by tenant farmers rather than slaves were variously abundant.[53] The situation is even more varied when taking into account the Roman provinces with their widely varying climates and cultures. On the one hand, the typical Italian-style villa with its large landholdings, its elaborate farmhouse, and its armies of mainly slave laborers can be found in

provinces with comparable social and climatic condi-
tions such as Gallia Narbonnensis and Hispania
Baetica; in these regions even the more compact,
inward-looking architecture of the older Italian villas
prevails. On the other hand, it is especially with
regard to its more distinctive regional variations in
the provinces that scholarly use of the term *villa* is
most wide-ranging.[54]

REGIONAL FORMS OF VILLAS: THE NORTH-WESTERN PROVINCES

In the north-western provinces,[55] where the greatest
number of relevant sites has been explored, the term
villa is usually used to denote rural estates that display
imported Mediterranean architectural features –
especially construction in stone – which distin-
guished them from native, mostly wooden-built

houses.[56] These complexes are usually referred to as
villae rusticae, even if the residence displayed lavish
architecture and decoration that would qualify it as
a *villa urbana* in Italy.[57] Extensive aerial photography
in this region in recent decades has added signifi-
cantly to the number of known ground plans, so that
it is now possible to distinguish a range of regional
forms both for the central buildings of the estate and
the residence. The villa yard was generally arranged
either haphazardly ("Streuhof" or "scattered yard" –
e.g., Köln-Müngersdorf and most sites in the
Hambach brown coal-mining region to the west of
Cologne in Germany: Figure 2.2)[58] or axially, with
the main residence in a central position at the back
of the block, and the secondary buildings
arranged in rows either side reaching to the front gate
(e.g., Verneuil-en-Halatte, France: Figure 2.3).[59]
The main residence was built either around an inner
peristyle (e.g., Bad Kreuznach, Germany),[60] or more

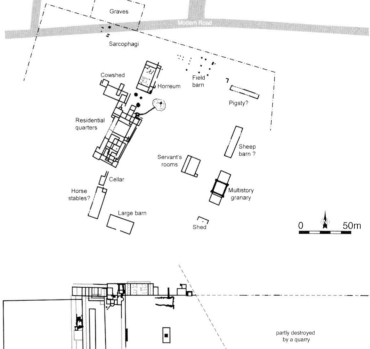

Figure 2.2. Köln-Müngersdorf, villa
complex, plan (after Percival 1976,
fig. 24).

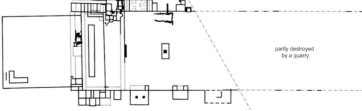

Figure 2.3. Verneil-en-Halatte, villa
complex (courtesy of Jean-Luc Collart,
SRA Picardie).

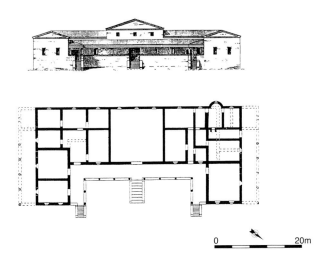

Figure 2.4. Blankenheim (Germany), villa. Above: reconstruction of the northeast façade. Below: plan of the earlier phase (Oelmann 1916: 210).

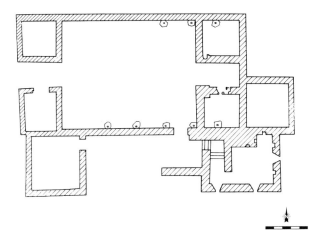

Figure 2.5. Grémecey, villa, groundplan (after Percival 1976: fig. 44).

often as a wide, shallow building with a portico along the front;[61] a typical design of the region is the "porticus with pavilions,"[62] in which extra rooms or towers acted as wings at either end of the front portico (e.g., Serville, Belgium, Friedberg-Pfingstweide or Blankenheim, Germany: Figure 2.4).[63] A house style confined to Britain was Richmond's "aisled house" with its three-span hall.[64]

The term villa for these structures is, however, highly problematic. There is every reason to believe that they were inhabited by indigenous families, and indeed roughly half of those currently known developed out of more simple farms, often originating in the pre-Roman period.[65] The main building frequently consisted of a *Hallenhaus* (or "hall house"), typical of the La Tène culture native to Gaul in the pre-Roman period, to which was gradually added a corridor and Mediterranean features such as a portico or a tiled roof, or which was rebuilt in stone (e.g., Grémecey in the Moselle region of France, where the postholes of the earlier *Hallenhaus* align perfectly with the later stone structure: Figure 2.5).[66] Such cases render the customary definition of villas in this area as stone-built structures somewhat arbitrary, as the attainment of a so-defined *villa* reflected perhaps no more profound a change than a slight improvement in financial capacity, especially when it is considered that the

transition often occurred many generations after Roman conquest. Moreover, some large farmhouses, such as at Druten in the Netherlands, had a distinctly Roman ground plan but were constructed entirely of wood.[67] Karl Heinz Lenz has convincingly argued that the ubiquitous native *Viereckschanzen* of the pre-Roman north-west – square, ditched enclosures containing several buildings – were not religious sites but in fact farms, and that these formed the basis of the characteristic farmyard arrangement of the later "villas."[68] Even the more Mediterranean-looking peristyle villas may have had a specific local development in that the pavilions at the ends of the portico grew over time to enclose three, and eventually four, sides of the central yard,[69] although there may have been parallel influence from the courtyard plan of the headquarters or *praetoria* of Roman army camps.[70] On the other hand, it is not insignificant that many of these structures show strong Mediterranean influence, not only in their structure but even in their positioning on hillsides and spurs, and the terminology used by Roman authors for rural dwellings in the region tends to suggest that they, too, were reluctant to call any farm a villa unless it had some Roman accoutrements.[71]

Villas housed families, and the variety in their forms prompted John T. Smith to link space and social structure in his investigation of provincial villas throughout the empire. On the basis of ground plans

for villas from Britain to Bulgaria, he argues that the way rooms, hearths, and corridors were arranged reflected the groups of people who lived there, and changes in these arrangements reflected changes in the composition of those groups. Smith claimed to have identified a kinship structure in north-western villas, consisting of several related families in separate residences with large communal areas like dining rooms and baths.[72] While there has been criticism of Smith's approach,[73] it deserves merit for attempting to marry architecture to social structure, aspects which had hitherto been treated separately in villa scholarship of the north-west.[74]

Widespread in studies of rural settlement in the north-west is a more socioeconomic approach to the development of villas, and it is perhaps in this regard that they are easier to grasp. In many parts of the north-west before the Roman period, small villages consisting of a handful of farms producing mainly or entirely for self-consumption were the normal rural settlement form. The introduction of a monetary economy[75] and taxation, together with towns and army camps whose populations required large quantities of food, led to a switch to cash crops and an accumulation and concentration of wealth that could be spent on such luxuries as baths and mosaic floors.[76] In the pre-Roman period, farms in the north-west had produced a small surplus for use by the elite and inhabitants of the permanently settled *oppida*; what changed with the Roman conquest was the dramatic *increase* of that surplus and the resulting change in agricultural practices.[77] Consequently, villas in the north-west tend to concentrate around cities and in particularly fertile areas like the region around Colonia Agrippina (Köln, Cologne) and the plains of northern France and Belgium.

Despite adaptations to Roman and Italian villa features, continuity with the pre-Roman past with regard to the social and economic structures seems to have existed in the form and functioning of these buildings. In contrast to the Italian use of villas as country retreats, most villas in the north-western areas of the Roman Empire appear to have been permanent, or at least main, residences. Substantial farm buildings were usual,

as was positioning on major roads and waterways, so agricultural production was central to their establishment and viability. *Otium* villas never developed, despite the considerable opulence of some of the sites. The range of foodstuffs produced by a single estate seems to have been more varied in the north-west, and a combination of pastoralism and cropping was common. There is also no evidence for slave agricultural labor north of Gallia Narbonnensis, while pictorial and other evidence points to the widespread use of tenant farmers who paid rent to the landowner in both coin and kind.[78] It would appear that the villa system as it evolved in the north-west allowed the social structure of pre-Roman society, with its landed elite and semi-dependent tenant farmers, to continue largely as before.

REGIONAL FORMS OF VILLAS: NORTH AFRICA AND EASTERN PROVINCES

In North Africa,[79] an entirely different scholarly discourse on villas has been underway. Here the term villa is used to refer mainly to the many Roman-period farms that grew olives and produced oil for both local and overseas markets.[80] In the first two centuries CE, they were often small in size and displayed very few Roman architectural features such as baths and mosaics, and it is likely that if they were discovered in Italy they would not be identified as villas at all. While the north-western "*porticus* with pavilions" type of villa was adopted in North Africa, probably via Spain,[81] the form it took was more compact and block-like, with high outer walls and portico galleries appearing on the upper floor (see Figures 16.4, 16.5, and 16.6 in Chapter 16).[82] The impression given is one of concern for safety at the expense of permitting the interplay between the inside of the building and the landscape that was such a major feature of villa architecture further north. Although the Carthaginians had already had large country estates before the Roman conquest in the second century BCE, the occupation of the region by the latter was characterized more by

discontinuity with the past than in other regions, especially as a great deal of Carthaginian land was carved up into small lots for Roman veteran settlers.[83] In this region, the advent of villas went hand-in-hand with the extension of land use into previously unusable areas such as deserts and mountains, primarily through improved investment in irrigation made possible by the commercial nature of many of the installations. As in the north-western provinces, agricultural labor was provided mainly by *coloni*.[84]

In addition to these unambiguously agricultural sites, North Africa also has pockets of what might be considered *otium* villas: large, luxurious, and primarily residential coastal estates catering to the lifestyles of the elites of metropolitan centers such as Leptis Magna and Carthage. These have often been referred to as villas, even when they are discovered within the city limits of places like Carthage, as they show many of the features of Italian-style maritime villas: peristyles with gardens, mosaics, fountains, and panoramic views out to sea,[85] although some scholars insist on the use of the term *domus* for those found within city limits.[86]

Archaeological scholarship on the eastern provinces of the Roman Empire, in particular Asia Minor and the Levant, has a long tradition of referring to elaborate Roman townhouses as villas.[87] These display a considerable degree of continuity from pre-Roman urban architecture: courtyard houses with public and private areas date back to Babylonian times (fourth to mid-second millennium BCE) and are typical of Near Eastern architecture in general, not least in the Hellenistic period.[88] Here, scholars identify a dwelling to be a villa on the presence or absence of Roman architectural features, not necessarily a position within a city or outside it. As such, despite a lack of agricultural or horticultural production, luxurious townhouses with *triclinia*, elaborate mosaics, and peristyles in cities like Zeugma (Turkey) and Sepphoris (Israel) are usually termed villas because their architectural elements link them with elite houses in other parts of the empire.[89] Similarly, another category of building referred to as villa by scholars of the Near East are the sumptuous residences built by Herod at Jericho, Caesarea, the Herodium, and other sites in Judaea. Herod's taste

was strongly influenced by elite architecture in Italy, and his villas display many of their typical features, such as baths, colonnades, gardens, and sumptuous mosaics. The positioning and layout of his villa complex on the promontory at Caesarea, for example, was clearly inspired by the *villae maritimae* on the Campanian coast in Italy.[90] However, the Roman practice of city elites escaping to agricultural estates or at least to more airy complexes on the outskirts of town was not widespread in the East until late antiquity.[91] Many of the handful of comfortable but often also, and perhaps primarily, productive suburban villas that date to the first and second centuries CE are thought to belong to newcomers to the area.[92] The words used in Greek for such estates reveal their nature: *Proásteion* can be translated as *suburbanum* in Latin, meaning either proximity to town or the extension of city amenities to a country location; the term *kêpos*, which is also often used, means simply garden or smallholding.[93]

The lack of a landed element in elite ideology in the East in comparison to Italy and the western provinces of the Roman Empire also influenced the structure of rural settlement and agricultural production. The main unit of rural habitation in the eastern provinces was the nucleated village (*kóme*) of small-scale farmers set in the agricultural environs (*chóra*) of the local town (*pólis*) and producing primarily for the town itself.[94] Elite investment went into imposing houses in the towns and rarely into estates in the countryside, which meant that, at least until the third century CE, Roman-style villas were, as has often been noted, much less common,[95] although improved survey work is tipping this balance somewhat.[96] The Near East had a long tradition of building medium-sized farms and a typical architectural form in the so-called courtyard house, which, by its vertical division into working and living space, its flat roof, and its grouping around a yard, was perfectly adapted to the conditions of the region. But such farms are not necessarily regarded as villas. Again we are faced with a problem of definition: As was the case with urban buildings, scholars often only classify Near-Eastern residences in the countryside as villas if they display Roman architectural features such as mosaics and porticos.[97] When these

architectural features are, as is often the case, a sign of habitation by a specific social group, such as the elite, they are indeed significant, perhaps even enough to warrant using a different term. But it is conceivable that such features often symbolized nothing more than a change in taste or an improvement in financial circumstances of one and the same family. It is not without significance that, generally until the Byzantine period, the pre-Roman style of farm prevailed, even on large estates and in close proximity to Roman-style cities.[98]

There were, however, some regional divergences from this pattern. In Judaea, for example, although small villages were the main rural settlement type, the Hellenistic kings and Hasmonean rulers also had large country domains worked by tenant farmers,[99] as did the Hellenistic rulers in Syria, where the tenant-farmer system was maintained into the Roman period.[100] Quite independently of the adoption or not of Roman architectural forms, there are a number of isolated farmhouses in Judaea that date to the first century CE,[101] and that century also saw a development in some places toward the subordination of peasants by larger landowners who, however, usually had their centers in villages.[102] The tension was particularly pronounced in areas where Herod settled his veterans and his administrators, who likewise ran large estates with tenants.[103] In some cases, however, the isolated farmhouses were indeed the centers of large estates, such as Ramat Hanadiv in the hills near Caesarea.[104]

The transfer of the imperial capital to Constantinople in 330 CE brought a new elite culture to the Roman east as well as intense Christianization, with the result that wealth and attention were lavished on the Holy Land and the landscape of the eastern provinces began to change. The senatorial elite at Constantinople indulged in a taste for country estates, a taste that was gradually adopted by rich urban citizens throughout the Roman east, and late antique sources often refer to country villas that served as retreats, especially from summer in the city, and as hunting lodges, although at times they also appear to have functioned as retirement homes or refuges in times of political strife.[105] Truly suburban recreational

villas tended to cluster around major cities like Antioch, Beirut, Beth-Shean, and Ephesus, although most of them also contained gardens and small plantations that produced food for the household.[106] The adoption of a "landed" ideology and the general increase in exploitation of the eastern landscape in late antiquity led to a boom in large, elite-owned farming estates in thoroughly rural areas as well.[107] A valuable description in a letter from Gregory of Nyssa (330–95 CE) to Adelphius, the owner of a villa in central Anatolia, reveals a layout and lifestyle not unlike earlier estates in Italy, but the description also mentions new features that set it apart from earlier structures: It was entered through a large gateway and was heavily fortified with walls and towers for protection against brigandage, the inner complex centered around a colonnaded courtyard with a pool in the middle from which one entered the main reception rooms. Garden furniture was placed under the trees outside the villa's main entrance for outdoor dining – a nod to the earlier Roman *stibadia* – and the complex included a chapel and a mausoleum at some distance from the main building. Curiously, no bath house is mentioned.[108] The presence of new and changed features in late-antique villas inevitably leads to the question as to whether we can still use the term for the structures of this period, as Near Eastern scholars do, or whether new terms should be applied, as is often the case in the western provinces.

MODERN INTERPRETATIONS: THE CHRONOLOGICAL DIMENSION

One of the most difficult, and for some most arbitrary, factors in determining what should be termed a villa is the requirement that it must be *Roman*. This in turn raises a chronological problem: From which point in time can we start to speak of *the* villa as an architectural, economic, and cultural category? A great deal of discussion has centered on the matter of the Hellenistic origins of the Roman villa. Some, like Andrew Wallace-Hadrill, see Roman villas as manifestations of the strong influence of Hellenistic styles and values on the Roman aristocracy following

the conquest of Greece in the second century BCE but translated into a manifestly Roman form, which justifies seeing them as a separate, *Roman*, architectural category.[109] Others see villas as the product of an aristocratic ideal that combined a landed economic base with the ability to retreat from the strains of urban political life to the beauty of the countryside that goes back at least as far as the Macedonian royal family's country houses of the fourth century BCE and perhaps even earlier:[110] Nicholas Purcell has pointed out that Odysseus' father Laertes retreated to a garden estate, and the style of Hellenized gardens with their fruit trees and their control and use of water owed much to the Oriental enclosed garden (*paradeisos*), which had a long history reaching as far back as the Assyrian royal palaces of the eleventh century BCE.[111]

Of course, many of the features we associate with Roman villas, such as peristyles and terraces, were directly and consciously copied from Hellenistic architectural templates, but does this make villas Hellenistic in substance? Hans Lauter has argued that, in terms of their forms and the inclusion of features that facilitated enjoyment of the landscape, Roman villas were indeed a continuation of Hellenistic traditions, but that the socioeconomic character of many Roman villas, with their large-scale farming operations and slave labor, and the resulting transformation of the countryside, was specific to the historical circumstances of Italy in the second century BCE.[112] But even this, some argue, was not necessarily *Roman*. Alexander McKay pointed out that "capitalistic farming" was already conducted by the Etruscans and Hellenistic kings,[113] and Harald Mielsch regards the intensification of agriculture in the Roman Republic as influenced by farming practices in Greek colonies.[114]

The chronological question comes even more sharply into focus when we try to determine when villas "end." The major political and economic changes of the third and early fourth centuries that had such a profound effect on the villa landscape of the eastern provinces had no less of an impact in Italy and the West. Although late Roman estates continued many of the features of earlier villas, such as division into productive and residential sections,[115] there were

also many new features and forms that catered to the new social and economic circumstances. Increasingly, grand entrances and belvederes[116] were intended to impress both visitors and passers-by, and the *aula regia*, an apsidal hall, was used to receive visitors with the regal splendor befitting the elevated status of the late-antique aristocrats (the *honestiores*) and their increasing social distance from the ordinary classes (the *humiliores*).[117] New fashions also emerged in the rounded courtyards and triconch dining rooms.[118] A new term began to emerge for these complexes – *palatium* – that had started out as the word for the dwellings of the Roman emperors[119] but was soon used to refer to other aristocratic residences as well. *Palatia* were often built in towns, and combined features of both the *domus* and the villa, but those in the countryside proper often served not as rural retreats but as main residences, especially in regions where urban life was in decline,[120] and in those regions where urban life continued, the country retreat began to appear inside the cities.[121]

A similar trend can be observed in the western provinces, where the local elite, who in earlier times had had at least some political connection with the town, retreated more and more to large country estates, laying the foundation for the feudal system of the Middle Ages.[122] These estates could be splendid, even idyllic,[123] but due to the increase in threat of both raids from outside the empire and banditry within, they tended also to be heavily fortified, and indeed another new term that took over from *villa* during the course of the fifth century CE and that was applied to these kinds of estates – *praetorium*[124] – was explicitly taken from the name of the residence of the military commander of a Roman army camp. Not just the name, but also the architecture, began to integrate military styles, rendering many of these farms barely distinguishable from late-antique *castella*.

What can we make of these changes? How significant is the preference for new terminology in the sources? The fourth-century CE writer Palladius still used the term *villa* in his farming manual, and his work testifies to a continued emphasis on agricultural production, but Domenico Vera has shown that there were also fundamental changes in those systems of production,[125] and the architecture of villas

suggests an increasing preoccupation with spectacle at the expense of pragmatism. Guy Métraux has explored this question from the point of view of economic function. He observed that the decline of many small-scale villa estates in Italy in the second century CE that is perceptible in the archaeological record was probably linked first to competition by producers from abroad, and then to the decline in urban life, which narrowed the market. Far from there having been a seamless continuity, many late-antique villas were built from scratch many years later on the sites of their earlier counterparts.[126] For Métraux there was, to address each end of the spectrum, a significant difference between the early Roman *domus*, which was "expressive of familial dignities," and the late-antique *villa urbana*, which was "influenced by imperial and hierarchical frigidities."[127]

But where do we draw the line? Despite an obvious continuity in social structure into medieval feudalism, the vast majority of villa estates in the north-west were abandoned during the course of the fourth century CE.[128] In the Roman east, on the other hand, early Arab conquerors often built country homes in the late Roman style, and they even hired the artists of the old Byzantine regime to decorate them.[129] If defined as the expression of a specific kind of aristocratic ideal that linked virtue to agricultural production, and the proper pursuit of leisure to enjoyment of the countryside, the phenomenon of the villa can be seen to reoccur in the Arab desert castles, Italian Renaissance country estates, and the rural seats of the English aristocracy, to name but a few.[130] The dilemma is that if we follow this line of reasoning to its logical conclusion, we risk diluting the term *villa* and removing it from its profound historical roots in the culture of Rome and the landscapes of its empire.

CONCLUSION

John Percival's observation in 1976 that "[t]he Roman villa is a subject about which we could be said to know a great deal and understand very little"[131] remains valid today. Our understanding of the individual phenomena scholars have for one reason or another termed "villa" has undoubtedly changed, but we are no closer to pinpointing exactly what it is that ties those phenomena together. It is not as though there is such a thing as a *villa perfecta*,[132] a prototype against which all potential cases can be measured and admitted or dismissed according to degree of conformity. As Lafon has noted, hand in hand with such an approach goes the consequence that "any variation from the basic model by its very nature reduces and devalues it."[133] In fact, even among the Romans there was a great deal of uncertainty as to the meaning of the term; the image of the "classic villa" proves to be less than certain on close inspection.[134]

One of the main problems in attempting to define the Roman villa is the existence of a great many separate discourses, both geographically and in terms of sources. Roger Wilson has suggested that "[t]he way forward is probably to set aside ... [written] source-based terminology in favor of a wholly archaeological definition and classification of the material remains."[135] This is both rational and methodologically pleasing, but it would result in a distancing of archaeological scholarship from the many rich literary references and descriptions that help us make sense of the remains. On the other hand, due to a lack of such literary evidence, scholars of the Roman provinces have largely been applying Wilson's principle to their material all along, and they are nonetheless a long way from agreeing with one another across, and at times even within, regional boundaries. In the end, what all villas had in common was their connection to an elite social group of one form or another, whether local or imperial, and the frequent formulation of elite taste in the use of elements from an empire-wide aesthetic language of architecture, which undoubtedly reflected aristocratic values propagated in an equally empire-wide cultural and educational canon. The way this is applied to interpreting bricks and mortar in the four corners of the empire is varied and, at times, even contradictory due to the lack of dialogue among scholars from different areas. It is hoped that the present volume will go some way to prompting further conversation of this kind.

NOTES

1. I am sincerely grateful to staff at the Roman-Germanic Commission in Frankfurt for their hospitality while writing this chapter, to Heinrich Zabehlicky and Susanne Zabehlicky-Scheffenegger for feedback on initial ideas, and to Guy P.R. Métraux, Roger J.A. Wilson, and Thomas Noble Howe for sharing their valuable thoughts on the *villa-domus* divide with me.

2. Sen., *Ep.* 86.

3. Cato, *Agr.* praef. 4. All translations are by the author unless otherwise stated.

4. Cato, *Agr.* 4.1–2: running of the farm; 1.6: extravagance.

5. Varro, *Rust.* 1.16.6: position of property; 3.14: income from land; 2.1: fancy Greek names.

6. See Agache 1999.

7. Vitr., *De arch.* 6.6.5.

8. Vitr., *De arch.* 6.5.3.

9. E.g., Mart., *Spect.* 10.14; Juv. 3.212–224; 14.86–95.

10. Stat., *Silv.* 1.3; 2.2; 2.3; 3.1.

11. Bodel 1997, 17. For further literary treatment of villas see, e.g., Deremetz 2008.

12. A distinction made by Millett 1990, 92.

13. Livy 21.63.3.

14. However, in practice senators made a great deal of money from trade and commerce indirectly through the use of (usually freedman) agents.

15. See Cato's list of profitable crops in *Agr.* 1.1.7.

16. For these developments see esp. Rostovtzeff 1957, 17; Hopkins 1978, 48ff.

17. See, e.g., Métraux 1998, who has suggested, moreover, that the decline in Italian villas perceived by archaeologists in the late second century CE was in part due to competition from abroad made possible through the use by urban authorities of such brokers.

18. Drerup 1990, 128.

19. Carandini and Filippi (eds.) 1985. For doubts on the identification as purely slave quarters see Marzano 2007, 129–37. In the more substantial scholarship of villas in the north-western provinces, on the other hand, economic function has always been at the forefront of interpretation (see discussion below).

20. E.g., Frazer 1998, vii. This definition runs into problems in the provinces, where slave labor was rare (see below), but even in Italy it is clear that land was also often worked by tenants (*coloni*). These *coloni* could often have been the original smallholders, so

that often, "although the pattern of land ownership had changed for good, the unit of tenure was much the same as ever" (Percival 1976, 119). For slave labor in villas and the problem of interpreting evidence of slaves in the archaeological record, see Marzano 2007, 125–53 with further references; for agricultural slave labor generally: White 1965; Hopkins 1978, 48–95; Finley 1980, 135–60; Rathbone 1981; 1983; Andreau et al. 1982, esp. contribution by Carandini; Purcell 1985, 1995; Morley 1996, 108–42, 2001; Jongman 2003; Roth 2007; and the various *Colloques sur l'esclavage* (= *Annales littéraires de l'Université de Besançon. Dialogues d'histoire ancienne*).

21. Percival 1976, 145.

22. McKay 1975, 102.

23. Purcell 1995, 172–73.

24. Purcell 1995, 169. Even if wealth was produced from less noble means such as trade, it could nonetheless not be shown off in this way. See also Wallace-Hadrill 1998, 43.

25. Ward-Perkins (in Kahane, Murray Threipland and Ward-Perkins 1968, 153–6) proposed that the term "farm" be used for all rural sites in central Italy without these high-status architectural features, and "villa" for those with them. This contradicts the use of the term *villa* by the Romans themselves as the Latin word for "farm." On the other hand, as Percival (1976) has pointed out, if we follow, say, Varro's definition of a villa, we have no use for the word in English at all; we could simply say "farm." It is clear that part of the problem here is a divergence between the original meaning of the Latin term and the fact that the same term has come to be widely used in English (also French, German, etc.) to mean a luxury building. It can, however, be argued that a separate term – why not continue to use "villa" in its modern meaning? – is, in any case, needed in modern scholarship to denote the very distinctive phenomenon of buildings with the features mentioned above.

26. For comprehensive general discussion of this ideology see, e.g., Brockmeyer 1975 and Ackerman 1990.

27. Swoboda (1924) first distinguished between villas with *atrium* and peristyle and villas with portico around the outside in Roman Italy, but see also, e.g., McKay 1975, 115–19.

28. Zanker 1990, 151.

29. Varro, *Rust.* 2.1. For Zanker (1990, 151), villas were in fact "a key factor in the reception of Hellenistic culture by the Roman elite."

30. Zanker 1990, e.g., 154.

31. For villas as places to exhibit art, see Gazda 1991; Vorster 1998; Neudecker 1998. For libraries in villas, see Blanck 1999. For villas as monuments, see Bodel 1997. For the layout and social role of Italian villas generally, see D'Arms 1970; Lafon 1981a; Schneider 1995, 2007; Howe 2004; Mayer 2005; Ortalli 2006.

32. E.g., Purcell 1995; Zarmakoupi 2006.

33. Varro, *Rust.* 3.2.17; Marzano 2007, 47–81 and Chapter 8 in this volume.

34. Wallace-Hadrill 1998, 51–2; Maiuri 1931.

35. Gros 2001, 302–13. See also Roffia 1997. Lafon 2001 for maritime villas. It is surely unnecessary to add a further level of terminology such as Carandini's (1994) "villa centrale" (villa near a town/harbor/major road) and "villa periferica" (villa in remote place). Further discussion by Gualtieri (Chapter 10) in this volume.

36. Cotton and Métraux 1985.

37. Wallace-Hadrill 1998, 2.

38. Zanker 1990, 155.

39. See *Dig.* 50.16.198 (Ulpian), where buildings are divided into those "in towns" (*in oppidis*) and those in villas and villages (*in villis et in vicis*); also more explicitly *Dig.* 50.16.211 (Florentinus): "urban buildings are commonly called: 'aedes,' rural buildings 'villae'."

40. E.g., Wilson 2008 and most German scholarship: e.g., Mielsch 1987, 7; Lauter 1998, 21.

41. See Howe in this volume (Chapter 6).

42. See Howe in this volume (Chapter 6).

43. Sall. *Cat.* 12.3. In fact, Melania the Younger's villa near Tagaste in North Africa was bigger than the town itself: Gerontius, *Vita sanctae Melaniae* 21; Clark 1984, 215.

44. Percival 1976, 54f.: the *villa suburbana* "belongs in all meaningful senses to the town rather than the country." See also Gros 2001, 266.

45. Vitr., *De arch.* 6.5.3.

46. Wallace-Hadrill 1998, 47.

47. Mustilli 1956; Carandini and Filippi (eds.) 1985. Of course, if one goes far enough back in time, the portico/peristyle of the country house and atrium/peristyle of the townhouse both probably developed from the same source of the primitive farmhouse with courtyard (see McKay 1975, 108).

48. Marzano 2007.

49. Caputo 2005.

50. E.g., the large plot in *insula* 1.15 (evidence of vines and olives).

51. Jashemski 1979, 18–19. Even small houses like the House of the Surgeon had a garden and the second-century BCE House of the Faun already had two large peristyles with greenery and gardens (Jashemski 1979, 16; 19–21).

52. Suet., *Ner.* 31. For the *Domus Aurea* in general, Ball 2003. It is interesting to note that Hadrian's rural villa at Tivoli, although equally opulent, was called a villa and not a *domus*. Gros (2001, 350–78) makes an altogether separate category out of "villas impériales."

53. Percival 1976, 119.

54. For a comprehensive overview see Leveau 1983.

55. Britain, the *Tres Galliae*, Upper and Lower Germany, and the Alpine and western Danube provinces.

56. E.g., Richmond 1969, 51: "the establishment of any folk who farmed the land and were able to build upon it a house of Romanised style"; Wightman 1970, 139: "all farms or country-houses built at least partly in stone." It should be noted, however, that some scholars do have a more nuanced definition in mind. For Agache (1973), a villa had to possess several constituent parts, like a residence, barns, storehouses, etc. For Dark (2004, 282), villas in Britain were "economic and tenurial centres" that were characterized by both the production *and* consumption of wealth.

57. Wilson 2008, 480.

58. E.g., Niederzier-Hambach 69: Smith 1997, 153 fig. 42 (a) and the examples in Lenz 1998, 53.

59. Collart 1991.

60. Hornung 2008.

61. Oelmann 1916.

62. Swoboda's (1924) "Portikusvilla mit Eckrisaliten." This essentially corresponds to the British "winged corridor house" (Richmond 1969).

63. Agache 1973; Reutti 2006, 380–5.

64. Richmond 1969. For villas in Roman Britain: Hingley 1990; De la Bédoyère 1993; Salway 1967; Percival 1976.

65. Reutti 2006, 376.

66. For a good example of a gradual transition see the villa at Mayen, Germany, which developed out of a La Tène farmstead and lasted through eight or nine building phases until the late fourth century CE (Oelmann 1928; Mylius 1928). A minority of villas

in the Roman north-west do not conform to this pattern and were clearly built with no connection with pre-Roman structures or practice. These can often be traced to Roman army veterans (e.g., Köln-Müngersdorf: Fremersdorf 1933).

67. Smith 1997, 11.

68. Lenz 1998. The French have come to a similar conclusion with their *fermes indigènes*: Bayard/Collart 1996.

69. Three sides: Téting (France), Borg (Germ.), Wiedlisbach (Switz.); Four sides: Newel (Germ.); Fishbourne (UK). See Reutti 2006, 380ff. and Richmond 1969 ("courtyard house").

70. Förtsch 1995. The *praetorium* at Anreppen, for example, shows clear links to local *villae*. It is worth noting that scholarship on the north-western provinces also has a similar rural-urban problem in the use of the term villa as was discussed above for Italy. In Carnuntum in Pannonia, for example, the most elaborate of the houses in the civilian city, assumed to be the residence of the governor of Pannonia Superior, has recently been called a "Stadtvilla," or "town villa" because of its luxurious furnishings and hypocausts, and its rambling arrangement with various corridors, courtyards, and gardens rather than around a central area (Cencic 2003, image plate 2, building 54).

71. Percival 1976, picking up on a point first made by Rivet 1969, 181f. See, e.g., Caesar, *BGall.* 3.29; 5.12: Gauls have *aedificia* and *tuguria*, but not *villae*.

72. Smith 1997.

73. E.g., Rossiter 2000. See also George 2002.

74. A number of other studies have applied a similar approach. For a methodology involving starting with a family structure and looking for evidence of it in the spatial layout of houses, see Hales 2003; For the reverse approach deriving information on family structure from the layout of houses see Hillier and Hanson 1984.

75. As opposed to merely coins, which the Celts, for instance, used for other purposes before Roman conquest.

76. For a discussion of this see Clarke 1990. Also: Ljapoustina 1992.

77. Mansuelli 1958; Percival 1976, 150–2; Lenz 1998.

78. See, e.g., the relief scenes of tenant farmers bringing rent in the form of farm produce and coins on funerary monuments from Neumagen and Trier (Germany): Espérandieu 1907–81, V, 4102, 4149; VI, 5148, 5268. For Gallia Narbonensis see e.g., Clavel 1970.

79. Excluding Egypt, whose special legal status as an imperial domain obstructed private agricultural enterprise, resulting in a lack of villas.

80. See, e.g., Rind 2009.

81. Mansuelli 1958.

82. This block-like and obviously defensive building style was also popular in parts of Syria.

83. Over time these small farms were often accumulated by wealthy landowners, causing Pliny to comment that half of Africa was owned by only six men (Plin., *HN* 18.6.35).

84. For villas in North Africa see, e.g., Hitchner 1989; Rind 2009; Wilson (Chapter 16).

85. Ennabli and Slim 1982, 57–61; Vismara 1998.

86. E.g., Carucci 2007, Lézine 1968. See also Wilson (Chapter 16).

87. See, e.g., Freyberger's (1998) general preference for neutral terms like "Palast" (palace) and "Wohnbau" (dwelling), but lack of reluctance to use the term villa for townhouses in Apamea with Hellenistic-Roman features like peristyles.

88. See, e.g., Amiran and Dunayevsky 1958.

89. In an interim report on rescue excavations by the Packard Humanities Institute in the "Valley of the Mosaic Houses" between the acropolis and the Euphrates in Zeugma, Robert Early and Janet DeLaine use the term "house," while their Turkish colleagues use the term *villa* for the same structures (Early 2003). See also Ergeç 1998 for the "Ergeç Villa." For Sepphoris, see Weiss in this book (Chapter 18) and Talgam and Weiss 2004.

90. For Herod's palaces, see esp. Netzer 1975a, 1975b, 1990, 2001a, 2001b.

91. See, e.g., Wickham 2005, 468, who sees the landed ideology of the European aristocracy in antiquity as "firmly part of western aristocratic identity" (leading to the feudal structures of the Middle Ages) and unmatched in the East.

92. E.g., Ein Yael just outside Jerusalem, probably the estate of a retired soldier who had been stationed at Jerusalem (Edelstein 1986, 1987, 1990). Perhaps the maritime villa at Apollonia near Tel Aviv also belongs to this list: Tal in this book (Chapter 17).

93. Rossiter 1997; 1989,102, n. 11; Champlin 1982.

94. Rossiter 1997. The reason for the agglomeration of farmers into villages would appear to have been security and water supply (Applebaum 1977, 363).

95. E.g., McKay 1975; Percival 1976; Mielsch 1987.

96. Rossiter 1989, 101.

97. See, e.g., Hirschfeld's seminal typology of Palestinian dwellings in Hirschfeld 1995, although this has been revised by Guijarro (1997) and Fischer et al. (1998), and Richardson proposed the use of the term only for very high-status dwellings like Herod's palaces (2004, 56, table 3). Likewise in Dacia, Thracia, and Moesia, where in the pre-Roman period large fortified farmhouses with enclosed court-yards existed, in the Roman period these are referred to by scholars as villas when they take on Roman architectural features (see, e.g., Valeva 1998).

98. Hirshfeld and Birger-Calderon 1991.

99. Applebaum 1977, 360.

100. For estates in Syria see, e.g., Villeneuve 1985; Freyberger 1998.

101. E.g., Khirbet Moraq near Hebron or Tirat Yehudah on the coastal plain (Applebaum 1977).

102. Applebaum 1977. For this trend also in Syria see Tchalenko 1953, 377ff.

103. See, e.g., Matthew 21.33–41.

104. Hirschfeld and Birger-Calderon 1991.

105. E.g., Libanius, Basil of Caesarea, *Ep.* 14, Gregory of Nyssa, *Vita Macr.* 33–34. See as an example Hebdomon on the Sea of Marmara: Thibaut 1922. Rossiter 1989 for a full discussion.

106. Rossiter 1989, 102. E.g., Yakto near Beirut (Lassus 1938) and also coastal villas involved in fishing and the production of purple dye, such as Yavneh Yam south of Tel Aviv (Kaplan 1993).

107. See, e.g., Broshi 1979; Piccirillo 1985; Hirschfeld 1997; Bar 2004.

108. Gregory of Nyssa, *Ep.* 20. Rossiter 1989 for a full discussion of this passage.

109. Wallace-Hadrill 1998 and in this volume (Chapter 3). See also Percival 1976.

110. See, e.g., Mielsch 1987: 32; Ackerman 1990; Lauter 1998, 22.

111. Purcell 1995.

112. Lauter 1998, 22 and n.2.

113. McKay 1975, 102.

114. Mielsch 1987, 32.

115. Lafon 1994, 222.

116. According to Drerup (1990, 146 note 33) taken directly from the towers of earlier Greek farms that were used to store fruit and grain.

117. See further Schneider 1983; Scott 2004.

118. The best-known example displaying these features is the complex at Piazza Armerina, for which see Wilson 1983 and this volume (Chapter 12).

119. Cassius Dio (53.16.5–6) tells us that imperial residences were called *palatia* because Augustus had lived on the Palatine in Rome, and that the residences of subsequent emperors in other places had nonetheless retained the name.

120. For late-Roman villas in Italy: Scagliarini Corlàita 2003; Sfameni 2006.

121. Rossiter 2007.

122. For late-Roman villas and palaces in the provinces see von Bülow and Zabehlicky (eds.) 2011. For the late-Roman palace at Bruckneudorf in Austria see Zabehlicky 1998; 2002; 2004. For links between the late Roman villa system and feudalism see Jones 1958.

123. E.g., Ausonius' description of the villa landscape around Trier in *Mosella* 12–42. The increased importance of Trier in late antiquity is perhaps the overriding factor here: The large villa at nearby Nennig is also late in date.

124. See, e.g., the letters of Symmachus or Cassiodorus' *Variae.*

125. Vera 1995. See also contributions to Christie 2004.

126. Métraux 1998. See Marzano 2005 and 2007, 199–222, for further discussion and the idea that the "agricultural crisis" of Italy has been exaggerated.

127. Métraux 1998, 3.

128. With the exception of the area around Trier (see above). For the abandonment of villas in the northwest see, e.g., Hinz 1970 (Kölner Bucht) and Reutti 2006, 385–6.

129. E.g., the palace at Khirbet El-Mafjar near Jericho (= "Hisham's Palace"): see Al-Asad and Bisheh 2000.

130. This is the view taken by Ackerman 1990 and Lauter 1998. See also Galand-Hallyn (ed.) 2008.

131. Percival 1976, 7.

132. Varro, *Rust.* 3.1.10; Carandini and Filippi (eds.) 1985.

133. Lafon 1994, 222.

134. See discussion of Varro in "Ancient Meanings" section in this chapter; also Lafon 1994, 222; Tamm 1973 for the lack of a perfect model for Roman houses in general.

135. Wilson 2008, 480.

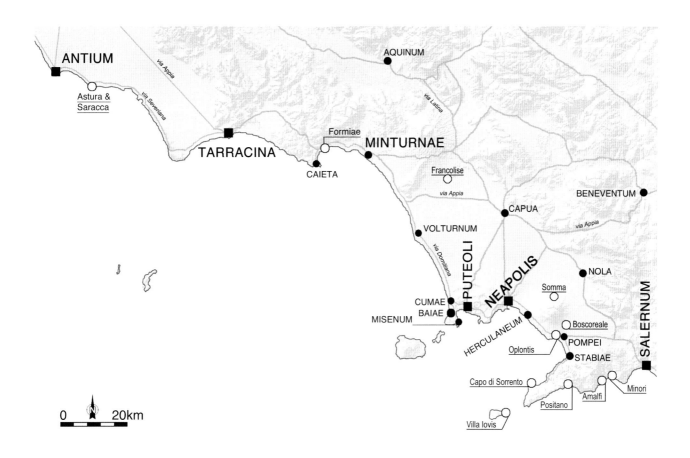

Map 2. Ancient towns and sites of southern Latium and Campania mentioned in Part I.

PART I

ROMAN VILLAS ON OR NEAR THE BAY OF NAPLES AND MARITIME VILLAS

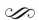

3

THE VILLA OF THE MYSTERIES AT POMPEII AND THE IDEALS OF HELLENISTIC HOSPITALITY

ANDREW WALLACE-HADRILL

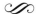

W HAT MAKES THE PERFECT VILLA, THE *villa perfecta*? Vitruvius in his *De Architectura* proposed a recipe for villas that purported to be both normative and ideal, made up of ordinary ingredients supposedly common to all villas but ultimately confecting an ideal, immutable type. Vitruvius' recipe for the ideal villa has found its best embodiment in the Villa of the Mysteries at Pompeii, but the correlation between them reveals that neither one was a *villa perfecta*. Rather, both were contingent on their historical times, incorporating specific cultural assumptions and obligations that belonged to late Republican high society in Rome. Neither map well onto an ideal villa nor fulfill modern expectations of architectural typologies.

VITRUVIUS' VILLA: RECIPE, MORALITY, AND ANOMALY

Vitruvius' recipe for an ideal villa does not exist; he often has strange omissions. But the blank he registers for a major and original form of Roman architecture – the villa – is explicable and culturally significant: his rules for villas are identical to those that he gave for town houses.[1]

For villas, Vitruvius makes their slight exception to the rules of domestic planning into a large difference from urban dwellings. The difference is this: in town, *atria* are usually next to the entrance doors, whereas in the country "with pseudo-urban buildings," the

peristyle comes first, having around it "paved porticoes looking over palaestras and walkways,"[2] and then the atrium in sequence after the peristyle.

This elliptical statement turns the villa into the inverse of the town house: the atrium-peristyle sequence is flipped to peristyle-atrium. The phrase *ab pseudourbanis* is heavily loaded. He is not saying that all villas are like this. In Latin, *villa* simply means a house in the country, including any farm house, and Vitruvius goes on to prove it by writing at length about farm buildings, farmyards, cow byres, oil presses and stores, sheep and goat folds, haylofts, bake houses – the panoply of the *pars rustica*. The perversity of modern usage often treats the word *villa* as applying only to luxurious buildings in the country as opposed to farmhouses. Latin usage did not incorporate this distinction, and agricultural writers repeatedly say that the villa exists for agriculture, and only contemporary decadence brought the luxury of the town into the country.

Such moral considerations lie behind Vitruvius' refusal to give any rules for the villa, except for its agricultural buildings, but they also underlie his expression *ab pseudourbanis* and his atrium-peristyle inversion. The luxury villa is a sort of a fake, a pseudo-house. It pretends to be city in country when it is not. Or rather, it inappropriately exports the manners, styles, and, consequently, the architectural rules of the town into the country, thus standing the natural order on its head. No longer does the atrium serve its proper function as a dignified

Figure 3.1. Pompeii, Villa of the
Mysteries, plan (surveyed by
G. Longobardi, with kind permission of
SANP, now Parco Archeologico
Pompei).

reception hall at the entrance; instead, it becomes perversely relegated to a secondary position in the building after the rustic appurtenances. No morally aware architect (and Vitruvius was certainly that) could endorse this decadence, this *in*version that is a *per*version.

Both Vitruvius' strange account of the villa and my own reading of what he is saying might be taken as a fantasy, were it not that the Villa of the Mysteries at Pompeii embodies so precisely what he says (Figure 3.1). While this account embodies themes I have already broached,[3] the *Soprintendenza di Pompei* has recently conducted a conservation/ restoration project generating important new data which allows us to return to Vitruvius' villa and the Villa of the Mysteries with fresh eyes.[4]

The villa's entrance was from the road which passed obliquely to the axes of the walls of the dwelling; the villa's orientation respects the layout of the field divisions in the area, which themselves follow the layout of the northwest quadrant of *Regio* IV at Pompeii.[5] The road postdates the field divisions: a short stretch can still be seen behind the service quarters, plus a bit of side road leading to the villa, which was entered through a proper *vestibulum* with benches for waiting *clientes*.

Beyond the *vestibulum* and the *ianuae* lies the *peristylium*, just as Vitruvius says. This one, though simply decorated, distinguishes itself sharply from the luxurious peristyles of the town by its rustic aspect. In the center is a lumpy shed covering access to the cellar, and no grand reception rooms open from it, only the kitchen and wine-press areas. The rooms to the north and south are all "secondary" rooms. From the peristyle, entrance is gained to the atrium, as Vitruvius suggested, and from it the access routes which lead to all the important reception rooms of the house open.

The atrium of the Villa is characterized with a central *impluvium* and high ceiling, but it lacks two of the defining characteristics of such Italic rooms: the cruciform layout created by the cross-axis of *alae* or wings to the side and an open axial view of a *tablinum* at its far end. While there is a room denominated a *tablinum*, it lacks the broad opening to integrate it spatially with the *atrium*. Originally, the *tablinum* could only be reached asymmetrically

through a corridor (the present access to the site is modern), thus completely negating the atrium-*tablinum* relationship but continuing the Vitruvian inversion. In its isolated form, the villa's *tablinum* opened toward the sea view to the south and was not so much an atrium as a pseudo-atrium, recalling the familiar urban space but significantly changing its spatial and sequential terms.

From this, as well as from the side passages off the atrium, access, and views to "paved porticoes looking over palaestras and walkways," Vitruvius' prescription is fully realized but with this significant difference: these elements of pleasure are detached from any peristyle, much less the unpretentious peristyle at the front (north side) of the house. Instead, the southern core of the villa is surrounded on three sides by porticoes with elegant mosaic paving in "basket-weave" pattern of oblong white *tesserae* enhanced with large chips in colored limestone and marble; beyond the porticoes lie open walkways to the edge of the platform (*basis villae*) on which the villa is built; these were the *ambulationes* of Vitruvius' villa recipe, in this case extending the villa's interior layout to the outside. There may have been plantings of trees to echo the columns of the porticoes.

The application of this "inverted" Vitruvian layout depends on how the construction history of the villa is understood. The principal excavator, Amedeo Maiuri, dug the house between 1928 and 1931 (the "Mysteries" room had been uncovered in 1910); he considered that the peristyle-atrium sequence was the product of pure chance because he saw two main phases in the formation of the building: a first phase belonging to the third or second century BCE in which the atrium was the principal room, and a second phase, in the early first century BCE (possibly the Sullan period of the 80s/70s) in which the peristyle with its tufa columns was built, thereby generating the peristyle-atrium sequence.[6] This account of the construction history of the villa was long accepted, but recent work has modified Maiuri's sequence of events.

THE VILLA OF THE MYSTERIES: CONSTRUCTION, CHRONOLOGY, CONTEXT

In 2006–7, Domenico Esposito, working as archaeological consultant to a conservation project, thoroughly re-examined the evidence both for the villa's construction and the larger landscape environment.[7] He discerned that what Maiuri had seen as two separate phases was actually a *single and unified* construction project; in addition, he showed that there had been subsequent modifications east and west of the atrium and elsewhere that Maiuri had overlooked (Figure 3.2).

In Esposito's reading, the main episode of the villa's construction belonged to the early first century BCE, precisely to the Sullan period: architecturally, the imposing basis villae with its blind arches on the south façade is close to that of the late second-century *Tempio Piccolo* at Terracina, or the slightly later *Logge* of Populonia. The earliest phase of decoration (later than the construction of the principal rooms) is in a Second-Style comparable to that of the Capitolium of Pompeii, and there is no trace of any earlier First-Style decoration which Maiuri's chronology should have predicated. Other important

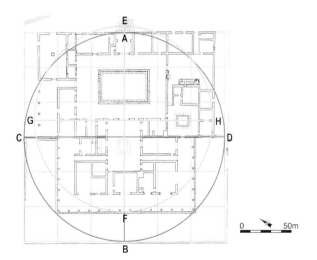

Figure 3.2. Pompeii, Villa of the Mysteries, plan of the original unitary build of the villa according to D. Esposito (drawn by T. Prisco, with a superimposed grid of 30x30 Oscan feet).

evidence derives from the relationship of the villa to the road system surrounding Pompeii. Esposito argues that the two roads extending from just beyond the town's Herculaneum gate, the *Via delle Tombe* and the *Via Superiore*, were laid out in the colonial period, namely in the early 70s BCE when a Roman colony of military veterans and others was planted in the town in consequence of having supported the Italians in the Social War. The field divisions were simultaneously established with the new roads. There is, however, this difference: whereas the *Via delle Tombe* cuts through the layout of both the so-called Villa of Cicero and the Villa of Diomedes, the *Via Superiore* sat comfortably with the Villa of the Mysteries, which occupies the triangle of land between the two new roads.

While the initial, unitary phase of construction can be dated to the Sullan period (effectively, the 80s/70s BCE), Esposito sees two subsequent phases of modification. The first is that which generated the famous Second-Style decoration of the principal rooms. The atrium shows clear traces of these modifications: in its original design, the atrium had given access through four doors to four rooms or suites of rooms (6, 7, 18, and 19). In the first modification, however, these four doors were blocked, in effect isolating the atrium from its surrounding rooms on the east and west but emphasizing its north-south axis from the peristyle toward the *tablinum*, the *ambulationes* or walkways, the garden, and the view.

The blocking of the doors was coordinated with adjustments to the decoration. In *oecus* 6, the new wall painting on the room's west wall *covered* the blocking, whereas the decoration on the atrium side (atrium east wall) *respected* the blocking. Similarly, the mosaic floors show clear traces of secondary modification, notably at the threshold of Room 5, the room of the famous "Mysteries" frescoes. Esposito dates this first modification to the 60s BCE (some twenty years after the initial construction of the villa), at the height of fashion for Second-Style decoration.

The second modification is characterized by construction in squared blocks of yellow tufa (*opus vittatum*) corresponding to the decoration in the Second-Style (Maiuri had seen these elements

as belonging to the last years of the villa). Esposito notes that in the peristyle outside room 20, the Second-Style decoration typical of the peristyle area as a whole covers a blocking in *opus vittatum*. The same construction technique is found in the two additions to the original design with curvilinear elements, the *Sala Absidata* (25) and the great *Exedra* (1).[8] Esposito sees these elements of a second modification in plan and decoration, together with the raising of head-high walls (*plutei*) between the columns of the peristyle, as dating to a single Augustan phase, sometime in the last years of the first century BCE or the early first century CE.

This new chronology, based on clear stratigraphic evidence, makes the correlation of the Villa of the Mysteries with Vitruvius' recipe even more plausible. If the peristyle-atrium sequence had been the result of an early first century BCE modification on a third- or second-century structure, it would be impossible to argue it was the product of the architectural principles that Vitruvius was to offer a century later. Instead, we are looking at a dwelling datable to the middle two quarters of the first century BCE, with direct influence from Rome, and perhaps constructed for one of Sulla's leading supporters and military henchmen: the depiction of piles of arms in the atrium points to an owner who had military successes. Esposito speculates that we might think of a figure like Marcus Porcius, the *duumvir* (municipal councilor) of Pompeii who put his name on the Amphitheatre and Small Theatre, and whose tomb stands just outside the Herculaneum Gate not far from the villa.[9]

MEASUREMENTS AND MODULES

The new dating of the Villa of the Mysteries – a unitary initial construction in the 80s/70s of the first century BCE – can be set in relation to evidence for a sophisticated mathematical system that underpins the design of the villa.[10] The *Soprintendenza* has recently commissioned a survey of the structures resulting in precise documented measurements.[11] From the survey, it is apparent that the design is based on a module of just over 8 meters. As Maiuri

had observed, the peristyle plus atrium complex is set in a square that he measured as 49.60 m: this is the length of the axis from the threshold of the entrance to the western edge of the *basis villae*, and it is also the measure from its north and south edges. These measurements correspond closely to the standard measure of the local Campanian *pes* ("Oscan foot"), of 0.275 m, which was shorter by 20 cm than the standard Roman foot of 0.295 m. Herman Geertman has studied the metrology of Pompeian houses in detail and has found numerous examples of modular layouts based on the Oscan foot; he has argued for some variation and imprecision in the measure, but never any so great as to allow confusion with the Roman foot.[12] 180 Oscan feet of 0.275 m give 49.50 m, whereas the closest corresponding measure in Roman feet would be an awkward 168. Many measurements fit well with all the rounded subdivisions of 180 Oscan feet (90, 30, 15, 10, etc.), and such subdivisions work better than the odd configurations (e.g., 84, 28, 14, 9.33) that would have to be posited were Roman feet being used.

Domenico Esposito and I have discussed these matters: he is cautious about accepting a module based on Oscan feet, considering it to be incompatible with a date *after* the Sullan foundation of the Roman colony and the newly Romanized town. But the local Oscan measure common to Campania was not necessarily rejected by the Roman colonists or fell out of use together with the Oscan language: outsiders often decide which items in an existing cultural array they will accept or discard. It is quite possible that, if a Roman architect produced a design in Roman feet, local builders may have continued to use the measures with which they were familiar. The date in the early first century BCE, the use of Second-Style decoration, and the blind arches of the basis villae allow for some margin of error in the years around the foundation of the Roman colony. An initial redistribution of land and transformation of the landscape could have happened after the fall of Pompeii to the forces of Sulla in 89, with the formal foundation of the colony in 80 BCE as the culmination, rather than the initiation, of the process; the building of the villa could have occurred in a period of transition between the independent Oscan city

and the Roman colony. Measurements of the villa in Campanian *pedes*, that is, in Oscan feet of 0.275 m and modules derived from them, may bear out this process of transformation in the newly Roman Campania.

Imposing a modular grid of 30x30 Oscan feet on the villa's simplified plan reveals some of the basic principles of its layout (Figure 3.2). The *basis villae* occupies the western half of this square: its west edge is 180 Oscan feet wide, the north and south edges extend only 90 feet, or three modules.[13] It is the *basis villae* area or footprint that determined the geometry of the layout. At its edges, there was an uncovered garden area (the *ambulatio* in Vitruvian terms) one 30-foot module wide: from edge of *basis* to edge of portico is between 29 and 30 feet, though it is evident that, in addition to the margin of error in measurement, the building itself allowed small variations in construction.[14]

After deducting the *ambulationes*, we are left with a core of construction 120 feet wide. But just as the *ambulatio* reduces the built footprint, so the portico that wraps around the central core of the villa further reduces the area for the rooms themselves. The porticoes on all three sides approximate to 15 feet wide, half the module of 30 feet.[15] Thus the internal built area is 90 feet wide.[16] This area itself is divided more or less equally into three strips of 30 feet (1 module) in width. The *tablinum* itself has an internal measurement of 29 feet width (30.5 feet mid-wall to mid-wall). The sets of rooms to its north are almost exactly 30 feet in width, measured from outer wall to outer wall. The sets of rooms to its south, on the other hand, are marginally wider, with an *internal* measurement for each room of just under 30 feet. Thus the south (and more important) set of rooms is marginally privileged in terms of size, since its wall-width intrudes on the width of the atrium on one side, and on the width of the portico on the other.[17] Exact precision is not to be expected in pre-industrial building techniques.

If the atrium core is divided into three strips vertically, the horizontal division is more complex. The *ambulatio* to the western, seaward aspect of the Villa reduces the vertical axis from entrance to edge of basis villae from 180 to 150 feet. This distance is

bisected by the wall that divides the peristyle from the atrium area, thus dividing the villa between rustic and urban quarters. The result is that the distance from the threshold of the entrance to the villa to the threshold of the atrium is 75 Oscan feet,[18] while from the same point to the edge of the western portico is slightly longer, 76.5 feet.[19] The atrium, as we have seen, at 29 feet wide (30 including a wall-width) is 43.5 feet deep, or 45 feet including a wall-width.[20] The *tablinum* beyond it is 20 feet deep.[21] To the sides, the four suites of rooms divided by the central corridors are 30x30 squares, allowing for variations.[22] The fascination with mathematical formulae (*symmetriae* in Vitruvian terms) is underlined by the layout of the *cubicula* with two alcoves for sleeping couches, creating a square within a square of 15x15 Oscan feet.[23]

It is evident that considerable care was given to the symmetry of the blocks of rooms around the atrium, marked out by their decoration, as well as the porticoes and elevated views afforded by the terrace of the *basis villae*, as the most desirable area of the dwelling. By contrast, the symmetries of the rustic peristyle area are less elaborate, though there is some care to make the peristyle itself compliant with the modular structure of the whole. The interior area of the peristyle, including the columns, is closely comparable in dimensions to the atrium itself, approximating 30x45 feet or 1x1.5 modules.[24] The whole peristyle including its porticoes approximates 80x55 feet.[25]

The key issue is not whether or not the villa was laid out in Oscan feet but whether it obeys something of the laws of symmetry and design which Vitruvius would have recognized as desirable. It is clear that there *is* a complex modular design: it just so happens that expressing the modules in Oscan feet gives us a series of round numbers for some of the crucial measurements, 180, 150, 120, 90, 75, 45, 30, 15. Such congruence of modules in whole numbers cannot be mere coincidence. Of course, it would be useful to be able to add measurements for heights of rooms, particularly for the atrium and the *tablinum*, because Vitruvius regarded the three-dimensional proportions of rooms to be as significant as their two-dimensional sizes in plan,

but the villa's upper walls and roofs are irretrievably destroyed. Notwithstanding these *lacunae*, the villa was clearly built to a system that encompassed all its major elements from the beginning.

THE VILLA OF THE MYSTERIES AND OTHER VILLAS: SOCIAL INTENTIONS

The Villa of the Mysteries was clearly laid out in a unitary scheme early in the first century BCE and architecturally planned with mathematical sophistication and care. That said, what *social* intention, rather than architectural imperative, underlay the design? The relationship of atrium and peristyle is inverted, just as Vitruvius suggests, but proving the rightness of a text by citing an archaeological instance is an insufficient answer: there is more to it than that. In the process of the inversion, the function of the atrium was transformed. It lost precisely those characteristics that gave urban *atria* their function as first-stop reception spaces for visitors coming from the street or road to pay their respects to the patron, with the *tablinum* in sequence as the culminating reception space for the enthroned patron framed by a wide opening to enhance his visibility. *Atria* would have been expanded by the cross-axial *alae* which, in traditional plans of urban houses, offered secondary reception spaces and emphasized, with their symmetrical formality, the grandeur of the *tablinum*.

By contrast, in the Villa of the Mysteries there was no direct access into the *atrium* from the street, and the atrium denuded of its *alae* did not orchestrate the *tablinum*. Instead, in the original design, the pseudo-*atrium* became a magnificent antechamber to the four suites that surrounded it. Also striking, and unparalleled in urban *atria*, are the two lateral corridors running off the *atrium*, their painted, burnished walls forming a mirror-like surface that reflected the light coming from the porticoes at their ends.

This very unusual design of spaces was not a one-off invention of some eccentric Pompeian architect or commissioner: there are important and impressive parallels in other first-century villas. That of the Villa of the Papyri at Herculaneum – a much larger and

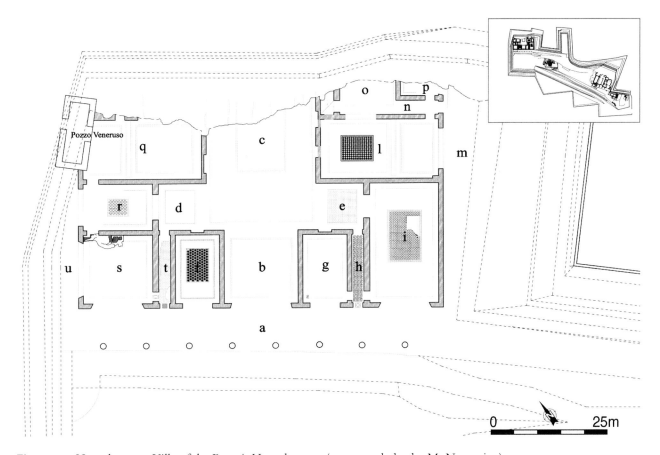

Figure 3.3. Herculaneum, Villa of the Papyri, Herculaneum (survey and plan by M. Notomista).

richer affair than the Villa of the Mysteries, and one built on several levels – is especially striking, the more so that new excavation and conservation work has exposed a large portion of its atrium area (Figure 3.3).[26]

In the Villa of the Papyri at Herculaneum, as in the Villa of the Mysteries, the atrium area is at the far edge of the villa, looking out over the sea from a high elevation and separated from the entrance by a peristyle. There are differences to note: the Villa of the Papyri preserves the traditional atrium with *alae* layout, though the *tablinum* itself has been transformed by its opening at both ends into a window-room framing the sea view, while the *alae* serve as antechambers for suites of rooms on either side. But the similarity between the Herculaneum villa and that at Pompeii is that the atrium is surrounded symmetrically by four suites consisting of *cubiculum-triclinium* sets. The *atria* divided both plans into three equal strips, a similarity of architectural design even

though the dimensions of the Villa of the Papyri are more than three times larger than those of the Villa of the Mysteries, with a module that approximates to 90 Roman feet rather than 30 Oscan feet. In the Villa of the Papyri, the southwest suite of rooms (Figure 3.3: rooms e, g, i) is reminiscent of the arrangement of the southwest suite in the Villa of the Mysteries (Figure 3.1: rooms 3, 4, and 5), and the rooms had similarly ambitious red-ground frescoes in a Second-Style, with large figures in what Vitruvius calls *megalographia*, especially in *triclinium* I, the room of the "Mysteries."[27] Unlike the Pompeian example, the rooms in the Villa of the Papyri are split by a corridor providing a staircase, arguably for rooms linked to the suite below, which was thus a mini-house or *domuncula*. The southwest suite (Rooms l, o, p) in the Herculaneum villa also had a corridor splitting *cubiculum* and *triclinium*. The northwest suite (Rooms f, s, r) is the mirror image of the southwest suite, including the corridor, except that room r also links

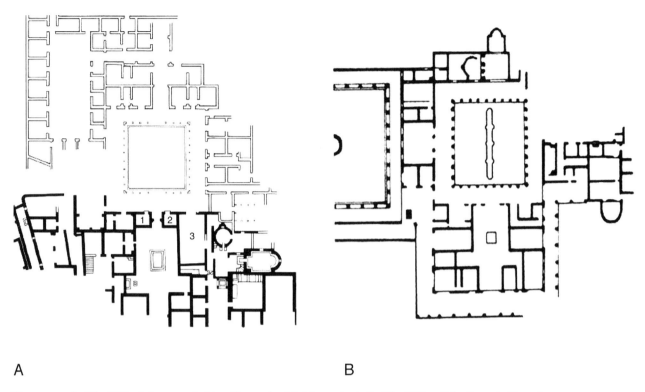

A B

Figure 3.4. A: The Villa Arianna at Stabiae (drawn by M. Notomista); B: The Villa of the Papyri, Herculaneum.

to room q and thus the northeast suite. On Karl Weber's plan (Figure 3.4 at B), it appears that all the rooms north of the atrium formed a single suite, but he missed the fact that room r, the northern *ala*, linked directly to the *atrium*, and thus formed the anteroom for two suites, one to the west, the other to the east.

Another close parallel to the plan of the Villa of the Mysteries is that of the Villa Arianna at Stabiae (Figure 3.4 at A). Again, good measurements are newly available. In the Villa Arianna, the atrium area marks not the entrance point, but the extremity of the villa, looking out over the sea from a high elevation, separated from the entrance by a peristyle. As in the Villa of the Papyri, there was a cruciform layout with *alae* and *tablinum*, the *tablinum* having two wide openings that made it a window-room looking out to sea. There was also elaborate Second-Style decoration, especially in the *cubicula* 1 and 2, with elements very reminiscent of that of the Villa of the Mysteries. While the spaces around the atrium of the Villa Arianna were subsequently modified, traces remain of what appears to have been four

symmetrical suites, best preserved in the *cubiculum-triclinium* pair of Rooms 2 and 3.

Another striking parallel is the villa at Settefinestre, again of a late Republican date with an imposing *basis villae* (Figure 3.5). In this case, it is the peristyle area rather than the atrium that looks out over the principal view. But the disposition of four suites around the atrium, each with a *cubiculum-triclinium* pair sometimes leading into further rooms (Rooms 32/33 with 34/35, 28/30 with 21 and 29, 10/11 and 50/51/55) follows the same pattern as those of the Villa of the Mysteries. If the peristyle at the Settefinestre villa is beyond the atrium, it is not as an *urban* sequence of atrium-peristyle in the convention of Vitruvius, but as an impressive spatial sequence that appropriated the central function of the atrium to define and introduce, in a grand way, the suites of rooms extending laterally from it. The Settefinestre peristyle formally presented the grandest suites of the villa: the *cubiculum* with its double bed alcoves, separated by a corridor from *triclinium* 23, and the mirror image pair of Rooms 2 and 3. The villa offers four principal suites with views

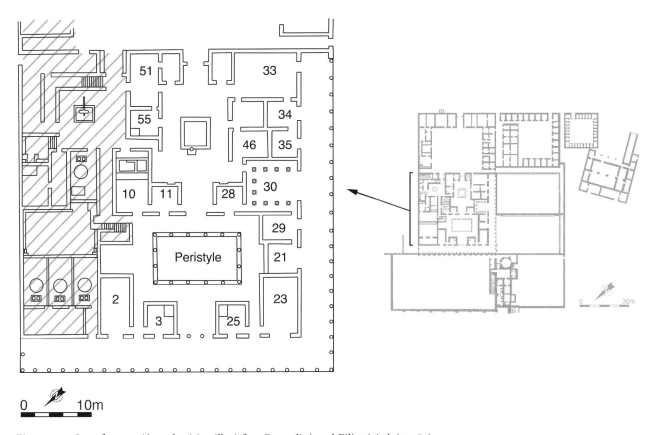

Figure 3.5. Settefinestre (Ansedonia), villa (after Carandini and Filippi (eds.) 1985).

out over the porticoes, and two further internal suites.

These four late Republican villas – that of the Mysteries at Pompeii, the Papyri at Herculaneum, the Villa Arianna at Stabiae, and Settefinestre – offer us the same sort of arrangements, albeit with variations. All present the same design: several suites of rooms extending from a grand traditional one: an atrium or peristyle reinterpreted as the center from which rooms or sets of rooms diverged but to which they also returned, in a centrifugal and centripetal disposition. All four villas were built a little before, or contemporaneously with, Vitruvius' writing on the architecture of villas.

Questions remain: architectural considerations apart, what were the *social* intentions that prompted this sort of design? Why organize the reception rooms around the atrium as symmetrically disposed suites? Why so *many* dining rooms, and why the link with bedrooms? Maiuri, as many others, thought in terms of the nuclear family: one suite for the parents,

one for each of the adult children. Similarly, houses with double-*atria* so common in Pompeii in the late second and early first centuries BCE are often explained as housing for two brothers. However, an interest in the family itself did not much interest Roman architects: Vitruvius cared most about visitors and guests. In his description of what he claims to be the "Greek house,"[28] what he calls the *andronitides* located in the guest quarters, he tells us:

To right and left are situated quarters (*domunculae*) with their own entrances, *triclinia* and comfortable *cubicula*, so that guests arriving may be received not in the peristyles but in these guest-quarters (*hospitalia*). For when the Greeks were more prosperous and luxurious, they used to lay out *triclinia* and *cubicula* for arriving guests and larders with supplies, and on the first day they were invited to dinner, on the second sent chickens, eggs, greens, fruit and other

produce of the fields. That is why painters imitated such presents for guests, which are called *xenia*. In this way, heads of family (*patres familiae*) on their travels don't feel as if they are mere guests, since they enjoy this secluded generosity in their guest quarters (*hospitalia*)."[29]

Just as Vitruvius gives the visitor pride of place in his account of the "public" areas of the house, especially the atrium, so the *visitor* and the visitor's *experience* drove the logic of the late Republican villa.

HOSPITIUM, HOSPITALIA, AND VILLAS

Vitruvius emphasizes the importance of hospitality in Roman houses, but he does so in his report of Greek modes. Hospitality was the context in which mutual awareness of domestic arrangements between Greek and Roman householders was generated.

The Roman concept of *hospitium* embraced the *act* of hospitality, the bundle of *obligations* tied up in it, and the *space* within which it was offered. *Hospitium* could be recorded in formal inscriptions: the earliest instance is from Fundi, dated to the late third or early second century BCE.[30] The language in which its relationships were set up between powerful Romans and local communities in Italy or the provinces (examples from Africa being numerous) came to be formulated in legal terms: in setting up *hospitium*, and typically recording it on a *tessera hospitalis* as an inscribed record or even on a bronze tablet to be displayed in the patron's home, the community nominated the Roman and his descendants as their special patron, and he received them and their descendants into the *fides* and *clientela* of himself and his descendants.[31] *Hospitium* could be forever.

The mixed language of *hospitium* and *clientela* is puzzling: *hospitium* should be a relationship of equality and reciprocity, implying an equal exchange of hospitality, whereas *clientela* is a language of dependence. Badian suggested that hospitium must originally have been a relationship of equality, but then came to be effectively indistinguishable from *clientela*. In practical – and therefore historical – terms, a Roman senator in the late Republic would not have distinguished *hospitium* from *clientela* or understood any practical difference between them.[32]

Nonetheless, linguistic practice in the late Republic would not have devalued the potency of the architectural language of *hospitium*. For educated Romans of the first century BCE, the authority of the Homeric epics clearly enshrined the sacred bond of hospitality under the protection of *Jupiter Hospitalis* (and other *dii hospitales*), as that of *Zeus Xenios* had been in Greek contexts. *Hospitium* was a matter of universal law, not national custom: bonds between strangers were under the protection of heaven. So the dying Hannibal cursed his host King Prusias and his kingdom of Bithynia, calling to witness that he had violated the trust (*fides*) of the gods of hospitality.[33] Later, Caesar invoked the same principle in relation to another king of Bithynia, Nicomedes, saying that his *hospitium* imposed on him a duty of support that could not be shirked, and that *clientes* could not be deserted without the highest infamy, placing them even above family members. Aulus Gellius, who cites this passage of Caesar, also cites the jurist Masurius Sabinus as defining a pecking order of obligations after *parentes*, starting with the *pupillus* (legal ward), next the *hospes* (guest), then the *cliens*, and only after them, the *cognatus* (direct relative) and the *adfinis* (allied relative or family).[34] Thus the relationship created by *hospitium* was seen as a pressing social obligation, at a level comparable to familial ties.

Hospitium was the principle on which Cicero represented the behavior of Gaius Verres, the famously corrupt Roman governor (proconsul) of Sicily in 73–71 BCE, as criminal in law and unacceptable in social tradition; it also represents a clash between a Roman in contact with Greek habits of hospitality. Prominent among Verres' victims was a certain Sthenius of Thermae, who had previously had a relationship of *hospitium* with the prominent Roman military leaders and politicians C. Marius, Cn. Pompeius, C. Marcellus, and L. Sisenna.[35] Sthenius had made a practice of entertaining powerful Romans, doubtless to his own political advantage: when he was accused before Pompey of enjoying the intimacy and *hospitium* of Pompey's enemy Marius,

Pompey was happy to acquit him and enter into the same relationship with the rich Sicilian.[36] But Verres, who had enjoyed Sthenius' hospitality so frequently as to have virtually moved in with him, exploited the relationship by helping himself to Sthenius' silver and art works, an abuse of the tradition of guest-giving which Sthenius endured, thinking that good manners required that he overlook the governor's thefts silently as befitted his position as a *hospes* (in this case, as a host).[37] But when Verres proceeded to steal *public* property, Sthenius at last denounced him, invoking the support of his other Roman *hospites*, to which Verres reacted by renouncing their *hospitium*, implying that it was a legal bond.[38] But the facts, as Cicero showed, went against him: Verres had violated the sacred bonds of hospitality, the *iura hospitis*.

Similarly, Cicero in his speeches against Verres invoked other instances: that of Eupolemus of Calacte, who had his hospitality rewarded by the theft of his best silver cups, of King Antiochus of Syria, who had been tricked into "lending" his finest pieces, and of Dexo of Tyndaris.[39] Their treatment was an offence against the gods, a slur on the reputation of the Roman people, and a betrayal of the sacred bonds of *hospitium*.[40] These episodes reveal Verres' abuses but also the mutual advantage inherent in *hospitium*: Verres could have claimed with some justice and tradition on his side that these had been voluntary gifts, normal exchanges between hosts and guests. Perhaps they were: rich Sicilians and King Antiochus stood to gain much from their close relationship with powerful Romans. Offering gifts to visitors to ensure their goodwill could be represented as a universal practice, divinely sanctioned and attested in epic poetry:[41] However, normal gifts given by a host to a guest was quite different from extortion (*res repetundae*, a serious legal offence), even though Roman governors who had enjoyed the hospitality of prominent locals could count on their needed support and advice, often expressed in honorific decrees issued by local senates.

The *hospitium* enjoyed by powerful Romans on their travels abroad had a corollary at home, in their houses and villas: they were expected to entertain their former provincial hosts when they visited Rome and Italy. Hence the provision of suitable guest quarters was a social obligation for a prominent Roman. Just as the atrium was the architectural space in which to receive the patrons' *clientela*, so the *hospitalia* provided suites of rooms in the *cubiculum-triclinium* formula to reciprocate *hospitium* abroad with *hospitium* at home. The atrium as antechamber to the *hospitalia* of the Villa of the Mysteries, the Villa of the Papyri, the Villa Arianna, and the Settefinestre villa is an instance of elastic use of a traditional room in Roman domestic architecture to serve new social obligations. Vitruvius embodied these new obligations indirectly in his description of a *Greek* house: hospitality brought the social practices and expectations of the larger Mediterranean world together with new *Roman* obligations. The Villa of the Mysteries and its four quarters of *hospitalia* were built, in all likelihood, to provide its Roman owner with the means to repay hospitality to several guests who had offered *hospitium* to him or to those near to him. Even as Verres was ransacking Sicily, riding roughshod over the laws and customs of hospitality itself, Roman hosts were planning their villas with *hospitalia* to entertain overseas guests who had graciously received them when they had been abroad.

NOTES

Note: the abbreviation pO (*pedes Oscani*) = Oscan foot/feet.

1. Vitr., *De arch.*: for villas, 6.5.3; 6.3.1–11 for town houses.
2. Vitr., *De arch.* 6.5.3: *porticus pavimentatas spectantes ad palaestras et ambulationes.*
3. In this chapter I am returning to ground covered in previous discussions, esp. Wallace-Hadrill 1998 and 2008, 196–208.
4. See esp. Esposito 2007.
5. Zevi 1982. The modern access for tourists to the villa begins in the atrium rather than the main entrance to the house from the road.
6. Maiuri 1947.
7. Esposito 2007.
8. These two rooms, as a perversion of the intention of the whole plan, are the ones that greet the modern viewer.
9. Esposito 2011, 462, n. 49. The suggestion of the impact of Sulla's supporters comes from Zevi 1996.

10. See my earlier attempts to analyze the layout in Wallace-Hadrill 1998, 47–51 with fig. 4.5, and in Wallace-Hadrill 2008, 201–4.

11. The survey was undertaken by Giovanni Longobardi of the University of Rome Tre for the *Soprintendenza*: I am grateful to Piero Guzzo, then *Soprintendente*, for permission to use this material and to Arch. Paola Rispoli for her gracious assistance.

12. Geertman 1984; see also Schoonhoven 2006; van Krimpen-Winckel 2009. I thank all three authors for many stimulating discussions of Roman metrology.

13. Length of northern *ambulatio*, including area of steps down: 24.84 m (= 90.33 pO); length of southern *ambulatio*, including steps, 24.73 m (= 89.93 pO).

14. Edge of N *basis* to edge of N portico at NW corner: 8.21 m (= 29.85pO); ditto measured at E end of portico: 8.00 m (=29.1pO); edge of S *basis* to edge of S portico at E end of portico corner: 8.27 m (= 30.07pO); ditto at SW corner, 8.11m (= 29.49pO). Western *ambulatio* at NW corner of portico to edge of basis: 8.11 m (= 29.49pO); at SW corner of portico to edge of basis, 8.06m (= 29.31pO).

15. As measured from the outer edge of the portico to the outer edge of the walls, the measurements vary between 3.92 m (= 14.25 pO) and 4.12m (= 14.98 pO).

16. Measured from outer wall to outer wall, the width varies between 25.07 m (= 91.16pO) and 25.11 m (= 91.3pO). Measured from mid-point to mid-point of the walls, this reduces to 24.73 m (= 89.93pO). The room area thus encroaches on the portico by half a wall-width.

17. Measurements at the level of the lateral corridor: north string from outer edge of threshold to outer edge, 8.23 m (= 29.92 pO), from wall to wall, 7.99 m (= 29.05pO), mid-point to mid-point, 8.39 m (= 30.5 pO); southern string from *inner* edge of wall of *oecus* 6 to inner edge, 8.18m (= 29.74 pO), from mid-point to mid-point, 8.61 (= 31.3 pO).

18. Measured from outer threshold of the entrance to inner threshold of atrium, 20.78 m (= 75.56 pO).

19. Measured from inner threshold of atrium to inner line of W portico wall, 21.01m (= 76.4 pO).

20. Atrium from inner threshold to *tablinum* wall, 11.92 m (= 43.35 pO); measured to include the *tablinum* wall, 12.29 m (= 44.7 pO).

21. Measured to include both walls, 5.48 m (= 19.93 pO); to include only one wall, 5.09 m (= 18.5 pO).

22. SE block (rooms 6–8), depth measured threshold to outer wall, 8.21m (= 29.85 pO). NE block (rooms 16–21), measured from threshold line of atrium to outer wall, 8.17m (= 29.7 pO). SW block (rooms 3–5), depth measured corridor wall to portico wall, 7.88 m (= 28.65 pO). NW block (rooms 11–15, depth measured corridor wall to portico wall, 7.95 m (= 28.9 pO). The western blocks are about 1 foot shorter than the eastern.

23. *Cubiculum* 8, width inner wall to inner wall, 4.11 m (= 14.95 pO), depth inner wall to threshold, 4.05 m (= 14.7 pO). *Cubiculum* 16, depth inner wall to threshold, 4.05 m (= 14.7 pO), width inner wall to threshold, 3.97 m (= 14.44 pO). *Cubiculum* 5, the most important, is given additional space by its extra alcove, with maximum measures of depth 5.10 m (= 18.5 pO), width 4 m (= 14.5 pO).

24. Depth measured from outside of wall to outside of wall, 7.89 m (= 29 pO); width from outer wall to outer wall, 12.57 m (= 45.7 pO).

25. Width measured from inside of wall to inside, 21.94 m (= 79.78 pO); depth from inner wall to inner wall, 14.99 m (= 54.5 pO).

26. On the new work, see in general Guidobaldi and Esposito 2009; 2010; Guidobaldi, Esposito and Formisano 2009. On the decoration, Esposito 2011.

27. Esposito 2011, 538.

28. Vitruvius' "Greek house" is a blueprint for features suitable for adaptation to the Roman house: Wallace-Hadrill 2008, 190–3.

29. Vitr., *De arch.* 6.7.4.

30. *CIL* 1.532.

31. On *hospitium* see *Dizionario Epigrafico* 3 (1895), 1044–60; for the inscriptions, 1058.

32. Badian 1958, 154.

33. Livy 39.51.12.2.

34. Gell., *NA* 5.13. Masurius may have been over formalizing the same passage of Caesar that Gellius was citing.

35. Cic., *Verr.* 2.2.111.

36. Cic., *Verr.* 2.2.113.

37. Cic., *Verr.* 2.2.83–4.

38. Cic., *Verr.* 2.2.89.

39. Euplemus: *Verr.* 2.4.49; King Antiochus: *Verr.* 2.4.60; Dexo: *Verr.* 2.5.109.

40. Cic., *Verr.* 2.4.60: *in quo di immortales violati, existimatio atque auctoritas nominis populi R. imminuta, hospitium spoliatum et proditum*; compare *Verr.* 2.5.109.

41. Among other instances are Telemachus' visits to king Nestor and king Menelaus and the ceremonials of gift-giving in their courts: Hom., *Od.* 1–4.

4

THE BUILDING HISTORY AND AESTHETICS OF THE "VILLA OF POPPAEA" AT TORRE ANNUNZIATA

Results from the Oplontis Project 2005–2014

JOHN R. CLARKE

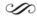

Although officially known as Villa A at Torre Annunziata, some scholars locate the Villa at ancient Oplontis and specify the owner as Poppaea, the second wife of the emperor Nero, because an inscription, *Secundo Poppaeae*, painted on an amphora found in the Villa, indicates that the container was sent to a certain Secundus, presumably a slave belonging to the *gens*, or clan, of the Poppaeae; some scholars have argued that the Villa belonged to the imperial consort.[1] The Villa lies covered to a depth of 8.5 m under the modern town of Torre Annunziata, three Roman miles to the west of Pompeii and at the point that the name "Oplontis" appears on the *Tabula Peutingeriana*.[2] The nature of the settlement at "Oplontis" is an open question: Excavations have yet to yield a coherent picture.[3]

While modern excavation of Villa A began in 1964, scholars had long known about the existence of an extensive structure in the area called Le Mascatelle (Figures 4.1; 4.2). Domenico Fontana uncovered and destroyed part of the south façade of the Villa while digging the Sarno Canal (*Canale del Sarno*) in 1598; in April, 1785, Francesco La Vega tunneled along the west side of the pool;[4] in 1839 Michele Rusca opened a small section in the area of the slaves' peristyle (32) and several tunnels along the wide corridor (45–6) leading to the pool.[5] Excavation and reconstruction efforts, initially

funded by the *Cassa per il Mezzogiorno* with the intent of developing the Villa as a tourist site, continued until 1984.

In 2006, with the permission and encouragement of Pietro Giovanni Guzzo, then *Soprintendente* of the *Soprintendenza Archeologica di Pompei*, the Oplontis Project took shape with a mission to conduct a multidisciplinary, systematic study of Villa A.[6] The institutional partners in this endeavor include the Department of Art and Art History at the University of Texas at Austin, the *Soprintendenza Archeologica di Pompei*, and the King's Visualisation Lab, King's College, London. Funding has been provided by the National Endowment for the Humanities, the University of Texas, the Leverhulme Foundation (UK), and anonymous private donors. Under my direction and with the assistance of Michael L. Thomas and Stefano De Caro, the Oplontis Project has assembled an international team of scholars who have produced the first volume of three "born digital," open-access monographs in the American Council of Learned Society's Humanities E-book series.

Research prior to our first season of study and excavation was daunting. The Villa had been restored and open to the public since the mid-1980s, but publication had been selective and sporadic and record-keeping for the first seven years was unusually poor. There exist no excavation day-books for this period, and the earliest photographs in the

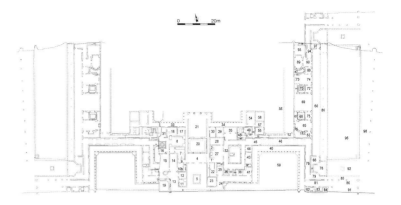

Figure 4.1. Torre Annunziata, Villa A (Oplontis), plan of the extant central core and eastern extension of the villa, with a reconstruction by Timothy Liddell of its possible symmetrical western extension in mirror-plan (Timothy Liddell).

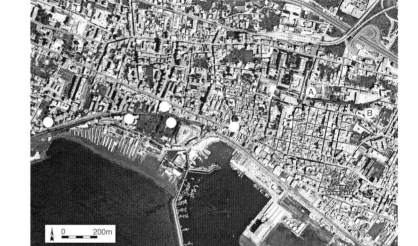

Figure 4.2. Torre Annunziata, location of known archaeological sites in the vicinity of Villa A. A: Villa A; B: Villa B. (Giovanni Di Maio).

Photographic Archives of the *Soprintendenza* date to 1970. In 1984, when excavations halted, ninety-eight spaces had been uncovered, leaving some 40 percent of the Villa still buried beneath modern roads and buildings on the west side of the site, and no systematic excavations had been undertaken beneath the 79 CE levels. A great quantity of unprovenanced wall-painting fragments lay waiting for study. The Oplontis Project, in conducting its own excavations and investigations, will also address problems of documentation, restoration, and cataloguing.[7]

A number of publications have addressed specific aspects of the Villa. Examples include Zarmakoupi on how Oplontis helps define the Roman luxury villa,[8] Clarke on the functions of the decorative ensembles,[9] Jashemski on what the Villa reveals about the planning of villa gardens,[10] Bergmann on the interplay between the painted gardens and the culture of *otium*,[11] Sauron

on how the painted program might reveal the owner's identity,[12] and Clarke, Ehrhardt, and Tybout on the chronology of its wall painting and mosaics.[13]

THE PLAN OF VILLA A: ITS DESIGN AND NEW DISCOVERIES

The successive owners of the Villa strove to impress their guests through a variety of visual strategies. The western core has an entrance from the north dramatized by the addition of the *propylon* (21) around the year 1. As we know from Vitruvius, a visitor entered the Roman town house (*domus*) from the street. From the entryway (*fauces*), he would be standing on an axis that directed his gaze through the atrium to the principal reception space, the *tablinum*. A catch basin, called the *impluvium* and

connected with an underground cistern to store water,[14] received the rainwater that came in through the opening in the roof above; the *impluvium* marked the axis from the *fauces* to the *tablinum*. The plan of Villa A reverses the usual sequence, just as Vitruvius instructs for villas. On the land side, a monumental entry or *propylon* (21) with a window (rather than the more usual door) gives an axial view through to the atrium. But between the *propylon* and the atrium is a garden or *viridarium* (22). The only way to get to the atrium is to move asymmetrically down one of the corridors to the right or left, passing the length of the *propylon* and *viridarium*: The sequence of spaces changes both the axiality of a *domus* and the movement between the axial "view-through" and the long, dark detour through one of the downward-ramping corridors (3 or 6) to arrive at an intermediary space (4) before reaching the atrium itself.[15]

Once the visitor arrived in the atrium, its magnificent Second-Style frescoes were meant to impress with their recreation of the colonnades and grand doorways of a royal hall worthy of a Hellenistic king. The huge rectangular *impluvium* (a post-excavation reconstruction) was surrounded by a polychrome mosaic in a swastika-meander pattern that reestablished the axial direction. Unfortunately, the south continuation of the atrium is truncated by a blank wall: This is the exterior north side of the Sarno Canal. Was there a *tablinum* to complete the axis, as in the Villa of the Mysteries, or some other arrangement?

Artists delighted in depicting these luxury villas; a painting from an unknown house at Pompeii gives an idea of what the Villa of Oplontis might have looked like from the land side (Figure 4.3). The *propylon* in the painting and the wide path leading up to it correspond in a general way to the landward view of the Villa. Jashemski's excavations of the north garden (56) revealed converging paths, much like those seen in the painting.[16] Four heads mounted on herm-like shafts were found along the eastern diagonal path. Proceeding from south to north: a portrait of a Julio-Claudian woman (7); a head of Aphrodite (5); a portrait of a boy of Julio-Claudian date (6); and the head of the child Dionysos (8: stolen). Nearby, just

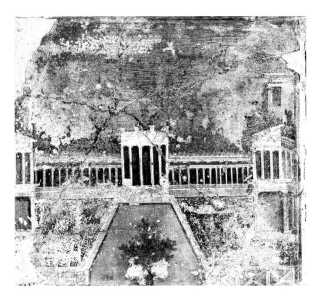

Figure 4.3. Painting of villa from Pompeii, Third Style, 40–45 CE. Museo Archeologico Nazionale, Naples, inv. 9406. (A black and white version of this figure will appear in some formats. For the color version, please refer to the plate section)

north of room 54, excavators found an archaizing herm of Dionysos (9).[17]

The view of the Villa from the land side has always been clear but not its aspect from the sea.[18] Recent work has solved the problem. To the south of the Sarno Canal, there are about two meters of undisturbed ground just before the deep foundations of a mill and modern pasta factory cut through all ancient evidence. Next to the south wall of the canal, our excavations revealed a portion of an *opus reticulatum* wall in the same masonry technique as the *propylon* (21) walls as well as a mosaic pavement (large black *tesserae* dotting a field of white bias-laid *tesserae* averaging 1 cm² datable to the first decade of the first century CE.[19] These features indicate that the Villa extended farther south, but by how much southward toward the Bay?

THE SITE OF VILLA A: NEW DISCOVERIES AND INTERPRETATIONS

Our question was answered with an exciting discovery: Villa A was set on a cliff with a spectacular view. A campaign of deep coring undertaken by Giovanni Di Maio for the Oplontis Project in 2009 and 2010 found that the villa extended no more than five

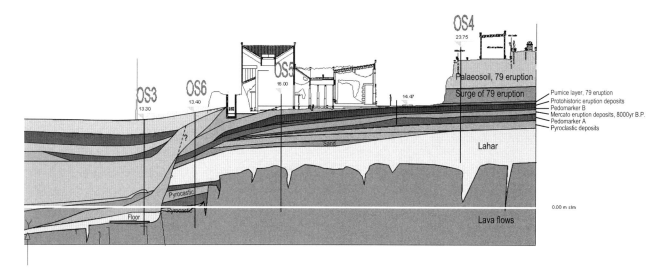

Figure 4.4. Torre Annunziata, Villa A (Oplontis), geological section north to south. (Giovanni Di Maio).

meters beyond the remains of the mosaic floor. The entire building sat atop a cliff at least 13 meters above the sea (Figure 4.4), a position like that of the Villa of the Papyri.[20] Villa A on its promontory held pride of place along a considerable stretch of coast because investigations at the site known as the *Terme Nunziate* and farther along the present-day *Lido Azzurro* of the modern town have revealed remains of Roman villas sited low-down along the modern coast (Figure 4.2). The Roman bath installation beneath the *Terme Nunziate* and remains of foundation walls of domestic buildings – most probably villas – can be found not more than 100 m from the modern harbor. Whereas volcanic debris filled the considerable distance (about one kilometer) between the cliff that Villa A commanded and the present coastline, these Augustan-period villas occupied the same nearly sea-level position as the modern apartment buildings that have supplanted them (Figure 4.2).

From the western core of the Villa, especially from the platform that terminated the *propylon-viridarium*-atrium axis, there was a splendid and dramatic view out over the cliff to the *crater delicatus* that was the ancient Bay of Naples, dotted with other villas. A viewer saw Capri in the distance, and the points of Surrentum (mod. Sorrento) to the south and Misenum (mod. Capo Miseno) to the

north.[21] Rooms 11 and 23, both situated at the sea and cliffside corners of the Villa's Second-Style core, offered spectacular views. Although room 11 has been identified as a bedroom (*cubiculum*) and room 23 as an *oecus* or informal sitting-room, both must have been multifunctional rooms serving as lounges and viewing pavilions, like the so-called *diaetae* of the House of the Mosaic Atrium and the House of the Stags at Herculaneum.[22] Besides great vistas, more mundane sites were within eyeshot: the so-called Villa B (a building for the processing of agricultural goods perhaps owned by Lucius Crassius Tertius) was about 300 m to the east.[23] In addition to terminating the great axis from the *propylon* (21) through the atrium (5), this dramatic sea prospect organized the suites of rooms further to the west, now lying under the modern street and military complex. Timothy Liddell's reconstruction of this western wing recognizes the importance of the great *oecus* 15 as the principal space that organized this area (Figure 4.1). Even though its excavation is yet to be completed, colonnade 19 has a jump in the height of the supporting columns and a wider intercolumniation at a point coinciding with the view southward from *oecus* 15. This room, with unusually high ceilings, likely carried a *fastigium* (a pediment like that of a temple) to dramatize its

importance as well as to mark the view to the sea.[24]

The axis terminating beyond the atrium and the framing axis of *oecus* 15 dramatized the view from the Villa. By contrast, the eastern wing emphasized a less dramatic, more sociable experience: the leisurely stroll (*ambulatio*) around the south garden (59), a walk that eventually led to the portico (60) bordering the eastern side of the long swimming pool.

The major discovery for the entire Villa has been, of course, that its site was on a cliff with dramatic views. This has transformed our understanding of the building, allowing us to reconstruct some of its design principles. A viewer's experience, moving from the south portico (24) to room 41 and then on to the south garden seems based on the principle of moving from low and closed spaces to high and spacious ones, and from socially lesser to visually greater ones, with decoration coordinated with the movement (Figure 4.1). Guests making their leisurely way – part of the *otium* – from portico 24 to stroll around the roughly U-shaped portico (40) surrounding the south garden would have noticed various markings or breaks, among them the doorway between portico 24 and portico 40. Several rooms opened along the north side of portico 24, quite unlike the blank walls backing the entire length of portico 40. The rooms along 24 offered various experiences: room 25 was a single-alcove *cubiculum*, which had formed part of a later-abolished early Third-Style suite;[25] room 37 is a corridor leading to the slaves' peristyle; room 38 was clearly not meant for guests, for although its Fourth-Style decoration is of high quality, its low ceiling reminds us that there were second-story rooms above it for slaves, accessible by a steep staircase opening off the slave's peristyle (32). Room 41, with high ceilings and double-alcove arrangement, terminates the movement along the north wing of portico 24 with a spectacular prospect; unlike the rooms seen before, it seems designed for the reception of guests who could enjoy the view outward from high up. The contrast between the busy variety of openings along portico 24 and the closed, rather contemplative aspect of portico 40 may have been intentional.

Portico 40 had high-quality Fourth-Style wall painting, but it had no pavement or cement bedding for a floor. This unusual situation suggests two interpretations: that the portico was under construction in 79 CE or that a fine pavement had been removed. Elsewhere, marble floor and wall revetments had been spoliated (in rooms 65, 69, 78, and 91); that of portico 40 may also have been removed.[26] Excavations at the southeastern extremity of portico 40 failed to find the end of the eastern wing (presumably cut by the Sarno Canal), but the geological survey indicates that it did not extend more than a few meters. The experience of this garden-cum-*ambulatio* combined the charm of the shaded walkway (further shaded by the ivy twining itself around the columns and the lemon trees planted in the center) with the sea view promised through the foliage.[27] Perhaps there was a room, now lost, located at the far southeast end of the portico for repose and enjoyment of the view.[28]

For a visitor wishing to explore the suite of rooms and gardens around the pool, a wide doorway led from the southeast end of portico 40 to an equally wide corridor (81) running east-west that in turn led to a large pavilion (91) paved in costly *opus sectile*. The remains of monumental columns as well as footings for bases suggest that this pavilion was meant to terminate the terrace south of the pool. Excavations in garden 92 to the north revealed that the builders filled the area between the southern edge of the swimming pool and pavilion 91 with building detritus containing fragments of Third- and Fourth-Style painted plaster from modified rooms and part of a Third-Style frieze original to room 8. The intention was to provide a fill for a new terrace, garden 92, which led south from the pool (96) to pavilion 91, in a new design most likely following the earthquake of 62 CE.[29] The wide openings of pavilion 91 gave views in two directions: to the north, a viewer had a prospect along the south-north axis of the swimming pool (96), marked by the crater-fountain that stood centered in garden 92; to the south, a breathtaking view of the Bay.

Grand porticoes such as portico 40 and gardens with *ambulationes* fit what we know of villa spaces in

painted views, but the design and position of corridor 45–46 is unique and enigmatic. The corridor is itself wide and high, but it runs eastward off the slaves' peristyle (32) and is connected to the slaves' bath and latrine (rooms 47–50) and a dark service corridor to the east (room 53). Neither of these quarters nor the corridor 45–46 would have been on guests' tours of the villa, though the fine set of rooms to the north of the corridor (rooms 55, 57, 54, and garden 58 at the east end of portico 34) may have had an access for slaves through the narrow service corridor 52.

Despite its servile character, corridor 45–46 is an unexpectedly grand space, not only because its ceiling is high but also because it was adorned with fine Fourth-Style ceilings (carefully reconstructed by Stefano De Caro) and upper walls lit from the south through clerestory windows rising above the roof of portico 40. In addition, ample benches on both sides of the corridor invite a visitor to sit. But why would a guest tarry here, next to the slave quarters and with little in the way of a view toward the pool? Most likely corridor 45–46 provided a grand space for the slaves belonging to the guests; they could have congregated there while waiting for their masters' summons. While the corridor's upper walls and ceilings are painted in refined Fourth-Style decorations, the lower walls have simple, even crude, black-on-white zebra-stripe decoration. Sandra Joshel has recently proposed that the zebra-stripe decoration coded the service, or servile, spaces of the Villa.[30] Illiterate slaves could "read" the zebra-stripe patterns to understand what spaces were meant for them. In her scenario of social indices, zebra-stripe decoration designated that not only the slaves' peristyle 32 and corridor 45–46, but also service corridors leading to the entertainment suites bordering the western side of the pool (53, 62, 63, 67, 71, 76, 83, 94, and 97) were reserved for the slaves. If we add together the spaces clearly meant for reception and entertainment in the eastern wing (65, 69, 74, 78, and 91), it is clear that serving guests reclining in these spaces would have required a huge serving staff. Wealthy guests and visitors would have been expected to bring their own slaves, adding to what must have been the already considerable servile personnel of Villa A.

Bypassing corridor 45–46 and its connections with the slaves' quarters and service passages, guests of the villa's hosts would have arrived in the eastern wing by the path I have traced from the atrium, along portico 24, and around portico 40 to the southeastern doorway leading to corridors 76 and 81. Further excavations to the north of the pool 96 would likely reveal a second, northern entrance to the east wing; we do not know the extent of buildings farther to the east, beyond the row of statues and herms found in place at the terminus of the excavations. (Modern visitors walk a ramp leading from north garden 56 through the west window of room 69, a circulation pattern impossible in antiquity.)

By contrast with the parts of the Villa that led progressively to outward-looking views, the spaces of the eastern wing look inward toward the pool, with the exception of pavilion 91. From the walls uncovered on the northeast and northwest corners of the pool, it seems likely that there was a suite of rooms on the north terminus of portico 60 that mirrored the suite (rooms 66, 77, 79, and 85) surrounding the polygonal room 78 on its south.[31] While its position should and could have provided a view southward to the Bay, room 78 was designed to direct the gaze eastward to the terrace (Figure 4.1, 92 at the southern extremity of the pool 96) through two windows asymmetrically placed side-by-side, one half the size of the other. Whereas the larger of the two asymmetrical windows on the eastern wall directed guests' eyes to the large crater fountain in the center of the terrace (92) at the south of the pool, the smaller window may have focused a viewer's gaze on the sculptural group of Hermaphrodite struggling with a satyr. These focused views eastward from room 78 contrast with its south window, which looks onto a blank wall (south wall of passage 79): The intention was to *exclude* any view of the sea. To get to the view, the guest would have to leave room 78 and explore pavilion 86, constructed, much like the pavilion of the House of the Stags at Herculaneum, to frame the view out to the Bay of Naples. A visitor leaving room 78 through either of its doorways on the northwest and southwest corners of the room would have to find his way through adjacent internal rooms (79 and 66) that blocked the view for a moment of movement, the better to dramatize it.

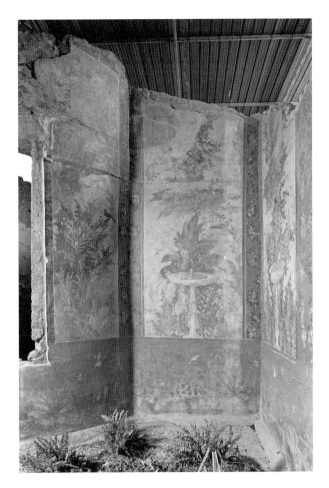

Figure 4.5. Torre Annunziata, Villa A (Oplontis), garden room 87, north wall.

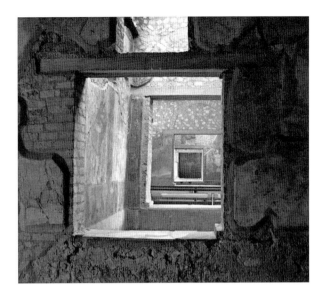

Figure 4.6. Torre Annunziata, Villa A (Oplontis), view of enfilade of windows from *oecus* 74. (A black and white version of this figure will appear in some formats. For the color version, please refer to the plate section)

The rooms along the eastern side of the pool alternated among three large covered dining rooms (65, 69, and 74) and the so-called garden rooms that were open to the air and painted to look like gardens (Figure 4.5). As in room 78, a viewer would have seen carefully framed views, differing according to his or her assigned place on the dining couches placed in the *triclinia*. Views eastward and outward from these rooms, across the portico 60, across the pool, and terminating in the sculptures placed along its eastern walkway, fit with what we know of view planning for static spaces in Roman *domus* and villas.[32] By contrast, the north-south views passing from the *triclinia* and garden rooms through windows aligned in *enfilade* along a north-south transverse axis. The aligned windows encouraged a viewer to look right and left into a series of rooms painted to imitate gardens – complete with plants, fountains, and birds.

These fictive garden rooms were unroofed, open to the air and thus bathed in daylight, whereas the dining rooms were covered, giving an effect of alternating light and dark spaces along a vista (Figure 4.6). The garden rooms were just for looking; they could be *viewed* but not physically *entered*. The *enfilade* and light and dark effects are design elements in several imperial palaces, notably in the Esquiline wing of Nero's *Domus Aurea*, built between 64 and 68 CE, where lined-up doorways create axial views to a series of rooms along the southern end of the courtyard.[33] In addition to the windows between *triclinia* and garden rooms, an *enfilade* of windows doorways visually links the rooms bordering portico 60 (94, 90, 88, 74, 72, 69, 75, 65, and 63: Figure 4.7). The effect is at once stately and delightful, giving a sense of depth but also of focus along the way.

THE BUILDING HISTORY, FLOORS, AND WALL DECORATION OF VILLA A: DISCOVERIES AND INTERPRETATIONS

The Oplontis Project has made considerable progress in understanding the building history of Villa A. The clearest evidence comes from the examination

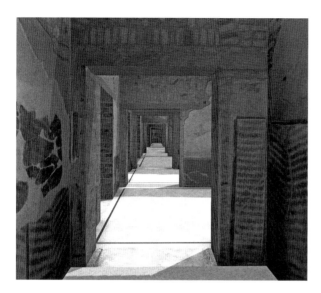

Figure 4.7. Torre Annunziata, Villa A (Oplontis),
enfilade of doorways from 94 to 63.

and dating of the sequence of wall paintings and
mosaic pavements in tandem with analysis of con-
struction technique and building materials. What
emerges is a plan that dates the building to four phases
and that also allows us to see how the spaces changed
and were redecorated.

1. The earliest phase of the villa dates to c. 50 BCE
 and includes most of the rooms of the western
 core, including the reception spaces that retain
 their Second-Style decoration (5, 11, 14, 15, and
 23) and undecorated secondary rooms (2, 6, 7, and
 9). The area of the slave quarters, including the
 slaves' peristyle 32 as well as its dependencies,
 seems to have been constructed at the same time
 as the spaces meant for the owners.
2. The second phase includes redecoration, in the
 early Third-Style of 1–10 CE, of rooms 8, 10 bis,
 12, 17, 21, 22, 25, and 30.
3. The third phase was redecoration in the early
 Fourth-Style of 45–55 CE of a group of rooms
 in the western core: 1, 4, 13, 16, 18, 24, and 31.
 Of particular interest is the imitation Third-Style
 used in redecorating what had been the *caldarium*
 of a bath (8) as well as the imitation Second-Style
 used to cover a repair on the east wall of *triclinium*
 14.[34] The slave quarters seem to have been
 redecorated in this period.

4. The fourth phase concerns the western rooms
 of the villa (corridor 45–46, peristyle 40, and
 all the rooms of the eastern wing. In one room
 (29, a triple *cubiculum* with spaces for beds on the
 west, north, and east walls), there were actually *two*
 campaigns of Fourth-Style decoration: The original
 simple scheme of red-ocher stripes on a yellow-
 ocher ground was then replaced with a second of
 red stripes on white, which provided a better
 white-ground surface for decoration that included
 a spatter pattern. The white-ground scheme of
 portico 60 belongs to this fourth phase and consti-
 tutes the finest Fourth-Style painting of the Villa:
 graceful tendrils inhabited by a variety of animals
 rather than the more usual carpet borders of ordin-
 ary Fourth-Style schemes.[35] If we date the painting
 of portico 60 to the post-earthquake period,
 a problem arises because some event left the entire
 portico in a state of collapse. Aside from one
 engaged column at the north extremity, none of
 the columns that once supported its roof have been
 found in place. Some of them were stored around
 the interior walls of *propylon* 21, but no indication of
 rebuilding has been found. If the portico was laid
 low by an earthquake that occurred after 62 CE or
 by some other event, together with the spoliation
 of the *opus sectile* floor of *oecus* 78 and most of the
 marble wall revetments of rooms 65, 69, and 74, it
 appears that the final owner of this property had
 been using it as a quarry for finely finished pieces of
 marble for architecture, wall decoration, and floors
 at the time of the eruption of Vesuvius in 79 CE.
 The villa – valuable and beautiful as it was – was
 uninhabited at the time of its destruction, so it may
 be that efforts to rebuild it, presumably after some
 seismic event, had been abandoned.

The Villa's abandonment is confirmed by its sculp-
tural decoration: only twelve of the nineteen garden
sculptures still stood in their original locations while
others were in inappropriate anomalous locations.
Sculpture *in situ* included four statues and three
busts along the eastern side of the pool; the satyr
and hermaphrodite group at the southeast corner of
the pool, and four busts along the eastern diagonal
path in garden 56.[36] By contrast, the large crater

fountain was found in a disassembled state in service corridor 53;[37] the two centaurs and two centauresses, no longer in use as fountain features, came from the extreme west end of portico 33; the boy with a goose also emerged from portico 33; and the Venus was stored in room 35. Found in out-of-place locations, these works of art may well have been intended for sale or reuse.

CONCLUSION

Organizing space around axial views and framing devices – whether in a modest townhouse or an enormous villa – was an important principle of Roman design and most decidedly so in Villa A. The geophysical and archaeological work by the Oplontis Project has allowed us to reconstruct the view out to the Bay as the terminus of the long axis that begins in *propylon* 21. However, more subtle design relationships can now be understood: In contrast to the rooms and porticoes that took advantage of the dramatic cliff-top site, most of the spaces surrounding the swimming pool (96) directed the gaze to framed views of the pool itself and the sculpture at its edges or even to the painted garden rooms visible through the *enfilades* of windows and doors. It seems that this difference between views to the sea and views to framed interior features arose from the uses of the spaces in question.

If the *propylon-viridarium*-atrium axis compels a visitor to find the goal – the view of the sea – it is because the architect framed a dynamic experience: The visitor must walk a tortuous path to arrive at that destination. The other dynamic experiences, such as the *ambulationes* suggested by the porticoes of the south and north gardens as well as the garden paths, also used the natural and manmade landscape as both their foil and goal.

For the spaces surrounding the pool, the architect had the resting, or static, viewer in mind. Just as Roman dining etiquette determined a guest's position according to his social status, so the architect determined the experience of the view out from the dining couches. The static views from the *triclinia* eastward across the portico 60 and the pool framed

real gardens with particular statues poised along the eastside of the pool, while the north-south view through the windows revealed the delights of *fictive* gardens – paintings of fountains, plants, and birds – that mimicked and recalled the real gardens outdoors.

The spatial and experiential context for the decorative elements of Villa A – its architecture, gardens, sculptures, and wall and floor decoration – were how the owners, personnel, and guests experienced Villa A in all its aspects: Bringing these elements into a total picture is the goal of the Oplontis Project. The Roman villa was a place for the pursuit of *otium*, or intelligent leisure, and Villa A demonstrates how its visitors and inhabitants engaged in its pursuit on a grand scale. It takes a greater hold on our imagination the more we understand the details of its decorative systems, the subject of the studies to be presented in volume 2 of our publication. From its inception in 50 BCE to its final state, the owners of Villa A charged painters and sculptors to provide them and their guests with topics of lively conversation at all points in their experience, whether walking the garden pathways and porticoes or as they settled to recline on their dining couches. On the sacred side, the artists represented gods, goddesses, demigods, heroes, shrines, and cult objects; on the mundane side, plants, fruits, birds, insects, and animals: the easy passage from sacred to mundane and back again is one of the challenges of the Oplontis Project team to frame in terms of ancient Roman attitudes. The rich allusions to ancient religion, architecture, and natural history encapsulated in its decoration, along with the articulation of its grand spaces in terms of framed views and *ambulationes*, point up the value of the kind of global study that we are undertaking for Villa A.

NOTES

1. De Franciscis 1975: 14–16; Fergola and Pagano 1998: 19.
2. The *Tabula Peutingeriana* is a twelfth-century copy of a fourth-century Roman map, which itself may have copied an earlier map still showing the towns of

Pompeii, Herculaneum, Stabiae, and Oplontis buried in 79 CE. Malandrino 1980: 9–40; discussion in Clarke 2014a: 722–30.

3. Malandrino 1980: 55–61; Fergola 2014.

4. Fergola and Pagano 1998: 11; Marasco 2014: 213–6 and 361–6.

5. Ruggiero 1888: 100–3; Marasco 2014: 217–31 and 389–96.

6. www.oplontisproject.org. Clarke and Muntasser 2014: 42–46.

7. Clarke and Muntasser 2014.

8. Zarmakoupi 2014 and Zarmakoupi in this book (Chapter 5).

9. Clarke 1991: 113–40.

10. Jashemski 1979b: vol. 1: 289–314.

11. Bergmann 2002: 87–120.

12. Sauron 2007: 98–128.

13. Clarke 1987: 267–94; Ehrhardt 1987: 34–40; Tybout 1979: 263–83.

14. Clarke 2014b: 343–7.

15. Drerup 1959: 145–74. In public architecture, the closest similar design is at the Sanctuary of Fortuna Primigenia at Praeneste, where a devotee had to deviate from the axis of the whole to climb the 100 m artificial mountain through one of the two lateral vaulted ramps connecting terraces IV and V.

16. Gleason 2014: 963–67, 997–1008.

17. De Caro 1987: 90–4, cat. nos. 5–9.

18. Jashemski 1979b: vol. 1: 297–306.

19. Clarke 1987: 267–94.

20. Di Maio 2014, 662–721. For the cliffside siting of the Villa of the Papyri, Guidobaldi, Esposito and Formisano 2009: 43–182.

21. *Crater ille delicatus*: Cic., *Fam.* 2.8.2. For the view, Di Maio 2014, 667 and 698.

22. Leach 1997: 50–72; for the Herculaneum houses, Clarke 1991: 242, 247.

23. Fergola 1984: 100–27; Fergola 2014: 169–77.

24. Maiuri posited a similar configuration in the eastern peristyle of the House of the Menander in Pompeii, where the *fastigium* signaled the importance of room 18, a huge reception space, but Wallace-Hadrill (1988, 61–4) cautions on the reconstruction.

25. Clarke and Muntasser (forthcoming).

26. If the floor was removed, evidence of its bedding should have been present, but this was not the case.

27. Gleason 2014: 1009–26.

28. Jashemski 1979b: vol. 1: 293–6.

29. Thomas and Clarke 2009: 358–9.

30. Joshel and Petersen 2014: 169–81.

31. There was probably a twin or matching polygonal room in the area of room 97 (only partially excavated) at the northern extremity of portico 60, which would have made a symmetrical *pendant* to room 78.

32. Clarke 1991: 14–18.

33. MacDonald 1965: 67; Ball 2003: 110–11.

34. Clarke and Thomas 2008: 466–7.

35. The decoration of portico 60 has a close parallel in *oecus* 7 of the House of the Centenary at Pompeii, conclusively dated after the earthquake of 62 CE: Esposito 2009: 114–16.

36. All find spots are recorded in the *Giornali di Scavo*, housed in the *Ufficio degli Scavi* at the site. Bergmann 2002: 92–4, with previous bibliography in note 26.

37. *Giornale di Scavo*, 17–30 April, 1975 (*Ufficio degli Scavi* at Villa A).

LANDSCAPE AT THE "VILLA OF POPPAEA" (VILLA A) AT TORRE ANNUNZIATA

MANTHA ZARMAKOUPI

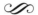

ROMAN VILLAS SHAPED NATURE. THE agricultural landscape of villas connected food production to the money economy and urban centers, in Italy and ultimately throughout the Mediterranean. At the same time, luxury villas framed views of landscapes that inflected mental and visual norms of how nature could be represented, controlled, and accommodated. Roman architects developed an architectural language from the vocabularies of Hellenistic architecture, but they did so in a new, pictorializing way. Owners of luxury villas were eager to make deliberate references to Greek architectural antecedents, but they refreshed them with an original appreciation of landscape and nature. In the new situation of the Mediterranean world after the conquest of the Hellenistic east, Roman designers and owners chose a Greek architectural vocabulary: They appropriated it to ask, and answer, different design questions, thereby creating a new language of architecture and landscape. This chapter outlines this fresh architectural language by which late Republican villas incorporated educated leisure *à la grecque* and the invention of landscape, using the example of Villa A at Torre Annunziata (Oplontis). Certain of its elements are attested at contemporary villas elsewhere, such as the Villa dei Papiri at Herculaneum and the Villa San Marco at Stabiae.[1]

LUXURY VILLAS AND THE BAY OF NAPLES

Luxurious villas and their culture were linked to the conquest of the Hellenistic east in the second century BCE and the ensuing influx of resources into Italy. Criticism of luxury country houses began in the period after the defeat of Perseus at Pydna in 168 BCE, one of the traditional dates assigned to the introduction of wealth, booty, slaves, luxury, grand houses, and – not incidentally – fine villas to those members of Roman society who benefitted from the rewards of foreign conquest.[2] Members of the senatorial and equestrian orders who wished to display their new wealth in a private context transformed their plain country houses into sumptuous edifices on the model of monumental Hellenistic architecture, and moralists were provoked to criticism as much political as ethical.[3] Living in a luxurious villa in the countryside in retreat from the political affairs of the City intertwined with an idealized Greek notion of educated leisure (*otium*). The attraction of this lifestyle was a frequent topic of Latin letters – notably those of Cicero – and centered on discussions of Greek philosophy, history, mythology, and the arts while downplaying productive agricultural endeavors of the estates on which the villas stood.[4] Owners and designers enhanced this encounter with an idealized Greek culture, filling villas with Greek

architectural elements and structures, wall paintings, famous statues and sculptural groups featuring Greek mythological themes, busts of philosophers, and Hellenistic kings – some shipped directly from Greece.[5]

These Greek imports – actual objects or versions of them – as well as ideas and topics of conversation were widely distributed in the culture of villas. However, one genuinely original – Italian or Roman – element in early villa design was a relation to the landscape setting. Villas came to lead the way in a cultural common language, prominently attested in contemporary literary and visual sources, that was concerned with nature in its pictorial aspect.[6] For the first time in Western culture, landscape was singled out as a theme in its own right. The qualities of landscape were praised in the pastoral poetry of Virgil, and its idealized and symbolic representations permeated public and private spheres: the garden paintings from the underground dining room of the Villa of Livia at Prima Porta and the sculpted reliefs of lush floral and vegetable elements on the altar enclosure of the Ara Pacis Augustae are but two of many examples.[7] This romance of landscape found an architectural expression in Roman luxury villas. In the realm of rural dwellings, landscape could simultaneously be represented in wall painting and framed by architectural design. Interior landscapes were embellished with water and sculptures and surrounded by views of and out to painted, sculpted, and real landscapes; the perforated architectural body of villas opened its spaces to engage both interior and exterior landscapes; the sprawling elements of villas responded to the landforms and dressed them with masonry and marble; the visually potent connecting elements of this fluid architecture marked the position of the villas in their landscape. In designing for luxury, Romans shaped a sophisticated interplay of architecture and landscape, an interplay that Renaissance architects rediscovered and that persists to this day.[8]

Villa A at Torre Annunziata (Oplontis) is a prime example of early imperial luxury villas in the Italian peninsula (Figure 4.1 in Chapter 4). It was built in the mid-first century BCE to a design following other villas with the atrium-centered plan of town houses;

it was expanded and constantly refurbished until its destruction in 79 CE. Villa A embodies many of the cultural and visual mannerisms of the early imperial period and its architectural language is a case-study, with others in the Bay, of how patrons and designers could exercise their ideas.[9] The Bay and the Campanian and Sperlonga-Gaeta coastlines were the first concentration-points of *villae maritimae*.[10] The Bay had attracted Romans since the early second century BCE,[11] and while some villas were simple *villae rusticae* like that described by Cato, many were turned by the beginning of the first century BCE into luxurious edifices; for example, the villa under the Aragonese Castle of Baiae, the so-called villa of Caesar.[12] Villa Prato at Sperlonga (second century BCE) is a notable example of an early monumental villa on the Sperlonga-Gaeta coastline that combined the luxury of bathing facilities and the practicalities of pisciculture.[13] Imperial properties on the Bay were numerous, but the social scene was mixed: Illustrious Romans of famous historical families and municipal magistrates of merely local importance, or descendants of ex-imperial or ex-senatorial slaves who had achieved wealth or influence, mingled in a life of leisure and luxury.[14] During the first century BCE, Cumae on the northern coast of the Bay became a center for luxury villas, a "Rome in miniature."[15] By the end of the century, villas presented so dense a front around the Bay that they resembled a single city; others were built along seacoasts and lakesides all over Italy.[16]

HELLENISTIC ELEMENTS IN LUXURY VILLA ARCHITECTURE

The architecture of luxury villas was informed by the civic, religious, and royal architecture that Romans encountered in their conquest of the Hellenistic east. Roman military expeditions included some cultural study and travel, and it was inevitable that monumental colonnaded architecture would be emulated in country houses and, in miniature, in city houses.[17] The peristyle courtyards of Hellenistic palaces and athletic training grounds (the *palaestrae* of the *gymnasia*), such as those of the palace at Aigai in Macedonia

and the *palaestra* in Olympia, informed the structure of the Roman peristyle garden, and the monumental terracing of colonnaded sanctuaries and royal capitals, such as the sanctuary of Asklepios in Kos and the Acropolis of Pergamon, was emulated in the raised terraced substructures of villas (*basis villae*).[18] These elements had first entered the Roman design vocabulary in the public and religious sphere: The colonnaded Porticus of Metellus in Rome (after 146 BCE) and the terracing of the Sanctuary of Fortuna Primigenia at Praeneste (early second century BCE) are significant examples. Peristyle structures had entered the design vocabulary of urban dwellings by the mid-second century BCE but were not fully integrated for 75 or 100 years, in the first century BCE, when, as in the case of the House of the Faun in Pompeii, they came to be fully incorporated in the actual plan of the house.[19] In villas, they could appear in two-dimensional representations in Second-Style wall paintings (mid-first century BCE),[20] and Villa A has an impressive example of a *painted* monumental colonnade on the east wall of Room 15 dating from the early phase of the villa (Figure 5.1).[21] In the representation, a double-tiered portico of noble size appears behind the columns of a grand *propylon*. In the building phases of the Oplontis villa itself – and many other villas – these porticoed structures entered the design vocabulary at about the same time. In Villa A, porticoes 13, 24, 33, and 34 (Figure 4.1 in Chapter 4) were added, or remodeled, around the end of the first century BCE, and

porticoes 40 and 60 were built around the middle of the first century CE (Figures 5.2, 5.3, and 5.4). The porticoed structures migrated from being two-dimensional representations painted *on* walls to be actually built *around* them.

By incorporating these monumental public structures in luxury villa architecture, Roman designers assimilated both the *luxuria* of the Hellenistic east and the relatively new grandiose character of Roman public architecture. Romans, however, did not aspire merely to the public, monumental, and sumptuous character of these structures. The peristyle and portico structures were representative of the architectural forms of the Greek educational institution, the *gymnasium*. Indeed, Cicero

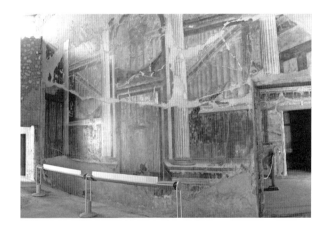

Figure 5.1. Torre Annunziata, Villa A (Oplontis), room 15, view of east wall. (Photo: author).

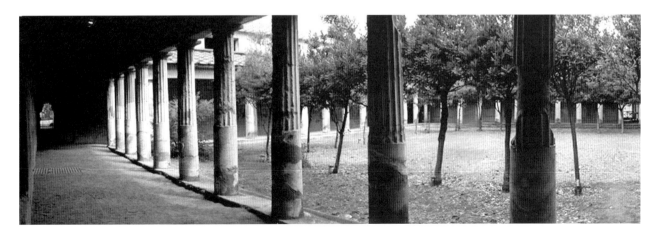

Figure 5.2. Torre Annunziata, Villa A (Oplontis), peristyle-garden 40-59, view from south end of west portico. (Photo: author).

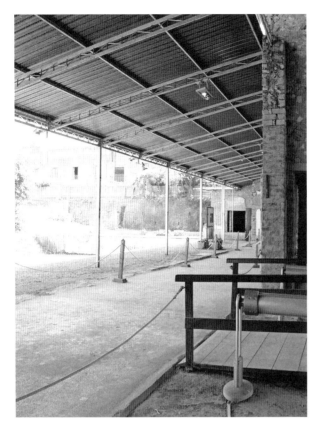

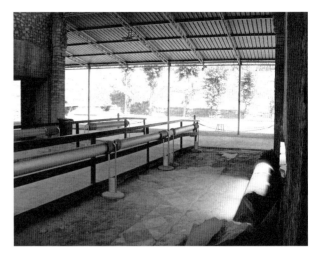

Figure 5.4. Torre Annunziata, Villa A (Oplontis), view from room 69 through portico 60 over pool 96 toward area 98. (Photo: author).

Figure 5.3. Torre Annunziata, Villa A (Oplontis), view of portico 60 from room 69 toward the south end 92 of east garden 96-98. The stairs leading down into pool 96 are seen to the far left. (Photo: author).

used the words *gymnasium* and *palaestra* interchangeably to describe the porticoed structures in his villas, although the former signified the institution and the latter the architectural structure of the peristyle training ground. Whatever the name used, the peristyle structure bore, for members of the Roman elite, associations with the places in which, in fact, they had studied and not merely visited.[22] In a discussion held at one of Crassus' grand villas in the second quarter of the first century BCE, one of the participants asked a question of Greek culture which was answered in a Roman architectural way:

> ... surely you do not think this is an inappropriate place (sc. for discussion)? Here, where this portico, in which we are now walking, and this *palaestra*, and sittings at so many places, awaken somehow the memory

of the *gymnasia* and the philosophical disputes of the Greeks?[23]

However, in Roman luxury villas, porticoes did not surround paved courtyards as they had in Hellenistic palaces and training grounds. Rather, they framed and enclosed lavish gardens. In villas, the contained space was a carefully constructed landscape that complemented the architecture: In Villa A, vines were planted in portico 40 and trained to climb the columns (Figure 5.2), and plantings shaped the design of the villas' gardens, such as the contoured beds that lined the paths of the north garden.[24] Gardens of villas were often lavishly furnished with waterworks: at Villa A, the pool 96 to the east of portico 60 supplied movement and reflection of architecture, vegetation, the sky, and sculpture (Figures 5.3 and 5.4). In such internal landscapes, certain themes could be evoked in copies of Hellenistic sculptures: *nature tamed and untamed* in the sculptural group of satyr and hermaphrodite that was placed to the south of pool 96; *athletic prowess as divine and human* in the two Herakles herms and the Ephebe statue in area 98 on the east side of the pool (Figures 5.3 and 5.4).[25]

Pleasure gardens were laid out in the royal parks of the successors of Alexander, such as those at the palace of the Seleucids in Antioch situated on an island in the river Orontes; these in turn emulated

Persian "paradises" or heaven-like parks (*paradeisoi*) around the palace complexes at Pasargadae and Susa.[26] A direct reference to Hellenistic and Persian architecture may not have been intended, but the gardens of Roman luxury villas with their water-works and ornamental plantings alluded to the luxury and pleasure with which the East was associated.[27] Roman gardens were not independent designs in which, as in a *paradeisos*, the garden itself dominated. Rather, gardens were subordinated to the architecture of the villas by being enclosed in peristyles framed by porticoes. In this way, and no matter how luxurious, such gardens alluded to the homely Roman *domestic* garden (*hortus*, which included herbs and green staples for the table) within the architecture of the house.[28] This homeliness could be readily played down: Exotic trees, ornamental shrubberies, moving water, and statues could accentuate a new glamour.

For villas in Italy, the pleasure garden and the colonnaded peristyle with free-standing colonnades had been distinct concepts with contrasting associations: the pleasure garden denoted the luxury of the East, while the architecture of peristyle and portico evoked the strenuous discipline of Greek educational institutions and venues. By incorporating the pleasure garden inside the structure of the peristyle, Roman designers "tamed" the unruly nature of the corrupting "Eastern" influence, constructing spaces in which pleasure was made acceptable to owners who wished for luxury without imputation of decadence. As Foucault has shown, the experience of pleasure is constituted, negotiated, and organized through certain forms of discipline.[29] In the framed gardens of the peristyle, the foreign pleasures of the East were under Roman moral control.

VILLA DESIGNS: ARCHITECTURE AND LANDSCAPE

The peristyle garden entered the design vocabulary of luxury villas in the first century BCE as a simple square or rectangular structure: At the Villa dei Papiri, there were two such gardens, and the Villa San Marco had one in its first phase. A little later, the

Figure 5.5. Torre Annunziata, Villa A (Oplontis), view of room 69 from portico 60 toward the north garden. The propylon in front of room 21 is seen in the far distance. (Photo: author).

formula of the square or rectangular peristyle centered on a garden was given some variations: designers retained the colonnaded structures but started using them in more open arrangements. We see this at Villa A when it was enlarged in the early first century CE and then again after 45. Although the form of the rectangular porticoed enclosure was retained (for example, peristyle-garden 40–59; Figure 5.2), it was more freely interpreted. The porticoes and gardens now followed the sprawling architectural body of the villa (portico 60 and garden 96–98) and created views to the surrounding landscapes as well as to the villa's architectural elements (Figures 5.3, 5.4, and 5.5). Porticoes as screening and liminal spaces between the closed rooms of the villa and its gardens were kept, but the result was that the architectural form of the closed peristyle was deconstructed, losing its character as a porticoed enclosure but retaining its other elements. The peristyle, portico, and garden were articulated in new ways.

This reordering of portico and garden opened up the architectural composition of villas and created a more immediate relationship to, and mastering the view of, the landscape around them. The change took place at a time when appreciation of landscape

Figure 5.6. Torre Annunziata, Villa A (Oplontis), *caldarium* 8, view of north wall from the east side of the room. (Photo: author).

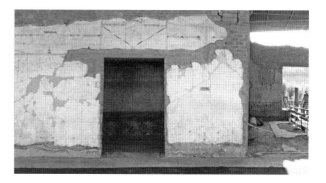

Figure 5.7. Torre Annunziata, Villa A (Oplontis), view of west wall of portico 60; to the left, view of the north garden through room 69. (Photo: author).

Figure 5.8. Torre Annunziata, Villa A (Oplontis), view of portico 60 toward the south from the entrance to room 69. (Photo: author).

was manifested in both literary and visual media. In Villa A, three groups of landscape paintings, one from the first phase of the villa (c. 50 BCE), a second from the refurbishment and enlargement of the villa around 1–10 CE and a third belonging to

transformations after 45 CE, give us an insight into changes in the visual and architectural values of landscape and how it was manifested.[30]

From the earlier phases of the villa, the painted walls of the Second Style (c. 50 BCE) are "minor players" in the decoration. The small *pinakes* (painted framed pictures) on the east wall of room 15 are tiny (14 x 44 cm) in relation to the size of the wall (8.80 m wide and some 5.80 m high); they are small decorative accents compared to the grand representation of the two-storied colonnade that occupies the major part of the wall (Figure 5.1).[31] By contrast, fifty years or so later, the Third-Style landscapes (1–10 CE) are large and have become the central subject of the decoration. For example, the landscape panel on the north wall of *caldarium* 8 (Figure 5.6) is large and prominently placed, vivid within its fragile linear architectural framework, which itself contrasts with the earlier, heavier Second-Style compositions. Landscape has become a central subject in its own right.[32]

In turn, and again about 45–50 years later, the landscapes in the Fourth Style, in Villa A's third phase after 45 CE, became small once again, but with this important difference: no longer high up on the walls as mere decorative adjuncts to larger architectural perspectives, they become, despite their small size, the principal subject of now sparsely decorated walls. The walls of portico 60 in the east wing had landscapes in the small *pinakes* format (24 x 7 cm; Figures 5.5, 5.7; 5.8, cf. Figure 5.6). These miniature landscapes alternated with *xenia*, food still-lives – not

an accidental subject, as we will see.[33] The paratactic representation of landscapes alternating with still-lives had appeared about 20 BCE (late Second Style) in the corridor F-G of the Villa "Farnesina" in Rome, where – besides *xenia* – landscapes alternated with theater masks from tragedy and comedy: there too, the scenes are painted in clear colors on white backdrops.[34]

Thirty or so years later, and unlike the Villa "Farnesina" landscapes, which are placed as a frieze rather high on the wall, the Villa A landscape *pinakes* of portico 60 were placed at eye-level in the median zone of the wall. Painted with frames, they stand out robustly against the white-ground walls, delicately outlined with metallic filigrees and thin tendrils inhabited by tiny insects and birds; with compositions such as these, the landscapes have become an essential subject of the decoration.

These Fourth-Style landscapes of portico 60 retained both the central placement of the landscape of the Villa A's Third-Style decoration in *caldarium* 8 (Figure 5.6) and the miniature size of the Second-Style *pinakes* of room 15 (Figure 5.1). The almost bare walls of portico 60 with its small landscapes and *xenia* have now become the backdrop of the real – and very robust – actual columns of the colonnade of portico 60 and the *propylon* in front of room 69 that interrupts it. A viewer standing on the east side of pool 96 looking toward portico 60 would see that the view recalls, in solid form, the Second-Style painting on the east wall of room 15 executed about a century before (Figure 5.2). Both are variations on the same theme: monumental architecture (painted or real) in combination with garden views, but now much more loosely conceived.[35] Portico 60 does not enclose the east garden as a peristyle would (as in the view on the east wall of room 15 where a colonnade surrounds a garden) but is an intermediate space between the closed rooms of the east wing and the east garden and pool. This open composition enabled designers to create views of *real* monumental colonnades: the view from portico 60 through room 69 frames the *propylon* in front of room 21 (Figure 5.5), an arrangement that repeats certain landscapes in portico 60 showing villas with prominent *propyla*.[36]

The architectural and decorative developments at Villa A over the course of about 100 years mark a changing appreciation for the landscape that Romans developed from the late Republic onward. From a marginal decorative accent in the Second-Style representations of monumental Hellenistic architecture, landscape became a bold protagonist in the decorative schemes of the Third Style and acquired a more refined and balanced role in the compositions of the Fourth. Two aspects of architecture and decoration were at play: the first was the transformation of the enclosed peristyle to open arrangements of portico structures adjacent to gardens, the architectural response to the growing appreciation for the qualities of the landscape around the villas. The second was painting the back walls of porticoes in the new Fourth Style as the decorative solution for big spaces facing the landscape. Designers departed from the norms of Hellenistic architecture to create an architecture that responded to the specific landforms and took advantage of the views to the surrounding landscape, while wall painters moved away from the solemn perspectives of the Second Style to create the sophisticated, almost-flat schemes of the Fourth.

LANDSCAPE AND LUXURY

The transformation of the peristyle enclosing a garden to more open articulations between colonnades and gardens was also associated with the needs of new, spatially demanding dining practices. In the early imperial period, hospitality became increasingly important in the social and political strategies of villa owners and, as a result, dining became more elaborate.[37] Literary sources mention entertainment for the diners that could include performances of music, dance, and pantomime, and Varro gave a spectacle for a feast at his villa in which a musician acted the part of Orpheus in a park with wild animals.[38] Plutarch mentions mimes acting in private dining parties in his "Table Talks."[39] The result of these augmented entertainments made the traditional dining room, the *triclinium*, insufficient: *Triclinia* had accommodated three oblong couches (about

2.20/2.40 x 1.20 m) for reclining diners arranged in a square U, with food and drink placed on small tables alongside.[40] The traditional arrangement had fostered conversation while dining, and as such did not accommodate the new performances developed in elite circles in the first century BCE. New spaces were needed for new pleasures.

In Villa A, the big rooms and clusters of rooms that appeared toward the end of the first century BCE and the beginning of the next accommodated those needs: rooms 21, 64/65, 69 and 73/74, and the cluster of rooms 66, 78, 79 (Figure 4.1). These rooms were designed as stages for movement and views (Figures 4.6; 4.7).[41] Rooms 64/65, 69 and 73/74 could hold a single dinner party, while light-wells 68 and 70 between them enlivened the atmosphere with painted and real vegetation.[42] The light-wells allowed visual contacts among the three principal rooms (rooms 64/65, 69, and 73/74), but their raised sills did not allow direct passage into them (Figure 4.6). Instead, a suggestively sinuous and indirect series of sight-lines was provided through rooms 71 and 67 to the west, and through rooms 72 and 75 and portico 60 to the east. The visual contacts combined with the physical constraints between these spaces would have intensified the experience of a performance: Actors could move through these passages to entertain the diners, who could watch and hear them directly or, tantalizingly, see and sense them obliquely, with enrichment of movement and variety of sight-lines.[43]

The small *pinakes* on the west wall of portico 60 enhanced the diners' experience (and appetites) by the representation of landscapes and *xenia* (Figures 5.5; 5.7). Gifts of food, fresh and often simple, were thought to have been what Greek hosts offered to their guests.[44] The artful depiction of these gifts celebrated the richness of the private banquet and the acts of hospitality, while literary *ekphraseis* of such gifts – Martial's poems, for instance – that accompanied them whetted the appetites of the diners.[45] Landscapes in pictures and views as well as depictions of food were combined in strolling and dining, and area 98 (the area east of pool 96) could have worked as a backdrop, or *scaenae frons* with its statues and trees (Figures 5.3, 5.4, and 5.8),

while the pool worked as a reflective surface for actors entertaining the diners – reminiscent of the pictorial intertwinement of dining, theatrical performance, and landscape staging in corridor F-G of the Villa "Farnesina."

The dining arrangements at Villa A represent a significant departure from habits of dining and hospitality that had been current in late Republican villas, namely the traditional *triclinia*. For a time, these were retained, but the old square U of couches plus the T for the central service area and the little tables were replaced, by the early imperial period, with a greater variety of shapes and sizes.[46] Villa A furnishes an example: *Triclinium* 14 (c. 50 BCE) is in the old square-U shape (though without a "U+T" floor pattern), whereas the three new dining rooms (64/65, 69, and 73/74; after 45 CE) ranged along portico 60 are quite different in design conception. It may also be that the use of the rooms depended on the time of day and the season: Roman rooms could be converted for convenience and circumstance.[47] Such changeable uses were doubtless available in Villa A; the landscape views and the weather would also have suggested the best use of a specific room.[48]

Besides being new and quite untraditional, the adaptation of VIlla A's new dining facilities to spectacle during the feast was precocious: In the late empire, entertainment while dining in luxury villas led to designs in a triconch arrangement in which three adjacent spaces (often apsidal) were set around a central space. This disposition provided a venue for the entertainment (dance, music, theatre, even gymnastic shows) that could be viewed equally from the three apses.[49] All such triconch arrangements are variations on the architectural theme of *feasting while viewing*. Villa A did not have a triconch, but the design of its facilities from which viewers could look *out* to open vistas or *through* a colonnade onto spaces for spectacles is an early instance of what would become a norm of hospitable reception later on.

PORTICOES: THE CONNECTIVE TISSUE

Columnar porticoes in the new late Republican designs of villas took on a new aspect: they masked

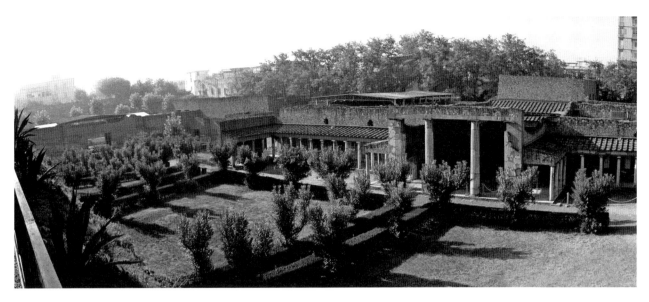

Figure 5.9. Torre Annunziata, Villa A (Oplontis), view from the north. The large propylon to the right marks room 21. (Photo: author). (A black and white version of this figure will appear in some formats. For the color version, please refer to the plate section)

as well as opened up the villa's façade, and expanded its presence in the landscape. The strong sun of the Mediterranean accentuates the volumes and features of an architectural object with cast shadows, giving focus and rhythm as seen from afar. Such effects are clear at the north façade of Villa A: Colonnades 33 and 34 retreat in relation to the *propylon* of room 21, and the shading accentuates the forward-breaking volume of the *propylon* (Figure 5.9). Pliny the Younger, in describing his own Tuscan villa, remarks on precisely these effects:

> A big part faces mainly south, and so from midday onwards in summer, a little earlier in winter, it seems to invite the sun into the wide and protruding colonnade. Many chambers open in this colonnade, as well as an entrance hall of the old-fashioned type.[50]

As the rooms of villas spread onto the landscape, their columnar porticoes operated as connective tissue, providing access and direction, protecting them from the elements and unifying the disparately disposed rooms behind them. Porticoes took on a new function in villas: They set the stage for the villa in the landscape and set the owners' social staging within the villa itself.[51]

Another type of portico came to be used in late Republican villas: the *cryptoporticus*, a form that had various manifestations but that, when above ground, was characterized by tracts of wall alternated with doors or windows to provide more protection from the elements than rows of columns.[52] Villa A had two L-shaped above-ground *cryptoporticus*, corridors 13 and 24 (Figure 4.1), on its south façade, framing the forward-breaking block of the atrium (room 5) and surrounding rooms. Pliny describes the environmental advantages of *cryptoporticus* in some detail for his seaside villa at Laurentum, explaining how the windows on both sides allowed for air circulation while maintaining a stable temperature; the corridors broke the north and southwest winds, thus protecting adjacent gardens and walkways (xystus).[53] The *cryptoporticus* at Villa A may have functioned in the same way.

CONCLUSION

In designing for modern luxury, Romans used the existing vocabularies of Hellenistic and Roman architecture to create a new language of architecture in landscape. The appropriation of Greek columnar porticoes in public and athletic venues, when combined with a reinvention of the traditional and

homely peristyle garden, ingeniously located Greek intellectual culture in the private sphere of villas without the corruption of its *luxuria*. In turn, porticoes were adapted to open, rather than enclosed, compositions to make a dialogue between architecture and landscape, and in doing so embodied a sense of nature as garden, nature as landscape and view, and nature as strong poetic theme and appropriate subject of painting. Villa architecture thus both led and followed new ideas particular to late Republican cultural developments.

NOTES

1. See also Zarmakoupi 2008, 2010a, 2010b, 2010c, 2011 and 2014.
2. Polyb. 31.25.6–7; Livy 39.6.7–9; D'Arms 1970, 15–31; Frank 1933, 208–14, 295–9. Wallace-Hadrill 2008, 315–55.
3. D'Arms 1970, 161–3; Lafon 2001, 58.
4. Cicero on villas: *De or.* 2.19–20; on the cultural speech of villas: Mielsch 1987; on the estates and their place in the cultural discussion: D'Arms 1981, 72–96; Marzano 2007 and Marzano in this volume.
5. On the input of owners in the design of their villas see Anderson 1997, 35–39. On wall painting, Fittschen 1976; Tybout 1989, 5–13, 46; Ehrhardt 1991; Kuttner 1998. On sculpture in villas, Neudecker 1988; Dillon 2000; Newby 2005, 88–140. The Mahdia shipwreck (c. 80–60 BCE) found off the coast of Tunisia in 1907 with a cargo of marble and bronze sculptures, high-quality furniture fittings, and architectural elements: Fuchs 1963; Hellenkemper Salies (ed.) 1994; Mattusch 1995; 1996, 171–90. On the relation of Roman copies to Greek originals, Marvin 1993; 2008. On the demand for copies of Greek sculpture around the Bay of Naples attested by discarded casts from the Baiae sculptor's workshop (Hadrianic or Antonine): Landwehr 1985; Métraux 2006, 136–7 and n. 10.
6. Literature: Leach 1988. Gardens: Grimal 1943; Jashemski 1979b (vol. 1) and 1993 (vol. 2); Jashemski and Meyer 2002. Wall paintings: Dawson 1944; Peters 1963; Bergmann 1991; 1992; 2002; La Rocca 2008. Art and politics: Sauron 2000.
7. On the garden paintings of the Villa of Livia: Settis and Donati 2002; Kellum 1994. On the Ara Pacis: Zanker 1990, 179–83; Sauron 2000; Förtsch 1989.

8. MacDonald and Pinto 1995, 266–85 and 306–30; Ackerman 1993.
9. De Franciscis 1975; Fergola and Guzzo 2000. For the more recent work conducted at the Villa see Thomas and Clarke 2007 and 2008, as well as Clarke in this book (Chapter 4) and Clarke and Muntasser 2014.
10. D'Arms 1970; Lafon 2001, 41–62.
11. Cornelia, the daughter of P. Cornelius Scipio Africanus Maior, wife of Ti. Sempronius Gracchus and mother of the Gracchi, owned the first attested seaside villa at Misenum. Plut., *C. Gracch.*19.1–2. Val Max. 4.4.1. D'Arms 1970, 8–9.
12. Cato's agricultural treatise (mid-second century BCE; *Agr.* 1.1–7) defined the villa as a farmstead producing agricultural goods and providing only minimal comfort. Discussion in Terrenato 2001; Becker 2006. The first luxurious villa mentioned in the literary sources is of C. Marius, a *novus homo*, at Misenum on the northwest corner of the bay of Naples, built before 88 BCE (Plut., *Mar.* 34.2; Sen., *Ep.* 51.11). In general, D'Arms 1970, 10–15. On the villa under the Baiae Castle: Miniero 2007.
13. Broise and Lafon 2001.
14. D'Arms 1970; D'Arms 1981, ch. 4.
15. D'Arms 1970, Catalogue I, 171–201; Lafon 2001, 89–95; Cicero's remark: *Att.*5.2.2.
16. Lafon 2001, 95–112; the "single city": Strabo 5.4.8.
17. Rakob 1976; Fittschen 1976, 549–56; Mielsch 1987, 120–25. On the miniature villa phenomenon in Pompeii: Zanker 1979.
18. Förtsch 1993, 28, n. 224, 92–93; Gros 1996, 296–99. On the palace at Aigai: Nielsen 1999, 81–94. On the palaestra in Olympia: Delorme 1960, 102–114 fig. 21; Wacker 1996, 13–19 fig. 4; 121–131. On the sanctuary of Asklepios in Kos and the Acropolis of Pergamon: Lauter 1986, 106–109, 122, 290–301. See also discussion in Zarmakoupi 2014, 104–109.
19. Dickmann 1997.
20. Schefold 1975, 53, 56; Borbein 1975, 61; Rakob 1976, 374; Tybout 1989, 5–13, 46; Ehrhardt 1991; Kuttner 1998. See also Zarmakoupi 2011 and 2014, 75–88.
21. c. 50 BCE; phase 2B of the Second Style.
22. Cicero on the *gymnasium: De or.*1.98; on the *palaestra: QFr.*3.1.3. An inscription from Attica attests the presence of young Romans studying in a *gymnasium* as early as 119–8 BCE: *IG* II.2, 1008. Cicero and his son studied in Athens (Cic., *Att.*12.32.2, Cic., *Fam.*7,16). See also: Marrou 1965; Crowther 2004, 375–422. On the institution of the Hellenistic *gymnasion:*

Delorme 1960; Kah and Scholz 2004. See also discussion in Zarmakoupi 2010c.

23. Cic., *Orat.* 2.19–20 (trans. O'Sullivan 2003).

24. Jashemski 1979, 297–306; 1993, 295–297; most recently Gleason 2014 and Zarmakoupi 2014, 114–122.

25. On the sculptural group of satyr and hermaphrodite: De Caro 1987, 98–100, no.12. Cicero asked a friend in Greece to buy some statues of athletes for his private *gymnasium: Fam.* 7.23.2; De Caro 1987, 103–107, nos. 13–15.

26. On the Seleucid palace in Antioch: Nielsen 1999, 35–51; 2001, 167. On the palace complex at Pasargadae and that of Dareius at Susa: Nielsen 2001, 169–172; Stronach 1978. The Greek word *paradeisos* was used to describe the gardens of Babylon in the late fifth or early fourth century BCE. It most likely derived from Median *paridaiza* and the Old Persian *paridaida*, referring to an enclosed pleasure garden: Tuplin 1996, 80–131; Bremmer 2008, 35–55.

27. Grimal 1943, 86–90.

28. Purcell 1996. For the economy of domestic gardens: Jashemski 1979b, 183–99; for their religious significance: Grimal 1943, 44–67; Jashemski 1979b, 115–40.

29. Foucault 1975; 1984.

30. See also discussion in Zarmakoupi 2014, 122–39. See Clarke 1996 for the comprehensive publication of all the landscape paintings in this villa. For the representation of landscape in wall paintings: Ling 1977; Peters 1963; Bergmann 1991; La Rocca 2008.

31. Clarke 1996, 87 and 94. Cf. the *pinakes* featuring landscapes on the upper register of the walls of the royal box above the cavea of the theater complex at Herodium (c. 15 BCE): Netzer 2011, 36–48.

32. Vitruvius criticized the decoration of the Second Style but did not remark on its landscape paintings: Vitr., *De arch.* 7.5; Yerkes 2000.

33. *Xenia*: Vitr., *De arch.* 6.7.4

34. Spencer 2011, 142–54b for a discussion of the experience of walking and looking at the landscape representations on the walls of corridor F-G in the Villa "Farnesina."

35. For how real and painted landscape and architecture merged in this villa: Bergmann 2002.

36. For the monumental architecture represented in late Third and Fourth Styles: Peters 1963, 110–18; 155–66.

37. Business allegiances were promoted through the choice of guests and the seating arrangements at banquets. D'Arms 1990; Dunbabin 1998, 89; Dickmann 1999, 291–6; Stein-Hölkeskamp 2005, 101–11.

38. Griffin 1976, 94. Sen., *QNat.*7.32.3) complains that the noise of pantomimes on private stages filled the whole city; Jones 1991; Slater 1994, 131; 1993, 205–11. Varro, *Rust.* 3.13.2–3. Orpheus among the wild animals was represented in the House of Orpheus in Pompeii: Michel 1980, 396–7.

39. Plut., *Mor. Qaest. conv.* 7.8.3, 711 E.

40. Vitruvius (*De arch.*6.3.8) says that the ideal proportions for a *triclinium* are twice as long as wide. For a definition of the word *triclinium*: Dunbabin 2003, 38, n.6.

41. Bek 1980, 164–203; 1983; Stewart 1977. See also discussion in Zarmakoupi 2014, 203–11.

42. See Michel 1980, 391–3; Jashemski 1979b, 289–314.

43. See Hall and Wyles 2008, 1–40. Diners could use portico 60, passages 72 and 75 to go from one room to another (Figure 5.8). Servants would have used the narrow passages 71 and 6,7 defined by zebra-stripe paintings for their movement: Goulet 2001; Laken 2003. See also Joshel and Hackworth Petersen 2014, 178–81.

44. Vitruvius (*De arch.* 6.7.4) describes *xenia*; Hanoune 1990; for the Campanian region: Beyen 1928; Eckstein 1957; Croisille 1965 and 2015. Live animals ultimately destined for the table could also be represented.

45. Darmon 1990; Wesenberg 1993; Junker 1996; 2003. On Martial's *xenia* see: Shackleton Bailey's translation with comments in the Loeb edition 2003, 173–225; Leary 2001.

46. Dunbabin 1996, 67–70; 1998, 89. *Triclinia* appear in other parts of the empire including the east: Dunbabin 1998, 92–5. From the end of the first century CE onward, the size and form of dining rooms changed and by the fourth century, the semicircular sigma-couch or *stibadium* prevailed; see Dunbabin 1991. See also discussion in Zarmakoupi 2014, 189–98; Chapter 1 (Marzano and Métraux) and Chapter 22 (Ripoll) in this book.

47. For example, the word *diaetae* designated a nucleus of two or three rooms for daytime activities of which one could be a dining room: Leach 1997, 67. See also discussion in Zarmakoupi 2010b, 164.

48. Dunbabin 1996, 66. For the dining rooms in Pliny's villas: Förtsch 1993, 100–16. Latin authors on

seasonal and spatial qualities of *triclinia*: Vitr., *De arch.* 6.4.1–2; Varro, *Ling.* 8.29. On the view toward the landscape from *triclinia*: Plin., *Ep.* 2.17.13; 5.6.19; 5.6.29–30. Analysis for seasonal room use at Villa A: Zarmakoupi 2008 and 2010b, 164–9.

49. The triconch of the villa at Desenzano on Lake Garda is one example of many: Dunbabin 1991; 1996; Rossiter 1991; see Brogiolo and Chavarría (Chapter 11), Teichner (Chapter 14), and Ripoll (Chapter 22) in this book.

50. Plin., *Ep.* 5.6.15.

51. Zarmakoupi 2014, 235–40.

52. The term *cryptoporticus* could also be applied to partially below-grade corridors without perforations (doors or windows) at floor level, or to completely underground corridors with openings to the outside at roof level. On the form of the *cryptoporticus* in Roman villas: Luschin 2002, 15–23; Förtsch 1993, 41–2; Zarmakoupi 2011, and 2014, 75–102.

53. Plin., *Ep.* 2.17.16–19; Zarmakoupi 2010b, 167–9, and 2011.

6

THE SOCIAL STATUS OF THE VILLAS OF STABIAE

THOMAS NOBLE HOWE

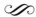

INTRODUCTION: THE SITE OF STABIAE

Ancient Stabiae lay only 4 km from Pompeii, but it was very different from that small bustling port city: It was almost nothing but villas, a dense cluster of a half dozen enormous seaside villas built next to the site of Stabiae, a *pagus* (village) without municipal status (Map 2). These are among the largest known Roman villas, up to 22,000 m², built directly next to one another over a distance of c. 1.8 km along the edge of a sea-cliff, c. 50 m high, facing the Bay of Naples. The ensemble constitutes the largest concentration of well-preserved large seaside villas (*villae maritimae*) in the Mediterranean (Figure 6.1).[1]

Campania and the Bay of Naples were one of the richest and most beautiful parts of Roman Italy, and the villas were built there in part for the same reason that Madame de Staël noted early in the nineteenth century: "Nothing ... gives a more voluptuous idea of life than this climate which intimately unites man to nature." In the first century BCE, shortly after the Social War of 91–89 and the granting of citizenship to all allied Italians (the *socii*) including Campanians, the area became one of the favorite resorts of the Roman elite. So many villas sprang up around the Bay that the geographer Strabo described the area about 9 CE as:

> ... strewn, in part with these cities ... and in part with residences and plantations which, following in unbroken succession, present the *aspect of a single city*.[2]

The first villas at Stabiae were built in the last decades of the Roman Republic (c. 80–49 BCE), a time of accelerating political competition within senatorial social circles that climaxed in the civil wars of Pompey, Caesar, and Crassus and, later, between Mark Antony and Octavian (33–31 BCE). It was during this period that the Roman elites sponsored, among other things, a new type of architecture: the panoramic luxury villa, designed to unite the arts of urban culture and the appreciation of nature.[3]

Villas on the Bay of Naples were not merely resorts of the rich and famous: They were a major center of political power. In the spring and fall months of the first century BCE, the capital virtually moved from Rome to the Bay.[4] Augustus, the first emperor, often vacationed in his villas on the island of Capreae (mod. Capri), so proximity to his person may have been desirable. In 27 CE, the capital literally moved, when Augustus' successor Tiberius (emperor 14–37 CE) withdrew to his villas on Capreae for the rest of his reign, never returning to Rome. Tiberius' decision might well have been based as much on the Bay's long history as a political center as on a desire to shirk his duties for what the ancient sources record as dalliance and debauchery.

Several events of the late Republic and early Empire occurred not in Rome but in the villas of the Bay. To secure political support from Cicero, Julius Caesar visited him at his villa near Puteoli (mod. Pozzuoli) in December 45 BCE (accompanied

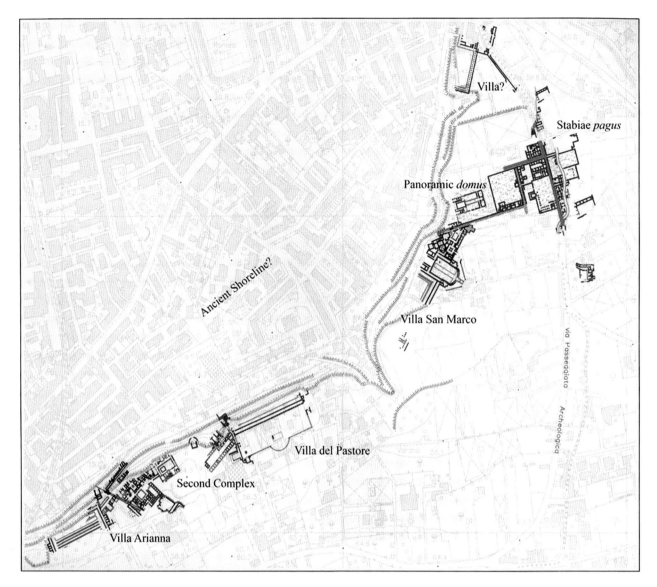

Figure 6.1. Stabiae, site plan: Blue: areas currently visible; red: areas excavated in the eighteenth century and currently reburied. (©RAS/Editrice Longobardi/Parco Archeologico di Pompei. From P.G. Guzzo, A.M. Sodo, and G. Bonifacio 2009). (A black and white version of this figure will appear in some formats. For the color version, please refer to the plate section)

by 2,000 soldiers); the visit started with a walk on the beach, continued with a conference about Caesar's wayward quartermaster Mamurra, and ended with a pleasant dinner chat between the two.[5] A little more than a year later, when the eighteen-year-old Octavian learned in April 44 BCE that Julius Caesar – assassinated the previous month – had named him his heir in his testament, he made straight not for Rome but for the villas of the Bay of Naples, after picking up an army of his adoptive father's veterans and confiscating a treasury.[6] Even well into the empire,

notorious and critical political events occurred at villas in the Bay, such as Nero's clumsy assassination of his mother Agrippina in 52 CE,[7] and the imprisonment of the last Roman emperor, Romulus Augustulus, on an island villa after his deposition by Odoacer in 476 CE.[8]

Stabiae, on the south side of the Bay, was not the main locus of elite villas: the Republican grandees of the later second and first centuries BCE for the most part resided on the north side, at Cumae, Baiae, and Puteoli or the Tyrrhenian coast to the north. Their

dwellings are for the most part gone. However, Stabiae's luxury villas provide insight into how the uses and spatial norms of urban houses of Roman high society were creatively converted to use in villas outside the City with new architectural, decorative, and landscaping ideas.[9] The competition among members of the high social and political classes had already been well established in Rome, but the greater amount of space on the Campanian seashore, together with an unbridled drive toward self-representation and magnificence, and the recollection of Greek traditions and culture, give the villas of the Bay a special place in Roman architectural history. That history is first and foremost political in nature, and the villas at Stabiae on the south side of the Bay illustrate how the clusters of the earlier and most elite "power-villas" of the late Republic would have been assembled on the north.[10]

Most of the construction at Stabiae dates after Actium (31 BCE), that is, a good two or three generations after the earlier villas on the north side and attests the Republican pattern of competitive, highly visible clustering on prime seashores in the first 80 years of the empire (c. 30 BCE–40 CE), responding at this time to the nearby presence of villas of Augustus and Tiberius on Capri.

URBAN HOUSES AND COUNTRY VILLAS: REAL ESTATE AND POLITICS

The political uses of palatial Roman villas were modeled on the urban *domus* of senatorial status in the late Republic. The *domus*, a single-family townhouse centered on an atrium and sheltering a kinship group with a cohort of servants (*servi* = slaves) and allied persons (making the *familia*) came to be a stage for power no matter its size in the urban space of Rome. Villas in Latin literary tradition were an antithesis to the somewhat artless *domus*: large and airy with gardens and views, pleasant venues of worthy pursuits such as writing and reflection, agreeable supervision of agricultural endeavors, hunting, exercise, art collecting, and even personal indulgence

and private luxury. However, the culture and politics of power of the senatorial elites did not cease at the edge of the estate or at the door of the villa.

Senatorial *domus* of late Republican Rome tended to concentrate, creating neighborhoods of political contestants on the Palatine and Velian hills; similarly, villas grouped themselves in three radiating rings out from Rome: the *horti* (gardens) directly overlooking the City; hillside or seaside villas at Tibur, Laurentum, and Tusculum a few hours ride away; and those further away around the Bay. Urban houses did not have to be lavish or up-to-date, and they could be held in a family for generations or even centuries or else sold, purchased, remodeled, destroyed, and rebuilt in the tumult of senatorial politics.[11] The most prestigious contained the wax ancestor effigies (*imagines*) that were carried in public funeral processions, a privilege of the *nobiles*, those with consular ancestors.[12] Some houses were permanently adorned (on their doorposts) with triumphal trophies of the previous inhabitants, whether they were the current owner's or his ancestors or neither: The trophies belonged to the house, no matter who happened to own it.[13] Exemplary ancestors watched contemporary politics from houses clustered around the Forum, on the various lower slopes and the top of the Palatine, on the Velian hill, on the Carinae (part of the Esquiline), along the Sacra Via to the southeast[14] and behind the Old Shops (*tabernae veteres*) to the south.[15] The tight imbrication of senatorial *domus* in these areas had a long tradition, so the clustering of dwellings seemed natural, traditional, and practical.

The neighborhoods near the Forum may not have been exclusive to one class, and there is no record of a specific plan or iconography of houses exclusive to senators other than the triumphal regalia on doorposts; still, the value of *domus* was their antiquity and their closeness to the center of political theater and power. Senatorial houses in Rome were used as backdrops for movement defining social and political relations, principally in the obligations of friends (*amici*) and dependents (*clientes*) at the morning and evening greetings (*salutationes*) to their *patronus* in his atrium. A complex differentiation

within the *clientela* existed both inside and outside the house, and the number of clients accompanying the great man could be in the thousands, the size and quality of the throng indicating his status.[16] The twice-daily political hospitality to friends and clients by senators and other highly placed members of the elite came, in the late Republic (c. 150–30 BCE), to be an almost ritual obligation in the setting of the *domus*, no matter how grand or simple, old or new, it might have been.

But houses were not enough: The intense competition for position and power made for a senatorial elite that understood the uses of art and architecture as well as military tactics, law, rhetoric, religion, mastery of public speaking, law, financial management, business and investment,[17] agriculture and estate management, military strategy, political maneuvering, foreign affairs, the management of building and engineering projects, and general administration.[18] Such talents were needed for scions of the old established *nobiles* of senatorial rank, members of the equestrian gentry or "knights" who could also aspire to the Senate, and for a "new man" (*homo novus*) from the Italian municipalities willing to undertake the risky and expensive gradually ascending career path through elected magistracies (the *cursus honorum*)[19] to reach the political pinnacles. All were in continual view of an alert electorate of the people which could determine their fate. In addition, military and managerial skills were not enough. By the second century BCE, a successful senator must also possess refined cultural and intellectual abilities for both advancement and to avoid ridicule, fluency in Greek language, knowledge of literature and history, and good judgment in art and architecture.[20] This last came to be a litmus test for success.[21]

Good judgment in art and architecture implied cultivated taste for public display, instinct for mounting large-scale entertainments, and shrewd knowledge of private real estate. Building projects and public entertainments mightily promoted public careers: When he was elected aedile (a magistracy overseeing religious festivals and public works) in 67 BCE, Julius Caesar "decorated" the *Comitium* (an assembly space in the Forum), some

neighboring basilicas, and the Capitol itself, besides repaving the Via Appia at his own cost.[22] Pompey the Great built his theater-cum-public-garden-and -art-museum and apparently a huge villa next door in the open area of the Campus Martius in c. 60–55 BCE shortly after his return from spectacular campaigns in the east.[23] This complex was promptly matched with Caesar's huge projects (managed from afar while he was still on campaign) financed from the booty of his campaigns in Gaul to build the Forum of Caesar and the *Saepta Iulia*.[24] Younger men of ambition followed suit: Marcus Aemilus Scaurus' temporary theater, offered for public entertainment in 58 BCE, contained 110 columns in Numidian marble; he transferred four of them to his private house, but they were later confiscated by Augustus for public enjoyment in the Theater of Marcellus.[25] Public architectural munificence could also offset excessive private *luxuria* in the way of building or refurbishing one's own *domus*.[26]

Luxurious houses coupled with – and perhaps also justified by – lavish public works may have given the Roman elite ideas and impetus for grand villas that had come into prominence already by the mid-second century BCE at Tibur[27] and even more intensely elsewhere. Why this ostentation seized the political class so fervidly is unclear, but fashions run like epidemics through competitive social groups. When they turned to building villas, the small spaces and tight proximities that the City had imposed on the relatively demure urban *domus* prompted Roman politicians and members of high society to group their countryside or seashore properties near one another out of historical habit, perhaps also the better to observe and supervise the comings-and-goings of their competitors. Villas became the new senatorial mansion, something exhibiting more up-to-date splendor than great antiquity, with gardens planted with special trees, marble columns and revetment, and art collections. The Elder Pliny remarked: "[In 78 BCE] ... there was no finer house in Rome than that of Lepidus, but only thirty-five years later it was not even in hundredth place."[28] Varro in his *De Re Rustica* (c. 34 BCE) deplored the cupidity

of his generation: Everyone competed to have the biggest and most elaborate villa.[29]

ARCHITECTURAL OSTENTATION: PANORAMIC VILLAS IN THE BAY OF NAPLES

The new panoramic villas of the first century BCE were among the new political tools that senatorial families manipulated with conscious skill in the period of intensifying rivalry and vastly increasing wealth. The ambitious *urban* building projects for the public good coincided with another, in some sense no less important, architectural and political development: the terraced palatial Roman luxury villa – most often specifically a villa with a panoramic view from the seaside or hilltop.[30]

The Roman senatorial elite were building some sort of seaside villas near or in the Bay of Naples as early as the early second century BCE (e.g., the villa of Scipio Africanus at Liternum in the 190s BCE or the villa of Cornelia, the mother of the Gracchi, at Misenum, c. 130 BCE),[31] but these seem to have had a more rustic, or even military, character than their successors.[32] The true *villa maritima* of the first century BCE was a highly original synthesis of urbane sophistication and appreciation of natural spectacle. The large maritime villas dedicated exclusively, or almost exclusively, to luxury and ostentation seem to have originated after the Social War of 91–89 BCE, or possibly after Pompey the Great cleared the seas of pirates in 67 BCE, supposedly making seaside locations safer. They developed rapidly into displays of architectural and artistic virtuosity in the last generation of the Roman Republic.[33]

Conditions in the countryside or by the sea modified the social context: Senators in rural or maritime villa communities performed not in direct contact with the urban *populus*, but for throngs of visiting clients who traveled far to get there, for local grandees (the so-called *municipales*, local businessmen and town councilors) with whom they cultivated business and political friendships, and for one another. We know less about how the senatorial elite used their maritime villas than how they used their *domus* in the City, but it is clear that there were a wide variety of functions, not least of which would have been to offer hospitality to one another and even to wealthy *liberti* (freedmen) who might themselves own villas. Owning more than one villa was the norm, and senators of importance had many. Besides four or five others elsewhere, Cicero (by no means the richest senator) had three in the Bay area: one at Baiae, which he called his *Cumanum*, one near Puteoli, and a modest one in Pompeii (which he liked because nobody bothered him there).[34] Pliny the Younger had six in the later first century CE.[35] Caesar had villas at Cumae and Baiae, Gaius Marius had one at Cumae and others elsewhere, Sulla and Lucullus had villas at Baiae, and Lucullus also had his famous villa on the Pincian hill outside the City's circuit (the *pomoerium*) overlooking the Campus Martius (much like a *villa maritima*), which he inhabited between 68 and 63 while waiting to be awarded his long-delayed triumph. Augustus seems to have built some twelve villas on Capreae (renamed after the twelve Olympian gods by Tiberius), and he probably had one nearby at Surrentum (mod. Sorrento). Even some of the provincial towns like Herculaneum and Pompeii had villas on their outskirts that were probably senatorial properties (Villa A at Oplontis, possibly of the family of Gaius Poppaeus Sabinus, consul in 9 CE, later inherited by Nero's second wife, Poppaea Sabina; the Villa of the Papyri at Herculaneum, almost certainly that of Caesar's father-in-law, Lucius Calpurnius Piso Caesoninus, and later his son Frugi; those of Sextus Pompeius, Marcus Vipsanius Agrippa, Agrippa Posthumus (M. Vipsanius Agrippa Postumus), and possibly Gaius Vibius Pansa near Pompeii; and the two villas fronting on the Bay that Cicero and his "municipal" friend and neighbor Marcus Marius had near Pompeii.[36]

The ideal of villas was *otium*, escape from the pressure of politics to cultivate the fruits of intellect and art. When fully developed, this was the type of contemplative and aesthetic activity complementing an active political life. Its importance in the acquisition of one or more villas – and certainly luxury villas – is highly doubtful.[37]

Otium as the ideal environment of villas seems to have developed as a fashion in the latter half of the second century BCE, although Scipio Africanus, who retired in the 180s, is the first person whose *otium* is connected with a villa (even though he is supposed – on doubtful evidence – to have farmed his fields himself!)[38] Cicero and Horace describe harmless sports and follies such as collecting seashells as *otium*, the kind of relaxation that can come only from escaping the constraints of the City.[39] But *otium* was not *languor* (laziness): It was meant to be productive, and much of Cicero's finest work was written when he was in self-imposed political exile at his villas during dictatorships from 49 to 44. *Otium* was real, but it came to be a concept not totally detached from politics. Rather, it was an extension of the association of elite social status with knowledge of Greek art and culture that became a universal mark of the Hellenized senatorial order in the late Republic.

Cicero bought his villa at Cumae (i.e., Baiae) for the prestige of the location. It was usually so crowded with visitors that he referred to it as a "little Rome," and he complained with some pretended satisfaction about the crowd of people that followed him to his villa at Formiae (on the coast road about halfway between Rome and the Bay). The throng that followed him there made it seem more like a basilica than a villa – he considered that he might as well have stayed in Rome.[40] Some villa owners continued the practice of the morning *salutatio*, receiving the greetings of local and traveling clients while in their Bay-area villas.[41]

But there was variety. Cicero, as mentioned, liked his Pompeian villa because nobody bothered him there. Later, the busy lawyer and senatorial bureaucrat Pliny the Younger preferred his villa in Tuscany (in *Tuscis* or *Tuscanum* well north of Rome in the upper Tiber valley) to those at Tusculum, Praeneste, and Tibur (nearer the City) because all was quiet there and he did not have to wear a toga (the sign of doing civic business).[42] His remark implies that senators and equestrians did sometimes have to wear the toga in their villas to conduct public business in them but also that some villas were outside the circuit of political activities. However, those in the Bay of Naples were certainly associated with important functions of office, career-building, and prestige.[43]

THE VILLAS AT STABIAE: CONTEXT, COMPARISONS, AND SCALES

A few large individual villas – those around Pompeii and Herculaneum and a few others – are known, but the great maritime villas grouped in close proximity at Cumae and Baiae are no longer visible and known only from literary sources.

The exception is Stabiae.[44] The site appears to have been an enclave of enormous cliff-side sea-view villas, at least six, up to 22,000 m², built side by side next to the village (*pagus*) of Stabiae (Figure 6.1).[45] The smallest villa is the so-called Second Complex of the Villa Arianna, some 4000 m². Five larger ones are very well preserved today, with walls standing up to 3.5 m in height, in some cases even to upper floors, and with very high quality frescoes executed by local workshops.[46] The villas were extensively excavated in the eighteenth century by means of trenches and tunnels, plans of them were drawn, and then they were reburied. Excavations since 1950 have partly uncovered some of the previously excavated areas, and recent excavations are adding new information on their layout.[47]

We do not know if the Stabiae villas were senatorial, but they certainly were huge. The situation at Stabiae seems similar to the origin of Baiae, which Strabo describes as having suddenly come into being as a dense cluster of contiguous luxury villas.[48] The situation may have arisen because of a somewhat distant municipal supervision: as Baiae across the Bay was subject to Cumae, Stabiae was never a *municipium* with its own territory or council but rather an administrative district of Nuceria and, after its destruction by Sulla in 89 BCE, had been administered from that *municipium*.[49]

The proprietors at Stabiae are elusive: We know the name of only one, a certain Pomponianus, who

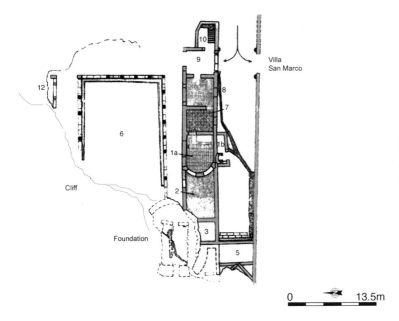

Figure 6.2. Stabiae, townhouse excavated in 2009 ("Panoramic *domus*"), plan. (Russo 2009: fig. 4).

owned the villa where Pliny the Elder stayed the night of the eruption in 79 CE.[50] Which villa he owned or what his social status was are unknown.[51]

THE VILLAS AND THE VILLAGE

The village of Stabiae, though reduced in status and subject to another municipality, was probably rebuilt shortly after the Social War. Despite Pliny's assertion (see p. 116, n. 49), its layout most likely preceded most of the villas' construction. The southernmost street is the line of the *limitatio* (the centuriation surveying grid for land divisions), which projects from the Porta Stabiana at Pompeii all the way across the Sarnus plain to Stabiae and its hinterland.[52] The Villa San Marco is built obliquely to this street and is the first building that changes the prevailing orientation in order to run parallel to the line of the cliff edge.[53]

At the same time, certain structures of the old village may have been adapted to – even adopted by – the new villas. A 2009 excavation on the cliff edge of the *insula* right across the street from the Villa San Marco has revealed a villa-like townhouse ("panoramic *domus*"), which appears to have had a central *coenatio* (dining room) projecting into a garden with a panoramic view (Figures 6.2; 6.3). The *coenatio* was surrounded by a high colonnade and

flanked by two symmetrical lower L-shaped colonnades joined to the higher in the manner of a Rhodian peristyle. The arrangement gave the *coenatio* a view to the north framing a view of the Bay itself; there were views on either side to small gardens, and a vista to the south of an internal garden and pool.

The four-way views with lateral gardens are remarkably similar to Vitruvius' "Cyzicene" *oecus*,[54] or the later *Coenatio Iovis* in the Palatine palace of Domitian. This "villa-like" town house appears to have been built over the out-of-use seawalls of Stabiae and was next to the city gate that spans the road descending to the port.[55] The layout seems to be very similar to large mansions such as the House of the Stags at Herculaneum, which had two symmetrical so-called *diaetae* ("day rooms") facing the sea-view over the former city walls, with a peristyle garden court behind.

The urban situation at Stabiae is the same as at Pompeii and Herculaneum in the early imperial period: panoramic urban villas were built over disused parts of the city walls that faced the sea, and a string of larger suburban villas lined the road that followed the coast just outside the city along the coast, with the villas built obliquely to the preexisting street and parallel to the shore.[56] At Stabiae, the side-by-side maritime villas were built also in proximity to the

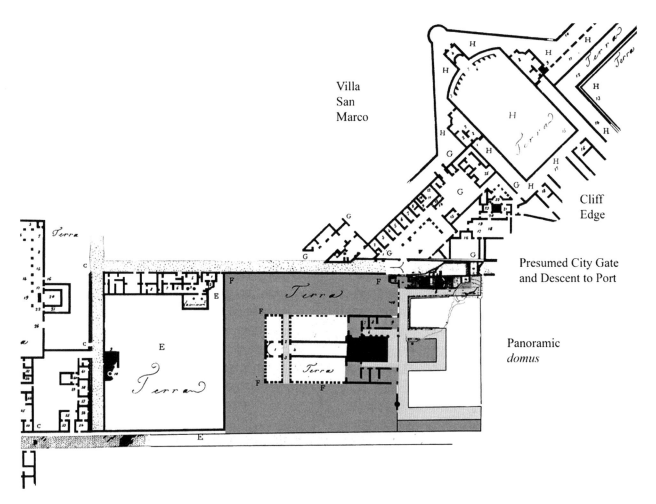

Figure 6.3. Stabiae, townhouse excavated in 2009 ("Panoramic *domus*"), plan of 2009 excavations imposed on Ruggiero plan of 1881, with modifications (T.N. Howe) reconstructing plan of west end. (Russo 2010: fig. 4. and Ruggiero 1881, Tav. I).

village and could thus be termed *villae suburbanae*, but they were built both disregarding the obsolete axes and remains of the old village houses while respecting their lines and some of their structures as well.

It is quite possible that the townhouse – part of the old village – might well have been incorporated into the Villa San Marco, or, rather, that the new villa was an extension of the old house. The village gate, through which the street descended to reach the shore, was crossed by an arched bridge that connected the two properties (Figures 6.2 at no. 5; 6.3).[57] The entrances to the villa and the townhouse faced each other directly across the street and had large doors framed by nearly identical stuccoed cannellated half-columns. They are so similar as to appear to mirror one another, and both the

townhouse, with its narrow sea frontage, and the villa, with its long sea frontage, are artfully up-to-date compositions that emphasize the view.

If they were conjoined, the townhouse and villa would have had a symbiotic functional relationship. The Villa San Marco has the character of being exclusively for grand hospitality and elaborate entertainment: It has almost no accommodation for elite residence, only four very modest viewless *cubicula* around the atrium (Figures 6.4 lower, rooms 60, 61, 57, 52; 6.4).[58] The atrium itself is not the core of the house, but rather a visual dead end and the beginning of a circuitous and spatially surprising tour through the spaces that converge on the panoramic entertainment spaces. Hence, without having yet excavated the townhouse, one might speculate that it may have

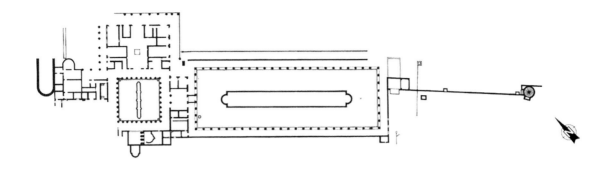

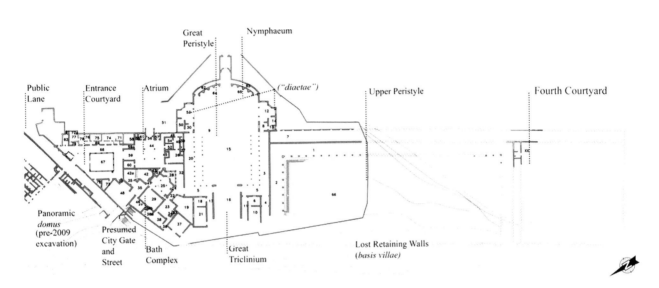

Figure 6.4. Villa San Marco and Villa of the Papyri plans at the same scale. Above: Herculaneum, Villa of the Papyri (Zarmakoupi 2014: fig. 2.1); below: Stabiae, Villa San Marco, plan after 2002 geophysical survey (RAS Foundation and 2006 excavation of upper peristyle [SANP]).

served as the actual residence and the villa as a glamorous and huge add-on for hospitality.

THE VILLAS AT STABIAE: CHRONOLOGIES, CONSTRUCTION, AND CONTENTS

The five large villas of Stabiae differed in design and chronology but had striking similarities. Four appear to have been built in Augustan times or a little later (late first century BCE to early first century CE). Only one, the Villa Arianna, had an earlier iteration as a villa;[59] the others appear to have been new structures built after Actium (31 BCE).

Three of the villas – the Villa Arianna, the Villa San Marco, and the Villa del Pastore – share a remarkable appropriation from public architecture, specifically Greek public architecture: large peristyle courts surrounding elaborate gardens, with the short sides measuring c. 35 m and long ones more than 100 m, giving a linear total of nearly two stades (c. 370 m).[60] Vitruvius (whose writings on architecture were contemporary with the Stabiae villas in their developed Augustan form) cited such dimensions as being appropriate for the public *palaestrae* of Greek *poleis*, so their appearance in villas was firmly based in the obligatory philhellenism of the elite (Figure 6.1).[61] Just as the Roman senatorial *domus* was more public

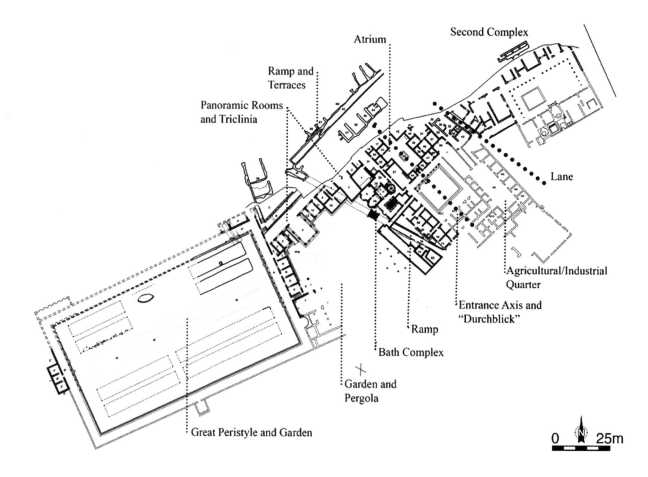

Figure 6.5. Stabiae, Villa Arianna, plan, Plan of the villa Arianna, with features imitating public monumental architecture indicated (RAS/University of Maryland; Howe, Gleason, and Sutherland 2011).

than private, ambitious villas were couched in terms of *public*, not merely private or even palatial, Greek architecture.

There are five well-preserved large Roman villas in the Bay of Naples. They include the Villa A at Oplontis and the Villa of the Papyri at Herculaneum, but three are at Stabiae. Two villas are under active investigation, the villa Arianna and the Villa San Marco; the Villa del Pastore and two others are omitted from this discussion to await further work on the sites.[62]

THE VILLA ARIANNA

The Villa Arianna is the earliest of the Stabian villas: It is the only one whose axis, at least in its first phase,

was perpendicular to the coast rather than parallel to it (Figures 6.1; 6.5). Its early phase represents a fairly conventional Vitruvian villa, with a large peristyle preceding the atrium, and the *tablinum* of the atrium facing the view of Naples and in effect becoming a sea-view entertainment room (an *oecus*?).[63] A provisional date in the 60s BCE is given by early Second-Style frescoes in two *cubicula* (44, 45), which opened on to the atrium in an original design. Unlike the other villas at Stabiae, the Villa Arianna included a large agricultural quarter: a work court-yard surrounded by several rooms (*ergastula? hospita-lia?*) and a stable.[64]

In the course of the first century CE, the dwelling was modernized with the addition of a panoramic wing in two or three phases, featuring a large *triclinium* (3, where the Ariadne/Arianna fresco after which the

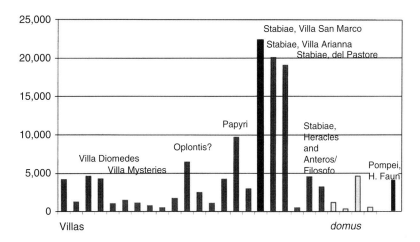

Figure 6.6. Graph showing the relative sizes of estimated surface areas of suburban villas in Pompeii, Herculaneum, and Stabiae. The villa at Oplontis (Villa A) may appear low in comparison because it was a *porticus*-villa with three-sided (non-enclosed) peristyles open to the view, whereas the Stabiae villas had enclosed peristyles (Adams 2006: 96, graph 34).

villa was named was found in 1950), sea-view apartments, another *triclinium* surrounded by gardens (Figures 6.6 at A; 6.7: the Vitruvian "Cyzicene" *oecus* is partly visible), and finally the enormous peristyle court and garden of the Greek type mentioned in this chapter. The garden of the peristyle incorporated three narrow rows of trees of many different species and origins, rather like a botanical gazetteer of empire similar to one discovered at the temple of Heliogabalus on the Palatine.[65] The trees supplemented four large planting beds (two exposed, two still buried), which give the first-known archaeological indication of a type of fictive "wild" thicket known only in frescoes, most famously those of the Villa of Livia at Prima Porta.[66] The villa also had private access to and from the shore: A ramp discovered in 1988 passed under the villa to the cliff face and then switchbacked down the slope.

THE VILLA SAN MARCO

The Villa San Marco (Figures 6.1; 6.4 lower) is generally dated to an initial Augustan construction with a subsequent Claudian-Neronian phase,[67] but it seems to have been designed with the development of panoramic views as a primary and integral part of the design from the outset, in that respect unlike the Villa Arianna. It had an entrance peristyle, excavated

already in the eighteenth century and re-excavated in 2007–8, with piers surrounding a garden with a large plane tree and numerous small rooms. The function is debated: *ergastula* (slaves'/workers' rooms), *hospitalia* (guest quarters), or agricultural/commercial storage units. Most likely it served several of these, and, again most likely, the function probably changed during the villa's lifetime.

As mentioned earlier, the atrium of the Villa San Marco is highly unusual. It is preceded by a peristyle entrance court, as in the Vitruvian sequence for villas, but it was off-axis and entered from the *tablinum* rather than leading to it, and it dead-ends against a large *lararium* altar (a late addition). In the traditional Republican *domus* or villa, there was a direct view from the front door to the back wall of the garden. Here, however, the atrium was embedded deep within the villa rather than launching the view from the entrance, and it served more as the start of a winding passage through the villa. The unconventional position of the atrium may announce a general decline of the importance of this room in later Roman houses and villas, but certainly it was unimportant in this particular dwelling. The primary rooms of the Villa San Marco were, from the outset, the grand panoramic entertainment rooms.

The bath complex of the Villa San Marco is most elaborate, with a *tepidarium* that has no parallel except

in the public Suburban Baths of Herculaneum: The pool is chest deep, and in the center of the floor of the pool there was a bronze tank (called a *testudo* or tortoise) in direct contact with the heating fire for rapid and continuous transfer of heat to the water.[68] The similarity in design may not be coincidental and may illuminate the character of the villa itself: The Suburban Baths at Herculaneum may have been a private club or health spa (*valetudinarium*) for the wealthy attached to a house of the proconsul and town benefactor Marcus Nonius Balbus, and the Villa San Marco could have served a like function.[69]

In its second phase (Claudian-Neronian, 50s and 60s of the first century CE), the Lower Peristyle of the Villa San Marco became an architectural *tour de force* with cross-axial views and decorative surfaces in different shining materials. A deep tank or *piscina* (fishpond) shaded by plane trees faced a huge *nymphaeum* featuring a segmentally curved wall, Fourth-Style relief stucco, fresco, glass mosaics, a water stair, jets, and marble sculpture, the whole confection backed by a cool *cryptoporticus* (an underground walkway for summer strolling) and flanked by two ingenious *diaetae* or daytime sitting rooms, with shade carefully calculated for enjoyment morning or afternoon. Monumental as the tank and courtyard are, they are quite close to the bath complex, and it is possible that the tank also served as a chest-deep swimming pool or *natatio* with a view through the main *triclinium* (16) to the sea.[70] The large Upper Peristyle was decorated with ceiling frescoes depicting an elaborate cycle of cosmic themes, including the famous planisphere fresco.[71] Curiously, this architectural and decorative deployment did not include *cubicula* facing the view, which supports the view that the Villa San Marco may well have been an impressive entertainment venue, sporadically inhabited or never lived in at all, with the neighboring townhouse being the owner's actual residence

CONSTRUCTION AND CONTENTS

The quality of the construction of all the Stabian villas is poor, indicating hasty building (there is

almost no cut stone other than marble floor- and wall-revetment, and almost no vaulting). By contrast, the quality of the surface decoration is very high, and not only high but also artistically and decoratively at the height of current fashion. The villas as excavated contained almost no valuable portable objects or remains of them, even though their destruction in 79 CE was quick.[72] There may be two reasons for this absence of objects: first, the contents of such villas including furniture, silver, items of *virtù*, clothes, and so on likely moved from villa to villa following the multipropertied owner, so a dwelling with no owner in residence on the date of destruction might well have looked somewhat bare.[73] Second, villa owners and staff at Stabiae, which was farther from Vesuvius than other communities, may have had plenty of time to move their possessions and get away.[74] Pliny the Younger specifically says that when his uncle arrived at Stabiae,

> … Pomponianus had loaded up his ships even before the danger arrived, though it was visible and indeed extremely close, once it intensified. He planned to put out as soon as the contrary wind let up.[75]

Absent their contents and in view of their relatively poor construction combined with high quality and up-to-date wall treatments, the villas of Stabiae present a picture of swift, quite possibly competitive, construction on a site made newly available for elite dwellings. Where their owners stood on the social scale of the late Republic and early Empire is a question about how domestic architecture relates to social status. Was there an established relationship between building form and social status, or was there a fluid and problematical relationship between the two?

STABIAE AND ITS VILLAS: A SENATORIAL ENCLAVE?

Can the Stabiae villas be identified as particularly "senatorial?" Although in the late Republic the largest fortunes were made in politics and military conquest, by the early Empire the tools of status and

wealth that senators could creatively appropriate from the Hellenistic east were no longer the exclusive property of their *ordo*.

In part, the answer may lie in the villas' size: They were vastly larger than other quite lavish villas such as the Villa of the Mysteries at Pompeii (Figure 6.6) and fully held their own vis-à-vis Oplontis Villa A and the Villa of the Papyri (Figure 6.4).[76] The difference in scale between the large Stabian villas and those next down the scale may be an illustration of the difference between the very great elites and the not-so-great ones.[77] Since the sources of very great wealth in the late Republic depended on the military commands and civilian appointments enjoyed almost exclusively by senators, the sheer size and decoration of the villas at Stabiae tend to support their affiliation with the senatorial elite.

Another feature of the five known Stabian villas is that each one had a private bath, a very rare feature of even the largest mansions of Pompeii and Herculaneum. Pomponianus[78] fits the archaeological evidence for a Stabian villa proprietor: The first thing Pliny did, dirty and hot from rescue work and observing the developing volcanic eruption, when he landed at his friend's villa was ask to bathe: "In order to lessen the other's fear by showing his own unconcern, he asked to be taken to the baths."[79]

The Villa Arianna, at 54 m above the shore, had a spectacular convenience for visitors to access the dwelling: the ramp rising from the beach up the steep cliff and then through a tunnel passing under the dwelling itself. After docking on a private jetty, visitors could access the villa in some comfort.[80] In addition, the impressive aspect of the villa from below would have been enhanced by its fictive battlements (or tiny fortification towers) on one of the terraces, intended to look like an imitation of a city with towers, public buildings, and temples in picturesque miniature (Figure 6.7).[81]

These elements – the direct access from the shore as well as the impressive aspect from the sea approach – also advertised the preference of this highly mobile upper class that had personal connections throughout the Mediterranean. This was an elite accustomed to the comfort of visiting one another by boat (in good weather, at least).[82]

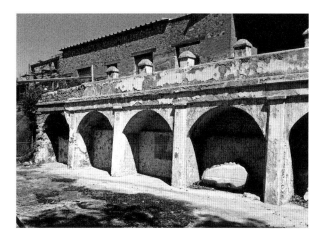

Figure 6.7. Stabiae, Villa Arianna, Terrace (54), with *tabularium* motif and fictive battlements, Cyzicene *oecus* behind. (Photo RAS).

Private seaside access was an assertion of high status. In wall paintings, the landscape/seascape vignettes of villas that became popular in the Augustan period, and which are well represented at the Villa San Marco, were often viewed *as if from the sea*, that is, from the point of view of the elite traveler, not the common tradesman, estate agent, or farmer coming on mundane business to the landward entrances of the villa.[83]

While senators tended to build their most prestigious villas in clusters, both in the later Republic and earlier Empire, they apparently were not able to create districts that were exclusively senatorial.[84] Obviously prime-view real estate was important, but Cicero makes it clear that it was an important concern of his to buy in certain prestigious locations such as Baiae, where he acquired (probably in 56 BCE) his *Cumanum*: in other words, to see and be seen; to be close not just to beautiful views but to prestigious persons, as he had done on the Palatine in Rome, building a house just down the street from the Claudian mansion.[85] The principal motivation for a senatorial politician in the shaping of his villa properties was political, not *otium*, so clustering of elite dwellings was a social and political necessity, and the proximity of the Stabiae villas to one another and their visibility as a group is not surprising. It is profoundly Roman, both in the tradition of *domus* at Rome and Roman social habits themselves.

SENATORIAL VILLAS: USES AND MEANINGS

When the political season was suspended, in April and May and in the autumn, the social and political activities of the senatorial elite were transferred to the main villa centers in the Bay of Naples.[86] Feasting invitations were extended, and there were political meetings and negotiations like that of Caesar and Cicero in 45, and vacations.[87] Hospitality in one's villa, whether one was resident or not, was often offered to traveling friends of the same social class.[88] Villa owners would often make visits lasting several days: Pompey stayed at Cicero's *Cumanum* in April 53; Publius Scribonius Curio was there in 49 at the outbreak of civil war; and Julius Caesar was staying at the villa of Octavian's stepfather, Lucius Marcius Philippus,[89] in Puteoli when he dined at Cicero's nearby villa in December 45. Cicero regarded the seasonal visits to his various villas and to those of his friends – the *peregrinatio* – a major source of pleasure.[90]

The grouping of villas also afforded senators the opportunity to intermingle with local municipal elites during the high season. After 90 BCE, when Campanian locals had been enfranchised and had acquired rich commercial connections with the Greek East, cultivating their financial and political connections became quite important.

Above and beyond this, there was a long and specifically Italian tradition of the mobility and bonding of elites from different areas.[91] The local *municipales* also had large villas, perhaps even before the Roman senators acquired the habit. One of Cicero's main purposes in visiting his villas was to strengthen his bonds with the local *homines municipales*.[92] Ever the snob, Cicero noted that his municipal friends were good company, but more interested in money than in issues of culture or matters of state policy, the paramount concerns for a Roman senator like Cicero.[93]

Given that the economic revenue from agricultural estates seems not to have been a consideration of the maritime villas of the senatorial elite,[94] the function of densely clustered, spectacular panoramic villas was to visit with and impress one another and local municipal elites: these were not stage sets on which they performed *sub conspectu populi* in urban *domus* but rather venues for their peers and for their local supporters and friends. A visit to a Cumaean villa was a continuation of the social and political life in Rome, but carried on "in a more attractive setting."[95] The major difference seems to have been that senators appear not have had to interact with the *populus* as in Rome, and visits may have been short and divided among several villa venues.[96]

Was there a typology or iconography of features that distinguished senatorial villas from those who wished to emulate them or even aspire to their status? Few verifiably senatorial villas are known.[97] As mentioned, only two probable such villas around the Bay can be identified: Oplontis Villa A and the Villa of the Papyri. Like the three large villas at Stabiae, they were of comparable size (Figure 6.5), and built directly on the seashore or on promontories directly above the water.[98]

Was there an architectural "iconography" of senatorial status? Vitruvius gives a description of "magisterial" *domus* (by which he could mean not only Roman senators who held the *cursus honorem* offices such as quaestor, aedile, and so on, but also the municipal town *decuriones*/councilors of Italy). His thought is that houses of such persons should clearly be modeled on *public* buildings and spaces to dignify their magisterial functions (which is what has been noted in the great peristyles of three of the Stabiae villas):

> For the most prominent citizens, those who should carry out their duties to the citizenry by holding honorific titles and magistracies, vestibules should be constructed that are lofty and lordly, the *atria* and peristyles at their most spacious, lush gardens and broad walkways refined as properly befits their dignity. In addition to these, there should be *libraries, picture galleries, and basilicas*, outfitted in a manner *not dissimilar to the magnificence of public works, for in the homes of these people, often enough, both public deliberations and private judgments and arbitrations are carried out.*[99]

As we have seen, the "new" luxurious peristyle gardens of houses at Pompeii in the late Republic and early Empire imitate Greek public architecture like *agorai* and sanctuaries and *palaestrae*, not Hellenistic palaces. The basilica-like hall in the House of the Mosaic Atrium in Herculaneum and the temple-like *fastigium* (pediment), which appears over some *triclinia* like those in the House of the Menander and the House of the Golden Cupids in Pompeii can be cited as examples of such emulation.[100] At the Villa Arianna, there were probably several rooms, mainly large *triclinia*, which had temple-like pediments facing outward to the sea or inward into the large public-like space of the main Great Peristyle garden.[101] These features were not exclusive to senators, no matter Vitruvius' fussy insistence on great men's need for grand architectural statements appropriate to their status. The examples in Pompeii and Herculaneum were by no means senatorial properties,[102] but they may have been houses of *decuriones* or rich freedmen wishing to surround themselves with quotations culled from an architectural repertory more appropriate at higher social levels. The language of architectural elements could easily be repurposed: The rich freedman Trimalchio's grand house was a grab-bag of aristocratic elements (private baths, porticoes, an atrium decorated with mythological and autobiographical wall paintings).[103] Although Vitruvius, and the senators and equestrians for whom he was writing, may have wished for an explicit architectural iconography to indicate their magisterial status, the symbols of architecture were not in their control, at least not in the way that senators jealously controlled the right to wear the *calcei patricii* (special closed, high-topped shoes in red leather) or the *tunica laticlava* (a sleeveless tunic with wide purple stripes running vertically from shoulder to hem). Still, some architectural elements could be a matter of state decision: During his Dictatorship for life (from 46 BCE to his assassination in 44), the Senate granted Caesar the liberty of building a *fastigium* or pediment over the entrance of his house, so some officially sanctioned systematic architectural iconography of social status may have existed.[104]

Vitruvius specified that houses for individuals at the highest social level require *bybliothecae* (libraries), *pinacothecae* (picture galleries), and *basilicae* (audience halls) not unlike those in public buildings.[105] In the villas at Stabiae, there is nothing like a basilican room, nor has a library been identified so far. Libraries are attested in villas like Hadrian's Villa at Tibur[106] and the Villa of the Papyri, but so far only one room at the Villa Arianna has been suggested as a possible "studio," based on the interpretation of its fresco decoration, an unlikely identification.[107]

Certainly an elite, if not a positively senatorial one, was active at Stabiae, as indicated in the inventory of floor- and wall-revetment marbles. Several of the villas featured newly imported or Italian colored marbles available only from agents of the imperial quarries, not just chips recovered from working scraps but in large compositions. This is seen most spectacularly in the main *triclinium* of the Villa San Marco (room 16), where the entire floor and dado of the lower wall was covered with an alternating geometric pattern of Lucullan, Chian, and Numidian revetment. To acquire such a freight of large marble pieces, the owner must have had high-level connections to access the imperial marble works.[108]

As for the wall paintings at the Stabian villas (and the other truly large villas), what is striking about them is their highly decorous, even anodyne, character: There is (at least so far) no pornography such as often enlivened many Roman walls, even of rather elite properties.[109] This kind of decorum seems to be a distinguishing trait of the very largest villas, hence possibly indicating a high social standing of the proprietors and a concomitant highly self-conscious sense of social poise and dignity, because the highest levels of political society were under artificial pressures to conform to sexual propriety. Sexual dalliance was certainly an open part of elite Roman life, but in politics it could be used as a weapon even if it were only alleged.[110]

WHAT WAS STABIAE?

Stabiae seems to present archaeological evidence for one of the two ways in which the clusters of villas in

the senatorial culture of power were laid out, and in both of these a mixture of Roman senators and local equestrians or *municipales* is attested. The first type of villa community was that at Tibur, where a few villas belonging to senators have tentatively been identified (none with complete certainty). These, close to Rome but not especially close to one another, seem to have been detached terraced structures (*basis villae*) on large properties that were scattered widely over the mountainside,[111] and the villas at Tusculum (also near Rome) probably conformed to this pattern of widely spaced residential structures with substantial estates as well.

The other way of grouping villas is that which probably prevailed at the great seaside centers at Cumae and Baiae, where high value was placed on panoramic real estate along the shoreline, either on high cliffs or low platforms, or sometimes even on artificial islands. Like Stabiae – and like Strabo's remark that the coastline looked like a single city[112] – these were likely zones exclusively of very large villas built directly next to each other for miles along picturesque seacoasts, with no significant agricultural area around or in back of them, and not in proximity to an important city or town. The villas in these clusters or enclaves were large but not exclusively senatorial, though senators probably faced a certain self-imposed pressure to have the largest, as indicated by the remarks of Cicero. The presence or absence of an urban center was immaterial; strictly speaking, these were not "suburban" villas.

Stabiae may have participated in the intense politically competitive villa culture of the main centers on the north side of the Bay. In the seasonable months, it was a short sail (a couple of hours) to Naples or Puteoli. There were other properties owned by senators that were scattered around the Bay at lesser centers like Pompeii, often near villas of the local elite, but these were more modest or isolated and hence removed from the main villa districts: Cicero's villa at Pompeii or that of Pollius Felix at Surrentum. The large scale, high visibility, and dense contiguity of the Stabiae villas are quite different: those residences proclaim the social grandeur of their owners and their corporate identity.[113]

Alternatively, most of the construction so far visible at Stabiae is Augustan or later, suggesting that the area was expanded as a subdivision for villas of new members of the recently refurbished 1000-man Augustan Senate: Augustus gave substantial gifts to certain new senators so they could meet the minimum property qualifications of *HS* 1,000,000 for admission. Market pressure could simply have caused the newly elevated owners to crowd together where they and the enthusiastically pro-Augustan local *municipales* of Campania could take advantage of a locale close to the emperor's new villas on Capreae and at Surrentum. Whether or not this helped their ambitious careers is unknown.

As such, most of the villas at Stabiae (except for the earlier Villa Arianna in its early phase) represent the general upswing of construction in Campania: villa-like urban townhouses were built over the seaside city walls inside the local towns, and suburban villas were located just outside, with many of the new elite inhabitants coming to these prime locations from other communities, either from Campania or Rome itself.[114] The construction of this elite enclave of very large villas in the early imperial period also may indicate a decline in the importance of the main centers of elite senatorial culture at Cumae, Baiae, and Puteoli, and a decentralizing of senatorial habitations to other locations in the Bay of Naples, just as the political circumstances of Augustus' principate and those of his successors brought about a decline in senatorial political life and a decentralizing of senatorial *domus* in the City of Rome itself.[115]

Though not at the center of the most prestigious villas in the Bay of Naples, the Stabiae villas are architecturally in the top rung of known villas, and the site was very likely an extension of that intense mixed political culture of Roman senators, equestrians, and Campanian *municipales* that had been originally centered on the north side of the Bay before Actium in 31 and the confirmation of the imperial system in 29 BCE. Stabiae was probably an extension of those older centers, closer to the new villas of Augustus at Capreae and Surrentum and to the later residence of Tiberius. The common culture of *peregrinatio* and the many public and social duties

continued unabated and in no less competitive ways architecturally at Stabiae.

NOTES

1. The date of August 24, 79 CE is derived from the manuscripts of Pliny the Younger's letters to Tacitus (Plin., *Ep.* 6.16; 6.20). However, good recent analysis has suggested dates later in that year (October 24 or November 23): Rolandi, Paone, De Lascio, and Stefani 2008, 87–98.
2. Strabo 5.4.8.
3. Luxury villas were initiated in this period, mainly but not exclusively by the senatorial class. Their early evolution is still being investigated (see Introduction), but considering that the 4,000 m² House of the Faun in Pompeii – dating to about 150 BCE – is larger than any known Hellenistic palace, palatial domestic architecture in Italy may have been given impetus by Campanian merchants and town councilors who were suddenly made wealthy by the opening of Greece to "Italian" trade after 166 BCE.
4. Senators were theoretically required to reside in Rome year round, but by Cicero's day there was a "holiday" from about April 5 to mid-May, and another in November: Lintott 1999, 74.
5. Cic., *Att.* 13.52.
6. Suet., *Aug.* 8.2.2, 8.10; Eck 1998, 9–11.
7. The assassination took place during Agrippina's return from a visit to the villa of Marcus Salvius Otho, later emperor in 69 CE: Suet., *Otho* 3.1.
8. The emperor was supposedly imprisoned in the Neapolitan villa of L. Licinius Lucullus, though the dwelling would have been some 600 years old by then: Marcellinus Comes, *Chron.* a. 476. Discussion of its location: D'Arms 1970, 108, and catalogue I, 185–6.
9. The only other well-preserved known probable senatorial villas at this scale in the Bay area are Villa A at Oplontis and, at Herculaneum, the Villa of the Papyri. See Clarke (Chapter 4), Zarmakoupi (Chapter 5), and Lapatin (Chapter 25) in this book.
10. The largest of the villas constitute a separate architectural and social phenomenon: D'Arms 1970; Zanker 1979; Wallace-Hadrill 1988, 244–5; Wallace-Hadrill 1998, 43–53; Zarmakoupi 2014, 8–13.

11. Cn. Pompeius, Mark Anthony and Tiberius (pre-emperor) seem to have owned the same house on the Carinae: Cass. Dio 48.38, Flor. 2.18.4, Suet., *Tib.* 15. Mark Anthony supposedly rapidly drank his way through Pompey's wine cellar.
12. The main source is from Polybius' description of a senatorial funeral: Polyb. 6.53–54. Cf. Flower 2004.
13. A *vir triumphalis* (later *triumphator*) had the right to affix battle spoils to the façade of his house as trophies and to display weapons inside, and the house was their permanent repository. The many shields and weapons on the walls of the house of M. Fulvius Flaccus (consul in 125 BCE) in honor of his triumph of 123 were seized by rioters to defend the cause of C. Gracchus in 121 BCE: Plin., *HN* 35.7. Suet., *Ner.* 38.2. Beard 2007, 29–30, 177. The "trophied house" became a monument, reminding or warning the population of watchful ancestors: Kuttner 2004, 294–321, esp. 318.
14. A zone of densely packed large plots with very ancient atrium dwellings and small gardens lined the Sacra Via, some originating in the regal period (seventh to sixth centuries BCE) according to Livy (1.35). See Purcell 1993 and the archaeological excavations in Carandini 2004, 90, fig. 6; Patterson 2000, 40–3.
15. Overall, some 510 *domus* and their owners' names are known from literary sources, inscriptions, or excavation: *LTUR*, vol. 2, 22-217 *s.v. domus*, but this number includes houses mentioned twice as they pass between owners, and public structures like the Domus Publica. In imperial times, senatorial *domus* were scattered more widely in the urban space.
16. According to Sempronius Asellio, T. Gracchus never went out of his house toward the end of his tribunate without a following of 3,000–4,000 people: Gell., *NA* 2.13.4; Plut., *Ti. Gracch.* 20.2. The *Commentariolum Petitionis*, allegedly a letter from Cicero's brother Quintus advising him on canvassing tactics during the election of 64 BCE, defines anybody as a friend "who cultivates your house regularly." For an account of the rankings within the body of clients: Patterson 2000, 34–5.
17. Senators were restricted by the *Lex Claudia* of 218 BCE from owning transport ships above a certain capacity (Livy 21.63.3-4) but not from investment in trade (Plut., *Cat. Mai.* 21), sometimes in joint ventures with their freedmen. Their profit from the agricultural

produce of their estates was always legitimate and laudable.

18. Lucius Aemilius Paullus, the victor at Pydna in 168 BCE over Macedonia, is quoted as saying, " … a man who knows how to conquer in battle should also know how to give a banquet or organize the games" (Livy 45.32.11).

19. Literally the "racetrack of duties/offices." For accounts of the structure of late Republican politics and the electorate: Lintott 1999, 65–89; Millar 1998; Mouritsen 2001.

20. Artistic sophistication was expected of the Roman upper class by the fourth century BCE: Kuttner 2004, 318. L. Mummius, whose army sacked Corinth in 146 BCE at the end of the Fourth Macedonian war, was one of the first cases of a *vir triumphalis* distributing works collected as booty to towns and clients, but he was also ridiculed for his vulgar philistinism when he demanded that if any famous works of art were damaged in shipment the shippers would have to replace them with similar ones. He shared his spoils with the Attalids of Pergamon, who nonetheless had to rescue a famous work of art from some of his soldiers who were playing dice upon it: Appian, *Hisp.* 236; Polybius 39.2 ff.; Dio Cassius 21. By the second century BCE, military commanders collected and distributed works of art from vanquished cities: Vell. Pat. 1.13.3-5; Polyb. 39.2-3; Dio Cass. 21. On a statue in the Apollo sanctuary in Pompeii, which was presumably part of Mummius' distributed spoils, Kuttner 2004, 305–6; Wallace-Hadrill 2008: 132-3.

21. In the reforms of Sulla in 80–79 BCE, the *ordo senatus* was fixed at 500 members. The number of equestrians may have been some 10,000. Lintott 1999, 68–72. In the first century BCE, C. Marius, Cicero, and C. Octavius (Augustus' natural father) were all "new men" who had held positions as municipal councilors (*decuriones*) outside Rome. The property qualification for senators came to be fixed at minimum *HS* 1,000,000, for equestrians at *HS* 400,000: Lintott 1999, 71. A political career was not obligatory: Atticus and Ovid, who could have been senators, opted for lives devoted to culture, friendship, and the arts.

22. Suet., *Iul.* 10.

23. In general, Monterroso Checa 2010.

24. Ulrich 1993, 49–80. Cicero's letter to Atticus in 54 BCE: *Att.* 4.17. Dio Cass. 43.22.2-3; 44.4.4 and following.

25. Coarelli 1989, 178–87. See also Asc., *Scaurus*.

26. In 168 BCE, Gnaeus Octavius built an indecorously luxurious house for himself from the spoils of victory in the Third Macedonian War but, from the same spoils, also built the first monumental *porticus* in Rome, the *Porticus Octavia*, using the Greek Corinthian order embellished with gilded bronze: Senseney 2011, 422–42.

27. Tombrägel 2012.

28. Plin., *HN* 36.109.

29. Varro, *Rust.* 1.13.7.

30. These are commonly referred to as "panoramic villas" or *villae maritimae*, or "suburban" villas (*villae suburbanae*), but the Vitruvian term for a luxury villa is *villa pseudourbana*: Vitr., *De arch.* 6.5.3. In general, the terms *villa maritima* and *villa suburbana* seem to be used to distinguish more luxurious villas from purely productive farms, e.g., *praedia rustica*. In the first century BCE, *villa suburbana* appears in Catullus (44.1-9) and *villa maritima* in Cornelius Nepos (*Att.* 25.14.3); Adams 2006, 9–15.

31. Seneca visited Scipio's villa much later and described it as fortified with gates and towers: *Ep.* 86.4. Cornelia, daughter of Scipio Africanus and mother of the Gracchi tribunes, retired to her villa at Misenum after C. Gracchus' death in 121 BCE: Plut., *C. Gracch.* 19.1-2.

32. However, Marzano argues that the association of maritime villas with some sort of "luxury" appears very early in the sources: Marzano 2007, 16, citing an incident in 125 BCE. The earliest record of protest against *luxuria* in domestic architecture is from a speech of M. Porcius Cato, made shortly after 152 BCE: Gell., *NA* 13.24.1. The archaeological record for the early luxury of maritime villa remains almost blank: D'Arms 1970, 1–17.

33. There were probably other centers of innovation for the development of luxury or maritime villa in the second and first centuries BCE besides Rome and its senatorial elite. The most lavish and innovative example of domestic architecture in all of Roman allied Italy in 150 BCE was the house of a Campanian merchant, the House of the Faun in Pompeii: Wallace-Hadrill 2008, 73–143 on "Hellenized" architectural patronage of local town councilors in Italic centers other than Rome.

34. Cic., *Att.* 14.16.1, 15.13. See Sollman 1953, 1239–46.

35. Laurentum (*Ep.* 2.17), Tusculum (*Ep.* 5.6), several villas on Lake Como (*Ep.* 9.7.1-2), probably Praeneste and Tibur (*Ep.* 5.6.45).

36. A short list from D'Arms 1970: M. Vipsanius Agrippa, Augustus' right-hand man from the beginning of his career, Catalogue I, no. 46, 231; Sextus Pompeius, Pompey the Great's son: Catalogue I, no. 32, 193; M. Marius, Catalogue I, no. 29, 191; Cicero, Catalogue I, no. 43, 198; L. Calpurnius Piso Caesoninus, cos. 58, Catalogue I, no. 5, 174; M. Vibius Pansa, cos. 43, Catalogue I, no. 44, 200–1. The identification of L. Calpurnius Piso Caesoninus or his son Frugi as owners of the Villa of the Papyri is concluded as being almost certain in Capasso 2010, 89–114.

37. The concept of *otium* as an integral part of the life of the Roman ruling senatorial elite had a relatively brief existence, probably not much more than the last generation of the Republic (c. 70–40 BCE). Before that time there had been a long and tense opposition between *otium* and *negotium*, between the acquisition of high culture – particularly Greek culture – and the tradition of the austere, dutiful Roman *nobiles*. In political rhetoric, Greek culture was often seen as a debilitating *luxuria asiatica*, which eroded Roman virtues. In the last generation of the Republic a synthesis may have been achieved in elite circles in which *otium* became complementary to public duties: Wocjik 1979–80, 360; also André 1962; André 1966; Dosi 2006.

38. D'Arms 1970, 12–13. Sen., *Ep.* 86.4.

39. Cic., *De or.* 2.22. Hor., *Carm.* 2.1.71-74.

40. Cic., *Att.* 5.2.2. D'Arms 1970, 48; Wallace-Hadrill 1994, 5. The villa at Formiae: *Att.* 1.13. Cicero's Cumaean villa had a view of both the Lucrine Lake and Puteoli, and was likely on the spot now occupied by the Monte Nuovo cinder cone.

41. Cicero was mildly irritated that a client, one Rufius, did not appear at a morning *salutatio* when he was at his *Cumanum: Att.* 5.2.2.

42. Plin., *Ep.* 5.6; 9.36. Pliny the Younger was a senator, his uncle, the *praefectus classis* of 79 CE and natural historian, was an *eques*, of a type that was a new class of very highly salaried elite administrator who rose up the ranks through imperial appointment.

43. The issue of the productivity of *villae maritimae* is under current reappraisal, especially in view of the profits derived from pisciculture: Marzano 2007; Marzano and Brizzi 2009; D'Arms 1970, 12. Cicero says that people were eager to buy farms in the *ager Campanus* north of the Bay in order to finance and supply their lavish maritime villas at Puteoli and Cumae: Cic., *Leg. agr.* 2.78.

44. Pliny the Elder had a friend with a villa at Stabiae: this motivated him to seek refuge there during the eruption of Vesuvius on the morning of August 25 (or November 24), 79 CE.

45. The sixth villa is not shown on the plan (Figure 6.1). It would have been to the SW, the lower left of the plan, where there is enough space for another villa the size of the Villa Arianna, but there are few indications of its remains.

46. Richardson 2000, 83–5; he identifies the painting of the famous Flora of the Villa Arianna as being by the same artist who worked at the so-called Villa of Cicero in Pompeii, one of the best known painters, and thus possibly from elsewhere (Rome?).

47. Excavations were conducted by engineers of Charles VII Bourbon of Naples (later Charles III of Spain) from 1749 to 1782, but plans and reports drawn up by Karl Weber were not published until 1881 (Ruggiero 1881). The site was then reburied, and its location forgotten until amateur excavations conducted by the principal of the local *liceo classico*, Libero D'Orsi, opened in 1950 using his own funds, working with a janitor and an unemployed car mechanic. The site was partially re-excavated by him, and then its management passed to the *Soprintendenza Archeologica di Pompei*, which continued work into the 1960s, with some small excavations in the 1980s and 1990s. So far, thorough publication has appeared of only one of the villas, focused mainly on the surfaces (frescoes, mosaics): Barbet and Miniero 1999. A general guide was published by the past and current directors of the site: Bonifacio and Sodo 2001. A good collection of up-to-date articles appeared in Camardo and Ferrara 2001. Also available are exhibition catalogues with several articles, *In Stabiano, Exploring the Ancient Seaside Villas of the Roman Elite* 2004. Since 2007, new excavations have been begun by the superintendency (now Parco Archeologico di Pompei) in partnership with the Restoring Ancient Stabiae (RAS) Foundation, a nonprofit entity that was created in 1998–2002 to develop and execute a master plan to create the site as a major archaeological park with its partners which now number some thirty-five institutions.

The author is the Coordinator General/Scientific Director of this Foundation.

48. Strabo 25.4.7.

49. The village (some remains are preserved) is probably the rebuilt former *oppidum* of Stabiae, laid waste by Sulla in April 89 BCE during the Social War and reduced to the status of a *pagus* dependent upon Nuceria. A remark by Pliny implies that, after the town was destroyed, the entire area was rebuilt exclusively as villas: Plin., *HN* 3.9.70. At Stabiae, archaeological investigations below the 79 CE level are just starting. Investigations in 2007–10 by RAS Foundation, Cornell and Maryland Universities in the garden of the Great Peristyle of Villa Arianna have found that the garden soil lies directly on top of earlier, as yet undated, cultivation horizons, and excavations by RAS Foundation and Columbia University in the Villa San Marco entrance court in 2011 came down very quickly on sixth century BCE habitation or cultivation horizons: Terpstra, Toniolo, and Gardelli 2011, 199–205.

The evidence for the villas being built contiguously is clear. The limits of some of the villas are known in two places: The Villa San Marco was built directly next to the last street in the village of Stabiae, and the Villa Arianna and the Second Complex are separated by a narrow alley.

50. There is no other reference to this Pomponianus in ancient literature except for Pliny the Younger's letter to Tacitus, *Ep.* 6.16. He may have been a local *municipalis* or business partner, of the sort that any senator would have had. Other prominent men may have owned villas at Stabiae: Marcus Marius, the friend of Cicero, is often cited as an owner of a villa at Stabiae, though Cicero's letter may indicate that their neighboring villas near Pompeii had views *of* Stabiae rather than *from* Stabiae: Cic., *Fam.* 7.1.1. Cicero had other friends with villas in the Bay: Cic., *Fam.* 9.16.7; D'Arms 1970, Catalogue I, nos. 29, 30, 191–2. A recent discovery of a graffito in room 89 of the Villa Arianna suggests that a late owner may have been of the family of "Vestorius," a *gens* known from both Pompeii and Puteoli. Varone 2014, 406, no. 25.

51. The owner of the Villa San Marco has been represented as having had ambitious seaborne trading ventures from the frequent (and quite standardized) sea motifs in the villa's frescoes (marine hippocampi

and the like), but this strains the evidence: Barbet and Miniero 1999, 382-6.

52. On the three centuriations in the Pompeii area (a pre-colonial one; a second for the *colonia* to accommodate Sulla's veterans of 80 BCE), and a third settlement of Caesar's veterans in 42 or later: Oettel 1986, 147–68; Zevi 1994, 5–13.

53. The situation may at first appear to be analogous to that outside the *Porta Herculanea* at Pompeii but probably is not. There the properties of the villa of Diomedes and the so-called villa of Cicero align with the earliest centuriation grid. They are cut obliquely by the presumably later street emanating from the *Porta Herculanea*. The property lines thus likely precede the later street to Herculaneum, and the villas postdate the street. At Stabiae the villas also probably postdate the town and street grid, but the oblique change of orientation is dictated by the need to align the long axis of the Villa San Marco with the shoreline. The "suburban" villas of Pompeii have their long axis perpendicular to the shoreline and are also much smaller than the Stabiae villas.

54. Vitr., *De arch.* 6.3.10. Vitruvius describes them as being a Greek, not Roman, habit. They are usually facing north, are large enough for two *triclinia*, and have shuttered windows on either side to give a view of the gardens. All of these apply to the *triclinium/oecus* at the Villa Arianna.

55. Russo 2010, 177–93; Esposito 2011b. No precise date is yet available from archaeological evidence; on the basis of masonry styles an early to mid-first century CE date is possible.

56. From Herculaneum, House of the Hotel, there are indications that the development of suburban villas was in full swing there by the 30s BCE: Dickman 2007, 421–34.

57. The bridge connects the portico of the townhouse and its small thermal quarter to a large room, a supposed "palaestra" or exercise room, in the thermal quarter of the Villa San Marco. The use of structures over an out-of-use city gate to connect private houses owned by one person is attested elsewhere: Gnaeus Calpurnius Piso (consul in 7 BCE) had built a bridge over the *via Flaminia* connecting two of his properties flanking the *Porta Fontinalis*: Bodel 1999, 43–63, esp. 58–60.

58. For an interpretation of these spaces, see Wallace-Hadrill (Chapter 3) in this book.

59. The best summary of information on all the villas at Stabiae is Camardo and Ferrara 2001. There are indications of earlier structures under some of the villas, particularly the Villa San Marco, and the investigation of those earlier phases began with the excavation in the Villa San Marco entrance courtyard in the summer of 2011: Terpstra, Toniolo, and Gardelli 2011, 199–205.

60. Recent excavations since 2007 have added significantly to the already well-known general layout of the big villas of Stabiae, but an early geophysical survey by the RAS Foundation in 2002 suggested that the Villa San Marco Upper Peristyle was not some 35 m long (and its end lost in a gully) as was previously thought, but much larger. This was confirmed by a sondage made by the *Soprintendenza* that revealed a spirally fluted half-column heart-shaped corner pier in the corner opposite the already known one: the two piers are 108 m from one another: Bonifacio 2007a, 197–9. The extension of the peristyle far beyond the 35 m visible in the 1960s excavation was predicted by D'Orsi (1965, 20–21) and noted as being 70 m long in D'Arms 1970, 129. The external dimension of the Villa San Marco Upper Peristyle, including covered walkways, would be 2 x 35 m + 2(108 + 20) m = 326 m.

61. Vitruv., *De arch.* 5.11.1. The Greek stade varied from 607 to 738 English feet (185–225 m). The Roman stade was normally 607 English feet, or 625 Roman foot of c. 296 mm (185 m). Vitruvius uses a stade of 625 Roman feet. The dimension remains controversial. The peristyles of the Stabiae villas were slightly larger than the similar peristyle garden at the Villa of the Papyri.

62. The most updated general accounts can be found in Camardo and Ferrara 2001: 75–84 (Villa Arianna), 93–6 (Villa del Pastore), 99–104 (Villa San Marco).

63. Vitr., *De arch.* 6.5.3.

64. The remains of two carts were found in excavations of 1981.

65. Valerie 2001, 94–6.

66. Besides those of the garden room from the villa of Livia at Prima Porta, there are "thickets" represented in the House of the Golden Bracelet and the House of the Marine Venus at Pompeii. Preliminary report in Howe, Gleason, and Sutherland 2011, 205–9; Jashemski 2007, 487–98, fig. 31.1.

67. Barbet and Miniero 1999, 380–2.

68. The tank was part of the treasure taken by Lord Hamilton and sank with the transfer ship Centurion in the Bay of Biscay.

69. Suggested in Deiss 1989, 134 and Koloski-Ostrow 2007, 224–56, but see the objections by D. Camardo (2009, 273–87). Stabiae did (and does) have springs known for their curative value: Columella., *Rust.* 10.133.D.

70. It is unlikely that the tank was a true *piscina*, as they usually have niches to provide shadowed hiding places for fish. The "pool with a view" in a villa is attested by the Christian lady Melania the Younger who, when she sold her properties in 404 CE, remarked that the only thing she regretted was that she could no longer enjoy the view of the sea and the forests while swimming in her pool: *Vita S. Melania Iunioris Latina* 18, cited in Littlewood 1987, 27.

71. The central panel of the fresco portrays what is often called a planisphere (more accurately, a simplified version of an armillary sphere). Published in various places, including *In Stabiano; Exploring the Ancient Seaside Villas of the Roman Elite*, curators: P.G. Guzzo, T. N. Howe, G. Bonfacio, A. Sodo (Editrice Longobardi, Castellammare di Stabia, 2004) catalogue no. 1.

72. The exception are three obsidian cups in Egyptianizing style found in the Villa San Marco, room 37, now in the *Museo Archeologico Nazionale* in Naples. They were recently shattered in an accident when a display shelf collapsed; they have been restored by the museum conservators.

73. D'Arms suggested that the villa owners may have made such brief visits that the great villas had very little economic impact on the area: D'Arms 1970, 159–64.

74. In Pompeii many people had enough warning to move many of their belongings out of the city. Beard 2008, 1–19.

75. Pliny, *Ep.* 6.16. See also Beard 2008, 9–14.

76. Adams 2006, 96, graph 34.

77. This could be said to be a "top 1 percent" phenomenon! Actually the senatorial elite of 70 BCE was less than 1 percent: 500 in a citizen population of c. 910,000, which would be .054 percent!

78. See p. 000.

79. Plin., *Ep.* 6.16

80. This ramp is paralleled by Statius' description (*Silv.* 2.2.1–146) of the seaside approach ramp of the villa of Pollius Felix at nearby Surrentum.

81. Purcell 1987, 187–203, esp. 197.

82. On the preference for the elite for sea travel: Marzano 2007, 25–6. Statius, a professional poet (not the highest status visitor by far) approached the Villa of Pollius Felix from the sea: *Silv.* 2.2.30.

83. Lafon 2001, 218; Marzano 2007, 27.

84. Marzano 2007, 17. Senators may have tried to create exclusive villa districts in their favorite locations, but they could end up having equally wealthy equestrians and even freedmen as neighbors. L. Licinius Lucullus at Tusculum had an equestrian and a wealthy freedman for neighbors. Cic., *Leg.* 3.13.30. Senators did not have monopoly on the language of authority through their use of art and culture; these tools were also available to moneyed or talented members of the lower orders. This is the purport of the freedman Trimalchio's famous banquet (the *cena Trimalchionis*): Petron., *Sat.* 26–78. Senators in the reign of Claudius resented the building activity of Posides, the emperor's freedman and minister: Suet., *Claud.* 28; Juv. 14.19.

85. Just as Cicero had felt that buying a *domus* close to the Forum in 62 BCE enhanced his political standing, so too he felt having a villa at Baiae enhanced his *dignitas*: Cic., *Att.*1.13.

86. Cic., *Fam.* 3.9.2, *Att.* 12.40.3, *Att.* 14.5.2; *Fam.* 9.23; *Att.* 13.52. Discussion in D'Arms 1970, 49.

87. Atticus' wife and daughter vacationed at Cicero's villa at Cumae. Cicero invited Brutus there, though he declined: Cic., *Att.* 12.36. For the meeting of Caesar and Cicero, see n. 5.

88. Cic., *Att* 7.5.3 on the hospitality he expects to receive from friends. In general, Chevallier 1988.

89. Cic., *Fam.* 16.10.2, *Att.* 10.7.3, *Att.* 13.52.1.

90. Cic., *Att.* 16.3.4.

91. The tradition went back to the legendary history of the kings: Romulus, the first king, invited young men from all over Italy to populate Rome, and the Tarquins, Rome's Etruscan kings, were a dynasty of partially Greek descent who had moved to Latium. Social status had long been more significant than place of birth: Livy 1.8 and 34; Cornell 1995, 57–63, esp. 60.

92. D'Arms 1970, 52; Cic., *Fam.* 13.7.1.

93. Cic., *Att.* 8.13.12. Two of Cicero's close Campanian friends were M. Cluvius and C. Vestorius, who were financiers, but after dining at Vestorius' house, Cicero declared him to be, although a fine fellow, as lost in philosophical discussion as he was at home in his accounting: *Att.*14.12.3. Some of his other Campanian friends, more to his intellectual liking, were apolitical, such as M. Marius of Pompeii, L. Papirius Paetus of Neapolis, and his longtime friend and correspondent Atticus.

94. Cicero, *Leg. agr.* 2.78, but see Marzano 2007, 16, 19, and Marzano and Brizzi 2009 for the profitability of investment in pisciculture.

95. D'Arms 1970, 48.

96. Perhaps this is why Juvenal describes Cumae as deserted, even though senators felt themselves overwhelmed by visitors and by social obligations when they were there: senators were there briefly but interacted intensely with one another and with local notables rather than with the *populus* as in Rome: Juv. 3.2-3.

97. The inland villa at Settefinestre, even if owned by a senatorial family (the Sestii) represented a lower-end senatorial property with comfortable accommodations for a visit by the owner: it was mainly devoted to agricultural production. It may have sat near or side-by-side with villas owned by local families such as the Pacuvii and Gavii who owned *figlinae* (tile kilns) in the area: Marzano 2007, 30. For *deversoria* associated with the senatorial family of the Sestii: Carandini and Filippi 1985, vol. 1, 149.

98. The limited excavation areas around Oplontis Villa A and the Villa of the Papyri do not yet tell us if they were part of "suburbs" of side-by-side villas. The Villa of the Papyri is immediately next to the town of Herculaneum and the "suburb" could have extended farther along the coast. At Oplontis, there is another known seaside villa (Villa B) some 400 m away, but excavation has not revealed the limits of the villa so nothing is known of its immediate neighbors. For the position of the Oplontis vis-à-vis the cliff and the sea, see Clarke (Chapter 4) in this book.

99. Vitr. *De arch.* 6.5.5. Emphases added.

100. Wallace-Hadrill 1994, 16–37. The House of the Faun in Pompeii is asserted to be an imitation of a Hellenistic palace.

101. It has been reconstructed as an arched opening in Barbet and Miniero 1999, fig. 112, but this is doubtful. The Villa San Marco main *triclinium* was probably an enormous pedimented opening facing the sea, much higher than the seaside front colonnade and flanking buildings. At the Villa Arianna, in the Upper Peristyle, there were widened intercolumniations in front of the entrance *propylon* and the

triclinium T, which likely had pediments, and there were probably pediments over the three main panoramic *triclinia* facing the sea.

102. Only one senator is known to have been from the Vesuvian area, Marcus Nonius Balbus, actually a citizen of Nuceria, although the prominent patron of Herculaneum.

103. Petron., *Sat.* 26-78.

104. Cic., *Phil.* 2.43; Flor. 4.2; Plut. *Caes.* 63; Suet., *Iul.* 81.

105. Vitr., *De arch.* 6.5.2.

106. Mielsch 1987, 79.

107. Bonifacio and Sodo 2001, 135–7. The Fourth-Style fresco in this small room (Room 7) features openings with two figures apparently reading scrolls. However, the room is not equipped with shelves like a true library and is in fact a panoramic *cubiculum*, hence a multi-functioning private quarter with a literary flavor in its decorative scheme.

108. Colored marble arrived in very small quantities and sizes at Pompeii in the early imperial period. By that time, all of the major quarries had been claimed as imperial property: Fant 2007, 336–46, esp. 338–40. Esposito has also proposed that the Villa San Marco may actually have been an imperial property, but as the argument is based largely on brickstamps, it only can be concluded that the *figlinae* from which the bricks were bought were imperial, not the villa itself: Esposito 2011b.

109. Often elite townhouses and even nicely decorated rustic villas would have rooms with pornographic images in them, as in the Villa at Carmiano near Stabiae. They would have been in rooms with external entrances and could well have been rented out as brothels: Guzzo 2000, 40–7. Lascivious behavior in senators, or even evidence of bad taste (e.g., the story of L. Mummius, n. 20) could negatively affect a career, as Cicero's letters often show.

110. The gossip about the young Julius Caesar, when on military and ambassadorial assignment in 80 BCE in the East, that he engaged in improper relations with Nicomedes IV Philopater, king of Bithynia (94–74 BCE) followed him for the rest of his career: Suet., *Iul.* 2.45-53.

111. Villas of Manlius Vopiscus, Quintilus Varus, and the so-called villa of Brutus: Mielsch 1987, 68–70, 43. See in general Tombrägel 2012.

112. See n. 2.

113. For that reason, the villa group at Stabiae has been interpreted as a deliberately planned colony or resort for members of the new 500-man Roman senate after the reforms of Sulla and the confiscations and settling of 4,000 veterans at Pompeii in 80 BCE, but this possibility needs investigation and further discovery: Adams 2006, 88. It has recently been proposed that the Villa of the Mysteries in Pompeii was built in its first phase only after the Sullan colony of 80 BCE was founded and therefore may have been a property given to one of Sulla's retired officers: Esposito 2007; Wallace-Hadrill 2008, 200–7 and Wallace-Hadrill (Chapter 3) in this book.

114. As mentioned (n. 56), the House of the Hotel in Herculaneum indicates that the development of seaside villa-like town mansions were in full swing by the 30s BCE. Given the history of the Balbi of Herculaneum who came originally from Nuceria, many of the new owners of the new villa-like seaside *domus* may have just recently moved there: Dickmann 2007, 421–34.

115. On decentralization of location of senatorial *domus* in Rome, see note 15. The greater extravagances of villa building in the Bay of Naples and in Italy in general seem to have declined in the reign of Vespasian, but more study of this is needed. The imperial example of restraint by Vespasian (Tac., *Ann.* 3.55.1-6) was not followed by his successor Domitian or the emperors of the second century CE. Grand villas may have conferred such symbolic status that the highest ostentation had to be reserved for the emperor. For senators, it became politically dangerous in the first century CE to overbuild and thus rival the emperor; Silius Italicus was criticized by Pliny the Younger (*Ep.* 3.7.1; 3.7.8) for the extravagance of his estates in the Naples area in the 70s and 80s CE. The Quintilii brothers, both consuls of the year 151 CE, were executed and their villa on the *via Appia*, the largest suburban villa in Rome, was confiscated by Commodus in 182 CE: S.H.A., *Comm.* 35–6.

THE ROMAN VILLA OF POSITANO

ADELE CAMPANELLI, GIOVANNI DI MAIO, RICCARDO IACCARINO,
MARIA ANTONIETTA IANNELLI, LUCIANA JACOBELLI[1]

WHILE THE VILLAS OF CAMPANIA, ESPECIALLY those of the Bay of Naples, are famous and some well-documented, the southern side of the Sorrentine peninsula overlooking the Bay of Salerno, now commonly known as the Amalfi Coast, was also a venue for maritime villas. Its topography presents high steep limestone cliffs rising to the cordillera of the Monti Lattari at an elevation of 1,400 m. The ravines – deep gorges often with perennial streams –[2] and small inlets discouraged land transport and communications except by way of mountain passes and trails, so in antiquity the sea connected the area with the wider region.

The northeast-southwest axis of the mountain range protects the area and creates a mild microclimate suitable for certain agricultural products (its lemons are famous), but there is little room for agriculture or large settlements. Inhabitants have adopted versatile solutions for the exploitation of the land, ranging from terraced vineyards and orchards on the lower slopes to wider upland grazing pastures. Roman maritime villas are known along this coast at Amalfi and Minori, with the Positano villa being the westernmost. Despite being more than 20 km away from Vesuvius, and in a low position at shore-level below the protection of the mountains to the north, the villa was initially buried under almost 2.00 m of fallout material consisting of ash and pumice in the eruption of 79 CE (Figure 7.1).[3] Pyroclastic material entered the buildings through doors and windows, and as it accumulated on the roofs it caused them to collapse. Almost simultaneously, the large quantities of pyroclastic material that fell on the steep slopes of the Lattari Mountains slid downhill, causing lahars or volcanoclastic flows moving at high speed, with devastating consequences for whatever happened to be in their path. The accumulations destroyed the Positano *villa*: the ground level rose about 20 m in some places and the shoreline advanced, as attested by the identification of a fan-shaped accumulation subsequently dismantled by marine erosion.

The presence of ancient material under the main church of Positano, S. Maria Assunta, had been known from *spolia* in structures around modern Positano and in archival documents (Figure 7.2 at A). During works to consolidate the bell tower in 1758, ancient remains were identified, and Karl Weber, the engineer of the royal Bourbon administration of Naples and the director of excavations at Pompeii, Herculaneum, and Stabia, was notified.[4] On 16 April 1758, Weber started excavating beside the church to a depth of 30 *palmi* (c. 7.80 m), where he found a "famous old building with a fine white marble mosaic."[5] Weber continued his investigations until the 20th of the month, describing in a short report the architectural features identified: small rooms with poorly preserved wall paintings depicting gryphons, small vessels, "goats" (Capricorn?), and more; two large brick columns covered with vivid red plaster; various masonry water channels; more columns covered in white plaster belonging to a large

peristyle with a water basin and a lead pipe, evidently a fountain. Weber also identified a rectangular garden measuring c. 200 *palmi* (c.52 m) on the long side (Figure 7.2 at C and D).

The sacristan of S. Maria Assunta, one Giuseppe Veniero, reported to Weber that extensive excavations had been carried out in the late 1600s to recover colored marble and architectural pieces, several of which had been sold to the convent of St. Teresa in

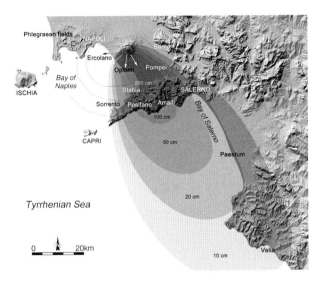

Figure 7.1. The area affected by the eruption of 79 CE – pumice-fall thickness distribution in grayscale; the arrows and associated lines indicate direction and extension of pyroclastic flows. (G. Di Maio, GEOMED).

Naples for funds to update the church's interior and exterior in the current baroque style. It was thought that the ancient structure had once been a temple; some guides still tell tourists of a "temple of Minerva," and Weber wrote in his report of "el templo antiguo."

In the 1920s, new parts of the villa were discovered at the back of a butcher's shop: some digging revealed the corner of the peristyle identified by Weber in 1758. Several stuccoed columns (their intercolumniations closed off by low walls) came to light, and a plan of the visible portion of the peristyle was published in the early 1930s.[6] A devastating flood in 1954 brought to light additional structures belonging to the villa, which Amedeo Maiuri, the director of excavations at Pompeii at the time, rightly identified as part of a villa buried by pyroclastic events in the eruption of 79 CE.[7]

THE FIRST MODERN INVESTIGATIONS

Starting in 1999, the Soprintendenza of Salerno has conducted a series of geo-archaeological investigations in order to reconstruct the extent of the archaeological complex buried under the church of S. Maria Assunta, bell tower, and surrounding gardens (Figure 7.2 at A). In 2003, stratigraphic investigations in the crypt of the Church of S. Maria Assunta were carried out. This work was constrained by the small size of the workable area and the need to consolidate the ancient

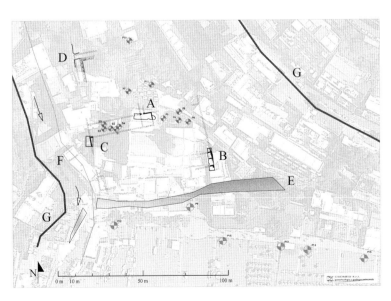

Figure 7.2. Positano, plan of town with location of finds and reconstruction of the villa extension. (G. Di Maio, GEOMED).

A: Location of the church of S. Maria Assunta.
A and B: current excavations of the *Soprintendenza*.
C and D: early excavations (Weber 1758; Mingazzini 1946/Maiuri 1955).
E – ancient shoreline.
F – Vallone Pozzo stream.
G – limestone bedrock.

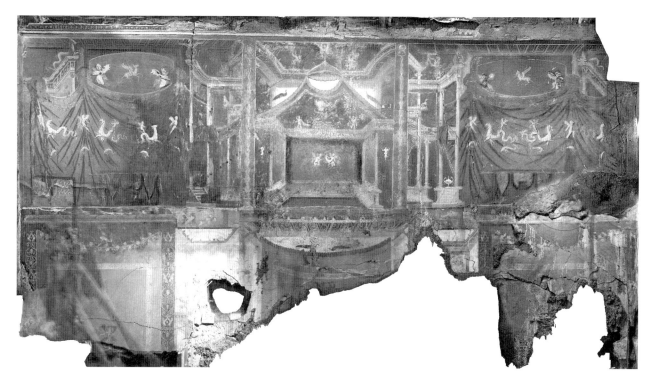

Figure 7.3. Positano, villa, north wall of *triclinium*, composite image (GEOMED). (A black and white version of this figure will appear in some formats. For the color version, please refer to the plate section)

structures and wall paintings while the excavations proceeded. In consequence, only the upper zone of the north wall of a probable *triclinium* of the villa was uncovered. The excavations were resumed only in May 2015, unearthing the entire north wall and the east wall of the room, down to its simple white mosaic floor framed by bands of black tesserae. Large fragments of a third wall on the west side have been found *in situ*, while the south side may have opened to a view of the sea or toward a peristyle; a stuccoed column collapsed into the room suggests a peristyle portico or a terrace with a colonnade.

The manner in which the villa was obliterated in 79 CE, with huge quantities of pyroclastic mud mixed with pumice and other volcanic material penetrating into the rooms, has paradoxically allowed for an exceptional state of preservation of the wall paintings. While the pyroclastic flow displaced the upper parts of the walls by over 30 cm southward (toward the sea), the paintings themselves are relatively intact (the gap is visible in the east wall, Figure 7.4).

The wall paintings, in the mature Fourth Style, are of high artistic quality and indicate the villa's opulence (Figures 7.3 and 7.4). The decorative scheme is unusual: There was abundant use of white stucco molded in relief in the upper part of the wall decoration for figures of cupids and fantastic animals. The combination of white stucco relief above and wall painting below has few comparisons in private houses; it was most often used in the vaults of baths and *nymphaea*.

The blue palette liberally used for the backgrounds of the paintings in the Positano villa also reflects the wealth of the owner: The pigment was expensive and therefore relatively rare in painted walls of private houses. The artists at Positano evidently intended to achieve maximum scenographic effect in the room.

The north wall has further remarkable features: In the upper part of the wall, painted green draperies or curtains "hang" on either side of the central axis of the composition, partially hiding the architectural perspectives behind them (Figure 7.3). The curtains, which have heavy pendant fringes, are held up by cupids rendered in stucco relief, and the cloth itself is

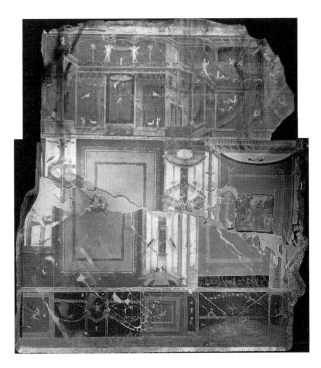

Figure 7.4. Positano, villa, east wall of triclinium, composite image (GEOMED).

decorated with stucco motifs: dolphins and cupids riding on sea monsters. The motif is also depicted on the east wall, but in this case the curtain is almost completely drawn, revealing larger portions of the architectural perspective: a *tholos*, structures with coffered ceilings supported by columns, views of buildings with balustrades, and half-opened windows and doors.

In the north wall, the upper register depicts a wooden ceiling supported by gilded columns, a complex composition featuring architectural vistas populated by cupids and fantastic figures rendered in stucco, and, in the two side panels, the drapery described in the previous paragraph. The lower register of the north wall is somewhat simpler: large yellow panels interspersed with architectural views, and, in the central panel, two facing peacocks on a garland (Figure 7.3).[8] The left and right lower yellow panels are framed, on the top section, by elegant garlands of vine leaves and grapes. Between the upper and lower registers and directly under the architectural views of the upper register, there are small painted *pinakes* depicting *xenia*.

The central decoration of the east wall differs from the north one (Figure 7.4). In the middle is a small round temple, a *tholos*, separating two panels with yellow backgrounds and red frames. At the center of the southern panel, which was being excavated at the time of writing, the yellow background frames a central scene depicting a male figure with a centaur, probably Chiron teaching Apollo how to play the lyre; a third figure could be Dionysus.

The wall decorations are of the highest quality; the colors are rich and vibrant, the palette used ranges from azure-blue to green, from red to yellow. The originality of the composition is also clear when compared to the examples from the Vesuvian area. The Positano villa paintings could have been the work of artists coming from Rome in the ambit of court artists in service at the imperial entourage at Capreae (mod. Capri) (see p. 124) or of local workshops operating for elite patrons in the Sorrento peninsula. Whatever their origins, the work reveals that the artists were up-to-date when it came to current fashions and that their patron had very fine taste and high standards. The artists displayed considerable attention to detail, aptitude for the realization of complex compositions, and attention to the use of color.

In the north side of the room, a piece of furniture appropriate to a *triclinium* has been found; the elements in wood are preserved as cyneritic deposits, and part of the piece was reinforced internally with an iron frame and had a barred iron door. It was probably an armoire or large strongbox containing stacked bronze vessels, presumably used for banquets in the room.

A test trench dug between the church façade and the bell tower has located another room with a mosaic floor and terracotta *tubuli* (rectangular hollow tiles applied vertically to jacket the walls) for radiant heating of one of the rooms of the villa's baths.

At the moment of its destruction, the villa was probably undergoing renovations. A large iron saw found in the *triclinium* attests work-in-progress, and a test trench opened to the southeast of the church has revealed *opus reticulatum* walls and a large pile of Neapolitan yellow tufa elements (*cubilia*) freshly roughed out, to be used in *opus reticulatum* wall

facings. Tufa chips and unfinished elements indicate that the *cubilia* were being shaped *in situ*.

CONCLUSION

Further investigation will be needed to reconstruct the plan of the Positano villa, but the recent excavations and earlier evidence have established that it occupied the entire seafront of what is now the core of Positano's historical center, from the main church area and gardens of the Hotel Murat to the ancient beachfront located no further than 50 m southward of the S. Maria Assunta church, where restaurants and shops are now located. The complex featured a peristyle with, most probably, a central garden and a fountain (as described by Weber), a bath quarter (the room with terracotta *tubuli* for radiant heating), and one lavishly decorated room, most probably a *triclinium*. As with other Roman *villae maritimae*, there may have been two or more levels. Exactly when the villa was built is not yet clear. Late Fourth-Style decorations are conventionally dated *c.* 40 to 79 CE, but the walls in *opus reticulatum* could be much earlier, although there are known issues in trying to use building techniques or wall painting styles as secure dating elements.

Luxury villas existed in Surrentum by early Julio-Claudian times, and possibly earlier: Agrippa Postumus, Augustus' grandson, was initially confined to one before being exiled to an island.[9] Villas on the Sorrento peninsula may have become desirable when Tiberius retired to the island of Capreae in 26 CE: members of the elite may have wished to be only a short boat-trip away from the imperial entourage. On the basis of epigraphic evidence attesting the presence of imperial freedmen from the reign of Claudius (41–54 CE) onward, D'Arms suggested that Claudius may well have built a villa on the south coast of the Sorrento peninsula.[10] His suggestion was preceded by an earlier one put forward by Della Corte: On toponomastic grounds (by which current place-names may recall the names of property-owners), the name Positano may be a derivation from *Posidetanum* (*praedium*) ("property of Posides"), thus connecting the villa with Posides, a freedman of the emperor Claudius, mentioned in the literary

sources for giving his name to famous hot water springs in Baiae and for being a real-estate speculator specializing in luxury villas.[11]

The Positano villa was clearly a maritime villa fully equal to villas in the Bay of Naples, built and belonging to owners who had special taste in fine wall painting with unusual combinations, composition (paint with stucco relief; the curtains), and colors (blue). The continuing excavations will uncover more of its plan and decoration, and its paradoxically good state of preservation in the face of disastrous destruction – but a different kind of destruction suffered by the towns and villas further north – may well bring to light more of its contents and circumstances.

NOTES

1. A. Campanelli and M. A. Iannelli: Soprintendenza per i Beni Archeologici di Salerno Avellino, Benevento, e Caserta, G. Di Maio and R. Iaccarino: Geomed - Geoarcheologia e Ambiente, Scafati (SA); L. Jacobelli: Consiglio Nazionale delle Ricerche.

2. The abundance of freshwater springs and streams along the Amalfi Coast has enabled the construction of aqueduct systems feeding grain mills, paper mills, and ironworks since the early phases of the Republic of Amalfi in the Middle Ages. The aqueducts that fed the baths of the Roman villas in Minori and Amalfi are still in working order.

3. The Amalfi and Minori villas were also buried by the eruption. On the Minori villa, see Johannowsky 1986; nothing has been published on the Amalfi villa.

4. K. Weber, report dated "Portici, April 23, 1758" published in Ruggiero 1888, 453–4.

5. Ibid.

6. Mingazzini 1931.

7. Maiuri 1955, 87–98.

8. One of the walls was marked with the imprints of wooden elements that probably belonged to a large partition in the room that was pushed against it, perhaps with pieces of furniture, when the pyroclastic flow hit the villa.

9. Suet., *Aug.* 65.1.

10. D'Arms 2003, 96.

11. Della Corte 1936; Suet., *Claud.* 28; Juv. 14.91; Plin., *HN* 31.2.

8

MARITIME VILLAS AND THE RESOURCES OF THE SEA

ANNALISA MARZANO

[T]he bay named Crater [i.e. the Bay of Naples] . . . is bounded by the two promontories of Misenum and the Athenæum, both looking towards the south. The whole is adorned by the cities we have described, by villas, and cultivated fields, so close together that to the eye they appear but one city.

Strabo 5.4.8

To a traveler by sea along the coasts of Tyrrhenian Italy in the first-century CE Mediterranean, certain areas would have appeared densely occupied by elegant maritime villas belonging to the moneyed elite. Whereas the earliest maritime villas were built on elevations at a certain distance from the shore proper and presented a self-contained architectural plan, by the late first century BCE maritime villas had multiplied and acquired a distinctive architectural typology featuring multiple terraces and an open seafront architecture with colonnaded terraces and loggias, and often bath quarters and dining pavilions right on the shore and in contact with the water.[1] The development of open-front maritime architecture and the spread of maritime villas may have been linked to the increased security of sea and coastline, particularly once the threat of piracy had been reduced after the campaigns of Pompey the Great in the 60s BCE.[2] The cessation of decades of civil war and the pacification of the Mediterranean under Augustus (27 BCE–14 CE) created the ultimate conditions for a boom of luxurious maritime villas with open-front architecture.

Once the new architectural fashion had become the norm, moralists often directed their attacks against practices that they saw as subversive of the natural order of things, such as this invective by the philosopher Seneca against villas' bath quarters of his time built in direct contact with the aqueous element:

> Don't they live against nature who drive the foundations of their baths right in the sea and who do not consider they swim in luxury unless the hot pool is struck with water and storm?[3]

The popularity of the Bay of Naples as a resort for wealthy Romans is well attested in ancient literature and in the archaeological record,[4] but it was not the only coastal area of Italy that was densely settled by the early imperial period. Along the stretch of coast just north of the promontory of Torre Astura (near modern Anzio, south of Rome), there were several elegant maritime villas located at an average distance of only 200 m from one another.[5] On the coast north of Rome and the mouth of the Tiber, the coastline near the ancient settlement of Castrum Novum (mod. Santa Marinella) featured a number of

monumental maritime villas, built on small pro-
montories and other commanding positions, on
average less than 1 km from each other; these villas
were all connected to the major coastal road, the *via
Aurelia*, running from Rome to Pisae. Such build-
ings, because of their architectural typology featur-
ing multiple terraces, must have been an impressive
sight to the traveler viewing them from the sea, and
it is not by chance that many vignettes from Roman
wall paintings depict maritime villas rising from
glittering waves and above dreamily sketched
beaches. Enjoyment of the panorama and scenic
views were one of the factors carefully evaluated
when choosing the position and orientation of
a villa. Inland, rural villas were often built on
imposing substructures (the *basis villae*) to dominate
the surrounding landscape and impress the
passersby. In the same way, maritime villas were
built not only for the enjoyment of the panoramic
views they offered, but also *to be viewed* by those
traveling by sea. An impressive example of
"monumentalization" of the coast is in the
grandiose maritime villas that by the second
century CE were built on the coasts of the Istrian
peninsula.[6]

In the ancient literary sources, discussion of, and
references to, maritime villas are normally found
coupled with the idea of their ostentatious extrava-
gant luxury and of their unproductiveness (in oppo-
sition to the "ideal" inland rural villa, a working
farm, which produced revenues). Such displays of
wealth could be even censured as immoral because
they deviated from the proper accepted social
behavior: The ancient literary discourse on elite
behavior and display of wealth associated maritime
villas with immodest display of luxury from the very
early stages of development of the open sea-front
establishments.[7] According to Valerius Maximus, in
125 BCE M. Aemilius Lepidus Porcina was repri-
manded by the censor "on a charge of having erected
a villa in the territory of Alsium too splendidly."[8]
Later, Varro alluded to the belief behind these moral
condemnations of ostentatious architecture in the
case of maritime villas when he wrote of the rich
villas of Lucullus and Metellus as being built "to the
greatest damage to the state and people";[9] the money

spent on these private estates should rather have been
used for public buildings and to benefit the commu-
nity. In other words, what in the public sphere was
seen as *magnificentia* (greatness) was on the contrary
perceived as *luxuria* (extravagance) in the private
sphere, and this is a recurrent theme in Roman
moralizing and political writings.[10]

But was the Roman maritime villa simply
the seat of vacation retreats and of conspicuous
consumption?

Close archaeological investigation reveals that
maritime villas were rarely devoid of productive
assets. As rural villas were indissolubly linked with
the land and the processing and storage of agricultural
produce, so maritime villas were often part of estates
of which the size and available natural resources
could vary greatly. In fact, some maritime villas and
their attached properties could offer a wider range of
opportunities than their rural counterparts when it
came to natural resources for productive activities,
coupled with the possibility of distributing the pro-
duct by sea transport in a very cost-effective manner.

MARITIME VILLAS AS PLACES OF PRODUCTION, PRIVATE CONSUMPTION, AND COMMERCIAL PROFIT

In contrast to the stereotype of unproductive and
costly to maintain maritime villas sketched in Latin
literary texts, the physical remains of this category of
villas found in Italy and the provinces give a much
more complex picture. Several maritime villas were
clearly part of landed estates producing oil and/or
wine like their rural counterparts. For instance, the
villa of Punta della Vipera in the area of ancient
Castrum Novum in Italy, built in the first century
BCE on the spot previously occupied by a sanctuary
dedicated to *Menerva*, had a *pars rustica* equipped with
a press as well as an impressive marine fishpond (*c.* 55
x 34 m). The villa at Marina di S. Nicola (Ladispoli),
just north of Rome, was built on an artificial platform
in order to compensate for the low sandy coastline of
the area, which did not offer the high cliffs and
promontories normally chosen as locations for

maritime villas. This complex not only featured the architectural elements to be expected in an elegant villa of the empire,[11] such as a four-sided portico and an enclosed *gestatio* (normally a stadium-shaped garden for exercise by walking or on horseback), but also a *pars rustica* and a separate nucleus with what seem to have been *tabernae* that may possibly have been used for commercial transactions and/or periodic markets.[12] Perhaps, especially in the case of the villa of Punta della Vipera, the production quarter was not processing agricultural surplus destined to the commercial market but simply processing produce for the needs of the very large households most of the Roman upper class had in their urban houses in Rome. Urban households of rich Romans could count hundreds of slaves who had to be fed, not to mention that, in order to maintain their social standing, members of the upper classes had to provide banquets and entertainments for friends and subordinates as a matter of social duty. The so-called house of Aemilius Scaurus excavated in Rome at the intersection of the Via Sacra with the Clivus Palatinus had large substructures with many bedrooms and even a bath suite, presumably to be used by house servants, clients, and other guests.[13] Roman society had an extremely hierarchical structure, and although there was a certain degree of social mobility, the relationship among patrons and clients was a two-way relationship with obligations on both sides. Often provisions such as wine and oil to be consumed in these households came from estates the patrons owned outside Rome.

The amount of foodstuff for personal consumption in elite houses transported from an owner's villas into Rome could be substantial, but regardless of its quantity, it was exempt from the normal tax levied at the city gates on goods destined for sale in the commercial market.[14] By late antiquity, wagons entering Rome with foodstuffs from estates destined for personal consumption displayed special plaques indicating to customs officers that the goods on board were exempt from duties.[15]

There are, however, examples of maritime villas in Italy and elsewhere that undoubtedly had estates of notable size whose agricultural produce was destined for an external commercial market, often transmarine. Two villas excavated in the Bay of Cavailaire in southern France can be taken as typical of this category, the sites of Pardigon 2 and 3.[16] Several maritime villas have been identified along the coast of this bay, not far from the port of Heraclea Caccabaria listed in the maritime itinerary known as the *Itinerarium Maritimum Antonini*.[17] The two villas in question were built just 500 m from each other. The villa labeled Pardigon 2 (La Croix-Valmer) started as a modest villa in the Augustan period, and was from the beginning devoted to the production of wine for export as indicated by the presence of a kiln producing the typical amphora used to transport wine in that period, the Dressel 2/4.[18] During the reign of Nero (54–68 CE) the villa was rebuilt on a grander scale and featured baths and a monumental porticoed façade. Viticulture continued to be the economic activity of this estate in this second phase, as indicated by the presence of a press room and wine storeroom with terracotta vessels sunken into the ground (*dolia defossa*), in which the must fermented into wine. The wine from villas like this one was largely supplying the needs of the city of Rome, which by the Augustan period had reached c.one million inhabitants.[19]

The nearby villa of Pardigon 3 presents a similar development, architectural typology, and type of production. Built in the Flavian period, its façade was also marked by a long portico sheltering an inner peristyle garden; it featured bath quarters and, on the north side of the complex, the production sector with wine press and large storeroom with space for about one hundred *dolia*. Maritime villas like these were in an excellent position to effectively engage in intensive viticulture: They had sizeable and fertile land plots suitable for growing vines, access to clay beds and fuel for the manufacturing of amphorae, and private port facilities for shipping their products by sea.

In Gaul, the appearance of villas presenting elegant residential quarters while producing wine for export was the outcome of the program of Roman colonization that began right after Caesar's conquest in 58–51 BCE. Before this, the region had largely imported wine from Italy. Indeed, in the late second

century and in the first century BCE, some areas of Roman Italy had seen a boom in viticulture, producing wine largely exported to transmarine regions such as Gaul.[20] According to the historian Diodorus (first century BCE), Gauls were ready to exchange one amphora of Italic wine for one slave, an opportunity seized by traders:

> The Gauls are exceedingly addicted to the use of wine and fill themselves with the wine which is brought into their country by merchants . . . Consequently many Italic traders, induced by their usual cupidity, believe that the Gauls' love of wine is their own godsend. They transport the wine on the navigable rivers by means of boats and through the level plain on wagons, and receive for it an incredible price; for in exchange for a jar of wine they receive a slave, thus getting the cupbearer in exchange for the drink.[21]

After Julius Caesar's conquests and the incorporation of Gaul into the empire, a program of land distribution to military veterans and foundation of colonies followed. The settlers, largely originating from central Italy, introduced viticulture to the region and, within one generation, Gaul turned from importing wine to being its exporter. Many villas in Gaul, maritime and rural alike, had started as very modest establishments, but by the Flavian period (69–96 CE) these buildings underwent major architectural modifications that transformed them into proper villas, with baths, colonnaded porticoes, mosaics, and frescoes, together with larger and more efficient processing facilities and an increase in the number of presses.[22] It is generally believed that the money capital that allowed the owners to ameliorate the residential and service quarters of their villas derived from the success of the viticulture that had started to accrue one or two generations earlier.[23] The villas, like Pardigon 2 and 3, which could count on their coastal location to ship goods by sea, had a clear advantage, but inland sites, particularly those located along waterways, also developed from wine-producing rustic farms to elaborate villas featuring Mediterranean-style amenities.

Maritime villa estates could be engaged in the exploitation of a variety of natural resources available to them, not simply in "traditional" agricultural production. The Roman idea of "agriculture" was, in fact, more flexible than our modern definition. For the Romans, different activities that could occur on an estate fell under the heading of agriculture, not simply cultivating crops and animal rearing. Thus, in the Latin treatises on agriculture we find also discussion of lime production[24] or of tile and amphora manufacturing.[25] Some villas on the island of Elba off the coast of Tuscany in Italy offer an interesting example of the connection between the construction and occupation of maritime villas and the exploitation of nearby natural resources besides activities in traditional agriculture. Elba (the ancient Ilva) had important iron deposits, which had been mined since early times.[26] By the time of Strabo in the early first century CE, processing of the ore largely took place on the Tuscan mainland at Populonia, probably due to the scarcity of fuel present on the island induced by centuries of ore smelting.[27] Several Roman maritime villas are known on Elba, all located in very scenic positions. The villa of Capo Castello, built on a promontory on the northeast end of the island, unfolded on six different artificial terraces.[28] The complex was not far from the iron mining area, and ore processing occurred on the estate, since very close to the villa several kilns and scoriae resulting from smelting have been found in association with pottery dating to the first century BCE and first century CE. The phases of occupation of the villa can be linked with the phases related to the extraction of ore. Partial abandonment or reduced use of the structures of the villa seem to have occurred already in the late first century CE, and this curtailment of residential occupation can be linked with the reduction of mining activity on the island in the same period.[29]

Although the scant remains of the villa at Capo Castello can hardly convey the past grandeur and monumentality of its architecture, a better idea of it can be gauged from another maritime villa on Elba,

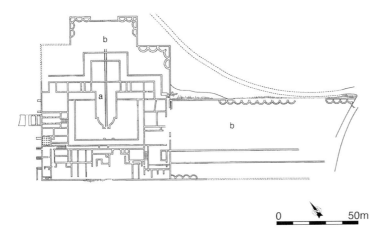

Figure 8.1. Elba, Villa delle Grotte, plan (A. Marzano, after Pancrazzi and Ducci 1996).

0 50m

the Villa delle Grotte. This villa, which for architectural typology and phases of occupation is similar to the villa of Capo Castello, stood on the promontory at the southeastern end of the gulf of Portoferraio, where a Roman settlement and port were located. The complex was built in the age of Augustus and featured a central block, square in plan, resting on a podium created by terracing walls and substructures, similar to the layout of Villa Iovis in Capri. A long rectangular pool ending in a curvilinear *exedra* surrounded by a central peristyle garden on the southwestern side constituted the central axis in the villa's plan (Figure 8.1). On the north side, a large room with a view to the sea and on axis with the pool was probably used for banquets. A lower terrace (b on the plan) was occupied by a garden, as inferred from the recovery of several *ollae perforatae* (terracotta pots with holes for the roots, used to bed plants grown in nurseries) and by a *nymphaeum* fed by the water overflow of the pool of the upper terrace. The maritime façade of this villa was spectacular: The terracing walls on the sea side had a series of vaults on a vertical axis and a grand staircase in three ramps on the west side, leading up to the villa from a small cove equipped with a granite dock, which besides its practical function would also have had a scenographic effect. The terracing wall on the south side of the villa had polychrome effects, also meant to be seen when approaching the villa: The wall was built with alternating *cubilia* in gray

limestone and green stone, with string courses of bright red tiles.

Elsewhere in Italy, the owners of a maritime villa at Tor Caldara (c. 5 km to the north-west of Anzio) similarly exploited the resources of their property in a nontraditional way. The villa was built probably sometime in the late first century BCE or early first century CE in proximity to hot sulfur springs and sulfur deposits, and a modern survey has shown that these deposits had been exploited in Roman times when the villas were occupied.[30] Roman tools and pottery related to sulfur extraction were recovered, while the apparent absence of subsidiary dwellings around the villa to house the workers indicates that the sulfur deposits were part of the estate and that the workforce was housed within the main body of the villa itself. That the residential part of the villa had a high level of architectural décor was clear despite the scantiness of the remains visible before the excavations: part of a *nymphaeum* featuring marble and painted stucco could be seen along the eroded seashore. But if in location and architectural typology this villa had close affiliation with other maritime villas, one element was distinctly different: sulfur springs and deposits release a strongly distasteful smell of rotten eggs. One would not expect to find a luxury villa in such a context, so the Tor Caldara villa contravenes modern notions about what Roman elite owners were prepared to put up with at their seaside dwellings.[31]

Maritime Villas: Freshwater and Marine Pisciculture

Of course, the natural resource that maritime villas had at their disposal, one not available to rural villas, was the sea. Fish farming, fishing, fish salting, and salt production were undertaken at some maritime estates, and many had private landings and jetties to move goods to market, transport by sea or river barge being by far the cheapest and most efficient means of distribution in Roman antiquity.[32]

Fish-Farming: Freshwater and Marine

Many anecdotes found in ancient literary texts deal with either the culinary fashions and the crazes for certain kinds of fish on the part of rich Romans, ready to buy them at auctions for considerable sums of money. For instance, we are told that, in the reign of Tiberius (14–37 CE), three red mullets were auctioned for 30,000 *HS* and, in the reign of Caligula (37–41 CE), Asinius Celer, a man of consular rank, had paid 8,000 *HS* for one mullet.[33] Other anecdotes deal with the extravagance of those called *piscinarii* – "fishpond-lovers" – by an exasperated Cicero: He considered that they wasted money and effort on marine fishponds rather than attending to the problems of the Roman state.[34] These rich Romans kept the fish rather as a sort of pets – we are told – adorning moray eels with earrings and weeping when one died.[35] Licinius Lucullus won for himself the nickname of "Xerxes in toga" for undertaking daring engineering works,[36] including tunneling through a mountain, at his villa on the Bay of Naples simply in order to ensure proper water exchange and circulation in his marine fishpond, so that, as noted by Varro, he no longer "needed to yield to Neptune in the matter of fishing."[37]

The Romans practiced both freshwater and marine fish farming, and they actually perfected the latter with technical innovations that allowed what in modern terminology would be called intensive fish farming. It is not clear when exactly the first marine fishponds appeared in Roman Italy. Pliny the Elder reported that the first person to create fishponds for all kinds of saltwater fish had been L. Licinius Murena in the early years of the first century BCE,[38] but the many archaeological examples known from this period indicate that the techniques of such pisciculture had been well understood and do not represent an early experimental phase.[39] Varro in the first century BCE and Columella in the first century CE discuss fish farming; their treatises on agriculture and management of agricultural properties were addressed to elite owners of agricultural property. The production of quality fresh foods for the urban market, such as rearing fowl and fish or keeping honey bees, was also part of villa entrepreneurship.[40] Indeed, production of specialty food was for villas near Rome: Varro reports the lucrative business his aunt had made by selling 5,000 thrushes from the aviary of one of her villas, on the occasion of a triumphal banquet held in the capital.[41] He recommends production of quality fresh food to his readers as a solution to generate some income from villas with little land or land unsuitable for crops. For instance, the owner of a maritime villa on a rocky island could rear peacocks, which were saleable as a delicacy to be served at banquets.[42]

Fish farming is discussed at some length in these works; Columella even gives technical specifications on how to build marine fishponds and which kinds of fish are best to keep in them.[43] He assumes that the villa owner is not merely showing off to his friends and guests or just assuring a ready supply of fancy fish for his own table: instead, he recommends raising ". . . fish from rocky bottoms which command a high price. For it is not worth to catch, much less to feed [raise], any kind of fish which is cheap."[44] He goes on to comment that "unless the fish is fattened with food provided by its owner, when it is brought to market, the fish by its leanness shows that is has not been caught in the open sea but comes from a place of confinement, and because of this a large sum is subtracted from the price."[45]

Earlier, and in contrast to Columella, Varro saw marine fish farming as nothing more than an expensive endeavor that brings no gains. He makes a clear distinction between freshwater fish farming and marine fish farming. In his view, the former was quite common (to be found, he writes, *apud plebem* – "among the common folk") and could be a remunerative activity to pursue on an estate, whereas saltwater farming belonged only to the nobility and "pleased the eyes, but emptied the owner's pockets rather than filling them."[46]

ARE THE DIFFERING VIEWS OF VARRO AND COLUMELLA RECONCILABLE?

This question can be answered by examining the fishponds themselves and their technical characteristics. Marine fishponds associated with villas are known archaeologically, particularly along the Tyrrhenian coast of Italy, and on other coasts of the Mediterranean from Spain to Egypt. These were complex structures, partly built by cutting the natural rock shelf, partly by erecting walls using hydraulic concrete. The fishponds featured several interconnected tanks, each equipped with openings regulated by sluices to let water in, and elaborate geometric designs (Figure 8.2). The seaward wall presented several openings to let new seawater in with the tidal swell. Whereas having several tanks was

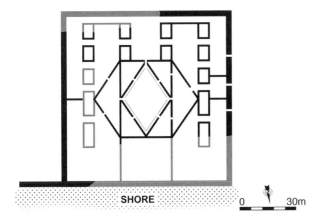

Figure 8.2. Formia, Villa Comunale: plan of fishpond offering an example of elaborate geometric design (A. Marzano after Aurigemma and De Santis 1955).

a practical need for fish farming, in order to keep fish at different stages of growth and various species separated, the creation of a complex geometric pattern by alternating tanks in the shape of lozenges, circles, or rectangles had a purely aesthetic purpose. Varro had compared such fishponds with a painter's color box: "For just as Pausias and the other painters . . . have large boxes with compartments for keeping their pigments of different colors, so these people have ponds with compartments for keeping the kinds of fish separate."[47]

In this respect, Varro was right in writing that fishponds "pleased the eyes" – they were part of the architectural display of the villa, and their artful arrangement was meant to be appreciated from above. Although in some cases the only surviving traces of the once-opulent maritime villas are the fishponds themselves,[48] better-preserved sites indicate that terraces, promenades, or pavilions overlooked the fishponds. The maritime villa of Torre Astura, which features the largest known Roman fishpond (c.15,000 m²; Figure 8.3), had an artificial island with a large pavilion in its midst, possibly used for summer banquets.[49] A similar arrangement can be seen in Tiberius' villa at Sperlonga, where a pavilion for *al fresco* banquets looked onto the fishpond and faced the complex sculptural display atmospherically placed in the middle of the circular pond and in the grotto behind it.[50]

In addition to elaborate displays of ponds in geometric patterns and sculpture, architectural decoration could complete the design of the fishponds. The fishpond of La Saracca had a very original design with this charming feature: a *faux* portico on top of the seaward wall of the fishpond in the form of a low concrete wall with reticulate facing decorated with small protruding pilasters ending with attached brick columns (Figure 8.4).[51] The columns were once covered in white stucco in imitation of marble. This miniature portico had a purely decorative purpose and was meant to be seen from above by the occupiers of the villa: It looked toward the interior of the fishpond facing the villa, which was erected on an artificial platform high above.[52] The effect was picturesque and enchanting.

Figure 8.3. Astura, Torre Astura: the large fishpond and harbor. The structures of the villa proper were to the north of the fishpond and are not shown on the plan. a) location of pavilion overlooking onto the fishpond; b) aqueduct feeding the fishpond with fresh water. (A Marzano, after Piccarreta 1977).

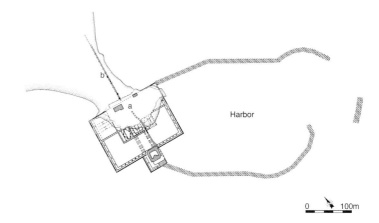

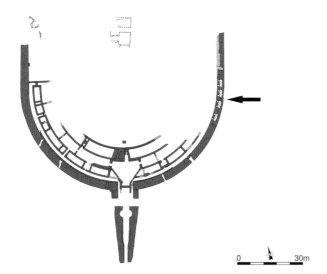

Figure 8.4. Astura, La Saracca: the semicircular fishpond; the arrow indicates the traces of the faux portico on top of the seaward wall of the fishpond (A. Marzano, after Higginbotham 1997).

However, Roman marine fishponds were not simply decorative: They incorporated a level of ingenuity and some technical solutions aimed at improving the efficiency of the enterprise. Tides in the Tyrrhenian Sea (and in the Mediterranean in general) are small in amplitude (on average c.20 cm), with the result that tidal swell itself could not completely refresh the saltwater in the tanks.[53] Fish in confined environments have two conditions for viability: proper oxygenation of the water (hence the importance of reliable water renewal), and removal of the waste produced by the fish themselves (ammonia, feces, etc.) to prevent suffocation. Freshwater fish

accommodate low oxygen levels, but marine fish are extremely susceptible to variations in the oxygenation of their water. In order to keep large quantities of fish in these marine fishponds, Roman pisciculturists added freshwater channels to their saltwater basins for the needed oxygenation that would not be supplied by the low tidal flows. The water in these fishponds was thus a mixture of seawater and freshwater: Freshwater, with its higher proportion of oxygen, offset the low oxygen of marine water, and its admixture helped to flush fish waste from the basins.[54]

The results of such simple expedients – mixing freshwater with saltwater in basins to raise marine fish – was staggering, as recent research has shown.[55] A fishpond like the one belonging to the villa of Punta della Vipera (Figure 8.5), mentioned above, which measured 1,310 m², could sustain only c.216 kg of fish if the water exchange was provided exclusively by the channels communicating with the open sea. However, with the use of a freshwater channel continuously flowing, the amount of sustainable fish in this same fishpond increased to 2,096 kg, some ten times the amount![56] Taking into account that, on average, these marine fishponds were of considerable size, measuring between 800 and 1,400 m², and that there are also examples of much larger fishponds, such as the one at Torre Astura (c.15,000 m²), it is easy to see that a simple technology of freshwater and saltwater mixing, no matter how difficult it might have been practically, offered a considerable increase in productivity and

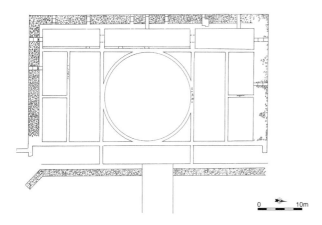

Figure 8.5. Santa Marinella, Punta della Vipera: the fishpond part of the maritime villa. (A. Marzano, after Schmiedt 1972).

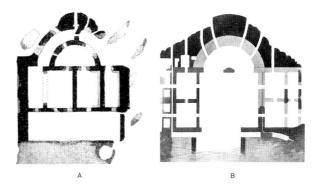

Figure 8.6. A: fishpond recorded in Nettuno, Italy; B: fishpond recorded on the Abukir Peninsula, Egypt. (A. Marzano, after Jacono 1924 and Breccia 1926).

harvest of fish, making any investment commercially profitable well beyond the internal needs of the villa and its inhabitants.

In the same way that villas could produce peacocks and wild boars for the urban banquets of the wealthy, so maritime villas provided fresh fish if they were located not too far from town. Geographic location was important, as the fish must have been transported alive in water butts or on boats equipped with tanks.[57] Since Rome was the major center requiring abundant luxury fresh food, it is not by chance that most of the fishponds known are to be found on the coast to the immediate north and south of the mouth of the Tiber.

The other region that featured many marine fishponds in antiquity was the Bay of Naples, which was as densely populated in Roman times as now. Therefore, when Columella advised his readers – namely members of the elite classes who farmed for profit – to choose fish for cultivation that fetched high prices on the market, or to take care in feeding them properly in winter so that, when brought to market, buyers would be fooled into thinking them wild rather than farmed, he was commenting on something that members of the elite did *for profit*, although it was a type of venture that required considerable capital outlay and risk. In order to build fishponds for viable and profitable pisciculture, specialized engineers and workmanship were needed.

In planning the outlay for the basins, it was necessary to consider prevalent sea currents and winds in order to choose the best orientation and minimize silting, besides many other considerations. It is possible that, as in the case of harbor structures, specialized engineers voyaged around the Mediterranean to offer their expertise for such projects.[58] Consultants, then as now, traveled, communicated, and copied readily: There are remarkable similarities in design between a fishpond recorded in Nettuno, in Lazio on the west coast of Italy, and one seen and recorded on the Abukir Peninsula in Egypt (Figure 8.6).[59] Once operational, fishponds needed daily attention, not only to feed the fish but also to operate the sluices at set times. Because large fish weighing 1 kg or more were appreciated in antiquity, waiting some time for the fish to grow was necessary, even 2–3 years, if the initial stocking of the pond was by juveniles weighing c.100 g. The anecdotes about villa owners keeping well-stocked fishponds in which they invested money but then sending the servants to buy fresh fish for their dinner at urban markets, as in the case of the famous orator Quintus Hortensius,[60] or about emotional attachments to fish that were kept for years, were not simply cases of irrational elite behavior but rested on the canniness of owners allowing their stock to reach a desirable size before consuming or selling it.

Marine fish farming attested at seaside villas was thus a form of production and was pursued as an investment, but it was an investment only the rich could afford: The capital outlay in building and

maintaining the structures was great.[61] Varro had his reasons to say about marine fishponds that "they are built at great cost, they are stocked at great cost, and they are kept up at great cost,"[62] but these structures were not simply a status symbol or an element of the competitive display of the upper class; they were also meant to generate revenue, as Columella clearly tells us. The difference between Varro and Columella is not about the morality of pisciculture. Rather, it is about the advisability of capital outlay: Varro was thinking short term and warning his readers about the initial expense, whereas Columella was thinking long term and was sanguine about the initial investment in view of eventual profits from it.

FISH SAUCES, SALTING, AND THE ECOLOGY OF FISH STOCKS

Most Roman recipes included *garum*, a fish sauce: a taste that may strike the modern eater as bizarre and unappetizing. *Garum* was a sauce obtained by fermentation and autolysis using salt and fish intestines (which contain the necessary enzymes to start the autolysis [enzyme decay] once exposed to sunlight); it is often imagined as a smelly substance made of rotten fish. In fact, properly manufactured *garum* was like modern fish sauces used in Asian cuisine: a clear, yellow-colored liquid with a salty and vaguely fishy taste, widely used in Roman cuisine at all social levels as seasoning in place of salt.[63] It was a byproduct of a more important food processing activity: the salting of fish flesh, made necessary when large quantities of fish can be caught only in short periods of time, as in the case of open-water migratory fish such as tuna, mackerel, or sardines passing through coastal locations on their way to spawning grounds. The catch of these fish required then, as now, preserving the flesh for later consumption and distribution elsewhere. Before the advent of refrigeration or modern canning industries, fish, as well as mammals' meat, were preserved in three basic ways: by drying, smoking, or salting.

Salting of fish flesh had been widespread as a method around the Mediterranean and practiced by Greeks and Phoenicians, but in the Mediterranean-wide Roman economy, the activity has become much more visible archaeologically. Impressive batteries of masonry-built salting vats replaced small workshops, and their number, geographical frequency, and size grew to almost factory-like scale. Often agglomerations of salting establishments were located on the outskirts of towns and cities, as at ancient Gades (Cadiz), but there are also examples of maritime villas with salting facilities on their estates. One such site is Cotta in Morocco, a few kilometers south of Cap Spartel, in a location in full view of the sea at the western entrance to the Strait of Gibraltar. A villa, a temple, baths, an olive press, and a large fish-salting complex (a rectangular building measuring 2,240 m²) were built in this promising location.[64] The building for fish salting has been better recorded than the other structures: It featured several salting vats placed on three sides of a courtyard, extensive storerooms, and a tower possibly used as a scouting post to alert fishermen when schools of migratory fish were approaching (Figure 8.7).[65] The proximity of this purpose-built fish-salting facility to the villa establishes a productive relationship between them.

Several other fish-salting facilities that appear to have been part of maritime villas have been identified in a coastal field survey in Tunisia.[66] Indeed, judging from the popularity that fishing scenes and depictions of the sea full of all kinds of fish and crustaceans have in Roman mosaics from North Africa,[67] it has been suggested that these scenes, while evoking and celebrating a general idea of abundance, might have also alluded to the source of wealth of those that commissioned them.[68] Mosaics with fishing scenes or with the theme of the "bountiful sea" are common in the coastal area around Hadrumentum and in the regions of Carthage and Utica which are known, on the basis of archaeological evidence, to have manufactured and exported salted fish and fish sauces.[69]

The connection between maritime villas and large-scale fishing for commercial purposes is also suggested by an intriguing passage in the *Digest*, a compendium of Roman law compiled by Justinian in the sixth century CE from works of

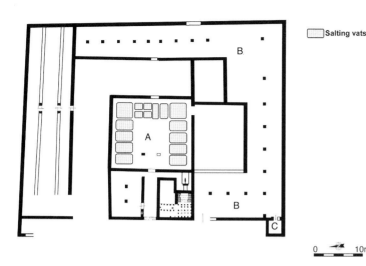

Figure 8.7. Cotta, Morocco: the fish-salting establishment part of a maritime villa estate: A) courtyard with salting vats; B) storerooms; C) tower. (A. Marzano, after Ponsich and Tarradell 1955).

earlier Roman jurists. The passage in question, attributed to Ulpian (third century CE), deals with the sale of one of two adjacent North African maritime estates. The sale contract had a special clause: The seller, who was retaining for himself one of the properties, prohibited the buyer of the other (and any of its future owners) *from fishing for tuna*.[70] The clause is unusual in that it contravenes the principle that the sea and access to it for fishing are common to all human beings, like air for breath.[71] The oddity of this clause has been interpreted by modern scholars in modern ways: Assuming that maritime villas were exclusively used for leisure retreats, it follows that the seller, motivated by the "quiet enjoyment" principle of property, wished to preserve his peace by preventing the noise and commotion connected to tuna-fishing operations on the villa estate adjacent to his.

In fact, the purpose of this special clause is quite different and entirely rational: to prevent competition for the same natural resource, namely the open-water seasonal passage of tuna. To allow for adequate catches and to justify the investment of equipment and personnel, it was necessary to leave a minimum distance between tuna fishing installations. The prohibition inserted in the sell-contract indicates clearly that the main economic activity on the estate the seller was keeping for himself was *already* tuna fishing, and, presumably, fish salting.[72] In addition, Roman methods of open-sea fishing required open beaches as part of villa estates:

The fish were caught in long seines launched from boats and then trawled ashore for slaughter and processing.[73] The seller, by prohibiting the buyer from tuna fishing, was not placing a (legally impossible) easement on the sea but rather on the use of the shore as well as prohibiting exploitation of the tuna migration at a fishing station too close to his own fishing installation for viable use.[74] In this region, several maritime villas are known, and there is evidence for fish salting activity in the Roman period.[75]

Commercially viable fishing and fish processing operations on a maritime estate in Roman times depended on a location favorable to large-scale fishing and on the availability of large quantities of salt, amphorae for packing the product, and commercial transport networks for its distribution. Favorable fishing locations were often those coastal zones between sea and coastal lagoons, which in antiquity characterized a large portion of the Mediterranean coastline.[76] These were, and still are, good fishing grounds, because many species of marine fish spend part of their life in the sheltered waters of coastal brackish lagoons and then migrate *en masse* back to the sea in winter. Such migrations allow for the capture of large quantities of fish by using traps called weirs.[77] Several Roman villas excavated along the coast of Provence and Languedoc were built at the interface between sea and lagoon to exploit the lagoons for fishing and oyster farming, and these coastal environments were also suited for salt production.[78] The most important salt pans of

antiquity were located in areas with wetland and coastal lagoons, as in the case of the salt pans of Rome at the mouth of the Tiber.[79] Salt pans could be part of maritime villa estates, as mentioned by Rutilius Namatianus in his poem *De reditu suo*, in which he gives an account of his sea journey from Rome to Gaul in 416 CE. He mentions the Tuscan villa of his friend Albinus Caecina at Vada Volterrana, which had salt pans, and he also describes some of the salt making process.[80]

There were other natural resources to be found in wetlands, and these could be of importance even to the running of a villa estate that also engaged in "traditional" agricultural production. For instance, reeds and brushwood that grow in marshy areas had many uses, most notably to prop up vines and, in the case of flexible reeds, to make baskets.[81] The importance of reeds in connection to viticulture is emphasized by Columella, who also comments that having to buy reeds outside of the estate was expensive and a nuisance.[82] In his view, possessing adequate reed beds to be used as vine props was important for a financially viable vineyard, so wetlands with reed beds could be an important part of villa estates. An inscription from the ancient town of Hypaipa, to the north of the Caystros River in Lydia (modern Turkey), records an act of foundation involving two vineyards, one deeded to the city, the other to a group of professional associations. In addition to the vineyards, reed beds are mentioned, to be divided equally between the two vineyards and used for props.[83] The overseer of these vineyards was in charge of the vines but also of planting new reeds, so that the necessary material would not be lacking in the future.[84]

CONCLUSIONS

Roman maritime villas were normally luxurious buildings, planned with great attention so that the various parts of the building offered the best scenic views and presented an impressive architectural display that could be appreciated by those residing in the villas and those passing them by sea. They were seats of leisure for the elite, and for this reason they

became almost synonymous with conspicuous consumption and the immoral excesses of the wealthy, particularly those located in very popular areas such as Baiae on the Bay of Naples. This is the image most prevalent in Latin literary writings about maritime villas and has been the image presented in modern studies as well. In part, this view of the foolish and oppressive extravagance of maritime villas has been the result of partial investigation prioritizing their luxurious residential quarters. The more recent view is quite different: maritime villas could, indeed, be very luxurious, but they also had estates attached to them supporting traditional agriculture and secondary agricultural processing that characterized inland villas. Fertile land on coastal locations that allowed for the shipment of agricultural produce by sea and for the development of a pleasing residence is best exemplified by some maritime villas of southern France and the spectacular villas of Istria, such as the villas of Barbariga and Verige Bay.[85]

There were other advantages to coastal locations: pisciculture, fishing, and their secondary activities. Almost all of the large maritime villas known along the Tyrrhenian coast of Italy were equipped with large elaborate fishponds, often with technical devices for supplying oxygen and assuring waste evacuation for the cultivation of marine fish. Such fish were appreciated for personal consumption and had real value on the commercial market in food. The fishpond structures were part of the general architectural display of the villa, and their design was carefully planned in order to please the eye, but they were also a very peculiar form of capital investment available only to the rich: fish farming of sought-after marine fish which could be sold fresh to other wealthy Romans in Rome for their frequent banquets or private delectation. Fishing and fish salting could also be activities practiced on maritime villas estates for commercial purposes, particularly those located in the path of the seasonal open-sea migrations of fish. Evidence for fish salting in villas is known for southern Spain, Gaul, and North Africa, areas from where we know, on the basis of amphora studies, that salted fish and fish sauces were exported to various regions of the Roman Empire. Sicily was another region where important tuna fishing and

salting activity occurred in antiquity (as it did and does in modern times),[86] and it is possible that, as for the maritime villas of North Africa, the Sicilian fish-salting installations were part of maritime villas. Future archaeological projects will hopefully extend our knowledge of Roman villas in Sicily, but for now one conclusion is clear: rarely were Roman maritime villas a place for consumption only – they were part of the composite landscape of production as much as the rural villas were.

NOTES

1. On the architectural development of maritime villas, see Lafon 1981b and 2001 and, for an overview, Marzano 2007, 13–46. Although literary sources refer to the existence of maritime villas as early as the second century BCE, archaeological evidence for these early establishments is scant. Villa Prato near Sperlonga is one of the few excavated maritime villas dated to the second century BCE: It was built on a hill c. 800 m from the modern shoreline (Marzano 2007, 463, with previous bibliography). The idea that early maritime villas had a self-contained architectural typology rests heavily on two passages by Seneca: *Ep.* 51.11 & 86. In the former, Seneca likens the villas built in Baiae by Marius, Pompey, and Caesar to military camps, in the latter he describes Scipio Africanus' villa in Liternum (a maritime colony of Rome in the territory of Cumae founded in 194 BCE) as a fortified, rustic mansion. See also D'Arms 2003, 15–29.
2. Lafon 1981b, 299. Pompey received extraordinary military powers in 67 BCE in order to fight piracy in the Mediterranean (*lex Gabinia* cf. Cicero, *De imperio Cn. Pompei*). Pirate attacks were a serious threat also for coastal towns, as had happened to Ostia, Rome's military and commercial harbor in 67 BCE: pirates took control of the town for several days and managed to destroy Rome's fleet; see De Souza 1999, 133–45.
3. Sen., *Ep.*122.8; see also Pliny the Younger's description of the *triclinium* projecting toward the shore in his Laurentine villa: *Ep.* 3.17.5.

4. D'Arms 2003, with discussion of ancient sources; Howe (Chapter 6) and Zarmakoupi (Chapter 5) in this book.
5. In some cases, villas were separated by much less; see Howe (Chapter 6) in this book.
6. Bowden (Chapter 20) in this book.
7. Marzano 2007, 15–22; 30–1.
8. Val. Max. 8.1 (*Damn.* 7): *crimine nimis sublime extructae villae in Alsiensi agro*; literally the Latin text says "built to an improper height," stressing the monumentality of the architecture.
9. Varro, *Rust.* 1.13.7: *villis pessimo publico aedificatis.*
10. E.g., Cic., *Mur.* 76.
11. On the basis of architectural typology, this villa belongs to the so-called pavilion-villas (i.e., featuring several dispersed nuclei) that were quite common during the second century CE, the ultimate example of which is Hadrian's villa in Tivoli. On Marina di S. Nicola, see Lafon 1990 and 2001, 262–4; Caruso 1995.
12. Caruso 1995, 293; Marzano 2007, 182. Lafon (2001, 263) also noted that the production quarters of the villa were in close proximity to the villa's own port, built on an internal canal communicating with the sea, and that this was intended to facilitate the shipping of goods.
13. Papi 1999, 714.
14. Palmer 1980 on custom boundaries in Rome; exemption for goods for personal use: *Dig.* 33.9.4.2–6.
15. E.g., *CIL* 6.8594.
16. See Buffat (Chapter 13) in this book.
17. Brun 2004, 37; Arnaud 2004.
18. In antiquity, products such as wine, oil, fish sauces, and salted fish were packed in two-handle terracotta containers with a pointy foot (amphorae) when meant to be transported by sea or, in the case of flat-bottomed amphorae, on river barges. For distribution by land routes, barrels and, above all, skins were used, which were more efficient in terms of the ratio between weight of container/weight of content, and more practical when using pack animals. On the use of barrels and skins, see Marlière 2002.
19. Rome at this time was a true mega-city, and it remained so in comparison to later historical periods: London in the early nineteenth century counted *c.*900,000 inhabitants, while Paris had *c.*550,000. On feeding such a metropolis: Mattingly and Aldrete 2000.

20. Tchernia 1983; Purcell 1985. A well-known example is the case of the many wine amphorae stamped *SES* discovered in shipwrecks off the coast of southern Gaul (e.g., the Madrague de Giens wreck) and at Gaulish sites on land, connected to the senatorial family of the Sestii and to properties they owned near Cosa, including, in all likelihood, the villa of Settefinestre, equipped with three wine presses: Manacorda 1981; Carandini and Filippi (eds.) 1985.

21. Diod. Sic. 5.26.3.

22. Brun 2005, 7–67, also Buffat (Chapter 13) in this book; for a similar connection between spread of commercial viticulture and Roman presence in the Iberian Peninsula, see Brun 2004, 261–78. On trends in capital investment in agricultural facilities in the region, see Marzano 2013c.

23. Brun 2004: 25.

24. Cato, *Agr.* 16 and 38 advises on the building of a lime kiln and of the terms of contract for burning lime on shares.

25. Varro, *Rust.* 1.2.22 reporting the opinion found in a (lost) first-century BCE treatise on agriculture by the father and son team of the Saserna, who discussed the management of clay beds as part of agriculture. Pottery kilns were rather common on villa estates – amphorae and *dolia* to transport or store agricultural produce were needed – and it is at times difficult to discern when production was directed at internal consumption and when it was meant for an external commercial market. Similar considerations apply to the production of bricks and tiles: see Gualtieri 2000.

26. Diod. Sic. 5.13.1–14.3.1.

27. Strabo 5.2.6.

28. The remains of this villa are poorly preserved and only seven rooms on Terrace 4 have been investigated; it appears that two of the terraces were probably occupied by gardens: Pancrazzi and Ducci 1996.

29. Pancrazzi and Ducci 1996.

30. The ancient remains have been severely disturbed also by illegal modern building in the area as well as natural erosion. The excavations carried out from 2001 have been very scantily published: Marzano 2007, 589. For the sulfur deposits: Quilici and Quilici Gigli 1984.

31. Recent research work has stressed how elite residences in towns and cities were often interspersed with artisanal activities that generate unpleasant odors, such as fish salting or tanning; constant exposure to a wide range of smells caused different olfactory sensibilities: Bartosiewicz 2003.

32. Greene 1986, 17–43.

33. Suet., *Tib.* 34.1; Plin., *HN* 9.31.

34. Cic., *Att.* 1.19.6; 2.9.1.

35. Plin., *HN* 9.172: Q. Hortensius Hortalus shed tears for the death of his favored moray eel; ibid. for a *muraena* (probably here the terms indicates a conger eel) decorated with earrings by Antonia, wife of Drusus. Higginbotham 1997, 43–5, for the flexibility of the Latin term *muraena*.

36. According to Velleius Paterculus (2.33.4), it was Pompey the Great who had called Lucullus "Xerxes of the toga." This definition implied hubristic behavior on the part of Lucullus: as the Persian king Xerxes had defied nature by building a bridge with ships over the Hellespont when invading Greece, so did Lucullus defy nature by cutting a tunnel that would let the "sea in the land."

37. Varro, *Rust.* 3.17.9.

38. Plin., *HN* 9.170.

39. For a study of the technical specifications of these fishponds and a gazetteer, see Giacopini et al. 1994; Higginbotham 1997. A possible early example of fishpond representing a "prototype" between freshwater fishponds and marine ones is the structure excavated by Amanda Claridge (2007) at Castel Porziano, near Ostia: see discussion in Marzano 2013a, 210–26.

40. These matters are the subject of book 3 of Varro's *De Re Rustica*.

41. Varro, *Rust.* 3.2.16.

42. Varro, *Rust.* 3.6.

43. Columella, *Rust.* 8.16–17; he concedes that the subject may appear most alien in a treatise on agriculture but that it can be a remunerative activity for maritime villas.

44. Columella, *Rust.* 8.17.8.

45. Columella, *Rust.* 8.17.15.

46. Varro, *Rust.* 3.17.2.

47. Varro, *Rust.* 3.17.4.

48. Modern sea-level in the Tyrrhenian is c. 1.20 m higher than the sea level of Roman times: Schmiedt 1972; Anzidei et al. 2004.

49. Piccarreta 1977.

50. This is believed to be the villa mentioned by Tacitus regarding a life-threatening accident that occurred while Tiberius was dining in a grotto at his villa called *ad speluncam* ("by the grotto"). The villa is famous for the sculptural groups here discovered, believed to be original Hellenistic works, all relating to the story of Ulysses and his deeds (e.g., the blinding

of Polyphemus, Scylla): Andreae and Parisi Presicce 1996; Cassieri 2000. For recent investigations of the Sperlonga fishpond see Pesando and Stefanile 2016.

51. The mini-portico is preserved only on the east side of the fishpond; at a later stage, the openings between the pilasters were walled off: Marzano 2007, 279.

52. Piccarreta 1977.

53. On Roman awareness of the importance of the cycle of sea tides in relation to the functioning of the fishponds, see Varro, *Rust.* 3.17.

54. Oxygen content in the water is inversely proportional to salinity, so that freshwater has more oxygen than seawater. In documented examples of fishponds, the channel was fed directly by an aqueduct or by cisterns; there are also cases of fishponds using a nearby freshwater spring.

55. Marzano and Brizzi 2009.

56. These are approximate and notional calculations that make a series of assumptions about the depth of the fishpond (unknown because the tanks are full of debris) and hence the volume, the amount of freshwater discharge/minute, and type of freshwater, as there is a difference in oxygen content between springs, water kept in cisterns, etc. For a full discussion of these technical aspects, see Marzano and Brizzi 2009.

57. For boats equipped with tanks for transport of fish as fresh goods to markets distant from the catch areas or fish-raising basins, there is tantalizing, though fragmentary, archaeological evidence and a few literary references. A small Roman fishing boat with a central rudimentary tank to keep the catch alive was discovered near Fiumicino, Rome's international airport: Testaguzza 1970; Boetto 2006 for a technical study of this boat. Literary sources mention ships equipped with fish tanks, used to transport a kind of fish found along the coast of Asia Minor to Italy: Plin., *HN* 9.39.62; Macrob., *Sat.* 3.16.10. A possible example of a ship so equipped is the Grado wreck, which might have had a water pump to feed a fish tank on deck with new water: Beltrame and Gaddi 2007; *contra* Oleson and Stein 2007; see also Beltrame, Gaddi, and Parizzi 2011.

58. Blackman 2008.

59. Jacono 1924; Breccia 1926.

60. Varro, *Rust.* 3.17.5: "Though our friend Quintus Hortensius had ponds built at great expense near Bauli, I was at his villa often enough to know that it was his custom always to send to Puteoli to buy fish for dinner."

61. There are not sufficient data to allow for a quantification of the cost needed for building fishponds and keeping them operational.

62. Varro, *Rust.* 3.17.2.

63. For a detailed study of *garum*: Curtis 1991.

64. Ponsich 1970: 283–4; Ponsich and Tarradell 1965: 55–7.

65. The important role played by the scouts in the fishing for migratory fish is well attested ethnographically (they either signaled to the fishing crew to start deploying the long, encircling seines, or, in the case of modern fixed tuna traps, the *tonnare*, signaled when tuna had started to enter into the trap). For antiquity there is literary and epigraphic evidence about the existence of tuna-scouting posts and for their rental for the purpose of fishing: Marzano 2013a, 66–79.

66. Slim et al. 2004: Besides traces of salting vats, the presence of architecturally elaborated dwellings was suggested by the surface presence of mosaic *tesserae*, marble fragments, elements pertaining to hypocaust systems, and other elements of elite villas. For Roman villas in North Africa, see Wilson (Chapter 16 in this book).

67. For Roman mosaics Dunbabin 1999; Ghedini 2005; Novello 2007.

68. Ghedini 2005: 126–7; Novello 2007: 37–8.

69. Evidence for fish salting in North Africa is abundant: the amphorae Africana II C, Keay 25, and Keay 35B produced in Neapolis (Nabeul, Tunisia) and probably used for the transport of preserved fish have been found at numerous Roman sites around the Mediterranean. Several Roman fish-salting workshops have been identified in modern Tunisia, and one was excavated at Nabeul: Ghalia, Bonifay, and Capelli 2005; Slim et al. 2004.

70. *Dig.* 8.4.13 pr.

71. On the basis of its oddity, the attribution to Ulpian has been doubted: discussion in Hallebeek 1987; Franciosi 2002; Purpura 2007.

72. The name of the estate being sold, as reported in the *Digest*, is *fundus Botrianus* and probably this property was located in the area of ancient Acholla, where the modern place-name Henchir Botria might preserve the ancient name *Botrianus* from *Botrius*, perhaps the name of one of the villa's owners.

73. The technique was in use in the modern Mediterranean, called in Italian *a vista* and in Spanish *de vista y tiro*; Garcia Vargas and Florido del Corral 2010: 209–10 for an explanation of the this technique

as used by Catalan fishermen in the eighteenth century.

74. Purpura 2008.

75. One of these villas is attributed to the senator M. Asinius Rufinus, who was consul in 184 CE, on the basis of an inscription found at Acholla mentioning his career: *AE* 1954.58; *AE* 1955.122.

76. Major reclamation works that have eliminated many wetlands areas occurred in the late nineteenth and in the twentieth century; for consideration of the ancient environment, Horden and Purcell 2000.

77. For instance, nineteenth-century data for one of the weirs at the mouth of the lagoons of Orbetello gives as 16,400 kg the amount of fish caught in the month of December 1899: Del Rosso 1905, Table B, data for "peschiera" of Nassa.

78. On salt in antiquity: Carusi 2008.

79. Roman historiographic tradition placed the exploitation of these salt pans in monarchical times: Livy 1.33.9; Dion. Hal., *Ant. Rom.* 3.41.3; localization of the exact area where the Iron Age salt works were is difficult, because the course of the Tiber and the coastline have changed repeatedly (Keay et al. 2005; Carusi 2008: 136, with other relevant bibliography). The salt pans are well attested in the Middle Ages, when they were located on the right bank of the Tiber

at Campus Maior, near Portus, and on the left bank at Bordunaria near Ostia.

80. Rut. Namat. 1.475–90.

81. Plin., *HN* 17.173.

82. Columella, *Rust.* 4.30.1: "For if the farmer lacks these [i.e., props and frames], he has no reason for creating vineyards, since all the necessary things for the purpose will have to be sought outside the estate; and, just as Atticus says, not only does the cost of purchase put a burden upon the overseer's accounts, but also the procuring of them is a very great nuisance."

83. Inscription published by Drew-Bear 1980; see also Van Nijf 1997, 67–8.

84. In the context of Greek Asia Minor, the myth of Karpos (the personification of the vine) and Kalamos (the personification of the reed) is a telling mythological etiology of the symbiotic relationships between the vine and the reed: Thonemann 2011, 62.

85. See Bowden (Chapter 20) in this book.

86. Several Roman fish-salting sites have been identified, but unfortunately only one has been partially excavated. It is not clear whether the salting vats identified were part of an "industrial" settlement of several fish-salting workshops or whether the activity took place on a villa estate: Bacci 1984–5a; Basile 1992.

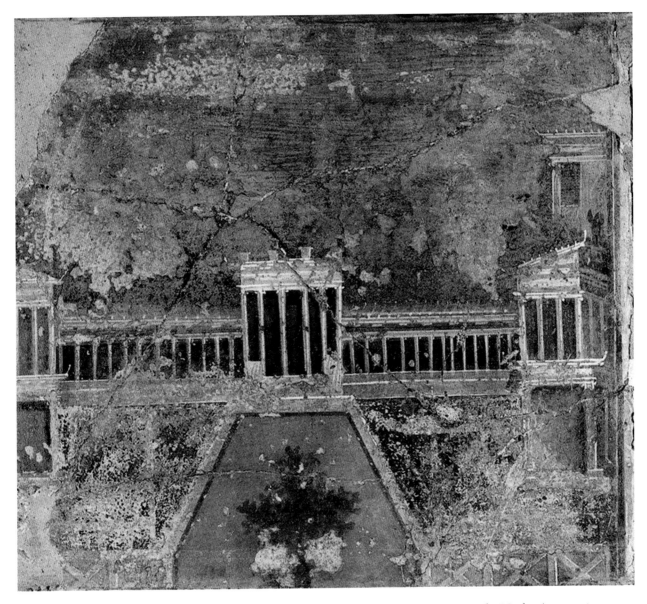

Plate I. Painting of villa from Pompeii, Third Style, 40-45 CE. Museo Archeologico Nazionale, Naples, inv. 9406.

Plate II. Torre Annunziata, Villa A (Oplontis), view of enfilade of windows from *oecus* 74.

Plate III. Torre Annunziata, Villa A (Oplontis), view from the north. The large propylon to the right marks room 21 (photo M. Zarmakoupi).

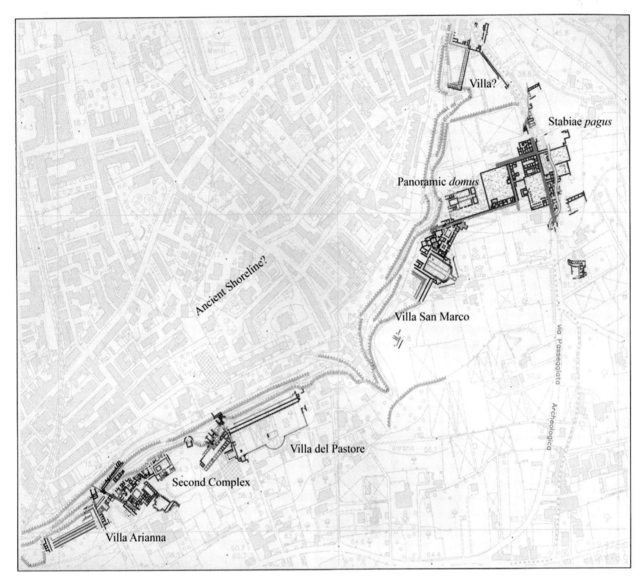

Plate IV. (Color image appears elsewhere in this volume) Stabiae, site plan: Blue: areas currently visible; red: areas excavated in the eighteenth century and currently reburied. (©RAS/Editrice Longobardi/Parco Archeologico di Pompei. From P.G. Guzzo, A.M. Sodo, and G. Bonifacio 2009).

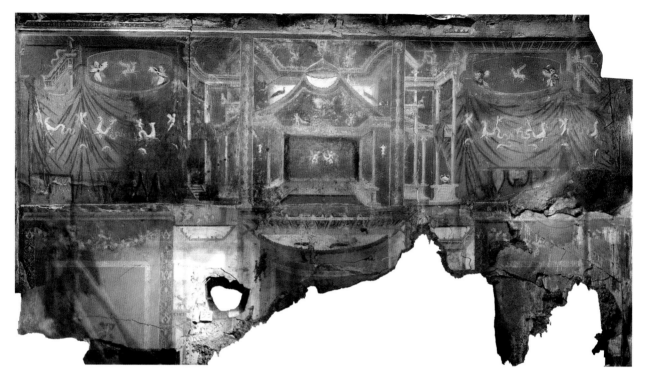

Plate V. Positano, villa, north wall of *triclinium*, composite image (GEOMED).

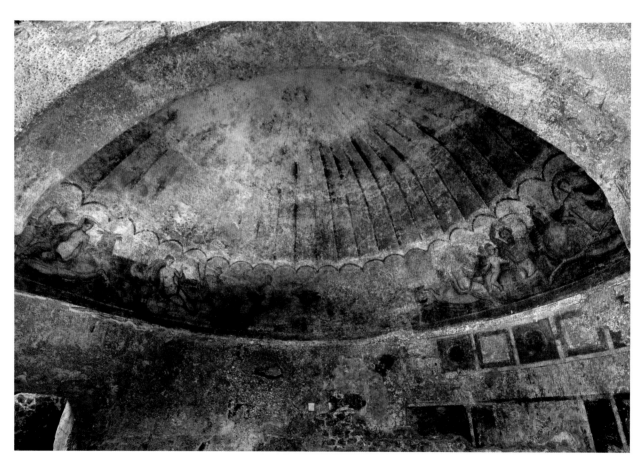

Plate VI. Room 7, painted apse with pavilion decoration and frieze with Nereids and Tritons, view from the east; on the left, upper part of door in the north side of the apse leading to Rooms 9 and 10.

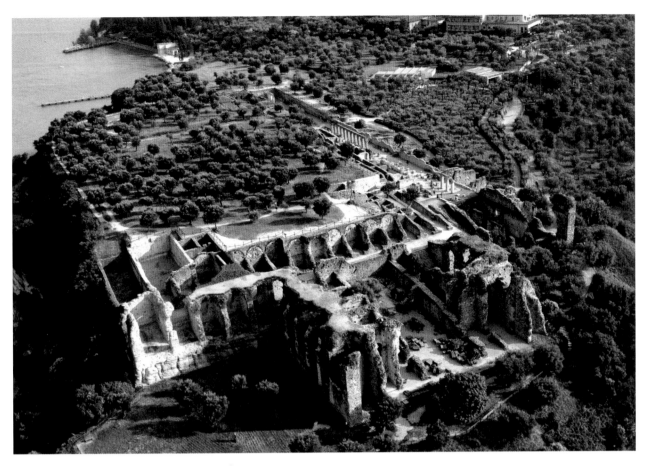

Plate VII. Sirmione (Brescia), "Grotte di Catullo" villa (Roffia 2013).

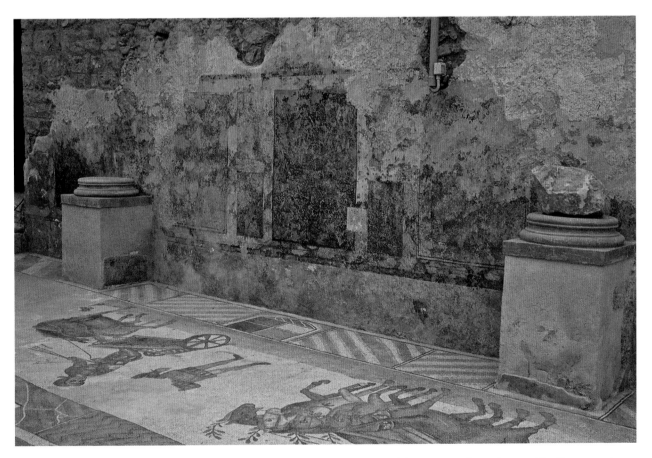

Plate VIII. Casale di Piazza Armerina, wall painting in the *apodyterium* (8) of the West Baths, and part of its floor mosaic showing a scene of a chariot race in the Circus Maximus (photo R.J.A. Wilson).

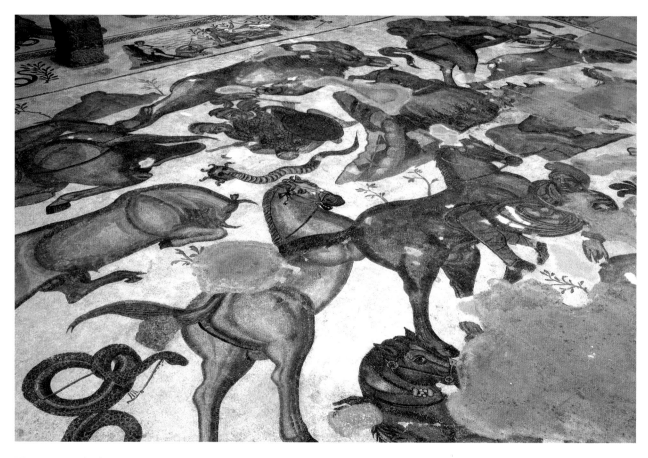

Plate IX. Casale di Piazza Armerina, *triconchos*, detail of the mosaic showing the aftermath of the Labours of Hercules (room 46) (photo R.J.A. Wilson).

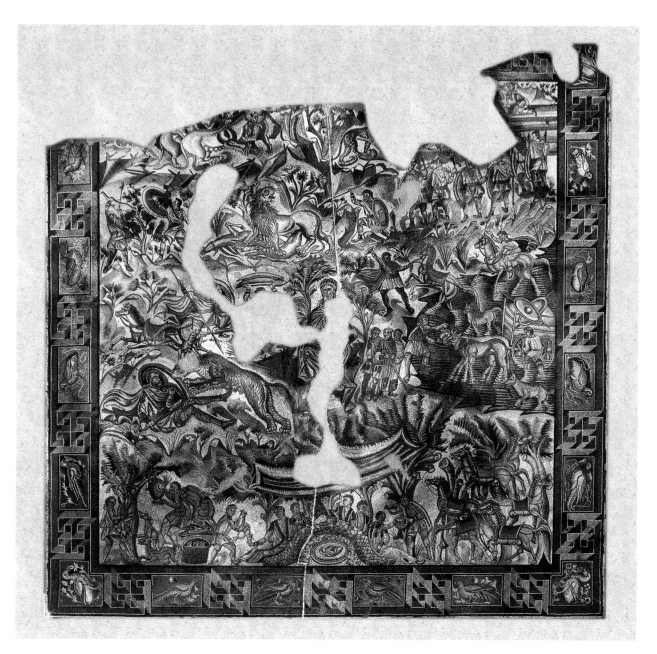

Plate X. Caddeddi on the Tellaro, the Hunt mosaic (room 10). Photo L. Rubino, reproduced by permission of the Regione Sicilia, Assessorato Beni Culturali e Identità Siciliana.

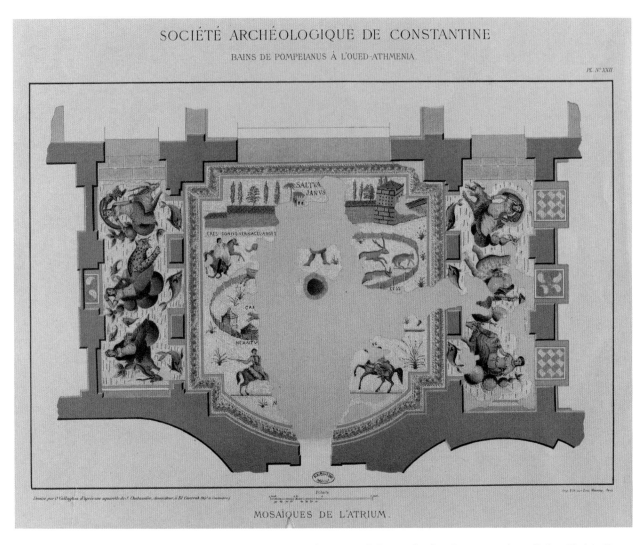

MOSAÏQUES DE L'ATRIUM.

Plate XI. Oued-Athménia, villa, *frigidarium* mosaic, nineteenth-century lithograph after the watercolor of Jules Chabassière (Paris, Bibliothèque nationale).

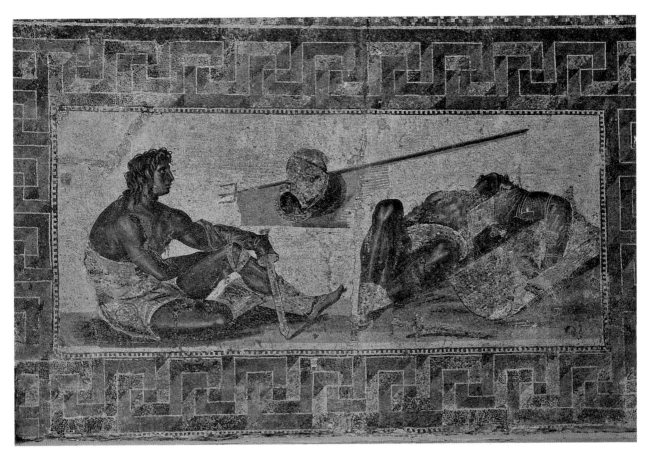

Plate XII. Wadi Lebda (near Lepcis), villa baths: mosaic panel depicting an exhausted gladiator and his dead opponent, c. 200/25 CE (?) (Lepcis Magna, Mosaic Museum: photo R.J.A. Wilson).

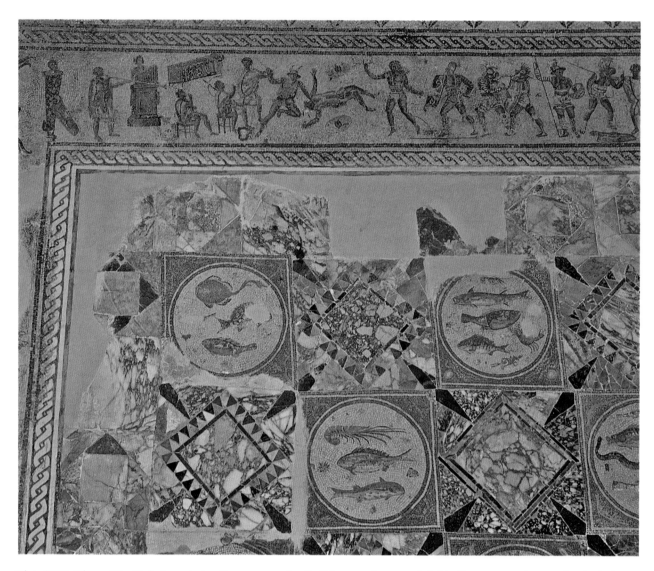

Plate XIII. Zliten (Dar Buk Amméra), villa, room 7, detail of the mosaic: central field of square panels, mosaics depicting fish alternating with *opus sectile* designs; border with mosaic of amphitheater scenes – musicians with their instruments, and gladiatorial contests (Tripoli Museum: photo R.J.A. Wilson).

Plate XIV. Diaporit (Butrint vicinity), Roman villa and Christian complex at Diaporit near Butrint: large apsidal fountain (*nymphaeum*) of the villa (photo W. Bowden).

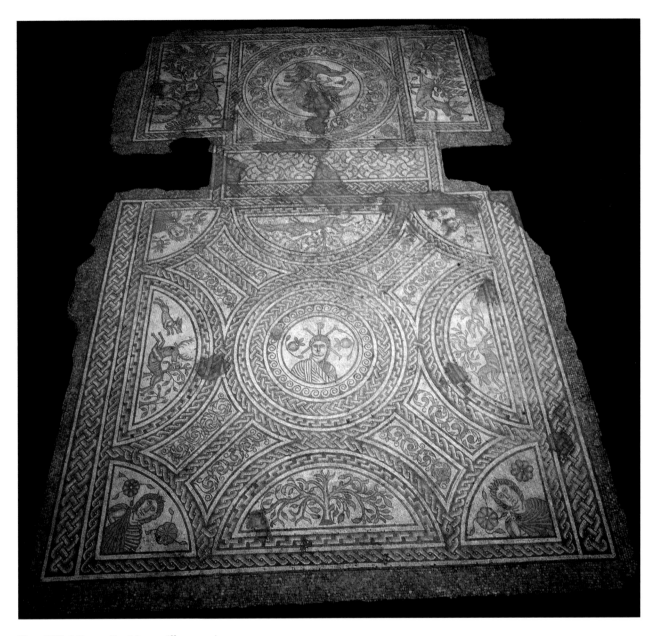

Plate XV. Hinton St. Mary, villa: mosaic.

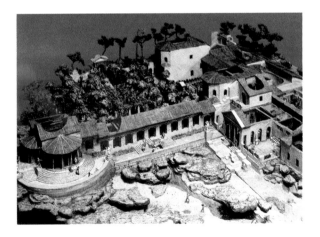

Plate XVI. C. Pember's scale model of Pliny's Laurentine
villa (1947). Ashmolean Museum, Oxford.

9

THE "VILLA OF AUGUSTUS" AT SOMMA VESUVIANA

MASANORI AOYAGI [M.A.] , ANTONIO DE SIMONE [A.DS] ,
AND GIROLAMO F. DE SIMONE [G.F.DS.] [1]

THE NORTH SLOPE OF VESUVIUS AND THE DISCOVERY OF THE SITE

The Bay of Naples evokes images of the Greek colonies at Neapolis and Pithecusae, the luxurious villas of *otium* owned by Roman senators and emperors on the coast, and the busy commercial towns of Pompeii and Herculaneum: these have been the emphases of three centuries of archaeology and scholarship in the Campanian area.[2]

However, excavations at the so-called Villa of Augustus at Somma Vesuviana (Map 3; Figure 9.1) show that this perception of Campania is incomplete because it ignores the Vesuvian hinterland away from the coast, namely the territories of Neapolis and Nola and the north slope of the volcano itself. Ancient authors themselves connected the Bay with its Greek origins and praised the Roman villas,[3] and modern scholars have followed their lead. The result has been that the Campanian interior has seemed unimportant and even somewhat uninhabited except for the relatively few villae rusticae in the environs of Pompeii and other coastal towns.[4]

The Villa "of Augustus" is located in the town of Somma Vesuviana, in an area called Starza della Regina. In antiquity, this land was in the western part of the territory of Nola, almost at the border with the territory of Neapolis.[5] The villa was

discovered in the 1890s during the course of agricultural works.[6] The upper part of an arch built in *opus caementicium* stood in the way of development of the estate, and the owner unsuccessfully attempted to destroy it with dynamite before abandoning the task. A second "discovery" occurred in 1929 and some intermittent small-scale work in 1932; a narrow trench was opened along the east wall of Room 1, and some exploratory tunnels between the pillars supporting the arch were dug (Figure 9.1).[7] This first attempt at uncovering the villa was abandoned in 1935, though in that year, analysis of the fill of volcanic material that covered the structures was undertaken; understandably, the deposit was attributed to the volcanic eruption of 79 CE.[8] However, our excavations have shown that, far from being destroyed with the towns and villas of the Bay, the villa "of Augustus" endured and flourished for several centuries – its life ended by a volcanic event in 472 CE.

Even in their partially excavated state, the tall brick wall and bases of double pillars arranged in pairs seemed unusually monumental in comparison to the far less massive construction of luxury villas of the Bay.[9] This led the excavators – the local Inspector Matteo Della Corte among them – to think that the building was not a "normal" villa but must have had some kind of public character. Because Latin literary

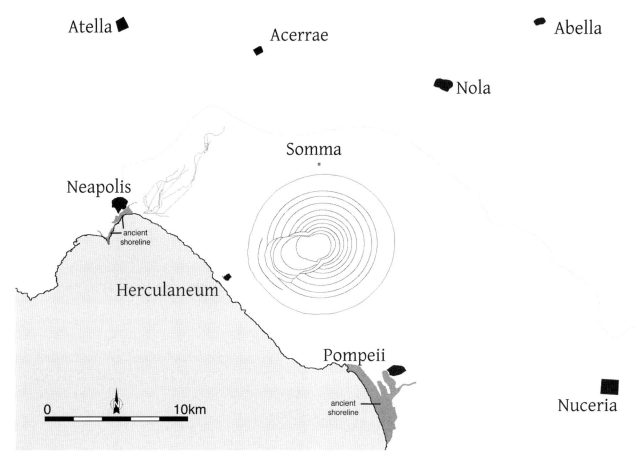

Map 3. Ancient southern Campania showing ancient cities and coastline, and an outline of Vesuvius before 79 CE. (G. F. De Simone.)

Figure 9.1. Somma Vesuviana, Villa "of Augustus," plan of site updated to October 2010 (plan: K. Iwaki, K. Sugiyama, S. Matsuyama).

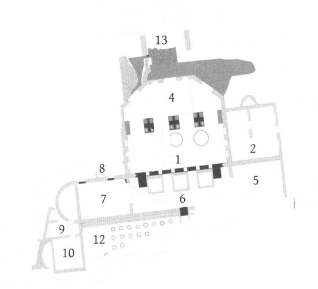

sources indicated that the Octavii, the ennobled plebeian *gens* to which Augustus originally belonged, had a villa in the territory of Nola, Della Corte suggested that the villa was that in which the emperor had come to die, and that the structure had been monumentalized on a grand scale after the cult of the divinized emperor was established.[10]

Della Corte's connection of the Somma Vesuviana villa with Augustus was eagerly taken up because it coincided with a reverence, in Fascist propaganda, for the Roman emperor's new empire and, by association, that of Mussolini. Copies of the famous statue of Augustus from Prima Porta were erected in all major urban centers of Italy, including Nola.[11] For the bi-millenary celebration of the birth of Augustus in 63 BCE, the *Mostra Augustea della Romanità* of 1937 was in preparation with particular emphasis on Augustus, and the possibility that the structure discovered in the territory of Nola might be the villa where the first emperor died was a stimulus to continue the investigations and an occasion of great civic pride. The local office of the Fascist party, the *Casa del Fascio di Somma Vesuviana*, prepared a letter addressed to the Duce himself requesting funds to continue the excavation.

The municipality's letter never reached its destination. It was intercepted by the regional *Soprintendente* himself, the redoubtable Amedeo Maiuri. In some respects, Maiuri supported Della Corte's work and the initiatives taken by the municipality, but he was playing a double game. Behind the scenes, he did all he could to hamper support for continuing the excavations at Somma Vesuviana because he was concerned that they would divert government interest and money from his own excavations at Herculaneum. His letter of March 21, 1935 is a model of bureaucratic and policy argumentation.[12] It goes without saying that excavations at Somma Vesuviana did not continue after 1935.

Excavations of the Villa "of Augustus" resumed in 2002 with an Italian project funded by the University of Tokyo; an area measuring c. 1,300 m^2 has been uncovered so far. Excavation at this site is difficult: The floors of the original structure are some

10 m below modern ground level, 5 m of which are volcanoclastic deposits from the eruption of Vesuvius in 472 CE, called the eruption of Pollena, with further deposits in the sixth century.[13]

The structures unearthed consist of a large open-air area to the south (Area 13) and nine rooms distributed on three terraces (Figures 9.1 and 9.2).[14] They are preserved as they were before their destruction in the fifth century, by which time the lavishly decorated rooms had been converted into productive units, so the archaeological snapshot shows the coexistence of the earlier construction and its decoration (wall paintings, mosaic floors, and statues) with the later utilitarian and agricultural features (wine cellar, ovens). In any case, the rooms so far uncovered represent a small sector – probably the grand entrance rooms in their reused state – of what had been a much larger architectural complex.

The most monumental and earliest remains on the three terraces appear to be those of the upper terrace (Area 13 and Room 1/4); they are datable to the second century CE. Architecturally and decoratively, Room 4 was the goal and culmination of a passage from the intermediate terrace; its doors led southward to a downward-sloping open space, Area 13, with a richly decorated arched doorway on axis at its south end deliberately framing and directing a view to Vesuvius itself (Figure 9.2). Room 1, also magnificently decorated and containing fine statues, gave advance orchestration for Room 4, and a grand

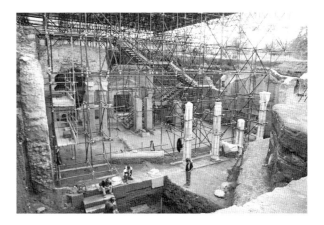

Figure 9.2. Somma Vesuviana, Villa "of Augustus," Panoramic view of the upper terrace from the northeast; north at bottom left corner (October 2005).

apsidal hall (Room 2) was also part of the architectural *ensemble* of the upper terrace.

The formal entrance to the villa was to have been from a cross-axial portico (Room 6) on the intermediate terrace; adjacent to it were reception rooms (Rooms 5 and 7). All the rooms of the intermediate terrace underwent some decorative modifications, but they continued to serve their original purpose, which was to orchestrate and lead to the monumental rooms of the upper terrace.

Later changes throughout the upper and intermediate terraces occurred when the entire complex was converted to utilitarian purposes: a wine-production unit on the lower terrace and other work and production spaces prompted drastic changes of use.[15]

For clarity, the description of the site proceeds room-by-room from the open-air area (Area 13) and the rooms that led to it (Room 1/4) and the formal hall (Room 2) on the upper terrace, then to the rooms of the intermediate terrace, which included the wide entrance portico (Room 6) and other impressive rooms (Rooms 5, 7, 8, 9, and 10). Lastly, the wine cellar on the lower terrace (Room 12) documents the late productive phase of the villa's estate and its modifications in the rooms of the other terraces.

[G.F.DS]

THE UPPER TERRACE

The Open-Air Paved Area (Area 13)

The southernmost portion of the site so far explored is the open-air Area 13 behind the monumental doorway of Room 4; its pavement sloped steeply downward from north to south beginning at the south doors of Room 4 and emphasized Area 13 as an impressive high viewing point in the design of the villa (see p. 151). No functional purpose can be discerned for the sloping pavement and it bore no marks of wear or vehicular traffic: It was not an access to either residential or working areas of the villa. The pavement was constituted of lava slabs (some slabs had been removed before the villa's destruction). On

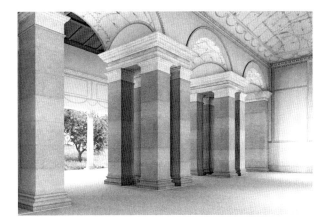

Figure 9.3. Somma Vesuviana, Villa "of Augustus," Reconstruction of the arcade between Rooms 4 and 1, from the northeast; north at bottom left (Author: Altair4).

the east and west sides of Area 13, two parallel, north-south walls made a visual funnel pointing to the south view of the volcano and its lower slopes, marking the coordination of the villa's architecture with the landscape.

Projecting into Area 13, the villa's main hall (Room 1/4) was a large, stately, and beautifully decorated and embellished sequence of spaces, a monumental hub in the design (Figures 9.2; 9.3).[16] It was hexagonal, with the south wall (in Room 4) in three angled sections, each with wide doors and semicircular niches on either side of the central door. The inner (north) wall of Room 4 was magnificently decorated and presents the aspect of an *exedra* preceding and framing Area 13.

Room 1/4 was divided into two parts by a row of three piers set between square wall pilasters on the east and west walls. The freestanding piers were massively built in *opus quadratum* of lava blocks with arches between them (Figures 9.2; 9.3).[17] Their design is unusual: They were composed of four square-sectioned pilasters clustered around square central cores, with capitals in the Tuscan order below white limestone architraves: the effect is one of thick monumental mass. They are set to cross the sightlines toward the three south doors of Room 4, thus enhancing the decorations and views of that room by contrast and surprise. In turn, approaching the piers from Room 1 in the north

gave an asymmetrical view of their massive presence, further screening the approach to Room 4 and contrasting with the lighter, elegant portico in the north wall of Room 1 itself.

Room 4 and Its Decorations

The main space of Room 4 had a vaulted ceiling, parts of which were recovered in the excavations. The room's roof above the vault was flat and accessible in some way because it was lined with a waterproof tile-dust and mortar floor (*cocciopesto*). The three inner sections of the south wall of Room 4 constituting an angular *exedra* had a decorated central doorway framed by niches and giving an axial view out to Area 13, and the doorways on the side walls leading obliquely to the open area were probably also decorated.

The inner side (north-facing) central doorway of Room 4 retains its original painted stucco decoration up to the height of the pediment (Figure 9.4).[18] Its doorposts were pilasters with reeded flutes and Corinthian capitals painted in light blue (the light blue background is pervasive throughout the decoration). The acanthus leaves in the lower part of the capitals frame wine chalices (*kantharoi*) from which tall vegetal stalks grow, forming a kind of bullet-shaped *candelabrum*. From the base of these stalks, vines emerge, ending in volutes with flowers at their

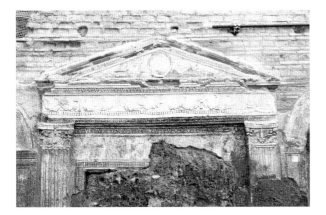

Figure 9.4. Somma Vesuviana, Villa "of Augustus," The central door with Dionysian decoration, south wall of Room 4 (October 2004).

centers. Between the capitals, the upper part of the doorway was decorated with paired clusters of grapes, introducing the imagery of Dionysus, god of wine.

This imagery continued in the entablature and pediment: vines and grapes. The upper part of the entablature's architrave had a molded grapevine garland or festoons, amid which representations in relief of various objects related to Dionysus: the *syrinx* (panpipes, symbol of the god's associate, Pan), the *kantharos* (wine chalice), the *oscillum* (a marble disc generally decorated with Dionysiac themes that was often hung between the columns of peristyles), and the tambourine (symbol of the Maenads, the god's female devotees). Above, the pediment originally had a circular wreath of ivy (damaged or effaced before the eruption of 472) flanked on the left by a basket sacred to Dionysus (*cista mystica*) from which a snake emerges, and on the right by a rudder with a dolphin, symbol of safe journey on the sea and thus introducing a theme of sea travel.

Two semicircular niches framed in molded panels flanked this doorway; their decoration continued the Dionysiac and marine themes (Figure 9.5). Their hemispheres were embellished with shells in three dimensions, and their lower walls were painted with vines and bunches of grapes. Parallels to these decorations can be found in Fourth-Style painting in the Vesuvian area, most usually dated to the mid- and late first century CE.[19]

Room 1 and Its Decorations

The north part of Room 4/1 (Room 1; Figure 9.1) was rectangular; it was entered from, and overlooked, the intermediate terrace to the north (see p. 148). Its north wall was an open colonnade of six monolithic columns in black African marble with white marble bases and Asiatic Corinthian capitals, supporting an architrave of alternating semicircular arches and horizontal epistyles (flat arches).[20] The architrave was built of bricks covered with plaster and painted in vivid colors. The whole colonnade, especially as viewed from Room 6 on the intermediate terrace below, made a rich, colorful introduction to Room 1/4.

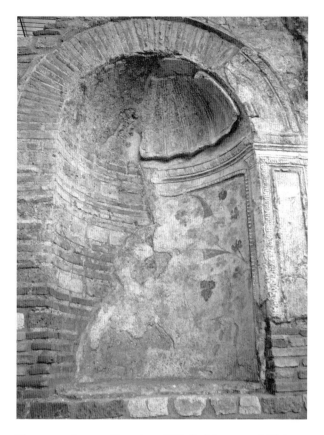

Figure 9.5. Somma Vesuviana, Villa "of Augustus," Niche in the south wall of Room 4, to the left of the central door (fig. 5), painted with vine branches and grapes.

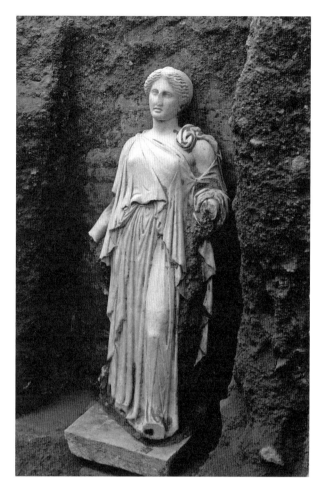

Figure 9.6. Somma Vesuviana, Villa "of Augustus," Marble statue of the *Peplophoros* from the west wall-niche in Room 1, at the time of its discovery.

Both the inner east and west walls of Room 1 had, at an elevation of c. 3 m from the floor, three niches, two square-topped rectangular ones crowned with pediments on either side of arched, hemispherical ones with semicircular floor plans (Figure 9.2, visible at far right). All the niches were plastered and decorated with painted stucco. They were evidently intended to exhibit statues, two of which have been found. In the south niche of the west wall was a *Peplophoros* (a female figure in Greek dress; Figure 9.6); a statue of Dionysus was found in fragments on the floor below the central niche of the east wall (Figure 9.7).[21]

The *Peplophoros* (1.16 m high; Figure 9.6) was found *in situ* in its niche. It was carved from one block of Parian marble except for the forepart of its feet and its arms below the elbow (on the right) and the wrist (on the left), which had been separately carved and attached with metal dowels; it had a

separate low base of blue-veined marble. The statue has traces of lilac color on its *peplos* and had metal attachments.[22] The loss of the attributes in the hands makes identification difficult, but the figurative context suggests a female figure close to the god, either a *Hora* representing the autumn season of the grape harvest or an attendant at Dionysiac rites.[23] The sculptural style of the head is generally inspired by classical models of the fifth century BCE, which persisted well into Augustan times and beyond.

On the east wall, a statue depicting a young Dionysus (1.20 m high, missing the lower part of its legs; Figure 9.7) was probably exhibited in the central niche; its fragments were found on the floor directly below. The statue in its present state has been reassembled from the pieces.

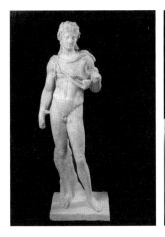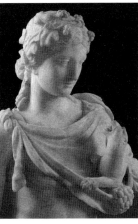

Figure 9.7. Somma Vesuviana, Villa "of Augustus," Marble statue of Dionysus with panther cub from the east wall-niche in Room 1, after restoration.

Like the *Peplophoros* opposite, the Dionysus statue was of Parian marble and had been assembled from separate parts in a "piecing" technique typical of other sculptors and workshops supplying Julio-Claudian buildings around the Bay.[24] Unusually, the youthful god holds a panther cub.[25] The subject depicted, its iconography, and the expression of the face place it as generically "Praxitelean,"[26] a style particularly popular in Roman taste in the late first century BCE and during the principate of Augustus, when this statue was made.[27]

A Formal Hall (Room 2) and Its Decorations

To the west of Room 1, communicating with it but placed at a level lower by 1.40 m, was a large square hall (Room 2; fig. 09–1).[28] In its original design, this impressive room had its main entrances on the north side through a wide central doorway flanked by two smaller doors.[29] On the south wall opposite these entrances, a doorway[30] on axis in the south wall provided the hall with a ceremonious and formal character.

Subsequently, Room 2 was modified: The doorway in the south wall became the frame for an apse on axis with the wide central door on the north, thus isolating the room spatially but giving it an even greater formality. In a yet later phase, the apse was walled off from the room and two north-south walls were built dividing the space into two halves, for a purpose unrelated to the room's original character.

The walls of the early phases of Room 2 were decorated with painted plaster (traces survive). The original floor of the room was of *opus sectile*, of which there are imprints on the concrete sub-floor. The cut marble slabs were framed by a simple black and white mosaic (some portions survive). Such floors – a central portion in *opus sectile* framed in mosaic – can date to the first century CE, but in this case a date in the mid-second century CE is proposed (p. 150).[31]

Room 1/4 and Room 2 in Later Use

The original floor of Room 1/4 has not been found, but at some point a white mosaic made of irregular limestone *tesserae* was applied to the area. The entire area ultimately became part of an industrial wine-producing facility in its last phase of use in the villa. The white mosaic floor was maintained but patched with repairs and curbs of utilitarian *cocciopesto*.[32] Two shallow vats covered by terracotta slabs were built for agricultural processing: one vat, with a settling tank, was placed in front of the monumental door on the south side of Room 4, and a second larger one was put in along the east wall, connected by a lead pipe to a drain in Room 6.[33] Later still, two ovens made of bricks brought from elsewhere in the villa were built in Room 4.

Between its construction and architectural modifications and its destruction in 472 CE, Room 2 had changed: Large terracotta vessels (*dolia*) were placed in the western half of the room, half sunken in the floor (their contents appear to have been olives and walnuts); the eastern half had post-holes and a manger along the south wall, indicating use as a stable. At some point the roof of the room collapsed: Its debris was covered and compacted to make a floor surface, and an oven was built in the northwest corner just before the final destruction.

The Intermediate Terrace

The Wide Corridor and Its Portico (Room 6)

The connection between the intermediate terrace and the level of Rooms 1/4 (1.60 m higher) was assured by two wide staircases leading up to the portico of Room 1 from Room 6: The stairs were set between the furthermost east and west intercolumniations (Figures 9.1; 9.9). In turn, the connection between Room 6 and the lower terrace (Room 12; 1.80 m lower) was assured by a single narrow staircase at the center of the north portico of Room 6; this staircase was original to its construction (Figures 9.1, 9.9, and 9.10).

Room 6 was a generously wide corridor[34] with three functions: Its colonnaded north side with brick columns constituted an entrance façade and belvedere overlooking the northward view, and it connected the intermediate and lower terraces; on its west-east axis, it connected two large rooms (Rooms 5 and 7).[35] The hall on the west (Room 5) was large but has not yet been fully investigated, so we confine our discussion to Room 7.

The Large Apsidal Hall (Room 7)

The hall on the east side of Room 6 (Room 7) had a wide and impressively decorated apse on its east side,[36] and it was illuminated from its north side by a prolongation, on square piers (one has survived), of the colonnaded north wall of Room 6; the piers supported arches. In the symmetry of the villa's design, the north wall of Room 5 on the west side could well have had a similar three-arched opening on piers: The north façade would thus have presented a six-column colonnade (Room 6) framed by three arched openings on either side (Rooms 5 and 7; see reconstruction, Figure 9.10).

Room 7 was apsidal, the apse as wide as the room itself. There was a door in the north part of the apse leading to a corridor (Room 9), which gave access to a door in the south wall of Room 10 (Figures. 9.1; 9.9).[37]

The painted plaster decoration of the apse of Room 7 simulated marble panels in the lower portion and, in the hemisphere or conch, a billowing cloth canopy (*velarium*) in bands of yellow, red, and blue, sewn in gored sections with upwardly scalloped edges (Figure 9.8).[38]

Below the canopy and above the painted marble slabs, a vigorous marine *thiasos* or procession is underway; it proceeds left to right with stock marine figures but closing with four important figures on the far right. In this group, a Nereid (a semi-divine female sea creature) seen from behind sits on the back of a *hippocamp* (a horse-bodied, fish-tailed sea creature) and turns to look at a child borne on a Triton (a man-torsoed, horse-legged, fish-tailed sea creature). Another Nereid on a *hippocamp* brackets the scene at the far right end.

Two personages in this scene can be identified.[39] The Nereid seen from behind looking at the child is Ino-Leucothea; the child is her son, Melicertes-Palaemon, later Latinized to Portumnus. Mother and son were invoked by sailors and sea-goers for safe passage during storms, with Portumnus as guarantor of safe return.[40] The marine theme had a connection to Dionysus: Ino-Leucothea was the sister of Semele, the god's mother, so Portumnus was his cousin.[41] The painted iconography of grapes and wine in many architectural elements (e.g., the painted plaster framing the monumental doorway of Room 4), together with the statue of Dionysus and, possibly, the Autumn *Hora* of the grape harvest (the *Peplophoros* of Room 1) added Dionysiac elements to the genealogical and iconographic subjects of this marine scene.

The *thiasos* of the apse of Room 7 had been formulated in the fourth century BCE and continued through Roman and Byzantine representations.[42] Stylistically, this version can be dated between the late second century CE and the beginning of the third century.[43]

The Small Apsidal Hall (Room 10)

Rooms 9 and 10 were at the same level as Rooms 5–7 on the intermediate terrace; Room 9 was a mere

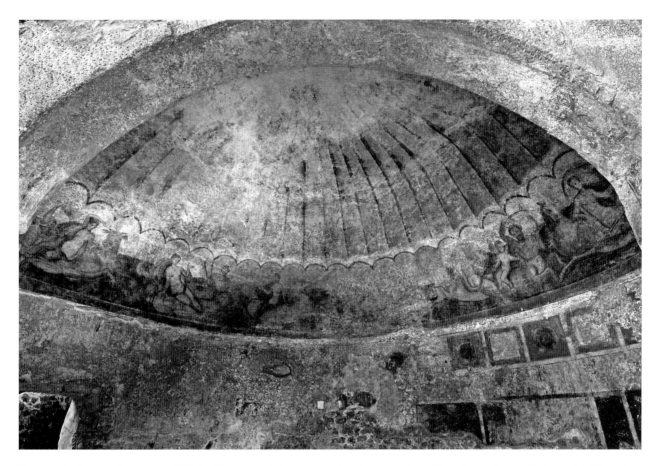

Figure 9.8. Somma Vesuviana, Villa "of Augustus," Room 7, painted apse with pavilion decoration and frieze with Nereids and Tritons, view from the east; on the left, upper part of door in the north side of the apse leading to Rooms 9 and 10. (A black and white version of this figure will appear in some formats. For the color version, please refer to the plate section)

passageway connecting the apse of Room 7 with the south side of Room 10.[44]

Room 10 was painted with simulated marble panels on the plastered walls and, like Room 2 on the upper terrace, had an impressive floor with a central *emblema* of cut-marble *opus sectile* surrounded by a wide black and white mosaic border of geometric design. The lower walls bore the marks of two successive stages of imitation marble. On the north wall, an initial scheme divided the wall into three horizontal bands: The lower band imitated slabs of yellow-orange *giallo antico* marble from Simitis in Africa, framed at top and bottom, respectively, by green and red strips. The central band presented panels separated by tall candelabra. The upper band depicted an architectural vista divided into three sectors:

an *aedicula* (a temple-like structure) with a coffered ceiling and a floral candelabrum on a pillar flanked by two birds. Windows bracketed the *aedicula* and were adorned with objects: a drinking horn, festoons of flowers and leaves, a *cista mystica*, and a shield, in a decorative scheme known from the early second until well into the fifth century CE.[45]

The lower walls of the apse of Room 10 were, like the walls of the room itself, painted with panels of simulated marble. Its hemisphere was decorated with a curtain motif at the base of which is a *velarium* and swags of garlands. The floor of the apse was a mosaic in white *tesserae* defined by a band of stylized dolphins and waves datable to the second half of the second and the beginning of the third century CE.

The Intermediate Terrace in Later Use

Later utilitarian phases of the intermediate terrace consisted of three vats of volcanic stone set into the *cocciopesto* floor were built in Room 6, next to the wall of Room 1.[46] In one of these vats, a life-sized bust of a Silenus, a small herm depicting a bearded Dionysus, and a fragment of funerary inscription were found, evidently pieces of the furnishings and decoration of an early phase of the villa. Room 8, whose use in the earlier phases of the villa is unknown, now housed wine presses, and two small channels ran down from the presses to the wine cellar on the lower terrace.[47]

THE LOWER TERRACE

The Wine Cellar in the Lower Terrace (Room 12)

Access from the intermediate terrace to the lower terrace was assured by a staircase set in the middle of the colonnade on the north side of Room 6; the stairs led directly to Room 12 (Figures 9.1, 9.9, and 9.10). The excavated area represents only about 25 percent of the whole, but what has been uncovered provided space for sixteen large *dolia* (capacity 1,500/1,600 liters each), part of an industrial wine-making facility (cella vinaria) of considerable size. Nine of the *dolia* were stamped with the names of makers who manufactured them in the first century CE.[48] The technique of delivering the must (wine-juice) from the press to the half-buried containers (*dolia defossa*) through channels is similar to wine-making facilities known in the Vesuvian area by the first century CE.[49]

[A.DS-M.A.]

THE CHRONOLOGY OF THE SOMMA VESUVIANA VILLA

Building Dates

Precise dating of the villa in its several phases is difficult. The area already investigated is large, but

it represents only part of an original complex, namely its monumental entrance attached to, but not necessarily contemporaneous with, the main residential and productive parts of the villa. Stratigraphic trenches below the mosaic and marble floors have been avoided to preserve floors themselves. However, in Area 13 (Figure 9.1) where paving stones were missing, a trench 3 m deep showed that the south walls of Rooms 2 and 4 were freshly built into foundation cuttings containing no datable material. The fill above contained pottery sherds (thin-walled pottery, Italian *terra sigillata*, and African *sigillata* A) dating the raising and leveling of the area to the second century CE.[50]

The walls of Rooms 1 to 7 were all of one building technique: *opus vittatum mixtum* (two courses of bricks and one of small blocks of tufa).[51] In contrast, the masonry techniques and stratigraphic relationships among the walls indicate that Rooms 9 and 10 as well as the apse of Room 7 date to a phase later than the other rooms on the intermediate terrace. It is not clear if these additions occurred during the first construction phase or, as seems more likely, afterward, because the wall paintings in the apses are datable to the early third century CE at the latest, rather than to a date in the second century, the probable date of the walls of Rooms 1/4 and 2 on the upper terrace. The apse on the south side of Room 2 was added sometime in the first half of the fourth century CE, and perhaps at this time the second phase of the wall decoration of Room 10 was added to cover earlier paintings. More radical changes in the structure and use of space occurred in the second half of the fourth century CE when the *cella vinaria* was added and the vats in Rooms 1 and 4 were built. The date for the construction of the *cella vinaria* facilities (in Room 12 and elsewhere) is given by the pottery around the large terracotta vessels, the *dolia*: sherds dating between the third and the mid-fourth centuries CE. During the fifth century, the ovens were added (Room 2) just before the destruction of 472 CE, and the lava blocks of the pillars of the arcade in Room 1–4 were spoliated.

Setting aside the late utilitarian reuses of the villa's rooms, a date in the second century CE for

the original construction of the villa concords with the evidence found so far; later modifications, some structural, others decorative, brought its residential use into the third century. The productive life of the wine-making facility began in the late third to mid-fourth century.

Dates of Artistic and Utilitarian Objects

There are conspicuous gaps in dates between the *structures* of the villa (second century CE for the upper terrace to early third century for wall paintings of rooms on the intermediate terrace to fourth century CE for the lower terrace and its *cella vinaria*) and *objects* of embellishment or use within them. The statues of Dionysus and the *Peplophoros* from Room 1 (Figures 9.6; 9.7) set into niches in walls dating to the second century were themselves early first-century objects made a century or so *before* they were put in place (and made well before the eruption of Vesuvius in 79 CE). They must have been part of a collection of earlier material brought to the villa for this new prestigious setting, or antiques purchased to complete an assemblage of statues for which the niches in Room 1 were specially constructed.

Utilitarian objects were also reused – the sixteen *dolia* in the *cella vinaria* (Room 12: Figure 9.9).

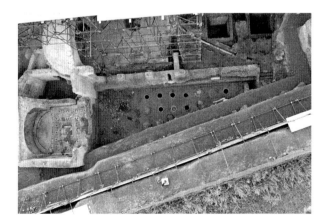

Figure 9.9. Somma Vesuviana, Villa "of Augustus," Overhead view of the north part of Room 7 and Rooms 9 and 10 on the intermediate terrace; *cella vinaria* (Room 12) on the lower terrace; north at bottom of image.

They were made in the first century CE but set into the late third-/fourth-century wine-making facility: They were about 300 years old when they were reused! This suggests that wine production at the villa had existed in another sector but that its *dolia* (possibly also other valuable apparatus) had been thriftily kept and ultimately moved to the new location (see p. 153).

[A.DS-M.A.]

CONCLUSION

The partial and ongoing excavation of the Somma Vesuviana villa makes it difficult to offer a full interpretation of its elements, but many facts have emerged. The following discussion starts at the entrance to the villa on the intermediate terrace and gravitates upward (southward) to Area 13.

The staircase connecting Room 12 on the lower terrace to Room 6 on the intermediate terrace was the means by which the villa was entered; it was narrow to monitor and control access to the complex. Our computer reconstruction shows the façade as it appeared from the lower terrace: The colonnade of Room 6, framed on either side by the arcades on piers of Room 7 and (most probably) Room 5, would have created a monumental front 38 m long, an impressive display denoting a grand entrance (Figure 9.10).[52]

The exterior aspect of the south wall of Room 6 with its colonnade was never modified, but the rooms with which it connected (Rooms 5, 7, 8, 9, and 10) were either changed or were additions. Rooms 5 and 8 need further investigating, but the original sequence of rooms was modified: Rooms 9 and 10, and the apse on the east side of Room 7, were additions in a different masonry technique.

With Room 6 as a wide corridor and grand vestibule on the cross-axis, the position and typology of the two richly decorated, interconnecting apsidal halls (Rooms 7 and 10) on its east side confirms them as private *auditoria* or "hearing-halls" – rooms used by the owner of the villa's property to receive guests and clients, adjudicate disputes from tenants and servants, discuss business, and enjoy entertainments such as

Figure 9.10. Somma Vesuviana, Villa "of Augustus," Reconstruction of the lower and middle terraces constituting the north façade of the Somma Vesuviana villa "of Augustus" (A. Baldi, R. Di Maio, A. Simeoli).

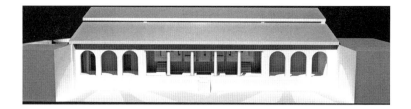

speeches and poetry. Such halls typically incorporated a vestibule or antechamber to accommodate those seeking to approach the villa owner, and Room 6 may have served this purpose.[53] *Auditoria* with apses providing impressive architectural backdrops for the *dominus* began to appear in private residences in the third century CE throughout the empire: The Villa Somma villa was no exception – it had two.[54]

The villa's design from the entrance vestibule of Room 6 through Room 1/4 to Area 13 was unusual in its pronounced asymmetrical and sequential screening of a fine, ultimately axial, view symmetrically framed by a notable decoration in the central door of the *exedra* of Room 4 and the vista of Area 13. The staircases leading to the various levels of the villa – on axis from the lower terrace (Room 12) to the intermediate one (Room 6), then symmetrically disposed but dictating asymmetrical movement from the intermediate terrace to the upper terrace (Room 1/4) – were designed to move visitors along a precise route through obliquely defined space to an axial revelation of landscape. The most important is the screening effect of the piers and arcade dividing Room 1 from Room 4: These occluded the view into the south wall of Room 4.

From the southern central doorway in Room 4, the space defined by the parallel north-south walls at the far end of the 20 m downward-sloping incline would have framed and dramatized an axial view of the volcano, first from the doorway itself, then along an expanding space beyond (Figure 9.11). The view was designed as the final revelation at the end of a process accomplished by oblique stages: Vesuvius and its vineyards as epiphany of Dionysus himself.[55] The iconography of Rooms 7 and 10 may well be linked to the productive life of the villa, its landscape, and a marine or seaborne connection: grapes, wine,

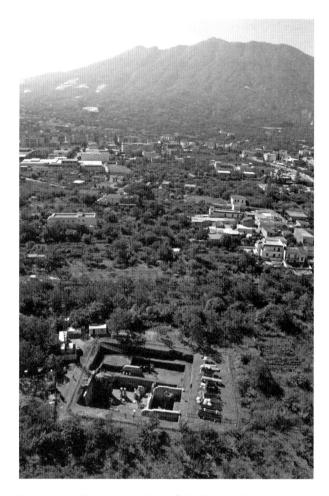

Figure 9.11. Panoramic view of the Somma Vesuviana villa "of Augustus" site from the north (September 2004).

Dionysiac objects and the god's mythological parentage, the marine *thiasos*, and Portumnus assuring safe return from sea voyages. The construction and continued modification and decoration of the villa from its construction in the second century into the third century, and the acquisition of much older statues (the Dionysus and *Peplophoros*) for impressive display in the niches of Room 1 attest the success of both the villa and the self-regard of its owners.[56] Their thrift in

reinstalling much older *dolia* in the later (but new at the time) *cella vinaria* of the fourth century attests their good business sense and the viability of the estate's wine (but not its venue for distinguished living, at least in the excavated areas) well into the fifth century, brought to an end only by its destruction. This flourishing conflicts with literary sources that claim that farms in (northern?) Campania were deserted (*agri deserti*) before the volcanic destruction of 472 CE.[57] Continuing work on this and other sites nearby is providing a comprehensive, accurate picture of the development and changes in the productive and trading activities of late antique Campania.

Finally, no connection between the villa "of Augustus" and the divinized Augustus can be established. Still, the very impressive architecture and its high quality wall- and floor-decoration attest the villa's importance, and its sculptural contents had connections to the time of Augustus if not his person. Its monumentality understandably prompted the excavators of the 1930s to see the Somma Vesuviana villa as having a public character.

[G.F.DS.]

NOTES

1. Masanori Aoyagi (Museum of Western Art, Tokyo), Antonio De Simone (Suor Orsola Benincasa University, Naples), and Girolamo F. De Simone (Accademia di Belle Arti, Naples).
2. For example, D'Arms 1970, reprinted in 2003 with other essays by D'Arms (ed. by F. Zevi).
3. Plin., *HN* 3.5.40–42; Sen., *Dial.* 9.2.13; Strabo 5.4.7; Varro, *Rust.* 6.15; Sil. It. 12.18; Tac., *Ann.* 15.13. For the perception of Neapolis and its Bay under the Romans, see Fedeli 2005, 21–35.
4. For the skewed picture of settlement in Roman Campania: De Simone 2008. For the Bourbon excavations in the Vesuvian hinterland: Allroggen-Bedel 1993, 38. In Campania itself, some excavations took place between 1894 and 1908 on the initiative of private landowners: Oettel 1996. Most recently, the Apolline Project investigated the northern side of

Vesuvius: De Simone and Macfarlane 2009; De Simone et al. 2009.
5. On the cities' territories and centuriation: Beloch 1890, 86–8; 461–4; Chouquer et al. 1987, 207–31; Sommella 1991, 187–9; Ruffo 2010, 254–75; on the enlargement of Nola's territory after 79 CE: Soricelli 2002. Because of a gap in the centuriation grids, the precise municipal jurisdiction in which the villa lay is not certain: Chouquer et al. 1987, ibid. This part of the land is also mentioned by Cicero (*Off.* 1.10.33).
6. The study of the archival documents is by G.F. De Simone and A. Matsuda. The information comes from the documents kept in the Naples office of the *Soprintendenza archeologica* of Naples (fascicule S 10/1) and from the publications by Angrisani, in particular Angrisani 1936; see also Della Corte 1932.
7. The project was a cooperation between a local amateur historian, the pharmacist Dr. Alberto Angrisani, and the inspector of the *Soprintendenza alle Antichità di Napoli e del Mezzogiorno*, Matteo Della Corte, who at the time was the director of the excavations in Pompeii. The project only opened a narrow trench (c. 5 x 6 m by a depth of about 5.60 m) along the east wall of Room 1 and in digging some exploratory tunnels between the pillars supporting the arch.
8. Angrisani 1936, with discussion at 45–7 of the geological analysis carried out on July 24, 1935, by Prof. Francesco Signore of Naples University.
9. A view shared by the archaeologists who visited the excavation or had read the report by Della Corte, including G. Q. Giglioli, G. Patroni, A. W. van Buren, R. Robinson, and others.
10. Octavian, the future emperor Augustus, was a member of the Octavii before his adoption by his maternal great-uncle Julius Caesar in a posthumous will in 44 BCE. The room of his birth as well as his deathbed chamber at a villa near Nola were reverenced in his memory: Tacitus, *Ann.* 1.5; 4.57; Suet., *Aug.* 98.5; 100.1; *Tib.* 40.1; Vell. Pat. 2. 23.1; Cass. Dio 56.29.2; 56.46.3. Analysis of these sources by Della Corte 2009.
11. The inscription on the statue base reads: *Ottaviano Augusto / Simbolo / dell'Italia Imperiale / nella città millenaria / ov'egli chiuse / la sua vita radiosa / Dono del Duce / Maggio 1938 – VI E[ra] F[ascista]*. Translation: "Octavian Augustus, symbol of imperial Italy here in the millenary city where his glorious life came to an end. Gift of the Duce, May 1938, in the VI year of the Fascist Era."

12. N.prot.1821 dated March 21, 1935, addressed to the *Alto Commissario* for the Province of Naples. Maiuri cites the importance of Somma Vesuviana but the greater urgency for work at Herculaneum, patronized by the regime and held in high regard by "elite tourists" worldwide.

13. For the eruption of 472 CE: Marcellinus Comes, *Chron.*, 68, in *Monumenta Germaniae Historica, Auctores Antiquissimi* XI, 1894, 90; on late antique eruptions: Colucci Pescatori 1986; Savino 2004; De Carolis and Soricelli 2005; De Simone, Perrotta, and Scarpati 2011. Volcanological aspects: Mastrolorenzo et al. 2002; Rolandi, Munno, and Postiglione 2004. For the volcanology of current research, Perrotta et al. 2006. The sixth-century deposits came from one of two eruptions in 505 or 512 CE. Both are mentioned in the *Paschale Campanum* (*Monumenta Germaniae Historica, Auctores Antiquissimi* IX 265; IX 747) and that of 505 CE by Cassiodorus (*Var.* 4, 50).

14. The intermediate terrace is 1.60 m lower than the upper one; the lower terrace is 1.80 m lower than the second. Other villas on multiple terraces: the Villa of the Papyri of Herculaneum, Villa A at Torre Annunziata (see Clarke in this volume), and, at Stabiae, Villa S. Marco and Villa Arianna (see Howe in this volume), the latter two covering surfaces between 10,000 and 15,000 m².

15. For example, Room 8 on the intermediate terrace; see p. 148.

16. The overall dimensions of Room 1/4 are c. 18 m EW and 16 m NS; Room 4 is 18 m EW and 7 m NS.

17. Of this original structure, to the east end the first arch is completely preserved (2.70 m wide) with part of the other supporting pillars. The others were largely dismantled in antiquity.

18. It is 9 m wide and survives to a height of 7 m.

19. De Simone 2009.

20. Five columns, 3.60 m high, survive.

21. The statue is securely identified as Dionysus by the grapevine crown, goatskin cloak, grapes, and, nestled in his left elbow, the panther cub.

22. Holes for attachment indicate a brooch on the torso and a crown/diadem on the head, and a strip of tin either gilded or plated in silver glued with egg-white was attached to the hem of the *peplos*.

23. In our opinion, the folds of the dress and the position of the arms are key elements in any comparison to help with iconographic identification. For example, the Autumn Hora is depicted on a stamp for Italian *terra sigillata* wares produced by Cneus Ateius, now in the British Museum (Walters 1908, II, 493, pl. 66; Stenico 1966, 32 n. 22P, pl. 10, 22a; Oxé 1933, 132–4, pl. 33–5); the female figure is shown stepping forward and holding grapes and fruit in the fold of the dress against her left hip: Its symmetrically arranged *peplos* and bare left shoulder are similar to the Somma Vesuviana statue. For the iconography of the attendants at rites of Bacchus (Dionysus), see the frescoes from Herculaneum and Stabiae (*Antiquités d'Herculanum* 1805, 1, pl. 22; 2, pl. 21; 2, pl. 24; fresco from Villa San Marco, Antiquarium Stabiano, inv. n. 2520, in Miniero Forte 1989, n. 14, 67). In these examples, the female figures (also with one bare shoulder) hold trays with offerings in one hand, an *oinochoe* or wine pitcher in the other. See Sengoku-Haga and Aoyagi 2010, 237–52; Sengoku-Haga dates the statue to the Hadrianic period, as first depicting a nymph or rite attendant, later reworked into a Diana, and finally reworked into a Maenad.

24. Claridge 1990, 135–62. These workshops made statues for the now-submerged Julio-Claudian *nymphaeum* of Punta Epitaffio at Baiae and those of the *nymphaeum* of the so-called *Grotte di Pilato* on the island of Ponza: Baiae: Andreae 1991, 237; Andreae 1992, 81–91; Ponza: Gasparri 2002.

25. Its only parallel is a first-century CE statue discovered in 1986 in the territory of Lanuvium: Ghini 1989, 49–53.

26. Martinez 2007, 296.

27. Plin., *HN*, 36.21–24; Corso, Mugellesi, and Rosati 1988, 551–5; Corso 1988–91, I, 96; 577; Celani 1998, 79; 102; 115–16; 119; 269; 283–5. There are strong stylistic similarities between the Dionysus statue of Somma Vesuviana and another youthful Dionysus from the *nymphaeum* at Baiae: Andreae 1983, 61–2, figs. 175–6. For the Augustan date: De Simone 2010a, 342–50.

28. EW 8.73 m; NS 8.96 m.

29. The larger door is 3.47 m wide, the smaller ones are 1.05 m.

30. 2.36 m wide.

31. Angelelli, Aoyagi, and Matsuyama 2010, 217.

32. In front of the second and third pillars the placement of the *tesserae* marks a circle c. 2.50 m in diameter.

33. Analysis of the facing surfaces identified traces of wine in the first vat and traces of resin, bitumen, pitch, and beeswax in the second.

34. 18x7 m.

35. Only the eastern half of the room was investigated; in it the brick column bases were found. As no other openings were evident, the façade of the intermediate terrace must have had a wider space between its central columns to accommodate the stairs.

36. 13 x 7 m.

37. To the west, the wall of an earlier cistern abutted the apse wall of Room 10: It belonged to an earlier phase as its walls were on a different alignment, and its construction faced with tufa blocks also differed from techniques in the rest of the villa.

38. De Simone and Aoyagi 2010 (pictures); Guarducci 1981 for *velaria*.

39. Comparisons: Antioch Museum, inv. n. 1017; Carandini, Ricci, and de Vos 1982, 343, 357–8; Antioch Museum, inv. ns. 830, 829, 825; Toulouse, Musée Saint-Raymond, cat. no. 20; Comotti 1960, fig. 1190; Balmelle and Doussau 1982, 161–70, table 11. On Ino-Leukothea: Nercessian 1990, 657–61.

40. Vikela and Vollkommer 1992, 437–44.

41. For Portumnus see Cic., *Nat. D.* 2.26; on the link with Dionysus see Seelinger 1998, 271–80.

42. Icard Gianolio 1997, 73–85; Icard Gianolio and Szabados 1992; Neira Jiménez 1994.

43. Stylistic elements: large-scale figures (*megalographia*), dissolution of shading or modeling toward the edges of shapes requiring definition by linear means instead of blended *chiaroscuro*, and so on. See Baldassarre et al. 2002, 322–58 for a treatment of key features of the period. For *megalographia*: de Vos 1993, 87. Line and shading: Caputo and Ghedini 1984. For the figures themselves, the head of Leucotea in relation to a painted figure in the house of St. John and St. Paul in Rome, late second-early third century CE: Bianchi Bandinelli 1969, 280, fig. 316; Baldassarre et al. 2002, 347–8. For Palaemon's head, a youth depicted on the Acilia sarcophagus dated 238 CE: Bianchi Bandinelli 1954, 200–20; see also the portrait of Erennius, son of the emperor Decius, dated 249–251 CE: Feletti Maj 1958, 196–9, Tables 33.102–104: 34.105. A parallel close in date to the *thiasos* at Somma Vesuviana is the paintings in the apse of the temple of Hercules at Sabratha depicting Marcus Aurelius' deification; this painting was made in the reign of Commodus between 180 and 192 CE: Caputo and Ghedini 1984, pls. 23.1, 24.2–24.3; B 6.

44. Room 10 measures 7.30 x 4.50 m.

45. As shown by paintings from Ostia and Rome: See the wall painting in the House of the Muses in Ostia (second century CE) and the paintings from the villa under the church of S. Sebastiano in Rome, dated to the late second century CE.

46. The measurements of the vats are slightly different; on average depth is 2.80 m, while the side measures 2.50 m.

47. The drain has the bottom faced in reused marble fragments and the sides faced in *cocciopesto*, and was covered by reused tiles or marble fragments.

48. There were three makers: five *dolia* were stamped by Cneus Aevius Mysticus, three have the name Caius Iulis Crispus, and one reads Lucius Lucceius Proclus. As is common on stamps, the names are in the genitive case: *CN AEVI / MYSTICI*, attested at Olbia/ Terranova as well (*CIL* 10.8333.3); *C IVLI / CRISPI* (*CIL* 4.10788 from Herculaneum); *L LVCCEI/PROCLI*.

49. A drain/channel in Room 6 probably delivered the must from Room 8 to the west part of Room 12 below. Similar arrangements are known: the Pisanella Villa at Boscoreale (Pasqui 1897; *Casali di ieri* 2000).

50. Mukai et al. 2010, 221–3.

51. There were exceptions: The apse on the west side of Room 7 (a later addition) had courses of bricks and areas of *opus incertum* with small tufa blocks. The original south wall of the *cella vinaria* (Room 12) was in *opus vittatum mixtum* with a coarser wall in *opus incertum* added, probably to set the channel that conveyed wine must to the *dolia defossa* in Room 12 below. Cruder masonry was used for patch-ups and to occlude doors in Room 2 and elsewhere.

52. The model is by the architects Alessandro Baldi, Rosalba Di Maio, and Anna Simeoli. It takes into account the types of roofing materials found in the excavations. At 38 m wide, the villa's façade compares in scale to the fronts of other villas: Lalonquette V (Lauffray, Schreyeck, and Dupré 1973) was 11 m wide; Piazza Armerina (Carandini, Ricci, and De Vos 1982) 27 m.; Montmaurin (Fouet 1969) 61 m (but the entrance inside the hemicycle measures just 15 m.).

53. The function of such halls as denoting magisterial status was discussed by Ellis (1991), whose conclusion have been criticized by Rossiter (2000) and Bowes (2010, 40), who argue for more flexible use of such spaces.

54. For western examples: Piazza Armerina and Montmaurin among many: Sfameni 2006: 75–96;

there are eastern examples: the "palace" above the theater at Ephesus, the "palace" of the governor or bishop at Aphrodisias, and the "Palace of the Dux" at Apollonia: Özgenel 2007.

55. De Simone 2011. Integrating architecture with views of the landscape and directing the gaze was common: Purcell 1987b, 187, 203; Bergmann 1991; Zarmakoupi 2014b.

56. The construction or enlargement of the Somma Vesuviana villa differed from a general contraction of villa sites, though the issue is not yet resolved: see Ortalli 1996; Brogiolo 1996. The Biferno Valley survey indicates that villas were being abandoned by the second century CE, a pattern repeated in northern Campania, but whether this was due to unviability of agriculture in the region or concentration of estates has yet to be determined: Lewit 2004.

57. A passage in Ausonius' *Mosella* (210) indicates that vines were the major cultivation on the slopes of the volcano in the late fourth century CE (Soricelli 2002, 466). For the *agri deserti, Cod. Theod.* 11. 28. 2; Savino 2004, 249–52. In towns, differences of continuity were also evident: At Nola, some neighborhoods were abandoned but Neapolis continued viable and wealthy.

PART II

ROMAN VILLAS IN THE MEDITERRANEAN

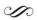

10

ROMAN VILLAS IN SOUTHERN ITALY

MAURIZIO GUALTIERI

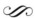

INTRODUCTION

Until two decades ago, evidence regarding Roman villas in southern Italy was uneven and poorly distributed in the region with the obvious exception of *regio* I, especially the environs of Herculaneum, Pompeii, and the Bay of Naples.[1] In consequence, a research tradition grew up emphasizing the category of *otium* villas or pleasure villas, based both on rich textual documentation and equally rich archaeological evidence.[2] The focus was on the residential sectors, but as early as 1931 R. C. Carrington included analysis of the economic role of such establishments in his study of both the residential and productive aspects of *villae rusticae* near the towns of the Bay.[3] More recently, systematic surface surveys have shifted the emphasis of research from individual sites to the configuration of Roman landscapes and "villa systems,"[4] with the result that the older emphasis on *otium* villas has been complemented by important projects aiming at assessments of the Roman rural landscape to which villas belonged. For example, the 1991 survey of the *ager Falernus* documented farms, villas, roads, field systems, and infrastructures, complementing the excavations conducted in the 1960s near Francolise north-west of Capua.[5] The survey and the excavations have provided data for how villas evolved in that area, with an integration of structural history and material culture rare for the time and infrequent even today.[6] The two Francolise villas (Posto and San Rocco) had

different historical trajectories. The Posto villa, built in the second century BCE, remained small well into the imperial period, little more than the type of Hellenistic farm centered on agricultural production, although it was later given some *luxe* in the mid-first century CE with the addition of a small *balneum*.[7] In contrast, the nearby villa at San Rocco, while showing a number of analogies in its first building phase, developed into a residence of some elegance with a fairly elaborate architectural plan. Around 30 BCE, the whole villa was rebuilt on a much grander scale: "a 30-room *villa urbana* incorporating modern plan and décor ... separated from a substantial *villa rustica* by a road that also linked the villa with others on the hill."[8] The differing development of these two quite proximate rural dwellings in the *ager Falernus* gave historical context for villas further south.

Villas of *regiones* II and III south of Campania and the Bay, namely the regiones of Apulia, Lucania, and Bruttium, are the specific topics of this chapter. Until very recently, their documentation was scarce and unreliable, with the notable exception of several villas of late-Republican and imperial date in the countryside of ancient Volcei (modern Buccino) in western Lucania.[9] Systematic large-scale explorations or detailed reports of villa sites were not available until the excavation and publication of the villa at San Giovanni di Ruoti (*regio* III, near Potenza).[10] Before then, Coarelli had remarked on the absence of villa studies in the south of the peninsula, noting that the priority given to the archaic and classical

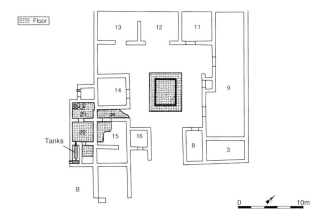

Figure 10.1. Moltone di Tolve (Potenza), villa plan, third century BCE.

antiquities of Magna Graecia discouraged field work and excavation of sites of the Roman period.[11]

The military campaigns in Lucania, intended by the Republic to bolster the defense and control of the peninsula, strongly modified the Greek cities of Magna Graecia and the situation of its native inhabitants.[12] The military presence coincided with, or brought, a residential and agricultural presence: In the heartland of Lucania, a well-preserved early villa has been uncovered at Moltone di Tolve (Potenza).[13] The building, which had two phases, documents the advent of Roman occupation. The first phase is pre-Roman and dates to the late fourth century BCE. However, in a second phase datable to the mid-third century BCE, after the Roman advance into Lucania in the 270s, the dwelling's plan developed many features in common with early houses at Pompeii and elsewhere: a series of rooms arranged around four sides of an atrium with an *impluvium* in the center. The term *villa* as designating a dwelling of fully Roman character is appropriate for the Moltone di Tolve site (Map 4: 2; Figure 10.1).

Southern Italy was Roman by the first century BCE, with the inevitable development of villas in districts of *regiones* II and III. As we shall see, the well-documented ones – Termitito on the coast between Heraklea and Metapontum, and that at Masseria Ciccotti in the upper Bradano valley – had significant similarities to better documented ones in central Italy, and new survey evidence from Lucania and Apulia now allows precise definition of how rural landscapes changed between the third and first centuries BCE leading to the establishment of villas.[14] Further work is needed to complete the picture for Bruttium.[15]

The relationship between farms in the Hellenistic tradition (e.g., small, simple houses with informal arrangements of rooms around a courtyard such as that at Banzi/Mancamasone, near Oppido Lucano (third and second centuries BCE) and emerging Roman villas is not always clear. In a number of cases, the farms remained important in the countryside, especially in the southernmost parts of the peninsula. The dwelling of the late first century BCE at Posta Crusta, north of Herdonia in northern Apulia, is a hybrid form between a farm and a small villa: its agricultural facilities were supplemented with a few elegantly decorated rooms with mosaic floors and painted plaster.[16] Other sites may reveal how the transition from simple farm to residential villa occurred in the south of the peninsula; the special emergence of Roman villas in this agricultural context has been a subject of speculation and needs further work.[17]

Surveys have shown that, in late Republican times (first century BCE) in eastern Lucania and western Apulia, villas increased in number while small farms diminished.[18] The change suggests that villas and their estates were absorbing the lands of earlier farms; a further change may have been a growth in the use of slaves as well as of free workmen (*coloni*) in tandem with the continued presence of independent smallholders engaged in agricultural production.[19] The process by which villas as a phenomenon of Roman culture and rural economy replaced earlier forms of exploitation finds good historical definition in the Italian south.[20]

WERE SOUTH ITALIAN VILLAS A "PERIPHERAL" SYSTEM?

The *suburbium* of Rome, southern Etruria, Latium, and northern Campania had been the privileged regions for the development and diffusion of Roman villas and villa systems in the late Republic and early empire.[21] These regions have provided the

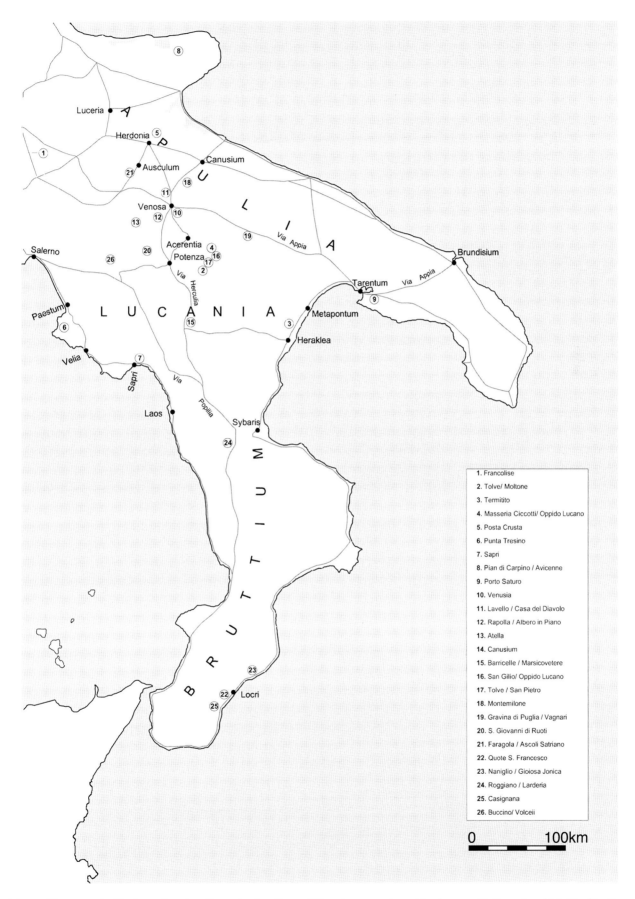

Luceria

Herdonia ⑤
Ausculum ㉑
Canusium ⑱
⑪
Venosa ⑩
⑬ ⑫
Acerentia ④
Salerno Potenza ⑯
㉖ ⑰
⑳ ②
Paestum
⑥
Velia
⑦
Laos
㉔
Sybaris

Metapontum
③
Heraklea

Tarentum
⑨

Brundisium

Locri
㉒
㉕
㉓

APULIA

LUCANIA

BRUTTIUM

Via Appia
Via Appia
Via Herculia
Via Popilia
Sapri

⑧

①

1. Francolise
2. Tolve/ Moltone
3. Termitito
4. Masseria Ciccotti/ Oppido Lucano
5. Posta Crusta
6. Punta Tresino
7. Sapri
8. Pian di Carpino / Avicenne
9. Porto Saturo
10. Venusia
11. Lavello / Casa del Diavolo
12. Rapolla / Albero in Piano
13. Atella
14. Canusium
15. Barricelle / Marsicovetere
16. San Gilio/ Oppido Lucano
17. Tolve / San Pietro
18. Montemilone
19. Gravina di Puglia / Vagnari
20. S. Giovanni di Ruoti
21. Faragola / Ascoli Satriano
22. Quote S. Francesco
23. Naniglio / Gioiosa Jonica
24. Roggiano / Larderia
25. Casignana
26. Buccino/ Volceii

0 100km

Map 4. Towns and villa sites of ancient Lucania, Apulia, and Bruttium mentioned in the text (S. Ferrari and M. Gualtieri).

richest documentation for the early development of the villa, and the site of Settefinestre in southern Etruria (near Cosa on the west coast, about 120 km north of Rome) has been claimed by its excavator, Andrea Carandini, as the model of the Varronian *villa perfecta*.[22] Carandini proposed classifying Roman villas in two distinct categories: *ville centrali* ("central villas," for which Settefinestre was the archetype) and *ville periferiche* ("peripheral villas," namely villas at the edges of good agricultural land or on the margins of Roman domination). His classification was based on the criteria for land quality in the texts of the Roman land surveyors, the *agrimensores/ gromatici*.[23] These surveyors, in describing the agricultural landscape of Italy, distinguished the "*suburbana regio Italiae*" (where the *ville centrali* would have developed) from the "*longiqua regio*," the more distant areas, where Carandini thought that *ville periferiche* would prevail.[24]

Carandini considered that the difference between *ville centrali* and *ville periferiche* would also have entailed fundamental differences in the economic function, organization of work, and, presumably, the layout and architectural development of the two types.[25] Allowing for the many different configurations and regional variabilities of villas in the peninsula including those of Apulia and Lucania, he argued that, for the most part, villas in southern Italy must have been *ville periferiche* because of region-specific conditions: limited access to ports, roads, and markets, location on poorer land, less capital investment, and agricultural production carried out mostly by tenants or some combination of tenants and slaves.[26]

Subsequent research has clearly indicated that villas in Lucania and Apulia were not "peripheral" at all.[27] At Termitito in remote southeastern Lucania (Map 4: 3), the late Republican dwelling was a fully developed Roman villa, with a tetrastyle atrium and ample peristyle of a type more usual in central Italy.[28] While its plan (Figure 10.2) is based on Roman, even "Varronian," models, its elegant decoration (especially the terracotta antefixes of the *compluvium* in the atrium) was based on Hellenistic traditions found at nearby Heraklea, showing a pleasant hybrid of Roman space with local taste.[29] Villas of comparable

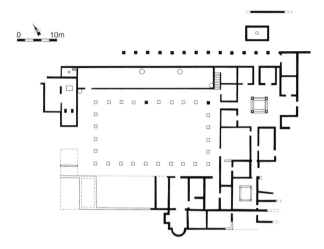

Figure 10.2. Termitito, villa plan, late Republican.

date in the area of Tarentum exhibit similar characteristics and indicate that landowners – whether local elites or newcomers – were ready to commission fully Roman houses combined with smoothly adapted local habits.[30] Villas were a way to integrate to new realities and accommodate old visual habits.

Another villa type, the distinctively Roman *villa maritima* familiar along the Campanian coast and especially around the Bay of Naples, was naturalized along the Tyrrhenian coast of Lucania and Bruttium in the late Republic. In general, maritime villas testify the early influence of domestic architecture from central Italy in their plans, but the many examples of their methods of construction and flooring – the extremely specialized construction techniques for walls in *opus reticulatum* and floor finishes in *opus signinum* – are even better indications of Roman presence.[31] The impressive substructure (*basis villae*) of a villa on a high scenic location of the Tyrrhenian coast of Lucania near Punta Tresino was intended to be viewed as a landmark from the sea.[32] At Sapri (in the Cilento, further south along the Lucanian coast between Velia and Laos; Map 4: 7), the Salerno *Soprintendenza* has excavated and restored a monumental and luxurious villa built on one of the few natural harbors of the coastline with its own quay jutting into the sea (Figure 10.3). Such private port facilities remind us that all villas – maritime or land-based – played important economic roles in the Roman economy of the peninsula and, in specific,

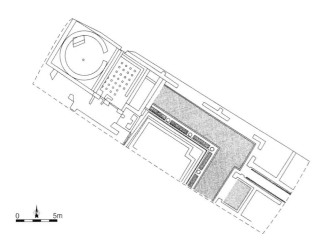

Figure 10.3. Sapri, baths of the *villa maritima*, plan (courtesy Soprintendenza Archeologica, Salerno).

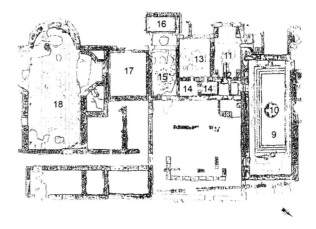

Figure 10.4. Porto Saturo (Tarentum), villa, plan of the residential sector of the villa.

the lifestyle of the upper stratum of Roman society.[33] Examples from other regions indicate that inland villa owners held extensive tracts of land that provided agricultural products for export: These goods could have been forwarded through such ports.[34] From the archaeological evidence for villas in southern Italy, there is an emerging picture of several different "villa systems" within variegated regional landscapes that go well beyond overly neat categories like *centrale* and *periferica*.

VILLA BUILDING IN *REGIONES* II AND III: EVIDENCE FOR THE FIRST AND SECOND CENTURIES CE

A recent overview of the Roman countryside emphasizes regional variations throughout the Italian peninsula and indeed throughout the Roman world in general: " ... the major problem of villa archaeology lies as much in the scattered and random nature of the sample of thoroughly studied sites as in the uneven nature of our evidence from the older sites."[35] This analysis is especially relevant to villas in the southern part of the Italian peninsula. With some notable exceptions, the few carefully excavated and well-documented sites in *regiones* II and III are scattered over a very varied landscape, while some important sites are long-known but still poorly documented. This situation is especially true

for a group of villas in the Gargano region of Apulia.[36] The large villa of Piano di Carpino at Avicenna (Foggia) in northern Apulia remains substantially unpublished: The original construction was a small late Republican villa built in *opus incertum*; it was much enlarged between the second and third century CE, to judge from the excavated bath suite of this period. A monumentalization of the complex in the course of the fourth century is indicated by the addition of an apsidal hall. The same sequence of architectural events occurred at the mid-to-late imperial villa at Porto Saturo in the coastal area southeast of Tarentum.[37] The vast residential sector of the Porto Saturo villa (Figure 10.4), partially excavated in the early 1970s, incorporated a magnificent bath suite and sophisticated architectural features: The large triconch (a reception hall combined with a *coenatio* or formal dining room) has been dated to the third or very early fourth century CE and is one of the earliest such impressive ceremonial features in south Italian villas, though not as early as a similar dining room in the Lucanian villa at Masseria Ciccotti, as we shall see.[38]

Comparable developments in villas in the second half of the second century CE occurred in the well-watered and fertile highlands between the Vulture and Venusia, ranging along the middle course of the Ofanto (Latin *Aufidus*). A number of villa sites datable to the last decades of the second and into the third century CE, together with study of the regional

rural settlements, provide instances of sophisticated villa architecture and the emergence of large estates that may have belonged to Roman families of senatorial rank as recorded in inscriptions.[39] One of the most impressive such complexes is the one at Lavello/Casa del Diavolo overlooking the Ofanto valley, long known for its standing ruins and a fairly accurate plan drawn on the basis of visible structures.[40] The large bath suite, to judge from its masonry, was added during the third century CE. Besides baths, villas could also have family tombs.[41] The villa at Rapolla/Albero in Piano southwest of Venosa, although still largely unexplored, had a small attached mausoleum containing an impressive sculpted sarcophagus of Asiatic type. The sarcophagus associates the villa and its estate with the family of the Bruttii Praesentes, landowners of senatorial rank attested throughout Apulia and Lucania.[42] The presence of such a family indicates that they, together with villas of the type common earlier in Rome's *suburbium*, had become fully naturalized in southern Italy by the late second century.

Juxtaposing *mausolea* and villas became usual in the course of the second century CE, with the funerary monuments often built in a new form, temple-like structures symbolizing *pietas* and strong family connections.[43] A comparable context may also be envisaged for the sarcophagus of Attic type dedicated to Metilia Torquata from an inscription incised on the front side, recovered long ago (but without archaeological context) in the countryside of Atella (c. 30 km south of Venosa). The sarcophagus and its inscription indicate the presence, as landowners, of the Metilii, a senatorial family connected to Herodes Atticus (L. Vibullus Hipparchus Ti. Claudius Atticus Herodes, c. 101–77 CE) and thus directly to the entourages of the Antonine emperors.[44] As the sarcophagus was probably placed in the mausoleum of a villa nearby, a senatorial estate can be surmised for this area of Lucania and Apulia, one in proximity to those owned by Herodes Atticus himself.[45]

New evidence of important senatorial estates in the Apulian/Lucanian region during the second century CE comes from a newly discovered site at Barricelle/Marsicovetere (c. 30 km south of Potenza; Map 4, no. 15).[46] The excavations (so far limited to

the *pars rustica*) have recovered tiles stamped in the name of C. Bruttius Prae[sens], consul in 139 CE. At some later point in the same century, the tile works may have become imperial property.[47]

The bricks and tiles of the Barricelle/Marsicovetere villa may seem like humble evidence. However, they directly and intimately connect the villa to the imperial entourage. The stamps indicate the presence, in Lucania, of the same senatorial family of the Bruttii Praesentes, which, as we have seen, owned a villa with a mausoleum and a fine sarcophagus at Rapolla/Albero in Piano in Apulia. Because C. Bruttius Praesens,[48] the owner of the estate as denoted by the stamps on the bricks and tiles, was most probably the grandfather of Bruttia Crispina who was married to the emperor Commodus in 178 CE, the villa must have belonged to the empress or her family.[49] Upon her execution (after 189 and before 192 CE),[50] the villa and the estate together with its tile works probably passed into imperial possession. The evidence of imperial landowning in southern Italy in the second century CE – or landowning by senatorial families and persons of courtly status – indicates that *regiones* II and III, rather sparsely populated with villas of Roman type even in the first century BCE, had become an area of elite villas within three centuries.

A CASE STUDY FROM *REGIO* III: THE VILLA AT MASSERIA CICCOTTI IN THE MID-IMPERIAL PERIOD

Against the background of a scattered and uneven sample of excavated villas of the first and second centuries CE in *regiones* II and III, the recent documentation from the upper Bradano valley is an exception. This micro-regional landscape – vast highland plains (an average of 350/400 m above sea level) gently sloping toward the upper catchment of the Bradano and Basentello rivers – was explored in the 1990s with large-scale excavations of selected sites and extensive surface surveys to reconstruct the changes in settlement patterns and land use between the first century BCE and the fifth century CE.[51]

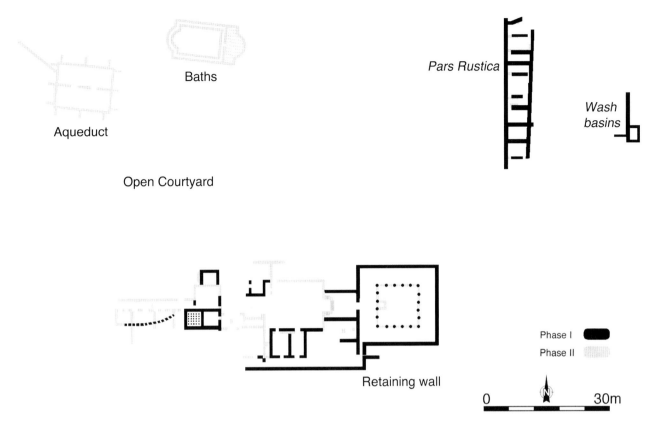

Figure 10.5. Masseria Ciccotti (Oppido Lucano), villa plan: phases I–II.

The study area is located immediately to the west of the *Fossa Bradanica*, a major geomorphological feature of the peninsula crossed by the middle and upper course of the Bradano River and a natural corridor of contact and exchange between eastern Lucania and western Apulia. A decade of systematic fieldwork has provided a detailed picture of the region, adding to our knowledge of villas in southern Italy and allowing formulation of hypotheses on their development in the Roman rural landscape.

Three sites have been excavated: Masseria Ciccotti, San Gilio, and San Pietro di Tolve (Map 4: 4, 16, 17). The results indicate that all three villas had become fully naturalized in the landscape by the late first century BCE. The villa at Masseria Ciccotti, the best preserved and most extensively excavated, was built on top of an earlier Lucanian farm in the second half of the first century BCE.[52] Phase I at Masseria Ciccotti was constituted by a massive terraced *basis villae* along the north bank of the Varco stream, in a form quite typical of late Republican

villas elsewhere in Italy (Figure 10.5). The terrace underpinned both the residential quarter (*pars urbana*) with the productive sector (*pars rustica*) and afforded a broad view over the surrounding countryside. The large peristyle (20x20 m) gives a "Varronian" character to this initial phase, connecting its design to central Italian models, a connection not at all surprising because stamped tiles found in the Phase I villa indicate that it and its estate probably belonged to (died 15 BCE) an immensely rich *possessor* of equestrian rank and a friend of the emperor Augustus, to whom he bequeathed much of his property.[53]

The other two villa sites excavated nearby also provide information on the earlier stages of villa building in Lucania and extend the documentation provided by Phase I at Masseria Ciccotti. The villa at San Gilio, a mere three kilometers away, may have belonged to the same estate as Masseria Ciccotti to judge from the same stamped tiles found at both sites. It was also built in the late first century BCE on an impressive *basis villae* of the late Republican

period.[54] The third and smallest of the villas in the upper Bradano district, at San Pietro di Tolve, was also a peristyle villa: A *triclinium* with a standard mosaic floor in the "U+T" format with simple geometric patterns was set at the northeast corner of a peristyle (partially preserved), the whole complex datable to the beginning of the first century CE. Most of the residential sector has disappeared, but the *pars rustica*, enlarged in the course of the first and second centuries, has provided very good evidence for wool production and an exceptional epigraphic document for the probable owners of the villa: Spindle whorls from the site were stamped with the name of L. Domitii Cnidi, most probably a freedman of Nero's aunt Domitia Lepida Major, working on an estate owned by her.[55] His presence is clear indication of investment by families of senatorial rank in the textile industry of villa estates in the region. This evidence for wool-working at the San Pietro villa is complemented by the discovery of water basins used for wool-washing in the east sector of the *pars rustica* at Masseria Ciccotti: The estates may have been centers for sheep ranching and textile production from the first through the fourth century CE.

The villa at Masseria Ciccotti underwent a major restructuring (Phase II) sometime between the end of the second and the first half of the third century (Figure 10.5).[56] The new architectural layout and decoration of the enlarged rooms constitute monumental transformations probably related to changes in ownership and in the overall organization and use of the villa and its estate. They also testify to an enhanced residential function of its *pars urbana*, a phenomenon also registered later in villas in Italy and elsewhere in the Roman empire. At Masseria Ciccotti, as we shall see, elaborate interior decorations were added to floors and walls of the main reception rooms in late antiquity, framing the owner's power and prestige with newly dignified, even ceremonial, spaces.[57] The villa may have been used by its owner as a residence for longer periods of time than when it had been a simpler dwelling (Phase I), but most important is the owner's new character as *dominus* of the estate.[58] This new intensity of residential arrangement was accompanied by structural transformations on the estate.[59]

The Phase II transformations at Masseria Ciccotti were ones known in other villas in Italy and elsewhere. However, their date – late second/first half of the third centuries – is earlier by some 40–50 years than the usual dates – between the later third and fourth centuries CE – when such transformations in villas became usual.[60] For this reason, the Phase II plan and redecoration of the Masseria Ciccotti villa are architecturally and socially precocious for their date.[61] They may be regarded as a sort of "missing link" in the changes from the traditional villa of "Varronian" type to the new forms of rural residences that became prevalent in late antiquity.[62]

The Phase II transformations to the villa at Masseria Ciccotti can be summarized as follows:

A. An impressive aqueduct was constructed, with the channel approaching the villa raised on arched substructures (Figure 10.5, top left).[63] The aqueduct was in all likelihood built at the same time as the large baths (Figure 10.5, top center), and both the new abundant water and the bathing amenities are clear indications of an enhanced residential character of the complex.

B. The rooms of the central residential sector of the villa (Figure 10.6), and particularly the reception rooms immediately to the west of the peristyle (rooms 21 and 13/14; Figure 10.6), were restructured and equipped with new floors. For example, room 21, a medium-sized hall (c. 6x8 m), opened from its east side onto the peristyle portico through a wide door (c. 2 m) on axis with a fountain apparatus set within a rectangular basin (*labrum*) in the open garden of the peristyle, thus providing a graceful connection between the older peristyle and the newly grand reception rooms.[64]

C. Though small in size, room 21 was re-floored with a mosaic depicting a personification of *Aiòn* (Time) with the wheel of the Zodiac by his side in a central octagonal frame and, in octagons in the corners of the floor, busts of the Four Seasons.[65] Room 21 served as the antechamber to a large and very impressive dining hall (*coenanatio*) in two formal sequences (rooms 14 and 13, respectively; Figure 10.6). Access was through a

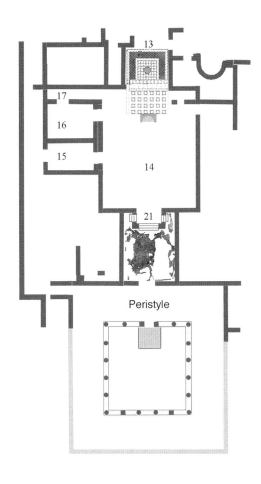

0 10m

Figure 10.6. Masseria Ciccotti (Oppido Lucano), villa: reconstructed plan of central residential sector, early third century CE.

wide door on the west side of room 21 and was preceded by a three-stepped ramping surface that raised the floor of the dining hall over a meter above that of its antechamber. The design of the *coenatio* at Masseria Ciccotti corresponds closely to the description provided by Sidonius Apollinaris (later fifth century CE) of the dining room of his large aristocratic villa, at *Avitacum* in central Gaul, the only difference being that Sidonius' dining room was equipped with a *stibadium* (a built-in dining couch in masonry) in the new fashion, whereas that at Masseria Ciccotti must have had separate, moveable dining couches in the earlier style.[66]

D. This high vantage point afforded guests a spectacular axial view back over the mosaic of *Aiòn* and the Seasons, through the peristyle portico, and into the peristyle garden with its fountain apparatus.

E. The *coenatio* was in two parts, a vast hall (room 14) serving as a prelude to the *triclinium* itself (room 13):

1. The open space of room 14 (c. 10x14 m) would have served as a place for the entertainment that accompanied and followed the banquet.[67]
2. The *triclinium* – namely the room proper in which the guests themselves would have been accommodated and waited upon – was room 13 (c. 5x6 m). It had the characteristic floor of such rooms: a U-shaped mosaic band for the couches defining a T-shaped area in a rich marble marquetry of geometric shapes (*opus sectile*).[68] Finally, a semicircular indoor fountain (*nymphaeum*) placed on the east border of the *opus sectile* floor centered the aspect of the room and reinforced the axial perspective toward room 21 with its mosaic, the peristyle, and the peristyle garden and its water amenities, giving a fluid transition from the formal interior spaces to areas of light, vegetation, and reflection.[69]

The design and decoration of the Phase II villa at Masseria Ciccotti represents a change at once *bold* in its architectural spaces, axes, and manipulation of levels and *subtle* in its viewing points, iconography, and transitions. The theme of the mosaic in room 21 was perhaps standardized, but the figure of *Aiòn* added some intellectual luster and prompted conversation, an important element of hospitality in any Roman villa.[70] The ceremonial aspects of the architecture certainly would have given formality and grandeur to the spaces, thus enhancing the status of its owner and his family.

As we have seen from brick stamps and spindle whorls from the three villas (Masseria Ciccotti, San Gilio, and San Pietro di Tolve) under discussion here, there are good indications for their ownership by *possessores* of senatorial rank in the region. For Phase II at Masseria Ciccotti as well as at the San Gilio villa, tiles stamped in the name of C.IUNIUS.

KANUS datable to the mid-first century CE were found. The name Kanus is an Italic name, not a Latin (or Roman) one. The stamps and the name suggest that the two villas and their estates may have been transferred into the hands of a local landowner by the mid-first century CE.[71] If so, they may have served as the economic bases for the ascent to senatorial rank of two illustrious descendants of this C. Iunius Kanus (otherwise unknown). Because the name is rare, he may well have been the ancestor of both Kanus Iunius Niger, a high official in the northern provinces under Trajan (*legatus Augusti pro praetore*), and his son, also Kanus Iunius Niger, consul in 138 CE in the reign of the emperor Hadrian.[72] In the social systems of the Roman Empire, villas and estates played their part in the rise of families and their members to the imperial court, in southern Italy as elsewhere.

IMPERIAL ESTATES IN APULIA AND LUCANIA

While the evidence from the villas clearly indicates the presence of villa owners of senatorial rank and even ones close to the imperial court in southern Italy, what of direct ownership by emperors in the region? As we have seen at the estate of the second century CE at Barricelle/Marsicovetere, identifying a rural site/villa as imperial property is most often based on literary references and/or inscriptions relating to imperial slaves, freedmen, or procurators. However, systematic surface surveys and studies of the distribution of rural buildings and their hierarchy within a landscape also identify imperial estates. For the middle Ofanto valley in Lucania, the field survey of a wide strip of the flatlands between the territories of Venusia and Canusium (around the modern town of Montemilone), in combination with inscriptions from the area mentioning emperors' slaves and freedmen, has shown that there was a sparse distribution of rural sites typical of agricultural activities over a large area and of sheep ranching, indicative of properties of imperial or near-imperial scale.[73]

Can such clues identify an estate as belonging directly to the imperial fisc? The Vagnari/San Felice project near Gravina di Puglia (*regio* II; Map 4: 19) carried out in the Basentello valley from the late 1990s through the mid-2000s has produced compelling evidence to answer this question, thanks to the combined application of large-scale systematic field survey, stratigraphic excavations of selected sites, and archaeometric analyses in order to define the topography and extent of an imperial estate and its productive economy.[74] Even so, humble but ultimately very important stamped bricks and tiles have been the starting point for an attempt to define the topography of an imperial estate. Two sites identified by the field survey, a *vicus* at Vagnari and a villa at San Felice, are the subjects of ongoing excavation. At Vagnari, a rural agglomeration including several kilns for tile production, a tile stamped GRATI. CAESARIS has been found.[75] Two other GRATI. CAESARIS stamped tiles have been found during surface survey of the slopes of the San Felice ridge, about 1.3 km to the southeast and 125 m above the site of the Roman industrial village. Excavation in 2006 of a collapse in the peristyle area associated with the abandonment of the San Felice villa produced a third GRATI.CAESARIS tile in the same fabric as those produced at Vagnari.[76] Thus, it is likely that the villa at San Felice was part of an imperial estate, and it, together with the structures and kilns at Vagnari, was in imperial ownership quite early in the history of Roman villas in the region, sometime in the first half of the first century CE.

While the estate at Vagnari, thanks to its strategic location near the via Appia, was used for large-scale production of bricks and tiles, several of the clusters of estates and some of the more isolated ones lay in areas suited for pasturing sheep and for the movement of transhumant flocks.[77] Inscriptions from the area record slaves who were employed either in the management of sheep (with the designation of *luparius*) or in the wool industry.[78] Studies of transhumance in the Roman period and the Middle Ages have shown that the movement of flocks was fundamental to the agricultural economy and ecology of Apulia, Lucania, and Samnium, and a network of drove roads may have existed from late Republican times.[79]

While this important aspect of the economy of imperial estates in *regiones* II and III requires further

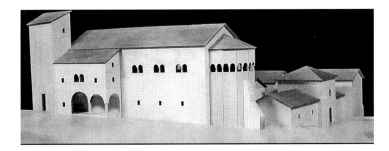

Figure 10.7. San Giovanni di Ruoti: architectural model of the late fifth-century CE phase (R. Haldenby, Waterloo University).

archaeological investigation, the presence of such estates cannot be doubted. The villas and estates confirm the acculturation of the rural landscape of southern Italy into a fully Romanized agricultural economy with varied terms of ownership from ordinary *possessores* to the emperors themselves.

DEVELOPMENTS IN LATE ANTIQUITY

Villas, many on a monumental scale, were built throughout southern Italy in the fourth and fifth centuries, especially in Apulia and Lucania.[80] In this respect, southern Italy was no different from regions elsewhere in both the Italian peninsula and the western parts of the empire.

Lucania

The villa at San Giovanni di Ruoti, in the Apennine hinterland of northern Lucania, is a premier example of such late antique villas (Map 4: 20; Figure 10.7). It had been built as a fairly modest rural residence in early imperial times by a small landowner from the locality.[81] However, its rebuilding on a grand scale in the late fourth and fifth century CE eclipsed the earlier villa by far.[82] In this late, very monumental phase, the San Giovanni villa provides documentation on the viability and persistence of villa life in southern Italy as well as for important developments in domestic architecture at the highest levels of design and social representation. In addition, one productive aspect of the estate has been convincingly reconstructed, at least in part. The character of the

San Giovanni villa in its late phases can be summarized as follows:

A. The residential parts of the villa itself were, in their design, quite new: a tight cluster of buildings separated by narrow passageways rather than the "Varronian" tradition of a spacious peristyle uniting rooms of different functions. For this new type of rural residence, the excavators reference Palladius, a late Roman writer on agriculture and other sources which suggest that the name for a rural estate center was no longer *villa* but *praetorium*, a term attested in occasional use in this sense from as early as the third century CE.[83] The grandeur of the new mid-to-late fifth-century architecture of the villa derives not only from its size and complexity, but from its cosmopolitan sophistication: The large apsidal hall (with its facetted apse) can be related to architectural models from the eastern areas of the Roman empire and their manifestation in the early Byzantine church architecture of Ravenna of the same period. The *dominus* or *domini* of the estate were careful to include the most urbane and up-to-date ideas in the architecture of their villa.

B. For the productive aspects of the estate at San Giovanni, the methods of excavation and survey have provided good evidence for the economy of the estate and the surrounding countryside. The rubbish heaps and middens of the villa contained a very high quantity of pig bones in a percentage of the contents not recorded elsewhere. This has prompted the interpretation of the estate – or part of it at least – as a supplier of pigs and pork products for the Roman markets. The economic argument

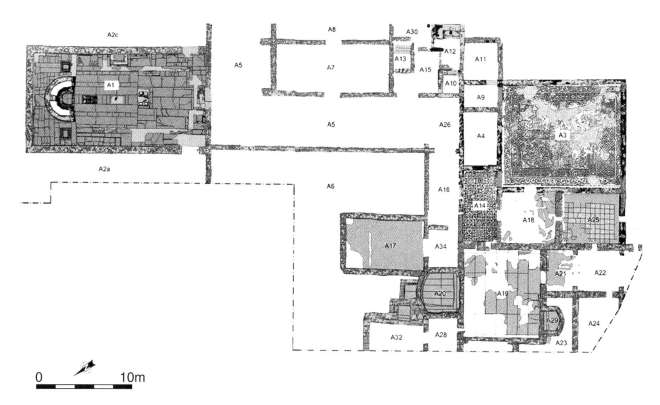

Figure 10.8. Faragola (Ascoli Satriano), villa: plan of large reception/dining room of the fifth-century CE villa (after G. Volpe).

is complex, but it rests firmly on facts about specialized cash-cropping in late Roman Lucania to satisfy the urban market demand as well as the distribution of meat products that were part of the *annona* or distributions of free food to the populace that still took place in Rome at that time.[84]

Apulia

In Apulia, documentation on late antique villas has been almost completely lacking, but excavations at the site of Faragola near Ausculum (mod. Ascoli Satriano, Foggia) have had important results. The monumental fifth-century villa with an ample *coenatio* and two major bath suites may have been part of an estate belonging to the senatorial family of the Scipiones Orfiti, to judge from an inscription associated with the earlier second-century villa on the site.[85] The dining room (Figure 10.8) had a curving built-in dining-couch (*stibadium*) with decorated masonry

enclosing an opus sectile floor in colored marbles that could be flooded with a sheet of water for spectacular effect to enhance the diners' enjoyment.[86] Like the late fifth-century *praetorium* at San Giovanni di Ruoti, the Faragola site attests the continuing prosperity of the countryside of southern Italy at this late date. Although less complex and more traditional in plan than San Giovanni, the Faragola villa may also have had unusual design elements: The dining couch (*stibadium*) was not set on axis to a peristyle to face the view of a peristyle garden but in a large rectangular hall with big windows on both long sides affording multiple views. The villa may have lacked a peristyle altogether, so its plan was now far from the traditional Roman prototype.

Bruttium

The evidence for Roman villas in Bruttium is incomplete, even in late antiquity when grand villas

were being built there and elsewhere. Symmachus uses a very effective phrase – *morbus fabricatoris* – to refer to the fourth-century CE boom in large villa construction, and there is sufficient documentation for a few monumental complexes.[87]

At Quote San Francesco near Locri, the villa recognized from its partially known plan appears to have been centered on a large rectangular reception room with an exterior polygonal apse rather than a peristyle.[88] This villa, like those at San Giovanni di Ruoti and Faragola in Apulia, may have been part of a trend in the fifth century: villas without peristyles as the common central space but with a grand representational hall as the dominating focus.[89]

Elsewhere in Bruttium, late-antique villas are sparsely known but tantalizing because of their size, sophistication, and fine decoration. The impressive ruins of the poorly documented villa at Naniglio (fourth century CE) near Gioiosa Jonica testifies to its architectural monumentality,[90] and the somewhat earlier villa at Roggiano/Larderia in the area of ancient Sybaris is one of the few that has produced rich mosaic decoration.[91]

A partially published site on the coast at Casignana near Locri is by far the most significant villa in the far south of the peninsula, and has been the object of new, ongoing excavations. The villa's *floruit* was in the fourth century, and its notable mosaic floors are mostly datable to that period. An elaborate bath building, already excavated in the 1970s, was impressive enough, but recent work has uncovered a monumental fountain (*nymphaeum*) and a suite of rooms arranged in *enfilade* facing the sea, many with mosaics depicting figures and scenes not unusual in late antiquity (Bacchus, the Four Seasons) but of high quality. The villa, like many others of its date, had a large hall, but this one was unusual for its cruciform plan with an apse at one end; it also was embellished with polychrome mosaics with geometric decoration.[92] The seaside façade was closed by a long corridor ending in symmetrical projecting circular rooms, evidently the bases of towers which must have given the villa an impressive aspect from the sea; the towers affiliate the design of the

Casignana villa to villas represented in North African mosaics.[93]

CONCLUSION

Despite the abbreviation and selectivity of this account of Roman villas in southern Italy, a number of general conclusions can be formulated on their architecture, interior decoration, and, not least, the part they played in the social and economic development of the peninsula between the late Republic, through the imperial period, and into late antiquity. Only a few decades ago, the region was considered merely peripheral to Roman Italy, and data on land use and rural changes during the Roman period were fragmentary, most often the result of chance finds or salvage excavations.[94].

Systematic surface surveys have made it possible to study Roman villas in their social and economic contexts and within their landscapes. The distinction between "productive" and "residential" villas and estates – an arbitrary and artificial distinction – can be set aside in favor of seeing agriculture and country living in tandem. For Apulia, the excavation projects of the senatorial villa at Faragola (Ascoli Satriano) and the vast imperial estate at Vagnari/San Felice (Gravina di Puglia) have provided, in the course of fifteen years, valuable evidence for both senatorial and imperial villas and estates. Heretofore, our knowledge of them relied almost exclusively on literary sources and scattered epigraphic evidence from funerary inscriptions and brick stamps.

Like Apulia, the inhabited countryside of Lucania used to be known mainly through literary sources.[95] The discoveries at San Giovanni di Ruoti changed all that: They documented unsuspected developments in the remote Lucanian hinterland in the later imperial period and into the early Middle Ages. The San Giovanni villa provides detailed documentation on the architectural transformations of a Roman villa in the centuries of the Roman Empire, but it does so in the wider context of social and economic developments of rural estates.[96] While changes in architectural layout and function of late

antique villas might have been inferred from literary references, recent fieldwork has provided detailed documentation that coordinates Lucania with developments elsewhere.[97]

The upper Bradano region was a key area of contact and exchange at the border of *regio* II with *regio* III). Its three excavated villas (Masseria Ciccotti, San Gilio, and San Pietro di Tolve) and surveys of their regional landscape have provided valuable evidence for the development of society and economy from the late Republic through late antiquity.[98] As we have seen, the third-century CE residential sector at Masseria Ciccotti was precocious in the ceremonial design of its formal reception area of the *coenatio*, presenting the *dominus* of the villa in an architectural backdrop and series of formal spaces that later *domini* also affected; the villa exhibits an early instance of the transformation of the traditional Roman villa into what the later literary sources and some epigraphic records refer to as a *praetorium* or administrative center of a large estate. In addition, the combined excavation and survey evidence from the upper Bradano valley has been instrumental in providing data on the role of villas as centers of regional economic exchange.[99] Within the particular geographical and economic reality of the *Fossa Bradanica*, an added role of villas and large estates was to cater to the major sheep ranching and wool industry centers of the Roman Empire located along the Ofanto basin, at Canusium and Venusia slightly to the north.

No less important is the contextualized recovery of the epigraphic record, mostly in the form of stamped bricks and tiles, which has greatly increased our knowledge about estate owners and manufacturing sites, especially the brick and pottery industries for which there is evidence on the estates explored in the region.[100] This combination of excavation, survey, and epigraphy has placed villa sites within their wider picture of a specific landscape of production. The same method – villa excavation, survey of key features of the countryside, and analysis of the road network – has been used in the exemplary excavation and prompt publication of the fifth-century CE villa at Faragola (Ascoli Satriano).[101] The results of archaeological excavations supersede the literary sources on villas in southern Italy but also extend

them. Villas were a complex and variable element in the evolution of rural settlement patterns in the diverse regions of Italy, especially in the variegated landscape of the southern part of the peninsula.[102] Far from being peripheral, the villas of *Regiones* II and III became central by the late Republic and are adding valuable evidence for how society and agricultural economy developed in the Roman Empire and late antiquity.

NOTES

1. Carandini 1988, 48 and 397; Smith 1997, 3.
2. The term *otium* villa is perhaps misleading because even luxury villas had an important social function for their owners; a better term is *ville residenziali* – villas designed for comfortable, even fine, living – as in Sfameni 2006 and Wilson 2008, 479–80. For an overview of villas in the Bay of Naples, Zanker 1979; see also Wallace–Hadrill, Clarke, Zarmakoupi, Howe, and Marzano in this book (Chapters 3, 4, 5, 6, and 8).
3. Carrington 1931, 110–30.
4. Villa systems: Dyson 2003, 77.
5. *Ager Falernus* survey: Arthur 1991. Francolise villas: Cotton 1979; Cotton and Métraux 1985.
6. Dyson 2003, 29–30.
7. Métraux 1998, 3.
8. Ibid.
9. The pioneer exploration of villas in the countryside of Buccino was conducted in the early 1970s: Dyson 1983, 189–91.
10. Undertaken by the University of Alberta (Edmonton) with a team under the direction of Alastair M. Small; Small, Buck et al. 1994.
11. Coarelli 1981, 217: sometimes the Roman period was even considered to be a period of decline.
12. The foundation of Latin colonies at Venusia (291 BCE) and Paestum (273 BCE) and the conclusion of the conflict with Tarentum in the later third/second century BCE virtually consolidated Rome's control of southern Italy. After the Hannibalic war, a number of *coloniae maritimae* were founded along the coasts and vast tracts of land were expropriated for *ager publicus populi romani* by which a stable Roman presence was confirmed: Gualtieri 2003, 24–7, 133–6.

13. Russo 1992, 41. Elizabeth Fentress has termed the building a "proto-villa," but the term remains matter of debate: Fentress 2003, 555.

14. For Lucania: Gualtieri 2008b; Fracchia and Gualtieri 2011. For Apulia: Goffredo 2010, 26–32.

15. For Bruttium: Sangineto 2001.

16. Volpe 1995.

17. Carandini et al. 2006, 590–610; Giardina 2009, 403.

18. Goffredo 2010; Fracchia and Gualtieri 1999; Fracchia and Gualtieri 2011, 24–6.

19. The staffing problems of these farms/villas were posed long ago by D. Rathbone (1981) but remain a matter of debate; more recently, Scheidel 1994, 160 and LoCascio 2004, 110–15.

20. The excavations at the Auditorium site on the via Flaminia just north of Rome have provided evidence for the early stage of villa development, although the interpretation of several aspects of the documentation on the formative stages of the villa in the *suburbium* remains a matter of open debate. For the villa itself: Carandini et al. 2006. For discussion, Terrenato 2001 *contra* Carandini 2002 and more recently Rosafio 2009. Fentress 2003: 553–6, provides an overview of the debate in the light of the most recent evidence of the earliest examples of *villae maritimae*. See also Chapter 1 in this book.

21. For detailed analysis and evaluation, Marzano 2007, 216–18. For the *suburbium* of Rome, De Franceschini 2005; Tombrägel 2012.

22. Applying categories extrapolated from literary texts to specific examples of villas documented through archaeological excavations needs caution: discussion in Terrenato 2001.

23. They were in charge of laying out and measuring land distributions and allotments to army veterans: Behrends and Capogrossi Colognesi 1992; Dilke 1971, 1992.

24. Dilke 1971; Carandini 1994, 168–70.

25. Carandini 1994. Concerns about the Carandini's classifications: Capogrossi Colognesi 1994, 212–13; overview in Sfameni 2006, 19–20.

26. Carandini 1993, 239–45.

27. The San Giovanni di Ruoti (Potenza) excavations paved the way to research not previously undertaken in these regions, but systematic field surveys have shifted the emphasis from individual sites to the configuration of Roman landscapes and villa systems: Dyson 2003, 77; Barker and Lloyd (eds.) 1991, 10–17. There are sparser excavation data

from Bruttium in *regio* III (modern Calabria): Sangineto 2001, *passim* but especially 215–31.

28. De Siena and Giardino 2001.

29. But see Terrenato's caution about categories extrapolated from literary texts to villas archaeologically documented: Terrenato 2001, 5–32.

30. Lippolis 2006, 45.

31. These very specialized building techniques point to a high-status villa, which, most probably, would have required a team of workmen brought specially from Rome or elsewhere in central Italy.

32. Lafon et al. 1985.

33. See discussion in Marzano 2007, 33–46 and on pisciculture, 47–56; synthesis in Marzano 2010.

34. Lafon 1981 and 2001. Port facilities were built at comparable maritime villas on the Tyrrhenian coast between the mouth of the Garigliano River and Formia. For maritime villas in Bruttium: Colicelli 1998; a helpful gazetteer, but without critical discussion in Accardo 2000. For Apulia, evidence of a comparable villa at Agnuli near Manfredonia: Lippolis 2006, 50–1 and fig. 12. Horace indicates economic activity and villa building also along the Adriatic coast of Apulia: *Carm.* 3.24.3.

35. Dyson 2003, 30–1.

36. Lippolis 2006, 49–51, esp. 50 and fig. 11.

37. Lippolis 2006, 89 and fig. 19 for a good general plan.

38. D'Auria and Iacovazzo 2006. The dating and interpretation of the different parts of this complex are tentative. A recent proposal (Lippolis 2006, 53) that it was the administrative center of a vast imperial property around Tarentum (known from literary sources) is to be considered with caution.

39. Madsen 2003; Gualtieri 2003, 197–8; Goffredo 2001, 154–5; Chelotti 1994; Manacorda 1995; Marchi 2004.

40. Rosucci 1987, 51–60 and fig. 4. The plan is accurate in general but needs revision in details.

41. For tombs at villas elsewhere in the Roman Empire, see Brogiolo and Chavarría, Wilson on Sicily, and Bowes in this volume.

42. The mausoleum itself is known in a sketch plan made from salvage excavations conducted by the *Soprintendenza Archeologica* in the 1920s: Delbrueck 1913, 277 and fig. 1. The famous sarcophagus (generally referred to as the "Melfi sarcophagus") was an imported item of eastern Roman manufacture: Ghiandoni 1995, 3–10; Gualtieri 2003, 229–32. For

its elaborate iconography and a new interpretation, Ghiandoni 1995, 50–8.

43. Griesbach 2005, 113; Graen 2004; see also Bodel 1997; Marzano 2007, 32, 218–19. For close parallels from Carranque and other Spanish villas, Fernandez-Galiano et al. 2001, 95–9. See also Zevi 2001, 643 with specific comments on the evidence from Apulia/Lucania.

44. Grelle 1993, 132.

45. Torelli 1991, 23. Herodes Atticus's estates in Apulia may explain why he was entrusted with the foundation of the colony at Canusium by the Antonine emperors. Ongoing excavations are revealing a villa with monumental sophisticated architecture at the site of Torre degli Embrici between Atella and Rionero del Vulture: Osanna 2008. Here, as at Masseria Ciccotti, the already impressive architecture was further monumentalized in late antiquity by the addition of a large apsidal hall.

46. Russo et al. 2007.

47. Russo et al. 2007, 109; Gualtieri 2003, 145–6 and n.52. At a slightly later date, an imperial slave or freedman owned a bronze punch to stamp bricks and tiles from the villa's tile works with his name (*Moderatus Augusti nostri*). This indicates that the tile works, and by association the villa and its estate, were in imperial possession by the late second century.

48. A friend of Pliny the Younger (mentioned in *Ep.* 7.3.1–2), he has been shown convincingly to be the consul of 118/9 and 139 CE: Picard 1951, 92–4; Gualtieri 2003, 145–6 and n. 52.

49. Hdn. 1.8.4; Hekster 2002, 39, 84; Cass. Dio 73.4.5–6 (trans. Foster 1982). The marriage of Commodus with Crispina brought him, as a dowry, a large number of estates: when added to the imperial holdings, they gave him control of a substantial part of Lucanian territory.

50. Hekster 2002, 71–2 and n.181.

51. This area has been the target of a project conducted in the 1990s by teams of Canadian and Italian universities under the auspices of the *Soprintendenza Archeologica della Basilicata*: Fracchia and Gualtieri 1999, 295. It is a pleasure to acknowledge the continued financial support of the Social Sciences and Humanities Research Council of Canada.

52. Analysis and interpretation of the pottery of the third–second century BCE in Fracchia and Gualtieri 2011, 22–7.

53. Some thirty tiles stamped *P.VEI.POLLION* were found in the peristyle. On this man's villa on the Bay of Naples: Pappalardo 2007, 44. On his properties around Beneventum (his place of origin) and his wine business evidenced by Dressel 2–4 stamped amphorae found at Carthage: Gualtieri 2009b, 358–9. Fausto Zevi has no doubt that this is a Lucanian estate of P. Veidius Pollio: Zevi 2001, 641.

54. The ownership of both the San Gilio and Masseria Ciccotti villas by P. Veidius Pollio may be indicated by tiles also stamped P.VEI.POLLION at San Gilio, though tiles from one villa's tile works may have been bought from or gifted to the other. In both cases, neither villa would have been built and roofed much after 16 BCE, the year of Pollio's death when his stamp would no longer have been used.

55. Di Giuseppe 2007; Gualtieri 2009b.

56. Fracchia and Hayes 2005.

57. The wall decoration of room 14, with *sectilia* of marbles imported from the major quarries of the Mediterranean area, has been the object of a preliminary study by A. De Stefano: Gualtieri 2009a, 277 and n. 22.

58. No reliable epigraphic evidence from the site and surrounding territory is available for the third century although recent evidence for the second century indicates the presence in the area of *possessores* of senatorial rank: Gualtieri 2003, 190–5. For use of the term *dominus*, see Métraux (Chapter 21) in this book.

59. Vera 2001.

60. Such developments may underlie visible changes in the organization of rural estates. Detailed analysis in Vera 1995; see also Romizzi 2003 and Sfameni 2004 and 2006. On the historiography of the third-century "crisis," see Giardina 2006 and 2007. The archaeological evidence for the transformation of rural landscapes and villa systems between the early and mid-empire and especially in the course of the third century is limited. For a synthesis of these developments in southern Italy: Madsen 2003.

61. A *terminus post quem* for this phase is established by a sealed pottery deposit found in the *pars rustica* that testifies to a major restructuring of the complex between the end of the second and the first decades of the third century CE: Fracchia and Hayes 2005.

62. On the residential aspects of late Roman villas in Italy, see Sfameni 2006 and the review in Wilson 2008.

63. On the aqueduct and its significance in the development of the third-century villa, see Gualtieri 2008a.

64. For a comparable architectural arrangement (at a slightly earlier period, probably second century CE), see the villa at Castroreale Terme (Sicily) in Dunbabin 1996, 74–5 and its plan at fig. 11.

65. Parrish 1981; Parrish 1995; Muth 1999a.

66. " . . . in this room are a semi-circular dining couch and a glittering sideboard and on to the floor on which they stand there is a gentle ascent from the portico by steps which are not made either short or narrow. Reclining in this place you are engrossed by the pleasures of the view, whenever you are not busy with the meal." Sid. Apoll., *Ep.* 2.2.11 (trans. Anderson 1980).

67. The major part of the space is not devoted to dining at all but rather to its architectural prelude, as Ellis (1997, 41–51) comments on a comparable *coenatio.* The large size of this spatial prelude (room 14) at Masseria Ciccotti is comparable to that of the late antique *coenatio* at Faragola in Apulia (see p. 00). For entertainments during dining, see Zarmakoupi (Chapter 5) in this book.

68. For this type of floor decoration in *triclinia,* Dunbabin 2003, 256.

69. This is in keeping with a growing emphasis on outdoor space in the arrangement of convivial spaces between the end of the Republic and the later imperial period; see comments on this "capacity to evoke nature" for *stibadium*-fountain arrangements in late antique villas in Vaquerizo Gil and Carrillo Diaz-Pines 1995, 121–54. See also Dunbabin 1996, 77. Literary texts: Dunbabin 1996, 78.

70. Parrish 1981 and 1995; Muth 1999a.

71. C. Iunius Kanus may have been a freedman of the Roman family of *Iunii Silani,* attested epigraphically in the area.

72. *PIR*² IV.3.782–3; Gualtieri 2003, 189–91.

73. The 1998–2000 regional survey was conducted for the Institute of Ancient Topography of the University of Rome by P. Sommella: Sabbatini 2001, 73–5; inscriptions: Chelotti 1994; recent overview: Marchi 2004.

74. Small 2003, 179–84, also includes a collection of the epigraphic and literary evidence for Apulia and part of Lucania, 193–6, and the very helpful location map of imperial estates at fig. 11.

75. Small 2003, 180–7. It has been demonstrated through neutron activation analysis that this tile was produced from clay excavated at a clay-pit next to the site at Vagnari. The stamp GRATI. CAESARIS means "by the favour of Caesar [viz., the emperor]."

76. McCallum and vanderLeest 2011. I am very grateful to M. McCallum for discussing with me the recent results of the San Felice excavations, on the occasion of a panel on imperial villas at the 2011 Archaeological Institute of America Annual Meeting in San Antonio, Texas.

77. Small 2003, 187–9. Frayn 1984, 45–65. The practice of transhumance, by which large flocks of sheep or other herd animals are moved from pasture to pasture according to the seasons, sometimes over quite long distances, different altitudes, and various geological bases, was an important aspect of both ranching and soil fertility in antiquity.

78. Grelle and Silvestrini 2001.

79. Gabba and Pasquinucci 1979, 176–82.

80. Grassigli 2000; Romizzi 2003, with a useful checklist of late-Roman villas in the south.

81. Buck and Small 1985; Silvestrini 2003, 62.

82. Small and Buck 1994, 91–101.

83. As indicated by a late Severan inscription from the villa at Muru de Bangiu (Sardinia): Zucca 1993, 602–3. See Brogiolo and Chavarría (Chapter 11) in this book.

84. Whitehouse 1983; Barnish 1987, 168–73.

85. Volpe and Turchiano (eds.) 2009, 82 and 176–7.

86. Volpe and Turchiano (eds.) 2009, 138–9. The decorated masonry of the *stibadium* is the only one of its kind found so far.

87. Symm., *Ep.* 2.60.2. For *morbus fabricatoris* (literally "building sickness," otherwise "démangeaison de construire," (Callu), or "folie d'architecture": Callu 1972, 194. Sangineto 2001, 222. For an account of other villas in Bruttium, Arslan 1999, 398; Noyé 1999, 461–4.

88. Sfameni 2005a.

89. Wilson 2008, 488.

90. Although only partially excavated and incompletely published, the size and architectural monumentality of this villa are reminiscent of Olympiodorus' description of suburban residences near Rome, which " . . . included everything that can be found in a small city: theatre, hippodrome, a forum, shrines and several baths and fountains." Olympiodorus Tebanus *ap.* Phot., *Bibl.,* 80; comments in Sfameni 2006, 177.

91. Naniglio villa: De Franciscis 1988; Di Giovanni and Russo 1988. For the villa at Roggiano/Larderia, Faedo 1993, 449–53 and pls. 23–5. She concludes that a mosaic workshop with strong ties to North African workshops was commissioned to make the mosaics.

92. Sabbione 2007, 50–9 and 86–7.

93. Mosaic representations of villas in North African mosaics show towers, though there are very few such towered villas on the ground: Wilson 2008, 496.

94. For a review of research and theories on the countryside of southern Italy in Roman times, including issues of so-called decline from a once glorious Magna Graecia and some merely alleged depopulation and land abandonment transitioning to subsistence agriculture and rough grazing in late antiquity, Gualtieri 2003, 10–11 and 37–40.

95. These literary sources gave evidence of very large-scale agricultural enterprises (*latifundia*), which could also be based on chain-gang slave labor (*vincti*) housed in confined buildings or basements (*ergas-ergastula*). For the late-antique period, Vera 1986, 234–5; Sirago 1987, 93–8.

96. Barnish 1987; Vera 2001, 2005; Giardina 2007.

97. To quote Wickham's effective formulation, " . . . the interest shown by aristocrats in rural living, comfort and display – unmatched in the east, outside suburban areas at least – was firmly part of western aristocratic identity" (Wickham 2005, 468). Further discussion on the fourth-century "villa phenomenon" in Bowes 2010, 85–92 and the map at fig. 21, illustrating the group of late antique villas in Apulia/Lucania, though ignoring data from late antique villas in Lucania, which had revealed developments in southern Italy during the later Roman empire (Whitehouse 1983; Barnish 1987; Small and Buck 1994). Bowes addresses the social implications of competition among the elites discernible from the monumentalization and distribution of late Roman villas in a number of districts of the western empire, pointing out that hierarchization of late antique society did not underlie the "boom" in villa building or has been overstated. She emphasizes continuity with earlier social aspects of élite social competition in general, with villas as the countryside venues for such competition: Bowes 2010, 95.

98. Vera 1995 and 2001.

99. Gualtieri 2009a; Fracchia and Hayes 2005.

100. Fracchia and Hayes 2005, 147–52; Di Giuseppe 2007.

101. Volpe and Turchiano (eds.) 2009.

102. Patterson 2006, 58–69.

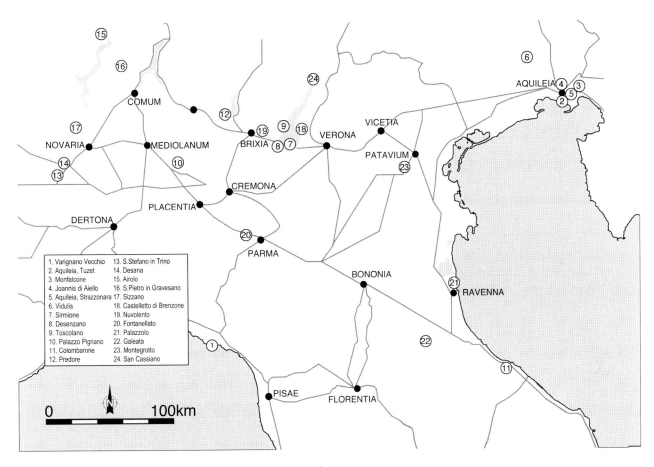

Map 5. Major Roman towns and villas sites mentioned in the text.

The map legend reads:

1. Varignano Vecchio
2. Aquileia, Tuzet
3. Monfalcone
4. Joannis di Aiello
5. Aquileia, Strazzonara
6. Vidulis
7. Sirmione
8. Desenzano
9. Toscolano
10. Palazzo Pignano
11. Colombarone
12. Predore
13. S.Stefano in Trino
14. Desana
15. Airolo
16. S.Pietro in Gravesano
17. Sizzano
18. Castelletto di Brenzone
19. Nuvolento
20. Fontanellato
21. Palazzolo
22. Galeata
23. Montegrotto
24. San Cassiano

Map labels: COMUM, MEDIOLANUM, NOVARIA, DERTONA, PLACENTIA, CREMONA, PARMA, BRIXIA, VERONA, VICETIA, PATAVIUM, AQUILEIA, BONONIA, RAVENNA, PISAE, FLORENTIA

0 100km

VILLAS IN NORTHERN ITALY

GIAN PIETRO BROGIOLO AND ALEXANDRA CHAVARRÍA ARNAU

INTRODUCTION

This chapter focuses on the early advent of Roman villas in northern Italy and especially on their late antique manifestations; the architectural type normally defined in late Republican and early imperial times as *villa* came to have, later on, a variety of uses and functions in this region, because the same architectural types used for private villas were also used for *public* buildings that served functions beyond merely residential ones.

Besides villas, the Roman countryside was populated with buildings called *stationes* (relay-points to change horses) connected to the state-run courier and transportation service (*cursus publicus*) and inns (*mansiones*) for travelers; by public buildings; by imperial residences; and by administrative centers (*praetoria*). This last term, *praetorium*, was used as of the fifth century CE as a synonym of villa.[1] Palladius, in his treatise on agriculture, uses the term *praetorium* to indicate the residential quarters of a rural mansion on an agricultural estate.[2]

The design characteristics of these buildings – country houses owned by private individuals or families, *praetoria* in the sense of the elegant residential parts of villas on agricultural estates, and official or even imperial residences – tended to blur and merge in late antiquity, with the result that distinctions of form among buildings of quite different functions (residential, agricultural, official) can be hard to differentiate.[3]

This blurring and merging of form was not exclusive to Northern Italy; it can be neatly exemplified in the villa at Muru de Bangius near Oristano in Sardinia. A third-century CE inscription on the site commemorated the inauguration of a *praetorium* or one of its annexes and lists a small bath complex, a guesthouse, and shops (*balneum, hospitium, tabernae*). The involvement of the governor indicates that it was a public building of some sort, most probably an official residence among others and certainly paid for with public funds (Figure 11.1). However, the plan of the building with its rectangular layout, with rooms surrounding a peristyle, with reception hall and baths, would ordinarily have been identified as a villa in private ownership rather than an official residence if the term *praetorium* had not been specified by the inscription.[4]

Modern scholars have occasionally used the term *praetorium* to refer to the architecturally monumental parts of late antique villas, the residential parts of large estates with satellite farms, of which the agricultural products (above all cereals) were stored in the facilities of the main mansion.[5] There were other designations for rural buildings apart from villas, especially ones at sites on communication routes. In the Veneto, for instance, the site of Corte Cavanella (Loreo, Rovigo) has now been identified as the *mansio Fossis*, an inn on the via Popilia, marked on the *Tabula Peutingeriana*, and another site, that of San Basilio di Ariano Polesine (Rovigo) can be designated as the *mansio Radriani*, also a waystation and inn

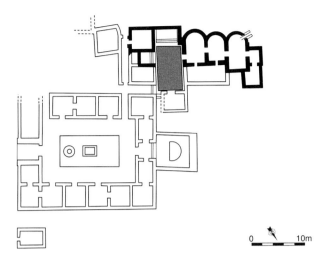

Figure 11.1. Muru de Bangius (Oristano), villa, plan (Zucca 1993).

for the *cursus publicus*.[6] Perhaps the most difficult problem in identifying the character of rural buildings is that of the *aedes publicae* or *palatia* – buildings with public character and official dignity – as in the architectural complexes of Galeata (Figure 11.10b) and Montegrotto (Padova; Figure 11.11) and of San Cassiano (Riva del Garda; Figure 11.12).

Besides their economic aspects as centers of agricultural exploitation with its constituent parts, the *pars rustica* and *fructuaria* (working areas of all kinds, stables, and storage spaces), villas also incorporated the *pars urbana* with dedicated spaces for the *otium* of the owners and guests (*balnea*, libraries, gardens, reception spaces); together, these *partes* expressed the wealth and the culture of the owners and/or the ambition of their architects.[7] Architectural spaces became the expression of life styles represented to a local and wider audience, combining the aspiration to, or affirmation of, aristocracy and venues to receive the admiration of social peers. Such lifestyles required particular geographic settings. In northern Italy, the wealthy families of Brixia (mod. Brescia) and Verona found it in the area of Lake Garda; the elite from Mediolanum (mod. Milan) preferred the Brianza region – St. Augustine, who lived in Milan for many years, evokes the villa of *Cassiciacum* near the modern town of Cassago Brianza;[8] others elected the shores of Lake Comum, where Pliny the Younger had owned several villas; and the elite

from Aquileia had the coast between Tergeste (mod. Trieste) and Pola (mod. Pula), as well as some of the Dalmatian islands.[9] These beautiful landscapes were the settings of villas by which an elite self-represented their high social status.[10] Such villas – proofs and guarantees of status – were the prototypes of monumental residences built from the Renaissance to the present, expressions of power with references, both cultural and architectural, to antiquity; the most distinguished examples of such buildings, of course, are those of the Vicentine architect Andrea Palladio (1508–80).

The Roman villa and the lifestyle that went with it were predicated on agricultural estates generating a surplus of goods for urban markets and the money economy. However, the locus of agricultural activity did not always coincide with the venue in which its profits were displayed and enjoyed. There were other considerations for residential villas: the amenities of the landscapes or proximity to the centers of power: Verona, Brixia, Padua, and, later, Mediolanum, Aquileia, and, from 402 CE, Ravenna (Map 5).

Social changes in the early Middle Ages modified the economic functions of villas. A small number continued to exist, but they outlived the regional and even Mediterranean-wide economic systems and local social structures that had ensured their viability heretofore: by the beginning of the fifth century CE, villa habitation diminished sharply, although in some exceptional cases villas survived until the sixth. Still, the memory of villas may have intensified their ideological value as an expression of political power: The Lombard king Liutprand, who reigned over most of Italy between 712 and 744, established an official country residence for himself at Corte Olona near Pavia, an architectural act so important that it was worthy of historical mention and an inscription.[11]

Recent studies devoted to villas in northern Italy have focused on early imperial villas[12] and on late antique ones and their transformations, with specific analysis dedicated to the most impressive sites (Palazzo Pignano, Desenzano, Galeata, Colombarone, and others).[13] The investigations are wide-ranging, even though the fragmentary state of many villas limits both research and

interpretation. Plans and subsidiary buildings are not completely known. Many sites were not excavated to reveal their stratigraphy, and recent investigations still await publication. While detailed documentation of any one villa's architecture and artifacts is very welcome, certain other aspects of villas have been ignored: earlier and later developments in the ecological, social, and political developments, methods of agricultural production and their ability to generate wealth, and on aspects of diet. Such studies, when they come, will give us a more detailed picture of the functions of villas and their relationship to other settlement types in the same territory (villages, castles) than is available now.[14] The relationship among villas, their owners, and the Christianization of the countryside is an important issue, as is the relationship between the architecture of rural residences and that of urban houses.[15] This chapter does not synthesize the wealth of studies on northern Italian villas, nor does it give a complete and detailed account of all that is known. Some background on the early villas of the region is provided, but our emphases are on future research, recent discoveries, and the reinterpretation of older data. An outline of early Roman villas is offered as well as a focus on late-antique villas and buildings of a public character related to the emperor or royal persons, as well as the "end of villas."

[A.Ch.A.-G.P.B.]

THE EARLY HISTORY OF ROMAN VILLAS IN NORTHERN ITALY

Villas in northern Italy appeared in consequence of Rome's military and political expansion in the third century BCE with the foundation of the colonies of Ariminum, Cremona, and Placentia and the construction of major road axes such as the via Aemilia (187 BCE) and the via Postumia (148 BCE). Subsequent developments for the implantation of villas were the close sociopolitical links between the region and Rome, marked by the grant, in 89 BCE, of Latin rights (ius Latii) to the major towns of the Celts and Veneti (Lex Pompeia de Transpadanis),

followed by the grant of citizenship in 49 BCE (Lex Rosica de civitate Transpadanorum).

The earliest rural buildings were farms. Rarely, and only in Emilia, was there any display of amenity such as mosaic floors.[16] In the second century BCE, however, some monumental impulse can be found in the villa of Varignano Vecchio near La Spezia (Le Grazie-Portovenere locality; Figure 11.2), which had a long life. Built on the coast along the slope of a hill, the villa overlooked the Bay of Varignano.[17] The first phase of the villa, built after 155 BCE, incorporated some rooms, the wing of a portico, a reception hall paved in opus signinum with a meander decoration, and another room with the floor displaying a rosette motif and First-Style wall decoration with molded stucco decoration. The villa was rebuilt in the early first century BCE, with the residential and service parts newly organized around a large courtyard. In the residential quarters, two separate sectors can be seen in the spatial organization: the first, smaller one (22x14 m) may have been the residence of the bailiff (vilicus) and his family; the other (36x23 m) was the residence for the dominus, the owner of the villa. This sector, unfolding around two atria in Tuscan style, featured the sequence atrium flanked by alae leading to the tablinum, the usual feature of Roman houses and Republican villas. The outer limit of the complex on the seaside is marked by a porticus triplex, which created an architectural frame to the view opening onto the bay.

The agricultural product of the villa was olive oil, and a substantial pars rustica was built at different elevations. In the second half of the first century CE, a large bath quarter was built in sector A, while the oil storage area was dismantled, its large terracotta containers (dolia) removed, and the entire area turned into a vegetable garden. With these transformations, the villa viably endured for more than four centuries.

The end of the villa occurred at the end of the fourth or early fifth century CE, when the complex underwent changes that drastically modified its use: the earlier walls on the sea side were cut, levels were raised and rooms enlarged, and structures built that are difficult to identify and interpret, though they were used until the end of the sixth century.

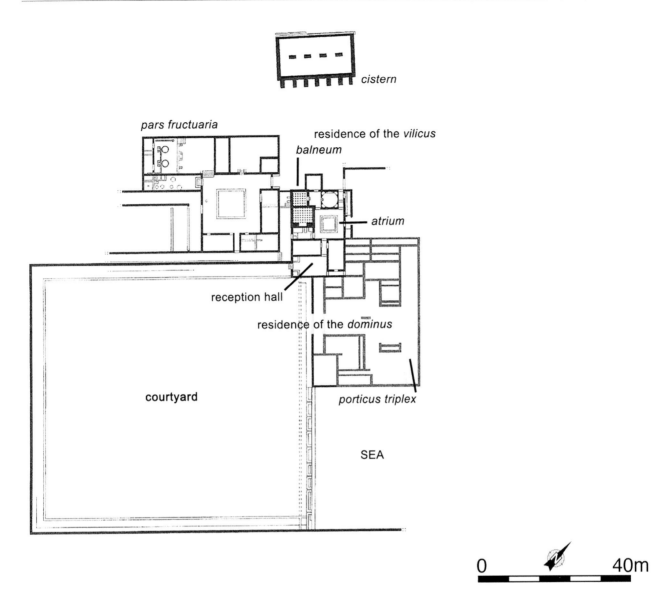

Figure 11.2. Varignano Vecchio (La Spezia), villa, plan of III phase (fourth century) (Gervasini 2004).

In Lombardy and Piedmont (to the north and north-east of La Spezia), no villas as ancient as that of Varignano are known; in these two regions, the villas appear only late, in the Augustan period.[18] This lag in the diffusion of villas in these areas vis-à-vis the earlier implantation in Emilia further east was due to the relatively late subjugation of the Alpine populations, concluded only in 16 BCE, even though fully Roman urban centers such as Brixia (Brescia) had been equipped with monumental architecture as early as the second century BCE.

The plains of Lombardy and Emilia are conspicuous for the near-absence of villas – monumental or ordinary – in what was (and still is) a fertile, well-watered area of great and continuous agricultural productivity. Their absence may be ascribable to the robbing and reuse of building material after they were abandoned.[19]

In northeastern Italy, the agrarian development of the territory, with centuriation systems appearing in the geographical areas less prone to floods, started in the late first century BCE, with major villa development in the first century CE. Villas concentrated near the coastal areas and in the jurisdictions of the main cities such as Aquileia, where settlements also show a wide chronological

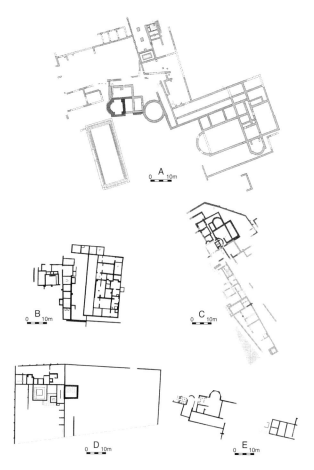

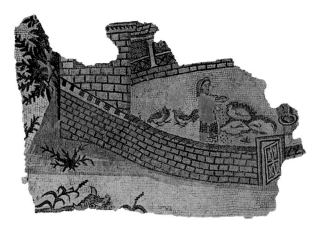

Figure 11.4. Oderzo (Treviso), mosaic pavement with porticoed villa (Busana 2002).

Figure 11.3. Villas in the territories of Aquileia - A: Aquileia, fondo Tuzet, B: Monfalcone, loc. Punta, C: Joannis di Aiello, loc. Macillis, D: Aquileia, loc. Strazzonara, E: Vidulis, loc. Tumbules (Busana 2008).

LAKESIDE VILLAS IN NORTHERN ITALY

Lakeside villas were in part designed to establish a strong relation between the architecture and the landscape, and the result was a developed articulation of the complexes in their naturally spectacular settings. The lacustrine villas of Sirmione and Desenzano are among the well-known sites in northern Italy, and recent research has identified new ones on the shores of Lake Garda. Villas have also been uncovered at Faustinella and Castelleto di Brenzone, while at the monumental villa of Toscolano, numerous rural structures have been investigated.

At Sirmione (anc. Sirmio), the so-called Grotte di Catullo villa was built in the first century CE in a commanding position on the tip of a peninsula jutting into the lake. Massive substructures allowed the building to follow the irregular topography of the site (Figure 11.5). This villa was probably owned by a very prominent family, maybe that to which a certain Sirmio, the dedicatee of poem 31 by Catullus (c. 84–54 BCE), belonged. The main building occupied an area of more than 2 ha and had a rectangular plan (167.5x105 m) with a central open space. It was organized on three different levels, the lower vaulted substructures being the best preserved. The building was violently destroyed at the end of the third century and abandoned, but it was incorporated into the fortifications constructed

span, from the second century BCE to late antiquity (Figure 11.3).[20] The mosaic pavement of an urban *domus* in Oderzo (Figure 11.4), showing a porticoed, possibly U-shaped villa delimited by an enclosure, represents the most common typology of rustic buildings found in this territory, although simpler farms and more elaborate structures have also been identified.

The dearth of villas in northern Italy in the late Republic was amply made up in the Augustan period by the boom of villa construction in the late first century BCE and the first century CE, when luxurious dwellings were built on the shores of lakes as famous for their beauty in the present as they were in Roman times.

[A.Ch.A.]

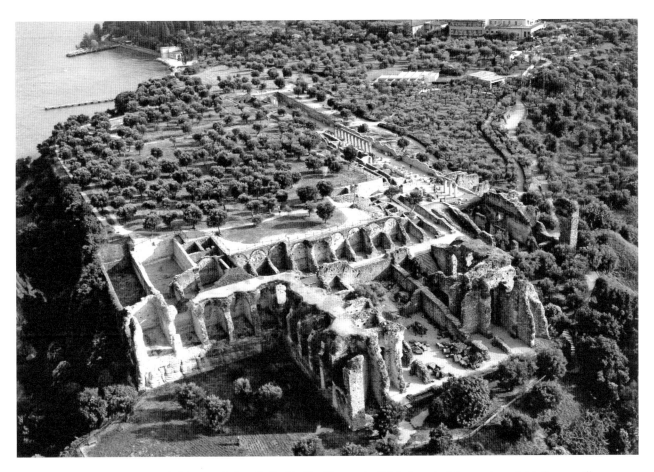

Figure 11.5. Sirmione (Brescia), "Grotte di Catullo" villa (Roffia 2013). (A black and white version of this figure will appear in some formats. For the color version, please refer to the plate section)

around the whole peninsula after the fourth century, so habitation of some kind continued. Dwellings in perishable building materials and groups of tombs appeared in this phase; some of them belonged to the military population that occupied the area, now transformed into a fortified settlement (*castrum*).[21]

At Desenzano on the southern shore of Lake Garda, an earlier villa was completely rebuilt at the beginning of the fourth century CE and equipped with monumental rooms with elaborate floors in mosaic and *opus sectile* and wall paintings (Figure 11.6). It had a collection of good quality sculpture of more than forty statues (mainly a standard repertory of figures from ancient mythology), one of the largest collections known from any private villa in Italy or elsewhere. The residential area comprised several different structures: building A centered on a rectangular peristyle accessed via an octagonal vestibule. It included an impressive

double-cube rectangular hall, the first cube flanked by apses on both sides, the second contiguous cube forming a large trichonch, a three-apsed space most probably used as a *triclinium* or dining room for feasting. The rest of the villa is poorly known, but there was a bath building and a large apsidal room paved with a marble floor.

On the northwest coast of Lake Garda, the villa of Toscolano was built in the first century CE; in the second century, the residence was further monumentalized with rich mosaic floors, wall paintings, and a grand rectangular fountain decorated with sculptures.[22] It probably belonged to the senatorial family of the Nonii; an inscription dedicated to M. Nonius Macrinus, consul in 154 CE, is known. This family owned considerable real estate and had economic interests in the trade of timber and other products, which were transported over the lake to and from the transalpine regions.[23] The contents

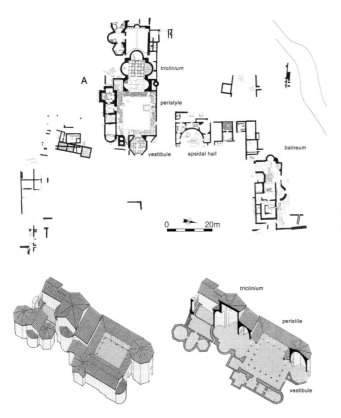

Figure 11.6. Desenzano (Brescia), via Borgo Regio villa, plan and axonometric reconstruction (Roffia 2013).

of the villa included an inscribed votive altar mentioning Claudia Corneliana, probably the same woman mentioned in the inscription of the so-called *cippus* of Arzaga.[24] The inscription mentions Corneliana's bequest of a valley free of any legal obligation (*immunis*) to the *coloni* (namely, nonslave tenants, local owners of small properties, or free laborers) of a *vicus* as a commemoration. The bequest indicates the extent of personal agency that the proprietors of villas had over both the land they owned and the personnel who farmed it: The recipients of Corneliana's generosity had a permanent obligation to celebrate her memory on the occasion of the religious celebrations for the dead and at the annual grape harvest.[25]

The same family – the Nonii – may have owned a villa at Predore, in the province of Bergamo, as indicated by a commemorative inscription.[26] Even though only the villa's bath complex of the imperial period has been investigated, this and other archaeological and epigraphic evidence lead us to two conclusions: First, that families of the senatorial elite owned multiple villas and estates in different (and sometimes far-apart) locations, in a land-tenure

strategy known in other parts of Italy and the empire. Second, and most important for this chapter, that in Roman north Italy, large estates (*latifundia*) employing slave labor and equipped with *ergastula* (slave-quarters) do not appear to have been a normal mode of exploitation. The slave-based agricultural economy known in other parts of Italy and elsewhere in the empire may have been inapplicable in a region where land distribution to Roman colonists in some areas of the plains of Lombardy and Emilia in part replaced, in part coexisted, with ownership systems of the aboriginal populations (the Veneti, Celts, Reti, and Liguri), about which we know very little.

VILLAS, MAUSOLEA AND CHURCHES IN LATE ANTIQUITY

Roman domestic architecture – both rural in the form of villas and urban in the form of houses – reached an apogee in the fourth century CE. Many earlier buildings underwent partial renovation or were completely rebuilt, displaying forms in

a monumental and often uniform architectural and decorative language. This phenomenon, which started in the late third century, is observable everywhere in the fourth century; it continued into the fifth century in certain regions. Besides the almost-obligatory bath complexes, peristyles, and gardens with *nymphaea*, a key feature of such villas are one or more large reception halls, very often with apses, used for semi-public events such as hearings, meetings, and banquets offered by the owner. Another relevant element of these late antique villas were the storage buildings (*horrea*), where the owners kept the agricultural produce of their estates, an indication of the productivity of their lands and the income deriving from the properties, sometimes in the form of rents paid in kind by their tenants.

Among the luxurious late antique villas discovered in northern Italy, four stand out: the well-known site of Palazzo Pignano (Figure 11.7), a villa featuring an octagonal peristyle centering the main reception rooms; the villa at Desenzano, which, as we have seen, included a bath complex and monumental halls (Figure 11.6); and the recently discovered villas of Faustinella also in Desenzano (Figure 11.9) and Colobarone, near Pesaro.[27] To existing villas that had been built already in the first and second centuries, new rooms – especially reception halls – were added, but in many cases the transformations were radical, intended to adapt the dwellings to both current architectural fashion and specific social needs. At the same time, their earlier contents and decorative apparatus were sometimes preserved: sculptural collections – often, as in the case

of Desenzano, large numbers of statues dating to different epochs – as well as frescoes, mosaics with geometric and figurative patterns, and marble floors.[28]

The monumentalization of villas went with socioeconomic transformations in the Roman empire starting in the Tetrarchic period (293–306 CE). Power, wealth, and land came to be concentrated in the hands of increasingly fewer members of the elite class. The process caused, on the one hand, the abandonment or reuse, exclusively for utilitarian purposes, of many small- and medium-sized earlier villas; on the other, some villas were made grander according to a model of aristocratic residence attested both in town and country in the western and eastern Empire.[29] In northern Italy, two events had bearing on the life of elite villas in this territory: the move of the capital and imperial seat to Milan (286–402 CE) and then to Ravenna as the residence of the western Roman emperor (402–76 CE) and then, until 540 CE, as capital of the Ostrogothic kingdom of Italy.

As we have seen, grand reception halls, often with apses, came to be the monumental focus *inside* late antique villas, but *outside* the dwellings, monumental *mausolea* – also with apses – were at times built in close proximity to these elite country residences. There was a tradition for this: Already during the Republic, rural properties were venues for tombs of the elite, and texts and funerary inscriptions indicate how, by the early imperial period (first century CE), monumental tombs came to be familiar elements in the rural landscape, especially in territories around cities or in the suburbs of towns. In northern Italy,

Figure 11.7. Palazzo Pignano (Cremona), villa, plan (Bishop and Passi Pitcher 1988–9).

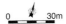

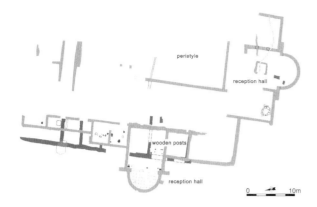

Figure 11.8. Faustinella (Desenzano del Garda, Brescia), villa, plan (Roffia 2007).

however, the elite had more freedom in the planning and construction of their *mausolea*.[30] Tomb buildings – many very impressive – were built near villas during the fourth century CE and became, just as the dwellings with their new architecture and decorative programs, monuments to commemorate the social, economic, and cultural importance of the owners, together with other forms of self-representation typical of late antiquity.

Such funerary structures have been identified at Santo Stefano in Trino (Vercelli), where a funerary monument was built next to a villa.[31] The building took the form of a rectangular hall with a west-facing apse flanked by two symmetrical rooms. Inside were several inhumation tombs, also in the apse, with no grave goods. Similar to this mausoleum is the multi-apsed building located to the north of the Desana villa, usually interpreted as a church but more probably the tomb-building for the villa.[32] Some *mausolea* with rectangular plan excavated in the Alpine region can be connected to rural estates at Airolo[33] or San Pietro in Gravesano,[34] generally dated from the fourth to the sixth century CE.[35]

Differentiating between a church or chapel attached to a villa's estate for use by its inhabitants (family as well as personnel) and the mausoleum of the members of a villa owner's family can be difficult; an example is the fifth-century building near the monumental villa complex at Palazzo Pignano (Cremona; Figure 11.7). Excavations under the later church of San Martino uncovered a circular

building (17 m in diameter) that had a marble and mosaic floor and a small apse to the east with a sort of ambulatory.[36] In a room next to the entrance, a small circular vat with a waterproof mortar surface was discovered: this would normally be interpreted as a font in a room reserved as a baptistery. However, the circular plan of the building, its small apse, the unusually small size of the so-called font, and the later evolution of the building (abandoned early and without any associated burial area) cast doubt on this interpretation in view of other considerations of Christian architectural types.[37] The circular plan of the structure at Palazzo Pignano is more in accord with *mausolea* like Santa Costanza in Rome, so it was more probably an impressive tomb rather than a church with baptistery.[38] Such buildings interpreted as chapels or churches have been cited to confirm the Christian faith of the owner of the villa and used as a pious amenity for his family and personnel, but they could equally well have been *mausolea* for a villa owner's family in their first manifestation, then transformed (but not before the seventh century CE) into churches by additions needed for ecclesiastical functions.

However, owners of villas did build churches and oratories on their estates, attested from sources in central Italy starting in the fifth century CE. A well-known example is the construction, around 450, of a basilica dedicated to St. Stephen at the third mile of the via Latina outside Rome sponsored by Demetriades, a member of the noble family of the Anicii. A little later, in 471 CE, Flavius Valila had a church built on his estate near Tibur and provided it with land and revenues for the living expenses of its clergy and for the illumination of the building.[39] These examples are rare, even though scholars are often eager to see church construction on rural estates as a widespread phenomenon. In fact, very few structures that can be classed as "villa churches" built by a rich and pious owner in the fourth and fifth centuries were still in viable use as elite residences. There are exceptions, but they prove the rule. Among the few examples of rural churches erected by villa owners in northern Italy, the church of Sizzano, in the province of Novara, is important (Figure 11.8). Here, in the context of a villa still in

viable use in the fifth century, a large church (15.40x11 m) with single nave and apse was built in the southwestern part of the villa. When, in the sixth century, the villa was abandoned, the church, around which a cemetery (most probably for the family of the owner) had already developed, also ceased to function.[40] In most of other rural churches, the villas near them had already been abandoned or had experienced a decline of residential standard when the church was erected.[41] The Christianization of the countryside was, in fact, a later and more complex phenomenon than previously thought, and it was not directly related to villas. In numerous cases, more than a century elapsed between the abandonment of a villa and the construction of a church on or near its site. Instead, the link between villas and churches is with settlements and villages that *replaced* the villas in the early medieval period. The issue of the late antique and early medieval settlements that developed in and around the structures of villas – part of the transition from antiquity to the Middle Ages – has been one of the most lively themes in scholarly discussions in the last few decades.[42] In the fifth century, churches with baptisteries were built in the principal settlements (both villages and castles) in connection with communication routes or at militarily strategic locations. This phenomenon might indicate that the construction of ecclesiastical networks was not casual (as it would have been in the case of single owners choosing to build churches on their properties), but followed to a clear strategy of territorial control. Only the ecclesiastical authorities, i.e., the bishops, could have directed such a development.[43] However, in the absence of direct testimonia, such as inscriptions or textual references, it remains difficult to determine which person or authority was responsible for the foundation of a church.

The late evolution of villas and their demise, which include abandonment, reuse of the structures for low-level habitation and/or artisanal purposes, and the presence of burials, are relatively standardized throughout the Roman Empire. The timespan of such phenomena is now believed to have been much longer than originally thought, and therefore the meaning of these changes is more complex.

The archaeological data indicate that the transformations in villas had already started in the third century CE, or maybe even earlier, as indicated by a famous letter of Pliny the Younger, in which he proposes to amalgamate a newly purchased neighboring villa and estate with one he already owned.[44] From the fifth century onward, amalgamation of estates and the consequent expansion of the villas on them appear to have been common and occurred in most of the examples discussed in this chapter, such as the Desenzano and Sirmione villas. Late occupation of still-standing buildings came to be a pattern. In some instances, the walls of the Roman villas were used as supports for new, simpler roofing structures made of wood or straw, as at Faustinella (Desenzano), where wooden posts were also used to support the roof in addition to the walls (Figure 11.9). The survival of original Roman elements is a testament to their fine construction: At the site of Castelletto di Brenzone, on the eastern shore of Garda, the original roof structure and covering of the villa survived until the early Middle Ages.[45] In other cases, the *sites* of villas themselves survived even if their structures had fallen down or disappeared:

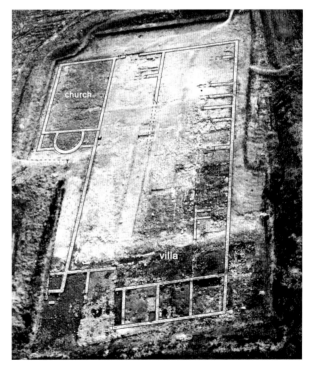

Figure 11.9. Sizzano (Novara), villa, plan from aerial photo (Pejranni Baricco 2003).

At Nuvolento, near Brescia, structures in perishable material were built above a layer of compacted debris of the earlier Roman villa.[46] At Fontanellato (Cannetolo, in the province of Parma), the villa was abandoned in the third century and partially covered up by a layer of silt c. 1.40 m deep; later, between the end of the fourth and the beginning of the fifth century, a hut was built on the same spot where some of the villa walls still protruded from the earth.[47] These new domestic structures are associated with substantially different economic and social conditions than had characterized Roman settlements: hearths, manufacturing activities, and the presence of cattle, with small cemeteries for the new people reoccupying the abandoned villa sites.[48] In some cases, the grave goods and burial typologies of these cemeteries allow identification of Goth or Lombard populations and thus of barbarian settlement in rural northern Italy.[49] The choice of abandoned villa sites by later populations, rather than exclusively strategic and fortified locations, ensured a degree of continuity with the Roman economic network, of which villas and rural estates had been an essential component.

[A.Ch.A.]

VILLAS AND PALACES

Although most elite villas of *privati* were abandoned in late antiquity, there are remarkable examples of continuity of occupation of buildings that can be classified as "public" villas. Indeed, the culture and architecture of villas seems to have had a revival, in northern Italy, in the later fifth and early sixth century, at the time of the Gothic occupation. The complex discovered at Palazzolo, near Ravenna (Figure 11.10, a), was said by bishop Agnellus in the early ninth century to have been a *palatium modicum*, a small palace, built two centuries earlier on the coast six miles from Ravenna by Theodoric, the king of the Ostrogoths (493–526 CE), whose hegemony included most of Italy. The complex was knocked down on orders of Agnellus himself, to take the building material for the construction of an ecclesiastical dwelling (*domus presbiterialis*) in Ravenna.[50] As a mansion built by the king, the Palazzolo structure could (in juridical terms) have been labeled a *palatium* like Theodoric's urban residence in his capital at Ravenna, even though it was in

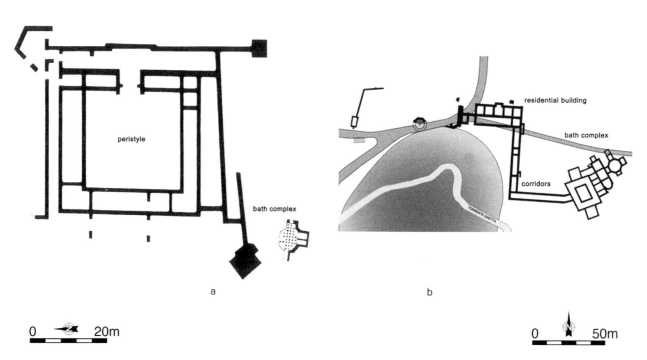

Figure 11.10. A: Palazzolo (Ravenna), villa, plan; B: Galeata (Ravenna) villa, plan (Baldini 2003).

fact a rural residence just like an elite villa. As was the case for other public properties, the building ultimately became church property, and a monastery was established in its vicinity. The villa-*palatium* of Theodoric incorporated a bath complex, a peristyle with colonnaded corridors on three sides and, on the fourth side, a building with various rooms flanking a central hall with a shallow rectangular apse (Figure 11.10, a).[51]

The Palazzolo complex may not have been Theodoric's only royal rural residence. Some 18 km south of Ravenna, at Galeata in the Bidente valley, a large complex consisting of a residential building and an adjacent bath complex connected by corridors, with wide uncovered areas, was built in several phases, including one datable to the reign of Theodoric (Figure 11.10, b).[52] There is no doubt that the paucity of residential and functional spaces combined with the monumentality of the baths in this complex indicates some kind of public building. The archaeologist who excavated the complex, on the basis of the eighth-century text *Vita Hilari*, maintains that it was a palace built by king Theodoric, while others have identified it as a *mansio* or waystation, but one with particular architectural grandeur.[53]

The complex of Meldola, a site not far from Galeata, may also be a candidate for Theodoric's rural *palatium* as mentioned in the *Vita Hilari*. Excavations in 1937 uncovered an apsidal hall, part of a large villa featuring figurative mosaic floors dated between the reigns of Theodoric and the eastern Roman emperor Justinian (493–565 CE). Recent investigations and the reexamination of the finds confirm the complex to have been a luxurious villa with a bath suite and an important building phase of the time of Theodoric. In use until the seventh century, the complex was subsequently replaced by an early medieval building of uncertain use and function.

Late Antique Villas in Northern Italy: Work in Progress

Recent archaeological investigation has further documented villas, villa sites, and public buildings

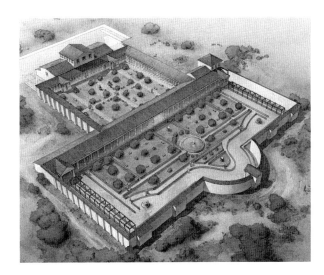

Figure 11.11. Montegrotto (Padova), villa, reconstruction (www.aquaepatavinae.it/portale/).

in northern Italy in the late antique and early medieval period. A complex interpreted as imperial is under investigation at Montegrotto (Padova; Figure 11.11), near one of the several Roman bath complexes known in the area. Two of them have been connected to the public building discussed in a letter written by Cassiodorus (c. 490–583 CE) who, though a Roman of senatorial rank and a landowner in southern Italy, was a high official of the Ostrogothic kingdom.[54] One, located on the hill of Bertolon, consisted of a large residential facility comprising several rooms, including an apsed hall surrounding a central peristyle on three sides.[55] At the foot of the hill was a complex consisting of a small theater, a portico, and thermal pools, as well as two other buildings as yet unidentified.

Cassiodorus' letter refers directly to a second villa and bath complex, only 500 m away from that at Bertolon, now under investigation by the University of Bologna. For modern convenience, it is called the *Terme Neroniane*. The site features two thermal pools and, at a distance of c. 100 m, an imposing building: a large courtyard bisected by a portico, and some rooms to the north and east of the courtyard. The northern sector, the more monumental of the two, has a series of rooms symmetrically placed at the sides of a rectangular central hall with an *opus sectile* floor. The design and décor of the complex makes it

likely to have had some imperial connection and is datable to the first century CE in the reign of Tiberius (14–37 CE), not as a villa, but as a public structure with a bathing establishment.[56]

This building and the bathing establishment connected to it are described in some detail more than 500 years after their construction in Cassiodorus' letter. Cassiodorus wished to restore both parts of the complex, which he calls *palatium*; he addressed his letter to the architect Aloisius, giving directions for the restoration on the basis of his own observations. Various sectors are mentioned in the letter:

1. The bath complex proper (*thermarum aedificia*), consisting of four rooms, one next to the spring used for the sauna, the second room featuring less warm water, the third with lukewarm water, the fourth with cold water called "Neronian";[57]
2. The conduits for the hot water;
3. The spring;
4. The latrines, with seats placed in a semicircle;[58]
5. A *palatium*, in poor condition because of its antiquity;
6. An open air space between the public building and the spring, which in Cassiodorus' time had been infested by undergrowth and bushes (*silvestri asperitate*).

All these buildings retained their superstructures and needed only repairs to the water conduits, the thermal complex, the palace, and clearing of vegetation that had invaded the area between the palace and the baths, perhaps originally a garden.[59]

Cassiodorus' description of the various architectural parts closely matches the known structures: pools (*thermarum edificia*), spring (*caput ignis fons*), open space, and *palatium/aedes publica*. The writer is specific as to the sequence of spaces and their state of disrepair, and he stresses the public nature of the complex in referring to the construction of a pool by Nero and its unrestricted use by sick people seeking cures.

Cassiodorus used two terms for the complex – *palatium* (specifically a royal residence) and *aedes publica* (a more generic term for a public building).[60] The official character of the complex is underlined by this terminology used. The *palatium/aedes publica*

at the *Terme Neroniane* complex, although some 500 years old, was still in use without major modifications when Cassiodorus was writing about it, and it endured two or more centuries after that: Its demolition occurred sometime between the late eighth and the ninth century; before then, it appears to have continuously retained its integrity and function.

After the *palatium/aedes publica* was knocked down in the early medieval period, the Roman bathing establishment continued to be in use. A wooden washtub found in one of the pools indicates (by carbon dating) activity into the fourteenth century, and the Paduan chronicler Rolandino wrote that, in 1253, a certain Iane Morro was arrested at the baths while bathing naked![61] A deliberation of the municipality of Padua dated 1339 confirming public ownership and regulating the use of a thermal complex very likely referred to the *Terme Neroniane* site: The deliberation mentions the *fontica magna*, the conduit for the hot water, and a pool.

Archaeological evidence and literary sources coincide at the villa of San Cassiano at Riva del Garda, in the province of Trento (Figure 11.12). It was a rustic building, one of many others built in

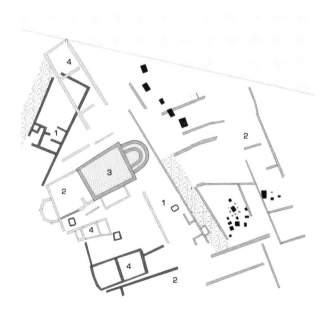

Figure 11.12. San Cassiano (Riva del Garda, Trento), villa plan: 1.) Roman villa; 2.) fifth-century building. 3.) church (eleventh century); 4.) early medieval buildings. (Brogiolo 2013b).

the first century CE in the suburbs of Riva on the north shore of Lake Garda, and consisted of a little villa and a cemetery. Like many other sites, its name relates to toponyms derived from Roman villa and estate names.[62] The persistence of such names does not imply an uninterrupted existence of the property, its social organization, or its agricultural practices, but the name *Cassiano* is relevant nonetheless. In the fifth century, a new U-shaped building was constructed on the site, in clear relation to the earlier villa and its cemetery; less than a century later, a church (ultimately that of S. Cassiano) was added. The whole rural and ecclesiastical complex was in use during the early Middle Ages for craft activities and food storage silos. The site's exceptional continuity may have been due to its having become a public property of some kind: It is mentioned as a royal Lombard domain (*curtis regia*) in a document of the mid-ninth century.[63]

These examples of the continuity of a specific architectural type – the Roman villa in this case – in the royal and public realms well into the Gothic period and the early Middle Ages shows that the *idea* persisted in the form of rural *palatia* of distinctly public and official character. In practice, and due to changes in land use and social organization, villas and estates associated with private ownership disappeared, but their amenities of a former private and luxurious nature, namely their bathing establishments, often persisted for centuries.

[G.P.B.]

CONCLUSION

While the early history of Roman villas in northern Italy is meager, rural residences of great architectural and decorative interest abounded in late antiquity. The architectural type that on the basis of plan and decorative apparatus is defined as a villa came to have uses and functions more various than the old Vitruvian and central Italian models of "Varronian" character. The same architectural types were used for public buildings, called in the ancient sources *palatia* and *aedes publicae*, which encompassed not only residential functions but also services. Some of these buildings remained in use as public structures

through the early Middles Ages and even later. This is not a matter of surprise: Both Theodoric and, later, the Longobard kings settled in the urban palaces left by their predecessors or built new ones, in town and in the country, building peristyle-centered residences displaying typologies similar to the Roman villas of the Republican and imperial periods. Continuity with ancient architectural tradition was maintained, and as of the later third and into the fourth centuries, new architectural forms – notably apsidal halls, very grand *triclinia*, luxurious bath buildings, and the like – were smoothly grafted onto older structures.

However, between the fifth and seventh centuries, the plans of rural habitations and their construction techniques changed significantly. In comparison to late antique residences, the architectural plans were notably simplified because – due to the changed conditions of the time – domestic structures had to be built in perishable materials, a characteristic of the majority of early medieval settlements. The contrast between the solidly built villas of the late antique elites and those of the later period indicates the shrinking, even disappearance, of traditional elites, due to a general impoverishment of society, to the collapse of the administrative and socioeconomic structures of the Roman empire, and to the political instability and consequent militarization of society. By the seventh century, the new aristocracies of the barbarian occupiers of northern Italy and the newly powerful ecclesiastical class had replaced the old late antique aristocracies.

In this context, the term "villa," which continues to appear in the written sources, takes on multiple meanings. In Isidorus of Seville's *Etymologiae* (seventh century CE) the term seems to refer not simply to the administrative center of an estate in which the *dominus* resided, but also to the whole complex of satellite settlements. "A villa" – writes Isidorus – "is named after *vallum* (rampart), that is to say, the heap of earth that usually was established as a boundary-line for the property."[64] In the writings of Gregory of Tours and in Merovingian documents, villa can refer equally well to the mansion of a landlord (as in the classic meaning of villa), to a group of estates, to an

administrative district, to properties belonging to different *domini*, and to a nucleated settlement resembling a village.[65] Also in the seventh century, Bede, in his *Ecclesiastical History* of Britain, used the term "villa" for both a village and a royal property; he calls Yeavering in Northumberland a *villa regia* even though no Roman villa had existed on the site – the term outlasted its own historical reality.[66] Villas were indeed finished.

[A.Ch.A. – G.P.B.]

NOTES

1. Originally *praetorium* was a military term, the residence of the *praetor* or the tent of the general in military camps. Emperors' residences were referred to as *praetorium*, thus by association residences of elite individuals and, from the fourth century on, particularly monumental dwellings: Mommsen 1900; Egger 1966; MacMullen 1963, 1976.

2. Palladius, *Op. Agr.* 1.11; 1.8.2. On Palladius, Introduction in Martin 1976; Frézouls 1980; Giardina 1986; Morgenstern 1989; Vera 1999a. *Praetorium* as synonymous of *villa* in Venantius Fortunatus (*Carm.*, 1.18), Cassiodorus (*Var.*, 11.14.3; 12.22.5) and Sidonius Apollinaris (*Carm.* 1.18.7).

3. For considerations on this issue in relation to urban domestic architecture: Ellis 2007.

4. Zucca 1993.

5. Vera 2005. See also Sfameni 2006: 234–5 with examples of *villae-praetoria*.

6. The *Tabula Peutingeriana* (a thirteenth-century map copied from a much earlier Roman original) shows the major roads used by officials of the *cursus publicus* and the amenities they could find along the way. For Corte Cavanella: Sanesi Mastrocinque 1984; Sanesi Mastrocinque et al. 1986. For San Basilio di Ariano Polesine: Toniolo 1987.

7. The vast bibliography on this is synthesized in Arce 1997a.

8. August., *Conf.* 9.3.5.

9. In the sixth century CE Cassiod., *Var.* 2.22.3–5, says that the fishponds of Istria recalled those of Baiae.

10. The representational aspects of villas have resulted in several studies, among them those of Ellis 1991. For

central Italy in particular, Marzano 2007; for late antique villas, Sfameni 2006.

11. Mentioned in Paulus Diaconus, *Historia Langobardorum* 6.58 some 40 years after the king's death; see Badini 1980 for the inscription.

12. Ortalli 1994; Scagliarini Corlàita 1997; Grassigli 1995; De Franceschini 1998; Busana 2002.

13. Among the first studies on this problem, Cagiano de Azevedo 1986. The evolution in research work is traced in Brogiolo ed. 1994; 1996; Brogiolo, Chavarría Arnau, and Valenti (eds.) 2005; Sfameni 2006; Castrorao Barba 2013; Pensabene and Sfameni eds. 2014.

14. Francovich and Hodges 2003; Brogiolo and Chavarría Arnau 2005.

15. For Christianization, see the opposing views in Chavarría 2010 and Cantino Wataghin 2013. For rural and urban domestic typologies, a start can be found in Scagliarini Corlàita 2003.

16. Gemmano, Rimini (second-first century BCE); Fiorano Modenese, Modena (second century BCE); Modena, Via Leonardo da Vinci (first century BCE); Fontanellato, Parma (first century BCE); Varignano Vecchio, La Spezia (mid-second century BCE); Basiliano, Udine (second–first century BCE); Ronchi dei Legionari, Gorizia (second/first century BCE).

17. Gervasini and Landi 2001–2; Gambaro, Gervasini, and Landi 2001; Gervasini 2004.

18. Scagliarini Corlàita 1997, 54.

19. Reuse of ancient building material was common because zones like Lombardy and Emilia, with their alluvial soil and flat topography, made building material scarce.

20. Busana 2009 for villas in the territory of Aquileia.

21. Brogiolo and Chavarría 2005, 41–2.

22. The complex has been known since the 1800s but has been recently investigated: Roffia and Portulano 1997; Ghiroldi 2002; Simonotti 2009.

23. The business was apparently carried out by another member of this family, M. Nonius Arrius Paulinus Aper (consul in 207 CE), who was a patron of the *collegium* of the *dendrofori* in Brixia, an association involved in religious ceremonies in which tree trunks were carried in processions, but also connected with carpenters and wood workers, and, possibly, wood transport. Another member of the family, the *vir perfectissimus* N. Nonius Cornelianus, left a legacy of

150,000 *denarii* to the *collegium nautarum B(rixianorum)* (the professional association of the boatmen of Brixia); see Boscolo 2006, 504–7; *AE* 1977.298.

24. *CIL* 5.4854.

25. Legal status of the property: Todisco 2001: Arzaga cippus: Gasperini 1996.

26. Fortunati and Ghiroldi 2007; 2008.

27. Faustinella: Roffia (ed.) 2007; Roffia and Simonotti 2008; Colombarone: Tassinari et al. 2008.

28. Such villas must have contained tapestries, rugs, and furniture of both utilitarian and grand character, the last inlaid and adorned with precious materials, that have not survived: Lewit 2003.

29. Whittaker and Garnsey 1998, Banaji 2001. For Italy, see Vera 1983; 1988; 1999a; 1999b; 2005.

30. Purcell 1987; Bodel 1997; Bowes 2006.

31. Ambrosini and Pantò 2008.

32. Spagnolo Garzoli 1998; Pantò 2003, 101–2.

33. A mausoleum with rectangular plan dating to the fifth–sixth century CE was transformed into a church in the seventh–eighth century by adding an apse and a porticoed atrium in front of the façade: Foletti 1997, 121–2.

34. In the area occupied by a Roman temple, a mausoleum was built in the fifth or sixth century CE; sometime in the seventh or eighth century, an apse was added to the building indicating its conversion into a church: Foletti 1997, 127–8.

35. Both sites in Brogiolo 2002, with earlier bibliography.

36. On the cult building: Mirabella Roberti 1965; 1968; Bishop and Passi Pitcher 1988–9.

37. Brogiolo and Cantino Wataghin 1994, 146; Fiocchi Nicolai and Gelichi 2001, 335.

38. The absence of subsequent tombs and the lack of substantial restorations of the floors and structures point to the structure being used for a short time rather than the longer lifespan of a church.

39. See Fiocchi Niccolai 2007. Bishops complained about rural districts in which pagan worship was still widespread, so these churches on rural estates may have been intended to serve an anti-pagan mission: see Maximus of Turin, *Sermo* 91.25.30.

40. As suggested by Pejranni Baricco 2003, 63.

41. This topic is discussed in Chavarría 2010.

42. The most relevant bibliography on villas and the transformation of the territory in late antiquity can be found in Chavarría and Lewit 2004; Christie (ed.) 2004; Chavarría Arnau, Arce, and Brogiolo (eds.) 2006.

43. Different points of view in Chavarría 2010 and Cantino Wataghin 2013.

44. *Ep.* 3.19.1–5. See also Chapter 1 in this book.

45. Bruno and Tremolada 2011.

46. Rossi 1996.

47. Catarsi dall'Aglio (ed.) 2005.

48. Munro 2012 has proposed that between the end of the villa and the later reoccupation a period of spoliation and recycling occurred, directed by the villa owner. This is an interesting hypothesis but is based on scarce data.

49. E.g., Sacca di Goito, Sovizzo, Spilamberto, Ficarolo, Palazzo Pignano, Mombello, Collegno, among others.

50. Agnellus, *Liber Pontificalis Ecclesia Ravennatis*, 94. A synthesis for this site, with bibliography, in Sfameni 2006: 222–3.

51. Excavations carried out between 1966 and 1996 were poorly documented, and the modern reports are less detailed than the ancient written sources! The Ostrogothic complex was built over a previous Roman site that had an apsidal structure. A three-nave church, part of the monastery of St. Mary, was later built over the baths. See Baldini 2003.

52. Excavations were carried out in 1942 by the German Archaeological Institute under the direction of F. Krischen and have been recently resumed by the University of Bologna: Krischen 1943; Villicich 2009. The date is given by some architectural elements, including a capital, reused in a nearby farmhouse.

53. *Palatium*: Villicich 2014 and *Acta Sanctorum*, MAII, die XV, III: 471–4; *mansio*: Jacobi 1943; *praetorium*: Deichmann 1989, 271.

54. Cassiod., *Var.*, 2.29; Bonomi, Baggio, and Redditi 1997.

55. These rooms were uncovered between 1771 and 1778 and destroyed in the second half of the nineteenth century.

56. Although it may have been a villa of the early empire in imperial possession with high-quality architecture, it is more likely that, rather than a rural residence with a bathing establishment, it was a public complex, possibly a *palaestra* or another kind of building connected to the baths built with imperial patronage. This interpretation is based on the following:

a.) the scarce number of finds recovered in comparison to the large area occupied by the complex, comprising at least two peristyles (possibly three on the basis of results of geophysical survey);

b.) the stratigraphic sequence (several rooms do not have more than one floor layer) and the scarcity of finds, particularly for the period after the second century;

c.) the presence of only very minor architectural modifications; villas – imperial or otherwise – that continued to be used until late antiquity commonly received numerous transformations, but no such modifications have been recorded.

57. Cassiod., *Var.* 2.39.5: "in the first, when the boiling element dashes against the rock, it is hot enough to make a natural *sudatorium*; then it cools sufficiently for the *tepidarium*; and at last, quite cold, flows out into a swimming pool like that of Nero" (transl. here and at n. 58 below by Hodgkin 1886, with modifications).

58. Cassiod., *Var.* 2.39.7–8: "from here a seat, connected from above and shaped in the manner of an apsis, which is perforated because of the human needs, receives the ill persons, with their internal humours flowing down."

59. Cassiod., *Var.* 2.39.9–10.

60. Cassiodorus was always accurate in his use of words, so the equivocal use of *palatium* and *aedis publica* may have come about because the king planned a stay, prompting restoration of the complex before his reception. Royal visits in the Gothic period to earlier buildings and monuments in Rome also prompted restorations.

61. Rolandino, *Cronica*, VII, 2.

62. These names are current at present and preserved in texts of the twelfth and thirteenth centuries: Italian toponyms ending in "—ano" connect to personal Latin names, so *Cassiano* related to a *praedium Cassianum* of the Cassii family. Other examples are sites named Varone, Varignano, Arco, and Bolognano.

63. Brogiolo 2013a, 179–80; Brogiolo 2013b, 35–7.

64. Isid., *Etym.* 15.13: *villa a vallo, id est agere terrae, noncupata, quod pro limite constitui solet.*

65. Samson 1987; Heinzelmann 1993.

66. Campbell 1986: 108–11.

ROMAN VILLAS IN SICILY

R. J. A. WILSON

INTRODUCTION

Sicily in Roman times was a byword for agricultural fertility. Early in the second century BCE, Cato the Elder was already calling the island "the nursemaid of the Roman people,"[1] and two centuries later Strabo remarked "as for the fertility of the place, why need I speak of it, since it is talked about by everyone and declared to be in no way inferior to Italy's."[2] It was above all as an exporter of grain that Sicily owed both her political importance and her economic prosperity during the Roman Republic; and although she lost that pre-eminence (in terms of grain-exporting capacity) during the Roman Empire to Africa and Egypt, with their much larger productive capabilities,[3] there is no doubt that the continuing export of Sicilian wheat and barley, and other commodities such as wine,[4] continued to underpin the island's prosperity down into early Byzantine times. Indeed, the founding of a new metropolis at Constantinople, and the diversion of Egyptian wheat largely for that new export market, led to renewed importance and increased prosperity for Sicily in the fourth century CE and beyond, as we shall see.

That the countryside of Sicily was densely settled with villages, villas and farms during the Roman period is clear from surface evidence – rural sites littered with fragments of pottery, tile, amphorae and glass and the other debris of human settlement. Some sites have long been known, some have been recorded casually in more recent times, others again have been found through systematic field survey.[5] Interpretation of surface data without excavation, however, is not always easy, and geophysical survey as a tool to furthering knowledge is still in its infancy in Sicily.[6] Establishing a hierarchy of sites is not, therefore, straightforward. How does one distinguish a luxury villa from a sprawling village on the basis of surface evidence alone? Size is not a criterion, because sites of both types can cover 3 ha or more. Luxury items such as fragments of marble, for wall veneer, floor paving, or statuary, are a more significant sign of a villa with architectural pretensions, as is evidence for columns of stone or of marble, but even large and wealthy establishments do not always leave such obvious surface traces.[7]

Villa in Latin means "farm" and applies to any rural structure where farming is its *raison d'être* (in contrast to the town-house, the *domus*), but modern archaeological parlance generally distinguishes between a "farm" and a "villa" on the basis of layout and the degree of architectural embellishment (in Sicilian terms, normally the presence of a peristyle, a bath-house, and mosaic or marble or both).[8] Farms are not the concern of this chapter; only those structures that fall into the second category are the focus of attention here. Both farms and villas were normally concerned with agricultural production, but exceptions are *villae maritimae*, situated on the sea, and *villae suburbanae* in the immediate environs of towns. Even there, however, the absence of agricultural activity

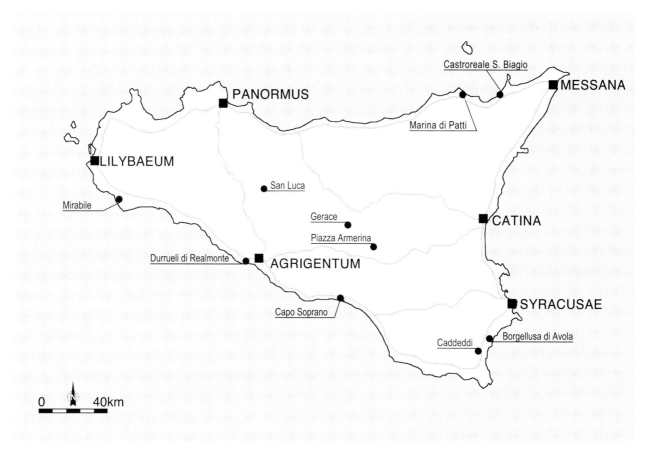

Map 6. Major towns of Roman Sicily and villa sites mentioned in the text (M. D. Öz).

cannot automatically be assumed; excavation has never, at any site, been extensive enough to cover the totality of buildings on a Sicilian villa estate.

Sicily possesses, in the great mansion near Piazza Armerina, one of the finest examples of a luxury Roman villa in the Mediterranean; but the number of villas substantially investigated anywhere in the island is disappointingly small. Many more elegant villas are suspected, either from chance finds of mosaics – *disiecta membra* of the villas to which they belonged, about which little or nothing else is known[9] – or from the casual discovery in rural locations of marble portraits or figured sarcophagi, or even the presence of monumental tombs[10] – finds which normally do not make sense unless a person of some pretension lived nearby. The isolated bath-house also usually denotes an unlocated villa in the environs;[11] but bath buildings are also found in quite humble agricultural villages, so certainty is

impossible.[12] A comprehensive coverage of all Sicilian villas lies beyond the scope of this chapter: rather my focus is on those villas about which we are tolerably well informed, and which provide us with a glimpse of the lifestyle of the Romano-Sicilian rural elite.

BEGINNINGS: SICILIAN VILLAS UNDER THE ROMAN REPUBLIC

Quite when villas started appearing in the Sicilian countryside is uncertain. Most of the island became a Roman province in 241 BCE, but Hieron II's kingdom in eastern and south-eastern Sicily was not added before 211 BCE, four years after Hieron's death. Whether any structure which might be classed a villa appears in Sicily as early as the third century BCE, however, is doubtful. One possible example is

a much-eroded *villa maritima* found in 1951 on the cliff edge at Capo Soprano at Gela, just outside the line of the Greek fortifications.[13] Little was recovered of its plan. A room nearly 6 m square had a tessellated mosaic in the center (with meander pattern), surrounded by a raised edge of *opus signinum* on three sides. Such an arrangement recalls the *andron*, the principal reception-cum-dining-room of mainland Greece, especially Macedonia. Parts of two other rooms were also found, both with *opus signinum* floors, one inlaid with chips of marble. Fragments of stuccoed wall decoration, and a limestone Corinthian capital of Sicilian type, were also discovered. The villa was dated to the late fourth century BCE, on the assumption that it could not be later than the destruction and abandonment of Gela in 282 BCE.[14] That, however, would be uncomfortably early for an example of tessellated mosaic, for the Sicilian version of the Corinthian capital, and even for *opus signinum* itself, of which the earliest examples at Carthage are not earlier than the late fourth century BCE.[15] More likely the seaside villa was built after Gela had ceased to function as a city, probably in the second half of the third century BCE.[16] But it remains an isolated example, at the very start of the Roman occupation of the island, a dwelling firmly part of the Greek tradition.

Little else is attested with a comparable degree of elegance in rural Sicily until the Roman Empire, although many well-appointed villas of Republican date must surely await discovery, especially in the central and western parts of the island. There, in the second century BCE, cities were flourishing, busily rebuilding their civic centers and other public buildings in the latest styles.[17] These projects were paid for by local benefactors who had grown rich from the produce of their agricultural estates, and it would be remarkable if none had the itch also to build comfortable villas on their rural properties to match the comfort and elegance of their urban dwellings. At any rate, by the 70s BCE, as Cicero's *Verrines* attest, Sthenius, one of the richest men at Thermae Himeraeae (mod. Termini Imerese), on the north coast, had *villae* on his estates in the neighborhood, while Gnaeus Pompeius Philo of Tyndaris, further east along the north coast, also had a rural villa in the

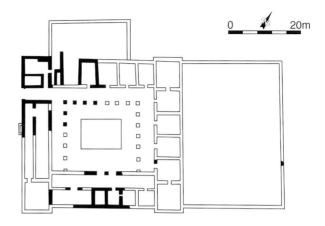

Figure 12.1. Mirabile, Mazara del Vallo (TP), villa, plan (excavated walls in black) (after Fentress 1998, 30, fig. 3.2).

countryside nearby (*in Tyndaritano*).[18] It was plush enough to entertain governor Verres to dinner, and the meal was served from silver tableware richly adorned with figured decoration, if Cicero is to be believed.[19]

Very few villas of this date have been excavated in Sicily. One of the earliest is that in contrada Mirabile (Timpone Rasta) near Mazara del Vallo, in the far west of the island.[20] Only two small parts were excavated, so the reconstructed plan (Figure 12.1) is largely hypothetical; in addition, its chronology is far from clear. Some second-century BCE pottery was found here, but this may come from an earlier, smaller farm on the same site (of which no structural trace was found), replaced by the main excavated building sometime in the first century BCE.[21] The latter is tentatively reconstructed as consisting of rooms arranged around a central peristyle with surrounding corridors (25 m²),[22] of which pier bases are assumed for three sides; if so, the main block would have been about 40 m², entered from the west. The walls were made up of a single row of tufa blocks supporting a *pisé* superstructure (rammed earth mixed with lime as a stabilizing agent), although the exterior walls, at least on the east, may have been stone to roof height. *Pisé* and mud-brick walling were traditional forms of building material in Sicily from archaic Greek times onwards, and enjoyed a long currency in the island down into late antiquity.[23] The excavators postulate two-storey towers at the four corners of the building,

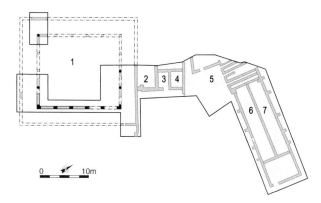

Figure 12.2. San Luca, Castronovo di Sicilia (PA), villa, plan (after Vassallo 2009, fig. 496).

but this is far from certain. As well one fragment of *scutulatum*, there are some traces of *opus signinum*, and a white limestone chip pavement in the east wing had inlaid tessera decoration at intervals, consisting of small blue crosslets with white centers. Fragments of stuccoed column and stuccoed cornice hint at a reasonable standard of elegance, but preservation of the structure was poor. It had been completely demolished by the early second century CE.[24]

Two other partly excavated villas also started life in the first century BCE. One at San Luca, midway between Palermo and Agrigento in the deep interior of western Sicily, was built c. 100/50 BCE (Figure 12.2).[25] It had a central peristyle (1) surrounded by corridors (20x24 m), with rectangular piers along the south-east side and limestone Doric columns on the other three. Both columns and piers used a mixed construction technique (brickwork as well as stone), which would have been concealed beneath a surface finish of white stucco. Only three small rooms opening off the north-east side of this court have so far been excavated (2–4). Floors here and in the peristyle corridor were of limestone chips or white mortar. Immediately to the north, and on a different alignment, is a separate *pars rustica*, probably added to the residential block in the second half of the first century BCE or early in the first century CE. It opened onto a paved yard (5) and included a buttressed store building for agricultural produce (6

and 7), one of few such buildings known in the Sicilian countryside.[26] Finds indicate continued occupation in the late second century CE, but stone robbing early in the third suggests decline and abandonment soon afterwards.

The other partly excavated rural dwelling of the first century BCE is the *villa maritima* in contrada Borgellusa near Marina di Avola, 22 km south-west of Syracuse.[27] Partly destroyed by a modern road that bisects the site, and in any case reduced to foundations, the villa features a central peristyle surrounded on all four sides by corridors 22 m long, floored in *opus signinum*. There were presumably rooms opening off all four sides, although few have been uncovered; they have either *opus signinum* pavements with white tessera inlay in reticulate and meander patterns, or plain white tessellation. One floor is of white marble slabs. In the center of the peristyle is a basin 4 m square, waterproofed in white mortar and edged in white and gray marble, probably Carraran. The excavator suggested that the villa was built between the last decades of the second century BCE and the mid-first century BCE on the basis of the occurrence of this type of *opus signinum* in central Italy, but its use in Sicily is attested down into the first century CE.[28] It is not clear if the use of marble is primary or secondary; if it belongs to the original villa, this *villa maritima* may belong to the Augustan period (or later) rather than earlier, since pre-Augustan use of marble flooring is hitherto unattested in Sicily. A wall on a different alignment under the peristyle court hints at an earlier building beneath. Limited excavation on the inland side of the modern road has revealed a paved area and other structures, but it is unclear if these are connected with agricultural activities or whether this seaside villa was indeed intended entirely as a pleasure retreat. How long it lasted is unknown. One white tessera floor had been extensively patched, but there are no other signs of later upgrading, and by the time fourth- and fifth-century CE pottery was dumped in the central basin, the site must already have long ceased to function as an elite dwelling.

Sicilian Villas of the Early Empire

The most coherent example of a Sicilian villa of the early Empire is that at Castroreale San Biagio, which lies 2 km inland from the north coast, 30 km west of Messina (Figure 12.3).[29] The main north-coast Roman road passed by it. Excavated in 1952/56 and more recently in 2003/4, the villa started life c. 50 BCE. Little is known of this phase, but the basic square plan of the heart of the establishment, measuring 139 by 136 Roman feet (41.15x40.40 m), was determined from the start, and part of the tufa large-block walling of this early building survives in part. In Augustan or Julio-Claudian times (c. 30 BCE/50 CE) the villa received a complete makeover within this shell. The peristyle and its corridors (33) were enlarged to form a square (25 m²); the columns (8x8) were of brickwork covered in stucco.[30] A small water basin inside the garden peristyle greeted visitors on entering the villa through the vestibule (53). There were rooms opening off all four sides of the peristyle corridor, but the focal point of the villa was the grand reception-cum-dining room on the far side (2), 10 m square (Figure 12.4, left). A surviving pavement from this phase (in 10) is made up of white mortar inlaid at intervals with square, hexagonal and rhomboid pieces of white and colored marble; other floors were of *opus signinum* (7), tiles or beaten earth. It has been suggested that part of the east wing may have had an upper storey, but this is far from clear; there are no certain staircase wells.

Around the middle or during the second half of the first century CE, living standards were further improved with the insertion of a tiny bath-suite at the south end of the west wing, entered from a passage at 39. Room 19 doubled as both *apodyterium* and *frigidarium*, and had a small cold immersion bath at one end; 20 was a *tepidarium* and 21 a small *caldarium* with its own hot water bath (22). The bath-suite had white tessellated floors and walls veneered in marble. Soon after, as part of the major upgrading at the villa that occurred in the first half of the second century, this bath-suite was enlarged by the addition

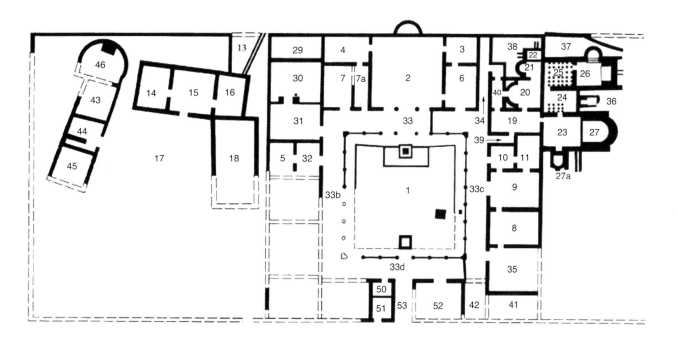

Figure 12.3. Castroreale San Biagio (ME), villa, plan (after Tigano 2008, Tav. 25).

Figure 12.4. Castroreale San Biagio, villa, view from the east across the south side of the villa's peristyle (photo: author).

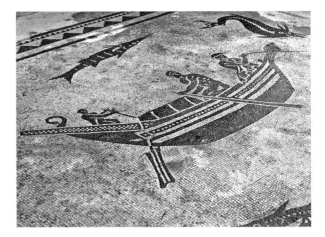

Figure 12.5. Castroreale San Biagio, men fishing, detail of the figured mosaic in the *frigidarium* of the baths (23) (photo: author).

of further heated rooms at 24 and 25 and of a new *frigidarium* at 23, with marble-paved cold-water pool at 27.[31] Various other alterations in the baths, including the replacement of 27 (presumably due to malfunction) by a smaller version inside it, and the addition of a further pool to the same room at 27a, occurred at some uncertain period later still.

The major embellishment of c. 100/150 CE, however, saw the laying of black-and-white mosaic floors in several rooms, of which those in 8, 9, 11, 19, and 23 are well preserved; fragments of others are known from rooms 5, 32, and 42. All except that in 23 are simple geometric compositions, carefully laid but of no great ambition. Only that in room 23, the *frigidarium* of the extended baths, is figured: it shows three men in a boat, one of them fishing, while four dolphins and three fish

swim around (Figure 12.5).[32] All are likely to have been the work of a local Sicilian *atelier*.[33] Several rooms in the villa have remains of polychrome frescoes; that in room 3, perhaps a bedroom, with a debased Fourth-Style design similar to contemporary frescoes at Ostia, still survives 2 m high.

Probably part of the same renovations at Castroreale San Biagio was a new pavement in the grand *triclinium* (2), a combination of mosaic and *opus sectile*.[34] The U-shaped area where the dining couches stood was laid in black-and-white mosaic, a meander and swastika pattern set obliquely; the T-shaped central part of the floor was paved in more expensive marble hexagons, each separated from its neighbor by a double row of black tesserae. A "mat" of polychrome *opus sectile* forms an elaborate threshold to the room, which opens through two columns onto the south peristyle corridor and the central garden. The walls of the *triclinium* had molded stucco "slabs" in imitation of marble veneer. A large niche in the rear wall, doubtless to hold statuary, provided a focal point for the whole room. Outside in the garden, closest to the *triclinium*, a substantial fountain was built either now or later, to enhance the dining experience with the additional delight of the sound of trickling water (Figure 12.4, right of center).

No definite evidence for agricultural production has been found at Castroreale, but it may well have been located in "service quarters" contemporary with the early-imperial villa that is believed to lie in

the eastern portion of the site, bounded by the outer enclosure wall; imperfectly known, it is not shown on Figure 12.3. In the later second century CE a store-building (18) was constructed over part of them. Then, in the fourth century CE, new "service quarters" on two separate alignments (14–16 and 43–46) were built at a much higher level, some 1.30 m above that of the villa proper.[35] It seems improbable that these structures were designed to serve the elite dwelling, still fully functional throughout this period, down to the final abandonment of the site c. 400 CE. Although removal of the relevant stratigraphy in the 1950s prevents certainty, the two buildings at the higher level were probably constructed when the adjacent villa proper was already in an advanced state of decay and no longer functioned as an elite residence. Quite when that decline started is unknown, but it may have occurred in the course of the third century CE.

The only other Sicilian villa of early imperial date that has been substantially explored is that at Durrueli di Realmonte, 10 km west of Agrigento. Discovered in 1907, and mainly excavated in 1979–81, it remains little known, despite its good state of preservation.[36] The main part of this seaside villa, which covers an area about 50 m², consists of rooms arranged around at least three sides of a central peristyle, 18 m² (Figure 12.6). There are five unfluted tufo columns on each side of the latter, with Doric capitals. As at Castroreale San Biagio, the spaces between the

columns were given low screen walls in a secondary phase. The main rooms lay on the north side of the peristyle facing toward the sea. One has a black-and-white geometric floor; two others have *opus sectile* pavements in a range of colored marbles.[37] The principal reception-cum-dining room, however, was paved in mosaic rather than marble.[38] Facing the latter in the garden, attached to the peristyle screen-wall, was a semicircular fountain basin[39] – a feature borrowed from the domestic architecture of North Africa, where it is commonplace.[40] Fragments of a marble statuette-group found in and around the basin give a glimpse of the dwelling's sculptural decoration. Two rooms on the west side of the peristyle also have black-and-white geometric mosaics. The villa's precise date is uncertain but it probably belongs to the first half of the second century CE.[41]

Probably contemporary is a substantial bath-suite immediately to the west of the villa's residential core. A corridor leads to an *apodyterium* floored with a black-and-white mosaic, the central panel of which features a bearded Neptune with trident, and dolphins in the sea below him (Figure 12.7); he was

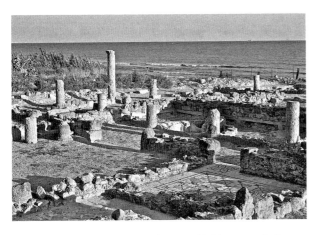

Figure 12.6. Durrueli di Realmonte (AG), general view of the villa's residential core, from the north-west (photo: author).

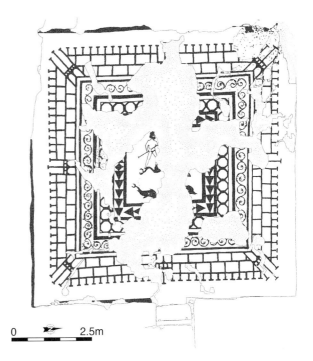

Figure 12.7. Durrueli di Realmonte, drawing of Neptune mosaic in the *apodyterium* (after Ayoagi 1988, 93, fig. 1).

probably accompanied by a second figure, now lost (Amphitrite?).[42] The border is a schematic depiction of a crenellated city-wall with towers, a design widespread in the Roman Empire and attested elsewhere in Sicily, in a *villa maritima* at Taormina-Giardini.[43] The poor standard in both layout and execution of the Durrueli mosaic suggests that it is the work of a Sicilian mosaicist, one, however, aware of both the iconography and the idiom of black-and-white mosaic then current in peninsular Italy; the sparing use of additional color (Neptune, for example, is outlined in brown) adds a touch of Sicilian distinctiveness.[44] The walls are veneered in bluish and white marble, both probably Cararran. Similar marbles are also used to clothe the walls of the adjacent *frigidarium*, the floor of which is executed in *opus sectile*. A step in its north wall leads down into a marble-lined immersion bath. A door on the south side of the *frigidarium* gives access to a vestibule, where the bather could either turn left (east) to a small square heated room with a furnace on its north side, or west to other heated rooms. A small necropolis is known on the left bank of the torrent, immediately east of the site. Excavation has also revealed two rooms, one heated, to the north of the modern road that skirts the main villa. Whether these indicate an ancillary building or a continuation of the main villa is unclear. It raises the question whether the Durrueli villa was the center of an agricultural estate with outbuildings, or was a true *villa maritima*, where some wealthy Agrigentine, anxious to escape the summer heat in the city, relaxed and partied.[45] How long it continued in use is unknown.[46]

SICILIAN VILLAS IN THE FOURTH AND FIFTH CENTURIES CE

Piazza Armerina

The villa in the Casale district, in a secluded landscape near Piazza Armerina, is an iconic site in late Roman studies. Antiquarian reports first recorded a marble floor and the villa's main aqueduct in the second half of the eighteenth century, and there were excavations at the start of the nineteenth

century, but the site's potential was revealed for the first time only in 1881, when part of the huge mosaic in the three-apsed banqueting hall was uncovered.[47] Further sporadic work continued during the Second World War, but it was only between 1950 and 1954 that the excavations of Gino Vinicio Gentili revealed the full extent of the villa and its mosaic pavements to an astonished world.[48] Doubts about the chronology proposed by him prompted limited test digging in 1970, and additional work on the south side of the villa took place in the 1980s.[49] Between 2004 and 2015 several major campaigns were conducted by Patrizio Pensabene. His work yielded much new detail on the early medieval settlement which grew up in the villa's ruins, as well as, more recently, a second bath-house.[50] Since 2007 further excavations have also been conducted in the villa itself in conjunction with a major restoration project, which has repaired damage to the mosaics and controversially replaced most of the plastic roofing (erected over the mosaics in the 1950s) by a new protection.[51]

The villa (Figures 12.8; 12.9) was probably laid out in a single phase c. 320/330 CE, replacing an earlier (first/third century CE) villa of which only fragments are known.[52] The fourth-century mansion consists essentially of an entrance area including an imposing triple gateway and semicircular court (1, 2 on Figure 12.9); a central core with rooms arranged on the north and south sides (16–25 and 37–9) of an ample garden peristyle, 40x30 m (15; Figure 12.10); an elaborate bath-house (8–12), laid out at a 45-degree angle to the peristyle; a 70 m-long transverse corridor (26), on the far side of which are bedrooms and the private quarters of the *dominus* and his family (27–9 and 31–6), and, at the center, a marble-clad *aula* (30); and finally, a separate banqueting suite consisting of a grand three-apsed hall, 24x19 m (46), a *triconchos* (in Latin probably a *trichorum*[53]), with attendant oval court, fountain-*nymphaeum* at the far end, and six sided rooms (42–45). Nearly every room was adorned with colorful mosaic pavements, either geometric or figured, except for the *aula*, which was marble-floored and had marble wall-panelling.[54] The total area of marble and mosaic flooring in the villa amounts to a staggering 4,103 m².[55] Furthermore, the good state of preservation of the walls means that their lower

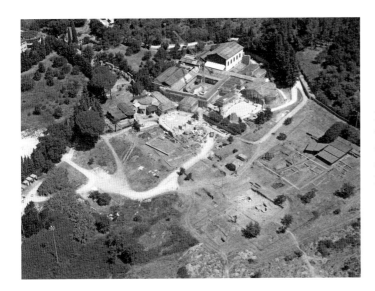

Figure 12.8. Casale di Piazza Armerina, villa, aerial view (2011) during the roof-replacement program; the newly discovered South Baths are under excavation at lower right (photo by courtesy of P. Pensabene).

parts still contain considerable elements, inside and out, of their brightly colored frescoes, demonstrating that the gaudy polychrome of the floors of each room was continued upwards on the walls as well (Figure 12.11).[56] The whole complex, which covers some 1.5 hectares, was liberally supplied with running water from two aqueducts (Figure 12.12) that fed fountains and flushed the villa's three latrines (6, off 14, and 47). There are fifty-eight marble columns in place, thirty-two of them in the main peristyle; originally the villa had close to one hundred of them.[57] Although fragmentary, something of the villa's sculptural program has also been preserved.[58] No other single villa found to date in the late Roman world can quite match that near Piazza Armerina for the sheer quantity of mosaic and marble adornment that has been preserved. The villa gives us a vivid insight into the luxurious lifestyle of a member of the aristocratic elite in fourth-century Sicily.

The program of figured mosaics tells us something about his personal interests and preoccupations. The stupendous composition in the long corridor of the so-called Great Hunt (26; Figure 12.13) records the capture of beasts from far-off locations and their transport to Italy. The latter is indicated symbolically at the center of the composition, framed by a ship on either side; the sea voyage to reach it is intimated, in a neat piece of artistic license, by the simultaneous loading and off-loading of each ship with their cargoes of live animals (and birds). The apses at either

end of the corridor depict Aethiopia (south end)[59] and Mauretania. The message was clearly that the *dominus* had gone "to the ends of the earth" to source the widest possible range of animals, in advance of the games that he had triumphantly presented in Rome while holding a magistracy there. Further interest in beasts for the arena is shown by the choice of animal heads to decorate the 156 laurel-wreath medallions in the corridors of the central peristyle (15), and of animal foreparts (*protomai*) to decorate the walkways around the oval peristyle (41). The choice of the Circus Maximus as the mosaic theme in the *apodyterium* of the baths (8) was surely also another autobiographical touch: the *dominus* was determined to have the highlights of "his" Roman games permanently commemorated as "snapshots" in stone. From other mosaics, we might guess that he shared the widespread love of the aristocratic elite for hunting (23), and that Hercules was a favorite hero (46). The story of Polyphemus (27), the other principal floor with a mythological theme, has Sicilian topicality;[60] but many of the other mosaics, like the numerous fishing cupids (9, 22, 31, 44, 45), are genre scenes, part of the standard stock-in-trade of the mosaicists who laid the floors.

That those mosaicists were not Sicilians but Africans, almost certainly based in Carthage, working in the island on a special commission which local *officinae* were unable to fulfill, has long been realized.[61] Quite apart from general similarities,

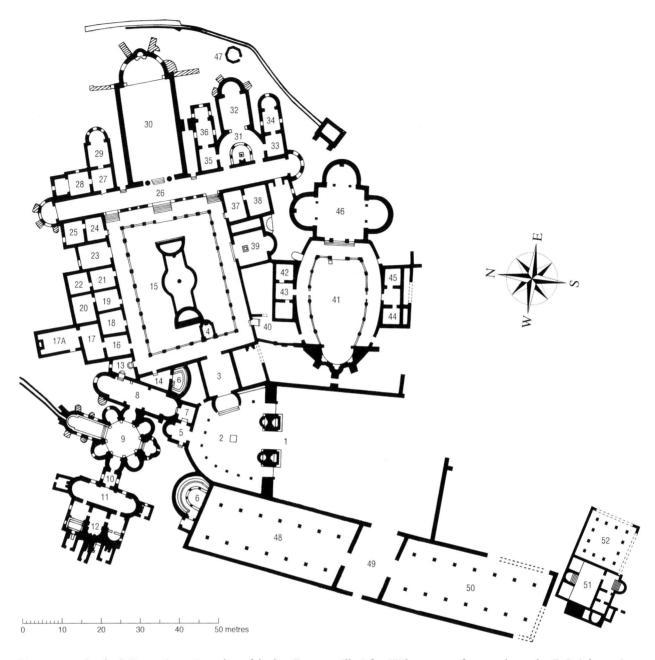

Figure 12.9. Casale di Piazza Armerina, plan of the late Roman villa (after Wilson 2016, fig. 1.3, drawn by E. Leinberger).

like the use of the African zig-zag convention for depicting the sea, there are close parallels in Carthage and its region for many of the floors at the Casale villa.[62] What we do not know, pending geological analysis of the tesserae, is whether the Africans brought their materials with them across the water, or whether they relied on local Sicilian supplies. The recent realization that the marble floor-design of the *aula*'s apse was laid out using

Punic rather than Roman measurements strongly suggests that an African hand was responsible for the villa's *opus sectile* as well. That in turn raises the question of whether the architect was an African too: the use, for example, of vaulting tubes in the villa's main baths is a typically African feature at this date, although they occur too widely in Sicily and indeed Italy for all of them to be interpreted as witness of the presence of Africans.[63]

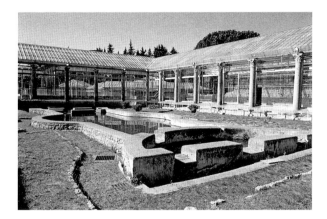

Figure 12.10. Casale di Piazza Armerina, peristyle garden with central pool and surrounding corridors (15), before the 2007–2014 restoration program (photo: author).

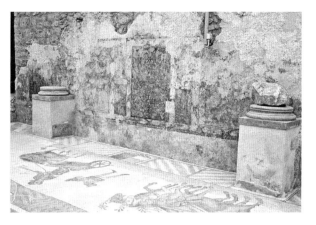

Figure 12.11. Casale di Piazza Armerina, wall painting in the *apodyterium* (8) of the West Baths, and part of its floor mosaic showing a chariot race in the Circus Maximus (photo: author). (A black and white version of this figure will appear in some formats. For the color version, please refer to the plate section)

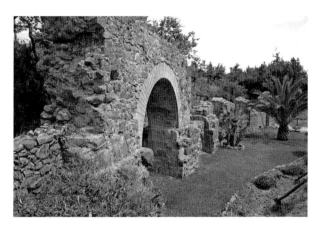

Figure 12.12. Casale di Piazza Armerina, the aqueduct supplying the main (west) baths, from the north (photo: author).

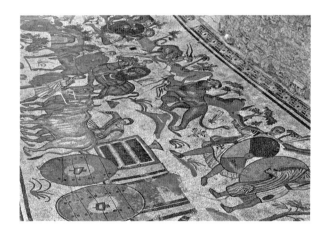

Figure 12.13. Casale di Piazza Armerina, detail of the mosaic in the Great Hunt corridor (26) (photo: author).

Inevitably, questions were raised about the identity of the *dominus* who commissioned this mansion as soon as its full splendor was first revealed. H. P. L'Orange suggested in 1952 that its owner was the Tetrarchic emperor Maximian (286–305 CE); he compared the flat-topped headgear (the *pileus pannonicus*) worn by officials on the Great Hunt mosaic with similar hats worn by emperors on the famous porphyry relief at S. Marco in Venice.[64] Gentili rapidly embraced L'Orange's theory and stuck with it to the end of his life.[65] Heinz Kähler, along the same lines, preferred to identify Maximian's son, Maxentius (306–12), as the owner of the villa.[66] Giacomo Manganaro, having first suggested that the mansion was lived in by the *procurator* of an imperial estate, later opted for Betitius Perpetuus Arzygius (312/24) and Domitius

Latronianus (314), two early-fourth-century governors of Sicily, as the men who commissioned and built the villa.[67] There is not a shred of evidence that any of these individuals ever had a connection with the villa. In particular, the flat-top cap is a badge not of emperors *per se*, but of soldiers.[68] The official with the staff who directs operations on the Great Hunt wears one to indicate that he is a military officer: rounding up wild beasts was a dangerous job, often best entrusted to the army.[69] Equally, the distinctive mushroom-headed staff he carries is not the badge of emperors but more generally a symbol of authority, used to denote clearly who is the person in charge.[70]

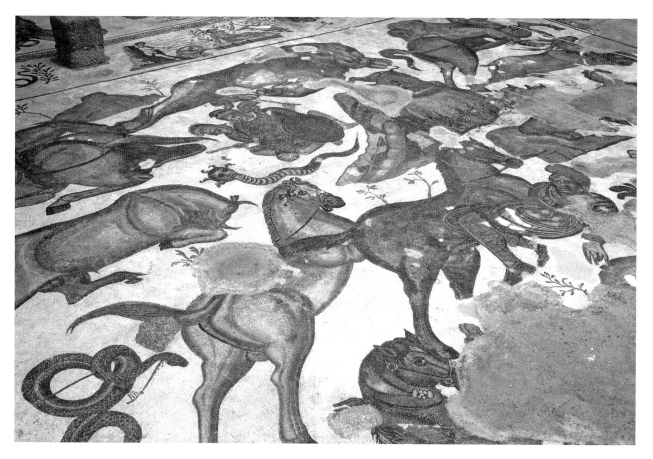

Figure 12.14. Casale di Piazza Armerina, *triconchos*, detail of the mosaic showing the aftermath of the Labours of Hercules (46) (photo: author). (A black and white version of this figure will appear in some formats. For the color version, please refer to the plate section)

There is another reason, however, to reject all these theories, and that is a chronological one. Ever since the 1970 excavations extracted stratified dating material, there has been a general consensus that the villa belongs to the mid-Constantinian period, roughly c. 320/30 – a date further strengthened by pottery from recent excavations.[71] An attempt by Baum-Felde to date the whole villa as late as 370/375 CE, on the basis of alleged African comparanda for the geometric mosaics, fails to convince, and is to be rejected; she has most recently been followed by Brigitte Steger, who also argues for a Valentinianic date for the villa.[72] It has long been appreciated, from numerous straight joints observable throughout the structure, that changes of plan during construction were likely;[73] but no major hiatus is attested, and the villa as we see it today seems essentially to be the product of a single building program. Pensabene and his colleagues, however, on the basis of work in the oval court, have suggested that the grand three-apsed dining room and accompanying rooms are significantly later than the rest of the villa; they tentatively suggest a date in the Theodosian era (379/395 CE).[74] If, however, such had been the case, we have to envisage a three- or four-decade delay in constructing the south-west side of the villa, after the completion of rooms 37–9: for there is no evidence of further rooms here, contemporary with the villa of 320/30 CE, that were later demolished to make way for the allegedly later grandiose enlargement.[75] Furthermore, the style of the mosaics in 41–46 does not suggest that they belong to a substantially later period than the rest. The pavements of the banqueting hall (Figure 12.14) are without doubt artistically superior, the work of master craftsmen, as one might expect in a space where the owner most wanted to impress his guests; but the scenes of fishing cupids in 44 and 45 are no different from those elsewhere in

the villa. Dunbabin, too, has pointed out the essential unity of the villa's mosaic program.[76] The banquet hall and the adjacent oval court might well have been an afterthought, not envisaged in the original master plan (in which case presumably the *aula* was intended originally to serve as both reception room and dining hall), but it seems most probable that if they were an addition, it was made in the course of construction, perhaps c. 330 CE, and not decades later.

The rejection of the long-cherished view that an emperor owned the villa leads to the obvious conclusion that the *dominus* was a *privatus*, and scholars have not been slow in looking for suitable candidates. Carandini followed Cracco Ruggini in advancing the case of L. Aradius Valerius Proculus;[77] Calderone espoused the candidature of Caeonius Rufius Albinus;[78] Pensabene has emphasized the claims of the Sabucii, a family that may be represented by the survival of the toponym "Sabuci" in the hinterland of Gela, and most recently Steger has advanced the candidacy of Virius Nicomachus Flavianus.[79] The fact remains, however, that no indisputable evidence links the Casale villa with any of these individuals. There are too many members of the senatorial aristocracy (the *clarissimi*) who are simply unknown to us, both Sicilians and non-Sicilians, for us to state with any confidence the name of the *dominus* of the villa. He was clearly a rich man, but perhaps not from the *crème de la crème* of the late Roman aristocracy: the marbles used for the villa's columns mostly come not from prestigious imperially owned quarries but from municipal ones; there is much use of second-hand marbles in wall veneering, and occasionally for columns too;[80] and the very predominance of mosaics on the floors and frescoes on the walls, rather than marble for both, as was increasingly the fashion for the mega-rich in the fourth century, suggests that the owner of Casale was not out of the very top drawer. We cannot even say for certain whether he was Sicilian or Italian, but that he held magistracies at Rome is highly probable, as already noted, because of the subject matter of certain mosaics. It is also likely that he and his family appear on the villa's floors and frescoes. It must surely be his wife and two children who are shown in the mosaic of the vestibule to the baths (14), and the

dominus may be the man sacrificing before the hunt (23). Pensabene and Gallochio have also recently drawn attention to the similarity of a man's face in an apse off the *frigidarium* of the baths with that of one of the figures receiving animals at the center of the corridor of the Great Hunt, who may therefore depict family members, not just anonymous officials.[81] It also seems clear, from the military standard painted on the entrance wall of the villa, and of frescoes showing soldiers with shields on the walls of the main peristyle, that the owner was keen to emphasize the military posts of his career as well as his civilian magistracies in Rome.[82] The whole palatial villa was conspicuously designed as an autobiographical display of the *dominus'* power, wealth and prestige.

Little is yet known about the service quarters, but two aisled buildings and connecting vestibule (48–50) west of the entrance were a great storehouse, presumably for agricultural produce, in which case the villa was indeed, as has always seemed likely, the center of a farming estate. A detached bath-house contemporary with the villa has recently been found further south (51–2).[83] One room has a geometric mosaic with a pair of sandals depicted on its threshold; an exercise yard with marble columns lies adjacent. It is unusual to have a villa with two contemporary sets of baths, especially as the main baths seem designed to have been used by estate workers as well as by the *dominus* and his family.[84] Were 51–2 intended for travel-weary visitors who need to freshen up before entering the villa? Other outbuildings may lie buried in the deep fills north of the villa: kilns for pottery or tile production, for example, probably of late Roman or early Byzantine date, are visible in section there below the medieval occupation.[85]

How long did the villa continue in use as a residence of elegance and sophistication? That there were various minor changes after the main building phase is abundantly clear: for example, mosaic repairs, sometimes not respecting the original design;[86] wholesale replacement of one floor, probably not long after 320/30 (because of rising damp?), with a new one representing female athletes in bikinis (38);[87] the replacement of some wall frescoes by marble veneering; the addition of strengthening wall

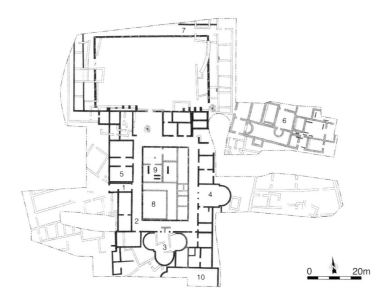

Figure 12.15. Marina di Patti (ME), plan of the late Roman villa (walls in gray are either earlier than the fourth-century villa in black [6, 8, 9]; those in open line post-date its abandonment) (after Bacci n.d., folding plan).

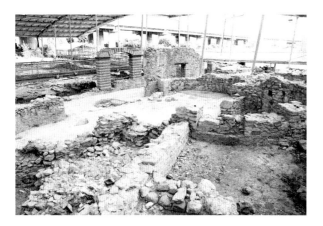

Figure 12.16. Marina di Patti, late Roman villa, view from the south-west of the *triconchos* dining-room (3) and the south corridor of the peristyle beyond (left of center), with the motorway which caused the site's discovery in the background (photo: author).

buttresses (30, 32, and the north apse of 26), probably after an earthquake in 361/3 CE.[88] Excavation in the new baths (51–2) has demonstrated that a great flood of alluvial soil in the second half of the fifth century overwhelmed the peristyle there and also caused the collapse of the *aula* (30) and the columns of the main peristyle (15); they were never re-erected. From then on the use of the villa as an elite residence ceased.[89] In the sixth and seventh centuries agricultural processing (mills and presses) invaded parts of the former residential spaces, as an agricultural village grew up in the villa ruins.

Marina di Patti

Until the 1970s, the villa near Piazza Armerina remained a unique phenomenon in Sicily, but two further substantial fourth-century villas explored over the past 40 years have helped set it in sharper focus. The villa at Marina di Patti, on the north coast 50 km west of Messina, was discovered in 1973 during the building of the Messina–Palermo motorway, which was then diverted to avoid the site.[90] Constructed in the first half of the fourth century, the villa (Figure 12.15) consists of a rectangular entrance court on the north (7), which gave access to a central peristyle garden (8) surrounded by corridors (33x25 m). Of the rooms that open off these on all four sides, the principal ones are an apsed hall in the center of the east wing (4) and a three-apsed dining-room (16x12 m), the focal point of the south wing (3; Figure 12.16). At the very limits of the excavation there is an intriguing, even larger, apsed hall (10), 22 m long, entered from the east but without access from the main residential core of the villa. Whether this functioned as a reception

room for the more "public" duties of the owner, which his visitors could reach directly without entering the residential part of the villa, or had some other function,[91] only future excavation will resolve.

A bath-house, detached from the main villa and with a separate orientation, also lies on this east side (6). The core of it was built in a different construction technique from that used for the residential villa, and might originally have served the smaller third-century villa on the site, the rest of which was demolished when the later establishment was laid out. Of this earlier villa some elements, including a fragmentary figured mosaic showing Bacchus and the four seasons (in the form of cupid charioteers driving felines), have been detected within the fourth-century mansion's peristyle (9). The latter consisted not of stone or marble columns (of which there are none at the villa) but of stone-and-brick piers. Nearly all the rooms in the central residential block appear to have been paved with mosaic; geometric patterns predominate throughout. There are echoes of the African style, in details such as the laurel-wreath medallions, but Sicilian mosaicists are likely to have laid them, as suggested above all by their few feeble attempts at figured representation – perfunctory animals within octagons in the *triconchos* dining-room (3), and a simple Medusa head in another room (5). No owner would have been prepared to pay for imported mosaicists if such substandard work was the best they could do. There are a couple of fragmentary marble statuettes and an elegant neo-Attic marble relief of *Nike* and Apollo, but few other signs of extravagant luxury: the *dominus* at Patti Marina clearly had considerably less economic muscle than his counterpart at Piazza Armerina.

The end of the Patti Marina villa was sudden: after a life of less than a century, it collapsed in an earthquake, probably the same as that which destroyed the nearby town of Tyndaris (mod. Tindari) c. 400 CE. The peristyle piers collapsed wholesale onto the corridor mosaics: left in part where they fell, they bear dramatic witness to the villa's destruction. In the sixth or seventh century, burials were made in the baths; and, as at Piazza Armerina, an early medieval village grew up in the ruins of the stricken mansion.

Caddeddi

A second fourth-century villa lies in contrada Caddeddi on the Tellaro river, near Noto in southeast Sicily.[92] Consisting once again of rooms arranged on all four sides of a central peristyle, here 30 m square (7/25/26 on Figure 12.17), it is more compact than the two villas just discussed (the main block is 60 m square), and the use of rudimentary Ionic capitals and columns of white limestone also suggests, as at Marina di Patti, a more modest level of affluence than that at Piazza Armerina. It has, however, been badly damaged by the early modern farmhouse built on top of it, so the plan will always be incomplete; it is also a multi-level site and contained more than the fifty-five or so rooms indicated in Figure 12.6.[93] There is an apsed room at the focal point of the south wing (6), but its mosaic has only a simple geometric design and the room is too small (8x6 m) to have served as the main *triclinium*. The principal show rooms were clearly on the north side of the villa overlooking the river, where the ground falls sharply away. Apart from three mosaic-paved rooms adjacent to the peristyle here (8–10), however, all we have now are substructures for the elite halls set at a higher level. This is witnessed by a fragment of mosaic with laurel-wreath border, found tilted at an angle, which had collapsed from the east corridor above.[94] The rooms at the lower level throughout clearly served as service quarters and include a kitchen (19).

The north peristyle corridor (7) was floored with an intricate mat of interlaced laurel-wreath circles, forming circular medallions and concave octagons, each filled with one of three repeating floral motifs. Of the pavement in the main apsed reception room on its north side (8), 10.80x7.92 m, only a fragment of one corner survives (Figure 12.18, A), with a panel depicting the ransom of the body of Hector, paid for by gold vessels equivalent to his body weight: the scale for weighing them is shown. Odysseus, Achilles, D(iomedes?) and Pr(iam) were also depicted, all conveniently labeled for viewers (in Greek). It was one of probably twelve such panels in this room, no doubt intended to show off the owner's classical erudition. The use of Greek in the

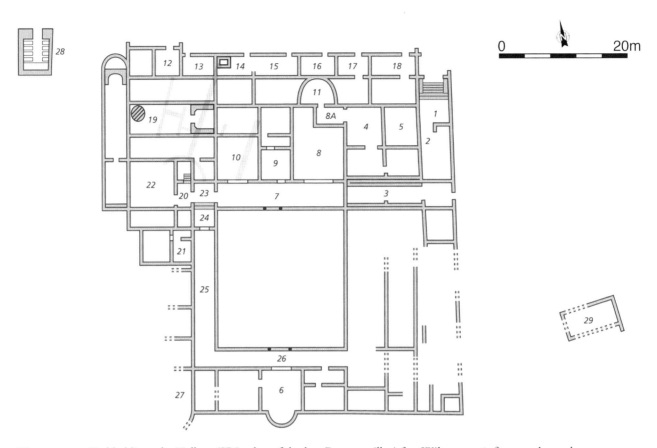

Figure 12.17. Caddeddi on the Tellaro (SR), plan of the late Roman villa (after Wilson 2016, fig. 2.2, drawn by E. Leinberger).

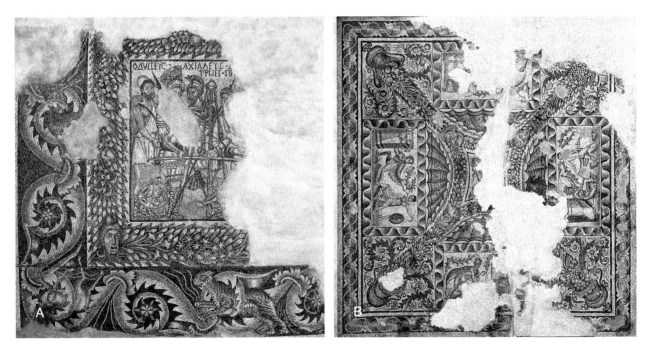

Figure 12.18. Caddeddi on the Tellaro. A: mosaic panel showing the Ransom of Hector (8); B: the Bacchus mosaic (9) (photos: L. Rubino, courtesy of Erre Produzioni, reproduced by permission of the Regione Sicilia, Assessorato Beni Culturali e Identità Siciliana, and of the Servizio Parco Archeologico di Eloro e Villa del Tellaro).

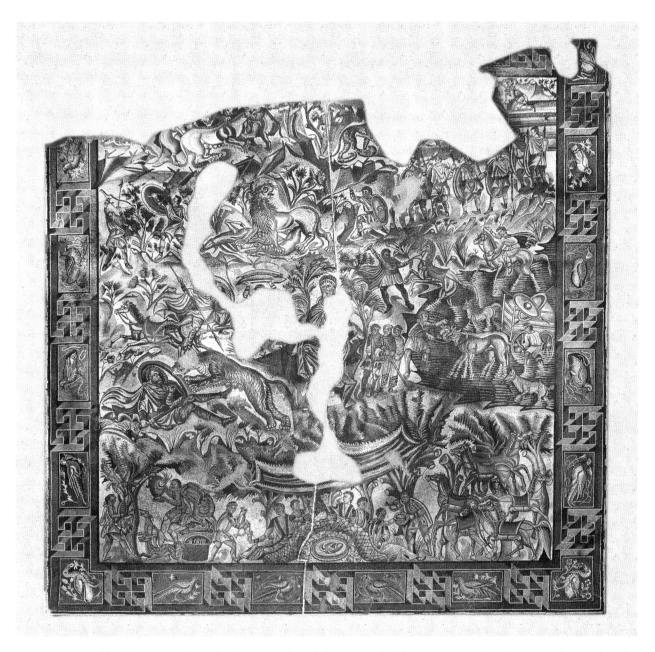

Figure 12.19. Caddeddi on the Tellaro, the Hunt mosaic (10) (photos: L. Rubino, courtesy of Erre Produzioni, reproduced by permission of the Regione Sicilia, Assessorato Beni Culturali e Identità Siciliana, and of the Servizio Parco Archeologico di Eloro e Villa del Tellaro). (A black and white version of this figure will appear in some formats. For the color version, please refer to the plate section)

mosaic, the *lingua franca* of eastern Sicily down into Byzantine times, occasions no surprise.

The mosaic of an adjacent room (9) shows a bust of Bacchus in the center surrounded by panels depicting cavorting maenads and satyrs (Figure 12.18, B). A third room (10), 6.40x6.25 m, is carpeted by an action-packed scene showing the hunting and capture of wild beasts, presided over by a personification of Mauretania at the center (Figure 12.19).[95] Coins under the Hector mosaic and in the floor make-up of another room date to no later than 346 CE, so the visible villa, or at least its mosaics, are later than this; they most probably belong to the third quarter of the fourth century, perhaps c. 370 CE.[96] The hunting

mosaic shows many parallels with scenes at Piazza Armerina – the capture of leopards in baited boxes, the lion with its prey, a feline with fallen hunter, and the picnic beneath the trees – but at Caddeddi, forty or fifty years after Piazza Armerina, the composition is much more crowded and frenetic. The repetition of these stock themes in itself suggests an African workshop, and details like the v on the forehead of the personification at the center of the composition may indicate that the same Carthaginian workshop which a generation earlier had laid the Piazza Armerina floors also worked at Caddeddi – if, as seems likely, the v is a type of trademark of a mosaic *officina*.[97] There are close parallels, too, between the Bacchus mosaic and a slightly later floor (c. 400) from Carthage now in the British Museum, and others in the same city.[98] The African origin of all the Caddeddi mosaics is clear: once again a (probably Sicilian) member of the aristocratic elite, anxious to show off to his friends figured pavements of the highest quality, found the abilities of contemporary Sicilian mosaicists wanting, and so summoned craftsmen from overseas capable of fulfilling his commission.

Life in the Caddeddi villa lasted less than a century: fire damage to several parts of the mosaics shows that it perished in a conflagration, apparently during the second half of the fifth century. Other late mosaics are now known also at Gerace (see below),[99] but it would not be surprising if still later ones turn up one day. We know, for example, that Nichomachus Flavianus finished revising a text of Livy in his villa "near Enna" in 408 CE, and that the historian Rufinus, who witnessed the burning of Reggio Calabria by the Visigoths in 410 CE in the company of Valerius Pinianus, husband of Melania the Younger, was accompanying them to their villa near Syracuse.[100] These were very wealthy members of the late Roman aristocracy, and if their Sicilian properties had been recently renovated, we might expect them to have mosaics and marble dating to c. 400 CE.

Gerace

Recent work at another villa, Gerace in Enna province, has provided further evidence of Sicilian

late-Roman vitality (Figure 12.20).[101] There was a villa here at least from the second century CE, swept away when a grand storehouse (*horreum*) was built, 49 m long, at some stage during the first half of the fourth century. It was of basilican form, with a central nave and two side aisles, neatly paved in stone except for a space along the side walls, which were perhaps lined with timber grain bins (Figure 12.21, B1–6). The architect used the Greek Ionian or Samian foot (34.8 cm) for its construction, so that the building measured 142 Ionian feet by 51 feet, with most walls 2 feet wide.[102] It was catastrophically destroyed in the mid-fourth century, probably during the earthquake of 361/3 CE. Unless the *dominus* was an absentee landowner at this time, his contemporary residence is so far unlocated. Soon after (c. 370?), he set about building a small residential villa alongside, about 21 m by 27 m, with

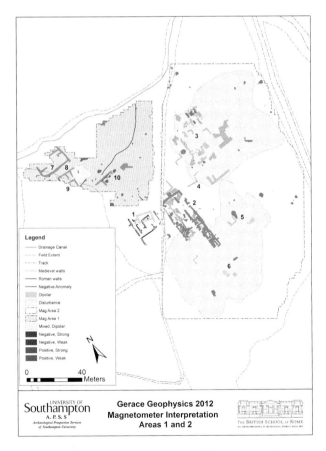

Figure 12.20. Gerace (EN), geophysical survey results: (1) late villa; (2) *horreum*; (3) position of bath-house (and later villa?); (5–6) kilns (courtesy of S. Hay and the British School at Rome).

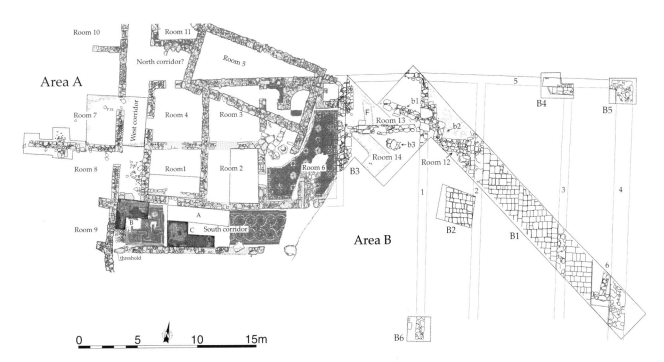

Figure 12.21. Gerace, plans: (a) the compact villa of c. 370 CE (5 is Byzantine); (b) the *horreum* of c.300/50 CE (B1–6), the hot pool, all that remains of a bath of c. 370 (12), and the storerooms (13–14) inserted c. 380/400 (b1–3 are Byzantine) (courtesy of L. Zurla and the Soprintendenza Beni Culturali di Enna).

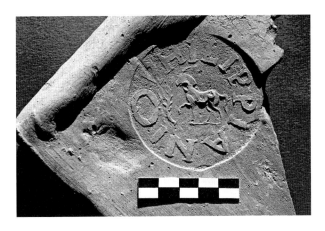

Figure 12.22. Gerace: one of over 200 tile-stamps naming or alluding to Philippianus (photo: author).

at least a dozen rooms, no peristyle and an acentrically set *aula* (Figure 12.21, 6).[103] A small independent bath-house was set on its east side, partly in the ruins of the west aisle of the destroyed *horreum* (Figure 12.21, 12). There were geometric mosaics in the *aula* and in the south corridor, but floors elsewhere were either of earth, mortar or (for the largest room) *opus signinum*. Unusually, we know the identity of the *dominus* at this period, one Philippianus,

whose name appears, or is alluded to, on more than 200 stamps on roof-tiles and on bricks, all manufactured on site (Figure 12.22).[104] The kiln where some of them were made was located and excavated in 2017. Some stamps show the imagery of the victorious racehorse, but whether this is a play on his name (which is cognate with Philippus, "lover of horses") or a nickname (*agnomen*), given to him because his passion was to raise and train horses at Gerace, is uncertain. The large quantity of horse bones from the site, however, including those of foals and equine milk teeth, tantalizingly supports the latter possibility.

The contrast between the mosaic of the south corridor at Gerace and the earth floor in the adjacent west corridor is striking. Did Philippianus die during construction and his heir or successor lose interest in the project? Or did Philippianus turn his attention to a more grandiose building scheme further up the hill? There, part of a substantial bath-house was uncovered in 2016–17 with walls still standing 2.30 m high. It had geometric mosaics in at least four rooms and a white mortar floor in a heated pool set within a semicircular apse (Figure 12.23), the latter roofed with vaulting tubes (as in the baths at Piazza

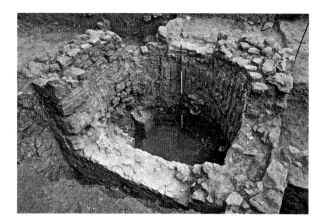

Figure 12.23. Gerace: detail of an apse once containing a hot water pool, with impressions of *tubuli* in the mortar on the walls, in the bath-house of *c*. 380 CE (photo: author).

Armerina). That Philippianus built the baths is witnessed by the monogram of his name appearing in the *frigidarium* mosaic, and by an inscription round the edge of the same floor referring to him and to another member of his family, Asclepiades. On decommissioning, the bath-house was systematically stripped and selected building materials recycled: the *tubuli* were taken from the walls, and the mosaics and pool floor were smashed to remove the hypocaust *pilae*, and in particular the large bricks spanning the gaps between them, before the whole bath-house was filled in. This occurred in the second half of the fifth century, probably the result of earthquake damage. The date of its construction is not certain, but is likely to have been around 380 CE. Parts of contemporary structures have been found nearby under Byzantine levels, associated with exclusively fifth-century pottery, including an amphora containing wine from the Greek island of Samos. Another bringing wine from Gaza in Israel is known from another context at Gerace; so the owner at this time (either Philippianus or his heir) was able to offer expensive imported vintages on his table, as well, no doubt, as local Sicilian ones. A substantial villa occupied during the later fourth and fifth century may await discovery nearby: the elite bath-house cannot have stood alone.[105]

Meanwhile the compact villa near the *horreum* continued to be inhabited until the second half of the fifth century. The small bath-house there was soon demolished and two storerooms were inserted where it had stood, now sunk deep into the earth to keep their contents insulated, dry and cool (13–14 on Figure 12.21). At some stage in the fifth century, insulation was improved when an additional wall was built alongside the existing one, on the west side of both rooms. Life was brought finally to an end in this compact villa by a devastating fire in the second half of the fifth century (perhaps associated with the earthquake that seems to have destroyed Philippianus' baths), when the contents of the storerooms also perished. They contained thousands of barley seeds and hundreds of bread wheat seeds, as well as broad beans, lentils and grapes. Gerace therefore continued to be an agriculturally productive estate until the second half of the fifth century CE. This was the time, as the evidence from Piazza Armerina, Caddeddi, and Gerace all suggests, that elite villa life as it had been known in Sicily finally came to an end.

The three fourth-century Sicilian Roman villas of Piazza Armerina, Patti Marina and Caddeddi are the most sumptuously appointed examples of any date so far discovered in the island, and reflect not just improving living standards in late antiquity but also the flourishing economic state of late Roman Sicily, demonstrable also on other grounds.[106] These mansions, with their peristyles, apsed reception rooms and *triconchoi* dining halls, form part of a widespread late Roman *koine* of villa architecture, without displaying any particular characteristics peculiar to Sicily – although the element of surprise at Piazza Armerina, with different parts of the villa set on differing alignments, is unusual, and the massive *aula* there is bigger than some counterparts in imperially owned properties.[107] As Chris Wickham has put it, "the interest shown by aristocrats in rural living, comfort and display – unmatched in the east, outside suburban areas at least – was firmly part of western aristocratic identity."[108] These Sicilian villas provide particularly eloquent illustrations of that late Roman social phenomenon.

NOTES

1. Cic., *Verr* 2.2.5: *M. Cato Sapiens… nutricem plebis Romanae Siciliam nominabat.* The following abbreviations (in parentheses after place-names) are used in the notes to denote the nine provinces in Sicily: Agrigento (AG), Catania (CT), Caltanissetta (CL), Enna (EN), Messina (ME), Palermo (PA), Ragusa (RG), Syracuse (SR) and Trapani (TP).

2. Strabo 6.2.7.

3. Soraci 2011.

4. Wilson 1990, 191–2; 261–4.

5. Bejor 1986 is still useful but needs updating. A project to catalogue all known Sicilian villas (Cilia Platamone 2000) had listed 139 sites up to 1998, but these include "farms" as well as villas and probably some rural villages. For a location map of the principal known villas in Roman Sicily (updating Wilson 1990, 212, fig. 173), Tigano et al. 2008, 46–7.

6. Two examples are Campanaio, a Hellenistic/Roman village (Wilson 1996a, 38, fig. 5.21), and the villa at Gerace (Wilson 2014a, 96–9, figs 1–4; 2016, 17, fig. 1.23), here Figure 12.20.

7. Patti Marina (ME), with piers of masonry, not columns of marble, flanking its peristyles was thought to have been an agricultural village before excavation revealed otherwise (Wilson 2014a, 95); and there is little on the surface at Gerace (EN) to suggest a sizable villa estate of some pretension: mosaics there were either revealed by chance through erosion of a water gully, or were buried so deep that they were beyond the reach of the plough.

8. On the criteria for distinguishing villa from village, see Kahane et al. 1968, 153–6 (J. B. Ward-Perkins); and on the use of misleading terminology such as "*villa urbana*" and "*villa rustica*," see my comments in Creighton and Wilson 1999, 20–1.

9. E.g. Taormina-Giardini (*villa maritima*), Annunziata di Mascali (CT), Maniace (CT), Biancavilla (CT), S. Teresa di Longarini (SR), S. Nicolò di Carini (TP), Trecastagni (CT), Lancine near Halaesa (ME) and Gravina di Castel di Tusa (ME) (von Boselager 1983, 100–3, 160–6, 205 and 211; see also Pettineo 2008, 80–2 for the last two). Other isolated mosaics from rural sites: Costa di Piraino (TP) (Barbera Lombardo 1965), Settefrati (PA) (Vassallo 1997), Rasalgone (CT) (Guzzardi 1997–1998, 303–4; Centonze 1999, 178–9 and 189; Greco in Meli

2004, 260), and S. Maria del Vocante near Reitano (ME) (Pettineo 2008, 42).

10. Marble portraits: Sabucina Bassa (CL); Case Adotta, Partinico (TP). Sarcophagi: Terravecchia (AG); Sambuca di Sicilia (AG); Racalmuto (AG). Marble architraves: Bagnoli di Priolo (SR); Agnone (CT) (for all seven sites, Wilson 1990, 212–14 with notes 94–9 on 389). Tombs: the still-standing brick tomb called Torre Rossa near Fiumefreddo (ME) lies close to an apsed hall recorded in the eighteenth century, and now part of a bath-house which has been excavated: all are surely part of a villa (Pelagatti 1998, 40–1 with figs. 5–7; Buda et al. 2013); another example may be the tomb ("of Marcellus") at Aguglia near Agosta (SR), but the nature of the accompanying settlement there (whether villa or village) is unclear (Cacciaguerra 2011, 156–63).

11. E.g., S. Gregorio, near Capo d'Orlando (ME): Spigo 2004, 91–146; contrada Falabia near Palazzo Acreide (SR) with figured mosaics featuring the Labours of Hercules (Guzzardi 2014, 32–6). Others include Misterbianco (CT), Leucasia (CT), Bella Cortina (CT), Reilla (ME), Canicattini Bagni (SR: von Boeselager 1983, 202) and Caffettedda di Noto (SR) (Wilson 1990, 210–11 and nn. 87–9 on 388; for Misterbianco, see Tomasello 1992).

12. E.g., at the villages of Sofiana (EN) and Vito Soldano (AG): Wilson 1990, 225, fig. 180; Rizzo 2014, 404, fig. 5, for the latter.

13. Adamesteanu 1956; Panvini 1997; Pilo 2006; also von Boeselager 1983, 24–6.

14. Adamesteanu 1956, 354; followed by Panvini 1997, 161.

15. Sicilian Corinthian capital: Wilson 2013a, 93; 2013b, 160–3. Origins of *opus signinum*: Dunbabin 1999, 101–3; Wilson 2013c, 220–1; Fentress 2013, 174 (but Kerkouane is post-310 BCE).

16. Pilo 2006, 157–60, suggests a date between the end of the third and the second century BCE (based on the latest datable finds); so also La Torre 2011, 262; and earlier Bejor 1986, 485, no. 81 ("villa repubblicana").

17. Wilson 2013a, 100–5.

18. Cic., *Verr.* 2.2.92 (Sthenius); 2.4.48 (Philo).

19. Verres is alleged to have detached the figured decoration from the rest of the vessel. Cicero may be thinking of decorated bowls consisting of a highly decorated *repoussé* outer part and a separate inner lining, or medallion bowls where the figured central *emblema* was detachable from the rest of the bowl;

both types were common in the later Hellenistic period (Strong 1966, 109–12), including examples in the Morgantina silver treasure in Aidone museum (Wilson 2013a, 84, fig. 4.4; 2013b, 169–71).

20. Fentress et al. 1988; Fentress 1998.

21. Fentress 1998, 31, argued that a second-century BC date was more likely, on the basis of fragments of *scutulatum* floor (a polychrome pattern of rhomboid stone pieces, arranged to give a *trompe l'oeil* appearance of perspective cubes), but examples of these are known in Sicily (and elsewhere) as late as the first century CE (Wilson 1990, 118, fig. 106 [Agrigento]; Dunbabin 1999, 255).

22. As elsewhere in this chapter, peristyle measurements include the accompanying corridors that surrounded the central open court or garden.

23. Wilson 2000, 349 (the Campanaio example, of c. 375/460 CE, there described as mud-brick, was in fact *pisé*). Another *pisé* wall (of c. 380 CE) was found at Gerace in 2017.

24. Pottery in the destruction layers is c. 80/130 CE. Later sporadic non-elite occupation down into the seventh century need not concern us here.

25. Vassallo 1993–1994; 2009.

26. 21x6.8 m. Others are at Casalotto (CT) (Wilson 1990, 191, fig. 159a), Piazza Armerina (EN), Gerace (EN) (for both see below) and Pietrarossa (CT) (Arcifa 2008, 51).

27. Bacci 1984–1985b, 711–13; Wilson 1990, 197–8 with fig. 165.1.

28. E.g., at Sofiana (EN) and Agrigento: La Torre 1994, 109.

29. Tigano 2008; Tigano et al. 2008. I use its traditional name, but boundary changes have altered the *comune* in which it lies to Terme Vigilatore.

30. In a later phase (later first century CE?), the peristyle intercolumniations were filled with walling (of unknown height), probably to reduce draughts; such practice was a common procedure in houses at Pompeii and Herculaneum in the years before 79 CE.

31. My account here differs from that in Tigano 2008 and Tigano et al. 2008, who treat both these phases as one, and believe that 21 is a *laconicum* (a dry-heat sauna) and 19 an *apodyterium* alone. *Apodyteria*, however, are not provided with immersion pools in Roman baths, and a *laconicum* by its very nature requires no pool of water. The fact that the original cold pool in 19 (not shown on Figure 12.3) was filled

in and covered by flooring when a new and separate *frigidarium* was built at 23 (after which 19 served as an *apodyterium* alone) demonstrates that there were two phases, not one, in this initial development of the baths.

32. Tigano 2008 and Tigano et al. 2008 interpret this floor and others as belonging to a later phase: they divide the Castroreale mosaics into two separate commissions – those in rooms 5, 32 and 42, c. 100/150 CE; the remainder, c. 150/200 CE. I follow von Boeselager 1983, 96, in believing them all to be part of the same refurbishment in the first half of the second century.

33. For the first five listed, von Boeselager 1983, 90–6. For a close parallel to that in room 9, see Branciforti 2010, 156, fig. 35 (Catania); the patterns of floors in rooms 8 and 32 are similar to those in a *domus* at nearby Tyndaris (Leone and Spigo 2008, 63–8 and Tav. II).

34. Tigano et al. 2008 also date this refurbishment to 150/200 CE; they implausibly date the decorative marble strip at the entrance (and the fountain at the south end of the garden) to the fourth century.

35. Tigano 2008, 59, accounts for the disharmony in levels as "dovuta forse all'andamento naturale del terreno"; I see it as a rise in ground level caused by wind-blown soil that had by then accumulated over an already abandoned villa.

36. Aoyagi 1980–1981; Fiorentini 2006; summary: Wilson 1990, 198–9; 1996b, 96–7 (see also works cited in notes 37 and 42 below).

37. Principally *greco scritto* from Annaba (Algeria) and *portasanta* from Chios; also *giallo antico* (Chemtou, Tunisia), *rosso antico* (Cape Tenaro, Greece) and white marbles: Guidobaldi 1997.

38. Apparently lifted and taken to Palermo in 1924, but now lost.

39. It has sides clad in white marble and white tessellation on the bottom.

40. See the numerous plans of African *domus* in Bullo and Ghedini 2003 and Carucci 2007.

41. Aoyagi 1980–1981, 673 ("tra la fine del I sec. e l'inizio del II sec. d.C."). The *opus sectile* designs are of second-century CE date rather than earlier (Guidobaldi 1997, 251).

42. Aoyagi 1988. An unpublished floor nearby depicts Scylla.

43. Von Boeselager 1983, 100–3 (little else is known of this villa).

44. Black-and-white mosaics in Spain sometimes display a sparing use of color: Dunbabin 1999, 146.

45. Walls of uncertain date (seventh-century?) in the peristyle area, at a higher level and on a different orientation, clearly postdate the villa. A new project here can be expected to add fresh knowledge about the villa in the next few years (Bonacini, Gullì and Tanasi 2016). Other villas of imperial date which for reasons of space cannot be fully treated here (or where the evidence is still too exiguous for a coherent account) include those at Ortomosaico di Giarratana, RG (Di Stefano 1997, 201–2; 2005), Margi di Giarratana, RG (*BTCGI* VIII, 115–21), Oliveri (ME) (Fasolo 2014, 156–61) and Cignana (AG) (Fiorentini 1993–1994, 728–9; Wilson 1996b, 97; Rizzo 2014, 411, fig. 8). All have geometric mosaic pavements (one room in a bath-house at Cignana has also a marine scene). It has been suggested on the basis of tile-stamps that the owner of Cignana in the second century may have been the senator M. Ota(cilius) Catulus, suffect consul in 88 CE: Rizzo and Zambito 2007, 276–7.

46. No new villas are known in Sicily for the third century, but several of the buildings described above continued in use then, and there are earlier villas below all four of the fourth-century sites described below: a third-century "hiatus" is more apparent than real.

47. Early exploration: Wilson 2011, 55, with references; 2016, 4, fig. 1.5.

48. Gentili 1950; 1959; 1962; 1966; 1999; Pace 1955; Carandini et al. 1982; Wilson 1983a; 2016, 1–10. In brief: Sfameni 2006, 29–46; Pensabene 2009; Pensabene and Gallocchio 2011a.

49. Ampolo et al. 1971; De Miro 1988.

50. Pensabene and Sfameni 2006; Pensabene and Bonanno 2008; Pensabene 2010.

51. Pensabene 2010–2011; 2013; 2014; 2016; Pensabene and Sfameni 2014, 545–621. Other details: Pensabene et al. 2009; Gallocchio and Pensabene 2010; and Pensabene and Gallocchio 2011b. Restoration project: Meli 2010–2011; 2014 (the temperature within has been brought under control, but the choice of dark wood and solid-panel walls has robbed too much natural daylight from the mosaics); pre-2007: Meli 2004, 245–73, 384–97, 453–65, 576–7, 589–91, 677–80 and 693–5.

52. Earlier villa: Pensabene 2010–2011, 174–6.

53. Wilson 2011, 58, note 11.

54. The upper parts of the large immersion pool in the baths, also marble-lined (in a secondary period), may even have had figured or vegetal decoration in cut *opus sectile* (Pensabene and Di Vita 2008, 83 and 93–5 with Tav. M and N1–2 on 109–10).

55. Meli 2010–2011, 140.

56. See especially Carandini et al. 1982, *passim*; Gentili 1999, 1, *passim*; Pensabene 2010–2011, 160–71.

57. Meli 2010–2011, 140.

58. Neudecker 1988, 176–7; Gentili 1999, 2:11–28; Sfameni 2009.

59. Wilson 2004; in brief, Wilson 2009. Settis 1982, 528–9, followed by Carandini et al. 1982, 230, identifies her as India, which I reject (also Pensabene 2010–2011, 154: "l'India o l'Arabia"). On the mosaic of the Great Hunt in general, see most recently Muth 1999b.

60. His cave was located on the slopes of Mount Etna at least since the third century BCE (Theoc., *Id.* 11.46). Perhaps the mosaicist's lack of familiarity with the theme is suggested by the presence of eyes in all three of Polyphemus' eye sockets instead of just one, in the center of his forehead. On this mosaic, see now Dunbabin 2015, 42–7. On Hercules, the subject of the composition in the north apse of 46, for long identified as the "triumph of Hercules," has now been convincingly reinterpreted as the punishment of Marsyas: Pensabene and Barresi 2017.

61. Gentili 1959, 1966, 1999 (vol. 3); Carandini 1964; Dunbabin 1978, 196–212; Dunbabin 1999, 131–42; Wilson 1983a, 44–68.

62. Similarities with Carthaginian mosaics of hunting (e.g., Dermech and Maison des Chevaux) and cupids fishing: Wilson 1983a, pls 26–37; also for comparison with the Maison des Nymphes at Nabeul: Wilson 2011, 62–4 with fig. 4a–b.

63. Punic measurements in *aula*: Verde 2008, 27–8; paradoxically, however, the African-laid geometric mosaics of the villa invariably use the Roman foot. Possibility of an African architect: Wilson 1983a, 78; but the African origin of the *triconchos* there suggested can be discarded, given the re-dating of African examples and the likelihood that the earliest known is now in the (likely imperial) villa at Cercadilla, Córdoba, of c. 296 CE (Wilson 2011, 72–4). Vaulting tubes (*tubi fittili*) from the *frigidarium*'s cross-vault recently located: Pensabene et al. 2009, 5.

64. L'Orange 1952.

65. E.g., Gentili 1996; 1999.

66. Kähler 1973.
67. Manganaro 1982 (procurator); Manganaro Perrone 2005 (governors). I have rejected both theories in Wilson 1983a, 93–4; 2011, 61.
68. E.g., on the Arch of Constantine at Rome, on sarcophagi (e.g., Wilson 2016, 144, fig. A15), and on a fifth-century ivory diptych: references in Wilson 1983a, 109–11, notes 54 and 72. For a discussion and rejection of the theory of emperor ownership, see Wilson 1983a, 86–92. The hypothesis has, however, died hard: local guides still refer to Piazza Armerina as a "villa imperiale," i.e., one owned by an emperor.
69. E.g., Julius Africanus, *Kestoi* 1.14.
70. See most recently Pensabene 2010–2011, 163–4; it is, for example, held by a master carpenter on a gold-leaf glass from Rome (Strong and Brown 1976, 158, fig. 264). See fig. 12.19, right of center (Caddeddi), for a close comparandum.
71. Ampolo et al. 1971; Carandini et al. 1982, 54–8; Dunbabin 1978, 243–5; Scarpone 2010–2011.
72. Baum-vom Felde 2001; 2003 (discussed by Wilson 2011, 62–7); Steger 2017 (reviewed by Wilson, forthcoming a).
73. Lugli 1962–1963; his conclusions on the villa's phases are not accepted today.
74. Pensabene 2009, 96; Gallocchio and Pensabene 2010; Pensabene 2010–2011, 193–6; Pensabene 2016.
75. Wilson 2014b, 694–5.
76. Dunbabin 1999, 142; see also Wilson 1983a, 38–9.
77. Cracco Ruggini 1980, 514 (but suggesting only that the owner was someone *like* L. Aradius Valerius); Carandini et al. 1982, 31–51 (reviewed by Wilson 1983b).
78. Calderone 1988.
79. Pensabene 2010–2011, 171–4; 2016. Steger: see n. 72. I have discussed ownership issues at Piazza Armerina (preferring anonymity in the absence of secure evidence) in Wilson 1983a, 86–99; 1983b, 542–4; 1988; and 2011, 59–62.
80. Pensabene 2010–2011, 146–9.
81. Pensabene and Gallocchio 2011b, 18–20 with fig. 6. For similar nameless portraits, see Ripoll (Chapter 22) in this book.
82. Pensabene 2010–2011, 160–8.
83. Pensabene 2010–2011, 185–9; 2014, 13–14 (with fig. 5); 2016, 245–51; Pensabene and Sfameni 2014, 545–92.
84. Wilson 1983a, 20; 2014b, 694.
85. Pensabene 2010, 15, fig. 15.
86. E.g., Wilson 1983a, 39–40 with figs 19–20; Pensabene and Gallocchio 2011b, 24, fig. 5.
87. Probably to be taken at face value; for an attempt to see a moral message (identifying only two participants, repeated four times), Simpson 2003.
88. Libanius 18.291–3 (I do not believe that the earthquake of 365 CE, commonly blamed for this damage, affected the villa: Wilson 2014b, 695–6).
89. Pensabene 2010–2011, 196–202; 2014; 2016. He suggests the possibility of Vandal destruction, but I think an earthquake (a century later than that of 361/3) is more likely.
90. Voza 1976–1977, 574–9; 1980–81, 690–3; 1982a, 202–7; 1982b, 111–26; 1983, 14–18; 1984–1985, 659–61; 1989; Wilson 1990, 204–6; 2016, 10–15; Bacci n.d. [2003]; Sfameni 2005b, 415–19; 2006, 46–9; Fasolo 2014, 30–3.
91. For example, an estate church, as I tentatively suggested in Wilson 2001–2002, 156, although it might seem unduly large for such a purpose.
92. Voza 1972–1973, 190–2; 1973; 1976–1977, 572–4; 1982a, 207–9; 1983, 5–14; 2003; 2008a and b; Wilson 1990, 206–8; 2014c; 2016; Dunbabin 1999, 142–3; Sfameni 2006, 49–52.
93. For example, no bath-suite, a *sine qua non* for a luxury villa, has yet been located.
94. Wilson 2016, 31, fig. 2.10.
95. Wilson 2015a; 2016, 104–11. The architect seems to have used the Olympian foot of 32 cm; this room would therefore have measured 20 feet by 19 feet 6 in, and its walls were 2 Olympian feet wide (Wilson 2016, 35–6).
96. An earlier villa is recorded on the site (pale gray walls in 10 and 19 of Figure 12.17). Wilson 2016, 34, tentatively suggests that the *tsunami* accompanying the earthquake off Crete in 365 CE, known to have devastated the east coast of Sicily, might have destroyed the earlier villa; but this is not certain.
97. On this point, Wilson 1983a, 67 and notes 40–1 on 105.
98. Wilson 2016, 70–3.
99. The perfunctory, two-dimensional treatment of figured work in pavements at Settefrati (PA) might suggest that these mosaics are close to 400 CE (Wilson 2016, 21–2) rather than c. 300 CE (Vasallo 1997, 64 and 68). Stylistic judgments are, however, always to be treated with caution.
100. Nichomachus: *subscriptio* to Livy book VIII, dated by his title "urban prefect for the third time." Melania's

villa and Rufinus: Migne, PG XII.283. Usually placed near Messina (Sfameni 2005b, 407–8), the villa appears to have been *apud Syracusas*, on the basis of *subscriptiones* in three manuscripts of Rufinus' translation of Origen's *Homilies on Numbers* (Soraci 2013, 93).

101. Wilson 2015b and c; 2016, 15–21; 2017; forthcoming b. Previous work: Cilia Palatamone 1996; 1997; Bonanno 2014; Bonanno et al. 2010.

102. In fact, for reasons unknown, the storehouse's east wall was built of double thickness (4 feet). A basilican granary of c. 400 CE is known in Villa 10 on the via Gabina near Rome (Widrig 2009, 38–54; www.via gabina.rice.edu chapter 5); there is also a basilican building, 50x17 m, of the late fourth century, at Passolombardo (Tor Vergata) (Ricci 2005), but used for wine-processing.

103. Acentrically set reception rooms and the absence of peristyle are features of some south Italian villas: Faragola, c. 400 CE (Volpe and Turchiano 2009, 97; 2010, 28 and 30); S. Giovanni di Ruoti, periods 3a and b, c. 400 and 460 CE (Small and Buck 1994, plates 61, 85, 86 and 133).

104. Wilson 2014d. A further name attested at Gerace, on bricks alone, is Cn. [*nomen*] Cylin[drus]. Whether this was an earlier (or later) landowner, or named bricks were being manufactured at the site for clients based elsewhere, is uncertain. Cylindrus, like Philippianus, is a Latinization of a Greek name.

105. Wilson forthcoming b.

106. Wilson 1990: 233–6.

107. On *aulae*, Wilson 2011, 68–72 with fig. 8 on 69. I there suggested (74–5) that the semicircular entrance portico might have been inspired by the (probably) imperially owned villa at Cercadilla; the latter is also extraordinary in having all its different elements on different alignments. On this aspect of Piazza Armerina, Wilson 1983a, 37–8, with note 38 on 103. For the architectural contextualization of these late Roman Sicilian villas, see *inter alia* Sposito 1995; Sfameni 2004; 2006, especially 29–73; Wilson 1983a, 73–85; 2011, 68–79.

108. Wickham 2005, 468.

13

VILLAS IN SOUTH AND SOUTHWESTERN GAUL

LOÏC BUFFAT

To the memory of Jean-Luc Fiches

Villas in the Roman provinces of southern Gaul have been the subject of significant study in the last twenty years, for many reasons. The areas in question – Gallia Narbonensis (Narbonnaise) and the several regions south and (at various times) north of the Garonne bordered by the Atlantic on the west, collectively termed Aquitania (Aquitaine) – correspond roughly to the modern French regions of Languedoc-Roussillon and Aquitaine, respectively. In both, numerous rescue excavations have been prompted by many large-scale infrastructure projects for economic development, and enlightened policies to safeguard historical sites and artifacts have resulted in the financing of large-scale and extensive archaeological work. In addition, field surveys have significantly contributed to the broad historical picture of rural life in the way of villas, farms, and agricultural production during the Roman and late antique periods.

To underscore the progress of recent research on villas in southern Gaul, the Languedoc region can be cited as an example: In the 1990s, only one significant villa, that at Loupian, was known as to its plan and organization. However, between 1995 and 2010, three more villas have come to light in excavations made before large infrastructure projects were underway (road and railroad projects, projects at urban edges). Over the whole region, it has also

become possible to draw up accurate detailed maps showing the geographical and chronological incidence and density of Roman villas. Excavations and field surveys in tandem have and are providing good insight into Gallo-Roman rural space throughout southern Gaul.

GALLIA NARBONENSIS (NARBONNAISE)

Early Villas of Roman Type

In the area later defined as the province of Gallia Narbonensis, few villas appear to have been built earlier than the reign of Augustus in the late first century BCE, even though the Roman presence in the *provincia*, as it came to be known, had been established as early as the second century BCE to guard the passage of military materiel and commercial transports to and from the Roman provinces of the Iberian peninsula. Only two are known, both near important Roman coastal urban centers at Forum Iulii (mod. Fréjus) on the east and Narbo Martius (mod. Narbonne, the administrative capital) to the west (Map 7).

About 7 km from Roman Fréjus, at a site called Capitou, a small establishment of the first century

220

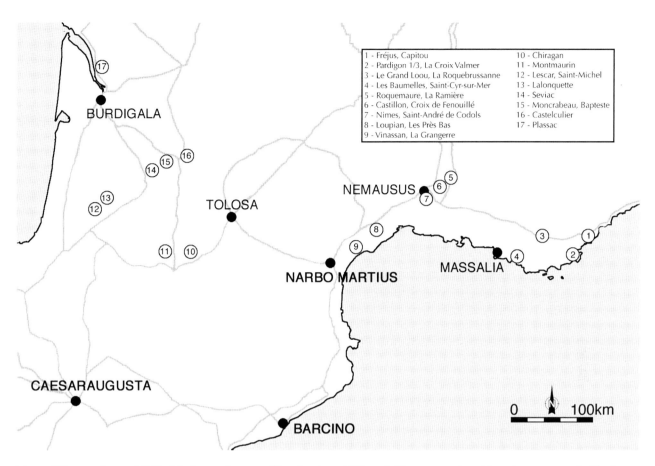

Map 7. The province of Gallia Narbonensis, part of Aquitania and Hispania Tarraconensis, with major towns and villa sites mentioned in the text (M. D. Öz).

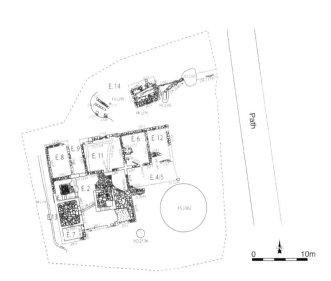

Figure 13.1. Fréjus, plan of the Capitou site (after Gaillard and Pasqualini 2010).

BCE has recently been excavated (Figure 13.1). Its excavators have termed it a farm, but more properly it should be termed a small villa, comprising a modest residence as well as areas for agricultural and industrial production. The building was about 500 m^2 and had an orthogonal plan with a small courtyard comprising a water basin in the center. Seven rooms surrounded the court, one of which had a mosaic floor with a geometric pattern. Adjacent to this building on its north side were two contemporaneous tile furnaces, so the combination of a residential area and productive facilities designates the site as a villa, no matter how modest its size.[1]

A similar but larger establishment has been found at the site of La Grangette at Vinassan, near Narbonne.[2] The villa is datable to the first half of the first century BCE; it replaced an earlier dwelling

in wood and other perishable materials dating to the end of the second century BCE. The new villa was built on an orthogonal plan with well-mortared walls. The habitable area was at least 1,500 m² and had a square U-shaped configuration surrounding a peristyle with porticoes on all four sides. In the middle of the peristyle was an impressively large pool with masonry walls, measuring 7.25x10.75 m. While the site is in poor condition and has not retained mosaic or other hard floor surfaces, the central peristyle, the pool, and the general aspect of the plan securely identify it as a villa on the model of those in central Italy, but one here translated to Gallia Narbonensis.

These sites (Fréjus, Vinassan) are exceptions; no others of such early date, but post-dating Roman presence in the area, have been found. Most rural dwellings contemporaneous to them in the first century BCE were built of perishable materials in the local native tradition, as archaeological work in the last few years has shown. South of Nemausus (mod. Nîmes), rescue excavations have revealed first-century BCE rural houses built of light materials ringed by defensive ditches. Elsewhere, at the site near Nîmes called Magaille Est, wide dry moats girdled an agglomeration of dwellings defined only by post-holes for wood uprights and shallow ditches, datable to the mid-second to the mid-first centuries BCE. A similar agglomeration of dwellings has been found at Gouffre des Bouchers, also in the environs of Nîmes.[3]

Villas in the Late First and into the Second Centuries CE

Villas developed in earnest surprisingly late in this region, both in quantity and in genuinely Roman or Italian architectural and agricultural character, with clear differentiation among residential (*partes urbanae* or *dominicae*) and agricultural sectors (*partes rusticae, fructuariae*) in their plans. In general, the expansion of villas in Gallia Narbonensis occurred in the last third of the first century, especially during the reign of the Flavian emperors (c. 69–96 CE). It is not yet clear why the province – otherwise rich in well-established municipalities with full legal rights as Roman colonies and urban elites enjoying full Roman citizenship – should have been so slow to create a villa-based landscape.

In addition, when villas appear with some frequency in the area, they are by no means uniform: Their varied character is conspicuous and they exhibit a clear social hierarchy in their plans, decorative finishes, and purposes. In the top tier are three *villae maritimae* with impressive plans and sumptuous decoration set on dramatic or lovely coastal sites; that at Baumelles at St-Cyr-sur-Mer (Var) was the most important, but there were others at Martigues (Bouches-du-Rhône) and La Croix Valmer (Var).

The villa at Baumelles near St-Cyr-sur-Mer was a palatial villa closely modeled on the maritime villas of the members of the senatorial, equestrian, and high financial circles of central Italy (Figure 13.2).[4] The site was excavated beginning in the eighteenth century and several times since then, but the recent synthesis by J.-P. Brun indicates that the villa was built in the last quarter of the first century CE over an earlier dwelling. The villa's site bordered a freshwater stream (the Madrague) and afforded optimal views of the sea. It also had private quays along the coast, an essential component of such villas both for access by owners and visitors and for shipping agricultural produce from the estate.[5]

The villa was impressive in its size: Its residential quarters (*pars urbana*) were about 1.4 ha in habitable surface, fully comparable to maritime villas in the Bay of Naples. The plan was centered on three courtyards, of which two were equipped with decorative pools; at least six wings of residential rooms, some with mosaic floors, surrounded these courtyards, and no less than two wings incorporated bath buildings. The villa faced the sea screened by a portico of 18 piers, 85 m long.

The Baumelles villa – magnificent by any standard – did not have real equivalents elsewhere in Gallia Narbonensis as to complexity of plan and finesse of decorative finish; there were others, but their state of preservation and our knowledge of them does not compare to Baumelles. A maritime villa called Laurons on the cove of Seneyme at Martigues (Bouches-du-Rhône) was certainly both smaller and less impressively decorated.[6] The same

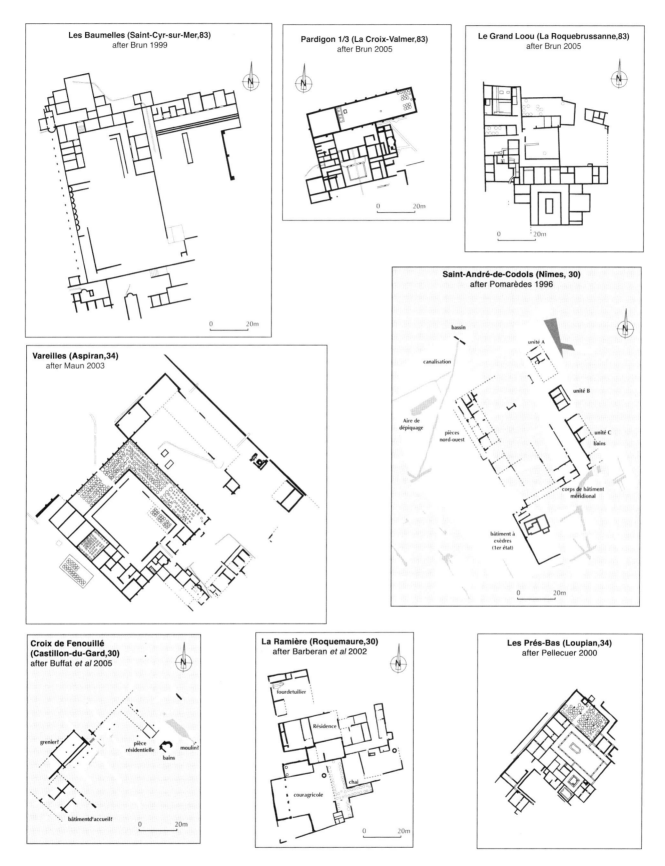

Figure 13.2. Plans of villas of the first and early second centuries in Gallia Narbonensis. (L. Buffat).

was true at the villa called Pardigon 2 at La Croix Valmer (Var) (Figure 13.2).[7]

For the most part, inland villas of the first century CE in the region are smaller than the maritime villas, usually between 2,500 and 5,000 m². Such villas, despite their small size, were sometimes carefully and fully decorated.

The Prés-Bas or Loupian Villa

At the site called Prés-Bas at Loupian (Hérault), a well-built villa exhibited a perfectly regular plan, organized according to the most up-to-date rules of rural architecture recommended by Columella (Figure 13.2).[8] Columella's prescriptions for rural estates were obeyed in all instances: On the southwest side of the complex, there was a *pars rustica* for the agricultural activity, and a *pars fructuaria* for storage of produce on the northeast. At the center, there was an impressive *pars urbana*, the residential heart of the villa.

Beginning as a rather modest farm earlier in the first century CE, the Prés-Bas site only became recognizable as a villa toward the end of the first or the early second centuries CE, known as phase II (Figure 13.2). In this larger manifestation, the villa followed the general organization of the earlier dwelling: three courtyards articulated its three distinct parts:

1. On the southwest, the *pars rustica* had incorporated rooms intended to house the estate personnel as well as store-rooms.
2. On the northeast, the *pars fructuaria* for storage had an impressive wine-cellar of half-buried *dolia* (*dolia defossa*), as its main constituent: There were about ninety of these *dolia* representing a total capacity in wine of c. 1,500 hectoliters. The investment and the space indicate that vineyards and wine-making were at the forefront of the estate's agricultural economy. In addition, the *dolia* at the Prés-Bas site were probably made in a workshop producing amphorae for shipping wine and other liquid and dry produce that was about 1 km south of the villa, next to the shore of the *étang de Thau* (an extensive marshy wet-land extending inland from the sea), so industrial as well as agricultural production may

well have been part of the local economy and even of the villa itself.[9]

3. The residential center of the Prés-Bas villa was deployed around a peristyle with a pool. The dwelling had formal reception rooms, and *cubicula* occupied the north wing and the north part of the west wing. The floors were simple *opus signinum* surfaces decorated with *tesserae* in simple geometric shapes (lozenges, squares, and hexagons). The use of the spaces appears to have been calculated for the seasons: On the north side of the peristyle, the rooms correspond to use in the hot summer months (*pars urbana estiva*), on the west to use in the winter (*pars urbana hiberna*, to catch the warming rays of the morning sun).[10] Baths were built to the south of the residence. Apart from hot and tepid rooms (*caldarium* and *tepidarium*), there were two high-quality amenities: a swimming pool with radiantly heated sides and a plunge-bath in the cold room (*frigidarium*) with a handsome stone border surrounded by a tessellated white mosaic floor set with larger pieces of colored marble (*crustae*) in the technique called *scutulatum pavimentum* widely used in Italy.

The Pardigon 1/3 Villa at La Croix Valmer

The villa of Pardigon 1/3 at La Croix Valmer (Var) is another example of a medium-sized villa, but with this difference: Unlike the early phase at the Prés-Bas villa, it did not replace an existing farm but was built as new sometime between c. 70–100 CE on a previously uninhabited site (Figure 13.2).[11] Its entire area was about 2,500 m². The façade had an entrance portico supported on piers leading to a small peristyle on the south side; the residential and reception rooms were set on three sides of the peristyle. No special floor or wall treatments appear to have enhanced them.

On the north side of the complex, a small courtyard had structures for agricultural activities, including a long room with buttressed walls enclosing a wine-producing unit: a mill, pressing surface, vats, and *dolia*. There was a bath building on the east side with the usual sequence of rooms from cold through tepid to

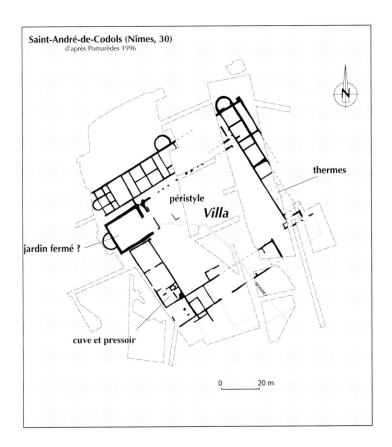

Figure 13.3. Plans of late-antique villas in Gallia Narbonensis. (L. Buffat).

hot: *frigidarium, tepidarium, caldarium.* The villa had a brief life of little more than a century; by the mid-third century, it had ceased operation.

The Villa at La Ramière Near Roquemaure

The site called La Ramière near Roquemaure (Gard) to the west of the Rhône river north of Arelate (modern Arles) offers an example of how, in successive constructions over three centuries beginning in Augustan times (last third of the first century BCE) through Flavian times (last third of the first century CE) and into the third century, a medium-sized villa in Gallia Narbonensis developed (Figure 13.2).[12] This villa was near that of the larger villa at Prés-Bas near Loupian, and to a certain extent its fortunes – both flourishing and dwindling – may have been dependent on its always-larger neighbor. Some construction – not really a dwelling but rather a building to secure farm equipment and provide temporary shelter for field workers – had been built in Augustan times, indicating that some agricultural activity had already been established. This building was razed in the second quarter of the first century CE to make way for a small farm with a dwelling on the west side and perhaps a workshop or agricultural area on the east. The dwelling was a simple affair on ordinary lines, centered on a small courtyard. The simplicity of the building is underscored by the construction of interior partition walls in mudbrick or adobe, though better-quality mortared walls were used in a few rooms on the west side.

In the second half of the first century, the La Ramière villa greatly expanded to the north of the original site. A flattening and terracing of the site afforded a space of some 5,000 m² for the new

building (Figure 13.3), and by the end of the century, the villa had been built on a well thought-out plan around several courtyards and with a clear separation of residential and agricultural areas. The *pars rustica* was on the south and incorporated two interconnecting wine cellars containing *dolia*. The *pars urbana* was in the center of the building, focused on a small court-yard or peristyle, though the absence or destruction of the floors and changes in plan and decoration have limited the interpretation of the rooms themselves. On the north side of the site, an L-shaped building was occupied by a tile furnace, so making wine and building materials seem to have been the productive activities of the villa. Finally, between the end of the second and the mid-third century, the villa was once again enlarged and modified, though the original plan was unchanged. An extension of the residential part northward engulfed the tile furnace building, and the new building had a distinctly representational plan, with a portico on its south façade and, in a later transformation, an apse attached to its north gable wall. The La Ramière villa was never either very large or very grand, but its changes and enlarge-ments mark differentiations as to agricultural produce (wine) and industry (tile-making) as well as increasing comfort (more residential rooms) and, ultimately, the nearly obligatory late antique apsed room conferring social dignity on its proprietor beyond mere owner-ship. As such, it may well represent similar develop-ments in other Roman villas of Gallia Narbonensis.

Villas of the Narbonnaise in Their Landscape Settings

Villas are set in natural environments which they change into productive landscapes, so their assembled geological, hydrological, and geographic settings give another perspective on villas and farms in their physical contexts. Field surveys in the region around Nemausus (mod. Nîmes) have been particu-larly abundant and precise, and they have differen-tiated, on the basis of various criteria, among agricultural estates with fully residential amenities (*villae*) and simple farms.

The valley of the Tave River has been inten-sely surveyed by H. Petitot for some 15 years, and the results of his surveys have been precise and extensive, though as yet unpublished (Map 8). Even granting that not all sites have been recorded, his surveys give a wide picture of rural life in the area. For the first and early second centuries CE, about twenty-five villas have been surveyed in the region, and about fifty farms: The proportion of developed residential and agricultural estates to simple farms is thus *one* villa to every *two* farms. The same proportion of villas to farms (1:2) has been documented in areas nearer to Nemausus itself, and in the Uzège region (Gard), around the Pont du Gard, the same distribution of villas to farms has been recorded as well as in nearby areas such as the plateaux of the Var.[13]

Still, there are significant local variations. In the mid-and-upper valley of the Gardon River, field surveys undertaken by P.-Y. Genty have resulted in quite a different picture. There, villas were much rarer, and by contrast there were many more farms, in a ratio of about *one* villa to *six* farms (Map 9). The statistical difference among regions is very sig-nificant, but it may be difficult to interpret. The incidence of farms can be very dense, as in the case of the area around Brignon, but the isolation of the area may have been the reason for this variation. The area was difficult to access and may well have been under-resourced for transport infrastructures. Villas set up on a cash basis for products need better and quicker means of communication and transport access to promote and move their relatively larger amounts and variety of commodities to markets, both in the way of agricultural goods and industrial products (e.g., tiles), so their incidence vis-à-vis farms may be dictated by proximity to geographical means of transportation – roads and rivers. The field survey evidence thus gives a picture of the Roman landscape of several different areas of Gallia Narbonensis: Villas aggregated in complement to, and possibly in competition with, twice as many farms near transport infrastructures, but farms domi-nated where the geological infrastructure was less developed.

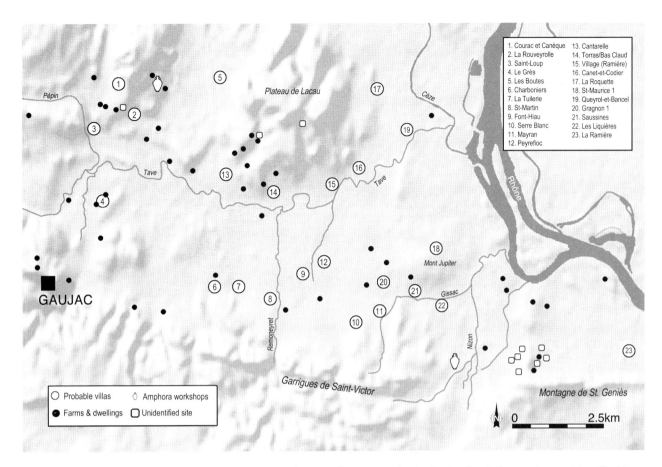

Map 8. Location of villas and farms in the first and early second centuries CE in the Gardon River region, as identified in field surveys (L. Buffat from surveys by P.-Y. Genty).

Villas of the Narbonnaise in Late Antiquity

Between the later second and the end of the third century, villas diminished in number in the province by about a third.[14] A similar falling-off by abandonment of villa sites in areas where they had been abundant heretofore has been observed in virtually all regions, with the notable exception of the villas set in the remote (and under-resourced in transport infrastructure) mid-and-upper valley of the Gardon river: As we have seen, there had been fewer of them relative to the incidence of villas elsewhere in the region and fewer of them relative to farms. It may be that the remoteness of the region itself ensured the persistence of its villas into late antiquity in some way.[15] In general, however, even with this falling-off of continuous habitation (and presumably some

loss of viability), villas remained an important organizing presence in the productive landscape of the Narbonnaise well beyond the late third century. Abandonment of some villas may also indicate that other estates were being enlarged and their activities concentrated in fewer venues.

Recent excavations have shown that late antique villas had quite particular developments. In its late antique manifestation, the villa at Saint-André-de-Codols near Nîmes was enlarged to nearly a hectare in size and came to have a monumental architectural character as well (Figure 13.3).[16] The transformations occurred piecemeal in the course of the third century, but it is clear that there was a masterplan intended to give the complex a majestic character with impressive façades marked by large apses. The façades must have risen two or more stories in view of their massive wall foundations, and while the

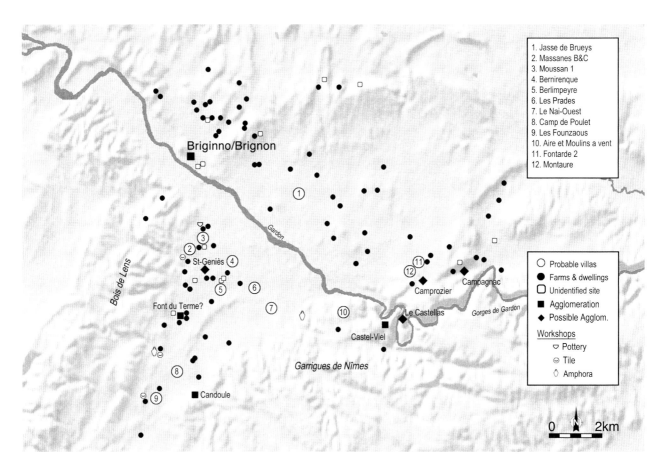

Map 9. Location of villas and farms of the first and early second centuries CE in the valley of the Tave River, as identified in field surveys (L. Buffat from surveys by H. Petitot).

embellishments of the villa (in marble veneers, mosaic, and colonnades in stone or marble) have disappeared due to later depredations, they cannot have been insignificant.

The new villa was organized on a simple scheme: Four wings surrounding a vast central courtyard. In the north wing, certain rooms were set in an interconnecting grid of regular divisions, which strongly suggests that they were storage rooms with a suite of grand rooms at an upper level, much like the contemporaneous villas of São Cucufate in Lusitania or San Giovanni di Ruoti in Apulia.[17] A large peristyle occupied the area south of the north wing, and on its west side there was a very large apsed room, which may have been an audience or reception room or, in view of its width, perhaps an enclosed garden.

The west wing harbored agricultural activities. Wine production included a basin and two masonry bases that supported presses. Because no *dolia* were found, the wine cellarage must have been in casks in the adjacent storage rooms. The east wing and the baths remained in use and were largely unchanged from their initial construction in the first century some 200 years before. One hundred meters west of the villa, there was a third-century cemetery with twenty-four inhumation burials.

The villa at the Prés-Bas site near Loupian – which we have already seen in its third-century manifestations – was also redesigned with a monumental character (Figure 13.3). It was largely rebuilt toward the end of the fourth or the first years of the fifth century, transforming it into an almost palatial rural dwelling, the most luxurious villa

known in the Languedoc-Roussillon region.[18] The new plan emphasized rooms with apsidal extensions that had come into fashion in the third century (as we have seen at Saint-André-de-Codols) and which became almost obligatory in the villas of the great landowners (*possessores*) throughout the Roman world in late antiquity. Almost the entire *pars urbana* of the third century was replaced with a formal reception hall in triconch form (an apse on the axis of the room with two others facing one another on the cross-axis, called a *trifolium*) and another squarish reception hall (*oecus*) beside it. These two rooms and many others were paved in multicolored geometric, floral, and figural mosaic floors – some 600 m² of them – in styles that were inflected by workshops from Aquitania further west, others deriving from eastern Roman visual modes, mainly from Syria. Marble in the way of column bases and borders was used throughout the residential rooms. The peristyle was considerably enlarged in this late phase of the villa's life, but its extension and other details remain to be studied. The new monumental grandeur of the Prés-Bas villa did not interrupt its agricultural character: Its wine production continued.[19]

The contrast between the monumental architecture of villas like those of Saint-André-de-Codols and Prés-Bas near Loupian with others in the same region and of the same date is historically significant. In the course of the fourth century CE, the La Ramière villa (see pp. 225–26) near the Prés-Bas villa at Loupian degraded considerably: several of its components collapsed and were buried by fills, and the plan lost its definition and structure (Figure 13.3). A small smithy replaced the residential *pars urbana* of the earlier villa, and in the fifth century, a new building at some distance to the north of the villa housed a pottery kiln for the production of coarse vessels; the kiln continued in use until the early sixth century.[20] These changes are not in the nature of any decline; rather, they may have been a change of use in consequence of the continuing and conspicuous flourishing of the other two nearby villas (Prés-Bas and Saint-André-de-Codols) and thus represent a redistribution of resources and reallocation of working spaces within a continuing landscape of successful agricultural and industrial exploitation in Gallia Narbonensis.

AQUITANIA (AQUITAINE)

Early Villas in the First and into the Third Century CE

The origins of Roman villas in Aquitania are not well known.[21] The limitation on our knowledge is due in part to the great number and very substantial late antique villas built in the region, many of which have masked or obliterated the earlier buildings.

The villa at Plassac (Gironde), very well linked to riverine transport both outward to the Atlantic and inland to the southeast at the estuary of the Gironde river, is a good example of the problem of origins. The first states of the villa's history cannot be securely discerned, and interpretations have differed both about the reconstructions of the early phases and even the later ones datable to the first century CE.[22]

The same problem of origins occurs at Montmaurin, where the details of the early villa have been questioned even though its outlines are secure: a large rectangular court surrounded mainly with agricultural and storage facilities with a dwelling on the west side.[23] The early phases of two other famous villas – those of Séviac and Chiragan – are also difficult to establish.

However, these cases may be clarified by the excavations of a villa of securely first-century CE date, that at Saint-Michel de Lescar (Pyrénées-Atlantiques): The excavations have revealed a very modestly embellished small villa of some 1,200 m² centered on a courtyard 18.5x35 m with residential quarters on three sides.[24] Similarly, recent excavations of a villa at Lamarque (Tarn-et-Garonne) give a good insight for the early villa, in this case datable to the early second century CE: It was about 1,800 m² with an impressively long colonnaded U-shaped façade of 66 m on the north side with two forward-breaking wings at its east and west ends, and with the west wing entirely devoted to a large bath building equipped with a swimming pool (*natatio*).[25]

Figure 13.4. Plans of villas in the first and second centuries in Aquitania (L. Buffat).

A clearer picture of the development of an Aquitanian villa over two or three centuries has been revealed in the recent work at a villa at Lalonquette (Pyrénées-Atlantiques), which has refined the results of earlier excavations of the 1970s (Figure 13.4; cf. the villa at Croix de Fenouillé in Figure 13.2).[26] The villa was built as a new construction in the early first century CE: It comprised a habitable area about 5,000 m² with two courtyards, a large principal one and a smaller secondary one. The plan was more of an aggregate of buildings rather than a defined sequence of coordinated spaces, and the construction and embellishment were lacking in solidity and sophistication, though the early villa already had a fairly impressive bath building.[27]

The Lalonquette villa was rebuilt in a much more ambitious way at the end of the second and early third centuries. It doubled in size, to 10,000 m². A new *pars rustica* with agricultural facilities and rooms was built on the south side of the villa around a new separate courtyard, and the main residential building was significantly enlarged around the original large courtyard.[28] Elegantly decorated and planned vestibules facilitated movement through the dwelling, and large halls with apsed ends were

built to give a monumental character to the whole villa.

The villa of Bapteste at Montcrabeau had an architectural history like that of the Lalonquette villa.[29] Its expansion was in stages, beginning in the middle of the first century CE with an early and very modest villa of some 1,500 m². The design was like that of the Lamarque villa that we have already discussed: a U-shaped plan with a long colonnaded façade framed by forward-breaking wings on either side, a type more frequently found in northern Gallic regions.[30] The villa then underwent small and sporadic enlargements: In a second phase (second century CE), the addition of a wine press was the main addition, and in a third phase (third century CE), the short sides of the villa's wings were lengthened to make more residential spaces. But it was only in the fourth century – that is to say, in late antiquity – that the Bapteste villa came to full expansion; it joined the numerous other villas of Aquitania to compete in architectural monumentality and luxurious embellishment.

There is thus an unknown, or poorly preserved, history of early villas in Aquitania, but what is certain is that, where they are known in their

first- and second-century manifestations, they were very modest affairs both architecturally and decoratively. As we shall see, the exceptions may have been the early phases of the villas at Chiragan and Plassac, but in general the early villas of Aquitania resemble the even more modest ones of the same date in Gallia Narbonensis. They also – and this is important – give few hints of the palatial villas of late antiquity.

Aquitanian Villas in Late Antiquity

Aquitania famously became a region of large, sumptuous villas in late antiquity, almost rivalling Hispania.[31] The archaeological and literary evidence give a very good picture of the architectural originality and decorative refinement demanded by the owners from their designers and decorators, and ongoing studies are adding to the very rich material about Aquitanian aristocratic dwellings catalogued and analyzed by Catherine Balmelle in 2001.[32] The great number and importance of Aquitanian villas in late antiquity can be summarized in four examples: the villa at Montmaurin, well known since its excavation in the 1970s and 80s, and three sites – the *villae* at Lalonquette, Moncrabeau, and Séviac – which have been further investigated since Balmelle's publication.

The villa at Montmaurin (Haute-Garonne) has become the exemplar of late antique villas in Aquitania because of its size and luxury; in addition, the formality and complexity of its plan marks it as a special case – though there are many others – of such residences (Figure 13.5).[33] The villa was entered through a very large and generously designed semicircular entrance courtyard (correctly characterized as a "cour d'honneur" for the ceremonious reception of guests).[34] A small hexagonal temple was contained within the porticoed arms of the courtyard, giving religious dignity to the approach to the villa.

The entrance courtyard set up the axis of the whole villa: It led directly to a vestibule giving access to the main dwelling, which was centered on a huge peristyle c. 1,000 m². This peristyle was surrounded by some twenty residential rooms (*cubicula*, formal reception rooms, smaller living

rooms, a *lararium*) as well as rooms in the form of *atria*.[35] Access to the baths was effected by a corridor on the west side of the peristyle; the baths covered an area of c. 500 m² and contained a swimming pool (*piscina*) and an impressive formal fountain (*nymphaeum*). On the northeast side of the peristyle, a suite of rooms suitable for use in the summer was centered on a secondary peristyle bordered by two gardens of semicircular shape on either side. The grand design of the Montmaurin villa – its strong axial direction along a stately rising topography, the generous size of its porticoes and rooms, the finesse of its architectural elements in marble and of its other embellishments – mark it as exceptional even within the corpus of grand Aquitanian villas.

At Lalonquette, the original villa of the early first century had been modified in successive stages in the second and third centuries, but in its late antique manifestation in the fourth century, it was considerably transformed toward a new monumentality and decorative luxury.[36] A big new courtyard of some 500 m² replaced the agricultural buildings on the south side of the site, and a new porticoed façade was built facing a view of the nearby river (Figure 13.5). Many rooms were equipped with floors supported on tile pillars and walls with jacket-tiles (*tubuli*) for radiant heating, and marble veneers replaced the earlier stucco wall treatments. In its latest phase at the beginning of the fifth century CE, the trend toward luxury continued with the laying of mosaic floors in several rooms.[37]

The villa of Bapteste at Montcrabeau – like that at Lalonquette built in the first century CE with successive modifications – was completely rebuilt at the end of the fourth century.[38] The earlier villa was replaced by a new one centered on a courtyard 35 m²; its initial size was some 5,000 m² (Figure 13.5, cf. Figure 13.4). In the fifth century, a small ceremonial peristyle was added on the east side. Some 1500 m² of mosaic floors were added to many of the rooms, confirming with decorative richness the already impressive new monumental architecture.

The Séviac villa was also designed around a central peristyle (Figure 13.5). As we have seen, the early plan of the villa is not well known, but the fourth-century

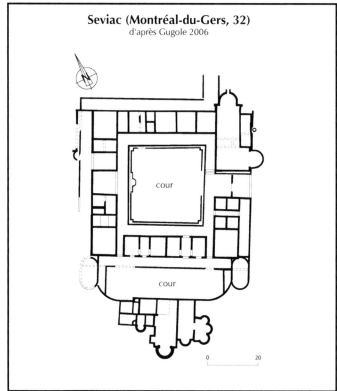

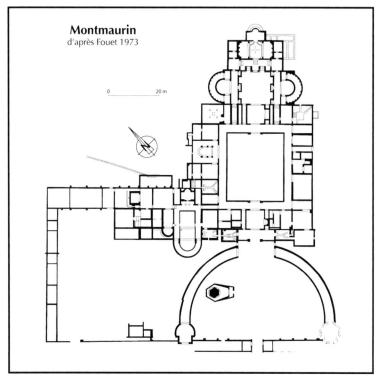

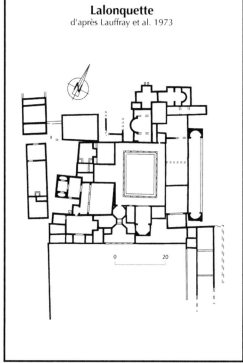

Figure 13.5. Plans of late-antique villas in Aquitania. (L. Buffat).

villa on the site covered at least a hectare. Four wings surrounded a central porticoed courtyard some 1,600 m²; several of the rooms appear to have had formal antechambers preceding them, and one had an apse suggesting that it was a formal audience room. To the south of the site, a second courtyard (narrower than the first but almost as long) gave access to a very large bathing complex, and some 700 m² of rich geometric and floral mosaic floors confirmed the decorative luxury of the late antique villa. The Montmaurin, Lalonquette, Moncrabeau, and Séviac villas are only a sample of the many other late antique villas of Aquitania, and their development in the fourth and fifth centuries attests the brilliant culture and superior viability of villa life in southern Gaul toward the end of full Roman domination of the region.[39]

CONCLUSION

This overview of Roman villas in southern Gaul reveals the variety of plan that the dwellings could take on as well as the diversity of their historical development. In Gallia Narbonensis, several different plans were used, though many included arrangements of functions (dwelling, agricultural activities, industrial installations) around several separate courtyards, and this was true in the first through the third centuries CE as well as in late antiquity (Figure 13.2). No typical villa plan specific to the region can be detected.

By contrast in Aquitania, the grandeur and originality of certain architectural parts and the dazzling decorative finish of many of the late antique villas obscure the fact that many of them were designed to a somewhat homogenous or standard plan: A square or slightly rectangular courtyard (between 500 and 1,200 m²) surrounded by four wings of residential rooms and a separate suite of baths (Figure 13.4). The social uses of these villas may have resulted in standardization of plan and conventions of space, but further study is required on this topic.[40]

The differences in the historical dynamic of the two regions – Gallia Narbonensis to the east, Aquitania to the west – can also be outlined. In Gallia Narbonensis, the first and second centuries

CE were the golden age of villas, for good economic reasons: wine production, which was a pillar – even *the* pillar – of agricultural wealth. Late antiquity saw many fewer villas built or remodeled.

The opposite was the case in Aquitania. The villas of the first and second centuries were not impressive, but by late antiquity, the sizes, architectural originality, and decoration of Aquitanian villas suddenly reached their apogee, outstripping by far those in Gallia Narbonensis (Figure 13.5). The precise reasons for this spectacular rise of rural dwellings on a nearly palatial scale is largely unknown and will provide a fascinating project of research for many years to come.

NOTES

1. Gaillard and Pasqualini 2010.
2. Le Roy et al. 2009, 57–8.
3. Pomarèdes and Breuil 2006.
4. Brun 1999, 639–46. For parallels, Lafon 2001, 295–300. See also Howe, Clarke, Wallace-Hadrill, and Zarmakoupi (Chapters 6, 4, 3, and 5, respectively) in this book.
5. Lafon 2001, 295–300; see Gualtieri (Chapter 10) in this book.
6. Leveau 2002, 77–80.
7. Brun 1999, 358–64. See Marzano (Chapter 8) in this book.
8. Pellecuer 2000.
9. The workshop produced amphorae of the type Gauloise 4, stamped at the lip MAF, possibly the initials of the owner's *tria nomina*; it may have produced the villa's *dolia* as well.
10. Pellecuer 2000.
11. Brun 1999.
12. Barberan et al. 2002.
13. Buffat 2012.
14. Pellecuer and Pomarèdes 2001.
15. Buffat 2012, 86–7.
16. Pomarèdes 1996, 125.
17. Pellecuer 1996a; for San Giovanni di Ruoti, Small, Buck et al. 1994, vol. 2. See Gualtieri and Teichner (Chapters 10 and 14, respectively) in this book.
18. Pellecuer 2000, 165–218.
19. Pellecuer and Pomarèdes 2001, 522.

20. Maufras and Fabre 1998, 210–21.

21. Aquitania is defined generally as south and east of the Garonne, though its administrative boundaries changed northward and its divisions were modified several times in the course of the empire.

22. Balmelle 2001, 101, on the early imperial remains; compare the history given in the official website for the villa [www.plassac.gironde.fr].

23. The Montmaurin villa was excavated and published by Georges Fouet 1969 (reprinted 1984), but see also Balmelle 2001.

24. Bats and Seigne 1972.

25. Jacques 2006, 82–84.

26. Lauffray et al. 1973, Réchin 2006.

27. Réchin 2006, 134, fig. 3.

28. Réchin 2006, 134, fig. 4.

29. Jacques 2006, 92–101.

30. Smith 1997, 117–43. See also Rothe (Chapter 2) in this book.

31. See Ripoll (Chapter 22) in this book.

32. Balmelle 2001.

33. Fouet 1969 (1984).

34. On the entrance courtyard at Montmaurin, see Métraux (Chapter 21) in this book.

35. For an interpretation of the *atria* at Montmaurin, see Métraux (Chapter 21) in this book.

36. Réchin 2006, 134, fig. 5.

37. Réchin 2006, 134, fig. 5.

38. Jacques 2006, 92–101.

39. For sculpture in Aquitanian villas, Stirling 1994 and 2005; for sculpture from the Chiragan villa, Balty and Cazes 2005 and 2008 and Balty, Cazes, and Rosso 2012. See also Métraux (Chapter 21) in this book.

40. Catherine Balmelle has noted that the widespread use of mosaic – often quite original and of both local and eastern or North African derivation – seems to have been an obligatory part of late-antique villa decoration in Aquitania and may reflect a certain homogenization of behavior among its elites: Balmelle 2001.

14

ROMAN VILLAS IN THE IBERIAN PENINSULA (SECOND CENTURY BCE–THIRD CENTURY CE)[1]

FELIX TEICHNER

The Iberian Peninsula was Rome's earliest overseas possession and as such provides an early instance of how Roman provincial culture in its material and architectural manifestations developed.[2] The implantation and spread of villas – which began only in the imperial period but flourished in late antiquity – are important aspects of this development.

The conquest of the peninsula began with the campaigns of Publius and Gnaeus Cornelius Scipio in 218 BCE but was only completed administratively when the emperor Augustus reorganized its provinces after the conclusion of his military campaigns in 16 BCE. The original division into Nearer and Further Spain – *Hispania Citerior* and *Ulterior* – had been dictated by strategic and geopolitical considerations, but Augustus replaced it with a civilian organization based on actual geographical conditions and the ethnic groups of the region (Map 10). In the west, the province of Lusitania was named after the tribe that inhabited that territory, stretching from the Atlantic coast to the river Anas (Guadiana); this province roughly corresponded to modern Portugal and parts of the Spanish regions of Galicia and Extremadura. In the south, the province of Baetica was organized around the fertile valley of the river Baetis (Guadalquivir), more or less the Spanish region of Andalusia. The entire north, between the Pyrenees, Atlantic, and Mediterranean, and including most of the high plateau of the Meseta Central, formed the province of Tarraconensis, named after the provincial capital, Tarraco. Much later, under Diocletian (284–305 CE), the provinces of Callaecia in the northwest and Carthaginensis in the southeast were separated from it. From the fifth century, Roman Hispania was dominated by the early medieval barbarian kingdoms, and later the southeastern Byzantine province of Spania.

Columella, Pliny the Elder, and Strabo mention commodities such as metal ores and secondary agricultural products, fish sauces, wine, and oil as the major exports from Hispania.[3] In the regions around Carthago Nova (Cartagena) and Castulo (Prov. Jaen), as well as in the Sierra Morena in Andalusia and the mining districts on the edge of the Asturian-Cantabrian mountains, sites still consisted of traditional nucleated settlements; the marketing of ores and the production of fish sauces (the famous *garum hispanum*) were concentrated in the small fishing towns and urban centers along the coast.[4] The main centers of this coastal industry were situated on the Mediterranean in southern Baetica, on the Atlantic in Lusitania, and in the Straits of Gibraltar, in the important economic zone of the "Circle of the Strait."[5]

The agricultural goods for which Hispania was famous, wine and oil, were produced in Roman-style farms and villas, to be found more or less throughout the entire peninsula.[6] However, the enormous geographical variety of the Iberian

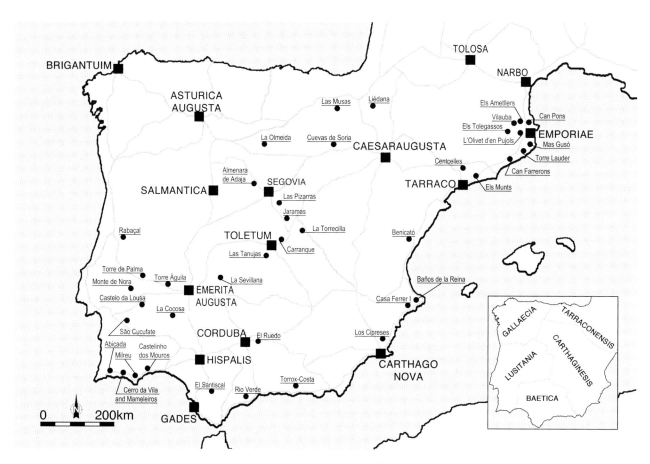

Map 10. Ancient towns and villa sites of the Iberian Peninsula (M. D. Öz, mainly after F. Teichner).

Peninsula and the slow pace of its conquest (over 200 years) made for great regional variations in the intensity of agricultural exploitation and economic development. In essence, the areas settled by the eponymous Iberians along the Mediterranean coast, which had been exposed to Punic, Phoenician, and Greek influence from an early stage, contrasted strongly with the homelands of the Celtiberians on the Atlantic coast and in the Meseta Central. Between them stretched the soaring peaks of the Sistema Iberico in the northeast and the Sierra Morena in the south.

In the Atlantic northwest, there is virtually no evidence in the archaeological record for the existence of a Mediterranean villa culture before the imperial period. In contrast, along the Mediterranean coast of modern Catalonia, in the territory of the Laietani as well as in the neighboring Ebro valley, agricultural specialization in the production of fine wines had

already started during the Republic. At the same time, wealthy Italian landowners began intensive oleoculture in the fertile Guadalquivir valley.[7] It was here, in the very south of Hispania, in the harbor town of Gades (Cadiz), that the family of Lucius Iunius Moderatus Columella lived, and his twelve-volume treatise on agricultural practice entitled *De Re Rustica* (written in the reign of Claudius [41–54 CE]) became an important handbook for Roman farming and the villa economy of the early Roman Empire.

HISTORY OF RESEARCH ON ROMAN VILLAS IN HISPANIA

During the eighteenth century, the Bourbon royal family had supported the excavations in Pompeii and Herculaneum and initiated that archaeological

patronage in Spain, specifically on Roman villas. Carlos III and his Foreign Minister (*Secretario del Despacho de Estado*), José Moñino y Redondo, Conde de Floridablanca, commissioned the director for architecture (*Director general de la Comisión de Arquitectura*) of the *Real Academia de San Fernando* to excavate the complex at Rielves (Toledo) outside Madrid.[8] Elsewhere, members of the clergy, in the spirit of the Enlightenment, drew attention to ancient ruins. D. Juan Lozano, a canonist from Cartagena, excavated the Villa de Los Cipreses (Jumilla, Murcia), with its numerous mosaics, between 1779 and 1787.[9] Similarly, on the coast of Andalusia, the local priest published a first report on the ruins of the Roman maritime villa at Torrox-Costa (Marbella) in 1773.[10]

By the early nineteenth century, Roman villas in Spain became a special class of monuments: In 1832, the *Sumario de las antigüedades que hay en España* by J.A. Ceán Bermúdez reported on them, and in the years that followed, ever more detailed reports on the architecture and decoration of villas in Spain were provided to the *Real Academia de la Historia*.[11]

Systematic exploration, advanced archaeological methods, and detailed documentation began in the twentieth century, in part because villas served as material proof that Spain and Portugal had been fully integrated into the classical world. Work was carried out at the villa of Fortunatus in Fraga (Huesca), with its remarkable mosaic floors; at the palatial villa at Centcelles (Tarragona), which had survived to its upper stories; and in the residential and agricultural buildings of the villas at La Cocosa (Badajoz), Liédena (Navarra), and Torre de Palma (Alentejo).[12] By 1944, Blas Taracena Aguirre published a first overview of the farmsteads and villas in Roman Hispania,[13] and within a few years studies on individual regions appeared, many of them by the leading figures in Spanish archaeology.[14]

The first large-scale contribution to the history and archaeology of villas of the Hispanic Roman provinces was made by Jean-Gérard Gorges in 1979 with his corpus of Roman country dwellings.[15] This work was a catalogue and analysis of some 1,300 sites in Spain and Portugal, and it met modern standards of scholarship in the field. Gorges' use of a comparative

methodology also established the basic forms and typology of buildings – this was a completely new vision – as well as their spatial distribution in the peninsula. The work was based on primary literature and field surveys; in consequence, the chronology and overall development of villas was less clear. Three years later, Maria Cruz Fernández Castro's general work on Roman villas in Spain focused only on the 149 most noteworthy sites with the best-preserved structural remains, a more traditional approaching facilitating a typological arrangement of the plans and analyses of the different architectural units and decorative elements.[16]

A recent upsurge in archaeological research, in part prompted by transformations of the rural infrastructure in Spain and Portugal, has led to an increase in the number of newly discovered sites. The excavation of the villa at Vilauba (Girona) by Spanish and English archaeologists from 1979 set high standards for research programs at other sites in the northeast of the peninsula (Catalonia and elsewhere).[17] Likewise, on the Atlantic coast of Iberia, the excavation of the São Cucufate (Vidigueira) villa, located between ancient Pax Iulia (Beja) and Ebora Liberalitas Iulia (Évora), by a combined Portuguese-French team from 1979 to 1984 demonstrated what could be achieved with the application of a precise research agenda and methods focusing on the architecture in stratigraphical context and analysis of the villa's hinterland.[18] This work has been followed by a comparative study of several rural settlements in the south of the Roman province of Lusitania based on a series of systematic excavations.[19] Specialized comprehensive studies of the production quarters of villas in Hispania – their *partes rusticae et frumentariae* – have shed new light on the economies of Roman villas,[20] even though the large estates of Baetica, which were empire-wide suppliers of olive oil, have not yet been adequately studied.[21]

In Hispania as elsewhere, the study of Roman villas must navigate between a concentration on historical events and/or artistic phenomena on the one hand, and independent, up-to-date archaeological analysis on the other. And in Hispania as elsewhere, a balance among the competing claims of

history, art history, and economic phenomena is particularly important for the history of residential rural estates. In this chapter, recent work on the buildings at a selection of sites, mainly in Lusitania, forms the basis for a review of the general tendencies in the development of Roman rural domestic architecture in the peninsula from its beginnings during the Republican period, through the imperial period when extensive villas with well-organized *partes urbanae* became a general phenomenon, to the third century CE when they became increasingly luxurious residences.[22]

The Early Rural Settlements: Subsistence Economy and Fortified Farmsteads

The campaigns of the Second Punic War (218–201 BCE) had been the first occasion that the Romans had to turn their attention to the local supply of their troops; shortly thereafter, during military actions in 197 BCE, the Roman governor Cato relied primarily on the existing indigenous economic and settlement structures. However, as urbanization of the new province progressed in the course of the second century BCE, individual farmsteads of Mediterranean/Italic type capable of producing more than merely subsistence or local-market comestibles began to appear in the territories of the newly established towns.

The best picture we have of rural settlement during the Roman conquest and consolidation phase in the Republic is for the northeast of the peninsula, the earliest contact zone between Romans and Iberians.[23] The first phase, immediately after the Roman conquest at the turn of the third and second centuries BCE, saw the establishment of simple farmsteads for single-family units that allowed for little more than subsistence agriculture. Structures from this earliest phase of Roman Hispania have been excavated in the hinterland of the Catalonian coast at Les Guardies, Les Teixoneres, Ca l'Estrada, and Can Pons.[24] The plan of the complex at Can Pons (Girona), in the mountains behind the Catalonian coast, allows the reconstruction of

a rectangular building with an area of 170 m². In the second century BCE there were seven irregularly arranged rooms in which the presence of hearths, stoves, and looms denote a division into living and working areas. The materials from the site indicate that an indigenous Iberian community lived here, away from the main communication and commercial routes. Its members only gradually came into contact with the Roman world, though by a late phase of the building distinctly Roman forms of roofing with characteristic roof tiles (*tegulae* and *imbrices*) and storage in terracotta vessels (*dolia*) were adopted.[25]

Not surprisingly, evidence of the end of this subsistence economy and the introduction of Roman-style agriculture, buildings, and architecture has been found less than 5 km into the hinterland of the coastal Greek colony of Ampurias. In 218 BCE, Ampurias had provided the first haven for the Roman army in the peninsula. At the turn of the second and first centuries BCE, a modest farmstead was established at L'Olivet d'en Pujols (Girona), but with substantial facilities for the fermentation of must into wine (Figure 14.1).[26] A small rectangular building was erected over older Iberian structures. From the outset, the building was roofed with typical Roman roof tiles and its plan was completed by a 300 m² walled courtyard. Must and

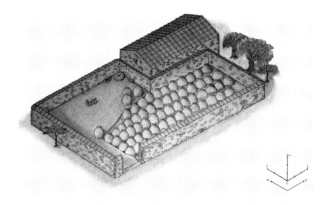

Figure 14.1. L'Olivet d'en Pujols (Gerona), villa, reconstruction during the Republican period, not far from the Graeco-Roman harbor town of Ampurias (Empories) (drawing by Zuzana Berková after Casas and Soler 2003).

wine were stored in seventy-five large terracotta storages vessels (*dolia*) sunken into the ground of the courtyard, a practice introduced by the Romans from Italy.[27] The extent of these storage and fermentation facilities at L'Olivet d'en Pujols is a clear indication of surplus production destined for the local urban market in Ampurias, and the importance of the region for this early Romanization of rural life is confirmed by a very similar picture at other sites.[28]

While such residential buildings with working areas were typical of the countryside of *Hispania Citerior* from the late Republican period, the southern and southwestern areas of the peninsula (*Hispania Ulterior*) were characterized by fortified farmsteads. These regions remained comparatively unstable almost until the beginning of the Principate in the late first century BCE, and they were plagued by troubles and rebellions (e.g., the revolts of Viriathus in 147–139 BCE and that of Sertorius in 83–72 BCE). For this reason, sturdy buildings were erected in strategic locations to provide protection for the new settlers and to secure and control transport routes and natural resources. These settlements are known from the hinterland of Carthago Nova (Cartagena) and along the coastal Cordillera of Baetica (Malaga), but the best research on them is in the region that later became the province of Lusitania.[29]

The sites of these Lusitanian settlements were chosen because they could be easily defended: protection of the new settlers was a primary concern. They tend to be located on promontories whence they dominated the surrounding landscape. Architecturally, the structures present a central building with a square plan, along with secondary structures that usually lie further down the slopes. The central buildings have very thick external walls, with only one door and very narrow window slits. Our knowledge of these settlements, which scholars frequently describe as *castela, casas fuertes* or fortified farmsteads, is drawn mainly from work carried out at Castelo da Lousa (Morão) in Lusitania.[30] This settlement was situated in the extensive plain of the Portuguese Alentejo, above the Rio Guadiana, and was dominated by a truly monumental central structure (Figure 14.2). The lower parts of the

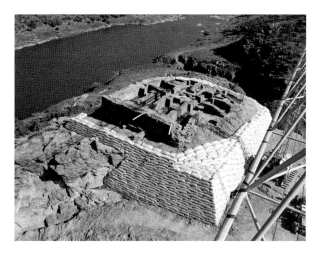

Figure 14.2. "Castelo da Lousa" (Alentejo, Portugal), villa, on the left bank of the River Guardiana, the ancient Anas. The central rectangular structure of the main building on the top of the natural slope during consolidation prior to the flooding of the Alqueva dam. (© Arkhaios - Ana Gonçalves, Évora 2008).

building consisted of unmortared walls of slate and flat stones. Thick layers of loam discovered inside suggest that the upper parts of the walls were made of mud-bricks, while stratigraphic observations indicate that slate was also used for the roof. Remains of a cistern in the middle of the building, a staircase, and window slits high up the walls suggest an upper story and an *atrium*-like colonnaded court with *impluvium* in the center. In the late 1970s, the Portuguese archaeologist Manuel Maia drew attention to a whole group of such buildings concentrated along the Guadiana River in the Baixo Alentejo region (Figure 14.3).[31] Besides the uniform, compact plan of the fortified farms, which could be several stories high, the buildings were constructed using a unit of measure based on the Roman foot (29.6 cm). At first, these fortified structures were believed to have played a part in the military defense of the area during the late Republic, but the fact that subsidiary residential and other buildings surrounded them suggests uses other than military. Analysis of the architectural origins of the buildings indicates the influence of prototypes from the Hellenistic east, such as the so-called Nekromanteion near Ephyra.[32] Their function was both to produce and protect the agricultural produce of the Roman colonists from roving

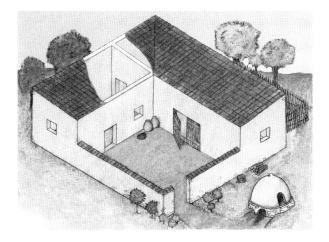

Figure 14.4. Monte da Nora (Portugal), reconstruction of the Roman farmstead constructed in the Augustan period over the leveled ditches of the Republican fortification. (© Felix Teichner/Zuzana Berková 2010).

Figure 14.3. Late-Republican and Early-Imperial protected farmsteads ("casas Fuertes"):

1.) Cerro da Vila, Quarteira, Algarve, Portugal;
2.) Castelo dos Namorados, Castro Verde, Portugal;
3.) Castelinho dos Mouros, Castro Verde, Portugal;
4.) Castelo do Manuel Galo, Mértola, Portugal;
5.) Los Paradores, Murcia, Spain; 6.) La Sevillana, Esparragosa de Lares, Spain; 7.) El Tesorillo, Málaga, Spain; 8.) Castelo da Chaminé, Castro Verde, Portugal; 9.) Castilinho dos Mouros, Alcoutim, Portugal; 10.) Castelo da Lousa, Morão, Portugal; 11.) Cabezo de la Atalaya, Cartagena, Spain; 12.) Cerro del Espino, Torredelcampo, Spain (after Teichner 2008, fig. 262 with modifications).

Lusitanian bandits mentioned in ancient written sources.[33]

The basic concept of these early farmsteads has similarities with the compact Italo-Roman style farmsteads of similar date found in Italy, for example the villa at Sambuco in Etruria or at Posta Crusta in Apulia.[34] It has also been possible to determine the identity of their inhabitants. At the Monte de Nora site (Alentejo), which was also fortified in the late Republican period, articles of attire such as brooches (*fibulae*) indicate the presence of new Italic colonists

from the Caput Adriae region (part of the northeastern Italian regions of Veneto and Friuli-Venezia Giulia, western Slovenia, and northwestern Croatia).[35]

The best-excavated sites, such as the fortified settlement at Castelo da Lousa (Morão) can be dated to the first century BCE on the secure evidence of Campanian wares, early Italic sigillata (terracotta tableware characterized by a glossy red surface), and amphorae for imported wine. The recent excavations at Castelinho dos Mouros further to the south (Figure 14.3: 9) suggest that the site may have been founded in the late second century BCE to secure the route that Lusitanian raiders used to gain access to the Baetis valley (Guadalquivir), the economic heart of the Republican province of *Hispania Ulterior*.[36] In the south of Hispania, fortified farmsteads continued to be occupied until the first century CE, even in some cases into the early second century. For example, the estate at El Tesorillo overlooking the Rio Gadalete near Málaga, only founded at the beginning of the first century CE, produced olive oil at least until the beginning of the following century (Figure 14.3: 7).[37]

Elsewhere, fortified central buildings of late Republican or early imperial date were transformed into residential villas. The villa at La Sevillana (Badajoz) has been thoroughly studied, and at Cerro da Vila near Quarteira (Algarve) the development of the settlement is particularly illuminating.[38]

During the early Empire, a fortified farmstead set deep into the slope of the Cerro da Vila controlled the approach to the excellent natural anchorage in the lagoon of the Riberia de Quarteira (Figure 14.3: 1). The rectangular central building was visible from far away on the open sea and was surrounded by smaller subsidiary buildings and a cistern typical of the early settlement phases. During the second and third centuries, the original farmstead grew into an extensive fishing settlement with at least one main building that can be styled as a villa (Figure 14.6: 2).

TOWARD A ROMAN MEDITERRANEAN LANDSCAPE OF VILLAS

When Augustus brought the conquest of the Iberian Peninsula to a close, the old Celtiberian territories in the northwest received a new administrative organization. The settlement of veterans and colonists on the land of the newly founded towns had consequences for the countryside. For example, in Portugal, in the area of the new town of Ebora Liberalitas Iulia, an existing late Iron Age/Republican fortification on Monte da Nora was systematically leveled and a new farmstead built. The building had numerous rooms arranged around a small working courtyard and was more spacious than the older fortified farmsteads (Figure 14.4).[39] The site was near the main road running from Olisipo (mod. Lisbon) to Emerita Augusta (mod. Mérida). Economic activities attested in the area until late antiquity included cattle breeding, grain cultivation, oil, and pottery production. In the first quarter of the first century CE, a farmstead with a similar layout was also established south of Emerita (Mérida), the capital of the province of Lusitania, in Las Rozas (Extremadura) on the Via de la Plata; this route was an old road leading to the Atlantic ports of the south coast.

Fishing was probably the occupation of the inhabitants of Mameleiros, another settlement built on the lagoon of Cerro da Vila, in the south of Lusitania. Habitation units consisted of long buildings with rectangular rooms arranged along a roofed corridor.[40] Increasing numbers of modest rural complexes of this kind dating to the early imperial period have been found in the neighboring province of Baetica, characterized by living and working quarters in the same architectural unit, either rectangular or square in plan, with various arrangements of the rooms. Similarly rectangular plans have been found at Las Cruces (Sevilla), Cortija Cecilio (Fiñana, Almería), and most probably in the earliest building at El Ruedo (Córdoba).[41] In these and other cases, advances in excavation techniques have revealed identification of these proto-villas beneath larger complexes of the early and high empire that had been the main body of evidence in the work of Jean-Gérard Gorges and Maria Carmen Fernández Castro: The *developmental* history of Hispanic villas can now be formulated.

The province of Tarraconensis, directly connected with the Mediterranean trade routes and markets, was Romanized much earlier than the northwestern portions of the peninsula. Regularly planned and extensive rural villas comparable to those in Italy were already in existence in the first century CE. Although only partially excavated, the complex plans of the villas at Els Ametllers (Girona), La Llosa (Tarragona), Els Tolegassos (Girona), and Torre Lauder (Barcelona) have attracted international attention. They display a clear distinction between the living quarters and the utilitarian sectors, in the *pars urbana, pars rustica* division typical of Italian villas.[42] The two sectors were arranged around rectangular internal courtyards – the hexastyle atrium at Torre Lauder is particularly impressive – and the buildings were generally surrounded by a wall. The increasing size of the villas reflects the growing prosperity of the estates and was accompanied by a gradual increase in the comforts provided in the residential parts, in particular the installation of mosaic floors and small bath suites (*balnea*). At the same time, a rise in the volume of agricultural production can be observed, as well as the rationalization and increasing specialization of the production quarters. For example, the estate in Els Tolegassos near Girona had over 100 sunken large storage vessels for wine production. They were larger than the *dolia* recovered at the nearby earlier site of Olivet d'en

Pujols, wine having become the main export of the Laietana region (roughly corresponding to modern Catalonia).[43] Such production is attested by the wine presses and storage areas provided with these vessels for the fermentation of must into wine that are regularly found at villa sites, as well as kilns for the production of wine amphorae, the usual transport container used for transmarine shipments.[44]

In the southwest of Hispania, a more complex division of villas into living and working quarters is attested only around the middle of the first century CE. The arrangement is very clear at Courelas de Antas (Vidigueira), Carrión (Mérida), São Cucufate (villa I), and Milreu (Algarve, phase B), where the separate parts are regularly divided into three wings (cf. Figure 14.5).[45] The two working units, which are identified as the production and storage quarters (*pars rustica* and *pars frumentaria*) in accordance with the layout described by Columella,[46] were connected by residential quarters (*pars urbana*) set between them. This arrangement produced

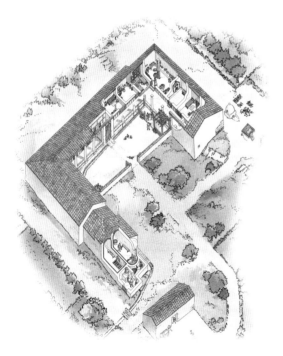

Figure 14.5. Vilauba (Girona), villa. The complex with three ranges ("*édifice à trois corps*") as constructed during the third century CE (after Castanyer and Tremoleda 2007).

a protected inner courtyard open on one side, used both for agricultural production and as a kitchen garden (*hortus*). The villa at Milreu (Algarve) included – in accordance with the recommendation of Cato in his agricultural manual – five oil and two wine presses.[47] The oil pressing and storage rooms were in the west wing overlooking a small river valley, while the winery, also provided with storage facilities for the produce, was built next to the vineyards to the east, in a compact, efficient plan. The residential quarters, on the other hand, were located facing the approach route to the south and were reached through a central vestibule. Inside this southern wing – integrated into the later peristyle villa (Figure 14.6: 1 and Figure 14.7, above left) – corridors and stairways led to less important rooms arranged in a row, some of which already had simple black and white mosaic floors.[48] The three-winged scheme – production areas and storage facilities radiating outward on either side of a central residence – came to be almost a norm in many Hispanic villas.

The structural and spatial concept of "three-building units" (*à trois corps*)[49] also proved to be viable: As late as the beginning of the third century, an existing villa at Vilauba (Girona) that had previously had a different plan was extended into a three-winged complex (Figure 14.5).[50] Similarly, the two distinct residential and agricultural *partes* of the Republican period at the Mas Gusó villa in the Girona district were joined by a connecting wing with a gatehouse in the late second century CE, thus forming a u-shaped, *carré*-like complex.[51]

MEDITERRANEAN ARCHITECTURE

The Peristyle Villa in Lusitania

Vespasian (reigned 69–79 CE) conferred Latin rights on all the inhabitants of Hispania and the grant of municipal rights on towns, acts that constituted the final step in the Romanization of the Iberian Peninsula.[52] The result was large numbers

of senators and knights from the Iberian provinces: The Aelii and the Ulpii, the families of the first non-Italian emperors Trajan and Hadrian (98–117 and 117–138 CE), both came from the Republican foundation of Italica (mod. Santiponce). Not surprisingly, Vespasian, his successors Titus and Domitian, and later emperors supported the monumentalization of public buildings in urban centers.[53] In the countryside, rural settlements in Hispania changed, with some stagnating or disappearing altogether, others modifying toward larger size and consolidation. Whole series of farmsteads were abandoned in the second half of the first century CE, leading to the merging of estates that previously had been cultivated separately.[54]

In Lusitania, the area surrounding the provincial capital at Mérida in the Guadiana valley saw merging of estates due to migration of some of the original colonists seeking opportunities in the expanding town.[55] The original distribution of land in the new territories at the beginning of the Principate had probably been very artificial and/or not or no longer viable: now, geographical and economic considerations as well as administrative changes strengthened and concentrated the more productive and successful estates. The process is well documented in the lagoon of the Riberia de Quarteira on the southern coast of the province: The early imperial fishing settlement at Marmeleiros led to a significant concentration of activity at nearby Cerro da Vila, where a prosperous port grew up on the site of one of the old scattered fortified farmsteads.[56]

The villa at Milreu (Faro), also in Lusitania, is a good example of this reorganization of structures for agricultural production and how many villas in the Iberian Peninsula developed between the first and second centuries CE.[57] In the early second century CE, the residential part, a typical early-first-century complex with three wings of the type described earlier (p. 242), was architecturally reconceived. The old open courtyard was modified by the construction of a fourth wing, thus creating a closed inner court. The individual rooms and suites of the living quarters could now be accessed from the colonnades of the peristyle that surrounded this

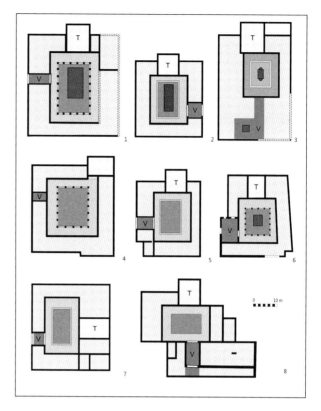

Figure 14.6. Some prominent peristyle villas in Lusitania: 1.) Milreu, Estói, Portugal; 2.) Cerro da Vila, Quarteira, Portugal; 3.) El Ruedo, Córdoba, Spain; 4.) Dehesa de la Cocosa, Badajoz, Spain; 5.) Monroy, Cáceres, Spain; 6.) Torre de Palma, Monforte, Portugal; 7.) Las Motas, Fuente de Cantos, Spain; 8.) São Cucufate, Vidigueira, Portugal (after Teichner 2008, fig. 264 with modifications).

court (Figure 14.6: 1), with the result that the villa became a formally planned, inward-looking residence with rooms articulated as to function by their location, proportions, and the differences among the mosaic floors in every room (Figure 14.7). The entrance area – the vestibule – was still located in the south, but at the western end of the peristyle garden a large dining room was installed (triclinium: Figures 14.6: 1; 14.8: A) and several living rooms and bedrooms (cubicula) were organized around the central garden area. Kitchen and service installations for the residence were arranged together in the eastern wing of the rectangular pars urbana.

With small differences, the majority of villas built in Lusitania at the beginning of the second century

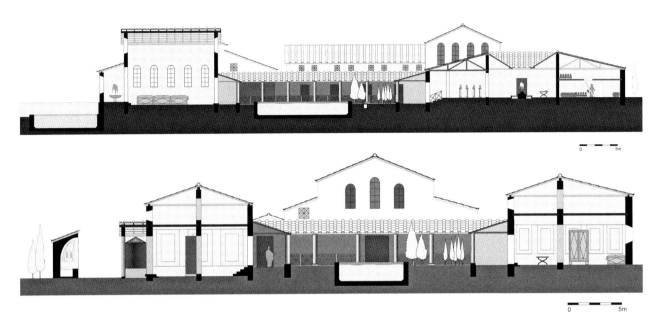

Figure 14.7. Milreu (Algarve), villa, sections.

Above: W-E section through the *pars urbana* of the Milreu villa. From left to right: *piscina* in the *balneum*, *triclinium*, peristyle with *piscina* and colonnade, private quarters with ancestors' gallery, atrium and kitchen (after Teichner 2008, figs. 59 and 60).

Below: N-S section through the *pars urbana* of the Mileu villa. From left to right: well, street, vestibule, peristyle with colonnade and pool (in the background the *triclinium*) and adjoining residential quarters.

CE adhere to the basic plan of the Milreu villa as it was remodeled: a peristyle in the center of a complex arranged symmetrically along a central axis (Figure 14.6). The rectangular peristyle, sometimes with a garden (*viridarium*) with its surrounding porticoes, usually contained a water basin, which, by reflecting the surrounding architecture, enhanced the decorative and visual effects of the villa as well as the reservoir for drinking water: Its large size (greater than the cistern of urban *domus*) was suited to the climatic conditions of rural southern Spain. Their capacity varied between 30 and 100 m³ and often were connected to sophisticated water-supply systems from nearby wells or natural springs: The traditional method of collecting water from inclined roofs surrounding the peristyle (*impluvium*) needed local adaptation. At some other sites, the adaptation of a secure water supply for the whole villa to garden design for the owners' pleasure was ingenious: Large reservoirs were placed outside and small decorative basins were installed in the inner garden.[58] Good examples of this are the round decorative basin in the *viridarium* found at Benicató (Nules, Valencia), or the four small circular structures subdividing the court of the villa at La Estación (Andalucia).[59]

As a rule, the long axis of the rectangular residential complexes included a vestibule that acted as the entrance to the living quarters, while the banqueting room (*triclinium*) had a prominent place in the center of one of the short wings (Figure 14.6). At São Cucufate, however, the dining room was placed in the long west wing of the peristyle court, an arrangement dictated by the architectural layout of the earlier complex (Figure 14.6: 8). The other three wings were occupied by smaller living rooms of uniform dimensions; bedrooms could be accessed directly from the peristyle porticoes. In fact, from the end of the second century rooms were generally arranged in groups of two or three to form independent accommodation units or suites. This hierarchical planning concept grew in popularity in late antiquity and normally consisted of an antechamber leading into one, or more rarely two, main rooms.[60]

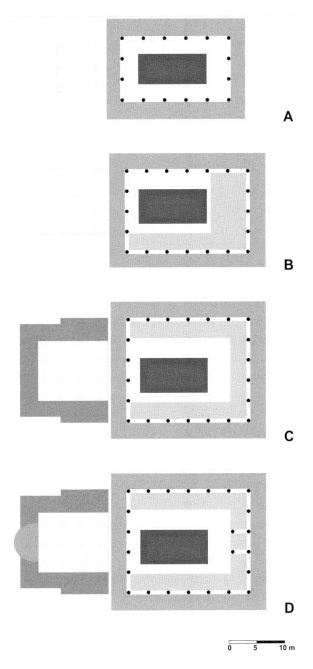

Figure 14.8. Milreu (Algarve), villa: development of the peristyle and *triclinium* from the second to the fifth centuries CE. The central court, with garden and pool (dark gray) was surrounded by a portico (gray). To the west was the *triclinium* (light gray), which at a later stage was extended with an ambulatory and an apse (after Teichner 2008, fig. 73).

The criteria for the division and proportions of these accommodation units varied to suit the individual needs of the inhabitants. For example, the antechamber and main room could be of similar shape and

size,[61] while at other sites the antechamber is smaller than the main room.[62] In some cases, one or more secondary rooms could be reached from the antechamber, further differentiating the functions of the rooms.[63]

In Lusitania, the architecture and dimensions of the residential quarters of Cerro de Vila and Milreu are remarkably similar to phase II of the villa at São Cucufate (Vidigueira) (Figure 14.6: 1, 2, 8).[64] The construction at Cerro de Vila dates as early as the late Flavian period, while Milreu was apparently built a little later in the Hadrianic period, and at São Cucufate the *pars urbana* is dated by the finds to about 130 CE. The main residential complex at Torre de Palma (Monforte), a large estate in the interior of Lusitania, is also arranged around a peristyle court (Figure 14.6: 6). The building is some 950 m² in size, but there is no agreement on its date of construction: the second half of the third/fourth century CE for some, the mid-second century according to others.[65] In contrast, period B of the complex at Dehesa de Doña Maria (Badajoz), which has an area of only 500 m², is clearly dated to the first half of the second century. Finally, the plans from the excavations at Monroy (Cáceres) suggest that there may have been an earlier structure of similar type with an area of at least 850 m² (Figure 14.6: 5), which was then radically modified by later additions and alterations – in particular the rooms with apses (discussed later). The same seems to apply to the newly excavated villas at Alberquilla (Badajoz) and Las Motas (Badajoz), where structures dating to the second and third centuries CE can be reconstructed with residential areas of at least 800 and 1100 m² (Figure 14.6: 7).[66] While these villas differ in date and geographical location, the similarities of their plans indicate that the peristyle combining centralizing and axial movement was a strong homogenizing design in Iberian architectural typology.

Jean-Gérard Gorges and Maria Carmen Fernández Castro already recognized that this architectural type, the so-called *villa bloc à peristyle à plan simple* (peristyle villa-unit with simple plan), found regularly in the first half of the second century CE, was the most common type of Roman villa in the Iberian peninsula.[67] Its prototype is

most certainly to be found in the axial peristyle townhouses of the western Mediterranean.[68] However, in contrast to the constraints of space imposed by the urban environment, the fact that plenty of space was available in the country to construct villas meant that the buildings could take advantage of the morphology of the landscape by means of artificial terraces, and that sight lines and structural axes could be expressively emphasized. Thus, the main façade, which generally faced the approach route, played a particularly important part, and this explains why the entrance hallway was often moved from the central axis (Figure 14.6: 3, 8) to one of the longer sides of the peristyle (Figure 14.6: 1–2, 4–7).

The Peristyle Villa in Tarraconensis

The direct predecessors of the peristyle villas in the western Iberian Peninsula are to be found in the Mediterranean coastal strip of Tarraconensis, which – as shown before – generally developed more rapidly and earlier. At El Moro villa near Tarragona, on the Catalonian coast, residential quarters with mosaic floors were built around a central court with porticoes (i.e., a typical peristyle) as early as the later first century CE.[69] Villas of this type were also being established at about this time in the hinterland of Carthago Nova (Cartagena). For example, in the second half of the first century CE, a peristyle villa with rich architectural decoration was constructed at Los Cipreses (Murcia) over older buildings dating back to the Republican period.[70] One of the largest wine producers in the hinterland of the ancient town of Saguntum built a residential complex with a peristyle toward the beginning of the second century.[71] At a villa devoted to the production of olive oil at Casa Ferrer I in the suburbs of ancient Lucentum near Alicante, the basic plan of the living quarters surrounding a peristyle was probably built in the first century CE.[72] In the hinterland of Tarraconensis there are also examples of villas with a similarly structured residential part dating after the middle of the first century CE, among them the

exceptional villa at Las Musas (Navarra), where a remarkable wine storage area was integrated into the central structure.[73]

Villas in Baetica

The province of Baetica in the south, which garnered its considerable wealth to the large-scale export of olive oil to the entire empire, was also populated with rural residences in the second century. The complex at El Ruedo (Córdoba) is one of the few systematically excavated Roman villas in the province and a paradigm of the settlement situation in the Baetis valley where most of the oil production in Hispania was situated.[74] In the second phase of the villa, a peristyle court and wings were added to the original building. Although the site was located very close to the provincial capital of Corduba (mod. Córdoba), this modification is clearly no earlier than the first half of the second century. The second example of villa architecture of the period in Baetica was constructed directly on the Mediterranean coast. The villa of Río Verde (Marbella), organized like all those described earlier around a peristyle, is dated on the basis of the mosaic floors in the porticoes. These mosaics, famous for their illustrations of a range of kitchen implements, date to the late first or early second century CE.[75]

Late-antique construction, particularly abundant throughout the peninsula, often obscures the earlier plans of peristyle villas: further stratigraphic analysis is needed.[76] Nevertheless, the state of research to date clearly suggests that the peristyle-villa type gradually spread from east to west. The oldest examples, such as the villas at El Moro and Río Verde described earlier, belong to the second half of the first century CE, while in the interior of Baetica and Lusitania this villa type generally appears only from the early second century CE.[77] Once established in most areas of Hispania by the mid-second century, the peristyle layout – a conscious symbol of Roman-Mediterranean lifestyle – continued to be popular for the *partes urbanae* of Hispanic villas until late antiquity.[78]

LUXURIOUS LIFE: THE SECOND AND THIRD CENTURIES

The military threats, political unrest, and economic crisis of the third century CE do not seem to have seriously affected the agriculture of Hispania: Wine and olive oil continued to be shipped throughout the empire.[79] As a result, the improvements in the comforts and luxuries of the residential quarters of rural villas begun in the second century continued – mosaic floors were added as well as wall paintings, and fine architecture and sculptural decoration supplemented the already sophisticated interiors. Recent excavations at the so-called villa of Maternus in Carranque (Toledo) have demonstrated that for the majority of the known late-antique residences a progressive, step-by-step evolution from an earlier peristyle villa can be posited.[80]

As in other parts of the empire, the owners of Hispanic villas paid particular attention to the creation of impressive banqueting rooms (*triclinia*). Because it was customary in antiquity to dine while reclining, the position of the individual couches (*clinae*) can often be reconstructed from the divisions in the polychrome mosaic floors. The plentiful supply of drinking water could be displayed to view inside the residence in pools and fountains, especially in regions where there was little rain. Dining rooms usually had a wide front opening onto the garden at the center of the peristyle, with its water basins providing a luxurious display.[81] In the villa of El Ruedo near Córdoba, terracotta and lead pipes beneath the 100 m² floor of the *triclinium* ran from the entrance to a basin in the middle of the room; the basin was surrounded by a semicircular dining couch (*stibadium*) in masonry.[82] In the villa at Milreu (Faro), two water basins lined with marble flanked the entrance to the dining room, and the center of another room had a stepped pyramidal-shaped fountain, over which the water pleasantly flowed.[83] At the villa of El Ruedo, mentioned earlier, as well as at Cerro de Vila (Quarteira), there were also fountains in wall-niches (*aediculae*) based on Campanian prototypes.[84] Most important, the construction of

bath quarters in villas, beginning in the early second century CE, brought a central element of urban Roman lifestyle to the Iberian countryside.[85]

The importance of villas as places of increasingly luxurious and complex social residence can be seen in their continual expansion and extension. During the third century, the decision was taken at Milreu to make room for the construction of a peristyle garden by moving the wine-making facilities in the east wing of the production quarters (Figure 14.8: B). At this time, a variety of innovations and additions to the dining room, living rooms, and the vestibule were made, which modified the traditional elements of the villa's architecture.[86] The dining room, already large at 112 m², was extended by adding a wide U-shaped corridor around it to make a new and more efficient space from which to serve the diners, and this modification allowed the main part of the room to be more densely furnished or else vacated for entertainment (Figure 14.8: C).[87]

Apses were often added to rooms (including dining rooms), as in a final stage at Milreu (Figure 14.8: D and Figure 14.9). At the villa at El Ruedo (Córdoba) in Baetica, in the late third century the addition of a semicircular apse to a room on one side of the original *triclinium* produced a *second* banqueting area. In other comparable villas, sumptuous floors in marble intarsia (*scutulatum pavimentum*) and polychrome mosaic were added to *triclinia*.[88]

In general, by the late third century CE, very formal reception rooms started to appear in villas in addition to the new, grand dining suites.[89] These rooms were elongated halls with an apse at one end, and they varied in size from 40 to 80 m²: examples are to be found at Milreu (Faro), La Olmeda (Palencia), Quintas das Longas (Elvas), La Malena (Zaragoza), Cuevas de Soria (Soria), and Carranque (Toledo).[90] The formality of the rooms did not preclude their comfort: underfloor heating was added to some of them in rich residences for double use as winter dining halls.[91]

The new architectural fashions in villas included the addition of architectural elements to existing buildings, in particular long galleries and impressive halls such as those at Milreu and São Cucufate.[92]

a rectangular peristyle court, even as the residential quarters expanded around it. The newly enlarged rooms were equipped with every single luxury that was available: mosaics, architectural ornaments, wall paintings, and sculptures. At Milreu in Lusitania, an impressive gallery was added for portrait busts of imperial personages as disparate as Agrippina Minor (15–59 CE) and the emperors Hadrian (reigned 117–38 CE) and Gallienus (reigned 253–68).[96]

SOME ALTERNATIVE DESIGNS AND LATE-ANTIQUE CONTINUITIES

Villas on the Iberian peninsula followed a predictable development in line with villas elsewhere: With Roman power fully established, peristyle villas with *partes rusticae* came to be the norm, and by the third century the new, almost universal formality in certain rooms (the addition of apses as backdrops, long corridors, and other impressive spaces) as well overt luxury (bath-buildings, mosaics, marble veneers) was followed by Hispanic owners. However, in the late third century, certain original architectural concepts began to appear.

In Lusitania, at Abicada (Mexilhoerira) on a high bank above an estuary on the south coast, a villa was built that was fundamentally different from the typical peristyle villa (Figure 14.10: 1). Its residential part incorporated two innovations in architectural concept.[97] First, the complex had a *linear* ground plan with units joined by a colonnaded façade ("*villa linéaire a galerie*").[98] Perhaps to keep leveling work to a minimum, the dwelling followed the contours of the hillside's natural terrace, with the various units arranged separately along a colonnade with an open view of the sea. As a result, the dining room and the internal court were no longer aligned together but each one formed the centerpiece of a separate building unit; on the west side was an impressive banqueting and guest block, while private living and sleeping quarters were arranged around the internal court, next to a kitchen and storage wing to the east. The design of three units brought together by a colonnade refers directly to the shore-

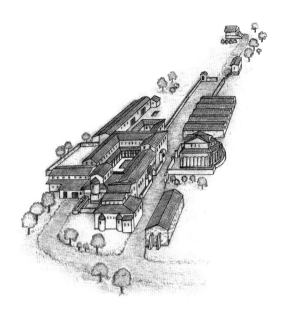

Figure 14.9. Milreu (Algarve), villa, view from the west in late antiquity. The *pars urbana* can be seen arranged around a peristyle, adjoined in the north by a winery and an oil press; to the west is a *balneum*. To the south of the street is a free-standing *horreum*, a late-antique *aula*, and various agricultural buildings and workshops. (© Felix Teichner/Zuzana Berková 2010).

These halls were generally situated in prominent positions and thus completely changed the effect of the buildings' existing layout and vistas. Open colonnades, some 80 m long, connected the main residential quarter with their baths at Tourega (Évora), Cerro da Vila (Quarteira), and Els Munts (Tarragona).[93] Elsewhere, broad corridors led to garden rooms separate from the main structure of the villa. These normally had a polygonal plan, as at Cerro da Vila (Quarteira), Ramalete (Navarra), La Madala (Zaragoza), and Rabaçal (Coimbra).[94] In some of the late-antique villas, impressive arrangements of corridors, some of them with apsidal niches along the sight lines, replaced traditional peristyles.[95]

As elsewhere in the Roman Empire, Hispanic villas of the third century exhibit a general tendency toward more elaborate living areas, often with large banqueting complexes, and grandiose self-representation. However, the basic concept remained that of a complex arranged around

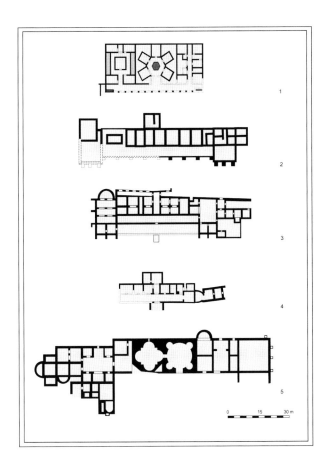

Figure 14.10. The linear structure of *villae maritimae* in Hispania. 1.) Abicada (Algarve), Portugal; 2.) Sant Amanç de Viladés (Barcelona), Spain; 3.) São Cucufate (Alentejo), Portugal; 4.) Benagalbón (Malaga), Spain; 5.) Centcelles (Tarragona), Spain (after Teichner 2008, fig. 313 with modifications; for no. 2 see: Martín and Alemany 1996/7).

side *villae maritimae* depicted in first-century CE wall paintings from Pompeii and elsewhere in the Bay of Naples.[99] Nor was the design confined to villas with a view of the sea: At São Cucufate (Vidigueira), at the beginning of the fourth century, the old peristyle villa of the second century was abandoned and replaced with a dwelling with a new linear plan (Figure 14.10: 3).[100] The central feature of the new villa was the long portico of the façade, behind which rose a two-story building with two corner projections detached from the main block and a wide water basin set in front of the residential unit. Similar fourth-century transformations of peristyle villas into linear complexes with portico façades have been observed elsewhere.[101]

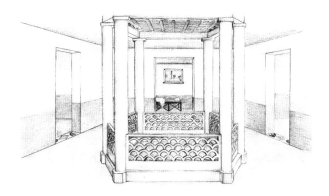

Figure 14.11. Abicada (Algarve), reconstruction view from the south of the hexagonal internal court (Zuzana Berková after Teichner 2008, fig. 260).

The second architectural innovation at the Abicada villa was its distinctive hexagonal peristyle surrounded by colonnaded porticoes some 2 m wide, with a hexagonal basin in the center bordered by a garden (Figure 14.11). The rooms surrounding this court were arranged so that their façades and openings faced only onto the central area with basin, thus conveying the impression that behind them was a dense closed complex of rooms, whereas the radial arrangement made for generous open spaces between the individual units. Hexagonal or polygonal peristyles or courtyards have been found elsewhere, and the architectural concept has been described as "central-plan villas."[102] The maritime villa on the Puerta Oscura in Malaga (later third century) may have had a hexagonal courtyard,[103] and the arrangement of living and dining rooms around a polygonal internal court dominated the designs of villas at Jaramas (Madrid), Can Farrerons (Barcelona), and Rabaçal (Coimbra).[104] At these sites, walls were specially constructed between the radially arranged elements to mask the spaces between them, so that the external aspect of the actual residential quarters paralleled the polygonal internal layout of the structure. This arrangement made the villas look larger and even more impressive than they were from both the outside and the inside, quite possibly an intended purpose. The most original plan was in the villa at

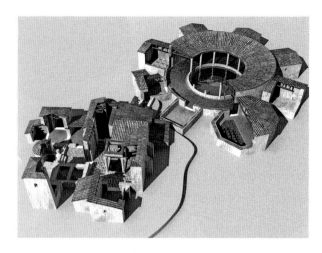

Figure 14.12. Baños de la Reina (Calpe, Alicante), villa, reconstruction view. The living quarters and a heated polygonal dining room are arranged around the circular court. The baths (left) were accessed via a corridor (after Abascal et al. 2007).

Baños de la Reina near Alicante, where the main rooms of the dwelling were arranged radially around a circular portico defining a round internal court: the old rectangular design of the peristyle villas was replaced with a truly original design (Figure 14.12).[105]

Such originalities were countered by continuities in Iberian villas in late antiquity: Among others, three large residences of the Theodosian period (379–95 CE) – those of La Torrecilla (Madrid), Las Tanujas (Toledo), and Las Pizarras (Segovia) – resolutely adhered to the concept of the axial and symmetrical villa disposed around a peristyle that had been established as the standard layout in the Iberian Peninsula as early as the beginning of the second century CE.[106]

CONCLUSION

While this overview of the Roman villas of Hispania Romana has been confined to their *partes urbanae*, the residential complexes indicate the growing influence of Romano-Mediterranean culture on the old Iberian and Celto-Iberian landscape from the Republic to late antiquity.

The absence of Roman villas in the northwest Atlantic coastal region of Celto-Iberia (Map 10) demonstrates the comparative reluctance of the

local cultures to accept this and other Mediterranean influences. Unsurprisingly, the first indications of Romano-Mediterranean organization of the rural community occurred in the northeast, around the bridgehead established at the end of the third century during the Second Punic War (Olivet d'en Pujols: Figure 14.1). It was here, in imperial Tarraconensis, that the first residential complexes with central courtyards were built (e.g., Torre Lauder), which in this early phase were of similar dimensions to the Roman *atrium* house.

In southern and western Hispania, other architectural models were at first employed, in particular protected farmsteads ("casas fuertes"/ "Wehrgehöfte": Figures 14.2; 14.3) and villas with three wings ("*édifice à trois corps*": e.g., Vilauba and Milreu: Figure 14.5), but soon villa complexes centered on extensive peristyles with colonnades or courtyards with gardens surrounded by the *pars urbana* became the norm (Figure 14.6). With a few exceptions involving experiments with linear and polygonal arrangements (Figures 14.10, 14.11 and 14.12), the Romano-Mediterranean type became dominant. Because the villas of the second century were arranged around a central element, there was enough space to develop villas that could become increasingly representational, even grandiose, rather than functional, a type that could take into account the higher standard of living of the owners and their increasing social importance (Figure 14.8). Furthermore, the increased luxury, size, and display in villas of the third century indicate that villa owners had come to regard such amenities as necessary to their status without, however, abandoning the tradition of the villa as a refuge from work and a place from which to contemplate nature. Even in southern Lusitania, where large formal halls (*aulae*) were added to certain villas (Milreu, São Cucufate, and Quinta Marin) in the fourth century, the additions were designed to look outward to refreshing views of well-watered gardens in peristyles or courts.[107] The simple enjoyment of nature – a perpetual theme in the culture of villas from Republican

times through late antiquity – found a profound embodiment in villas in the Iberian Peninsula.

The residential parts of Roman villas were only one element in the total picture: agricultural activities developed from the heterogeneous constructions of the pre-Roman rural-agrarian settlement sites to the structured, almost standardized villa system of the imperial Roman period with its distinct separation of different areas of activity (*pars rustica, frumentaria, pars urbana*). Hispanic villas were highly specialized to support a large-scale export-oriented surplus production to the empire. The result was an increasing separation of production spaces from residential spaces, as at sites like El Moré (Catalunya) and Marroquíes Bajos (Jaen): These are standalone wineries and oil mills without fine residences for which an administrator (*villicus*) was responsible, while the affluent owner (*dominus*), possibly of senatorial rank, resided in the neighboring towns.[108]

NOTES

1. The translation of this article is by Dr. David Wigg-Wolf (Roman Germanic Commission of the German Archaeological Institute in Frankfurt am Main). For all the work during the careful editing process, I have to thank G. P. R. Métraux and A. Marzano. The research was done as part of the Heisenberg fellowship program of the German Science Foundation (DFG). Final corrections were made as part of the PN-II-ID-PCE-2012–4-0490 program of the Rumanian Academy of Science (project "The Others in Action. The Barbarization of Rome and the Romanization of the World") and the "Villas romanas de la Bética" program of the Universidad Pablo de Olavide, Seville (Proyecto I+D+I HAR2011-25250; Agencia Obra Pública de la Junta de Andalucía G-GI3000/IDI1).

2. E.g. Alföldy 2002; Panzram 2002; Teichner 2008; 2014a.

3. E.g., Strabo 3.1.7; 3.2.7; 3.2.10; Columella, *Rust.* 3.2; Plin., *HN* 14.94; 15.8; 33.78.

4. Blázquez, Domergue, and Sillières 2002; Teichner 2014a.

5. Lagóstena Barrios 2001; Étienne and Mayet 2002. See also Teichner and Pons Pujol 2008; Teichner 2014a.

6. Indications of a Mediterranean villa economy are, however, relatively rare in the remote northwest. For a summary: Teichner 2008, 583 esp. notes 1153–6.

7. Teichner and Peña Cervantes 2012.

8. Arnal 1788.

9. Lozano Santa 1794, 34–6; see Noguera and Antolinos 2010.

10. An English traveler, Francis Carter, mentioned the Torrox-Costa villa in 1777 (Carter 1777 but see Posac 1972); the villa is now a museum open to the public: Rodríguez Oliva 1979.

11. For example Villaverde Bajo (Madrid): Rada y Delgado 1875, 451; Almenara de Adaja (Valladolid): *Bull. Real Academia Historica* 11, 1887, 451; El Santiscal (Arcos de la Frontera): Mancheño y Olivares 1901, 68–72, referred to in de Mora-Figueroa 1977; Santa Colomba de Somoza (Léon): Fita 1892.

12. Serra Rafols 1943; 1952; Domenech i Montaner 1931; Taracena Aguirre 1949; Heleno 1962.

13. Taracena Aguirre 1944.

14. For example, A. Balil (1954) for the east coast, A. Arribas Palau (1962) and M. Tarradell i Mateu (1968) for Catalonia, and P. de Palol i Salellas (1977) for the northern Meseta Central with the late-antique residences at La Olmeda and Pedros de la Veiga (Palencia).

15. Gorges 1979. There had been an important earlier study by J. Rodríguez Hernández (1975) that had not been much noticed. See on this subject Ripoll (Chapter 22) in this book.

16. Fernández Castro 1982 (based on a doctoral thesis submitted at the Complutense University of Madrid). However, the antiquarian approach employed in Fernández's and Gorges' works meant that rarely were they able to provide anything more than a superficial chronological comparison of the structural and settlement phases of individual sites. Although the plans of the villas were collected for the first time, no distinction is made among structures that span several centuries.

17. For Vilauba: Roure et al. 1988; Castanyer and Tremoleda 1999. Long-term research excavations that have received international attention were conducted at villas such as Adarró, El Moro, Els Munts,

Els Ametllers, Els Tolegassos, and La Pineda. Together with an inventory of archaeological monuments as yet unexcavated, this research offers an overall picture of the development of Roman villa culture outside Italy: Prevosti and Guitart 2010; Revilla 2004; 2010; Revilla, González, and Prevosti 2008–11. Cf. Tremoleda et al. 1995.

18. De Alarcão, Étienne, and Mayet 1990.

19. Teichner 2008.

20. Such production quarters comprise presses and storerooms for wine and oil, the *horrea* for grain, and the vats (*cetariae*) for the production of fish sauces and dyes. Documentation can be found in García-Entero 2005; Peña Cervantes 2010; Teichner and Peña Cervantes 2012. Specifically on architecture and economic basis: Teichner 2008. For the development of archaeological research on this subject see the different emphasis in Fernández Ochoa and Roldán 1991, 218 and Keay 2003. For the surprisingly fragmentary and unsystematic state of investigation on villas in Baetica: Fornell 1999. On the importance of olive oil production in the region: Remesal 2001; Teichner and Peña Cervantes 2012.

21. Recently on this subject and the structures of olive oil production (not only for the *annona* of Rome): Teichner and Peña Cervantes 2012. The University Pablo de Olavide (Sevilla) has prepared a corpus of all the Roman villa sites in modern Andalucía: Hidalgo 2017.

22. The surveys listed in the bibliography, together with regional archaeological inventories, some of which are available online, provide swift, unproblematic access to the relevant literature on more than 3,000 Roman farmsteads and villas. For developments in late antiquity and the early Medieval period, see G. Ripoll (Chapter 22) in this book.

23. See on this subject the results of the important project AGER TARRACONENSIS: Prevosti, López Vilar, and Guitart i Duran 2013.

24. Fortó, Martínez, and Muñoz 2008–11. For a summary: Revilla 2004; 2010, 49–51 fig. 6. Discerning: Olesti 1997.

25. Font 1994/5.

26. Casas i Genover 1988; Casas and Soler 2003.

27. While the excavators (see note 26) are convinced that the *dolia defossa* of L'Olivet d'en Pujols were used to store grain, all the available evidence from Italy proves that they were used for must fermentation into wine: Teichner and Peña Cervantes 2012.

The best examples of this Roman agricultural practice are found at Villa Regina (Boscoreale): De Caro 1994; Brun 2004, 17–20.

28. A complex of the same date in Mas Gusó (Girona): Casas and Soler 2004, 141–74 fig. 111 and 137; the villa at Tolegasos (Girona) had probably a comparable Republican phase: Casas and Soler 2003, 15–45. For the on-going discussion of the concepts of Romanization and *resistance* in Roman Spain, see: Curchin 2004; Jiménez Díez 2008; Dopico Caínzos, Villanueva, and Rodríguez 2009 and Gouda 2011.

29. Cartagena: Antolinos, Noguera and Soler 2010, 206–7 fig. 6 (Cabezo de la Atalaya); Brotóns and Lopez-Mondéjar 2010, 413–38 esp. fig. 4 (Los Paradores); Malaga: Serrano, Atencia, and de Luque 1985.

30. De Alarcão, Carvalho, and Gonçalves 2010.

31. Maia 1986; Moret and Chapa 2004; Fabião 2002.

32. Wahl 1985, esp. 169–73.

33. On these "*latrocinia*": Varro, *Rust.* 1.16.2. The most prominent "*latro*" of Lusitania was Viriathus: Cass. Dio 23 (fragm. 73); Livy, *Per.* 52. Cf. Cic., *Fam.* 10.33.3.

34. Moret 1999, 59–61 fig. 3d (Posta Crusta); Gros 2001, 276 fig. 298 (Villa Sambuco).

35. Teichner and Schierl 2009.

36. Teichner et al. 2010; Teichner et al. 2012; Teichner et al. 2015; Teichner et al. 2017.

37. See note 29.

38. Teichner 2008, 279–81; 581; 2012; 2014b; 2017a; 2017b.

39. Teichner 2008, 68–71 fig. 14B–C. See: Teichner and Schierl 2010; Teichner et al. 2012 and Teichner et al. 2017.

40. Teichner 2008, 413–16 fig. 239.

41. In summary: Teichner 2008, 256 ff. with fig. 263 (list 3). For El Ruedo (Córdoba): Vaquerizo and Noguera 1991, fig. 8 (structures in red). The situation at San José de Valle (Vega Elvira I) from the same period is not certain: Martí Solano 1995.

42. Tremoleda et al. 1995. For details: López Mullor et al. 2001; Prevosti 1987/8; 1993; García and Puche 1999; Palahí and Nolla 2010.

43. Casas and Soler 2003.

44. Prevosti and Martín 2009; Teichner and Peña Cervantes 2012; more general: Brun 2004.

45. Teichner 2008, 104; 581–2 fig. 36. Cf. de Alarcão, Étienne, and Mayet 1999; Sillières 1994; Picado 2001.

46. Columella, *Rust.* 1.6; 2.1.

47. Cato, *Agr.* 12.2; Teichner 2010/11; 2013.

48. For details, Teichner 2008, 105–7 fig. 45B.

49. Sillières 1994, 96.

50. Castanyer and Tremoleda 1999; 2008. Cf. also the complex at Font del Vilar (Girona), which also has its origins in the first century CE: Casas et al. 1995; Tremoleda et al. 1995.

51. Casas and Soler 2004, 175–228 fig. 138 and 181.

52. Plin., *HN* 3.30.

53. Teichner 2006 for an overview, with previous literature.

54. Escacena and Padilla 1992. Cf. Teichner 2008, 580–2.

55. Rodríguez Martín 1999.

56. Teichner 2008, 411–16. Cf. Teichner 2014b; Teichner and Wienkemeier in press.

57. The site was known in the late eighteenth century but has been the object of recent investigation: Teichner 2008, 93–269.

58. See, for example, the big reservoirs with a capacity of 600–800 m^3 outside the *pars urbana* at São Cucufate: de Alarcão, Étienne, and Mayet 1990, 58–59 plate 51.

59. Gusi and Olaria 1977; Gusi 1999 (Benicató). Romero 1998 (La Estación); Hidalgo 2017, vol. 2, 437–47.

60. Cf. Balmelle 2001, 135 f.

61. For example, at Milreu (Faro), La Malena (Zaragoza) or Rielves (Toledo): Teichner 2008, 469–72 fig. 267, 1–3.

62. For example at Cerro da Vila (Quarteira), Las Motas (Badajoz), or Pisões (Beja): Teichner 2008, 469–72 fig. 267, 6.11.

63. For example, at Los Quintanares (Soria), Almenara de Adaja (Valladolid), and Aguilafuentes (Segovia): Teichner 2008, 469–72 fig. 267, 12–14.

64. These measure 1,500 m^2, 1,070 m^2, and ca. 1,300 m^2, respectively.

65. See Maloney and Hale 1996 for the dating by the American excavator of the site to the third/fourth c. CE; Lancha and André 2000 for the earlier, and more likely, date. On problems in the work: Maloney and da Luz Huffstot 2002. For the later evolution of the site, see Ripoll (Chapter 22) in this book.

66. For a summary, with previous literature: Teichner 2008, 462 Fig. 264, 3. 7.

67. Gorges 1979, 125 fig. 19; Fernández Castro 1982, 174 ff.

68. Meyer 1999.

69. Remolà Vallverdú 2003.

70. Noguera and Antolinos 2010.

71. Gusi and Olaria 1977; Gusi 1999. Cf. Peña Cervantes 2010, 450–2.

72. Pastor, Tendero, and Torregrosa 1999. Cf. Peña Cervantes 2010, 297–9.

73. Mezquíriz Irujo 2003, 32.

74. Vaquerizo and Carrillo 1995; Vaquerizo and Noguera 1991; Hidalgo 2017, vol. 2, 174–85. For the later evolution of the site: see Ripoll (Chapter 22) in this book.

75. The date is based on the shape of the kitchen implements illustrated: Posac 1972; Mondelor 1984/5; Hidalgo 2017, vol. 2I, 562–73.

76. Typical of this are the Lusitanian complexes at Dehesa de la Cocosa and Torre Águila, both near Badajoz. Extensive excavation has not produced stratigraphic dating for the different architectural units, and unusually early dates (e.g., Flavian) need verification: cf. García-Entero 2005, 332–8; Peña Cervantes 2010, 314–18. The same problem applies to Torre Águila, which has only theoretically been described as a "peristyle villa": Rodríguez Martín 1995; 1999.

77. The villa at Santa Colomba de Somoza (León) has its origins in the reign of Tiberius. However, it is unclear when it was redeveloped with a peristyle court. What is more, the fact that it is close to the rich gold mines of northwest Spain makes it a special case: Gorges 1979, 276–8 fig. 36.

78. Among the best-known examples are the complexes at Aguilafuente (Segovia), Casa del Mitra (Cabra, Córdoba), La Olmeida (Palencia), Quesada (Jaén), Cuevas de Soria (Soria), the Villa of Cardilius (Torres Novas), and the villa of Fortunatus (Fraga).

79. Recently on the question of the third-century CE crisis in Hispania: Witschel 2009; Sommer 2015.

80. García-Entero et al. 2008; García-Entero and Castelo Ruano 2008; for the later evolution of the site: see Ripoll (Chapter 22) in this book. Another example is the villa at Milreu: Teichner 2008, 95–270 fig. 108–13.

81. Complex installations for the water supply have been carefully documented in the villa of El Ruedo near Córdoba, discussed earlier: Vaquerizo and Noguera 1991, 71 fig. 21.

82. On this subject (*stibadia*) see Ripoll (Chapter 22) in this book.

83. Teichner 2008, 141–3 fig. 57–8 and 178 fig. 81, cf. fig. 265.

84. Vaquerizo and Noguera 1991, 65 fig. 19; Teichner 2008, 364 fig. 204–5 (building F).

85. García-Entero 2005. Cf. Teichner 2008, 182–207 fig. 82–6; 493–504 fig. 279.
86. Cf. Nolla i Brufau 2008.
87. Previously, this kind of service area around dining rooms had been a typical feature of North-African houses; at Volubilis (*Maison à la monnaie d'or, Maison au cadran solaire*) or Utica (*Maison de la Cascade*): Dunbabin 1996; Teichner 2008, 465 note 605.
88. A good example of this kind of arrangement is provided by the banqueting hall in the villa at Quintas das Longas (Elvas), which had a marble-tile floor forming an intricate pattern: Nogales, Carvalho, and Almeida 2004. Cf. Teichner 2008, 466–9 fig. 266, 2; cf. Ripoll (Chapter 22) in this book. But see also the polychrome mosaic floor in the dining room of the complex at Almenara de Adaja (Valladolid): García Merino, and Sánchez Simón 2004. Cf. Teichner 2008, fig. 266, 3.
89. Balmelle 2001, 159.
90. For a summary: Teichner 2008, 472–5 fig. 66–7; 268. Cf. Ripoll (Chapter 22) in this book.
91. Examples include the villas at La Olmeda (Palencia), El Rudeo (Córdoba), Carranque (Toledo), Barros (Idanha-a-Nova), and Milreu (Faro); cf. Balmelle 2001, 174–5.
92. Teichner 2008, 514 fig. 287.
93. Vaz Pinto and Viegas 1994; Tarrats Bou et al. 2000; Teichner 2008, 319–20 fig. 152.
94. Teichner 2008, 475–8 fig. 269.
95. This development can be observed at Rio Maior (Santarem), Monte do Meio (Beja), Barros (Idanha

a Velha), and Torre Águila (Badajoz). For a summary: Teichner 2008, 476 nn. 652–6.
96. Teichner 2008, 592 with note 1223 and plate 28. See also Trillmich 1974; Fittschen 1984, 1993. For other examples of portrait collecting in villas, see Métraux (Chapter 21) in this book.
97. Teichner 2008, 419–47; in press..
98. Gorges 1979, 122 fig. 19; Balmelle 2001, 126 d.
99. Lafon 2001, 287 fig. 39b. Cf. Teichner and Ugarković 2012.
100. De Alarcão, Étienne, and Mayet 1990, 123 ff. plate 70. For the later evolution of the site: see Ripoll (Chapter 22) in this book.
101. E.g., at the villa on the Monte da Cegonha at Vidigueira: Lopes and Alfenim 1994.
102. On this subject, see Ripoll (Chapter 22) in this book.
103. The mosaic floors of the villa indicate such a plan: Serrano and Rodriguez 1975.
104. For a summary: Teichner 2008, 480–3 fig. 272–3. Cf. the hexagonal peristyle court of a suburban villa in Córdoba, which was also built toward the end of the third century CE: Teichner 2008, 483 fig. 272, 6.
105. Abascal et al. 2007. On this subject, see Ripoll (Chapter 22) in this book.
106. Teichner 2011, esp. fig. 6; see also Ripoll (Chapter 22) in this book.
107. On this building type in general, Teichner 2008, 514–16 fig. 287.
108. Teichner and Peña Cervantes 2012, 400–3; 422–5; cf. Revilla 2008, 113–14; Teichner 2016, 562–3 (Las Maravillas).

ROMAN VILLAS IN THE MALTESE ARCHIPELAGO

ANTHONY BONANNO

INTRODUCTION

In their quest to dominate the European and Mediterranean world, the Romans faced many different climates, topographies, and native traditions, but they brought with them some standard ideas of what houses – in urban centers, in the countryside, or on the coast – might be in the way of amenities and decoration. When Roman agricultural estates were established on the two larger islands (Malta and Gozo), such importations were naturalized in the archipelago at the center of the *mare internum*, separated from Sicily by a stretch of sea only 90 km broad but perceived to be wide and dangerous.[1] However, the much greater distance (290 km) between the archipelago and the African coast (east coast of Tunisia) is more significant for our purposes: the Roman agricultural estates appear to have replaced or continued earlier agricultural enterprises that had pre-existed the Roman presence, namely those of the Punic or Carthaginian hegemony over the islands which had existed long before the defeat of Carthage in the Second Punic War (218–201 BCE).

Only the larger of the two islands of the Maltese archipelago was fully inhabited in Roman times: Malta, having an area of 246 km² (known as Melite; Map 11). The much smaller island of Gozo (known as Gaulos) with an area of 67 km² was less developed, but both islands formed separate administrative entities (*civitates*) within the province of Sicily, each with an eponymous town administering its own territory.[2]

Archaeological work in Melite, the chief town of the larger island in Roman times, has revealed important houses, and while these are urban *domus* rather than villas, the most impressive of them (the *domus* of Rabat) had a near-suburban setting, views, a plan, and very fine decorations and contents that distinctly gave it the character of a *villa suburbana*.

AN OUTSTANDING HOUSE IN MELITE: THE *DOMUS* OF RABAT

In Melite, the remains of a large peristyle house containing rooms adorned with very fine mosaic floors in a late Hellenistic style were uncovered in 1881.[3] For more than a century after its discovery, the building was known as the "Roman villa of Rabat,"[4] probably because of what seemed to be its position vis-à-vis the modern fortified town of Mdina, but subsequently it has been recognized as an urban house at the northern edge of the ancient town overlooking a picturesque valley and now is known as the "Roman *domus*" (Figure 15.1).[5]

Its mosaics date the original construction of the building to shortly before, or shortly after, the beginning of the first century BCE, during the conflict between Marius and Sulla and the opposing social orders they represented. The Rabat *domus* was an early instance of the wealth of the Melite town: in 70 BCE, a Maltese gentleman with a Greek name was the subject of an anecdotal episode in Cicero's

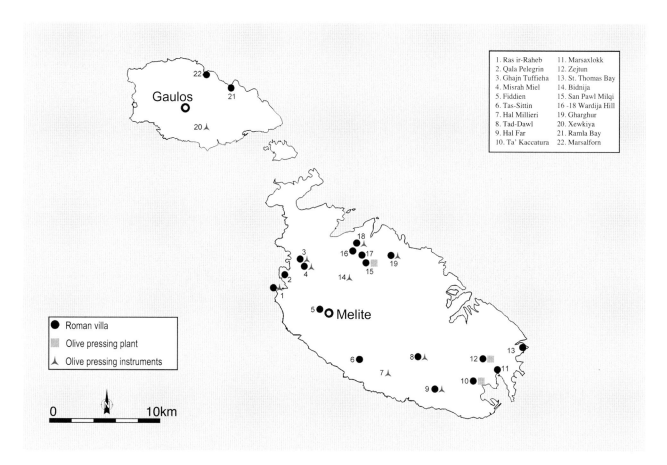

1. Ras ir-Raheb 11. Marsaxlokk
2. Qala Pelegrin 12. Zejtun
3. Ghajn Tuffieha 13. St. Thomas Bay
4. Misrah Miel 14. Bidnija
5. Fiddien 15. San Pawl Milqi
6. Tas-Sittin 16 -18 Wardija Hill
7. Hal Millieri 19. Gharghur
8. Tad-Dawl 20. Xewkija
9. Hal Far 21. Ramla Bay
10. Ta' Kaccatura 22. Marsalforn

● Roman villa

▨ Olive pressing plant

⅄ Olive pressing instruments

0 10km

Map 11. Map of Malta and Gozo, with the location of the Roman towns of Melite and Gaulos, and distribution of recorded Roman villas.

prosecution of Verres, the corrupt governor of Sicily.[6] This was a certain Diodorus by name with Melitensis as an added name (*cognomen*) but with no patronymic or *gentilitium* which would have indicated Roman citizenship. In spite of this, Cicero praises him as a man of noble birth and *propter virtutem splendidus et gratiosus* – "famous and well-loved because of his virtue" – and wealthy: Diodorus owned a priceless collection of silver cups wrought by the hand of Mentor, which Verres as governor of Sicily wished to have for himself in an abuse of his official mandate.

A gentleman such as Diodorus or another of his social class must have built and owned this urban *domus* on the edge of Roman Melite. The house stood out from the surrounding dwellings of perishable materials (such as mud brick), which have not survived. The Rabat *domus* may have been sited in its modest

neighborhood to take advantage of the views of the countryside, giving it a villa-like position and distinction. It had several rooms built around a peristyle with Doric columns supporting architraves in local limestone. The use of limestone may indicate that the owner was not quite rich enough to afford imported marble, but his designers did the next best thing: the stone surfaces were covered by a thin layer of stucco and painted in a standard architectural polychromy: the lower third of the columns in red; the Doric frieze in blue; and the plain architrave below it in yellow.

The floors of the peristyle corridors, open courtyard, and surrounding rooms of the Rabat *domus* were decorated with mosaics of the finest quality for the time, clearly commissioned from specially hired mosaicists.[7] All of them were framed by intricate borders, some of which had geometric patterns with *trompe-l'œil* effects; these surrounded square

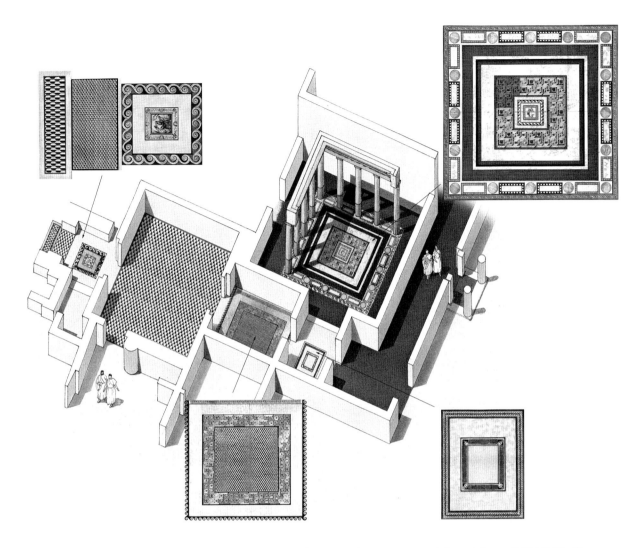

Figure 15.1. Rabat *domus*, axonometric reconstruction with mosaics in reconstructed form (photo: INKLINK, Florence. Courtesy of Midsea Books).

panels containing a picture (*emblema*) rendered in extremely small *tesserae*, in the *opus vermiculatum* technique. These *emblemata*, laid in specially prepared stone trays, could have been imported in finished state and laid on-site in already prepared floors. The centers of production of these decorative elements were in the Hellenized East, perhaps Alexandria or Pergamon, and they are of special interest in the history of ancient art. The anatomy and posture of the satyr or Pan depicted in one of them recalls the figure of Laocoön in the sculpture group now in the Vatican Museums, while the scene with the two doves perched on a shiny brass basin is a variation of a famous wall mosaic by Sosos of

Pergamon, often reproduced in paintings and floor mosaics elsewhere (Figure 15.2).[8] The references to famous works of art – the Laocoön, the Sosos mosaic – may well have been a topic of erudite conversation between the landlord and his guests.[9]

The Rabat *domus* survived in the same form for about a century and a half. Toward the mid-first century CE, it must have been occupied by a person of some high political standing who undertook the expense of adorning it with a cycle of fine portrait statues representing the emperor Claudius and members of his family (Figure 15.3).[10] We cannot tell who the owner of the house was, whether he was a visiting Roman (or Italian)

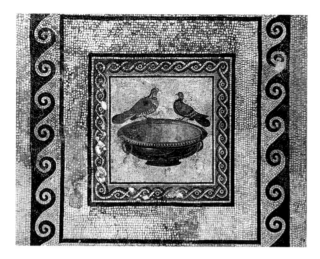

Figure 15.2. Rabat *domus*: *emblema* with scene of doves perched on metal basin (courtesy D. Cilia).

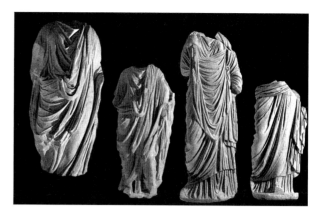

Figure 15.3. Rabat *domus*: four surviving torsos of a cycle of imperial portrait statues of the reign of Claudius (41–54 CE) (courtesy D. Cilia).

magistrate, or a local Maltese dignitary, but a fragmentary inscription found on site makes reference to the dignity of a *decurio*, a municipal office appropriate to a local magnate. The surviving marble portraits of Claudius, one of his daughters, and the other portraits in the group are of very high quality and must have been commissioned from workshops (probably in Italy) and shipped to Malta at considerable expense by a wealthy, strongly motivated patron clearly affiliated with the entourage of the reigning emperor.

The Rabat "villa" became disused sometime in the second half of the first century CE; its walls of fine ashlar were re-used in the construction of irregularly laid-out houses on the sloping ground toward the valley.

HOUSES BEYOND MELITE: THE VILLAS

Beyond the city, the whole island of Melite was marked by properties of various sizes, with agricultural activity focused on a score or so of well-built villas of different sizes and complexity spread out in the Maltese landscape, one on a sandy shore at the water's edge, others in different inland settings to take good advantage of the local hydrology and topography.

None of these villas has so far produced mosaic floors or contents of the caliber of the Rabat *domus*,

although the bathing facilities of a villa discovered in the eighteenth century on the water's edge on the Valletta side of the Grand Harbor had figured mosaics on the floor as well as on the walls. According to the contemporary writer Gian Antonio Ciantar (1696–1778), five figures could be seen representing "fish and serpents, or dragons." From the small size of the baths, Ciantar argued that they were of a domestic nature.[11] On the island of Gozo, a *villa maritima* at Ramla Bay was excavated in 1910; it had at least one large room paved in colored marble and stone *opus sectile* (Figures 15.4 and 15.5). On Melite, the large villa of San Pawl Milqi had several rooms of the *pars urbana* decorated with fresco-painted plaster (see p. 261–2).

We have no knowledge of the identity and origin of the owners and occupiers of these dwellings.[12] Their owners were certainly a cut above the ordinary inhabitants living in mud-brick houses in town or in the country. Given the mobility of Roman citizens across the empire, the owners of these villas could well have been high-status Romans or Italians or businessmen (*negotiatores*) with enough capital to buy a piece of land, planting it with vines or olive trees and building a sturdy house equipped with the heating facilities for domestic bathing and with the required apparatus for olive oil (and possibly wine) pressing. They could have been members of the local, possibly Romanized, elite, or others of means from elsewhere in the empire. The evidence of

amphorae indicates that Malta seems to have largely depended on imported wine, but its olive oil production justified the making of one or two local types of amphorae for transport, possibly also for export, so investment in land, and thus in a villa, may well have been profitable.[13]

TYPOLOGY OF VILLAS IN THE MALTESE ARCHIPELAGO

There were two main types of villas in Roman Malta: the purely residential one, meant for the leisure (*otium*) of the owner, on the same lines as the villa of Cicero at Tusculum and the Laurentine villa of Pliny the Younger but on a much smaller scale;[14] and the agrarian villa, which combined the residential area (*pars dominica* or *pars urbana*) with an area largely devoted to agricultural activity (*pars rustica*), better known from references in the works of Cato, Varro and Columella.[15]

The size of the more extensive villas in the archipelago (like the Ramla Bay and San Pawl Milqi ones), though not comparable with the luxury ones on the Bay of Naples or with those commanding large estates like that of Settefinestre or Piazza Armerina and Patti Marina in Sicily, is still large. There were ample residential spaces for owners and their respective *familiae*, and slaves must also have been housed.

RESIDENTIAL VILLAS

Ramla Bay Villa

Apart from the site in the Grand Harbor area already mentioned and the bathing complex of Għajn Tuffieħa (p. 260–1), the only purely residential villa found in the archipelago is that discovered on Gozo in 1910–11 on a sandy beach, almost right on the water's edge, in the paradisiacal setting of the Ramla l-Ħamra Bay (Figure 15.4 and 15.5).[16] Like the Għajn Tuffieħa baths, it exploited the presence of a natural spring.

Figure 15.4. Ramla Bay, Gozo, reconstruction view of the *villa maritima* (photo: INKLINK, Florence. Courtesy of Midsea Books).

The Ramla Bay villa was a *villa maritima* provided with a heated bathing system and adorned with marble floors and painted plastered walls. It was apparently approached from the landward side as no facilities for berthing boats have been found. The building extended over a large area on the gently sloping ground. The main entrance and other parts of the villa had not survived at the time of the excavation, but nineteen rooms were uncovered, six of them (Figure 15.5, nos. 1–6) intended to serve as living quarters around a courtyard on the north side. The courtyard may have provided access to rooms 7–11, which led to the bathing complex (rooms 13–19), an interconnected series of heated rooms and baths.

In the sequence of use, rooms 10, 11 and 13 were likely dressing rooms (*apodyteria*) for the baths: all three were equipped with stone benches. The *frigidarium* or cold bath was the octagonal room (19) on the east end. The heat for the warm rooms was supplied by a furnace (*praefurnium*), probably in room 18, which sent hot air under the floors of rooms 14–17; the concrete floors of these rooms were supported on low pillars of stone or clay bricks, and rectangular flue-tiles (*tubuli*) jacketed the walls for radiant heat. The baths at the Ramla Bay villa were decorated with colored marble veneer. The cold bath, for instance, was veneered with slabs of gray marble, but the most richly decorated room was between the hot rooms and the cold bath (13). Its

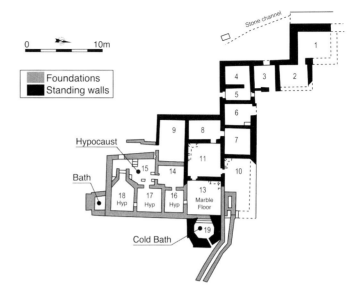

Figure 15.5. Ramla Bay, Gozo, plan of the *villa maritima* (1910).

floor consisted of successive rectangular bands of "Gozo stone," and black, red, and gray marble framing a central square of eight slabs of fine breccia, perhaps Africano. Some of the walls were covered with plaster painted in imitation colored marble. Fragments of mosaics were found in room 1 but no designs were recovered. Several pieces of sculpture also came to light, including one in local limestone in room 2 of a nude satyr with pointed ears and a crown of ivy, evidently intended to support an architectural element.

Għajn Tuffieħa Baths

This enigmatic building complex was discovered in 1929 on the north side of a valley leading to the two enchanting sandy beaches of Għajn Tuffieħa (the "Apple Spring") on Malta, just over a kilometer east of the sea.[17] It was located in proximity to an abundant water spring and was equipped with a heating system and furnace for both hot water and radiant heat from the floors supported, in the case of the *caldarium*, on rows of low brick arches (Figure 15.6). While the rooms were arranged in the sequence of bathing found in large urban public baths, the size of the Għajn Tuffieħa complex was too small and too far away from a town for such a purpose. It was suitable to a private residential

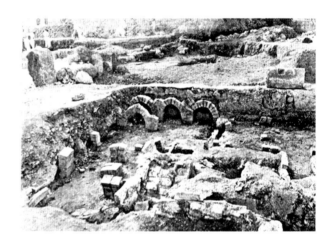

Figure 15.6. Għajn Tuffieħa baths discovered in 1929: hypocaust system on arches.

villa like those found in Sicily and Libya,[18] and traces of an ancient building have been recorded on the hill immediately above it, possibly those of the villa with which it was connected.

The complex had a series of indoor heated bathing rooms, a changing room (*apodyterium*), an outdoor swimming pool (*natatio*) and a communal latrine that could accommodate eleven persons at a time, as well as a line of small rooms serving as bedrooms (*cubicula*) (Figure 15.7). The surviving mosaics were in geometrical patterns, that of the cold bath showing an illusion of cascading cubes, like the one in the *domus* of Rabat. The 1929

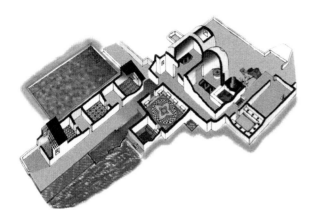

Figure 15.7. Għajn Tuffieħa baths, axonometric reconstruction of the surviving sections (photo: INKLINK, Florence. Courtesy of Midsea Books).

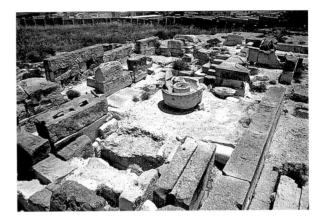

Figure 15.8. San Pawl Milqi, villa: view of the large courtyard with three parallel olive presses (courtesy D. Cilia).

excavation also brought to light some remains of painted wall plaster.

From the style and finesse of the mosaics that decorated the floors of the bathing rooms, the swimming pool and several of the *cubicula*, the building was built for use by members of the elite of Maltese society of the second half of the first century and the first half of the second century CE.

AGRICULTURAL VILLAS

The agricultural villas in the Maltese archipelago are far more numerous than the residential ones: no less than a score of such buildings in the countryside have been recorded and some are still visible. The better preserved ones had sections devoted to habitation, but what identifies a site as a villa is the presence of one or two parts of the apparatus for the pressing and production of olive oil: the basin of the mill (*trapetum*) to separate the olives' pulp from their stones or the anchoring counterweight stones for the press, which survive *in situ* because of their weight and size. Agrarian villas can be illustrated in three examples: the largest and most complex one (San Pawl Milqi); one with unique features (Tad-Dawl); and the one being currently excavated by Professor Nicholas Vella and myself for the Department of Classics and Archaeology of the University of Malta (Żejtun).

The Villa at San Pawl Milqi

The most extensive remains of a villa typical of Malta are those of San Pawl Milqi, brought to light in the 1960s.[19] They are located halfway up a hill overlooking a fertile plain near Salina Bay on the north coast of the island, which, from current investigations, is emerging as having been a busy harbor in antiquity.[20]

The 1960s excavations uncovered the remains of a large Roman villa that was occupied for at least six centuries, from the second century BCE to the fourth century CE. It replaced an earlier Punic occupation of the site related to productive activity not yet defined. The remains show signs of several reconstructions and additions, which modified the general layout of the building.[21] Most of the walls are built in very fine *opus quadratum* from blocks of local limestone.

The most striking part of the villa is a sizable industrial unit consisting of several stone instruments related to olive pressing, fitted tightly inside a vast rectangular space, probably a courtyard (Figure 15.8). As many as three *trapeta* (olive mills) were recovered, one practically intact. There were also three olive presses disposed in parallel along the long axis of the courtyard, with three sets of stone anchoring blocks for maneuvering the end of the horizontal wooden beams (*prela*): one probably using a helical wooden screw, the other a fixed capstan. The area also had a set of three vats for the decantation of the oil, set in

sequence so that the freshly pressed oil would flow into the first one, allowing sediment to sink before the oil flowed into the second vat for further sedimentation, repeating the process before the refined oil passed into the third vat, whence it was collected.

The residential part of the villa had living quarters with several rooms decorated with fine wall paintings: the decoration consisted primarily of imitation colored marble in the First Style, with a few floral motifs but no figures.[22]

At the southwest corner of the living quarters, a stout semicircular wall supported what may have been a tower, and there may have been another squarish tower on the southeast side. Although the date of these structures is not clear, the excavators noted the insecurity in this part of the Mediterranean immediately before the Third Punic War (149–146 BCE) and in the following century due to widespread piracy. The villa was in a strategic position, dominating the then navigable port of Salina Bay. However, more recent work by the *Missione Archeologica Italiana* (begun in 1997) may indicate a much later date for the San Pawl Milqi villa towers in the troubled years of the third century CE.[23]

The Villa at Tad-Dawl

One of the gravest losses to the Maltese archaeological heritage is that of the remains of a rural villa discovered and explored in 1888.[24] All that survives of this agricultural complex is a well-preserved olive mill. Luckily, the record of the villa, a three-page report by its excavator, Annetto Caruana, was accompanied by a good plan signed by Caruana himself (dated 21 April 1888; Figure 15.9). The villa lay to the west of the small village of Ħal Kirkop, some 8 km to the south of Valletta in an area now covered by stone quarries: there is no mention of the remains after 1889.

Only the industrial wing of the Tad-Dawl villa was uncovered. The residential area probably extended to the east of this. For some reason, Caruana identified some rooms as "stables or sheeppens" (P, P, P) and other rooms as "stores for olives" (Q, Q). Like other villas of the archipelago, the ashlar

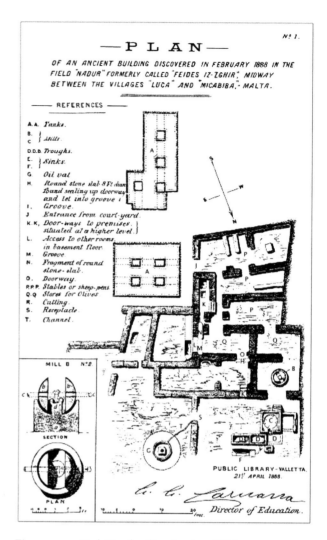

Figure 15.9. Tad-Dawl, villa, plan in 1888 (now destroyed).

foundations and socles of the walls were constructed of large limestone blocks; the structure of the upper walls is not certain.

Unique in the Maltese and, as far as I know, in the central Mediterranean context are the large round stone slabs (8 feet in diameter) that sealed two doorways (L and O) by being rolled in specially cut grooves. Similar devices were used to seal tombs in the Levant.[25] The caption of Caruana's 1888 plan suggests that doorway L led to "other rooms in basement floor." Besides the olive mill mentioned in this section, the plan shows the presence of another olive-crusher and a system of vats and troughs for the decantation of the pressed oil (D, D, D).

On its south side, the villa was also equipped with two rock-cut cisterns, one L-shaped, the other square (both marked A). In both cisterns, four square pillars supported horizontal thick stone beams covering a span of 1.5 m over which in turn lay the horizontal roof of thick stone slabs about 1.7 m in length. This roofing technique of both cisterns is identical to that of the cistern at another villa, that at Ta' Kaċċatura.

The Villa at Żejtun

Traces of Roman masonry on the site were brought to light in 1961 while the ground was being cleared for a new school on the east side of Żejtun.[26] Archaeological excavations were begun in 1964: a large cistern, a foundation wall and some stone water channels were uncovered, together with a stone-paved area.[27] From 1972 to 1976, investigations continued sporadically: parts of the stone apparatus were found and a plan of the site drawn (Figure 15.10).[28]

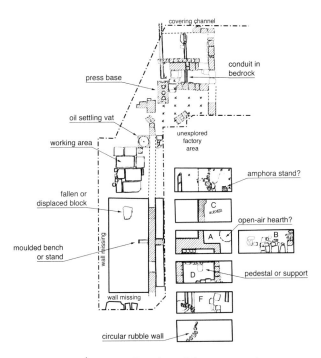

Figure 15.10. Żejtun, villa, plan of the excavated parts (1972).

Full-scale scientific excavations by the University of Malta resumed at the Żejtun villa in 2006. Since virtually no records survive of the previous excavations, the purpose of the current project is to define the different sectors of the building and its chronology. The mouth of the large cistern mentioned in the 1960s excavation reports has been relocated. A number of large tapering stone blocks with roughly the same thickness (c. 0.50 m) lying in the vicinity of the cistern may be voussoirs belonging to its roofing system; if this is correct, the Żejtun cistern should have had one or more flat arches supporting stone roof slabs, very much like those covering the rectangular cistern connected with another Roman villa discovered at Tal-Ħlas in central Malta.

The remains belong to a typical Roman agricultural villa combining a residential area with an area for the pressing of olive oil. At least three rooms of the residential area had floors paved with lozenge-shaped terracotta tiles of different colors, possibly intended to produce the same illusion of cascading cubes as in one of the floors of the Rabat *domus*. Some traces of painted plaster had been noted in 1976 on the surviving stumps of the walls of the paved rooms, but these have since faded.

Immediately to the north of the residential area stood the production area for olive oil, with some components still visible: a large stone block used for the screw-driven traction of the horizontal pressing lever; a section of the press bed (a large flat slab with cup-like depressions); and a stone vat, probably one of several originally used for settling oil. The water from the cylindrical cistern close by could well have been used in the same process.

PUNIC ANTECEDENTS FOR ROMAN VILLAS IN MALTA

All three Roman agricultural villas in Malta that have been excavated to modern archaeological standards since the beginning of the twentieth century have provided important evidence of occupation prior to their existence in Roman times. Malta had been taken over by the Romans in 218 BCE from the

Carthaginians whose ancestors, the Phoenicians, had occupied the islands since the late eighth century BCE. Already in 1910, Thomas Ashby found evidence of Punic presence in his excavation of the Roman villa near Borġ in-Nadur, at the southeastern harbor; he even identified walls in the *opus africanum* technique as typical of Punic construction.[29] Similarly, at San Pawl Milqi, remains were found of an earlier complex of Punic-Hellenistic date that might have been involved in oil production or the dyeing of textiles; these functions continued in the large villa of late Republican times.[30]

At the Żejtun villa, examination of the pottery from the excavations of the 1960s and 1970s revealed the likelihood of a Punic phase in the life of this building. Indeed, a fragment of a cooking pot unearthed in 1976 in excavations undertaken under my direction bore an inscribed dedication to Ashtart, similar to ones found in the neighboring sanctuary of Ashtart/Juno only 1 km away.[31] The dedicated pottery at both the Żejtun site and the Punic sanctuary suggests that the agricultural facility (the land and farmstead) might have been owned or operated by the religious center. Since then, as a result of an intensive field survey project in the northwest of Malta, it has been ascertained that building activity at the Żejtun site took place as early as the fourth century BCE, fully within the Punic hegemony.[32] Recent excavations (2013) have uncovered a system of rock-cut "vine trenches" extending under both Roman and Punic walls indicating agricultural activity on the site before the Roman occupation.[33] The agricultural and productive history of the Maltese islands has thus been extended by several centuries, and the continuity between the Punic presence and the later Roman exploitation of the islands can be confirmed.

The discovery of Punic activity before the construction of the villas at San Pawl Milqi, Borġ in-Nadur, and Żejtun serves to remind us that the Romans knew and respected Punic agricultural expertise contained in the monumental work on farming in twenty-eight books by the Carthaginian writer Mago. His Punic text is long lost, but some fragments of it are known from quotations in later Greek and Latin writers such as Columella's *De Re Rustica*. This agricultural manual was so highly esteemed that the Roman Senate sponsored the translation of the whole work into Latin.[34]

CONCLUSION

To these examples of the Punic ancestry of Roman villas in Malta can be added the clusters of Punic tombs that indicate the nearby location of Punic and later Roman rural settlements.[35] While the Roman villas mentioned here are just about the only ones that have been investigated with modern methods (in contrast to many others explored over the last two centuries), it can confidently be said that the Maltese rural landscapes and habitat in the Roman era were to some degree influenced, even predetermined, by developed exploitation in Punic times. A recently published collection of essays on Punic rural landscapes in five western Mediterranean geographical regions, including one comprising Sicily and Malta, has offered an outline for such a development.[36]

NOTES

1. Cic., *Verr.* 2.4.103: *Insula est Melita, iudices, satis lato a Sicilia mari periculosoque disiuncta.*
2. Cic., *Verr.* 2.4.103; Diod. Sic. 5.12.1–4; Ptol., *Geog.* 5.3.13. See Bonanno 1998.
3. Caruana 1881.
4. For example, see Zammit 1908; 1930a; Ashby 1915, 34.
5. Bonanno 2005, 308–17.
6. Cic., *Verr.* 2.4.38–41.
7. Probably itinerant mosaicists, although there seems to be evidence for a local workshop producing mosaic *tesserae* from hard stones of different colors in a building excavated in 1970 on the opposite edge of Melite (Museum Annual Report 1970: 6). Mosaics of the Rabat *domus*: Pernice 1938, 6–7, 9–12, 125–8, 137, 141, 160, 165.
8. Plin., *HN* 36.184.
9. Bonanno 2005: 164–7. The satyr or Pan figure – bound and struggling like Laocoön – was the subject of a painting cited in Philostratus (*Imag.* 2.11).

10. Bonanno 1997.

11. Ciantar 1772: 150. Soon after their discovery, they were vandalized and have since disappeared.

12. So far only one Maltese villa near Borg in-Nadur (Ta' Kaċċatura) has produced a fragment of an inscription. It consisted of a piece of gray marble bearing the letters PII, dated by Ashby (1915, 65) to the second half of the second century CE. The letters could be the genitive ending of *municipium* or of *Pius*, referring to the emperor Antoninus Pius.

13. Bruno 2004, 85–97.

14. Cicero's Tusculum villa: McCracken 1935. Pliny's villa: Plin., *Ep.* 2.17.

15. Cato, *Agr.* 10–22; Varro, *Rust.*1.13; Columella, *Rust.*1.6. Vitruvius (*De arch* .6. 6) gives instructions regarding the construction of such farmsteads. For the term *pars dominica*, see Fornell Muñoz 2005.

16. Detailed account of the site: Ashby 1915, 70–4. As no coins were found, Ashby assigned the villa broadly to the "Roman period" on the basis of the pottery (p. 74). The site is now protected under a cover of sand and is no longer visible

17. Zammit 1930b.

18. For Sicilian examples, see Wilson 1990, 194–214, especially those at Durreli di Realmonte, Castroreale S. Biagio and Patti Marina. Some "detached bath houses," similar to the Għajn Tuffieħa one, imply, according to Wilson, the presence nearby of unrecorded residential villas. For two Libyan examples, situated along the coast between Tripoli and Lepcis Magna, see Kenrick 2009, 142–7. See also Wilson on African villas (Chapter 16) in this book.

19. The excavations were conducted by the University of Rome (*Missione* 1964–9). Synthesis in Locatelli 2002.

20. Since ancient times, the harbor has silted up; Gambin 2004.

21. Locatelli 2005–6.

22. Bozzi 1968.

23. Locatelli 2005–6, 270–1, fig. 3.

24. Caruana 1889. Caruana erroneously identified the building as a Greek one. It is obvious, however, that it was a Roman villa.

25. Matthew 28.2; McCane 2009, 621.

26. Museum Annual Report 1961: 5.

27. Museum Annual Report 1964:6.

28. The plan is by F. S. Mallia, the Director of the Museums Department of Malta at the time: Museum Annual Report 1972–3: 72; 1973–4: 51; 1974–5: 56; 1975–6: 60; 1976–7: 64.

29. Ashby 1915, 52–66. The technique is compared to "Phoenician construction, as at Motya and at Carthage, [where] pillar-stones were frequently used for the framework of a wall, the intervening spaces being filled in with lighter material" (p. 53).

30. Bruno 2004, 127, 131; Locatelli 2005–6, 258, 262–3, n. 16.

31. Frendo 1999.

32. Docter et al. 2012. The evidence for these dates comes from a fragment of an Attic black gloss bowl and a fragment of a squat lekythos found in a sealed layer abutting onto a wall of the Punic structure (Bonanno and Vella 2012). The field survey was conducted by the University of Malta and a team from the University of Ghent.

33. Vella et al. 2017.

34. Plin., *HN* 18.22; Varro, *Rust* 1.1.10; and Cic., *De or.* 1.249.

35. Said-Zammit 1997, 2–3, 13–15; Vidal Gonzàlez 2003, 262–8; Sagona 2002, 268–9.

36. Van Dommelen and Gómez Bellard 2008.

16

ROMAN VILLAS IN NORTH AFRICA

R. J. A. WILSON

INTRODUCTION

The African provinces were among the richest in the Roman Empire. This vast area, bounded by the Mediterranean to the north and the Sahara to the south, covers some 3,500 km from the Atlas Mountains in the west to the borders of Egypt in the east. Within that huge zone there is of course a wide diversity of landscapes, with mountain ranges and hilly regions alternating with large plains and extensive plateaux (Map 12). In Tripolitania, and in particular its eastern area where it borders Cyrenaica (largely within the confines of modern Libya), the coastal strip disappears altogether as the desert touches the shores of the Mediterranean. Not all areas within this vast territory were equally fertile, and natural springs and other water sources were always in short supply; but the sheer prosperity of, in particular, the heartlands of the African provinces, covering what is now central and northern Tunisia and north-eastern Algeria, is demonstrated above all by the density of urban settlement there, and the sumptuousness and scale of its public and private building. The cornerstone of urban prosperity was the agricultural productivity of the surrounding territory, the fertility of which is constantly marveled at by ancient writers. Pliny, with obvious exaggeration, noted that Africa is "given over to the corn goddess Ceres" almost to the exclusion of the olive and the grape;[1] but the latter two, and especially the olive, also made huge contributions to the well-being of the African economy, as did also, in coastal areas, fish-processing and the production of *garum* – all exported in massive quantities to Rome and around the Mediterranean and beyond.

What part did "villas" play in the North African landscape – to what extent did landowners commission and build comfortable rural dwellings for occasional or continuous occupation? In other words, was there a fully developed "villa system" as in Italy and elsewhere in the Roman West, or was rural settlement exclusively made up of farms and agricultural villages, while the aristocratic elite (who owned the bulk of the land) preferred instead to reside permanently in the towns? The evidence at our disposal is, as we shall see, exiguous, and often difficult to interpret. The number of excavated "rich" villas that are likely candidates as the rural homes of the aristocratic elite is, for the whole of North Africa, very small. Should we conclude from this that large-scale, lavish villas were a rarity in the African landscape, and that landowners must have resided largely in the towns, where there is abundant evidence for wealthy residences being occupied down into late antiquity?[2] Or is such a conclusion premature? Is it simply the consequence of a comparative neglect of fieldwork in the countryside (in contrast with the emphasis on urban archaeology), and so one that does not reflect the true situation in antiquity?

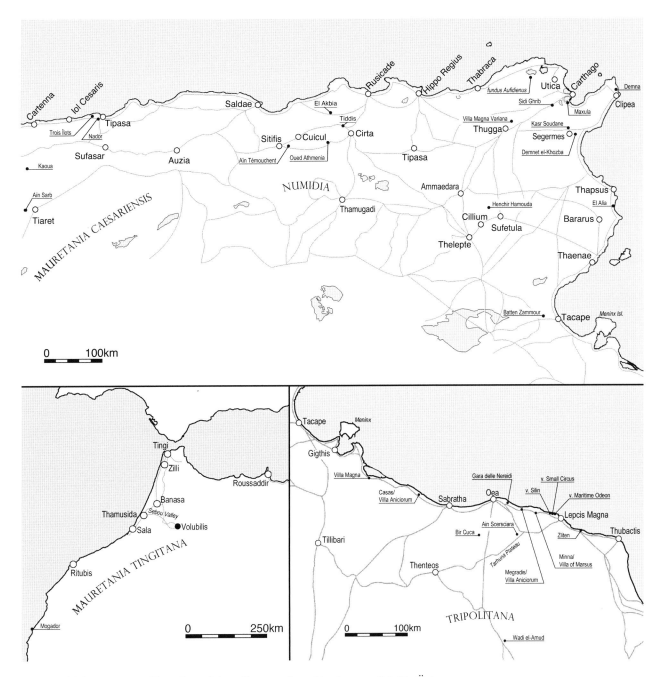

Map 12. Major towns and location of the villas mentioned in the text (M. D. Öz).

THE NATURE OF THE EVIDENCE

First, a word about definitions. *Villa* in Latin can mean any rural residential building, normally one associated with agricultural production, but sometimes, as with the *villa suburbana* or the seaside *villa maritima*, an establishment planned solely for the proprietor's pleasure and relaxation (*otium*).[3] The word should not be used of a town-house (*domus*), discussion of which forms no part of this chapter.[4] Even, however, in its true rural context, the word "villa" in modern scholarship is interpreted by different writers in different ways, and this lack of consistency is a ready source of confusion.

The relevant maps in the *Barrington Atlas of the Greek and Roman World*, for example, give the impression that the African landscape is littered with villas, because hundreds of black triangles (denoting "estate centre, villa") appear to indicate as much.[5] Sixty years ago, R. G. Goodchild, in compiling data for another map, the Lepcis Magna sheet of *Tabula Imperii Romani*, took a different approach. He distinguished between "farms" and "villas" (using a separate symbol for each), commenting that "it seems desirable to apply the term [villas] only to those Roman structures which contain mosaics, baths or other characteristically Roman features."[6] The last category includes columns and capitals, likely to indicate the presence of a colonnade, although not all villas had large peristyles. This distinction between farm-sites and villas is the one adopted here: those sites classified as "farms," the vast majority of known rural settlement in North Africa, are not considered.[7] The presence of its own bath-house, whether integral to the main structure or as a separate block, and of geometric or figured mosaic pavements (but not plain tessellation), will be among the factors taken as indicative of a villa, but there will in addition have been (in many cases) features like presses which indicate on-site agricultural production in another part of the villa, features that are also present, of course, in simple farms. This distinction between "farm" and "villa" is one to which we will frequently return in this chapter, because not all scholars use it, or use it in the same way,[8] and in any case there are many examples where the distinction between the two is blurred, especially at a site (again the vast majority) where excavation has not taken place.

Four categories of evidence will be used to provide a framework for discussion, all with their own problems of interpretation. One is textual evidence – the reference to named villas or estate centers in literary sources, road itineraries and inscriptions. Another concerns field survey, areas of territory around selected Roman towns where intensive topographical research has been carried out, and a hierarchy of rural settlement proposed on the basis of surface evidence. A third data-set is the depiction of country villas on mosaic pavements, all found, with two exceptions,[9] in town houses. Finally,

there are the excavated remains of the wealthy villas themselves. Only a handful of these have been fully uncovered; in many others excavations were suspended before the full character and extent of the site had been ascertained.

TEXTUAL AND EPIGRAPHIC EVIDENCE

That there were indeed villas in the African countryside is suggested by scattered references in literary sources, but the nature of such dwellings cannot often be determined because, as we have seen, the term "villa" is used in Latin to refer to a wide range of rural establishments, from the humblest farm to the grandest elite residence. Augustine in the fourth century, for example, in his letters and sermons, mentions *villae* in the hinterland of Hippo Regius (mod. Annaba) in Algeria, and in one passage he distinguishes between *castella* (another term for rural residences) and *villae privatae*, but he gives no hint as to whether any were high-ranking estates.[10] Apuleius, two centuries earlier, is more helpful. In his defense against a charge of sorcery (the *Apologia*), delivered in late 158 or early 159 in the basilica at Sabratha in Tripolitania, he mentions that his wedding in late 157 or early 158 to the very rich Pudentilla took place in a country villa, a place where she went to escape the pressures of life in Oea (Tripoli).[11] It seems likely that the property that she chose for her wedding would have reflected her wealth and status. Nor was this her only country estate. Later in his address, Apuleius says that he "urged her to donate very fertile fields from her possessions, and a large and richly-equipped house, a great amount of wheat, barley, wine, oil and other produce; and no fewer than 400 slaves."[12] That she could spare another property with 400 slaves as a gift, even allowing for forensic hyperbole, implies the scale of her wealth. As we shall see (pp. 285–97), Tripolitania is known from archaeological evidence to have had a number of high-status villas.

Further east, around 400 CE, the pagan philosopher Synesius of Cyrene, later bishop of Ptolemais, owned a town-house in his birthplace, but he

indicates in his letters that he preferred to write on his rural estate far away, somewhere south-west of Apollonia.[13] He makes no reference to its degree of comfort: in the total absence of luxury villas anywhere in Cyrenaica, along with many other areas of the eastern half of the Roman empire,[14] we have to assume that he lived in one of the sturdy late-antique farmsteads with thick walls and few external windows (*gsur*) that featured prominently in both the Tripolitanian and the Cyrenaican countryside.[15] By contrast, in Tunisia, later in the fifth century and in the sixth, we gain a very different impression of the lifestyle of the Vandal kings and their high-ranking associates, even if the evidence derives largely from sycophantic court poets who exaggerated in order to please their Vandal overlords.[16] Geiseric, the first Vandal king, often went to his estate on the coast near Radès, the *Maxulitanum litus*, and the properties of Gelimer at Grassa, 73 km from Carthage, and of Thrasamund at Alianae, a suburb of Carthage, where he constructed a much-lauded new bath-house, were all *villae maritimae*.[17] The poems sometime mention constructional details, such as peristyles, porticoes (one allegedly gilded), a *salutatorium* (reception hall, in a villa at Anclae), even a private amphitheater; references to marble and statues are commonplace.[18] Nor were such grand rural residences confined to the Vandal royalty: Hoageis and Fridamal are among the high-ranking officials who also possessed country villas of elegance.[19] Even allowing for literary hyperbole, villa culture was clearly flourishing, at any rate in the hinterland of Carthage, well into the sixth century.

Another pointer to estate ownership and its location is provided by epigraphy. Plentiful inscriptions all over the African provinces refer to estates, variously called *praedium, saltus* or *fundus*, their appellations often enshrining the names of *domini*, past or present. Inscriptions by themselves, however, do not indicate whether the landowner was absent or actually had a high-status villa on the property for occasional visits or longer stays. When detailed fieldwork has attempted to discover more about a specific named estate, an elite villa has generally been elusive. Research was carried out in the 1970s in the north of

Tunisia, for example, in and around the *fundus Aufidienus*, which Peyras[20] suggested covered some 1600 ha – although defining property boundaries is always difficult, and this figure cannot be taken as certain. A dozen farms and three villages were detected within it, and although some Roman-period capitals were reused in modern buildings, there was no sign of any major residential villa. The same conclusion emerges from similar examples across North Africa: When detailed fieldwork on a named estate has been carried out, landowner absenteeism appears to have been the norm.[21]

In a very few cases, inscriptions or road handbooks record a place-name as a villa. One is Villa Magna Variana, on an inscription from an imperial estate in the Bagradas valley;[22] another is listed in the Antonine Itinerary, an early third-century road-book later revised, as "Villa Magna, Villa Privata" in western Tripolitania. The latter sounds like a place that wanted to emphasize that it was not an imperial estate, at least not originally; but an inscription from a bath-house at this site (which on the ground looks like a typical small village settlement) states clearly that the construction, carried out by the provincial governor's office, was for public use.[23] The Antonine Itinerary also lists Casae and Megras (or Megradis) on the Gabes–Lepcis Magna road, each of which is named also as Villa Aniciorum (one west of Sabratha, the other east of Tripoli), while a third site is labeled "Minna, villa of Marsus," 29 miles west of Lepcis.[24] Presumably, in each case a villa became in time the center of an expanded settlement with facilities such as accommodation and stabling, and, being situated on or close to a major highway, they were listed for the benefit of travelers using official handbooks. All three remain to be identified on the ground. Might the latter have originally been the property of C. Servilius Marsus, whose name-stamps occur on third-century Tripolitanian oil amphorae, and who is known from an inscription at Lepcis Magna to have been the "official overseer of the region of Tripolitania"?[25] Might the villas of the Anicii have belonged to the family of Q. Anicius Faustus, builder of the fort at Bu Ngem in 200/201 CE as legate of the Third Legion, and patron of Lambaesis, Timgad, Constantine and Djemila?[26]

Future fieldwork and excavation might one day pro-
vide answers.

One category of inscription, the funerary epitaph
still *in situ* on a rural mausoleum, raises the further
question about whether each indicates the likely
location of a wealthy rural villa. Caution is necessary,
however. Surviving tombs unambiguously attached
to simple farms show that even people who made
a modest living set high store on leaving for posterity
prominent grave-memorials in the landscape. A pair
of tombs alongside a small olive farm at Wadi el-
Amud in Tripolitania (erected for Imrar and his wife
Zut, and for Nimran son of Mashukkasan) is
a salutary reminder that impressive grave markers
are not necessarily *per se* indicators of high status.[27]
What about tombs where the accompanying inscrip-
tion, detailing the career and social standing of the
deceased, suggests higher status? Do they indicate the
presence of an elite villa nearby on their estate, as is
sometimes claimed?[28] Or did such people merely
wish to be buried on their property even if in life
they had spent little time there? Let one example
suffice to highlight the problem. Standing alone in
fields 4 km north of Tiddis in eastern Algeria is
a circular mausoleum, an unusual shape in
a Romano-African context, and one surely influ-
enced by the great circular mausolea of imperial
Rome (Figure 16.1).[29] It was built by and for
Q. Lollius Urbicus, a local-boy-made-good from
the backwoods, the tiny nearby town of Tiddis (a
place with a forum so small there is not even room for

a portico); he rose to be Prefect of the City of Rome
under Antoninus Pius, as the inscription on his
African tomb, repeated four times at the points of
the compass, proudly proclaims. His estate must have
lain all around. But did he ever build a comfortable
villa there to enjoy a little *otium* whenever he went
back to his home town? Or did he merely choose to
be buried in splendid isolation in a dramatic land-
scape of rolling hills on land where he had never
resided? In the absence of detailed fieldwork, we
simply do not know.

FIELD-SURVEY EVIDENCE

That parts of rural North Africa were densely settled
in Roman times has been known since the earliest
pioneering archaeological research in the nineteenth
century. Numerous "ruines romaines" were noted in
the landscape and their positions mapped by the
Brigades Topographiques of the French colonial admin-
istrators, but these men were soldiers, not archaeol-
ogists, and very little in detail can be said about each
on the basis of their reports.[30] Only after intensive
surveys in a number of areas during more recent years
has that situation begun to change. How many "vil-
las," in the sense defined above, have been revealed
by this work?

The first research of this kind was conducted by
Philippe Leveau in the hinterland of Iol-Caesarea
(Cherchel) in Mauretania: he surveyed an area
about 30 km east–west and some 20 km inland
from the coast.[31] Leveau detected three principal
types of site – the isolated "villa," the rural agglom-
eration based on a central "villa," and the indepen-
dent village. There was virtually no sign of pre-
Roman rural settlement, and it was only c. 50 CE
that the territory of Cherchel saw the first substantial
rural buildings. Sites were not confined to the coastal
plain but extended into hilly regions as well,
although the density of "villas" gets less the further
the distance from the city. Olive cultivation is
attested by numerous weight-stones from presses.
Some of the bigger sites may have been abandoned
in the fourth century, but the evidence is inconclu-
sive; there was no major rural decline, and Cherchel

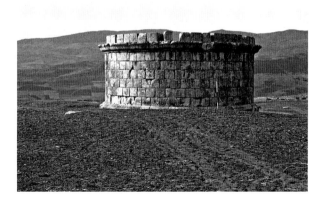

Figure 16.1. Tiddis (nearby), the tomb of Lollius Urbicus
(photo: author).

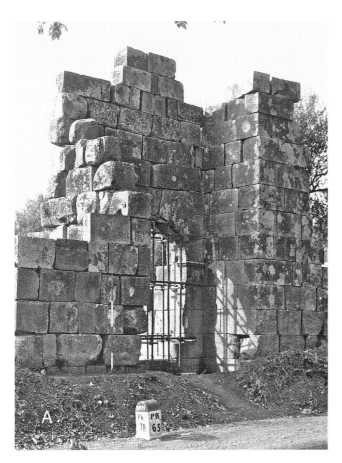

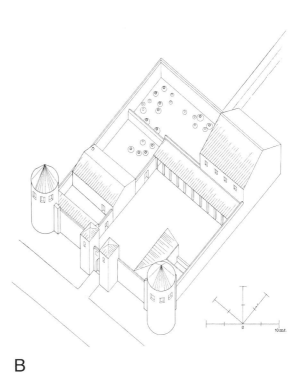

Figure 16.2. Nador: A: the main entrance; B: suggested reconstruction of the farm of M. Cincius Hilarianus (A: photo: author; B: after Anselmino et al. 1989, fig. 49).

itself was certainly flourishing then. Significantly, however, in the entire survey area, not a single site yielded evidence for a bath-suite, and reports of capitals and column drums (indicating possible peristyles) are extremely few.[32] Only Trois Ilôts, on the sea east of Cherchel, produced any evidence of mosaics,[33] and even here the existence of a surrounding village raises questions as to whether this site is an *agglomération rurale* and not a villa.[34] The elaborate cruciform shape of the basin in the central peristyle, however,[35] is more appropriate to a villa than to a building in an agricultural village, and Trois Ilôts was probably a *villa maritima* which in time became the center of a large rural estate, including eventually a small church. Such doubts about the exact status of rural sites are commonplace in North Africa, and can only be resolved by further research into the different phases of site development.

Another "villa" in the same area, Nador, on the road between Cherchel and Tipasa, provides another vivid illustration of the problems of site classification.[36] This has an imposing façade built in large-block masonry with a "fortified" central gateway and corner towers. An inscription still *in situ* declares that the estate (*praedia*) belonged to M. Cincius Hilarianus, priest of the emperor cult for life (*flamen Augusti perpetuus*) and his wife (Figure 16.2). As a result, Nador was once regarded as a rare survival in North Africa of the "fortified" rural villa depicted on mosaics, discussed in this chapter (pp. 273–6). Yet the grandiose façade is no more than that (the "defenses" do not continue for the rest of the perimeter), and excavation behind it has revealed utilitarian structures, including stores, cisterns, presses and an oven, arranged around a central yard. Residential quarters here amount to no more than a tiny steward's apartment to the left of

the entrance, and some further rooms to the right. M. Cincius Hilarianus is unlikely to have spent a single night there.[37] The visible site at Nador, erected c. 325/350 CE on the ruins of an earlier building, was no luxurious fortified villa but a rural farm, which happened to have been given, by its self-important, non-residential owner, a pretentious mock-military façade, designed solely to impress the passing traveler.[38]

The vast majority of "villas" in the Cherchel hinterland similarly lack any evidence of decent residential quarters. They are often substantially built and represent considerable investment by a landowner anxious to maximize agricultural efficiency; and the materials sometimes used, in particular large-block construction and good-quality rubble aggregate, in building platforms, rural temples and monumental tombs, are indicative of both the wealth and the level of architectural sophistication displayed by the Cherchel urban elite who built them. But very few of these sites were even part-time residences for the landowner. We may assume that the families living in them were either direct employees or tenant farmers, although assessing the social status of occupants (whether slave, tenant or free) on the basis of surface evidence is problematical, and guessing legal relationships between one rural site and another even riskier.[39] Leveau, for example, envisaged a distinction in the Cherchel hinterland between the "Roman" based on "villas" within easy proximity of the city, and the "African" elsewhere, especially in the more mountainous interior; yet the distinction between sites here has more to do with the level of investment provided by each owner than with the social level of the occupant. There was the occasional well-appointed villa, such as the likely *villa maritima* at Trois Îlots, where a member of the wealthy elite periodically resided; but the overwhelming impression gained from Leveau's work is that the local land-owning aristocracy of Caesarea continued to reside permanently in their spacious, comfortable town-houses down into late antiquity.

Similar conclusions can be drawn from other survey work. In the Sebou valley of central Morocco, north of Volubilis and east of Thamusida, systematic field-walking has discovered some 250 farms at intervals of between 500 m and 1 km.[40] Here, too, there was rapid development of the rural landscape during the first century CE and great prosperity in the second century, based in part on oil. Again, there is little sign that any of these sites served as elite country residences; and exactly the same conclusion was drawn from another survey, conducted further south around Volubilis.[41]

Tunisia has been more intensively studied. A survey carried out (largely in the 1990s) centering on the town of Dougga (Thugga), identified 186 farms within an area of 150 km²; in addition twelve villages were detected.[42] One may have been a villa, since it appears to possess a three-apsed dining room of familiar late Roman type; but apart from a couple of cisterns little else is known about this site, and other interpretations are possible.[43] Evidence for bath-houses appears to be absent throughout the survey area, and only two sites, with considerable quantities of mosaic tesserae and in one case a floor of marble, might have some claim to be considered elite villas; but the evidence is far from certain.[44]

Also of great interest is the survey work in south-west Tunisia near Kasserine (Cillium).[45] This is semi-arid landscape, now largely deserted; but upstanding remains of presses show that the whole Kasserine-Thelepte-Sbeitla region was intensively planted with olive trees in Roman times. As elsewhere, a hierarchy of sites was revealed: large agricultural villages, small rural agglomerations, isolated farms with one or two presses (the most common) and tiny one- or two-roomed structures. Settled agriculture began c. 100 CE, soon after the foundation of Cillium. There are, however, no signs of villas in the sense defined above (pp. 267–8), and even though a bath-house with mosaic was located at one of the smaller villages, the structure is tiny, hardly suggestive of a wealthy owner.[46] What is found, however, in this landscape are monumental tombs. One at Henchir Hamouda, 7 km south-east of Kasserine, was built for Q. Gellius Secundus, son of Quintus, of the Papiria voting tribe, who had held the chief magistracy, the duumvirate, presumably at Cillium.

Another is that of C. Iulius Dexter, who, after a military career, served as *duumvir* at Thelepte, but who chose to be buried in the mausoleum he erected over 30 km west of his home town. It was to such people, members of the local elites here and at Cillium, that the vast majority of the territory surveyed surely belonged; but in the absence of any reports of comfortable residential villas in this entire region, Q. Gellius Secundus and C. Iulius Dexter were presumably absentee landowners who preferred to be buried in isolated splendor on their rural estates rather than in a communal urban necropolis, even though they had apparently not chosen to reside in the countryside in their lifetimes.[47]

The conclusion that substantial residential villas were not a regular part of the landscapes around Cherchel, Volubilis, Kasserine and Dougga does not apply all over North Africa. Another survey, for example, of 400 km² in the Oued R'mel basin around Segermes, 60 km south of Carthage, has shown that of 106 habitation sites located, six, covering an area of between 1500 m² and 3000 m², produced evidence for baths and/or mosaic floors. These are assumed to have been elite villas: all are larger than simple farms (which lack both baths and mosaics), and more affluent than larger settlements interpreted as villages.[48] One of the best defined is Kasr Soudane, with imposing bath-house and well-preserved temple-tomb with marble columns.[49] Even if all six were occupied simultaneously, however, we cannot assume that land-ownership in the entire valley was dominated by just six *domini*[50] – how many other landowners at Segermes preferred to reside permanently in town-houses, whether in the small urban center there, or further afield? Once again defining the legal relationships in land ownership is impossible to establish through archaeology alone. In any case, that all six sites were indeed residential villas awaits the confirmation of the spade, although future geophysical research might also contribute to resolving problems of site classification.

Preliminary conclusions are also available for another survey, which sampled about 12 percent of Djerba, an island of 568 km².[51] "Villas" were defined as sites over 2500 m² with evidence for architectural

elaboration, usually on Djerba visible as large tells rising up to 3 m above the surrounding landscape. They were distinguishable from larger sites, "villages" over a hectare in size, the debris of which generally did not form a tell. The distinction between "farm" (normally smaller) and elite "villa" is, however, sometimes difficult to make from surface evidence alone. At a "villa"-site, north of Meninx, for example, geophysical survey showed a rectangular building c. 26 m by 46 m, with rooms on all four sides of an open yard; of interest is its apparently early date (second century BCE).[52] There were no signs of architectural refinement; instead kilns were detectable immediately north and south of the building, which might suggest that the site was a ceramics production-center, not a luxury villa. There are certainly examples of the latter on Djerba by the early Empire, some with mosaics, others with their own mausolea. The scale of construction work (including baths and cisterns) intensified during the middle empire (second/third century); one site with a huge bath-building and cistern complex, only 1 km north of the town of Meninx, was presumably a *villa suburbana*.[53] The numbers of villas occupied in the middle Empire declined by comparison with the early Empire, but remained steady during the late Empire before tailing off drastically in the sixth century. Their greatest concentration was on the southeastern side of the island.

DEPICTIONS OF VILLAS ON MOSAIC PAVEMENTS

Villas first appear on African mosaics[54] as background props, such as on two floors from El Alia on the east coast of Tunisia of c. 125/50 CE,[55] and they continue to appear spasmodically into early Byzantine times. Some accompany marine scenes, usually at the top of the composition, and are clearly meant to represent *villae maritimae*. They are generally single-story buildings with towers on either side and porticoes between (such as several from Carthage: Figure 16.3).[56] Others accompany scenes of everyday life, like the hunting pavements at Aïn Tounga (Tunisia) in the third century, Constantine (Algeria)

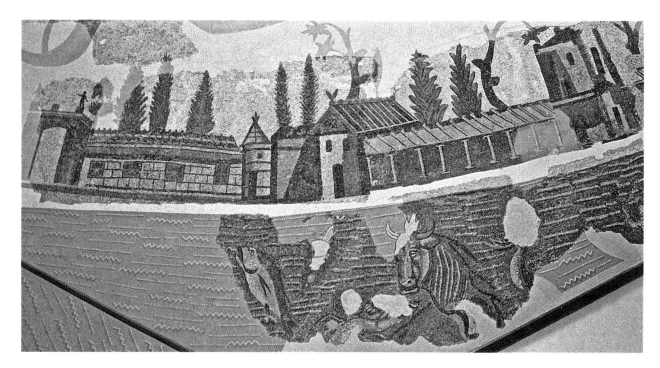

Figure 16.3. Carthage, the Great Marine mosaic, detail: *villa maritima* (Tunis, Musée du Bardo) (photo: author).

in the fourth, and Djemila (Algeria) and Carthage in the fifth and sixth (Figure 16.4).[57] Others again show other scenes of life on the farm, such as the famous *Dominus Julius* mosaic at Carthage of c. 400 CE (Figure 16.5).[58] The interpretation of all these is problematical. Are they stock designs taken from copybooks, symbolic images representing rural life in a generalized way, even ones imbued with elements of idyllic fantasy? Or are they accurate representations of the owners' country estates, and therefore *prima facie* evidence for the physical appearance of villas in the African countryside?

Rural structures appear in landscapes from Hellenistic times, and again in numerous paintings of the first century BCE/CE from Pompeii, Herculaneum and Stabiae, as well as in Rome (the "Farnesina" House, and the "House of Livia" on the Palatine hill in Rome). Some of these structures appear in "sacro-idyllic" landscapes, others as scene-setting elements in depictions of everyday life, of the type pioneered during the age of Augustus.[59] By the mid-first century CE, depiction of seaside villas had become a genre in its own right, and the extent to which these are fantasy villas or real depictions of

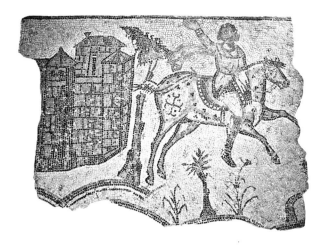

Figure 16.4. Carthage, mosaic detail: a Vandal lord leaves his villa for the hunt (London, British Museum) (photo: author).

Campanian *villae maritimae* has been much debated.[60] The earliest African examples show the same elements – sacro-idyllic rural "shrines" in one of the El Alia pavements, simple background villas in *emblemata* from the villa at Zliten.[61] A third-century mosaic showing fifteen Mediterranean islands from Haidra (Ammaedara) in Tunisia, however, is

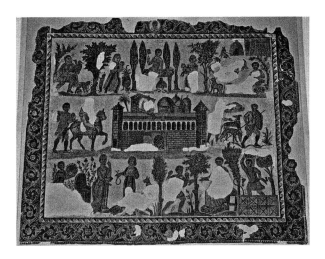

Figure 16.5. Carthage, the so-called *Dominus Julius* mosaic (Tunis, Musée du Bardo) (photo: author).

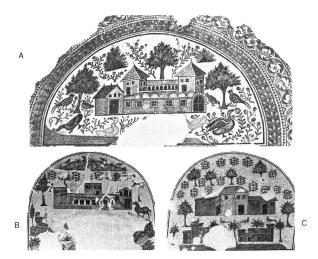

Figure 16.6. Tabarka, *villa suburbana*, mosaic of the three-apsed dining room: (A) central apse depicting a residential villa; (B) and (C) side apses, showing adjunct buildings (photo: author).

a warning against interpreting such images too literally.[62] On each of the twelve surviving islands are stock copybook varieties of *villae maritimae* bearing little relation to historical accuracy, all paralleled on other African mosaics – straight-sided villas with towers at the corners and at intervals along a columned façade (I); a curvilinear version of the same (II); villas with additional wings branching off at angles (III); and square enclosures with towers on all four sides (IV).[63]

The most striking of such villa representations in Africa is the so-called *Dominus Julius* mosaic from a house in Carthage, probably laid around 400 CE (Figure 16.5).[64] The floor has an autobiographical touch, featuring the *dominus* (at bottom right, seated) and the *domina* (at bottom left, and again in the top register) being handed estate produce or other gifts by their attendants or tenants. Scenes around include olive-gathering, the shepherd with his flocks, and the *dominus* setting off for the hunt. At the center, dominating the composition, is the owner's rural villa, shown as the nerve-center of a productive estate and so a symbol of his wealth. The imposing façade consists of a plain wall with central door and continuous arcading (forming a loggia) above, with polygonal towers at either corner. Behind are the villa's baths – domed chambers with smoke from the hypocausts shown escaping from their roofs. The mosaic decorated a room with a semicircular fountain.[65]

The architecture shown here is more impressive than on most other African villa-mosaics: the arcaded loggia, for example, recalls the south façade of Diocletian's palace at Split in Dalmatia.[66] Does, however, this example, and others like it, reflect a real villa built in the African landscape, or is it merely a stock "late-Roman-villa image" taken from pattern-books?

Several scholars argue that these are indeed faithful representations of real buildings, and have reconstructed their appearance on the basis of the mosaic "evidence," believing that the "fortified villa" had indeed a real presence in rural Africa.[67] The paucity of excavated villas with more or less complete ground-plans neither confirms nor denies such speculation. Leaving out the mock façade at Nador, which fronted a simple farm (pp. 271–2),[68] only two excavated examples in Africa conform to the architectural type of columnar portico or arcading between corner towers – the seaside villa west of Lepcis Magna known as the Villa of the Maritime Odeon (p. 288), and that at El Alia on the east coast of Tunisia (pp. 280–1). Such villas are in fact more common in central and north-western Europe, with only a few Mediterranean examples so far known, such as Casignana in the toe of Italy and Mlet off the Croatian coast.[69] Although more

examples might one day turn up in North Africa, we cannot at present use villa images on mosaics as evidence to prove their widespread existence there.

Finally, there are two examples of villa buildings depicted on mosaic pavements that do come without question from rural villas, not town houses. One, at Oued Athménia in Algeria, will be discussed on p. 279. Another comes from the three-apsed dining-room of an actual villa (c. 400 CE) near Tabarka in northern Tunisia, where each of the apses showed a different type of building (p. 281).[70] In this case one might argue that all the mosaicist had to do was to create images based on what he saw around him; so here at least we might have confidence that the mosaic depicts what was actually to be found on that estate. Is such a literal approach, however, a misleading modern construct? In antiquity, mosaicists would have stuck to a stock repertory of images unless instructed otherwise. The owner is likely to have wanted on the dining-room floor only generic representations of estate buildings that suggested his or her considerable status and wealth: factual accuracy is unlikely to have been a major concern. The main villa depicted in the central apse at Tabarka, for example, shows multiple domes along the front wall, probably a garbled interpretation of bath-suite roofs converted here into a purely decorative device (Figure 16.6a).[71] The side apses show simpler buildings for variety, but attempts to give them specific functions are probably misguided (Figure 16.6b–c).[72]

These villa images are not unique to North Africa. It is significant that, when they do appear, the type shown is almost invariably that with corner towers, as on a mosaic from Arróniz in Spain now in Madrid, or, in silverware, on the rim of the great Sevso silver hunt plate now in Budapest of the second half of the fourth century.[73] The iconic image was, in other words, a visual shorthand, used not just in North Africa but elsewhere, to denote the wealth and power of the rural *dominus*.[74] As evidence for what Romano-African villas looked like on the ground, they are best left to one side.

EXCAVATED VILLAS

Countless mosaic pavements were recorded during the nineteenth and early twentieth centuries and duly listed in the *Inventaire des Mosaiques de l'Afrique*.[75] Most were found in towns, but the many discovered in rural locations might potentially indicate the location of wealthy villas. About most, however, we know nothing more than that mosaics were found; details were rarely recorded of the settlement around them. Caution is therefore needed before accepting them as coming from putative villas. Another type of settlement in the African countryside, the agricultural village, is likely to have had a bath-house (or two), the social club of its day; and a well-appointed bath-house was often paved in mosaic. One found thirty years ago at Batten Zammour, for example, 25 km east of Gabes in southern Tunisia, had two figured pavements, one showing athletic games, the other Venus in a marine setting (a popular theme in bath-houses).[76] The settlement around the bath-house, although not studied in detail, was probably an agricultural village.[77] Not all mosaics from rural locations came from villas.[78]

Bath-houses pose problems of a different kind. In both village and villa they were often detached buildings, often easily recognizable on the surface from fragmentary box flue-tiles from the walls or *pilae* bricks from hypocausts. Yet isolated bath-houses *per se* do not make sense: their *raison d'être* is that they served a community, whether a villa-owner and his family, or the inhabitants of a village. Many isolated bath-houses are known in the African countryside, but without contextualization not much can be said about them. In a recent survey of coastline archaeology in Tunisia, for example, several bath-houses were duly recorded, right beside the sea.[79] Some may have belonged to *villae maritimae* of which no other trace is currently visible; only future geophysical survey and/or excavation might one day tell us more.

A summary of what is known about excavated villas in North Africa follows. The information is too fragmentary for a coherent chronological account of their development, so they will be presented by

geographical region, from west to east. Just a single "luxury" villa is known in Morocco (Mauretania Tingitana), on the tiny offshore island of Mogador.[80] Situated on a cliff-top close to a harbor, the much eroded remains of a *villa maritima* were excavated in the 1960s.[81] The building spread along 100 m of coastline, of which about twenty rooms were partly excavated, as well as a cistern and a small basin. One room was decorated with a rudimentary mosaic of peacocks. The excavator thought that the villa was constructed at the time of Juba II in the first century BCE, and occupied into late antiquity, but many of the finds may relate to other activity on the islet,[82] which was famed for its production of purple dye from the murex shell. Doubtless it was from the profits of this industry that the seaside villa was built, but more work is needed to bring this site into sharper focus.

1. Algeria

Apart from the possible *villa maritima* at Trois Îlots near Cherchel (p. 271), a handful of villas elsewhere in Algeria have been partially excavated. At Aïn Sarb near Tiaret, south of Algiers, three rooms and part of a fourth, with clay floors apart from one of *opus signinum*, were excavated on the west side of a small peristyle court with limestone columns.[83] Molded stucco fragments with dentils and floral and geometric designs hint at a modest level of comfort. The villa was thought to belong to as early as the first century BCE, on uncertain stylistic grounds (that of the only capital found), but pottery suggested occupation into the fourth century CE. The excavated part of the villa covered barely 15x12 m.

The other Algerian villa-sites are all nineteenth-century discoveries. By far the most significant is that at Oued Athménia, 32 km southwest of Constantine (Cirta) and close to the major road to Sétif (Sitifis).[84] Here a richly decorated bath-house was excavated between 1875 and 1878, some 30 x 40 m and containing twenty rooms (Figure 16.7);[85] it probably dates to c. 400 CE.[86] An entrance on the north-west side of the

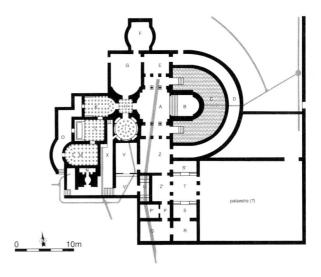

Figure 16.7. Oued-Athménia, villa, plan of the baths of Pompeianus (after Gsell 1901b, 24, fig. 88, redrawn by M.D. Öz).

building gave access to an apsed *apodyterium* (G), off the north side of which opened a small room of uncertain purpose (F).[87] The bather then passed from the *apodyterium* into a small heated vestibule (H), from which there was a choice of rooms. A circular, dry-heated *laconicum* opened off the vestibule's south side (I), with four shallow wall-recesses for benches; this room had its own separate furnace, stoked from service corridor X. Alternatively, the bather could turn west into a standard set of moist-heat rooms, first into an apsed *tepidarium* (K), and then through another heated room (L, with warm-water pool on one side) into the *caldarium* (M), heated by an elaborate furnace area (N). After retracing steps to the vestibule (H), the bather entered a spacious *frigidarium* (A),[88] divided into three bays by a pair of columns on either side. In the center of its east side was a cold-water immersion pool (B), reached by steps; the pool was itself embraced on three sides by a large swimming pool (*natatio*: C) which, highly unusually, was horseshoe-shaped, entered from the *frigidarium* also via steps on the latter's east side. Swimmers could be watched from a semicircular corridor around the outside of the *natatio* (D), presumably through windows in, or between columns set on, the wall dividing the two. Z was a transitional room from which the south-east side of the baths could be reached. Except for U, a four-seater

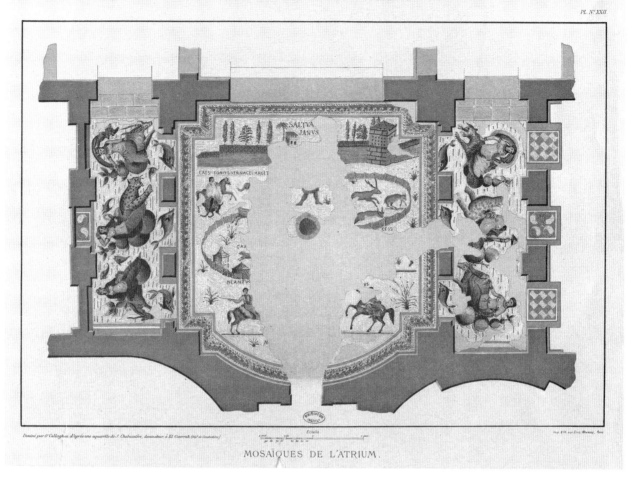

SOCIÉTÉ ARCHÉOLOGIQUE DE CONSTANTINE

BAINS DE POMPEIANUS À L'OUED-ATHMENIA.

MOSAÏQUES DE L'ATRIUM.

Figure 16.8. Oued-Athménia, villa, *frigidarium* mosaic, nineteenth-century lithograph after the watercolor of Jules Chabassière (Paris, Bibliothèque nationale). (A black and white version of this figure will appear in some formats. For the color version, please refer to the plate section).

latrine, the function of other rooms here is uncertain: only P, Q and R were not mosaic-paved.[89] T had a broad triple-opening leading to the court beyond, presumably a *palaestra*, with a marble statue-base in the center. As villa baths go, this was a facility for private bathing on the grand scale.

Marble was used for thresholds and columns, and as wall revetment in some rooms; the remainder were frescoed. Molded stuccowork was also recorded, as well as fragments of Corinthian capitals. A dozen chambers were provided with geometric mosaic floors; a further three (the *frigidarium*, the second *tepidarium* and the *caldarium*) had figured compositions. These were carefully recorded by Jules

Chabassière, but a plan to lift the mosaics at the time of discovery fell through, and by the time the site was investigated again, in the 1920s, they had already suffered substantial damage. All are now presumed lost: Chabassière's illustrations therefore constitute a precious record.[90]

The central panel of the *frigidarium* mosaic (Figure 16.8) shows huntsmen on foot or horseback driving deer into nets. The estate is bordered by a simple masonry wall, with a large tower to one side where it changes direction, and a smaller tower, damaged, toward the center. The latter is identified as the *saltua[rius?] janus*, "the entrance gateway of the estate."[91] The rectangular side panels each depict

competitive racing in the circus, whether locally or further afield. The top half of the composition, in two separate registers, shows where the *dominus* lived, and in between he gives his name, Pompeianus. The upper register shows the estate boundary wall again, with towers at intervals; a grandiose gatehouse stands at the center with engaged columns on either side of the entrance, and a domed roof. The second register shows an articulated two-story building with single door at ground level and many windows on the upper floor.[94] Palm trees and other shrubs are seen in the background of both registers. How far was this a faithful reflection of the appearance of Pompeianus' actual villa?[95] If the bath-house was completed after the main house, the mosaicist could (in theory) have created on this floor some approximation of what he saw around him – if so instructed by his client. Much more important to the landowner, however, would have been the clarity of the message conveyed – that Pompeianus was a man of wealth and substance, reflected in the size and architectural grandeur of his rural estate.

The villa itself, on a level spur 100 m west of the baths, was partially explored in 1856–7 when columns and capitals were extracted; but the work was never published, and nothing else is known about it.[96] Later, in the 1950s, one of the estate's dependencies was unearthed: a vast building 70 m² with rooms arranged around a central court 52 m², which also lay 100 m west of the baths.[97] On one side, a long room was divided longitudinally into two by a series of stone troughs (over forty in all), which served as mangers: this was clearly Pompeianus' stables. Part of another wing provided accommodation for the stable lads; the two remaining sides were not fully explored. A structure in the vicinity, at a place called Kharba ("ruins" in Arabic), also c. 400 CE, had two olive presses, as well as more stone basins (also animal mangers?), and a tiny bath-suite – a very slightly up-market farm (which are rarely provided with baths, even small ones).[98] This may, however, have had no connection with Pompeianus' estate.[99]

Few villas are known elsewhere in Algeria. Individual finds of mosaics suggest probable villas at (for example) Aïn Témouchent, 8 km east of Sétif,

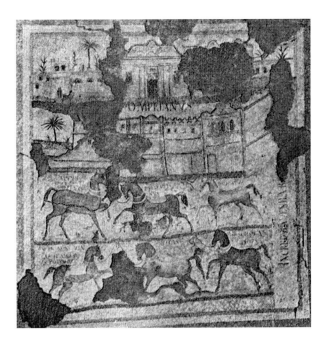

Figure 16.9. Oued-Athménia, villa, *caldarium* mosaic, nineteenth-century lithograph (from L'Afrique du nord illustrée, 18 Jan. 1908, 4).

three nereids riding marine creatures. In the second *tepidarium* the emphasis was again on the hugely popular pastime of hunting, with more deer being driven into a net. The scene is labeled as a *saeptum venationis*, "the game preserve," apparently a permanent feature of the estate.[92] In an upper register, a garden scene is shown, with the *domina* seated by a tree and fanned by an attendant. Alongside, two flimsy structures are named, enigmatically, as "the herdsman's place" (*pecuari(i) locus*), and "Philosophus' (?) place" (*Filosofilo locus*), references, it seems, to estate retainers in a rare acknowldgment by a landowner (in commemorating them through such a permanent medium) of his debt to his employees.[93]

Finally, in the *caldarium*, is another mosaic that provides insight into the *dominus*' personality and passions (Figure 16.9). The lower half shows six prancing racehorses in lively agitation. No doubt the *dominus*' pride and joy, they are all named, in two cases with added comment: "Altus ('the tall one'), you are the one and only: you leap like a mountain"; and "Polydoxus, win or lose, let's love you (anyway)." It is clear that horses were being trained (and probably bred) on the estate for

and El Akbia near El Milia, some 50 km north-west of Constantine – both isolated sites located well away from urban settlements.[100] By contrast, a rural building 2 km north of Aumale, the ancient Auzia, which produced a mosaic of Leda and the Swan, and another 1 km south of Constantine (Cirta), both very close to major towns, are likely to have been *villae suburbanae*.[101] The latter yielded a very large mosaic (8.35 x 7.15 m) of c. 325/50 CE now in the Louvre, with a central panel featuring Neptune and Amphitrite; it must have decorated a grand reception room in the villa.[102] Half a dozen rooms of this building, one with an apse, were recorded in 1845, and a plan made; an elaborate fountain-*nymphaeum* lay close by. As often happened, however, work was suspended before the full extent of the villa was revealed.

A *villa maritima* (but also *suburbana*) lay close to Rusicade (mod. Skikda), a major town on the north coast.[103] It lay to the north-west on the road to Stora, picturesquely perched on a rocky cliff above the sea. Part of the villa was built on vaulted substructures because of the uneven terrain. Its central hall, 6 m by 4.50 m, was floored with geometric mosaic. A stoke-hole suggests a bath-suite was located to one side; there were four barrel-vaulted cisterns for water storage. The site was first recorded in 1850, but much had already disappeared when Gsell visited it sixty years later; today it has completely disappeared.

Our last Algerian villa, Kaoua, is an enigma. Stéphane Gsell, the great historian of Roman North Africa, called it a *castellum*; most recent scholars classify it as a (fortified) villa.[104] Built on a hill-top overlooking the Oued Sensig, in the Relizane area east of Oran (Figure 16.10), its large-block, rusticated masonry gives it an air of solidity and permanence; a century ago it stood up to 9 m high. Each voussoir in its arched entrance (1), on the south, was sculpted in low relief, and the keystone was inscribed (within a wreath) "[Have] faith in God, Ferianus! Amen!" – presumably an exhortation to the owner whenever he entered his property.[105] The plan is cruciform, with rooms on all four sides of a central rectangular peristyle (2); two cisterns for collecting rainwater lay below. A staircase near the entrance shows that at least the front part of the structure had an upper story. The two largest rooms on

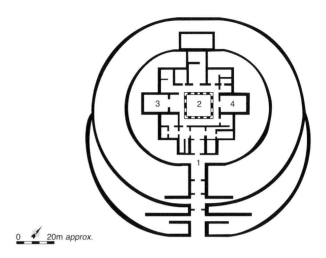

0 4 20m *approx.*

Figure 16.10. Kaoua, villa, plan (after Leveau, Sillières and Vallat 1993, 168, fig. 27, redrawn by M.D. Öz).

the ground floor (3–4), presumably the main reception room and the dining room, were symmetrically arranged either side of the central court. The lintel at the entrance to the eastern one had a crude carving showing an armed huntsman, a dog and a gazelle: like so many of the elite in late antiquity, Ferianus liked hunting. These large rooms, the peristyle with its octagonal columns, engaged columns in the entrance vestibule, and architectural details like capitals, all suggest that Kaoua qualifies as a "villa" (p. 268); but there was, it seems, no bath-suite, nor mosaic or marble floors. Its Christian association and the style of sculptured decoration make a date before the late fourth century improbable; it may be much later (sixth century?), perhaps the stronghold of a local warlord in unsettled times. Certainly the double perimeter of defenses around the villa is eloquent testimony that it was built at a time when rural security was compromised.

2. Tunisia

Very little is known in detail about Roman villas in Tunisia. Of the many found in the nineteenth and early twentieth centuries, we often know nothing beyond their existence, usually indicated by one or more mosaics.[106] Details are scarce, plans rare, and chronology or phasing non-existent. The *villa maritima* at El Alia, 24 km south of Mahdia near Cap

Caboudia, is one such example, investigated in 1898 and 1899.[107] Located on a cliff overlooking the sea, it consisted of a long, single-storey corridor, apparently horseshoe-shaped, with a square tower at each end.[108] Geometric mosaics were found in several rooms, including bedrooms, now lost without record. Two reception halls occupied symmetrical wings at either end of the building; it is not clear if these were the towered structures or were additional rooms. Each featured a mosaic with Nilotic scenes: one, a vast floor 6.20 m square, is now in the Musée de Sousse; fragments of the second, originally almost as large, are housed in the Musée du Bardo in Tunis.[109] Modern scholarship on stylistic grounds (the only chronological criterion we have) dates these to c. 125/50 CE. Interior décor elsewhere in the villa was reported as *de luxe*, with frescoes on the walls.

It was not the only villa on this beautiful stretch of coastline with its limpid waters. Another nearby, also at El Alia, has a rare example of a three-apsed dining-room (*triconchos*), one of only two known in African villas,[110] but popular elsewhere around the Mediterranean in aristocratic residences from c. 300 CE onwards.[111] A small bath-suite was situated adjacent to the dining area on the ground floor (convenient for guests if invited to bathe before dinner); but this villa was built on a split-level site, and most rooms (with geometric mosaics throughout) were situated on an upper level.[112] Substantial remains of fallen vault mosaics (one featuring a white gazelle on a red ground) were reported, as well as a fresco in the baths showing the Rape of Europa.[113] Further stretches of the Tunisian shore seem also to have been popular playgrounds for the wealthy elite, such as that around La Chebba, 12 km further south, where more *villae maritimae* are known;[114] but in all cases our knowledge of them is disappointingly meagre.

The only other African *triconchos* in a residential villa is that discovered in 1890, 1 km south-east of modern Tabarka, just east of the ancient town of Thabraca.[115] Parts of its foundations were still visible 125 years ago, when what was described as the "central core" of buildings produced fragments of columns and capitals. The grand dining-room lay to the north of this. Badly damaged hunting mosaics occupied its central chamber (c. 400 CE), off which opened three

Figure 16.11. Sfax (nearby), plan of the villa in the former property of M. Salah Ouarda (after Fendri 1963, plan II).

semicircular apses, each with depictions of villa buildings (p. 276). This *villa suburbana* may have been the center of a working agricultural estate, but that remains unconfirmed by archaeological evidence.

A more recent Tunisian discovery than any so far mentioned is an inland villa 7 km west of Sfax, where an area of about 31×19 m was excavated in 1953 (Figure 16.11).[116] All eleven rooms in the western part were paved in mosaic, seven with geometric and four with figured compositions. The large apsed reception room (1) had a mosaic with four figured panels containing animals and birds. Hercules drunk features as a mosaic tableau in 2, while a poet is surrounded by the Nine Muses in 3; they all date to c. 250/300.[117] A nearby chamber (4) was unusual in being heated, a rarity for living rooms in North Africa, especially so far south. The apsed hall had marble wall revetment; the rest were frescoed. To the east of 1 most rooms are much smaller, and two basins here (6: for collecting wine or oil?) suggest that this was a *pars rustica*, unusually integrated with the residential part; but the excavation was incomplete and the resulting plan fragmentary. Four years later, and 18 m further east, the villa's dining room, 8 m x 7.50 m, was found (5), identifiable from the layout of its mosaic (in a "U+T" arrangement).[118]. Cupids fishing and a large head of Oceanus occupy the main field. Much more of this villa, including a bath-suite, surely awaits discovery.

Few villa sites have been excavated in Tunisia in recent decades. A suburban villa of courtyard type, on the north-eastern fringes of Carthage, was

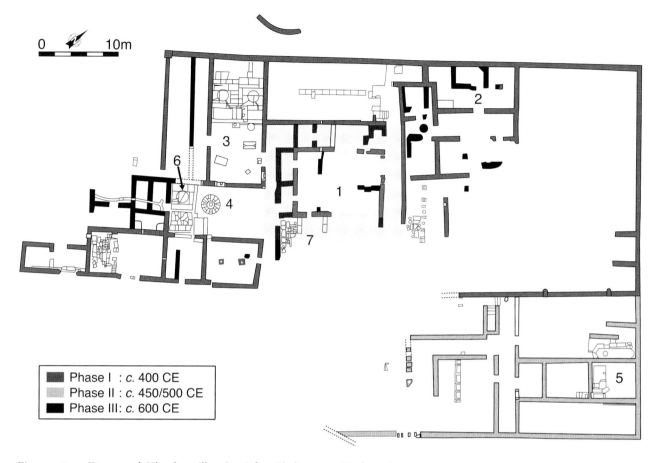

Figure 16.12. Demnet el-Khozba, villa, plan (after Ghalia 2005, 66, fig. 17).

built c. 400 CE but abandoned after a short life when the Theodosian city wall was erected close by c. 425 CE; fragmentary geometric mosaics and frescoes with floral themes were recorded. It then became a garbage dump; and later in the fifth century three vaulted rooms were used as a burial ground for some thirty individuals.[119] Of greater interest is the villa which lies 5 km east of Segermes, just outside the Danish 1980s survey area (p. 273): a hitherto unknown site, Demnet el-Khozba was discovered in 1997 and excavated in advance of flooding by an artificial lake.[120] It consisted of three parts – villa, baths, and temple-tomb. The villa, measuring some 78 m by 46 m, was built c. 400 CE. It had a central living area (*pars urbana*) arranged around all four sides of a peristyle court (1), with further rooms to the north, one of them (2) paved with geometric mosaic (Figure 16.12). To the south of the peristyle,

a double olive-press was installed in one room (3), and an olive-crusher in the yard outside (4). In the fifth-century expansion wine-processing facilities were added in a new group of rooms to the north-east (5), and a further olive press installed next to the olive-crusher (6). By the end of the sixth century, the villa was in decline, and although occupation continued in the seventh century, many of the rooms were by then subdivided and the peristyle corridor partitioned. A glassworks was installed (7), and oil production continued, but burials invaded the former *pars urbana*; final abandonment occurred c. 700 CE. The bath-house, also built c. 400 CE, lay 200 m to the north-east, and showed the common North African arrangement of *frigidarium*, two *tepidaria* and a *caldarium*;[121] all were paved in geometric mosaics in the same style as that in the villa. Nearby, an imposing third-century temple-tomb (15 x 6.62 m) was converted into a church in the

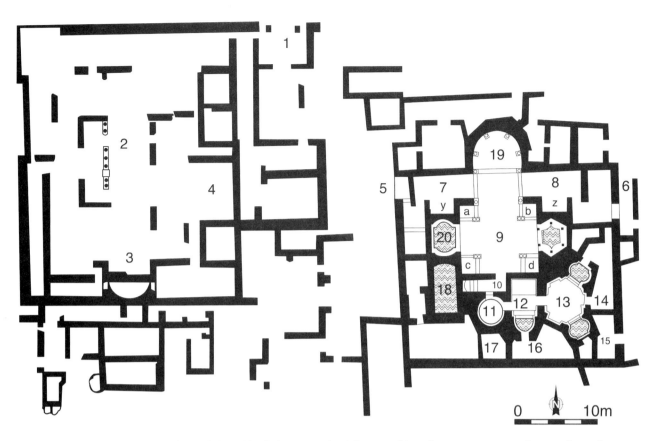

Figure 16.13. Sidi Ghrib, plan of villa (left) and bath-house (right) (after Ennabli and Neuru 1994, 209, fig. 1, redrawn by M. D. Öz).

fifth century, with contemporary burials around it. Whether the tomb stood alone or was associated with a hypothetical earlier villa here is unknown. Demnet el-Khozba is a rare example in North Africa of an excavated villa of modest size, with small living area furnished with mosaics, and rooms for agricultural processing close by, all integrated into what was essentially a single complex. Countless similar such examples surely await excavation across Africa Proconsularis.

Another recent Tunisian research project, at Demna–Wadi El Ksab on the tip of the Cap Bon peninsula, 7 km north of the Kelibia (ancient Clupea), is also of great interest.[122] Less is known of the early phases of settlement here (which started in the first century CE), but by the fourth century there was a substantial *villa maritima* and associated detached bath-house, with mosaic floors and marble wall veneer. In the fifth century a much larger settlement grew around it, based above all on fish processing, at a plant on the coast linked by a pebbled road to other buildings set slightly

inland. A church richly decorated with mosaics (including an elaborate baptismal immersion pool), as well as a substantial storehouse, were added at the same time. The site provides an interesting illustration of a process often suspected elsewhere in North Africa, but rarely seen with such clarity – how what started as a modest villa was later upgraded into a richer establishment, and then became the heart-beat of a still larger agricultural village for estate workers, with investment also being made in substantial store buildings, processing facilities and, as here, a lavish estate church.

By far the most comprehensive and intelligible example of a Roman villa in Tunisia is that at Sidi Ghrib, in the Mornaguia plain 35 km south-west of Carthage.[123] Discovered in 1975, the villa lies on a slight hillock not far from the Medjerda (the ancient Bagradas), the principal river-system of northern Tunisia. It consists of two parts, the villa proper to the west, and the bath-block alongside, which, unusually, is almost as big (both measure c. 30x25 m)

(Figure 16.13). Both are contemporary, built c. 400
CE on the basis of pottery found sealed beneath the
mosaics. There had been, however, a building on this
site since the first century, and by the third century it
was already a well-appointed villa with at least one
floor in mosaic and marble; stuccowork and column-
and capital-fragments also come from these earlier
phases. The villa of c. 400 CE was entered through
a vestibule on the north-east (1) and was arranged
around a small central court (2). The corridor round
the latter had a mosaic floor with a repeating pattern
of baskets decorated with ribbons. The principal
focus of the house was the apsed dining-room on
the south, on the central axis of the house (3), and
there was another large room on the east (4).
The mosaic of the dining-room was badly damaged
but showed horsemen pursuing wild asses (*onagrî*), at
least two of which have been lassoed; at the center,
one is quietly drinking from a (now-vanished) pool
beneath a palm tree.[124] Loose *tesserae* in other rooms
showed that most if not all had been floored with
mosaics, but the whole structure had been badly
damaged, first by Byzantine activity, and later by
modern settlement. There were associated buildings
to the south that included olive presses and a tank:
this was clearly a working farm as well as a luxurious
retreat. The villa perished in a fire c. 525 CE, and so
had an active life as a luxury residence (in its visible
form) of a little over a hundred years. In the sixth
century, a row of basins was placed in the court (left
of 2), and east of it parts of the villa were demolished
or walled up to make new rooms for storage and
other commercial activities.

The bath-house was better preserved. It had two
entrances, one from the main house (5), the other
from outside the complex (6), implying perhaps that
estate workers had access to bathing facilities when
they were not in use by the *dominus*. Rooms 7 and 8
probably served as *apodyteria*. The square *frigidarium*
(9), at the heart of the complex and its largest room,
was flanked by cold immersion baths, one rectangu-
lar with a shallow convex curve on each short side,
the other hexagonal with concave sides. A short cor-
ridor (10) gave access to a circular *tepidarium* (11),
which in turn led to a rectangular heated room (12),
with a warm-water pool installed in the south

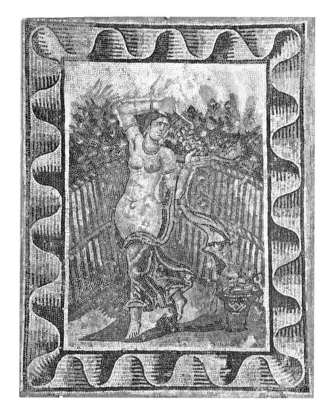

Figure 16.14. Sidi Ghrib, bath-house of the villa,
apodyterium: mosaic panel in alcove 9d showing a female
figure with a basket of flowers (Carthage Museum)
(photo: author).

apse.[125] The *caldarium* that follows (13) is hexagonal,
with separate hot-water immersion baths opening off
two sides.[126] The heated rooms were fired from four
stoke-holes, accessed from yards 14–17. A cistern
stored water at 18. The vaulted and domed roofs
used the hollow vaulting-tube technique widespread
in North Africa. The ever-changing room-shape is
typical of late Roman bath-house design, and the
presence of three heated steam-rooms is matched
also at Oued Athménia (p. 277); the dry-heat *laconi-
cum* facility present there is, however, missing at Sidi
Ghrib.

The baths were richly floored with mosaics, most
of them figured. The central part of the *frigidarium*
was dominated by a marine scene (as so often in
baths), with tritons and nereids riding fantastical
sea creatures arranged in registers; among them,
Neptune embraces Amymone at the top.[127]
Beyond them, in an apse decorated with columns
(19), Venus sits on a marine lion; a cupid with toilet-

box is in attendance. In each corner of the *frigidarium* (9a–d) are female figures unconnected with aquatic revels. Two are tipping out the contents of a basket of flowers, the other two are pouring water into a bowl; the action repeatedly takes place in a fenced yard beyond which blooms a garden in full flower (Figure 16.14). The figures have been interpreted as Seasons, but they lack normal attributes for them and so cannot be individually identified; they remain therefore enigmatic. The *caldarium* (13) featured a head of Oceanus set at the center of complex acanthus decoration.

Three aspects of the floors provide a personal touch. One of the *frigidarium* panels (east alcove of 9), badly damaged, appears to show figures on land in contrast to the rest of the composition, and one personification is labeled as Mount Gaurus, alluding to an area on the Bay of Naples where *vinum Gauranum* was a prized beverage.[128] This choice of imagery was probably not dictated by any personal links of the owner with Campania, but by his awareness and appreciation of the work of his near-contemporary, Q. Aurelius Symmachus, a powerful member of the aristocratic elite in Rome and distinguished man of letters, who mentions Gaurus in one of his poems.[129] By choosing a subject so obscure that it needed an identifying inscription, the *dominus* was displaying to his guests his up-to-date literary erudition. Second, on the riser of a step on the outside of cold immersion pool 20, a mosaic inscription reads "I did more than I could, less than I wanted. If you like it, it's everyone's; if you don't, it's ours. Just three words: to the wise (bather), the seat is brimful."[130] The end of the inscription is enigmatic: the "three words" may be an exhortation to take care. The owner clearly loved his baths, and self-deprecatingly admits that he would have liked to have lavished even more money on it.

A third personal touch comes in two alcoves of the changing area (7y and 8z), where separate panels portray the *dominus* and *domina*, each with a pair of attendants. Both are probably shown on their way to, or just arrived at, the baths: the owner has one assistant carrying bundles of firewood and a (water?) flask,[131] while the lady of the house (Figure 16.15), richly embellished with earrings, necklace and

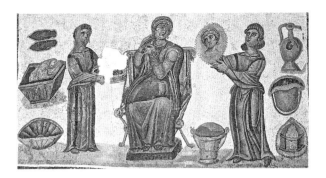

Figure 16.15. Sidi Ghrib, bath-house of the villa, *apodyterium*: mosaic panel in alcove 8z depicting the *domina* (Carthage Museum) (photo: author).

multiple bracelets, is surrounded by the paraphernalia of the baths, including a clothes chest, a wash basin, a bucket, a toilet casket and a water jug, all depicted as being of gold or silver.[132] Through such conspicuous visual imagery the *dominus* intended to convey to the viewer a powerful message of his family's high social status and considerable wealth.

3. Tripolitania

Wealthy villas in Tripolitania have been more fully studied than in Tunisia or Algeria. Careful recording over many decades in certain areas, such as the hinterland of Lepcis Magna south of the city, make it clear that whereas olive farms, sometimes with multiple presses, were commonplace inland, elite villas were not. The utilitarian appearance of olive farms is in stark contrast to the luxury of the rural sites along or near the coast.[133] Only two elite villas are known inland, one at Bir Cùca and the other at Aïn Scersciara, both 50 km, respectively, south and south-east of Oea (Tripoli). Little is known of either. The latter is attested by a colonnade over 20 m long with at least nine columns, and a corridor behind it paved in geometric mosaic in the second century CE, but accompanying dwelling rooms to the south have not been located. The villa was situated beside a spring with waterfall, a rare feature in this water-deprived landscape.[134] Two pottery kilns and an amphora kiln 6 m in diameter, which lie 100 m to the north, are part of the same property. The amphora kiln in particular implies that the owner invested in making his own transport

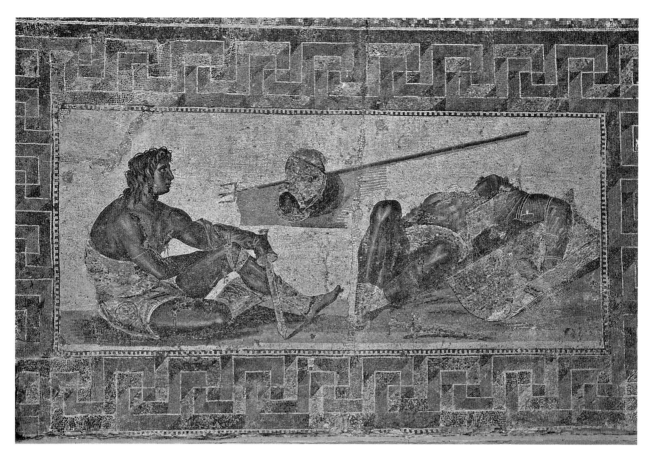

Figure 16.16. Wadi Lebda (near Lepcis), villa baths: mosaic panel depicting an exhausted gladiator and his dead opponent, c. 200/25 CE (?) (Lepcis Magna, Mosaic Museum). (A black and white version of this figure will appear in some formats. For the color version, please refer to the plate section)

containers for the agricultural goods (presumably oil) that the estate was producing.

The villas on or near the coast concentrate not surprisingly around the three major cities of Tripolitania, with the fewest known around Sabratha, and many more nearer Tripoli and Lepcis Magna. In addition, there are one or two outliers, like the pair near Zliten, east of Lepcis. With few exceptions, not much can be said about them, either because little had survived at the time of their discovery, such as one north of Sabratha mapped in 1948,[135] or because interest was lost once mosaic floors had been found and raised: as elsewhere in North Africa, the architectural contextualization of many mosaics is often missing.[136] As recently as 2000, a *villa suburbana* on the Wadi Lebda, just south of the walled area of the city of Lepcis, yielded a detailed mosaic of amphitheater *munera*, including *venationes*

(animals hunts), presumably of the type presented at Lepcis itself,[137] which decorated the *frigidarium* of the villa's baths. One panel, depicting a victorious gladiator seated pensively on the arena sand beside his butchered opponent, is a striking psychological study of exhaustion, created sometime perhaps in the early third century CE (Figure 16.16); but details of the rest of the villa are unknown.[138]

Of the clutch of elite establishments on the coastline of central Tripolitania, the best known is the Gara delle Nereidi villa, near Taguira, 29 km east of Tripoli (Figure 16.17).[139] Found in 1964, the villa is arranged on two terraces immediately above the shore. At the lowest level were the principal living rooms and probably bedrooms, partly rock-cut, opening off a peristyle corridor (1), of which only a small part has escaped marine erosion. Rooms and corridor here had black and white ornamental

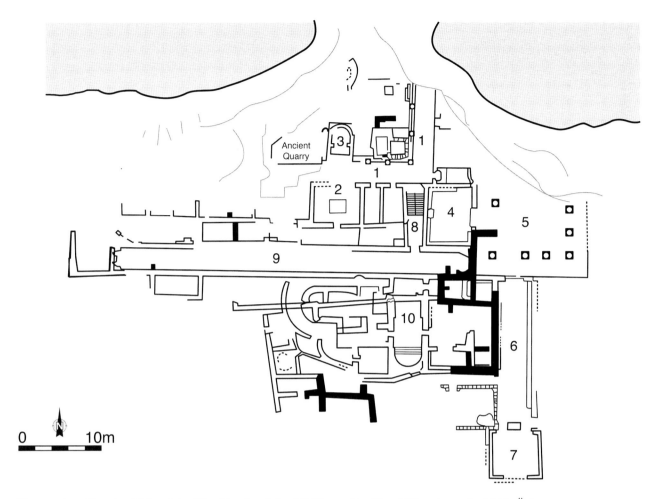

Figure 16.17. Taguira, Villa of the Nereids, plan (after Di Vita 1966a, Tav. XV, redrawn by M.D. Öz).

mosaics except for the largest (2), which was floored in marble and had two columns at the entrance. It was probably the principal dining room, as it looked seawards across the portico corridor toward a large fountain-basin (3) projecting into the court – a common feature facing *triclinia* in town-houses in North Africa.[140] East of this range is another large reception room (4), facing east toward its own small peristyled court (5); off the latter, to the south, opened a broad corridor with benches (6) and a further elegant reception room (7, perhaps where the *dominus* received his *clientes*, with waiting room outside).[141] Both reception rooms have partly figured mosaics, in each case featuring the Nereid Amphitrite in its central roundel. A stairway (8) led up from the lower peristyle to a transverse corridor (*ambulatio*) on the upper level, 45 m long (9), no doubt with

splendid views of the sea, around which the whole villa was articulated; the lower parts of its walls were painted with imitation marble designs, and its stucco vault had floral and figured decoration. On its south side opens an elaborate bath-house of a dozen rooms, which saw some alterations in a secondary period. The changing-room (10) just beyond the entrance vestibule has a figured mosaic of marine beasts with tritons and nereids, which gives the villa its name. The original building is unusually well dated by imported bricks from Rome (itself a great rarity in North Africa) produced between 145 CE and 160 CE. Coins show that the villa was still in use in the fourth century; but it seems unlikely that this or any other low-lying coastal villa in Tripolitania survived the gigantic *tsunami* which accompanied the earthquake off Crete on 21 July 365.[142]

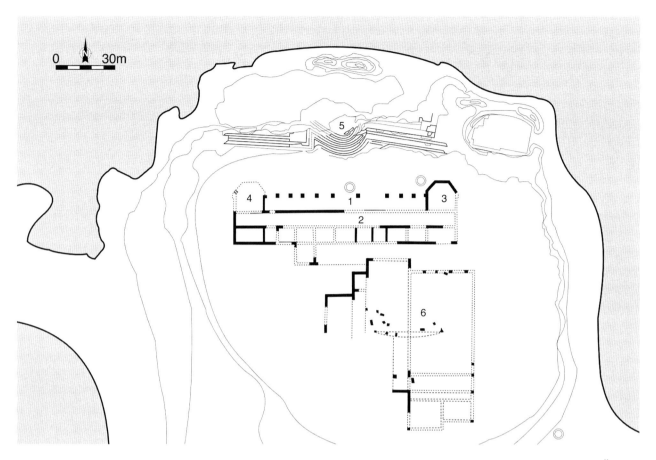

Figure 16.18. Silin, Villa of the Maritime Odeon, plan (after Salza Prina Ricotti 1970–71, Tav. I, redrawn by M.D. Öz).

The area around Lepcis Magna has been more intensively explored, and several of its *villae suburbanae*[143] investigated in recent years.[144] About 12 km west of Lepcis, in the Silin district, an additional half a dozen *villae maritimae* are known at intervals along a 5-km stretch of coastline. Two were surveyed in the 1960s when enough remained visible to enable their outline plan and some details to be established without excavation.[145] One, the Villa of the Maritime Odeon, sits on a low bluff overlooking the sea, next to a sheltered inlet with landing stage (Figure 16.18). It has a classic *villa maritima* façade of the type so often shown in Campanian frescoes and African mosaics (pp. 273–6) – a colonnade (1), of ten columns,[146] fronting a 55-m-long corridor (2), and flanked by towers (here polygonal: 3–4). In front of this, carved in the natural rock (5), is a semicircular area of seating (hence "odeon"), flanked on either side by a section of

straight seats: presumably the owner and his guests sat and relaxed here in the evening, watching the sea and the sunset. Off the corridor open an estimated dozen small rooms, but the main part of the villa was situated in a block immediately south which was less intelligible (6). Fragments of geometric and floral mosaics *in situ* were observed, as well as marble and stucco pieces. The bath-house lay detached on a separate hillock 80 m to the south-east.

Two km to the west lies the so-called Villa of the Small Circus, also on a coastal bluff next to a small sheltered bay (Figure 16.19). Overall it is larger than the Villa of the Maritime Odeon, covering an area of some 300 m by 100 m. The western portion, in part eroded, focused on a broad *ambulatio* 16.50 m by 85 m (1), with a narrow, 70 m-long feature down the middle: it probably served as a flower-bed, with an off-center water basin and a further semicircular basin at either end. The superficial resemblance of

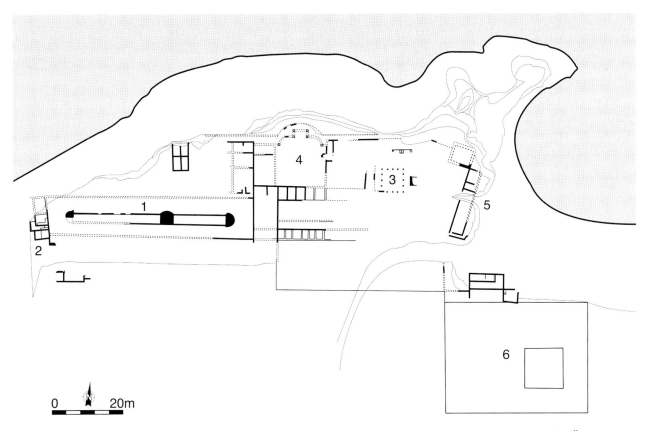

Figure 16.19. Silin, Villa of the Small Circus, plan (after Salza Prina Ricotti 1970–71, Tav. III, redrawn by M.D. Öz).

this space to a circus, with semicircular *metae* (turning-posts) at the ends of the central barrier, is the source of the villa's name. Attached to its west side were the baths (2), including one room with a geometric mosaic, perhaps of the second century. Immediately east of the *ambulatio* were hints of a small peristyle (3) and more rooms, of which the most conspicuous is a pavilion with bay window looking out over the beach (4).[147] An L-shaped building further east again (5), overlooking the bay, has one room with unusually broad foundations suggesting an upper story – perhaps one containing an attractive belvedere or a roof-top *triclinium* with an even better view of the setting.[148] Further structures lie to the south-east in a detached block (6); many pieces of marble here (including red Egyptian porphyry) indicate that it contained further major living- and reception rooms. Both this villa and that of the Maritime Odeon are presumably of early/mid imperial date. Neither had the capacity for farming, an activity concentrated in known farms in the

immediate hinterland; it is logical to think of these as part of the estate of one or other of the owners of these coastal villas.[149]

At the mouth of the Wadi Yala, 1.5 km further west again, stands an extremely well-preserved structure (dubbed "Villa of Silin" or the "Villa of the Bull"), excavated and conserved since 1975 by the Libyan Department of Antiquities.[150] A grand colonnade, now partly lost to erosion,[151] ran across the entire façade, making this *villa maritima* particularly striking when seen from the sea. Its complex interior plan, fine *in situ* floor mosaics, and well-preserved frescoed and marbled walls make this site the most complete example of a Roman villa in the whole of North Africa. Here as nowhere else can the modern visitor capture something of what it was like to live in a Romano-African luxury villa.

The entrance in antiquity was probably from the north-west. The western half of the villa is arranged around three sides of the façade colonnade (forming a three-sided "peristyle" here), the

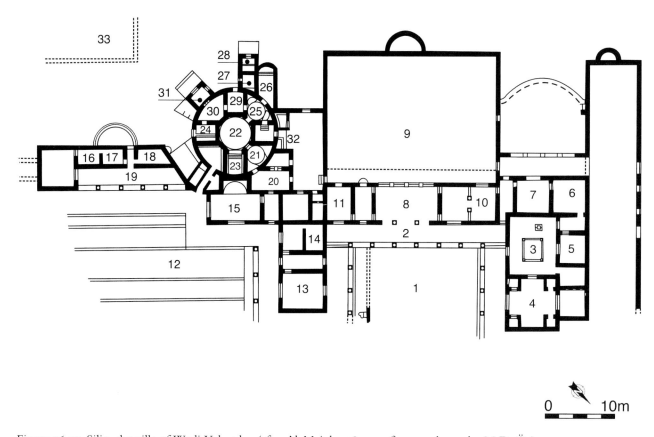

Figure 16.20. Silin, the villa of Wadi Yala, plan (after Al-Majub 1987, 71, fig. 2, redrawn by M.D. Öz).

central space (1 on Figure 16.20) no doubt planted with a garden. Its three accompanying corridors (that on the south, 2, at a higher level) were carpeted with a rich geometric composition of squares, each containing intricate and very varied designs in dark red, mustard yellow, black and white. Additional panels of figured mosaic in the west and east corridors on the garden side depict charming and humorous scenes of pygmies, armed with silver vessels as shields and helmets; they are fighting cranes, and all is set in an exotic Nilotic landscape, with lively ducks also contributing to the action (Figure 16.21).

The rooms of the villa's west wing were reached from the west corridor via a small tetrastyle light-well (3), with covered walkways around. The walls here bear substantial remains of fresco decoration, including a scene of professional hunters (*venatores*) doing battle with animals in the amphitheater (Figure 16.22). A large room on its north side (4) has a mosaic featuring cupids, Victories, theatre masks and Oceanus heads alternating in small squares in the main field,

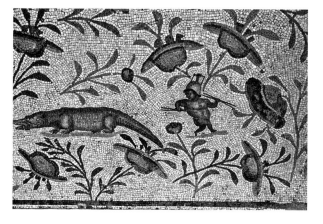

Figure 16.21. Silin, the villa of Wadi Yala, east peristyle corridor mosaic: a pygmy in a Nilotic landscape with crocodile (photo: author).

with birds and flowers occupying smaller lozenges between. Four tiny enclosures in the corners, plausibly interpreted as containing cupboards for book-scrolls, may indicate that this was the owner's library, a room-type rarely identified in Mediterranean villas.[152]

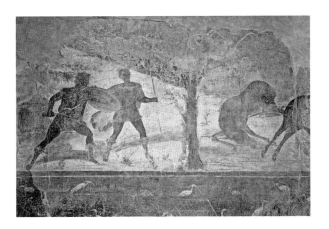

Figure 16.22. Silin, the villa of Wadi Yala, corridor of the internal court (3): fresco painting of *venatores* (photo: author).

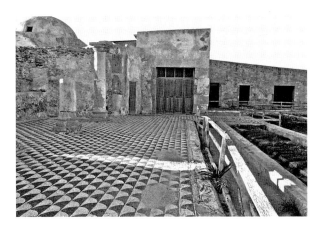

Figure 16.23. Silin, the villa of Wadi Yala, garden area 12, looking westward toward room 15 (beyond the columns) (photo: author).

The other rooms around the tetrastyle court all have mosaic floors, two mythological (Lycurgus being throttled by the vine in 5; the Four Seasons in 6 with Aion, personification of eternal time, accompanied by Venus and Helios); and one showing a chariot race in progress in a circus, from a cartoon based ultimately on the Circus Maximus in Rome (7). The choice of theme surely reflects the owner's interest in the circus *ludi* at nearby Lepcis Magna. If there was no predecessor to the visible stone circus there, the mosaic is surely not earlier than 161/2 CE, when it was finished; but there is slight evidence that the visible building might have replaced an earlier, smaller one, in which case the dated inscription has no bearing on the mosaic's possible chronology.[153]

The spacious central room (8) looked outwards through two gray marble columns toward the peristyle and the sea in one direction, and through windows toward a large walled garden on the other (9).[154] The floor arrangement of *greco scritto* marble slabs in the center[155] and a simple geometric mosaic surround (where couches would have been placed) suggests that it was one of the villa's two *triclinia*, perhaps when the owner was dining with his family or just a few guests.

Of the rooms flanking it, that in 10 features a mosaic panel with nereid and marine centaur, with cupid fluttering in attendance; the minute size of its tesserae contrasts markedly with the coarser geometric border. Room 11, which the mosaic

layout suggests was a bedroom, has a striking figured panel showing a condemned prisoner in tunic and trousers being pushed toward a gigantic bull which is about to gore him to death. A ringmaster with stick is in attendance, and the other two figures here are probably meant to represent dead bodies (in ill-judged perspective), previous victims of the bull, rather than as somersaulting over the animal as it tosses them in the air, as usually claimed. Much debated also is the inscription above, *Filoserapis comp* [...].[156] Philoserapis ("Serapis-lover") is probably the name of the mosaicist, and the letters *comp* stand for *composuit*, "composed."[157]

To the east lay a second, more loosely arranged court, with rooms set around two sides of another garden (12) (Figure 16.23). The long flower-beds here are separated by low walls bearing mosaic decoration of animals and birds within a running acanthus tendril, a highly unusual feature in a garden. Of the rooms facing it, 13 was the principal *triclinium*, with a large central panel of cut marble pieces (*opus sectile*), and a simple geometric mosaic border (for couches) in a *pi*-shaped arrangement.[158] A marble-paved vestibule beyond[159] leads behind a partition to a tiny bedroom (14), still preserved to roof-height: its frescoes show *putti* and delicate tendrils in red, green and yellow on a white ground. On the south side of the garden are further rooms (16–19) with mosaic decoration and frescoed walls.

Figure 16.24. Silin, the villa of Wadi Yala, room 15, with marble paneling of Algerian *greco scritto* below, and fresco decoration above (photo: author)

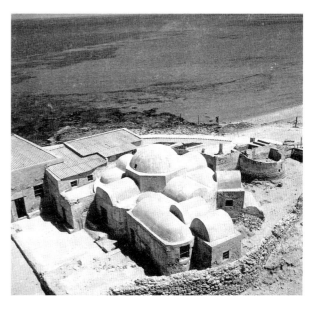

Figure 16.25. Silin, the villa of Wadi Yala, aerial view of the bath-house (photo courtesy of Y. Al-Khattali)

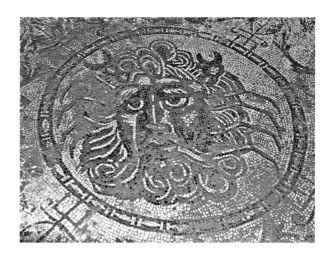

Figure 16.26. Silin, the villa of Wadi Yala, bath-house, *frigidarium* (22): detail of the central roundel of its mosaic floor, head of Oceanus (photo: author).

Also striking in this eastern part of the villa is Room 15, a salon for relaxation looking out toward the sea through a wide doorway. The walls here, also preserved to roof-height, have *greco scritto* marble paneling on their lower half, and plain plaster above (Figure 16.24). The latter was originally adorned by a number of removable panels (the settings and the corner nail-holes remain) – presumably wooden *pinakes* containing figured frescoes, taken away for recycling when the villa was abandoned. The elaborate marble niche forming the room's focal point was presumably the setting for a statuette.[160]

The final part of the villa is the bath-house (Figure 16.25), reached through vestibules 20 and 21. Unusually, the suite of chambers is inscribed within a circular plan, resulting in four odd quadrant-shaped rooms that provided an architectural challenge in roofing: there are early examples here of squinches, once thought of as a Byzantine invention, but present also in the Hunting Baths at nearby Lepcis Magna, probably of c. 200 CE.[161] The central octagonal *frigidarium* (22), with two immersion pools (23 and 24), has a mosaic featuring Oceanus at the center (Figure 16.26), fine Corinthian pilaster capitals of stucco flanking the northern pool, and a mosaic-lined niche in its semi-dome featuring a pair of boxers. Tiny heated rooms lie beyond an intermediate passage-room (25), with another pool opening off it. First comes a *tepidarium* (26) with

a pool in its apse and then a second *tepidarium* (27) with separate pool (28). Then the bather had to retrace steps through 25 and pass through 29 to the *caldarium* (30), with its accompanying hot-water bath (31). The latter now has a semicircular hole in the wall above the furnace, where once a metal boiler (*testudo*, "tortoise") was inserted, providing extra hot water. There was a smaller *testudo* also in pool 28. A mosaic-paved latrine (32) was reached round the back of the building.

The chronology of the Silin villa must await full publication, but it was most likely built c. 150/75 CE. It seems to have been built in a single phase, although detailed study may reveal some later alterations; how long it was occupied is uncertain.[162] Whether the owner also farmed from the same property, or won his wealth from agricultural land elsewhere, is also unknown: outbuilding(s) 33, which may have housed the unlocated kitchens and attendants' quarters, are so far unexcavated. He may well have been a *decurio* (town-councilor) at Lepcis Magna, with a *domus* there, and the Silin residence served as his delightful *villa maritima*. Perhaps if he had also served as magistrate he was responsible for presenting at Lepcis both circus games and amphitheater spectacles which were recorded in permanent form in the frescoes and mosaics of his villa; at the very least, he was a fan of the *ludi*. The rooms are not large, nor is the overall size of the building (it measures only 85x50 m); but the rich embellishment

of nearly every room with mosaic, marble and fresco provides eloquent testimony of very considerable wealth.

The most easterly of the *villae maritimae* on which we have substantial information is that at Dar Buk Amméra on the north-western outskirts of Zliten, 20 km east of Lepcis Magna.[163] This was initially uncovered in 1913 by Italian soldiers, before archaeologists took over the following year; soon afterwards most of its now famous mosaics, as well as portions of wall- and ceiling-painting, were transferred to Tripoli Museum.[164] One hundred years on, the site is still visible, although comparison of the remains today with excavation photos shows how much the walls have degraded, and how far the corridor mosaic, once intact, has been damaged. One figured mosaic with a Nilotic scene left *in situ* is also now reported to have been destroyed.[165]

The villa lies on an attractive rocky promontory on the west side of a shallow bay (Figure 16.27).

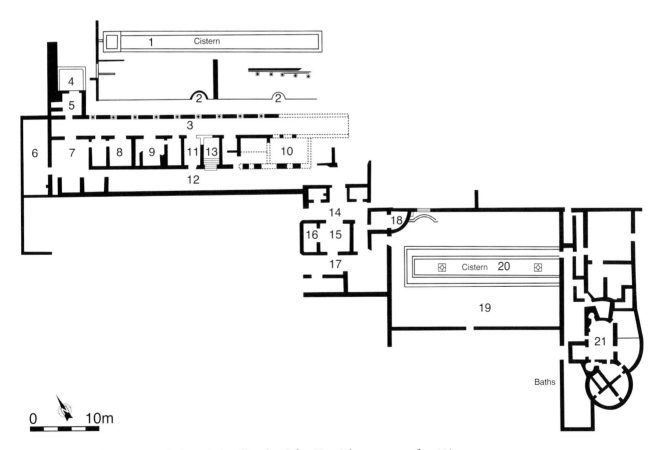

Figure 16.27. Zliten (Dar Buk Amméra), villa, plan (after Kenrick 2009, 151, fig. 66.).

The rock has been partly leveled to accommodate the villa, but its bipartite layout, the eastern part being set back from the coast, was dictated by topography. The main living block lies to the west. Its most northerly feature is now a barrel-vaulted cistern (1) set below what may have been a spacious garden court, with two mosaic-lined semicircular fountain-basins (2) on its south side, adjacent to a path that surrounded the assumed garden. If the cistern was centrally placed within the latter, as much as 8 m of the villa, possibly more, have been lost to the sea on this side.[166]

South of this stretches a corridor more than 45 m long,[167] lined by a colonnade of thirteen columns (3). This was later walled up and given window embrasures, enabling the view still to be enjoyed; the change no doubt provided additional shade and more protection from sea breezes, as well as from occasional inclement winter weather. The corridor itself was paved with a floor of simple but effective geometric pattern, swastikas alternating with octagons (the latter enclosing floral motifs), executed in red, black and white. Most of the main living rooms open off the south side of this corridor, but two interconnecting rooms lie on its north side at the west end of the garden (4–5).[168] The most westerly room on the south side (7)[169] was floored with the famous gladiator mosaic (Figure 16.28), and room 8 with that depicting the Four Seasons (Figure 16.29); room 9 had a pavement of simple geometric design with a broad border in marble *opus sectile*; and room 10 was provided with a geometric grid mosaic of twenty-four squares, each containing varied ornamental designs. Near room 9 a passage (11) led to a rear corridor (12) which did not communicate with any of these living rooms except for room 7. Area 13 is a staircase to an upper floor, or perhaps to a roof terrace.[170]

The eastern end of this rear corridor, and perhaps also a passage-room from the north corridor, gave access to a group of rooms, of which the most important is 15. This (about 4.25 m²) may have been a living room or even the main dining room, although it is unusual for a *triclinium* not to have a closed back wall: here it opens to the south onto a further room or corridor which has a marble *opus*

sectile floor (17).[171] Room 15 also combined *opus sectile* with mosaic pavement: the central part featured nine square *emblemata*, only two of them well preserved (half of a third also survives). They show scenes of agricultural activities on a farming estate. On its west side, steps led up to a Nilotic mosaic at a raised level (16), accompanied by a fountain with seven jets and attendant water-channel on three sides. It was, therefore, a *nymphaeum*, providing a pleasant background (the sound of trickling water) to the activities in the main room. It seems certain, however, that this fountain was installed in the alcove in a later period.[172]

East of this, a passage led to a curious quadrant-shaped room (18), of unknown function. The space was decorated by a damaged but exquisite mosaic depicting marine creatures in a central area, and an elaborate acanthus tendril, teeming with birds and other creatures, in the remainder (Figure 16.30). The floor is a work of the highest skill, often using minute tesserae, with an astonishing range of color gradation, providing striking three-dimensionality. Intriguingly, unrelated to the rest of the subject matter, a pair of human feet appears at one point next to the wall, implying that the figure continued upwards on the wall itself (a most unusual conceit), perhaps also in mosaic. Further to the left, more damaged, is a pair of cloven feet in the same position. The room is too small (its radius is only 2.60 m) to have served as a living space: was it a small shrine, dedicated, in view of the teeming life represented, to *Abundantia* or *Fecunditas* or the like? Or else to Bacchus-Liber, with maenads and Pan (the cloven feet) in attendance?

The rest of the villa was excavated in 1923 but remains largely unpublished. The central courtyard paved in *opus spicatum* (19) contains another barrel-vaulted cistern below (20), with a draw-hole at each end (Figure 16.31). A bath-house, its layout not readily intelligible, lies further east (21); it yielded fragmentary mosaics depicting marine divinities and fish.[173] They come from the quadrant-shaped rooms on the south side of the baths, an arrangement which foreshadows similarly shaped chambers in the somewhat later bath-suite at Silin (Wadi Yala; see p. 292).

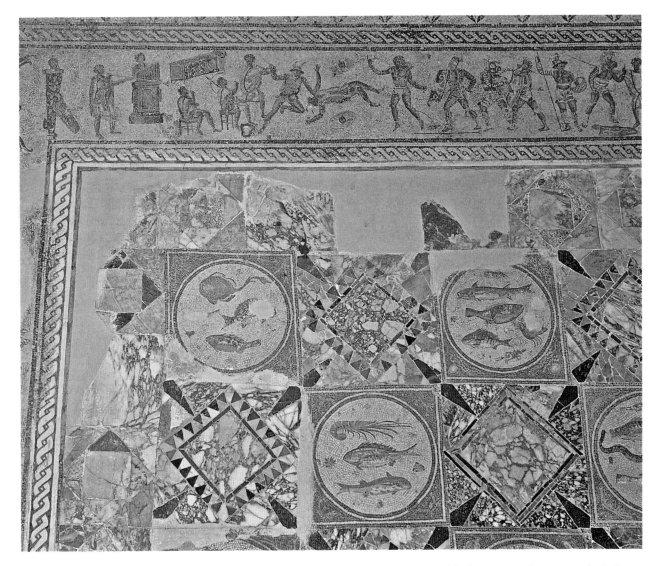

Figure 16.28. Zliten (Dar Buk Amméra), villa, room 7, detail of the mosaic: central field of square panels, mosaics depicting fish alternating with *opus sectile* designs; border with mosaic of amphitheater scenes: musicians with their instruments, and gladiatorial contests (Tripoli Museum). (A black and white version of this figure will appear in some formats. For the color version, please refer to the plate section)

Large quantities of fallen plaster were recovered from the collapsed vaulted ceiling of the south corridor (12) of the Dar Buk Amméra villa at Zliten.[174] Its central section, depicting Bacchus-Liber on his leopard in an octagonal panel, could be reconstructed more or less entire. Nearby were two roundels with Medusa heads, and two rectangular panels, one with a pair of antelopes, the other a landscape with small buildings and pairs of figures standing around, chatting (Figure 16.32). The overall framework of delicate tendrils and other decorative bands is reminiscent of Fourth Style painting in Campania, which had a long afterlife in the provinces after 79 CE. The style is impressionistic; the silhouette figures in the landscape, with a single blob of white paint to denote faces, without further detail, are especially striking. Other details catch the eye – a green Mars (representing a bronze statue?); an intense Diana with windswept hair and large eyes, recalling the faces of the Seasons mosaic; a lively marine *thiasos* with tritons and nereids; and sacro-idyllic scenes too.

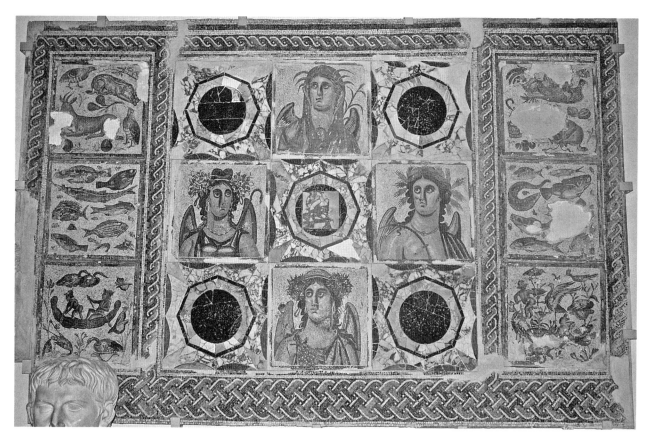

Figure 16.29. Zliten (Dar Buk Amméra), villa, room 8: mosaic floor depicting the Four Seasons (Tripoli Museum) (photo: author).

Figure 16.30. Zliten (Dar Buk Amméra), villa, room 18, floor mosaic with acanthus tendril design and the feet of a human figure (upper left) (Tripoli Museum) (photo: author).

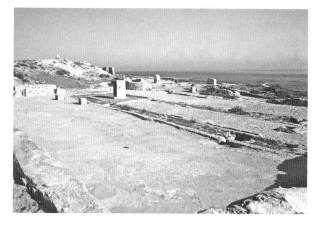

Figure 16.31. Zliten (Dar Buk Amméra), villa, eastern sector, courtyard 19 from the southeast, paved in *opus spicatum* (photo: author).

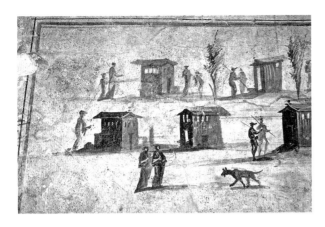

Figure 16.32. Zliten (Dar Buk Amméra), villa, south corridor (12), landscape scene of small two-story buildings with figures in silhouette (Tripoli Museum) (photo: author).

Fresco fragments elsewhere at Dar Buk Amméra include Nilotic scenes (the ever-popular pygmies) and a panel depicting Hercules killing Geryon, within a Fourth-Style framework.[175] The frescoes add enriched perspective on the interior décor of this sophisticated African villa, in a degree of detail not often found even in more recently excavated sites, and their preservation represents a pioneering and successful recovery at a very early date of a notoriously fragile medium.

The mosaics from Zliten are so well known that detailed description is unnecessary here. Among the earliest from Roman North Africa, they form a distinctive group of the highest quality; the frequent employment of figured and/or ornamental mosaic together with marble in the same floor is also distinctive, and rare elsewhere in the early imperial period. Their date has been much discussed. They probably belong c. 100/150 CE rather than earlier; attempts to down-date them to the third century or even later,[176] on the basis of such features as the large staring eyes of the Four Seasons (Figure 16.29) (which to some recall late antique images), ignore the genuine originality and independence of Tripolitanian mosaicists. The more recently discovered Silin (Wadi Yala) mosaics, which are probably a little later than 150 CE (p. 293), look technically less accomplished than Zliten's (although the use of stylistic criteria is always hazardous in dating). That in room 10 at Zliten, however, which shares the same scheme and similar complexity with that of the

peristyle mosaic at Silin, may be later than the rest of the pavements at Zliten and indicate a direct, contemporary connection between the two sites.[177] It also seems unlikely, when marble floors were only reaching private houses at Pompeii and Herculaneum not long before 79 CE, that they would have been available to North African villa-builders much before the beginning of the second century. Without supporting archaeological evidence, not recorded a century ago, the villa's true chronology will remain uncertain. Perhaps Zliten dates to c. 120/40 CE, Silin c. 150/175 CE, but such a chronology can only be regarded as tentative and approximate. How long the Zliten villa remained occupied is (once again) unknown.[178]

What can be said about this group of Tripolitanian *villae maritimae* – Taguira, the three villas near Silin and Zliten – as a whole? In terms of their siting, their architectural refinement and the quality of their decoration, they are among the most coherent in North Africa as a whole. All probably belong to the second century,[179] but they show considerable variety in their plans. Apart from sharing features such as baths and luxurious living rooms, which all elite villas were expected to have from the first century CE onwards, the recurrence of the long corridor (*ambulatio*) is one distinctive feature of several, one shared also by some Campanian *villae maritimae* and indeed others in Italy.[180] It has often been said that these Tripolitanian seaside villas owed a good deal to the Italian villa heritage. That may be right, but any architect, designing a house by the sea, will want to maximize the opportunities of the seaside setting by suggesting an elongated layout; and, within the limits imposed by the local topography, arrangement by terraces or separate blocks on different orientations and the provision of long porticoed corridors would be natural outcomes of discussions between architect and client. African architects were creatively original, not consciously imitating Italian models at every turn: for these Tripolitanian villas are not readily paralleled in detail by their contemporary counterparts on the shores of Italy.[181]

CONCLUSION

This chapter began by asking whether there was a villa system in North Africa at all during the Roman period. There clearly was, although lack of excavation and poor recording of nineteenth-century discoveries hinder full appreciation of its extent. There are no villas at all in Cyrenaica, and virtually none in Morocco. Elsewhere, *villae maritimae* were especially common, in Tripolitania above all, but also on the coast of the Sahel in eastern Tunisia and around Carthage. A handful is known also in Algeria. They seem to have had their apogee in the second century CE; few elite villas are known anywhere from the first century CE. More were added in the third century, but in Tripolitania there is little evidence for maritime villas continuing into late antiquity. In Tunisia, by contrast, seaside villas were still being built or upgraded in the fourth century, while around Carthage at least the presence of the Vandal elite ensured that villas went on being used there into the sixth century. There were also *villae suburbanae* outside many large towns, especially between the second and fourth centuries. Few of these villas, *suburbanae* or *maritimae*, have produced direct evidence of farming activities, and it is assumed that the wealth they so conspicuously display was won from farms elsewhere on the same estate or on other properties in the same ownership, although in some cases the absence of agricultural buildings at an elite site may be due to inadequate exploration. Inland villas are more scarce, and both relatively modest examples (such as Demnet el-Khozba, p. 282) and spectacular ones (Oued Athménia, Sidi Ghrib, pp. 277 and 283) happen to be late (c. 400 CE), a reflection of late fourth-century prosperity in the African provinces. That, however, may be no more than an accident of survival: the sample is too small for meaningful conclusions. Other inland villas detected by field survey around Segermes and on the isle of Djerba (p. 273) indicate that more examples await the attention of the spade. Equally, survey work elsewhere shows that elite villas were completely absent around, for example, Dougga or Kasserine: in both regions landowners apparently preferred to live in the comfort of their town houses. But the number of excavated villas in North Africa remains very small. Future discoveries will sharpen our focus and enrich our understanding of the character of villa settlement in Roman North Africa.

NOTES

1. Plin., *HN* 15.8: *Cereri id totum natura concessit, oleum ac vinum non invidit tantum.*

2. E.g., Bullo and Ghedini 2003; Carucci 2007; Djemila: Blanchard-Lemée 1975.

3. The only significant synthesis is Rind 2009; see also Romanelli 1970, 252–8, and in brief Picard 1986 and Leveau 1993, 164–9. For Algeria, Gsell 1901b, 23–38; on rural North Africa as a whole, Leveau 1993.

4. Examples of erroneous modern usage include the "Park of the Roman Villas" (Carthage) and the "Villa des Fresques" (Tipasa), both of course referring to *domus*. See also note 143 in this chapter.

5. Talbert 2000, maps 28–38 (some, however, e.g., maps 31 and 34, use the black triangle with restraint).

6. Goodchild 1954, 5, followed by Mattingly (1995, 141, fig. 7.2; but not in Talbert 2000, map 35).

7. For such farms in Africa (focusing on oil and wine production), Brun 2004, 185–260; for farms with wine presses in Mauretania, Brun 2003.

8. For example, Rind (2009) uses the traditional German terminology of *villa rustica* and *villa urbana*, and so includes many examples of what I would call farms (her *villae rusticae*) as "villas." On the difficulties of this terminology, see my remarks in Creighton and Wilson 1999, 20–1.

9. Oued Athménia (p. 279) and Tabarka (p. 276).

10. E.g., *Serm.* 137. 11.14; 345.2; *Ep.* 66.1, cf. 21.5 (*villa ecclesiae*): Kotula 1988; Coppolino 2008.

11. *Apol.* 87.6; in general, Pavis d'Escurac 1974.

12. *Apol.* 93.4. He refers sneeringly to the *villa* of his accuser, Sicinius Aemilianus, as lacking even a shrine or sacred grove in its grounds (*Apol.* 56.5), but gives no hint of the main building's level of comfort.

13. Goodchild 1976, 239–54, who argues, since the letters were posted from the port of Phycus (Zaviet el-Hammama, 25 km west of Apollonia: *Ep.* 148), that it lay well inland from there, mid-way between the

coast and salt marshes, possibly in the Slonta district. It had a garden where *silphium* was grown (*Ep.* 106).

14. Rossiter 1989, 101–4.

15. Goodchild 1976, 253: "in the Cyrenaica of his day, the unit of rural habitation seems to have been the fortified farmstead, a building in which comfort was sacrificed to defensibility" (modern scholarship downplays their alleged quasi-military aspect: Kenrick 2013a: 14–15). Examples of "fortified" farms: Kenrick 2013a, passim; 2013b.

16. Rossiter 1990.

17. Maxula: Victor of Vita, *HP* 1.17; Grassa: Procop. *Vand.* 2.6.6–9. Alianae: *Anth. Lat.* 201–5; 371–2.

18. Anclae: Luxorius 90. Amphitheatre: ibid. 60 (Rosenblum 1961, 164 and 146). Peristyles (called *atria*): *Anth. Lat.* 287; 289; gilded portico: 287 (Rosenblum no. 6, line 3); marble: 194, 287; paintings (or mosaics) and statues: 299, 320, 329, 342, 350, 369. Some may refer to *domus*.

19. *Anth. Lat.* 299, 327, 364.

20. Peyras 1975; 1991, especially 398–401; discussion in Kehoe 1988, 230–4.

21. Another example (among many) is the Saltus Beguensis at Henchir El Begar north of Kasserine, the property of the senator Lucilius Africanus in the Antonine period, which survey work has shown to contain oil-production buildings and cisterns, also a small mausoleum, but no well-appointed "villa": Sehili 2008.

22. *CIL* 8.25902 (Henchir Mettich) = *AE* 1993, 1756; Kehoe 1988, 28–55; Jacques 1993; Desanges et al. 2010, 289. The site was also known by its indigenous name *Mappalia Siga, mappalia* meaning in Punic "huts" but later used simply to denote "villa."

23. *It. Ant.* 60.3. Site (Bou Garnin): Drine 2002; Desanges et al. 2010, 288–9. Inscription: *CIL* 8.897; Fagan 1999, 295, no. 183.

24. *It. Ant.* 61.2; 62.3; 63.1; Kolendo 1986. Another is *Agma sive Fulgurita villa* ("The villa struck by lightning"): *It. Ant.* 59.7.

25. *AE* 1959.271: *cur(ator) reip(ublicae) reg(ionis) Tripolitanae* under Gordian. Stamp: Mattingly 1988b, 34, no. 35 (c. 220–30); Kolendo 1986, 154 who unnecessarily reckons they are father and son with the same name (153–5 for other possible candidates).

26. *IRT* 914–16 (Bu Ngem); *PIR*² A 595.

27. Brogan 1964.

28. See note 47.

29. Gsell 1901b, 97–9; *CIL* 8.6705. Modest pre-Roman (Numidian) *tumuli* known at Tiddis (Berthier 2000, 169–75) apparently had no lasting influence on funerary architecture in Roman North Africa; they are unlikely candidates to have inspired Lollius' tomb.

30. Babelon, Cagnat and Reinach 1892–1913; Gsell 1911; Cagnat and Merlin 1920.

31. Leveau 1984, 217–505; also 1982, 1989, 1990 and Fentress 1984.

32. Leveau 1984, 409. One site (Thalesa) on the coast, with large building platform, a column, a press weight-stone, an artificial dam to create a safe anchorage, and nearby kilns, might have been both *villa maritima* and working farm (Leveau 1984, 254–7; Rind 2009, 94).

33. Leveau 1984, 410 notes on the basis of local hearsay the possibility of mosaics at two further sites.

34. Leveau 1984, 248–52; for doubts about its status, Février 1990, 82.

35. An elaborate version (probably of two phases) of Farrar's largest type (G) of garden fountain-basins (1998, 81).

36. Anselmino et al. 1989; Mattingly and Hayes 1992.

37. A building only 1500 m from the town of Tipasa formed part of the *praedia* of M. Hortensius Gaudentius in 278 CE, but this was also wholly a working farm: Brun 2004, 239, with plan on 240; also Brun 2003, 22–3 with fig. 5 on 29.

38. Comparable is the farm at Tamesmida (Tunisia), also with projecting towers flanking the entrance and at the corners of the façade only: Brun 2004, 227, plan.

39. As the late C. E. Stevens remarked, you can "dig up a villa but you cannot dig up its land-tenure system" (Thomas 1966, 108).

40. Rebuffat, Lenoir and Akerraz 1985; Rebuffat 1986.

41. Rebuffat 1986, 652–61 (M. Euzennat); Akerraz and Lenoir 1990 (seventy-one pre-Roman sites, of which forty-two continued into the first century CE, when they were joined by ninety-seven new sites). Only one farm in Morocco is recorded as having bathing facilities (Jorf el-Hamra near Tangier), and that of the most perfunctory kind – a square cold room and a tiny adjacent heated room, off which was a tiny immersion bath (1.35x0.72 m); the whole bath-suite measured only 5x3 m (Thébert 2003, 260–1 with pl. CXXI).

42. De Vos 2000; De Vos Raaijmakers and Attoui 2013.

43. De Vos Raaijmakers and Attoui 2013, 89 (site 182: "il pourrait s'agir d'une *villa*, d'une *mansio* ou d'une

église") with 304, pl. 69. Site 478 is described as a "villa" in De Vos 2000, 83, but on the flimsy basis of a single Ionic architrave block, not *in situ*, which "suggère une portique à colonnes" (De Vos Raaijmakers and Attoui 2013, 133).

44. Site 049 (tesserae, fragments of *cipollino* marble floor, and painted plaster) and 054 (black tesserae, perhaps a "site de luxe discrète"): De Vos Raaijmakers and Attoui 2013, 48–50 with pl. 20. Plain white tessellation at site 329 (De Vos 2000, pl. 32.4) does not count as "mosaic"; this is another farm (De Vos Raaijmakers and Attoui 2013, 114–15). An apsidal room may suggest a *balneum* at site 634 (De Vos Raaijmakers and Attoui 2013, 183), but this does not appear on the plan (pl. 171). Further discussion and analysis is expected in a future volume in this series.

45. Hitchner 1988, 1989, 1990, 1992–1993. Two sectors of 35 km² each, to the west and south-west of Kasserine, and two much smaller sectors to the east, were selected.

46. Hitchner 1989, 394 describes this 9-hectare site (Henchir el-Guellali, 3 km. south of Kasserine) as a "large, probably owner-occupied villa complex with attached hamlet"; it may rather be a rural village. Hitchner (ibid.) also suggested Henchir et Touil was a "villa" (site 225), modified in Hitchner 1990, 233–6, 246–7.

47. *Pace* Février 1990, 82, who takes (other) examples (Thelepte, Sétif, Sigus) as evidence for wealthy villas awaiting discovery nearby. Hamouda: *BAC* 1912, ccxii–ccxiii; *ILAfr* 111. Papiria is the voting tribe of both Cillium and Thelepte. C. Iulius Dexter: *CIL* 8.2094; *ILS* 2518.

48. Dietz et al. 1995a, 371 (C. Gerner Hansen: six large villas); but contrast 1995b, 792–3 (S. Dietz: thirteen large villas). However, Dietz includes in this number sites between 1000 and 1500 m², and also ones that lack baths and mosaics; I would exclude D 10–2 (despite its roughly made sandstone column and capital), G 16–1, H 14–2 and R 12–1 as unlikely elite villas; E 15–1, K 16–1 and O 12–1 are more borderline, having produced tesserae or pieces of mosaic. There is also a category of "small villas" (none elite), which I would label farms. Another category is the isolated bath-house (22: Dietz et al. 1995b, 797–8), some attached to villas, others to villages; others again were (apparently) isolated, a category difficult to explain (see further below, p. 276). Other

survey details: Ørsted et al. 2000 (especially 58–72 on site classification); Carlsen 1998.

49. Villa (E 9–2): Dietz et al. 1995a, 242–5; mausoleum: Ørsted et al. 2000, 293–301 (T. Kampmann).

50. *Pace* Ørsted 1992, 81.

51. Drine et al. 2009, especially 29, 89–90 and 189–200; a second volume detailing evidence is forthcoming.

52. Drine et al. 2009, 89–90 (site K050), with figs. 7.4–5.

53. Drine et al. 2009, 195 (site K202).

54. Sarnowski 1978; also Duval 1980; 1985; Blázquez Martínez 1994; and the bibliography cited below. Rind 2009, 35–46 is a well-illustrated summary.

55. Sarnowski 1978, pls. 28–31; Picard 1990; and note 107.

56. Sarnowski 1978, pl. 34, 35, 39 and four at Piazza Armerina (Sicily), almost certainly laid by Carthaginians.

57. Sarnowski 1978, pl. 3, 7, 8, 12, 14 and 33.

58. Merlin 1921; reproduced many times since, e.g., Dunbabin 1978, 119–21 with pl. 109; 1999, 118–19 with pl. 122; Yacoub 2002, 216, fig. 112.

59. Ling 1977; 1991, 142–9; Mielsch 2001, 179–88; Croisille 2005, 205–19.

60. E.g., Lafon 2001, 276–9.

61. El Alia: Picard 1990, 9, fig. 5. Zliten: Aurigemma 1926, 85–95 with figs. 50, 54 and 57.

62. Bejaoui 1997; 2002 (one, Cnidus, is not an island but a promontory).

63. Examples include: I: Carthage; II: Aïn Tounga; III and IV: El Alia.

64. See note 58.

65. Morvillez 2004.

66. Villas with arcading and/or columns at an upper level appear also at Constantine and Bordj Djedid, Carthage: Sarnowski 1978, pls. 14 and 21.

67. Sarnowski 1978; Duval 1980; 1985; and see note 54.

68. See also note 38 for another.

69. Casignana: Sabbione 2007; De Nittis 2006, fig. 21 (two alternative reconstructions). Mlet: Mulvin 2002, 101 with fig. 55 and pl. 75 (Polace). In general: Rind 2009, 58–65.

70. Dunbabin 1978, 122–3 with pls. 111–13; Yacoub 2002, 211–14, figs. 111a–d (but many times reproduced).

71. Sarnowski 1978, pl. 18; Duval 1985, 169, fig. 1. The arcading here is taken to belong not to the façade but to a wing on the far side of an assumed courtyard.

72. E.g., that the building to which a horse is tethered is the stable (with an arched façade and upper arcade with columns?): so Rossiter 1992, 45–6.

73. Arróniz: Blázquez and Mezquíriz 1985, 17–20 with pls. 51–3; Sevso plate: Mundell Mango and Bennett 1994, 94, fig. 1–47. Other examples include a bronze chair-back in Florence and the "Meerstadtplat" in the Kaiseraugst treasure if, as Carile 2011, 28–9 suggests, this is a villa image adapted to appear urban. A towered villa (fragmentary) is still a stock image in the sixth century (Great Palace mosaic at Istanbul: Yücel 2014, 18).

74. Nevitt 2008 (on the *Dominus Julius* mosaic); Swift 2009, 131–2; Carile 2011, 32: "representations of country mansions should not be considered strictly accurate photos of the estates, because they also bear strong ideal and symbolic value." See also Novello and Salvadori 2004, on the natural landscape shown in the background of such villa mosaics ("Il forte simbolismo... rinunzia alla produzione della realtà topografica": 865).

75. Gauckler 1910; De Pachtère 1911; Merlin 1915.

76. Khanoussi 1988; 2003.

77. Near the bath-house was a "quartier d'habitation" and a (later) Christian church; a similar example is Henchir Safia (Algeria), a bath-building in an unexplored settlement of 2.5 ha (Thébert 2003, 205–6).

78. Similar is the bath-house near Kerkouane, 2 km north of the Punic town (Thébert 2003, 143–4 with pl. XLIV), apparently part of a village (Courtois 1954, 182–202 at 196; Fantar 1984, 47, note 85). By contrast, a bath-house with spectacular late fourth-century mosaics at Nasr Allah (near Kairouan, central Tunisia) is tentatively ascribed to a villa (Ennaïfer and Ben Lazreg 2005, at 531).

79. E.g., Sidi Abdallah el Merrakchi near La Chebba; Mnaka Nord, north of Salakta (Sullecthum); Sidi Ameur Bou Chouika, east of Nabeul (Neapolis); Gasser Saad, further east, toward Menzel Termine; Ain Bou Thouir, on Lac Bizerte, south of Bizerte; and Sidi Mechrig, between Bizerte and Tabarka (Slim et al. 2004, 141–3, 149, 169, 174, 202–4 and 206, respectively nos. 88, 97, 136, 144, 186 and 206). On the last, also Thébert 2003, 151–2 with pl. XLIX.

80. One farm (Kuodiat Daïat near Tangier) has a row of posts on two sides of the yard (so not a fully developed peristyle: Ponsich 1970, 214–17 with fig. 57; Fentress and Docter 2008, 124–5 with fig. 5.12; Rind 2009, 90–1), and another (Jorf el-Hamra near Cotta: Ponsich 1964, 235–52; Thébert 2003, 260–1; Rind 2009, 91–2) has a minute bath-suite (see note 41); but neither qualify as a "villa" (p. 268).

81. Jodin 1967; summary in Rind 2009, 92–3.

82. The earliest pottery seems to predate the villa; the latest may represent not occupation but garbage tipped into a disused building.

83. Cadenat 1974; Rind 2009, 105–6. The west peristyle had three columns, and one each was found on the north and south sides. The assumed peristyle plan of 3 x 3 columns (internally 4 m²), was never verified archaeologically (it might have been oblong).

84. Poulle 1878, 431–54 (unillustrated); Boissier 1895, 152–62; Gsell 1901b, 23–8; Alquier and Alquier 1926; 1929; Dunbabin 1978, 62, 94–5 and 123; Thébert 2003, 218–20 and pls. XCII–XCIII; Morvillez 2006; 2013; Benseddik 2012, 106–9.

85. Including the possible *palaestra* and other walls the bath building measures about 40 x 37 m overall.

86. Dunbabin 1978, 123; Morvillez 2006, 320; 2013, 112 ("entre la fin du IVᵉ et le début du Vᵉ siècle").

87. It has a mosaic, and is of unusual shape, so it is not just an attendant's room. Perhaps it was used as a *cella unctuaria*, where the body was anointed with oil.

88. It measures about 9.50 m by 5.65 m (Morvillez 2006, 315).

89. Also the cold immersion pool and the *natatio* were both lined with plain tessellation, not ornamental mosaic.

90. Chabassière recorded the mosaics in watercolor, the basis for accurate colored lithographs prepared by a Mr. O'Callaghan. Copies that were circulated in 1880 to members of the Société Archéologique de Constantine and to sister societies in France were published in an album (Anon. 1880a), now impossible to track down; part of it (Anon. 1880b), with just five plates, can be found in two Paris libraries. It is particularly regrettable that the drawings used to illustrate this site in most modern publications, with the missing portions "restored" and with other details willfully mishandled, are a fanciful version made by the Abbé Rousset and are totally unreliable.

91. This simple boundary wall becomes a multi-story dwelling with windows in Rousset's version: e.g., Sarnowski 1978, pl. 17; Benseddik 2012, 107. I take *saltuarius* here as adjectival, "belonging to the *saltus*" and qualifying *janus*, "gate"; it seems hardly likely that such an insignificant tower was worth labeling as the estate-keeper's lodge – the alternative interpretation, followed by earlier scholarship (based on Rousset's misleading "evidence" of a substantial building being depicted here).

92. Chabassière's illustration of this mosaic is untraceable; the details derive from Rousset's reconstructed drawing. A *saeptum venationis* is an estate feature recorded by Varro, *de Re Rustica* 3.12.2.

93. It has been widely assumed that this reading was misrecorded or partly invented (Philosophilus is not an attested name), and that it must have been FILOSOFI LOCVS. If so, Philosophus could have been a nickname for an estate employee, "the philosopher," or a real name (it occurs five times in the *Lexicon of Greek Personal Names*: www.clas-lgpn2.classics.ox.ac.uk/). I take both labels to refer to buildings; Dunbabin 1978, 123, and Morvillez 2013, 117 think the "place of the philosopher" refers to the garden.

94. So also Gsell 1901b, 26, and Morvillez 2013, 116; but Poulle 1878, 437–8 and Rossiter 1992, 46–7 think it represents Pompeianus' stables. Rousset's version subsumes the gatehouse into a decorative border and displays only a single building prominently (with palm trees growing out of two pediments on either side!).

95. The representation of palm trees may have been a stock insertion by the mosaicist, and not a true reflection of the Oued Athménia landscape, where the climate is too cold to sustain palms.

96. Alquier and Alquier 1929, 290–2, note 2.

97. Berthier 1962–5, 12–20; also Brun 2004, 234, 237; Benseddik 2012, 106–7. Berthier locates the stables west of the baths, specifically correcting Poulle 1878, 438; Poulle alone gives the distance.

98. See note 41 for a similar very small example in Morocco (Jorf el-Hamra).

99. See note 39. Berthier 1962–5 (who at 18–19 mentions another small bath-house with mosaics nearby) gives no location map and no distances; Février 1990, 82, by contrast, states that Kharba is 3 km away and that "rien ne force à établir un lien avec la villa."

100. El Milia was, however, a small Roman town (Milev). El Akbia: Ménétret 1895–6 with plan and photograph (a mosaic with nine square panels featuring flowers, fish, birds and snakes, in a room with a shallow apse); Gsell 1901b, 106. Aïn Témouchent: Gsell 1901b, 101; Dunbabin 1978, Sétif 4 with pl. 143 (a pavement featuring a gigantic head of Ocean, c. 400 CE). The find-spot is not to be confused with another Aïn Témouchent, south-west of Oran in western Algeria.

101. Aumale: Gsell 1901b, 102. Constantine: see next note.

102. Baratte 1978, 28–40 with figs. 17–24; Delamare 1850, pls. 137–43 with Gsell 1912, 131–2. For its location, Benseddik 2012, 47, at bottom. The mosaic is Dunbabin 1978, Constantine 3 (with pl. 154).

103. Delamare 1850, pls. 41–2 with Gsell 1912, 42–3 (see also Vars 1896, 26–30); Stora lies only 4 km from Skikda. The caption of two illustrations of a fine mosaic showing nereids on the backs of sea-beasts (= Delamare 1850, pls. 20–1) in Benseddik 2012, 73, incorrectly states that the mosaic came from this villa; in fact it was found in a small bath-house in the town of Rusicade (Gsell 1912, 17).

104. *CIL* 8. 21553; Gsell 1901a, 102–6; Romanelli 1970, 256 and 652, pl. 188b.

105. Gsell 1901a, 105, fig. 35 (engraving); Duval 1992, pl. 186.1 (photograph).

106. Among the earliest discoveries (1857–8) were two *villae maritimae* on the coast at Gammarth north of Carthage; three mosaics of c. 150 CE from the more northerly one went to the British Museum (Freed 2011, 164–7 with figs. 11.1–3; locations 24 and 25 on 53, fig. 4.3). Nearer Carthage a further eight *villae suburbanae* are suspected on the basis of nineteenth-century finds (Rossiter 1993, 303, fig. 1); for one of them, see pp. 281–2. The "villa of Scorpianus," near the amphitheater just outside Carthage on the west, may be a *villa suburbana* but the adjacent bath-house is probably a public establishment (Rossiter 2005, *contra* 1998). On villas near Carthage, see also Rossiter 2007a, 382–8.

107. For the first discovery, P. Gauckler in *CRAI* 1898, 828–9; more details in 1899, 580–1; see also Picard 1990, 5. H. Saladin's judgment on Gauckler's assistant, D. Novak, was: "les plans ne sont pas presentés avec assez de clarité pour pouvoir être publiés utilement" (*BCTH* 1902, p. CXLV). The site should not be confused with another El Alia, near Bizerte in northern Tunisia (ancient Uzelis), a mistake most recently made by Barbet 2013, 15.

108. Gauckler 1910, no. 91 (El Alia was mistakenly identified at the time with the town-site of Acholla, now located elsewhere).

109. Yacoub 2002, 19–24.

110. This villa is known as El Alia-El-Erg: Gauckler 1910, no. 89; Novak 1901. For the *trichorum*, see the plan in Bullo and Ghedini 2003, 83, fig. 6, also in Barbet 2013, 16, fig. 2 (= Novak 1901, fig. 2). The whole stretch of coastline at El-Alia was at that time full of

"nombreux vestiges de constructions romaines, pavées de mosaïque" (Gauckler 1910, no. 90). All have now disappeared, probably through coastal erosion: none is recorded in Slim et al. 2004.

111. Earliest examples: Wilson 2011, 72–4 and 2014, 692–3. For another three-apsed structure, but possibly not from a villa, see p. 272.

112. For a plan, Novak 1901, 6, fig. 1 = Barbet 2013, 16, fig. 1: twenty rooms are shown at the upper level.

113. Novak 1901, 10, fig. 4 = Barbet 2013, 16, fig. 3. Barbet (2013, 15) thinks that the baths were at first-floor level (room 4), immediately above the rooms that I interpret as baths (21–24). Europa comes from room 23; a fresco of dancers was reported from the dining room. Surviving fresco scraps: Barbet 2013, 17–19.

114. The well-known mosaic (c. 150 CE) of the Triumph of Neptune in his chariot, with the four seasons at the corners (Bardo Museum, Tunis), comes from one such *villa maritima* at La Chebba. It decorated the main hall (*apodyterium* or *frigidarium*?) of the villa's bath-suite (the residential rooms – only five rooms and a corridor were uncovered – had only geometric mosaics): Gauckler 1910, no. 86; Dunbabin 1978, La Chebba 1 with pls. 97–8. Two separate villas are known on this same stretch of coastline (Gauckler 1910, nos. 88 and 89 with plates), each of which yielded a figured mosaic – a panel of Silenus on a donkey (now in Sfax), and a fishing scene and flanking panels featuring Orpheus and Arion (in Tunis). These are dated to the fourth century and the third century, respectively: not all *villae maritimae* belong to the second century, or ceased being occupied then. None of these sites are recorded in Slim et al. 2004 and are assumed destroyed.

115. Toutain 1892, 198. The accompanying map (pl. XIX) indicates its location south-east of the Roman town, west of the road to Aïn Draham, *pace* Longerstay 1988, 230 (and 234), who places it west of the town.

116. Fendri 1963, summarized in Fendri 1985, 154–5; at 153–4 Fendri mentions in addition two private baths in the suburbs of Thina (Thaenae), probably belonging to *villae suburbanae*, and of a villa with baths at Sakiet-ez-Zit, 7 km north of Sfax, with a mosaic of Orpheus charming the animals (Thirion 1955).

117. Poet: Dunbabin 1978, 132 and pl. 132; Yacoub 2002, 145, fig. 66. Hercules and Pan: Fendri 1963, pl. IV.

118. Dunbabin 2003, 41. For the mosaic: Fendri 1963, pls. XIII–XVII and XIX; Dunbabin 1978, 151 with n. 71.

119. Dietz 1985, 111–12 with fig. 5 on 118; 1992, 147–8; not well preserved, and only partially uncovered.

120. Ghalia 2005; in brief Badisches Landesmuseum Karlsruhe 2009, 253, no. 164. The site is also referred to as Demna, but in view of another Demna, on the Cap Bon peninsula, discussed below (p. 283), I call the one in Oued R'mel (also spelt Arremel) Demnet el-Khozba, to avoid confusion. The temple-tomb and olive presses were dismantled and re-erected beside the Bou Ficha–Zaghouan road in 1997/8. Villa plan: Ghalia 2005, 66, fig. 17; for the temple-tomb, 58, fig. 8; no plan of the bath-house has been published.

121. Double *tepidaria* are a feature of other rural baths in North Africa, such as those at Oued Athménia (p. 277, rooms K–L), Sidi Ghrib (p. 284, nos. 11–12) and Silin (Wadi Yala: p. 292, nos. 26–7).

122. Ghalia 2007, 59, 69 and 101; Badisches Landesmuseum Karlsruhe 2009, 343, Kat. 288.

123. Ennabli 1986a and b; 2009; Picard 1987; Blanchard-Lemée 1988; Ennabli and Neuru 1994; Neuru and Ennabli 1993; Curchin et al. 1998; Thébert 2003, 149–51; Rind 2009, 113–14.

124. A scene rare in African mosaic iconography, but compare the Hippo Regius hunt mosaic: Dunbabin 1978, pl. XIV, top right.

125. Thébert 2003, 150, interprets the circular room as a *destrictarium*, where the strigil was used to remove dirt from the skin, and 22/23 as the *tepidarium* proper.

126. Sometime during the fifth century, the door into the *caldarium* was blocked and the room disused; in 22/23, the original direct access from the *frigidarium* was also blocked, in order to add a second pool at its southern end. In this reduced set of baths, 21 was clearly the *tepidarium* and 22/23 the (only) *caldarium* (Thébert 2005, 151 and pl. XLVIII.3).

127. The composition echoes a fresco at Stabiae over 300 years earlier, on the west wall of the *triclinium* of the Villa Carmiano (Bonifacio 2007b, 61). The Sidi Ghrib mosaics are now in the Carthage Museum.

128. Gal. 6.806–07.

129. Symm., *Ep.* 1.8 (dated 375 CE). On his career, *PLRE* I, 865–70 (Symmachus 4).

130. Ennabli 1986b, 7, with photograph, and 56–7 (L. Ennabli): *plus feci quam potui minus quam volui. si placet commune est, si displicet nostrum est. hic sunt tria verva: catu sedes ebria. Verva* = *verba. Catu* is presumably African Latin for *cato*, from *catus*, a "wise person" (*o* and *u* merge in Late Latin and mis-spellings are

attested elsewhere, e.g., *curtis* for *cortis* = *cohortis* at Vindolanda: Adams 1995, 91). *Ebria* literally means "drunk," but also "drenched," "overflowing," "brimful." *Sedes* may refer to the step into the bath on which bathers could also sit; the "three words" may therefore constitute a warning to the bather, either in the sense of "take care, slippery step," or else that water might spill into the *frigidarium*, through over-energetic activity in the pool. Ennabli, by contrast, took *sedes* in the sense of "place" (the owner's "seat," i.e., his estate), and *ebria* as "intoxicating," i.e., "stunning"; but *ebria* does not have an active sense in Latin ("intoxicating"), only a passive one ("intoxicated"). I am grateful to my colleagues Lyn Rae and Susanna Braund (Vancouver) for their help with this inscription.

131. Ennabli 1986b, 44–6, understands this as showing the lord setting out for the hunt, and the sticks as limed ones reading for catching birds; I follow Dunbabin 1999, 322, n. 24, in thinking that he is inappropriately dressed for the hunt, and that the destination of the baths is more probable.

132. Some of the shapes can be paralleled in contemporary silverware, e.g., the clothes chest (casket), the toilet casket and the fluted dish in the Proiecta treasure of 400 CE, exactly contemporary with the Sidi Ghrib mosaic (Shelton 1981, nos. 1, 2 and 4 with pls. 1, 15 and 22); also the water jug (Kent and Painter 1977, no. 104). For discussion, Elsner 2007, 211–13. On the season it depicts, and the jewelry of the *domina*, Métraux 2008, 277–8.

133. Mattingly 1995, 140–4 with fig. 7.2; 1998, 168. An absence of elite villas inland has been confirmed by a recent field survey of Lepcis Magna's territory: Munzi et al. 2008; Munzi 2010.

134. Goodchild 1951 (= 1976, 84–8); Rind 2009, 126; Kenrick 2009, 161. The site is sometimes spelt Aïn Sharshara. Bir Cùca is marked as an elite "villa" on Goodchild 1954 and subsequent maps, but details are sketchy.

135. Alcock 1950; Rind 2009, 114 (SA 2). Another *villa maritima* near Sabratha is known from surface evidence (Rind 2009, 114, SA 1).

136. Examples include: 1. *Zanzur* (Janzur), 18 km west of Tripoli, second century (Aurigemma 1960, 42–3); 2. *Gurgi*, 4.5 km south-west of Tripoli (not on the coast, so a *villa suburbana*), six mosaic-paved rooms (c. 200 CE?) and a linking corridor (Aurigemma 1960, 41–2 with pls. 63–7; Rind

2009, 115 with other bibliography). 3. *Ain Zara*, a probable villa, 10 km south-east of Tripoli (Aurigemma 1960, 35–7 with pls. 53–5; Rind 2009, 118). 4. *Gargàresc*, 7 km west of Tripoli, second century (Aurigemma 1960, 39–40 with pls. 59–62; Rind 2009, 118). 5. *Bag eg-Gedid*, immediately west of Tripoli between the city wall and the sea, four rooms with mosaic (Rind 2009, 118–19). 6. *Sidi-Andallùlsi*, 15.5 km east of Tripoli, a *villa maritima*, one room and parts of two more and portions of two sides of a peristyle corridor (Aurigemma 1960, 34–5 and pls. 51–2; Rind 2009, 117). 7. *Zliten East*, also maritime (Fòndugh Scifè) (Aurigemma 1960, 60–1 and pl. 175). See also note 139. Isolated bath-houses (p. 276) in Tripolitania with mosaics: En-Ngila (17 km SW of Tripoli), Uàdi ez-Zgàia (between Tripoli and Lepcis) and Mellaha (13 km east of Tripoli) (Aurigemma 1960, 38–9, 43–5 and 33); Wadi Guman on the Tarhuna plateau (Ali Asmia and Ahmed al-Haddad 1997, 218). For another list, Di Vita 1966a, 27 (twenty maritime "pleasure villas" in all).

137. Initially reported by Merrony 2005.

138. Sintes 2010, 132–3 (gladiator panel). There is preliminary publication now in Musso et al. 2015; discussion also in Dunbabin 2016, 193–4.

139. Di Vita 1966a; Carucci 2007, 167–8; Rind 2009, 116–17; Kenrick 2009, 142 (Tajura). Another villa in the same region, south of Tagiura, and a little inland, is suspected on the basis of two adjoining geometric mosaics, one dedicated (c. 100 CE?) by a certain Calpurnius Candidus, presumably its owner (Aurigemma 1960, 37–8 with pls. 56–7).

140. E.g., Bullo and Ghedini 2003, 75–6; Carucci 2007, 23–5.

141. Carucci 2007, 168, identifies both as *triclinia*, possible when more guests were invited than the lower-level dining room could accommodate; but the upper chamber, with marble decoration and its uninterrupted view of the sea, was surely the principal dining room.

142. The latest coins are two of Gratian (378/83 CE), one from a disturbed post-Roman context in the baths, the other found 1 m above where coins of 346 and 351 were found (Di Vita 1966a, 26): the Gratian coins therefore probably post-date the elite occupation of the villa. *Tsunami* of 365 CE: Guidoboni 1989, 567–70 with fig. 320; 678–80; Kelly 2004; see also Wilson 2014b, 695–6. For an interpretation of the

bricks used at the Taguira villa, see Chapter 1 in this book; on their rarity in Africa, Thébert 2000, 348–9.

143. I omit the "Villa of the Nile" (Aurigemma 1960, 45–9; Rind 2009, 123–4), which lies within the Roman urban area (and so a *domus*) before the city retreated inside new fourth-century walls. New maritime villas found during the Lepcis Magna Coastal Survey: Schörle and Leitch 2012, especially 151.

144. 1. *Wadi Lebda*: see notes 137–8. 2. *Wadi Zennad*, Khoms, 3 km west of Lepcis, 200 m from sea, discovered 1923, re-excavated 1988, eleven rooms on two sides (rest unknown) of a peristyle (colonnade, 5 x 5 columns, 15 m square), *opus sectile* and mosaic floors; the largest room on the north side with *pi*-shaped arrangement of part of the mosaic floor, clearly the *triclinium*, also opposite a small fountain in the peristyle court; two figured mosaics (Tripoli Museum), probably third century CE; geometric mosaics now in Lepcis Museum (Bartoccini 1927; Aurigemma 1960, 50–2; Matoug 1995; Rind 2009, 124–5). 3. *Wadi al-Fani*, west of Khoms, surface survey of a villa platform 40 m², one mosaic room identified, detached bath-house on north-west (mosaics, marble); oil press and mausoleum, 200 m to the south-west, the latter later than but probably associated with the villa (Absalam Ben Rabha and Masturzo 1997). 4. *Wadi es-Rsaf*, western suburb of Lepcis, immediately north-west of the early urban perimeter rampart, complex multi-phase building (in cemetery area) with peristyle (?) and mosaic, built in mud brick c. 175/200 CE, rebuilt c. 200/250 in *opus Africanum*, abandoned and used as a garbage tip from c. 300 CE (Musso 1997, 258–62 and 272–5; Munzi and Felici 2008; Rind 2009, 127–8 with further bibliography). 5. *at-Thalia*, an unpublished *villa suburbana* near Homs, late Antonine/early Severan (plan and details of frescoes: Bianchi 2004, 1736, fig. 3 and 1740–9). Discussion of rural settlement in the territory of Lepcis Magna: Cifani et al. 2003.

145. Salza Prina Ricotti 1970–1; 1972; 1972–3, 77–84; Rind 2009, 119–22. Another of the Silin group is less informative (villa area 35x40 m, baths to east (?), second/third century (?); associated tomb monument slightly inland: Masturzo 1997; Rind 2009, 122).

146. Salza Prina Ricotti 1970–1, 141, note 16, is unsure whether these were freestanding or part of a screen wall pierced with windows (she adopted the former in her reconstruction).

147. It recalls (on a tiny scale) the semicircular *exedra* with the cliff-top view east from Tiberius' Villa Jovis (Krause 2003, 71–8 with Abb. 99, 107 and 111a).

148. It measures c. 6.45 by 7.45 m. Pliny the Younger had one such feature in his Laurentine villa: *Ep.* 2.17.12: "on one side a tower has been built with two sitting rooms on the ground floor, two more on the first floor, and above them a dining room which commands a very wide expanse of sea, a very long stretch of shore, and the most pleasant (neighbouring) villas. ..."

149. See note 39, however, for the impossibility of proving such relationships.

150. Al-Mahjub 1983; 1987; Picard 1985; Dunbabin 1999, 122–4; Carucci 2007, 165–6; Wilson 2008a; Kenrick 2009, 143–7.

151. I.e., it did not run straight but weaved in and out, hugging the exterior of the villa's rooms.

152. The Villa of the Papyri outside Herculaneum (a *villa suburbana*, but also *maritima*) is a famous exception (Sider 2005). Private libraries: Casson 2001, 69–79; Fedeli 2014; in *domus* at Pompeii: Knüvener 2002.

153. The first stone circus is probably not pre-Hadrianic (Humphrey 1986, 53–4).

154. Carucci 2007, 166, mistakenly treats the garden as the *triclinium*.

155. From Cap de Garde, near Hippo Regius (Algeria); they are separated by strips of a red marble, probably *rosso antico* from Greece.

156. Picard 1985 thinks that the prisoners are easterners captured on Caracalla's campaign in 216 CE, and that Philoserapis refers to Caracalla himself, a known epithet; but the notion that news of a *munus* in Rome reached an African villa-owner who then chose to depict it on his floor is far-fetched; nor is it probable that the mosaic is as late as the third century.

157. Philoserapis has been claimed to be stager of the games (*comp* standing for *comparavit*, "prepared" or "arranged"), and possibly therefore owner of the villa; it does not sound like the name of a wealthy African magistrate staging games (who might on mosaic have recorded his *tria nomina*), but rather that of a slave or freedman, appropriate to the mosaicist (in Rome, of six examples of Philoserapis, four are slaves or freedmen, two *incerti*: Solin 2003, 172). *Componere* is not used elsewhere in mosaic signatures, but it is used in this sense by Augustine (*Ord.* 1.1.2: *compositio*;

Donderer 2008, 29 and 78–80, no. a32). The choice of scene may indicate that the owner wanted to record a show he himself had presented (or just enjoyed?) in the Lepcis amphitheater; but it was for private reflection rather than the appreciation of guests (it was in a bedroom).

158. On abandonment (when is unknown), the marble was stripped for recycling, leaving only impressions in the mortar. Of the mosaic in the room east of 10, only depiction of a foot was left behind.

159. By contrast with 13, this is still intact (using mainly *giallo antico* from Chemtou (Simitthus) and *africano* from the Troad).

160. Kenrick 2009, 147, suggests it was a *lararium* (color photo in Pensabene 2013a, 414, fig. 9.7).

161. Ward-Perkins and Toynbee 1949, 170 with fig. 2.

162. Apparently, it did not survive into the late Roman period (Kenrick 2009, 143). Bianchi 2004, 1737, detects some redecoration of walls; he suggests occupation "perlomeno dal I sec. d.C. alla prima metà del III sec."

163. Aurigemma 1926; Haynes 1955, 145–8; Kenrick 2009, 150–1. Apart from Zliten East (see note 136, no. 7), no certain *villae maritimae* are known further east.

164. Other portions are in the Zliten museum and in the Mosaics Museum at Lepcis. Mosaics: Aurigemma 1926, 43–266; 1960, 55–66 with pls. 116–74; Dunbabin 1978, pls. 1, 2, 46–9 and 95–6; 1999, 119–22; and many times reproduced.

165. Information from Youssef Al-Khattali (Tripoli). Haynes 1955, 146–7 reports this mosaic in 16 (Aurigemma 1926, 82, fig. 48) had already "vanished" by the 1950s, but sand was brushed back for me from part of it in 1973 and what I saw was intact.

166. The four small columns (and an adjacent corridor?) shown south of the east end of cistern 1 (see Fig. 16.28) are unexplained. Do they represent a fragment of an earlier villa on the site? Column stumps were re-erected at the time of excavation (Aurigemma 1926, 35, fig. 13), but it is not clear if they were found at a lower level (Aurigemma makes no mention of them).

167. The corridor is 47.50 m long (Aurigemma 1926, 60, n. 6); if complete, and if the Roman foot (296 mm), not the Punic cubit (515 mm), was in use, a length of 160 Roman feet may have been intended (the *ambulatio* at Taguira [Fig. 16.17] was perhaps planned as 150 feet = 44.40 m). Precise modern surveying is needed, however, before we can confidently make progress on understanding the metrology used by villa architects here.

168. Room 5 had a fragmentary mosaic based on a centralized circular design, and 4 a marble *opus sectile* floor and marble wall veneer (fragments remain: personal observation); neither room is mentioned by Aurigemma 1926.

169. Room 6 off the west side of 7 is of uncertain function (it is not mentioned in Aurigemma 1926).

170. Fragments of *emblemata* in terracotta trays found among collapsed debris in the south corridor and around room 14 had fallen from an upper floor (Aurigemma 1926, 67–72 with figs. 35–8). Perhaps there was a tower room or rooms above, with dining facilities where a fine panorama over the sea could be enjoyed (see note 148).

171. The whole of this southernmost part of the dwelling is poorly understood.

172. It is hard to deduce from Aurigemma (1926, 78 with figs. 45–8) how this fountain worked. He says that the Nilotic mosaic was viewed under a film of water, but on three sides of the pavement there is nothing to contain the water even if the jets managed to spray water onto it. The east side, with its trough and five jets, appears to impede access to the room; yet the presence of a lower step shows that access had once been intended. The fountain with its mosaic must have been a secondary insertion in what originally was a raised recess approached by two steps, of which the upper was broken when the fountain was inserted, and access was no longer envisaged.

173. Date of excavation: Aurigemma 1926, 207, caption to fig. 28; he published photographs of part of the brick-paved court (fig. 129) and the baths (fig. 39), but no overall plan: Kenrick 2009, 151, fig. 66 was the first to do so. Baths mosaic: Aurigemma 1926, 72–8 with figs. Kenrick (2009, 150) mentions a threshold mosaic in the baths depicting sandals, still *in situ*, unpublished (a common motif in bathhouse mosaics, as at Timgad, Sabratha, Jonvelle in France and now Piazza Armerina in Sicily, etc.).

174. Aurigemma 1962, 9–77 and pls. 1–71, unjustly neglected in recent studies of Roman painting (ignored by Ling 1991 and Mielsch 2001; passing mention only in Croisille 2005, 104; also 220, fig. 323). See Bianchi 2004 for a reassessment of Tripolitanian wall-painting.

175. Aurigemma 1962, pl. 66 = Croisille 2005, fig. 115, who follows Aurigemma's Flavian date.

176. Dunbabin 1978, 235–7; 1999, 119, n. 48; Parrish 1985.
177. Also likely to be secondary is the Nilotic mosaic (note 172). Both the draughtsmanship and the overall composition of both pavements lack the finesse of other floors at Zliten.
178. Aurigemma 1962, 17–20 suggested occupation until the Asturian invasions in the second half of the fourth century; but mosaics in continuous use for 250 years would surely have shown signs of wear and tear.
179. I refer here only to sites discussed in the text; a few known only from their mosaics may be third-century; others may have started in the first century.
180. Long corridors are present at Zliten (Dar Buc Amméra), Tagiura and Silin (Villa of the Maritime Odeon). For Campania, there are famous examples at the Villa of the Papyri (Herculaneum), and on Capri, at Augustus' Damaceuta villa and Tiberius' *Villa Jovis* (Lafon 2001, fig. 144, west; fig. 142; fig. 138A, far north side); but there are many others.
181. On the sheer variety of *villae maritimae* in one part of Campania, the Sorrento peninsula, and their distinctive individuality, each adapted to the exigencies of the coastal landscape, see now Filser et al. 2017, especially 66–7 and 71.

THE ROMAN VILLA AT APOLLONIA (ISRAEL)[1]
OREN TAL AND THE LATE ISRAEL ROLL[2]

PART I: THE SITE

Apollonia-Arsuf is located on a *kurkar* (fossilized dune sandstone) cliff overlooking the Mediterranean shore in the north-west part of the modern city of Herzliya, c. 17 km north of Jaffa and 34 km south of Caesarea (Map 13). The architectural remains of the Roman period are built at an elevation of approximately 26 m above sea-level, within the geological unit of the Tel Aviv *Kurkar Bed*, which constitutes the coastal ridge.[3] The building materials used were mainly quarried from the site itself or from its immediate surroundings.

The southern coast of the Sharon plain has little natural anchorage, but Apollonia-Arsuf offers safe harbor because the calcareous sandstone outcroppings at the foot of the south and central parts of the site rebuff sea waves from the shoreline. As a result, the site was used in Persian, Hellenistic and Roman times, and modern fishermen still use its calm waters protected by beach rocks.[4]

Excavations at Apollonia-Arsuf have unearthed sporadic occupation layers of the Chalcolithic period and the Iron Age II, but the site has a continuous history, beginning as a coastal settlement and developing into a maritime urban center covering a period of approximately eighteen centuries, from the late sixth century BCE through the mid-thirteenth century CE. It is in Roman times, however, that the site makes its appearance in written sources, in Josephus and others.[5] The depiction of Apollonia on the *Tabula Peutingeriana*, on the coastal highway between Joppa and Caesarea and at a distance of 22 miles from the latter, is of great importance: it indicates that it served as an official way-station on the imperial road network. In addition, the impressive Roman-style villa uncovered in Area E of the site provides tangible proof for the cultural and physical presence of Rome.[6]

THE VILLA

Excavations in Area E (the southernmost excavated area of the site) began in 1980 and 1981, outside and beneath a medieval town wall, and lasted intermittently through 2000 (Figure 17.1). After the removal of the Byzantine remains, a central peristyle courtyard (Locus 1844) was uncovered, as well as several other rooms around it: these constituted a dwelling of the peristyle type, dated on the basis of the finds to the early Roman presence in the area in the second half of the first century CE (Figures 16.2, 16.3 A–B). A great many of the preserved components of the building were excavated: its plan, the method of its initial construction, the structural changes that occurred at a later stage, and the cause of its final destruction and abandonment.

While not all peristyle-type buildings have a domestic character, the variety of finds (table ware, cooking pots, storage jars, and lamps) in Area E attested the domestic uses of the building at least in

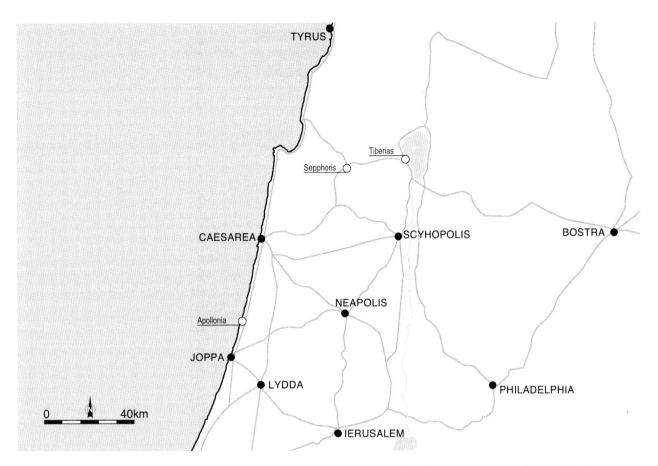

Map 13. Part of the Roman province of Judea, with major towns; the underlined locations are sites discussed in the text (M. D. Öz).

its second phase (Stratum Roman 2B) where these finds originated.[7] Moreover, the inner plan of the building, with almost every room approachable via two doorways in the first phase (Stratum Roman 2A) further corroborated its residential nature. With its west façade facing and framing views of the sea, this was clearly a building designed as a *villa maritima*, and the choices of height and alignment for construction indicate that dramatic perspectives over the sea and the coastal cliffs were determinants of the villa's design, as they were in other Roman seaside villas.

SITING AND DIMENSIONS

The creation of the villa and its marine perspectives were difficult to effect, but the patron and designers were determined, and determined in a very Roman way. The location, almost at the top of the seashore slope and above a small ravine that descended to the harbor, was not easy to access. To construct the building, the slope's natural sandstone rock was hewn to a depth of more than 3 m on the east side, then leveled horizontally toward the west to a flat surface at an average height of 26.20 m above sea-level for the floors of the dwelling (Figure 17.2). The surface thus obtained was a maximum of 21.50 m north to south and somewhat more than 24 m east to west (the west side of the site is eroded and has fallen into a ravine). These dimensions are significant because they clearly indicate that the site was planned in standard Latin (Roman) feet (1 *pes* = 0.2957 cm).[8] The platform for the villa was thus 72 *pedes* north-south and somewhere near 88 *pedes* in east-west length, in a ratio of width/length of 8:10, very firmly expressed in Latin feet.

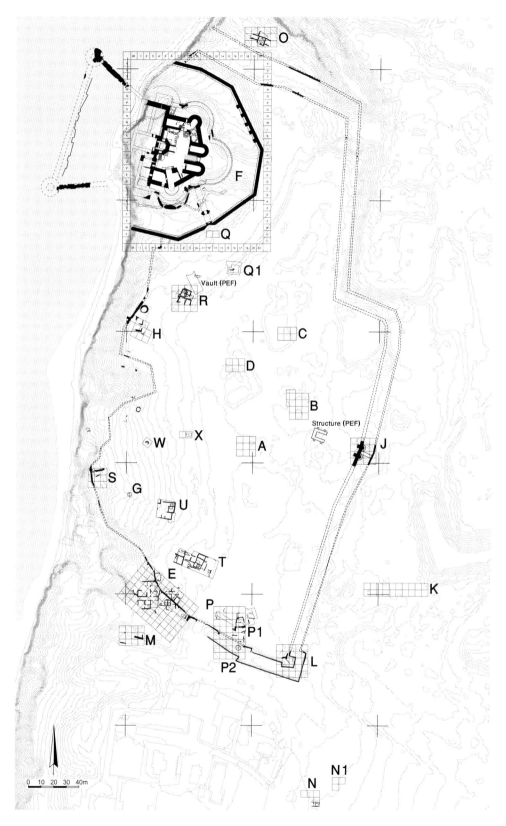

Figure 17.1. Apollonia-
Arsuf: site plan.

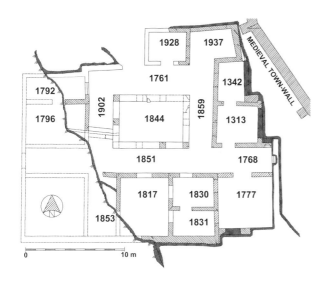

Figure 17.2. Apollonia-Arsuf, Roman villa, plan.

Within the platform dimensioned in Latin feet, the outlines of the villa itself are less regular. The line of its east wall steps slightly inward three times, from south to north. The south wall extends one step outward, south of Locus 1831. The north wall of the villa turns at a slight northward angle when approaching Locus 1928. The leveled surface as a whole, however, permitted the construction of a full peristyle villa aligned with the four cardinal points. The courtyard itself was open to the sky: a water channel took rainwater and passed under the stylobate of the columns on the west side.

PLAN AND DATING

To the south of the courtyard, a long corridor (Loci 1851/1768) crossed the entire building from west to east (Figure 17.2). The entry to the villa was most likely located at the eroded west end of this corridor and has not been preserved. In the upper part of two of the walls at the corridor's east end (Locus 1768), there are two plastered niches facing its northeast corner, at a height of c. 2.35 m (8 *pedes*) above the floor (Figure 17.4). The niches are recessed and arcaded; their shape and location recall *lararia* typical of Roman dwellings in central and southern Italy.[9] Three shorter corridors surround the courtyard on its other sides (Loci 1859, 1902 and 1761): they, with the long corridor (Loci 1851/1768) provided roofed access to all the rooms surrounding the peristyle through doorways of an average width of 1.35 m (= 3 *cubiti*). The doors were equipped with stone or rock-cut thresholds, and the construction of the entire complex was impressively robust.

The overall dimensions of the site in Latin feet was continued in the interior components and spaces: the thickness of the inner walls, with the exception of the walls of the peristyle, ranged between 0.40 and 0.45 m, equaling 1 *cubitus* (1.5 *pedes* = 0.44 m). Interior dimensions of the rooms also corresponded to Latin feet. The focus of the villa was its peristyle (Locus 1844), clearly planned in Latin feet: it had interior dimensions of c. - 6.45×3.85 m, corresponding to 22×13 *pedes*, and the width of its corridors (2.40 m in width on average) corresponded to 8 *pedes*. Even the villa's building elements obeyed the Latin standard: the peristyle was defined by square sandstone piers supported on a stylobate built of sandstone headers (rectangular blocks set with their short side facing out). Of the original ten piers that surrounded the courtyard, only the lower parts of four are preserved. They are built alternately of headers and stretchers with parallel square cavities – likely for the insertion of horizontal wooden beams to block passage from the central courtyard to the surrounding corridors when necessary. The building blocks of the piers and stylobate are on average 0.29–0.30 m in width (= 1 *pes*), 0.43–0.44 m in height (= 1 *cubitus*), and 0.59–0.60 m in length (= 2 *pedes*), thereby confirming the use of Latin feet and its subdivisions as much in the shaping of construction elements as in the overall dimensions of the whole platform hewn out for the villa site.

The walls of the villa were strongly built of large *kurkar* ashlars laid as stretchers (blocks with the long side facing out) and set with gray mortar typical of Roman construction techniques (*opus caementicium* or rubble construction, though neither of these methods are present). Their dimensions are not always uniform, but their average size is similar to the size of the stones of the stylobate and piers of the peristyle, that is, with a variation between 0.30, 0.44, and 0.60 m. The lower sections of the east and south walls were cut into the bedrock and plastered. Their upper

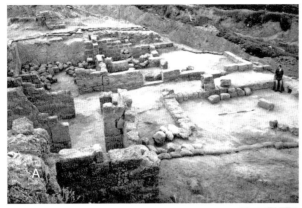

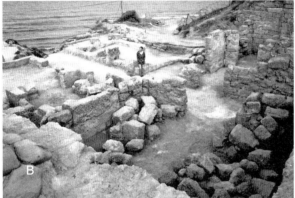

Figure 17.3. Apollonia-Arsuf, Roman villa: A: view to northwest; B: view to south.

Figure 17.4. Apollonia-Arsuf, Roman villa: *lararium*, view to northeast.

sections overlay the bedrock and were solidly built of headers c. 0.60 m (= 2 *pedes*) thick. The robust construction and the preserved height of the walls in the east and south areas of the villa imply the existence of a second story for these parts of the building. There may also have been a second story on the west side of the villa, but the evidence for its walls is missing due to the collapse of the structures into the ravine below.

The rooms that surround the peristyle courtyard differed in shape and size as a result of the irregular exterior perimeter of the villa. Little can be said about the nature and function of the rooms because no furnishings of any kind were discovered. However, the niches at the eastern end of the long corridor serving as the dwelling's *lararium* were in some proximity to a clay oven built into the bedrock in the south-east corner of Locus 1937, indicating that the room also served as a *culina* (see later in this chapter), in that combination of pious and practical uses well

known at Pompeii and elsewhere in Italy.[10] The rooms located to the south of the long corridor (Loci 1777, 1817, 1830 and 1831) are better planned, better built, and more carefully plastered than the other rooms, so the southern group of rooms must have served the owner or manager of the villa, his family and guests, while the northern units were primarily used as service spaces.[11]

At first glance, the long corridor (Locus 1851) is reminiscent of the *pastas* of Hellenistic dwellings, which usually bisected the building and had an entry or a window on either side.[12] At Apollonia, however, the east end of the corridor is not only without an opening but also takes the form of a *lararium*, in an arrangement of distinctively Roman type and Western origin.[13] A comparison with other peristyle dwellings of Roman and Byzantine Palestine shows that the Apollonia villa is the earliest example of its kind yet uncovered along the coast.[14]

Only a few finds can be connected with the initial phase of the villa, i.e., those in Stratum Roman 2A. These finds were retrieved from Loci located right above the bedrock (Loci 1313, 1342, 1761, 1844, 1928). Their fragmentary condition as well as their variety and small number suggest that they were most probably embedded in foundation fills placed beneath the second-phase floor (i.e., Stratum Roman 2B): as such, some may be intrusive in consequence of the second-phase disturbances. Even so, the fragments of bowls, casseroles, cooking

pots, jugs, juglets, storage jars, amphorae, and lamps point to a late first-century CE date for the initial design and construction of the villa. A bronze coin of Neapolis issue dated to 159/60 CE may be intrusive in the material. In any case, some finds discovered on the bedrock hewn for the original villa (Stratum Roman 2A) were closely related to those of the second-phase (Stratum Roman 2B), so affinities of the finds on bedrock and those under the second-phase floors indicate that the villa in its earliest phase must have been very briefly occupied after its initial construction.

The second phase (Stratum Roman 2B) of the Apollonia villa represents a degradation of its original design: the building's internal plan underwent significant alterations. The entries to several rooms were sloppily but intentionally blocked to convert the dwelling into several separate units of different periods, presumably by different inhabitants. Several adjacent rooms initially linked to one another were turned into independent units, with floors made of packed earth embedded with sherds and crushed rubble laid upon a thin layer of packed brown soil. Most of the finds from the villa were discovered in these floors.[15] In Locus 1937, mainly cooking vessels were found, as well as a fireplace (a *ṭabun*), suggesting that it functioned (at least in this phase) as a *culina*.[16] The two coins retrieved in Stratum Roman 2B (from Rooms 1937 1777) are dated to the reign of Emperor Vespasian, to 71 and 79 CE.

Later still, a devastating earthquake destroyed the villa in its degraded form. Ashlar blocks fallen from the surrounding walls were found in practically all the rooms. In the north corridor (Loci 1902 and 1761), the north wall collapsed in its entirety toward the south; almost all of its ashlars are still preserved in their fallen position, one course lying next to the other. In the east rooms (Loci 1313, 1342 and 1777), as well as in two of the side rooms (Loci 1928 and 1830), the collapse was particularly severe, as is evident from the large number of fallen stones and from numerous crushed vessels found beneath them. This pottery dates mainly to the late first and early second centuries CE. In this period, one major earthquake was recorded; it occurred sometime in

the first quarter of the second century CE.[17] The earthquake had a disastrous impact on the entire Sharon plain, from Caesarea to Nicopolis. Moreover, the early second-century CE destruction of the Caesarea harbor seems to have been caused by a tsunami which may have been the result of this same earthquake; the dating of the tsunami has been set to December 115 CE.[18] It is logical to assume, then, that the destruction of the Roman villa at Apollonia was the result of this cataclysmic event. Afterwards, the structure was not rebuilt, and because it was partially underground and at a lower level than the surrounding area, the ruined site became a garbage dump. Discarded refuse included large quantities of pottery that came from surrounding buildings. The few Roman coins found in the refuse of Stratum Roman 1 are municipal and imperial coins which post-date the second and the third decade of the second century CE.[19]

PART II. NEW INTERPRETATION OF THE ROMAN VILLA AT APOLLONIA

The villa of Apollonia-Arsuf is one of the earliest examples of a peristyle-type building documented on the coast of Palestine. The term *villa maritima*, although it has been used in our previous publications, should be corrected to *villa literalism* given the fact that the building was not erected on the sea shore but rather above it and overlooking it.[20] Still, it is unlike classical houses of this type in the Greek and Roman architectural tradition; peristyle houses were usually individual units opening onto a street with an interior invisible from outside, sharing walls with adjacent houses. By contrast, the Apollonia villa is structured as a self-contained, isolated unit. True peristyle courtyards like that at Apollonia are, in general, quite few among the dwellings of the Hellenistic period in Palestine.[21] Such buildings were introduced to the region by Herod and his successors, but it is only much later, in the second and third centuries CE, that they were adopted in Palestine for domestic and other buildings.[22] The early Roman villa at Apollonia is an exception,

and an exception for the whole site because it was the only structure that can be dated early in the Roman hegemonic occupation in Palestine.[23] In addition, its early date is anomalous vis-à-vis the much later development of Apollonia itself.

The early mention of Apollonia by Josephus (see p. 00) compared to the much later development of the town is puzzling, and why the early Roman material should be concentrated in a single area on the south part of the site (Area E-south, Figure 17.1) is also a question.

Previously, and in view of the dwelling's fully Roman plan including the two niches of its *lararium*, we interpreted the Apollonia peristyle villa as having belonged to a rich foreign merchant or to a local magnate who had embraced Roman cultural norms.[24] However, this interpretation does not provide a good or complete account of the villa's construction and date. A rich foreign merchant or a Romanized local magnate could not act on his own, in a way uncoordinated with other local developments. Instead, a broader perspective should take into consideration the geo-political conditions that prevailed at the time of the villa's construction, datable, as we have seen, to the later first century CE as verified by coins and pottery sherds compatible with a date ±70 CE. The site's location on the coastal trunk highway, 17 km north of Jaffa and 34 km south of Caesarea, later became an official way-station in the network of imperial roads: the site was important from the early Roman occupation of the area to late antiquity.

Both urban centers, Jaffa (Joppa) and Caesarea (Maritima), played an important role in the First Jewish War (also known as the Great Revolt) that began in 66 CE. According to Josephus, the revolt began at Caesarea at the outset of religious tensions between Greeks and Jews which then mutated into anti-taxation protests and attacks on Roman citizens and symbols.[25] Jaffa (Joppa) was captured twice and ultimately razed to the ground by Cestius Gallus, the legate of Syria, who brought a legion to the country (the *Legio* XII *Fulminata*) and auxiliary troops as reinforcements to restore order, after which Vespasian erected a stronghold on the Jaffa acropolis.[26] While milestones date Judaea's imperial road system mainly to the time of Hadrian and the Antonines in the second century (the area was a military province that served the imperial expeditions launched against Persia), recent discoveries show that Roman roads had been established in Judaea earlier and in the context of the First Jewish War.[27]

The first discovery to indicate Roman road-building, transport, and communications activity in the area is a milestone discovered in the Valley of Jezreel (near the modern town of 'Afula), marking the construction of the Caesarea-Scythopolis road and giving it a date of 69 CE (see Map 13).[28] Although this road may have been a short-term military project not related to any important reorganization of the province in consequence of the war, it was not an isolated instance of Roman presence in the area.[29]

Further evidence for the construction of the Caesarea-Scythopolis road comes from the recently discovered Roman *mansio* at 'Ein ez-Zeituna in Wadi 'Ara (Naḥal 'Iron); this villa-like building, with a peristyle plan similar to that at Apollonia, can be securely dated to ±70 CE especially from coin evidence.[30] The fact that both peristyle buildings from 'Ein ez-Zeituna and Apollonia are similarly dated, sharing the same building design and both built according to the standard of the Latin foot, relate them both to the activities of the Roman military in the contexts of the First Jewish War. We can conclude that the Roman villa at Apollonia served (at least in its construction and early habitation, Stratum Roman 2A) as a *mansio* along the Jaffa-Caesarea road built to ensure Roman military movements during the First Jewish War 66–73 CE). This conclusion makes the date of the villa in the last third of the first century CE plausible in view of historical events, and it squares its early date relative to the other, later Roman structures at Apollonia; it also explains the very short habitation history of the building. When it lost its function along the road, it was converted to other uses and eventually became a rubbish dump.

The construction of a *mansio* at Apollonia-Arsuf in the form of a Roman peristyle villa complete with a *lararium*, serving as a way-station along a militarily important road in the Sharon plain in Flavian times

would be unusual if there were not another quite similar one at 'Ein ez-Zeituna on one of the lateral branches of this north-south coastal route. Together, their plans and amenities were intended to provide environments which distinctly recalled their Italian prototypes. We cannot know for certain who would have patronized these *mansiones* in this pacified area of Palestine, and the clientele may well have been a combination of local businessmen, transport officials, official and private messengers, and others bent on commerce in the region. Prominent patrons would also have been Roman military officers, magistrates, administrators, and official guests moving up and down the coast road on state business. For them, the *mansio* at Roman Apollonia would have been a venue that was architecturally familiar to them, a "home away from home" along the lines of a domestic architecture that they already knew in Italy, but here transposed to a land in which it was unfamiliar. The villa – an Italian archetype – signified hospitality and rest no matter where it might be, so its use for busy military and civilian personnel as a temporary dwelling would have been welcome in the newly colonized region. However, once it outlived its original function with the stabilization of the province, it was converted to other uses.

NOTES

1. The first part of this article is a synopsis of a previously published material on the Roman villa of Apollonia (Roll and Tal 2008). The second part is an epilogue that offers some new interpretations on the site's role in the late first to the early second centuries CE and is the result of research of O. Tal.

2. Prof. Israel Roll (1937–2010) taught at Tel Aviv University's Department of Classics and Department of Archaeology and Ancient Near Eastern Cultures from 1970. As one of the most prominent archaeologists of Palestine's classical period, he headed archaeological excavations at many sites, but mainly at Apollonia-Arsuf (1977–2006), where he transformed it from a neglected site into an official national park (2001), furthering its recognition by the World Monuments Fund as one of the world's 100 most endangered heritage

sites (2004) and its inclusion among the Crusader castles on UNESCO's Tentative List of World Heritage Sites (2006). His friends and colleagues remember him as a peacemaker and bridge-builder, a remarkable scholar and intellectual, a wonderful educator and a *mensch*. He is sadly missed.

3. This layer represents the uppermost and youngest *kurkar* unit. It forms the top of the coastal ridge and is composed of large, semi-to fully cemented calcareous grains and fossilized terrestrial snails.

4. Grossmann 2001.

5. Joseph., *BJ* 1.8.4 [166], 1.21.5 [409]; *AJ* 13.15.4 [395], 14.5.3 [88]); Plin., *HN* 5.13.69 and Ptol., *Geog.* 5.15.

6. The figure of 22 miles corresponds to the actual distance between the two ancient sites of Caesarea and Arsuf, thus providing proof for the identification of Apollonia with Arsuf: Roll 1999, 1–8, n. 5–10).

7. Peristyles could characterize buildings of various functions: *horrea* (warehouses), *macella* (markets), and so on. See Patrich 1996 and 1999, 75–81.

8. Adam 1999, 40–3.

9. Boyce 1937, 10–12; Orr 1978, 1575–87; Bakker 1994, 8–20.

10. For *lararia* in proximity to kitchens, Foss 1997.

11. For recent discussion on various aspects of this subject, see Zanker 1998, 9–25; Ellis 2000, 166–87; Allison 2001.

12. Graham 1966; Krause 1977.

13. For discussion, Ackerman 1990, 35–61; Gros 2001, 263–313; Wallace-Hadrill 1994, 65–90.

14. Roman peristyle buildings are relatively less common in Palestine: Hirschfeld 1995, 85–97, 101, table 4. See also Weiss (Chapter 18) in this book. There is preliminary publication of the Roman *villa maritima* discovered at Gaza and dating to the first century CE: Humbert 2000, 117–19; Sadeq 2007, 228.

 A recently discovered peristyle building in Naḥal 'Iron, identified as a *mansio* alongside the Caesarea-Legio road, shows a striking resemblance to the Apollonia-Arsuf villa in building design, chronology, and finds: Glick 2006; see also Milson 2006; Winter 2006; Bijovsky 2006.

15. They consist of table vessels such as bowls (including Roman *terra sigillata* A), jugs and juglets; cooking vessels, such as casseroles (one with its original lid, which were manufactured jointly) and cooking pots; storage vessels, such as local jars of the Palestinian ridge-neck type and early "Gaza" type and imported amphorae from production centers in the Mediterranean and Aegean, and local and imported lamps. Smaller quantities of stone and glass vessels, bone objects, and human and animal figurines were also discovered.

16. General references to the pottery can be found in Herr (1996: 201–8, *passim*).

17. In 113/114 CE, according to Russell 1985, 40–1, or in 126/127 CE, according to Guidoboni 1994, 234.

18. Reinhardt et al. 2006.

19. In contrast to Judaea, the Palestinian coast lacks good published examples of well-stratified pottery assemblages of the late first and early second centuries CE. Stratum Roman 2b assemblage is therefore unique. Most of the vessels and fragments belong to known coastal, Palestinian, Mediterranean, and Aegean pottery types, but their unified assemblage at the villa site gives evidence for the coastal material culture at the time.

20. This definition is not found in the ancient sources and is a modern classification ultimately going back to Piccarreta 1977, where a strict distinction between "ville littorali" and "ville marittime" is adopted.

21. Tal 2017, 97–121 *passim*. For urban peristyle houses with villa-like characteristics, see Weiss (Chapter 18) in this book.

22. Lichtenberger 2011, 135–8. See Weiss (Chapter 18) in this book.

23. Twenty-five seasons of excavations were carried out at the site (from 1977 to the present), in addition to salvage excavations in 1950, 1962, 2012–2013 and 2017. Eighteen areas of excavations were dug, seventeen within the medieval fortified town area (A, B, C, D, E-north, F, G, H, J, L, P, Q, R, S, T, U, W), and five (E-south, K, M, N, O) outside it; in six excavation areas we reached virgin soil (D, E, H, M, O, P). These resulted in late antique and medieval structures, with only the villa substantially earlier in date.

24. Roll and Tal 2008: 142.

25. Joseph., *BJ* 2.14.4 ff. [284– ff.]

26. Joseph., *BJ* 2.18.10 [507–9]; 3.9.3 [414–26].

27. Isaac 1998: 65–66. In the context of road-building, the northern section of Ptolemais-Tyre-Antioch road is dated by milestones to 56 CE; Alt 1928. The road coincided with the foundation of Ptolemais as a veteran colony by Claudius between 51/52 and 54; Isaac 1992, 322–3. The milestones explicitly mentioned the road from Antioch to Ptolemais, namely outside the Province of Judaea, so its construction is not directly related to the Jaffa-Caesarea-Ptolemais road, which may not have yet been constructed. The earliest evidence for the Caesarea-Ptolemais road is dated to Marcus Aurelius 162 CE, though it could have been earlier: *AE* 1971.470; Roll 1996.

28. Isaac and Roll 1998.

29. Two other inscriptions on milestones suggest the existence of a road leading somewhere from Jerusalem, dated 72–9 CE despite unexplained tampering with their inscriptions in antiquity; for the first milestone: Isaac and Gichon 1998, esp. 86; for the second milestone: *AE* 2003.1810; Reich and Billig 2003; Cotton and Eck 2009, 99★-101★). I am indebted to B. Isaac for his comments on these two inscriptions.

30. Glick 2006, 63; see also Milson 2006. For the coin evidence, Bijovsky 2006.

HOUSES OF THE WEALTHY IN ROMAN GALILEE

ZEEV WEISS

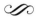

Private space in the Roman world is represented by a combination of architectural forms. Its location within a city was determined by the local topography, road and street systems, as well as its relation to public space. Urban dwellings themselves, at times built close to each other, varied in their size, construction, decoration, and purpose; the differences among them also differentiated the socioeconomic status of their residents. While the majority of a city's population lived in simple dwellings, wealthy inhabitants resided in large, spacious, and well-planned houses that could be modeled on quite different standards.[1]

In the Roman east, villas had a different trajectory than they had in much of the Roman Empire. In Roman Palestine and Syria, there is little or no evidence of rich and luxurious villas aligned with working farms as had become common elsewhere, in a system of such establishments in the rural landscape. The wealthy, of course, owned rural estates, but these were characterized by rural villages for the tenants and farmers of the estates rather than by well-appointed villas for the owners. In these regions, the wealthy expressed their social standing through the luxury and décor of their urban houses.

However, the architecture of these rich houses and the decorative repertoire they display show clearly that they were participating in the same architectural vocabulary used in the rural villas of the rest of the empire. For these reasons, these houses can be considered villa-like urban mansions in geographic areas that, based on current available knowledge, would otherwise not feature elite villas at all.[2] In addition, the characteristics of these dwellings and the evidence from other sources of the time, such as rabbinic writings, show how, from the second through the fourth centuries CE, some members of the Jewish elite actively assimilated Roman cultural elements and visual vocabulary, including that of villas. The process of Romanization or acculturation has been explored for various provinces and regions of the Roman world, but this phenomenon, bearing in mind the particular cultural and religious context of Roman Palestine, is particularly important. Allusions to villas in urban houses at Pompeii or other towns in the Bay of Naples might be expected, but in Palestine, such allusions have a special character.[3] Discoveries from the towns of Sepphoris and Tiberias (Map 13) show how the architectural vocabulary of urban houses incorporated some elements of Roman villas of the empire; emulation of the vocabulary by owners – pagan as well as non-pagan – is also a consideration.

The archaeology of Roman Palestine, as of other urban centers around the Mediterranean, has focused primarily on public buildings, and although domestic quarters must have occupied a large area within these cities, the evidence for private dwellings is limited and sometimes fragmentary.[4] Only a few houses of the wealthy have been unearthed in the cities of ancient Palestine in recent years, and at sites such as Aphek, Apollonia and Samaria, for example, only single

instances of fine residences have been uncovered. Elsewhere, such structures have only been partially excavated, and in most cases their relationship with other domiciles or within the urban context is not apparent.[5]

By contrast, archaeological data from Sepphoris and Tiberias, the two major Jewish cities in the Lower Galilee during the Roman period, shed new light on private architecture and its place within the urban sphere at this time. To date, the remains of six peristyle houses dating to the third and fourth centuries CE are known in Sepphoris. Two additional buildings excavated in Tiberias in the last few years were mistakenly identified as public edifices but, based on an examination of their interior design and decoration and in comparison with other structures in the Roman world, they are now regarded as private houses. The dwellings of the wealthy in Sepphoris and Tiberias exhibit a variety of architectural plans and do not follow a single pattern: some adopt contemporary models prevalent in the Roman world while others imitate them, but even then they still exhibit architectural differences.

SEPPHORIS

In the Hellenistic period, Sepphoris stretched across a hill and its slopes, but in Roman times (late first and early second century CE) it was expanded to include the plateau located eastward, with an impressive grid of streets and a colonnaded *cardo* and *decumanus* intersecting at its center.[6] Some of the new streets east of the acropolis were supposedly linked to existing ones on the hill itself and continued to run beyond the city limits, connecting Sepphoris with its agricultural hinterland and interurban roads. Various public and private buildings were erected throughout the Roman city, the former including a Roman temple, a forum, bathhouses, a theater, and a monumental building identified as a library or archive.[7] Six houses unearthed in Sepphoris were also constructed in this phase; owned by the wealthy upper class residing in the city, two are located on the acropolis and four others in various parts of the Lower City. All were spacious, well-constructed,

and lavishly decorated with wall paintings as well as geometric and figural mosaics.

Some of these houses were only partially excavated or not well preserved. One of them, uncovered initially by Leroy Waterman in 1931, is located on the western side of the acropolis. Its central peristyle courtyard was surrounded by several rooms containing traces of mosaics with geometric designs.[8] Another building north of the forum exposed the remains of the original dwelling, which had a peristyle courtyard paved with colored mosaics in the center of a building and several adjacent rooms decorated with wall paintings. Scattered remains of a third building were found south of the central bath, and the remains of a fourth were located on the southeastern side of the Lower City. This last house, constructed adjacent to the southern *decumanus*, was built on two levels.[9] The rooms on the lower level apparently surrounded a colonnaded courtyard with Doric columns and an ornamental fountain, a common feature in homes of the wealthy during the Roman period.[10] The courtyard, facing south, had a fountain on its northern side, while its façade was decorated with three semicircular niches revetted with slabs of white marble (looted in antiquity). Some rooms inside this house had mosaic pavements with geometric designs, while others had plaster floors.

HOUSE OF DIONYSOS

The best preserved as well as the largest and most significant dwelling of Sepphoris was the House of Dionysos, located on the acropolis.[11] Constructed around 200 CE, it was apparently destroyed in the earthquake of 363 CE. The building (45x23 m) had a second story covering its northern and central parts (Figure 18.1). A courtyard (14.5x11.6 m) with colonnades on three sides was located in the center of the building; its shape and colonnades allude to the peristyles common in villas throughout the Roman Empire, in this case with the flagstone paving common in urban houses of the Roman East rather than garden planting. A rectangular basin serving as a decorative fountain stood in its center, while the portico corridors had simple mosaics (now damaged).

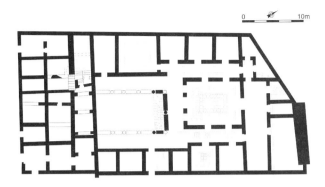

Figure 18.1. Sepphoris, House of Dionysos, plan, c. 200 CE.

Figure 18.3. Sepphoris, House of Dionysos, overview of the lavatory with the inscription *YGEI[A]* (health), set in the mosaic floor.

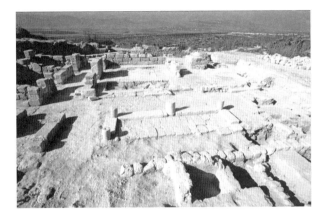

Figure 18.2. Sepphoris, House of Dionysos, north view. In the forefront the peristyle courtyard and the *triclinium* behind it, after the mosaic was removed for restoration.

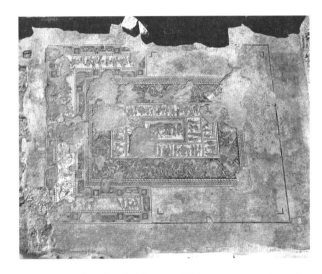

Figure 18.4. Sepphoris, House of Dionysos, overview of the Dionysiac mosaic of the *triclinium*.

To the north, a *triclinium* with three doors opened onto the courtyard (Figure 18.2). The other rooms of the house were arranged around the *triclinium* and the peristyle. The northern wing inside the building, beyond the *triclinium*, was used for service and working areas and included a long and narrow open courtyard with a deep cistern on its eastern end. Several rooms were located on its northern and western sides, including some utilitarian spaces with water installations and a lavatory (Figure 18.3); the lavatory, as we shall see, may have had a special significance in the dwelling. These installations were coated with plaster, and the lavatory had a white mosaic with a framed Greek inscription (*YGEI[A]*, Health) in black tesserae. The rooms south of the courtyard were built on two levels, one at the level of the courtyard and the other below it. Some of the rooms on the lower level served as storerooms, while those on the south, which opened onto the street that ran along the southern edge of the hill, functioned as shops.

The original mosaic floors in various rooms of the House of Dionysos incorporated geometric patterns in colored tesserae. Fragments of painted plaster retrieved from the debris covering the building indicate that some of the rooms were decorated with frescoes in geometric and floral patterns.

The Dionysiac mosaic (9x7 m) in the *triclinium* covered almost the entire floor with a colorful rectangular carpet. Its "U+T"-shape was the common arrangement of mosaic floors in *triclinia* at other sites in the Roman world (Figure 18.4).[12] The central

carpet incorporated fifteen panels depicting various scenes from the life of Dionysos and his cult; Greek inscriptions identifying the figures and scenes in the mosaic accompanied each panel.[13] Four panels in the central carpet illustrate the complex relationship between Dionysos and Herakles, his friend and rival; their theme is Dionysos' superiority over Herakles. Some panels depict specific events in the life of Dionysos, such as the bathing of the god at birth and his triumphal return from India. Other depictions illustrate various aspects of the Dionysiac cult: treading grapes, gift-bearing, shepherds, and joy.

The outer frame of the floor's central carpet is formed by intertwining acanthus leaves framing twenty-two round medallions.[14] Each medallion contains naked hunters and animals in a hunting scene or a struggle between animals and two or three figures. The medallion-frame runs from the middle of the two short sides of the mosaic, which are adorned with portraits of two beautiful women (the face at the southern end is partially destroyed, that at the northern end well preserved).

The U-shaped strips south of the main carpet depict a rural procession of people preparing for the Dionysiac festivities.[15] An unusual aspect of this section is that, rather than presenting various aspects of the god's life, it portrays the Dionysiac cult and its symbols as practiced throughout the Roman Empire: a procession of men and women bearing baskets of fruit, animals, garlands, a tripod, and other items. Each participant had a specific responsibility defined by the object he or she carries, or a task that he or she is portrayed as fulfilling, in outdoor festivities. The procession appears to have been designed as two continuous scenes, one beginning at the eastern end of the "U," the other at its western end, both converging at the mid-point of the southern strip of the floor. In all probability, the damaged center of this strip, which was replaced at a later stage with the Nilotic scenes, may have originally depicted an altar with a statue of the god beside it.[16] Various themes in the mosaic have several parallels in Roman art, but their length and the detail by which the myth, objects, and rituals of the Dionysian cult in one

floor make this mosaic unique, not only among the mosaics of Sepphoris but in Roman art generally.

The location of the House of Dionysos on the acropolis of Sepphoris, its dimensions, and especially its elaborate ornamentation indicate that it was intended to be used by a family holding a special status in the city. The iconography of the Dionysos mosaic may suggest that the owners of the mansion were among the city's pagan inhabitants, although it would not be surprising if, in the future, new data would surface to prove that one of the wealthy Jews of the city lived there,[17] or even Sepphoris' most famous citizen, R. Judah Ha-Nasi, a member of the Galilean elite in the early third century CE.[18] For someone of R. Judah's status who sought to cross religious boundaries in order to bring the pagan world closer to him while maintaining a position of strength and security among his fellow Jews, it is not inconceivable that he, or such as he, would have lived in such a house. The Patriarch's home would certainly have been large and magnificent, and his wealth would have justified such an elaborate building in a central and strategic location in the Upper City.[19] R. Judah's positive attitude toward Roman culture, and the fact that the Jews of Palestine did not avoid using figural art and pagan artistic representation, allow us to assume – with great caution – that the building might have been occupied by one of the great figures of the city.[20]

HOUSE OF ORPHEUS

In the Lower City, the House of Orpheus, though built to a smaller scale, had a villa-like layout similar to the House of Dionysos. It also had a central location in the city plan, adjacent to the intersection of the *cardo* and the *decumanus* close to the western baths (Figure 18.5).[21] The building (28.5×17 m), covers a third of the insula and is named after the mosaic of Orpheus on the floor of its *triclinium*. Two architectural phases were identified in the building: an initial construction in the second half of the third century CE (some fifty or more years after the House of Dionysos), then partial damage in the mid-fourth century CE, probably in the earthquake of 363, and

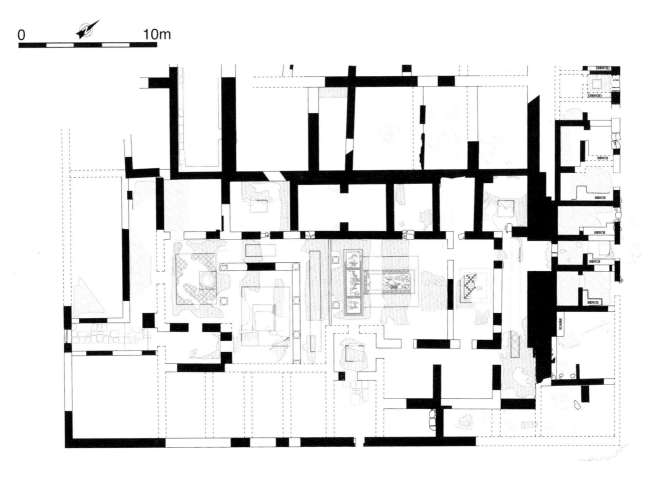

0 10m

Figure 18.5. Sepphoris, House of Orpheus, plan, second half of the third century CE (first phase).

then a renovation immediately thereafter lasting until the end of the fourth or early fifth century CE.

The House of Orpheus has three entrances, from the north, east, and south, but the main access to the building was through the eastern doorway and a small stone-paved antechamber – a *vestibulum* – next to the *cardo*. In the center of the building was an L-shaped peristyle courtyard (c. 6.6x8.95 m) with its two aisles paved in mosaic (partially preserved). The courtyard, located west of the *vestibulum*, separated two *triclinia*: one, on the north side, was large and lavishly decorated and faced the other, smaller *triclinium* on the south. It is in the large and lavishly decorated *triclinium* that the master of the household would have entertained his important and influential guests, while the small dining room – much less impressive in size and appearance – would have been used by the owner

for meals with his family and close friends.[22] Various other rooms were disposed around these two dining areas and the courtyard; some contained mosaics with simple designs, others were paved with plaster.

The two *triclinia* were adorned with mosaics arranged in designs suited to the particular needs of each room. The southern (smaller) *triclinium* (4.3x5.75 m) was decorated with a mosaic floor containing a single central panel surrounded on three sides by a U-shaped strip with a geometric design. The medallion in the central panel bears a Greek inscription, of which only a few letters are preserved.

The northern (larger) *triclinium* (6.3x9.25 m) is decorated with a colorful mosaic composed of four panels facing south and resembling the characteristic "U+T"-shape of the *triclinium* in

the House of Dionysos. Orpheus, the divine musician, is depicted in the central carpet sitting on a rock and playing a string instrument, soothing the wild animals and birds around him. The three other panels depict scenes from daily life. The larger middle panel features a banquet scene, the left-hand panel depicting two men playing dice and the right-hand panel two men embracing.[23] These last three panels seem to depict the various stages of the *convivium* connected with the feast and the entertainment of guests, and the central location and large size of the banquet scene alludes to wine-drinking as the height of hospitality. The figure of Orpheus enchanting the animals with his music completes the theme of hospitality on a metaphorical level, but may also be suggestive of entertainment during or after dinner in which music played a role. The orientation of all four panels to the south toward the entrance was designed to greet the guests as they entered the *triclinium* from the peristyle courtyard and presage the hospitality that awaited them.[24] These images are the tokens of hospitality – the *xenia* – shown to the guest by the host who, in displaying such virtuous and traditional good manners, becomes a lifelong friend.[25]

As we have seen, the original third-century House of Orpheus was partly damaged in the mid-fourth century CE. The renovated house followed the original plan but underwent some interior modifications, primarily in the innermost and eastern rooms of the building.[26] Its central space continued in use as an open courtyard, while a new *triclinium* with a "U + T"-shaped mosaic was located on its northern side. The remodeled rooms were decorated with new mosaics, some having simple geometrical designs, others with figurative scenes already badly damaged in antiquity. The mosaic in the open courtyard contained a large panel featuring aquatic imagery, and the T-shaped mosaic in the *triclinium*, a circle set within a square, depicted a personification of the Four Seasons. Summer, the only personification that has been preserved, occupied the square's northwestern corner.

TIBERIAS

Located on the western shore of the Sea of Galilee, Tiberias was founded in 19 CE by Herod Antipas, who had been appointed tetrarch of the region on the death of his father Herod the Great: He made it his capital. The archaeological evidence from Tiberias is less impressive than that of Sepphoris but still provides information about this major Galilean city, which flourished in the Roman period. A monumental gate with round projecting towers flanking it, as well as the beginning of a northbound paved street, were uncovered on the southern boundaries of the city.[27] Several public buildings are known in Tiberias and its nearby suburb of Hammat Tiberias, including a colonnaded street, a partially excavated stadium, a theater, a bath building, and synagogues.[28]

Two structures originally identified as public buildings have recently been excavated in two different areas of Tiberias. In one, located north of the civic center, Yizhar Hirschfeld unearthed part of a building that he believed was the Great Academy of Tiberias.[29] All that remains of this splendid third-century CE structure is a peristyle courtyard with three porticoes paved with simple geometric mosaics (Figure 18.6). Next to the eastern colonnade of the courtyard was a pool with steps on both sides, and opposite it, in a section to the west that has not yet been fully excavated, was a wall built of hewn stones

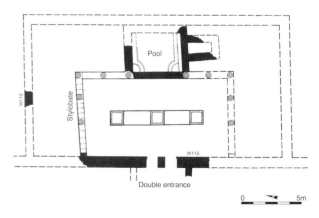

Figure 18.6. Tiberias, peristyle house north of the civic center, third century CE, plan.

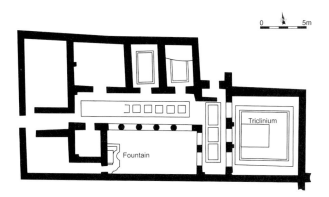

Figure 18.7. Seleucia Pieria, House of the Drinking Contest, early third century CE, plan.

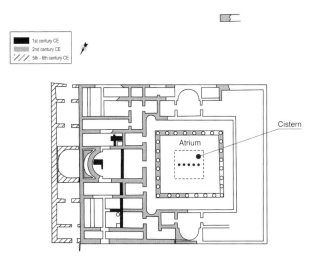

Figure 18.8. Tiberias, the "Basilical Complex," fourth century CE, plan.

with two doorways giving access to rooms that bordered the courtyard on this side, with further rooms probably surrounding the other sides of the courtyard as well.

The quality of the construction, the existence of a pool rather than a *miqveh* (ritual bath), and the mosaics with simple geometric decorations are not themselves proof that the building was a *bet midrash* (study hall). Rather, with its three-porticoed peristyle, it resembles houses of the wealthy such as the House of Dionysos in Sepphoris (p. 318) and other dwellings at sites throughout the Roman world.[30] Moreover, the pool located across from the entrances was a decorative fountain, a feature indicating the degree of the owner's wealth, as such features also signified in villa-like urban dwellings at Sepphoris and elsewhere: A close parallel is the House of the Drinking Contest in Seleucia Pieria near Antioch, dated to the third century CE (Figure 18.7).[31]

The other building in Tiberias, the "Basilical Complex," is located in the center of the city, close to the bath and the colonnaded street. The structure, originally uncovered by Adam Druks and further excavated and studied by Yizhar Hirschfeld and Katharina Galor from 2004 to 2006, was constructed in the fourth century CE and covers at least 2,000 m² (Figure 18.8).[32] A peristyle courtyard with a cistern stood in the center of the building complex; its eastern portico served as a kind of cross-axial narthex with small apses at either end leading to an impressive spacious hall (12.8x7.4 m.) in the east. The hall, which dominated the entire building,

had an apse at its far end opposite the entrance and a mosaic floor with geometric designs. Among the rooms arranged around the peristyle courtyard, there were two apsidal halls (*exedrae*) positioned symmetrically on the northern and southern sides of the courtyard. The building is oriented on an east-west axis and contains diverse architectural spaces lavishly decorated with poorly preserved geometrical, floral, and figurative mosaics, some of high quality. The original entrance to the building has not yet been excavated, although it is probably located in the unexcavated area west of the complex facing the main colonnaded street. The building has a special formality and spaciousness more usual in villas than in urban *domus*.

Druks identified this building as a Christian church, while Hirschfeld and Galor compared it to the governor's complex at Caesarea and argue for a civic function.[33] Its location within the civic center and its proximity to other public buildings, as well as the apsidal hall, prompted them to suggest that it could have been the site of the post-70 Sanhedrin – the legal, religious, and political authority of the Jewish people headed by the Patriarch. Even though the actual existence and responsibilities of the Sanhedrin at this late period are unclear, Hirschfeld and Galor interpret the complex, especially the spacious apsidal hall, to have been used for gatherings of religious authorities.[34]

Hirschfeld and Galor's identification of this building with the Sanhedrin or another Jewish institution that might have functioned in fourth-century Tiberias is hard to sustain.[35] In all probability, it served as a palatial mansion for a local aristocrat. The urban houses of the wealthy known throughout the Mediterranean in the early Byzantine period are characterized by their large size, often with a central peristyle, and an apsidal room on a main axis with additional *exedrae* or smaller apsidal rooms for more intimate gatherings, positioned symmetrically on either side of the courtyard; these could be decorated with mosaics, wall paintings, and statuary. In the case of the "Basilical Complex," the apsidal room – the *triclinium* – was modified to accommodate a *stibadium*, a semicircular couch: The change in dining customs in houses and villas elsewhere in the Roman world in the late third and continuing in the fourth and fifth centuries was also registered at Tiberias. *Stibadia* often replaced the traditional three couches of *triclinia*, which had been the norm in the earlier House of Dionysos and House of Orpheus at Sepphoris.[36] The owner of the "Basilical Complex" could impress his guests with his wealth and hospitality as well as his up-to-date dining arrangements.[37]

The splendor of the building in Tiberias follows the same pattern of the houses of the wealthy; it also corresponds to their dates of construction and span of occupation. This spacious building was constructed in the right proportions and with the appropriate architectural spaces, designed with an impressive internal symmetry and lavishly decorated with mosaics. It thus should be regarded as a private dwelling owned by a wealthy citizen in fourth-century Tiberias rather than as a public or religious building. Wealthy citizens residing in fourth-century Tiberias were interested in religious buildings: We know that some contributed to the construction of the synagogue at Hammat Tiberias, including one Severos, "disciple (*threptos*) of the most illustrious Patriarchs," who had close ties with the incumbent Patriarch who dwelt in the city itself.[38] However, no evidence was found inside the "Basilical Complex" itself to indicate whether its owner was of the Jewish

or pagan community, so its interpretation as a private house is preferable.

HOUSES OF THE WEALTHY IN THE GALILEE

The architectural layout, decoration, and spatial arrangement of the peristyle houses in Sepphoris and Tiberias confirm that the wealthy population in both cities, like their counterparts elsewhere, chose to live in luxurious homes that proclaimed their social and political status and affiliation with the Graeco-Roman lifestyle and culture. The large ornate dwellings uncovered in Upper and Lower Sepphoris were not clustered together but were webbed into the urban environment of small, simple houses and public buildings; a similar arrangement may have occurred in Tiberias. At the same time, the emphasis on internal spaciousness, the large peristyles, the pools and fountain, and the dining rooms facing open spaces have a distinct villa-like character: urban houses of the Galilean wealthy incorporated aspects of villas, thereby implying their membership in the elite and land-owning classes. From the examples discussed, it emerges clearly that the *triclinium*, with its setting within the house plan and decoration, such as the elaborate mosaic floors, was a focal point of the house. It was also where the relationship between the social importance of hospitality and the decorative strategies adopted in the ancient house were closely interconnected. Such features are not exclusive to these villa-like urban houses, nor are they exclusive of this region at this or other times in Roman antiquity. Late-antique villas in Aquitania, for instance, show a similar emphasis on the *triclinium/stibadium* space, and there are examples from villas in other parts of the empire.[39]

Several rabbinic sources, some of which took shape in the Galilee during the Roman and early Byzantine periods, illustrate various aspects of these dwellings, their furnishings, and their actual use. For example, the entrance room or antechamber to a building (the *vestibulum*) is called a gate-house.[40] Located next to the courtyard, it functioned as a

waiting room before entering the house; this finds expression in a parable attributed to Rabbi Yudan, which states:

> When a human being has a patron and a time of distress befalls [that person], he cannot suddenly show up at [the patron's] doorstep [to ask for advice]. Rather, he must first come and stand by his patron's doorway, and call out to [the patron's] servant or household member, and he [the servant or household member] announces to [his patron], "So-and-so is still standing at the entrance to your courtyard". [The patron] might allow him to enter [to hear his plea for help] or might leave him outside [and will never hear what he has to say].[41]

It may be assumed that Rabbi Yudan based his sermon on a reality known to have existed in the sumptuous houses of that period such as the House of Orpheus in Sepphoris, where one side of the stone-paved vestibule opened onto the *cardo*, east of the house, and the other opened onto the L-shaped peristyle courtyard. Here, in the vestibule, the client awaited his patron and here an attendant or hostess welcomed guests before entering the house.

The *triclinium*, the main room for receiving guests in such domiciles, is also mentioned in rabbinic sources; several others refer to dining customs that prevailed during meals, such as reclining, eating, and drinking.[42] Furthermore, permanent lavatories near the living and dining rooms like the one found in the House of Dionysos in Sepphoris (see p. 319) were not common features in Roman domestic plans, though there are a few examples.[43] However, a Talmudic source gives expression to the absence of the lavatory in the simple homes of the common people and its presence in the houses of the wealthy: "Our rabbis taught: Who is a wealthy? ... Rabbi Yose said: He who has a privy (lavatory) near his table."[44] The term "his table" probably refers to the *triclinium*, and the entire saying illustrates the reality evident in the House of Dionysos.

The identity of the owners of the house at Sepphoris and Tiberias is not known. At first glance, it seems that wealthy pagan families owned the peristyle houses, especially those decorated with mythological images, but it may well be argued that wealthy members of the Jewish community having an Hellenic orientation could also have owned these homes. Rabbis residing in Tiberias and Sepphoris were familiar with specific features characterizing such houses and included them in public sermons. The mélange of Jews, pagans, and, later, Christians in Sepphoris and Tiberias, and the mutual hospitality of the elites in these cities would have made such familiarity socially normal; the reference, in the plans and decorations of their houses, to Roman *villas* would have confirmed a mutual affiliation with the habits of the Mediterranean-wide Roman elites.

NOTES

1. See, e.g., Owens 1996, 7–32; Perring 1991, 273–93. See the special attention given to the finds from Pompeii in Wallace-Hadrill 1994, esp. 65–82; Laurence 1994, 20–49; Raper 1977, 189–221.

2. The emulation of villas in urban houses, and the various ways in which this emulation expressed itself at various social levels in Roman towns and cities, attests the cultural prestige of villas themselves, as real or ideal. This phenomenon of emulation can be seen throughout the Roman Empire, even in the Roman East where evidence for villas is slight. See Rothe (Chapter 2) in this book for a discussion of the use of the term "villa" in modern scholarship.

3. For the emulation and decorative application of villa imagery in urban houses in the Bay of Naples, Zanker 1979.

4. Archaeological surveys and excavations in Roman Palestine and Transjordan have resulted in some information on rural dwellings. Most were in villages and towns outside urban contexts and are very simple: none embody the lavishly decorated large urban peristyle houses of the upper classes discussed here: see Hirschfeld 1995, 15–19; 1999, 258–72; Galor 2000, 109–24.

5. Reisner et al. 1924, 180–5; Kochavi 1989, 109–11; Roll and Tal 2008, 132–49. Several mosaics decorating *triclinia* in few other places, e.g., Neapolis (Nablus) and Gerasa, may suggest the existence of other such

dwellings elsewhere in the region; see, e.g., Dauphin 1979, 11–33; Piccirillo 1993, 282–3.

6. Weiss 2007a, 387–414.

7. For further discussions of the archaeological remains at Sepphoris: Netzer and Weiss 1994; Nagy et al. 1996; Weiss and Netzer 1997a, 2–21; 1997b, 117–30. On the relationship between private and public buildings in ancient Sepphoris: Weiss 2007b, 125–36.

8. Strange 1992, 344–51, Strange et al. 2006, 71–122.

9. Weiss 2001b, 27★; 2002, 23★-4★; 2005, 224–6.

10. See, e.g., Morvillez 2007, 51–78; Abadie-Reynal 2008, 99–118. Fountains were installed in conjunction with the *stibadium* in the dining hall of some late-antique houses; Morvillez 2008, 37–53.

11. Talgam and Weiss 2004, 17–33.

12. Dunbabin 1991, 121–47. On the uses of the *triclinium* in the Roman house: Dunbabin 1996, 66–80; on reclining arrangements in *triclinia*, Clarke 1991, 16–17.

13. Talgam and Weiss 2004, 47–73.

14. Talgam and Weiss 2004, 88–94.

15. Talgam and Weiss 2004, 73–88.

16. Talgam and Weiss 2004, 82–3.

17. The wealthy of Sepphoris are often mentioned in rabbinic literature; see Y Shabbat 12, 3, 13c; B 'Eruvin 85b-86a; Esther Rabbah 2, 3; Büchler 1909, 34–49; Goodman 1983, 33–4; Levine 1989, 167–70, 176–81.

18. Guttmann 1954, 239–61; Safrai 1975, 51–7. The Talmud mentions that Sepphoris' geographical location and high altitude agreed with R. Judah's poor health, but his move was probably meant to bolster his status within the country and abroad as the Jewish Patriarch; B Ketubot 103b; Safrai 1958, 209–11; Levine 1989, 33–42; Oppenheimer 1991, 68–9.

19. Rabbi was accustomed to distributing food among the populace from his silos in famine years (B Bava Batra 8a) and his table lacked nothing (B Berakhot 57b); he hosted the wealthy in his home (B 'Eruvin 85b–86a) and invited rabbinic students to dine at his table (B Berakhot 43a); he held feasts in his home at which wine was served (B Nedarim 51a; B Sanhedrin 38a).

20. Weiss 2001a, 7–26.

21. Weiss 2003, 94–101; 2008, 2032.

22. Two *triclinia* of different size, decoration, and function are known in elite houses in North Africa; see, e.g., Carucci 2007, 37–61.

23. The central panel depicts four banqueters reclining on a *sigma* couch approached by two servants, one holding a cup of wine, even though the scene is embedded

in a more traditional rectangular *triclinium*. According to Dunbabin (2003, 164–9), it may reflect the owners' awareness of the new fashion, though it probably conveys a message of conviviality, wherein the participants assembled in a relaxed atmosphere.

24. Talgam and Weiss 2004, 11.

25. The placement of Orpheus adjacent to *xenia* motifs appears already in the mid-third-century CE mosaics of North Africa; see Jesnick 1997, 96–7.

26. Weiss 2003, 100–101.

27. Foerster 1977, 87–91; Stacey 2004, 23–8. For a reconstruction of the gate: Hirschfeld and Reich 1988, 114–15.

28. Hirschfeld 1988; 1991, 170–1; 1992; 1993, 1464–70.

29. Hirschfeld 2004, 3–13, 219–22. The Great Academy is the Sidra Rabba, the distinguished house of learning (*bet midrash*) founded by R. Yoḥanan in Tiberias.

30. Cf. Carucci 2007, 19–22.

31. Stillwell 1941, 31–3; Dobbins 2000, 51–61.

32. Druks 1964, 16; Hirschfeld and Galor 2007, 207–29.

33. Cf. Patrich et al. 1999, 71–107.

34. Hirschfeld and Galor 2007, 227–9.

35. According to Levine (1989, 76–83), the use of the title Sanhedrin to describe this institutional framework in the third century CE is historically worthless and should be viewed as a polemical assertion of its superiority to the local Tiberian academy. Hezser argues that there is no evidence for the Sanhedrin as a central rabbinic court in tannaitic or amoraic times, although some rabbis may have been appointed judges in an officially recognized public court; see Hezser 1997, 186–95.

36. For *stibadia* in Roman villas, see Ripoll (Chapter 22) in this book.

37. Ellis 1991. The use of a *stibadium*-dining setting in a mono-apsidal or triconched hall was widespread in a large number of fourth-century houses and villas throughout the Roman world: Rossiter 1990, 199–214.

38. Dothan 1983, 60. According to Stemberger (2000, 258–9), the term *threptos* reflects a close relationship with the patriarch and his court.

39. Balmelle 2001.

40. See, e.g., M Ma'asrot 3, 6; M Bava Batra 1, 5. Most of the sources were collected by Krauss 1910, 52, 365 n. 674.

41. Y Berakhot 9, 1, 13a.

42. See, e.g., M Bava Batra 5, 4; T Shabbat 16 (17), 18; Y Rosh Hashanah 4, 2, 59b. For the use of the term

triclinium in Talmudic literature, Sokoloff 1990, 231 (s.v. *triclinium*). According to Noy (2001, 134–44), some of the dining practices described in rabbinic texts would have been quite familiar to well-to-do non-Jews, whereas some others, such as the blessing over food or wine, not to speak of the nature of the food being eaten, were foreign to them. Levine (1998, 119–23) clarifies the relationship between the Passover meal and the Roman *symposia*, arguing

that the rabbis were aware of the relationship to the Roman *symposia* but made a clear distinction between the two.

43. Hirschfeld 1995, 276–9; Thébert 1987, 381, 398 fig. 41; Daszewski 1976, 204.
44. B Shabbat 25b. According to the Babylonian tradition, Rabbi Judah the Patriarch, who resided in Sepphoris, had a lavatory in his house; see B Bava Metzia 85a and B Ketubot 104a.

VILLAS IN ROMAN GREECE

MARIA PAPAIOANNOU

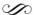

" . . . at the villa called Kephisia, . . . we protected ourselves against the trying temperature by the shade of its spacious groves, its long, soft promenades, the cool location of the house, its elegant baths with their abundance of sparkling water, and the charm of the villa as a whole, which was everywhere melodious with splashing waters and tuneful birds."

Aulus Gellius, *Noctes Atticae* 1.2.1–2.

Roman villas, their agricultural and industrial economies, and even the life and culture that went with them were highly exportable, as exportable as Greek ideas were throughout the Mediterranean and to the Roman and Italian elites. Villas and estates in the period of Roman hegemony in Greece include all three permutations of the phenomenon: villas located on the outskirts of towns or cities (*suburbanae*), along coastal areas (*maritimae*), or inland (*urbanae* and/or *rusticae*) where agricultural production and/or animal husbandry were of primary concern.[1] Estates varied in size, ranging from modest establishments such as those allotted to the veteran-colonists at Patrae to vast estates like Herodes Atticus' *latifundium* at Marathon. They formed a complex system functioning as economic production units involved in a variety of enterprises: agriculture, pastoral activities, mining, quarrying, fish farming, and making pottery and clay-based food-storage and transport containers as well as building materials. In some instances, they also served as restful retreats with sumptuous accommodations where the owner resided on a permanent or, for those who had numerous estates like Herodes Atticus, a seasonal or sporadic basis.[2] Aulus Gellius' description (quoted above) of the Kephisia villa

belonging to this famous wealthy Athenian, friend of emperors and patron of culture, testifies to the presence of luxury estates in the Aegean region that were similar to – or even rivaled – those in the western Mediterranean as described in the letters of Pliny the Younger.[3]

Publications of Roman villas in Greece are small in number and mostly limited to brief excavation reports and preliminary accounts in Greek. For that reason, they have had a restricted readership, while the few books published are either not easily accessible or focus primarily on the decorative aspects of the residential quarters.[4] Overviews – of a particular villa within its region, addressing the choice of location, landscape, residential quarters, associated economic and leisure activities, private cemeteries and *mausolea*, or a more general account of villas as self-contained entities or as participating in a larger economy with roads, sea-borne transport, water-management systems, and access to markets – are not yet available.[5]

These lacunae are due in part to the limited number of systematic excavations of villa sites, to their destruction due to quarrying from antiquity to modern times, to illicit digging, and to modern

farming methods and construction projects.[6] Furthermore, since most of the evidence comes from salvage excavations bound by time constraints or from field surveys where interpretation of the evidence can be ambiguous, complete plans and interpretative treatments of villas and their features are absent. In the past, research has also been hampered by scholarly indifference to Roman-period remains in this region of the empire where the study of the Bronze Age and classical/Hellenistic periods has been a priority.[7] As a result, investigations of such sites were often conducted in a hasty fashion by amateurs and archaeologists alike, with disastrous results.[8] A good example is the "Lechaion Villa" at Corinth, which stands as a paradigm of the sometimes destructive nature of archaeological inquiry and the modern maxim "to excavate is to destroy." It was illegally uncovered in 1894 by a Corinthian land-magnate, Theophanes Rentis, who kept no records of his work, abandoned artifacts at the site, and transferred to his own residence only those that caught his fancy.[9]

In some publications, the Latin term *villa*, reserved in antiquity for country estates with dwellings, has been misused to include well-appointed urban houses.[10] The mistake is understandable in cases when fortifications in certain cities were destroyed.[11] At Corinth, for example, Mummius dismantled the walls in 146 BCE, so the "Roman Villa" at Cheliotomylos that straddled the line of the classical wall could be equally urban or suburban.[12] Some have even argued that the term *villa* is a western concept and therefore cannot be applied to wealthy estates in the eastern Mediterranean, including Greece.[13] How, then, can we define the estate of Cicero's friend, Atticus, in Epirus (the *Amalthea*), those of Herodes Atticus at Eua Loukou and Marathon, the rural villas of the Roman colonists at Patrae, and other similar estates in Asia Minor and the Balkans?[14] These methodological considerations have clouded villa scholarship in Greece, and the paucity of publication relative to villa studies in the western Roman provinces has further blurred the view. As a result, little is known about landed estates and owners in Greece, with the exception of those of Herodes Atticus.[15] This chapter outlines the

range of information available on Roman villas in Greece – the literary and archaeological evidence about villa owners and estates – and provides an overview of some recent discoveries and directions for future studies.

VILLA OWNERS

Textual and epigraphic evidence confirms that wealthy individuals, both Greek and Roman, were involved in a variety of enterprises and owned, or had the financial means to support, substantial villa estates, both within Greece and abroad.[16] According to Varro and Cicero, large Roman agricultural estates of the so-called *Synepirotae* appeared in northwest Greece as early as the second century BCE.[17] Among them were those owned by Titus Pomponius Atticus (110 or 109–32 BCE): one called the *Amalthea*, near Bouthrotum (Butrint) and another near Kalama at the mouth of the Thyamis river that supported 120 herds of oxen (Map 14).[18] Elsewhere, epigraphic evidence records the presence in Epirus of the Cossinii family, a family from Puteoli on the Bay of Naples that is well-attested in Greece and may have owned estates of the type found at Strongyli and Riza, north of Nikopolis.[19] Additional evidence for foreign ownership is documented in central Macedonia, at Beroia, where Roman aristocrats known as *Rhomaioi engektemenoi* (Romans who had the right to own land in a foreign country) were given large farmable tracts and formed an exclusive community, the *conventus civium Romanorum*.[20]

There were two other groups of potential villa owners: Roman veterans settled as colonists abroad and much more prominent owners, local dignitaries with international interests. As early as the first century BCE, funerary inscriptions record the names of veteran colonists from the Tenth and Twelfth legions (the *Legio* X *Equestris* and *Legio* XII *Fulminata*) who were allotted small- to medium-sized plots of land in the Patraean countryside after the battle of Actium (31 BCE).[21] Two small family chamber tombs of the first century CE on a villa estate record the name of one such veteran, a certain Gaius Laetilius Clemens, and his family.[22]

A second group of villa owners were members of the senatorial class or wealthy individuals such as Poplius Granius Rufus, an Italian of Sabine origin who may have held office on Crete.[23] Some were absentee landowners, either Roman or Greek, residing elsewhere in the empire but with substantial interests in Greek properties.[24] In the second century CE, for example, three senatorial families are known to have resided on the island of Crete, those of A. Larcius Sulpicianus and M. Roscius Lupus at Gortys, and the Flavii at Ierapetra.[25] In the Peloponnese on the mainland, the names of eminent families appear in literary and epigraphic records (honorary inscriptions and tombs).[26] Among them are the Saethidae from Messene who, like other illustrious families of Roman Greece, claimed descent from both mythical heroes and prominent historical figures of the classical and Hellenistic periods. As descendants of Saithidas the Elder (third century BCE), the Saethidae produced the first senator from Messenia, Tiberius Claudius Frontius, during the reign of Hadrian, and they owned estates both in Messene and Abellinum in Campania that rivalled those of Herodes Atticus, though nothing specific is known about the properties.[27] Another important family among the super-elite in Roman Greece was the Euryclid from Sparta who produced two senators and was extremely influential in Achaea.[28] This family was honored in Athens where statues of Gaius Iulius Eurycles and his son were set up on the Akropolis.[29] Eurycles, in particular, expanded his political activities beyond the boundaries of Achaea by establishing ties with Herod the Great and the court of Cappadocia; he has been acknowledged as the "most notable personality in the history of Augustan Greece."[30]

The most celebrated benefactor of Roman Greece was Herodes Atticus, a member of a prestigious and ancient Greek family, the Claudii Attici from the deme of Marathon. They laid claim to a heroic lineage as descendants of the mythological Aeacids and the Herakleides (founders of races of men in the Peloponnese) and, from the more recent past, the Athenian generals Miltiades and Cimon.[31] As with the other important families of Achaea, the Claudii Attici were also awarded political honors in

Greece and abroad. Herodes' father, Atticus, became governor of Judaea twice, and Herodes himself served as consul in Rome and advisor to the emperor Marcus Aurelius.[32]

The fame and wealth of these families allows us to infer that their estates and assets were substantial, and their political status as consuls and senators in Rome would have required them to maintain a material façade appropriate to their roles in society. Representational dwellings advertising one's status, the *atria ambitiosa* of Martial in his address to those of senatorial rank, would have been the norm.[33] Indeed, studies of the economic changes taking place throughout Greece during the imperial period indicate that landholdings of the wealthy (both equestrian and senatorial classes) were slowly expanding into enormous estates with elegant villa residences supported by wealth generated from large-scale agricultural and pastoral activities.[34] However, precise information on these matters (size of properties, fixed or moveable assets) remains elusive, as in the case of the Saethidae. Others are better known: according to Strabo, the Euryclidae inherited a fortune amassed by Gaius Iulius Eurycles from the booty he collected after the battle of Actium in 31 BCE.[35] The family had vast estates on the island of Kythera and at Asopos in Laconia, including the marble quarries at Krokeai, and conducted business transactions at the Spartan ports of Gytheion and Boiai.[36] In the case of the Claudii Attici, their main source of wealth was in the grain trade from the family's landholdings at Marathon. Additional sources also included the exploitation of the marble quarries in the region of Mani (yielding so-called *rosso antico* marble), Krokeai (the *lapis lacedaemonius* marble), and perhaps Ano Doliana whence marble was extracted for the construction of Herodes' villa at Eua Loukou. At Brexiza on his Marathon estate, Herodes fish-farmed, while his marriage to Appia Annia Regilla, a member of the family that produced the Antonine dynasts, brought him a villa along the *via Appia* outside Rome as part of her dowry.[37]

Roman villas and estates of different size and with diverse agricultural and other activities manifested themselves prominently in Greece from the early decades of the Roman presence in the second

century BCE through late antiquity. The literary and epigraphic evidence indicates that the villas themselves and their owners, who belonged to several different social classes, had significant social, political, and economic clout; both could rival villas and owners in the western provinces.[38]

VILLA ESTATES: THE ARCHAEOLOGICAL EVIDENCE

Before the Roman hegemony, agricultural estates with farmsteads of a size to provide surplus for the urban markets and with elaborately adorned residences have been documented in the Greek countryside of the classical and Hellenistic periods: Towers were often associated with these rural sites and were particularly popular in Macedonia.[39] Equally impressive remains have been excavated in Attica and the islands:[40] These estates are acknowledged in the textual sources as *agrós*, *horíon*, and *kleísion* (among others), all loosely interpreted as "farm/farmstead." Under Roman hegemony however new terms developed, analogous to the word *villa*, which better defined the different types of landed estates (large or small) that emerged as a result of the *synoecism* of Greek and Roman cultures: The word *agroikia* (once denoting rusticity, boorishness etc.) was used in the first century BCE for land and residence, while *alos* (agricultural land) and *aule* (manmade structures) defined the estate inherited by Herodes Atticus at Marathon .[41] In addition to large agricultural estates, the landscape also had small farms, villages, and, of course, urban centers, traditionally considered the long-preferred settlement type in Greece. Urban centers seem to increase in size during the Hellenistic period as they often provided a safer environment for economic growth and activity. On Crete, for example, it has long been postulated that warfare in the countryside coupled with piracy along the coast may have hindered the establishment of large agricultural estates.[42] All this notwithstanding, the island's landscape may also have played a decisive role as it was mountainous with small tracts of fertile soil, an ecosystem best suited for small farms.[43] During the imperial period, however, villas (perhaps not as large as the late-antique examples) gained popularity in the plain of Messara in the south where larger tracts of fertile land were available.[44]

The Roman presence in Greece continued to favor large villa estates with some specialization of agricultural produce and, in many cases, comfortable, even luxurious rural residences. The regions that have produced the most abundant evidence for Roman villas are Macedonia, Epirus, and Achaea; these constituted, very roughly, the Roman provinces of the Greek mainland, so their villas are presented here region-by-region. However, the villas of Herodes Atticus at Kephisia, Marathon, and Eua Loukou require separate consideration.

MACEDONIA

In Macedonia, farmstead residences covering 0.2–0.4 ha (excluding the agricultural property) had been strategically located along major arterial routes as early as the late classical and Hellenistic periods.[45] Some had walls (with or without towers) defining the enclosures and contained a main residential quarter, often with one or two towers, a second story, a large central courtyard surrounded by porticoes, and additional courtyard/s. Cellars, sewage facilities, pottery kilns, and porticoes for additional work space occupied areas along the exterior of the main residence.[46] Ancillary buildings and possible burial grounds were farther afield. The archaeological evidence also indicates that there was a specialization of agricultural production from region to region, with some estates specialized in honey (Apollonia), others in wine (Platania), olive oil (Brasna), or animal husbandry (Asprovalta); almost all sites produced grain and such necessities as textiles and agricultural equipment. Lastly, fishing and fish-farming activities were documented even at inland sites: numerous lead fishing weights were found at Agios Konstantinos (Grevena) in western Macedonia.[47]

The establishment at Agios Konstantinos (Grevena) set a high standard for rural residences: It was sited in a stunning landscape with views to the Aliakmon river gorge and covered some 6,475 m², with a well-appointed courtyard house (750 m²)

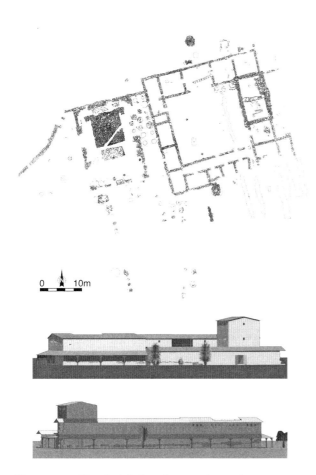

Figure 19.1. Komboloi, farm house, plan and
reconstruction (after Poulaki 2003: 65, 66).

designed on principles of axiality and symmetry with
fine finishes (painted wall plaster, small marble pla-
ques). The complex included structures for agricul-
tural activities and animal husbandry (stables, pens).[48]

Two sites at Komboloi (Figure 19.1) and Tria
Platania on the coastal road connecting Thessaly with
Macedonia produced wine and, to a lesser degree,
also olive oil.[49] An impressive establishment was also
located along the *via Egnatia*, at the foothills of
Mount Kerdyllion.[50] The site commanded a specta-
cular view of the Strymon River and the farmland
below. The total area of the complex, including
courtyard space, covered over 0.35 ha. In its final
phase, the two-story courtyard house (28 x 28.5 m)
with a tower was surrounded by multiple courtyard
areas for stables and subsidiary buildings, and various
enclosures for other activities such as metalworking
(iron) and animal pens.[51]

Early agricultural estates of the Hellenistic period
along major arterial routes had obvious viability in
Roman times: Sites that had been established as
production units were reoccupied and sometimes
survived into the fourth century CE. Beginning as
early as the second century BCE, the *via Egnatia*
(linking Dyrrachium and Byzantium and crossing
Illyricum, Macedonia, and Thrace) and its secondary
routes provided a network of roads that facilitated the
distribution of goods from source to market. In turn,
the country estates played an important supervisory
role in the economy of the region by controlling the
production and movement of goods, and in the
management of land.[52] The location and wealth of
these establishments brings to mind the opulent and
luxuriously appointed country houses described by
Diodorus Siculus at Megalepolis in North Africa
with their farm buildings, vines, olive groves, fruit
trees, pasture lands with herds of cattle and sheep, and
meadows with grazing horses.[53] Fragmentary
remains of similar estates have been identified 2 km
east of the city boundaries of ancient Lete, all within a
350 m range of one another. Pieces of painted wall-
plaster and marble revetment from salvage excava-
tions at the sites are evidence of wealth and fine
taste.[54]

At Lete, the best-preserved site is Country
House A, built in the mid-second century CE. It
was a two-story courtyard farmhouse, measuring c.
802 m², which provided living quarters and spaces for
the production and storage of grains and wine.[55]
During the second phase of occupation, the resi-
dence was enlarged with the addition of a spacious
independent apsidal *triclinium* surrounded by a corri-
dor and three rooms measuring 220 m² in total.[56]
The late addition of independent dining/reception
facilities to preexisting country residences is docu-
mented in other areas of the empire; in this region,
such architectural additions began in the second half
of the third century onward.[57] From a design per-
spective, such external *triclinia* closely parallel house
types in the west, as they resemble the so-called Hall-
Type (*Hallenhaus*) villa with apsidal halls documented
at Budakalász in Hungary and elsewhere.[58] In urban
contexts, apsidal *triclinia* were also incorporated into
the luxurious urban houses of the later fourth to sixth

centuries, as seen in Thessaloniki.[59] In some instances, in villas where space was not an issue – as in the maritime villa at Abdera – both types of apsidal halls are present, one within the main residence that functioned perhaps as a formal reception area, and a second, independent complex, adjacent to the residence and associated service areas.[60]

Such external *triclinia* are documented in the literature of the period. St. Gregory of Nyssa's description of Adelphius' villa at Nyssa (Cappadocia) refers to "the external dining area" situated in front of the residence where banquets were held.[61] Could this dining facility be associated in any way with an independent *triclinium* constructed outside the perimeter of the villa itself? If this is the case, then the "external dining area" in Adelphius' villa may not have been an open-air *triclinium* as postulated but an enclosed building adjacent to the main residence like those excavated at Lete and Abdera.[62]

Although of modest size, Country House A at Lete has a well-documented plan, even though little is known about its estate or its operations as a whole.[63] There were, however, larger estates in Roman Macedonia: at Paliomanna (Beroia), a large villa of Italian type had a *pars urbana* (not excavated) and a *pars rustica* dating from the first century BCE and in continuous use into the third century CE.[64] Cisterns (possibly wine vats), a storage chamber, large terracotta containers for foodstuffs, and hearths indicate varied agricultural activities as well as intensive aquaculture evidenced by a freshwater fishpond, technologically similar to others of Roman date elsewhere.[65]

Fragmentary remains of mosaics and architectural features in the region indicate that there may have been numerous suburban luxury villas in the area. Some with distinctively Italian architectural features (*atria*, *opus signinum* floors, garden grottoes) have been found at ancient Mieza (Naoussa).[66] Two examples are particularly noteworthy: one is located just outside the Naoussa city walls at the Valavani field and a second at Baltaneto, in the vicinity of the Hellenistic cemetery and the Lefkadia tombs.[67] The villa from the Valavani field (Figure 19.2) incorporated the remains of its Hellenistic predecessor (late

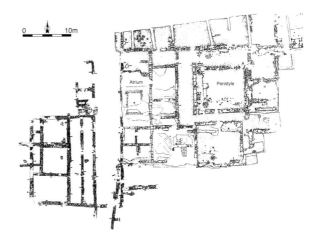

Figure 19.2. Mieza, Valavani field, plan (after Allamani and Misaelidou 1992).

third to early second centuries BCE), which had two courtyards: a simple rectangular entrance court and a central peristyle court. During the early Roman phase, the residence was remodeled and the entry courtyard was transformed into a tetrastyle atrium with a shallow *impluvium* and fountain, while *opus signinum* pavements similar to Italian examples were added in the atrium and adjacent rooms.[68] From the numerous Roman-period floor mosaics found around Mieza (Naoussa), the region must have been a prime area for villas.[69]

At Baltaneto (Naoussa), a villa of the second century CE was dramatically sited on two terraces at the base of a precipitous cliff (Figure 19.3). Excavations focused on a small section of the residential quarters: a dining-room complex with a water canal, a series of axially and symmetrically arranged rooms with a *tablinum* opening onto a peristyle adorned with a fountain, and possibly a bath suite.[70] Only a part of the residence (c. 2,000 m²) has been excavated, but the remains of polychrome geometric mosaics, colored wall plaster, marble wall revetments, architectural elements, and figural sculpture reflect the wealth and sophistication associated with elite establishments of this period in other areas of the Roman Empire.[71] The dining arrangement is noteworthy: It took the form of a *biclinium* (a design comprising two areas for couches facing each other rather than the more usual U-shaped configuration of a *triclinium*). A canal (called *Euripus* after the

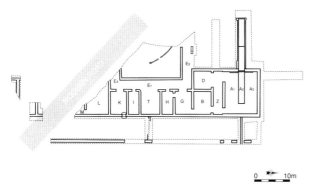

Figure 19.3. Baltaneto Naoussa, villa (after Petsas
(1966b).

narrow strait between Euboea and the Boeotian
mainland) extended from the center of the room
westward into the garden in a design found or
described in Italian houses.[72] The garden, located
on the west side of the villa and with its spring
flowing from the northwest, was overhung by the
precipitous cliff that created a grotto-like setting ideal
for a summer dining environment.[73] By the imperial
period, these landscape elements (waterworks, gar-
den, and grotto) had become standard features of the
dining experience in villas of the Roman elite.[74]

Most of the farmhouses of the first to the sixth
centuries CE excavated to date in western and central
Macedonia retained their traditional character during
the Roman period: They were small in contrast to
the villas at Lete and around Naoussa.[75] In their
modest size, they followed many comparable Italian
villas and estates.[76] The expansion of the farmhouses
(in particular country House A at Lete) with the
addition of dining rooms and baths also has parallels
in Italy during the second century.[77] However, there
were also large rural villas (e.g., at Paliomanna
[Beroia], unfortunately not fully excavated) which
seem to have featured both *partes rusticae* and *partes
urbanae* like larger villas in central Italy.[78]

In contrast to villas at a distance from towns, the
suburban villas of Macedonia subtly combined tradi-
tion and Roman innovation. Local decorative and
spatial elements, such as the peristyle, grottoes,
canals, and luxury gardens originating from the
Hellenistic palatial tradition, were blended with a
variety of exported Italian architectural and decora-
tive forms adapted to local materials and building

traditions. The tetrastyle atrium and *opus signinum*
floor pavements from the Valavani villa, for example,
or the combination of *biclinium*, canal, and garden
grotto from the Baltaneto villa suggest a Roman
inspiration and the owner's self-representation of
wealth, status, and identity in a western display of
luxury.[79]

EPIRUS

In the mountainous region of Epirus and the Ionian
islands, rural villas dating from as early as the second
century BCE to the third centuries CE and beyond
have been documented at Ladochori and Masklenitsa
in Thesprotia, at Strongyli, Hagia Pelagia, and in the
community of Riza in Preveza, at Valanidia by the
mouth of the Acheron and Louros rivers, and on the
Ionian islands of Kephallonia and Leukas (Map 14).[80]

These sites display characteristics of villa estates
elsewhere in the empire: access to major roads, abun-
dant water supply, scenic view, strategic and defend-
able locations, close proximity to urban centers, and
cemeteries and/or private mausolea.[81] The residen-
tial quarters vary in size and construction, ranging
from modest courtyard houses to more elaborate
corridor or portico villas that incorporated elements
of decidedly Roman construction (walls in *opus tes-
tacaeum*, pavements of *opus spicatum*). The residential
units (*partes urbanae*) were supplemented by subsidi-
ary structures (*partes rusticae*) of varying function;
more impressive establishments had bath buildings
(*balnea*), fountains (*nymphaea*), and *mausolea*. Because
Epirus was a pastoral region, stables, sheepfolds, and
pens have also been found. Local variations in
soil types and climate allowed cultivation for other
products: near Cassiopeia, for example, estates grew
apples, vegetables, and pulses and logged timber
as well.[82]

From coin and pottery evidence, Epirote villas
could have varying lifespans: The Ladochori villa was
an early foundation of the second century BCE and
continued to late antiquity,[83] the farmhouse at
Masklenitsa (Thesprotia) survived only into the
mid-third century,[84] while the establishment at
Riza functioned in the third and fourth centuries.

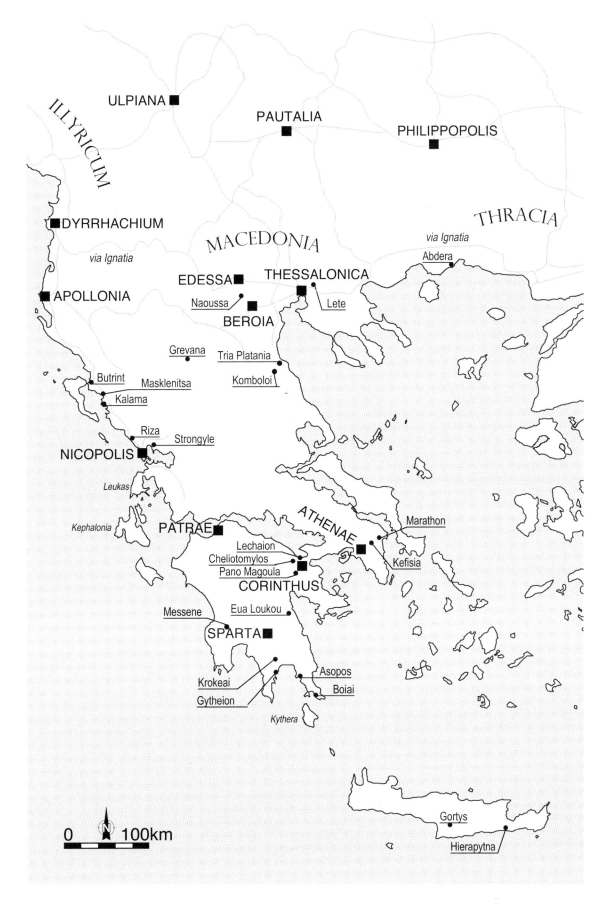

Map 14. Major towns and recorded villas sites for Roman Greece, Epirus, and Macedonia (M. D. Öz).

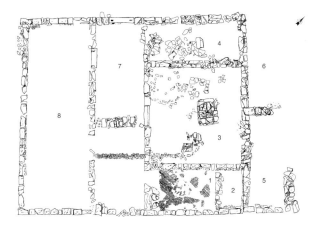

Figure 19.4. Thesprotia, Masklinitsa villa, plan (after Preka-Alexandri 1994: 428, fig. 8).

Figure 19.5. Manerau, villa, plan with possible division of internal space (Smith 1997: 210, fig. 60, b).

None have been fully excavated or published, but enough of the Masklenitsa dwelling on the coastal road from Bouthrotum to Nikopolis (Figure 19.4) remains: It was a corridor-type house like that found at Manerau in Romania (Figure 19.5) and also typical of corridor- and portico-type villas in the northwestern provinces.[85] A block arrangement placed rooms (1 to 6 in Figure 19.4) and/or an open space (8) on either side of a central entrance corridor (7), an arrangement quite unlike villas of Italian architectural type.[86] Even so, the combination of *opus spicatum* (a utilitarian pavement of brick) and black-and-white mosaic techniques found in the more formal area, the *triclinium* (1), were clear importations from Italy.[87]

Like the Masklenitsa dwelling in its affinity to the corridor- and portico-type plans, the villa at Strongyli, northeast of Nikopolis and overlooking a valley and the Gulf of Ambracia (Figure 19.6), has been documented to the imperial period (first to third centuries CE).[88] The interior space was adorned with elegant mosaic pavements and comprised two primary wings: a main corridor entrance with a portico or walled façade surrounded by six principal rooms, a garden, and a service wing with courtyard and adjacent rooms to the north.[89] Subsidiary structures housed oil production, processing of grains (two presses and three mills), and perhaps livestock.[90] To the northeast was an octagonal bath complex of sophisticated architectural form similar to other polygonal *balnea* of late antiquity

elsewhere in the Mediterranean.[91] While the Strongyli site has not produced a cemetery or mausoleum, burial grounds associated with Epirote villas cannot have been lacking. At the Hagia Pelagia estate south of Nikopolis, a second-century mausoleum (8.6 x 8.5 m) and associated garden displayed distinctly Italian construction and adornment: walls in *opus testacaeum*, a blue glass wall mosaic, and stucco decoration for the interior chamber resembling examples found in the Isola Sacra at Ostia, in the cemetery buildings under St. Peter's in Rome, and elsewhere.[92]

Epirus, the region closest in proximity to Italy, witnessed some of the earliest establishments of villas owned by Romans and Italians who either settled in this area or managed their estates from across the Adriatic. These landholdings testify to the economic viability of the region as a source of overseas wealth by foreigners and locals and their continued sustainability. While, ultimately, the villas were equipped with the full panoply of Italian forms (construction methods and floor-types, baths, and tombs), their plans did not always follow the Italian pattern but

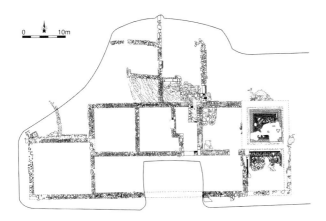

Figure 19.6. Strongyli, villa, plan (after Dousougli 1993).

rather the design of villas in the Roman northwest, as at Masklenitsa and Strongyli.

ACHAEA

Villas were more abundant and of variable size and diversity in Roman Achaea than in rural Epirus. Some have been recorded in remote regions such as Arcadia, but many were in proximity to cities: Patrae, Corinth, Athens,[93] Messene, and Sparta.[94]

Patrae

The extramural region of Patrae, a Roman colony as of 14 BCE and a major port connecting Italy to southern Greece, had at least eighty villa sites that date from the first to the first half of the third centuries CE. With the colony had come land-redistribution in favor of Roman veterans, thereby supplanting preexisting small Hellenistic settlements and farms.[95] The estates varied in size, but most were small and located close to the city, arranged in rows or clusters along three major and a number of minor roads where the primary cemeteries of the city were located. Villas located further inland from Patrae and in the semi-mountainous regions were fewer in number, but they may have been larger. There were also a number of luxury villas.[96]

Estates in the Patrae region have been inventoried with vats and presses for the production of wine and oil, stone mills for grinding grains, wells and small water cisterns, storage areas with terracotta vessels for wine and oil, and granaries. Agricultural production was supplemented with pottery workshops, vats for purifying clay, and kilns. Burials attest long-term rural residence. The villa residences themselves are fragmentary, but it seems that rooms were articulated around courtyards and their walls were made in imitation of well-known Roman techniques: *opus testaceum*, *opus reticulatum*, and *opus mixtum*.[97] In larger estates, where emphasis was also placed on luxury accommodations, the usual Roman range was found: monumental fountains, *mausolea*, baths, gardens, and elaborate mosaics.[98]

Near Patrae itself, the first-century CE villas were of modest size, appropriate to the majority of their proprietors who were, from epigraphic and literary records, demobilized soldiers, their families, and their descendants.[99] The dwellings and subsidiary structures resemble the courtyard houses and associated ancillary buildings found in Italian villas – for example, the earlier villa at San Giovanni di Ruoti[100] or others near and north of Rome.[101]

With the establishment of these early imperial villas in the region of Patrae, there was an intensification and specialization of agricultural production due to their proximity to major transportation routes. Such locations facilitated the ready movement of large quantities of agricultural produce to the city markets and the harbor for export. This intensification of production resulted in the development of new technologies and products which made the production of agricultural surplus more efficient.[102] As for the estates further inland and those in the mountainous regions, activities centered on pastoralism, forestry, honey production, and game hunting, while literary references mention the cultivation of *byssus* from which fine linen textiles were made.[103] In addition to the agricultural products from inland sites, the urban market was supplied with fresh and salted fish, and salt from the coastal villas.[104] The significance of the fishing industry in this area, and in other areas of Greece, is corroborated by the textual and archaeological evidence. A lake near Kalydon (across the bay from Patrae) renowned for its abundant fish was handed over to the new Roman

colonists for exploitation,[105] and inscriptions from this region record the names of Roman veterans who were involved in pisciculture and may have owned estates in the vicinity.[106] Material remains possibly associated with the processing (salting) of fish were discovered at a villa site at Akti Dymaion (12–14) Street, as evidenced by a series of shallow cavities dug in a row and lined with wood that resemble similar installations employed in local, traditional fish-salting methods.[107]

Corinth

The region north of Corinth underwent an intensification of agricultural production similar to the Patrae area. The Corinth computer project has identified extensive planning and land division during the Roman period based on Roman centuriation.[108] Findings indicate that, for the Caesarean colony, approximately 12 to 24 *iugera* of land (3 to 6 ha = 7.5 to 15 acres) – enough to meet the needs of a six-member family – had been allotted to each colonist, while by the Flavian period that amount had tripled.[109] However, in contrast to the plethora of sites explored through surveys and salvage excavations near Patrae, villa sites recorded from the Corinthia are fewer. They are found primarily along ancient thoroughfares or near the urban center of Corinth and surrounding farmland, and evidence for them has come mainly in the form of the dwellings themselves rather than equipment for agricultural or industrial activities. Furthermore, while the villas near Patrae and in the Peloponnese give evidence of large-scale wine production, the absence of wine vats and the frequent presence of imported wine amphorae suggest that vinting was not a significant activity in the Corinthia.[110]

From the small number of sites, three lying outside the city limits of Roman Corinth exhibit the varieties of villas in Greece: Pano Magoula (at the 3rd km along the Corinth-Argos road), Cheliotomylos (Kokkinobrysi, commonly known as the "Roman Villa" or "Shear's Villa"), and a seaside establishment at Lechaion, near the north

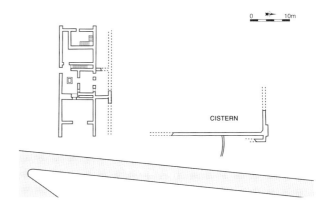

Figure 19.7. Corinth, Pano Magoula, atrium house with *impluvium*, and cistern (right).

port of the city.[111] All three were situated within the boundaries of fertile regions but also in close proximity to the urban center. The Pano Magoula and Cheliotomylos villas had oil presses, vessels, holding tanks, and cisterns; they were centers of agricultural activity, while the Lechaion villa was mostly residential.[112] In addition, all three were adorned with one or more of the amenities found in luxury villas: baths, peristyles, *nymphaea*, mosaics, and Roman types of architectural forms – *triclinia*, *tablina*, and *atria* with *impluvia* in the Italian mode. Some of these architectural forms feature much earlier in urban dwellings (e.g., at House 10 at Kastro Kalithea in Thessaly of the third to late second centuries BCE) or in suburban villas (as at Baltaneto [Naoussa] in the second century BCE) but are most prominent in urban houses (Patrae, Sparta, Messene) of the imperial period.[113]

The estate residence at Pano Magoula (Figure 19.7), established in the latter part of the third and occupied into the seventh century, was constructed in the garden of a much larger and more sumptuous earlier complex (first to second centuries CE), which featured a large cistern and numerous architectural elements that were incorporated into the third-century residence.[114] The millstones, oil press, and fragments of large terracotta vessels confirm the agricultural nature of the estate, whereas the plan of the residential quarters combined elements of the Roman house (atrium with *impluvium* and a *tablinum* and possible

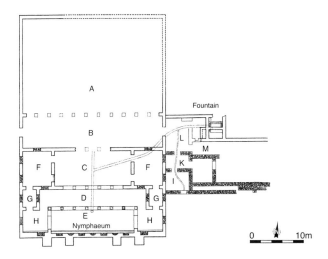

Figure 19.8. Corinth, Lechaion villa, plan (Stikas 1957: 90, fig. 1).

peristyle court) and thus embodies Italian villa formulae.[115] These amenities were notably evident in the "Roman Villa" at Cheliotomylos, where elaborate polychrome mosaics have survived in a number of rooms, along with a marble-lined *impluvium* in the atrium.[116]

In addition to rural villas, a series of maritime villas may have existed along the north coast of the Corinthian Gulf: these are evidenced by the remains of a large villa recently excavated at Loutraki and by the second to sixth century CE remains at Lechaion, first investigated in the nineteenth century (Figure 19.8).[117] While evidence for its economic activity is absent, excavations of the Lechaion villa have revealed a section of the residential unit that covers an area of approximately 1,500 m², which included a large courtyard (Figure 19.8: A, B), a *triclinium* complex (Figure 19.8: C, F) with a *nymphaeum* (Figure 19.8: E, D, H) covered by a vaulted ceiling and having alternating rectangular and semicircular niches on its back wall, and associated service areas (Figure 19.8: I, K, M, L). Rooms were arranged axially and symmetrically (courtyard, rooms G-F-C-F-G, and *nymphaeum*) in line with Italian architectural designs and had sumptuous decoration in the Roman manner: *opus sectile* floors, marble-reveted walls, green (*verde antico*) and white marble columns in the Corinthian order. The opulent marble-lined

interior along with the shade produced by the tall southern wall of the *nymphaeum*, the cool flowing water, and the many doorways provided a well-ventilated environment for the *triclinium*, ideal for summer dining.[118] This complex is not unique in villa design: Comparable arrangements have been documented in Herodes Atticus' villa at Eua Loukou where a *nymphaeum* and *aula*, used perhaps for formal reception and dining, dominated the western end of the peristyle garden (Figure 19.11; the *aula* is marked by letter j). In Italy, the combination of *nymphaeum* and *triclinium* is exemplified in House V6-7 at Herculaneum and in the late antique House of Cupid and Psyche at Ostia.[119]

From the corpus of villa remains in the Roman provinces of Macedonia, Epirus, and Achaea, a variety of exportable features of Italian villa design and villa culture have been documented, both in literary and material records. However, only in a very small number is the owner's name recorded – be it a wealthy foreigner or local landowner (like Titus Pomponius Atticus or Herodes Atticus) or a humble veteran (like Gaius Laetilius Clemens) – or the name of the estate (Atticus' *Amalthea*). For the most part, the villas and owners remain anonymous.

However, one individual, Herodes Atticus, was the exception: His fortunes permitted an unusual display of wealth expressed in part through the construction of villas. Herodes had a long life, great wealth, a prestigious marriage, friendships with emperors and high persons at court, political influence, important artistic and architectural patronage, and even a career as a teacher of philosophy. His gifts and good fortune assured him a place in the history of the high imperial period of the second century; therefore his luxury estates deserve special consideration.

THE VILLAS OF HERODES ATTICUS AT KEPHISIA AND MARATHON

Villas belonging to famous owners – be they emperors such as Hadrian, members of Roman high society such as Cicero and Pliny the Younger, or notables

whose villas were made notorious or noteworthy in literature – are always topics of interest, especially if they are archaeologically documented with epigraphic extensions and objects in the way of works of art. Three of Herodes Atticus' Greek estates had such rich documentation: two were in Attica, the smaller being the suburban villa at Kephisia northeast of Athens and a grand complex of villas in the region of his birthplace and his family's origins at Marathon (comprising two or more separate dwellings). The third villa was in the Peloponnese, at Eua Loukou between the modern villages of Astros and Kato Doliana (Map 14).[120]

The Villa of Herodes Atticus at Kephisia

The villa and estate of Herodes at Kephisia stood in a region famous for its fertility, and despite its small size, its proximity to Athens made it prominent in the literary record.[121] This estate included, among other things, a bath suite, marble portrait busts of Herodes and his students, curse inscriptions on a variety of stone monuments, a garden cemetery, and mausoleum; the description allows us to place the villa along the south and perhaps also the north side of the Pyrna stream.[122] The setting agrees with Aulus Gellius' account relating that the residence "with its spacious groves, long promenades, elegant baths and abundance of sparkling water" was situated in a "cool location."[123] Family members were interred in the garden cemetery, a funerary custom common among Greek aristocratic families of the imperial period. In some exceptional cases, interments appear to have taken place even within an urban villa, as documented at Messene.[124] The Kephisia villa functioned as a family retreat where Herodes buried his loved ones, taught his students, and entertained guests: magistrates, intellectuals, and sophists from the eastern and western parts of the empire. In addition, the abundant flowing water from the stream and surrounding fertile land provided ideal conditions for a variety of agricultural activities, including perhaps a *vivarium* that supplied fresh fish for consumption at the villa itself.[125]

The Villa or Villas and the Estate of Herodes Atticus at Marathon

Herodes' ancestral home and estate were located at Marathon, in the deme of Oinoe (Map 15), and comprised dwellings and facilities beyond those partially excavated or identified by surface investigations.[126] The estate may have extended from the area of Oinoe to the north to as far south as the coastal site of Brexiza; to the east toward the area of Kato Souli, and close to the mass grave, the *soros*, set up in honor of the Athenians who died at Marathon.[127] The plain was accessed from the north via a land route, while a small private port at Brexiza with a residence assured access from the south. The inclusion of a private harbor as part of an estate is documented elsewhere in the east. The sophist Damianus had one close to his estate for his merchant vessels.[128] The size of Herodes Atticus' Marathonian estate and its diversity of landscapes supported a wide variety of economic activities pastoral, agricultural, and maritime – that must have required a significant workforce and a variety of installations, including an aqueduct that provided fresh water from Mt. Agrieliki for the dry region between Aulona and Brexiza. The size of the estate and its range of installations are fully equal to large estates in Italy and are quite impressive in scale of production for the eastern Mediterranean.[129]

The estimated size and extent of Herodes' estate, based on the material remains, has been corroborated by the discovery of an inscribed stele found at the church of Hagiai Paraskevi and Kyriaki at Kato Souli.[130] Herodes himself composed the inscription (138–43 CE) after his father's death and possibly before his marriage to Regilla.[131] He states that the Marathon estate (called *Attikos* in honor of his father) is the largest attested landholding known in Greece, extending to the east and west of Mt. Akoni (mod. Mt. Kotroni) and southward to include the plains of Aulona and a large part of the land of Marathon.[132] Herodes indicates that the estate, as received from his father, was rather arid and deserted, but the land was fruitful with "bountiful game hunting," which he "ploughed, planted with olive trees and vines, cultivated grains, and constructed a farm establishment." As a result of these endeavors and, in

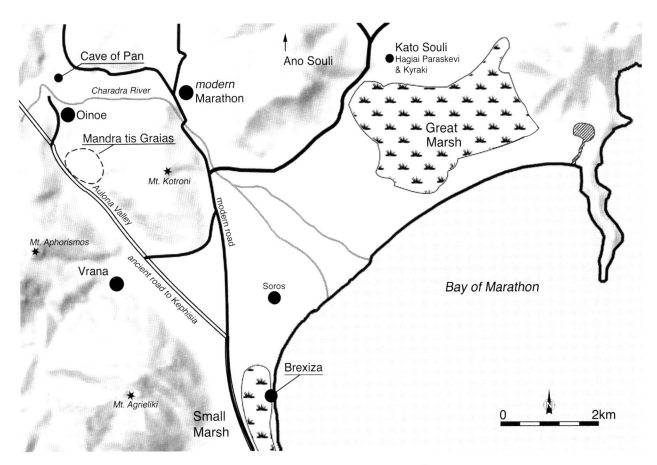

Map 15. Area of Marathon with location of Herodes' estate at Brexiza (M. D. Öz, after Dekoulakou 1999–2001).

particular, with the construction of an aqueduct, Herodes transformed his inherited landholdings and made them famous for their grains, wine, oil, hunting grounds, and perhaps piscicultural activities.[133] Given the size of the estate, there may well have been a number of residences, but three are known: a possible hunting lodge in the area of Oinoe, the original family estate known as *The Old Woman's Sheepfold*, and an elaborate residential complex at the port of Brexiza where a bath complex, a columnar courtyard with storage and dining facilities, and an Egyptian-type shrine have been excavated (Map 15).[134] The structures at Brexiza were additions, by Herodes, to his inheritance.

The Estate of Herodes Atticus at Marathon: Oinoe

The remains identified near Oinoe are located approximately 500 m north of the estate identified

as that of Herodes' wife Regilla (see p. 342), near the cave of Pan (Map 15). Limited excavations in this area and surface finds have identified the possible estate cemetery, herms with curse inscriptions to protect the monuments and surrounding property, a second-century bath complex, a monumental fountain, and an inscribed pillar with the name of Herodes' mother, Vibullia Alcia.[135] The presence of a nearby spring and the location of the monuments, nestled in the foothills of the surrounding mountains, provided an appropriate setting for a lodge as a restful retreat after hunting excursions, suitable for Herodes' private entertainment and that of his guests.[136]

The Estate of Herodes Atticus at Marathon: The Old Woman's Sheepfold

The second estate in Herodes' Marathonian property was located in a region traditionally known as *The*

Old Woman's Sheepfold. It lies just to the south of Oinoe, cradled between the slopes of Mt. Akoni (mod. Mt. Kotroni) and Mt. Aphorismos, and adjacent to an ancient roadway (no longer visible) that led up from the valley of Aulona toward the deme of Kephisia (Map 15).[137] The nearby terrain, suitable only for pastoral activities, is surrounded by a rubble wall 1 m high x 2 m wide and 3.3 km long, encompassing an area of 680,000 m² (approximately 15 ha or 27 acres). The area has not been excavated, but surface investigations have identified fragments of marble revetment, piles of building material, column blocks, hypocaust and roof tiles, and Roman second-century bricks.[138] From the inscribed stele found at Kato Souli (Map 14), Petrakos has proposed that the remains within the enclosure are those of the *original* family estate at Marathon that contained the main residential complex and various ancillary buildings associated with storage and agricultural and pastoral activities.[139] Herodes may have later refurbished this estate in order to present it as a gift to his wife Regilla by adding, among other things, an inscribed monumental arched gate framed by two seated marble statues, one of himself, the other of his wife.[140] The inscribed keystones of the external and internal sides of the arch confirm the ownership of the estates: "The Gate of immortal harmony. The place you enter belongs to Regilla" and on the inside "The Gate of immortal harmony. The place you enter belongs to Herodes." In addition to these enigmatic inscriptions, the epigram inscribed on the side of the arch, inserted after the death of his wife, informs the passerby that they are about to enter the *new polis* of Regilla, built by Herodes himself.[141]

This inscribed arch raises numerous cultural questions concerning identity, gender, space, and even political considerations in villas. Most recently, M. Gleason has examined these issues by analyzing some of the commemorative monuments set up by Herodes in honor of his wife.[142] Gleason argues that the Marathon Arch, which belongs to a category of monuments normally reserved for public spaces, served a dual purpose and conveyed multiple messages to its viewers: the visitors to the estate, those who lived and worked there, and

passersby.[143] Its presence within a private context served to commemorate and immortalize the owners and define the boundaries between two properties, those of Herodes and Regilla: a *Romanized* Greek and a *Hellenized* Roman, respectively.[144] More importantly, the phraseology and format of the inscriptions call to mind those said to have been recorded on the Pillar of Theseus at Isthmus, and those on the Arch of Hadrian in the city of Athens, as both appear to have defined boundaries: the former between the Peloponnesus and Ionia, and the latter between the city of Hadrian and that of Theseus.[145] In this context, Herodes' inscriptions served as political tools to evoke his ancestral ties to the land of Attica, his role as a magistrate, and his close connection to Hadrian, as manifested also in the adornment and plans of his villas and his multiple benefactions in Greece and elsewhere.[146] In particular, the inscription on the side of the Marathon Arch, which portrays Herodes as a city founder, is to be understood in a literal sense. Like Theseus (who founded Athens) and Hadrian (who founded many cities including a re-foundation of Athens), Herodes had transformed the entire Marathon estate by the time of Regilla's death into more or less a virtual *polis* with all the equipment of a city and its environs: villas, sanctuaries, temples, cemeteries, gardens, settlements for workers, a road system, a harbor, and honorary monuments. In fact, the inscription on the arch may very well be a declaration "that a very large part, if not all of the glorious deme [of Marathon], was his private property."[147] That said, Herodes (having lived in Rome and owning a villa along the Via Appia) may also have been influenced by the Roman concept of a villa as a city, as documented in Sallust's account whereby "houses and villas [were] reared to the size of cities."[148] Regardless of whether he was influenced by former city founders or villa estates, or inspired by both, it is clear that the Marathon Arch, both politically and culturally, conveyed multiple meanings: It defined and amalgamated Greek and Roman identities on a personal and public level.[149]

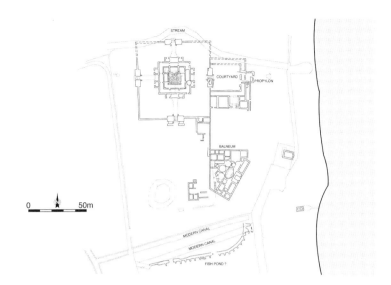

Figure 19.9. Plan of Brexiza (after
Dekoulakou 2011, 43, plan 4)

The Estate of Herodes Atticus at Marathon: Brexiza

Herodes' most elaborate and eccentric Marathon residence – the center of the vast estate and the primary dwelling of its owner – was located on the coast at Brexiza, on a small island in the middle of marshland where lies the *Canobus* mentioned by Philostratus.[150] According to accounts of early travelers and the investigations conducted by Soterides, a manmade island (no longer visible) was created by a canal cut to drain the surrounding marshes. Within this secluded area, a sanctuary to the Egyptian deities Isis and Osiris has been excavated, along with an elaborate miniature version of a bath building of imperial type, a courtyard framed with porticoes on three sides that provided access to storage and dining facilities, a propylon entrance, and scattered remains of walls and buildings that may have been part of a residential complex, an elliptical wall 120 m long located south of the modern canals and possible remains of a small harbor in the northeast corner, no longer visible (Figure 19.9).[151] All evidence points to a date in the second century CE, in particular the middle of the century, for the creation of this complex.[152] While a principal residence has yet to be uncovered, the Egyptian sanctuary, the *balneum*, and the spacious columnar courtyard complex must have served a dwelling of some size and magnificence.

The unique plan of the Egyptian sanctuary is axially and symmetrically arranged and comprises a rectangular wall accessed via a towered Egyptian-type propylon on all four sides, each flanked by Egyptianizing marble statues identified as images of Isis and Osiris (Figure 19.9).[153] In the center of the enclosure stood a rectangular triple-stepped construction (10x10 m; 3.42 m high) of pyramidal form and unknown function, framed by a raised colonnade supported by a retaining wall and surrounded by an underground corridor (20x20 m; 1.3 m below ground level).[154] To the southeast lay a palatial bath complex that dates from the mid-second to the mid-fourth centuries, of which 1,440 m² have been excavated (Figure 19.10).[155] The main bath area consists of a series of eighteen rooms, most with hypocausts, in various shapes and sizes that radiate out from the large, central oval pool in an axial and symmetrical fashion. Service rooms (Figure 19.10: A–F), many of which also seem to have hypocausts, were found along the north side, while the room with an *impluvium* (F) and adjoining space (G) perhaps served as part of a formal entrance to the baths: a sequence that may replicate the formal entrance (vestibule-atrium) of an Italian *domus*.[156]

The plan of the bath building, like that of the sanctuary, is also unique: No parallels have been documented in Greece. In concept, it follows the so-called Ring-type or half-axial Ring-type plan of imperial baths that feature a series of interconnecting

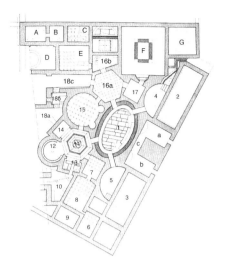

1. *calida piscina*
2, 3. *palestrae*
4, 5. *piscinae*
6. *tepidarium*
7. *sudotorium/caldarium*
8, 9. *tepidaria*
10. *caldarium*
11. *praefurnium*
12. *sudotorium/caldarium*
13, 14. *alvea*
15. *sudotorium/caldarium*
16a. *caldarium*
16b, 17. *tepideria*
18a-c. *praefurnia*
C. *tepidarium*
D. *caldarium*
E. *sudatorium*
F. *apodyterium-atrium*
a-c. *praefurnia*

Figure 19.10. Brexiza, bath complex, plan (after Arapogianni 1993).

0 10m

rooms radiating outward from a central space.[157] The architect was perhaps inspired by, and incorporated elements from, both the Small Baths (half-axial ring-type) and the Heliocaminus baths ("Ring-type") of Hadrian's Villa at Tibur.[158] Moreover, the size of the *balneum*, its wealth of decorative marble and wall plaster, and the symmetrical distribution of space, a feature uncommon in baths of Roman Greece, point to a patron intent on imitating imperial *thermae* in Rome and metropolitan cities. From his residence in Rome and his imperial friendships, Herodes Atticus may well have been familiar with Hadrian's Villa and other imperial baths.

Collectively, the material remains from Brexiza comprise a unified, multifaceted complex that covered the entire island. The long wall connecting the baths, sanctuary, and courtyard area, with the partially excavated rectangular structures interspersed throughout, and the discovery of portrait sculptures of Herodes, Marcus Aurelius, Lucius Verus, and Polydeukion, similar to those found at Herodes' estate at Eua Loukou and Kephisia, lend visual confirmation to the presence of a grand-scale residence with high representational values (Figure 19.9).

Excavations to the south of the baths during the construction of a modern canal have revealed the substantial curved stone wall (120 m long) of a cistern. It is lined with thick waterproof plaster and divided along the exterior side by a series of short cross walls placed at regular intervals of 1.5 m, with terracotta pipes located at the apsidal eastern section of the long wall for the outflow of water: this structure may be a large fishpond (Figure 19.9). If this identification is correct, then these remains attest to Herodes' business ventures in pisciculture, as proposed by Spawforth and alluded to by Soteriades.[159] As saltwater fish were in high demand during the Roman period, marine fish farming became a lucrative business for maritime villas if appropriate measures were taken to ensure suitable installations and knowledgeable staff, namely an oxygen-rich water environment and close proximity to urban markets for quick transport of perishable goods. The location of Herodes' Marathon villa – part coastal but within easy distance of Athens – coupled with environmental factors that supported natural fishponds would have provided an ideal setting for such a venture.[160]

The remains of the site at Brexiza were enclosed in the barrier of the canal, repeating with water the enclosure in stone of the family estate at *The Old Woman's Sheepfold*.[161] This canal, or moat-like feature, isolated the complex of buildings but gave it a picturesque presence from a distance. The enclosure wall of the Egyptian sanctuary and its gateways with framing towers had a military aspect appropriate to the entry façades of grand rural residences of the second and later centuries, such as Milreu in Portugal and Nador in Algeria (cf. Figure 16.2 in Chapter 16).[162]

Other clues at Brexiza point strongly to the presence of a villa on the manmade island. Besides its religious character, the Egyptian sanctuary had at least two other functions: It was a *heröon*–mausoleum in memory of Herodes' daughter Athenais or was remodeled to have that function. Memorials to the dear-departed were not infrequent at villas, and Herodes was much given to such commemorations: At his villa at Eua Loukou, the temple of Antinöos-Dionysos was remodeled into a *heröon*-cenotaph in honor of deceased family members and at his Marathon estate he built a temple in honor of his father Attikos.[163]

The second function of the Egyptian sanctuary was to serve as a monumental entrance for guests. Visitors arriving at Brexiza from the north via the land route from Kephisia would have approached the complex from the north, through the Egyptian sanctuary, accessed by a bridge over the canal. As the estate may have had more than one entry point, those arriving from the harbor entered from the courtyard propylon. This can be deduced from Philostratus' account concerning Herodes' dinner invitation to a certain Agathion. According to this narrative, Agathion seems to have accepted Herodes' invitation on the condition that he would first be served a bowl of milk not milked by a woman at the "Shrine of Canobus" (*Kanobus hieron*).[164] It is possible that the *Canobus* (or *Canopus*) refers not only to the Egyptian sanctuary but also to Herodes' entire villa residence, with the shrine serving as a grand vestibule into the estate. It would have been fitting, after all, for a *kyrios* (the lord of the estate) to greet an invited guest at the entry hall of his residence – whence the guest Agathion refused to enter into the more private areas of the villa residence and dine with his host until his request for special milk was fulfilled. Thus Philostratus' *Canobus* may well refer not only to the Egyptian sanctuary but to the entire island complex and to the villa itself, following the elite tradition of giving special names to estates and grand rural dwellings. This practice is confirmed by the epigraphic evidence – the designation *Attikos* given to the Marathon estate in honor of Herodes' father, as we have seen, and the name *Amalthea* given to Cicero's friend Atticus' estate in Epirus much earlier, so

named after the shrine, the *Amaltheion*, housed within it.[165] *Canobus*, therefore, may also have been the name of Herodes' villa at Brexiza, a name borrowed from the sanctuary it housed.

The Villa of Herodes Atticus at Eua Loukou

The third and most celebrated estate of Herodes – recently and currently under investigation, though very incompletely published – lay in the fertile plain of ancient Thyreatis at Eua, 2 km northeast of the modern village of Kato Doliana and next to the Monastery of the Transfiguration, locally called the Monastery of Loukou (Map 14).[166] Epigraphic evidence confirms the identification of the site and records the names of Herodes' parents, Alcia and Atticus, and his grandfather Hipparchos.[167] Two decades of excavations (1980–2001) by the Greek Archaeological Service have brought to light a large part of the luxury residential complex erected by Herodes. Of this, only approximately 6,500 m² out of a total of some 20,000 m² have been uncovered (Figure 19.11).[168]

The villa residence was constructed on three successive terraces (Levels I, II, and III). Level III was only slightly elevated, whereas Levels I and II were supported by two parallel retaining walls aligned east–west: a north wall (Figure 19.11: a–b), reinforcing the north side of the apsidal hall (1), and a south wall (c–d) supporting the north side of the peristyle court.[169] The apsidal hall (I) (with a central nave, two aisles, and an internal five-conch apse) and surrounding subsidiary spaces, were erected on the northern and lowest terrace: To the east was an enclosed gymnasium-palaestra (x).[170] From the south end of the basilica's eastern corridor (e), a series of steps provided access to the middle terrace. Here, a peristyle "island-garden" (2) formed the centerpiece of the entire residential complex.[171] It was surrounded by a canal (f), with porticoes (g) along the north, south, and east sides, a double-portico (h) at the east end and a *nymphaeum* (i) at the west.[172] Access to the "island-garden" (2) in the center would have been provided by bridges, like those at Hadrian's "Island Enclosure" at the Tibur villa.[173] West of the *nymphaeum* is an apsidal

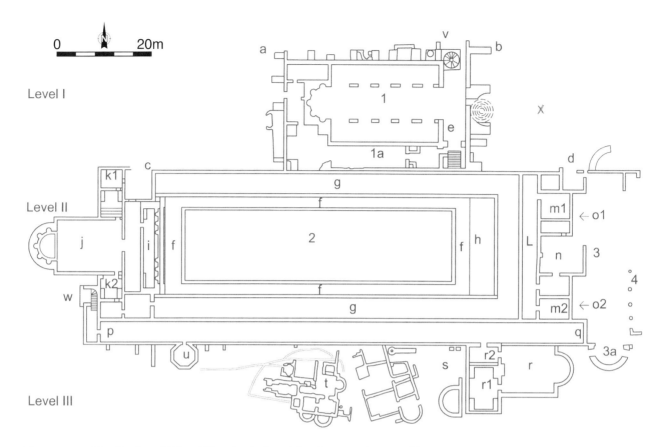

Figure 19.11. Eua Loukou, Villa of Herodes Atticus (after Spyropoulos, 2006b).

structure (j) identified as an *aula*: this structure had a five-conch apse and adjoining private apartments (k1 and k2) to the north and south.[174] Beyond the east portico (g) of the peristyle, there was a parallel corridor (L), followed by a cluster of interconnecting rooms (m1 and m2) located on either side of a summer *triclinium* (n) that comprised part of the main entrance into the peristyle garden.[175] The east façade of the summer *triclinium* (n) was framed by *nymphaea* on either side (o1 and o2) that faced onto a garden-stadium (3), like the one found at Hadrian's Villa and other villa residences of the period.[176] Further to the east stand the remains of a colonnade (4): these may indicate that an additional courtyard, possibly a peristyle, extended beyond the boundaries of the excavated area.[177]

South of the central terrace, at a slightly higher level (Level III), are the remains of four complexes accessed from a long east-west corridor (Figure 19.11: p-q). The easternmost structure is the temple-*heröon* (r) of apsidal plan and originally of Hadrianic date; it was modified during the Antonine period to include an entrance vestibule (r2) and *triclinium* (r1) (Figure 19.12).[178] To the west are the adjacent remains of an apse, scattered fragments of curved and linear walls, and water pipes for what may have been a grotto-*triclinium* (s on Figures 19.11; 19.12). Excavations in this area have also uncovered a *balneum* (Figure 19.11: t) of the parallel or angular row-type found at Olympia (Bath IV) surrounded by a network of water installations.[179] Adjacent to the bath complex stands an octagonal tower (Figure 19.11: U) accessed from the southern corridor (p-q) with subsidiary structures attached to it. Two additional towers have also been identified, one to the north (v) and a second to the west (w). These structures, which gave a military aspect to the silhouette of the villa, were common features in other rural residences and in those represented in painting and mosaic.[180]

The Basilicas of the Villa at Eua Loukou

Of particular interest at Eua Loukou are its three apsidal structures or basilicas (Figure 19.11: 1, j, and r) and their uses and developments. The basilical plan had its early origins in Hellenistic palaces, but the architectural conception is Roman, even though it was always and primarily a *public* edifice. However, for private residences, Vitruvius as early as the late first century BCE claimed that persons of high rank "who hold offices and magistracies" needed *basilicae* for their social roles and to represent their status.[181] A basilical hall emerges in Domitian's palace on the Palatine Hill in Rome (late first century CE) and later became the hallmark of late antique palatial structures of the Tetrarchic period, but it appears with great frequency in nonimperial villas and houses, particularly in the west. Within these private residences, however, there was often only *one* apsidal structure that served a variety of functions: formal reception area, local judicial/administrative center, and dining facility.[182] To my knowledge, basilica 1 at Loukou is the earliest excavated example of such a building-type found within a domestic context in the provinces, as it dates to the end of the first or beginning of the second century CE, perhaps as early as Domitian's reign.[183]

Basilica (1)

All three of the apsidal halls (Figure 19.11: 1, j and r) at Eua Loukou appear to have had a specialized function, but all three were subtly different and thus can be characterized accordingly. Whether the term "basilica" for such halls is appropriate to private dwellings (*aula* has been suggested as a better term),[184] the design of basilica (1) – a nave with two lateral aisles giving it a distinctly judicial form – makes its appellation basilica appropriate.[185] Like the imperial *basilicae* in Rome, Herodes' basilica (1) may also have had a legal function, to conduct business with members of the community and estate workers.[186] In addition to its political role, basilica (1) perhaps also symbolized Herodes' assimilation

and friendships with emperors, his social status, his status as a magistrate, and his wealth. It also afforded him the opportunity to showcase to locals and visitors alike his ancestral and familial ties, religious piety, and cultural affinities through the display of statuary and portrait busts.[187]

Aula (j)

The west "basilica" (j), which lies along the central east-west axis of the garden peristyle opposite the main entrance at the east end, follows a plan observed elsewhere in late antique villas and palatial structures.[188] In those examples, the apsidal structure is best identified as an *aula* that functioned as a formal reception and dining area. Based on this evidence, the apsidal structure (j) in the Loukou residence should also be identified as an *aula*, not as a basilica. Visitors upon entering the garden peristyle from the east end would have proceeded down a designated route to reach this reception area. Since the *aula* (j) also opened onto a monumental *nymphaeum* (i), water canal, and garden peristyle, it would have provided a dining environment ideal for impressing guests.[189]

Heröon (r)

The rectangular apsidal building (r) was the smallest – but surely the most important – of the basilical structures of the villa. It had two major phases. The first was constructed during the Hadrianic period, after 130 CE, as a simple apsidal plan that was accessed from the portico to the north and from the fragmentary remains of a building (s) to the west (Figure 19.12, A). The discovery of a statue of Antinöos-Dionysos and inscribed fragmentary marble plaques, one of which mentions the god Dionysos, has prompted the excavators to identify this space (r) as a temple-*heröon* to Antinöos-Dionysos.[190] The second phase belongs to the Antonine period, after the deaths of Herodes' loved ones, at which point the apsidal structure was

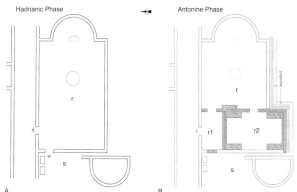

Figure 19.12. Eua Loukou, Villa of Herodes Atticus, the Temple-heroon and heroon-cenotaph (line drawing by Z. Evangelopoulou, after Spyropoulos 2006b).

transformed into a *heröon*-cenotaph (a space dedicated both to a god or hero – in this case Antinöos-Dionysos – and to the commemoration of the human dead) by the addition of an entrance vestibule (r1) and *triclinium* (r2) (Figure 19.12, B).[191]

Funerary banquets may have been conducted within the *heröon* in honor of Herodes' deceased family members,[192] while fragments of marble revetment and gilded plaster highlight the status and sumptuousness of this room.[193] To the west, the aforementioned remains of curved and linear walls (s) and water pipes, and sculptural adornment of two river gods have been associated tentatively by the excavator with a possible *Serapeum* and/or grotto-*triclinium* (s), inspired perhaps by a similar feasting complex at Hadrian's Tibur villa and/or the famous *Serapeum* of the Canopus in Alexandria.[194] Like others of his time, Herodes was drawn to the pretentiousness of the grotto-*triclinium*.[195]

The discovery of ceramic tableware in the vicinity and the remodeling of the temple-*heröon* into a *heröon*-cenotaph with dining facilities confirm the use of these rooms for feasting. Continuity can be observed: when the Hadrianic *heröon* (r) acquired its new, rather small, dining facilities (r2) when it was transformed into a *heröon*-cenotaph in Antonine times, the old grotto-*triclinium* (s) in the complex became redundant, so the old door accessing the *heröon* (r) from the grotto-*triclinium* (s) was blocked (Figure 19.12, A; B). The epigraphic evidence and

the statue of Antinöos-Dionysos indicate an original use for the space (r) as a Hadrianic temple-*heröon* and later as an Antonine *heröon*-cenotaph with a triple function: as a *triclinium*, as a religious and commemorative space, and as a ceremonious *aula*.[196]

The Sculptural and Mosaic Adornment of the Eua Loukou Villa

In addition to its elegant architecture and decoration, the Eua Loukou villa contained an unprecedented wealth of sculptural and mosaic adornment – certainly for any villa in Greece and even in the empire.[197] The assemblage is a testimony to Herodes' philosophical beliefs, ancestry, and his spatial conception of the dwelling. An ardent art connoisseur, Herodes transformed his living quarters into a virtual museum, displaying both copies and original works from various periods of Greek and Roman art.[198] Spyropoulos suggests that these were arranged according to the function of the room, with themes of Greek *paideia* (education) and *arete* (virtue) prevailing in the sculptural decoration as a whole. In the basilica (Figure 19.11: 1), statues of the Athena Farnese-type and Dionysos were perhaps positioned within the north apse, while busts of philosophers and portraits of family members adorned the rooms to the south, possibly associated with a library (1a).[199] Indications of Herodes' piety and affiliations figured prominently in the south apse of the garden-stadium (3a), which Spyropoulos identifies as a *lararium*. in which images of Hygeia and Asclepius were displayed as emblems of health and medical knowledge, alluding to Herodes' personal ties with the nearby healing sanctuary to Polemokrates, grandson of Asclepius, a monument recorded by Pausanias.[200]

Within the peristyle garden (Figure 19.11: 2), the sculptural themes embody "the family's authority or power (*kyros*), their display of wealth and love of beauty (*philokalia*), including restful leisure (*otium*) associated with Dionysiac luxury (*tryphe*) and the toil (*negotium*) of their physical and spiritual labors."[201] These concepts are represented by statues depicting members of Dionysus' entourage, along with athletes,

philosophers, rhetoricians, gods, and heroes. In the statue collection, there were three notable groups: an Achilles and Penthesileia, a so-called Pasquino duo (one soldier, maybe Menelaus, supporting the body of the slain Patroclus or another man) and the six Amazons that served as columnar supports for the portico (h) at the eastern end of the garden-canal – these last six statues closely parallel the Amazons that bordered the *Scenic Canal* in Hadrian's Villa.[202] At the opposite end of the peristyle garden stood the dancing *Lacaenae* (young Laconian women), identified as original works of the late fifth century BCE that resemble the dancing Maenads of Callimachus. These may have been displayed in the six niches of the east façade of the *nymphaeum* (i), while along its west façade (facing the *aula* [j]) stood perhaps the classicizing sculptures of the Mattei-type Amazon.[203]

Spyropoulos maintains that the renovations, which took place following the deaths of Herodes' family members (165–70 CE), also altered the display of this sumptuous sculptural décor. The semicircular niches of the *nymphaeum*, where statues of the dancing Laconian women once stood, were replaced with rectangular niches displaying images of Herodes' deceased family members reclining on couches. These changes parallel the transformation of the *heröon* (Figure 19.11: r) from a temple-*heröon* of Antinöos-Dionysos into a private *heröon*-cenotaph, where funerary portraits of members of Herodes' family, and possibly other funerary banquet reliefs, were added.[204] Finally, Herodes' close affiliation with Egyptian cults, already discussed in the case of the Brexiza residence, is also represented in sculptural form at Eua Loukou: The fragments of a sphinx have been found as well as statues of the gods Osiris and Isis, the granite horns of a cow (possibly belonging to a statue of the goddess Isis-Hathor), and the Nile as a reclining river god, all perhaps connected with the possible grotto-*triclinium* (s).[205] Such Egyptian themes for the adornment of villas were fashionable during the High Empire and embellished other grand residential complexes: the *Scenic Triclinium* and *Canal* complex at Hadrian's Tibur villa had Egyptianizing statues.[206]

In addition to the images of deities, the villa contained portrait busts of Herodes Atticus himself, members of his family, beloved students (Memnon, Achileas, and Polydeukion), members of the imperial family, and philosophers of the early second century, constituting a hall of fame combined with a hall of memory: they are similar to, but greatly outstrip in quantity and detail, collections known from Italian villas such as those excavated in the Villa of the Papyri at Herculaneum.[207]

In contrast to the sculpture, the polychrome tessellated floors located in the porticoes (g) of the peristyle and in the external east and south corridors (Figure 19.11: L; p–q) are well preserved and cover a total area of approximately 1,300 m².[208] They are of primary importance because the figurative mosaic panels are identified by name-labels and are the earliest examples of floor pavements using inscriptions to identify scenes and personages, a practice that became more common in the late second to early third centuries in the Greek east.[209] In addition, an exceptionally important coordination between floor scenes and statues or sculptural groups was planned: The subject matter of the mosaic panels of the porticoes was matched to the works of art behind them.[210] In the north portico (Figure 19.11: g), for example, behind the tessellated pavement depicting the Pasquino group stood a sculptural representation of the same theme. Other floor pavements in the north portico included images of the personifications of *Ktisis* (the Act of Foundation) and *Apolausis* (Enjoyment), topics that became popular in late-antique houses in the east, as at Antioch. These abstract concepts may have served to represent the philosophical aspirations of the owner, the various moral or ethical values associated with his *paideia* (education) and cultural achievements.[211] References to Greek education are highlighted in the representations of the Muses in the northern and eastern porticoes, accompanied by a head of Medusa, while the southern portico displayed personifications of natural elements, the Labors of Heracles, and the Achilles and Penthesileia group.[212]

Curiously different from these predominantly *Greek* themes stands the scene of Aeneas and Dido, a distinctly important and romantic moment in Roman historical narrative. It points to Herodes'

marriage to the Roman noblewoman Regilla and his dual cultural and political identity as both a Greek and Roman citizen.[213] There may well be, in this scene, a touching note of personal self-reflection by the owner himself.

The sculptural and mosaic program of the Eua Loukou villa represents Herodes' artistic tastes, his multifaceted character (Greek-Roman, philosopher-politician, benefactor-businessman), and his political and philosophical aspirations, strongly formulated by the Second Sophistic.[214] Various elements of the villa décor exemplify his euergetism (his role as a benefactor) and teacher, his personal achievements, family life, and his devotion to the heroic, intellectual, and mythological past. Spyropoulos has correctly maintained that these highly personal aspects of the decorative program of the Eua Loukou villa are special to Herodes himself.[215] Its program was quite different, in choices and themes, from that at Hadrian's villa at Tibur, where an eclectic iconography predominated (except for the presence of Antinöos images).[216] Conversely, earlier collections – the statues in bronze and marble from the Villa of Papyri (amassed from the second half of the first century BCE to 79 CE) – were more abstract, conventionalized, and less personal than the program of Herodes.[217]

Continuation and Later Changes in Mosaics and Sculpture

Following Herodes' death in c. 177 CE, the Eua Loukou villa residence functioned for about 250 years under new ownership and with a decorative agenda that differed from Herodes' more personal themes. After an earthquake at the end of the third century CE, new mosaic pavements were laid in the villa residence. Among other images, a mosaic showing a chariot race was interpolated, a scene from the Roman hippodrome that was standardized in late-antique imagery, very popular and widely used elsewhere; this clichéd image contrasts with the mythological themes of the earlier mosaics.[218]

The sculptural panoply of the villa continued: portraits of philosophers and of unknown men and women (perhaps subsequent proprietors and their families) of the late second to fourth centuries CE were displayed in the private suites adjoining the western aula (j) and in other areas of the dwelling as well as imperial portraits.[219] The latter descend through the emperors Marcus Aurelius (161–80 CE), his son Commodus (180–92 CE), Septimius Severus (193–212 CE), Pupienus (238 CE) and possibly one of Pertinax Arabic (193 CE) who is mentioned in an inscription: their presence indicates that the estate had become imperial property and was in lively use long after its original construction and adornment.[220]

In the later third century CE, the villa suffered from the Herulian attacks and from earthquakes, but it was restored and used until the end of the fourth century.[221] At the beginning of the fifth century, major changes took place: the basilica (1) was transformed into a church, and the baths became workshop areas.[222] Other parts of the villa were used for burials, and new activities were introduced: glassmaking, pottery, and wine production. After renewed earthquakes in the mid-sixth century, the residential quarters were abandoned and subsequently used as a quarry for building material in the construction of the nearby Monastery of the Transfiguration.[223] The villa site became an area for the monastery's agricultural establishments and crafts. A final major destruction attributed to Slavic invaders seems to have occurred in the seventh and eighth centuries, but the site was never completely abandoned: Evidence for human activity has been documented into Byzantine, Ottoman and modern times.[224]

The Villa at Eua Loukou: Summary

In its original program, the Eua Loukou villa had some very personal and familial elements pertaining specifically to the character and achievements of its builder, including his career as a teacher, pious man, and friend of emperors. At the same time, Herodes' tastes did not depart from the standardized eclecticism of his time: The themes of famous men, mythological depiction, and abstract virtues were

part of the baggage of intellectual life in the Second Sophistic. In a broad sense, the choices of décor at Herodes' residence (and others like it) were congruent with the empire-wide fashions of other aristocratic villas: display of luxury and personal self-aggrandizement. These fashions were reinforced by the use of luxury building materials and the construction of palatial-size residences, and they were further enriched by the incorporation of standard themes – Egyptianizing elements as well as athletic, educational, mythological, and imperial images, among others – into the decorative repertoire of villas. Herodes, at Eua Loukou and in his other residences at Kephisia and Marathon, was thus both no exception and exceptional.

The Grounds of the Villa at Eua Loukou

Although excavations at Eua Loukou have focused primarily on the residential quarters, traces of its environment and estate have also been identified. Among these are sources of water, the location of the villa for pleasant views and hunting, and proximity to religious centers and towns; viability of agricultural activities as well as the local burial of the dead were also important.

A significant water source was needed to feed the baths, the *nymphaeum*, fountains, gardens, and the 170 m long canal, besides serving the daily needs of the occupants. A spring, located approximately 1.5 km to the northwest and known as the Manna Spring seems to have served this purpose. It was part of a sophisticated water management system that directed water from the source to the estate via a double-arched aqueduct located just south of the Monastery of Loukou. From this point, water was distributed throughout the villa via water installations excavated in the area of the *balneum* (Figure 19.11: t), grotto-*triclinium* (s), and the *heröon* (r).[225]

The choice of location is also an important aspect of villa sites. The Eua Loukou villa lay on a plateau surrounded by mountains on three sides, with a commanding view of the Bay of Thyreatis to the east. From the garden-stadium

(Figure 19.11, 3) there was a panoramic view toward the Bay of Astrous.[226] The location also afforded an abundance of rich vegetation and wild game, close proximity to the fertile plain of Thyreatis, the presence of a nearby healing sanctuary of Polemokrates, the large town of Eua, and a local limestone quarry.[227] Consequently, the estate functioned not only as a luxurious philosophical retreat but also as an economic production unit involved in agricultural activities associated with the processing of wine and olive oil, animal husbandry, game hunting (a favorite passtime of Herodes), and stone quarrying – with profitable marble quarries located at Ano Doliana and surrounding territory.[228] The discovery of wine vats in the residence, although of a later (fifth century CE) date, may be taken to suggest that such agricultural activities had existed earlier. Pausanias' observations on the excellent soil for the trees "particularly olive-groves ... that stretched down to the sea" as he made his way up inland to the site of Eua, allows us to postulate that the estate may also have been involved in olive-oil production.[229]

According to recent studies on land exploitation in the Peloponnese during Roman times, there was an agricultural intensification and specialization of crops, with priority given to grapes and olives.[230] Surveys in the area of Patrae, for example, have confirmed the ancient sources that mentioned important viticulture in this region, while in other areas such as the region of Corinth, olive oil may have been the predominant product. Local markets would not have entirely absorbed this agricultural produce: they must have been exported as well.[231] Herodes may have commercially exploited the vineyards and olive groves of the region, a practice that continued into the late fourth and fifth centuries when the villa complex was transformed into a Christian center, and into the late Byzantine period.[232]

So large and important a property would have generated its own dead, and tombstones discovered both within and around the dwelling area indicate that the villa, as an institution, provided for its personnel in death as well as in life.[233]

CONCLUSION

Roman villas in Greece emerged in the form of estates and residences established by Italians and Romans as early as the second and first centuries BCE with the arrival of traders (*negotiatores*) from Italy and the purchase or allotment of vast tracts of land in Macedonia and Epirus to Roman military veterans and entrepreneurs. The estates of Cicero's friend Atticus are prime examples. Further afield, Romans became involved in pastoral activities in Arcadia, an area known for its excellent agricultural lands and grazing fields for breeding horses and mules.[234]

In addition to large estates, small- to mid-sized establishments were granted to Roman colonists and military veterans with the foundation of colonies in the early imperial period in Epirus, the Corinthia, around Patrae, and elsewhere. The Roman villas were different from the pre-Roman agricultural establishments in quantity and quality: There was an increase in size of the estates and the residences, and the importation of Italian architectural and decorative elements such as the atrium with *impluvium*, floor pavements in *opus signinum*, *opus spicatum*, and black-and-white mosaic, and construction techniques and materials (especially the use of fired bricks). There was also intensification of land-use, use of new technologies and methods of cultivation, and the processing of agricultural products for regional consumption and export.

Owning villas and estates was not a one-way street. Prominent Greek families, some of senatorial rank like the *Saethidae* and the Claudii Attici, had estates both in Greece and Italy: the *Saethidae* at Abellinum in Campania, the Claudii Attici along the Via Appia. Like Roman estates in Greece, the landholdings of such families may have comprised several scattered properties focused on a villa complex; Herodes' estates at Marathon and Eua Loukou were so constituted.[235] Such villas surfaced in Greece and elsewhere (e.g., Africa and Gaul) primarily in the second century, and their owners incorporated Roman and western villa culture and agricultural technologies to assert their power, status, piety, and

philosophical bent besides turning profit on their estates.[236]

Despite the similarities, the expansion and development of villas in Greece followed a slightly different course than their western counterparts. In addition to the villas of Italian type established by the Italians/Romans in Macedonia and Epirus during the second to first centuries BCE, there are also more modest estates in the imperial period. These were endowed with well-appointed residences, some nicely embellished, that seem nevertheless to model themselves on traditional local farmhouses, such as House A at Lete.[237] However, villas in the province of Macedonia for the most part developed along the lines of villas in Italy, a mix of rural, suburban, and maritime villas. Chronologically, they belong to three phases: one as early as the second and first centuries BCE; a second wave of building activity in the second century CE; and a third phase from the third to fourth centuries. What is unusual for Macedonian villas is their continuity: Many sites were occupied or reoccupied beyond the fourth century, sometimes into the fifth and sixth centuries,[238] but only a few new villas were built in late antiquity (the fortified estate at Oraiokastro near Thessaloniki, a rural villa at Paliochora Euboea, and probably a maritime villa in the area of Molos, near Abdera).[239]

In Epirus, animal husbandry and pastoral work prevailed as the main focus for villa estates, and to a lesser extent agricultural activity. Chronologically, these estates fall into two groups: the first appearing as early as the second (the Masklenitsa villa) and first centuries BCE with continued occupation into the second and third centuries CE; a second wave of villa-building activity occurred between the early to mid-imperial period, from the first into the third centuries. Most sites seem to have been abandoned by the end of the third century (only the Ladorchori estate was reoccupied from the fourth to sixth centuries); animal husbandry and pastoral activity beyond supplying local needs may have declined, possibly due to disturbances associated with the Herulian invasion of the 260s.[240]

In the Roman provinces of Achaea and Crete, a different picture of villa development emerges. Villa sites appeared later, during the first three centuries of the empire, with the earliest examples identified at Patrae, the region of Asea, and primarily the south coast of Crete, as evidenced by the maritime villa at Markys Yialos. Elsewhere – at Corinth, in Attica and possibly along the northern coast of Crete – most villas seem to have been constructed during the second century CE;[241] among these, at least three sites were occupied into the Byzantine period (Eua Loukou, Lechaion, and Pano Magoula). By and large, a greater variety of villa sites, both in size and function, have been investigated in the province of Achaea. The numerous examples from Patrae are mostly small to medium-sized agricultural establishments, which appear to follow similar patterns of size and growth observed in the modest villas of Italy. In the region of Corinth, villa sites seem to have been fewer in number but larger in size and with well-appointed residences.

Despite the early appearance of the villa in northern and northwestern Greece, the majority of villa sites in the Aegean region did not appear until the early to mid-imperial period (later first century BCE and into the second century CE). This was the high point of villa-building activity in Greece, and it was a delayed development when compared to central Italy, where the peak of villa construction occurred a century before, in the early first century BCE.[242] The villas functioned well into the third or early fourth centuries, at which point they were either abandoned or continued operating into late antiquity and early Byzantine times (Pano Magoula, Lechaion, Eua Loukou, Ladochori, Masklenitsa, House A at Lete), with a very small number of new establishments appearing in Macedonia (Abdera and Oraiokastro Thessaloniki) and on Euboea (Palaiochora), though on Crete large rural villas seem to have flourished during late antiquity.[243] The decrease in the number of villa sites that functioned into late antiquity and the founding of new estates has also been documented in Italy.[244] In general, the evolution of villa estates in Greece seems to parallel developments across the Adriatic and elsewhere, where, in general, the Roman concept of

villa-dwelling ends by the mid-fifth century, as sites are either abandoned altogether or transformed into villa settlements, palaces, and/or religious centers.[245]

The abandonment of numerous villa sites in certain regions (Patrae, Asea, and some in Epirus) at the end of the third century may be due to the disturbances associated with the Herulian invasion of the 260s. The proprietors of some of the smaller estates may have left their villa residences (not necessarily the ownership of their farms) and sought protection in villages or towns. Aristocratic owners of large estates, on the other hand, perhaps chose to relocate for safety to larger urban centers or even to, or near, the new capital of the Roman Empire, Constantinople, as did the villa-owning aristocracy of Rome when the western capital and imperial residences were transferred to cities (Milan, Ravenna) in northern Italy.[246] A drop in the number of large villa sites in one region may be compensated by a rise in another region and not necessarily the abandonment of villas altogether, in a process of dispersion and amalgamation. Only further excavations, intensive field surveys, and publication of villa sites will give us a clear picture of the history of later Roman rural structures and adaptations in Greece.

Change by no way means decline: Some villa residences continued to function very well, and a few even witnessed a transformation as parts were converted into centers for Christian worship, denoting a creative adaptation to new circumstances. This is clearly evident in the basilica (1) of Herodes' villa at Loukou during the fifth and sixth centuries and in the villa at Kephallonia where a church was established near the end of the fourth century.[247] What is not clear is whether any of these villa estates became villa settlements of the type witnessed in the west, since they are neither fully published nor extensively excavated: Investigations have not yet gone beyond the limits of the residences to their outbuildings and annexes where the phenomena of village acculturation, other industrial work, and differently organized agriculture might have happened.[248] However, the evidence from Eua Loukou, which includes burials, workshops, pottery kiln, baths, wine vats, and the basilica church (Figure 19.11: 1),[249] attests some form of productive habitation and religious activity

ongoing at the site during the fifth and sixth centuries. The exact character of this settlement (monastic, lay or a combination) is uncertain, but the establishment of a monastery near the villa residence in the mid-sixth century, a date which coincides with the previous residential use of the villa, suggests that a small monastic community had already developed at the villa prior to its abandonment. As the religious community grew, the old villa accommodations were no longer suitable, so new lodgings better suited to the needs of a monastery (cells, church, and service areas within an enclosure wall) were erected nearby. The religious community made ready use of available building materials (including inscriptions) from the old residence (and possibly from the nearby Asklepeion) for the new Monastery of the Transfiguration. After abandonment, the villa became an ancillary area for agricultural activities and crafts.[250]

This survey of Roman villas in Greece has outlined the main features of the introduction and development of villas in a region of the empire that up until now has been almost absent – or certainly peripheral – from villa studies. The absence is serious: It has prompted the view that villas did not exist in the Aegean region because they were "a western not an eastern phenomenon,"[251] and "part of western aristocratic identity."[252] This view was heightened by the limitations posed by the Hellenocentric emphasis that once dominated Greek cultural studies under the Roman empire, and in particular the study of houses and households, since under this notion even "the houses of the Greek east were never *Romanized*."[253]

By contrast, the evidence clearly shows that the villa as an economic production unit with farmland, residential structures, and associated buildings as described by Varro, Columella, and other Roman authors were fully naturalized in the Aegean basin. In fact, the Latin word *villa* had its equivalent in the Greek words *agroikia* (land and residence), found in the works of early-Roman period authors (Dionysios of Halikarnassos and Diodorus Siculus), and also *aule* (all physical structures) and *alos* (agricultural land), terms used by Herodes to describe his Marathon estate.[254] The view that the Greek east had a more

urban character than the western provinces cannot be sustained:[255] it scants the evidence of the villas themselves. As elsewhere in the empire, a new super-elite class was eager to adopt ostentatious displays of wealth, status, and power in the countryside as well as in towns and cities. Lower down on the social spectrum, even the small to mid-size villa owners prospered: They renovated and upgraded their villa residences with fair regularity. Additional work remains to be done: Systematic surveys and excavations focusing on Greek villas of the Roman period as productive and residential entities will shed light on the various questions and hypotheses posed in this chapter. The Roman villa beyond Italy – in this case mainland Greece and the Aegean islands – was a strong and vital export, fully assimilated by the Roman provinces in this region of the eastern Mediterranean.

NOTES

1. Research for this manuscript was supported by the University of New Brunswick SSHRC Internal Research Grant. I would like to thank the editorial board for inviting me to contribute to this book (I consider it an honor) and especially the editors, Annalisa Marzano and Guy Métraux, for their superb job in editing this villa volume, a true *magnum opus*. A special thanks to Guy Métraux for transforming this rather lengthy manuscript into a more friendly read for the public. Errors are solely the responsibility of the author. Thanks are also due to the Archaeological Receipt Fund of the Greek Ministry of Culture and Sports, the archaeologist Victoria Allamani, and the Archaeological Society of Athens for granting permission to publish plans and images illustrating this chapter. A special thanks to the architect Zoe Evangelopoulou for line drawings of plans of Eva Loukou and Brexiza.

 Roman Greece comprised the provinces of Achaea, Crete, and those sections of the provinces of Macedonia, Epirus, Asia Minor, and the Aegean Islands that lie within the boundaries of the modern state of Greece; however, Bouthrotum, although in Albania, is included because it was an important Hellenistic center, part of the Macedonian kingdom and Roman Macedonia. This study examines estates

and modest landholdings (of the second and first centuries BC to the fourth to fifth centuries) that feature elements commonly associated with estates in the west; this chapter n. 13. For the complex definition of the term *villa*, see Chapters 1 and 2 in this book.

2. Herodes Atticus' full legal name was Lucius Vibullius Hipparchus Tiberius Claudius Atticus Herodes (101–77 CE); for function of villas and villa types: Dyson 2003, 21–3; Marzano 2007, 226; Laurano 2011, 127–8, 156, 167–8, n.7; this chapter n.12; and Gualtieri (Chapter 10) in book

3. Plin., *Ep.* 2.17.

4. Shear (1930) published the mosaic pavements at Corinth, while Spyropoulos' more recent publications in German (2001) and Greek (2006) focus on the sculptural program of Herodes' villa at Eua Loukou, Arcadia. A summary has been published in German: Spyropoulos and Spyropoulos 2003. An exception is the publication by Adam-Veleni et al 2003, which is an exhibition catalogue and synthesis of the finds originating from the salvage excavations conducted during construction projects along the National Road, the *Via Egnatia*, and National Railway in central Macedonia. The volume focuses on the economic activities and social aspects of everyday villa life from classical to Roman times and includes a discussion on landscape, environment, and floral and faunal analyses; more recently, Gerofoka (2015) published a synthetic treatment of the Hellenistic estate at Tria Platania in Macedonia.

5. The term "new city" was used by Herodes Atticus to describe the villa at Marathon, his gift to his wife Regilla (p. 342 and n. 141); Rizakis (1997, 32) in his examination of settlements outside the Roman colony of Patrae has identified two types of settlement patterns: villages and "dwellings of peasant farmers" clustered around a *villa rustica*; from the field survey of the third-century CE Berbati-Limnes villa baths, main residences, possible tenants' or slave quarters, a smithy, granary, storage areas, olive mill, cistern, burial grounds (shaft graves) for laborers, a *hypogeum* (possibly) for the owner, a nearby road, and so on, were identified: Forsell 1996, 338–40.

6. Deep ploughing used in modern farming destroyed the stone foundations of a villa at Pano Magoula: Pallas 1955, 201.

7. Greater recent interest in Roman Greece has resulted in books on a variety of topics: e.g., Alcock 1993, Cartledge and Spawforth 2002, Bonini 2006, and Sweetman 2013, and edited volumes by The National Hellenic Research Foundation on Greek and Roman Antiquities (www.eie.gr/editions/editions-iera-gr.html) through the series *Meletemata*, the Greek Archaeological Service, and the Hellenic Ministry of Culture Archaeological Receipt Funds have also appeared; the most recent volume of *Meletemata* 68 (Rizakis and Touratsoglou, eds. 2013) appeared in June 2014. It comprises a series of articles on the rural economy and individual farmhouses of the Roman province of Achaea.

8. Sir Arthur Evans' excavations at Knossos focused on the Bronze Age, and publication of the post-Minoan town was sparse. In the area of the Unexplored Mansion, Greek and Roman strata were cleared away with little or no mention: Sackett 1992, vii.

9. Theophanis Rentis, a topographer and army officer, and others were openly involved in illegal excavations and collection of artifacts in the area of Corinth during the nineteenth century. Artifacts from these illicit digs were sold, kept in private collections, or abandoned at the site: Petrakos 2010, 41–2; Kyriakopoulou 2010, 297–9. Illegal digging persisted: in 1944, at a site in Miampeli on the island of Kephallonia, a certain A. Kourkoumellis in search of a "treasure" excavated part of a villa residence and destroyed a section of a mosaic pavement, and illegal digging continued in 1957 by the president of the local community, further destroying sections of the mosaic and the stratigraphy of the site: Kallipolitis 1961–2, 3.

10. As Rothaus (1994, 391) has proposed for Corinth.

11. At Abdera, houses of the Roman period were constructed over the Late Classical/Hellenistic city walls no longer in use by the first century BCE: Kallintzi and Chryssaphi 2010, 3.

12. For Corinth: Carpenter et al. 1936; Rothaus (1994, 394) does not indicate if the Cheliotomylos villa lay within or outside the walls and that the walls had been dismantled; I have used the urban boundaries in Romano 1993, fig. 7. For extra-urban villas just outside city walls, see Métraux (Chapter 21) in this book. In late antiquity, there was a new type of suburban estate that was formulated within an urban center after the abandonment of urban houses and the subsequent re-ruralization of city plots for agricultural purposes.

13. Percival 1976, 14–15, views the villa phenomenon as Roman and its presence in the provinces as a form of

"Romanization." In contrast, Papaioannou 2016, 32-5, 40-1 examines how *synoicism* (living together), rather than *Romanization*, shaped the cultural landscape. Greene1986, 88–9, discusses the term *villa* and its problems and various definitions from province to province; Rothaus 1994, 391–2, defines a villa "as a large residential complex evidencing substantial wealth and located in a suitably comfortable position … (It) is a Latin word, a western not an eastern phenomenon, and it seems best to avoid redefining the villa to make it appropriate to the East." Rothaus' view is too restrictive given the discovery of Herodes Atticus' estates and other villas in the Aegean and Balkans; for villas in the Balkans: Mulvin 2004, 377–410; see also Bowden (Chapter 20) in this book.

14. For the *Amalthea*: Cic., *Att.* 2.1; *Leg.* 2.3.7; for Herodes' estates see pp. 340–351; for villas of the Adriatic coast, see Bowden (Chapter 20) in this book.

15. For Herodes Atticus: Graindor 1930; Rutledge 1960; Ameling 1983; Tobin 1997, Agrafioti 2002; Galli 2002.

16. For Atticus' estates in Epirus and in Italy at Tusculum and Pompeii: Cic., *Att.* 2.1.11; for Herodes Atticus' estates in Greece and Rome: Tobin 1997.

17. Varro, *Rust.* 2. 2.1–2; 2.5.1; 2. 5.10–12, 18; Cic., *Att.* 1.13; 2.1; 2.20; the *Synepirotae* were wealthy Romans who acquired land in Epirus after the battle of Pydna (168 BCE): Preka-Alexandri 1994, 429; for Roman land division in Epirus: Doukellis 1990, 269–83; for the establishment of the (Caesarian or Augustan) colony of Photike in Epirus: Rizakis 1997, 18; for literary references to villa sites and production: Dakaris 1971, 93.

18. Çondi 1984, 151–2; 132, fig. 2, associates the first-century BCE remains at Malathrea, east of Butrint, with Atticus' *Amalthea*, located along the Thyamis River in Epirus (cf. Cic., *Leg.* 2.3.7: "you must not imagine that anything is finer."). It was adorned with plane trees and had a shrine, the *Amaltheion*, with an altar dedicated to Amalthea and appropriate furnishings. Cicero was so impressed that he requested a detailed description of the shrine in order to build one on his own estate at Arpinum (*Att.* 1.16); for Atticus' estates in Epirus also: Karatzeni 2001, 171; the passage in Varro (*Rust.* 2.5.12, 18) concerning the number of cattle in a herd is not clear. He states that Atticus' herds each consisted of two bulls and seventy breeding cows, whereas he himself and other breeders favored 100 cattle in a herd. The passage ends as follows: "But Atticus has 120, as does Lucenius." Dakaris 1971, 93, has interpreted this as Atticus having 120 herds of cattle. The "but" may indicate that, although Atticus had a smaller number of animals in his herd, he may have had more herds than other landowners. On Atticus' wealth: Nep., *Att.* 14.3.

19. For Strongyli: Dakaris 1971, 93 and n. 287; Karatzeni 2001, 171 and Petropoulos 1991, 119-121, n. 212; at the Athanasiou field, in the community of Riza in Preveza, a large rural villa (first to third centuries CE) with a decagonal *balneum* and panoramic view is known: Zachos 1993a, 301–2, fig.17; for *villae rusticae* at Riza and Hagia Pelagia: Katsadima and Angeli 2001, 91–107, suggest that villas in the region of Nikopolis may have belonged to Greeks rather than Romans as inferred from the local funerary inscriptions; the name of the Cossinii is also attested at Leukas, Kos, and Delos (*CIL* 3.574), Strauch 1996, 311, n. 290 and Hatzfeld 1919, 39; 62–4; 153, n. 1; other foreign proprietors in Epiros include Murrius *de Reate*, Vaccius (Hatzfeld 1991, 62) and possibly Marcus Arkison: Kahrstedt 1950, 556 and Petropoulos 1991, 120, n. 212

20. *Rhomaioi engektmenoi* (Ῥωμαῖοι ἐγγεκτημένοι): Roman aristocrats who had the right to own land in a foreign country and were granted vast sections of fertile land in Macedonia after the formation of the new province: Adam-Veleni 2003, 35; by the mid-first century BCE a *conventus civium Romanorum* is also found at Akanthos, Idomenai, Styberra, Edessa, and Thessaloniki: Loukopoulou 1996, 143. Italian presence is attested by the *negotiatores* (traders) who were actively involved in gold, silver, and timber exploitation in Chalkidike as early as the second century BCE (Polybius 2.8.1; Ceas., *BCiv.* 3.102; Cic., *Pis.* 40.96); epigraphic and literary evidence indicates that Roman/Italian *negotiatores* were operating in Greece as early as the third century BCE: Loukopoulou 1996, 143–8; for Roman *negotiatores* at Gortys, with their own distinct governing body and imperial cult, as late as 195 CE: *IC* 4.278; Sanders 1982, 18.; for Cos: Derow and Forrest 1982, 87–91; Papaioannou 2010a, 98 and n. 149; 2010b, 59–60.

21. Petsas 1971, 113–14; many of the veterans of the X and XII Legions from Antony's army had settled at Patrae after the battle of Actium (*CIL* 3.504; 3.507–509): Petropoulos 1999, 41. We do not know the size

of the plots granted or, for that matter, the size of any agricultural estate in Greece. The lands of neighboring Dyme, which became a part of Patrae, were divided into centuries of 20 x 20 *actus* (1 *actus* = 35.5 m): Rizakis 1997, 27; one of the earliest villa owners was a certain Marcus Coelius Publius whose name was recorded on a late first-century BCE /early first-century CE funerary inscription: Petropoulos 2014, 156; Rizakis 1998, 200–10; 202, n.154; a Roman veteran colony was also established on Crete by Augustus and numerous Roman citizens were sent there to settle in the cities of Gortys, Lyttos, Ierapetrea, and elsewhere: Harrison 1993, 54–9; 178–9.

22. The tombs were found near villa remains. One was for Marcia Maxima, the wife of Gaius Laetilius Clemens: Rizakis et al. 2001, 80–1, cat. no. 142; Petropoulos 2014 156, n.8.

23. *IC* 1.17.17–18. Poplius Granius Rufus' political status is unknown. He had visited the Asklepeion at Lenda for health reasons and was honored in a proxy decree by the city of Gortys: Harrison 1993, 286–7.

24. A certain senator Rogatus of the fourth century from Nikopolis owned tracts of land in the area: Karatzeni 2001, 171. See also Stat., *Silv.* 2.6.67 (written 89–99 CE); Statius consoled one Flavius Ursus, who owned fruitful farmland in Crete and Cyrene, on the death of a servant.

25. For the Roscii, Flavii, and Larcii: Harrison 1993, 286; some estates on Crete also belonged to a city-state or were imperial holdings. Gortys owned land at Pyranthos and Melidochori: *IC* 1.26.2–3; Sanders 1982, 23; imperial estates may have existed elsewhere (e.g., Tiberius had a modest suburban villa and an urban residence on Rhodes: Suet., *Tib.*11.1).

26. Elsewhere in northern Greece, L. Calpurnius Piso Caesoninus was proconsul in Macedonia between 55 and 57 BCE and honored as patron of three cities: Eilers 2002, 29; for the Vallii and Apustii at Abdera and Thessaloniki: idem, 109–94; Papaioannou 2010a, 101; 2010b, 60, and nn. 50–2.

27. Saithidas or Aithidas (Paus. 4.32.2); Themelis 2010, 102–5; Luraghi 2008, 306–18; hero shrines of the aristocracy are located behind the west portico of the gymnasium, while their monumental tombs (dated to the second to third centuries BCE) stand outside the Arcadian Gate. The mausoleum of the Saethidae, however, lies within the city, south of the stadium: Themelis 2010, 102; 104. Touratsoglou

2010, 248–9, identifies wealthy villa owners based on the number of silver coins found in villa estates.

28. G. Iulius Eurycles Heraculanus and Tiberius Claudius Brasidas: Steinhauer 2010, 81, n. 28.

29. Strabo 8.5.

30. Bowersock 1961, 112; Iulius Eurycles was a *hegemon* of the Lacedaemonians. For the title of *hegemon* and its transformation into a *procuratio* in the first century CE, and Euryclis' ties with Augustus and his other political duties: Steinhauer 2010, 75; 79–81, n. 2 and in particular Bowersock 1961, 112–13.

31. Also descendants of Achilles, Aiakos, and Rhadamanthis: Philostr. *V S* 546; *SEG* 26.546; *IG* 6.471 and *IG* 2².3606.2; Ameling 1983, 3–4; Spyropoulos 2006a, 31; 183; Rife 2008, 93.

32. Atticus' appointment was considered exceptional for a *homo novus*: Philostr., *V S* 545; for Atticus see Ameling 1983, 21–35; Herodes Atticus became an eponymous archon in Athens, a member of the Areopagos, a *XXvir, quaestor principis*, tribune of the plebs, praetor in Rome, a *corrector* in Asia and a *legatus* of Augustus in Alexandria Troas: Spyropoulos 2006a, 186–7; for Herodes' career: Ameling 1983, 48–60; Galli 2002.

33. Mart., *Spect.* 12.68, 1–2. The dwellings of the aristocracy throughout the empire shared certain commonalities, thereby creating a cultural *koine* where elements of the Roman aristocratic *domus* were adopted and tailored to meet local cultural and political needs. For an overview of the function of the Roman house in the western provinces during the imperial period: Leach 1997, 58; Papaioannou 2010a, 95–8. Approximately a century and a half earlier, Cicero insisted that those in public office should have a grand *domus*, a symbol of one's social and political status: Cic. *Off.* 1.138–40; Treggiari 1999, 36, 47, 53 and n. 18.

34. Woolf 1997, 10; changes in land ownership, estate size and increased focus on crop specialization began in the Peloponnese during the Hellenistic period: Stewart 2010, 221; field surveys in the area of Asea (Megalopolis region) indicate that by Pausanias' time the number of small villages declined while new large villas increased, as few farmsteads were replacing earlier rural settlements, as, for example, at Romaiiko (first century BCE to third century CE) and Chranoi and Skorstinou (first to third centuries CE): Pikoulas 1988, 89–90 no. 43; 118, no. 72; 173, no. 133; Roy 2010, 65-7 and n.54; for the Asea valley

survey: Forsén and Forsén 2003; a similar organiza-
tion has been observed at Sparta: Rizakis 2010, 8; for
Rhamnous: Oliver 2001, 140–2; 148–50; 153; for
Boeotia and other areas of Greece, with evidence
of substantial villa remains at Eutresis, Kreusis,
Thisbe, and Siphai in southwest Boeotia: Alcock
1997, 292–3, n. 33 and 1989, 5–34.

35. Strabo, 8.5.7.

36. Steinhauer 2010, 75–6 n. 2; 79–8; Lane 1962, 397–8.

37. Brexiza (Map 15) is a modern name for a coastal,
small marshy area (Mikro Elos) located along the
boundaries of New Makri and Marathon:
Arapogianne 1993, 133; the estate of Hipparchos,
Herodes' grandfather, was estimated at *HS* 100 mil-
lion: Spyropoulos 2006a, 44–5, 186, 206; for the
extensive use of marble in the villa residence at Eua
Loukou from the quarries at Ano Doliana (Mt.
Parnon) and surrounding region: idem, 33; for
Herodes' wealth: Philostr., *V S* 2. 547–8; for
Herodes' fish-farming activities: Spawforth 1996,
171, nn. 17–18; Papaioannou 2010a, 102; 2010b, 62
and n.64; and also p. 344 and n. 159.

38. For leading families in Boeotia: Alcock 1997b, 293–
4; at Thespiae (first century BCE to the third century
CE): Jones 1970, 247; at Messene: Themelis 2010;
for elites from Messene and Corinth, and Achaeans
of equestrian rank: Spawforth 2002; for the Argive
elite: Marchetti 2010, 43–57; for an extremely
wealthy individual, Epaminondas from Acraephia,
in northeast Boeotia: Oliver 1971, 221–37. A valu-
able source for the study of potential villa-owning
elite families are the prosopographies of the
Peloponnese, Macedonia, and Thrace published by
KERA (the Centre for Greek and Roman
Antiquities) in the series *Meletemata* and publications
of the *Centre of Messenian Studies* for Messene, in
particular Luraghi 2008 and the numerous articles
and books by the director of the Messene project,
P. Themelis, some of which are listed in Themelis
2010, 109; for colonists, veterans, and others see
pp. 329, 337–8 and nn. 21, 99, 106, 109.

39. The number of large estates, and monumentality of
associated buildings increased during the late
Hellenistic and early Roman periods in the south
Argolid and in Achaea (Dyme), while in Messenia
villas appear during the early Roman period, in
particular at Dialiskari, a seaside estate: Alcock et al.
2005, 182–7; for the area of Laconia: Shipley 2002,
288–97; 326–37; Stewart 2010, 220–1; a large

farming establishment dating to c. 200 BCE was
discovered during the Berbati-Limnes valley survey:
Penttinen 1996, 229; 271–2; 279–81; for large estates
also appearing during the Hellenistic period in
Boeotia: Alcock 1997, 293. Numerous towers, of
varying function (agricultural, mining, and watch
towers) have been identified in the Greek country-
side, and in Macedonia some may have played a dual
role, serving both agricultural and strategic purposes.
The construction of towers on a private estate
required a proprietor of significant wealth:
Dousougli and Morris 1994, 217–19.

40. Substantial estates of the fifth to the second centuries
BCE have been excavated with towers at Palaia
Kopraisia in Attica, possibly the ancient deme of
Amphitrope, in addition to boundary walls of fields,
terracing and property lines, building complexes (c.
790 m^2 and 990 m^2) with multiple courtyards for
living quarters and work areas, stables, threshing
floors, olive presses, terracing along the slopes of
the surrounding hills for olive groves, terracotta bee
combs, and a nearby small, rural sanctuary and road
leading to it. The size and adornment of these estates
(an *andron* with red wall plaster) and the accompany-
ing towers reveal major production units, providing
products for the urban market and a substantial
profit: Lohmann 1994, 81–105; towers associated
with agricultural and/or mining activities have
been documented at the Souriza estate in Attica,
Goette 1994, 133–7; for towers that served as watch-
towers: 55 at Siphnos, 33 at Thasos and 27 at Kea.
Those on the island of Leukas have been associated
with agricultural estates: Dousougli and Morris 1994,
217–19; for some classical and Hellenistic towers as
places of confinement for "unfree" labor of agricul-
tural or mining estates with absentee landowners:
Morris and Papadopoulos 2005, 155; 184–200.

41. For the meaning of the word *agroikia* in the classical
period, Plato *Grg.* 461c; *R.* 560d, and in the early
Roman period: Diodorus Siculus 1.36.9; 20. 8.3;
4.6.4; for interpretive problems of the Greek and
Latin equivalents of the words farm/farmstead:
Gerofoka 2015, 52–8; for other terms used in the
Roman period: p. 331 and n. 133; for the *synoecism* of
Greek and Roman cultures: Papaioannou 2016, 32–
5, 40–1; see Petrakos 2002, 88.

42. The theory has been challenged by R. Sweetman
who downplays the role of warfare and piracy as tales
prompted by the island's isolation and Roman

attempts to annex it: Sweetman 2013, 9. By contrast, in Boeotia, urban sites were favored because wars and brigandage during the first and second centuries BCE forced populations into cities: Alcock 1997, 290; see p. 353 and n. 255.

43. Harrison 1993, 105–6. In the second century CE, changes in the taxation system led to the amalgamation of smaller farms into larger estates.

44. A few villas did appear on the north coast of Crete in the first century CE, as, for example, at Koleni Kamara in the west, Pachyammos on the Ierapetra Isthmus, and Plaka Kalis near Eleutherna: Sanders 1982, 30; for a possible early second-century example at Ellinikon near the village of Pyrgos in the Istrum Valley: Sanders 1982, 18, 23, 142 and Hayden 2004, 202–3, 213, 226; Sweetman (2013, 11) argues that there is no evidence for "large-scale villa sites" on the island until the fifth century CE, but what constitutes a *villa* site is not clearly defined: Papaioannou 2015, 362. On the south coast, prosperity and peace came a little earlier (in the first century CE) than on the north, as evidenced by a large seaside, first-century CE villa residence at Makrys Yialos (or Makriyialos), Siteia, of which 2,210 m² have been excavated: Papadakis 1979, 406–9, fig. 2 and 1980, 524–5. Remains include a large courtyard surrounded by rooms, a bath complex, cisterns (one possibly a holding tank for fish), a horseshoe-shaped pool, fountain, walls and floors lined with multi-colored marble, a propylon-type entrance, and black-and-white mosaic pavements, which may point to a Roman proprietor. For a description of the villa in English: Harrison 1993, 272–5; for suburban villas at Knossos, possibly associated with the remains for "agricultural processing" and "possible dye works on the edge of the urban space" mentioned by Sweetman 2013, 94; see Papaioannou 2015, 362.

45. Adam-Veleni et al. 2003; Rizakis 2010, 9, n.38; Bresson 2007, 158–9; Adam-Veleni 2009, 1–15, presents a catalogue of over twenty-three farmsteads that have been excavated, of unknown size, eight from the classical-Hellenistic period and nine from the Roman period; for the estate (dwelling and subsidiary structures) at Agios Konstantinos near the village Dimitra (Grevena) in western Macedonia: Karametrou-Mentessidi and Theodorou 2009, 113–29, figs. 4, 2–17, 19.

46. The large 750 m² Hellenistic (third to second centuries BC) farmhouse at Agios Konstantinos, Grevena in western Macedonia may have had four towers (my personal observation) as deduced from the width of the walls (70–80 cm) and the house plan with projecting foundation walls at the four corners: Karametrou-Mentessidi and Theodorou 2009, 116–17, fig. 3, 125, fig. 4; external *stoas* or verandas are of Hellenistic origin and are common in northern Greek dwellings (cf. the palace and Hellenistic house at Vergina) and the islands: Tsigarida and Hadad 1993, 69–73, figs. 2–3; Pandermalis 1976, 389, fig. I; 394–5. They afforded a view and additional work space, in particular during the summer months as in the veranda houses at Petres: Adam-Veleni 1996, 5–11; in southern Greece, the exterior colonnade is found along the façades of the House of the Masks at Delos and House of Dolphins: Chamonard et al. 1922, pl. XXIV, and in the seaside villa at the port of Kenchreai, the so-called *Atrium Veneris*: Scranton et al. 1978, ills. 37; 38.

47. Adam-Veleni 2009, 5; 46 lead fishing weights were found in Room ΣΤ of the residence and parallel examples have been found at Stageira (Chalkidiki) and at Vergina: Karametrou-Mentessidi and Theodorou 2009, 122, fig. 12 and 125, fig. 4; and in a Roman peristyle house at Abdera: Papaioannou, 2010b 2011, 62.

48. It dates to the third to second centuries BCE. The agricultural structures are in alignment with the residence and are located at a distance of 94.5 m to the southwest: Karametrou-Mendesidi and Theodorou 2009, 113, fig. 4; 114–15, fig. 2; for a plan: p. 116, fig. 3 and 125, fig. 4; for chronology: p. 126; on the remains of interior decoration: p. 120; for English summary: pp. 130–1; see also nn. 45–7.

49. The ancient route lies next to the modern Thessaloniki-Athens National Road: Poulaki e. 2003, 56–60; 63–9; Adam-Veleni 2009, 1–15. Towers are typical of farm houses in this region; see p. 330 and n. 39; the dimensions of the tower courtyard house at Tria Platania are 55x42.5 m, a ground floor space of 2447.5 m². The residential unit at Komboloi (28.5x28.5 m), only partially excavated, may have had more than one courtyard. In both examples large quantities of grape pips were found, together with *pithoi* (large terracotta vessels for wine or other foodstuffs), wine cellars, and resin, which indicate that viticulture was the primary focus of these estates in the classical and early Hellenistic periods: Margaritis 2003, 61; 70; for the estate at Komboloi

(mid-fourth to the first quarter of the third centuries, and reoccupation in the second century BC): Poulaki 2003, 69; for a synthetic treatment of the Hellenistic estate at Tria Platania: Gerofoka 2015. Phase I: late fourth century BC to 279 BCE, phase II: time of Antigonus Gonatas (277–239 BCE) to the beginning of the second century (Philip V, 221–179 BCE), idem, 324.

50. The site lies at the 85th kilometer of the modern National Road Thessaloniki-Kavala, near Asprovalta, and was discovered during the construction of the new *Via Egnatia*. This and other estates may have been part of the land grants given by Phillip II to his companions: Adam-Veleni 2003, 101; 105; four phases, not dated, have been identified between the time of Philip II (359–336) and the abandonment of the site in 240–230, idem, 101–2, 105.

51. Adam-Veleni 2003, 101–7 suggest that it may also have served as a guest house, while three corbel vaulted furnaces and a 40 m-long enclosure wall located 50 m northeast of the residential complex possibly served as workshop area for iron smelting.

52. Adam-Veleni 2003, 37–8; 144. The ancient sources show the importance of these highways, especially the *Via Egnatia*, so frequented that journeys to Rome were delayed up to several months: Cic., *Att.* 3.14; Adam-Veleni 2009, 8, suggests that these country estates may be categorized as early versions of *latifundia* established by the Macedonian monarchy; Morris and Papadopoulos 2005, 196, 206 suggest that the Greek farm may be viewed as "a more modest forerunner of the Roman *latifundium*, including its *ergastulum*, labour camp," while " ... the towered *villa rustica* of Republican Italy described by Pliny (*Ep.* 2.17.13) bears some symbolic, if not structural, relation to its Greek forebears and Medieval successors."

53. Diod. Sic. 20.8; Megalepolis is located near Carthage.

54. Damage to the sites at ancient Lete was due to quarrying for building material: Tzanavari 2003a, 77–8. The stucco wall decorations from Country House B (first century BCE to first century CE), adorned with red floral patterns on a white ground, are similar to those found in southern Italy and in the northern provinces: Tzanavari 2003a, 84–5.

55. Numerous millstones and wine *pithoi* were found in Country House A, storage *pithoi* in House D, and loom weights in Country house B: Tzanavari 2003a, 78–89; for the site report: Tzanavari and Philes 2000, 153–68.

56. The site dates from the mid-second to the mid-third centuries, with a temporary abandonment in the third, a reoccupation phase in the late third, and final abandonment in the late fourth or early fifth centuries. A coin hoard containing coins of Gordian III and his wife Tranquillina (238–244 CE), perhaps associated with the raids of the Goths in the third century CE, was found concealed next to the foundations of a wall from House A: Tzanavari 2003a, 81–2; the *triclinium* of House A measures 16.5x15 m and the main room is 6.30x7.20 m. For House D the surviving dimensions are 15.20x12.50 m: idem, 48; Adam-Veleni et al. 2009, 12–13.

57. This observation is supported by the discovery of another independent *triclinium* of similar plan and dimensions (207.5 m²) next to Country House D. For houses A and D: Tzanavari 2003b, 48; 2003c, 87–8.

58. Smith 1997, 200, fig. 54.

59. No less than twenty apsidal *triclinia* of varying size and dating from the fourth to the beginning of the sixth centuries CE have been found in urban houses in Thessaloniki: Karydas 2009, 139–41.

60. The villa site at Molos, Abdera dates from the fourth to the seventh centuries: Kallintzi and Chryssaphi 2007, 457, fig. 2; 460–1; the authors find the presence of two *triclinia* (identification rests on the plan and fragments of glass drinking ware) to be problematic for an estate of this size and suggest that they perhaps belong to two different phases, but only 367 m² of the residence has been excavated: a series of rooms, a *triclinium*, a possible bath complex, storage facilities and evidence for a second story. Additional structures include an adjacent, external, independent *triclinium* (172 m²), a stable or storage area, and some wall remains in the vicinity that may or may not be part of an enclosure wall; remains of a second villa with a kiln at Kalathara were located 1.5 km to the north and belong to the third to fourth and fifth to sixth centuries: idem, 462–3, fig, 3.

61. Gregory of Nyssa, *Ep*.20.

62. Rossiter 1989, 105, suggests that this passage may refer to outdoor furniture, a stone *stibadium* or wooden furniture, or a *stibadium* cushion.

63. The salvage excavations sponsored by the construction company *Egnatia Odos SA*, were restricted in scope: Tzanavari 2003a, 78.

64. The site, which is not part of an ancient settlement, lies along the Thessaloniki-Beroia highway, 4 km

from the city limits of Beroia and near an ancient road: Koukouvou 1999, 572. The Roman phase begins in the first century BCE, but most remains of the *pars rustica* date to the second to third centuries CE. The site was destroyed around the end of the third century, partially reoccupied in the fourth century, with a final abandonment around the end of the fourth or beginning of the fifth centuries. The residential part was not excavated, but remains of mosaic *tesserae* and foundations of two mosaic pavements indicate that it lies beneath the modern roadway: idem, 569; 572.

65. The rectangular tank (c. 3.5x5x0.6 m deep) was lined with hydraulic plaster and supplied with water via a terracotta pipe. The immured clay vessels reflect a design resembling descriptions of saltwater fishponds mentioned in Latin texts (Columella, *Rust.* 8.17.6; Varro, *Rust.* 3.17.2) and comparable to freshwater installations found at Pompeii, Herculaneum, Timgad (so-called villa of Sertius), and at Tsatalka near Stara Zagora in Bulgaria: Koukouvou 1999, 571; for the plan, cross-section, and photographs of the fish tank: idem, 569 fig. 2; 571, fig. 3; 577, figs. 5–7. For intensive aquaculture and villa fishponds: Marzano 2013a, 205–10.

66. The region near the modern city of Naoussa that includes the famous Macedonian tombs at Lefkadia has been identified as ancient Mieza: Allamani and Misaelidou 1992, 203; for fragmentary remains: see n. 69. *Opus signinum* floor pavements seem to have originated in North Africa (Punic) during the Hellenistic period: Hales 2003, 202; for Hellenistic origins of canals and grottoes, see pp. 345–6 n. 172.

67. As discussed with the archaeologist Victoria Allamani, the villa is located outside the city walls: Papaioannou 2010a, 88, n. 62. A section of the fortification system has been identified but the actual circuit of the wall has not been traced: Allamani et al. 2009, 21 and fig. 1.

68. The beginning of the Roman phase of the residence seems to coincide with that of Roman theatre, and Allamani (personal correspondence) tentatively suggests a date sometime after the Roman conquest of Macedonia, perhaps near the end of the second BCE, based on pottery and coin evidence and a very thin destruction layer: Allamani and Misaelidou 1992, 211; Papaioannou 2010a, 88, n. 62; 89, n.69; the mosaics are not accessible but with the permission of the archaeologist Victoria Allamani, to whom I

am extremely grateful, I was able to view photographs of the pavements. The designs bear a striking resemblance to those found in the houses of Pompeii, Herculaneum, Ostia, and Rome: idem, 88, n. 63, figs. 26a & b, 27, 28; for the excavation report: Allamani and Misaelidou 1992, 208–12, fig. 4; 214–15, pl. 2–3, esp. 210–11 for the pavements; for a similar shallow *impluvium* documented in the fourth to fifth centuries BCE house at Fregellae: Wallace-Hadrill 1997, 237; Papaioannou 2010a, 88–9, n. 65.

69. Petsas 1963b, 78–9 suggests that they may be associated with villas; Allamani et al. 2009, 19–21; possible remains of a villa-residence that include mosaic pavements, *balneum*, pottery kiln, and water installations have been identified on a hillside south of Lefkadia. In the same region, at the site of Tsifliki, other mosaic pavements and architectural remains of the second to the beginning of the fifth centuries CE were also excavated: Stikas 1959, 85–9, fig. 1, pls. 77–83.

70. For excavation reports: Petsas 1963a–c; 1964; 1965; 1966a–b; I have identified rooms B and G as *cubicula* (bedrooms) based on the presence of a plain, undecorated, section of the floor mosaic, at one narrow end of each room, designed for the placement of the couch/bed: Petsas 1963b, pl. A; terracotta pipes brought in water from the northwest to the open court (E) of the peristyle where in the center a marble water basin (*perrhiranterion*) served as a fountain: Petsas, 1966b, 32; 1966a 22–3, plan fig. 20; room T, according to Petsas, 1964, 27–8, may have served as an entry-point into the peristyle from an exterior portico, although it could also have served as a type of *tablinum* connecting the peristyle court with another court, of which only one portico has been excavated: Petsas, 1965, 36–8, fig.1.

71. Petsas 1963b, 68–77; 1964, pl. A (insert) for the mosaics; for finds in general: idem, 1964, 30–2.

72. E.g., in Pliny's account (*Ep.* 5.6.35) of the *triclinium* in the garden-stadium of his Tuscan villa; the garden *biclinium* and T-shaped canal in the House of D. Octavius Quartio at Pompei (personal observation). Petsas 1963b, 61–2, fig. 2; 1964, pl. A (insert), identifies this complex as a "room (A1–3) with a cistern (A3)" (A1–3); however, I believe it is a dining area, a *biclinium* rather than a *triclinium* because the space at the east side of the room, approximately 2 m wide, would have been used as a passageway between the

north and south sides of the canal (A2) (22.27 long x 1.68 wide x 0.50 m deep) and couches along the north and south walls (A1, A3). The *biclinium* (A1–3) was part of a private apartment that included a bedroom (*cubiculum* B), an *exedra* (D) and connecting corridor (Z); for water *biclinia* and *triclinia*: Richardson 1988.

73. Petsas 1964, 26–7; according to Petsas 1963b, 66, beyond the west wall of room A (*biclinium*) "rose a sharp majestic rock cliff that hid the view and the sun rays." Windows in the north and perhaps the east walls, as inferred by the discovery of metal hinges and nails among other things, provided a light source for the room.

74. MacDonald and Pinto 1995, 3–4.

75. Agricultural practices in most cases seem to have relied on local traditional farming techniques and agricultural products suitable for the region, but Roman-type fish tanks have been found in a villa at Beroia: Adam-Veleni, 2009, 8; Koukouvou 1999, 567–78 (for the fish-tank); see n. 65 .

76. Examples of small villas gaining some architectural and decorative additions: the farm at Crocicchie along the Via Clodia was refurbished with a bath complex and mosaic pavement: Potter 1980, 75–6; along the Via Gabina (site 11), the modest living quarters of a small early imperial villa were transformed into a *domus* with the addition of an atrium with *impluvium*, while a tiny bath suite and garden plunge pool were added during the Trajanic period: Widrig 2009, 52; idem, 1980, 124–7; 133, fig. 1;134–7, figs. 2–9.

77. Adam-Veleni 2009, 8; remains of *balnea* were identified in two establishments: at Asprovalta (Adam-Veleni 2003, 102–14; 2009, 13–14); and at Oraiokastro, Thessaloniki (Adam-Veleni 2009, 14), which may be associated with inns. For Italy: Widrig 2009, 25–9; 51–2, 75. The Via Gabina site 10 was redecorated under Domitian or in the early Hadrianic period with the addition of a luxury *triclinium*: idem, 2009, 25.

78. Marzano 2007, 106, 654–7, fig. T3. For villa complex at Paliomanna (Beroia) see p. 333, nn. 64–5.

79. For Hellenistic palatial tradition: MacDonald and Pinto 1995, 4; Bodel 1997, 7.

80. For a survey of Roman period remains in Epirus: Karatzeni 2001, 163–79; Papaioannou 2003, 374–5, Appendix nos. 244–50; Roman remains at Valanidia, at the mouth of the Acheron and Louros rivers:

Dakaris 1972, 24–5; 1971, 93; for Thesprotia: Preka-Alexandri 1994, 427–9; for first-century BCE Roman farmhouses at Leukas: Pliakou 2001, 155; for villas at Riza and Hagia Pelagia: Katsadima and Angeli 2001, 91–107 and Dousougli 1998, 74–8.

81. Coastal villas had access to a harbor: on the Riza estate, there was a bath complex c. 500 m from the natural harbor of Artolithia: Katsadima and Angeli 2001, 91; secluded estates may have been fortified, as was Atticus' estate in Epirus: Cic. *Att.* 3.7. Roman land surveyors used mausolea and cemeteries to define estate boundaries: Campbell 2000, 69, lines 9–18; 253, lines, 40–1; 255, lines 8–9, 35–8; 257, lines, 22–5; 262, line 23; a mausoleum established ownership and remote burials defined estate boundaries: Behrends 1992, 242–3; 254–5; for the location of Herodes' burial site: Rife 2008, 94; for burials at the Berbati Pass near Argos: Wells and Runnels 1996, 295; 336–40, fig. 10; for Sparta: Cartledge and Spawforth 2002, 142; Mee and Cavanaugh 2005, 10. For scenic views see the villa at Kephallonia, with baths and *nymphaeum* overlooking a deep riverbed: Kallipolites 1961–2, 2–3, fig. 1; 28. The villa was established in the second century, destroyed by fire in the fourth, and supplanted by a church that was also destroyed by fire in the fifth century, but activity at the site continued into post-Byzantine times. Of particular interest are the late-antique figural mosaic pavements with inscriptions: idem 4; 10–11.

82. For apples: Plin., *HN* 15.51; pulses: Pylarchus in Athenaeus 3.73B = *FGrH* 81 F 65; for production in Cassiopaia in general: Dakaris 1971, 93, and for the famous wine from Ambracia: Plin., *HN* 14.76.

83. At Ladochori, the residential unit consists of a simple courtyard house of local design and construction techniques (stone rubble), and comprises three phases: (1) 146 BCE to first century CE; (2) first to third centuries CE; and (3) fourth to sixth centuries CE: Preka-Alexandri 1995, 445.

84. For Masklenitsa: Preka-Alexandri 1994, 427–8; for Riza: Katsadima and Angeli 2001, 94. Dates are based on coin and pottery evidence.

85. Preka-Alexandri 1994, 428, fig. 8. A similar plan has also been observed at Miampeli in Kephallonia (Kallipolites 1961–2, 2, fig. 1) and at Malathrea, associated by Çondi (1984, 132, fig. 2) with Atticus' villa *Amalthea*; see Preka-Alexandri 1994, 429 and n.

18; for the villa at Manerau: Smith 1997, 204; 210, fig. 60b.

86. Entrance corridor (7) is accessed from the north via a large threshold; the Roman period (first and second phases) domestic remains of this courtyard house (23 x 16 m) reflect the amalgamation of local elements, such as the hearth room and use of local building materials, with certain Roman influences in the distribution of space and adornment: Preka-Alexandri 1994, 427–9, fig. 8. For Roman villa plans in the northwestern provinces of the empire, see Rothe (Chapter 20) in this book.

87. Preka-Alexandri 1994, 427-9. *Opus spicatum* pavements were common for open-air spaces and utilitarian floors in the Republican period (e.g., Cosa): Bruno and Scott 1992, 40; 121, pls. 19, 67; examples in Northern Italy: George 1997, 24. By the first century CE, such floors appeared also in closed areas and take on a decorative appearance: *idem* 24.

88. It is situated on the hilltop of Podarouli and dated by coins and domestic pottery from the first to the end of the third centuries CE: Dousougli 1993, 282–5, figs. 9–10; idem, 1998.

89. There is also evidence of a second story with three surviving steps in *opus testaceum* in the courtyard, and efforts to create a pleasant interior by incorporating a garden: a flowerpot was discovered in the southern wing: Dousougli 1993, 285; Plin., *HN* 17.97–98; Cato, *Agr.* 52; Jashemski 1979a, 406, pl. 58, fig. 10; for the various types of portico villas and villa enclosures and distribution of buildings: Smith 1997, 130–43; 144–62.

90. The land was suitable for raising livestock: Katsadima and Angeli 2001, 103; Dousougli 1993, 282, fig. 9; 285; Dousougli 1998.

91. Located 230 m north of the residential remains, its pumpkin-shaped concrete dome has been compared to those of the baths at Baiae and Rome: Katsadima and Angeli 2001, 94; Dousougli 1993, 285, fig. 9; Adam 1994, 187; 189, fig. 446; a third to fourth centuries CE brick-built decagonal *balneum* that survives to a considerable height at the villa at Riza covered an area of over 1,800 m² and was initially identified as a *nymphaeum*: Chrysostomou 1982, 10–21; Alcock 1993, 70–1, fig. 24; Zachos 1993, 301, fig. 17, pl. 96δ; similar bath complexes at Bouthrotum: Nielsen 1993, 205, fig. 245, C 353, Leptis Magna, Antioch, Bath C, and the Olympeion Baths: idem, 168–9, figs. 184–5; 210, fig. 254, C 374; 186, fig. 208, C 255.

92. The Hagia Pelagia mausoleum was dated on the basis of pottery and surrounding architectural remains: Katsadima and Angeli 2001, 99–101. Wall remains located near a spring and perhaps associated with a reservoir may have been part of the water supply for a garden that adorned the mausoleum: ibid. 96–7. Garden cemeteries were a common feature in the Greek east: idem, 97; for the garden cemetery at Herodes' villa at Kephisia: see p. 340 and nn. 123–4. The examples from the Isola Sacra and St. Peter's necropolis date to the end of the second century. Others near Rome: at Fornello, Mola di Monte Gelato, and Santa Maria in Fornarolo: Griesbach 2005, 115 fig. 2, 117, figs. 4 and 5; for villas with mausolea and tombs: Marzano 2007, 31–3.

93. Remains of a large stoa and peristyle structure with at least four *exedrae* of the second century CE found next to the *Demosion Sema* perhaps belonged to a suburban villa located along the road leading to the Academy, first investigated by Koumanoudes 1872, 7; Dontas 1971, 22–5, proposes that this may be the site of the famous gardens of Epicurus mentioned by Plin., *HN* 19.50–1 and Cic., *Fin.* 5.1–3, but the excavated remains could not belong to those seen by Cicero since they date to the second century: Papaioannou 2003, 48–49, n. 134.

94. For farms in the Roman province of Achaea: Rizakis and Touratsoglou 2013; for surveys of seven first to second centuries estates in Nichoria, south of Messene: Themelis 2010, 102; in western Arcadia: Eckstein and Meyer 1960. In the area of ancient Heraia, in Arcadia (Philadelpheus 1931–2, 58–68), excavated Roman remains of tessellated pavements, hypocaust, a series of rooms, and other remains scattered within an area of approximately 48,000 m² may all belong to a single villa. As Heraia was a famous wine-producing region along the Alpheios River on the main route connecting Olympia to central and southern Arcadia, there must have been other villa estates in the area. So famous was the region's wine that according to Theophrastos (*apud* Athenaeus 1.31), it had magical properties: "Men drinking it would go into ecstasy and women would have babies." Papachatzis 1980, 281–2 provides a detailed account of the site and history of Heraia but does not mention Philadelpheus' investigations.

95. Petropoulos and Rizakis 1994, 199–20; 205; Stavropoulou-Gatse and Alexopoulou 2013, 101;

for Roman land centuriation: Rizakis 1997, 26–32; for veterans at Patrae: n. 21; the names of some of the veteran colonists are known from first-century CE tomb inscriptions: Petropoulos 2014, 156 and n. 9.

96. What exactly is meant in the publications by small, medium, and large estates is not clear, as their dimensions are unknown. A. Rizakis (personal communication) confirmed that the Roman classification system was used as a model; consequently, small farms average around 10–80 *iugera*, medium-sized farms measured 80–500 *iugera*, and large estates over 500 *iugera* (1 *iugerum* = 0.252 ha): White 1970, 387; at Patrae, fifteen sites with mosaics and/or remains of baths have been documented. Eight large well-appointed villas associated with agricultural and artisanal activities were found both close to the citadel and one far away at Brachnaika. For a summary and catalogue of these sites: Stavropoulou-Gatse and Alexopoulou 2013, 88–153; Petropoulos 1994, 411; 413; 418.

97. Petropoulos 1994, 411–12; Petropoulos 2014, 158.

98. Petropoulos 2014, 157–8.

99. The veteran soldiers of the *Legio* XII *Fulminata*, under Antony's command, were recruited by Caesar in the 50s from the regions of Rome and Pompeii, and had settled at Patrae after Actium: Keppie 2000, 85; Petropoulos 1994, 416; see n. 21. The descendants of veterans settled in Greece after Actium are known to have prospered in various entrepreneurial activities like the Vibullii, who acquired significant wealth by fish-farming in Boeotia. The mother of Herodes Atticus, Vibullia Alcia Agripinna, was perhaps a descendant of the Vibullii whose ancestor had been a Roman veteran at Corinth: Spawforth 2002, 103; Papaioannou 2010a, 102; Papaioannou 2010b, 62, n.64; Spawforth 1996, 171, nn. 17–18; fish-farming under certain conditions became a lucrative business by the first century BCE in Italy: Marzano 2007, 35; Marzano and Brizzi 2009 215, 220, 228–9; see n. 160.

100. Small 1980, 91–2.

101. North of Rome mid-size villas/farms were favored from Augustan times to the second century. In general there appears to be a decline in the third century, Widrig 2009, 75; but this is not univerisal as others prospered, as at Crocicchie along the Via Clodia: Potter 1980, 74–6. Recent studies indicate a general increase in the number of both villas and farms during the first century BCE and first century CE:

Launaro 2011, 166–7; for modest estates, 2–20 hectares, along the Via Gabina: Widrig 2009, 13; 75.

102. Particularly noteworthy were the installation of large wine vats built of stone supplanting the earlier small portable Hellenistic ones, the discovery of a possible still at Mintologli, Patrae, for the production of a type of *proto-stipouro* (distilled spirit), and the appearance of a new type of container for separating oil from water: Petropoulos 1997, 287–8; Rizakis 1997, 29–30; Petropoulos 2014, 166–9, figs. 15–19 and p. 171–3, figs. 26–7.

103. Paus.7.21.14. This must have been linen or flax; seed hairs of cotton were also known: Herodotus 2.86; the numerous shuttles in rural villas indicate initial stages of textile manufacture, the product then transferred to urban workshops at Patrae for finishing: Rizakis 2010, 9; Alcock 1993, 80; Petropoulos 1999, 42, n. 233. The "water containers" (*cuniculi*) or vats may have been used for whitening cloth or another secondary purpose: Petropoulos 1994, 414 and n. 76: for similar vats at S. Giovanni di Ruoti, Small 1980, 92.

104. Descriptions of saltpans are found in the ancient sources: Rut. Namat. 1.475; Vitr., *De arch.* 8.3.10; for a discussion of the archaeological evidence: Marzano 2007, 62–3; 2013a, 126–38. According to Pliny (*HN* 31.8), on Crete salt was made "by letting the sea flow into the [salt] pools" without adding fresh water. The salt was probably extracted using shallow pools where seawater can evaporate, for which there is no evidence from the Roman period, first century BCE to fifth century CE: Tsougarakis 1987, 319; for salt pans in Caunos, Turkey, and Vigo, Portugal: Marzano 2013, 126–7, figs. 24-5.

105. Strabo 10.2. 21.

106. Stavropoulou-Gatse and Alexopoulou 2014, 91–2, n.5; Keppie 2000, 84–5, mentions two funerary inscriptions of veterans at Naupaktos and one at Kalydon; for fish-farming ventures elsewhere: Papaioannou 2010a, 102; Papaioannou 2010b, 62, n.64; Spawforth 1996, 171, nn. 17–18; see n. 160

107. Eleven shallow cavities originally lined with wood were found in a row along a stone-paved area (possibly a road): Stavropoulou-Gatse and Alexopoulou 2014, 93, fig. 3; 134–6; their use was identified by similarity to modern fish-salting methods: Alexopoulou 1995, 205. There may have been fish-salting in Achaea: Rizakis 1997, 30; on remains of "wooden elements" of Roman salt-works at

Pakoštane (Croatia) and the Roman sites of Tagurium and Salona: Marzano 2013a, 128.

108. The Corinthia Project is a collaborative (University of Pennsylvania Museum of Archaeology and Anthropology and the Corinth Excavations of the American School of Classical Studies at Athens) field and research venture that involves mapping the area of Corinthia: Romano 2010, 155.

109. Romano 2010, 155; 168–71, fig. 14a; the amount of land allotted to Roman colonists depended on their social status, location, and the time period in question, as plots tended to increase in size from earlier to later periods. In later periods, war veterans and ranking officials were allocated larger tracts of land, as much as 200 *iugera*: Frayn 1979, 91; 93.

110. Evidence for agricultural facilities was not found at the Lechaion villa: Stikas 1957, the Loutraki villa of the mid-second to sixth centuries and the Corinthia in general: Aslamatzidou-Kostourou 2013a; 2013b, 186–8; At Sykion, both literary sources and the abundance of locally made amphorae indicate that this was an important wine-producing area: Lolos 2009, 119–23; for an overview of literary and archaeological evidence for wine production in the Peloponnesos: Pikoulas 2009, 53–66.

111. Rothaus 1994, 392–4, identified six villa sites but they are not well published, or are known only through field surveys; for recent developments in the study of villas in Corinthia: Aslamatzidou-Kostourou 2013b, 186–99, and in particular excavations of the large seaside villa at Loutraki: Aslamatzidou-Kostourou 2013a, 176–85

Four other villa sites are not included in this account: (1) the Anaploga villa as it lies near the edge of the city but still within the Roman town plan: Romano 1993, 11, figs. 1; 7; 2010, 163, fig. 9; for the Anaploga villa see, Miller 1972; (2) the Kenchreai complex (*Atrium Veneris*) – a house and not a sanctuary to Aphrodite as identified by Scranton et al. 1978, 79–90 – situated at the edge of the harbor town and "perched between agricultural land and the civic centre": Rothaus 1994, 394; (3) the Akra Sophia estate since it is an early Byzantine site (fifth to seventh centuries); (4) and the villa at Vareia near Aghios Vasilios, south of Corinth, which dates from the early fourth century, was repaired in the mid-sixth century, and functioned into Byzantine times.

112. The agricultural facilities were identified in an area just to the north of the Cheliotomylos villa and appear to be a part of the same estate: Rothaus 1994, 392; excavations at the Lechaion site were limited to part of the residential structure, where no agricultural implements were recorded: Philadelpheus 1918; Stikas 1957.

113. For a report of the house (building 10)at Kastro Kalithea with *impluvium* in the courtyard: Rupp 2011, 3–5, fig. 3; M. Haagsma, director of the Kastro Kallithea project in Thessaly, has indicated (personal communication) that the house has been securely dated based on numismatic and pottery evidence to two phases: before 217–197 BCE and from 197 to later second century BCE: for atrium-type houses at numerous sites in Greece such as Patrae, Sparta, Athens, Dion, Pontokomi, Mieza, and Nikopolis: Papaioannou 2003, 2007; 2010a; 2016, 39–40; for Messene: Themelis 1999; see also Bonini's 2006 catalogue of houses of the Roman imperial period; for ties between Messene and Rome: Themelis 2010, 95–6.

114. A Hellenistic establishment seems to have preceded the later Roman one. Chronology was based on the type of wall construction (a type of *opus mixtum*), coin, and Type XXVIII lamps found in a sealed deposit: Pallas 1955, 215–16.

115. Pallas 1955, 215–16; Papaioannou 2003, 108–9 and 2010a, 91–3, nn. 83, 93, 106; an *opaion* (a conical object of terracotta used in the vaults to provide light and ventilation) indicates the presence of a *balneum*: Pallas 1955, 212–14, figs. 5–6; the atrium with *impluvium* may have carried a compluviate Tuscan roof. The *tablinum* opened into a peristyle portico as in the House of the Vettii at Pompeii: idem, 208–10.

116. Shear 1930, 19–26, Pls. 1, 3, 7; Papaioannou 2007, 354–6.

117. For the two-story villa residence at Loutraki with an elegant bath house, marble revetments, mosaic pavements, sculptural fragments, a kiln, and a central apsidal hall framed by rooms arranged axially and symmetrically: Aslamantzidou-Kotsourou 2013a, 176, fig. 1, 184. No evidence for agricultural activities or equipment has been found (idem, 185). Pottery finds point to a period of occupation between the first/second to sixth centuries, with most fragments from the third to fifth centuries: idem, 181. The Lechaion villa: Philadelpheus 1918, 125–35, who identified the remains as those of a private *nymphaeum* belonging to a second-century villa estate with modifications of the sixth; Pallas 1955, 216, dates it to the sixth century; Stikas 1957, 83; 89–94 and plates 35 a-b, 36 a-b, identifies it as a

nymphaeum of the third century; Rothaus 1994, 391, n.1, as a public *nymphaeum*; and Kosso 1996, 215, fig. 6; 224, as a villa similar to a suburban villa complex from the late Roman period at Palaiochora on Euboea.

118. The remains faced north toward the sea, while the south wall of the *nymphaeum* served as a retaining wall for the 3 m high ridge against which the villa residence was constructed: Philadelpheus 1918, 132; the rooms to the east (I; K), are later additions and possibly included a kitchen area (*magereion*), latrine, and service area: idem 125–35. I identify room G as a possible *triclinium*, based on the location of the room that is close to the service areas and opens onto a *nymphaeum*, and accessed through a colonnade and stoa via a 5.30 m central doorway with two columnar supports. The marble revetments of this room are of a later sixth-century date: Stikas 1957, 93; a third-century date proposed for the first phase is based on coin evidence and wall building techniques (*opus testaceum* and *opus mixtum*): idem, 94; for a first to second centuries date: Philadelpheus 1918, 135. In neither case is pottery evidence presented. The building techniques and materials used point to a date as early as the early second century for the initial phase of the building. *Opus testaceum* was used in the *Atrium Veneris* at Kenchreai (Scranton et al. 1979) and *opus mixtum* appears in the second century in the houses of Patrae: Papaioannou 2003, 205–6 and idem, 2007, 358. For *opus mixtum* in the second and third centuries: Dodge 1987, 108; Adam 1994, 143; Vitti 1993, 1693–9.

119. Ward-Perkins 1981, 211–12, fig. 128 B; Maiuri 1958, 397–402; the House of Neptune and Amphitrite: Clarke 1991, 250–7, fig. 153. Examples of a *triclinium* complex with a portico or piers through which a courtyard and/or *nymphaeum* could be viewed are found in an early third-century house (House 1) at Seleucia Pieria, near Antioch: Ward-Perkins 1981, 325, fig. 210, and also the House of Menander at Antioch: Levi 1947, 66–7, fig. 26; however, unlike the example from Lechaion, symmetry and axiality are commonly avoided in these eastern Roman houses.

120. Herodes perhaps also owned property at Rhamnous and at other sites, as suggested by a stone curse inscriptions and sculpture found at the sanctuary of Rhamnous: Tobin 1997, 276–83.

121. Gell., *NA* 1.2.1–2; Philostr., *VS* 2.562.

122. Herodes placed curse inscriptions on honorific monuments (portrait herms, bases, stelae, and reliefs) erected on his estates, especially along the boundaries and burial grounds; each dedication ended with a curse against anyone who would harm the monument: Tobin 1997, 114–15; for marble portrait bust of Polydeukion, Herodes' student, at Kephisia: Tobin, 1997, 100–4.

123. The fragments include Ionic capitals and column drums, inscribed statue bases, a garden fountain, family tomb, portrait sculptures, sarcophagi, and associated inscriptions: Tobin 1997, 371; on the south side of the stream the villa extended from the area of the modern church of Panaghia tis Xydous to as far as, or even beyond, Rangavi Street 4; for curse inscriptions and personal family inscriptions from the Kephisia area: Tobin 1997, 234–6; 214–39, figs. 42–48 for a detailed overview of the finds from the Kephisia estate, the residential area, and the cemetery. For the garden cemetery, located c. 500 m to the south beyond the area of the modern Plateia tou Platanou, idem, 1997, 211–39; Galli 2002, 162–74 and figs. 64, 67, pls. 16–18; idem, 154–7; also for the garden cemetery: Rife 2008, 96–7.

124. For the garden cemetery at Hagia Pelagia, Epirus (n. 92) and at Kephisia (n. 123); during the Roman period private *mausolea* on one's home were permitted within the city limits. A small mausoleum containing two sarcophagi and bone remains was incorporated in a third to fourth centuries CE well-appointed urban house at Messene, accessed only from the main street onto which it faced: Themelis 1999, 100; 101, fig. 10.

125. Diodorus 11.25.4; Leatham and Hood 1958–9, 264 and discussion on p. 333 and n. 65; for *vivarium*: Marzano 2007, 89–90.

126. Tobin 1997, 241–83; Galli 2002, 134–8; 178–203. For the sculptures, inscriptions, and monuments: Goette and Weber 2004, 106–28; Steinhauer 2009, 273–323.

127. For the extent of the estate: Dekoulakou 1999–2001, 125; Rife 2008, 94–5; Pausanias 1.32.4. Monuments with inscriptions found at Vranas, Ano Souli, and Kato Souli perhaps outlined the limits of Herodes' Marathon estate; some of these inscriptions were curse inscriptions, while others were dedications made by Herodes to honor his wife Regilla and his pupils (*trophimoi*). There were curse inscriptions at Rhamnous and Polydendris connecting these areas

with his estate: Tobin 1997, 251; 282–3, fig. 74; 278–80.

128. The port at Brexiza, which may have served the city of Marathon, had the submerged remains of a mole (no longer visible) and a wide canal that extended inland to serve both as a drain and a harbor, assignable to Herodes' estate by the wall masonry; Soteriades 1927, 123, 126, 144–50; idem, 1932, 37–9; Petrakos 1995, 69; Tobin 1997, 265. The port of the sophist Damianus: Philostr., *V S* 2.606; Pleket 1983, 137; maritime villas had small ports: Marzano 2007, 41–2.

129. For Herodes' Brexiza aqueduct and pipes that lead to the Roman bath complex: Soteriades 1933a, 40–1; Lolos 1997, 305. Tobin (1997, 15–16) suggests that the earliest example of a *latifundium* in Greece may have been the landholdings of Hipparchos, Herodes' grandfather, whose estates had been confiscated by Domitian and perhaps divided up into small plots and sold to poor farmers.

130. Petrakos 2002, 84. The text also provides details of the estate's acquisition and what was cultivated on it.

131. Petrakos 2002, 86–7 suggests that the stele was perhaps set up prior to Herodes' marriage to Regilla in 148 CE as she is not mentioned in the text.

132. Petrakos 2002, 83; *SEG* 53 2003.220. The reference to Petrakos' article in *SEG* 53 2003.220 (*PAAH* 77 2002, 83–90) is incorrect. Petrakos' publication is not in the *PAAH* (*Praktika Arxaiologikis Hetaireias Athenon*) but in the *PAA* (*Praktika Akademias Athenon*).

133. For the aqueduct, see: n. 129. Petrakos 2002, 84; 86, points out that the word *aule*, or farmhouse/country house, includes not just the residential quarters but subsidiary structures for storage of food, equipment, animal pens, etc. and can therefore be interpreted as a "country house," a usage found in the later authors, e.g., Dionysius of Halicarnassus 6.50: "and seeing our farm-houses (*aulas*) plundered," see n. 41; Petrakos 2002, 89, asserts that all these structures (including the dwellings) were part of *The Old Woman's Sheepfold*.

134. For a recent plan and brief description of remains see, Dekoulakou 2011, 22–4, 43, fig. 1, plan. 4; for remains at Brexiza, see pp. 00–00.

135. The remains are attributed to Herodes' estate because of an inscription discovered in the area that mentions a dedication by his mother, "Alkia to the Immortal Gods": Petrakos 1995, 95, fig. 41; for the remains at Oinoe: idem, 91–6, figs. 39, 40, 42. The foundations of a rectangular, unrecognizable, monument (13.6x17.3 m) have been interpreted as those of an incubation hall of the Pythion of Oinoe: Petrakos 1995, 95; Steinhauer 2009, 277–8 has identified them as a *nymphaeum* surrounded by pillars, which may not, however, be of the Roman period, although a nearby staircase, outer enclosure wall, and corridor behind the fountain are of Roman date; evidence for the cemetery include bone remains, fragments of funerary stelae, and blocks of a small marble monument, which may have been reserved for freedmen and those who worked on the estate: Rife 2008, 95 and n. 20.

136. Tobin 1997, 266–71.

137. Soteriades (1933a, 32) is the only source that I am aware of in which there is a reference to this ancient roadway in connection with the estate, although Fauvel (1792, in Petrakos 1995, 70, fig. 26) does indicate on the map of Marathon a road branching from the Kephisia road and going south as far as what appears to be *The Old Woman's Sheepfold* enclosure; Tobin 1997, 242, says that the valley between the two mountains of Kotroni and Aphorismos "is a natural passage … through which a road probably passed in antiquity"; Dekoulakou 1999–2001, 114 fig. 1, provides a map of the area of Marathon with the ancient mountain route; the road may have continued southward toward the Brexiza complex, thus connecting Herodes' two residential estates.

138. Petrakos 2002, 84; the area has a view toward the bay of Marathon. It may have been more wooded than now. There is no evidence of a spring, but one may have existed in antiquity, or water was brought to the site via an aqueduct: Tobin 1997, 246–9; for an aqueduct, see n. 129; the earliest reference to the site is Chandler 1817, 188–9 who visited the area in 1765–6, and mentions the story of the impious woman who, along with her flock and fold, was turned into stone. The discovery of a headless female statue at the site and the "craggy rocks" with the enclosure wall gave rise to the identification of the site as *The Old Woman's Sheepfold*.

139. Petrakos 2002, 89.

140. Petrakos 2002, 89.

141. On the exterior, *CIG* 537, and on the interior, *IG* 2^2.5189 and *SEG* 23.131. The epigram *SEG* 23.121, on one of the door jambs of the gateway mentions the "new (*polis*) city" that Herodes built for Regilla:

"Ah, blessed is he who has built a new city, calling it by Regilla's name; he lives in exultation. But I live in grief because my dwelling has been built without my beloved wife, and my home is half complete. For the gods, in truth, when they have mixed the cup of human life, pour out joys and griefs as neighbors side by side:" Gleason 2010, 135; 136 fig. 7.2; 140; Vanderpool 1970, 43–4 and nn. 11–12; the *new polis* may refer to the renovations conducted by Herodes on the already existing estate, and not, as Pomeroy (2007, 75) has suggested, to women's quarters (*gynae-ceum*) separated by Herodes' estate, the men's quarters, by an encircling wall. Such symbolism cannot be applied to an estate/s belonging to a Roman couple and one as unique as this one: Gleason 2010, 125–62.

142. Gleason 2010, 125–62.

143. Gleason 2010, 125–62; to my knowledge, only Soteriades 1933a, 32, mentions an important arterial mountain route between the ancient city of Marathon and Oinoe that passed "by the Gate of the estate of Herodes and Regilla"; see also n. 137 ; I suspect that this road would have been frequented by travelers going to and coming from Kephisia and the plain and port of Marathon who would have taken notice of the inscribed arch.

144. According to Gleason 2010, 135, Herodes seems to have gone beyond the accepted social norms, since even the emperors did not set up commemorative arches to honor themselves. However, I note that Herodes' inscription would have been facing the *interior* of the estate and so had a more restricted, private, audience, while Regilla's inscription on the exterior would have had a public audience.

145. According to Plutarch (*Thes.* 25.3), Theseus had set up a pillar inscribed on both sides: on the east side, "Here is not the Peloponnesos, but Ionia" and on the east west side, "Here is the Peloponnesos, not Ionia." Hadrian's Arch in Athens was inscribed on the west and east sides with the following texts: "This is Athens, the ancient city of Theseus" and "This is the city of Hadrian and not of Theseus": *IG* II2 5185; for a discussion of these inscriptions: Tobin 1997, 243–4 and n. 10.

146. Evidence for Herodes' close ties with Hadrian is also found at his estate in Eua Loukou where portrait busts of Hadrian and Antinöos were displayed: Spyropoulos 2006a, 105, fig.16; 130, fig. 34.

147. Steinhauer 2009, 278.

148. Sall., *Cat.* 12.3. See also Marzano 2007, 22–3.

149. After Regilla's death it may also have defined the worlds of the living and the dead, serving as a gateway from one world to the other, or possibly the harmony in an imperial marriage – male/female bonding, as suggested by the words *concordia aeterna* ("immortal concord"): Gleason 2010, 138; 139 fig. 7.4. In particular, that of Antoninus Pius and Faustina as demonstrated on the coins of the period, whereby a couple holding hands over an altar in miniature size is depicted standing beneath the clasped hands of a similar, but larger sized couple; for a more detailed account of the multiple meanings of the arch: Gleason 2010, 135–42; for Herodes as a city founder within a private context: Galli 2002, 134–8.

150. Graindor 1930, 186–8 was the first to identify this site as the *Temple of Canopus* mentioned in Philostr., *V S* 2. 554, an identification accepted by Tobin 1997, 262, n.69, Galli 2002, 188–93, and Rife 2008, 94. The original *Canopus* was a long canal that ran through the sanctuary of *Canopus* to Alexandria in Egypt, and Herodes may have visited the Egyptian *Canopus* to honor the captain of Menelaus' fleet at Troy who, on his return voyage, was bitten by a snake in Egypt and as a result was buried there. On the other hand, Herodes may also have been inspired by the canals (the *Scenic Canal* and the *Island Enclosure*) at Hadrian's Villa. The *Scenic Canal* was once thought to have been a version of the Egyptian *Canopus* (Tobin 1997, 255–63 and n.69; Galli 2002, 188–93), an identification convincingly rejected by MacDonald and Pinto 1995, 108–16. Grenier 2000, 74–5, views it as a representation of the Nile framed by the arcaded porticoes that represent the narrow fertile Nile valley.

151. The canal now lies beneath an American army base and a hotel complex to the north. I would like to thank the Greek archaeologist Ka. Kalliopi Fotiadiou for this information and tour of the site. Accounts of early travelers identified the area as an island situated in a swamp, almost square according to Prokesch von Osten, approximately 150 x 100 m: Soteriades 1927, 139. Investigations in 1926 and 1927 by Soteriades (1927, 122–3; 127; 137–50) in the northeast corner of the "Small Marsh" revealed a manmade canal to a length of 800 m from the sea that was silted with deposits of clay and sand. It was 40 m wide at the top (Soteriades 1935, 121), 30 m wide at the bottom (Soteriades 1927, 139) and was lined with 2 m thick

walls of Roman date, in an area where Fauvel (French vice-consul at Athens) in 1792 had identified ancient remains (seen later by Soteriades 1932, 33) and the busts of Herodes and contemporary Roman emperors (Lucius Verus and Marcus Aurelius). This canal once surrounded the island along the north and southwest sides connecting the swamp area with the sea: Soteriades, 1932, 33; Soteriades 1933b, 536 and 1935, 121; Dekoulakou 1999–2001, 115, fig. 3;; for the columnar courtyard and dining facilities see n. 164; Oikonomakou 2001–2002, 388 fig. 119 and 2005, 43–4, Figs. 4–5, discovered an elliptical "strong" wall 120 m long south of the *balneum* and modern (south) canal. This wall had a series of small, projecting walls at regular intervals and of equal size that may be associated with fish farming. For a detailed plan of the site: Dekoulakou 2011, 43, Plan 4; the exterior of the elliptical wall resembles images of harbor walls as represented in wall painting scenes of seaside villas found at Stabiae and Pompeii: Ackerman 1990, 57, 2.14, 15 and Mattusch and Lie 2005, 13, Fig.1.6; for a discussion of the identification of the remains, see p. 344.

152. The identification of the complex was also confirmed by a series of large lamps depicting busts of Isis and Serapis, while the statues resemble those found at Hadrian's Villa at Tibur depicting Antinöos as Osiris; Herodes' statues are more Egyptianizing than those of Hadrian's villa and perhaps depict Herodes' adopted son Polydeukion: Dekoulakou 1999–2001, 124–6; 2004; Tobin 1997, 257–8; Graindor 1930, 187, proposed that this complex was constructed after Herodes visit to Egypt, following in Hadrian's footsteps. Arapogianni 1993, 169, suggests a mid-second-century CE date for the *balneum*, while Dekoulakou 1999–2001, 124–5, also indicates a date in the latter part of Hadrian's reign for the sculpture from the sanctuary and the large Isis-Serapis lamps; for the small harbor: see n. 128 .

153. Evidence for additional influences from Hadrian's Villa includes the gateways into the sanctuary that were flanked by Egyptianizing male statues. A similar arrangement was also documented in the Tibur Villa: MacDonald and Pinto 1995, 111.

154. For the architecture: Dekoulakou 1999–2001, 116–22, figs. 4, 5, 6, 10; Steinhauer 2009, 274.

155. Nielsen 1993, vol. 1, 98; 104–5; 112; vol. II, 33, C269 and fig. 214; Nielsen's interpretation of the bath complex was formulated on the available plan and not on the excavation data, which had not yet been published. In consequence, her interpretation of the space differs from that of Arapogianni 1993, 133–86; the chronology of the baths rested on pottery and coin evidence: Arapogianni 1993, 169.

156. Nielsen 1993, 112, suggests that these two spaces may have formed part of a monumental entrance at the northeast corner entrance into the baths; however, Arapogianni 1993, 166 and n.35, states that area " G" is badly destroyed and the entrance to the baths remains unknown.

157. Arapogianni 1993, 137, n.11; 139, fig. 8; Nielsen 1993, 33, C269.

158. For the Small Baths: Nielsen 1993, vol. II, 103, fig. 84, C55; for the Heliocaminus Baths: idem 9 C56; 103, fig. 85.

159. Description of the 120 m-long wall of a "cistern": Dekoulakou 2011, 23–24, 43, plan 4 and Oikonomakou 2005, 43–4, figs. 4–5, who notes that the apsidal part of the "cistern" (where now water collects) faces eastward toward the sea, incorporated the remains of an opening "on a surface slanting toward the sea". The *Vibullii*, ancestors of Herodes from his mother's side, were known for their fish farming ventures in Boeotia: Spawforth 2002, 103; for Herodes' possible fish farming activities: Spawforth (1996) 171, nn.17–18; see nn. 37, 99, 106, 151, 160; according to Soteriades (1927, 145–50), the natural bay area that existed at the mouth of the north canal formed a "natural fish-pond," and in the 1920s residents from Nea Marki had intended to expand and transform the bay into a fish farm. Soteriades (1927, 150) also noted a manmade cavity in the northeast corner of the "Small Swamp" at Brexiza and suggested it was "a small lake for plants, birds and lilies" (or a "fish farm"), part of a "coastal park" created by Herodes. The Brexiza area as a fishing-farming region in antiquity was mentioned by Pausanias (I. 32.7), who also observes a "natural fish-pond" where "out of the lake (the Great Marsh of Drakonera) flows a river . . . [and] near its mouth it becomes salty and full of sea fish."

160. According to Marzano and Brizzi 2009, 215, 220, 228–9, marine fish farming was an expensive venture requiring appropriate installations and staff, a well-ventilated and oxygen-rich environment, and close proximity to urban markets; for the natural fish ponds see, n.159 .

161. The framing of a building complex with water may recall the Egyptian *Canopus* (n. 155) possibly Hadrian's *Island Enclosure* at Tibur: Spyropoulos 2006a, 196.

162. The arched gateway of the estate at Nador in Algeria had an inscription over the entrance identifying the owner, much like the arched gateway into the estate of Regilla at Marathon. Wilson (2011, 75–6) sees these fortified towered façades as inspired from military architecture; the *villa urbana* at Milreu (Fano, Portugal, fourth to fifth centuries) had a monumental entrance leading to steps accessing the main peristyle court: Teichner 2011, 295, Abb. 2 and 296–7, Abb. 3.

163. Recent excavations at Brexiza have yielded numerous female Isis-type statues and an inscription reading "*Athenais lemin*" (the harbor of Athenais). According to Steinhauer 2009, 278, the word *lemin* is used as a metaphor for a grave and therefore the "Sanctuary of the Egyptian Gods," which is next to the sea, may have been the resting place and/or mausoleum of Herodes' daughter Athenais. It was constructed after her death and at the same time that the Brexiza complex was remodeled. Likewise, *Athenais Lemin* could also be taken in a literal sense as the small estate harbor may have been named in honor of Athenais; for a possible temple to *Attikos* at the Marathon estate: Petrakos 2002, 88; Herodes, after the death of his loved ones, transformed his estates, or at least part of them, into memorials, while throughout his entire Marathon estate in the "fields . . . by springs or in the shade of plane trees" he set up inscribed images of his deceased students: Philostr., *V S* 2.559.

164. Philostr., *V S* 2.554. Agathion was a man who lived on Herodes' estate and was famous for his herculean strength, prompting Herodes' invitation. Herodes acceded to this request about the milk, but Agathion by divine insight realized that women had milked the animal and abruptly departed: Philostr., *V S* 2.552–3. A dinner invitation implies some type of dining facility: Tobin (1997, 262) suggests that Agathion was invited to dine at Herodes' home while Spyropoulos (2006a, 196) suggests that there was a *triclinium* in the shrine itself; Fig. 19.9: Dekoulakou 2011, 43; see nn. 151 and 165.

165. See nn. 14, 18; Cic., *Att.* 2.1; next to the Egyptian shrine, the dining area includes a spacious columnar courtyard 26.4x22.8 m (stoas 3.6 m wide) with a large dining room (possibly vaulted – personal

observation) along the south side and other dining and storage facilities (four large and three smaller rooms in total). It was accessed from a monumental propylon facing the sea, one of a number perhaps of main entrances into the area according to Dekoulakou (2005a, 47–8, fig. 2); it appears that this entrance was intended for those approaching the villa residence from Herodes' private harbor in the northeast corner; for the harbor: see n. 128; freestanding shrines and temples in large Roman villas: Smith 1997, 291–2.

166. For an overview: Spyropoulos 2006a, 11–12; Phaklaris 1990, 96–104; Pritchett 1989, 84–90, for earlier investigations and the general topography of the villa estate.

167. For the inscriptions: Spyropoulos 2006a, 15–16; 29–30; initial construction of the residence may have begun under Herodes' grandfather Hipparchos, who was condemned around 92–3 CE on the charge of tyranny against the Athenians (by whom is unknown, possibly a member of the Athenian aristocracy), or construction began after 96–8 CE when the family's fortunes were restored under Nerva: Tobin 1997, 16; Philostr., *V S* 2.547.

168. Investigations began in 1978 by G. Steihauer and P. Phaklaris, and later by Alkmini Stavridi (between 1984–7 and 1989), under the auspices of the 5th Ephorate (now the Ephorate of Antiquities of the Argolid) of Classical and Prehistoric Antiquities. Salvage and systematic excavations of the villa residence were continued by T. Spyropoulos (former director of the 5th Ephorate) who was joined by G. Spyropoulos in 1990: Spyropoulos 2006a, 16; 229. A detailed publication of the architecture has not appeared, so I have used the scale provided in Spyropoulos 2006a, 46–7 to present a very rough estimate of the approximate size for each terrace and the total excavated area: north terrace c. 45x26 m = 1,170 m^2; central terrace c. 35x20 m + 359 = 4,559 m^2; south terrace: east section 35x8 m=630 m^2 and west section 5.5x5 m = 137.5 m^2. The total excavated area is approximately 6,377.5 m^2; for an estimate of the size of the entire villa: Spyropoulos 2006a, 230.

169. Spyropoulos 2006a, 378.

170. Basilica: 23.6x15.65 m: Spyropoulos 2006a, 34–5; an inscription identifies the gymnasium-palaestra area: Spyropoulos 2012, 293.

171. Peristyle "island-garden": 56x16.20 m; the central courtyard is c. 1,000 m²: Spyropoulos 2006a, 230.

172. The canal is 172 m long and 2 m deep: Spyropoulos 2006b, 9; the canals along the north, south and east sides are 2.70 m wide and the west one 4.70 m. The north and south canals were later reduced to 2.00 m in width, while the west canal was reduced to 3.90 m with the modifications made to the *nymphaeum*. For prototypes of villa canals, such as the retreat of Dionysios I of Syracuse (430–367 BCE) at Ortygia and the palace of Herod the Great (73–4 BCE) and Roman examples (Herodes' island at Brexiza, and Hadrian's at Tibur): Spyropoulos 2006a, 196–8.

173. MacDonald and Pinto 1995, 81–2, figs. 95, 93. The "Island Enclosure" was identified in earlier publications as the *Teatro Marittimo*.

174. This *aula* measures 14.5x11m; K1 and K2 measure 5.5x5.5 m and 9.5x4.5 m. A similar grouping of rooms at the Piazza Amerina villa in Sicily was associated with living quarters: Spyropoulos 2006a, 171.

175. Spyropoulos 2006a, 59, identifies this space (n) as an "(*aule*) veranda," with a raised floor level, which he suggests served as a summer *triclinium* (part of the *opus sectile* floor), so I refer to it as summer-*triclinium*.

176. Spyropoulos 2006a, 195; 230; 232, suggests that Herodes was inspired by Hadrian's garden-stadium; however, the garden-stadium was a standard architectural feature in Roman villas and is also mentioned by Pliny (*Ep.* 5.6.35) in the description of his villa at Tifernum: MacDonald and Pinto 1995, 3–4.

177. Spyropoulos 2006a, 222.

178. Dimensions of the temple-*heröon* complex: *aula* (apsidal hall) 15.20 x 9.52 m; *triclinium*, 6.17 x 8.45 m; vestibule, 6.35x3.38 m: Spyropoulos 2006b, 90. Spyropoulos 2006b, 97, fig. 18, also suggests that the apsidal hall may have had two interior rows of columns based on the discovery of part of a column shaft (2.49 m long) of Egyptian granite found within the nave, idem 91, fig. 18, and Spyropoulos 2006a, 36, fig. 1, and 154. However, as no foundations for a stylobate or column bases were found (they are not mentioned, nor are they visible in the photograph), and since the site witnessed continuous occupation, this fragment may have been deposited here at a later date.

179. It is difficult from the plan to discern communication patterns as categorized by Nielsen 1993, vol. II, 53,

figs. II (angular), III (parallel). For the baths at Olympia (Bath IV): Nielsen 1993, vol. II, 34; 190 fig. 215, C271; the hypocaust floors were supported by terracotta columnar supports.

180. MacDonald and Pinto 1995, 60. Multiple towers were also identified at Hadrian's Tibur villa: Spyropoulos 2006a, 153.

181. Vitr., *De arch.* 6.5.2.

182. Wilson 2011, 68–70, fig.8; Spyropoulos 2006a, 38–9, identifies basilica (1) as a *Repräsentationsbasilika*.

183. If this is indeed the case then the appearance of the basilica plan at Loukou is perhaps associated with either Atticus' or Herodes' consulships in Rome; Spyropoulos 2006a, 37; 44, tentatively dates the construction of the basilica (1) to the Flavian period, since the composite capitals from the structure resemble those found on the Arch of Titus (81 CE) and the Colosseum (80 CE) in Rome. Spyropoulos (2006a, 38–9) also assigns the construction of the internal apse for the rectangular raised platform of basilica (1) to Herodes Atticus, while prior to this the basilica may have had a simple platform for a tribunal; however, he does not present evidence for this hypothesis.

184. Wilson 2011, 68–9; Teichner 2011, 296.

185. For a plan of the example from Split, which has an apse inscribed within a rectangle like the Eua Loukou example: Wilson 2011, 69, fig. 8.I.

186. Portrait busts found in this area (if they originally were displayed here) suggest that this was a formal area where the patron received his clients: for sculptures: Spyropoulos 2006a 191–2; idem 55, 202 and nn. 199, 219.

187. Hipparchos and also Herodes Atticus were accused of tyranny probably by the Athenians: Philostr., *V S* 2.547; 559; Tobin 1997, 15–16; 35-47; Ameling 1983, 109-10; for Atticus' political career: Tobin 1997, 23 and Ameling 1983, 36; the basilica also functioned as an art gallery displaying Herodes' religious, educational and philosophical affiliations: Spyropoulos 2006a, 40; 191–2; 209; in this display was a funerary stele commemorating members of the Erechtheis tribe (among them Herodes' ancestors) who died at Marathon: Spyropoulos 2012, 294, fig. and n. 574.

188. *Aula* (j), like the basilica (1) and the *heröon* (r), is identified by the excavator as a basilica, "the west basilica": Spyropoulos 2006a, 171; 173.

189. Wilson 2011, 70–2, n. 71 also suggests that the *aula* (j) in the Loukou estate is best seen as a formal dining area; for a description of the *aula* (j): Spyropoulos 2006a, 171, 222, who identifies it as an audience hall, while the entire western area of the residence served as Herodes' "private *sacrarium.*"

190. Spyropoulos 2006a, 155–6 mentions that the inscribed fragmentary marble plaques reused in the fourth century as wall revetments in the vestibule (not yet published) may have formed part of a balustrade that surrounded the statue of Dionysos; the worship of Dionysos in the temple-*heröon* (r) is confirmed by the discovery of a later second-century CE Greek inscription (193–99 CE): "to Pertinax Arabicus … to the god Dionysus (Περτίνακι Ἀραβικῷ …. Θεῷ Διον[ύσῳ])." A statue of Antinöos-Dionysos was found within the temple at the west end: Spyropoulos 2006a, 154–6; 2006b; 92; 97.

191. According to Spyropoulos 2006a, 170, the transformation of the temple into a family *heröon* took place sometime after the death of Regilla (157 CE) and before that of Polydeukion (170 CE); in the first phase the apsidal *heröon* (r) connected with the area to the west (s) via a doorway in its western wall (idem 93, fig. 19; Figure 19.12, A) which was walled in during the second phase when the vestibule (r1) and *triclinium* (r2) were added (idem, 94, fig. 20; Figure 19.12, B).

192. Spyropoulos 2006a, 219, also refers to the *heröon*-cenotaph as a *heröon-triclinium*; banquets may also have been conducted nearby: idem, 219–20. A fragment of a *kline* (dining couch) was found, which may indicate that *klinai* with reclining images of the deceased were placed in the niches of the *triclinium*, much like the example from the nymphaeum as restored by Spyropoulos 2006b, 24, fig. 4; 95. He also suggests that reliefs of funerary banquets found in the south canal may have originally adorned the *triclinium* of the *heröon*-cenotaph: idem 96.

193. Spyropoulos 2006a, 154–5. The nave was adorned with a horseshoe-shaped pool in the center and a fountain in the apse supplied with water by a system of terracotta pipes extending from the aqueduct running along the south wall of the basilica (Figure. 19-12, B); an inscription of the sixth century CE (not from this villa) lists the types of furnishings often found in a cenotaph: stone table, water cistern, a fountain in the shape of a lily, chairs, couches, and

so on: idem 2006b, 92; 155; for opulence in villa decoration: MacDonald and Pinto 1995, 199–201.

194. Spyropoulos 2006a, 157–8. In my view, the assemblage of spaces and their sculptural decoration requires further study to determine the precise identification of the complex.

195. MacDonald and Pinto 1995, 108–16; according to Tobin 1997, 370, a grotto-like space was also found in Herodes' villa along the Appian Way in Rome.

196. Spyropoulos 2006a, 159; 219–20.

197. Spyropoulos' 2006a publication focuses primarily on the sculptural adornment of the villa and to a lesser extent on the mosaics.

198. Some were original works from late classical and Hellenistic periods, while others were recent commissions from the workshops of Attica and Aphrodisias: Spyropoulos 2006a, 192.

199. Athena Farnese: a Roman statue-type now in the Naples National Archaeological Museum based on a fifth-century original (Fuchs 1979, 194–5, fig. 206). The original contents of the north basilica were cleared away when it was transformed into a Christian church: Spyropoulos 2006a, 42, 190, 193. The rooms in the corridor (1a) south of the basilica may have served as a service area, archives, a *lararium*, and a library, but this is not certain, though family portrait busts and busts of philosophers were found: idem 41; 45; 191. The area is inappropriate for a library as it lies between two long, windowless walls, trapped between the north wall of the peristyle and the south wall of the basilica (1), and the entrance way into this area is partially blocked by a staircase leading to the second terrace. Vitruvius (*De arch.* 6.4) prescribes an eastern exposure for libraries, for sufficient light and to prevent the decay of scrolls; the plans of libraries often resembled *exedrae*, a space with only three walls for the placement of bookshelves, or cabinets, while the fourth side opened onto a court or portico as in the Villa of Papyri: Sider 2005, 62, fig. 64; for the House of the Menander at Pompeii: Richardson 1977, 398–9; for libraries in general: Johnson 1984.

200. Paus. 2.38.6; Spyropoulos (2006a, 193) suggests that Herodes may have wanted to express his *philophrosyne* (friendliness) to the priests of the nearby sanctuary of Asclepius, possibly located in the area of the later monastery at Eua Loukou. Statues associated with the Dionysiac procession (*thiasos*) and Herakles' cycle were also found in the garden-

stadium (3) and are similar to those from the Villa of the Papyri: idem 2006a, 193–5.

201. Spyropoulos 2006a, 204–5. A theme reflected in the mosaics from the north portico with the images of cupids, the personification of *Apolausis* (pleasure), the Hours, and the river gods Arethousa and Elikoneios. The relief sculptures are primarily from the classical and Hellenistic periods; few are of an archaizing style, while no archaizing sculpture in the round was found, unlike the numerous examples found in Hadrian's Villa.

202. There were six Amazons that served as columnar supports (Spyropoulos uses the term *Amazon-carya-tid*), positioned at 3.90 m intervals. Those at Hadrian's Villa were located at the east end of the Scenic Canal: Spyropoulos 2006a, 198–9; MacDonald and Pinto, 1995, 143, fig. 175; 148. Within the south portico statues depicting the Labors of Herakles were displayed, while a series of dedicatory reliefs of victorious athletes of later Hadrianic date were positioned on the wall or within the intercolumniations: Spyropoulos 2006a, 203; evidence of plaster and color suggests that the reliefs were inserted into the walls: idem 205; Cic., *Att.* 1.10 mentions the practice of setting relief panels into stucco walls; five Caryatids of Pentelic marble from an Athenian workshop were also found at Herodes' villa along the Via Appia in Rome: Tobin 1997, 370–1.

203. According to Spyropoulos 2006a, 87–94, fig. 11–12; 199–120, the dancing *Lacaenae* are the *Saltantes Lacaenae* mentioned by Pliny (*HN* 34.92), of which only the remains of two were found at Eua and a third in Rome, known as the *Aura Palatina*. These are original late fifth-century BC works by the Greek sculptor Callimachus and may have come from the Athenian Acropolis. The Amazons of the Mattei type are neo-classical works of the Hadrianic period, idem 96–8, based on a Roman marble copy of a bronze original (440–430 BCE) by the Greek sculptor Pheidias for the Sanctuary of Artemis at Ephesos: Plin., *HN* 34.75; Fuchs 1979, 196–8, fig. 210; they may also be based on an original by Cresilas: *LIMC* I.2, pl. 605 and I.1, 625.

204. For changes to the *nymphaeum*: Spyropoulos 2006a, 70; 72; for changes to the villa décor following the deaths of Herodes' family members: idem, 55; 154–5; 156; 214; for a discussion of the reliefs: idem, 207–9; 213–14; for the funerary banquet reliefs: idem,

163–70. Thirteen of the surviving reliefs, of which some are original works of the classical period taken from Attic *heroa*, were found in the south corridor of the peristyle: idem, 55; 214.

205. Spyropoulos 2006b, 105; see p. oo and n. 195.

206. MacDonald and Pinto 1995, 142; 150–1.

207. However unlike the Villa of the Papyri collection that included bronze sculptures, Mattusch and Lie 2005, 143–81; 189–331, no bronzes were found at Eva Loukou.

208. Spyropoulos 2006a, 136 and n. 189. These measurements do not include the pavements in the south corridor (p-q) and the east corridor (L) which measure 140x4 m = 560 m^2 and date to the fourth century CE.

209. Leader-Newby 2005, 233.

210. The *Pasquino* and *Achilles and Pentheseleia* statue groups were positioned symmetrically across from each other, the former in the west end of the north portico and the latter in the west end of the south portico. In front of each statue group, a mosaic pavement was laid depicting the corresponding sculptural theme: Spyropoulos 2006a, 136–7; 148; for images: Spyropoulos 2012, 294–5, figs. and nn. 579–81.

211. In late-antique mosaics, *Ktisis* (founder) is a term used for praising the building activities of a benefactor. Examples at Antioch are found in the Constantinian Villa, the House of Gea (Earth) and the Seasons, the House of the Sea Goddess, and the House of Ktisis: Leader-Newby 2005, 240–1; Spyropoulos 2006a, 140, however, interprets *Ktisis* as the "creative power of the Kosmos" and "guardian of the cultural works of mankind" and views these personifications as expressions of Epicurean "pleasures."

212. Personifications of nature include Mount Helikon, the river gods Alpheios, Arcadius, Ladas and Acheiöos, and the nymph Arethousa and the homonymous spring: Spyropoulos 2006a, 141–3, fig. 36; for the Muses: idem, 140–1; 143, fig. 37; for the Labors of Heracles: idem, 143–8 and figs. 38–9; for Achilles and Penthesileia: idem, 148; 150, fig. 40.

213. As we have seen, Herodes' ties with Rome were multi-faceted: a Greek and Roman citizen, a consul twice over, married to a Roman aristocrat of the imperial family, of Italian descent on his mother's side (the Vibullii veteran colonist family at Corinth; see nn. 99, 159). Spyropoulos (2006a, 143) suggests

that this mosaic reflects Herodes' dual citizenship; I tend to see it as an allusion to his marriage with Regilla. For a description of the mosaic: idem, 140.

214. The Second Sophistic was a philosophical movement (60–230 CE) that embraced the cultural achievements of the Greek past.

215. Images of Herodes, Antoninus Pius, Lucius Verus, Marcus Aurelius: Spyropoulos 2006a, 209.

216. Hadrian's villa included personifications of the provinces and various Greco-Roman themes inspired from his travels and education: MacDonald and Pinto 1995, 141, 147–51; Spyropoulos 2006a, 191–209; 232 (especially 209) seems to interpret all sculptural adornment of the villa (with the exception of the later portrait busts), of which only the marble survives but no bronzes, as Herodes' own conceptions and does not take into consideration that some may have been brought to the villa by later proprietors who renovated it and commissioned the fourth-century mosaic pavements.

217. The Villa of Papyri collections were regional products produced in the Bay of Naples and reflect the tastes of multiple owners and gift-bearing guests over a period of approximately 180 years (c. 100 BCE to 79 CE): Mattusch and Lie 2005, 332–3. In comparison, Herodes' collection and that of subsequent owners is incomplete as bronze statues, wall paintings and other decorative trappings, integral to villa adornment, have not survived.

218. Destruction of the villa at the end of the third century has also been attributed to barbarian attacks. The new mosaic pavements (covering a total area of 4x140m) were added in the external east (L) and south (p-q) corridors of the peristyle. Themes include primarily polychrome geometric designs: Spyropoulos 2006a, 151, fig. 41; 152, fig. 43; 174, fig. 46, and three figural scenes in the external south corridor (p-q), two of a young woman and a third panel depicting a chariot race: Spyropoulos 2006a, 148; 151, fig. 41–2.

219. Spyropoulos 2006a, 222. Atticus, Herodes' father, also displayed busts of ancient orators in his home: Philostr. V S 1.521; portraits were also found in the basilica (1), the heröon complex, and may have also been displayed in numerous other areas of the villa, as their find spots do not necessarily indicate their original position. For the disturbance to the stratigraphy and find spots of sculpture: Spyropoulos 2006a, 190; 193;

201; for a brief summary of sculptural finds at Loukou: Tobin 1997, 337–54; see n. 186.

220. In fact, the portrait of Severus was an import from Rome: Spyropoulos 2006a, 27; 74; 103–6, fig. 15; 111; 202; 220; 222. Spyropoulos (2006a) focuses primarily on Herodes' décor. For a brief catalogue and some accompanying images of emperor portrait busts and those of unknown men and women from the late second to fourth centuries: Spyropoulos 2006a, 103–32, figs. 15; 21; 25–6; 29; 32; idem, 201–2. After abandonment the site fell prey to treasure hunting, scavenging of the area for reusable objects (metal in particular), collapse, quarrying of building, disturbance and redistribution of artifacts by animals and humans, and later and recent cultivation of the terrain.

221. Changes were made in the south section of the villa, with entry points walled off in the south external corridor, and internal organization of rooms to the east and west sides of the villa and the Antinöos-heröon (r). The mosaics of the chariot race and the panels of female busts were added, sometime during the early to mid-fourth century: Spyropoulos 2006a, 153, 220.

222. As deduced by the presence of Christian symbols and inscriptions identified on the small columns of the double arched windows originating from the central nave of the north basilica: Spyropoulos 2006a, 40.

223. Spyropoulos 2006a, 43, 220.

224. Spyropoulos 2006a, 43–4, 220–1.

225. The spring lies 1.5 km northwest of the two-arched bridged aqueduct constructed in opus testaceum: Lolos 1997, 308. Phaklaris (1990, 98, n. 316) mentions it. See also Pritchett 1989, 86, and Spyropoulos and Spyropoulos 1996, 10, who associate wall remains and columns of Egyptian granite with this aqueduct.

226. Spyropoulos 2006a, 195; 229; for an excellent overview of past scholarship and archaeological investigations of the area: Phaklaris 1990, 96–104 and Pritchett 1989, 84–90.

227. Pausanias 2.38.6: "and the third and biggest [village], Eua, which has a sanctuary of Polemokrates, son of Machaon and brother of Alexanor, who cures the local people and is honoured by the whole district." The monastery appears to have been built over the site of this healing sanctuary (Asklepeion): Spyropoulos 2006a, 14–15; Phaklaris 1990, 102, see n. 200. For connections of villas to sanctuaries: Spyropoulos 2006a, 193 and n. 84; a limestone

quarry was identified within the vicinity of the villa residence whence blocks of limestone were extracted to build the basilica (1): idem 33.

228. The marble quarries at Ano Doliana, from where some of the marble used to adorn the residence was quarried, may have been exploited by the Claudii Attici: Spyropoulos 2006a, 33; see n. 37.

229. Pausanias 2. 38. 4. Phaklaris 1990, 102–3, comments on the plain of Thyreatis for its wine and oil production, a potential that perhaps did not escape Herodes' attention; according to Alcock 1993, 81, olive oil seems to have been an important export commodity in the southern Argolid and Attica. The remains of enclosures of dry rubble and mounds of stone rubble may have belonged to stables and animal pens for animal husbandry on a smaller scale: Phaklaris 1990, 99, n. 318.

230. As in the case of Laconia, Methana, Berbati, and South Argolid: Stewart 2010, 224; 226–7.

231. Rizakis 1997, 30; Pykoulas 1995, 278.

232. West of the temple-_heröon_ (r) of Antinöos-Dionysus, kilns, wine presses, small structures (_oikiskoi_) were built during the fourth and fifth centuries. Wine presses from the late Byzantine period were also found: Spyropoulos 2006a, 157.

233. Spyropoulos 2006a, 31–2; tombstones inside the residence may have originated from surrounding cemeteries: idem 2006a, 55; for tombs in villas in Italy: Raeder 1983, 303; in the early nineteenth century, tombs were found in the area around the monastery: Phaklaris 1990, 96.

234. For the villa at Kalliani in the area of ancient Thelpousa that dates from the mid-first century into late antiquity: Roy 2010, 71; during the second century CE in particular, large farms and imperial estates were established both in Italy and Greece: Tzanavari 2003c, 136.

235. Marzano 2007, 126–7 also indicates that most of these large estates were not necessarily one large unit but made up of a multitude of scattered properties.

236. For villas as a place for display of personal achievement: Marzano 2007, 230–1; Bodel 1997, 17–8.

237. See p. 332 and n. 57.

238. Kalathara, Abdera, Kalithea, Lete, and Lefkadia.

239. For the fortified villa at Oraiokastro, Thessaloniki; Marki and Akrivopoulou 2003, 283–98; for Euboea: Kosso 1996, 201–30; the maritime villa at Molos, Abdera, incorporated remains of earlier structures dating from the fifth to fourth centuries BCE to the third century CE: Kallintzi and Chryssaphi 2007, 460.

240. For general political instability in the area and abandonment of villa sites and the rise of small, fortified settlements: Karatzeni 2001, 171–2. An exception is the Villa at Kephallonia (island), which survived into the late fourth century: Kallipolites 1961–2.

241. According to Sweetman 2013, 20–2 the first evidence for large rural villas on Crete appears in late antiquity; see n. 4.

242. Marzano 2007, 232.

243. Modest size rural villas defined as farmsteads by Sweetman (2013) appeared as early as the first century CE; see n. 44.

244. E.g., the villa at S. Giovanni in Tuscia: see Bowes (Chapter 23) in this book.

245. In Latium, inland rural estates appear to have declined during late antiquity, though coastal villas continued to function until the fifth century at least: Marzano 2007, 323; Lafon 2009, 302–4, fig. 5, observes that a similar transformation may have occurred with a seaside villa of Trajan, which perhaps became a military garrison in the second to third centuries, and then later (possibly fourth century CE) expanded into the town of Centumcellae (mod. Civitavecchia). Diocletian's residence at Split may have followed a similar form of development, originating from an earlier villa at the site.

246. For the movement of the Roman aristocracy to northern Italy: Marzano 2007, 231.

247. Kallipolites 1961–62. A similar transformation perhaps also occurred at a villa site at Tsifliki in area of the Lefkadia tombs in Macedonia, where remains of a stone chancel screen were discovered: Stikas 1959, 85–9, and at a villa on the island of Kephallonia: see nn. 81, 85, 240; a basilica of the eleventh century and later cemetery was established on the Hellenistic-Late Hellenistic estate at Agios Konstantinos, Grevena in upper Macedonia: Karametrou-Mentessidi and Theodorou 2009, 115, fig. 2, 127.

248. For an example of a villa settlement: see n. 245; for the evolution of villas in late antiquity: see Bowes (Chapter 23) in this book.

249. See n. 232; for the church n. 222; and for villa burials and _mausolea_ in general nn. 81, 92.

250. Only a final publication of the site and field surveys of the surrounding region will help shed light on later activity in the area.

251. Rothaus 1994, 391–2.

252. Wickham 2005, 468; the villa at Piazza Armerina according to Wilson 2011, 79, is representative of this western aristocratic lifestyle.

253. For a synopsis of other scholarly views: Hales 2003, 207 and for an overview of the *oikos* in the Greek East pp. 207–11.

254. Classical and Hellenistic terms (*agrós, horíon* and *kleision*) associated with farmsteads differ from those (*agroikía, aulé* and *aulós*) used by later authors: see nn. 41, 133 and pp. 331 and 354. Petrakos 2002, 88.

255. Woolf 1997, 10.

VILLAS OF THE EASTERN ADRIATIC AND IONIAN COASTLANDS

WILLIAM BOWDEN

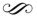

INTRODUCTION

The eastern coasts of the Adriatic and Ionian seas – the regions of Istria, Dalmatia, and Epirus – saw early political and military intervention from Rome, ostensibly to combat Illyrian piracy but also to participate in the internecine struggles between Macedonia and its neighbors, sometimes at the request of one or other of the protagonists. Istria fell to Rome in 177 BCE and was ultimately incorporated into *regio* X (*Venetia et Histria*) of *Italia* by Augustus in 7 BCE. After 168 BCE, much of the coast to the south was effectively under Roman control, with merchant shipping able to operate under Roman protection.[1] The Illyrian tribes, however, notably the Delmatae, continued to exist in periodic conflict with Rome until they were finally subdued by Octavian (who later took the name of Augustus) from 35 to 33 BCE. Further to the south, many of the tribes of Epirus sided with the Macedonians against Rome in the Third Macedonian War, consequently suffering significant reprisals at the hands of Aemilius Paullus in the aftermath in 167 BCE. Epirus was formally incorporated within the Roman province of Macedonia after 146 BCE.

The founding of Roman colonies in Epirus (at Butrint, Photike, Dyrrhachium, and Byllis), Dalmatia (at Iader, Narona, Salona, Aequum, possibly Senia, and Epidaurum), and Istria (at Tergeste, Parentium, and Pula) is likely to have had a decisive

effect on landholding patterns because land was redistributed among civilian colonists from the Italian peninsula as well as veterans.[2] The colonies of Pola and Parentium in Istria, in particular, had more extensive territories than those known for Dalmatia.[3] The centuriation of this hinterland also extended to the numerous islands, although it should be noted that in some cases, notably on the island of Hvar, this land division may have been much earlier, belonging to the *chora* of Greek settlements such as Pharos.[4] There is also evidence of extensive centuriation around Nikopolis, the town founded by Augustus following his victory at Actium in 31 BCE.[5] Although there remains some doubt as to whether Nikopolis was ever a veteran colony, it was populated through a synoecism that transplanted the populations of many existing towns to the new city.[6] Other areas of centuriation have been noted in other regions not immediately adjacent to colonies (for example, the Drinos valley close to the site of the town of Hadrianopolis)[7] and the territories of the *coloniae* may have included areas of land at some distance from the towns themselves.

Epirus was one of the first areas outside the Italian peninsula where the senatorial aristocracy of Rome established major land holdings and estates to a significant level. These were the "Epirote men" noted by Cicero and Varro, of which the most famous was Titus Pomponius Atticus, Cicero's correspondent and archivist, who owned an estate in the territory of Butrint (Map 17).[8] Epigraphic evidence

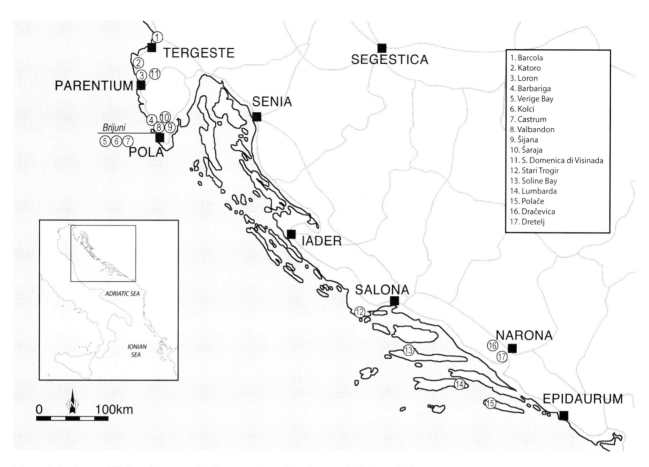

1. Barcola
2. Katoro
3. Loron
4. Barbariga
5. Verige Bay
6. Kolci
7. Castrum
8. Valbandon
9. Šijana
10. Šaraja
11. S. Domenica di Visinada
12. Stari Trogir
13. Soline Bay
14. Lumbarda
15. Polače
16. Dračevica
17. Dretelj

Map 16. Istrian and Dalmatian coastal villas mentioned in the text (W. Bowden)

shows that Dalmatia and Istria also saw the Roman senatorial class establish major estates.[9]

The first villas in this restructured landscape appear in the late first century BCE. Although the term villa is the cause of some debate (and in antiquity could be used in a wide variety of circumstances), I shall use it here in its modern definition to denote residential buildings whose owners aspired to, or participated in, the leisured life of the Roman aristocracy with its accompanying complex architectural and decorative vocabulary. A large number of these sites have been identified in the coastal lands of the eastern Adriatic (Maps 16; 17), and it is not my intention to offer an exhaustive treatment of them but rather to provide an overview of some of the evidence and highlight some facets of these villas, with particular reference to the better understood and documented examples.

Some of the Istrian villas, such as that around Verige Bay on the island of Brioni, were built on a colossal scale with all the architectural ambition of the *villae maritimae* of the Tyrrhenian coast of Italy, while others, particularly those of the Ionian coastlands, appear to have been more modest in size. The area was within easy reach of Italy (and of Rome itself) and would have been well known to many inhabitants of the Italian peninsula: It is unsurprising that the villas of the region have strong similarities with their Italian contemporaries. Istria in particular, as part of *regio* X, was an area that had particularly strong links to the senatorial aristocracy of Rome, and this is reflected in the *villae maritimae* of the region, which are on a greater scale and aspiration to villas elsewhere on the Adriatic coast.

Many of the villas also have evidence of late Roman phases, including in some cases the

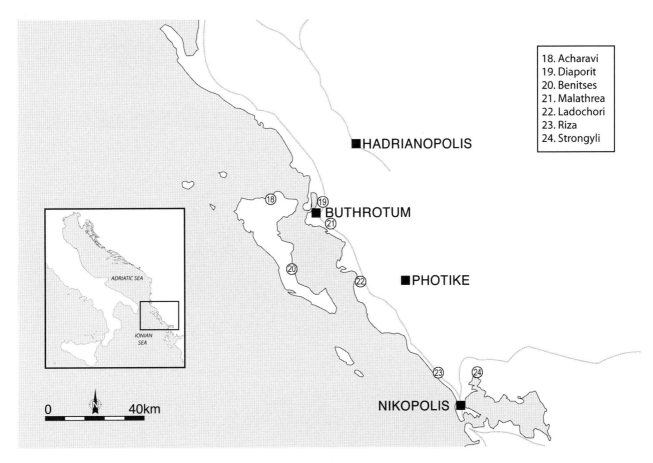

18. Acharavi
19. Diaporit
20. Benitses
21. Malathrea
22. Ladochori
23. Riza
24. Strongyli

Map 17. Ionian coastal villas mentioned in the text (W. Bowden).

construction of churches. These late-antique manifestations mark some of the changes that were occurring in the late Roman countryside and in the lives of the landowning classes, and it is clear that the occupation of villa sites in the fifth and sixth century was often radically different than that of the early imperial period. As luxury residences, the villas did not survive beyond late antiquity, although some show signs of early medieval activity.

METHODOLOGIES AND FRAMEWORKS OF RESEARCH

Archaeological research in the region has very much reflected prevailing geopolitical situations. In the nineteenth and early twentieth centuries, European powers (which invoked the Roman Empire as a natural ancestor) played out their own imperial

ambitions on the archaeological sites of the western Balkans. In the post-WWII period, however, pre-Roman tribes were coopted into different constructed ancestries in Albania and parts of Yugoslavia (utilizing opposing pseudohistorical narratives), while the post-Roman period was reimagined as an era in which modern national identities began to coalesce. At the same time, constructs of past ethnic identities were invoked as justification for territorial claims.[10] In Greece, the creation of an idealized Hellenic ancestry (a process which began in the nineteenth century) continued, with Byzantine Christianity forming the bridge between a mythologized classical past and the present-day Greek population.[11] In these post-WWII national narratives, the Roman period represented an uncomfortable cultural hiatus, in that, as a foreign invading imperial power, Rome could not be incorporated within a linear history of national development. This had a decisive impact on the study of

Roman archaeology in much of the area in question (with the exception of Istria), a situation that has not changed markedly following the breakup of the former Yugoslavia. Roman sites tended to be examined (if at all) within a passive framework in which buildings and their decoration were studied according to typology and were compared to one another rather than being used to inform wider questions regarding the society that constructed them.

These differing research frameworks, in which archaeological material was used to illustrate preconceived historical narratives, have unsurprisingly led to an archaeological focus on recovering building plans and decorative elements such as sculpture and mosaics rather than the establishment of detailed archaeological sequences relating to the construction phases or use of these buildings. Although there are exceptions to this tendency, the result is that many villas are dated according to very wide or loose chronologies, making it difficult to observe wider regional correlations in villa building with any degree of reliability. Equally, there is an almost total absence of environmental archaeology or faunal-remains study that would better define the types of agricultural regimes that accompanied the villas.[12] Gaffney noted that relatively little had changed in the study of rural settlement in Dalmatia since Wilkes had lamented "the paucity of archaeological evidence" for the topic more than thirty-five years before.[13] Gaffney criticized the work that has occurred since then as "lacking in methodological rigour, ... qualitative in nature and consequently ... limited in analytical potential."[14] Notwithstanding the unsatisfactory evidential base, however, a large number of villas are known from the region and certain themes can be explored regarding the social context of these buildings and the economic systems that supported them.

THE VILLAS OF THE EARLY EMPIRE

As noted in the previous section, the incorporation of these eastern Adriatic regions into the Roman Empire had some effects on settlement patterns,

though not all changes are attributable to historically documented events.[15] The defended hilltop settlements that were characteristic of the region until the third century BCE were often abandoned prior to, or during, the Roman period,[16] or saw settlements move to the more accessible lowlands, though some, such as Radovin near Iader, remained occupied into late antiquity.[17] A similar trend can be observed in farms, and many (although not all) of the fortified farmsteads of the Hellenistic/Illyrian period did not survive into the Roman period. Those that did were often occupied in a way that did not involve significant structural change, with the earlier buildings continuing to be occupied in the Roman period.[18] Interesting examples of this include Malathrea near Butrint in Epirus (Map 17: 21), where a strongly fortified Hellenistic farm with four corner towers, constructed halfway up a steep valley side, survived to the fourth century CE.[19] The earlier structure was subdivided by a number of roughly built walls, which may be associated with this later occupation. Whether occupation was constant, however, is less certain, a point to which I will return.

Some Roman villas do show signs of earlier occupation, although the evidence is seldom conclusive. Although it is sometimes argued that the coastal and lowland locations of the villas were not favored during the pre-Roman period, this perception may relate more to archaeological methods than ancient reality, as the work by Chapman et al. in the hinterland of Zadar suggests Bronze and Iron Age settlement on the lowlands, and a similar picture is suggested by field survey carried out as part of the Adriatic Islands Project.[20] Investigation on some villa sites does suggest that they occupy the sites of earlier settlements. These include the villa at Diaporit near Butrint in Epirus, which was occupied from perhaps the end of the third century BCE, and the villa at Soline Bay on the island of Hvar (Map 17: 19; Map 16: 13).[21] Many of the villas in the area of Narona also seem to have been located at earlier settlements,[22] although the nature of that earlier settlement and its precise relationship to the villas is difficult to ascertain. Given the geographical variation and ancient ethnic diversity of the Adriatic coast,

0 100m

Figure 20.1. Brijuni, Verige Bay villa, plan. The early *villa rustica* is on the south side of the bay. The approximate edge of the current bay is also shown in gray; the black outlines indicate the now–underwater ancient structures (W. Bowden after Schrunk and Begović 2000).

it is clear that no clear *supra*-regional pattern of rural settlement change or development can be envisaged, though in some areas (especially those of the Roman colonies), changes would have been very significant.

During the first century CE, or possibly slightly earlier, the coastal plain and islands of the eastern Adriatic saw the rapid installation of villas. These were particularly prevalent along the western coast of Istria, where there is an average density of almost one villa per kilometer.[23] The villa economy here was significantly different to that further south, with intensive production of wine, olive oil, and sometimes purple dye, as indicated by deposits of murex shells at villa sites.[24] Much of this area of Istria was

under direct ownership of Rome's senatorial aristocracy, as evidenced by stamps on amphorae and tiles and also by epigraphic evidence.[25] This included the Laecanii, who owned the largest amphora workshop in Istria (at Fazana, producing Dressel 6B amphorae). The workshop was subsequently taken into imperial control under Domitian, giving some indication as to the scale and importance of oil production in the region.[26] Most probably the Laecanii owned one of the largest and most elaborate villas on the Adriatic coast, which was built around Verige Bay on the island of Veli Brijun, the largest island of the Brijuni archipelago (Map 16: 5; Figure 20.1). This is the most extensively explored and published of the

Istrian villas and one of the only sites in the region where the late Republican and early Imperial phases have been clearly identified. Amphora stamps of the Laecanii link the Verige Bay villa with other villas that exploited the resources of the Brijuni archipelago, suggesting they were part of a single estate.[27]

The villa at Verige Bay began perhaps around the mid-first century BCE as a *villa rustica* focused primarily on wine production. The first phase, built in a slightly elevated position around 50 m from the shore, was built around a small peristyle, with a long wine storage room with a number of *dolia defossa* (large, half-buried ceramic vessels in which the must fermented into wine) on the east side, the pressing facilities to the south, and modest residential quarters to the east. Perhaps in the mid-Augustan period, this earlier villa was augmented with a major *pars urbana*, or residential quarter, built around a second larger peristyle with a sunken central courtyard. The new rooms included an Egyptian *oecus* (a reception room in the form of a basilica) paved with *opus sectile* and a substantial *triclinium*.[28] Slightly later, the entire complex was extended toward the shoreline where a wide terrace backed by a portico some 80 m long was built, creating a unified façade for the two earlier villa phases. There were a number of elaborate reception spaces with mosaics that would have greeted those arriving by sea. The complex was supplied with water from a well/*nymphaeum* tapping a spring at a higher level a short distance away that also fed a series of cisterns.

Probably during the post-Augustan period, the Verige Bay villa was enhanced by a series of major individual structures that stretched around the north side of the bay. The head of the bay was adorned with three temples (dedicated to Venus, Neptune, and possibly Mars) linked by a semicircular portico. Adjacent to this was what seems to have been an outdoor apsidal *triclinium*, which formed one end of a 150 m long colonnaded *ambulatio* with a central tower. At the eastern end of this structure was a further building interpreted as a library, followed by a massive bath suite connected to a peristyle garden or *palaestra* measuring 54x38 m. In front of the baths was a *piscina* (now submerged), giving the villa a supply of fresh fish. A large industrial complex (little

investigated) primarily devoted to the processing of olive oil occupied the final area of the bay.

Verige Bay in many ways conforms to Xavier Lafon's definition of a true maritime villa, in which the buildings were in direct contact with the sea itself.[29] The sea was an integral part of the architecture of the villa, which was linked to the water by porticoes and other architectural features that were lapped by the waves themselves. These villas were often separated from the productive landscape, although supported by it. Annalisa Marzano has noted that textual sources make a clear distinction between the *villa rustica* as a center of production and the *villa maritima* as a place of luxury and relaxation, although she suggests that the reasons for this may be ideological, based on the perceived superiority of the *villa rustica* as a means of generating socially acceptable wealth.[30] Certainly at Verige Bay, this separation was not apparent, with the *pars rustica* of the original villa remaining fully operational as the *pars urbana* became ever more elaborate and the second major agricultural complex was built across the bay, together with the *piscina*. It is clear that large-scale productive activity continued throughout the life of the villa, recalling the links of agricultural and marine production with social status familiar from the pages of Varro.[31]

The Brijuni archipelago also has evidence of salt production and quarrying together with six *villae rusticae*, which have seen varying degrees of excavation. The villa at Kolci recalls the first phase of the Verige Bay villa, being built around three sides of a courtyard with the southeast and northeast wings occupied by productive facilities including tanks and pressing beds (Map 16: 6; Figure 20.2). It seems to be primarily devoted to the production of olive oil.[32] A similar villa has been identified in the late-Roman fortified settlement of Castrum (discussed further later), although in this instance the original *villa rustica* was expanded with a range of small rooms interpreted by the excavators as slave quarters, as well as a *fullonica*. The latter was a facility for the laundering and dying of cloth, with remains at some sites possibly representing a primary stage in the production of cloth.[33] The original activity at the site seems to have been wine and subsequently expanded to include oil,

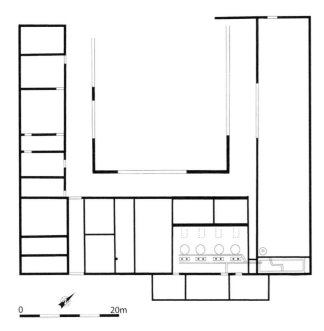

Figure 20.2. Kolci, villa, plan of the complex. Productive facilities are concentrated in the eastern part with a large storage room forming the northeastern wing of the villa (W. Bowden after Matijašić 1982).

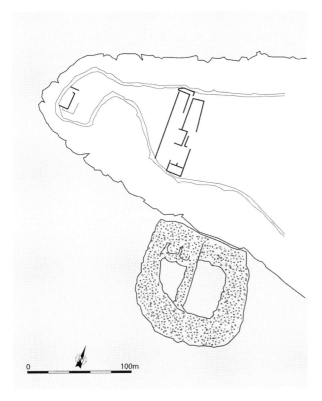

Figure 20.3. Katoro, villa occupying the promontory, with evidence of a substantial *piscina* (W. Bowden mainly after Begović Dvoržak and Dvoržak Shrunk 2004).

though the phasing of the site, never conclusively published, is uncertain.[34]

In 2004, Vlasta Begović Dvoržak and Ivančica Dvoržak Schrunk identified a further nine villas on the Istrian coast that they suggest conform to Lafon's definition of a *villa maritima*, although they note that some of these villas show evidence of extensive productive activity as well as architectural elaboration. They include two villas in the hinterland of the colony of Tergeste (mod. Trieste). One, at Katoro, occupies much of a promontory and incorporates an impressive system of terraces (Map 16: 2; Figure 20.3). The rooms were decorated with mosaics and marble veneers; there was a large *piscina* (now submerged) to the south of the promontory.[35] The second, at Fornače, was largely destroyed during the construction of a soap factory but preserves traces of a *fullonica* together with structures built in *opus reticulatum*, a building technique possibly indicating high-status buildings (see later in this chapter). Meanwhile at Valbandon, on the mainland a few kilometers from Brijuni, an elaborate villa was built on both sides of a narrow bay, part of which was seemingly enclosed to form a *piscina* supplied with water by a stream (Map 16: 8; Figure 20.4). Here, too, there was evidence of other productive activity – parts of olive presses were found in the vicinity.[36]

Production was also a key element of the villa estate at Barbariga, which was probably one of the largest oil-producing estates in early imperial Istria. Four sites with oil production facilities were noted within a 2 km² area, including one with twenty olive presses. The area also has evidence for a *fullonica* with evidence of murex shell processing nearby.[37] The fact that multiple productive sites are located within a relatively small area has some implications for the running of the estate. The Laecanii amphora stamps, as well as naming the estate owners, also mention a large number of *vilici* who were seemingly managers of different parts of the estate, and the individual villas in the Brijuni and Barbariga estates were perhaps each overseen by a *vilicus*.[38]

At Barbariga, unlike the Verige Bay villa, there is no evidence for productive activity at the main residential complex on the waterfront (Map 16: 4;

Figure 20.4. Valbandon, villa
built on both sides of a bay that
was also used as a *piscina* (W.
Bowden after Matijašić 1998).

0 100m

Figure 20.5). This stretched across 120 m of the
western shoreline of a promontory. The earlier
wing of the building, apparently dating to the first
century CE, was based around a portico almost 70 m
long, fronted by a flight of steps c.50 m wide that led
down to the water. The later wing of the villa, which
included a bath complex, was built around
a peristyle, the fourth side of which had no buildings,
allowing an uninterrupted view of the sea from atop
a wide flight of steps which led directly from the
peristyle to the shore.[39] Even the Barbariga and the
Brijuni villas, however, were eclipsed by one that
was possibly the largest on the entire eastern Adriatic
coast, covering the promontory of Vizula at the
southern tip of Istria. Built across three terraces and
now partly submerged, its remains are visible along
a kilometer of the shoreline, and it seems to have
covered an area of around 10 ha. Partial excavations
have revealed mosaics and grandiose porticoes, giv-
ing some idea of the grandeur of the complex.[40]

Like Verige Bay, other maritime villas on the
Istrian coast also appear to have been associated
with productive estates. Of particular interest is that
located slightly to the north of the colony at
Parentium (mod. Poreč), where the bay of Cervar-
Porat has proved to be the location of a major site of
amphora, tile, and *terra sigillata* production. Stamps
on these products confirm that the owners of this

estate were Sisenna Statilius Taurus (consul in 16 CE)
and later Calvia Crispinilla (one of Nero's more
notorious mistresses), although from the reign of
Domitian the stamps indicate imperial control of this
activity.[41] On the north side of the bay, at Loron,
there was a major waterfront complex some 180 m
long with a linear complex of multiple rooms, part of
which formed a substructure for a raised terrace in
the *basis villae* associated with a peristyle complex on
the slope behind (Map 16: 3; Figure 20.6).[42]
Although in plan it appears to be a monumental
villa based around a central courtyard or garden
some 50 m wide, recent excavations suggest that
most of the complex appears dedicated to produc-
tion, with multiple furnaces present in many of the
rooms.[43] The entire area, including the adjacent bay
of Santa Marina, appears to have been the focus of
intensive activity, with a massive structure, possibly
a *vivarium* for fish farming, clearly visible under the
water at the western end of the Santa Marina bay.
This *vivarium* (together with others on the Istrian
coast) may have been connected with the industrial
production of fish sauce (*garum*, *liquamen*) rather than
merely supplying fresh fish with which a villa owner
could impress his guests.[44] The Loron site reminds us
to be wary of too rigidly interpreting these coastal
complexes as mere luxury villa sites for delectable
residence.

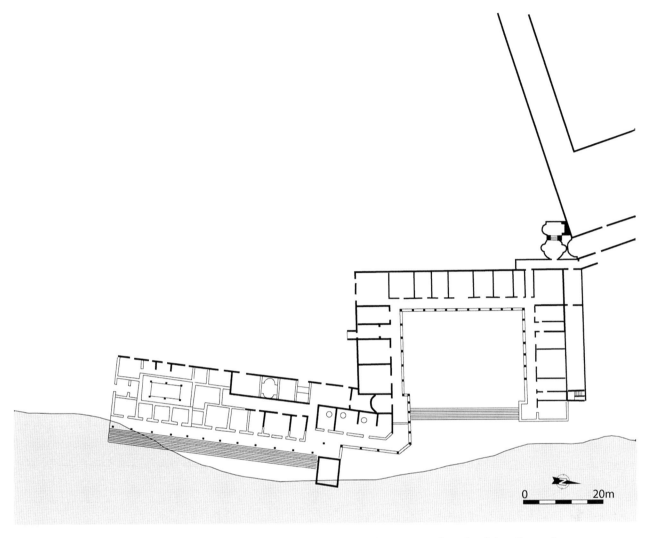

Figure 20.5. Barbariga, villa, with the earlier wing on the left (south) side (W. Bowden after Schwalb 1902).

The *villae maritimae* of the Istrian coast were the most spectacular aspect of the region's villas, but there are also numerous examples of *villae rusticae* (with varying degrees of architectural elaboration) suggesting intensive productive activity. Xavier Lafon saw such villas as part of a hierarchical structure in which they supported the true *villae maritimae*, which were essentially nonproductive in nature, an interpretation that has been supported by Vlasta Begović Dvoržak and Ivančica Dvoržak Schrunk, even though the presence of major production facilities at, or close to, most of the *villae maritimae* suggests that this division was by no means constant.[45] The majority of sites identified as villas by

Marina De Franceschini in her survey of the villas of *regio* X were on or very close to the coast, although this is likely to relate as much to the archaeological visibility of structures as it does to site distribution.[46] One of the few non-coastal Istrian villas for which a plan is known is a small *villa rustica* at S. Domenica di Visinada, a short distance to the northeast of the colony of Parentium (modern Poreč) and within the zone of centuriation associated with the Roman colony (Map 16: 11; Figure 20.7). The villa, which measures no more than 20 m across, comprises a complex of six rooms laid out around a portico with an *impluvium*. The building was not elaborately decorated, with simple pavements of *opus*

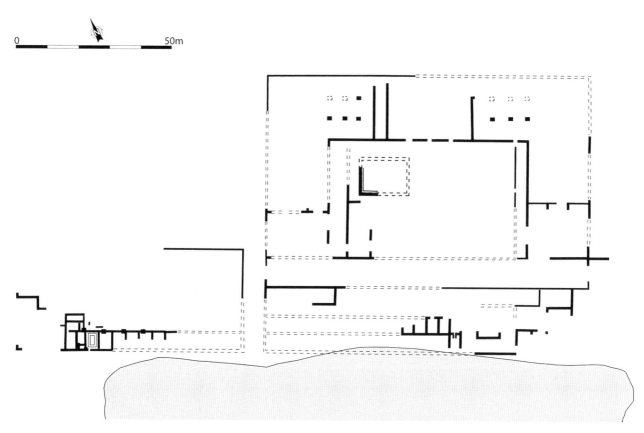

Figure 20.6. Loron, *villa rustica*, plan (W. Bowden after Kovačić et al. 2011).

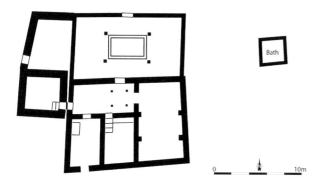

Figure 20.7. S. Domenica di Visinada, villa, one of the
few inland villas in Istria for which a plan is known
(W. Bowden after Babudri 1920).

signinum, *opus spicatum*, and brick *tesserae*. There
was evidence of an olive mill and an inscription
datable to 176 CE, which named the owner as
a freedman named Sextus Appius Hermias.[47]

Other *villae rusticae* for which partial plans have
been recovered have been found in the region of

Pula. These include a villa at Šijana, at which the
residential rooms and those associated with agricul-
tural production appear intermingled (Map 16: 9;
Figure 20.8). The villa was based around
a courtyard, which led on to a small *triclinium* that
was apparently flanked by a granary, with a long
stable block forming the northeast side of the court-
yard with a cowshed to the south.[48] Evidence of oil
production was found in the form of a press and large
dolia.[49] A building of similar size was found at Šaraja, to
the north of Pula (near the village of Peroj), the north
wing of which was used for olive oil production with
evidence for presses, an olive mill, and large tanks for
the settling of sediment (Map 16:10; Figure 20.9).[50]
There are at least thirty sites in the region of Pula that
have evidence of oil production, and a similarly
intense level of activity was noted in the territory of
Tergeste, with no less than seventeen rural complexes,
of which eleven were luxury villas with productive
quarters, with the other six thus far having evidence

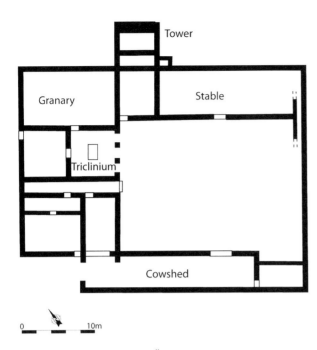

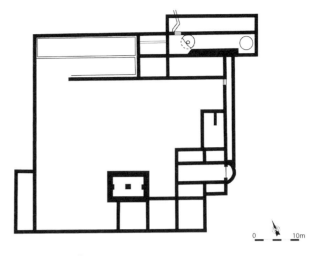

Figure 20.9. Šaraja, *villa rustica*, plan (W. Bowden after Matijašić 1982).

Figure 20.8. Villa rustica at Šijana (the interpretations of the room functions are those of the excavator) (W. Bowden after Matijašić 1982).

only of productive activity.[51] Dating evidence for these sites is very limited, although Robert Matijašić suggests that the remains point to intense activity between the first and third centuries CE, driven initially by the arrival of colonists who were allocated land in the territory of Pula.[52]

As well as the *villae maritimae* and possibly associated *villae rusticae*, a number of *villae suburbanae* have been noted, including a spectacular example at Barcola on the outskirts of Tergeste (mod. Trieste; Map 16: 1).[53] The villa seems to have developed from a relatively modest building with an atrium and peristyle to a vast complex including a large garden, a *nymphaeum*, and a so-called *palaestra*. The villa featured extensive use of *opus sectile* pavements and mosaics. A possible productive area was not explored. Tile stamps suggest that the villa was owned by P. Clodius Quirinalis, who was prefect of the fleet at Ravenna during the reign of Nero.[54] A further complex, including a colossal semicircular *exedra* with radiating rooms and a bath house, may have been part of a major maritime wing of the villa, or possibly a separate villa altogether.[55] Other possible suburban villas have been recognized at Pula and further to the

south at Erešove Bare near Narona, although there is no understanding of the role played by such complexes in the economic life of the *coloniae*.[56]

Istria was exceptional in the scale and density of its coastal villas. The coasts of Dalmatia and Epirus, although in some areas very similar to that of Istria in terms of opportunities for agricultural exploitation, did not see the same level of villa construction. The region immediately to the south of Istria as far as the colony of Iader has seen little exploration of villa sites, although a number are known, particularly on the islands.[57] These may have included one of the estates of the Calpurnii Pisones from epigraphic evidence from the island of Pag and elsewhere.[58]

By contrast with the region around Iader, the picture from southern Dalmatia suggests intense exploitation of the landscape in the hinterland of Salona and the adjacent islands, with widespread production of wine, olive oil, and also salt.[59] Adam Lindhagen argues for major production of Lamboglia 2/Dressel 6A wine amphorae in the region, probably centered on the island of Issa, for the export of huge quantities of wine from the region.[60] The Adriatic Islands Project noted numerous wine and olive presses, as well as frequent cisterns, indicating irrigation to support intensive agricultural production. Of particular interest is the evidence from the small island of Šćedro (which lies to the south of the larger island of Hvar), where there was a major coastal villa

with evidence of mosaics and a possible *vivarium* (fishpond). There were also traces of a Roman farm in the interior but, most intriguingly, Roman material was found in the collections of stones removed during plowing that are deposited along the edges of the fields across the islands, suggesting that the clearance of the fields occurred during the Roman period. This has led Vincent Gaffney to speculate that the island effectively formed a single estate, with a luxury residence and a further settlement housing the field hands.[61]

The area around Narona, particularly to the north and along the valley of the Naro, saw intensive activity in areas similar to those that had seen the most intensive activity in the pre-Roman period. Villas seem to have been numerous, though few have been coherently excavated.[62] One of the most substantial is a *villa rustica* at Dračevica (Map 16: 16). Covering an area of more than 60 m², there are ten rooms known of a larger complex.[63] The Dračevica villa had large amounts of imported tiles produced at the *figlina Pansiana* and C. Titius Hermerotis' workshops on the northern Adriatic coast. The Pansiana workshop was probably located in the delta of the Po valley and was under direct imperial control from the reign of Augustus until the reign of Vespasian, when production apparently ceased. *Pansiana* stamps have also been found at another impressive villa at Dretelj on the Naro, which had mosaics, marble veneers, and painted plaster, although no plan of the villa is known, and also in the area of Vitaljina, located in the Naro valley as well.[64] *Pansiana* stamps are by far the most dominant of the imported stamps in the region; they may indicate that the imperial tilemakers kept an eye on villa-construction along the coast and inland and sent their products to where there was a good market for them.[65]

As in Istria, it is the major maritime villas in southern Dalmatia, of which there are a number of examples on both the mainland and the islands, that have seen the greatest level of archaeological attention, although excavation remains piecemeal. These include a substantial site at Stari Trogir, 22 nautical miles (just over 40 km) to the west of Salona, where a villa was built on a series of terraces running around a semicircular bay (Map 16: 12). Of special interest

was a circular structure, interpreted as a fishpond, built within a series of rectangular compartments recalling similar structures from Italy.[66] Another villa at Sustjepan close to the Roman colony at Epidaurum was also built over a series of terraces and included some evidence of productive activity in the form of storerooms.[67] Elsewhere there is little evidence of productive activity at the *villae maritimae* of the region, although further excavation may prove otherwise.

As well as the *Pansiana* brick stamps in the region of Narona, there is possible evidence of imperial involvement in the supply of materials and craftsmen to the region in the form of a very substantial *opus reticulatum* wall used at a villa at Lumbarda on the island of Korčula (Map 16: 14), a building technique rare in domestic building in the region.[68] Use of *opus reticulatum* is very unusual on the eastern side of the Adriatic, first appearing in the Actium monument at Nikopolis, where Malacrino argued its use was indicative of the presence of Italian workers, so its appearance in the construction of a villa may well indicate the same.[69]

Moving southward, the situation of Roman villas in Epirus (an area divided between the modern states of Albania and Greece) is less clear, though again the lack of evidence may be due to the level of research and the bias of researchers toward other topics. However, the often unrelenting and precipitous rocky coastline of much of this region was less suited to villa building than the bays and islands of Istria and Dalmatia, although one would expect to find numerous villas in the area of Dyrrhachium (mod. Durrës).[70] There are, however, a number of villas that have now been recognized around the Roman colony of Buthrotum (mod. Butrint) and on the nearby Ionian island of Corfu.[71]

The most fully excavated of the Epirote villas is that of Diaporit on the shore of Lake Butrint (Map 17: 19; Figure 20.10). The villa, which faces west toward the town of Butrint, has its origins in the Hellenistic period, probably the late third or early second centuries BCE. It was an undefended lowland site, quite different from the fortified farmsteads that characterized the region in the fourth and earlier third centuries BCE. In the late Augustan/

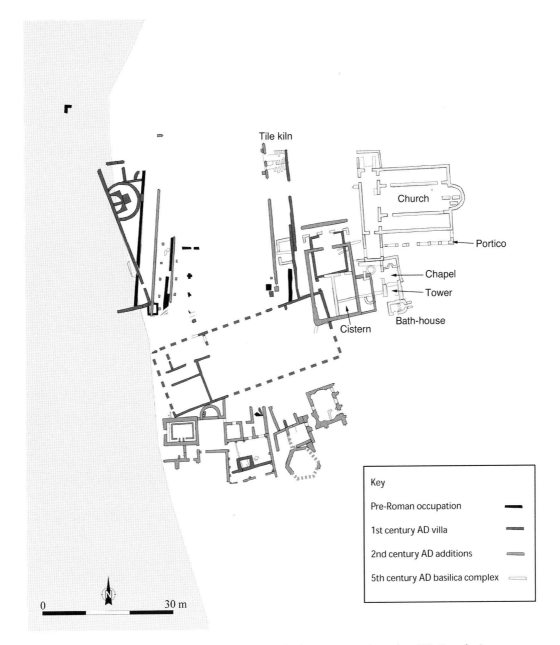

Figure 20.10. Diaporit (Butrint vicinity), the Roman villa and Christian complex, plan (W. Bowden).

early Tiberian period, further structures were built on the shoreline, though few remain. Around 40–80 CE, a larger and more grandiose villa replaced these buildings (Figure 20.10 upper). The new structures were constructed on a different orientation to those that preceded them and were seemingly built with the deliberate intention that they should face directly toward the city of Butrint. The villa was built on a series of terraces

around a garden or peristyle on the lower terrace. The west wing, closest to the water, also contained a large apsidal fountain, probably supplied with water by a spring that issued from the hills to the rear of the site (Figure 20.11). Although the waters of the lake have risen since antiquity, it is likely that the buildings of the villa extended out into the water, creating the direct relationship that for Lafon characterizes the true *villa maritima*.[72]

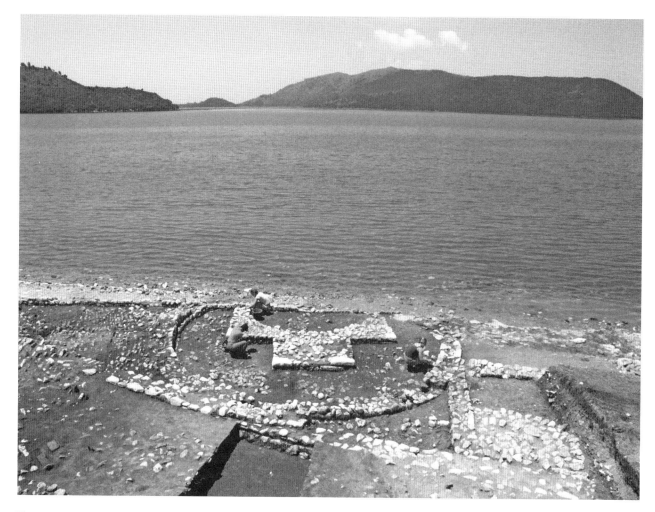

Figure 20.11. Diaporit (Butrint vicinity), Roman villa and Christian complex at Diaporit near Butrint: large apsidal fountain (*nymphaeum*) of the villa (W. Bowden). (A black and white version of this figure will appear in some formats. For the color version, please refer to the plate section)

The eastern wing of the villa was built on an upper terrace and included what was probably an opulent dining or reception room that allowed a view across the central garden to the lake beyond. This room was paved with a geometric mosaic that framed a large rectangular panel of *africano* marble (Figure 20.12). The south wing comprised a bathhouse, although its earliest elements were largely buried beneath later phases. From 100 to 200 CE, there was almost continuous construction work on the villa. The terracing system became more sophisticated to accentuate the height of the buildings, while the bath complex became progressively more grandiose. In its last phases (c. 200 CE), it boasted a large apsidal room with a plunge bath and

a hexagonal room in a dominant position on the upper terrace. The excavations revealed no sign of any productive activity, and it seems clear that the sole function of the building was as a luxury residence. It seems likely that it was only intermittently occupied (perhaps on a seasonal basis), given that it lies in a very exposed position on the lake, often making it difficult to land boats there.

Between 200 and 250 CE, Diaporit was apparently abandoned as a luxury residence. All the marble was removed from the rooms, and a small oven was inserted into the *frigidarium* of the bathhouse. A crude door was cut between the *frigidarium* and an adjacent room with a hypocaust. Refuse from this secondary use of the bath was

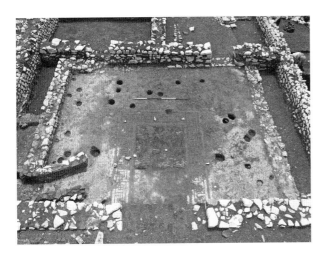

Figure 20.12. Diaporit (Butrint vicinity), Roman villa, reception room on the upper terrace showing mosaic pierced by post-holes dating to the third century (W. Bowden).

thrown through the doorway and rapidly accumulated above the hypocaust. On the upper terrace, some wooden buildings were constructed, with post-holes cut through the mosaic of the reception room mentioned earlier. A further small keyhole-shaped oven or furnace was subsequently built in the corner of this room (Figure 20.12). After 250 CE, it appears that the complex was abandoned completely before the site was reoccupied in the fifth century.

None of the remaining coastal villas of the region have been excavated to any extent, but it is clear that many of the known examples have characteristics in common with Diaporit. As well as views over water, those sites that can be identified as villas include bath complexes with polygonal rooms, extensive use of terracing, and often the presence of natural springs for abundant supplies of fresh water. These features can be seen at probable villas at Riza (on the coast to the north of Nikopolis), Strongyli (on the Ambracian Gulf), and Benitses and Acharavi (on the island of Corfu) (Map 17: 18, 20, 23–4). The extensive remains at Ladochori near Igoumenitsa may also belong to a major coastal villa (Map 17: 22), which featured an elaborate *mausoleum* containing highly decorated sarcophagi.[73]

TRANSFORMATIONS IN LATE ANTIQUITY

Although the dating of many of the villas described above is unreliable, they seem to have been primarily a phenomenon of the late first century BCE into the second century CE. However, a number of the villas have evidence of late Roman phases. These include the villas of Valbandon, Barbariga, and Vizula and others described in greater detail in this chapter.[74] Many of the possible villas in the area of Narona also have evidence of late antique occupation, although detailed excavations are lacking.[75] It should not be assumed that there was necessarily direct continuity of occupation between the earlier and later phases. As noted earlier, at Diaporit in Epirus, the villa was seemingly abandoned around 250 CE, with no direct continuity between the villa and the Christian site of the fifth and sixth centuries.

In 537 CE, Cassiodorus wrote that:

What Campania is to Rome, Istria is to Ravenna – a fruitful province abounding in corn, wine, and oil; so to speak, the cupboard of the capital. I might carry the comparison further, and say that Istria can show her own Baiae in the lagoons with which her shores are indented, her own Averni in the pools abounding in oysters and fish. The palaces, strung like pearls along the shores of Istria, show how highly our ancestors appreciated its delights. The beautiful chain of islands with which it is begirt, shelter the sailor from danger and enrich the cultivator.[76]

It is intriguing that Cassiodorus writes of the "palaces" as creations of the past, but notwithstanding some rhetorical flourishes, it seems that Istria was still a highly productive landscape. However, the relationship between the villas and their settings was clearly changing. Many of the sites show evidence of significant quantities of wine and oil being imported from the Aegean and North Africa, indicating that their inhabitants were no longer being wholly supplied with these staples from their immediate hinterlands.

At the same time, as is the case in many other places in the Roman Empire, there is evidence of rural productive activity moving into the urban centers: Late antique oil presses have been found in urban areas in recent excavations in Poreč, Pula, and Umag.[77]

On the larger of the Brijuni islands, the villa at Verige Bay clearly saw some activity into the sixth century and possibly later. The excavator, Anton Gnirs, suggested that the central apsidal room of the bath complex on the north side of the bay (perhaps a *triclinium*) was converted into a church in the late fourth century, with the adjacent *frigidarium* used as a baptistery. Christian burials in sarcophagi were found outside the apse. There were other undated changes to the main residential complex, including the construction of a lime kiln in the peristyle of the *pars urbana*. Marble from Verige Bay may have been reused in the episcopal complex in Poreč, although there is no obvious use of decorative *spolia* from the villa elsewhere in Brijuni.[78] Late Roman pottery including Late Roman 1 amphorae and Phocaean Red Slipware have also been found in the harbor, while the main residential building on the south side of the bay contained fragments of Late Roman 1 and Late Roman 2 amphorae. Late Roman amphorae have also been noted at the Kolci Hill *villa rustica*.[79]

The most striking late Roman activity on the Brijuni islands comes from the site of Castrum, where a *villa rustica* was surrounded by a wall circuit at an unknown late Roman date to create a fortified site that was densely inhabited in the sixth and seventh centuries (Figure 20.13). The villa included late Roman olive presses but also had amphorae showing importation of oil, wine, and fish sauce from Tunisia and other parts of the Mediterranean, suggesting that local supply was not sufficient at certain points. There were also large quantities of Aegean slipware and African Red Slip.[80]

Most of the datable late Roman pottery finds from the Brijuni villas have not been recovered from stratified archaeological contexts and so indicate little more than that there was activity on these sites between the fourth and late sixth centuries. However, they show the extent to which these sites were connected to supply networks originating in both the Eastern Mediterranean and North Africa,

the latter perhaps via Ravenna. It is possible that Castrum along with other similar island sites on the Adriatic was garrisoned and connected to the Byzantine military supply networks in the second half of the sixth century, as seems to have been the case at the Byzantine enclave at Koper slightly to the north.[81]

Other villas on the Adriatic coastline have similar late phases. At Polače, on the island of Mljet close to Narona, an earlier villa was dramatically embellished in the late Roman period with an impressive two-story apsidal building with polygonal corner towers on the façade (Figure 20.14). This seems to have been at least in part an audience hall, reflecting the late Roman development of second-story reception rooms.[82] It is often associated with a certain Pierius, an official of the Ostrogothic king Odacer, who is recorded as giving the island to him in 489 CE, although it has recently been argued that the apsidal building is more likely to date to the fourth century and was associated with the emperors Licinius or Galerius.[83] It may have had a military function in the sixth century, and a late-antique fortification and two early-Christian churches have been noted. Amphorae and slipware from North Africa and the Aegean again indicate that basic products such as oil and wine were being imported, although whether this indicates permanent residence or sporadic use of the site is not known.[84]

The character of villas in late antiquity was clearly very different to those of the early empire, which were predicated on both luxury living and intensive production. Although there are sites such as that at Polače (Figure 20.14) that clearly continued to function as elite residences, others are characterized by the subdivision of buildings into smaller residential units and the insertion of burials (for example, in the latest phases at Loron and also at Sustjepan), phenomena that have been recognized in formerly grand houses elsewhere in the Roman empire. Another common feature in many of the villa sites on the Adriatic and Ionian coasts is the appearance of Christian churches, which became one of the predominant mechanisms for elite display from the mid-fifth century.[85] Numerous early-Christian buildings have been

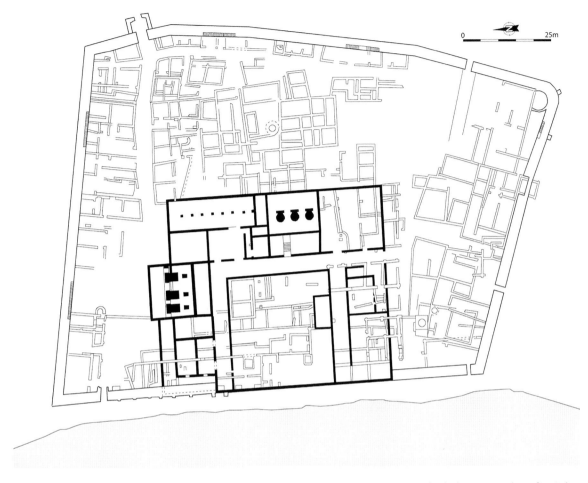

Figure 20.13. Castrum, late-antique fortified complex, plan, with the original *villa rustica* shaded (W. Bowden after Schrunk and Begović 2000).

partially excavated or recognized and many are associated with the sites of earlier villas.[86] Of the villas noted in this section, as well as the possible church noted by Anton Gnirs at Verige Bay, churches have been found at, or close to, Katoro and Fornače, with that at Katoro associated with a major late-Roman cemetery.

The relationship between the villas and Christian churches is by no means straightforward, as the case of Diaporit in Epirus clearly shows. There, a three-aisled basilica was constructed in the late fifth century on the remains of a villa that had been abandoned as a luxury residence almost 250 years earlier (Figure 20.10, light shading). The villa itself was extensively quarried for building materials. The church was built to house three tombs that were almost entirely emptied of their contents in the later Middle Ages. Only a single

leg remained, which gave a calibrated radiocarbon date range of 80–250 CE, suggesting the tombs had been used to house the bodies of individuals treated as Christian martyrs in the persecutions of the second and third centuries. The martyrdom of St. Therinus is recorded as having taken place in an as yet undiscovered amphitheater at nearby Butrint in 251 CE, although the earliest documentary source dates to the ninth century. A major cult site dedicated to the Forty Martyrs of Sebaste was also located at the port of Saranda (ancient Onchesmos) some 18 km to the north, and it is clear that martyr cults became key points in the late antique landscape.[87] The church at Diaporit was accompanied by a complex that suggested a small hostel for pilgrims, which also had a productive aspect or at least storage facilities evidenced by the remains of numerous *dolia* fragments.

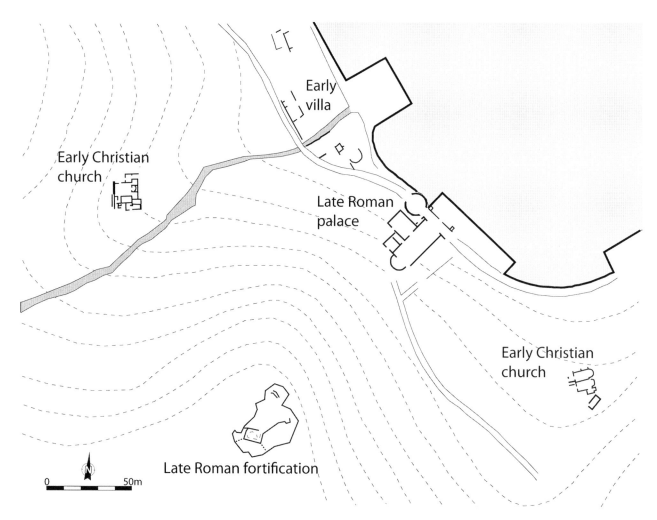

Figure 20.14. Polače, late-antique site, plan (W. Bowden after Turković 2011).

Burials in the villa bathhouse seem to have accompanied the latest phase of this Christian complex, which was abandoned about 550 CE.

The evidence from Diaporit certainly does not suggest that the church belonged to the latest phase of the villa, but rather that the site of an abandoned villa was used and quarried for the construction of a later, possibly unrelated, Christian complex. However, although the residential buildings at Diaporit had long since been abandoned, it is still possible that the site remained part of a coherent property and was thus available to be used to express the elite mores of the late fifth and sixth centuries. The relationship between the villas of the early Empire and the Christian buildings that appear on

them in late antiquity is a matter for further archaeological work.

CONCLUSION

Although villas can be found along the length of the long coast of the Adriatic and Ionian seas and its numerous adjacent islands, there were marked regional variations in the density of villa distribution and scale and opulence of their construction. While some of the variation in distribution may well be simply due to twentieth- and twenty-first-century research priorities, it is clear that the villas of Istria were built to a scale and level of luxury that was not replicated anywhere else on this stretch of coast. The reasons for

this stark difference may partly lie in the fact that Istria, as part of *regio* X of Italy, had closer links to the senatorial aristocracy of Rome than other parts of the eastern Adriatic. However, textual and epigraphic evidence indicates that Roman senatorial families held estates on the coastlands of Dalmatia and Epirus as well, so this could not have been the only factor. Shifts in landholding patterns must also have been important: the colonies of Pula and Parentium had vast associated territories by comparison with the colonies south of Istria. The sheer size of the major estates may have been a factor in generating the wealth that enabled their proprietors to create such grandiose architectural visions on the bays and islands of Istria. By contrast with some of the Italian *villae maritimae* that were wholly devoted to the pursuit of *otium*, many of the Istrian villas give good evidence for extensive production of oil and wine.

Many of the villa sites in question were excavated in the late nineteenth century, and few have been investigated with sufficient precision to allow more that the broadest outlines of their construction phases and chronologies. However, the most grandiose buildings seem to belong to the first and second centuries CE. Although many have traces of late antique occupation, evidence for this late building indicates that these sites fulfilled a very different role in the late Roman period. In particular, there is evidence for significant importation of staple products like wine and oil that in the early Empire would have been produced on an industrial scale in the region. The villas of late antiquity were clearly consumers as much as they were producers, perhaps suggesting the presence of garrisons connected to the military supply networks of the late Roman Mediterranean. In addition, the widespread evidence of Christian building suggests that the villas were architecturally very different from the villas of the early Empire, which by the fifth and sixth centuries had become primarily sites that could be quarried for ordinary or exotic building materials. Cassiodorus's "palaces, strung like pearls along the shores of Istria" and the other villas of Dalmatia and Epirus were ultimately the products of a highly specific and relatively short-lived socioeconomic system.

NOTES

1. Wilkes 1969, 29–31.
2. Bowden 2011; Wilkes 1969, 231.
3. Wilkes 1969, 226.
4. Kirigin 2006.
5. Doukellis 1988.
6. Hjort Lange 2009, 100–2.
7. Giorgi 2002; Giorgi 2003.
8. Cic., *Att.* 1.5, 2.6; Varro, *Rust.* 2.1.1–2; 2.2.1.
9. Lindhagen 2009, 100–1; Tassaux 1982.
10. Kaiser 1995.
11. Bowden 2003, 22–6.
12. This is now changing. Work at the villa of Loron, for example, includes publication of some faunal remains: Brajković and Paunović 2001.
13. Gaffney 2006, 89; Wilkes 1969, 394.
14. Gaffney 2006. 89.
15. Bowden 2008.
16. Wilkes 1992, 190–2.
17. Batović 1968.
18. This perception may be skewed by elements in wood or other perishable materials not recognized with archaeological techniques not yet designed to record them.
19. Çondi 1984.
20. Zadar hinterland: Chapman et al. 1996; Adriatic Islands Project: Gaffney 2006, 91–3.
21. Diaporit: Bowden and Përzhita 2004; Soline Bay: Kirigin et al. 2010.
22. Prusac 2007, 143–59.
23. Begović Dvoržak and Dvoržak Schrunk 2004, 66. Anton Gnirs carried out much of the early work on the villas of Istria with reports published almost annually in the *Jahreshefte des Österreichischen Archäologischen Instituts* from 1902 to 15. The most comprehensive recent treatment, listing primary bibliography on all sites, is that of De Franceschini 1998. Other syntheses can be found in Matijašic 1982, with lengthier treatments (in Serbo-Croat) in Matijašic 1998. A fairly complete list of the maritime villas of Istria can also be found in Lafon 2001, 454–9, with more complete descriptions of many of these in Begović Dvoržak and Dvoržak Schrunk 2004. Begović et al. 2009 provide a further list with additional data on the Adriatic islands.
24. On the question of *fullonicae* in Istria, see Tassaux 2009, who argues that many sites have been

mistakenly identified and were in fact associated with wine and oil production or possibly salt production.

25. Tassaux 2003.

26. Tassaux 2003: 102; Verzár-Bass 1986, 651–4.

27. Bezeczky 1995; Bezeczky 1997. There is a very extensive literature on the Verige Bay villa. It is usefully summarized, together with the evidence for the *villae rusticae* on the Brijuni islands, in Schrunk and Begović 2000.

28. The name Egyptian *oecus* derives from Vitruvius's description of this type of room (*De Arch.* 6. 3. 9).

29. Lafon 2001, 4. Lafon separates his maritime villas from coastal villas (*villas littorales*), a device that, although typologically convenient, does not fully reflect the use of the term *villa maritima* in ancient sources. See Marzano 2007, 15–16, for a less strict application of the term, effectively encompassing any villa near the sea. Marzano also notes that villas on lakes could also be described in the sources as *villae maritimae*.

30. Marzano 2007, 19–22.

31. Purcell 1995.

32. Wine production has also been suggested; Schrunk and Begović 2000, 265–8; Bezeczky 1997, 58–62; Matijasic 1982, 54–5.

33. On *fullonicae* in general, see Wilson 2003, with references. For *fullonicae* in Istria, see Tassaux 2009.

34. Schrunk and Begović 2000, 267–8; Bezeczky 1997, 62–8.

35. De Franceschini 1998, 443–4; Begović Dvoržak and Dvoržak Schrunk 2004, 76; on the fishpond (*piscina*): Carre and Auriemma 2009.

36. De Franceschini 1998, 677–94; Begović Dvoržak and Dvoržak Schrunk 2004, 68; Matijasic 1982, 59–60.

37. Schwalb 1902; Begović Dvoržak and Dvoržak Schrunk 2004, 68.

38. Bezeczky 1997, 69–71.

39. De Franceschini 1998, 589–618; Schwalb 1902.

40. Begović Dvoržak and Dvoržak Schrunk 2004, 72; Džin 1995; Džin 2011, 101–3.

41. Tassaux 2003, 98; Tassaux et al. 2001, 315–21.

42. Tassaux et al. 2001.

43. This recent work by a collaborative Croatian-French-Italian mission began in 2003 and has published annual reports in the journal *Histria Antiqua*. D'Incà et al. 2010 for full bibliography of this project to date.

44. Carré and Auriemma 2009. I am grateful to Annalisa Marzano for bringing this volume to my attention.

45. Lafon 2001; Begović Dvoržak and Dvoržak Schrunk 2004, 65–8.

46. De Franceschini 1998.

47. Babudri 1920; De Franceschini 1998, 484–6.

48. Matijašić 1982, 60–61. The villa was excavated in the early 20th century and the evidence for identifying the functions of these rooms is not wholly clear.

49. Matijašić 1982, 60–61.

50. Matijašić 1982, 61–2.

51. Region of Pula: Bezeczky 1997, 45; Trieste region: Fontana 1993, 196.

52. Matijašić 1982, 62–3.

53. Fontana 1993; De Franceschini 1998, 694–742.

54. Fontana 1993.

55. De Franceschini 1998, 733; Fontana 1993, 733.

56. Begović and Schrunk 2003, 102.

57. Begović Dvoržak and Dvoržak Schrunk 2004, 78–9.

58. Wilkes 1969, 331.

59. Zaninović 1995.

60. Lindhagen 2009.

61. Gaffney 2006, 104.

62. The evidence is summarized in Basler et al. 1988. See also the useful gazetteer in Prusac 2007.

63. Wilkes 1969, 397.

64. Dretelj villa: Wilkes 1969, 396–7; area of Vitaljina: Prusac 2007, 152.

65. Other workshops are represented in the Narona region. There is a very extensive bibliography on the brick stamps of Istria and Dalmatia, helpfully listed by Pedišić and Podrug 2008.

66. Begović Dvoržak and Dvoržak Schrunk 2004, 79.

67. Begović Dvoržak and Dvoržak Schrunk 2004, 79.

68. Kilić-Matić 2004, 98–9.

69. Malacrino 2007; Bowden 2011, 107.

70. This is particularly true given the rampant commercial and private construction along the coast in the Durrës area in the first decade of the twenty-first century, although there is little incentive for builders to report archaeological discoveries.

71. Bowden and Përzhita 2004.

72. Lafon 2001, 3–4.

73. Publication of these sites is limited. Full references can be found in Bowden and Përzhita 2004.

74. Begović Dvoržak and Dvoržak Schrunk 2004; Girardi Jurkić et al. 2010.

75. Prusac 2007, 143–59.

76. Cassiod., *Var.* 12.22.

77. Matijašić 2007. The "ruralisation" of the late-antique city is now widely recognized; see Métraux (Chapter 21) in this book.

78. Gnirs 1915, 141, n. 11; Schrunk and Begović 2000, 274.

79. Bezeczky 1997, 55–62; Begović and Schrunk 2011.

80. Bezeczky 1997, 67–8.

81. This supply network is discussed by Reynolds 2004, 241–2.

82. Polci 2003.

83. On Pierius, see Hodgkin 1885, 141, 170. The fourth century date was suggested by Turković 2011.

84. Begović Dvoržak and Dvoržak Schrunk 2004, 85.

85. Bowden 2008.

86. The bibliography on these sites is very extensive. Many, however, are helpfully listed with earlier bibliography in the gazetteer in Chevalier 1995.

87. For the martyrdom of Saint Therinus (recorded by Bishop Arsenios of Corfu): Soustal 2004, 20 (with references). For the Church of the Forty Martyrs in Saranda, see Mitchell 2004.

PART III

ROMAN VILLAS
Late Antique Manifestations

21

LATE ANTIQUE VILLAS
Themes

GUY P. R. MÉTRAUX

INTRODUCTION

Villas and their plans, decoration, and furnishing were lively matters for elites in the late antique period (third through the fifth centuries CE), activities conditioned by traditions of villa ownership as well as contemporary understanding of those traditions. The prestige of owning a villa (or villas) and estates was unabated or even rising, but the practice may have been less so. Concentration of estates and changes in urban structure and viability may also have conditioned ownership of rural property, not necessarily negatively: the burgeoning of very large villas in Gaul and elsewhere is conspicuous in late antiquity, but there were mixed results as well. In certain districts, the situation of existing owners vis-à-vis the settlement rights of "barbarian" newcomers made issues of ownership particularly delicate.

Villa management in Palladius' late fourth- to early fifth-century agricultural manual seems to indicate a rural situation less fluidly coordinated with regional and Mediterranean-wide economies, certainly less free than the easy movement of goods assumed in the much earlier (but still-circulating) Roman agricultural manuals. Still, the tradition of the manuals, both practical and conceptual, persisted into late antiquity, as did other aspects of villas, but in new forms.

In the architectural and cultural history of members of the elite, what to live in and how to live in it were – still are – major questions. Individuals and social groups acquire or build, decorate, furnish, and maintain dwellings and behave in them in ways that are subject to historical definition; then as always, judgments about us are made on the basis of where and how we live.[1] What some of these behaviors were – and the particular strengths or weaknesses of late-antique villas – is the subject of this chapter, as well as some of the preoccupations of villa owners as shown in their houses and writings. Western, and specifically Gallic, villas are emphasized with examples from other villas elsewhere.[2]

Despite their abundance, villas were the perishable part of elite preoccupations in late antiquity: much more important was the preservation of law and the engagement in literary pursuits (rhetoric, poetry, history and letter writing, medical treatises, books on natural history, compendia of old, new, and exotic customs and languages, miscellanies of all kinds). Law, literature, and learning sturdily survived to the very last moments of Roman civilization in the Mediterranean and well beyond, even in those areas in the north and west of the empire that were actually or nominally under "barbarian" occupation. Latin rhetoric and its forms also endured: Listening to speeches was a form of public entertainment, their forms adapted to Christian homiletics, also very entertaining and edifying. The persistence of rhetoric

throughout the Middle Ages and the Renaissance were occasions of renewal in literary forms and story-telling ideas in the visual arts.[3] By contrast, villas do not appear to have endured in any great numbers in the Latin West after the late sixth century, or if they did, they did so with intrusions of agricultural or manufacturing activities into the residential areas – this ensured their survival at the expense of the *partes urbanae*. The name *villa* was also attached to purely agricultural properties with no indication of the particular residential and cultural amenities in rural settings that were part of the elite Roman definition, or else to isolated official residences that happened to be in rural settings.[4] The post-antique disappearance of villas stands in contrast to their robust late-antique flowering, and the causes of both may have had something to do with two historical phenomena: a general tendency toward concentration of estates into large entities (a process that had begun already in Hellenistic and Roman Republican times), and ownership of multiple estates by the elites whose properties were spread Mediterranean-wide in some cases.

"STATUS CREEP": NAMES OF OWNERS AND PARTS OF VILLAS, SECOND CENTURY BCE TO FIFTH CENTURY CE

Knowledge of agricultural techniques for Roman farmers was not limited to the treatises on farming that have survived: local experience, specialized manuals, well-versed personnel, and friendly advice doubtless played their part. Still, and with the exception of Cato, agricultural treatises now lost were often referred to in the agricultural treatises that survive, namely those of Varro, Columella, and Palladius, with a detail that confirms their variety of subject and Mediterranean-wide application. Late-antique owners' understanding of villas would have been inflected by their reading and understanding of literary and historical traditions about them, so what might the "take-away" have been for such readers – contemporaries of Palladius in the late fourth century – as well as what they might have learned

from Latin letter writing, and poetry? To summarize a partial answer to the question, a contrast between the still-circulating or epitomized early treatises (Cato, Varro, Columella) and that of Palladius some four to six centuries later can be compared in two broad rubrics: the named status of the villa owners as addressees of the treatises and the authors' assumptions about infrastructure supporting villas and their geographical horizons.

Cato's mid-second century BCE treatise *De Re Rustica* was the earliest agricultural treatise in Latin. It was addressed to *patres familiae*[5] – heads of families – but with a referent to both an ordinary farmer (*agricola*) and an agricultural tenant (*colonus*). It set up a tradition of farm-and-estate management emphasizing cash revenue from agriculture, expertise by a nonresident owner, and verbal and written delegation to a farm manager (*vilicus*) who was a slave; the rest of the personnel (*familia*) were slaves under the manager's guidance.[6] The treatise's agricultural geography was quite small, centered entirely on the corridor between Rome and Nola (near Naples) on either side of the *via Appia*, and the towns he mentioned (for shops and equipment yards to buy farm tools) are not far distant from one another: Suessa Aurunca, Pompeii, Capua (mod. Sta. Maria Capua Vetere), Casinum (mod. Cassino). This area of Campania was, along with Latium, the heartland of Roman agriculture, and Cato assumes – as later villa owners did not – that any one villa was connected to an existing landscape of villas, a strong infrastructure of roads, trustworthy brokers and shippers for moving produce offsite, building contractors, and reliable hardware suppliers in towns for all specialized goods and services for the farm. Cato does not write much about pleasure in the countryside.

About a century after Cato, Varro's three-volume treatise is a much more elaborate conspectus of villas and estates with pleasing rhetorical devices to establish some intellectual principles for being an owner. His agricultural manual (c. 37 BCE; *De Re Rustica* or *Rerum Rusticarum*, written when the author was in his eighty-first year) cited a bibliography of Greek, Punic, and Latin sources appropriate to

a polymathic author who, besides having a military and political career, was a very famous librarian and editor. Like Cato, Varro addressed the villa owner as *pater familias*, but the term had by now become far more elevated than Cato's, related to owning *multiple* properties for whom ownership itself was a responsibility for the public good, endowed with the dignity of a quasi-civic duty and honor (*honos*). Varro and his wife Fundania ("she who owns a *fundus* [farm]," the dedicatee of the first book) had villas and estates north of Rome, south of Rome, and as far south as Apulia, a larger swathe of property than Cato's;[7] his friend Turranius Niger (the dedicatee of the second book) operated a cattle-droving business the entire length of the Italian peninsula. Cash revenue remains Varro's goal for ownership, but his treatise greatly expands Cato's narrow Italian corridor: It contains a geography of nearly Mediterranean-wide agricultural information (Greece, Spain, Gaul, and Africa). Varro, like Cato, assumes that villas are set in an existing landscape of other villas, solidly connected by a reliable transport system to towns and cities, market outlets, suppliers of equipment and services, and commercial brokers.

In addressing the *patres familiarum* of his day, Varro took their need for some intellectual underpinning for the practical activity of farming by defining the proper balance between agricultural productivity and social representation in villa life and management. The issue was framed in rhetorical antinomies: Without disparaging pleasure in the villa lifestyle as such, Varro aligns *utilitas* (functionality, viability, profitable use) with *voluptas* (pleasure) in an almost equal antinomy, but he does not hesitate to state his preference for *diligentia* (frugality) as opposed to *luxuria* (luxury). The result, for his readers, was an easy to understand tradition of rusticity *vs.* urbanity (with an obligatory moral superiority of the former over the latter) and so-called ancient simplicity (*mos mairorum*) versus garish modernity (also with the superiority of the former over the latter).[8]

Varro's rhetorical antinomies could have subtler outcomes in other literary genres, of which owners in late antiquity may have also been aware. In the same years that Varro was writing his agricultural manual, the poet Horace wrote a satirical poem on precisely these topics. In the second poem of his *Epodes* (c. 30 BCE), Horace lampooned the pretensions of *both* the aristocratic villa-owning elite in promoting false, Cato-like traditions of rural affiliation *and* the foolish attempt of Alphius, a rich social-climbing banker (*foenator*, most probably an ex-slave) to buy into the aristocratic traditions and lifestyles by purchasing a villa and an estate from some (perhaps ruined) nobleman. Alphius' readymade *otium* was entirely personal and nonproductive: He seems to have observed, rather than supervised, the estate slaves.[9] The tension of rhetorical antinomies continued: In Nero's day, Seneca the Younger set villas up as a kind of moral question in three letters intended to illustrate houses as examples of ancient probity or modern vice.[10] Houses were a way of determining what the owner's moral character really was, which in part motivated letters about villas. More subtle are Pliny the Younger's self-complimentary literary descriptions (*ekphraseis*) of his own villas about a generation later.[11] His famous accounts of them read both as tributes to his own taste and as disengagement from material considerations: He simultaneously owns and disparages his villas, an antinomy as ambiguous as it is common and an attitude probably shared by his readers.[12] He owned, but did not enjoy, all parts of his villas, but what he did enjoy were his villas as venues for writing.[13] He even equated hunting, at all times the noble, traditional, and usual occupation of villa owners, with writing.[14] Such was the power of these attitudes that some 400 years later, as we shall see, Paulinus of Pella and Sidonius Apollinaris did the same.

Returning to the Latin treatises on agriculture that included villas, Columella, in his *De Re Rustica* written in the 60s of the first century CE, indicates that the freeborn gentleman – *ingenuus* – is the correct term to denote the status of a villa owner.[15] Gone are Cato's *agricola* and Cato's and Varro's *pater familias*. Instead, Columella locates villas in a sociogeographical context less narrow, less family-bound, and less specifically Italian than the earlier treatises. His books are addressed to gentlemen of equal, or easily equivalent, status in any part of the

Roman Empire, not just Italy. Villas, rather than Italian descent or Roman family connections, are for Columella the mark of such persons, and he assumes an international, Mediterranean-wide community of interests and identities. No matter how far he may travel, the *ingenuus* or gentleman will recognize other gentlemen by their villas: This means of identifying social peers was still, in the fifth century CE, the way Sidonius Apollinaris identified his friends and social equals, and later, the mutual recognition of social parity, superiority, or inferiority by means of country houses came to be extremely important in England and France from the seventeenth century on.

Columella, a native of Gades (mod. Càdiz) in Baetica, also assumed that agricultural estates were cash-based with a personnel of slaves. He himself owned four vineyard estates in Italy,[16] but his geography of agricultural information is even more Mediterranean-wide than Varro's, with careful consideration of climatic variations that call for intelligent adaptation by villa owners throughout the empire.

In contrast to Cato and Varro, Columella did not assume that infrastructure, roads, and suppliers were easily available to villa owners: He emphasized the storage aspect of villas (*pars fructuaria*) as an essential part of the profitability of the estate, though the estate's barns and storage seem to be designed to hold over one year's harvest only. It may be that Columella, keeping in mind that provincial estates might be more isolated and less well connected to transport facilities and markets, felt that his readers should pay close attention to warehousing their produce on site, and his emphasis on resources (*facultates*, by which he means having the cash and/or cash flow to keep going from year to year) may indicate that, by the 60s CE, owners of villa-estates could not rely – or could no longer rely – on the immediate conversion of their produce (*fructus*) into money (*pecunia*).[17] Financial prudence, backed up with cash, and leverage may have become the new norm of estate owners and the inhabitants of villas.[18]

In Columella's treatise, the villa residence itself is, as in the earlier manuals of Cato and Varro, summarily described, but with one difference: unlike Cato and Varro, Columella assumes that the villa will have a *balneum*, that is, a small thermal establishment consisting of three or more rooms in the standard cold to warm-wet or warm-dry to hot sequence.[19] In this, Columella is up-to-date because, by his day, baths had become indispensable in villas, as his near-contemporary Seneca also noted. There was a pervasive creep of *luxuria* that ultimately became obligatory, and ceremonies of hospitality eventually included bathing before feasting.[20] By the third century, *balnea* in villas became virtually obligatory, both architecturally and in the literary tradition.[21]

There is an instructive contrast between the treatises of Cato, Varro, and Columella, on the one hand, and that of Palladius.[22] After a first book on villa architecture, the manual is organized as a calendar of plantings and activities from January through December (books 2–13) and a poem about techniques of plant- and tree-grafting (book 14).[23]

Palladius unequivocally calls the villa owner *dominus* – lord.[24] The lordship of a villa-estate consisted in the similitude of the landowner's authority to the authority of a military commander or a civil magistrate, even an emperor. Palladius also overtly used terms of military and civil administration to designate parts of the villa or arrangements of rooms: the residential villa-block is called the *praetorium* as if it were the headquarters of a military camp, and the functional arrangement of the *cella vinaria* with its raised press is like that of a legal *basilica* with a raised platform on which the judgment seat of a magistrate would be set.[25] Palladius culled from Varro and Columella, but his agricultural geography is further flung than theirs: He personally owned agricultural estates near Naples and in Sardinia, a farm near Rome and another elsewhere in Italy, besides connections in Gaul, and he tells his readers about Hispanic and Gallic estate owners who have given him tips on techniques directly, not from books.[26] His writing on agriculture is even more relevant to provincial villa owners than Columella's, because he details more alternative methods for cold countries or very warm ones: The application of his treatise was, theoretically, empire-wide.

Palladius did not elaborate much on the residential villa, even though he used the manuals on architecture by Vitruvius and Faventinus (see p. 409, n. 60) and, like Columella, assumed that a considerable suite of baths was part of the plan and use of villas.[27] Instead, and tellingly, he gives instructions and recipes for foundations, manufacture of bricks, mixtures for mortars and caulking, plans for cisterns, and so on, showing clearly that the *dominus* of the villa can no longer assume that reliable contractors are available locally. Rather, the *dominus* will have to know, do, and supervise everything himself. The practical directives are more abundant in this treatise than any heretofore. Contractors, craftsmen, conveyors, and brokers can no longer be assumed to be on call from outside the estate; instead, at a villa, blacksmiths, carpenters, and potters are essential as part of the permanent personnel, and large-scale storage of produce and its transport to market by pack-mules are responsibilities of the *dominus*.[28] While Palladius' villa is not in any sense a self-contained manor, what he says seems to point to a deterioration of commercial and public infrastructure with a concomitant increase in the owners' responsibilities and a compensating rise in status and commitment.[29] It is possible that these pressures prompted late-antique villa owners to emphasize – even to overemphasize – their literary and *otium*-related activities, and as the status of *dominus* came to be the norm, so did also his need to know about the material and mundane duties of the villa and its estate.

With the owner now confirmed in Palladius' treatise as *dominus*, its author gave his readers a sense of new responsibilities and personnel management, an ability to recognize social peers, and a western empire-wide geography that must have seemed reassuring and up-to-date. Villa ownership and villas themselves gained prestige. Palladius may have followed current usage, but flattering his readers was a good way for him to engage them, so it is no wonder that the manual had enduring circulation and gave elevation and focus to villa owners. One such possible reader, his contemporary Paulinus of Pella, whom we will encounter next, was just the kind of person who could have benefited from it.

GRAND LATE ANTIQUE VILLAS AND THE VILLAS OF PAULINUS OF PELLA

If *dominus* came to be the name of a villa owner in late antiquity, was there a difference between the term of address and the everyday hard slog of owning an estate and making it work? The late-antique persistence, even flowering, of residential villas was a function of the socioeconomic conditions that had promoted or modified their viability, but villas appear to have been a normal form of social and economic expression in the West. If the estate-with-a-residence system was not fully integrated in the Roman orient, themes of western villas were taken up, pictorially at least, in decorations of a few urban houses and in residences in the East.[30]

By the late fourth century CE, new ideas about the nature of villa owning may have extended their lives. Some proprietors converted their country estates into religious centers while staying on; others may have given or deeded property and rural residences to religious entities outright.[31] The very luxurious villa at Séviac (near Montréal [Gers] in Aquitania) appears to have acquired a baptistery, then a small church, and finally another church or chapel adjacent to the villa in the later fifth or sixth century,[32] and there are other examples attested in literary sources.[33]

While owners' Christian piety may have prompted such acts, it may also be that communal, ecclesiastical, or corporate tenure ensured the integrity and continuity of a villa and its estate. Such acts of pious solidarity would not have diminished the distance between owners and the objects of their charity; if anything, charity reinforces social distance.[34] The late fourth century is particularly full of issues about villas: St. John Chrysostom, an influential ecclesiastic at Antioch (381–98 CE) and ultimately bishop of Constantinople (398–404 CE), approved the construction of baths by owners of country estates for their slaves and tenants as a matter of hygiene and kindness, but he insisted that Christian duty should prompt them to build churches on their estates for their spiritual health as

well.[35] Religion always entered in: St. Augustine, the bishop of Hippo Regius (mod. Annaba or Bône) in North Africa and an influential theologian and writer on Christian topics, expressed his horror at attacks on country estates and the molestation and even murder of villa owners by certain contemptibly fundamentalist Christian mobs (who were also lawless, low-class, and ignorant). While Augustine was reproving the destructive excesses of these *Circumcelliones*, his letters also imply that villa owners had, in fact, been living in decent tranquility before the attacks; he was as much lamenting the end of the pleasant, productive lifestyles that the patrician owners had enjoyed as decrying their violent end perpetrated by angry social scum.[36]

Christian preachers like St. Augustine and St. John Chrysostom attest both the viability and vulnerability of villas in the fourth and fifth centuries. Indeed, the attractions and profitability of villas were not lost on the Visigothic occupiers who invaded southern Gaul in the early years of the fifth century and whose presence and mixed fortunes ultimately transformed the terms of land use, tenancy, and rural life in the area as completely as they modified the lives of the established owners.[37]

A poignant example is that of Paulinus of Pella (376–c. 459/460s CE). Paulinus was a second or third son of a noble Aquitanian family with important connections that fell on hard times when the Visigoths occupied Burdigala (mod. Bordeaux) in 413 CE.[38] Before the invasion, when he was in his early thirties, Paulinus had been living near the city, in a very nice villa situated on a pleasant estate with good hunting, good silver, good food, not much effort, and all the other pleasant amenities of noble living in the Roman provinces.[39] The estate had come to him as part of his wife's dowry, and he owned other properties in Aquitania, as well as estates in northern Greece that had belonged to his mother (Paulinus had been born at Pella in Macedonia during his father's tenure as an imperial official there). After the Visigothic takeover of Aquitania beginning in 406, and the fall of its capital Burdigala seven years later, Paulinus moved his family further afield, to an ancestral estate and its villa residence near Bazas about 70 km away. Some

years and hard times followed: the deaths of his mother, a son, and wife, the ingratitude of his surviving sons, an aborted trip to Greece to retake possession of his mother's estates, and a lawsuit against him about the disposition of his father's estate brought by a brother.[40] He was also saddled, for a few months, with the expenses of an onerous (though prestigious) official appointment by an emperor whose reign did not, fortunately, last very long.[41]

By now (in the later 410s), Paulinus had to move again, from his villa at Bazas — itself a downturn from his previous villa — to something much more ordinary. His account contrasts sharply with our archaeological documentation, which is mainly of the really grand, luxurious villas of Gaul. As Catherine Balmelle and others have shown, the abundance and wide distribution of big rural establishments in Aquitania and Gallia Narbonensis,[42] many beautifully decorated and equipped with sculpture, are striking. How, then, could an owner of narrow means undertake the tasks of securing and developing a villa property without much capital or resources? What might be the outcome of such efforts? Paulinus' account of his "villa" at Massilia (mod. Marseilles) gives us an outline and antidote to the late-antique history of grand villas in Gaul: Not all dwellings and estates were big ones, and Paulinus' were very small indeed.

Paulinus' misfortunes caused him to give up his villa at Bazas. His only recourse was to move to a town house (*domus urbana*), which had belonged to his grandfather: The house was in Massilia, about 500 km away. The property had a garden of no consequence (a *hortus* with no profitable grapevines; exporting wine was the main Massiliote activity at the time). There was also some other tillable land outside the city, a small property of 4 *iugera* (= c. 2 hectares = 3½ acres), enough for him to build a house on a rocky hilltop (to avoid taking up cultivatable land). Paulinus says that, at the time, he owned more slaves than land, so he shrewdly leased some extra acreage, probably by mortgaging the original property and thus losing its freehold but adding to the amount of land he could cultivate.[43]

Paulinus does not tell us how many years this project in Massilia lasted. In the end, he considered

his efforts to have failed, and he returned to Burdigala to become, humiliatingly, a dependent of his relatives. His sons, now denizens of the Visigothic court and comfortable from their professions and/or marriages, do not seem to have helped him much.[44] As the former owner of profitable and *otium*-creating villas, Paulinus felt that he had reached the social lower depths.

PAULINUS OF PELLA'S PROPERTY AT MASSILIA: URBAN AND SUBURBAN CHANGES IN GAUL

What might Paulinus' Massiliote town house and its little garden have been in the 410s and 420s, together with the other nonadjacent 4-*iugera* property on which he built a hilltop house and the extra land he leased? Paulinus is clear that his grandfather's property was a *domus urbana*, but he seems to have farmed from it; ultimately all the parts he was able to put together (fruits of inheritance and his own hard work) came to be a working agricultural entity, even though his account is vague about how it was used and where precisely it was vis-à-vis the city itself.

Paulinus' vagueness may come from the fact that the situation of cities and towns in Gaul had changed: new fortifications, re-ruralization of city land, and creation of suburbs from formerly urban neighborhoods were relatively new phenomena, which modify our – and Paulinus' – view of residence-and-estate situations and of *domus urbanae* and villas themselves in late antiquity.

Beginning as early as the third century, Massilia and other towns and cities in southern Gaul responded to civil wars, invasions, local brigandage, and other threats by building walls, as municipal projects or responding to imperial prompting or both. These new walls most often encircled the urban cores – temples, forum, basilica – and some adjacent residential neighborhoods. However, the fortifications typically truncated the actual space of cities, leaving houses and other buildings (even public buildings) stranded outside their perimeter.[45]

At Burdigala, for example, the new walls of the third century left more than three-quarters of the inhabited space of the town as it had developed since the second century outside their perimeter, including some public buildings in the north part of the city.[46] This may have turned once-urban neighborhoods into rural or semi-rural locales, leaving houses to be reinhabited as villas or villas built within eyeshot of the city – Ausonius (310–95 CE) tells us that, from his villa on a hill to the northwest of downtown Burdigala, he could clearly see the confluence of the two streams (the Devèze and the Peugue) with the estuary of the Garonne.[47] Elsewhere, the contraction in the Aquitanian town known variously as Mediolanum Santonum or Santones (mod. Saintes) was even more severe: The forum and its adjacent buildings were left outside its fortifications, and the amphitheater was stranded some 400 m distant from the new perimeter.[48]

The results of these urban contractions were various. For example, at Narbo (mod. Narbonne), the capital of the Roman province of Gallia Narbonensis, in the excavated area known as the *Clos de la Lombarde*, finely planned and well-decorated second-century CE houses formerly fully and firmly webbed into the urban fabric, were left some 500 m outside the third-century walls.[49] The whole neighborhood began to change.[50] The house known as the *Maison à portiques* suffered degradation and began to develop industrial and agricultural storage spaces within its fine residential rooms. A house next door (*Maison* III) survived as a grand house and was even redecorated, but it came to be surrounded by workshops of various kinds encroaching aggressively and messily on the public right-of-way in the neatly surveyed streets and their gracious porticoes, which had formerly defined the urban dwelling blocks in which the houses had been built. Many of these new workshops were devoted to the processing of agricultural or marine products, activities that would heretofore have taken place elsewhere in the city or outside the urban area, on villas and estates or beside wharves and seashore facilities. A factory for making fish sauce

(*garum, liquamen*) or for processing shellfish was built very near the houses, further degrading the urban residential character of the neighborhood with smells and traffic. What happened at Narbo in the later third and fourth centuries is that hitherto *urban* houses slowly changed into isolated *suburban* dwellings with newly agricultural spaces – not villas, exactly, but certainly not *domus urbanae* either, hybrids in a new liminal space neither fully rural nor fully urban.[51] A process of re-ruralization is not uncommon in cities and towns undergoing change, and the encroachment of villas or villa-like uses for urban houses can be expected.[52]

However, harsh necessity engenders creative ingenuity. Fortifications that contracted urban areas and stranded houses outside the newly smaller urban spaces may well have generated opportunities for Paulinus and his like. At Massilia, the city fortifications had been built in the third century and reinforced at various times throughout the fourth. The result was not dissimilar to what happened at Narbo, except that clustered suburban dwellings together with agricultural processing facilities and some small manufacturing workshops grew up in the immediate vicinity outside the gates, making a kind of unstructured *faubourg* or semi-suburban area.[53] Paulinus' operations could well have been precisely in the liminal area near, but no longer in, the shrunken city, a new area of mixed-use buildings for residential, manufacturing, and agricultural uses. Old urban neighborhoods now found themselves in newly extramural situations like his grandfather's *domus urbana*; others would have been new venues, like the hilltop house Paulinus built himself. Paulinus obviously found good opportunities, in the new urban/suburban environments in southern Gaul, to build up a small but solid agricultural business that closely resembled a villa, but one in easy distance from the town. That he felt disappointed in the results was a feeling, but only a feeling, and we need not feel sorry for him – he did a good job of that himself.

In fact, Paulinus was successful in his endeavors at Massilia, both materially and, equally important,

getting a lift from the low status and low spirits he fell into after the humiliating return to Burdigala. To his surprise and pleasure, a Goth unexpectedly wrote him a letter offering to buy his *domus urbana*, the garden, the extra land, and its new *domus*, as well as the leased land at Massilia![54] His old age was assured. Of course, Paulinus claimed that the Goth's offer was far less than the actual value of the property,[55] but the price he got enabled him to pay off his obligations and support himself for 20 or more years until at least 459 CE when he wrote his autobiographical poem, *Eucharisticus*, in his eighty-third year.[56] For all his resentments and showy exercise of pious patience, Paulinus did very well for himself in the sale of his Massaliote property, and the "barbarian" purchaser of Paulinus' encumbered estate saw its value and may have built it up into something even better. The purchase price certainly enriched Paulinus: It supported him materially for a good long time in dignified circumstances and afforded him the opportunity to do what he really wanted to do all along: to *praise God*, and to *write poetry*, and his autobiographical poem centers on the grandeur and misery of villa ownership. Paradoxically, if he was unable to both live and write in a villa simultaneously, at least his profits on his little villa estate at Massalia resulted in him taking up literary pursuits in emulation of those that Pliny the Younger had exercised at his own villas.[57] Villas and writing went together in late antiquity.

Building Villas in Parallel with Rhetoric, Poetry, and History

Paulinus got what he wanted – to write poetry – from the sale of his villa, but rhetorical aspirations (including their concomitant, holding high office), exercise of poetic gifts, and history writing were also activities in and of villas, not only by owner-inhabitants themselves but by the commissioners of villas, their designers, and their describers in poems and letters. In this respect, the late-antique iconography of villa architecture and decoration can, in some instances, respond closely to the mental and literary

vocations of owners. Only some villas known archaeologically give us a picture of their owner's interests and attitudes, so clues from literary sources can supplement the archaeological record.

ATRIA AT THE VILLA OF MONTMAURIN

An interface between so-called tradition and late-antique villa design can be seen at the impressively large and, for its date in the later fourth century, architecturally up-to-date plan of the villa at Montmaurin (near St.-Gaudens [Hte.-Garonne]; Figure 21.2).[58] The residence in its newly built form was entered through a semicircular porticoed courtyard (a form known by the neologism *atrium lunatum*; see p. 412 and n. 82) enclosing a small temple; the porticoes led to a peristyle surrounded by sets of formal rooms and a luxurious bath-suite with an impressive fountain room (*nymphaeum*), all decorated with high-quality mosaics. A rising natural topography allowed for a further small peristyle, again with apsed halls most probably used as *triclinia*, on the cross-axis; a final, even higher, suite of dining facilities gave onto an apsed belvedere at the apex of the design. From the semicircular entrance courtyard to the *triclinia* for feasting, the plan of Montmaurin corresponded to the most modern fourth-century conceptions of villa design and ceremonious hospitality that late-antique designers and owners had to offer, with two exceptions.[59]

The exceptions were unique, as far as I am aware, to this particular villa: two *atria* of the most resolutely traditional kind. *Atria* had been a normal, even obligatory, element in Roman urban houses at a certain high social level and in houses emulating them. While urban houses in late antiquity could have other kinds of reception rooms, *atria* as a distinctively Roman architectural element had been enshrined by Vitruvius in the late first century BCE in his architectural treatise. For our purposes, more relevant is an epitome (a short version) of Vitruvius' book by Faventinus (Marcus Cetius Faventinus, *fl.* mid-fourth century) that Palladius had used and that was in circulation in the late fourth century.[60] For villas, both

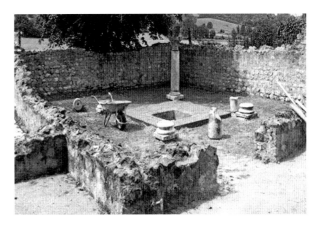

Figure 21.1. Montmaurin villa, small atrium (room 38) from the south (Photo: author).

Vitruvius and his epitomizer note that *atria* come after peristyles in villas (rather than in the front of the dwelling as in the *domus*), with formal rooms and access to gardens and walkways ranged around it.[61]

Atria in Roman houses could take different forms, but archaeologically the simplest was usual in Roman urban environments: a squarish room with a shallow pool (*impluvium*) in the center and an inward-pitching roof with an opening (*compluvium*) to direct rain water into the pool and thence into a cistern to provide the house with water.[62] The roof of the atrium could be supported by four or more columns, or it could be self-supporting on rafters and beams set into the walls. Most often, *atria* were on the axis of the main rooms of the *domus* in the Vitruvian recipe, visible from the entrance to the building and introducing an *enfilade* of formal rooms in various sequences. The atrium took on a cultural meaning, because having one came to be a mark of Roman expansion and affiliation in Italy and in the early provinces of the Republican empire.[63] However, progressively over time and geographical extension, *atria* were replaced by other forms and ultimately went out of use almost entirely.

Still, despite the fact that *atria* were no longer part of the architectural norm for villas and had ceased to be built, two *atria* were nonetheless built at Montmaurin (Figure 21.2): a larger one (rooms 43–46 which constituted a single room) and a smaller one (room 38 with corridor 40, Figure 21.1).

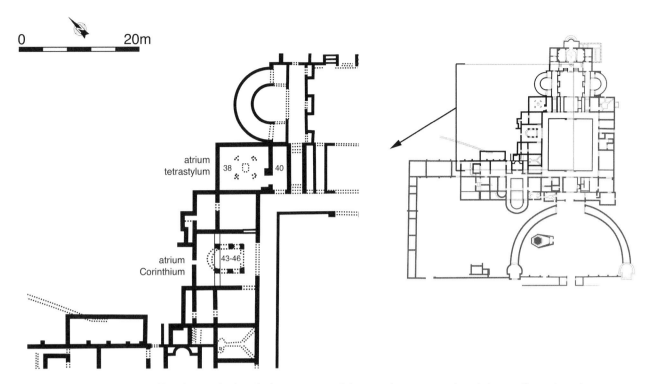

Figure 21.2. Montmaurin villa, plan marked with the positions of the *atria* (rooms 43-46) and the smaller atrium (rooms 38 with its adjacent corridor 40). (Plan by M. D. Öz, courtesy of L. Buffat, after Fouet 1973).

The Larger Atrium at Montmaurin, Rooms 43–46 (a Single Room)

This atrium was rectangular (10 m long x 8 m wide; Figure 21.2); it was positioned off-axis of the whole plan of the residence and asymmetically set vis-à-vis the cross-axis of the main peristyle from which it was entered through a wide door; it also communicated with two large halls on its northeast and northwest sides. A wide window on the northwest axis appears to have framed a view and gave no access to the outside or to further rooms. Its roof was supported on six columns, of which the brick bases (0.46–0.60 m²) remain; their small size indicates that the tall but narrow columns in stone or marble found elsewhere in the villa also supported the roof and *compluvium*, which must have been rectangular like the room itself. The area defined by the columns and open to the sky was not an *impluvium* intended to hold water as such; rather, it was a waterproof surface of plaster and tile-dust sloped to direct rainwater into a small

semicircular basin on its northwest side, with no access to a cistern. The larger Montmaurin atrium was a self-contained room with a view rather than having that combination of a centralizing and axial plan that characterized earlier, traditional *atria*.[64] With more than four columns, the larger atrium at Montmaurin was designed, in the Vitruvian standard, to be an *atrium Corinthium*, by the fourth century an almost unknown, but certainly picturesquely antiquarian, item of domestic design.[65]

The Smaller Atrium at Montmaurin, Room 38 and Corridor 40

This atrium itself was a squarish room (8.50x7.10 m; Figure 21.2) accessed through corridor 40 set asymmetrically on the northwest side of the main peristyle of the villa: It was thus off the main axis of the villa's plan, but, more importantly, it led nowhere, though, if the excavator is right,

a window in its northwest wall may have framed a view (Figures 20.1 and 20.2). The room contained a square pool or *impluvium* lined in marble at its center and four columns on bases indicating the presence of an inwardly pitching roof with a *compluvium* to channel rain water into the pool, which then drained the water into a cistern elsewhere in the building.[66] In comparison to the grandeur of other spaces in the villa, the atrium is small, even somewhat miniaturized, though it corresponds in some ways to Vitruvius' prescription for an *atrium tetrastylum*.[67] The architecture of the room, even its reduced form, is aridly "correct" architecturally, but its approach through an asymmetrically placed door from an off-axis corridor makes nonsense of the actual function of *atria* in Roman houses and of their importance in establishing the axis of view and movement in a house.

The Montmaurin *atria* are recollections of *atria*, allusions to their functions in the tradition and representational value of Roman houses but without their dominating presence in the axial arrangement of domestic spaces and their uses in ceremonies of domestic hospitality (neither have the *alae* of the Vitruvian recipe). At the same time, the owner and designer at Montmaurin were anxious to show their knowledge of, perhaps even affection for, the *form* of the atrium, reproducing its traditional design even though the rest of the villa was designed to a modern, quite different, plan. The traditional atrium form could have been learned from reading or antiquarian erudition rather than firsthand experience of actual *atria*: At Montmaurin, the designs were perhaps reproduced from books (e.g., Faventinus' epitome of Vitruvius), the better to parade for guests the learning of the villa owner. The Montmaurin *atria* were museum-like curiosities, pious but *Disneyfied* instances of old-fashioned values and memories about houses.

There may have been another, less bookish, source for parachuting-in the Montmaurin *atria*: actual experience. The aristocrats of Aquitania and other provinces were frequently called upon for their services as officials at the imperial court, and while the court was not always in Rome or even Italy, sometimes it was.[68] In 455 CE, Sidonius Apollinaris, on his way to Rome in the entourage of his father-in-law, the emperor Avitus (Eparchius Avitus, reigned 455–6 CE), wrote a letter to a friend, Eutropius, urging him to leave his Aquitanian villa to take up a high imperial appointment requiring residence in Rome. The trip would afford Eutropius – who, it seems from Sidonius Apollinaris' letter, had never been to Rome before – the opportunity to see the City and its glories, and to observe traditional urban *domus* of the capital with *atria* in elite residential neighborhoods.[69] The owner of Montmaurin may also have had such opportunity for tourism in antique *domus* at Rome or elsewhere and bade his designer to reproduce, for show and parade of learning, *atria* in his new home. Such self-representation in domestic architecture may well have been part of the cultural continuum with high office, rhetorical expertise, and letter writing in late antiquity.[70]

TRADITION IN THE "CASTLE" OF PONTIUS LEONTIUS AND ITS *ATRIUM LUNATUM*

Being a *dominus* required some social and historical context, and villas were understood as significant representations of individuals and families. The addition of family *mausolea* in or near villas has been documented for both Italy and Spain, and the imperial retirement residence that Diocletian built for himself in the early years of the fourth century at Spalato (mod. Split) in Dalmatia incorporated an impressive tomb building for himself, subsequently transformed into a church as if it had been built to enclose members of a Christian family and community rather than a pagan emperor.[71]

Investing buildings with the names of their patrons and/or builders had been a customary act of *public* architecture since remote Greek times and well before, but houses and villas could also be so invested: Urban houses in North Africa came to be named in mosaic inscriptions by the late second century CE: at Thysdrus, one Sollertius or Sollertianus gave his name to his house, also stating his felicity and family group, and others are known.[72] Villas could

also be marked with names; the *villa rustica* at Nador near Tipasa in Mauretania, a big farm with a small dwelling and warehouses for agricultural produce surrounded by thin walls but having two stout round towers more impressive than useful in defense on its south façade, had an inscription above its entrance gate identifying one M. Cincius Hilarianus as its builder and owner in the later fourth or early fifth centuries.[73]

Other villas could have similarly impressive and evocative historical markers. One such was that belonging to Pontius Leontius in Aquitania, on the Garonne River near Bordeaux.[74] At the end of the fourth century, Sidonius Apollinaris who, besides being a poet, famous rhetor, and letter writer, was a nobleman of Gaul, well-connected through family and marriage, a high imperial official, and ultimately a Christian bishop, praised the rural dwelling (his friend Pontius' family home) in a long descriptive poem, calling it a *burgus* ("castle"). At the entrance, the poet tells us, there was a stone with an inscription identifying its founder (*conditor*), presumably Paulinus Pontius, the ancestor of the family to which the poet's friend belonged. The inscription was explicitly placed there to invest the villa with the name of its founder and to enshrine the family and its members in the memory system of posterity.[75]

Investing villas with the names of their builders and owners had been a convention of Roman property listings for tax purposes: Italian assessment rolls of farms and rural residences were designated by the original owners' names rather than those of the subsequent proprietors.[76] No doubt a similar method continued into late antiquity, but there were modifications similar to the "status creep" of increasingly grand terms to designate villa owners that we have seen: *dominus* for the owner, and *praetorium* or *basilica* for parts of buildings. In his poem on the villa of his friend, Sidonius describes the approach to the walled *burgus* and mentions that it had two towers, much like the towers on the façade of the villa at Nador.[77] The towers had grand names: one was called *Pompa* ("Pomp," meaning stateliness or stately dignity), the other *Auxilium* ("Helpful Strength" or "Support"), sententious names based in concepts of high status and gracious demeanor, respectively.[78] Such towers

were normal in the floor mosaics representing and celebrating villas, villa activities, and estates from North Africa, with the added attraction that the depictions show cupolas and roofs intimating the presence of private *balnea*, essential components of elite hospitality in the countryside.[79] In actual villas, impressive forward-breaking, tower-like wings framing porticoes were a common form of villa in the northern provinces of the Roman Empire; it is possible that they, too, were given names.[80] Names denoting the character of an entire villa (rather than merely its location or previous ownership) could also be devised: at Sisteron in Gallia Narbonensis, Claudius Posthumus Dardanus, a former Praetorian Prefect of Gaul, had a fortified villa that he named *Theopolis* ("God's City").[81]

Theopolis for a villa, *Pompa* and *Auxilium* for towers: in late antiquity, "status creep" for domestic architecture was not unlike the designation of *dominus* for earlier locutions. There were also neologisms: Sidonius gives us *atrium lunatum*, formed in part from tradition, in part from contemporary architectural fashion. In his poem on Pontius Leontius' villa, Sidonius calls the semicircular entrance court *atrium lunatum*, fulfilling in part the function of ceremonious introduction to the house and family that *atria* had always had but using the traditional name to designate an open crescent-shaped form that was fully modern in late antiquity but without any precedent whatsoever in any Vitruvian prescription.[82] Catherine Balmelle has shown the incidence, from the fourth century on, of courtyards with U-shaped colonnades framing the principal entrance to villas, and while the examples are not numerous, their distribution in Italy, Spain, and Aquitania indicates that the motif had an established popularity in grand rural residences and to which the traditional name *atrium* for an entrance space to a villa seemed suitable to Sidonius.[83]

The ruins of the Montmaurin villa tell little about the iconography of the *atrium lunatum* besides the fact that it contained a small temple in a pavilion, but Sidonius on his friend Pontius' villa tells us a lot about how such an atrium might have functioned in the late fourth century as a purveyor of meaning. Besides the inscription naming the villa founder, the entrance courtyard of his friend's dwelling

spoke a very specific language of wall paintings based on Roman history.[84]

On the back walls of this *atrium lunatum* in Sidonius' account, paintings depicted events of the Third Mithridatic War of 74 to 67 BCE, in particular specific events of the siege of Cyzicus in Mysia (Asia Minor).[85]

These scenes – if, indeed, they were actually shown on the walls of the *atrium lunatum* and not invented by the poet – appear technically in a kind of reverse-engineered *ekphrasis*, one in which the work of art represents the historical account, and then is re-presented by Sidonius in his poem on the mural paintings of his friend's dwelling. But why the siege of Cyzicus?

In my interpretation, Cyzicus represented an *easternmost* Roman conquest just as Aquitania (the site of Pontius' villa) was a far *western* province. The far western location of the villa is an emphatic theme in Sidonius' poem: Paulinus Pontius' *patria* will become dominated by the Latin rule and be worthy of senatorial status.[86] The reference is to the *ius Latii* enjoyed in the Gallic provinces – and thus by the Pontius family – and gives Roman cultural and political authority to the villa and its inhabitants. The completely naturalized and longstanding Roman-ness of the area may have become a matter of recent concern among the elites of southwestern Gaul as a result of the Visigothic occupation of the central and eastern provinces of Aquitania in the years following 406 CE, so Roman history marshaled as a kind of myth in painting proclaimed the Roman-ness of the family, though the family was Christian, as indicated by the paintings of Jewish history in the *domina*'s sitting room.[87] Pictures were important to identity and social status in the heightened visual sensitivity of late antiquity; the decoration of villas with images reinforced the connection between the dwelling and the *persona* of the owner.[88]

PORTRAITS AND IMAGES IN LATE ANTIQUE VILLAS

How the *persona* or public character of an individual could be related to his villa had a long tradition:

It persisted into late antiquity with new variations.[89] As we have seen (p. 411), Sidonius Apollinaris urged his friend and fellow-nobleman Eutropius to accept a call to high office in Rome and to leave, temporarily, his ancestral villa estate in southwestern Gaul. Sidonius' method of persuasion involves a parallel of honor and shame with respect to his friend's villa. He honors his friend by complimenting him on the collection of portrait images (*imagines*) of his ancestors dressed in consular robes (*trabea*) that he saw daily in his dwelling, but he playfully shames his friend with the consequences of pointlessly living in his villa (his future: a broken-down provincial nobleman, rich, but with a rusty sword disgracing his ancestry), developing his estate (full granaries, vats of foaming wine, big flocks of fat sheep), and "adding to [your] inheritance by mundane effort." All this is nothing, Sidonius tells his friend, in comparison to the dazzling honors of Rome and high office.[90] Sidonius ends by adjuring his friend where villa and *persona* converge:

> It is important for a man of your birth to cultivate your [public] character (*persona*) in the same way you cultivate your villa.[91]

Eutropius' villa is thus both a repository of honor and a source of shame: His *persona* is dependent on his attachment to his estate, his villa, and its ancestral contents *and* his willingness to leave them to accept high "Palatine" office in Rome.[92] The portraits of his ancestors in the villa were impressive, but in alluding to them, Sidonius perhaps used them as a spur to action for his homebound friend. The villa has become simultaneously a place of refuge and a springboard for advancement.

Portraits had had a place in villas from Republican times through late antiquity.[93] Sculptural portraits were known in the villa of Scipio Africanus (P. Cornelius Scipio Africanus Maior, 236–184/3 CE) at Liternum as early as the 180s BCE: Seneca the Younger, writing in the early 60s CE about his visit to the villa (by then more than 200 years old), says that it contained a cenotaph of Scipio as well as some portraits of Scipio as well as his friend the poet Ennius (Quintus Ennius, 239–169

BCE) and possibly his son Lucius Cornelius Scipio.[94] Of course, portraits were common in tombs, but they were also assembled in villas to extend the dwelling's character with reference to family, hospitality, history, and stimulation to reflection and conversation.[95] A century or so after Seneca, in the 160s CE, the portraits assembled in the "Representation Basilica" in the villa of Herodes Atticus at Eua Loukou in Arcadia included images of the owner, his wife, his imperial friends as well as other standard types of philosopher-portraits; with exquisite refinement, one of the busts depicting Hadrian in military garb had a portrait of the emperor's lover Antinous in place of the traditional Gorgon's head (gorgoneion) on the breast-plate or cuirass.[96] By the late second century, the bust came to be the favored formula for portraits set up as assemblages, perhaps to give an opportunity for close scrutiny by viewers wishing to focus and reflect on the personalities as evidenced by the faces. Playing at deep interpretation of others' superficial physiognomies has always been a pleasant pastime, but there were deeper meanings as well.[97]

Such occasions for reflection must have been the motivation for Marcus Aurelius (emperor 161–80 CE) to have portraits, in gold, of his favorite teachers and philosophical friends in his lararium. Fifty years later, Severus Alexander (emperor 222–35 CE) had two portrait collections: one was in his lararium maius, which, besides images of his ancestors, contained portraits of "holier souls" (animi sanctiores), including Apollonius of Tyana (a mystic and philosopher of the first century CE), Orpheus, Abraham, Alexander the Great, and Christ. By contrast, non-"holier souls" images, those of Achilles and Vergil, were in a secondary lararium. Some of the images were objects of prayer or worship, but others may have been used to prompt conversation: the young emperor opined that "Vergil was the Plato of poets."[98]

Some six long centuries after the portraits in Scipio's villa, and two centuries after those of Severus Alexander, portraits in villas were still used in the same ways, but, like the villas themselves, with variations incidental to their historical circumstances and some with Christian extensions. In the late fourth century CE, Sulpicius Severus (c. 360–420 CE), an Aquitanian nobleman, had converted his ancestral estate at Primulacium somewhere in southwestern Gaul into a kind of residential retreat for a Christian community complete with churches. As he was finishing the building projects, he wrote to his fellow-noble Paulinus (Meropius Pontius Paulinus, 353/4–431 CE) asking for his friend's portrait. Paulinus had left his life in Gaul and Spain to become the builder of the shrine of St. Felix at Nola (near Naples) and ultimately the town's bishop. Both men were busy with construction: Sulpicius had recently built a baptistery on his estate, and he needed portraits to finish it off nicely. Around the immersion font, he had set up a painted portrait of St. Martin, the recently deceased bishop of Tours, whose biography he had written: St. Martin's portrait was positioned so that the catechumens would see it before stepping into the baptismal water, to inspire them with the example of the saint's life and virtue. To give them a further example as they emerged from the font as new-born Christians, Sulpicius wanted them to see a portrait of his friend Paulinus, whom he regarded as a living saint: at the transition between the old life and the new, the dead and living ancestors (St. Martin and Paulinus) were portrait imagines appropriate to the villa and its new Christian function. Sulpicius thought of portraits as leading to virtue, virtuous action, and deep spiritual reflection, and his notions were not dissimilar to how portraits had been used in the five or six Roman centuries before.[99]

Two Late-Antique Portrait Collections in Villas: Chiragan and Welschbillig

Collecting portraits to instill good values, to prompt conversation, and to promote education can be found in two great late-antique portrait collections, widely separated geographically but conjoined thematically and by date in the late fourth to early fifth centuries, at villas at Chiragan (Martres-Tolosane [Hte.-Garonne], c. 60 km SW of Toulouse) and Welschbillig near Trier (Augusta Treverorum, the

capital of Gallia Belgica on the Moselle; the villa is c. 14 km north of the city). Neither has been fully published, and both need further analysis, so conclusions must be brief.[100] However, their importance to the history of late-antique villas can be provisionally outlined: their structure as assemblages, rather than their specific contents.

The Chiragan Villa Portraits

The Chiragan villa, in the far southwest corner of the Gallic provinces near Toulouse, was large, but its architecture is very poorly preserved. Neither how nor where the portraits were exhibited in the dwelling is known, much less how and by whom they were acquired. The date of their presence in the villa may well be the date of the latest portrait, that of a woman of the late fourth to early fifth century CE (Figure 21.3B). However, the inventory of the portraits is significant. It was a "historical" collection, consisting mainly of emperor images or imperial family busts, with a few images of private individuals. The general artistic quality of the works is very high (in some cases excellent), even though the styles, materials, formats, sizes, and dates of the busts differ widely. For the most part, the busts were genuinely original items sculpted more or less at the time of their subjects' lives rather than later copies or versions. Some appear to have been acquired as groups of images, or parts of such images, of similar manufacture and date.[101] In other words, a bust of a certain man or woman appears to have been made at or around the time of her/his time rather than in the early fifth century CE when the collection was made or amalgamated at the Chiragan villa; the busts and portraits go from early imperial times (a fine head of Augustus of the Prima Porta type (Figure 21.3A) through the late fourth to early fifth century CE (a fine head of an unknown woman, Figure 21.3b). Other items date from the Augustan period, others from the first and second centuries CE, mostly of male imperial effigies, some in duplicate versions. Portraits of the later third and fourth centuries were mainly vigorous portraits of unknown individuals. Finally, the Chiragan villa portraits (now beautifully

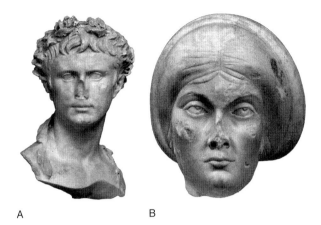

Figure 21.3. A: Chiragan villa, portrait head of Augustus, first century CE, marble, life-size. (Toulouse, Musée Saint- Raymond, Inv. Ra 57);

B: Chiragan villa, portrait head of an unknown lady, Theodosian period, late fourth to early fifth century CE, marble, life-size. (Toulouse, Musée Saint-Raymond, Inv. Ra 82). (Photos: © J.-F. Peiré/Musée Saint-Raymond).

exhibited in the Musée St.-Raymond, Toulouse) may be the whole, or only part, of a larger collection dispersed over time or by accident.

There are several possible interpretations for such an "historical" collection. Among many, three possible alternatives present themselves:

1. That it was a collection disparately (or purposefully) formed by a family, families, or related families over nearly 400 years (12–16 generations), then consolidated to be grouped and exhibited as a whole at the Chiragan villa together with other sculptural objects. In this case, the collection must have been formed over a very long time and then edited or culled by the ultimate collector/s, to incorporate busts of successful or fairly successful emperors whose goodness had been attested by the writers of the *Historia Augusta* or similar opinion-making texts in circulation at the time. The collection, in any case, also included images of private, otherwise unknown, persons, which were evidently meaningful to the collector/s.

2. That it was purchased, disparately over time or all at once, from different sources by an individual or individuals to make a grouping that would have been politically suitable to the standards of the

early fifth century CE, which included (or to which were added) images of private unknown persons for reasons of family ties or friendships. Among the imperial portraits, the emperors and imperial family members have for the most part been securely identified; what the basis of selection might have been in the political historiography of Rome may also be a topic of discussion.[102] In the case of the imperial busts, whoever bought the works had an exquisite and careful judgment (or got first-rate advice) as to the "genuineness" of the items within their periods. Such effort of judgment – of connoisseurship of objects already old – may have been perfectly possible in late antiquity.

3. That the "collection" is not a collection at all, but rather a crude and/or unintentional gathering-together of objects transported from another venue or venues elsewhere that had, or had had, purposeful intent as to selection. In this case, their findspot at the Chiragan villa was arbitrary and not subject to much interpretation beyond unknown circumstances.

These three alternative interpretations (there may have been others) for the Chiragan portraits and the villa's other works of art indicate an intentionality of collection, either over time (alternative 1) or all at once (alternatives 2 and 3). All three are different, but they are all similar as to the combination of imperial images and private portraits: Evidently, the greater world of imperial personages and the lesser, domestic and villa-based world of family members were streamed together, in ways that suggest affinities among them – of chronological coincidence, relationship, or social affiliation, or similarity of moral character. The logic of the Chiragan portrait busts is, in a way, the same as Sulpicius Severus' combining the dead and sainted Martin of Tours with his living friend Paulinus of Nola for his baptistery.

The Welschbillig Villa Portraits

Diagonally across the Gallic provinces from Chiragan, in the far northeastern corner of Gallia Belgica, the Welschbillig villa north of Augusta

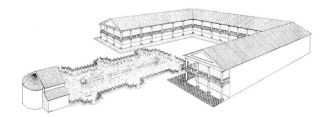

Figure 21.4. Welschbillig villa near Trier (Gallia Belgica), reconstruction perspective view from the north, late fourth century CE. (Wrede 1972, fig. 2, by permission of Walter de Gruyter and Company, Berlin, per Copyright Clearance Center RightsLink®).

Treverorum (mod. Trier) was a distinguished venue near a city whose fame was enhanced as the residence of Valentinian I (emperor, 364–75 CE), his son Gratian (Flavius Gratianus, 359–383, co-emperor from 375 as Augustus of the West with Theodosius I as Augustus of the East and Valentinian II), and the heir's tutor Ausonius. These three men may have known the villa containing about one hundred small-scale sculptural portraits of literary men and philosophers – figures of the classical *paideia* – as well as military heroes and "types" of Asiatic, German, "Celtic," and African barbarians, emperors and perhaps empresses, and several classes of unknown persons.[103] The portraits were in the form of herms (portrait heads as the finials of upright shafts), and they were part of a balustrade of terracotta grilles surrounding a pool measuring c. 58x18 m in an imposing open garden (Figures 21.4, 21.5, and 21.6). The pool was a shallow *nappe d'eau* reflecting the architecture of the villa but suitable also for light boating. Significantly, the herms looked *inward* toward the water, so the physical and mental exercises of rowing and learning could go together. The herms were made all at the same time: Unlike the Chiragan portrait busts, the Welschbillig portraits constitute a homogenous group, of the same material (a kind of gray limestone not usually used for sculpture because of its dry, rough finishing surface) and all of a uniformly mediocre quality.

The pool (floored with limestone flagstones) had a long "island" in the form of a circus *spina* or divider with fountains running down its center (Figures 21.4 and 21.6), suggesting an athletic or agonistic venue.

Figure 21.5. Welschbillig villa near Trier (Gallia Belgica).
 A: sketch of the herm structures;

 B: herm 9 (portrait of Socrates), and: C: herm 21 (portrait of Antoninus Pius), stone, under life size, late fourth century CE. (Wrede 1972, figs. 8–9, table. 1,1 and 18,2, by permission of Walter de Gruyter and Company, Berlin, per Copyright Clearance Center RightsLink®).

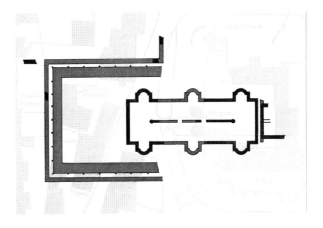

Figure 21.6. Welschbillig villa near Trier (Gallia Belgica), plan of villa and surrounding structures. (Wrede 1972, fig. 3, by permission of Walter de Gruyter and Company, Berlin, per Copyright Clearance Center RightsLink®).

On the southwest side, it faced a square U-shaped portico two stories high, and on the northeast, a *nymphaeum* with an apse faced the portico and terminated the pool (Figure 21.4). The villa itself – or at least the portico that was part of it – was built in the early fourth century, but the pool and balustrade with herms can be dated to within a few years of c. 375 or a little later, a date certainly compatible with the presence of Valentinian I, his young heir Gratian, and the tutor Ausonius.[104] The large size and lavish decoration of the villa as well as its proximity to the provincial capital at Trier put the Welschbillig assemblage into a context of high society affiliating its learned display with the imperial environment. If not an imperial residence as such, it would have been the residence of a court official who made it his business to surround himself with an appropriate cultural and historical panoply.

 The assemblage of herms at Welschbillig represented a veritable genealogy and anthropology of the empire.[105] Working backward chronologically, six of the herm-heads appear to represent contemporary or near-contemporary individuals or types of the later fourth century on the basis of their hairstyles. For the third, second, and first centuries CE and back to the late Republic, there were imperial portraits that seem to show one Severan, two Antonine (Marcus Aurelius, Antoninus Pius), and Hadrianic

or Trajanic types that may have been those emperors (Hadrian and Trajan). Vespasian (or Titus) was represented, as well as a herm based on portraits of Julius Caesar. The images are thus a grouping of "good" emperors. At another level, philosophers were shown: Socrates was the subject of one of the herms, and if Alcibiades was there, then a dramatization of the teacher–disciple relationship may have been intended. Henning Wrede has identified one of the herms as a portrait of Vibullius Polydeuces, a young disciple of Herodes Atticus, so a dramatization of the pedagogical situation may have been intended as a reinforcement of the teacher–pupil relationship between Ausonius and the young Gratian as future emperor.[106]

 The Welschbillig portrait herms present a homogenous, iconographically consistent grouping, whereas the Chiragan portrait busts, disparate as to their time of sculpting, were unified as an assemblage by the iconographical intention of its collector/s. Superficially, the difference between the assemblages is great, but there is a fundamental mental *unity* between them: both made analogies and connections between or among private and public persons on the basis of their histories, well-known to all in the case of emperors, imperial personages, philosophers, and military leaders, or obscure merely to us in the case of private persons whose memory was otherwise solidly commemorated in the portraits and recognizable to

their owners. We cannot precisely know the terms of analogy and connection: The pedagogical theme seems clear in the Welschbillig herms, and a "good emperors" editing is apparent in both collections. Doubtless there were other themes, but the sense of cultural consumption of the past strongly unites the two portrait groups.[107] Such apparently different formats as panegyric speeches lauding emperors, table-talk compilations,[108] the scenes depicted on mosaic floors, and the poetry of late antiquity are united in their use and manipulation of the past as an encyclopedia of personalities and relationships relevant to present circumstances. The *loci* of the past and its personalities were well-established mental territories in late antique villas.

CONCLUSION

Paulinus of Pella and his desire to write poetry, the owner and designer of the Montmaurin villa with its two strangely positioned *atria*, and Sidonius' description of the wall paintings in the *atrium lunatum* of Pontius Leontius' villa represent a continuum of literary habits, architecture, and painting from early-Roman practices to late-antique ones, but with several differences. The *otium* conferred by estate ownership also made the villa the venue for writing — Sidonius and his friends engaged in several different kinds of writing on their country estates, and Paulinus' sale of his Massaliote estate ultimately allowed him the leisure to do so as well. However, his poem *Eucharisticus* is an account of his life framed by his villas, in that respect different from the topicality of letters, philosophical writing, or the complex structures and allusions of descriptive or narrative poetry of earlier writers who wrote from or about their rural dwellings. Paulinus' self-absorption is not merely personal but corresponds to a new and anxious feeling of social dispossession symbolized by the successive losses of his villas and failures of his enterprises, as well as the dislocations he felt he had suffered in consequence of the barbarian presence in Aquitania.

Something of the same anxiety may be evident in the wall paintings of the *atrium lunatum* of the *burgus* of Pontius Leontius as described (or invented) by Sidonius. The call upon Roman military events in Asia — distant geographically and chronologically (by some 500 years!) — seems at once antiquarian and stridently "Roman," as if the antiquity of Aquitania needed renewed assurance from a mythologized history. The same historicizing drive is evident in the oddity of the two *atria* at Montmaurin, where traditional forms were built for show, placed out-of-spatial context as a learned display, resolutely advertising Roman Republican "tradition" in an otherwise thoroughly up-to-date fourth-century architectural plan. Finally, while portraits in villas had a long Roman history, their particular manifestations in Gallic villas indicate that the two different strategies, namely either collecting antiques (Chiragan) or making a new show of images (Welschbillig), had similar intentions and results: both made subtle connections between the past and the present. Villas in late antiquity, no matter how modern in other respects, refreshed the Roman past by both boldly and subtly including it.

NOTES

1. Using houses to express character is a universal literary trope from Xenophon's *Oeconomicus* in the fourth century BCE to the present. In Latin literature, the third book of Varro's *De Re Rustica* is an extended essay of social judgments on individuals and social types — positive and negative — based on the character, decoration, and profitability of villas; Seneca the Younger's letters 51, 55, and 86 align moral character with villas; his letter 114 restates the idea: see Métraux 2014.

2. This volume includes significant surveys of late-antique villas in the Mediterranean basin in Gaul (L. Buffat, Chapter 13), Italy (M. Gualtieri, Chapter 10; G. P. Brogiolo and A. Chavarría Arnau, Chapter 11), Sicily (R.J.A. Wilson, Chapter 12), Hispania and Lusitania (F. Teichner, Chapter 14; G. Ripoll, Chapter 22), North Africa

(R.J.A. Wilson, Chapter 16), Malta (A. Bonanno, Chapter 15), and Greece (M. Papaioannou, Chapter 19).

3. Knowledge and preservation of the law were among the highest callings in the upper echelons of late-antique society, and law stolidly underwent translation, reformulation, transmission, and promulgation in "barbarian" legal codes: see Bloch 1942, 173–84; Gaudemet 1979 and, for a succinct account in English, Stein 1999, 22–32; 38–43. Other accounts: Honoré 1998, 179–274; Harries 1999, 36–55, esp. 42–47; Padoa-Schioppa 2005, vol. I, 13–42 for a general account, 48–55 for the means of transmission, 59–72 specifically for Visigothic legal system.

 The history of late-Latin rhetoric and its preservation cannot be briefly summarized. In general, Mayer 2005; for Gallic orators, L'Huillier 1992; for late Latin panegyrics, Nixon and Rodgers 1994. The revival of rhetoric in medieval and early modern times: Carruthers 1998; other articles in Carruthers 2010. Baxandall 1971 for the thirteenth century and the later Renaissance; narrative methods in early Christian, medieval, and Renaissance church decorations: Lavin 1990.

4. For the varieties of definition of the Roman villa, see Rothe (Chapter 2) in this book; Sfameni 2006, 9–12; for the special case of Gaul, Leveau 1983. For the use of the term in the medieval period, Martinez Melon 2006. For late-antique usage: Brogiolo and Chavarría (Chapter 11) in this book.

5. Cato, *Agr.*1.1.1 and *passim*. For Cato's moral and social motivations: Terrenato 2012.

6. Cato was hard-headed and hard-hearted: along with broken tools, he famously recommended selling old or sick slaves: *Agr.* 2.7.

7. Varro owned family estates at Reate in Sabina some 75 km north-west of Rome, a boar and deer farm at Tusculum 23 km south-east of the City, a villa at Casinum (Gell., *NA* 3.10.17), a cattle farm, a sheep ranch in Apulia, and a stud-farm near Reate.

8. Varro, *Rust.* 1.3–4 and 3.2.2–18 and *passim*. For *utilitas* vs. *voluptas*: 1.13.6–7 for *diligentia* vs. *luxuria*; for the definition of the *villa perfecta*: 3.1.10. Discussion in Schneider 1995.

9. Hor., *Epod.* 2. After a life of conspicuously successful *negotium* (commerce, including banking, semiprofessional work such as assisting a lawyer, contracting, or actual labor), Alphius thought he could buy *otium*, the leisure that conferred gentlemanly status in part guaranteed and proven by villa ownership. *Otium* included pleasant hospitality, feasting with friends, a nice wife, napping on a smooth lawn, sport (especially hunting, always aristocratic), and the other advantages of villa life. The deal even included his buying the former owner's family altar (*lararium*). In fact, Alphius only brought ridicule on himself and, after two weeks, was mightily bored in the country, sold the villa and its estate, and went back to banking – the literary and moral tradition did not work for him; D'Ambra and Métraux 2006, viii.

10. Seneca the Younger emphasizes these distinctions in moral letters on villas; see Métraux 2014 with preceding bibliography.

11. The evocation of villas in prose, letters, or poetry was a minor genre of the description of works of art and architecture that was called *ekphrasis* (pl. *ekphraseis*): for bibliography, Métraux 2014.

12. Pliny, *Ep.* 2.17.20–22. Pliny has his villa-cake and eats it, too, praising his villas beauty but emphasizing their antique and antiquated inconveniences, noting that they put him closer to nature even though their manmade appurtenances were grand, and investing in his disengagement by building a simple four-room house of his own (he called it "my loves" – *amores meae*) adjacent to the grand formal villa at Laurentum, so he could live his own life in parallel with the life of grandeur, formality, personnel, and guest lists of the villa itself. The emperor Hadrian may have had the same idea: If the Island Enclosure ("*Teatro marittimo*") at his palatial villa at Tibur (mod. Tivoli) represents an architectural and personal separation in a simpler and isolated locale from the grandeurs, obligations, and stresses of the rest of the complex, then Pliny's disengagement in his *amores meae* from the rest of the Laurentine villa is a precocious instance of a later architectural attitude by an emperor. Philosophically, such behavior is both Stoical and Epicurean: Stoical in that it emphasizes disengagement of the soul (Gr. ψυχή, Lat. *anima*) from the material environment; Epicurean in that it enhances that solitary self-absorption essential to full understanding of the self. On Hadrian's Villa: MacDonald and Pinto 1995, 81–9, for nomenclature and previous bibliography. See also du Prey (Chapter 24) in this book.

13. He also used his villa properties for benefactions: He mortgaged one of them at his hometown of Comum to set up *alimenta* (a charitable fund) for local children, even though the mortgage permanently encumbered the property title and depressed the

estate's value. Pliny, *Ep.* 7.18; Duncan-Jones 1982, 298–300, 306; Métraux 1998, 13.

14. *Ep.* 4.6.2–3. Pliny may not have been much of a hunter or athlete, but he wrote and spoke a lot.

15. *Genus liberale et ingenuum*: Columella, *Rust.* Praef.10.

16. At Ardea and Caere (?) north of Rome, and at Alba and Carseoli in Latium, south of the City: Columella, *Rust.* 3.3.3 and 9.2.

17. Columella, *Rust.* 3.3.

18. On this topic, Corbier 1981, 427–44. A generation later, Pliny tells us – perhaps somewhat ruefully – about the successive discounts (up to 30 percent) that he offered to middlemen to take his estates' produce off his hands quickly: *Ep.* 8.2.

19. Columella, *Rust.*1.6.2; for nomenclature, Vitr., *De arch.*5.10.

20. Sen., *Ep.* 86 on Scipio's villa at Liternum, but most of the letter concerns making fun of luxurious private *balnea*; discussion in J. H. D'Arms 1970 (2003), 15–16 and n. 11, 25–6. The guests at Trimalchio's Dinner (*cena Trimalchionis*) are treated to a bath before feasting: Petron., *Sat.*28. Sidonius Apollinaris, describing the sequence of reception in his description of his villa Avitacum (*Ep.*2.2), indicates that feasting occurred after bathing, though elsewhere (*Ep.* 2.9) *vice-versa*.

21. Balmelle 2001, 137, 178–20, for *balnea* in Aquitania who notes that they were most often the object of lavish finish in mosaic, marble walls, and so on. For baths in villas elsewhere in Gaul, Auson., *Mos.* 337–48. Representation of such bath buildings in mosaics: Sarnowski 1978. See also Buffat (Chapter 13), Teichner (Chapter 14), Ripoll (Chapter 22), Brogiolo and Chavarría (Chapter 11), and Wilson (Chapter 16) in this book.

22. Palladius' treatise was in circulation throughout late antiquity, the Middle Ages, and the Renaissance, making his name more prominent than those of his predecessors. Andrea Palladio (1508–80), the designer of villas and other buildings near and in Vicenza and Venice, was given his artist's name after him: Ackerman 1966, 20.

23. For a remarkable study of late-antique villas in their literary and visual aspects, Schneider 1983.

24. Palladius, *Op. Agr.* 1.6.8, *passim*. The designation had an equivalent in Greek: ὅ κύριος. For an example, see the mid-fifth-century inscription in a house at Scythopolis-Beth Shean in Galilee: Zori 1966, 124, 127–34; Belayche 2001. Since this house has been

interpreted (Tsafrir and Foerster 1997, 104, n. 85) as a possible hostel with a large hall built by an Alexandrian Jew resident in Scythopolis, the title "lord" (ὅ κύριος) has indeed spilled over to mere owners of urban property. Christian martyrs were also termed *domini*: Grig 2004, 54, 175 n. 91.

The floor of the house at Scythopolis-Beth Shean had an impressive inscribed mosaic punctuated with the representation of a menorah; in a panel above, a scene from the Odyssey (Odysseus and the Sirens) and, below, a panel of a sailing scene with *pithoi* or amphorae secured on the deck of a ship, a personification of the Nile, and a representation of the Nilometer of Alexandria. The Nilometer had been destroyed or moved by the date of the representation, so this is a historical memory: see Schwartz 1966; Baldini 1985; Trombley 2001, vol. I, 129–45.

25. *Pars urbana* as *praetorium*: 1.11; *cella vinaria* as *basilica*: 1.18. See also MacMullen 1963, 23–48 on militarization of nomenclature in civil architecture and villas, 41–4; Ripoll and Arce 2000, 64–5. See Gualtieri (Chapter 10) and Brogiolo and Chavarría (Chapter 11) in this book. Basilicas in villas, some with raised floors in their apses, were frequent in late-antique villas or added to earlier ones.

26. Palladius mentions his own villas and estates in context of their produce: his Neapolitan and Sardinian villas produced lemons (*Op. Agr.* 4.10); his farm near Rome produced quinces (3.25); one in Italy produced figs (4.10). He had connections in Gaul both in the way of practical knowledge and perhaps paternity and family-estates: he mentions a special Gallic harvester as if he had seen one in operation (7.2): White 1970, 30 and n.56; on Palladius' paternity and origins: Martin 1976, 207.

27. *Balneum*: 1.42

28. *... ferrarii, lignarii, doliorum cuparumque factores necessario habendi sunt*: Palladius, *Op. Agr.*1.6; Martin 1976, xxxii–xxxix. See also storage issues at villas in Métraux 1998, 8–12.

29. On manorial issues: Ripoll and Arce 2000, 101–2.

30. For Antioch: Dobbins 2000 with reference to the houses discovered in the excavations of 1932–9; Kondoleon 2000 on the mosaics. For Sepphoris and Tiberias, see Weiss (Chapter 18) in this book. For Utica: the urban *Maison de la Chasse* showed a villa in the context of mosaic panels depicting various forms of hunting: *CMT* I, 1, 67–81; Métraux 2006, 143–5.

31. Primulacium in Aquitania, a family property inherited by Sulpicius Severus, a nobleman,

lawyer, and literary figure, was converted by him into a center of religious worship and a pious community: Ripoll and Arce 2000, 86, n. 54, 110. Sulpicius' friend Paulinus of Nola, himself a very wealthy nobleman, gave properties outright to the church, as did other villa owners such as Melania the Younger and her husband Valerius Pinianus, even convincing their relatives to do so as well: Palladius, *Lausiac History* 61.168; Clark 2001, 267. The suburban villa near Rome belonging to the Valerii, a very great senatorial family claiming descent from the Valerii Poplicolae, Valerii Proculi, and the Valerians of the Republic and early empire, has yielded objects referencing its Christianization: Chastagnol 1956; Brenk 1999: 69, 81, figs. 2, 10–11; Pietri 1961; Huskinson 1982. Melania and her husband Pinianus owned the villa, and when they put it up for sale, Serena, daughter of the emperor Theodosius and wife of Stilicho, considered buying it, but even she could not afford it: Gerontius, *Vita sanctae Melaniae* 14 in Clark 1984. See also Bowes (Chapter 23) in this book as well as Bowes 2001.

32. Séviac near Montréal: Lapart and Petit 1993, 32; Lapart and Paillet 1996, 160–7; discussion in Duval 1991, 190; Balmelle 2001, 106–11, 121–2. However, G. P. Brogiolo and A. Chavarría Arnau (Chapter 11) in this book note that what look like churches next to villas may well have been family tombs later converted to ecclesiastical uses.

33. In the *burgus* of Pontius Leontius: Sid. Apoll., *Carm.* 22.218, where he calls it *templa dei*, and in the Villa Reontium: Gregory of Tours, *Liber de Gloria Beatorum Confessorum* 47.

34. On this distance, especially with regard to the metaphors of rural life in sermons by urban preachers, see Clark 2001, 265–84.

35. For rural euergetism in the eastern empire, Patlagean 1977: 200–1.

36. August., *Ep.* 108.18 (*CSEL* 34^2, 632); 185.15 (*CSEL* 34^2, 632); *Enar. in Ps.* 132.6 (Migne, *PL* 37, 1732).

37. The exact status of the Visigothic and Alan groups that entered Gaul in 406 is difficult to define: their settling had been encouraged by the emperor Honorius in 418 but their depredations were protested as well. See Wallace-Hadrill 1962, 9–42 for a general history of Gaul in the later fourth and fifth centuries; their assimilation in Heather 1991, with

a consideration of fifth-century villas in Percival 1992. For the Visigoths and towns in southern Gaul: Ripoll 2010, 168; for Visigoths and villas in Spain and southern Gaul: Ripoll and Arce 2000, 102.

38. His grandfather (Decimus Magnus Ausonius), besides distinction as a teacher, poet, and other achievements, had been a consul in 376 CE, and his father had been a high imperial official in Greece and Africa when Paulinus was a child and young man in the 370s and 380s.

39. *Euch.*176–225.

40. Because his sons appear to have grown up and been well embarked on their own careers by this time, Paulinus must have been in his 50s when these misfortunes came upon him, that is to say, in the later 420s; *Euch.* 246–253. Paulinus was not the only Gallic nobleman to suffer misfortunes: Victorinus, a high imperial official and a *comes illustris*, had been dispossessed of his estates near Toulouse when the Visigoths under Ataulf conquered the area in 413 CE: Rut. Namat. 491–510.

41. His official appointment was as *privatae comitiva largitionis: Euch.* 291–301. Paulinus knew full well the hollowness of this appointment.

42. See Buffat (Chapter 13) in this book.

43. *Euch.* 516–63.

44. *Euch.* 498–515.

45. Goodman 2007, 203–9; for Aquitania, specifically Bordeaux (Burdigala), Dax (Civitas Aquensium), Périgueux (Civitas Petrucoriorum), and Bazas (Cossio Vasatum): Garmy and Maurin 1996; general considerations for Italy and elsewhere: Christie 2001, 118–20; for a legal and urbanistic view of fortifications in Gaul, Gros 1998. A general overview of the fortifications of cities in the western empire: Johnson 1983b, 82–135; 82–117 for Gaul. For urban issues in Gaul in later times, Laseby 1998, 251.

46. Sivan 1992; Barraud 1988; *TCCG* X, 26–7.

47. Ausonius, *Ep.* 23.90–95; *TCCG* X, 27, 33.

48. Maurin 1978, 329; Laurenceau and Maurin 1988, 54–50; *TCCG* X, 58–9.

49. For the fortifications, see Cairou 1976; Solier 1986; Caille 2005, 17–20; Sabrié 2011, 321–7.

50. Sabrié, M. and R. 2004, 49–50 on the formerly urban streets, 126–37 on late-antique developments and burials.

51. It can be noted that the reverse could also happen: A suburban villa could become a *domus urbana* as the city grew outward. Such happened at Vasio

Vocontiorum (mod. Vaison-la-Romaine) in southern Gaul where a villa built around 40 BCE, the *Maison au Dauphin*, was absorbed into the growing town in Flavian times, about 140 years later: Goudineau 1979, 1: 85–114, 243–4.

52. A contemporary example is the re-ruralization of the abandoned urban residential areas of Detroit, Michigan. More than 50 years of depopulation has recently resulted in the municipal government tearing down large numbers of houses, leaving a few isolated dwellings still in habitable condition. A proposed plan has included offering these dwellings to purchasers for nominal prices or for free to homesteaders seeking *agricultural* space, in exchange for cessation of municipal services (roadway maintenance, water supply, sewage disposal). See the *Community Development Advocates of Detroit Futures Task Force* report, February 2010: www.detroitcommunitydevelopment.org/CDAD_Revitalization_Framework_2010.pdf (accessed September 6, 2010).

53. Bouiron 2001, 321–4, fig. 321; Heijmans 2006, 57, fig. 27.

54. *Euch.* 570–81.

55. Complaining about the expense, poor return, and ruinous purchase and/or sale price of country properties is a conventional lament among villa- and country house-owners from Roman times to the present.

56. *Euch.* 12–16. Paulinus' *Eucharistus* is the only poem of his that has survived.

57. For a lively account of literary preoccupations in town and country among Gallic noblemen in this period: Frye 2003.

58. Fouet 1969; Balmelle 2001, *passim* and 379–85; on dating, Stirling 1994, 23–5, 162–85; Février 1981, 571.

59. The *atria* are not mentioned in Balmelle 2001, Ellis 1991 and 1997, or Smith 1997.

60. M. Cetius Faventinus: edition in Cam 2002. I note that Palladius follows Faventinus and does not mention *atria* in villas, only *triclinia* and *cubicula*; Palladius, *Op. Agr.* 7–15; 40.

61. Vitr., *De arch.* 6.5.3. See Wallace-Hadrill (Chapter 3) in this book.

62. On the form and varieties of *atria*; Clarke 1991, 6–12 and *passim*; Zaccaria Ruggiu 1995, ch. 8; Pesando 1996, 27–198, 211–15; Wallace-Hadrill 1997; George 1998.

63. See Gualtieri (Chapter 10) in this book.

64. Fouet 1969 (1984), 68, fig. 33 (mislabeled "le petit *atrium*") and pl. 1.

65. Vitr., *De arch.* 6.3.

66. Fouet 1969 (1984), 68, fig. 38 and pl. 1. The water supply of the Montmaurin villa was assured by means much larger than whatever small quantity of water would have been collected in the *impluvium* of room 38. In fact, there were fountains and basins with running piped water at higher levels to the northeast of the smaller atrium, and the baths of the villa to the west had impressive water displays requiring greater pressure than the northeast to southwest sloping topography would have afforded; for the hydrography of the villa, Fouet 1969 (1984), 145–8.

67. Vitr., *De arch.* 6.3.

68. The proliferation of villas in late antiquity used to be interpreted as a "flight" from cities by landowners and aristocrats to avoid municipal pressures to undertake important civic, provincial, diocesan, and even imperial responsibilities, but this has been shown to be a false inference: general discussion in Février 1981 and Mathisen 1992.

69. The listings of monuments and other buildings of Rome called the *Curiosum urbis Romae regionum* XIIII and the *Notitia urbis Romae*, both fourth century, list large numbers of *domus*: for the Palatine (*Regio* X), 89 houses, for the Circus Maximus area (*Regio* XI), about the same: Nordh 1949.

70. Sid. Apoll., *Ep.* 1.6; Mathisen 1992, 232–4; Harries 1992, 300. In the same letter, Sidonius compliments his friend for living in his villa filled with the images of his ancestors.

71. On the mausoleum of Diocletian: Živkov 2009, 515–16, 518; Nikšić 2009; Johnson 2009, 59–70. For *mausolea* in villas, Brogiolo and Chavarría (Chapter 11), Gualtieri (Chapter 10), and Bowes (Chapter 23) in this book.

72. *SOLLERTIANA / DOMUS SEMPER / FELIX CUM SUIS*, "The always-happy Sollertiana house with its inhabitants," *CMT* III, fasc. 1 (p. 5, n. 5, page 23, pl. XII, plan 1).

73. On the towers, Anselmino et al. 1989, 46–55, figs. 13, 48–9; its character as a villa, 56. On the date and inscriptions of the building, Pucci 1989, 116–17. See Wilson (Chapter 16) in this book.

74. Balmelle 2001, 114–15, 144–5; Bodel 1997, 16.

75. The inscription stone also bore the names of others (*auctores*), probably family members, who had a hand

in its foundation. Next to the inscription was a fountain as an amenity for visitors to wash before entering the house: Sid. Apoll., *Carm.* 22.142–5.

76. This is clear from estate lists made for the *alimenta* loans in Italy: Pachtère 1920, 304; Veyne 1957, 112–25; Veyne 1958, 205–22; Criniti 1991, 275–83. The designation by name of original owner/s continued: Sidonius' favorite villa came to him from his wife's family, the Aviti, which he called his *Avitacum*: Sid. Apoll., *Ep.* 2.9. Villas could also be known from their location: Pliny the Younger called his villa at Laurentum his *Laurentinum*, that in Tuscany his *Tuscanum*, and so on, but these were unofficial names. Cicero inherited a villa at Puteoli on the Bay of Naples from a certain Cluvius and ambivalently called it his *Cluviana* [*praedia*] or his *Puteolanum*: D'Arms 1970 (2003): 61, n. 76; 190.

77. See Wilson (Chapter 16) in this book.

78. The names of these towers seem to have been actually used to identify them. Of course, Sidonius as a poet did not hesitate to apply the most erudite (not to say far-fetched) designations to parts of the villa: Pontius' wife's *textrina* or weaving-room is "like a Temple of Athena (divine patroness of weaving)," and so on: Sid. Apoll., *Carm.* 22.193–4. For the names of the towers and castellated villas elsewhere: Wightman 1970, 169–72 (Pfalzel villa).

79. Sid. Apoll., *Ep.* 18; 19; for bathing and bathing after eating, *Ep.* 2.9.8–9.

80. Smith 1997, 117–43. See Rothe (Chapter 2) and Wilson (Chapter 16) in this book.

81. For Claudius Posthumus Dardanus, *ILS* 1279; Salway 1981, 452–3; Salway 1997, 452–3, 729; Matthews 1990, 323–5; Ripoll and Arce 2000, 97.

82. Sid. Apoll., *Carm.* 22.157. The term is unique; the poet may have invented it himself.

83. Balmelle 2001, 147–53, figs. 59–60.

84. The description in the poem is confusing. Evidently, there was an outside wall of which the inside was partially covered with marble slabs rising to a gilded ceiling (*sectilibus paries tabulis crustatus ad aurea tecta venit*) covering a portico. This straight wall then gave way to curving porticoes defining a crescent-shaped courtyard; it is these walls that were painted with scenes of Roman history. As architectural description, most of the rest (lines 146–57) is obscure.

85. Mithridates sacrificing four horses to Neptune, then the siege of Cyzicus and the Roman general Lucullus raising the siege, with various other episodes. App., *Mith* 70–77 (12.10–11 Loeb); Flor. 1.40.16.

86. Sid. Apoll., *Carm.* 22.116–19. Sidonius presents the villa and its wall paintings by the god Apollo as a future home for him and the god Bacchus (who is drunk) in the far west. Apollo says that, in the future, they will both live in the *burgus* when it is built. The earlier privilege of *ius Latii* for Gaul had been confirmed by the *Constitutio Antoniniana* of 212 CE.

The east-west theme is not without its earlier manifestations: Pomponius Mela (3.13) indicates that on the western shore of Lusitania, L. Sestius Quirinalis dedicated three altars to the *numen* of Augustus (cf. Ptol., *Geog.* 2.6.3 and Plin., *HN* 4.14). Closer to Sidonius' time, Orosius (6.21.19) explicitly introduces a "far east/far west" theme in his account of the visit of Indian and Scythian ambassadors to Augustus at Tarraco. The theme is touched on in Gros 2015, 199, n. 52.

87. Sid. Apoll., *Carm.* 22.200–2. The *domina*'s sitting room next to her *textrina* (weaving rooms) had paintings of Jewish history, at this time identifying her as a Christian. Sidonius' description (*Ep.* 2.9) of his own villa *Avitacum* near Augustonometum (mod. Clermont-Ferrand) follows a sequence of hospitality similar to the tour of the premises of Pontius Leontius' *burgus*; see also Mratschek 2001. In the generation previous to Sidonius, Paulinus had the walls in the porticoes surrounding the sanctuary of St. Felix at Nola painted with biblical scenes to impress simple country folk on feast-day pilgrimages and thereby keep them from getting drunk.

88. Four centuries before Pontius' villa, Trimalchio's house had had similar wall paintings depicting events in his own life and scenes from the *Iliad* and gladiatorial combat: Petron., *Sat.* 29.

89. Métraux 2014, 36–9.

90. Sid. Apoll., *Ep.* 1.6.4: *faeculento patrimonium promovisse compendio.,*.

91. Sid. Apoll., *Ep.* 1.6.3: *Non minus est tuorum natalium viro personam suam excolere quam villam.* Eutropius had been Praetorian Prefect of Gaul, a high administrative position with direct access to the emperor: Sid. Apoll., *Ep.* 3.6. Sidonius and Eutropius were fellow-Christians, fellow-Plotinians (followers of the third-century CE philosopher Plotinus), and fellow-Platonists (devotees of the particular branches of later Neo-Platonist or "Second Sophistic" thought that had been popularized among

intellectual elites in the third century and after) as well as non-Epicureans (from the Greek philosopher Epicurus, whose ideas Sidonius incorrectly and jeeringly describes as a philosophy of mere pleasure). Both later became bishops: Sidonius of Augustonometum (mod. Clermont-Ferrand), Eutropius of Arausio (mod. Orange): Sid. Apoll., *Ep.* 6.6. See Arnheim 1972, 105–6.

92. The opposition relates to *otium vs. negotium*, a literary commonplace originating many centuries before. Cicero discusses *otium* in *De Officiis* Book 3; in general, André 1962; 1966; Dosi 2006. One of Sidonius' sources was Pliny the Younger: for *otium* in Pliny: Méthy 2007, 353–413. For *otium* in Pliny's Laurentine villa, *Ep.*1.9.6; Pliny also expressed the dichotomy as *studia* vs. *officia*; for his take on *otium* in relation to his literary activity, Gamberini 1983, 103–10.

93. For portraits in houses, see in general Flower 1996.

94. Sen., *Ep.* 86. Scipio's villa came to be a political monument to his forced retirement (187–184/3 BCE), and the portraits may have served to extend and emphasize this meaning. Seneca says that the current owner, a certain Aegialus, had maintained the old portraits as a prestigious part of the villa and estate: portraits stayed with the property rather than with the family: see also D'Arms 1970 (2003), 15–16 and n. 11, 25–6; Gargiulo 2000, 115–17. It is possible that Seneca made up seeing the statues at Scipio's *Literninum* villa on the basis of the known statues in the Tomb of the Scipios beyond the Porta Capena, in which Livy (38.56) says that there were statues of Scipio Africanus, his second son Lucius Cornelius Scipio, and the poet Ennius. Cicero (*Arch.* 22) says that a statue of Ennius was in the Tomb of the Scipios, but this proved not to be the case, though confusion with the statue at the Liternum villa may have prompted Cicero's error.

95. Neudecker 1988.

96. Photo: www.flickr.com/photos/53144528@N04/5205911489/in/photostream/ (accessed January 8, 2015). Fejfer (2008, 240) has noted that portraits, rather than generic figures, tended to be in the bust format. For an account of the sculptures of Herodes Atticus' villa at Eua Loukou, see Papaioannou (Chapter 19) in this book.

97. In the first century BCE, Varro had written a treatise called *Hebdomales* sketching verbal portraits of 700 famous men; it was known to Ausonius four centuries later: Auson., *Mos.* 283–286; Plin. *HN* 1.35.2.

98. Marcus Aurelius: *SHA., Marc.* 3.5; Severus Alexander: *SHA, Alex. Sev.* 29.2; 31.4. Portraits of the emperors and the imperial family could also be assembled in villas. The group of portraits from a villa most probably built by Lucius Verus at Aquatraversa on the *via Cassia* (north of Rome) included a portrait of Plotina and another of Faustina Minor: these would have provided a female familial line (through marriage and adoption) of imperial succession from Trajan through Antoninus Pius to Marcus Aurelius and Lucius Verus. These two last were represented in no less than twelve or thirteen identifiable heads or busts, some perhaps intended as paired *pendants* of one another: Mastrodonato 1999–2000, 201–28; Fejfer 2008: 422–5, n. 199–201.

99. The correspondence can be reconstructed from Paulinus' responses to his friend: *Ep.* 30.2–3 and *Ep.* 32.1–4 (Migne, *PL* vol. 61, 322–3 and 330–2, respectively); English translation in Walsh 1966; Trout 1999. Sulpicius completed the portrait project even though Paulinus demurred from sending a portrait (modesty apart, Paulinus was afraid that the portrait might not be a good likeness! So much for his faith in contemporary art). For an analysis of other aspects of their correspondence, see Bowes (Chapter 23) in this book.

100. Chiragan portraits: The ongoing publications are those produced by the Musée Saint.-Raymond, of which three have been published: Balty and Cazes 2005 (early imperial), Balty and Cazes 2008 (Tetrarchic), and Balty, Cazes, and Russo 2012 (Antonine); three more volumes are promised and forthcoming; brief account in Balmelle 2001. At Chiragan, there must have been some intentionality to the collecting and patronage besides the portraits: The sculptures included twelve very large reliefs of the Labors of Hercules, which formed a group united in a vigorous style, a collection of *tondi* of the gods, and a few copies of Greek works denoting a refined and knowledgeable taste. On the mythological iconography at Chiragan, Bergmann 1999, though she mentions portraits 28–31, 40–1, figs. 7–10, pls. 11–15.

For the Welschbillig herms: Espérandieu 1925, vol. 9, no. 7279; Wrede 1972; see also Wrede 1986 for bibliography.

101. Queyrel 1992, 80; this group consists of busts of Augustus, Antonia Minor, and Agrippa Postumus [inv. n° 30160 in 1992], which appear to be similar in style and size, prompting Queyrel to the view that they were or had been part of a unified assemblage.

102. In other words, political bias may have operated simultaneously in the selection of imperial images and in the biographical accounts in Suetonius, Tacitus, the *Scriptores Historiae Augustae*, and so on.

103. The herms began to be found in 1841–58; excavations were undertaken in 1891–92. The material was first presented in Espérandieu 1925, vol. 9, no. 7279. For the architectural setting, Wrede 1972: 10–29. The herms were, in a sense, mass-produced, the individual herms cut in groups of twenty-four from single big blocks: Wrede 1972, 33–4. The height of the shafts varied between 85 and 101 cm, with square sections between 24 and 31 cm; the busts are between 34 and 45 cm high. Sixty-three herms are extant plus seven shafts or fragments of a total between 108 and 112 or 94 and 98 (the placement of the herms around the pool is not completely clear).

104. Henning Wrede (1972, 90–7) has strongly suggested a connection among the herms, the emperors, and Ausonius the courtier-educator.

105. As far as I am aware, the assemblage has so far resisted any precise iconography or compositional interpretation, even though it is clear that there were "pairs" (for example, Philip II of Macedon [herms 14 and 24] and his enemy the Athenian rhetor Demosthenes [herm 23], or, if the former is, in fact, Alcibiades, then he would be paired with Socrates [herm 9]). Wrede (1972, 35–6, 40–52) has also suggested symmetrical compositions mirroring one another; there does not seem to be any chronological composition or much in the way of an intellectual progress, though a rhetorical and pedagogical "tour" of some kind was evidently part of the arrangement.

106. For a similar dramatization in a villa owned by Herodes Atticus in Greece, see Papaioannou (Chapter 19) in this book.

107. For iconography and imagery in dwellings as cultural consumption: Scott 1997, 64–7; from the side of the craftsmen-suppliers: Métraux 2006.

108. Table-talk compilations: Plutarch (*Moralia*, early second century CE), Aulus Gellius (*Noctes Atticae*, late second century CE), and Athenaeus (*Deipnosophistai*, third century CE). Plutarch's *Parallel Lives* is an early example of seeking connections and affiliations among persons widely separated by geography, chronology, and ethnicity.

22

ARISTOCRATIC RESIDENCES IN LATE-ANTIQUE HISPANIA

GISELA RIPOLL[1]

Le seul véritable voyage ce ne serait pas d'aller vers de nouveaux paysages, mais d'avoir d'autres yeux.

[The only real voyage would not be to go to other lands but to have other eyes.]

Marcel Proust, *À la recherche du temps perdu*, V, *La prisonnière*, 1923.

DEFINING THE LATE ANTIQUE VILLA IN HISPANIA: ANCIENT AND MODERN PROBLEMS

By late antiquity, substantial *civitates* and *urbes*, towns and cities, had become the centers of commercial, legal, military, and administrative activities in Roman Hispania. However, villas and other economic entities in the countryside assured their food-supply, social networks, cultural participation, transportation amenities, and even defense. This strong economic and social articulation between rural and urban entities was supported by smaller settlements and properties: legal designations made sharp (if often ambiguous and changing) distinctions among different kinds of land and its vegetation, watering, planting, buildings, settlement entities, annexes, location in the transportation system, and so on (colloquial usage was looser). Later, rural settlements developed around ecclesiastical buildings, but these also were distinguished as to legal function and designation.

Among all forms of rural settlement, literary and archeological sources single out the *villa* – understood as a large aristocratic private residence – as one of the most characteristic elements in the management of agricultural land during late antiquity (Map 18). In the Iberian Peninsula, the first structures of this type had coincided with the processes of Romanization in the Republican era, and their initial architectural expansion, especially as it relates to the residential parts or *partes urbanae*, took place during the second and third centuries CE. While there is some unanimity on the definition of architectural structures, the vocabulary used to describe settlements ranging from the Roman Republican and imperial periods to the end of late antiquity remains a problem, as does the vocabulary for architectural elements from later periods.[2]

A "boom" of Hispanic villas took place in the fourth and fifth centuries, in both newly built villas and on existing ones extended or rebuilt; it involved architecture as well as innovative decoration.[3] This sudden, complex, and widespread expansion of a social and cultural phenomenon had local permutations, and change preceded evolution: There had been changes of use in villas, coarsening and disintegration of habitation, and abandonment of some sites, but there were also conspicuous new constructions, addition to existing buildings, and redecorations. The Hispanic villa flourished late and

426

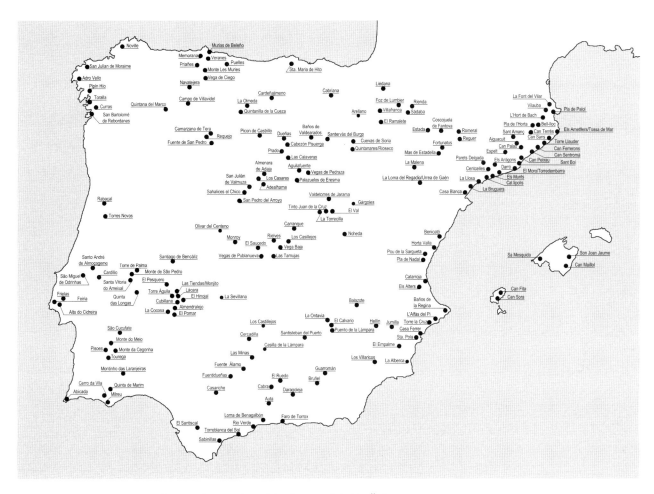

Map 18. Late-antique sites of Hispania mentioned in the text (M. D. Öz).

vigorously in late antiquity, and it responded to mutations of the Roman economy both in the Iberian Peninsula and elsewhere in the empire. Late antiquity had a special intensity in Hispania. Christianity came early to the peninsula: Its wide spread and social influence was reinforced by the Visigothic occupation, which assimilated the existing systems, with the result that subtle transformations took place within continuities of social, cultural, and economic life without abrupt historical fractures. Hispanic villas are an instance of these continuities. In addition, scientific investigation of Roman (not only Iberian) villas has considerably modified how historians write about them: The process from vigorous expansion to decline has been replaced with evaluations of the particular conditions of rural organization and architecture in late antiquity.[4]

The "boom" in Hispanic villas was both widespread and spectacular. The recently discovered villa of Noheda (Castilla-La Mancha, Cuenca) is fully comparable to that of Piazza Armerina in Sicily in its general dimensions, complexity of architecture, and mosaic, wall, and sculptural ornamentation (Figure 22.1).[5] The very large mosaic paving in its triapsidal reception room (one of many formal rooms) covered c. 300 m^2 (c. 231 m^2 preserved) and is of exceptional iconographic richness and stylistic verve: a large Dionysiac procession, and scenes of the lives of Paris and Helen, Pelops and Hippodamia, scenes of pantomime with musical instruments and costumed actors, and animated marine scenes, all with many figures and details (Figure 22.2). The Noheda ensemble, dated after the first quarter of the fourth century CE, is only a particularly magnificent

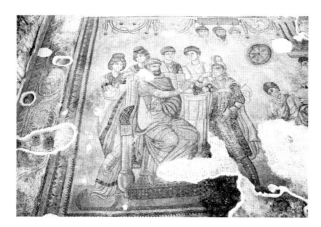

Figure 22.1. Noheda (Villar de Domingo García, Cuenca), villa: mosaic depicting the race between Oenomaus and Pelops, detail of panel A (Photo:© M.A. Valero Tévar).

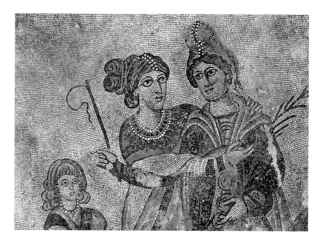

Figure 22.2. Noheda (Villar de Domingo García, Cuenca), villa: mosaic depicting Hippodamia hugging Pelops, detail of panel A (Photo: © M.A. Valero Tévar).

example: other grand residences and large properties were owned by the elites of ancient Valeria (mod. Las Valeras, Cuenca), Ercavica (near Cañaveruelas, Cuenca), Segobriga (Saelices, Cuenca), and Complutum (Alcalá de Henares). Such villas, as well as the many others discovered in the twentieth century, document both the use and function of these aristocratic residences and their evolution and abandonment. They also underscore the value owners placed on décor – not merely for visual enhancement or pleasure, but for real exercise of cultural knowledge and discriminating taste – in mosaics, painting, and sculpture in the practice of refined *otium* in their villas.

The Hispanic aristocratic proprietors of late antiquity were expert exploiters of agricultural lands and natural resources, so their villas are both a timeline and an indicator of their economic rise and changing fortunes, providing deep knowledge of their owners in late antiquity and vivid evidence of their lives and outcomes in various aspects.[6]

The sudden expansion of Hispanic villas in the fourth century has been interpreted in two, now largely discarded, ways: the first is Christianization, once thought to have been a primarily rural phenomenon and thus incubating villas. The second is the notion that urban aristocrats in troubled times fled to the countryside, seeking refuge from turbulent and vulnerable cities. Neither of these is

satisfactory: Christianization first took hold in urban areas and only later expanded to rural districts, precisely because the aristocracy had homes in both the city and the countryside. Furthermore, there are no historical or archaeological instances of "flight" to the countryside. Cities, their rural territories, suburban houses, rural settlements, and villas were firmly interconnected and continued to be so into late antiquity, though all the entities evolved. Cities continued to consume the produce of villas and served as hubs for reception and redistribution of wealth and export of goods, but with this difference: Local bishops became increasingly important in the collection of tax revenues and in organizing parish, territorial, and urban life.[7] The late-antique aristocracy, both civil and ecclesiastical, and its exploitation of the land were important economic engines of the Roman Empire: villas are their impressive surviving representatives.[8]

LATE-ANTIQUE VILLAS IN HISPANIA

This chapter limits its scope to grand rural residences, many recently discovered. Of course, small villas on small properties have been found: they proliferated – for reasons not yet fully understood – in the area north of the Meseta Central and in the area

corresponding to the territory of ancient Valencia.[9] In the Balearic Islands, where maritime villas would be expected, modest farms inland have been documented by field surveys but with little architectural information.[10]

By contrast, large late-antique villas in Hispania are sufficiently well-known that they can be grouped under four main themes: the owners' *identities*, the architectural types of plan and forms of rooms in the dwellings, the particular shape of the dining beds that framed their owners' *hospitality*, and the *choices* the owners made (or were offered by the artisans) in the content and iconography of mosaic floors (and some sculpture). Other changes in late-antique villas are treated in the last part of this chapter.

IDENTIFYING OWNERS: ARCHITECTURAL AND ARCHEOLOGICAL CONTEXTS

The status of the owners of villas and other rural entities varied significantly. Some were great aristocrats, and the Latin terms *possessores* or *potentiores* ("landowners" and "more powerful men," respectively) aptly describe their wealth in terms of ownership of large estates without addressing other social affiliations. Who were these owners and what do we know about them?

The question has sometimes been answered by associating the architecture, decoration, and iconography of the villas: These elements have then been called upon to ascertain the social status and even the mentality of the Hispanic elites of the fourth century, as if grandeur of architecture and décor inevitably denoted high social and political standing, even senatorial rank or glamorous ties to the imperial family. This equation of villas and high social status is erroneous: Its adoption coincided with the concept of "architecture of power" in the interpretation of buildings, a concept freely used in 1979 by J.-G. Gorges to describe what he regarded as a specific typology of the "aulic" (or courtly) villa, due to its resemblance to imperial palaces. In doing so, Gorges was understandably prompted by concepts emanating from the

publications about the recent discovery of the great villa of Piazza Armerina in Sicily.[11]

In fact, and with the exception of the Noheda villa (see p. 427), no Hispanic villa is comparable in dimension, monumentality, and ornamentation to that of Piazza Armerina, which boasts a floor area of c. 15,000 m^2 covered by more than 3,500 m^2 of mosaics.[12] In addition, facile associations cannot be sustained: The emperor Theodosius I (reigned in the east 379–92 CE; sole emperor, 392–5 CE) was of Hispanic origin, but linking some of the great villas of the Meseta Central with him, his family, and the Hispanic aristocrats associated with his administration, as some scholars have done, goes beyond any historical and archaeological evidence.[13]

VILLA OWNERS: LOOKING FOR NAMES

At times, the archaeology of villas has been distorted by exaggerated searches for supposed imperial owners or proprietors with high connections. The villa of La Olmeda (Pedrosa de la Vega, Saldaña, Palencia), is a conspicuous example of such exaggeration. This large, finely decorated residence (more than 1,400 m^2) has been directly – but very feebly – linked to Theodosius or his family from the discovery of a medallion minted in the time of Theodosius: thin evidence for a grand claim.[14] In consequence, the mosaics of the villa were said (erroneously in my view) to belong to the second half of the fourth century CE in order to advance a claim of imperial identity to what is a charming and unusual family portrait-series. One of the mosaic floors had a central panel depicting an adventure of Achilles, with a beautiful border (0.87 m wide) of vegetation, personifications of the Seasons, and ducks (Figures 22.3). Within this border were eighteen medallions framing portraits of the owner and his family: Three males, twelve females (Figure 22.4). They are not named or equipped with imperial or official props and clothing: Giving them "imperial" status or affiliation is foolhardy. These are images of family members in their home: Likenesses, not names or status. How and why they might have been commissioned are more plausible subjects of investigation.[15]

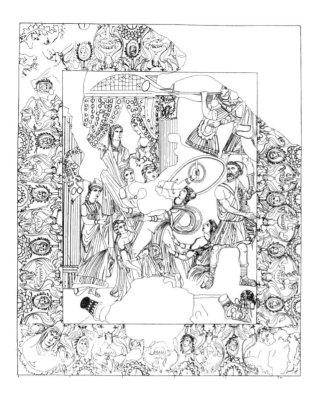

Figure 22.3. La Olmeda (Pedrosa de la Vega, Palencia), villa: drawing of mosaic depicting Achilles in Skyros (central scene) and medallions with portraits in the frieze framing the scene (drawing by P. de Palol and J. Cortés 1974).

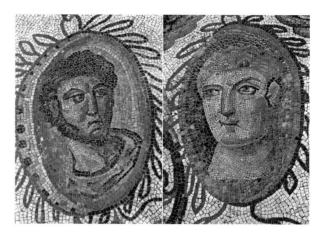

Figure 22.4. La Olmeda (Pedrosa de la Vega, Palencia), villa: detail of two portraits from the freeze of the mosaic of Achilles in Skyros in Figure 22.3 (Photo: ©J. Arce).

Even though it was half the size of the La Olmeda villa, that at Carranque (Toledo) with c. 600 m² of residential quarters and many outbuildings has also been given a glittering association with the imperial court. On the basis of an inscription mentioning a certain Maternus on a mosaic at the entrance to a *cubiculum*, the building has been claimed for no less a personage than Maternus Cynegius, praetorian prefect of the East (384–8 CE) under Theodosius I.[16] However, the name Maternus was a common name in Roman Hispania, with about 150 documented cases: Coincidence of names cannot justify any connection to a high imperial official.[17] There are other instances of such arbitrary claims.[18]

The forced interpretation of the family portraits at La Olmeda as imperial personages and the attempt to give the Carranque villa to a high court officer are perhaps innocuous: more serious is when owner-identity distorts archaeological facts. For example,

the large central-plan construction at the villa known as Centcelles (Constantí, Tarragona) has been strangely identified by some scholars as the mausoleum of the emperor Constans (337–50 CE), and by others as that of some unidentified important ecclesiastical figure.[19] However, its position adjacent to the villa's baths more plausibly identifies it as a reception room, in a typical sequence of late-antique hospitality whereby a guest was greeted and then invited to bathe. The iconography of the dome's decoration (in both paint and mosaic) were likely scenes representing the owner as a hunter in the aristocratic *venatio* rather than any funerary motif: He was the central figure, surrounded by other male participants, in a hunting scene on axis to the entrance to the dwelling, with a mosaic depicting the villa and its property above it, the whole to celebrate the reception of any honored guest, whomever he might be.[20] Such iconography is not funerary: It is gracious and welcoming, promising hospitality and noble sport without reference to imperial situations or individuals, funerary or otherwise.[21]

VILLA OWNERS: NAMED OWNERS

When owners of villas gave their names, they did so with full confidence and pride in their social identity.

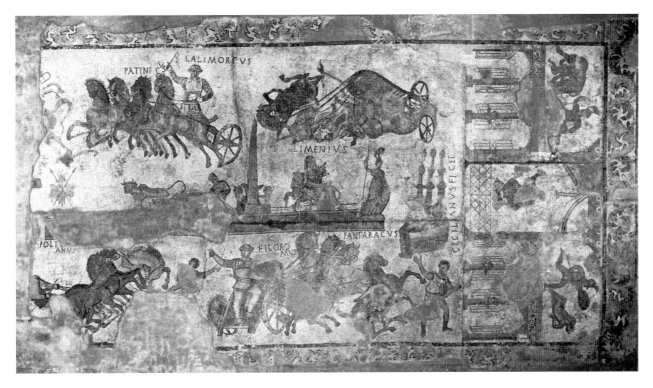

Figure 22.5. Villa de Bell-lloc (*suburbium* of Girona), villa: mosaic depicting a chariot race (around 1989, just before restoration) (Photo: Archaeological Museum of Catalonia, after Darder and Ripoll 2000).

One such was the owner of Bell-lloc, a suburban villa of Gerunda (mod. Girona; the building, also known as Can Pau Birol, has disappeared.)[22] He had his name placed in the mosaic floor of an open court on axis with the entrance to a reception room; the mosaic included a circus scene and, in a geometric border, an exciting depiction of victory, that of Bellerophon's fight with the Chimera (Figure 22.5). The proud owner showed himself in a portrait and identified himself as a sponsor of circus games: "Cecilianus paid for this."[23] The pride of Cecilianus and others in providing public entertainment for their fellow citizens was a frequent theme of municipal engagement, in Hispania and elsewhere.

At the villa of Els Ametllers, in Tossa de Mar (Girona, also Turissa, Torsa, or mod. Tossa), one Vitalis allied himself intimately with the local municipality in the mosaic floor of a corridor leading to the main reception room.[24] The mosaic panel is divided into three panels, the central panel showing a female figure in the personification of the city of Turissa, wearing a crown of walls and turrets (a *corona municipalis* or mural crown), a common iconography of cities since early Roman times. The upper panel bears an inscription: *Salvo / Vitale felix Turissa*, "If Vitalis is safe, Turissa will be happy," while the bottom one reads: *ex of/ficina Felices*. Vitalis, the owner, wishes good health to himself, so that happiness will prevail in Turissa, the town near which his villa is located. This is a common and usual invocation of good fortune, and although we do not know who Vitalis was, he was undoubtedly a prominent member of the town for whose happiness he hopes. The lower panel of the Els Ametllers mosaic is an artist's signature: "From the workshop of Felix." This may seem like advertising by a commercial decorator, but possibly it complimented the owner for his wealth and fine taste in choosing such an artisan.[25]

Hunting was a popular identifying theme for villa owners: at the villa of El Ramalete (Tudela, Navarra), the name Dulcitius, inscribed on the central emblem in an octagonal mosaic representing a horseman out on a hunting expedition, was the name of the owner of the villa. Such names of owners

could persist in other ways: The villa of Arellano may derive its name from the Roman patronymic *Aurelianus*, possibly the name of the owner of the magnificent villa in Navarra dedicated to agricultural and livestock farming and wine production.[26]

Besides such things as names, patronage of circus games, hunting, and municipal well-wishing, religion was also a means of identity in late-antique times in Hispania. Fortunatus, in a mosaic inscription adjacent to the *tablinum* of a villa in Fraga (Huesca), had his name conjoined with the Christogram (the Chi-Rho combination of Christ's initials) with the Alpha and Omega inverted on either side. This arrangement emphasized the legibility of the specifically Christian elements around the name, from either the *tablinum* or the space in front of it, and it strongly stated the case for Fortunatus' ownership of the villa as well as his piety. In the Lusitanian villa of Quinta das Longas, in Elvas, a Christogram was *added* to one of the mosaic floors of the reception rooms in the fourth century to show off the owner's newly acquired belief.[27]

These inscriptions on mosaics identified the owners, but *objects* found in villas specify – even more accurately – the status of those who may have owned or frequented them. For example, a crossbow *fibula* (a pin to secure cloaks on the right shoulder, intended, like badges, to proclaim the status and dignity of the wearer) of a very special type was excavated at the villa El Pesquero, near Mérida. Another came to light in Pla de l'Horta (Girona) in northeastern Spain. These are not casually found objects or mere accessories: They denoted high social standing and were reserved for Roman patricians and high civilian officials in the late fourth and early fifth centuries.[28] Belt buckles worn only by officers or other military personnel also give a picture of who frequented villas in the later fourth century.[29]

Pins and buckles are solid indicators of the rank of the villa owner or who his high-status guest would have been, without supposing any direct imperial connection. However, the owner of a villa or rural property c. 40 km. south of Emerita (mod. Mérida) really did have a tie to the imperial entourage, as shown in the discovery in his villa of a large ceremonial silver dish known

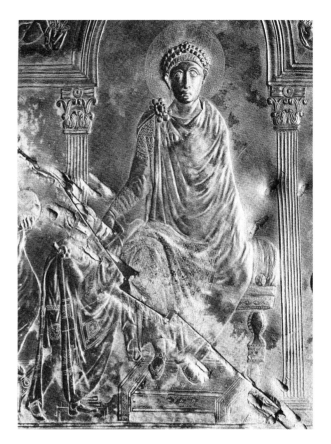

Figure 22.6. *Missorium* of Theodosius discovered at Almendralejo (Mérida, Badajoz), now at the Royal Academy of History, Madrid. Detail showing Theodosius and, to his right, the *vicarius Hispaniarum* (©J. Arce).

as the *Missorium* of Theodosius (Figure 22.6).[30] The *Missorium* (dated to 387 or 388 CE), which depicts the emperor Theodosius flanked by family members or colleagues enthroned in front of the palace of Thessalonica (mod. Thessaloniki), may have been made to celebrate the tenth anniversary (*decennalia*) of the emperor's reign; it was grouped with other objects including silver vessels. Such a gift would have been sent, at the emperor's behest, to commemorate an important event or appointment directly from the office of the *comes sacrarum largitionum* (Count of the Sacred Largesse, a senior fiscal official in the imperial administration). The recipient of the emperor's gift would have been a senior official, in this case even the *vicarius Hispaniarum* residing at Emerita, capital of the *diœcesis Hispaniarum*: An official of such high

status might well have owned or made use of a residence in the area.[31]

The *Missorium* of Theodosius is an exception, but for the most part, villa owners in the Iberian Peninsula can rarely be identified from the iconography, archaeological materials, and architectural typology of their dwellings, though these elements offer insight into their social aspirations and economic positions. Where they were located on the social and administrative ladder in the larger empire is less important than their specific elite status in the Hispanic provinces as aristocratic landlords who combined the exploitation of the land with a life of rural leisure and tranquility.

Their habits as embodied in their villas persisted beyond the Roman presence in the peninsula and were ultimately adopted by the new barbarian kings. The Visigothic monarch Recceswinth (second half of the seventh century) owned a villa in Gerticos, near which he chose to be buried;[32] his ownership of a villa was probably not an isolated case, and the villa may have had some degree of continuity from an earlier dwelling.[33] The villa of Liño, for instance, is listed among the properties of King Alfonso III (866–910 CE): it included palaces, bath houses, and the church of San Miguel.[34]

ARCHITECTURE: CENTRAL-PLAN VILLAS

Central-plan buildings – whether centered on a rotunda, octagon, cruciform (cross-shaped) room, triconch (three-apsed), tetraconch (four-apsed), polyconch (many-apsed) – had been Hellenistic and Roman architectural developments, but their peak occurred during late antiquity throughout the empire, including Hispania, in villas and other types of buildings.[35] Given their spatial versatility, the use and function of central-plan structures could be ambivalently civil or religious, for *martyria* (structures built around martyrs' tombs or places of execution), baptisteries, churches, *mausolea*, baths, reception rooms, dining halls (*stibadia*), or circulation areas and antechambers providing access to other rooms. The elites built structures with central floor plans in their

residences in emulation of late-Roman imperial palaces, symbols of wealth and status.[36] In Hispania, designers provided villa owners with many remarkable instances of this type of plan, and more will be found. The octagonal plan appears the most common, but there are circular, triconchic, tetraconchic, and polyconchic examples as well. In the fourth century, central plans were the plan of choice when new monumental construction and/or remodeling of reception rooms and bath quarters were undertaken; villa owners in Hispania and elsewhere tended toward homogenized tastes in architectural space and sequences.[37]

The villa at Baños de la Reina (Calpe, Alicante), on the Mediterranean coast, comprised a fine residence and facilities to exploit marine resources. Among the several reception areas, the principal one had a circular central hall 22 m in diameter with seven rooms radiating from it, bringing the whole complex to c. 1,250 m² and possibly even larger (2,000 m²). The impressive circular hall, paved with a geometric mosaic of the early third century CE, was the point of access to the various reception rooms, one of which, built on an octagonal central plan, housed the baths. The villa became a burial site in the fourth century and was abandoned in the fifth.[38]

At Almenara de Adaja (Valladolid), a great villa with c. 2,500 m² of residential rooms (most with painted walls and mosaic floors) combined several central-plan rooms around two peristyles: these included triconchic and octagonal rooms, as well as rectangular halls with an apse or an *exedra* (which could be semi-oval) on either one or two sides (Figure 22.7).[39] One of the octagons was paved in mosaic: A shield-shaped border framed a central *emblema* depicting Pegasus and the nymphs (Figure 22.8). The rooms seem to be designated for specific purposes – reception, dining, and so forth – but the number of spaces of similar function is puzzling: It is almost as if the designer were building a veritable manual of fourth- and fifth-century architecture for the villa owner! The Almenara de Adaja villa is prominent by its size, but it was only one among other large residential villas and rural mansions with agricultural buildings located in the area of

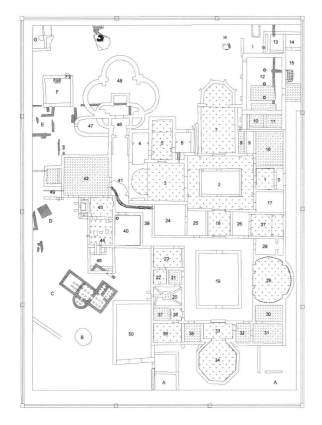

Figure 22.7. Almenara de Adaja (Valladolid), villa,
general plan of structures (© C. García Merino
and M. Sánchez Simón 2010).

the Duero valley, including La Olmeda (Pedrosa de
la Vega, Palencia), Quintanilla de la Cueza
(Palencia), Los Quintanares (Rioseco, Soria) and
Baños de Valdearados (Burgos), and other smaller
properties.[40]

Central-plan rooms of various uses in the
Portuguese villa of Rabaçal (Penela, south of
Conimbriga) opened onto a large octagonal peristyle
with porticoes built in the second half of the fourth
century. The ensemble's architecture had a calcu-
lated monumental aspect and was unified by
a precise iconography in its mosaic floors.[41]

The octagonal central-plan hall in the villa of
Arellano (Navarra),[42] in the north of the peninsula,
was the result of major renovations undertaken in the
fourth century (Figure 22.9).[43] Its ingenious archi-
tecture was supplemented by an equally complex
panoply of mosaic floors: In a small room justly called
a *musaeum*, there was an assemblage of images of
philosophers and the Muses in nine trapezoidal sec-
tions around a central circular emblem – the room
may have been used for reflection and intimate con-
versation. Both the architecture and decoration at
the Arellano villa were settings for characteristic late-
antique forms of dining and hospitality: An *oecus* with
a semicircular *exedra* defined the placement of a wooden
stibadium, the half-round dining couch, a form of furni-
ture to which we will return.

The same type of octagonal central plan was used
in the early fourth century in the villa of Can
Ferrerons (Premià de Mar, to the northeast of
Barcelona), in ancient Laietania, a coastal area
where other important late-antique villas have been
found. Different sections of the villa, which spreads
over more than 5 ha, have been excavated, one of
them a sumptuous bath building. An octagonal room
of exceptional size and walls standing to nearly full
height has been recorded: It had a diameter of 30 m
and was c. 735 m^2 (Figure 22.10).[44] The villa's floor
decorations were stripped in two subsequent reuses
of the residential areas: By the fifth century, parts of
the villa were in use for warehousing, wine produc-
tion, and metal-working on a fairly large scale.
Burials began inside and outside the rooms, and the
villa site had become a cemetery by the second half of
the sixth century.

The central plan came to be typical of Hispanic
villas,[45] but within the type there were imaginative
variations: At Valdetorres de Jarama, north of
Madrid, a building with a double-octagon central-
plan structure opening onto a number of rooms with
square, rectangular and four-apse floor plans has been
found, built in the later fourth century and in use
until the mid-fifth.[46] The building – quite possibly
not a villa at all – is idiosyncratic: It is a standalone,
isolated structure, apparently without outbuildings
or agricultural facilities. As such, it could have been
a kind of commercial center for agricultural and

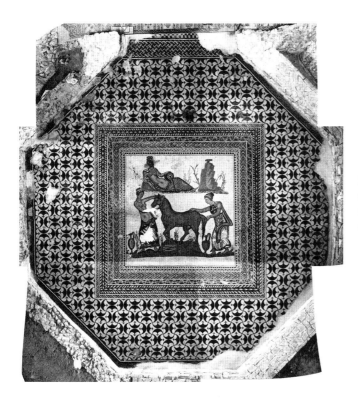

Figure 22.8. Almenara de Adaja (Valladolid), villa: octagonal *oecus* with geometric mosaic and central emblem depicting Pegasus (Photo: G. Gillani; © C. García Merino and M. Sánchez Simón 2004).

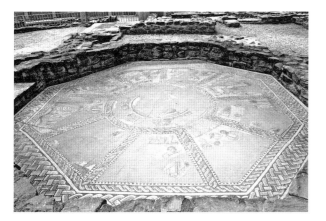

Figure 22.9 Arellano (Navarra), villa: octagonal hall with mosaic depicting the Muses (Photo © P. Guillot).

Figure 22.10. Can Ferrerons (Premià de Mar, Barcelona), aerial view of octagonal building and surrounding rooms, showing later modifications (Photo: Actium Patrimoni Cultural SL).

commercial goods, a *macellum* serving as a clearing-house for the "ninth-day" markets (*nundinae*). The connection, in late antiquity, among buildings of different functions (villas, market buildings, martyrs' shrines), all based on the central plan, may well be in evidence here.[47] Even more important for the character of the building at Valdetorres de Jarama is the discovery of works of sculpture and ivory artifacts from the eastern Roman empire: How these objects came to be imported there, as decorative parts of a building and its furniture or as commercial goods

in trade from distant parts of the empire, must be part of a broader discussion.[48]

Almost as impressive – and also apparently isolated from other buildings but not necessarily from an estate in the region – is the central-plan octagon (24 m in diameter) known as Las Vegas de Pueblanueva (Talavera de la Reina, Toledo). This structure housed a crypt containing three late-fourth-century sarcophagi, one depicting an enthroned Christ with Apostles datable to the reign of Theodosius I (379–95 CE).[49] The monumental structure and the three sarcophagi have been interpreted as a group tomb for a family, and such buildings were part of significant investment in the construction of private *mausolea* in Hispania as elsewhere, sometimes near villas, sometimes somewhat isolated.[50] Aside from Las Vegas de Pueblanueva, there are other *mausolea* in the peninsula: Sádaba (Zaragoza); Las Vegas de Pedraza (Segovia); Jumilla (Murcia); La Alberca (Murcia); La Cocosa (Badajoz); Quinta de Marim (Olhão, Algarve); the recently discovered one in Sidillà (Foixà, Girona);[51] and the smaller-scale *mausoleum* found in Can Palau (Sentmenat, Barcelona), with a circular exterior and octagonal interior housing two tombs in mosaic.[52]

STIBADIA: FORMS OF DINING IN LATE-ANTIQUE IBERIAN VILLAS

An architectural innovation of late antiquity was the introduction of a type of dining hall designed to act as a setting for the *stibadium*, a semicircular structure on which mattresses and cushions were placed, and which arched around a sigma-shaped round or semicircular table.[53] *Stibadia* could be moveable and transportable if they were in wood and constructed in sections, or, if in masonry, they could be a permanent part of an architectural setting. This type of dining couch was in use from the first century CE onward in aristocratic settings with summer gardens, often for outdoor eating in connection with hunting, but the main evidence for the *stibadium* is in the second and third centuries. Much later, *stibadia* were used for Christian funeral feasts and appear in representations of them, in catacombs and in other

venues.[54] It is from these iconographic records and from the space marked for the placing of the couch on floor mosaics that we know the number of guests that were customarily present, four to eight, and the placement of each, the preeminent seating position being at the left end of the table, to the right of the other diners. The *stibadium* dictated the organization of the table, emphasized social differences and a hierarchy among the diners, and defined and calibrated intimacy or distance among guests and between guests and host.[55] The form, when rendered in masonry, was capable of rich decorative elaboration.[56]

Stibadia were not a Hispanic invention, but the form must have been a welcome novelty in the newly formal and inventive architectural designs of villas in the later third and fourth centuries: *Stibadia* were widespread in both urban houses and villas of the Hispanic elites.[57] The remodeling of many villas in the fourth century often involved a reorganization of the reception areas and the addition of new central-plan rooms (rectangular, apsidal, triconchic, and so on), well suited to the new form of dining. When specially built, some of these rooms were equipped with water features, either a fountain or a canal, not only for pleasure and entertainment but also for cleaning before and after feasting.

Central-plan rooms certainly increased in Hispanic villas, and many – though not necessarily all – could have been used for dining when equipped with wooden *stibadia* capable of being moved in sections.[58] Masonry *stibadia*, while less versatile, were permanent investments in the architectural design of a room and are thus of special interest.

As novelties, *stibadia* were often additions to, or remodelings of, existing structures. In a phase of remodeling of the Andalusian villa of El Ruedo in the late third or early fourth century, a *stibadium* was built into an existing rectangular room opening onto a peristyle (Figure 22.11).[59] Its mode of construction is of particular interest: Brick lined with *opus signinum* and mottled with red paint, and its floor was re-laid with mosaic and *opus sectile* (Figure 22.12). A system of water pipes surrounded the platform for ease of cleaning; a round hole at the center of the platform has been interpreted as a fountain but was more

probably a support for the base of a table, and the position of the feature well into the room facilitated the movement of servants around it. In a further remodeling, the dining area became even more elaborate: In the fifth century, a *nymphaeum* was added on the east side of the room when a two-apsed fountain with lead piping and channels for water supply and drainage was added in the peristyle.

Seasonal considerations were important for dining rooms. In the villa of Quinta das Longas (Elvas), several reception rooms opened onto a central rectangular peristyle (Figure 22.13). On its west side was a room of triconch plan; on the north side, a rectangular room with an *exedra* floored in *opus*

sectile facing a central fountain (Figure 22.13, no. 23).[60] It is possible that this room was a summer *stibadium* sheltered under the roofed *exedra* – and thus facing away from the sun in the afternoon hours and in the evening. The forepart of the room in front of the *exedra* was unroofed and housed a shrine ornamented with sculptures.[61] The siting of a summer *stibadium* in the Quinta das Longas villa may imply that another room or rooms would have housed dining facilities for the winter. In any case, *stibadia* for various seasons and views tended to multiply at other villas – for example, those at El Ruedo and Almenara of Adaja (Valladolid). In the Almenara

Figure 22.11. El Ruedo (Almedinilla, Córdoba), villa, aerial view. (Photo © D. Vaquerizo).

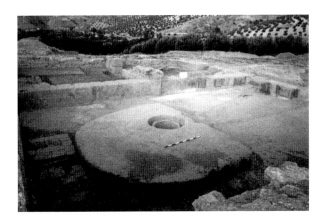

Figure 22.12. El Ruedo (Almedinilla, Córdoba), villa: *stibadium*. (Photo © D. Vaquerizo).

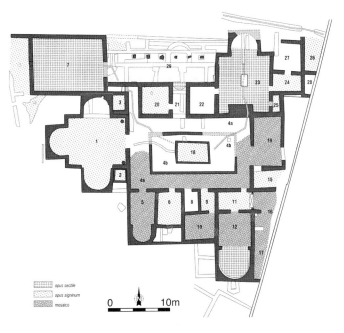

Figure 22.13. Quinta das Longas (Elvas), villa, plan of the villa in the fourth and fifth centuries, with types of paving indicated. (Drawing: © M.J. Almeida and A. Carvalho).

villa, piping in various rooms (Figure 22.7, nos. 3 and 29) could well identify them as alternate *stibadia*.[62]

As we have seen, the *stibadium* arrangement (whether permanent or portable) had the great advantage of establishing clarity of social difference and hierarchy among the diners. As such, its aristocratic associations in villas would have appealed to *ecclesiastical* patrons. While the use of *stibadia* has often been said to have been abandoned in the late sixth century when many villas were changing, a newly excavated example in the annexes of the ecclesiastical ensemble of Illa del Rei, in the port of Mahón (Menorca, Balearic Islands), is dated very late in the sixth century and was in use throughout the seventh century and even later.[63] The *stibadium* itself was impressive: A semicircular double wall lined with slabs of local polished slate mimicking marble on which rested a wooden structure to support mattresses and cushions.[64] Its presence in a religious center, a place of worship or pilgrimage, shrine, or perhaps a monastic community, as well as its late date and long use, project the habits of villa owners into new social *milieux* and communal meals different than, but perhaps looking a lot like, Roman secular feasts[65]

Owners' Preferences: Mosaic Floors in Villas

The *content* of the subjects and programs of mosaic floors in Hispanic villas raises longstanding issues about late-antique culture. Two important ones are discussed here: the persistence of classical knowledge among villa owners (and the nature of this persistence), and how classical themes and Christian culture cohabited in fourth-century villas and later. As we shall see, the Christian beliefs of owners cannot be dissociated from the decorative and iconographic programs of their residences.

The elites of late antiquity – Hispanic and throughout the empire – favored Graeco-Roman mythological repertoires.[66] The fact that property owners decorated their homes with simple scenes or complex iconographic programs of this type has sometimes prompted scholars to surmise that the

aristocracy was largely or persistently pagan, and that its paganism was a "cultural resistance of provincial aristocracies" to the imperial, and therefore Christian, hegemony.[67] Other lines of research suggest a different reading, stressing the seamless continuity of Hellenic culture in the Christian empire.[68] The Graeco-Roman *paideia*, or educational construct, was maintained among Christian elites for its cultural prestige, rhetorical power, and moral acuity as an impressive political instrument.[69] The recreation of a mythical and heroic past was important to the expression of grandeur for late-antique aristocrats, appropriate in the domestic decorations of Christian and non-Christian owners alike.

Certain images were straightforwardly pagan: In the reception room (*oecus*) of the villa of La Malena (Zaragoza), the wedding of the dwelling's *dominus* and *domina* was represented, with the groom clad in the toga designating his senatorial rank, and his bride wearing the matronal mantle or *pallium*. The wedding was solemnized by *dextrarum iunctio*, the clasping of the right hands, the ritual traditional to Roman pagan upper-class marriages. The gods of Olympus are witnesses: Zeus, Hermes, Aphrodite, Neptune, Minerva, and Diana are present to bless the piously pagan villa owners.[70]

The clarity of the wedding scene in the La Malena villa contrasts with other pagan or mythological scenes, which, if the pictorial tradition is slight, can achieve a blurred complexity that is resolvable only with difficulty. In some cases, the architectural context of the scenes can help clarify their meanings. For example, in the villa of Arellano (Navarra; see p. 434), a square room (Figure 22.14) with an *exedra* contained two mythological scenes with at least two conflicting interpretations, one emphasizing *erudition*, the other narrative *sequence*:

1. For an *erudite* reading, the central motif (partially destroyed) in the square room may have shown the farewell of the goddess Cybele to the handsome human youth Adonis before the hunt during which he met his death. In the *exedra*, another, quite different and unrelated scene: the marriage of Attis with the daughter of Midas, king of Pessinus.[71]

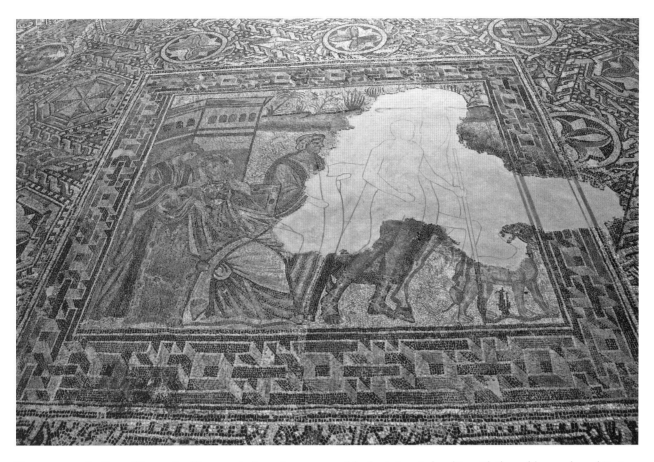

Figure 22.14. Arellano (Navarra), villa: mosaic from the *oecus* possibly depicting Aphrodite with the golden apple and Paris leaving. (Photo: © P. Guillot).

These mythological references are obscure, so another interpretation presents itself: The scenes, instead of being *unrelated* references to disparate myths, are set in *sequence* with the architectural and decorative articulation of the room:

2. For a *sequential* reading, the scene in the square room can also be interpreted to depict the aftermath of the Judgment of Paris (Aphrodite holding the golden apple, and Paris departing to find Helen), with the *exedra* showing the next episode in the narrative: Helen accompanied by Paris who is clutching a *lagobolon* (a throwing-stick used in hunting) to identify the setting of Paris' rustic exile.[72]

Both interpretations are plausible, but both are based on different assumptions: further testing of these assumptions within the context of elite villa life is needed.

To what extent does this type of recondite iconography reflect the owners' cultural level? Can we say that owners really knew the content and meaning of what was represented, or did they consume them only by vacuous custom or as choices offered by artisans?[73] There are several answers: mosaic workshops made and distributed pattern books throughout the Mediterranean from which buyers could choose readymade templates according to their knowledge, tastes, and the fashions of the day.[74] In addition, the sequences and personages of Greek and Roman myths had become confused as they were transmitted from their original sources to compendia and abbreviated versions and recolored with allegorical or other interpretations.[75] However, the recycled ensembles of late antiquity are genuine enough, even as amalgams and pastiches.[76] Thus the

cultural level of urban and rural elites is not the issue; rather, it indicates that villa owners, pagan or Christian, participated in the continuity of classical culture at all levels of education and awareness.[77]

General continuity of culture does not fully satisfy mythological questions in detail. To take one example among many: A room in the Carranque (Toledo) villa had a room paved with a scene of Adonis wrestling a boar; two dogs accompanying the hero were specifically inscribed with the names Titurus and Leander, dogs mentioned in poems by Virgil and Ovid. Would the owner have really known the texts of these poems, or were they known only in epitomes or some other form? The same could be asked about the owner of the Pedrosa de la Vega villa: Did his knowledge of the scene in which Achilles is discovered by Ulysses in Skyros, depicted in the paving of the great hall (Figure 22.3), come from the Greek original in Homer or the Latin version in Statius, or some other and much later literary or visual source?

These mythological scenes were not marginal to the villas' designs: They were prominently displayed in their spaces and visual axes. The depiction of Pegasus and the Muses on Mount Helicon was placed in a prominent raised position in the central octagonal room of the villa of Almenara de Adaja (Valladolid), on axis with the entire *pars urbana* of the residence (Figure 22.7).[78] This mosaic has been dated to the middle of the fourth century, part of the construction of the new villa replacing an earlier dwelling. What did the owner wish to convey with this scene? A similar question can be asked about the mosaic "of the Muses" in the villa of Arellano (Navarra), which paved the octagonal-plan building in the villa's remodeling in the fourth century (see p. 434 and Figure 22.9). The Arellano villa also contained a precinct or yard with steles of local stone engraved with the heads of bulls called a *taurobolium*. The area was in use in the fourth and fifth centuries, and while it may represent some continuity of custom specific to the villa or the region, did it have religious connotations?[79] As we shall see, the same villa has produced sculpture that also attests continuity of classical culture.

Horses were important images in Hispanic villas, often placed in positions as prominent as mythological scenes. Their importance came in part because breeding and specialized commerce in horses were substantial exports of the aristocratic stud-farms of the peninsula. Chariot races or *ludi circenses* were frequently shown on villa floors, but such images were widespread throughout the empire. However, Hispania was the source of horses famous for their speed,[80] and a fascinating series of letters of Quintus Aurelius Symmachus (c.340–402) documents their reputation. Symmachus, a nobleman and senator, was the *Praefectus Urbi* of Rome in 384–5 CE and became a consul in 391, thus occupying the highest positions in the empire below the emperor. In 401, when Symmachus' son Memmius was elected *praetor* in Rome, the father wrote several letters dealing with the organization of the grand games his son was about to present. The letters were addressed to senior administration officials in Hispania, and they document how Symmachus arranged the purchase and transport of the horses that raced in the Roman circus as part of the celebration.[81] An entire cadre of officials became involved. The senator Euphrasius selected animals from the estate owned by a certain Pompeia and Flavianus. In Hispania, selection was also undertaken by a certain Marcellus and by no less personages than Helpidius, the proconsul of Africa, and Longinianus, the *comes sacrarum largitionum* (Count of the Sacred Largesses). One Perpetuus as well as Sallustius, the prefect of Rome, and Messala, prefect for Italy and Africa, were also involved. The transit of the horses from Hispania to Italy was helped by Bassus, a senator and owner of stables in Arles. Symmachus wrote to Petronius, the governor of Hispania, to his brother, as well as to the prefect of Gaul, Vincentius, and to Stilicho himself, the highest commander of the imperial armed forces in the West, to arrange for the use of the *cursus publicus* (the state-run courier and transportation service). In view of the high officials brought to bear in the matter, the reputation, value, commercial, and sporting importance of horses from the Hispanic peninsula cannot be doubted.

Several mosaic floors illustrate the passion for chariot races in Hispania, both in villas and urban

houses: One from the suburban villa of Bell-lloc (Girona) (Figure 22.5), another from an urban house of Barcino (mod. Barcelona).[82] A mid-fourth century mosaic in the Portuguese villa of Torre de Palma set at the entrance to the triconch reception room underscored the importance of the races and the victorious horses to the villa's owner: The horses were labeled with their names, Hiberus, Inacus, Leneus, Lenobatis, and Pelops. The horses Tagus and Eufrata, presumably the pride of the owner's stable, were portrayed in a villa at Aguilafuente (Segovia).[83] Owners did not hesitate to align their own horses with mythological scenes: In the summer *triclinium* of the villa of Camarzana de Tera (Zamora), four winning horses, carefully named,[84] were deployed around a depiction of Orpheus and the animals.

Besides the mythological and circus scenes, villa mosaics feature other themes, some special, others much more usual and widespread: An octagonal room in a suburban villa of Vega Baja (Toledo) showed an unusual seaport scene, while many depicted various kinds of hunting, the universally favorite activity – whether real or ideal – of aristocrats in the countryside. Hunting could be by human hunters, as at the mosaic in the villa of Pedrosa de la Vega (Palencia, see p. 434), but battles among local animals (deer, wild boar) or among exotic ones (tigers, lions) could also be depicted. Occasionally, the owner and the horse were shown together as a hunting team: At Centcelles (Tarragona), in the dome of the complex, the owner appears portrayed with his caparisoned horse;[85] in the villa of El Ramalete (Tudela, Navarra, see p. 431), the owner Dulcitius was shown out on a hunt with a similarly outfitted horse, and another named *Amor* was represented in the villa of Dueñas (Palencia).

Similar scenes of villa activities and sport appear in wall paintings. One, dated to the second half of the fourth century, was displayed on the right wall leading to the reception hall of a house in Roman Barcelona: the names of rider and horse were inscribed in white paint above their heads.[86] In the same period, a room in a house at Emerita Augusta (mod. Mérida) also depicted race horses together with hunting scenes.[87] Villas and the life of breeding

horses, racing, and hunting were iconographically inseparable, in the Iberian Peninsula as elsewhere.

OWNERS' PREFERENCES: SCULPTURE IN IBERIAN VILLAS

Besides mosaics and paintings, the villas of the imperial period and late antiquity contained sculpture amassed as collections or chosen in iconographic programs by owners over a long time; this was a Mediterranean-wide phenomenon.[88] When Hispanic villas were built anew or overhauled in the fourth and fifth centuries, new statuary was not available, so earlier sculptures – relatively more abundant and/or more prestigious than recently made items – were used to decorate the new reception rooms, baths, fountains, and gardens.[89] The reuse and rearrangement of older artifacts in new settings could well have enhanced an atmosphere of learning and tradition, powerful visual tools in the self-representation of aristocratic status. The impressive sculpture ensemble of Chiragan, in Aquitania, is an example: The sculptures set in gardens and fountains presented objects from the past that confirmed the present aspirations of the owners.[90]

The reuse of old sculptural works of art to ennoble recently built villas was a strategy used by the late-antique owners of the seaside villa of Els Munts in Altafulla, in the territory of Tarraco. The second-century sculptures that ornamented the villa's new rooms, halls, bath quarters, and gardens had been purchased and installed in an earlier villa by Caius Valerius Avitus, a magistrate of Tarraco (*duumvir*), and his wife Faustina, who had lived in the villa in the mid-second century (his name was inscribed on a cistern). The couple had amassed its sculptural panoply, including representations of Aesculapius, Hygeia, Fortuna, Eros, Tyche, Hermes with the infant Dionysus, gladiators (fragments corresponding to two such figures were found), a portrait of either the owner of the villa or of the emperor Commodus (reigned 180–92 CE), and another of Antinous, the favorite of the emperor Hadrian.[91] Such a collection would not have been unusual for a villa owner of the

mid-second century, so Valerius' and Faustina's tastes were conventional.

The second-century villa of Els Munts was destroyed by fire and silting-up at the end of the third century, but some of the statues were rescued – how, we do not know. They were integrated into the villa as it continued to be inhabited into the fourth and fifth centuries, an instance of good luck of preservation and piety vis-à-vis old images.[92] The old sculptural panoply was recognized as readily reusable and culturally appropriate to the new residence.[93]

Sculptural collections could be preserved, but they could also be discarded, even destroyed. At the villa of El Ruedo (Almedinilla, southeast of Cordoba), there had been a collection of first and second-century sculpture, at least forty known items. This had been an exceptional decorative ensemble: Its iconographic program was based, very generally, on Dionysiac themes to ornament the villa's peristyle, *nymphaeum*, and gardens.[94] The collection continued in use until the fourth century, when it appears to have been discarded all at once and became part of the level of debris.[95]

Sculptural collections in marble and bronze were amassed throughout the peninsula in late antiquity.[96] Sculptural production and imports continued over the fourth and fifth centuries CE, albeit on a smaller scale, as exemplified in the ensemble found in the villa of Quinta das Longas, in the Elvas region of Portugal (Figure 22.13). Originally built in the imperial period (Villa I), the villa was extensively remodeled over the course of the fourth century (Villa II) until its abandonment in the fifth century.[97] In its fourth-century iteration, it had imposing reception and residential rooms embellished with marble revetment and mosaics and a central peristyle containing a *nymphaeum* with *opus sectile*. Isolated sculptures or groups of sculptures likely adorned this part of the villa: Many fragments have been found in a small room (Figure 22.13, no. 24) and in a layer of abandonment (Figure 22.15).

Certain sculptural works from the Quinta das Longas villa coordinated iconographically with sculpture and mosaics elsewhere: The tastes of villa owners tended to homogenize. For example,

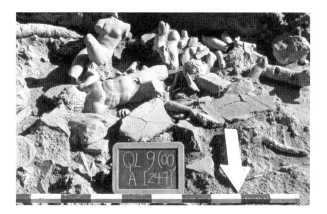

Figure 22.15. Quinta das Longas (Elvas), villa: sculptures discovered during the excavation. (Photo: © M.J. Almeida and A. Carvalho).

a Venus holding her sandal at Quinta das Longas is similar to one in the baths of the villa of Milreu; a dog and a deer that belonged to a hunting-themed sculpture group (with most probably a representation of Diana) were common in other villa gardens; a hand of the Muse Urania (the Muse of astronomy) found in the nearby villa of Torre de Palma (Monforte) denotes an iconography like that of the mosaics of the Muses in other Hispanic villas; and other fragments of sculptural groups or figures with aquatic and hunting themes were very typical of peninsular villas and houses and in late antiquity generally.

Sculpture was imported from the eastern Mediterranean for use in Hispanic villas. The sculptural collection of the Quinta das Longas villa incorporated items in styles and materials that identify their provenance.[98] The snake-legged male figure as well as a very similar statue found in Valdetorres del Jarama (Figure 22.16) both appear to have been made in sculptural workshops at Aphrodisias in Asia Minor.[99] These works, in the distinctively animated Aphrodisian styles and techniques (continuing Hellenistic traditions), as well as the Anatolian and other eastern Mediterranean marbles of which they were made, are unmistakable as imports to Hispania. Their presence at the two villas indicates that an export market for sculpture from eastern centers of production to connoisseurs in the west existed until quite late in antiquity,[100] and other items in transit to the peninsula from the east give

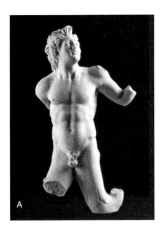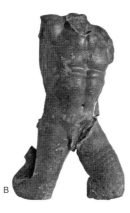

Figure 22.16. A: Quinta das Longas (Elvas), sculpture of anguiped (Photo: © J. Pessoa). B: Valdetorres de Jarama (Madrid), statue depicting a triton (© J. Arce, L. Caballero and M.A. Elvira 1997).

insight on villa owners as cultivated collectors in the fourth and well into the fifth century.[101]

Imported sculpture was both prestigious and conferred prestige on its owners. Their acquisition is one part of the economic systems of late antiquity, in which trade in high-status items among distant geographical regions as well as essential comestibles such as wheat, oil, and wine continued as before. At the same time, local markets and small-scale production emerged as an alternative to large-scale buying and selling of consumer goods: Agricultural products, the products of pastoral enterprise (skins, cloth, and so on), and home-based crafts. As of the fifth century, the heretofore robust and well-established empire-wide economy underwent a process of disarticulation, a profound transformation anticipating the exchange-systems of the medieval period. The end of Roman villas had begun.[102]

THE END OF IBERIAN VILLAS

The Religious Transformations in the Fifth and Sixth Centuries

Many villas in the Iberian peninsula, Gaul, and Italy underwent transformations and partial or total disruptions of their original uses and functions over time, even at a time when other villas were continuing as viable residential and agricultural centers.[103] Discerning which elements brought about big changes and/or the demise of villas has focused on their economic and cultural roles in the territorial organization – civil and ecclesiastical – of the early Middle Ages. The processes of religious, agricultural, and economic transformation can be illustrated by a few exemplary sites.

Christianity and its spread made a difference to villas. The construction of a church in part of a villa, the conversion of residential and/or reception areas into productive spaces indicating new uses, the establishment of monastic communities in an old villa (with the appearance of a necropolis within the residential structures) – all these were typical rearrangements for religious purposes. Whether the villa owners cooperated positively in these changes or were mere bystanders is also relevant.

Acts of euergetism (public, civic-minded good works) are well documented among the aristocracies of late antiquity. The transfer of land ownership to the Church was a common occurrence and propelled the growth of ecclesiastical property in land. In turn, this brought about an increased presence, in local and regional landscapes, of the Church as an institution, often ruled by bishops chosen from the higher, propertied social echelons. The result was a weakened parochial organization of the territory in favor of direct episcopal domination, an increasing concentration of large properties, and the crowding out of secular owners by ecclesiastical proprietors: The combination of factors may have resulted in the changes to villas that had been perfectly viable heretofore; it may also have resulted in their disappearance.[104]

Transforming spaces and uses of villas into the religious functions of oratories and churches was widespread in the later Roman Empire; it became somewhat common in Hispania in the fifth and sixth centuries. We have already seen the villa of Fortunatus, in Fraga (Huesca); it had been built in the third century CE with residential and reception spaces arranged around a central peristyle with porticoes paved with mosaics of the late third and early fourth centuries. The inscription with the name

Fortunatus conjoined with the Christogram and Alpha and Omega belonged to a refurbishment of the existing pavement in the late fourth or early fifth century (see p. 432). While the old villa continued in existence as a residence, a new rectangular church with three apsidal naves reincorporating several original rooms was grafted into the southwest corner of the original villa, around the time that Fortunatus' name in pious context was added to the mosaic of the main room. Starting in the sixth century, graves began to populate the inside of the church and its surrounding area.[105]

The São Cucufate site in the territory of Pax Iulia (mod. Beja, Portugal) also saw the construction of a church in the large villa complex.[106] The villa had had a long life: An original structure of the first century CE was remodeled in the second century and remained in use until the end of the third century to early fourth century. In the major remodeling of the first half of the fourth century, *tablinum* 4 (from the second-century villa) was converted into a church, and the portico of the western façade of the earlier villa, where perhaps the *memoria* (tomb) of St. Cucufate was located, started being taken over by graves. The conversion of the villa site to Christian uses was a long one: Between the eighth and the thirteenth century, a monastery was founded on the site that functioned until the mid-sixteenth century, and the associated church continued to operate as a rural chapel until the eighteenth century. A similar transformation took place in the villa of Milreu (Estoi, Faro), a large ensemble with both a residential sector and structures for agricultural production, with a long occupation history ranging from the first century to the tenth century, well into the Islamic period.[107] The temple of the earlier villa-complex was transformed into a church endowed with a baptistery and a necropolis.

These examples of villas acquiring churches are merely some among many, and they show how ecclesiastical territories were organized into rural parishes on the basis of existing population nodes clustered around villa properties.[108] The configuration which started taking shape in the sixth century laid the foundation for the consolidated parochial networks of the early Middle Ages: These sacred

places, based in late-antique villas and imbued with a strong individual identity, characterized the later landscape of medieval communal devotion and work.

Villas' Economic Transformations in the Sixth Century

Villas were modified for religious purposes, but other modifications came to bear: The conversion of residential quarters into manufacturing and processing and/or storage facilities for farm products. The remodeling could be severe or partial, but ultimately agricultural and artisanal activities came to outweigh residential amenities.

This phenomenon occurred virtually all over the Hispanic peninsula. For example, in the villa of Torre Llauder (Mataró), north of Barcino (mod. Barcelona), the remodeling carried out after the fourth century rendered the bath complex almost unusable: Several walls subdivided the rooms and water pipes were blocked. The repurposing modified the function of one of the rooms (7) to become a storage unit in which eighteen *dolia* (probably for wine) were sunk into the mosaic pavement; in addition, two tanks plastered in waterproof *opus signinum* were built in the adjacent room (5), and another tank was put into the peristyle (9), destroying part of the floor mosaic.[109]

In the northern part of the territory of Valentia, recent excavations in the villa of L'Horta Vella (Bétera) have revealed a productive and residential architectural complex that had first been built and inhabited in the late first century-early second century.[110] Impressive bathing facilities had been built (Figure 22.17), but these were downscaled in the fourth century. The great 60 m² swimming pool (*natatio*) was converted into a warehouse, and graves appeared throughout the area of the baths. In the second half of the fifth century, other rooms of the baths were turned into a storage area, a space dedicated to metallurgical activity (as evidenced by the presence of hearths and slag), and an olive press with a decantation tank. A series of silos were also built.

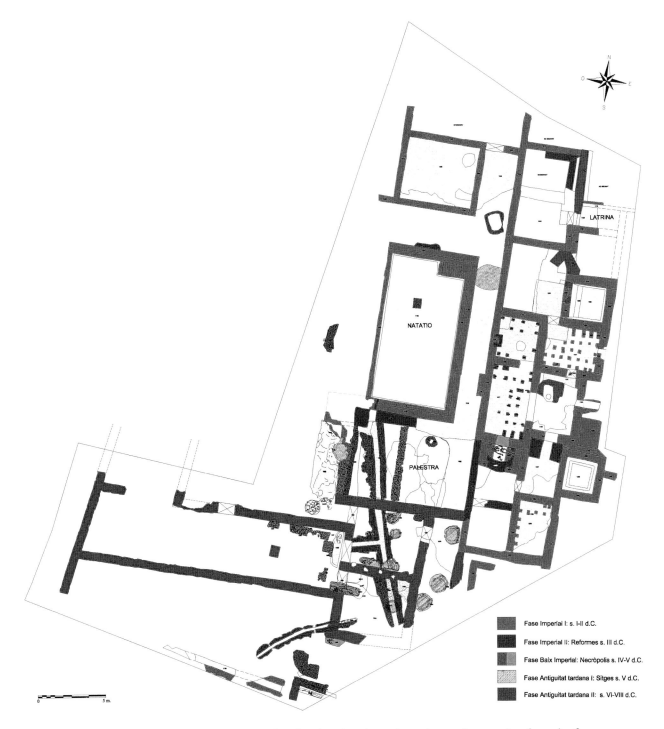

Figure 22.17. L'Horta Vella (Bétera, Valencia), villa, plan showing the various phases of occupation from the first century CE to the eighth century (© J.L. Jiménez and J. Burriel).

The transformations of the first half of the sixth century continued in use until the middle of the eighth century and involved the wholesale conversion of the estate into a farm with vastly different characteristics: The large pool became a dump, the cemetery fell into disuse, and a large building was built in the southwestern sector, probably for storage. All of this allowed the villa site, if not the villa

itself, to remain in use until the Islamic period, in the ninth and tenth centuries.

Maritime villas, always favored as residential venues, developed two related, but distinct, activities – fish farming and fish salting – especially on the Mediterranean coast and in the vicinity of Gibraltar. Both products were of great economic importance. In Calpe, the villa of Baños de la Reina had fishponds ingeniously cut into the rock bed and fed with water from the sea.[111] Others had masonry vats used to produce the popular fish sauce known as *garum*. Its production and marketing still took place in the sixth century, and villas may have become venues to supply *local* demand for the sauce, which had once had a Mediterranean-wide distribution, now diminished or compromised. Late developments at villas may well indicate the new importance of local markets: At Santa Pola (Alicante), the small existing salting factory of a villa was very extensively remodeled in the fourth century and was still in use a century later.[112]

Villas' Necropoleis

Graves and *necropoleis* on the grounds of villas were part of the process of transformation and demise of these residential structures. In many cases, several changes in use and function of rooms occurred before the appearance of graves, with burials taking place only in the sixth and seventh centuries. A few examples are representative.

The original function of the splendid central-plan structure in Can Ferrerons (Premià de Mar, Barcelona, see p. 434) was replaced with storage and production facilities, and these in turn began to accommodate graves in the second half of the sixth century (Figure 22.10).[113] The central-plan building in Baños de la Reina in Calpe (see p. 433) began receiving graves at the end of the fourth century when, in a formerly residential area ("Dwelling No. 1"), a church and baptistery were built.[114] In the villa of La Ontavia, in Terrinches (Ciudad Real), about thirty graves containing the remains of fifty individuals are located on top of the partially demolished architectural structure belonging to the earlier villa.[115] The villa of Aguilafuente

(Segovia) was completely overlaid by a necropolis of nearly two hundred graves, many containing Visigothic grave-goods dating from the sixth century.[116]

Ephemeral Structures and Squatting

Squatting and ephemeral structures built in abandoned villas were other ways in which villas were transformed. Uninhabited villas were temporarily occupied or sporadically frequented in the repurposing or reoccupation of a portion of or the entire residential sector by huts or similar lightly constructed dwellings.[117] Examples are very numerous, and include the villa of El Val (Alcalá de Henares) in the *suburbium* of Complutum. The ensemble had been monumentalized in the fourth century with the addition of a 15x10 m *oecus* or reception room paved with a mosaic depicting a victorious charioteer. However, in the sixth and seventh centuries, a hut was built on the floor of the room, and a necropolis was established nearby.[118] In the villa of Arellano (Navarra), the previously unroofed *taurobolium* area was divided into small spaces for habitation in the sixth century, with many hearths and ovens during the last phase of the site's occupation; graves of adults and children have been found inside the rooms of the old villa.[119] The villa site at Tinto Juan de la Cruz (Pinto, Madrid) had nearly all of the transformation modalities: On the old residential structure, a series of post holes were dug to support another type of dwelling (perhaps a hut of wood or wattle-and-daub or a combination), some spaces were reused as manufacturing sites or for artisanal production, and parts of the surrounding areas were given over to a necropolis of over eighty graves containing Visigothic personal adornments.[120]

Undoubtedly, these examples are only a small sample of developments in the peninsula, and, indeed, throughout the western Roman Empire.[121] The diversity and shifts in settlement patterns starting in the sixth century and intensifying in the seventh century call into question our understanding of the dwellings that characterized the end of late antiquity. Historians of Greek and Roman domestic

architecture often prioritize construction in stone and brick, but there was, in late antiquity, a new, more ephemeral and precarious, "model" of dwelling, in wood construction with wattle-and-daub infill or clay chinking, quite different from the previous Roman norm of solid masonries but freshly versatile and well adapted to new conditions of life.[122]

The great aristocratic residences that had marked the landscape of the fourth and fifth centuries fell into disrepair and, eventually, ruin, and they were replaced with ephemeral dwellings that do not, in general, produce artifacts of solid material use or luxury. This shift was associated with significant regional deforestation, which entailed modification of grain and legume-based agriculture and the gradual introduction of livestock ranching.[123] This type of territorial reorganization is similar to that which took place in the territory of Emerita (mod. Mérida), where a concentration of property ownership (and a consequent reduction in the number and frequency of villas) can be detected starting in late antiquity, even though the city, as the seat of the *vicarius* of the *diœcesis Hispaniarum*, should have supported an important concentration of rural aristocratic residences.[124] The same happened in the Meseta Central and the peninsular northeast,[125] where the dismantling of the network of aristocratic rural residences gave way to a fragmentation of dwellings that, if not completely ephemeral, were utterly different (e.g., huts, silos, ovens, scattered structures), the early components of a new landscape whose final configuration coalesced later in the Middle Ages.

All rules have exceptions, and one such exception was the villa at Pla de Nadal, in the western territory of Valencia on the Mediterranean coast. This residence was built in the second half of the seventh century and remained in use until the second half of the eighth century (Figure 22.18). Pla de Nadal was a two-story residential ensemble of which the longitudinal central structure (17x5.30 m) has been preserved. This long narrow rectangle opened onto front and rear courts embellished with high quality decorative/sculptural artifacts, including a circular object decorated with foliated scroll and a monogram bearing the letters T, E, B, D, E, M, I, and R. From

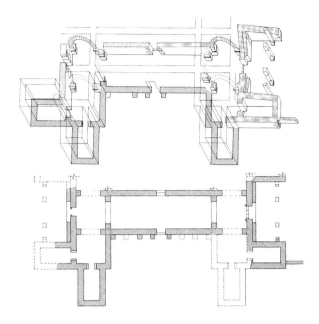

Figure 22.18. Pla de Nadal (Valencia), villa, plan and axonometric drawing (E. Juan and F. X. Centelles, in Palol and Ripoll 1988).

these, the owner has been identified as one Tebdemir/Tudmir, who entered into a pact of tolerance with the local Arab communities in 713 CE (Figure 22.19).[126] Although the building may seem exceptional given its plan, construction technique, and sculptural decoration – hence the use of the terms "courtly" or "palatial" villa – it is less so if we consider that it was built on a plan that was typical of the classic villas featuring a portico-façade framed by angular projecting towers. Another, similarly designed, building has been found in the vicinity, and there are more elsewhere in the peninsula. New finds in the territory of Valentia are revealing yet other modes of occupation.[127]

The ensemble of Pla de Nadal attests to the continuities of concepts ordering life and land exploitation from late antiquity into medieval contexts: The changes were profound and fundamental, but certain organizations and values persisted. The terms and nomenclature about property (such as *vicus, villa,* or *villula,* as well as *castellum, possessio,* and many others) found a new applicability and continued into the early Middle Ages with few

Figure 22.19. Pla de Nadal (Valencia), villa: sculptural
element with monogram: T, E, B, D, E, M, I, R,
probably referring to the name Teodomiro/Tudmir
(Photo: © G. Ripoll).

semantic differences. Late-antique villas were ulti-
mately emulated by the new kings of the peninsula:
King Recceswinth in the seventh century, and
Alfonso III in the late ninth and early tenth centuries
(see p. 433). Nevertheless, the agricultural landscape,
always the venue and mechanism of identity and
social cohesion, is never immutable, and its percep-
tion and ordering, as well as its socioeconomic and
religious dimensions, constantly evolved.

NOTES

1. This text is part of a research project of the Ministry
 of Economy and Competitiveness of the
 Government of Spain (MINECO, PN I+D+i,
 HAR2012-35177/Hist.), which has received the
 support of the European Regional Development
 Fund. My thanks also go to G. P. R. Métraux and
 A. Marzano for their editorial work; my colleagues
 R. Alonso, M. Darder, J. M. Gurt, E. M. Koppel,
 C. Mas, T. Nogales, and I. Velázquez gave me advice
 on specific matters; J. Arce, C. García Merino, and
 P. Reynolds closely read the text and gave me keen
 insights. Some of the illustrations in this text owe

their inclusion to the generosity of M. J. Almeida,
J. Arce, J. Burriel, R. Coll, C. García Merino,
P. Guillot, J. L. Jiménez, M. A. Valero, and
D. Vaquerizo. The translation is by M. Relaño
Tennent with careful editing by G. P. R. Métraux.

2. On the terminology of the rural landscape of
 Hispania, see Isla 2001; Arce 2006a; Martínez
 Melón 2006; on the transition to medieval terms,
 Francovich and Hodges 2003. The masterly over-
 view in Duby 1973, 13–59, remains essential; see also
 Leveau 1983 and Carandini 1989. For imperial villas:
 Marzano 2007. For late antique nomenclatures:
 Sfameni 2006. See also articles in *Mondes ruraux en
 Orient et Occident* (2012 and 2013) in *AnTard* 20 and
 21.

3. The term "boom" is a suitable descriptor taken
 from A. Giardina and his well-known article
 "Esplosione del tardoantico" (1999). Javier Arce
 (2005) reintroduced the term in his review of the
 literature on late antiquity in the Iberian Peninsula.
 On Hispania, the following are of particular inter-
 est: Chavarría Arnau, Arce, and Brogiolo 2006;
 Fernández Ochoa, García-Entero, and Gil Sendino
 2008, which contain numerous previously unpub-
 lished data. The rise of rural studies has also undergone
 a "boom" of sorts: see bibliographical compilation by
 Chavarría Arnau and Lewit 2004; Revilla Calvo,
 González Pérez, and Prevosti Monclús 2008–11,
 vol. 2.

4. For a further account of the historiography of
 Hispanic villas, see Teichner (Chapter 14) in this
 book.

5. The media have reported it as a recent discovery, but
 the site and part of its mosaics were actually uncov-
 ered in the late twentieth century. Systematic exca-
 vations began in 2005; see Valero Tévar 2009, 2010,
 2013, and in press.

6. Arce 1997a; Sfameni 2006, 15–18.

7. For the conciliar edicts and laws on the regional and
 proprietary authorities of bishops, Ripoll and
 Velázquez 1999.

8. Martínez Melón 2008; Reynolds 2010. For Hispania:
 Guardia 1992, Chavarría 2007 and Oepen 2011; for
 Gallia: Balmelle 2001; and for Italy: Brogiolo (ed.)
 1994; 1996; Francovich and Hodges 2003; Sfameni
 2006; Santangeli 2011. See also Lewit 2003; Bowes
 and Gutteridge 2005. For other issues of Christianity,
 see Bowes (Chapter 23) in this book.

9. Regueras Grande 2007; Pérez Mínguez 2006.

10. Mas and Cau 2011.

11. Gorges 1979; 2008.

12. The term villa – as a term defining a rural residence – cannot be used as the equivalent of "palace" with imperial implications, even though some authors, notably Mar y Verde 2008, insist on using this terminology. See the important contributions of Duval 1992; 1997a; and Lavan 1999.

13. Review in Arce 2008a.

14. Chavarría Arnau 2008. Contorniates are coins with special imagery produced for special occasions: They were keepsakes but may also have been used as currency.

15. Lancha 1989; Kiilerich 2001; Arce 2008b; Arce 2012.

16. The inscription, on a *tabula ansata* (a plaque with trapezoidal extensions on either side) reads: *Ex officina Ma . . . ni / pingit Hirinius / utere felix Materne / hunc cubiculum*. Fernández Galiano 2001; García-Entero and Castelo Ruano 2008. See also Teichner (Chapter 14) in this book.

17. Arce 1986; Arce 2003; Arce 2008a; Arce 2008b.

18. Scholars have speculated that the monumental ensemble of Cercadilla near Córdoba was the emperor Maximian's campaign palace during his stay in Hispania en route to Africa in 296–7 CE, then that it was connected to Hosius, bishop of Córdoba and friend and councilor of the emperor Constantine (reigned 306–37 CE): Hidalgo and Ventura 1994; Hidalgo 2002. In fact, the dates of construction and the function and ownership of the villa remain matters of discussion: Arce 1997b.

19. For the latest debate, see the discussion in *Pyrenae*: Sotomayor 2006a; 2006b; Arce 2002 and 2006b; Duval 2002. In 2010, A. Arbeiter and D. Korol organized a workshop entitled *La sala de cúpula de Centcelles. Nuevas investigaciones en torno a un monumento enigmático de categoría capital* as part of an international conference held by the Madrid-based Institut Goethe, see Arbeiter and Korol (eds.) 2015. Recently, J. A. Remolà and M. Perez Martínez have offered a new interpretation: The authors believe the building was the *praetorium* of Asterius, who was *comes Hispaniarum*: Remolà and Pérez Martinez 2013, 161–86. See also Arce and Ripoll 2017.

20. The dome measures 10.7 m in diameter and 13.60 m in height.

21. Warland 2002.

22. Nolla et al. 1993.

23. *Cecilianus ficet; ficet* is taken to be a variation of the verb *fecit* ("made," in this case, "sponsored"). On such inscriptions as evidence of sponsorship rather than authorship of the mosaic, see Balmelle and Darmon 1987; Darder 1996; Darder and Ripoll 2000.

24. López Mullor et al. 2001; Palahí and Nolla 2010.

25. Epigraphers, philologists, and archaeologists, from García y Bellido 1955, 8, to Rodà 1994, and Oroz Arizcuren 1999, 509–10, have contributed different interpretations of this inscription. Oroz Arizcuren asked whether the double mention of the name of Felix meant that the owner and the mosaic artist were the same person. In my opinion, in this case Vitalis was clearly the owner, Turissa the location of the villa, and Felix the name of the artisanal workshop, with *Felices* standing for *Felicis* (with the mutation of the short i of the genitive ending into an e); this was a common *cognomen* and just coincidentally also the adjective used to describe people as happy. I am grateful to J. Arce and I. Velázquez for their observations on this matter.

26. Mezquiriz 2003, 161.

27. Carneiro 2009, 213.

28. Finds of the villa of El Pesquero: Cordero Ruiz 2011, 550; finds at the villa at Pla de l'Horta: Llinàs et al. 2008. The crossbow *fibulae* (*Zwiebelknopffibeln*) were pins made of gold or gilt bronze with pierced lattice-like apertures. On the *fibula* (Keller type 6): Ripoll 1999.

29. Such buckles have been found at two sites: Abásolo, Cortés, and Pérez Rodríguez 1996; Ramón 2007; Ripoll 1999.

30. The site was at Almendralejo (Badajoz) on the Via de la Plata. Regarding the site, the discussions as to whom is represented, as well as the technical issues related to the production and restoration of the *Missorium*, see Almagro et al. 2000.

31. Arce 1976, 1998, 2000.

32. Alonso 2008, 18–19; Alonso 2013; Isla 2001, 13.

33. On the meaning of the term "villa" during the transition from late antiquity to the Middle Ages: Francovich and Hodges 2003. Regarding medieval villas, the following is still essential reading: Genicot 1990, 21–42.

34. The will is dated in 905 but is spurious. See: Fernández Conde 1971 and Alonso 2011, which include relevant texts and bibliography.

35. Duval 1996; Cantino 1996; Morvillez 1995; Mar y Verde 2008.

36. Lavin 1962; Duval 1978; 1987.

37. García-Entero 2006 on baths in Hispanic villas.

38. Abascal et al. 2008. See also Teichner (Chapter 14) in this book.

39. García Merino and Sánchez Simón 2004; 2012.

40. García Merino 2008.

41. Pessoa 1995.

42. From one of its mosaics, the Arellano villa has been known as the "Villa of the Muses," or as the villa of Arróniz from the nearby town of that name. Both municipalities are southwest of Pamplona and Estella.

43. Mezquiriz 2003; 2008.

44. Coll 2004, 266–70; Bosch, Coll, and Font 2005.

45. Examples include the villas at Noheda (Cuenca); Carranque (Toledo); Los Quintanares (Rioseco, Soria); La Malena (Azuara, Zaragoza); El Ramalete (Tudela, Navarra); Torre Águila (Badajoz); Centcelles (Tarragona); Torre de Palma (Monforte); Quinta das Longas (Elvas).

46. Arce, Caballero, and Elvira 1997.

47. Arce 1993. A villa as a standalone residential structure would have been unusual, as villas, with very few exceptions, had separate structures for living quarters and areas devoted to farming activity. Arce argued for its function as an agricultural center or market on architectural and archaeological grounds as well as its affinity to Roman market buildings, on which see De Ruyt 1983.

48. Puerta, Elvira, and Artigas 1994; Carrasco and Elvira 1994.

49. The meager artifacts of the late antique, Visigothic, and Islamic periods found in the excavations of the late 1960s indicate that the building was infrequently used over this long period, and they could not give a date of construction and original function for the structure. Hauschild 1978; Bowes 2006.

50. For mausolea, attached to villas or isolated, see Brogiolo and Chavarría Arnau (Chapter 11), Wilson (Chapter 16), and Bowes (Chapter 23) in this book.

51. Bowes 2006; Graen 2005; for Sidillà see: www.care .info (accessed September 2017).

52. See Coll and Roig 2011 for a brief preliminary description.

53. Dunbabin 1991; 1996; 2003; Duval 1997b; Morvillez 1995; 1996. The design of floors to accommodate the dining furniture can be seen in the villa at Dewlish, in Dorset (England) where the trapezoidal sectioning of the floor divisions indicate that five diners could be accommodated: Ellis 1995. In an urban domus at Argos in the Peloponnesus known as the Villa of the Falconer, seven diners could be accommodated: Åkerström-Hougen 1974.

54. Jastrzebowska 1979.

55. Métraux 1999, 398.

56. Among the many stibadia already found, that of the villa of Faragola in Ascoli Satriano (Apulia), had special decorative richness: It was ornamented with an opus sectile facing of marble, glass, and sculptural reliefs and housed in a room of equal decorative richness: Volpe 2006.

57. Duval 1984.

58. Lavin (1962) equated triconch rooms as dining facilities, while Morvillez (1995) and Witts (2000) were more prudent on the matter. N. Duval believes that many triconch rooms did include stibadia, cf. Cintas and Duval 1976; Duval 1997. Rooms with semicircular designs in the mosaic floors are often claimed to have been accommodations for stibadia (e.g., rooms at Fuente Alamo [Puente Genil, Córdoba], San Julián de Valmuza [Salamanca], Prado [Valladolid], and Daragoleja [Granada]), but they may have had other functions; Chavarría 2007, 102–3. A detailed study of rooms equipped with water supplies and drainage systems that could have been settings for stibadia would be welcome.

59. Vaquerizo and Noguera 1997, 60–77; Vaquerizo 2008. I am grateful to Prof. D. Vaquerizo (Universidad de Córdoba) for the information regarding the paving of the space housing the stibadium and the building's plan, as well as for photographs of the villa (published in Vaquerizo and Noguera 1997). The site, also features in the recent book edited by Hidalgo Priego (2017). See also Teichner (Chapter 14) in this book.

60. Nogales, Carvalho, and Almeida 2004; Almeida and Carvalho 2005.

61. There was piping for a water element in the open area. I thank M. J. Almeida for the information on the organization problems, covering, paving, and stratigraphy at Quinta das Longas.

62. García Merino and Sánchez Simón 2010.

63. Cau et al. 2012.

64. The dimensions and surface of the stibadium structure were similar to those of the villa at Faragola in

Apulia: see n. 56. That at Faragola was 4 m; the one at Illa del Rei was 3.90 m.

65. Others may yet be found: a *stibadium* in an ecclesiastical context at Stobi at the House of Psalms was attached to the south side of the Central Basilica, a Christian church built in the second half of the fifth century; Wiseman 2006, 802, fig. 10. I thank Prof. Wiseman for this information.

66. Liebeschuetz 1995.

67. Gorges 2008, 39; Chavarría 2006.

68. Bowersock 1990.

69. Brown 1992.

70. Arce 2008b, who rejects Fernández Galiano's interpretation (1992) of the scene as representing a *Kabirion* sanctuary with Cadmus and Harmonia.

71. Mezquiriz 2003, 230–4.

72. Paris often held the *lagobolon*; it alludes to his exile on Mount Ida. Mezquiriz 2003, 227–35. The mosaic of Arellano is closely related to some of the representations in the mosaics of Noheda (Cuenca), currently being studied by M. A. Valero Tévar (see n. 5); see also Valero Tévar 2013.

73. As proposed by Arce 2008b.

74. Balmelle and Darmon 1987.

75. Arce 2008b.

76. Hannestad 2007.

77. Brown 1971, 70–81; Bowersock 1990, 1–13.

78. Ant. Lib., *Met.* 9; García Merino and Sánchez Simón 2004; 2012; García Merino 2008.

79. Mezquiriz 2003; Mezquiriz 2008.

80. Arce 1982; Vilella 1996; Darder 1996, Ripoll and Darder 1994.

81. Arce 1982.

82. On the mosaic of Bell-lloc: Darder and Ripoll 2000; on the Barcino mosaic: Darder 1993–4.

83. Darder 1996: Torre de Palma no. 30; Aguilafuente no. 33.

84. Their names were Germinator, Venator, Evnis or Fenix (?), and Aerasius. The initials between the horses' legs either refer to the stables' names or to their owners: Regueras Grande 2010.

85. On horses in late-antique *Hispania*, see: Darder and Ripoll 1989; Darder 1996; Ripoll and Darder 1994.

86. Because some of the letters were destroyed, the names could not be satisfactorily deciphered. The house was discovered on Bisbe Caçador Street; Palol 1996; Puig i Verdaguer 1999.

87. Álvarez Saenz de Buruaga 1974. Artifacts that are contemporary with the representations – horse harnesses and bits – confirm details in the paintings and mosaics: Ripoll and Darder 1994.

88. Stirling 2005; 2007. See also Métraux (Chapter 21) in this book.

89. Nogales and Creus 1999. Few works have been published on the theme of gardens and water in Hispania, but the overview by García-Entero 2003–4 is recommended.

90. Bergmann 1999. See Buffat (Chapter 13) and Métraux (Chapter 21) in this book.

91. Koppel 2000; Koppel and Rodà 2008.

92. Tarrats et al. 2000; Tarrats and Remolà 2007.

93. The villa became the site of a large necropolis of 169 graves from the later fourth and into the seventh centuries: García, Macias, and Teixell 1999; Tarrats et al. 2000; Tarrats and Remolà 2007.

94. The sculptures were cast in bronze or carved in local granite or imported and local marble; only some of them are complete. Highlights include: a portrait of Nero, later reworked to be a portrait of Domitian; a portrait of a child; a fragmentary bust wearing the *paludamentum* or military cloak; a poorly preserved Perseus and Andromeda group; a satyr; several herms; two heads identified as Venus; a bronze piece representing Hypnos; a small bronze sculpture of a dancing Hermaphrodite; a standing Attis, headless; an allegory of the seasons; several fragments of possible Erotes; fragments of different human body parts (the type of sculpture they belonged to has not been determined); and fragments of marble reliefs, *oscilla*, and architectural elements such as columns, plinths, and a capital.

95. Vaquerizo and Noguera 1997, 97–210; Vaquerizo 2008.

96. In the Córdoba region, examples found in the villas of Casilla de la Lámpara (Montilla); Las Minas (Aguilar de la Frontera); and the Mithraic ensemble known as "House of Mithras" found northwest of Cabra: Vaquerizo and Noguera 1997, 102–4. From northeast of the peninsula: findings in the villas of the *ager Tarraconensis*, including Els Antigons, La Llosa, Parets Delgada, and the splendid collection in the *nymphaeum* of the villa of Els Ametllers, in Tossa de Mar, Girona: Koppel and Rodà 2008, In the rest of the peninsula, the statuary of the following villas stand out: La Olmeda (Pedrosa de la Vega, Palencia); Quintana del Marco (León); Los

Quintanares (Rioseco, Soria); La Malena (Zaragoza); Fortunatus (Fraga, Huesca); Romeral (Albesa, Lérida); and Jumilla (Murcia); to which others with architectural, sculptural, and decorative elements of great quality should be added, such as Rabaçal (Penela, Conimbriga); Carranque (Toledo); El Saucedo (Toledo); Balazote (Albacete) and Pla de Nadal (Valencia).

97. Nogales, Carvalho, and Almeida 2004. The villa had some sporadic occupation after the 5th century.
98. Nogales, Carvalho, and Almeida 2004.
99. Puerta, Elvira, and Artigas 1994; Hannestad 2007.
100. Roueché and Erim 1982; Hannestad 2007. The export of such items from Aphrodisias gives a new reading of that school of sculpture.
101. Nogales, Carvalho, and Almeida 2004; Hannestad 2007. The trade in marble sculptures and furniture from the East is documented into the seventh century; the cargo of the Marzameni (Sicily) and Cap Favaritx (Menorca, Balearic Islands) shipwrecks indicate that such products moved readily between the two ends of the Mediterranean well into late antiquity.
102. Wickham 2005, 694–824.
103. For a general treatment: Ripoll and Arce 2000; Brogiolo and Chavarría 2005; Brogiolo 2006; Brogiolo and Chavarría 2008; also García-Entero 2005–6 and the references cited in n. 6.
104. Ripoll and Velázquez 1999; Brogiolo and Chavarría 2003; Bowes 2006; 2007; 2008; Oepen 2011. Ripoll et al. 2012 for the problems posed by Hispanic church architecture.
105. The apses were later remodeled: Navarro 1999; de Palol 1999.
106. Alarcão, Étienne, and Mayet 1990. See Teichner (Chapter 14) in this book.
107. Teichner 2008, 95–270.
108. Ripoll and Velázquez 1999.
109. Chavarría 2007b, 175–7.

110. Jiménez et al. 2005; 2008; Jiménez and Burriel 2007.
111. This site is not to be confused with the Baños de la Reina at Punta de l'Arenal, Javea, where a larger rock-cut fishpond as well as fish-salting vats are known. Martin and Serres 1970; Rosselló 2004; Abascal et al. 2007.
112. Reynolds 1993, 55, no. 47.4. Villas may have been minor suppliers: Along the Strait of Gibraltar, large salting factories were concentrated in or near urban areas – some forty plants in the area of San Nicolás in Iulia Traducta (mod. Algeciras), others in nearby Baelo Claudia (Tarifa, Cádiz): Arévalo, Bernal, and Torremocha 2004.
113. Coll 2004, 268–70.
114. Abascal et al. 2008, 290.
115. Benítez de Lugo et al. 2011.
116. Lucas and Viñas 1977; Esteban Molina 2007.
117. For a similar phenomenon affecting the villas of northern Italy see also Brogiolo and Chavarría (Chapter 11) in this book.
118. Rascón, Méndez, and Díaz 1991.
119. Mezquiriz 2003, 194–6.
120. Barroso et al. 1993; Ripoll 2010.
121. Wickham 2009; Quiros 2009.
122. On this issue see Lewit 2003.
123. The work carried out in various parts of the former *Ager Tarraconensis* reflect this description: Riera and Palet 2005.
124. Cordero Ruiz 2011.
125. Vigil-Escalera 2009; Roig 2009; Coll and Roig 2011.
126. Juan and Pastor 1989; Juan and Lerma 2000; Rosselló Mesquida 2005: 287–9.
127. These include the cases of the villa of l'Horta la Vella (Bétera, north of Valencia); the *castrum* of València la Vella, in the area of Pla de Nadal (Riba-roja de Turia); and the coastal monastic ensemble of Punta de l'Illa (Cullera), south of Valencia, which dates from the sixth century. Rosselló Mesquida 2005; Jiménez Salvador et al. 2005.

23

CHRISTIANIZATION OF VILLAS

KIMBERLY BOWES

SOMETIME IN THE MIDDLE YEARS OF THE SIXTH century, Flavius Magnus Aurelius Cassiodorus (c. 485–c. 585), senator, advisor to the Gothic king Theodoric, and newly minted Christian ascetic, sat down on his Calabrian estate, *Vivarium*, to write an *encomium* to his fishponds.[1] His vivid description of saline aquaculture, his pride in the control of nature, and the use of these descriptions to frame his own image as a landowner call to mind the villas, and the villa worldviews, of the high empire as embodied in the works of Pliny. Yet this was not Pliny's world: Cassiorodus' description ends the first book of his *Institutiones*, a study-guide for monks, and the fishponds themselves were merely an introduction to a larger spiritual program: an estate-cum-monastery.

Cassiorodus' *Vivarium* stood in the twilight of one world – that of the elite Roman rural villa which comes to an end sometime in the sixth century – and the dawn of another – the rise of Christianity. Texts like the *Institutiones*, Paulinus of Nola's letters, or Ausonius' *Ephemeris* describe the transition between these worlds as both seamless and natural, in an easy process by which the structures of the villa – physical and ideological – were adopted for Christian use. The archaeological evidence seems to concur: Churches were constructed in or alongside villa residences; some of the earliest ascetic establishments, like *Vivarium*, were established on rural estates, and villas helped to shape the post-Roman landscape, acting as magnets for parish churches and villages.

However, several decades of new archaeological and textual work have shown that the Christian role in the history of the Roman villa was richer and more complex than Cassiodorus' easy meshing of fishponds with monastic discipline intimates.[2] This chapter provides a brief sketch of that history, focusing on the rural villas of the western empire. It introduces the problems attendant to the study of Christianity in the Roman villa and presents an introduction to the archaeological evidence for Christian practice and the textual discourses that surrounded those practices. It posits two major phases of Christian villa history. In the fourth and fifth centuries CE, Christian practices and discourses were fundamentally shaped by the villa itself, its physical buildings and its ancient ideologies as a place of rural retreat and elite self-construction. Rather than a Christianization of the villa, we might better think of the "villa-ization" of a specific strand of Christian culture.[3] In the later fifth and sixth centuries, however, the relationship between villa and Christianity changed. As the physical structures of the villa were abandoned, Christianity's tie with the villa became largely topographical. In many regions, abandoned villas became the focal point of fifth- through seventh-century mini-villages, and churches frequently formed part of those agglomerations. Christianity was now part of the history of the villa not merely as the locus of elite

identity, but as a space of communal settlement and communal memory.

PRACTICE: ARCHAEOLOGICAL EVIDENCE AND ITS PROBLEMS IN THE FOURTH AND FIFTH CENTURIES

What did Christian practice in rural villas look like? That is, what sorts of Christian rituals were carried out in the rural villa, and what material form – worship spaces, altars, burials – did such rites take? The answers to these questions are complicated by the nature of the evidence to hand, both textual and archaeological. There exist a number of texts attesting to Christian practice in villas: Ausonius' *Ephemeris* includes a prayer, offered in a house or villa *sacrarium*, praising "God and the Son of God most high," and begging for protection from sin, a life of moderation and the perpetuation of his respectable reputation. Paulinus of Nola offers epigrams praising the two churches and baptistery built by his friend Sulpicius Severus. Augustine offers a catalogue of rural miracles, many of which took place in villa martyr-shrines.[4] Taken as a whole, such texts seem to describe the normalcy of villa-based ritual and ritual spaces, including martyr cult, baptism, and personal prayer. On the other hand, none of these texts is normative, for each calls upon personal, villa-based ritual of its protagonists to do important rhetorical work. Ausonius' use of the term *sacrarium*, an ancient, obscure term, and his carefully constructed *encomium* to moderate devotion form part of a poetic construction of the balanced self.[5] Paulinus' epigrams for Sulpicius' Christian buildings are intended as much to write himself into his friend's project as to enhance it spiritually.[6] Augustine's villa-miracles form part of a tirade against Christian disunity in which private churches contribute to the fracturing of Christian community.[7] To read these texts simply as descriptions of practices or places is to miss half their message – the construction of a kind of Christian *sophrosyne* in elite self-fashioning, the central role of friendship networks in the constitution of elite villa-based communities, and bishops' ambiguous response to such communities. The texts that "describe" Christian practice in

Roman villas are thus in need of as much excavation as the sites themselves.

The archaeological evidence is also not always clear. Finding private Christian ritual spaces in functioning rural villas demands archaeologically verifiable definitions of "Christian," "ritual," "functioning," and "villa." As two generations of Christian archaeologists have been at pains to point out, the material markers of Christian presence are rarely unambiguous: Christian symbols might be shared by non-Christians, apsed spaces are common components of late-antique domestic architecture, and even buildings containing burials are no guarantee of Christian affiliation.[8] Markers of Christian ritual can be straightforward – the presence of an altar or baptismal font is relatively unambiguous – but distinguishing altars from dining tables and fonts from fountains is not always easy, and Christian ritual and its material traces were not limited to the Eucharist and Baptism. On the other hand, Christian images or symbols may point to Christian presence but are not necessarily evidence for ritual. More challenging still is definitively relating a Christian ritual space to a functioning villa.[9] Well-defined churches might be located some distance from a villa: Are these to be considered villa churches? In other cases, a functioning church may be built over or near a villa that had been abandoned centuries earlier: Is the relationship between church and villa mere spatial coincidence or did villas serve as points of memory around which Christian worship coalesced? Finally, defining "private" in meaningful archaeological terms is virtually impossible: When a Christian space is inserted into a functioning villa, how can we be certain that the property is that of a private person rather than a project of the institutional church? What is the material footprint of private ownership, or of episcopal control? The definitive signposts of an earlier generation of archaeologists – baptismal fonts, for instance – have been revealed to be false friends, since both private and episcopal projects alike engaged in similar rituals and used similar ritual equipment.[10] In short, the interpretation of Christian remains in

villas is a multi-stepped process that rarely produces unambiguous conclusions. The result is that the very thing the textual sources take for granted – private villa-based churches and other Christian spaces – are virtually impossible to define archaeologically. Thus, each of the sites presented here as "examples" of the phenomenon – and these are among the most convincing examples of the hundreds alleged in the literature – can be no more than "maybes."

Once we separate the most promising of these "maybes" from the numerous nonfunctioning or abandoned villas, structures of unverifiable date and/or uncertain Christian function, some basic characteristics can be isolated upon which even the most skeptical would probably agree.

The first is geography: As this volume describes, private rural estates obviously existed in both the eastern and western empires, but the propensity to build luxurious rural residences seems to have been more common in the West. This, in combination with the greater number of villa excavations in the West, means that nearly all of the archaeological examples of villa churches can be found there, particularly in Hispania, Gaul, Italy, and Britain. That villa churches existed in the East is certain – the writings of Gregory of Nyssa, for example, describe martyr shrines near elite rural residences – but as yet we have no excavated examples.[11]

The second characteristic is chronology: The most convincing examples of the phenomenon are fourth to mid-fifth century in date. This is largely a product of lifespan of the Roman villa as modern archaeologists have defined it: As many chapters in this book describe, the practice of building and maintaining monumental rural residences begins to fade at some point in late antiquity – by the early fifth century in Britain and northern Italy, in the later fifth century in Hispania, southwest Gaul, and southern Italy, with some continuity into the early sixth century. The bulk of convincingly identified Christian villa churches fall into the last phase of monumental villa-building in their respective provinces. As the villas themselves begin to fall into disrepair, it becomes increasingly difficult to distinguish a "villa-church" as a private elite project

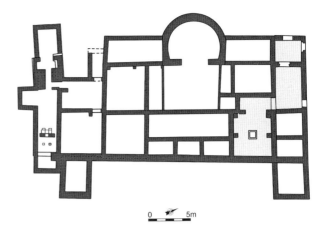

Figure 23.1. Lullingstone Villa, plan.

from other kinds of projects – community or parish church, rural episcopate, and so on.[12] These later phenomena will be taken up at the end of this chapter.

Some of the earliest and clearest instances of villa-based Christianity are ritual spaces inserted inside villa residences. The well-excavated Lullingstone villa in Britain is the best-known example (Figure 23.1).[13] A villa founded in the early empire, Lullingstone in the later fourth century was a small villa with an overly large apsed hall at its rear, a bath complex to the south, and, to the north, a semi-subterranean cellar containing a small shrine to the family's ancestors (previously dedicated to the nymphs). Over this cellar was inserted the Christian church complex: It was composed of a main rectangular room and a vestibule and antechamber set between the main worship space and a door to the exterior. The church was identified as such not by any ritual equipment but by Christian-themed frescoes that had originally decorated the main space and antechamber and were found in collapse in the cellar below. Smashed into small fragments, these frescoes have been painstakingly reconstructed, but many questions remain because of their shattered state and missing pieces (Figure 23.2). The eastern wall of the antechamber, the southwestern corner of the main space, and an eastern niche in that same room were all seemingly decorated with large images of the *Chi-Rho*: the symbol thus guided the visitor from antechamber

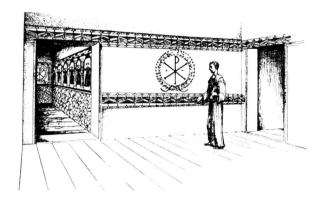

Figure 23.2. Lullingstone Villa, reconstruction of antechamber and main space.

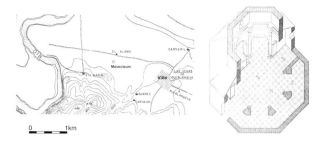

Figure 23.3. Pueblanueva Villa, overall site plan and axonometric reconstruction of the mausoleum.

into the main space and directed his or her attention to the cultic focal point. On the west wall of the main room, male and female figures clad in fine fourth-century attire were shown as orants in an attitude of prayer, standing with arms outstretched; they repeated, in painted form, the actions of the worshipping community. The nature of that worship, however, is unknown: no ritual equipment was found (a chunk of *opus signinum* found in the cellar collapse was suggested as an altar or its base) and the other frescoes that covered the walls of the main space are too fragmentary to permit any reconstruction of their subject matter. The identity of the worshippers is equally unclear: While the presence of an exterior door might point to worshippers outside the owner's family and servants such as the villa's dependent peasants, the small size of the space (some 7 m long) and a possible door leading from church into the villa proper, as well as the fine attire of the worshippers on the western wall, all point to the villa-owning family as the predominant members of the congregation and the users of the space and its iconography.

While sites like Lullingstone find the Christian worship space inserted into the residential complex, the construction of separate, freestanding ritual spaces is more common. This extra-villa topography conforms to an age-old tradition of extra-villa pagan temples, particularly common in the villas of northern Gaul, southern Lusitania, and perhaps central Italy, and the ubiquitous practice of extra-villa *mausolea*.[14] Indeed, many of the Christian buildings

adjacent to elite villas are funerary in nature. Hispania boasts several of these, although in some cases, their Christian attribution is uncertain.[15] At Pueblanueva in central Hispania, a large villa (unexcavated, but with surface remains pointing to a major late-antique phase) was accompanied by an equally large mausoleum, set on a rise some 500 m to the south (Figure 23.3).[16] The building was constructed with a central octagonal space encircled by an ambulatory and capped by a trussed roof. A subterranean crypt on the building's east side contained three sarcophagi, one of which depicted images of the Twelve Apostles. This find points to at least one Christian occupant, while the separation of the eastern bay of the octagon by two partition walls contemporary with the building's first phase may point to some kind of Christian ritual. The whole of the project – a grand monument to the family, dominating the landscape and sign-posting the villa and the *dominus* by its emphasis on the funerary cult – recalls the long tradition of villa funerary monuments dating back to the late Republic.[17] Other possible Christian examples at La Cocosa and Carranque in Hispania, Muline in Dalmatia, or Valentine in southwest Gaul share these qualities.[18] The "Christian" aspect of all these projects is hard to discern; in fact, the Christian attribution of some of these can be doubted. Christian religious identity is not broadcast in these buildings; rather, they seem intended principally as monuments to self and family, grand funerary extensions of the villas' designs to enhance their owners' status and the panoply of their honored dead.

To a certain extent, this is also true of the more traditional-looking churches built beside or at some distance from functioning villas. Like the pagan

villa-temples of earlier generations, these churches are often monumental structures, set on strategic view-sheds or approach roads, while their liturgical equipment, much richer than the *mausolea* or the intra-villa churches, seems to refer to public church architecture. The villa-church complex at Palazzo Pignano in northern Italy has many characteristics common to the group (Figure 11.7).[19] The villa itself is organized around a somewhat unusual octagonal courtyard with radiating wings for reception hall, baths, and residential rooms. Set some 40 m away on a possible approach road, the church, like the villa, was centrally planned: A double-shell rotunda with a timbered roof was supported by masonry piers. Near the roadside entrance there was a tiny baptismal font, while the eastern end had a projecting apse containing a small *cathedra* or clergy-seat fronted by a screened sanctuary area. The liturgical equipment of this church makes it grandiose in conception, and even more grandiose was the fact that its circular form seemingly mimicked the plan of the church now known as Santa Costanza in Rome, the mausoleum of Constantina, the daughter of the emperor Constantine. The affiliation of the villa-church at Palazzo Pignano with this important imperial exemplar has suggested that it was the seat of a bishop or the church of a major parish, a claim that has been made for many other extra-villa churches.[20] The liturgical equipment, particularly the font, would seem at first glance to bespeak an institutional project, but caution is in order: The font is extremely small and set off to the side of the main rotunda. The double-shelled circle, besides referencing the most up-to-date mausoleum design in Rome and elsewhere, also echoes the centralized plan of the villa itself. One must also remember that bishops in many parts of the West in this period were largely city-bound creatures with neither the resources nor the ambition to build in the countryside: rural *domini* far exceeded them in power and influence, and the parish system as a network of episcopally controlled satellites would only really take real form a century or more later.[21] It is certainly possible that the extra-villa churches like Palazzo Pignano, Loupian in southern

Gaul, or Souk el-Lhoti in Tripolitania were bishops' projects, but the archaeological evidence combined with the historical realities in the late fourth and fifth centuries militates against such an interpretation. It is more likely that these churches were built and controlled by villa owners, principally as monuments to personal *pietas*. Of course, the villa as familial monument embraced the whole of the rural *familia*, including dependent peasants, at whom these churches may also have been aimed.[22] Like the villa-temple projects of previous generations whose topography they echo, these churches were very likely designed as pious extensions of the land-holding apparatus.

If the Christian aspects of this first-generation of villa churches are often muted, the same cannot be said for the earliest villa-based ascetic retreats, described by their now-famous impresarios – Sulpicius Severus, Paulinus of Nola, and, later, Cassiodorus, among others. As self-proclaimed rejections of everything the landowning elite stood for and with their emphasis on constant prayer and devotion, these villa-retreats are often termed the first "monasteries," and many attempts have been made to find them in the archaeological record.[23] Thus far, the attempts have failed: excavations in textually attested sites, like Cassiodorus' *Vivarium*, have turned up churches but no living quarters, or as at Benedict's *Subiacum*, revealed living quarters indistinguishable from any other "transformed" villa of the period.[24] At other sites, like Diaporit in Albania, a large church, portico, tower, and bath complex might just as easily be identified as a martyr shrine and pilgrim hostel as a monastery (for plan, see Figure 20.10).[25] At Parc Central outside Tarragona in Spain, a well-preserved villa and church, which were directly across from one another but separated by a main thoroughfare, present the same problems.[26] In short, the archaeology of villas as monasteries seems to be indistinguishable from the archaeology of villa-churches generally, either as prestige apparatus or as settlement *locus*.[27] The earliest generation of these ascetic projects should thus not be imagined as constituting a different kind of physical space from those we have already seen. Rather, Sulpicius' and Paulinus'

"monasteries" were constructed largely through texts, reshaping a shared material culture of villa and churches into a distinct ascetic space using the power of words.[28]

DISCOURSE: SELF AND SPIRITUALITY IN THE CHRISTIAN VILLA

Villas were not only places where Christian rituals happened; they were also places where Christian thinking occurred. Or, more correctly, they were places that figured in the self-imagining of Christian elites. For centuries, as this volume describes, the place and, above all, the *idea* of the villa served as raw clay for the molding of the aristocratic notion of self. For Cicero, Seneca, Pliny the Younger, and their peers, villas were seats of ancestral piety, places of mental clarity and balance, or fragments of rural nature that could channel cosmic harmony through the correct disposition of buildings and gardens.[29] Villas were the rural, contemplative *ying* to an urban, political *yang*, the opposing force upon which the Roman ideal of civic duty depended. Villas, in short, were good to think with, not simply as places but as ideas.

Villa-based thinking was expressed in many forms, from images within the villa itself to descriptions of villas or estates embedded in letters and poems. Images and words are both, in different ways, expressions of the same impulse – to use the rural estate to construct a particular image of the self and thus one's social group. This propensity to use a rural estate to define oneself has often been described as "self-display," a kind of showing-off to one's peers by describing or bragging about one's estates. While bragging is undoubtedly part of it, self-display implies a kind of suburban lawn-competition style of presentation, in which one's wealth or accomplishments is paraded before an audience. Self-display implies both passive villas and passive audiences – the one the mere conveyance of aristocratic ideals, the other obligingly consuming the intended message. Instead, it might be more useful to imagine, like Arcimboldo's composite-head portraits *cum* still-

lifes, aristocratic identity actually built from fragments of villas, in which villas are not a mirror of identity, but part of it. The process of building – personalizing age-old tropes of *otium* and retreat – was not a unidirectional presentation, but a discourse, one that required constant counter-response in the form of letters, buildings, or images.[30] It was as *discourse*, more than display, that villas helped build the aristocratic self.[31]

Christian villa-owners used their rural estates to think with no less than their pagan contemporaries and through similar discursive modes – through images and words. If we turn first to images, it is important to note the paucity of clearly Christian images in rural villas. As is the case for the first generations of Christian building projects, villa-owners did not often use blatant pictorial statements of religious affiliation as part of their self-imagining. This fits with the rare indicators of any kind of cultic membership in Roman houses: the houses of a Mithraist, Isaic, or even Dionysian devotee are rarely signposted, suggesting a general *discretion*, by pagans, in the proclamation of religious affiliation as part of domestic self-construction. The archaeological record has revealed three very interesting exceptions to this pagan discretion, all three tightly regional clusters of Christian proclamation at villas and tightly related chronologically, but widely dispersed in the western Roman Empire:

1. In northeastern Hispania in the late fourth-century villa at Centcelles, a floor mosaic in the vestibule juxtaposed hunting scenes, Old and New Testament images, and a probable image of the *dominus*; at the nearby Villa Fortunatus of similar date, a mosaic in an *exedra* depicted images of plenty and the owner's name, Fortunatus, bisected by a *Chi-Rho*.[32]
2. In Britain in the late fourth century, where the bulk of such domestic Christian images have been unearthed, the villa mosaics at Hinton St. Mary juxtaposed an image of Christ with that of Bellerophon (Figure 23.4). At the nearby villa at Frampton, Bellerophon, Venus, and Adonis images are interrupted by a *Chi-Rho*.[33] One might also add to this British group of

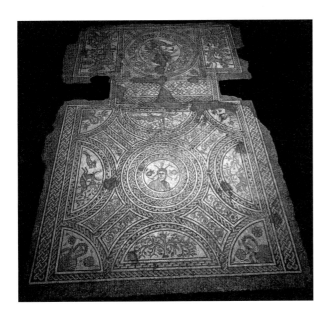

Figure 23.4. Hinton St. Mary, villa: mosaic. (A black and white version of this figure will appear in some formats. For the color version, please refer to the plate section).

monumental images in mosaic a sizable collection of domestic portable objects found in villas.[34]

3. In Syria, in houses of the sixth century, visual symbols and written prayers graced the doors and windows of Syrian village houses like those at Anasartha, Herakêh, El Bardoune, Kerratin, and Sabbâ.[35] This latter group is quite distinct in chronology, context, and function, and it deserves separate consideration.

Important in all cases, however, are the tight regional and chronological groupings; these are images that worked *in conversation* with other, neighboring images as part of a locally centered discourse, one in which landowners' identities were framed in part by mutual Christian affiliation and belonging. In Britain, where the evidence is most plentiful, scholars have seen the mosaics in the Frampton and Hinton St. Mary villas as evidence for complex theologies of salvation, of Gnostic practices, or of a populist mixing of apotropaic symbols.[36] Other interpretations have rightly drawn attention to the body of images shared among various pagan and Christian cultures, particularly the prevalence of Bellerophon. Such images from what may seem, to us, discordant cultures clearly responded to one another in Roman Britain in

the late fourth century, and they did so when there was a boom in villa building and decisions about domestic decoration. As such, the association of Bellerophon *et alia* in the way of pagan gods and Christ's image may well have supported the prestige of a villa owner.[37] It is certainly possible that some of these images, particularly the mosaic pavements, were intentionally imbued with complex signification intended to be puzzled over and debated by the villa owners and their peer-guests as aspects of both hospitality and spirituality. It is through such conversations that the images really did their work.

Perhaps even more so than buildings or images, villas of words were also good to think with. The villa as physical space was transformed by *ekphrasis* and interpretation into an agent of moral and philosophical analysis. The letter was a particularly popular instrument with which to erect villas of words.[38] Letters were penned while on one's rural estate, distant, at least spatially, from the cares of public office and surrounded by the rural nature that served as epistolary and poetic muse. Villa life and distance from the city also meant distance from one's friends; letter exchange bridged that distance and the villa served as an all-important *mise-en-scène* in the drama of epistolary friendships. But villas were not only the backdrops for these exchanges; they were the currency with which the friendship was carried out. As emblems of their owners' virtues, as embodiments of the welcome due absent friends, and as the very cause for the absence that made letter writing necessary, letters and villas were in some sense one. Together, they built and sustained the *otium/negotium* binary that lay at the heart of Roman elite self-identity.

Some of our richest evidence for villas as building blocks of self-identity come from fourth-century Christian writers. Radical ascetics such as Paulinus of Nola and Sulpicius Severus, and more temperate Christians such as Ausonius of Bordeaux, used villas to think with. We have already encountered Ausonius' *ekphrasis* of a Christian shrine, part of a longer encomium to the balanced life. The letters of Paulinus of Nola provide an even richer source, one that can be parsed into two major themes – villa-church building and rural nature. Paulinus' *Letter 32* includes lengthy discussions of Sulpicius Severus'

villa-church projects on the latter's rural estate of
Primuliacum.[39] The first part of the letter includes
a series of epigrams that Paulinus, at Sulpicius'
urging, has composed to appear in Sulpicius'
churches. The epigrams offer interpretive guidance
on the buildings' form – two basilicas joined by
a baptistery, on their relics – the Holy Cross and
the body of Clarus, an acolyte of St. Martin of
Tours – and on the decorative program that included
images not only of Martin, but also Paulinus.
The first point to note is that Paulinus knows of his
friend's villa projects not only from the latter's letters,
but also from the letter carrier, a trusted servant and
fellow-Christian named Victor. As Catherine
Conybeare has noted, letter carriers could be as
important as letters themselves, carrying *viva voce*
descriptions of whence they came (in this case,
Primuliacum) to complement the writer's words.[40]
It is likewise important to note that Paulinus' epi-
grams on the new churches and baptistery at
Primuliacum are intended not as mere descriptions
but as ekphrastic counter-gifts to the verbal and
written descriptions sent by his friend Sulpicius.
As such they both praise Sulpicius and reimagine
Primuliacum in Paulinus' words. Through the epi-
grams, Paulinus writes himself into these projects –
the image of Paulinus himself is imagined as an
inspiration for the newly baptized; the altar to
St. Martin's acolyte, Clarus, is recast as a *memoria* to
Paulinus' and Severus' friendship. Paulinus then lays
Sulpicius' recast project beside descriptions of his
own works at Nola and elsewhere, the one not
only competing with the other, but completing it:
"So that in this additional way the fusion of our
minds, however remotely we are separated, may be
symbolized, and though these buildings are
separated ... [they] are joined to each other by
a chain of letters."[41] The villa, or here the villa-
church, is the currency of epistolary friendship; villa
ekphrasis, taken apart, reassembled, reinterpreted, and
redispatched, forms part of the glue that binds
Paulinus to Sulpicius.[42]

Paulinus also uses the social dynamics and the
natural setting of the rural estate to make sense of
what it means to become a Christian.[43] He repeat-
edly casts himself as, and invites Sulpicius to become,

a *colonus* (a tenant farmer bound by various obliga-
tions to an estate) of St. Felix, laboring under his
benign lordship and patronage.[44] He likens the strug-
gles to live a truly Christian life to a farming compe-
tition among *coloni,* in which the efforts are repaid by
a fruitful harvest.[45] In a letter to the ex-provincial
governor Aper and his wife Amanda, who had taken
up residence on their rural estate, his enumeration of
the couple's virtues reads like an agricultural manual
of Christian analogy – as care produces a fruitful
estate, so their prayers have yielded a fine spiritual
estate; their chastity, their increasing faith, and the
new Christians they have converted all produce an
ever greater "yield"; yet their fields must be carefully
tended lest the destructive worms and locusts of sin
destroy it.[46] These are not mere literary metaphors:
For Paulinus, the structures of seigniorial life and its
agricultural outputs were gristmills that ground bib-
lical calls to spiritual discipline into proximate and
digestible chunks. The social and natural world of the
villa and its estate might thus be hermeneutic tools
used to interpret scripture.

CHRISTIANITY AFTER THE VILLA: LATER FIFTH AND SIXTH CENTURIES

The relationship between villas and Christianity
described thus far is a tale of the late fourth through
mid-fifth century. That is, it is a story set in a world in
which villas still functioned, as places and ideas, in
quintessentially Roman ways – as places to dwell,
both physically and discursively.[47] By the mid-fifth
century in most of the western empire, and a half-
century earlier in Britain, this villa-world was
coming to an end. Elites ceased to maintain the
physical structure of villas, as monumental domestic
architecture slowly ceased to be part of the building
blocks of elite identity. That is, being an elite
no longer required participation in the villa-based
discourse of past centuries.

The gradual abandonment of villas as monumen-
tal spaces did not, in many parts of the West, mean
the abandonment of villas as spaces of human habita-
tion. In many regions, of which Hispania, Aquitaine,
Languedoc, Piedmont, and Lombardy have been

best studied, later fifth through sixth-century settlements continued to center on villas.[48] The material culture of those settlements was very different from the sparkling mosaics and soaring vaults of monumental villas: Rooms were subdivided, hearths built over mosaic floors, graves often inserted into living spaces, post-built structures erected inside reception rooms, and agro-industrial facilities inserted into the residential rooms. These "transformations" of villas have received much scholarly attention in recent years and their meaning has been hotly debated.[49] Were they the mini-villages of peasants who had taken over spaces abandoned by elites?[50] Were these humble remains actually the elite residences of a new age?[51] Were they barbarian settlements?[52] In many cases, the material evidence points to multi-family occupation in restricted quarters – a significant social shift from most villas' original uses. However, in many other cases the nature of the new occupation is wholly unclear. The fact that the material culture of rich and poor, of peasant and landowner, and of Roman and barbarian has become largely indistinguishable indicates that, by the sixth century, houses had ceased to perform the work that they had in centuries past, as seats of elite identity.[53]

As villas ceased to do that work, churches seem to have taken it up. Many "transformed" villas also include a church built either in or near the humble settlements built into the previous residence.[54] The example at Monte Gelato, outside Rome in the Ager Faliscus, is among the better excavated, and contains elements common to many (Figure 23.5).[55] A large peristyle villa was abandoned in the early third century, but its structures were reoccupied in the late fourth century, its baths transformed into a stable and metal workshop and the porticoes taken over by hearths and wooden storage bins. The only major piece of new construction was a small church, built adjacent to the villa and reusing one of its walls. Oriented east-west, it seems to have been surrounded by a roughly contemporary graveyard. Evidence for increasing pasturage at the expense of arable land, a diet increasingly dependent on pasture animals, and a small amount of imported ceramics suggest that a new population of rural workers with practical and spiritual needs different from those of the abandoned

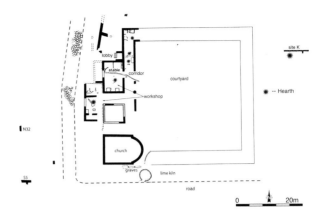

Figure 23.5. Monte Gelato, site plan, early fifth-century phase.

villa had moved in. Other examples with similar features have been documented throughout the western empire: at El Saucedo in central Hispania, a portion of a bath complex was converted for use as a church by the addition of a baptismal font at some point in the later fifth to sixth century when the villa seems to have been transformed into a small village.[56] In the fifth or sixth century, a garden pavilion at the villa of Séviac in southwestern Gaul may have received a baptismal font: later, an apse was added and some nearby burials about the same time that the villa's other rooms were subdivided and multiple hearths appeared over the once-fine mosaics.[57] In other examples, the church was built nearby the transformed villa: At Milreu in southern Lusitania, the villa's temple/*nymphaeum* was used as a graveyard and later received a baptismal font, all during a period in the later fifth or sixth centuries when ceramic sequences in the villa largely came to a halt, a fact that indicates, archaeologically, a new isolation of the site, even a regression in its material culture.[58] At Torre de Palma, also in Lusitania, a great 30 meter-long double-apsed basilica was built in the early sixth century near a villa probably subdivided and in a state of secondary use.[59] In all these instances, the church is the most monumental part of the settlement and often the only new masonry structure.

In most cases, it is impossible to determine whether the villa was reoccupied at a lower socio-economic level *before* the church was constructed, or

if the church preceded that occupation. At Monte Gelato, the reoccupation seems to have slightly preceded the church, whereas in other sites, like El Saucedo, the church may have served as a locus, even a magnet, for a long-lasting, slightly later settlement. If we knew for certain whether the churches were built before the settlements came into being, or whether the settlements formed before the churches and prompted their construction, we could go some way to determining who the accompanying populations were, how these churches were used, and who controlled them. There is almost certainly no single answer, for their chronologies, surrounding ecclesiastical circumstances, not to mention the archaeology itself, are so diverse that we must imagine a range of circumstances. The elaborate liturgical installations of a Torre de Palma with its long life and seemingly numerous local population would suggest a parish project – although the distance (some 75 km) between the site and the bishopric in Évora would require a particularly energetic episcopal sponsor. By contrast, at the transformed villa of Trois-Îlots on the Algerian coast, the church's mosaic floor seems to have been paid for piecemeal by individual donors, so we might imagine a project initiated by members of the local population itself.[60] It is also always possible that some of these projects are estate churches, built and controlled by elites, either absent or materially invisible to archaeology. Contemporary church councils continue to attest to such private churches, but the difficulty of distinguishing elites from non-elites in the material record makes their archaeological attribution problematic, if not impossible. In any case, the majority of these later villa-churches have large baptisteries, liturgical furnishings for the mass, and/or accompanying graveyards, which are signs of communal use that point to worshiping populations broader than a single family.

The role played by the villa itself in this phenomenon of Christianization is debated and varies from region to region. While previous generations of scholars had assumed that parish boundaries were coincident with earlier Roman estate limits, and thus that the villa was the origin of the parish

system, in most regions this has been shown to be unlikely, not least owing to the diverse after-lives of both villa and post-Roman settlement patterns.[61] In southwestern Hispania and southwest Gaul, where the later Roman villa system was dense and powerful, villas continued to serve as the nexus of later, non-elite settlements through the seventh century: Some of these settlements have churches that assume a variety of forms, from small burial churches to large basilicas with full liturgical equipment.[62] In northern Italy and Mediterranean Gaul, villas, *vici, mansiones*, and *castra* were all poles of attraction for churches and the later, agglomerated populations that accrued around those churches.[63] Villa and parish are nowhere consistently linked because the evolution from ancient to medieval landscape was far more complex than a simple switch from villa to parish: Villas were often not the only mode of settlement, parish churches were not the only kind of church, and each region had different institutional church histories that impacted the development of parish systems.

Furthermore, the broad trajectories of settlement history were not the only factor. In various regions – central and southern Gaul, Hispania, to a lesser extent northern Italy – villas entered a new form of discursive identity, as points of Christian memory and as stages upon which bishops and holy men might showcase their power. In the miracle tales narrated by Gregory of Tours and other Gallic authors, the ruins of villas are haunted spaces where holy men successfully vanquish ghosts or locate the bones of long-vanished martyrs.[64] In Hispania, villas – increasingly defined as tracks of land more than buildings – and their now-common villa-churches both required the steadying hand of a bishop or holy man to keep them on the correct path.[65] In these stories, the villa is often a threatening place, one that must be reintegrated into the broader community by miraculous Christian intervention.[66] Urban bishops described rural private churches in special terms – *in villam* or *in agro* – and they circumscribed their rituals and sought to fold them into the institutional church's supervisory control like parish churches; these measures further cast villas in an

outsider's role, as much spiritually as materially.[67] Villas are extra-communal foils to orderly Christian communal identity: Reimagined as outliers to that order, they are still useful to think with.

CONCLUSIONS

Much work remains to be done on these issues, not least the clarification of chronologies for both villas and churches and on the micro-regional histories that shaped their development. What does seem clear, however, is that the later fifth- through sixth-century Christian history of the villa is quite distinct from that of the preceding phase. In the fourth and fifth centuries, Christian practice and discourse were fundamentally shaped by the villas themselves, that is, shaped by villas as components of elite self-imagining. As villas were used to construct the self, they were likewise used to construct a particular kind of Christian self.

In the later fifth and sixth centuries those villas slowly died: In their ruins arose a new kind of villa – the villa as organizing unit of agglomerated settlement. Villas were, at least in some regions, places where mini-villages grew up, where burial grounds were established and where communal legends accrued. The churches that sometimes appeared in these villas, whatever their institutional affiliation, are typically outfitted for communal use – burial, baptism, or Eucharistic services. Even Christian discourse surrounding this later villa is communal – the miracles narrated by Gregory of Tours and other Gallic sources reimagine villas as haunted places where the intervention of a holy man produces group conversions and spiritual relief for the whole region. The Christian history of this post-elite villa is a history of the Christian collective.

NOTES

1. Cassiod., *Inst.* 1.29 (ed. Mynors 1937, 73–5). On the location of *Vivarium* and its possible archaeological remains, see Courcelle 1938; Bougard and Noyé 1989; Zinzi 1994.
2. Some overview include: Percival 1997; Piétri 2002; Brogiolo and Chavarría 2003; Chavarría 2007b; Bowes 2007; idem. 2008.

3. For a more sustained version of this argument, see Bowes 2008, ch. 3.
4. Auson., *Ephemeris* 2.2 (ed. Green 1991, 7–8); Paulinus of Nola, *Ep.* 32 (*CSEL* 29.1: 275–301); August., *De civ. D.* 22.8 (*CSEL* 40.2:595–612).
5. On *sacrarium* see, *Dig.* 1.8.9.2 (Ulpianus); Wissowa 1912, 468–9; on Ausonius and moderation, Fontaine 1972, 579. Fontaine does not believe the term *sacrarium* refers to a building but to internal withdrawal for the purposes of worship.
6. Conybeare 2000, 104.
7. Bowes 2008, 169.
8. For cautionary statements, see Duval 1982; Holden 2002; Percival 1976, 184.
9. See Percival 1997; Chavarría Arnau 2007a.
10. Cf. Paulinus of Nola, *Ep.* 32 (*CSEL* 29.1: 275–301); Sid. Apoll., *Ep.* 4.15 (ed. Mohr 1895, 90–1); Monfrin 1998.
11. Rossiter 1989.
12. Cf. Brogiolo and Chavarría 2003, for a different interpretation and chronology.
13. See Meates (ed.) 1979; Meates et al. (eds.) 1987; Neal 1991.
14. On villa temples and mausolea, see Lafon 1989; Bodel 1997; Bowes 2006; Chavarría 2007a.
15. See Bowes 2006, cf. Chavarría 2007b.
16. Hauschild 1972, 1978.
17. Bodel 1997; Purcell 1987.
18. Serra Rafols 1952; Fernández Galiano ed. 2001; Suić 1960; Février 1996.
19. Mirabella Roberti 1965; Massari and Roffia 1985; Passi Pitcher 1990; Bishop and Passi Pitcher 1988–9.
20. Cf. Cantino Wataghin 1994, 142–7.
21. Violante 1982; Sotinel 1998; Bowes 2005. Cf. Volpe 2007.
22. For the early legislation controlling villa churches, Piétri 2002.
23. E.g., Lorenz 1966; Lienhard 1977; Percival 1997; Cantino Wataghin 1997.
24. Cassiodorus: Bougard and Noyé 1989; Zinzi 1994; Benedict: Fiore Cavaliere, Mari, and Luttazzi 1999; Fiore Cavaliere 1994; idem. 1996.
25. Bowden and Përzhita 2004. On the Diaporit villa, see Bowden (Chapter 20) in this book.
26. Mar et al. 1996.
27. Bowes 2014.
28. Bowes 2011.
29. See for instance Bodel 1997; Riggsby 1998; Henderson 2004.
30. On the efficacy of objects, see Gell 1998; Gosden 2001.

31. Cf. Henderson 2004.
32. Arce (ed.) 2002; Guardia Pons 1992, 89–91. See also Ripoll (Chapter 22) in this book.
33. Toynbee 1964; Painter 1965; Huskinson 1974.
34. Cf. Mawer 1995.
35. Maguire, Maguire, and Duncan-Flowers 1989.
36. Huskinson 1974; Toynbee 1967; Perring 2003.
37. Scott 2000; cf. Millett 1990.
38. On epistolary rituals and elite self-construction, see Ebbeler 2009; Bruggisser 1993; Conybeare 2000; Riggsby 1998; Henderson 2004.
39. Paulinus of Nola, *Ep.* 32 (*CSEL* 29.1:275–301).
40. Conybeare 2000, 144–6.
41. Paulinus of Nola, *Ep.* 32.10 (*CSEL* 29.1:285).
42. Conybeare 2000, 104.
43. See Fontaine 1972.
44. *Ep.* 5.15; 39.6; 24.11 (*CSEL* 29.1:34–35, 338, 211). The comparison is also made many times in the *Carmina: Carm.* 20.1–21; 21.60, 84–104, 464–87; 27. 135–47 (*CSEL* 30:143–4, 160–1, 173–4, 268).
45. *Ep.* 11.12 (*CSEL* 29.1: 70–1).
46. *Ep.* 39 (*CSEL* 29.1: 334–9).
47. The phrase is John Henderson's.
48. Brogiolo and Chavarría 2003; Ripoll and Arce 2000; Pellecuer and Pomarédes 2001; Brogiolo ed. 1996.
49. Van Ossel 1992; Brogiolo ed. 1996; Sodini 1997; Cantino Wataghin 1999; Ripoll and Arce 2000; Christie ed. 2004; Chavarría 2007a; Bowes and Gutteridge 2005.
50. Chavarría 2007b; Francovich and Hodges 2003.

51. Halsall 1995; Lewit 2003.
52. Evidence for Hispania is summarized by Chavarría 2007b; for Aquitaine, Kazanski and Lapart 1995.
53. The precise chronology of these transformations varies by region; Bowes and Gutteridge 2005.
54. Summaries can be found in Brogiolo and Chavarría 2003; Balmelle 2001, 118; and the many essays in Pergola (ed.) 1999.
55. Potter and King (eds.) 1997.
56. Bendala Galan, Castelo Ruano, and Arribas 1998; Castelo Ruano et al. 1998; Aguado et al. 1999.
57. Lapart 1987; Lapart and Paillet 1996.
58. Teichner 1997; Teichner and Neville 2000; see Teichner in this book.
59. Maloney and Hale 1996; Maloney and Ringbom 1998. On Torre de Palma see also Teichner (Chapter 14) in this book.
60. Gui et al. 1992, 18–19; Leveau 1984, 249–53. For an account of the villa itself, see Wilson (Chapter 16) in this book.
61. On villa and parish, see Violante 1982; Monfrin 1998.
62. Ripoll and Velázquez 1999; Faravel 2005.
63. Brogiolo and Chavarría 2003; Schneider 2001. For an overview of the variety of settlements and villa afterlives, see Brogiolo and Chavarría 2005.
64. Percival 1996.
65. Chavarría 2004. On the changing use of the term villa, see Monfrin 1998; Heinzelmann 1993.
66. Cf. Fumagalli 1994.
67. See Wood 1979; Piétri 2002; idem. 2005.

PART IV

ROMAN VILLAS
Later Manifestations

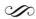

CONVIVIALITY *VERSUS* SECLUSION IN PLINY'S TUSCAN AND LAURENTINE VILLAS

PIERRE DE LA RUFFINIÈRE DU PREY

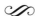

A famous letter by Pliny the Younger (Gaius Plinius Caecilius Secundus, c.61–113 CE) explains how the author, then still an adolescent, was so engrossed in reading and writing that he almost missed the eruption of Mount Vesuvius taking place across the Bay of Naples. The natural disaster in the year 79 CE took the life of his illustrious uncle, the Roman naturalist Pliny the Elder, and the young man eventually penned his eyewitness accounts of the cataclysmic event.[1] They survive among the 247 other Latin letters ascribed to him, including one addressed to a certain Gallus and another to Domitius Apollinaris.[2] These two texts conduct carefully crafted house-and-garden tours of country estates that purportedly belonged to Pliny: one for winter use by the flat seacoast at Laurentum near Rome – his *Laurentinum*; the other in the Tuscan hill country primarily for summer and autumn – his villa *in Tuscis* or *Tuscanum*. Such verbal descriptions extolling the architectural and horticultural charms of ancient Roman villas put flesh on the bare bones provided by archaeological excavation. For centuries, therefore, the younger Pliny's words have prompted imaginary reconstructions based on them.[3]

The impact of an influential passage from each of these two letters forms the focus of this chapter. Significantly, the passage in question serves as a culmination at the end of each letter. Reading them attentively leads to the distinct impression that they were composed primarily as an exercise in literary *ekphrasis* – architectural equivalents of Homer's celebrated description of Achilles' shield in the *Iliad*. The so-called Laurentine and Tuscan villas are so different in character as to suggest the letters' function as a pendent pair, meant in some way to highlight two different sides of Pliny's personality: conviviality versus a desire for seclusion. The letters may not refer to any archaeological truth, and the villas may be more or less pure figments of their author's imagination. Hence, the search for physical remains of the villas largely falls outside the scope of this chapter; more important to its aim is the transposition from villa into epistolary language and the differing ways the language of Pliny's villa letters has been construed since the numerous printed editions began appearing with the *editio princeps* in 1471.[4] Mounting, but as yet inconclusive, archaeological evidence does point to the location of the villa *in Tuscis*.[5] But to a considerable extent, Pliny concerned himself less with descriptions of actual villa or garden sites and more with an elegant literary exposition of the themes of conviviality and seclusion.

CONVIVIALITY

The Tuscan villa in many respects epitomizes conviviality, one of the perennial attractions of villa life. Pliny's letter to Apollinaris – the lengthiest of his entire literary oeuvre – concludes with a flourish by describing a hippodrome-shaped area of the garden

Figure 24.1. Detail of imaginary reconstruction drawing of Pliny's Tuscan villa by F. I. Lazzari (c. 1700).

Figure 24.2. Imaginary reconstruction of Pliny's *stibadium* at the Tuscan villa by J.-F. Félibien des Avaux (1699).

defined by hedges. In the center stood a quite spectacular dining pavilion or *stibadium*.[6] Here Pliny entertained special guests. His detailed description of the structure caught the attention of a polymath by the name of Francesco Ignazio Lazzari, born in 1633 at Città di Castello, a small Umbrian city that lays claim to being near the site of Pliny's Tuscan villa. A dig outside the town in the 1970s and 80s turned up bricks stamped with Pliny's insignia, thus strengthening the local legend. True or not, Lazzari demonstrated his antiquarianism and flattered his civic pride by producing, around 1700, the first known imaginary reconstruction drawing of the Tuscan villa (Figure 24.1, showing a detail of the *stibadium* section). Now in a private collection, the rather battered and stained right-hand section of the paper triptych shows Pliny's modest-sounding building expanded to enormous proportions by Lazzari. In aerial perspective, he succeeded in conveying an overview of the upward-sloping Plinian site. Far away at the top, attached to the triple domed *stibadium* structure proper by a long staircase, is a strange towered building unlike anything Pliny described. But its prominence indicates that Lazzari literally and figuratively understood the dining pavilion as the highpoint of the Tuscan villa description.[7]

A less fanciful imaginary reconstruction of Pliny's *stibadium* was published for the first time by the French Latinist Jean-François Félibien des Avaux. A minor bureaucrat in the court of King Louis XIV, Félibien brought out *Les plans ... des plus belles maisons de campagne de Pline* in Paris in 1699, around the same time as Lazzari produced his drawing. But unlike the Italian, the separate engraved plate that Félibien devoted to the *stibadium* and its immediate environs shows them in plan only (Figure 24.2).[8] In fact, Pliny's villa letters rarely give detailed architectural information. Only once or twice do they even mention the word column. An exception to the general rule exists in the instance of the dining *stibadium* surrounded by what the text specifies as "*quattuor columellae Carystiae*," that is to say, Carystian marble columns. Félibien's plan shows them at number 44. At a distance stood a secluded sleeping alcove, numbered 46, to which Pliny could retire after entertaining dinner guests. It had a bed inside, benches, and more fountains interconnected with those in the *stibadium* by underground canals.

In Félibien's overall plan of the Tuscan villa complex, illustrated by another of his engravings (Figure 24.3), the *stibadium* occupies the top right extremity of the racecourse-shaped area defined by shrubs. While Félibien recognized the importance of the *stibadium* in Pliny's description, he conveyed an impression of geometric control over the lollypop trees, regimented in rows like soldiers on parade at Versailles. Typical of reconstructions in general, Félibien's says more about the era of its creator than about that of Pliny, who had stressed the hilliness and variety of the site.

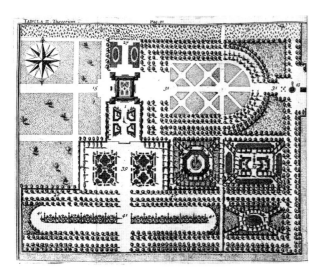

Figure 24.3. Imaginary plan of Pliny's Tuscan villa by J-F. Félibien des Avaux (1699).

Figure 24.4. S. Wale's imaginary reconstruction of Pliny's *stibadium* at the Tuscan villa (1751).

Félibien was a translator, an *amateur* of the arts in the best sense, and even less of an architect than Lazzari. The Frenchman shared some of these traits with John Boyle, the fifth earl of Orrery and Cork, an Anglo-Irish nobleman with a bent for translating Latin. Orrery decided to publish a two-volume English translation of Pliny's letters in 1751 in London, with commentaries intended for his son's edification. He had the volumes copiously illustrated by Samuel Wale, an artist and professor of

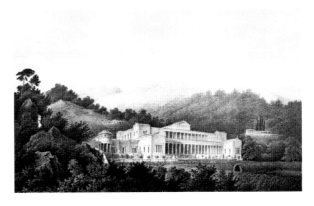

Figure 24.5. Imaginary reconstruction of Pliny's Tuscan villa by K. F. Schinkel (1841).

perspective. Like the aristocratic Pliny, who inherited villa properties around Como and elsewhere from his deceased uncle, Orrery was to the villa born. This enabled him to penetrate close to the heart of Pliny's architectural letter to Apollinaris. When he chose the passages for engraving, he no doubt directed Wale to Pliny's description of the *stibadium* (Figure 24.4). Orrery praised it as "the most beautiful and most expensive summer house in Pliny's garden," although he had reservations about Pliny and other Romans' excessive eating habits, for which the little structure was a venue.[9] Within Wale's engaging Rococo surround can be made out a fountain, topiary bushes, a standing figure in a toga, presumably Pliny, and the four Carystian marble columns entwined with vines.

Lazzari, Félibien, and Orrery emphasized the *stibadium* of the Tuscan villa to point up the theme of conviviality, a theme elaborated in the reconstructions by Karl Friedrich Schinkel, the architect who perhaps understood the Latin author best. Schinkel's memories of his Grand Tour to Italy probably prompted his initial speculations about the appearance of Pliny's villas and gardens. He produced drawings of them in the 1830s, and they finally saw publication as a series of color lithographs contained in his *Architektonisches Album* published in Berlin just before his death in 1841.[10] Schinkel romantically envisioned the Tuscan villa set amid the Apennine foothills as though it were a sanatorium in the high Alps, open to sunshine and every passing breeze (Figure 24.5). Indeed, Pliny had commented that

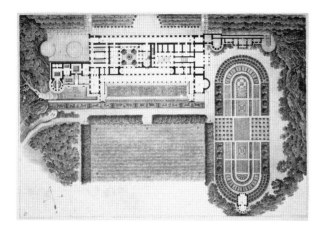

Figure 24.6. Imaginary plan of Pliny's Tuscan villa by
K. F. Schinkel (1841).

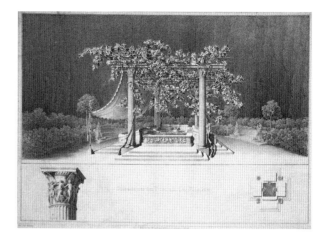

Figure 24.7. Imaginary reconstruction of Pliny's *stibadium*
at the Tuscan villa by K. F. Schinkel (1841).

his Tuscan neighbors had an enviable reputation for
longevity (Pliny himself died far from his villas in 113
on the shores of the Black Sea where the emperor
Trajan had posted him). The corresponding Schinkel
plan of the Tuscan villa (Figure 24.6) indicates vine-
yards at the top, a sea of soft acanthus at the front
surrounded by tunnel-like trellises, and on the ter-
race in the middle, box hedges clipped into the
shapes of animals or letters of the alphabet. These
letters, according to Pliny, spelled out the master and
his gardener's names. What a lovely conceit! Over to
the right, the hippodrome-shaped garden contains
two buildings set within it: the sleeping alcove and, at
the opposite end, the four-columned *stibadium* for
dining.

Of all the seventy-four or so authors, architects,
and archaeologists known to have attempted imagin-
ary reconstructions of Pliny's villas, until recently
only Schinkel produced a separate and quite detailed
study of the *stibadium* (Figure 24.7; cf. Figures 24.13
and 24.14). It is a delightful and revealing illustration.
In addition to the basic information conveyed by
Lazzari, Félibien, and Samuel Wale, Schinkel's artis-
try enabled him to conjure up some of the more
pleasantly decadent features of this part of the garden
in Tuscany. Pliny described how the four columns
enclosed a bench on which diners reclined while
water from beneath them gushed into a central
basin forming a liquid table top. The lighter sweet
meats or appetizers would float about in little bird- or
boat-shaped vessels on the surface. Presumably the

diners could "sail" them back and forth to one
another. In Schinkel's conception, a vine pergola
formed a canopy so that the guests might reach up
and actually pluck the grapes above their heads. This
engaging image of hospitality and conviviality is per-
haps unmatched in all architecture.

SECLUSION

Implicit in any villa, however open and convivial,
there exists a strong desire for seclusion.
The scholarly Earl of Orrery considered himself
Pliny's kindred spirit when he wrote: "To the stu-
dious mind, no retirement can be too private . . .
and . . . the greater the distance from the metropolis
the more complete will be the scene of
tranquility."[11] Orrery's comment relates to the
lengthy letter to Gallus (*Ep.* 2.17) describing the
villa at Laurentum, Pliny's seaside retreat outside
Rome. Shown from offshore in Schinkel's color
lithograph (Figure 24.8), the placid Mediterranean
mirrors the architecture, and hardly a ripple of wind
on water ruffles the tranquil scene. Orrery drew
special attention to one extremity where there
stood "a little garden [structure] . . . built by [Pliny]
himself. He tells us that he . . . found himself not
only enclosed in . . . solitude, but perfectly defended
from all kinds of interruptions . . . He raised it as an
asylum to his studies and a sanctuary to his

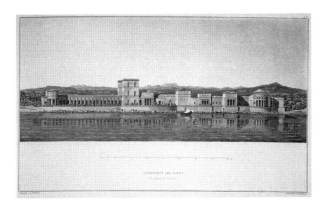

Figure 24.8. Imaginary reconstruction of Pliny's Laurentine villa by K. F. Schinkel (1841).

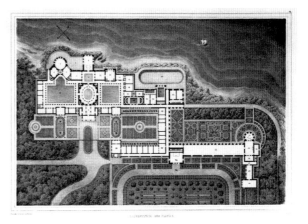

Figure 24.9. Imaginary plan of Pliny's Laurentine villa by K. F. Schinkel (1841).

speculations; he speaks of this favorite edifice in the rapturous style of a lover."[12] Orrery understood perfectly the special part of the Laurentine villa for which Pliny took personal credit and therefore lovingly called "*diaeta est amores mei, re vera amores; ipse posui.*" Schinkel intuitively grasped Pliny's emphasis. The view of the Laurentine villa somewhere near Ostia, with the Alban Hills in the background, pictures the *amores mei* pavilion on the far left, reflected mirage-like in the waters; something almost too ephemeral and good to be true, in effect a work of fiction.

Schinkel's plan (Figure 24.9) depicts the plant forms of the garden eddying around the pavilion's sun room, or *heliocaminus*, as though it were a pool of tranquility. He understood the value of being able to pursue artistic goals in peace and quiet. He could sympathize when Pliny wrote that, separated from the "Big House" by a long *cryptoporticus*, his favorite haunt contained his private inner sanctum. It could be completely darkened and soundproofed if necessary (*cubiculum noctis et somni*). A dead space protected it from noise and intrusion, but a small hypocaust heating system made it cozy in winter. During the *Saturnalia* celebrations, which occurred annually in December, merrymaking among the household got boisterous; at such times, Pliny retreated to his favorite suite of rooms. Schinkel located it near the beach, where Pliny said he liked to walk. Views extended up and down the coast, and at night distant twinkling lights were the only signs of civilization. No wonder translators and architects, in an attempt

to convey Pliny's delight in this suite, have variously described it with such phrases as: "*mes délices,*" "*meine Lust,*" "my delight . . . my mistress."

Unlike the *stibadium*, Schinkel provided no separate image of the *amores mei* pavilion. That task fell to his friendly rival at the Berlin *Bauakademie*, the teacher and architect Wilhelm Stier, who was engaged around the same time in the 1830s on his own Laurentine and Tuscan villa imaginary reconstructions, which finally appeared in print in 1868 thanks to his son's efforts – and Herculean efforts they were. The posthumous volume of plates titled *Architektonische Erfindungen* is elephant-folio in size.[13] Stier's enormous ground plan of the Laurentine villa (Figure 24.10), first exhibited as a drawing in Leipzig in 1842 after Schinkel's death, is something of a tribute to the older architect. Unlike Schinkel, however, Stier could not resist cramming in every imaginable farming structure that might have serviced an ancient country estate, even though Pliny does not indicate that any agricultural annex existed. The French legends to the sides of the plate list seventy-eight separate buildings or spaces. Pliny's letter to Gallus, although it is more architecturally explicit than the letter to Apollinaris, mentions half that number. Clearly Stier elaborated a great deal on Pliny. At the end of a 100-meter-long *cryptoporticus* at the bottom right, Stier situated Pliny's *amores mei* cluster of rooms. Their charm gets blown up out of all proportion to the affectionate and diminutive

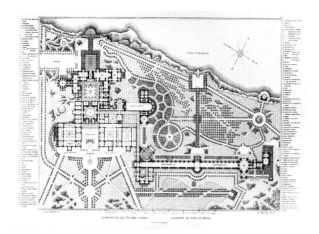

Figure 24.10. W. Stier's ground plan of Pliny's Laurentine villa (c. 1842).

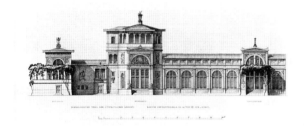

Figure 24.11. W. Stier's elevation of the *amores mei* pavilion at the Laurentine villa (c. 1842).

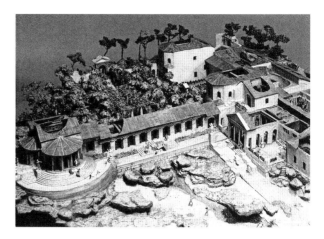

Figure 24.12. C. Pember's scale model of Pliny's Laurentine villa (1947). Ashmolean Museum, Oxford. (A black and white version of this figure will appear in some formats. For the color version, please refer to the plate section).

terms in which Pliny wrote about them. What holds true for the Laurentine villa applies equally to its Tuscan counterpart, first exhibited in public in 1843. The ground plan is so complex as to prefigure an intergalactic space station. Yet, for all that, the *stibadium* that so fascinated Orrery and Schinkel – and which was important to Pliny as well – features only peripherally on Stier's plan.[14]

Stier argued that the literary, probably fictive, and certainly imaginative quality of Pliny's letter to Gallus entitled him to his own *Erfindungen*, or flights of inventive fancy. The fanciful finials on the elevation Stier produced of the *amores mei* have the shape of tripods in allusion to poetic inspiration (Figure 24.11). He also liberally applied to the façades a mixture of Pompeian and Italian Renaissance grotesque decoration that blur the building's lines. The key importance of the darkened and soundproofed study, the *raison d'être* for the entire pavilion, is lost. Stier may be an instance of

someone so erudite about antiquity that he could not restrain himself from showing it off. The simple, at times humble, style of the letters is obscured by these decorative frills: Pliny sought to convey restraint and on occasion reveals his disapproval of the excessive luxury of some contemporary villas.

A much later restitution, similar to Stier's in terms both of decadence and of preparation for exhibition in public, takes the form of an ingenious scale model of Pliny's Laurentine villa made in 1947 for display in Oxford's Ashmolean Museum.[15] Its maker was an English architect-turned-set-designer named Clifford Pember (1881–1955) who had a fairly illustrious career in movies, plays, and Broadway musicals from 1916 to 47 and in London's West End thereafter. In a 1947 *Illustrated London News* article devoted to the model, Pember confessed that he made it "as if for the setting of a film."[16] He cunningly fashioned bits of cork, twig, mirror glass, cardboard with gaily painted surfaces, and tiny plasticine figures to enliven this most colorful of Plinian imaginary reconstructions (Figure 24.12).[17] The roof is cut away at various places to reveal the interiors: At one end, the viewer can look down into Pliny's private study, a space that the artistic Pember prioritized.[18] Pember shared with Pliny the artist's occasional aversion to intrusion and the need for tranquility, translating into the miniature architecture of his

model an innate sensitivity to the gist of the letter to Gallus: Pliny's quest for seclusion.

EPISTLES AND EMULATION

Apart from the realms of publication and artistic exhibition, the villas of Pliny have traditionally occupied a place of some importance at the core of academic architectural education. This happened because the villa letters furnished a ready pretext for architectural competitions on a set theme, or *programme* in architectural parlance. The tradition stretches back to nineteenth-century Europe and has its own lengthy story – too lengthy for discussion here. The pedagogical principle of emulation, however, remains a constant throughout, by which is meant that artists learn from one another's example and seek to outdo past precedent in a friendly process of one-upmanship and competition. A fresh burst of imaginary Laurentine villa reconstructions took place in France, and to some extent such projects have continued in architecture schools ever since. The impetus came in 1981–2 when Maurice Culot, the head of archives at the then recently established Institut Français d'Architecture in Paris, revived the custom of imaginary reconstructions based on Pliny by setting up a friendly limited competition on the topic of the letter to Gallus. No gold medal was awarded as in the old days of the academies, but the competitors got their work displayed in an exhibition accompanied by a printed catalogue titled *La Laurentine et l'invention de la villa romaine*.[19] In the end, thirteen architects or teams of architects from around the world participated. Among the projects submitted, some were archaeological; others Marxist; others tongue-in-cheek; still others sublimely ethereal.

Among the participants in the *La Laurentine …* display, one in particular focused on Pliny's underlying theme of seclusion. He was the literarily minded, Cuban-born David Bigelman, who now teaches architecture in Paris. In preparation for participation in Culot's exhibition, Bigelman filled a booklet with numerous preliminary sketches of the villa based on a close reading of Pliny's letter to

Figure 24.13. D. Bigelman's sketch plan of the *amores mei* pavilion at the Laurentine villa (1982).

Gallus, taking the time to think about what Pliny had written. From that sketchbook comes his plan of the *amores mei* pavilion (Figure 24.13). Some readers will immediately detect the source of inspiration as the so-called Serapaeum at Hadrian's Villa at Tivoli. Indeed, the draft of a letter to Culot in the sketchbook admits the derivation. This made sense to Bigelman. He assumed that Pliny might have employed someone in the circle of Apollodorus of Damascus, the preferred architect of the emperors Trajan and Hadrian. Bigelman's distinctively shaped "*chambre silencieuse*" clearly derives from the reclusive Hadrian's Serapaeum/*triclinium* at Tivoli.[20]

A Bigelman perspective drawing of the *amores mei* (Figure 24.14) is the culmination of his entire design, in the same way as the relevant passage is the climax of Pliny's letter to Gallus. In keeping with the retreat-like function, the pavilion overlooks a coastline with a single sailboat tacking along the mountainous shoreline that is far more deserted and precipitous than anything along the flat Lido at Ostia. Inexplicably, the drawing was

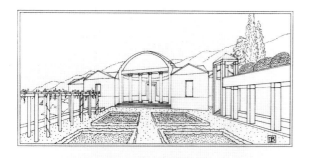

Figure 24.14. D. Bigelman's perspective drawing of the *amores mei* pavilion at the Laurentine villa (1982).

left out of the show, despite its meticulous perspectival execution and the careful lettering of the title suitable for exhibition. The organizers of *La Laurentine* ... did not sufficiently recognize Pliny's and Bigelman's emphasis on the importance of seclusion. The words *ipse posui* written at the top of Bigelman's drawing recall Pliny's claim to have designed the *amores mei* pavilion himself. The inscription reveals Bigelman's self-identification with Pliny – the same close bond that links the Latin writer with architects from the seventeenth century to the present.

Ultimately, then, the imaginary reconstructions of the Laurentine and Tuscan villas represent their respective designers' aspirations for a personal space in which to draw inspiration from their own thoughts and share them with a chosen few. There, they surmise, one can surely pursue one's art in solitude as Pliny did in the *amores mei* in his *Laurentinum*. But, as Pliny often remarked to his correspondents, villas also epitomize conviviality: good food, wine, company, music, and conversation – as promised in the Tuscan *stibadium*. These two special places mentioned by Pliny convey the ethos of life in a villa and provide insights into many real antique villas that have been excavated all over the Mediterranean basin. Above all, the selected Pliny passages and the designs they have inspired explain the villa letters' perennial fascination. They are about ideal country houses with few budgetary limitations or constraints on the artistic imagination,

where conviviality, seclusion, and communion with nature mingle, nourishing body, mind, and spirit.

NOTES

1. Plin., *Ep.* 6.16 and 20.

2. Plin., *Ep.* 2.17; *Ep.* 5.6.

3. In order of publication, the three chief sources to have considered the architecture of the villas of Pliny as a whole are: Tanzer 1924; Förtsch 1993; and du Prey 1994. But as Förtsch rightly remarked to me in a letter of 1991, "my own ... commentary about the villas of Pliny ... attempt[s] to understand the significance of Pliny's letters ... confronted with the ... preserved remains of Roman villa room-types ..." His room-by-room typological analysis of Pliny's villa letters with reference to excavations, wall paintings, and mosaic representations differs from my own. See also Gibson and Morello 2012: their chapter 7 is devoted to the villa-letters and introduces much recent archaeological information and textual analysis.

4. Du Prey 1994, 40–73, deals with some of the intricacies of the various early editions of Pliny but it is by no means a substitute for the meticulous philological studies by Stout 1962, Mynors 1963, and Sherwin-White 1966.

5. Marzano 2007, 110–13, 737, provides a full account of the in-depth if incomplete archaeological excavations at the Colle Plinio site, midway between S. Giustino and Città di Castello.

6. For further references to the *stibadium* as a prevalent room-type in Roman villas, see Ripoll (Chapter 22) and Wilson (Chapter 16) in this book.

7. Du Prey 1994, 74–81. The Lazzari drawing (private collection) is supplemented by illustrated manuscripts by the same author in the Biblioteca "Storti Guerri," in Città di Castello and in the Garden Library at Dumbarton Oaks, Washington, D.C. The drawing and variant manuscripts probably became separated in the twentieth century. Dumbarton Oaks' *Ex Horto* series proposes to reunite all three pieces in a forthcoming publication.

8. Félibien 1699, 7. Félibien considered that Pliny did not give enough information for him to reconstruct its elevation in any detail.

9. Orrery 1751, vol. I, 393.

10. Some of Schinkel's preliminary drawings for Pliny's villas are illustrated in du Prey 1994: 47–8; figs. 40–3. They are located in the *Schinkel Archiv* in Berlin. See also Schinkel 1841. Philipp 2014: 33–7, discusses some of the antecedents and successors of Schinkel's reconstructions.

11. Orrery 1751, vol. I, 388.

12. Orrery 1751, vol. I, 175.

13. Stier 1867.

14. Stier 1867.

15. It inspired the well-known plan of the 1960s published by Betty Radice in the Loeb Classical Library edition of Pliny's letters: Radice 1969, vol. II, 554.

16. Pember 1947; 220.

17. Figure 24.12 is taken from the Ashmolean's popular postcard.

18. Pember wrote of Pliny's "horror of being caught unawares by the unwelcome visitor": Pember 1947, 220.

19. Pinon and Culot 1982. Although restricted to the Laurentine villa exclusively, this exhibition catalogue is a fundamental resource for anyone interested in the historical influence of Pliny's villas, particularly their impact on architectural posterity.

20. In a satirical anecdote, Bigelman tells us that he saw the *original* plan of Pliny's Laurentine villa for sale one day in Rome's Porta Portese flea market, but by the time he had returned with money to buy it, the vendor and plan had vanished! The anecdote hints at the fictional quality of Pliny's writings. Pinon and Culot 1982, 202, published the edited and abbreviated version of Bigelman's manuscript version of his letter to Culot (in which the anecdote appears). The manuscript original is now in the Canadian Centre for Architecture, Montréal, Québec (DR 1984, fols. 24 recto to 25 verso).

25

THE *VILLA DEI PAPIRI*
Herculaneum and Malibu

KENNETH LAPATIN

IN THE SPRING OF 1750, FRAGMENTS OF COLORED marble were found by workers digging a well at Portici (south of Naples) for a landowner in the village of Resina, close to the villa of Charles VII, King of the Two Sicilies. Although often described as accidental, this discovery, at the depth of 25 m, could not have been unanticipated. Similar finds had already been made in the environs of Mount Vesuvius: Almost 40 years earlier, Emmanuel-Maurice de Lorraine, later Duc d'Elbeuf, removed numerous statues, including the three figures now known as the "Herculaneum Women," from a buried theater just 100 m distant (Figure 25.1). Official excavations of that ancient theater and its city, which was soon recognized to be Herculaneum, had already begun in 1738 under the auspices of the Bourbon king, and the discovery of the polychrome marble fragments prompted the royal administration to take over the excavations. By August 1, diggers had uncovered – but not yet raised – a beautiful marble pavement composed of triangles of *giallo antico* and *africano* marbles (i.e., Tunisian yellow and Tean black, which the ancient Romans called Numidian and Lucullan) set in concentric circles around a centerpiece of *rosso antico* and *serpentino* (red Taenarum and green Laconian, both from the Peloponnesus), the whole set into a border of white marble (modern replica in foreground of Figure 25.5). This *opus sectile* floor, c.5.2 m in diameter, was cut into smaller sections so as to maneuver

it through the horizontal excavation tunnels and hoist it up the shafts carved through the layers of hardened pyroclastic flow that had buried the site in 79 CE.

Supervision of the diggers, paid workmen, forced laborers, and convicts, was entrusted to the Swiss military engineer Karl Weber, who reported to the Spanish engineer Roque Joachin Alcubierre. The two did not get along, and Weber is usually presented as the hero of Herculanean archaeology, while Alcubierre is cast as its villain. The art historian Johann Joachim Winckelmann famously complained that Alcubierre was "as familiar with antiquity as the moon is with crabs," but he praised Weber, one of the first excavators to draw precise plans of the buildings he unearthed and to mark the find spots of the artifacts recovered. The reality, of course, was more complex, but it is certainly to Weber and his annotated plan (Figure 25.2) that we owe much of our knowledge of the suburban seaside luxury villa located just outside Herculaneum, known as the Villa dei Papiri, one of the largest and most sumptuous ever found, covering at least 20,000 m² (65,000 ft.²). Its excavation proceeded on and off from 1750 to 1761 with minor investigations in the mid-1760s; noxious gases by then had forced the closure of all of the shafts and tunnels. Many of those had been backfilled during the course of excavation to prevent collapse of the

earth above and to ease the burden of extracting debris from 25 to 30 m beneath the surface.[1]

The ancient villa was first entered through a shaft called the "Pozzo de' Ceceri," on Via Ceceri (now Via Roma, 31). Other vertical shafts were later sunk

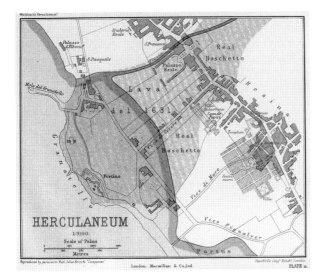

Figure 25.1. Herculaneum, plan of modern town with Villa dei Papiri ("Villa Suburbana Casa de Papiri [sic]") toward upper right (from Waldstein and Shoobridge 1908: 57; The Research Library, Getty Research Institute).

to provide better access, more light, and fresh air. Moving eastward from the spectacular circular pavement, which was soon recognized as the floor of a seaside pavilion or belvedere, diggers eventually encountered an enormous rectangular peristyle garden or *viridarium*, measuring 94.4x31.7 m. This adjoined a smaller, square peristyle 29.6 m[2] or 100 Roman feet[2] (Figure 25.2). Both had a long narrow central pool and were adorned with bronze and marble statues. The approximately ninety statues and busts from the site constitute the largest collection of ancient sculpture so far discovered, with subjects ranging from images of gods and heroes – including an archaistic *Athena Promachos* in marble and a bronze herm bust of the *Doryphoros* of Polykleitos signed by Apollonios, son of Archias of Athens – to portraits of poets, philosophers, and Hellenistic kings, satyrs, deer, a piglet, and Pan copulating with a she-goat (Figure 25.3).[2] A third area, adjacent to the square peristyle, was an atrium complex with three large *triclinia*. These, like some of the rooms between the two peristyles, were richly decorated with wall frescoes and floors paved with mosaics and colored marbles, some of which were also cut from the fabric of the building and removed by the excavators to enhance the royal collections.[3]

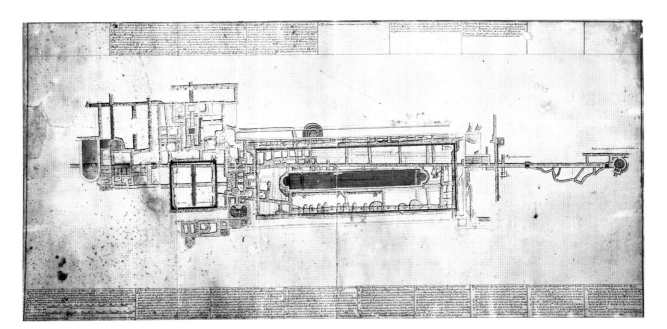

Figure 25.2. Karl Weber's plan of the excavations of the Villa dei Papiri. (Photo: courtesy of the Museo Archeologico Nazionale di Napoli).

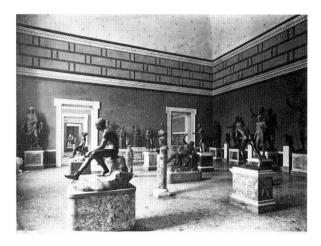

Figure 25.3. Ancient bronzes, mostly from the Villa dei
Papiri, on display in the Museo Archeologico Nazionale di
Napoli, ca. 1890–5. (Photo: Giorgio Sommer, courtesy
Cornell University Library) [www.commons.wikimedia
.org/wiki/File:Sommer,_Giorgio_(1834-1914)_-_n.
4428-_Bronzi_-_Museo_di_Napoli_-
_Cornell_university_website.jpg]

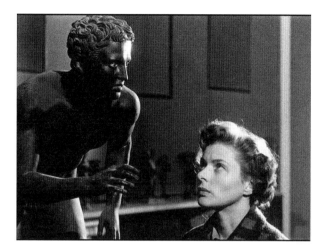

Fig. 25.4. Still of Ingrid Bergman in the Museo
Archeologico Nazionale di Napoli with a bronze statue
from the Villa dei Papiri in Roberto Rossellini's *Viaggio
in Italia*, 1954. (www.mutanteggplant.com/
virto-nasu/2010/05/23/viaggio-in-italia).

A fourth sector of the building housed private baths
and a library depository where excavators discovered
most of the approximately 1,800 carbonized ancient
Greek and Latin book scrolls on papyrus that gave the
villa its modern name. These were initially taken for
charcoal, and some were broken, discarded, or used
for fuel. Many have subsequently been laboriously
unscrolled and deciphered, most recently using mod-
ern multispectral imaging techniques. Most of the
scrolls seem to contain works of the first-century
BCE Epicurean philosopher and poet Philodemos
of Gadara, but the writings of other Greek and
Latin authors have also been recovered.[4]

The identity of the owner(s) of the villa is uncer-
tain, but Lucius Calpurnius Piso Caesoninus, the
father-in-law of Julius Caesar and patron of
Philodemos, is the most likely candidate (the build-
ing is sometimes called the "Villa dei Pisoni").[5]
The villa's sculpture collection – whether it was
gathered programmatically or haphazardly – and
whether more papyri remain to be discovered are
ongoing topics of discussion.[6]

Weber's plan of the site was not published until
1876, and the finds themselves, initially removed to
the Museum Herculanense in the royal villa at Portici
and now, for the most part, housed in the National

Archaeological Museum and the National Library in
Naples, remain the chief sources of information
about the villa, especially as the building itself was
inaccessible to visitors until the end of the twentieth
century. Nonetheless, the villa – and its sculptures in
particular – came to be well known, and the originals
were even featured in Roberto Rossellini's film
Viaggio in Italia (1953) starring Ingrid Bergman and
George Sanders (Figure 25.4).[7]

Coincidentally, late March of 1953 marked the
return of the millionaire American oilman J. Paul
Getty (1892–1976) to the Bay of Naples, which he
had first visited some forty years earlier and again in
1939 when he started to collect antiquities. On his
return to the region, Getty again traveled to
Pompeii, Posillipo (where he later purchased
a villa), and Sorrento; his diary records that he visited
the Naples Archaeological Museum four times in as
many days, paying special attention to the galleries of
marble statuary.[8] His diary does not explicitly men-
tion the Villa dei Papiri or its bronzes, which accom-
pany the marbles in the galleries devoted to Weber's
finds, and the museum also has rich holdings from
Pompeii and other Vesuvian sites, as well as the
statues of the Farnese collection transferred from
Rome in the eighteenth century, but both the villa
and its history figure prominently in Getty's novella

entitled "A Journey from Corinth," published in 1955.[9]

The protagonist of Getty's story is Glaucus, a Corinthian landscape architect whose name echoes that of the hero of Edward Bulwer-Lytton's best-seller, *The Last Days of Pompeii* (1834). Emigrating to the Bay of Naples in 147 BCE, Glaucus obtains employment with Lucius Calpurnius Piso, who in Getty's tale "owned one of the largest villas in that part of Italy. Its buildings covered some ten acres, and its gardens extended along the sea-coast for over half a mile ... and in recent years [he] occupied his time building this great villa. The work had progressed well. Only some of its gardens remained to be completed ... "[10] Getty's Piso is a far cry from the historical Piso: Cicero, a political rival, denounced him thus:

> [his] hypocritical assumption of austerity, [no] mental vigour, ... eloquence, or military skill ... [having] an unkempt, boorish, sullen figure, ... uncouth and churlish, ... a libertine or a renegade

Warming to his invective, Cicero makes a point that may strike at Piso's villa and its library directly:

> But now see our friend at home ... profligate, filthy, and intemperate! ... when he developed an enthusiasm for the humanities, when this monster of animalism turned philosopher by the aid of miserable Greeks, then he became an Epicurean; ... the one word "pleasure" (*voluptas*) was quite enough to convert him.[11]

Getty's Piso, in contrast, seems a self-portrait:

> A pleasant-looking Roman ... although a trifle pompous in manner ... Piso was born in Rome, the only child of a very rich father who was now Consul. He had hoped to make a career for himself in politics, but after a brief experience decided that he possessed little political ability and since he was a man of great wealth, would be better out of political life than in it.[12]

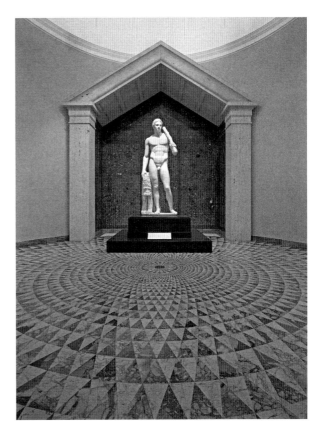

Figure 25.5. The Lansdowne Herakles within the "Temple of Herakles" at the Getty Villa, Malibu (JPGM 70.AA.109. (JPGM).

In the wake of the Roman sack of Corinth of 146 BCE, in Getty's anachronistic fantasy, Glaucus advises Piso to purchase artworks from that city at auction in Rome, including several bronze copies of Greek works and a marble statue of Herakles that the landscaper and his bride, Daphne, had known in Corinth. The marble Herakles now in the Getty Villa collection was, in fact, purchased by Getty in 1951, having long been in possession of the Lansdowne family (Figure 25.5). Discovered in 1790 near the ruins of Hadrian's Villa at Tibur, it was considered one of the finest antiquities in Britain: In 1816, the connoisseur Richard Payne Knight compared it favorably to the Parthenon sculptures.[13] It became Getty's favorite possession. Recognized today as a Roman copy of a fourth-century BCE Greek original, its date was uncertain when Getty acquired it, hence "A Journey from Corinth" provided the statue with a fanciful back-

story, allowing for a late classical Greek origin before
the statue was transferred to Italy. Following its ahis-
torical sojourn at Piso's Herculaneum villa, the sculp-
ture – in Getty's tale – escaped the eruption of
Vesuvius by being given by Piso's son to the emperor
Nero. The emperor, we are told, "took a great fancy
to the young Herakles, and used this young man of
marble as his audience when rehearsing roles he was
going to play in the theater."[14] After Nero's suicide,
the statue was eventually moved to Hadrian's Villa,
before, "like many other choice works of art, the
young Herakles from Corinth, silent witness to the
courtship of Daphne and Glaucus, to worlds long
since gone, and to man's age-old struggles, followed
the sun westward to the New World."[15] It may have
been this recent acquisition of the Herakles
in November 1951 that inspired Getty to concentrate
so intently on the marbles in the Naples Museum
in March 1953, shortly before he opened his own
collection to the public.[16]

In direct and indirect ways, Getty seems to have
absorbed what he perceived to be the ideas and
motivations of Roman villa owners, and by his
death in 1976 he realized them with a conviction
and plenitude perhaps not seen since the eighteenth
century (Figure 25.6). Many elements converged:
He believed that works of art have a capacity to
improve people, and his collections were ultimately
a gift to his adopted hometown.[17] At the same time,
his works of art and their venue were an extension of
his public face or *persona*: beginning at what was
called the "Ranch House Museum" on the 64-acre
Malibu property he bought in 1945, incorporated as
a museum in late 1953, and opened to the public in
early 1954. For more than two decades, the J. Paul
Getty Museum received from its founder gifts of
classical antiquities, Old Master paintings, and
French decorative arts.[18]

By the late 1960s, the Ranch House and a new
wing built in the 1950s could no longer contain the
collections. Getty was advised by his architects that
an entirely new structure just down slope toward the
Pacific Ocean would be preferable to unwieldy
extensions. Spanish, Renaissance, and modern styles
were proposed, and all three were rejected.[19] Getty's
architectural advisor, Stephen Garrett, colorfully

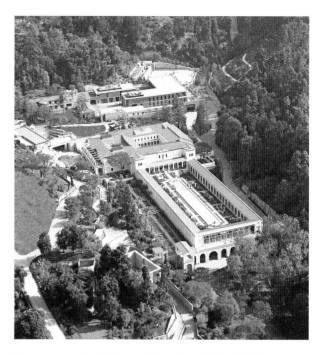

Figure 25.6. Aerial view of the Getty Villa, Malibu.
(JPGM).

recalls that "Getty suddenly said, on a November
evening in 1968, in his rather deep voice, 'I want
you to recreate the Villa dei Papiri.' I had absolutely
no idea what he was talking about, and I think that
very few people except for a few scholars of antiquity
would have known what he was talking about."
Getty's diaries, however, reveal a more complex
story, as the millionaire also toyed with the idea of
constructing a replica of his Tudor manor house,
Sutton Place in Surrey, and combining it with
a Roman peristyle.[20]

Getty's decision to reconstruct the Villa dei Papiri
may have been unanticipated, but had, apparently,
long been in preparation: The ancient villa must have
been in the collector's mind for some twenty years.
Already, in his novella "A Journey from Corinth,"
the Lansdowne Herakles had been placed in Piso's
villa: Now, Getty could place it in his *own* villa,
in a special gallery of its own embellished with
a replica of the circular *opus sectile* floor discovered in
1750 (Figure 25.5).[21] A reconstructed Villa dei Papiri
was, for Getty, the correct context for a collection of
Greek and Roman art: "What could be more logical
than to display it in a classical building where it might

originally have been seen?"[22] Getty's constructed per-
sona and his benefactions to the Museum fused in his
villa, although, ironically, he never returned to Malibu
to see the building itself.

Weber's plan (Figure 25.2) provided the model
for Getty's villa (Figure 25.6), but changes had to be
made: The building in Malibu, sited in a narrow
valley or canyon, was rotated by 90°, its length run-
ning perpendicular rather than parallel to the coast.
The positions of the atrium and the square peristyle
had to be reversed, and the entrance to the Malibu
site was originally from the long peristyle rather than,
as in the original, from the sea or through the atrium.
Weber's plan, moreover, recorded only a single
level, but the reconstructed villa was given an upper
story to provide gallery space for Getty's post-
antique collections and a basement for storerooms,
offices, and other facilities. A parking garage was
installed beneath the large peristyle. Modern materi-
als were employed throughout the building's con-
struction, and amenities for visitors (restrooms and
elevators) were installed. The site is approached by
a pseudo-Roman road (made of molded asphalt imi-
tations of polygonal lava flagstones) leading up from
the Pacific Coast Highway, giving visitors a bumpy
introduction to the ancient past.

Because Weber's plan did not record every spe-
cific architectural element of the Villa dei Papyri,
types of column capitals, wall treatments, and eleva-
tions had to be invented for Malibu. For this, Getty
turned to the architectural historian Norman
Neuerburg. Diverse elements from ancient buildings
of more or less appropriate date and location were
assembled for replication: from the Villa dei Papiri
itself; from structures at Herculaneum, Pompeii,
Stabiae, and other Vesuvian sites; from Rome,
Ostia, and further afield. For example, the floor at
the entrance to the atrium is paved with *opus sectile*
panels of illusionistic "tumbling blocks" copied from
the House of the Faun at Pompeii; wall decorations
in the First Pompeian Style that adorn the
atrium imitate those from the House of Sallust at
Pompeii, while the engaged columns of the
upper story are derived from those of the Samnite
House at Herculaneum (Figure 25.7). Neuerburg's
deep knowledge provided many other details

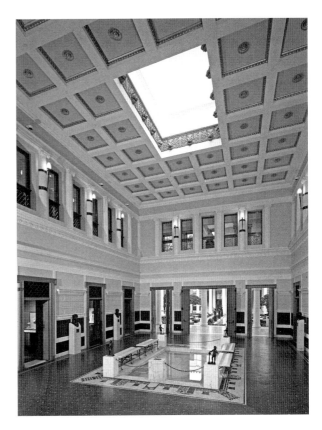

Figure 25.7. The atrium of the Getty Villa, Malibu.
(JPGM)

incorporated into the new building.[23] The eclectic
compilation has a distinctly Roman character,
because Roman owners of villas and urban houses
emulated one another, resulting in a somewhat
homogenized architectural and decorative culture.
At the same time, Roman proprietors thriftily or
out of pious regard for tradition often conserved
old decorations when they could, resulting in
a diversity of styles and modes in any given house.
Getty's building is admittedly a pastiche, but the
impulse of emulation and conservation might be
considered authentic in a Roman way.

Like his fictional Piso and other villa owners,
Getty was as interested in the gardens of his villa as
in its architecture. In addition to the elaborate rec-
tangular and square peristyle gardens, which were
outfitted with replicas of bronze statues from the
Villa dei Papiri cast in Naples by the Chiurazzi
Foundry, the Malibu villa has a large herb garden
planted with various fruits and vegetables, and

a smaller "West Garden" with an exact replica of the mosaic fountain from the House of the Large Fountain at Pompeii. Each of these spaces was originally planted with flora attested in classical antiquity by archaeological, art historical, or literary sources, and most of the plants were imported from Italy.[24]

Public response to the Getty Villa was enthusiastic – where else could you wander through marble-floored colonnades, alongside Roman-style frescoes, enjoying the ocean air? (Getty himself had remarked on the similarity of the climate of southern California to that of the Mediterranean.) But its critical reception was harsh: some found it gauche, tacky, or kitsch. Others complained that it was a bloodless copy or that it deviated too far from the ancient original, being an amalgam of diverse elements. While he never visited the villa under construction and did not attend its opening in 1974, Getty closely followed its progress and affirmed his intention to see it, though he died at age 83 before doing so. Even so, and in the manner of some Roman villa owners who chose to find final rest on their villa estates, Getty is now buried at the villa on a private plot overlooking the sea. His passion for his villa and its contents went beyond his patronage while still alive: In his will, he unexpectedly bequeathed his personal fortune to the Museum, very much in the manner of late Republican grandees (Lucullus, Pompey the Great, Julius Caesar, Maecenas) who left their gardens and estates as public parks to their fellow citizens.[25]

Villas, be they Roman or modern, are never static. Getty's Greek and Roman antiquities remained at the villa, but the bequest of 1976 prompted the transfer of later works of art to the new Getty Center in Brentwood (opened in 1997) and the closing of the villa for renovations and ultimately a new mandate for the exhibition, conservation, and study of classical art and cultures.

A design competition for the Getty Villa was won by Boston architects Machado and Silvetti, who reimagined it as a kind of multilayered artifact in the landscape, like those found around the Bay of Naples. In working drawings, the architects even buried and excavated the building. The upper floor of the villa, which originally had wood floors,

flocked wallpaper, and no windows, was redesigned in a style that unified it with the lower galleries. Terrazzo replaced parquet, and windows and skylights were cut through walls and ceilings. Behind the scenes, new provisions were installed to mitigate potential effects of earthquakes and to protect the collections; conservation laboratories, freight elevators, and other necessary service spaces were added. The Ranch House was refurbished to create offices and a library for curators and scholars, and a new training program for conservators was established.[26]

Machado and Silvetti's mandate was to respect the look and feel of the Getty villa but return its spatial experience to that of Piso's grand seaside house by changing its access to a more authentic Roman entry route, directing visitors into the villa through the atrium rather than through the large rectangular peristyle garden. Their study of the Herculaneum villa, the geology of the volcanic deposits, and how the Villa dei Papiri is now approached from above and to the side prompted their design for an entry pathway into and along the adjacent landscape of the Malibu canyon, so that visitors first walk alongside the site looking down upon the villa as today at Herculaneum, before descending to enter (Figure 25.6). Rather than try to replicate the villa's classical architecture in their new buildings (entry pavilion, café, shop, and auditorium), the architects employed a deliberately postmodern vocabulary of columns and shims that reference, but do not quote, the villa's classical elements; their use of "strata-walls" suggests the geological layering of volcanic deposits that surrounds the Herculaneum villa itself (Figure 25.8).

Today we can identify three principal phases at the Getty Villa in Malibu, as at any good archaeological site: I – the Ranch House; II – the Villa; and III – the post-Villa renovation, each with various sub-phases. For the 2006 reopening, the collections were reinstalled thematically rather than chronologically or geographically, and many – but not all – of the Chiurazzi bronze replicas were repositioned in the gardens in accordance with their find spots at the ancient Villa dei Papiri.[27] (A new reinstallation of the collection, organized chronologically, opened in Spring, 2018.)

Figure 25.8. "Strata walls" from Machado and Silvetti's renovation of the site of the Getty Villa, Malibu, 1997–2005. (JPGM).

Modern archaeological study of Piso's villa since its discovery in 1750 has paradoxically but decisively mitigated the initial criticism of the Getty Villa as an eclectic assemblage and inconsistent, arbitrary pastiche of borrowed (if genuinely Roman) decorative sources. Weber's plan has proved to be accurate overall, but the Villa dei Papiri itself, though apparently built all at once in the third quarter of the first century BCE, was refurbished and redecorated over the century or so of its existence in styles that themselves were changing from one generation to the next: Paintings of both Second and a transitional phase between the Third and Fourth Pompeian Styles have been found, in a time frame from the late first century BCE to the demise of the villa in 79 CE.[28] The architectural parameters did not change, but the decorative assemblage might be considered as

eclectic as that devised for the Getty Villa. Far from being a pastiche, the decorative program of the Malibu villa holds true to *Roman* methods of decorative modification. Unfortunately, as these new discoveries at the Villa dei Papiri itself have been made, its fragility and complex physical access have simultaneously kept it invisible to the public, and the site remains closed.[29]

The Getty Villa in Malibu is not a fully accurate reconstruction of the Villa dei Papiri at Herculaneum. But at 1:1 scale and built more or less to plan, with colored marbles from ancient quarries and surrounded by flora attested in ancient Campania and adorned with copies of the ancient villa's bronze statuary, it presents modern visitors with the opportunity to experience, for the duration of a visit, the spaces, sounds, and smells of an ancient Roman luxury villa: smooth marble floors, light reflecting off the walls, the sound of water in the fountains, the odor of herbs in the garden, the song of birds. About these we can write and read, but in the end they are best seen, felt, and enjoyed. If Piso was truly an Epicurean as Cicero attested, he would be pleased.[30]

NOTES

1. Daehner 2007 for d'Elbeuf and the "Herculaneum Women"; for Weber, Alcubierre, and the history of the early excavations: Parslow 1995; see also, on Winckelmann, Mattusch 2011; Pagano 1998.
2. See, e.g., Mattusch 2005; Moesch 2008; Moesch 2009; Mattusch 2010.
3. See, e.g., Moesch 2009; Guidobaldi and Esposito 2010; Moormann 2010.
4. See, e.g., Sider 2005; Sider 2010.
5. See, e.g., Capasso 2010.
6. See n. 2.
7. The statues were quickly restored, and some plaster casts were made and distributed as early as 1765. Major museums and university collections in Europe and the United States acquired casts in the nineteenth century, and in the early twentieth century the Chiurazzi foundry and other Neapolitan workshops made bronze replicas, especially those of the deer, running youths, and a seated Hermes, at various scales:

Mattusch 2005, 339–59. For *Viaggio in Italia* see Hirsch 2007; Fox 2011.

8. For Getty's earlier trips to Italy and his later acquisition of two villas there, Lapatin 2011.
9. Getty 1955.
10. Getty 1955, 312.
11. Cic., *Red. sen.* 6.13–14 (trans. N.H. Watts, Loeb Classical Library 1979).
12. Getty 1955, 311–12.
13. Payne Knight 1816, 99, 107; cf. Michaelis 1854, 451–2, no. 61; see also Howard 1978; Stewart 2017 pp. 119–125, cat. 14.
14. Getty 1955, 325.
15. Getty 1955, 329.
16. For Getty's obsessive study of works he had acquired, or was planning to, see Lapatin 2011.
17. He also gained tax advantages both from giving works to the Los Angeles County Museum of Art before founding the museum that bears his name, and by building and stocking the Malibu villa.
18. See Getty 1976, esp. 269–71, 285–8. Ironically, Getty left California in 1951 and never returned.
19. "I refuse to pay for one of those concrete-bunker-like structures that are the fad among museum architects – nor for some tinted-glass-and-stainless-steel monstrosity." Getty 1976, 278, 283; for some of the rejected plans see True and Silvetti 2005, 10–11.
20. Video interview conducted with Garrett in summer 2005, prior to the reopening of the Getty Villa; Getty's diary entries between 1968 and 1971.
21. Lapatin 2005, 80–2.
22. Getty quoted by True and Silvetti 2005, 17.
23. The examples are numerous: see Neuerburg 1975; Lapatin 2005, 65–8, 74–7; True and Silvetti 2005.
24. Lapatin 2005; Bowe and DeHart 2011.
25. The bequest transformed the Museum: departments for manuscripts, sculpture and decorative arts, and photography were added, but their collections, which were first installed on the upper floor, could not be accommodated in the villa itself. The J. Paul Getty Trust, which oversees the Museum as well as a new Research Institute, Conservation Institute, and a grant-giving division (now the Getty Foundation), decided to build a new complex: the Getty Center in Brentwood, five miles inland from Malibu. When construction of the Center, designed by Richard Meier, was completed in 1997, the villa in Malibu was temporarily closed for renovations.

26. Lapatin 2005; True and Silvetti 2005.
27. For an account of the replicas (mainly bronze, one marble) and their placement in the villa in the find spots recorded by Weber or, when not known, in other appropriate locations, see Mattusch 2005. While the Getty Villa has flourished both before and after the renovation, new explorations were taking place in Herculaneum, first in the 1980s when the Bourbon tunnels were rediscovered and partially explored, and then in the 1990s, when a limited portion of the ancient villa's *atrium* block and the adjacent ancient coastline were brought to light with the removal of more than 30 m of volcanic overburden.
28. For an account of the villa's date and redecorations, Conticello and Cioffi 1990; De Simone 2010b; Guidobaldi and Esposito 2010.
29. It has been determined that the villa was constructed on a slope and had at least four different levels below those seen by Weber. The level directly below the atrium block had at least six rooms with views to the Bay of Naples; one has been partially cleared of volcanic debris and has elaborate stucco ceiling featuring friezes of weapons as well as frescoed walls. The lower stories apparently served residential or service functions, and a grand pavilion with a large rectangular swimming pool and a small staircase led directly down to the beach. The rooms, apparently being restored in 79 CE, had mosaic floors and wall paintings; two marbles (a standing female figure and a head of the Sciarra Amazon type) were also found, as were components of ivory-veneered wooden furniture, apparently tripods, decorated with Dionysiac scenes carved in low relief. See De Simone 2010b; Guidobaldi and Esposito 2010.
30. Favro 2010; Fish 2011.

CONCLUSIONS

ANNALISA MARZANO AND GUY P. R. MÉTRAUX

THE POPULATIONS LIVING AROUND AND INLAND of the Mediterranean basin interacted economically and culturally by way of the sea; information, objects, food, and ideas traveled easily, to the advantage of agricultural and other production on villa estates. The material means of Roman political and military hegemony traveled the same sea. During six centuries or more, free navigation distributed components of life through the lands of the *mare nostrum* – people, social structures, law, language, economic systems, religious ideas, art and architecture, technical devices, craft know-how, and much else. The sea could separate and protect peoples from one another, but it was also the means to spread power and multiply centers of authority, to increase the markets for local manufacture and exploitation of resources, to expand agricultural production, and to establish the kind of rural residences – villas and estates – that had become the norm in Italy. By means of roads, waterways, and bridges, the Mediterranean worked centripetally and centrifugally: power and productive capacity radiated from Rome to local centers of authority and returned to it. Ultimately, it was Rome and Italy that provided templates of Mediterranean-wide living for hitherto isolated locales. Local preferences and adaptation to terrain and circumstances could exist in parallel with the inevitable homogeneities of an internationalized and transregional hegemony, but villas were a strong solvent for making the Mediterranean recognizably Roman.

The chapters gathered in this book have illustrated and investigated the diversity, but also the remarkable homogeneity, of the Roman villa "phenomenon." It has been often said in past scholarship that the villa – and the system it encapsulated (market-oriented agriculture; type of labor; combination of the *utilitas* of its service quarters with the *voluptas* of the villa's architectural display of the *pars urbana*) – was a typical feature of the Roman world. Yet, as discussed by Rothe (Chapter 2) in this book, *villa* is a term that, both in antiquity and in modern studies, has been used to describe diverse rural buildings, from relatively modest farms displaying characteristically Mediterranean building techniques to lavish country "palaces" where the original essence of the villa as a working farm had been relegated to the background or suppressed altogether. But villas were not simply rural entities linked to agriculture and animal husbandry; there were maritime villas built to take advantage of panoramic views, impress with their grandiose architecture, and dominate the landscape. An easy and general definition of villas is as non-urban establishments with a productive *and* residential function. However, reality was a bit more complex and not easily categorized. As seen in Chapter 18 (Weiss) on the urban houses in Galilee, the urban *domus* adopted the architectural vocabulary used in the villas of the rest of the empire, even though the residences were in a region of the Roman world characterized by rural villages rather than villas. The urban houses of the wealthy of Roman Galilee used a vocabulary of villas following an empire-wide emulative culture. This phenomenon in part explains why many scholars working

on the Roman east often use the term "villa" to refer to urban houses, a practice rejected by scholars working on the west of the empire.

As seen in Chapters 4 (Clarke), 6 (Howe), and 16 (Wilson), positioning maritime villas on dramatic cliffs not only afforded panoramic views artfully enhanced and framed by the villa architecture: It also allowed the building to dominate the natural landscape, its architecture acting as a symbol of order and civilization imposed onto tamed nature. In addition, Chapter 8 (Marzano) has shown how maritime villas took advantage of their sites to exploit the natural resources of the sea, thus transcending land-based agriculture in favor of high-capital investment to produce high-return comestibles.

The relationship among villas, the land of their estates, and the surrounding natural resources was indeed very important and a powerful element in the diffusion and development of villas. However, the impetus to profitable production also gave rise to its opposite: the magnificent villas of the *suburbium* of Rome in the imperial era, entirely residential and devoid of agricultural activity. As observed by Purcell, the intentional *negation* of productivity in the context of villas, which by their nature ought to be *productive*, was also a parade of wealth and power.[1] It is worth remembering the (incorrect) etymology Varro gives for the noun *villa*: from the verb *vehere* (to transport), because, he writes, "the crops are hauled into it."[2] Notwithstanding this busy activity, some wealthy owners could afford to reject *utilitas* and only embrace *voluptas*, even when agricultural treatises such as that of Columella, giving advice on how to run an agricultural estate, were being continuously read, internalized, and re-elaborated by elite readers.

Notwithstanding these contradictions, there are common elements by which Roman villas can be identified, core qualities that have been touched upon in this volume: a shared set of architectural features; the exploitation – whether simply for internal needs or for the market – of the natural resources present on the villa estate; and the combination of ideological values (hospitality, self-sufficiency, and intellectually productive *otium*) that were staged at and experienced in villas. In the

developing empire, and as provincial elites became integrated into the imperial system, entered the senate, came to share a common culture and ideology, and even gave Rome its first provincial emperor (Trajan), so were the ideological aspects and physical characteristics of the villa transplanted abroad. Agriculture and land owning were at the heart of Roman aristocratic values, as they were of the social and political structure of the Roman hegemony; ownership of land was the paramount factor in determining social standing.

The preceding chapters have clearly shown that, whether considering villas in Gaul, Italy, North Africa, or Dalmatia, within some specific regional architectural solution or building techniques, these establishments shared a common vocabulary in terms of architecture, décor, and, broadly speaking, common aspirations in regard to social interactions to take place in the villa and its productive dimension. Villas were nodes supplying both goods and lifestyles in the Mediterranean basin, in parallel with the success of Roman towns and cities, for which they supplied food and from which their owners derived their wealth and prestige: Having a *domus* in town and place in the country (or many places) came, for Romans of Rome and ultimately municipal and provincial grandees, a social obligation, even in regions such as Africa where the upper echelons of society preferred urban living. Villas also demanded goods and services: Sculptural products from Aphrodisias in Asia Minor found their way, sometimes in duplicate, to villas in Hispania (Ripoll, Chapter 22), bricks and tiles made in Italy were used in the construction of a villa in Libya arriving as ballast for boats on the return trip from delivering the villa's agricultural produce to an Italian port (Chapter 1), and mosaic workshops from North Africa plied their trades in Sicilian and Gallic villas as seen in Chapter 16 (Wilson).[3]

The Mediterranean had become safer after the campaigns of Pompey against piracy (67 BCE) and the stabilization of the imperial system after Actium (31 BCE): Villas of the Roman and Italian type spread with the extension of imperial governance. However, agriculture had always been the main economic work of antiquity, and knowledge was

not lacking. It is perhaps typical of the Roman mentality that synoptic treatises on agriculture embodying either personal experience or book-based knowledge, most often both, should have framed the terms of agriculture vis-à-vis an economy almost fully monetized by the early second century BCE.

Villas of the Roman and Italian type changed the Mediterranean because they were versatile and exportable. Their spread and the trade in their products – grains, wine, olive oil, other short- or long-shelf-life agricultural goods, fresh and preserved meat and fish, condiments (*garum*) and essentials (salt), as well as tiles, amphorae, and stone – gave impetus to, and took advantage of, a commercial seaborne trade as well as to an expansion of local markets bolstering the growth of cities and towns. The result may have been a normalization of dietary expectations in the Roman Mediterranean as well as plans for residential and working spaces and new agricultural methods. Even central-Italian construction techniques (e.g., *opus caementicium*), wall painting, and flooring (e.g., mosaic) for *domus* and villas were exported, as were in some cases Italian know-how in processing of agricultural produce.[4] As seen in Chapters 13 (Buffat) and 14 (Teichner), viticulture became an important part of agriculture in the Gallic provinces and in the Iberian Peninsula: *Cellae vinariae* with sunken *dolia* for the fermentation of the must are a typical feature of villas here as they are of villas in Italy (e.g., as seen in the "villa of Augustus" presented in Chapter 9). This wine-making process was indeed exported from Italy to these provinces by the many veteran colonists settled there during the colonization programs run by Caesar and Augustus. It is not common to the whole of the Roman world; we do not have evidence of *cellae vinariae* with sunken *dolia* in Malta or in North Africa, where local tradition followed the Punic practice of having the fermentation occur directly in the amphorae.

Dates are important: The spread of villas chronologically has been documented in the chapters of this book, but the origins of the villa are still a matter of debate. What seems clear is that they arose in tandem with the growth of Rome itself. The Auditorium villa was well developed as early as the fourth century BCE, and this discovery has reinforced the criticism of the theory that villas evolved from small, early farms, growing progressively and linearly in size and in architectural décor over time, as Rome's dominion expanded in Italy and the Mediterranean. Studies of villas in the City's *suburbium* are evidence for an earlier (and heretofore unsuspected) growth, by the third century BCE, of Rome as a major population center. By the second century BCE, terraced villas for residence and representation came to be built in fashionable locales not far from Rome (e.g., Tusculum, Tibur) and spread to the Bay of Naples. Rome and villas grew together, but such was the magnetic effect of political and cultural competition that both *domus* in towns and coastal or inland villas tended to cluster; the sharing of infrastructure (transport for agricultural goods, but also easy access for people; water supply), concentrating the efforts of brokers, and efficient deployment of personnel (slave and free) may also have been an impetus to such clustering.

The historical sequence, for the Mediterranean, was an early implantation of a few villas and their assimilation to both southern and northern Italy and the northeastern areas of Hispania by the mid-second century BCE, then to firmer establishment of villas when, in the first century BCE, opportunities for Romans and Italians in Epirus and Greece as well as on Malta and some in southern Gaul opened up. These are the early moments of villa expansion, following in many cases some 80 to 100 years after nominal Roman conquest in those regions. When combined with grants of land to veterans demobilized from the factional armies of conquest or civil war in the late republic, estates and villas, no matter how modest, were ductile means of colonization, exploitation, and assimilation. The properties in the environs of Patrae, originally land grants to veterans, are also good examples of such initially modest, later more developed, villa estates.

Once the overseas countryside had been stabilized, villas were versatile and had quite different origins: Roman or Italian men of property bought estates and built residences on them, as Titus Pomponius Atticus and others did in Epirus; Atticus' descendant Herodes Atticus, a member of

high intellectual and court society, was based both in
Italy and Greece (a villa on the via Appia; villas at
Kesphisia, Marathon, and Eua Loukou). As demon-
strated in Chapter 19 (Papaioannou), villas, both in
the meaning of farms and of lavish county residences,
were present in Greece too, contrary to what was
believed in the past. This is an important fact emer-
ging from this book and worthy of emphasis:
Research agendas and limited circulation of publica-
tions can project a skewed picture.

At the same time, and certainly by the imperial
period, established Greek families (the Saethidae
from Messene, the Claudii Attici from Marathon)
assimilated themselves to the Roman system by
establishing residential estates and agricultural busi-
nesses, and the same grafting onto villa estates by
non-Roman locals occurred in southern and north-
ern Italy, and the same occurred in Hispania, Gaul,
and North Africa. High society almost always finds
its favorite devices for living, and villas were one of
them.

Recent scholarship has stressed, in the case of the
Italian villas of the Republic, that regardless of the
discussion of villa productivity found in the treatises
of the agronomists, which gave some emphasis to the
economic relevance of viticulture, aristocrats could
not have, in fact, derived significant revenues from
viticulture.[5] It has also been said that villa estates and
agricultural intensification were not the main source
of the wealth that was displayed in the architecture of
villas, but rather the object of expenditure of wealth
from other sources.[6] At the same time, the studies in
this volume about villas in Gaul, Hispania, and, to an
extent, in Greece, show a contrary impulse: Initial
modest farms built by veteran colonists and engaging
in market-oriented agriculture made the transforma-
tion into proper villas within one or two generations.
The residential quarters were enlarged and beauti-
fied, *euripi* were placed in gardens, mosaic and *opus
sectile* floors were laid down, while service quarters
for secondary agricultural production were enlarged
(e.g., additional wine/oil presses and larger *cellae
vinariae* were installed).[7]

Were such developments enabled by successful
agricultural activity that brought financial revenues
that could be spent in raising the owner's standards

of living and social standing? Or did, in fact, indi-
viduals with diverse business interests and streams
of revenue buy up estates from veteran colonists
and their descendants, consolidate land ownership
into large units, and invest wealth made elsewhere
in land and agriculture as befitting to anyone who
aspired to climb the social ladder? Cicero famously
wrote that having been involved in commerce was
not completely disreputable if, satisfied with
the gains made, one moved from the port to the
country estate; if, in other words, one started
to invest in land and agriculture because "for the
freeborn man nothing is better ... and worthier
than agriculture."[8]

Villas of the Roman and Italian type – basically a
peristyle with two or three reception rooms (an
atrium, a *tablinum*, and *triclinium* in various sequences),
sleeping quarters (*cubicula*), and quarters for agricul-
tural processing and storage (the *partes rusticae* and
frumentariae or *fructuariae*) – were a formula capable of
variation: one was the type represented by the Villa of
the Mysteries and others with plans that incorporated
units of hospitality (*triclinium-cubicula*) or special ele-
ments such as scenic colonnaded terraces, grand
entrance architecture, and dramatic changes of level
with terraces and ramps. Villa owners and architects
were capable of originality (as Teichner in Chapter 14
and Ripoll in Chapter 22 clearly show), even though
elite villas were most often standardized at a high level
of taste: wall paintings and mosaic floors (mainly geo-
metric, some floral and figural) made for a homoge-
nized visual culture and iconography (e.g., the Four
Seasons, Dionysos and his imagery) deviating only
occasionally from certain norms. Craftsmen saw that,
at the elite level, commissioners wanted what they
already knew, so villas came to have a certain stan-
dard form and décor. In some cases, of course,
craftsmen offered "special" images for the more
public rooms of villas devoted to hospitality, and
villa owners may have wished to exhibit their artis-
tic taste and literary knowledge: Villas could be
venues for elite table-talk and mythological
embellishment.

Throughout the empire, certain modifications in
villa design (corresponding to other developments in
the spatially circumscribed *domus*) began to raise the

status of villa owners architecturally: *stibadia*, tri-conch *triclinia*, increasingly rich spaces of hospitality (private *balnea*, ceremonious entrance courts), and so on. The already-rich villas of the late Republic and first century CE in Italy (the Villa of the Mysteries, the Villa dei Papiri, those of Stabiae, Oplontis, and Positano) seem quaint and almost homely in comparison to later developments in the provinces. The villa owner as *dominus* certainly seems to have been the intent of many villa designs in the second century through late antiquity: the panoply of spaces and decorations, sculptural collections, portraits on mosaic floors and in marble or other media, mythology and personal events (hunting, giving of games in local towns or at Rome itself) depicted in mosaics and in wall paintings described in literary sources freighted villas owned by *privati* with a cultural and social glamour hardly seen since Hellenistic times or in imperial palaces. This was especially true in Hispania and southwestern Gaul, where villas boomed prodigiously and with surprising architectural *panache*. There and elsewhere, the older standard imagery for mosaics was retained and rummaged through, but there may have been a competitive taste for originality, particularly in floor mosaics (and some literary accounts of wall paintings and *pinakes*) in which quite arcane and unusual mythological and historical scenes and personages were depicted. How such developments relate to intellectual culture in late antiquity as well as early instances of Christian imagery in rural residences is a topic for further investigation, but earlier representations of "pagan" mythology had been part of conversation in villas, so Christian themes smoothly

followed suit as villa owners adopted the new faith. As presented in Chapters 10 (Gualtieri), 22 (Ripoll), and 23 (Bowes), several Christian features appear in late antique villas, whether a Christian symbol on mosaic floors, the erection of a shrine/mausoleum for a martyr, or of a proper church on the villa estate. Conversation, whether on "pagan" topics or piously Christian subjects, never stopped in villas, and despite the changes – social and political changes in late antiquity, the breaking down of urban structures in the west and what has been called the disarticulation of the Mediterranean economy (Chapter 22) – the *idea* of the villa, in its essence, lived on.

The idea of the villa became an ideal in later developments and ultimately was realized in ever more elaborate ways, in the European and even American architectural imagination, as shown in both Chapter 24 (du Prey) and 25 (Lapatin).

NOTES

1. Purcell 1995, 163.
2. Varro, *Rust.* 1.2.14.
3. Bricks and tiles of the villa called "Gara delle Nereidi" at Tagiura, Libya: see Chapter 1 and Wilson (Chapter 12); for stockpiling of marble from overseas; for tiles, Boucheron, Broise, and Thébert 2000.
4. Gualtieri (Chapter 10) in this book; Spanu 2015.
5. Rosenstein 2008.
6. Terrenato 2001, 27.
7. Marzano 2015.
8. Cic., *Off.* 1.151

GLOSSARY

ANNALISA MARZANO AND GUY P. R. MÉTRAUX

Note: this glossary covers many of the words used in defining Roman villa terminology, construction, decoration, and contents used in this volume as well as other terms. Words in Latin are italicized and given in the singular and plural; others that have entered common English usage are not. For further definitions and multi-language translations, see Ginouvès, R., R. Martin, and F. Coarelli 1985; Wright 2000.

aedes publicae – public or governmental buildings.

ager publicus – public land, property of the Roman people as a whole, which had been annexed by Rome or ceded to her by defeated enemies. Roman magistrates, especially the censors, administered it by leasing it out to tenant-farmers or lease-contractors (for pasturage). It could also be available for centuriation (q.v.) and assignment to colonists.

agnomen, agnomina – a nickname added to a Roman citizen's name, often recalling a significant event or military achievement (e.g., *Africanus* added to the name of P. Cornelius Scipio for his victories against the Carthaginians). *Agnomina* could also refer to personal characteristics such as *Caecus* (blind) or *Pius*, or recall biographical events such as *Caligula*.

agricola – a farmer of Roman citizen status.

ala, alae – literally, wing or wings; in an atrium, extra spaces on the cross-axis toward the end of the room providing architectural backdrops for relatives (wife, children) of the *paterfamilias*.

ambulatio, ambulationes – walkways or garden paths.

amphora, amphorae – heavy terracotta containers for liquid goods such as wine, *garum*, and olive oil, typically large- or long-bodied with two handles, small mouths for sealing and pointed feet for tipping and ease of stacking on ships.

Smaller, flat-bottomed amphorae for transport on river barges were also made.

annona – state sponsored distribution system for staple food in operation in the city of Rome. It started in 123 BCE as the sale, at a fixed price, of set monthly rations of wheat to adult male citizens. In 58 BCE, these distributions were made free. Heads of families would receive 5 modii (= c. 33.5 kg) of wheat monthly. In 2 BCE, Augustus revised the list of *annona* recipients, bringing the number down to about 200,000 and reorganized the system of storage and distribution, which he placed under the supervision of a *praefectus annonae*, an official of equestrian rank. The emperor Septimius Severus at the end of the second century CE added olive oil to the distributions, and Aurelian in the 270s topped them up with free wine and pork.

apodyterium – see *balneum*.

ashlar, ashlar construction – masonry of squared or rectangular blocks; a block of such shape.

atrium, atria – the principal formal room of a Roman or central Italian house, by tradition the "black" (*ater*) room with sooty walls where the family hearth would have been located (thus the need for a roof opening or *compluvium*). The atrium could also have a sub-floor cistern for storing water from roof run-off gathered from the inward-pitching roofs surrounding the *compluvium* (q.v.) In historical times, hearths were no longer located in *atria*, but the *compluvium-impluvium* (q.v.) arrangement with sub-floor cisterns is often encountered. The location of *atria* could vary: it could be the second room of a *domus* after entranceways (*vestibulum, ostium, fores*) or the centralizing space after a peristyle in villas. Various types of roof defined an atrium (*Tuscanicum* with no internal supports, *tetrastylum* with four columns, *Corinthium* with more than four supports, *displuviatum* with

490

outward-pitching roof, and *testudinatum* with no *compluvium*). Also called *cava aedium* or *cavaedium*.

auditorium, auditoria – any room designated for hearing of legal cases, disputations, speeches, or literary presentations; in late antique villas, *auditoria* could take the form of square or rectangular apsed rooms like private *basilicae*.

balneum, balnea – a bath building of a size smaller than public *thermae*; a term commonly used to designate bath buildings in private residences and villas. While there are many variations to the bathing sequence, and not all *balnea* incorporate all the types of rooms or facilities, many included the following:

apodyterium, apodyteria – the lobby of the *balneum* or public *thermae*, used for disrobing and storing clothes by the bathers preparatory to using the facility.

frigidarium, frigidaria – the cold room of a *balneum*, often equipped with a plunge-bath or even a *natatio*.

tepidarium, tepidaria – the partially heated tepid room of a *balneum*.

caldarium, caldaria – the hot and wet room, sometimes equipped with a *labrum* and/or plunge-bath.

laconicum, laconica – the hot and dry room, sometimes equipped with a plunge-bath or *labrum*.

Other terms for bath buildings:

hypocaust – a hollow space under a floor supported on large tiles upheld on *pilae* (q.v.) to provide radiant heat for *caldaria* and *laconica*, though sometimes *triclinia* and other rooms were heated in this way as well.

labrum, labra – a basin or bowl for water in gardens and baths buildings, often found in *caldaria* and/or *laconica* for cooling the bather or for sauna-steam effect.

natatio, natationes – a swimming pool.

pila, pilae – in a hypocaust (q.v.), short pillars made of tiles supporting the floor of a heated room (*caldarium* and *laconicum*) and making space for the circulation of air heated from an adjacent stoke-hole (*praefurnium*).

testudo, testudines – boilers, most often of metal, used to supply added measures of very hot water in *balnea*.

tubulus, tubuli – hollow tubes (usually rectangular) applied vertically to walls to direct the heat from the hypocaust below the floor of the caldarium and/or laconicum to their walls, for radiant heating effect.

basis villae – substructures; the artificial platform (*basis*) onto which a villa was built, offering commanding views. Often the *basis* housed large cisterns.

basilica, basilicae – the traditional form of a public law court in Roman judicial architecture. Most often, *basilicae* incorporated a rectangular room, often with porticoes on one or two floors on three or four sides, ending (on one or both short sides) with an apse to frame the chair of the magistrate set on a dais or platform. *Basilicae* in smaller but still impressive form were built in many late-antique villas, most probably to provide a space for the exercise of quasi-magisterial authority by the owner or to enhance his prestige.

cadaster – an official listing of the location, size, orientation, and category of survey land, sometimes including terms of ownership and value. Cadasters were used for distribution and assignment of farmable land in *ager publicus* (q.v.) to colonists or veterans, or to recover the survey of land that had become disordered, or for purposes of taxation in the provinces or assessment for the *alimenta Italiae*.

caldarium, caldaria – see *balneum*.

cardo, decumanus – in Roman urban centers, the north-south *cardo* (hinge) was the principal street, intersecting at 90° with the *decumanus* or secondary thoroughfare, though there are many variations to this general rule.

castrum, castra – a fortress or fortressed form.

cella, cellae – in religious architecture, the principal room of a temple; in domestic architecture, any room with a special designation.

cella olearia or oletum – the room/s for processing the fruit, separating the oil components, and decanting the various finished products are present in many villas. A *cella olearia* could include a *trapetum* or *mola olearia* to separate the fruit-flesh from the pits, and the *torcularium* machine with its base (*ara*) on which the fruit-flesh would be crushed in a bin (*galeagra*) by means of a lever (*prelum*) on a fulcrum-frame (*arbores*) and equipped with a press-board (*orbis*), the pressure applied by winching the *prelum* down on a rope-drum (*sucula*) attached to counter-weights. There were many other ingenious devices to apply pressure to the fruit, including a screw-driven mechanism.

cella vinaria – in villas or other productive venues, a room or rooms devoted to the production and fermentation of wine.

centuriatio, limitatio, centuriation – a method of surveying by trained surveyors (*agrimensores*) to establish divisions between property units in urban and agricultural land and to categorize such land for private and public allocation, allocation to property assignees, and designation of types of land, e.g., wasteland or *subseciva*, forest, and so on. Centuriation of newly conquered territories in small plots by marking out a network of boundary paths was at the basis of Roman colonization.

clientage, clientela, *cliens, clientes* – a form of Roman social relationship involving a *patronus* (in its original meaning, a legal advocate, later also a former master of a freedman, a protector of individuals or groups ranging from voluntary associations to entire cities) and his subordinates (*clientes*), also referred to as patronage. It was an asymmetrical, voluntary, and exploitative relationship marked by unequal exchange of the differing resources possessed by the two parties: protection and deference. Ideologically, the main contribution of clients to the relation with their patron was the symbolic enhancement of the latter's social status. In the case of former slaves becoming clients of their ex-master, the relationship was not voluntary but regulated by law.

cocciopesto – modern Italian term for an *opus signinum* (q.v.) floor made of ground tile and lime mortar.

coenatio, coenationes – in Roman domestic and palatial architecture, a dining room, the equivalent on a grander scale and often different plan of a *triclinium*.

colonia, coloniae – originally, towns of 300 Roman citizens, often veterans, established as garrison centers at distance from Rome; later, the legal designation of urban centers of authority in Italy and elsewhere in the Roman provinces.

colonus, coloni – in its origins, a free citizen of a *colonia*; ultimately, the term designated a tenant farmer or a tenant under various obligations to a landowner.

compluviate roof – see *compluvium*.

compluvium, compluvia – in an atrium (q.v.), the opening in an inward-pitching roof intended to direct rainwater into a pool below (the *impluvium*), thence to a sub-floor cistern.

cryptoporticus, cryptoporticus – a passageway or set of corridors closed on parallel sides rather than open on one side with a colonnade, piers, or arches. Such *cryptoporticus* could be below grade, partially underground, or above grade with or without windows in the wall or vaulted ceiling.

cubiculum, cubicula – a bedroom, most often for a single bed, though double cubicula for two single beds are known.

cubilium, cubilia – facing stones of wall masonry, most often referring to the square-faced pyramidal tufa elements of walls of *opus reticulatum* (q.v.).

cubitus, cubiti – 1 *cubitus* = 1½ *pedes* = 44.4 cm. This, or various approximations and multiples, was sometimes a standard width for bearing and nonbearing walls in Roman domestic architecture.

curia, curiae – the term refers both to the political body governing a city and to the building in which its members assembled.

cursus publicus – the system of public conveyances (horses, mules and donkeys, other pack-animals, and carts or other wheeled vehicles) established as the imperial communications system by Augustus throughout the Roman empire; its nodes were *mutationes* (for changing animals), *stationes*, and *mansiones* (q.v.).

Cyzicene *oecus* – see *oecus*.

decumanus – see *cardo*.

Diaeta, diaetae – a room with multiple social uses: dining, conversation, reading, or even the central room for a set of *cubicula*.

dolium, dolia, dolia defossa – large terracotta containers with globular body, no handles, and a large mouth with a broad rim, used for the storage of cereals, oil, and wine in farms/villas. The interior was regularly pitched when used to hold liquids. *Dolia* partially buried in the ground are often found in *cellae vinariae* and were the containers in which the fermentation of must into wine occurred, hence *dolia defossa*.

dominus, domini and *domina, dominae* – "lord" and "lady," terms of respect and honor. *Dominus* was apparently first demanded as a form of address by the emperor Domitian in the late first century CE, later applied to imperial and important personages including villa owners.

domuncula – a small *domus* (q.v.).

domus, domus, domusfamilia – an urban house housing the family of a *paterfamilias* (q.v.), sometimes including relatives, slaves, and other persons related to the family in some way.

ekphrasis, ekphraseis – a literary genre by which objects, works of art, buildings, landscapes, and so on were described in evocative words. Villas were often the subject of the genre in both poetry and prose.

emblema, emblemata – in mosaic floors, a separate section, usually made elsewhere and laid flush into a floor already under construction. *Emblemata* were often of superior workmanship and sometimes in *opus vermiculatum* (see *opus*, mosaic) and sometimes with additions of glass *tesserae* (q.v.) for glittering effect.

encomium, encomia – a literary production in prose or poetry praising a person or a praiseworthy entity such as a city or building, including a villa.

epistyle – an architrave, the lowest part of an entablature; the frieze stands above it, and the entire entablature is topped by the cornice.

equites – "knights," designating members of the *ordo equestris* below that of the *ordo senatorius*. In Roman social hierarchy, members of the *ordo equestris* had a traditional status as

self-mounted military units, but in practice they were associated with commerce, land ownership, administrative posts, intellectual pursuits, and military duties below those of generals with *imperium*. Equestrians could aspire to senatorial dignity or choose, as was often the case, to enjoy the freedoms and responsibilities of their lower status, villa ownership and its *otium* being one of them.

ergastulum, ergastula – a prison or workhouse for offenders (slaves, debtors). Modern authors use the term to refer, in the context of villas, to a lockable compound for housing slaves or simply to slave quarters in general.

euergetism – charitable activity of all kinds, from funding banquets for designated members of a community to funding buildings (fountains, libraries, baths) or entertainments (games, processions, commemorations) for the public good, hygiene, and enjoyment.

euripus, euripi – in gardens or open-air dining rooms, a waterway or canal for ornamentation, irrigation, and delight. The term derives from the narrow strait between Boeotia and the island of Euboea in central Greece.

exedra, exedrae – see *oecus*.

familia, familiae – best translated as "household." It denoted members of the same family living in the same household, together with the household slaves, all being under the authority of the *pater familias*, the male head of the household. Freedmen/freedwomen with very close connection to the household could be part of the *familia*.

fanum, fana – a consecrated religious edifice, a temple.

fastigium, fastigia – in religious architecture, the triangular shape on the front façade (or both façades) of a temple following the structure of a pitched roof; in private architecture, *domus* were allowed to have such a feature to honor the special status or achievement of an individual; the temple-like effect was often used in villas.

forum, fora – the civic center of a town or city, an open space centering the municipal *curia*, temples, commercial buildings (*macella*), and legal *basilica*.

frigidarium, frigidaria – see *balneum*.

garum, allec/hallec, liquamen – different types of fish sauces and pastes commonly used in Roman cuisine. *Garum* was a fermented fish sauce, akin to the modern Vietnamese *nuoc nam* sauce. It was made with the guts and other parts of larger fish discarded during the fish salting process. By adding a great quantity of salt, the proteolytic enzymes found in the gastrointestinal tract of fish cause autolysis and almost complete degradation of fish material; the final result is a yellow-amber colored sauce with a salty taste that was used as seasoning agent. *Allec* or *hallec* followed the same

process but was made using whole small fish (anchovies, sardines, sprats) and therefore contained small bones. *Liquamen* was similar to *garum* and the two terms are at times interchangeable. In the Byzantine work *Geoponica*, *liquamen* is defined as the strained liquid from *garum* made with both fish guts and small fish.

gestatio, gestationes – a stadium-shaped garden for walking.

headers and stretchers – in masonry, the arrangement of elements (ashlar or bricks) with their short and long sides alternating in horizontal courses.

heredium, heredia – in areal definition, a *heredium* = 2 *iugera* = 5,047 m² = c. 0.5 ha; in the early years of the Republic, the normal amount of arable land supporting a family; in Roman legal terminology, an inheritable or inherited unit of agricultural land.

horreum, horrea – a warehouse or store room.

hortus, horti – a garden of any kind or size, but the term applied to very large suburban parks, sometimes containing *villae suburbanae*.

hospes, hospites – a term designating both a host and a guest.

***hospitalia* (plural neuter form of adj. *hospitalis*)** – rooms in a *domus* or villa set aside for guests.

hospitium – the act of hospitable reception, the bond between hosts and guests.

ianua, ianuae – door or passageway marked by door.

imbrix* or *imbrex, imbrices – the semicylindrical tile in a roof sealing the separation between phlanged *tegulae* (q.v.).

impluvium, impluvia – a pool, square or rectangular, situated below a *compluvium* (q.v.) in an atrium.

instrumentum, instrumenta – tool, implement of any kind. In a legal context, the stock and implements of a farm, business, or trade. Slaves assigned to an agricultural estate/villa were considered part of the *instrumentum* (*instrumentum vocalis* = tools equipped with voice) and were sold with the property.

intercolumniation – the space between the edge of one column and the next in a linear, polygonal, or circular colonnade.

iugerum, iugera – an areal unit of measurement = ½ of a *heredium* (q.v.) = 28,800 pedes² = c..25 ha (see also *heredium*).

labrum, labra – a basin or bowl for liquids (usually water) in gardens but often found in *balnea* (in *laconica* or *caldaria* [q.v.]).

laconicum, laconica – see *balneum*.

lararium, lararia – in Roman houses, the shrine (often with an architectural framework) dedicated to and housing the images of the *dii familiares* comprising the *lares* and the *di penates/penates*), the protective deities of the *familia*.

latifundium, latifundia – "wide farm," a term to designate an especially large agricultural estate, often operated with slave labor and housing a villa.

libertus, liberti **or fem.** *liberta, libertae* – a person (male or female), previously a slave, enjoying freedom (but not citizenship) after manumission but tied to his/her former owner with bonds of respect and obligation (*clientela*).

limitatio – fixing of boundaries by land surveyors; see *centuriatio*.

macellum, macella – a public building or a building accessible to the public for the sale of goods, most often comestibles.

mansio, mansiones – an inn or waystation along a road for housing travelers (private and military) and personnel of the *cursus publicus* (q.v.), supplying food, hosteling, fodder, and remounts.

matrona, matronae – the traditional name of the wife of the *pater familias*.

mausoleum, *mausolea* – a building housing the tomb of a deceased individual or the tombs of several persons.

megalographia – in wall painting, a mode in which figures (human and animal) are depicted at life-size or near life-size, most often on a painted platform against a wall to emphasize their size and immediacy.

mos, *mores* – "custom." Most often modified by *maiorum*, meaning "the custom (habits, praise-worthy behavior) of the ancestors."

natatio, natationes – see *balneum*.

negotiator, negotiatores – in general, businessmen; for agricultural produce of villas; middle-men.

negotium – business, meaning commercial business but also political engagement, the opposite of *otium* (q.v.).

nobilis, nobiles – patrician and plebeian individuals or families who, by Roman birth and long existence (*patres*) or by virtue of election of a family member to the consulate, achieved noble status.

novus homo, novi homines – first man in a family to enter the Senate and, more specifically, to be elected consul. Cato the Elder and Cicero were originally *novi homines* in the *ordo senatorius* (q.v.) and, on obtaining election as consul, became *nobiles* (q.v.).

nundinae – markets held every ninth day in various towns or cities.

odeum, odea – a hall, usually covered and in the shape of a theater, used for poetry recitations and musical presentations.

oecus, oeci – a room, sometimes open on one side, without specific use (e.g., not for sleeping, eating, or specific reception) often found in villas. There were several types: a four-column type (*tetrastylum*), a porticoed oecus (*Corinthium*), the grand *Aegyptium* like a small basilica, and the *Cyzicenum* or Cyzicene *oecus* facing north overlooking a garden and closed with doors, for use in the summer. In domestic architecture, *oecus* and *exedra* were interchangeable.

oikos, oikoi – in Greek, a house or dwelling room of any kind.

olla perforata, ollae perforatae – in ancient horticulture, a clay vessel with perforations at the bottom and sides for planting. The *olla*, filled with soil, conserved water but allowed the roots to spread. Often used for climbing plants such as vines.

opus, opera – in Latin, a "work"; in the agronomists, man-days. The term is used in Roman architecture and flooring as follows:

Opus in Wall Construction

Core Techniques

opus africanum – a type of masonry typical of Roman North Africa consisting of vertical "chains" of large blocks of stone with infill in *opus caementicium* (q.v.) between them.

opus caementicium – wall core of rubble construction consisting of an aggregate of roughly graded field-stones held in a matrix of sand, lime, and volcanic ash or sand (*pulvis Puteolanus*, mod. *pozzolana*) in various proportions depending on dry or sub-water conditions, cured in removable wooden formwork. The various facing techniques and materials of the *opus caementicium* core are listed in the next section.

opus quadratum – ashlar masonry consisting of squared or rectangular cut blocks set in courses in different alignments (e.g., headers and stretchers, q.v.).

Facing Techniques

opus incertum – a core of *opus caementicium* faced with irregularly shaped but roughly graded field-stones cut on one side, set randomly or in diagonal zig-zag lines.

opus mixtum, opus vagecum, opus compositum – any combination of brick *opus testaceum* with other facings, e.g., *opus reticulatum* panels set between courses of brick, or brick quoins (corner or door edges) framing other facings.

opus reticulatum – a core of *opus caementicium* faced with pyramidally shaped square-faced *cubilia* (q.v., most often of tufa) set on point in a continuous net-like pattern.

opus testaceum, opus latericium – a core of *opus caementicium* faced with bricks.

opus vittatum, opus listatum – a core of *opus caementicium* faced with small, smoothly or roughly surfaced blocks, often of tufa, set alternately with courses of brick.

OPUS IN FLOOR SURFACES

Note: the foundations of floors (the bed or *rudus*, the mortar matrix or *nucleus*) and grouting (the modern term *supranucleus*) are not described here; for further discussion, see Dunbabin 1999; Ling 1998.

opus musivum, opus tesselatum – any floor or part of a floor covered with a continuous surface consisting of *tesserae* (q.v.).

opus sectile – a floor composed of variegated pieces of marble or other stone in geometric marquetry designs (some had floral inserts).

opus signinum – a floor made of ground tile or marble chips and dust in a matrix of lime mortar, sometimes decorated with lines of tesserae (mod. *cocciopesto, terrazzo*).

opus spicatum – a pattern of arranging tiles or stones in a herringbone pattern, used mainly for floors but sometimes as wall-facing.

opus vermiculatum – a mosaic floor, section of floor, or *emblema* made of especially small *tesserae* to create an intense effect of detail, light and shade, relief, and vivid color.

ordo, ordines, ordo equestris, ordo senatorius – the *ordo* to which Roman citizens belonged was determined by census or statement of wealth. The equestrian and senatorial *ordines*, formalized in the Augustan age, were at the apex of wealth-determined social status.

otium – in general, pleasurable leisure, comprising such diverse activities as reading, writing, conversation, physical exercise, gardening, hobbies, interior decoration and collecting, hospitality, hunting and fishing, all with some moral and self-representing purpose. Its opposite is *negotium* (q.v.).

PAINTING STYLES ("POMPEIAN")

Note: the following is a simple listing of the Pompeian painting styles. In historical terms, the styles often overlapped, were revived and copied, and did not correspond to the dating sequences of modern scholarship about them; further discussion in Ling 1991.

First Style – a wall treatment in which panels (flat, beveled, molded) emulating ashlar walls in blocks of colored marbles were painted, sometimes with plaster moldings to suggest horizontal divisions or pilasters for vertical rhythmical effect. In general, second century to mid-first century BCE.

Second Style – an elaborately constructed and vividly colored wall treatment in which deep extensions of architectural space beyond the wall surface were painted in a kind of isometric (rather than linear) perspective technique. Statues, *pinakes* (q.v.), still-lives, real and mythical animals, and human figures – all robustly painted – enriched the painted architecture, and *megalographia* (q.v.) characterized the Second Style, though for certain *pinakes* and other minor elements, a contrastingly sketchy and atmospheric style was developed. In general, 80s BCE to early first century CE.

Third Style – a wall treatment emphasizing linear, rather than spatial, effects. Broad areas of color (or white or black) were set between spindly architectural elements, with thin swagged garlands, tendrils, or painted cloth hangings linking elements of the composition, and little animals or figures in symmetrical arrangements. The Third Style often displayed *pinakes* of landscapes, still-lives, and other subjects as objects for delectation, sometimes rendered in monochrome or near-monochrome. In general, late Augustan through the third quarter of the first century CE.

Fourth Style – a continuation, but with a more robust architectural framework and spatial effect, of the Third Style, but with a return to the perspectival effects of the Second Style and its paraphernalia of statues, figures, animals, framed paintings of genre, or mythological scenes. In general, 50s to 79 CE when the sequence of styles ends with the eruption of Vesuvius.

palatium, palatia – *palatium* originally denoted the imperial palace on the Palatine Hill in Rome; by extension, it came to refer to any imperial dwelling and later to palaces in general.

palaestra, palaestrae – in Greek public architecture, a rectangular or square space surrounded on four sides with colonnaded porticoes, usually as part of a *gymnasium*.

Palaestrae were used for training youths in such sports as wrestling and boxing; by extension, they were used as venues for teaching and conversation.

pars, partes – the section or sections of any building with designated uses. In villas, the following are encountered:

pars fructuaria, partes fructuariae – storage rooms for grain, wine, olive oil, and other products, adjuncts of a villa's *pars rustica*.

pars frumentaria, partes frumentariae **(a modern label)** – a larder, "cold room," or storage room for cereals, preserved comestibles (pickles, dried fruits), often for use in the villa itself.

pars rustica, partes rusticae – the spaces and structures allocated to agricultural activity (olive oil production, wine making, milling of grain), also housing the *vilicus* (q.v.) and his family and other servants and/or slaves.

pars urbana, partes urbanae or *pars dominica, partes dominicae* – the residential section of the villa affording some (or great) comfort, decoration, and representational effects to the villa owner, his family, and guests.

pastio villatica, pastiones villaticae – the "productions of the villa." With these terms, Varro refers to the production of a range of quality foods for the urban market in the context of villas, particularly when the estate was small or the land not very fertile for traditional agriculture. *Pastio villatica* included raising game (e.g., wild boar), poultry and other birds sought after as delicacies (peacocks, thrushes), fattening ducks, dormice, keeping apiaries for honey and escargots, and fish farming.

pater familias, paterfamilias, patres familiae – the actual or nominal head of a *familia* (q.v.).

peregrinatio, peregrinationes – a departure from one's home and homeland and a journey; by extension, a pilgrimage.

peristyle – a courtyard, often with a garden, surrounded by columns, piers, or arches holding the roof of covered corridors.

pes, pedes – a Latin or Roman foot = 29.6 cm, but there are regional and even local variations.

pinax, pinakes – a picture, either a separate panel or else a small painted image in a larger wall painting.

pisé – rammed earth floor construction.

pluteus, plutei – low walls built between columns of a portico or colonnade to separate open areas from the surrounding corridors, to minimize dirt and drafts in the residential areas.

polis, poleis – in Greek, a city state.

porticus villa – a term describing a villa fronted with, or screened by, a portico of columns or piers.

possessor, possessores – an owner of any kind, though most often designating a landowner of high social status.

praedium, praedia – any estate, most often with a residential villa.

praetor, praetores – elected Roman magistrates charged with the administration of justice, ranking below the consuls.

praetorium, praetoria – in Roman military architecture, a building used as the headquarters and residence of the commander and his entourage. By late antiquity, it designated the *pars urbana* or owners' residence of a villa.

prelum, prela – see *cella, cella olearia*.

privatus, privati – a term describing a private person.

proconsul – an ex-consul who at the end of his consulship in Rome became governor of a province or military commander under a governor.

rubble construction – see *opus caementicium*.

scrinium, scrinia – a container, chest, or closet for storing papers and documents such as books in roll or codex form.

spina, spinae – the raised central platform, often decorated with objects, statues, and lap-marking devices, separating the two long sides of a stadium or circus for chariot races and defining the "start" and "turn."

stationes – on the *cursus publicus*, a waystation supplying food, fodder, and remounts.

straight-joints – in ashlar or *opus caementicium* masonry (q.v.), a discontinuity of two walls that nonetheless form a continuous surface or change of direction. Straight-joints may indicate the later addition of one wall to another or merely a contemporaneous change of plan during construction.

stibadium, stibadia – a semicircular form of dining platform equipped with mattresses or cushions on which the feasters would recline to eat in *triclinia* or *coenationes* (q.v.). *Stibadia* could be permanent, made of masonry and sometimes decorated, or they could be made of wood in sections to be moved for placement elsewhere.

Suburbium – suburbs, areas around a town or city encompassing not simply possible urban sprawls, but also agricultural estates, villas, and villages. Rome's *suburbium* is often referred to in scholarship, with varying criteria used to define its territorial extension as no clear demarcations for this area existed in antiquity.

taberna, tabernae – units for retail and service commerce; tabernae could be standalone, streetside, or intentionally grouped for any purpose (comestibles, clothing, laundry, and so on) and are usually found in towns and cities but sometimes in rural venues.

tablinum, tablina – the principal room of a Roman *domus* and villa, most often preceded by the atrium and leading to a peristyle or garden; it was used as the space for reception and business by the *pater familias*. *Tablina* could be screened by doors or curtains and might contain family documents and the images of ancestors.

tegula, tegulae – flat roof tiles phlanged on two sides, the space between them covered with an *imbrix* (q.v.).

tepidarium, tepidaria – see *balneum*.

terrazzo – a modern term for *opus signinum* (q.v.)

tessera, tesserae – a cube of stone (usually limestone in different colors), marble, tile, or glass c. 1 cm² used in the surface of floors of *opus musivum* (q.v.).

testudo, testudines – see *balneum*.

thermae – bath buildings, but the term usually designates a large public facility rather than the smaller *balneum* found in villas or urban neighborhoods.

thiasos – a procession with one or more principal protagonists and accompanists; the *thiasos* of Dionysus shows events in the god's life; the *thiasos* of Neptune and Amphitrite shows their wedding procession.

trapetum, trapeta – see *cella, cella olearia*.

triclinium, triclinia – a dining room, often elaborately decorated, equipped on three sides in a square U by *klinai* or feasting beds with cushions for reclining and eating from moveable tables. The floor in mosaic and/or *opus sectile* was often set in a "U+T" disposition, the U being the border (most often plain) on which the *klinai* were placed, the T (often elaborately decorated because visible to the diners) for the tables, service, or a floor for entertainments.

triconch, triconchos – any three-lobed room, usually with the lobes in apse form.

"U+T" – see *triclinium*.

valetudinarium, valetudinaria – a hostel or facility designed for rest and recuperation.

velarium, velaria – a cloth covering, sometimes sewn into gored trapezoidal or triangular sections to form a hemicycle.

vicus, vici – in towns and cities, officially designated neighborhoods or urban regions; in the countryside, a village or village-like agglomeration.

vilicus, vilici – the manager (either slave or free) of a villa.

voussoirs, curved and flat – the wedge-shaped or trapezoidal components of an arched opening or flat epistyle (q.v.).

xystus – in Roman architecture, a walkway, often running parallel to a colonnade and defining a garden, or an *allée* framed by shrubs or trees.

BIBLIOGRAPHY

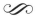

Abadie-Reynal, C. 2008. "Eaux décoratives, eaux symboliques à Zeugma." *Syria* 85: 99–118.

Abascal, J.M. et al. (eds.) 2007 (R. Cebrián, A.M. Ronda, and F. Sala). *Baños de la Reina (Calpe, Alicante). Un vicus romano a los pies del Peñón de Ifach.* Calpe: Ayuntamiento de Calpe.

Abascal, J.M. et al. 2008 (R. Cebrián, I. Hortelano, and A.M. Ronda). "Baños de la Reina y las villas romanas del Levante y de los extremos de la Meseta sur." In Fernández Ochoa, García-Entero and Gil Sendino (eds.): 285–300. Gijón: Trea.

Abásolo, J.A, J. Cortés, and F. Pérez Rodríguez 1996. "Sobre algunas guarniciones de cinturón tardorromanas de presumible carácter militar." In *Spania. Estudis d'Antiguitat Tardana oferts en homenatge al professor Pere de Palol i Salellas,* 25–36. Barcelona: Publicacions de l'Abadia de Montserrat.

Abela, R. (ed.) *The Żejtun Roman Villa: Research – Conservation – Management.* Malta: Wirt iż-Żejtun, 2012.

Absalam Ben Rabha, K. and N. Masturzo 1997. "Wadi al-Fani (Khoms): Villa, Mausoleum and Gasr." *LibAnt* n.s. 3: 214–16.

Accardo, S. (ed.) 2000. *Villae Romanae nell'ager Bruttius: Il paesaggio rurale calabrese durante il dominio romano.* Roma: "L'Erma" di Bretschneider.

Ackerman, J.S. 1966. *Palladio.* 2nd edn. Harmondsworth: Penguin.

Ackerman, J.S. 1990. *The Villa: Form and Ideology of Country Houses.* Princeton, NJ: Princeton University Press.

Adam, J.-P. 1994. *Roman Building: Materials and Techniques.* London: B.T. Batsford.

Adam, J.-P. 1999. *Roman Building: Materials and Techniques.* London and New York: Routledge.

Adamesteanu, D. 1956. "Scoperta di una casa ellenistica a Caposoprano." *NSc* 10: 343–54.

Adamesteanu, D. (ed.) 1999. *Storia della Basilicata,* vol.1. Bari: Laterza.

Adams, G. 2006. *The Suburban Villas of Campania and Their Function.* BAR-IS 1542. Oxford: Archeopress.

Adams, J.N. 1995. "The Language of the Vindolanda Writing Tablets: An Interim Report." *JRS* 85: 86–134.

Adam-Veleni, P. 1996. "Πέτρες Φλώρινας: δώδεκα χρόνια ανασκαφής." *AErgoMak* 10A: 1–22.

Adam-Veleni, P. 2003. "Economy and Trade in Macedonia." In Adam-Veleni, Poulaki, and Tzanavari (eds.): 141–9.

Adam-Veleni, P. 2003. "Mygdonia. Gulf of Strymon." In Adam-Veleni, Poulaki, and Tzanavari (eds.): 91–114.

Adam-Veleni, P. 2003. "Via Egnatia." In Adam-Veleni, Poulaki and Tzanavari (eds.): 35–38.

Adam-Veleni, P. 2009. "Αγροικίες στη Μακεδονία: οι απαρχές της Φεουδαρχίας." In Adam-Veleni and Tzanavari (eds.) 2009: 1–15.

Adam-Veleni, P. and K. Tzanavari (eds.) 2009. *20 Chronia: to archaiologiko ergo sti Makedonia kai Thraki,* Commemorative vol. Thessaloniki: Ministry of Culture and Tourism, Aristotle University of Thessaloniki.

Adam-Veleni, P., E. Poulaki, and K. Tzanavari (eds.) 2003. *Ancient Country Houses on Modern Roads: Central Macedonia.* Athens: The Archaeological Receipts Fund.

Adriano. Architettura e progetto. Catalogo di mostra, Tivoli, Villa Adriana 13 aprile 2000 – 7 gennaio 2001. 2000. Milan: Electa.

Agache, R. 1973. "La villa gallo-romaine dans les grandes plaines du nord de la France." *Archéologia* 55: 37–52.

Agache, S. 1999. *s.v.* "Villa Publica." In *LTUR* vol. 5, 202–5.

Agache, S. 2008. "La villa comme image de soi: Rome antique des origines à la fin de la République." In Galand-Hallyn and Lévy 2008: 15–44.

Agrafioti, K. 2002. *Ηρώδης Αττικός.* Athens: Kaktos.

Aguado, M. et al. 1999 (R. Castelo Ruano, A. Torrecilla, R. Arribas, O. Jiménez, A. López, C. Sierra, C. Talens). "El yacimiento arqueológico de El Saucedo (Talavera la Nueva, Toledo). Balance y perspectivas." *CuPAUM* 25: 193–250.

Akerraz, A., and E. Lenoir 1990. "Volubilis et son territoire au 1er siècle de nôtre ère." In *L'Afrique dans l'Occident romain (Ier siècle av. J.C.–IVe siècle ap. J.C.): Actes du colloque organisé par l'École française de Rome sous le patronage de l'Institut national d'archéologie et d'art de Tunis (Rome, 3–5 décembre 1987).* CÉFR 134: 213–29.

Åkerström-Hougen, G. 1974. *Calendar and Hunting Mosaics of the Villa of the Falconer at Argos: A Study in Early Byzantine Iconography.* Stockholm: Svenska Institutet i Athen; Lund: distributed by P. Åströms Förlag.

Alamichel, M.-F. and R. Braid (eds.) 2011. *Texte et Contexte. Littérature et histoire de l'Europe médiévale.* Paris: Michel Houdiard Editeur.

Al-Asad, M. and G. Bisheh. 2000. "Palatial Residences." In *The Umayyads: The Rise of Islamic Art,* 50–1. Vienna and Beirut: Arab Institute for Research and Publishing.

Albore Livadie, C. (ed.) 1986. *Tremblements de terre, éruptions volcaniques et vie des hommes dans la Campanie antique* (Bibliothèque de l'Institut Français de Naples, Deuxième série, vol. 7). Napoli: Centre Jean Bérard – Institut français de Naples.

Alcock, L. 1950. "A Seaside Villa in Tripolitania." *PBSR* 18: 92–100.

Alcock, S.E. 1989. "Roman Imperialism in the Greek Landscape." *JRA* 2: 5–34.

Alcock, S.E. 1993. *Graecia Capta: The Landscapes of Roman Greece.* Cambridge, UK: Cambridge University Press.

Alcock, S.E. 1996. "Changes in the Ground in Early Imperial Boeotia." In Bintliff (ed.) 1996: 287–303.

Alcock, S.E. (ed.) 1997. *The Early Roman Empire in the East.* Oxbow Monograph 95. Oxford: Oxbow Books.

Alcock, S.E. and J.F. Cherry (eds.) 2004. *Side-by-side Survey: Comparative Regional Studies in the Mediterranean World.* Oxford: Oxbow Books.

Alcock, S.E. et al. 2005. "Pylos Regional Archaeologial Project, Part VII. Historical Messenia, Geometric through Late Roman." *Hesperia* 74: 147–209.

Alcock, S.E., M. Egri, and J. Frakes (eds.) 2016. *Beyond Boundaries. Connecting Visual Cultures in the Provinces of Ancient Rome.* Los Angeles, CA: Getty.

Alexopoulou, G. 1995. "Ακτή Δυμαίων 12–14." *ArchDelt, Chronika* B1 50: 205.

Alföldy, G. 1988. *Antike Sklaverei: Widersprüche, Sonderformen, Grundstrukturen.* Bamberg: C.C. Buchners Verlag.

Alföldy, G. 2002. "*In omnes provincias exemplum*: Hispanien und das *Imperium Romanum*." In Urso (ed.) 2002: 183–9.

Ali Asmia, M. and M. Ahmed al-Haddad 1997. "Tarhuna, Wadi Guman Area: Recent Finds." *LibAnt* n.s. 3: 218–20.

Allamani, V., A. Koukoubou, and E. Psarra 2009. "Μίεζα, πόλη Ημαθίας." In Adam-Veleni and Tzanavari (eds.) 2009: 17–30.

Allamani, V. and B. Misaelidou. 1992. "Ανασκαφικές Έρευνε ς στην αρχαία 'MIEZA'." *AErgoMak* 6: 208–12.

Allison, P.M. 2001. "Using the Material and Written Sources: Turn of the Millennium Approaches to Roman Domestic Space." *AJA* 105: 181–208.

Allroggen-Bedel, A. 1993. "Gli scavi di Ercolano nella politica culturale dei Borboni." In Luisa Franchi dell'Orto (ed.): 35–40. Roma: L'Erma di Bretschneider.

Almagro, M. et al. (eds.) 2000. *El Disco de Teodosio.* Madrid: Real Academia de la Historia.

Al-Mahjub, O. 1983. "I mosaici della villa romana di Silin." In Farioli Campanati (ed.) 1983: 299–306.

Al-Mahjub, O. 1987. "I mosaici della villa romana di Silin." *LibAnt* 15–16 [for 1978/1979]: 69–74.

Almeida, M.J. and A. Carvalho 2005. "*Villa* romana da Quinta das Longas (Elvas, Portugal): A lixeira baixo-imperial." *Revista portuguesa de arqueologia* 8.1: 299–368.

Alonso, R. 2008. "Hornija, Bamba, Pampliega: las elecciones funerarias de los reyes hispanovisigodos." *Territorio, sociedad y poder: revista de studios medievales* 3: 13–27.

Alonso, R. 2011. "El Corpus pelagianum y el Liber testamentorum ecclesiae ouetensis: las 'reliquias del pasado' de la catedral de Oviedo y su uso propagandístico en la obra del obispo Pelayo de Oviedo (1101–1153)." In Alamichel and Braid 2011 (eds.): 519–48.

Alonso, R. 2013. "Las sepulturas de los reyes godos en *Hispania.* Chindasvinto, Recesvinto y Wamba." *Pyrenae* 44.1: 135–55.

Alquier, J. and P. Alquier 1926. "Les thermes romains du Val d'Or." *Recueil des notices et mémoires de la Société archéologique du Département de Constantine* 57: 81–121.

Alquier, J. and P. Alquier 1929. "Les thermes romains du Val d'Or (près Oued-Athménia)." *Recueil des notices et mémoires de la Société archéologique du Département de Constantine* 59: 289–318.

Alt, A. 1928. "Die Meilenzählung an der römischen Strasse Anthiochia-Ptolemais." *Zeitschrift des deutschen Palästina-Vereins* 51: 253–64.

Alto Bauer, F. and C. Witschel (eds.) 2007. *Statuen und Statuensammlungen in der Spätantike: Funktion und Kontext (Spätantike, Frühes Christentum, Byzanz: Kunst im ersten Jahrtausend, Reihe B: Studien und Perspektiven 23).* Wiesbaden: Reichert Verlag.

Alvar Ezquerra, J. (ed.) 2008. *Entre fenicios y visigodos. La historia antigua de la Península Ibérica,* 351–64. Madrid: La esfera de los libros.

Álvarez Martínez, J.M. and P. Mateos Cruz (eds.) 2011. *Actas del Congreso internacional 1910–2010. El yacimiento emeritense.* Mérida: Ayuntamiento de Mérida.

Álvarez Sáenz de Buruaga, J. 1974. "Una casa romana con valiosas pinturas en Mérida." *Habis* 5: 169–87.

Amadasi Guzzo, M.G., M. Liverani and P. Matthiae (eds.) 2002. *Da Pyrgi a Mozia. Studi sull'archeologia del Mediterraneo in memoria di Antonia Ciasca.* (*Vicino Oriente*– *Quaderno* 3/2). Rome: Università degli studi di Roma "La Sapienza."

Ambrosini, C. and G. Pantò 2008. *Trino, località S. Stefano. Villa tardoantica, edificio funerario e necropolis. Quaderni della Soprintendenza Archeologica del Piemonte* 23: 225–26.

Ameling, W. 1983. *Herodes Atticus.* Hildesheim and New York: G. Olms.

Amiran, R.B.K. and I. Dunayevsky 1958. "The Assyrian Open-court Building and its Palestinian derivatives." *BASOR* 149: 25–32.

Amphoras project, Bibliography of Amphora Studies: www.projects.chass.utoronto.ca/amphoras/bib/amph-bib.htm.

Ampolo, C. et al. 1971. "La villa del Casale a Piazza Armerina. Problemi, saggi stratigrafici ed altre ricerche." *MEFRA* 83: 141–281.

Anderson, J.C. 1997. *Roman Architecture and Society.* Baltimore, MD: Johns Hopkins University Press.

André, J.M. 1962. *Recherches sur l'otium romain.* Paris: Les Belles Lettres.

André, J.M. 1966. *L'Otium dans la vie morale et intellecturelle romaine, des origines à l'époque augustéenne.* Paris: Presses universitaires de France.

Andreae, B. 1983. "Le sculture." In Tocco Sciarelli (ed.) 1983: 49–66.

Andreae, B. 1991. "Il ninfeo di punta dell'Epitaffio a Baia." In Bonanno Aravantinos and Stucchi (eds.) 1991: 237–65.

Andreae, B. 1992. "Il palazzo imperiale sommerso di Punta Epitaffio." In Gigante (ed.) 1992: 81–91.

Andreae, B. and C. Parisi Presicce (eds.) 1996. *Ulisse: il mito e la memoria. Roma, Palazzo delle Esposizioni, 22 febbraio–2 settembre 1996.* Rome: Progetti museali.

Andreae, B. and H. Kyrieleis (eds.) 1975. *Neue Forschungen in Pompeji und den anderen vom Vesuvausbruch 79 n.Chr. verschütteten Städten (Internationales Kolloquium Essen 11.–14. Juni 1973).* Recklinghausen: Bongers.

Andreau, J. 1994. "Encore quelques mots sur les latifundia." In *Mélanges Pierre Lévêque. Vol. 8: Religion, anthropologie et sociéte,* M.-M. Mactoux and E. Geny (eds.): 1–12. Paris: Belles Lettres.

Andreau, J. 1999. "De l'esclavagisme aux esclaves gestionnaires. Présentation de la journée d'études de Lille (21 novembre 1998)." *Topoi* 9: 103–12.

Andreau, J., et al. 1982. *Problemi della schiavitù. Un incontro con M.I. Finley su Ancient Slavery and Modern Ideology:* Special Issue of *Opus* 1.1.

Andreau, J. and W. Berelowitch (eds.) 2008. *Michel Ivanovitch Rostovtzeff.* Pragmateiai 14. Bari: Edipuglia.

Andreau, J. and R. Descat 2006. *Esclave en Grèce et à Rome.* Paris: Hachette. (English: Andreau, J. 2011. *The Slave in Greece and Rome,* partial edition of Andreau, J. 2006, trans. M. Leopold. Madison, WI: University of Wisconsin Press.)

Andreu Pintado, J., J. Cabrero Piquero, and I. Rodà de Llanza (eds.) 2009. *Hispaniae – Las provincias hispanas en el mundo romano (Documenta 11).* Tarragona: Institut català d'arqueologia clàssica.

Angelelli, C., M. Aoyagi, and S. Matsuyama. 2010. "La cd. Villa di Augusto a Somma Vesuviana (NA) alla luce delle più recenti ricerche archeologiche (campagne di scavo 2002–2008)." *Amoenitas* 1: 177–219.

Angrisani, A. 1936. *La Villa Augustea di Somma Vesuviana.* Aversa: Nappa.

Anon. 1880a. *Plans et mosaïques des bains de Pompéianus près de l'oued Atménia.* Paris and Constantine: [publisher unknown].

Anon. 1880b. *Plan d'ensemble des bains de Pompéianus à Oued Atménia.* Paris: Imprimerie Lemercier.

Anselmino, L. et al. (eds.) 1989. *Il castellum del Nador: storia di una fattoria tra Tipasa e Caesarea (I–VI sec. d.c.).* Monografie di archeologia libyca 23. Rome: "L'Erma" di Brestschneider.

Antiquités d'Herculanum 1805. Paris: Piranesi.

Antolinos Marín, J.A., J.M. Noguera Celdrán, and B. Soler Huertas 2010. "Poblamiento y explotación minero-metalúrgico en el districto minero de Carthago Nova." In Noguera Celdrán, J.M. (ed.) 2010: 167–231.

Anzidei, M. et al. 2004. "Siti archeologici costieri di età romana come indicatori delle variazioni del livello del mare: un'applicazione al mare Tirreno (Italia centrale)." In De Maria and Turchetti (eds.) 2004a: 115–26.

Aoyagi, M. 1980–1981. "Ripresa degli scavi nella villa romana di Realmonte." *Kokalos* 26–27: 668–73.

Aoyagi, M. 1988. "Il mosaico di Posidone rinvenuto a Realmonte." *QuadMess* 3: 91–103.

Aoyagi, M. and S. Steingräber (eds.) 1998. *Le ville romane dell'Italia e del Mediterraneo antico.* Tokyo: Tokyo University Press.

Applebaum, S. 1977. "Judaea as a Roman Province: The countryside as a political and economic factor." *ANRW* 2.8: 355–96.

Arapogianni, X. 1993. "Το ρωμαϊκό βαλανείον στην Μπρεξίζα του Μαραθώνος." *Archaiologiki Ephemeris* 132: 133–86.

Arbeiter, A. and D. Korol (eds.) 2015. *Der Kuppelbau von Centcelles. Neue Forschungen zu einem enigmatischen Denkmal von Weltrang.* Iberia Archaeologica 21. Madrid and Berlin: Deutsches Archäologische Institut and Ernst Wasmuth Verlag.

Arce, J. 1976. "El missorium de Teodosio I: precisiones y observaciones." *ArchEspArq* 49: 119–39.

Arce, J. 1982. "Los caballos de Símmaco." *Faventia* 4.1: 35–44.

Arce, J. 1986. "El mosaico de "Las Metamorfosis" de Carranque (Toledo)." *MM* 27: 365–74.

Arce, J. 1993. "Mercados rurales (*nundinae*) en la Hispania tardorromana." In Padró, Prevosti, Roca and Sanmartí (eds.) 1993: 867–71.

Arce, J. 1997a. "*Otium et negotium*: The great estates. 4th–7th century." In Webster and Brown (eds.) 1997: 19–32.

Arce, J. 1997b "Emperadores, palacios y villae. (A propósito de la villa romana de Cercadilla, Córdoba)." *AnTard* 5: 293–302.

Arce, J. 1998. "Teodosio I sigue siendo Teodosio I." *ArchEspArq* 71: 169–79.

Arce, J. 2000. "El Missorium de Teodosio I: problemas históricos y de iconografía." In Almagro et al. (eds.) 2000: 281–88.

Arce, J. (ed.) 2002. *Centcelles. El monumento tardorromano. Iconografía y Arquitectura*. Bibliotheca Italica, Monografías de la Escuela Española de Historia y Arqueología 25. Rome: "L'Erma" di Bretschneider.

Arce, J. 2003. "La villa romana de Carranque (Toledo, España): *identificación y propietario*." *Gerión* 21: 17–30.

Arce, J. 2005. "Antigüedad Tardía hispánica. Avances recientes." *Pyrenae* 36.1: 3–28.

Arce, J. 2006a. "*Villae* en el paisaje rural de Hispania romana durante la Antigüedad Tardía." In Chavarría Arnau, Arce, and Brogiolo (eds.) 2006: 9–15.

Arce, J. 2006b. "Obispos, emperadores o propietarios en la cúpula de Centcelles." *Pyrenae* 37.2: 131–41.

Arce, J. 2008a. "La Hispania de Teodosio: 379–395 AD." *AntTar* 16: 9–18.

Arce, J. 2008b. "Musivaria y simbolismo en las *villae* tardorromanas." In Fernández Ochoa, García-Entero, and Gil Sendino (eds.) 2008: 86–97.

Arce, J. 2012. "Los retratos de los medallones del mosaico de Aquiles de la villa de Pedrosa de la Vega (La Olmeda, Palencia): propuestas de interpretación." In Fernández Ibáñez and Bohigas Roldán (eds.) 2012: 87–91.

Arce, J., L. Caballero, and M.A. Elvira 1997. "El edificio octogonal de Valdetorres del Jarama (Madrid)." In Teja and Pérez González (eds.) 1997, vol. 2: 321–38.

Arce, J. and G. Ripoll 2017. "De nuevo sobre Centcelles. La función de la sala de la cúpula y la identificación del propietario." *AnTard* 25: 411–22.

Archibald, Z.H. et al. (eds.) 2001. *Hellenistic Economies*. London: Routledge.

Arcifa, L. 2008. "*Facere fossa et victualia reponere*. La conservazione del grano nella Sicilia medievale." *Mélanges de l'École française de Rome. Moyen Âge* 120: 39–54.

Arévalo A., D. Bernal, and A. Torremocha 2004. *Garum y salazones en el Círculo del Estrecho*. Granada: Ediciones Osuna.

Arheološki leksikon 1988. Zemaljski muzej. T. III 25: 320–38.

Ariño, E., J.M. Gurt, and J.M. Palet 2004. *El pasado presente. Arqueología de los paisajes en la Hispania romana*. Salamanca and Barcelona: Universidad de Salamanca and Universitat de Barcelona.

Arnal, P. 1788. *Pavimentos de mosaícos encontrados en la villa Rielves (con un discurso sobre el origen y principio de los mosaicos y sus varias materias contraído a los que nuevamente se descubrieron en las excavaciones de la villa de Rielves de orden de S.M.)*. Madrid: [s.n.].

Arnaud, P. 2004. "Entre Antiquité et Moyen-Âge: l'Itinéraire Maritime d'Antonin." In De Maria and Turchetti 2004b: 3–19.

Arnheim, M.T.W. 1972. *The Senatorial Aristocracy in the Later Roman Empire*. Oxford, UK: Clarendon Press.

Arribas Palau, A. 1962. "La Arqueología romana en Cataluña. Problemas de la Prehistoria y de la Arqueología catalanas." In *III Symposium de Prehistoria Peninsular (Barcelona 1962)*, 187–206. Barcelona: Instituto de Arqueología.

Arslan, E. 1999. "Il territorio del Bruzio nel IV–V secolo (il paesaggio rurale)" in *Italia Meridionale Tardoantica*, 391–423.

Arthur, P. 1991. *Romans in Northern Campania: Settlement and Land-Use around the Massico and the Garigliano Basin*. London: British School at Rome.

Ashby, T. 1907. "The Classical Topography of the Roman Campagna III, (VIII. The Villa called Sette Bassi)." *PBSR* 4: 99–111.

Ashby, T., 1915. "Roman Malta." *JRS* 5: 23–80.

Aslamatzidou-Kostourou, Z. 2013a. "Roman Farmhouses in the Corinthia: The Loutraki Case." In Rizakis and Touratsoglou (eds.): 176–85.

Aslamatzidou-Kostourou, Z. 2013b. "Roman Farmhouses in Corinthia." In Rizakis and Touratsoglou (eds.): 186–99.

Atkinson, R.J.C. 1952. "Méthodes électriques de prospection en archéologie." In Laming (ed.): 54–67.

Aubert, J.-J. 1994. *Business Managers in Ancient Rome: A Social and Economic Study of Institores, 200 B.C.– A.D. 250* (Columbia Studies in the Classical Tradition 21). Leiden: Brill.

Aubert, J.J. and Z. Várhelyi (eds.) 2005. *A Tall Order. Writing the Social History of the Ancient World. Essays in Honor of William V. Harris.* (Beiträge zur Altertumskunde 216). Munich and Leipzig: K. G. Saur.

Aurigemma, S. 1926. *I mosaici di Zliten*. Africa Italiana 2. Rome and Milan: Società editrice d'arte illustrata.

Aurigemma, S. 1960. *L'Italia in Africa. Le scoperte archeolo-giche (a. 1911–a. 1943). Tripolitania, vol. I. Parte prima: i mosaici.* Rome: Istituto Poligrafico dello Stato.

Aurigemma, S. 1962. *L'Italia in Africa. Le scoperte archeolo-giche (a. 1911–a. 1943). Tripolitania, vol. I. Parte seconda: le pitture d'età romana.* Rome: Istituto Poligrafico dello Stato.

Babelon, E., R. Cagnat, and S. Reinach (eds.) 1892–1913. *Atlas archéologique de la Tunisie. Édition spéciale des cartes topographiques publiées par le ministère de la guerre, accompagnée d'un text explicative.* Paris: Éditions E. Leroux.

Babudri, F. 1920. "La villa rustica di Sesto Appuleio Ermia presso S. Domenica di Visinada." *Atti e Memorie della Società Istriana di Archeologia e Storia Patria* 32: 13–32.

Babusiaux, U. and A. Kolb (eds.) 2015. *Das Recht der "Soldatenkaiser." Rechtliche Stabilität in Zeiten politischen Umbruchs.* Berlin, Munich, and Boston: Walter de Gruyter.

Bacci, G. 1984–5a. "Portopalo (1982–1983) – antica 'ton-nara.'" *Kokalos* 30–31: 716–21.

Bacci, G. M. 1984–1985b. "Scavi e ricerche a Avola, Grammichele, Portopalo, Taormina." *Kokalos* 30–31: 711–25.

Bacci, G. M. (ed.) n.d. [*c.* 2003] *Patti Marina. Il sito arche-ologico e l'antiquarium.* Patti: Comune di Patti.

Badian, E. 1958. *Foreign Clientelae (264–70 B.C.).* Oxford: Clarendon Press.

Badian, E. 1972. "Ti. Gracchus and the Beginning of the Roman Revolution." *ANRW* 1.1: 668–731.

Badini, A. 1980. "La concezione della regalità in Liutprando e le iscrizioni della chiesa di S. Anastasio a Corteolona." In *Atti del 6° Congresso internazionale di studi sull'Alto Medioevo (Milano 1978),* 283–302, vol. I. Spoleto: Centro Italiano di Studi sull'Alto Medioevo.

Badisches Landesmuseum Karlsruhe (ed.) 2009. *Das Königreich der Vandalen. Erben des Imperiums in Nordafrika.* Mainz am Rhein: Philipp von Zabern.

Baker, D. (ed.) 1979. *The Church in Town and Countryside [Papers read at the 17th Summer Meeting and the 18th Winter Meeting of the Ecclesiastical History Society].* London: Basil Blackwell.

Bakker, J.T. 1994. *Living and Working with the Gods.* Amsterdam: J. C. Gieben.

Baldassarre, I. et al. 2002. *Pittura romana.* Milano: Motta.

Baldini, A. 1985. "Problemi della tradizione sulla 'distru-zione' del Serapeo di Alessandria." *RivStoAnt* 15: 97–152.

Baldini, I. 2003. "La fine di domus e palatia." In Ortalli and Hinzelmann (eds.) 2003: 173–86.

Balil, A. 1954. "La economía y los habitantes no hispánicos del Levante español durante el Imperio romano." *Archivo de Prehistoria Levantína* 5: 251–73.

Ball, L.F. 2003. *The Domus Aurea and the Roman Architectural Revolution.* Cambridge, UK: Cambridge University Press.

Balmelle, C. 2001. *Les demeures aristocratiques d'Aquitaine. Société et culture de l'antiquité tardive sans le Sud-Ouest de la Gaule.* Bordeaux and Paris: Ausonius–Aquitania.

Balmelle, C., P. Chevalier, and G. Ripoll (eds.) 2004. *Mélanges d'antiquité tardive. Studiola in honorem Noël Duval.* Bibliothèque de l'Antiquité Tardive 5. Turnhout: Brepols.

Balmelle, C. and J.-P. Darmon 1987. "L'artisan-mosaïste dans l'antiquité tardive. Réflexions à partir des signa-tures." In Barral i Altet (ed.) 1987, vol. 1: 235–53.

Balmelle, C. and S. Doussau 1982. "La mosaïque à l'Océan trouvée à Maubourguet (Hautes-Pyrénées)." *Gallia* 40: 149–70.

Balmelle, C., H. Eristov and F. Monier (eds.) 2011. *Décor et Architecture en Gaule: Entre l'Antiquité et le haut Moyen Âge. Actes du colloque international Université de Toulouse II-Le Mirail 9–12 octobre 2008.* Bordeaux: Éditions de la Fédération Aquitania.

Balmelle, C. and A.-M. Guimier-Sorbets (eds.) 1990. *Xenia. Recherches franco-tunisiennes sur la mosaïque de l'Afrique antique.* Rome: École française de Rome, 1990.

Balty, J. (ed.) 1984. *Apamée de Syrie: bilan des recherches archéologiques, 1973–1979: aspects de l'architecture domes-tique d'Apamée. Actes du colloque tenu à Bruxelles les 29, 30 et 31 mai 1980.* Bruxelles: Centre Belge de Recherches Archéologiques à Apamée de Syrie; Paris: Diffusion De Boccard.

Balty, J.-Ch. and D. Cazes 2005. *Sculptures antiques de Chiragan, I.1. Les portraits romains. Les Julio-Claudiens.* Toulouse: Musée Saint-Raymond.

Balty, J.-Ch. and D. Cazes 2008. *Sculptures antiques de Chiragan (Martres-Tolosane), I.5. Les portraits romains. La Tétrarchie,* Toulouse: Musée Saint-Raymond.

Balty, J.-Ch., D. Cazes, and E. Rosso 2012. *Sculptures antiques de Chiragan (Martres-Tolosane), I.2. Les portraits romains. Le siècle des Antonins.* Toulouse: Musée Saint-Raymond.

Banaji, J. 2001. *Agrarian Change in Late Antiquity: Gold, Labour and Aristocratic Dominance.* New York: Oxford University Press.

Bar, D. 2004. "Population, Settlement and Economy in Late Roman and Byzantine Palestine (70–641 AD)." *Bulletin of the School of Oriental and African Studies* 67: 307–20.

Baradez, J.L. 1949. *Vue-aérienne de l'organisation romaine dans le Sud-Algérien: Fossatum Africae.* Paris: Arts et métiers graphiques.

Baratte, F. 1978. *Mosaïques romaines et paléochrétiennes du musée du Louvre.* Paris: Éditions de la Réunion des musées nationaux.

Baratte, F. 1986. *Le trésor d'orfèvrerie romaine de Boscoreale*. Paris: Ministère de la culture et de la communication, Éditions de la Réunion des musées nationaux.

Barberan, S. et al. 2002. "Les *villae* de La Ramière à Roquemaure, Gard." In *Archéologie du TGV Méditerranée, Fiches de Synthèse, tome 3, Antiquité, Moyen Age, Epoque moderne*. Monographies d'Archéologie Méditerranéenne 10. 889–919.

Barbera Lombardo, E. 1965. "Riportati alla luce nei pressi di Mazara i resti di una villa patrizia del V o VI secolo." *Trapani* 10.5: 21–3.

Barbet, A. 2013. *Peintures romaines de Tunisie*. Paris: Éditions A. et J. Picard.

Barbet, A. and P. Miniero (eds.) 1999. *La Villa San Marco a Stabia*. Naples, Rome, and Pompei: Centre Jean Bérard, Ecole française de Rome, Soprintendenza archeologica di Pompei.

Barker, G.W. and J. A. Lloyd (eds.) 1991. *Roman Landscapes. Archaeological Survey in the Mediterranean Region*. Archaeological Monographs of the British School at Rome 2. London: British School at Rome.

Barley, M.W. and R.P.C. Hanson (eds.) 1967. *Christianity in Britain, 300–700*. Leicester: Leicester University Press.

Barnish, S. 1987. "Pigs, Plebeians and Potentes: Rome's Economic Hinterland." *PBSR* 55: 157–85.

Barral i Altet, X. (ed.) 1987. *Artistes, Artisans et Production Artistique au Moyen Âge. Colloque international, Centre national de la recherche scientifique, Université de Rennes II, Haute-Bretagne, 2–6 mai 1983*. Paris: Picard Ed.

Barraud, D. 1988. "Le site de 'La France', origines de Bordeaux antique." *Aquitania* 6: 3–59.

Barroso, R. et al. 1993. "El yacimiento de Tinto Juan de la Cruz (Pinto, Madrid). Algunas observaciones sobre el reparto de bienes y transformaciones de usos agrarios en época visigoda." In *IV Congreso de Arqueología Medieval Española*, vol. 2, 295–301. Alicante: Asociación Española de Arqueología Medieval, Diputación Provincia de Alicante.

Bartoccini, R. 1927. "Villa romana presso il cimitero israelitico di Homs." *Africa Italiana* 1: 226–32.

Bartoldus, M.J. 2012. *Palladius Rutilius Taurus Aemilianus: Welt und Wert spätrömischer Landwirtschaft*. Augsburg: Wißner-Verlag.

Barton, I.M. (ed.) 1996. *Roman Domestic Buildings*. Exeter: Exeter University Press.

Bartosiewicz, L. 2003. "'There's Something Rotten in the State . . .': Bad Smells in Antiquity." *European Journal of Archaeology* 6.2: 175–95.

Basile, B. 1992. "Stabilimenti per la lavorazione del pesce lungo le coste siracusane. Vendicari e Portopalo." In *V Rassegna di archeologia subacquea. V premio Franco Papò. Atti. Giardini Naxos 19–21 ottobre 1990*, 55–86. Messina: Edizioni P&M.

Basilopoulou, V. (ed.) 2005. *Αττική 2004, Ανασκαφές Ευρύματα, Νέα Μουσεία*. Athens: Ministry of Culture.

Basler, Đ., B. Čović and N. Miletić 1988. *Arheološki Leksikon Bosne i Hercegovine (vol 3)*. Sarajevo: Zemaljski muzej Bosne i Hercegovine.

Batović, Š. 1968. "Investigation of the Illyrian Settlement at Radovin." *Diadora. Glasilo arheoloskog muzeja u Zadru* 4: 53–74.

Bats, M. and J. Seigne 1972. "La villa gallo-romaine de St-Michel à Lescar (Bénéharnum)." *Bulletin de la Société des siences, lettres et arts de Pau*, p. 20–62.

Baum-vom Felde, P. C. 2001. "Zur Werkstatt der geometrischen Mosaiken der Villa bei Piazza Armerina und zu neuen Erkenntnissen der chronlogischen Einordnung ihrer Böden." In D. Paunier and C. Schmidt (eds.), *La mosaïque gréco-romaine VIII. Actes du VIIIe colloque internationale pour l'étude de la mosaïque antique et mediévale, Lausanne, 6–11 octobre 1997*, 111–21. Lausanne: Bibliothèque Historique Vaudoise.

Baum-vom Felde, P. C. 2003. *Die geometrischen Mosaiken der Villa bei Piazza Armerina. Analyse und Werkstattfrage*. Antiquitates 26, 2 vols. Hamburg: Kovac.

Baxandall, M. 1971. *Giotto and the Orators: Humanist Observers of Painting in Italy and the Discovery of Pictorial Composition, 1350–1450*. Oxford, UK: Clarendon Press.

Bayard D. and J.-L. Collart (eds.) 1996. *De la ferme indigène à la villa romaine. Colloque Amiens 1993*. Revue Archeologique de Picardie 11. Amiens: Université de Picardie Jules Verne.

Beard, M. 2007. *The Roman Triumph*. Cambridge, MA: Harvard University Press.

Beard, M. 2008. *The Fires of Vesuvius: Pompeii Lost and Found*. Cambridge, MA: Harvard University Press.

Beard, M. 2013. "Taste and the Antique; Visiting Pompeii in the Nineteenth Century." In Mattusch (ed.) 2013: 205–228.

Becher, M. and S. Dick (eds.) 2010. *Völker, Reiche und Namen im frühen Mittelalter (Mittelalter Studien 22)*. Munich: Wilhelm Fink.

Beck, H., D. Geuenich and H. Steuer (eds.) 2006. *Reallexikon der Germanischen Altertumskunde*, 2nd edn. Berlin and New York: Walter de Gruyter.

Becker, J. A. 2006. "The Villa delle Grotte at Grottarossa and the prehistory of Roman villas." *JRA* 19: 213–220.

Becker, J.A. and N. Terrenato (eds.) 2012. *Roman Republican Villas. Architecture, context, and ideology*. Ann Arbor: Michigan University Press.

Beckh, H. (ed.) 1895. (reprint 1994). *Geoponica sive Cassiani Bassi scholastici de re rustica eclogae*. Leipzig: Teubner.

Bedon, R. 2011. *Macellum, taberna, portus : les structures matérielles de l'économie en Gaule romaine et dans les*

régions voisines. Limoges: Presses universitaires de Limoges.

Begović Dvoržak, V. and I. Dvoržak Shrunk 2004. "Roman villas in Istria and Dalmatia, Part III: maritime villas." *Prilozi Instituta za Arheologiju u Zagrebu* 21: 65–90.

Begović, V. and Schrunk, I. 2011."A Late Antique Settlement in Madona Bay, Brijuni Islands." *Histria Antiqua* 20: 375–90.

Begović V., Kereković D. and Schrunk I. 2009. "The Archaeological Topography of Croatia in Classical Antiquity, Roman Villas in Croatia (Part of Roman Pannonia, Histria and Dalmatia)." In D. Kereković (ed.): 131–42.

Behrends, O. 1992. "Bodenhoheit und privates Bodeneigentum in Grenzwesen Roms." In Behrends and Capogrossi Colognesi (eds.) 1992: 192–284.

Behrends, O. and L. Capogrossi Colognesi (eds.) 1992. *Die römische Feldmesskunst. Interdisziplinaere Beitrage zu ihrer Bedeutung fur die Zivilisationgeschichte Roms*. Gottingen: Vandenhoeck & Ruprecht.

Bejaoui, F. 1997. "Îles et villes de la Méditerranée sur une mosaïque d'Ammaedara (Haïdra en Tunisie)." *CRAI et* 141: 825–58.

Bejaoui, F. 2002. "Deux villes italiennes sur une mosaïque de Haïdra." *AfrRom* 14: 503–8.

Bejaoui, F. (ed.) 2003. *Histoire des Hautes Steppes. Antiquité et Moyen-Age. Actes du Colloque de Sbeitla. Session 2001*. Tunis: Institut National du Patrimoine.

Bejaoui, F. (ed.) 2008. *Actes du 6^{ème} Colloque International sur l'Histoire des Steppes Tunisiennes. Sbeitla. Session 2006*. Tunis: Institut National du Patrimoine.

Bejor, G. 1986. "Gli insediamenti della Sicilia romana: distribuzione, tipologie e sviluppo da un primo inventario dei dati archeologici." In Giardina (ed.) 1986, vol. 3: 463–519.

Bek, L. 1980. *Towards Paradise on Earth. Modern Space Conception in Architecture. A Creation of Renaissance Humanism*. AnalRom Supplementum 9. Odense: Odense University Press.

Bek, L. 1983. "Quaestiones Convivales. The Idea of the Triclinium and the Staging of Convivial Ceremony from Rome to Byzantium." *AnalRom* 12: 81–107.

Bekker-Nielsen, T. and D. Bernal Casasola (eds.) 2010. *Ancient Nets and Fishing Gear: Proceedings of the International Workshop on "Nets and Fishing Gear in Classical Antiquity: A First Approach." Cádiz, November 15–17, 2007*. Cadiz and Aarhus: Universidad de Cádiz, Servicio de Publicaciones and Aarhus UP.

Belayche, N. 2001. *Iudaea Palaestina. The Pagan Cults in Roman Palestine (Second to Fourth Century)*. Tübingen: Mohr Siebeck.

Bellet, M.E. and J.-C. Mefre 1991. "L'habitat gallo-romain de Ratavous à Camaret (Vaucluse) et le cadastre B d'Orange." *Bulletin archéologique de Provence* 20: 23–31.

Beloch, J. 1890. *Campanien. Geschichte und Topographie des antiken Neapel und seiner Umgebung*, 2nd edn. Breslau: E. Morgenstern.

Beltrame, C. and D. Gaddi 2007. "Preliminary analysis of the hull of the Roman ship from Grado, Gorizia, Italy." *IJNA* 36: 138–47.

Beltrame, C., D. Gaddi, and S. Parizzi 2011. "A Presumed Hydraulic Apparatus for the Transport of Live Fish, Found on the Roman Wreck at Grado, Italy." *IJNA* 40.2: 274–82.

Bendala Galan, M., R. Castelo Ruano, and R. Arribas. 1998. "La villa romana de 'El Saucedo' (Talavera la Nueva, Toledo)." *Cuadernos de Prehistoria y Arqueología de la Universidad Autónoma de Madrid* 39: 298–310.

Benítez De Lugo, L. et al. 2011. "*Villae* en el *municipium* de *Mentesa Oretana*. Termas romanas y necrópolis tardo-romana en La Ontavia (Terrinches, Ciudad Real). Resultados de la investigación y proyecto de musealización." *Herakleion* 4: 69–124.

Benseddik, N. 2012. *Cirta-Constantina et son territoire*. Paris: Éditions Errance.

Bentmann, R. and M. Müller 1970. *Die Villa als Herrschftsarchitektur: Versuch einer kunst- und sozial-geschichtlicken Analyse*. Frankfurt am Main: Suhrkamp. (English transl.: *The Villa as Hegemonic Architecture*, trans. T. Spence and D. Craven. Atlantic Highlands, NJ 1992: Humanities Press.)

Bergmann, B. 1991. "Painted Perspectives of a Villa Visit: Landscape as Status and Metaphor." In Gazda (ed.) 1991: 49–70.

Bergmann, B. 1992. "Exploring the Grove: Pastoral Space on Roman Walls." In Hunt (ed.) 1992: 21–48.

Bergmann, M. 1999. *Chiragan, phrodisias, Konstantinopel: Zur mythologischen Skulptur der Spätantike*. Palilia 7. Wiesbaden: Reichert.

Bergmann, B. 2002. "Art and Nature in the Villa at Oplontis." In *Pompeian Brothels, Pompeii's Ancient History, Mirrors and Mysteries, Art and Nature at Oplontis, the Herculaneum "Basilica"*. JRA supplement 47, 87–120. Portsmouth, RI: Journal of Roman Archaeology.

Bernstein, A.H. 1978. *Tiberius Sempronius Gracchus: Tradition and Apostasy*. Ithaca, NY: Cornell University Press.

Bertelli, C., L. Malnati, and G. Montevecchi (eds.) 2008. *Otium. L' arte di vivere nelle domus romane di età imperiale*. Milan: Skira editore.

Berthier, A. 1962-5. "Établissements agricoles antiques à Oued-Athménia." *Bulletin d'Archéologie Algérienne* 1: 7–20.

Berthier, A. 2000. *Tiddis. Cité antique de Numidie.* MémAcInscr n.s. 20. Paris: De Boccard.

Bartoldus, M.J. 2012. *Palladius Rutilius Taurus Aemilianus: Welt und Wert spätrömischer Landwirtschaft.* Augsburg: Wißner-Verlag.

Beyen, H.G. 1928. *Über Stilleben aus Pompeji und Herculaneum.* Gravenhage: M. Nijhoff.

Bezeczky, T. 1995. "Amphorae and amphora stamps from the Laecanius workshop." *JRA* 8: 41–64.

Bezeczky, T. 1997. *The Laecanius Amphora Stamps and the Villas of Brijuni.* Vienna: Österreichischen Akademie der Wissenschaften.

Bianchi, B. 2004. "Pittura residenziale nella Tripolitania romana: lo stato degli studi e i nuovi dati." *AfrRom* 15: 1729–50.

Bianchi Bandinelli, R. 1954. "Sarcofago da Acilia con la designazione di Gordiano III." *BdA* 39.2: 200–20.

Bianchi Bandinelli, R. 1963. "Paesaggio." *EAA* 5: 819–28.

Bianchi Bandinelli, R. 1969. *L'arte romana nel centro del potere.* Milano: Rizzoli.

Bigi, E. 1971. "Bracciolini, Poggio." *Dizionario biografico degli Italiani* 13, s.v.

Bijovsky, G. 2006. "Coins from 'Ein ez-Zeituna," *'Atiqot* 51: 85–90.

Binsfeld, A. 2010. "Archäologie und Sklaverei: Möglichkeiten und Perspektiven einer Bilddatenbank zur antiken Sklaverei." In Heinen (ed.) 2010: 161–77.

Bintliff, J. (ed.) 1996. *Recent Developments in the History and Archaeology of Central Greece: Proceedings of the 6th International Boeotian Conference, Bradford University.* BAR-IS 666. Oxford: Archaeopress.

Birley, A.R. 1997. *Hadrian: The Restless Emperor.* London: Routledge.

Bishop, J. and L. Passi Pitcher 1988–9. "Palazzo Pignano (Cr). Pieve di San Martino. Chiesa battesimale." *NSAL* 1988–1989: 294–95.

Blackman, D. 2008. "Sea Transport, Part 2: Harbors." In *The Oxford Handbook of Engineering and Technology in the Classical World*, J.P. Oleson (ed.): 638–70. Oxford: Oxford University Press.

Blanchard, M. et al. 1973. "Repertoire graphique du décor géométrique dans la mosaïque antique." *BullAIEMA* 4th fascicule: Paris: AIEMA.

Blanchard-Lemée, M. 1975. *Maisons à mosaïques du quartier central de Djemila (Cuicul).* Études d'antiquités africaines. Paris: Editions Ophrys.

Blanchard-Lemée, M. 1988. "À propos des mosaïques de Sidi Ghrib: Vénus, le Gaurus et un poème de Symmaque." *MÉFRA* 100: 367–84.

Blanck, H. 1999. "Bibliotheken in römischen Villen und Palästen." In *Le ville romane dell'Italia e del Mediterraneo antico*, M. Aoyagi and S. Steingräber (eds.) 155–65. Tokyo: Tokyo University Press.

Blánquez Pérez, J. and S. Celestino Pérez (ed.) 2008. *El vino en época Tardoantigua y Medieval.* Madrid: Universidad Autónoma de Madrid.

Blázquez, J.M., C. Domergue and P. Sillières 2002. *La Loba (Fuenteobejuna, Province de Cordoue, Espagne). La mine et le village minier antiques.* Ausonius Mémoire 7. Bordeaux: Diffusion De Boccard.

Blázquez, J.M. and M.A. Mezquíriz 1985. *Mosaicos romanos de Navarra.* Corpus de mosaicos de España 7. Madrid: Instituto Español de Arquelogia.

Blázquez Martínez, J.M. 1994. "El entorno de las villas en los mosaicos de Africa e Hispania." *AfrRom* 10: 1171–87.

Blickle, P. 1981. *The Revolution of 1525: The German Peasants War from a New Perspective.* Transl. Brady Jr., T.A. and H.C. Midelfort. Baltimore, MD, and New York: Johns Hopkins University Press.

Bloch, M. 1942. *La société féodale. La formation des liens de dépendance.* Paris: Éditions Albin Michel.

Blondeau, C. et al. (eds.) 2013. In Ars Auro Gemmisque Prior. *Mélanges en hommage à Jean-Pierre Caillet.* Turnhout: Brepols.

Blue, L., F. Hocker, and A. Englert (eds.) 2006. *Connected by the sea. Proceedings of the 10th International Symposium on Boat and Ship Archaeology, Roskilde 2003.* Oxford: Oxbow Books.

Boak, A.E.R. 1955. *Manpower Shortage and the Fall of the Roman Empire in the West.* Ann Arbor, MI, and London: Michigan University Press and Geoffrey Cumberledge.

Bodel, J. 1997. "Monumental Villas and Villa Monuments." *JRA* 10: 5–35.

Bodel, J.P. 1999. "Punishing Piso." *AJP* 120: 43–63.

Boetto, G. 2006. "Roman Techniques for the Transport and Conservation of Fish: The Case of the Fiumicino 5 Wreck." In Blue, Hocker, and Englert (eds.) 2006: 123–9.

Boissier, G. 1895. *L'Afrique romaine. Promenades archéologiques en Algérie et en Tunisie.* Paris: Librairie Hachette.

Bon, S.E. and R. Jones (eds.) 1997. *Sequence and space in Pompeii.* Oxford: Oxbow.

Bonacasa Carra, R.M and E. Vitale (ed.) 2007. *La cristianizzazione in Italia tra tardoantico ed altomedioevo. Atti del IX congresso nazionale di archeologia cristiana.* Palermo: Carlo Saladino.

Bonacini, E., D. Gulli and D. Tanasi 2016. "3D Imaging Analysis and Digital Storytelling for Promotion of Cultural Heritage: The School Outreach Project of Realmonte." In *Proceedings of the 8th International Congress on Archaeology, Computer Graphics, Cultural Heritage and Innovation "ARQUEOLÓGICA 2.0", Valencia (Spain), Sept. 5–7, 2016*, 392–5. València: Editorial Univeristat Politècnica de València.

Bonamente, G. and K. Rosen (eds.) 1997. *Historiae Augustae Colloquium Bonnense.* Bari: Edipuglia.

Bonanno, A. 1997. "The Imperial Portraits from Malta: Their Contextual Significance." In Bouzek and Ondřejová (eds.) 1997: 62–4.

Bonanno, A. 1998. "Malta (Melite-Gaulos)." In Mayer i Olivé and Rodà de Llanza (eds.) 1998: 322–5.

Bonanno, A. 2005. *Malta. Phoenician, Punic, and Roman.* Malta: Midsea Books.

Bonanno, A. and Vella, N.C. 2012. "Past and Present Excavations of the Multi-Period Site." In Abela (ed.) 2012: 8–25.

Bonanno, C. et al. 2010. "Nuove esplorazioni in località Gerace (Enna, Sicilia)." In S. Menchelli et al. (eds.), *LRCW 3. Late Roman Coarse Wares, Cooking Wares and Amphorae in the Mediterranean. Archaeology and Archaeometry. Comparison between Western and Eastern Mediterranean.* BAR-IS 2185, 261–72. Oxford: Archaeopress.

Bonanno, C. 2014. "La villa romana di Gerace e altri insediamenti residenziali nel territorio ennese." In Pensabene and Sfameni (eds.): 79–94.

Bonanno Aravantinos, M. and S. Stucchi (eds.) 1991. *Giornate di studio in onore di Achille Adriani, Roma 1984, 26–27 nov.* Studi Miscellanei 28. Roma: "L'Erma" di Bretschneider.

Bonifacio, G. 2007a. "Ufficio Scavi di Stabia. C. mare di Stabia: indagini archeologiche nell'area del pianoro di Varano." *RivStPomp* 18: 197–9.

Bonifacio, G. 2007b. "Villa Carmiano." In Guzzo, Bonifacio, and Sodo (eds.): 57–61.

Bonifacio, G. and A.M. Sodo 2001. *Stabiae. Guida archeologica alle ville.* Castellammare di Stabia: Longobardi Editore.

Bonini, P. 2006. *La casa nella Grecia romana. Forme e funzioni dello spazio privato fra 1 e VI secolo.* Rome: Quasar.

Bonomi, S., E. Baggio, and S. Redditi 1997. "Le scoperte e gli scavi. Carta Archeologica di Montegrotto." In *Delle antiche Terme di Montegrotto. Sintesi archeologica di un territorio,* S. Bonomi (ed.). Montegrotto Terme.

Borbein, A.H. 1975. "Zur Deutung von Scherwand und Durchblick auf den Wandgemälden des zweiten pompejanischen Stils." In Andreae and Kyrieleis 1975: 61–70.

Borriello, M., M.P. Guidobaldi, and P.G. Guzzo (eds.) 2008. *Ercolano, tre secoli di scoperte.* Milan: Electa.

Bosch, M., R. Coll, and J. Font 2005. "La villa romana de Can Farrerons (Premià de Mar, Maresme). Resultats de les darreres intervencions." *Tribuna d'Arqueologia* 2001–2002: 167–89.

Boscolo, F. 2006. "I dendrofori nella Venetia et Histria." In *Misurare il tempo. Misurare lo spazio. Atti del Colloquio AIEGL,* M.G. Engeli Bertinelli and A. Donatin (eds.): 487–514. Faenza: *Fratelli Lega Editori.*

Boucheron, P., H. Broise, and Y. Thébert (eds.) 2000. *La brique antique et médiévale. Production et commercialisation.* CÉFR 272. Rome: École française de Rome.

Bougard, F. and G. Noyé 1989. "Squillace au Moyen Âge." In Spadea (ed.) 1989: 215–29.

Bouiron M. 2001. "Les espaces suburbains." In Bouiron and Tréziny 2001: 319–35.

Bouiron, M. and H. Tréziny (eds.) 2001. *Marseille. Trames et paysages urbains de Gyptis au Roi René, Actes du colloque international d'archéologie, Marseille, 3–5 nov. 1999.* Coll. Études massaliètes 7. Aix-en-Provence, Édisud.

Bouzek, J. and I. Ondřejová (eds.) 1997. *Roman Portraits. Artistic and Literary; Acts of the Third International Conference on the Roman Portraits Held in Prague and in the Bechyně Castle from 25 to 29 September 1989.* Mainz-am-Rhein: Philipp von Zabern.

Bowden, W. 2003. *Epirus Vetus: The Archaeology of a Late Antique Province.* London: Duckworth.

Bowden, W. 2008. "Cristianizzazione e status sociale nell'*Epirus Vetus* tardoantico: le evidenze archeologiche." *Antichità Altoadriatiche* 66: 301–32.

Bowden, W. 2011. "'Alien Settlers Consisting of Romans': Identity and Built Environment in the Julio-Claudian Foundations of Epirus in the Century After Actium." In Sweetman (ed.) 2011: 101–16.

Bowden, W., L. Lavan, and C. Machado (eds.) 2004. *Recent Research on the Late Antique Countryside.* Late Antique Archaeology 2. Leiden and Boston: Brill.

Bowden, W. and L. Përzhita 2004. "Archaeology in the Landscape of Roman Epirus: Preliminary Report on the Diaporit Excavations, 2000–3." *JRA* 17: 413–34.

Bowe, P. and M.D. DeHart 2011. *Gardens and Plants of the Getty Villa.* Los Angeles, CA: Getty.

Bowersock, G.W. 1961. "Eurycles of Sparta." *JRS* 51: 112–18.

Bowersock, G.W. 1990. *Hellenism in Late Antiquity.* Ann Arbor, MI. University of Michigan Press.

Bowersock, G.W. et al. (eds.) 1986. *Colloque genèvois sur Symmaque: à l'occasion du mille six centième anniversaire du conflit de l'autel de la Victoire: douze exposés, suivis de discussions.* Paris: Les Belles Lettres.

Bowersock, G.W., P. Brown, and O. Grabar (eds.) 1999. *Late Antiquity: A Guide to Postclassical World.* Cambridge, MA: Harvard University Press.

Bowersock, G.W. and T.J. Cornell (eds.) 1994. *Studies on Modern Scholarship.* Berkeley: University of California Press.

Bowes, K. 2001. "'... Nec sedere *in* Villa.' Villa-Churches, Rural Piety, and the Priscillianist Controversy." In Burns and Eadie (eds.) 2001: 323–48.

Bowes, K. 2005. "'Une coterie espagnole pieuse': Christian Archaeology and Christian Communities in Fourth- and Fifth-Century Hispania." In Bowes and Kulikowski (eds.) 2005: 189–258.

Bowes, K. 2006. "Building Sacred Landscapes: Villas and Cult." In Chavarría, Arce, and Brogiolo (eds.) 2006: 73–95.

Bowes, K. 2007. "'Christianization' and the Rural Home." JECS 15.2: 143–70.

Bowes, K. 2008. Private Worship, Public Values and Religious Change in Late Antiquity. Cambridge, UK: Cambridge University Press.

Bowes, K. 2010. Houses and Society in the Later Roman Empire. London: Duckworth.

Bowes, K. 2011. "Inventing Ascetic Space: Houses, Monasteries and the 'Archaeology of Monasticism'." In Dey and Fentress (eds.): 315–51.

Bowes, K. and A. Gutteridge 2005. "Rethinking the Later Roman Landscape." JRA 18: 405–18.

Bowes, K. and M. Kulikowski (eds.) 2005. Hispania in Late Antiquity: Current Perspectives. Leiden: Brill.

Bowman, A.K. and A.I. Wilson (eds.) 2013. The Roman Agricultural Economy. Organisation, Investment, and Production. Oxford Studies on the Roman Economy. Oxford: Oxford University Press.

Boyancé, P. 1969. "Le colonel Jean Baradez (1895-1969)." MÉFRA 81: 861–2.

Boyce, G.K. 1937. Corpus of the Lararia of Pompeii. MAAR 14. Rome: American Academy in Rome.

Bozzi C. 1968. "Gli intonaci dipinti." In Missione Archeologica Italiana a Malta. Rapporto preliminare della campagna di scavo 1967, 75–82. Rome: Istituto di Studi del Vicino Oriente.

Braconi, P. and Uroz-Sáez, J. (eds.) 1999. La villa di Plinio il Giovane a San Giustino: primi risultati di una ricerca in corso. Perugia: Quattroemme.

Bradley, K. 2010. "Römische Sklaverei: Ein Blick zurück und eine Vorschau." In Heinen (ed.) 2010: 15–38.

Bradley, K. and P. Cartledge (eds.) 2011. The Cambridge World History of Slavery. Vol. 1, The Ancient Mediterranean World. Cambridge: Cambridge University Press.

Brajković, D. and Paunović, M. 2001. "La faune des vertébrés du site archéologique de Loron." In Tassaux, Matijašić and Kovačić (eds.): 279–91.

Branciforti, M. G. 2010. "Da Katane a Catina." In M. G. Branciforti and V. La Rosa (eds.), Tra lava e mare. Contributi all'archaiologhia di Catania. Atti del Convegno, 135–258. Catania: Le Nove Muse Editrice.

Braund, D. 1985. Augustus to Nero: A Source Book on Roman History 31 BC–AD 68. London and Totowa, NJ: Croom Helm and Barnes and Noble Books.

Breccia, E. 1926. Monuments de l'Egypte gréco-romaine, vol. I. Le rovine e i monumenti di Canopo. Teadelfia e il tempio di Pneferôs. Bergamo: Officine dell'Istituto italiano d'arti grafiche.

Breda, A. and I. Venturini 2007. "Cazzago San Martino (Bs). Località Bornato, ex pieve di San Bartolomeo." NSAL 2005–2007: 40–45.

Bremmer, J. N. 2008. Greek Religion and Culture, the Bible, and the Ancient Near East. Leiden: Brill.

Brenk, B. 1999. "La cristianizzazione della Domus dei Valerii sul Celio." In Harris (ed.) 1999: 69–84.

Bresson, A. 2007. L'économie de la Grèce des citiés (fin VIe-Ier siècle a. C.)., vol. I. Les structures et la production. Paris: A. Colin.

Bricault L. and R. Veymiers (eds.) 2011. Les cultes isiaques en Grèce: actes du IVe colloque international sur les études isiaques, troisième journée, Liège, 29 novembre 2008: Michel Maliase in honorem. Bordeaux: Ausonius Éditions.

Bringmann, K. 1985. Die Argrarreform des Tiberius Gracchus. Legende und Wirklichkeit. Frankfurter historische Vorgträge 10. Stuttgart: Fr. Steiner.

Brockmeyer, N. 1975. "Die Villa Rustica als Wirtschaftsform und die Ideologisierung der Landwirtschaft." Ancient Society 6: 213–28.

Brogan, O. 1964. "The Roman Remains in the Wadi el-Amud. An Interim Note." Libya Antiqua 1: 47–56.

Brogiolo, G.P. 1991. "Il popolamento e l'organizzazione del territorio tra età romana e l'alto medioevo." In Atlante del Garda. Uomini, vicende, paesi, Catalogo della mostra organizzata nel ventennale di fondazione dell'ASAR, 143–165. Brescia: ASAR.

Brogiolo, G.P. 1994. "Castra tardo antichi (IV–metà VI)." In Francovich and Noyé (eds.): 151–8.

Brogiolo, G.P. (ed.) 1994. Edilizia residenziale tra V e VIII secolo, 4° Seminario sul Tardoantico e l'Altomedioevo in Italia centrosettentrionale, Monte Barro-Galbiate (Lecco) 2–4 settembre 1993. Documenti di Archeologia 4. Mantua: Padus.

Brogiolo, G.P. 1996. "Conclusioni." In Brogiolo (ed.) 1996: 107–10.

Brogiolo, G.P. (ed.) 1996. La fine delle ville romane: trasformazioni nelle campagne tra tarda antichità e altomedioevo, 1° Convegno Archeologico del Garda, Gardone Riviera-Brescia 14 ottobre 1995. Documenti di Archeologia 11. Mantua: Società Archeologica Padana.

Brogiolo, G.P. 1997. "Continuità tra tarda antichità e altomedioevo attraverso le vicende delle villae." In Roffia (ed.) 1997: 299–313.

Brogiolo, G.P. 2002. "Oratori funerari tra VII e VIII secolo nelle campagne transpadane." Hortus Artium Medievalium 8: 8–31.

Brogiolo, G.P. (ed.) 2003. Chiese e insediamenti nelle campagne tra V e VI secolo. 9° Seminario sul Tardoantico e l'Alto Medioevo (Garlate, 26–28 settembre 2002).

Documenti di Archeologia 30. Mantua: Società Archeologica Padana.

Brogiolo, G.P. 2006. "La fine delle ville: dieci anni dopo." In Chavarría, Arce, and Brogiolo 2006: 253–73.

Brogiolo, G.P., G. Bellosi, and L. Vigo Doratiotto (eds.) 2002. *Testimonianze archeologiche a S. Stefano di Garlate*. Garlate: Parrocchia di S. Stefano.

Brogiolo, G.P. and A. Chavarría Arnau 2003. "Chiese e insediamenti tra V–VI secolo: Italia settentrionale, Gallia meridionale e Hispania." In Brogiolo (ed.) 2003: 9–37.

Brogiolo, G.P. and A. Chavarría Arnau, 2005. *Aristocrazie e campagna nell'Occidente da Costantino a Carlo Magno*. Metodi e temi dell'Archeologia Medievale 1. Florence: All'Insegna del Giglio.

Brogiolo, G.P. and A. Chavarría Arnau, 2008. "El final de las villas y las transformaciones del territorio rural en el Occidente (siglos V–VIII)." In Fernández Ochoa, García-Entero, and Gil Sendino (eds.) 2008: 193–213.

Brogiolo, G.P. and A. Chavarría Arnau (eds.) 2007. *Archeologia e società nell'Alto Medioevo, 11° Seminario sul tardo antico e l'alto medioevo (Padova, 2005)*. Documenti di Archeologia 44. Mantova: Società Archeologica Padana.

Brogiolo, G.P., A. Chavarría Arnau, and M. Valenti (eds.) 2005. *Dopo la fine delle ville: evoluzione nelle campagne tra VI e IX secolo, 11° Seminario sul tardoantico e l'alto medioevo, Gavi, 8–10 maggio 2004*. Documenti di Archeologia 40. Mantua: Società Archeologica Padana.

Brogiolo, G.P., N. Gauthier, and N. Christie (eds.) 2000. *Towns and their Territories between Late Antiquity and the Early Middle Ages*. Leiden: Brill.

Broise, H. and X. Lafon 2001. *La villa Prato de Sperlonga*. CÉFR 285. Rome: École française de Rome.

Broshi, M. 1979. "The Population of Western Palestine in the Roman-Byzantine Period." *BASOR* 236: 1–10.

Brotóns Yagüe, F. and L. López-Mondéjar 2010. "Poblamiento rural romano en el Noroeste Murciano." In Noguera Celdrán (ed.) 2010: 413–38.

Brown, P. 1971. *The World of Late Antiquity from Marcus Aurelius to Muhammad*. London: Thames & Hudson.

Brown, P. 1992. *Power and Persuasion in Late Antiquity. Towards a Christian Empire*. Madison, WI, and London: Wisconsin University Press.

Bruggisser, P. 1993. *Symmaque ou le rituel épistolaire de l'amitié littéraire. Recherches sur le premier livre de la correspondance*. Fribourg: Éditions Universitaires Fribourg Suisse.

Brun, J.-P. 1999. *Carte archéologique de la Gaule, Le Var. 83/2*. Paris: Maison des Sciences de l'Homme.

Brun, J.-P. 2003. "Les pressoirs à vin d'Afrique et de Maurétanie à l'époque romaine." *Africa. Série Séances Scientifiques* 1: 7–30.

Brun, J.-P. 2004. *Archéologie du vin et de l'huile dans l'Empire romain*. Paris: Éditions Errance.

Brun, J.-P. 2005. *Archéologie du vin et de l'huile en Gaule romaine*. Paris: Errance.

Brunet, J.-Ch. (ed.) 1860–5 (reprint 1965–6). *Manuel du libraire et de l'amateur de livres*. 5ème édition refondue et augmentée d'un tiers par l'auteur, 7 vols. Paris: G.-P. Maisonneuve et Larose.

Bruno, B. 2004. *L'Arcipelago maltese in età Romana e Bizantina: attività economiche e scambi al centro del Mediterraneo*. Bari: Edipuglia.

Bruno, V. J. and R.T. Scott 1993. *The Houses. Cosa IV*. MAAR 38. University Park, PA: Pennsylvania State University Press.

Bruno B. and R. Tremolada 2011. "Castelletto di Brenzone: recenti indagini presso la chiesa di San Zeno de l'Oselet." In *Nuove ricerche sulle chiese altomedievali del Garda. 3° Convegno Archeologico del Garda (Gardone Riviera, 6 novembre 2010)*, G.P. Brogiolo (ed.): 85–106. Mantua: SAP.

Brunt, P.A. 1971. *Italian Manpower, 225 B.C.–A.D. 14*. Oxford: Clarendon Press.

Büchler, A. 1909. *The Political and Social Leaders of the Jewish Community of Sepphoris in the Second and Third Centuries*. London: n.p.

Buck, R. 1983. *Agriculture and Agricultural Practice in Roman Law*. Wiesbaden: Franz Steiner Verlag.

Buda, G., M.R. Grasso and F. Privitera 2013. *Torre Rossa. La riscoperta di un sito archeologico a Fiumefreddo di Sicilia*. Fiumefreddo: Comune di Fiumefreddo di Sicilia.

Buffat, L. 2012. *L'économie domaniale en Gaule Narbonnaise. Les villas de la cité de Nîmes*. Lattes: Monographies d'Archéologie Méditerranéenne, 29.

Buffat, L., A. Masbernat, and S. Longepierre 2005. "Entre villa et auberge : Croix de Fenouillé (Castillon-du-Gard)." In *Les campagnes dans l'Antiquité : la villa gallo-romaine*. Archéologies Gardoises, 2, Conseil Général du Gard, 73–7.

Bullo, S. and F. Ghedini 2003. Amplissimae atque ornatis-simae domus *(Aug. civ., II,20,26)*. *L'edilizia residenziale nelle città della Tunisia romana. Saggi*. Antenor Quaderni 2.1 and 2.2. Rome: Edizioni Quasar.

Burnand, Y. 1975. *Domitii Aquenses. Une famille de chevaliers romains de la région d'Aix-en-Provence. Mausolée et domaine*. Paris: De Boccard.

Burns, T.S. and J.W. Eadie (eds.) 2001. *Urban Centers and Rural Contexts in Late Antiquity*. East Lansing, MI: Michigan State University Press.

Busana, M.S. 2002. *Architetture rurali nella Venetia romana*. Roma: "L'Erma" di Bretschneider.

Busana M.S. 2009. "Le ville." In Moenibus et portu cel-eberrima. *Aquileia. Storia di una città*, F. Ghedini,

M. Bueno, and M. Novello (eds.): 171–82. Rome: Libreria dello Stato.

Butcher, A.F. 1987. "English Urban Society and the Revolt of 1381." In Hilton and Alton (eds.): 84–111.

Cacciaguerra, G. 2011. "Tra insediamenti ellenistici e romani nel territorio di Priolo Gargallo." In D. Malfitana and G. Cacciaguerra (eds.), *Priolo romana, tardo romana e medievale. Documenti, paesaggi, cultura materiale*, vol. I, 155–72. Catania: IBAM–CNR.

Cadenat, P. 1974. "La villa berbéro-romaine d'Aïn-Sarb (Départment de Tiaret, Algérie)." *AntAfri* 8: 73–88.

Cafasso, G., J. Ehrard, G.P. Migliaccio, and L. Vallet (eds.) 1998. *Il Vesuvio e le città vesuviane 1730–1860. In ricordo di George Vallet 1998*. Naples: CUEN.

Cagiano de Azevedo, M. 1986. "Ville rustiche tardoantiche e installazioni agricole altomedievali." In Fonseca, Adamesteanu, and D'Andria (eds.) 1986: 313–48.

Cagnat, R. and A. Merlin (eds.) 1920. *Atlas archéologique de la Tunisie. Édition spéciale des cartes topographiques publiées par le ministère de la guerre, accompagnée d'un text explicatif*. Deuxième Série. Paris: Éditions E. Leroux.

Cagnetta, M. (ed.) 1993. *L'edera di Orazio: aspetti politici del bimillenario oraziano*. Venosa: Osanna Venosa.

Cahn, H.A. and E. Simon (eds.) 1980. *Tainia: Roland Hampe Zum 70. Geburtstag Am 2. Dezember 1978*. Mainz-am-Rhein: Philipp von Zabern.

Caille, J. 2005. "Les remparts de Narbonne des origines à la fin du Moyen-Âge." In Reyerson (ed.) 2005: 9–37.

Caillemer, A. and R. Chevallier 1954. "*Les centuriations de l'Africa vetus*." *AnnESC* 11: 433–60.

Calderone, S. 1988. "Contesto storico, committenza e cronologia." In Rizza (ed.): 45 -57.

Callu J.-P. 1972. *Symmaque, Lettres*, Tome 1. Paris: Les Belles lettres.

Cairou, R. 1976. "Narbonne: vingt siècles de fortifications, première partie." *Bulletin de la Commission archéologique de Narbonne* 38: 1–63.

Cam, M.-Th. 2002. *M. Cetius Faventinus concordance: documentation bibliographique, lexicale et grammaticale*. Hildescheim: Olms-Weidmann.

Camardo, D. 2009. "I medici nel mondo romano ed il problema dei valetudinari a Stabiae." *Oebalus* 4: 273–87.

Camardo, D. and A. Ferrara (eds.) 2001. *Stabiae dai Borbone alle ultime Scoperte*. Castellammare di Stabia: Longobardi Editore.

Cameron, A. 1965. "The Fate of Pliny's Letters in the Late Empire." *CQ* 15: 289–98.

Cameron, A. 1967. "Pliny's Letters in the Later Empire: An Addendum." *CQ* 17: 421–2.

Campana, S. and S. Piro 2009. "Putting Everything Together: GIS-Based Data Integration and Interpretation." In Campana and Piro (eds.) 2009: 325–30.

Campana, S. and S. Piro (eds.) 2009. *Seeing the Unseen: Geophysics and Landscape Archaeology*. London: CRC Press.

Campbell, J. 1986. *Essays in Anglo-Saxon History*. London: Hambledon Press.

Campbell, J.B. 2000. *The Writings of the Roman Land Surveyors: Introduction, Text, Translation and Commentary*. Journal of Roman Studies Monograph 9. London: Society for the Promotion of Roman Studies.

Campos Carrasco, J.M. (ed.) 2017. *Los Puertos Atlánticos Béticos y Lusitanos y su relación comercial con el Mediterráneo*. Hispania Antigua, Serie Arqueológica, 7. Rome: L'Erma di Bretschneider.

Cantino Wataghin, G. 1994, "Tardoantico e Alto Medioevo nel territorio padano." In Francovich and Noyé (eds.): 142–50. Florence: All'Insegna del Giglio.

Cantino Wataghin, G. 1996. "Les édifices à rotonde de l'antiquité tardive: quelques remarques." In Jannet and Sapin (eds.) 1996: 203–28.

Cantino Wataghin, G. 1997. "Archeologia dei monasteri l'altomedioevo." In Gelichi (ed.) 1997: 265–67.

Cantino Wataghin, G. 1999. " … *Ut haec aedes Christo Domino in ecclesiam consecretur*. Il riuso Cristiano di edifici antichi tra tarda antichità e alto medioevo." In *Ideologie e pratiche del reimpiego nell'alto medioevo*, 643–749. Spoleto: Centro italiano di studi sull'Alto Medioevo.

Cantino Wataghin, G. 2013. "Vescovi e territorio: l'Occidente tra IV e VI secolo." In *Atti del XV Congresso Internazionale di Archeologia Cristiana (Toledo 8-12.9 2008) - Episcopus, civitas territorium*. Studi di Antichità Cristiane LXV, 431–62. Vatican City: Studi di Antichità Cristiana.

Cao, I. 2010. *Alimenta: il racconto delle fonti*. Padua: Il Poligrafo.

Capasso, M. 2010. "Who Lived in the Villa of the Papyri at Heculaneum? A Settled Question?" In Zarmakoupi (ed.): 89–114.

Capogrossi Colognesi, L. 1994. "Introduzione al dibattito." In *L'Italie d'Auguste à Dioclétien: actes du colloque international (Rome, 25–28 mars 1992)*. CÉFR 198, 207–13. Rome: École française de Rome.

Caputo, P. 2005. "Una domus-villa urbana a Cuma, in Campania, e il suo rapporto con la città." In Ganschow and Steinhart (eds.): 39–46.

Caputo, G., Ghedini, F. 1984. "Il tempio di Ercole a Sabratha." *Monumenti di Archeologia Libica* 19: 102ff.

Carafa, P. 1998. *Il Comizio di Roma dalle origini all'eta' di Augusto*. Rome: "L'Erma" di Bretschneider.

Carandini, A. 1964. *Ricerche sullo stile e la cronologia dei mosaici della villa di Piazza Armerina*. Studi Miscellanei 7. Rome: L'Erma di Bretschneider.

Carandini, A. 1988. *Schiavi in Italia. Gli strumenti pensanti dei romani fra tarda repubblica e medio impero*. Rome: Nuova Italia Scientifica.

Carandini, A. 1989. "La villa romana e la piantagione schiavistica." In *Storia di Roma. Caratteri e Morfologie*, Gabba and Schiavone (eds.): vol. 4. 101–200.

Carandini, A. 1993. "Paesaggi agrari meridionali ed etruschi a confronto." In Cagnetta (ed.): 239–45.

Carandini, A. 1994. "I paesaggi agrari dell'Italia romana visti a partire dal'Etruria." In *L'Italie d'Auguste à Dioclétien. Actes du colloque international organisé par l'École française de Rome, l'École des hautes études en sciences sociales, le Dipartimento di scienze storiche, archeologiche dell'antichità di Roma La Sapienza et le Dipartimento di scienze dell'antichità dell'università di Trieste*, 167–74. CÉFR 198. Paris and Rome: De Boccard and "L'Erma" di Bretschneider.

Carandini, A. (ed.) 2000. *Roma antica*. Roma-Bari: Laterza.

Carandini, A. 2002. "Introduzione: risveglio dopo un decennio." In Carandini et al. (eds.): 5–12.

Carandini, A. 2004. *Palatino, Velia e Via Sacra, Paesaggi urbani attraverso il tempo*. Rome: Edizioni dell'Ateneo.

Carandini, A. 2010. *Le case del potere nell'antichità*. Rome and Bari: Laterza.

Carandini, A., L. Cracco Ruggini, and A. Giardina (eds.) 1993. *Storia di Roma III.2, L'età tardoantica. I luoghi e le culture*. Torino: Einaudi.

Carandini, A., M.T. D'Alessio, and H. Di Giuseppe (eds.) 2006. *La fattoria e la villa dell'Auditorium nel quartiere Flaminio di Roma*. Rome: "L'Erma" di Bretschneider.

Carandini, A. and M.R. Filippi (eds.) 1985. *Settefinestre: una villa schiavistica nell'Etruria romana*, 3 vols. Modena: Panini.

Carandini, A., A. Ricci, and M. de Vos 1982. *Filosofiana. La Villa di Piazza Armerina*. Palermo: Flaccovio.

Carandini, A. and S. Settis, 1979. *Schiavi e padroni del Etruria Romana. La Villa di Settefinestre dallo scavo alla mostra*. Bari: De Donato.

Carandini, A. and T. Tatton-Brown, 1980. "Excavations at the Roman Villa of 'Sette Finestre' in Etruria. 1975–79. First Interim Report." In Painter (ed.) 1980: 9–43.

Carandini, A. et al. (eds.) 2002. *Paesaggi d'Etruria: Valle dell'Albegna, Valle d'Oro, Valle del Chiarone, Valle del Tafone: progetto di ricerca italo-britannico seguito allo scavo di Settefinestre*. Rome: Edizioni di storia e letteratura.

Carcopino, J. 1939 (1975). *La vie quotidienne à Rome à l'apogée de l'Empire*, new edition. Paris: Hachette.

Carile, M.C. 2011. "Memories of Buildings? Messages in Late Antique Architectural Representations." In Lymberopoulou (ed.): 15–33.

Carlsen, J. 1995. *Vilici and Roman Estate Managers until AD 284*. AnalRom Supplementum 24. Rome: "L'Erma" di retschneider.

Carlsen, J. 1998. "The Rural Landscape of the Segermes Valley: Some Propositions." *AfrRom* 12: 239–47.

Carlsen, J. and E. Lo Cascio (eds.) 2009. *Agricoltura e scambi nell'Italia tardo-repubblicana*. Bari: Edipuglia.

Carlsen, J., P. Ørsted, and J.E. Skydsgaard (eds.) 1994. *Landuse in The Roman Empire*. Rome: "L'Erma" di Bretschneider.

Carneiro, A. 2009. "Sobre a cristianização da Lusitânia: novas reflexões a partir dos dados históricos e das evidências arqueológicas." *Espacio, Tiempo y Forma. Serie I, Nueva época. Prehistoria y Arqueología* 2: 205–20.

Carpenter, R., A. Bon and A.W. Parsons 1936. *The Defenses of Acrocorinth and the Lower Town. Corinth.* Vol. I, Part II. Cambridge, MA: Published for the American School of Classical Studies at Athens, Harvard University Press.

Carrara, M. 2005a. "La Villa di Livia a Prima Porta da praedium suburbanum a villa Caesarum." In Santillo Frizell and Klynne (eds.) 2005: 25–32.

Carrara, M. 2005b. "ad Gallinas Albas." *LTUR* 3: 17–24.

Carrasco, M. and M.A. Elvira 1994. "Marfiles coptos em Valdetorres Del Jarama, Madrid." *ArchEspArq* 67: 201–8.

Carré, M.-B. and Auriemma, R. 2009. "*Piscinae* e *vivaria* nell'Adriatico settentrionale." In Pesavento Mattioli and Carré: 83–100.

Carrié, J.-M. and R. Lizzi Testa (eds.) 2002. *"Humana Sapit." Études d'antiquité tardive offertes à Lellia Cracco Ruggini*. Turnhout: Brepols.

Carrington, R.C. 1931. "Studies in the Campanian 'Villae Rusticae'." *JRS* 21: 110–30.

Carruthers, M. 1998. *The Craft of Thought: Meditation, Rhetoric and the Making of Images, 400–1200*. Cambridge, UK: Cambridge University Press.

Carruthers, M. (ed.) 2010. *Rhetoric beyond Words: Delight and Persuasion in the Arts of the Middle Ages*. Cambridge, UK: Cambridge University Press.

Carta archelogica del Veneto. 1988–. Modena: Panini and Venice: Regione del Veneto.

Carta archeologica della Lombardia. 1991–. Modena: Panini.

Carta archeologica e ricerche in Campania, L. Quilici and S. Quilici Gigli (eds.) 2001–. Rome: "L'Erma" di Bretschneider.

Carte archéologique de la Gaule. 1990–. Paris: Académie des Inscriptions et Belles-Lettres.

Carter, F. 1777. *A Journey from Gibraltar to Malaga*. London: T. Cadell.

Cartledge, P. and A.J.S. Spawforth 2002. *Hellenistic and Roman Sparta. A Tale of Two Cities.* London and New York: Routledge.

Caruana, A.A. 1881. *Recent Discoveries at Notabile.* Malta: Government Printing Press.

Caruana, A.A. 1889. *Remains of an Ancient Greek Building Discovered in Malta in February 1888.* Malta: Government Printing Press.

Carucci, M. 2007. *The Romano-African* Domus. *Studies in Space, Decoration and Function.* BAR-IS 1731. Oxford: Tempus Reparatum.

Carusi, C. 2008. *Il sale nel mondo Greco (VI a.C. – III d. C.). Luoghi di produzione, circolazione commerciale, regimi di sfruttamento nel contesto del Mediterraneo antico.* Bari: Edipuglia.

Caruso, I. 1995. "La villa romana di Marina di S. Nicola a Ladispoli." In Christie (ed.): 291–6.

Carver, M.O.H., S. Massa, and G.P. Brogiolo 1982. "Sequenza insediativa romana e altomedievale alla Pieve di Manerba (BS)." *Archeologia Medievale* 9: 237–98.

Casali di ieri casali di oggi. Architetture rurali e tecniche agricole nel territorio di Pompei e Stabiae. 2000. Napoli: Arte Tipografica.

Casalis, L. and A. Scarfoglio 1988. *Il tesoro di Boscoreale (gli argenti del Louvre e il corredo domestico della "Pisanella").* Milan: Franco Maria Ricci Editore.

Casas i Genover, J. 1988. *L'Olivet d'en Pujol i Els Tolegassos. Dos establiments agrícoles d'època romana a Viladamat (Campanyes de 1982 a 1988).* Série Monogràfica 10. Gerona: Centre d'Investigaciones Arqueológicas de Girona.

Casas i Genover, J. and V. Soler Fusté 2003. *La villa de Tolegassos. Una explotación agrícola de época romana en el territorio de Ampurias.* BAR-IS 1101. Oxford: Hadrian Books.

Casas i Genover, J. and V. Soler Fusté, V. 2004. *Intervenciones arqueológicas en Mas Gusó (Gerona). Del asentamiento precolonial a la villa romana.* BAR-IS 1215. Oxford: Hadrian Books.

Casas i Genover, J., P. Castanyer i Masoliver, J. Tremoleda i Trilla, and J.M. Nolla i Brufau 1995. *La vil.la romana de la Font del Vilar (Avinyonet de Puigventós, Alt Empordà).* Estudis Arqueològics 2. Girona: Aula de Prehistòria i Món Antic, Universitat de Girona,

Cassieri, N. 2000. *La Grotta di Tiberio e il Museo Archeologico Nazionale di Sperlonga.* Rome: Istituto poligrafico e Zecca dello Stato.

Casson, L. 2001. *Libraries in the Ancient World.* New Haven and London: Yale University Press.

Castagna, L. and E. Lefèvre (eds.) 2003. *Plinius der Jüngere und seine Zeit.* Beiträge zur Altertumskunde 187. Munich: K. G. Saur.

Castanyer, P. and J. Tremoleda 1999. *La vil·la romana de Vilauba. Un exemple de l'ocupació i explotació romana del territori a la comarca del Pla de l'Estany.* Girona: Ajuntament de Banyoles.

Castanyer, P. and J. Tremoleda 2007. *Vilauba. Descobrim una vil·la romana.* Figuers: Ayuntament.

Castanyer, P. and J. Tremoleda 2008. "Arquitectura i instrumentum domesticuma la vil·la de Vilauba al segle III dC." In Nolla i Brufau (ed.): 35–77.

Castellanos, S. and I. Martín Viso (eds.) 2008. *De Roma a los bárbaros: poder central y horizontes locales en la cuenca del Duero.* León: Universidad de León.

Castelo Ruano, R. et al. 1998. "La villa de el Saucedo y su conversión en basílica de culto cristiano. Algunas notas sobre el mosaico de iconografía pagana ubicado en su cabecera." Paper read at V Reunió d'Arqueologia Cristiana Hispànica, 2000, at Cartagena.

Castillo Ramírez, E. 2005. *Tusculum,* 3 vols. Rome: "L'Erma" di Bretschneider.

Castrorao Barba, A. 2013. "La fine delle ville romane in Italia tra tarda antichità e alto Medioevo (3.-8. secolo)." PhD Thesis, Università degli studi di Siena.

Catarsi dall'Aglio, M. (ed.) 2005. *La villa romana di Cannetolo di Fontanellato.* Bologna: TAV Edizioni.

Cau, M.A. et al. 2012 (C. Mas, G. Ripoll, F. Tuset, M. Valls, M. Orfila, and M.J. Rivas). "El conjunto eclesiástico de la Illa del Rei (Menorca, Islas Baleares)." *Hortus Artium Medievalium* 18.2: 415–32.

Cavanagh, W.G. et al. (eds.) 2002. *The Laconia Survey. Continuity and Change in a Greek Rural Landscape I, Methodology and Interpretation.* ABSA supplement 26. London: British School at Athens.

Cavanaugh, W. et al. (eds.) 2005 (C. Mee, P. James, N. Brodie and T. Carter). *The Laconia Rural Sites Project.* ABSA supplement 36. London: British School at Athens.

Cavanaugh, W., C. Mee, P. James, N. Brodie and T. Carter (eds.) 2005. *The Laconia Rural Sites Project.* ABSA supplement 36. London: British School at Athens.

Cébeillac-Gervasoni, M. (ed.) 1996. *Les élites municipales de l'Italie péninsulaire des Gracques à Néron. Actes de la table ronde internationale, Clermont-Ferrand 28–30 novembre 1991.* CÉFR 215. Naples and Rome: Centre Jean Bérard and École française de Rome.

Cébeillac-Gervasoni, M. and L. Lamoine (eds.) 2003. *Les élites et leurs facettes: les élites locales dans le monde hellénistique et romain.* Rome and Clermont-Ferrand: École française de Rome and Presses universitaires Blaise-Pascal.

Čečuk B. et al. (eds.) 1976. *Jadranska obala u protohistoriji. Kulturni i etnički problemi. Simpozij Dubrovnik 1972.* Zagreb: Sveučilišna naklada Liber.

Celani, A. 1998. *Opere d'arte greche nella Roma d'Augusto*. Naples: Edizioni scientifiche italiane.

Celuzzi, M.-G. and E. Regoli 1982. "La Valle d'Oro nel territorio di Cosa. Ager Cosanus e ager Veientanus a confronto." *Dialoghi di Archeologia* n.s. 4, 31–62.

Cencic, J. 2003. "Römische Wohnbauten in Carnuntum." *Carnuntum-Jahrbuch: Zeitschrift für Archäologie und Kulturgeschichte des Donauraumes*: 9–116.

Centonze, L. 1999. *Vizi, costume e peccati nelle ville romane di Sicilia. Il Casale di Piazza Armerina*. Palermo: Walter Farina Editore.

Cervera Vera, L. 1978. *El códice de Vitruvio hasta sus primeras versiones impresas*. Madrid: Instituto de España.

Chaisemartin, N. de 2003. *Rome: paysage urbain et idéologie, des Scipions à Hadrien, IIe s. av. J.-C. – IIe s. ap. J.-C.* Paris: Colin.

Chamonard, J., P. Paris, and L. Couve 1922–1924. *Le quartier du theatre: étude sur l'habitation délienne à l'époque hellénistique*. Exploration archheologique de Délos 8. Paris: De Boccard.

Champlin, E. 1982. "The Suburbium of Rome." *American Journal of Ancient History* 7: 97–117.

Chandler, R. 1817. *Travels in Asia Minor and Greece, or an Account of a Tour Made at the Expense of the Society of Dilettanti*. London: Printed for J. Booker and R. Priestley.

Chapman, J.C., R. Shiel and Š. Batovic 1996. *The Changing Face of Dalmatia. Archaeological and Ecological Studies in a Mediterranean Landscape*. Society of Antiquaries of London, Research Report 54. London: Cassell.

Chassignet, M. 1986. *Caton, Les Origines (Fragments)* (Collection Budé). Paris: Les Belles Lettres.

Chastagnol, A. 1956. "Le sénateur Volusien et la conversion d'une famille de l'aristocratie romaine du Bas-Empire." *REA* 58: 241–53.

Chastagnol, A. 1965. "Les cadastres de la colonie romaine d'Orange." *AnnESC* 20: 152–9.

Chavarría, A. 2004. "Osservazioni sulla fine delle ville in Occidente." *Archeologia Medievale* 31: 7–19.

Chavarría, A. 2006. "Aristocracias tardoantiguas y cristianización del territorio (siglos IV–V): ¿otro mito historiográfico?" *RACrist* 82: 201–30.

Chavarría, A. 2007a. "*Splendida sepulcra ut posteri audiant*. Aristocrazie, mausolei e chiese nelle campagne tardoantiche." In Brogiolo and Chavarría Arnau (eds.) 2007: 127–45.

Chavarría, A. 2007b. *El final de las villae hispánicas*. Bibliothèque de l'Antiquité Tardive 7. Turnhout: Brepols.

Chavarría, A. 2008. "Villae tardoantiguas en el valle del Duero." In Castellanos and Martín Viso (eds.): 93–122.

Chavarría, A. 2010. "Churches and Villas in the Fifth Century: Reflections on Italian Archaeological Data." In *Le trasformazioni del V secolo. L'Italia,*

i barbari e l'Occidente romano S. Gasparri and P. Delogu (eds.): 639–62. Turnhout: Brepols.

Chavarría, A. and T. Lewit, 2004. "Recent Research on Late Antique Countryside: A Bibliographical Essay." In Bowden, Lavan, and Machado (eds.): 3–51.

Chavarría Arnau, A. 2004a. "Interpreting the transformation of late Roman villas. The case of *Hispania*." In Christie (ed.) 2004: 67–102.

Chavarría Arnau, A. 2004. "Monasterios, villas y campesinos: la trágica historia del abad Nancto." In Balmelle, Chevalier, and Ripoll (eds.): 113–25.

Chavarría Arnau, A., J. Arce, and G.P. Brogiolo (eds.) 2006. *Villas tardoantiguas en el Mediterráneo occidental*. Anejos de AEspA 38. Madrid: CSIC, Instituto de Historia, Departamento de Historia Antigua y Arqueología.

Chelotti, M. 1994. "Per una storia delle proprietà imperiali in Apulia." *Epigrafia e Territorio* 3: 17–35.

Chevalier, P. 1995. *Salona II (2). Ecclesiae Dalmatiae. L'architecture paleochrétienne de la province romaine en Dalmatie (IVᵉ–VIIᵉ s.)*. Rome-Split: École française de Rome – Musée archéologique de Split.

Chevallier, R. 1959. *Bibliographie des applications archéologiques de la photographie aérienne. Bulletin d'Archéologie marocaine* 2 (*Supplément*). Casablanca: Edita.

Chevallier, R. 1964. *L'avion à la découverte du passé*. Paris: Fayard.

Chevallier, R. 1965. *Photographie aérienne; panorama inter-technique*. Paris: Gauthier-Villars.

Chevallier, R. (ed.) 1966. *Mélanges d'archéologie et d'histoire offerts à André Piganiol*, 3 vols. Paris: S.E.V.P.E.N.

Chevallier, R. 1980. *La romanisation de la celtique du Pô: géographie, archéologie et histoire en Cisalpine*. Paris: Les Belles lettres.

Chevallier, R. 1983. *La romanisation de la Celtique du Pô: essai d'histoire provinciale*. Rome: École française de Rome.

Chevallier, R. 1988a. *Geografia, archeologia e storia della Gallia Cisalpina*. Turin: Antropologia alpina.

Chevallier, R. 1988b. *Voyages et déplacements dans l'empire romain*. Paris: A. Colin.

Chinn, C.M. 2007. "Before Your Very Eyes: Pliny *Epistulae* 5.6 and the Ancient Theory of Ekphrasis." *Cphil* 102: 265–80.

Chouquer, F., M. Clavel-Lévêque, and F. Favory 1982. "Cadastres, occupation du sol et paysages antiques." *AnnESC* 37: 847–82.

Chouquer, G. 1993. "Un débat méthodologique sur les centuriations." *DHA* 19: 360–3.

Chouquer, G. 2008. "Les transformations récentes de la centuriation. Une autre lecture de l'arpentage romain." *AnnESC* 63: 847–74.

Chouquer, G. and F. Favory 1991. *Les Paysages de l'Antiquité. Terres et cadastres de l'occident romain*. Paris: Errance.

Chouquer, G., et al. 1987. *Structures agraires en Italie centro-méridionale: cadastres et paysages ruraux*. Roma: Ecole française de Rome.

Christie, N. 1995. *The Lombards: The Ancient Longobards*. Oxford and Cambridge, UK: Blackwell.

Christie, N. (ed.) 1995. *Settlement and Economy in Italy. 1500 B.C.–A.D. 1500. Papers of the Fifth Conference of Italian Archaeology*. Oxbow Monographs 41. Oxford: Oxbow Books.

Christie, N. 2001. "Urban Remodelling and Defensive Strategy in Late Roman Italy." In Lavan (ed.): 106–22.

Christie, N. (ed.) 2004. *Landscapes of Change. Rural Evolutions in Late Antiquity and the Early Middle Ages*. Aldershot, Hants, UK, and Burlington, VT: Ashgate.

Christie, N. 2011. *The Fall of the Western Empire: An Archaeological and Historical Perspective*. London and New York: Bloomsbury Academic.

Chrysostomou, P. 1982. "Το νυμφαίο των Ριζών, Πρεβέζης." *AAA* 15: 10–21.

Ciantar, G.A. 1772. *Malta Illustrata ovvero Descrizione di Malta*, vol. I, Malta: F.G.Mallia.

Ciardiello, R. (ed.) 2007. *La villa romana*. Naples: Arte Tipografica.

Cifani, G. et al. 2003. "Ricerche topografiche nel territorio di *Leptis Magna*. Rapporto preliminare." In Khanoussi (ed.): 395–414.

Cilia Platamone, E. 1996. "Recente scoperta nel territorio di Enna: l'insediamento tardo-romano di contrada Geraci." *AfrRom* 11: 1683–9.

Cilia Platamone, E. 1997. "Rinvenimenti musivi nel territorio di Enna: tra passato e presente." In *AISCOM* 1997, 273–80.

Cilia Platamone, E. 2000. "Il patrimonio storico-culturale di età romana imperiale: le ville rurali e costiere in Sicilia." *AfrRom* 13: 1405–12.

Cima, M. and E. La Rocca (eds.) 1998. *Horti Romani. Atti del convegno internazionale, Roma 4–6 Maggio 1995*. Rome: "L'Erma" di Bretschneider.

Cintas, J. and N. Duval 1976. "III, Le martyrium de Cincari et les martyria triconques et tétraconques en Afrique." *MÉFRA* 88.2: 853–927.

Cirillo, A. and Casale 2004. *Il Tesoro di Boscoreale e il suo scopritore. La vera storia ricostruita sui documenti dell'epoca*. Pompei: Associazione Amici di Pompei and Soprintendenza Archeologica di Pompei.

Claridge, A. 1990. "Ancient Techniques of Making Joints in Marble Statuary." In True and Podany (eds.): 135–62.

Claridge, A. 2007. "Interim Report on Archaeological Fieldwork at Castelporziano. April–May 2007." Available at www.ads.ahds.ac.uk/catalogue/archive/castelporziano_ahrc_2010/downloads_s2.cfm?archive=200&CFID=573996&CFTOKEN=39545028 (accessed September 2012).

Clark, A.J. 1996. *Seeing Beneath the Soil. Prospecting Methods in Archaeology*. London: B.T. Batsford.

Clark, E.A. 1984. *The Life of Melania the Younger. Introduction, Translation, and Commentary*. Lewiston, NY: Edwin Mellen Press.

Clark, E.G. 2001. "Pastoral Care: Town and Country in Late-Antique Preaching." In Burns and Eadie (eds.): 265–84.

Clarke, D.L. (ed.) 1977. *Spatial Archaeology*. London: Academic.

Clarke, J.R. forthcoming. "Decorations of the Third Style at Oplontis Villa A." In Clarke and Muntasser (eds.).

Clarke, J.R. 1987. "The Early Third Style at Oplontis." *RM* 94: 267–94.

Clarke, J.R. 1991. *The Houses of Roman Italy, 100 B.C.– A.D. 250: Ritual, Space, and Decoration*. Berkeley, CA, and London: University of California University Press.

Clarke, J.R. 1996. "Landscape Paintings in the Villa of Oplontis." *JRA* 9: 81–107.

Clarke, J.R. 2014a. "History of the Excavations 1964–1988." In Clarke and Muntasser (eds.): 722–928. New York: ACLS-HEB.

Clarke, J.R. 2014b. "*Domus*/Single Family House." In *A Companion to Roman Architecture*, R.B. Ulrich and C.K. Quenemoen (eds.): 342–62. Malden, MA: Wiley-Blackwell, 2014.

Clarke, J.R. and N.K. Muntasser (eds.) 2014. *Oplontis; Villa A ("of Poppaea") at Torre Annunziata, Italy (50 B.C.- A.D. 79)*. Vol. I, *The Ancient Setting and Modern Rediscovery*. New York: ACLS-HEB.

Clarke, J.R. and N.K. Muntasser (eds.) forthcoming. *Oplontis: Villa A ("of Poppaea") at Torre Annunziata, Italy*. Vol. II, *Decorative Ensembles: Painting, Stucco, Pavements, Sculptures*. New York: ACLS-HEB.

Clarke, J.R. and M.L. Thomas 2008. "The Oplontis Project 2005–2006: New Evidence for the Building History and Decorative Programs at Villa A, Torre Annunziata." In Guzzo and Guidobaldi (eds.) 2008: 465–71.

Clarke, S. 1990. "The Social Significance of Villa Architecture in Celtic North West Europe." *OJA* 9.3: 337–53.

Clavel, M. 1970. *Béziers et son territoire dans l'antiquité*. Annales Littéraires de l'Université de Besançon 112. Paris: Les Belles Lettres.

Clavel-Lévêque, M. (ed.) 1983. *Cadastres et espace rural: approches et réalités antiques: Table ronde de Besançon, mai 1980*. Paris: CNRS.

Clavel-Lévêque, M. 2008. "Les vignes comme marqueur spatial dans les paysages cultivés: Gromatici et agronomes." *Collection "ISTA"* 1120.1: 217–22.

Clavel-Lévêque, M., I. Jouffroy, and A. Vignot (eds.) 1994. *De la terre au ciel : XIIe stage international, Besançon, 29-31 mars 1993*. Paris: Diffusion Les Belles Lettres.

Clavel-Lévêque, M. and R. Plana-Mallart (eds.) 1995. *Cité et territoire: colloque européen, Béziers, 14-16 octobre 1994*. Paris: Les Belles Lettres.

Clavel-Lévêque, M. and G. Tirologos (eds.) 2004. *De la terre au ciel. II, Paysages et cadastres antiques*. Besançon: Presses universitaires de Franche-Comté.

Clavel-Lévêque, M. and A. Vignot (eds.) 1998. *Cité et territoire II: colloque européen, Béziers, 24-26 octobre 1997*. Besançon and Paris: Presses universitaires Franc-Comtoises and Les Belles Lettres.

Coarelli, F. 1981. "Il Vallo di Diano in età romana." In *Storia del Vallo di Diano. L'età antica*, B. d'Agostino (ed.): 47–95. Salerno: Laveglia.

Coarelli, F. 1989. "La casa dell'aristocrazia romana secondo Vitruvio." In Geertman and De Jong (eds.) 1989: 178–87.

Colicelli, A. 1998. "Paesaggi rurali e trasformazioni economiche nei Bruttii in età romana." *Rivista di Archeologia* 22: 113–32.

Colivicchi, F. (ed.) 2011. *Local Cultures of South Italy and Sicily in the Late Republican Period*. JRA supplement 83. Portsmouth, RI: Journal of Roman Archaeology.

Coll, J.M. and J. Roig 2011. "La fi de les vil·les romanes baiximperials a la depressió prelitoral (segles IV–V): contextos estratigràfics i registre material per datar-los." In *IV Congrés d'Arqueologia Medieval i Moderna de Catalunya (Tarragona, juny 2010)*, vol. I, 161–72. Tarragona: Ajuntament de Tarragona and ACRAM.

Coll, R. 2004. *Història arqueològica de Premia*. Premià de Mar: Editorial Clavell.

Collart, J.-L. 1991. "Une grande villa: Verneuil-en-Halatte ." In *Archéologie de la vallée de l'Oise: Compiègne et sa région depuis les origines. Catalogue de l'exposition de Compiègne, 17 janvier –23 février 1991*: 169–73. Compiègne: CRAVO.

Colucci Pescatori, G. 1986. "Fonti antiche relative alle eruzioni vesuviane ed altri fenomeni vulcanici successivi al 79 d.C." In Albore Livadie (ed.) 1986: 134–41.

Community Development Advocates of Detroit Futures Task Force report of February 2010: www.detroitcommunity development.org/CDAD_Revitalization_Frame work_2010.pdf (accessed September 6, 2010.

Comotti, A. 1960 *s.v.* "Glauco." In *Enciclopedia dell'Arte Antica, Classica e Orientale*, vol. 3, 951–2. Rome: Istituto della Enciclopedia Italiana.

Çondi, Dh. 1984. "Fortesa-vilë në Malathresë." *Iliria. Revistë arkeologjike* 14.2: 131–52. Ministry of Culture.

Conticello, B. and U. Cioffi, U. 1990. "Il 'rientro' nella Villa dei Papiri di Ercolano." In Franchi dell'Orto (ed.): 173–90.

Conybeare, C. 2000. *Paulinus Noster: Self and Symbols in the Letters of Paulinus of Nola*. Oxford: Oxford University Press.

Coppolino, E. 2008. "*Castellum etiam villam potuisse appellari* (Aug. *cons. evang.* 3, 25, 71): riflessioni su alcuni aspetti socio-economici dell'*Africa Proconsularis*." *AfrRom* 17: 733–44.

Corbier, M. 1981. "Proprietà e gestione della terra: grande proprietà fondiaria ed economia contadina." In Giardina and Schiavone (eds.) 1981: vol. 1, 427–44.

Corbier, M. 1992. "City, Territory and Taxation." In Rich and A. Wallace-Hadrill (eds.) 1981: 214–44.

Cordero Ruiz, T. 2011. "El territorio emeritense durante la Antigüedad Tardía." In Álvarez Martínez and Mateos Cruz (eds.): 547–61.

Cormack, S. 2007. "The Tombs at Pompeii." In Dobbins and Foss (eds.) 2007: 585–606.

Cornell, T.J. 1995. *The Beginnings of Rome: Italy from the Bronze Age to the Punic Wars (1000–264 B.C.)*. London and New York: Routledge.

Cornell, T.J. and K. Lomas (eds.) 1995. *Urban Society in Roman Italy*. London: UCL Press.

Corpus agrimensorum Romanorum. 4 vols. 1993–6. "Introduction, traduction et notes par Jean-Yves Guillaumin." Naples: Jovene Editore.

Corso, A. 1988. *Prassitele. Fonti epigrafiche e letterarie, vita e opere*, 3 vols. Rome: De Luca.

Corso, A., R. Mugellesi, and G. Rosati 1988. *Gaio Plinio Secondo. Storia Naturale. Libri 33-37*. Turin: Einaudi.

Cosgrove, D.E. 1998. *Social Formation and Symbolic Landscape* (2nd rev. ed.). Madison, WI: Wisconsin University Press.

Cotton, M. Aylwin 1979. *The Late Republican Villa at Posto, Francolise*. London: British School at Rome.

Cotton, H.M. and W. Eck 2009. "An Imperial Arch in the Colonia Aelia Capitolina." In Geiger, Cotton, and Stiebel (eds.): 97–188.

Cotton, M.Aylwin and G.P.R. Métraux 1985. *The San Rocco Villa at Francolise*. London and New York: British School at Rome and Institute of Fine Arts, NYU.

Coulston, J. and H. Dodge (eds.) 2000. *Ancient Rome: The Archaeology of the Eternal City*. Oxford, UK: Oxford University School of Archaeology.

Courcelle, P. 1938. "Le site du monastère de Cassiodore." *MÉFRA* 55: 259–307.

Courtois, C. 1954. "Ruines romaines de Cap Bon." *Karthago* 5: 182–202.

Cracco Ruggini, L. 1980. "La Sicilia e la fine del mondo antico (IV–VI secolo)." In E. Gabba and G. Vallet (eds.), *La Sicilia antica. II.2: La Sicilia romana*, 481–524. Naples: Società editrice Storia di Napoli e della Sicilia.

Crawford, M. 2003. "Metapontum after Metapontum." In Cébeillac-Gervasoni and Lamoine (eds.): 15–30.

Creighton, J. and R.J.A. Wilson (eds.) 1999. *Roman Germany: Studies in Cultural Interaction. JRA* Supplementary series 32. Portsmouth, RI: Journal of Roman Archaeology.

Criniti, N. 1991. *La tabula alimentaria di Veleia.* Parma: Presso la Deputazione di storia patria per le province parmensi.

Croisille, J.-M. 1965. *Les natures mortes campaniennes: répertoire descriptif des peintures de nature morte du Musée national de Naples, de Pompéi, Herculanum et Stabies.* Collection Latomus 76. Brussels: Latomus.

Croisille, J.-M. 2005. *La peinture romaine.* Paris: Éditions A. and J. Picard.

Croisille, J.-M. 2015. *Natures mortes dans la Rome antique: Naissance d'un genre artistique.* Paris: Picard.

Crook, J.A., A. Lintott, and E. Rawson (eds.) 1994. *The Cambridge Ancient History I (2nd edition), Vol. 9: The Last Age of the Roman Republic, 146–43 BC.* Cambridge, UK: Cambridge University Press.

Crowther, N. B. 2004. *Athletika: Studies on the Olympic Games and Greek Athletics* (Nikephoros, vol. 11). Hildesheim: Weidmann.

Crova, B. 1942. *Edilizia e tecnica rurale di Roma antica.* Milan: Fratelli Bocca.

Curchin, L.A. 2004. *The Romanization of Central Spain: Complexity, Diversity and Change in a Provincial Hinterland.* London and New York: Routledge.

Curchin, L.A., A. Ennabli and L. Neuru 1998. "Surface Survey in the Roman villa at Sidi Ghrib." *Echos du Monde Antique/Classical Views* 42, n.s. 17: 373–84.

Curtis, R.I. (ed.) 1988. *Studia Pompeiana et Classica in Honor of Wilhelmina Jashemski I.* New Rochelle, NY: Aristide D. Caratzas.

Curtis, R. I. 1991. *Garum and Salsamenta. Production and Commerce in Materia Medica.* Leiden and New York: E.J. Brill.

d'Agostino, B. (ed.) 1981. *Storia del Vallo di Diano. L'età antica.* Salerno: Laveglia.

D'Ambra, E. (ed.) 1993. *Roman Art in Context: An Anthology.* Englewood Cliffs, NJ: Prentice Hall.

D'Ambra, E. and G.P.R. Métraux (eds.) 2006. *The Art of Citizens, Soldiers and Freedmen in the Roman World.* BAR-IS 1526. Oxford: Archeopress.

D'Ambra, E. and G.P.R. Métraux 2006. "Introduction." In D'Ambra, E. and G.P.R. Métraux (eds.): viii–xviii.

D'Arms, J.H. 1970. *Romans on the Bay of Naples: A Social and Cultural Study of the Villas and Their Owners from 150 BC to AD 400.* Cambridge, MA: Harvard University Press.

D'Arms, J.H. 1977 (2003). "Proprietari e ville nel Golfo di Napoli." In *I Campi Flegrei nell'archeologia et nella storia = Atti dei Convegni Lincei, 33* (Rome: Accademia Nazionale dei Lincei, 1977), 347–63; reprint in *Romans on the Bay of Naples and Other Essays on Roman Campania,* ed. by Zevi, F. 2003, 331–50. Bari: Edipuglia.

D'Arms, J.H. 1979 (2003). "Ville rustiche e ville di 'otium'." In *Pompeii 79, Raccolta di studi per il decimonono centenario dell'eruzione vesuviana,* ed. by Zevi, F. 2003, 65–86. Rome: Buffetti, reprint in *Romans on the Bay of Naples and Other Essays on Roman Campania,* ed. by Zevi, F., 351–83. Bari: Edipuglia.

D'Arms, J.H. 1981. *Commerce and Social Standing in Ancient Rome.* Cambridge, MA: Harvard University Press.

D'Arms, J.H. 1990. "The Roman Convivium and the Idea of Equality." In Murray 1990: 308–20.

D'Arms, J.H. 2003. *Romans on the Bay of Naples and Other Essays on Roman Campania,* F. Zevi (ed.) Bari 2003: Edipuglia (a reprint of the 1970 monograph).

D'Arms, J.H. and E.C. Kopff (eds.) 1980. *The Seaborne Commerce of Ancient Rome: Studies in Archaeology and History.* Rome: American Academy in Rome.

D'Auria C. and Iacovazzo, P. 2006. "La villa romana di Porto Saturo." *Siris* 7: 127–59.

D'Inca, C. et al. 2010. "Loron-Lorun, Parenzo-Poreč, Istria. Una *villa maritima* nell'agro Parentino: la campagna di ricerca 2009." *Histria Antiqua* 19: 313–27.

D'Ippolito, F.M., (ed.) 2007. *Filia. Studi in onore di Gennaro Franciosi,* 4 vols. Naples: Satura.

D'Onofrio, C. 1992, 3rd rev. edn. *Gli obelischi di Roma: storia e urbanistica di una città dall'età antica al XX secolo.* Rome: Romana società editrice.

D'Orsi, L. 1965. *Gli scavi archeologici di Stabia e breve guida dell'Antiquarium statale,* Comitato per gli scavi di Stabia (a cura di). Milan: L'Eroica.

Daehner, J. (ed.) 2007. *The Herculaneum Women: History, Context, Identities.* Los Angeles, CA: Getty.

Dakaris, S. 1971. *Cassopaia and the Elean Colonies.* Ancient Greek Cities 4. Athens: Athens Centre of Ekistics.

Dakaris, S. 1972. *Thesprotia.* Ancient Greek Cities 15. Athens: Athens Centre of Ekistics.

Dalby, A. 2011. *Geoponika: Farm Work: A Modern Translation of the Roman and Byzantine Farming Book.* Totnes: Prospect Books.

Darder, M. 1993–4. "El mosaic circenc de Barcino. Implicacions iconogràfiques a partir de les aportacions semàntiques." *Butlletí de la Reial Acadèmia Catalana de Belles Arts de Sant Jordi* 7–8: 251–81.

Darder, M. 1996. *De nominibus equorum circensium. Pars Occidentis.* Barcelona: Reial Acadèmia de Bones Lletres.

Darder, M. and G. Ripoll 1989. "Caballos en la antigüedad tardía hispánica." *Revista de Arqueología* 104: 40–51.

Darder, M. and G. Ripoll 2000. "*Calimorfus (est) Patinicus.* La cuádriga vencedora del mosaico circense de Bell-lloc (Gerona)." In Prevot (ed.): 127–39.

Dark, K. 2004. "The Late Antique Landscape of Britain, AD 300–700." In Christie (ed.): 279–99.

Darmon, J.-P. 1990. "En guise de conclusion: propositions pour une sémantique des xenia." In Balmelle and Guimier-Sorbets (eds.): 107–12.

Dassié, J. 1978. *Manuel d'archéologie aérienne.* Paris: Technip.

Daszewski, W.A. 1976. "Les fouilles polonaises à Nea Paphos 1972–1975, rapport préliminaire." *Report of the Department of Antiquities, Cyprus*: 185–222.

Dauphin, C.M. 1979. "A Roman Mosaic Pavement from Nablus." *IEJ* 29: 11–33.

D. Davison, V. Gaffney, and E. Marin (eds.) 2006. *Dalmatia: Research in the Roman Province 1970–2001.* BAR-IS 1576. Oxford: Archaeopress.

Dawson, C. M. 1944. *Romano-Campanian Mythological Landscape Painting.* Yale Classical Studies 9. New Haven, CT, and London: Yale University Press and Humphrey Milford, Oxford University Press.

Day, J. 1932. *Agriculture in the Life of Pompeii.* YCS 3. New Haven, CT: Yale University Press.

Dayron, G. (ed.) 1989. *Hommes et richesses dans l'Empire byzantin I: IVe–VIIe siècle.* Paris: P. Lethielleux.

de Alarcão, J., J.P. Carvalho and A. Gonçalves 2010. *Castelo da Lousa – Intervenções Arqueológicas de 1997–2002.* Studia Lusitana V. Mérida: Museo Nacional de Arte Romana.

de Alarcão, J., R. Étienne and F. Mayet 1990. *Les villas romaines de São Cucufate (Portugal).* 2 vols. Paris: De Boccard.

De Caro 1987. "Sculptures of the Villa of Poppaea at Oplontis: A Preliminary Report." In *Ancient Roman Villa Gardens* (Dumbarton Oaks Colloquium on the History of Landscape Architecture, vol. 10), E. B. MacDougall (ed.): 77–134. Washington, DC: Dumbarton Oaks.

De Caro, S. 1994. *La villa rustica in località Villa Regina a Boscoreale.* Rome: Bretschneider.

De Carolis, E. and G. Soricelli 2005. "Il sito di via Lepanto a Pompei: brevi note sul Tardoantico in area Vesuviana." In Volpe and Turchiano (eds.): 513–32.

De Franceschini, M. 1998. *Le ville romane della X Regio: Venetia et Histria. Catalogo e carta archeologica dell'insediamento romano nel territorio, dall'eta repubblicana al tardo impero.* Rome: "L'Erma" di Bretscheneider.

De Franceschini, M. 2005. *Ville dell'Agro romano.* Rome: "L'Erma" di Bretschneider.

De Francesco, D. 1998. "Partizioni fondiarie e proprietà ecclesiastiche nel territorio romano tra VII e VIII secolo. Prospettive di ricerca alla luce dei dati epigrafici." *MÉFR-Moyen-Ages, Temps modernes* 110, 29–77.

de Franciscis, A. 1975. "La Villa Romana di Oplontis." In Andreae and Kyrieleis (eds.): 9–39.

de Franciscis, A. 1979. "Beryllos e la villa "Di Poppea" ad Oplontis." In Moore and Köpcke (eds.): 231–33.

de Franciscis, A. 1980. "La dama di Oplonti." In Stucky and Jucker (eds.): 115–17.

de Franciscis, A. (ed.) 1982. *La regione sotterrata dl Vesuvio. Studi e prospettive (Atti del convegno internazionale, Napoli 11–15 novembre 1979).* Naples: Università degli studi di Napoli.

de Franciscis, A. (ed.) 1988. *La villa romana del Naniglio a Gioiosa Ionica: relazione preliminare delle campagne di scavo 1981–86 dirette da Alfonso de Franciscis.* Naples: Bibliopolis.

De Haan, N. 2010. *Römische Privatbäder. Entwicklung, Verbreitung, Struktur und sozialer Status.* Frankfurt-am-Main and New York: Peter Lang.

De la Bédoyère, G. 1993. *Roman Villas and the Countryside.* London: B.T. Batsford.

De Ligt, L. and S. Northwood (eds.) 2008. *People, Land and Politics. Demographic Developments and the Transformation of Roman Italy, 300 B.C.–AD 14.* Leiden: Brill.

De Maria, L. and R. Turchetti (eds.) 2004a. *Evolución paleoambiental de los puertos y fondeaderos antiguos en el Mediterráneo occidental. El patrimonio arqueológico submarino y los puertos antiguos; I Seminario, Alicante 14–15 Noviembre 2003.* Soveria Mannelli (Catanzaro): Rubbettino.

De Maria, L. and R. Turchetti (eds.) 2004b. *Rotte e porti del Mediterraneo dopo la caduta dell'impero romano d'Occidente. Continuità e innovazioni tecnologiche e funzionali.* Soveria Mannelli (Catanzaro): Rubbettino

De Maria, S. (ed.) 2004. *Nuove ricerche e scavi nell'area della villa di Teodorico a Galeata: atti della giornata di Studio (Ravenna 26 marzo 2002).* Bologna: Ante Quem, 2004.

De Maria, S. and S. Gjongecaj (eds.) 2002. *Phoinike I: rapporto preliminare sulla campagna di scavi e ricerche 2000.* Florence: All'Insegna del Giglio.

De Maria, S. and S. Gjongecaj (eds.) 2003. *Phoinike II: rapporto preliminare sulla campagna di scavi e ricerche 2001.* Bologna: Ante Quem.

de Marinis, R.C. and G. Spadea (eds.) 2004. *I Liguri. Un antico popolo europeo tra Alpi e Mediterraneo*. Milan: Skira.

De Miro, E. 1988. "La villa del Casale di Piazza Armerina. Nuove ricerche." In Rizza (ed.): 58–73.

de Mora-Figueroa, L. de 1977. "La villa romana de 'El Santiscal' (Cadiz)." *Habis* 8: 345–358.

De Neeve, P.W. 1984. *Colonus: Private Farm-Tenancy in Roman Italy during the Republic and the Early Principate*. Amsterdam: J.C. Gieben.

De Nittis, V. 2006. "La villa romana di Casignana. I *balnea*, l'aula basilicale e la facciata a galleria frontale tra due torri." *Polis: rivista di studi interdisciplinari sul mondo antico* 2: 294–315.

De Pachtère, F.G. 1911. *Inventaire des mosaïques de la Gaule et de l'Afrique III. Afrique Proconsulaire, Numidie, Maurétanie (Algérie)*. Paris: E. Leroux.

De Pachtère, F.G. 1920. *La Table hypothécaire de Veleia. Étude sur la propriété foncière dans l'Apennin de Plaisance*. Bibliothèque de l'École des hautes études, sciences historiques et philologiques 228. Paris: École des hautes études, sciences historiques et philologiques.

de Palol, P. 1996. "Un cavaller del segle IV a Barcino: a propòsit de la pintura mural descoberta l'any 1994." *Quaderns d'Història* 2.3: 163–75.

de Palol, P. 1999. "Basílica de la vil·la Fortunatus." In de Palol and Pladevall (eds.): 193–4.

de Palol, P. and J. Cortés 1974. *La villa romana de La Olmeda, Pedrosa de la Vega, (Palencia). Excavaciones de 1969 y 1970*. Acta Arqueológica Hispánica 7. Madrid: Comisaría General del Patrimonio Artístico y Cultural.

de Palol, P. and A. Pladevall (eds.) 1999. *Del romà al romànic. Història, art i cultura de la Tarraconense mediterrània entre els segles IV i X*. Barcelona: Enciclopèdia Catalana.

de Palol, P. and G. Ripoll 1988. *Los godos en el Occidente europeo. Ostrogodos y visigodos, siglos V–VIII*. Madrid: Ediciones Encuentro.

de Palol i Salellas, P. 1977. "Romanos en la Meseta: el Bajo Imperio y la aristocracía agrícola." In *Segovia y la arqueología romana*: 297–308. Barcelona: Instituto de Arqueologia y Prehistoria.

De Ruyt, C. 1983. *Macellum. Marché alimentaire des romains*. Publications d'histoire de l'art et d'archéologie de l'Université catholique de Louvain 35. Louvain: Université catholique.

De Siena, A. 2007. "L'attività archeologica in Basilicata nel 2006." *AttiTaranto* 46: 407–63.

De Siena, A. and L. Giardino 2001. "Trasformazione delle aree urbane e del paesaggio agrario in età romana nella Basilicata nord-orientale." In Lo Cascio and Storchi Marino (eds.): 129–67.

De Simone, A. 2009. "Ricerche e scavi a Somma Vesuviana." In De Simone and Macfarlane (eds.): 157–71.

De Simone, A. 2010a. "La cd. Villa di Augusto in Somma Vesuviana: il Dioniso e la Peplophoros." In Gasparri, Greco, and Pierobon (eds.): 337–53.

De Simone, A. 2010b. "Rediscovering the Villa of the Papyri," In Zarmakoupi (ed.): 1–20. Berlin and New York: Walter de Gruyter.

De Simone, A. and M. Aoyagi 2010. "Il thiasos marino dalla villa di Somma Vesuviana." In *Atti del X Congresso dell'AIPMA – Napoli 18/21.09.2007*, 583–94. Naples: Università degli Studi di Napoli "L'Orientale."

De Simone, G.F. 2008. "Il territorio nord-vesuviano e un sito dimenticato di Pollena Trocchia." *CronErcol* 38: 329–49.

De Simone, G.F. 2011. "Con Dioniso fra i vigneti del vaporifero Vesuvio." *CronErcol* 41: 287–308.

De Simone, G.F., A. Perrotta, C. Scarpati 2011. "L'eruzione del 472 d.C. ed il suo impatto su alcuni siti alle falde del Vesuvio." *RStPomp* 22: 61–71.

De Simone, G.F. and R.T. Macfarlane (eds.) 2009. *Apolline Project vol.1: Studies on Vesuvius' North Slope and the Bay of Naples*. Naples and Provo, UT: Università degli Studi Suor Orsola Benincasa and Brigham Young University.

De Simone, G.F. et al. 2009. "Pollena Trocchia, località Masseria De Carolis: Campagne d'indagine 2006–2009." *RStudPomp* 20: 153–56.

De Souza., P. 1999. *Piracy in the Graeco-Roman world*. Cambridge: Cambridge University Press.

de Vos, M. 1993. "Roma. La pittura parietale tardoantica." In Carandini, Cracco Ruggini, and Giardina (eds.): 85–91.

de Vos, M. 2000. *Rus Africum. Terra acqua olio nell'Africa settentrionale. Scavo e ricognizione nei dintorni di Dougga (Alto Tell tunisino). Mostra, Palazzo Thun, Trento, 23 novembre 2000– 7 gennaio 2001*. Labirinti 50. Trento: Università degli Studi di Trento.

de Vos Raaijmakers, M. and R. Attoui 2013. Rus Africum. *Tome 1. Le paysage rural antique autour de Dougga et Téboursouk: cartographie, relevés et chronologie des établissements*. Bari: Edipuglia.

Decramer, L.R., R. Hilton, L. Lapierre, and A. Plas 2006. "La grande carte de la colonie romaine d'Orange." In *Autour des Libri coloniarum: colonisation et colonies dans le monde romain. Actes du Colloque international (Besançon, 16-18 octobre 2003)*, A. Gonzales and J.-Y. Guillaumin (eds.): 93–114. Besançon: Presses universitaires de Franche-Comté.

Deichmann, F.W. 1989. Ravenna. *Hauptstadt des Spätantiken Abendlandes, II, Kommentar 3: Geschichte, Topographie, Kunst und Kultur.* Stuttgart: Franz Steiner.

Deines, R., J. Herzer, and K.-W. Niebuhr (eds.) 2011. *Neues Testament und hellenistisch-jüdische Alltagskultur. Wechselseitige Wahrnehmungen. III. Internationales Symposium zum Corpus Judaeo-Hellenisticum Novi Testamenti 21.–24. Mai 2009 in Leipzig.* Tübingen: Mohr Siebeck.

Deiss, J.J. 1989. *Herculaneum, Italy's Buried Treasure*, rev.edn. Malibu, CA: J. Paul Getty Museum.

Deissler, J. 2010. "Cold Case? Die Finley-Vogt-Kontroverse aus deutscher Sicht." In Heinen (ed.): 77–93.

Dekoulakou, I. 1999–2001. "Νέα στοιχεία από την ανασκαφή του Ιερού των Αιγυπτίων Θεών στον Μαραθώνα." *AAA* 32–34: 113–24.

Dekoulakou, I. 2005a. "Το Ιερό των Αιγυπτίων Θεών στον Μαραθώνα." In Basilopoulou (ed.): 45–8.

Dekoulakou, I. 2005b. *Το Ιερό των Αιγυπτίων Θεών στον Μαραθώνα.* Attiki 2004. Athens.

Dekoulakou, I. 2011. "Le sanctuaire des dieux égyptiens à Marathon." In Bricault and Veymiers (eds.): 23–46.

Del Rosso, R. 1905. *Pesche e peschiere antiche e moderne dell'Etruria marittima.* Florence: Osvaldo Paggi.

Delamare, A.H.A. 1850. *Exploration scientifique de l'Algérie pendant les années 1840, 1841, 1842, 1843, 1844 et 1845. Archéologie.* Paris: Imprimerie Nationale.

Delaplace, C. (ed.) 2005. *Aux origines de la paroisse rurale en Gaule méridionale (IVe –IXe siècles).* Paris: Éditions Errance.

Delbrueck, R. 1913. "Die roemische Sarkophag in Melfi." *JdI* 28: 275–82.

Dell'Aglio, A. 1999. *Il parco archeologico di Saturo Porto Perone.* Taranto: Scorpione.

Della Corte, M. 1932. "Somma Vesuviana. Ruderi romani." *NS*: 309–10.

Della Corte, M. 1936. "Posides Claudi Caesaris libertus – Positano da *Posidetanum*?" *Rivista Indo-Greco-Italica* 20.1–2: 67–73.

Della Corte, M. 1965. *Case ed abitanti di Pompei.* Naples: Fausto Fiorentino.

Della Corte, M. 2009. "Augustus in His Last Visit to Campania: Capri and Apragopolis; Octavianum and Somma Villa." In G.F. De Simone and Macfarlane (eds.): 144–56.

Delorme, J. 1960. *Gymnasion. Étude sur les monuments consacrés à l'éducation en Grèce (des origines à l'empire romain).* Paris: De Boccard.

Dentzer, J.-M. (ed.) 1985. *Hauran I.* Paris: P. Geuthner.

Deremetz, A. 2008. "Descriptions de villas: Horace et Martial." In Galand-Hallyn and Lévy (eds.): 465–60.

Derow, P. and Forrest, W. G. 1982. "An Inscription from Chios." *ABSA* 77: 79–92.

Desanges, J., N. Duval, C. Lepelley and S. Saint-Amans (eds.) 2010. *Carte des routes et des cités de l'Est de l'Africa à la fin de l'antiquité, d'après le tracé de Pierre Salama.* Bibliothèque de l'Antiquité Tardive 17. Turnhout: Brepols.

Dey, H. and E. Fentress (eds.) 2011. *Western Monasticism Ante Litteram: The Spaces of Monastic Observance in Late Antiquity and the Early Middle Ages.* Turnhout: Brepols.

Dickson, A. 1788. *Husbandry of the Ancients. In Two Volumes.* Edinburgh: J. Dickson and W. Creech; London: G. Robinson and T. Cadel.

Dickmann, J.-A. 1997. "The Peristyle and the Transformation of Domestic Space in Hellenistic Pompeii." In Laurence and Wallace-Hadrill (eds.): 121–36.

Dickmann, J.-A. 1999. *Domus frequentata: anspruchsvolles Wohnen im pompejanischen Stadthaus.* Studien zur antiken Stadt 4. Munich: Verlag Dr. Friedrich Pfeil.

Dickmann, J.-A. 2007. "Residences in Herculaneum." In *The World of Pompeii*, J.J. Dobbins and P. Foss (eds.): 421–34. London and New York: Routledge.

Dietz, S. 1985. "Fouilles danoises à Carthage, 1975–1984." *CahÉtAnc* 16 [1983, pub. 1985], 107–18.

Dietz, S. 1992. "Le secteur nord-est de la ville: Falbe point 90." in Ennabli (ed.): 143–9.

Dietz, S., L.L. Sebaï and H. Ben Hassen (eds.) 1995a. *Africa Proconsularis: Regional Studies in the Segermes Valley of Northern Tunisia.* Volume I. Copenhagen: Carlsberg Foundation and the Danish Council for the Humanities.

Dietz, S., L.L. Sebaï and H. Ben Hassen (eds.) 1995b. *Africa Proconsularis: Regional Studies in the Segermes Valley of Northern Tunisia.* Volume II. Copenhagen: Carlsberg Foundation and the Danish Council for the Humanities.

Dilke, A.O.W. 1971. *The Roman Land Surveyors. An Introduction to the Agrimensores.* Newton Abbot: David and Charles.

Dilke, A.O.W. 1992. "Insights in the *Corpus Agrimensorum* into Surveying Methods and Mapping." In Behrends and Capogrossi Colognesi (eds.): 337–47.

Dillon, S. 2000. "Subject Selection and Viewer Reception of Greek Portraits from Herculaneum and Tivoli." *JRA* 13: 21–40.

Di Giovanni, V. and D. Russo 1988. "Nuovi contributi allo studio della villa romana del Naniglio di Gioiosa Ionica." *Klearchos* 30: 57–128.

Di Giuseppe, H. 2007. "Proprietari e produttori nell'alta valle del Bradano." *Facta* 1: 157–82.

Di Maio, G. 2014. "The Geoarchaeology of the Oplontis Coast. Il paesaggio archeologico della costa di Oplonti." In Clarke and Muntasser (eds.) : 662–721.

Di Stefano, G. 1997. "Notizie preliminari sui mosaici della villa di età imperiale di Giarratana e della chiesetta bizantina di Kaukana nella Sicilia orientale." In *AISCOM 1997*, 199–216.

Di Stefano, G. 2005. "Nuovi mosaici dalla villa romana di Giarratana in Sicilia." In *AISCOM 2005*, 281–85.

Di Vita, A. 1966a. *La villa della 'Gara delle Nereidi' presso Tagiura: un contributo alla storia del mosaico romano, ed altri scavi e scoperte in Tripolitania*, 13–64. Supplement to *Libya Antiqua* II. Tripoli: Directorate-General of Antiquities, Museums and Archives.

Di Vita, A. 1966b. "Archaeological News 1963–1964. Tripolitania – Tagiura." *LibAnt* 2, supplement 3: 132–3.

Dobbins, J.J. 2000. "The Houses at Antioch." In Kondoleon (ed.): 50–61.

Dobbins, J.J. and P.W. Foss (eds.) 2007. *The World of Pompeii*. London and New York: Routledge.

Docter, R.F. et al. 2012. "Rural Malta: First Results of the Joint Belgo-Maltese Survey Project." *BABesch* 87: 107–49.

Dodge, H. 1987. Building Materials and Techniques in the Eastern Mediterranean from the Hellenistic Period to the end of the Fourth Century AD. Unpublished Ph.D. dissertation, Newcastle University.

Domenech i Montaner, L. 1931. *Centcelles. Baptisteri i celle-memoria de la primitiva eglesia-metropolitana de Tarragona*. Barcelona: Industria del Papel.

Dommelen, P. van and C. Gómez Bellard 2008. *Rural Landscapes of the Punic World*. London and Oakville: Equinox.

Donderer, M. 2008. *Die Mosaizisten der Antike II. Epigraphische Quellen – Neufunde und Nachträge*. Erlangen: Universitätsbund Erlangen-Nürnberg e. V.

Dontas, G. 1971. "Εικονιστικά Β΄." *ArchDelt* 26, *Meletai* A: 16–33.

Dopico Caínzos, D., M. Villanueva, and P. Rodríguez (eds.) 2009: *Do castro a cidade. A romanización na Gallaecia e na Hispania indoeuropea*. Lugo: Deputación de Lugo.

Dosi, A.M. 2006. *Otium: il tempo libero dei romani*. Rome: Quasar.

Dothan, M. 1983. *Hammath Tiberias*. Jerusalem: Israel Exploration Society.

Doukellis, P.N. 1988. "Cadastres romains en Grèce: traces d'un réseau rural à Actia Nicopolis." *Dialogues d'histoire ancienne* 14: 159–66.

Doukellis, P.N. 1990. "Ένα δίκτυο αγροτικών ορίων στην πεδιάδα της Άρτας." In Sakellariou (ed.): 269–86.

Doukellis, P.N. and L.G. Mendoni (eds.) 1994. *Structures rurales et sociétés antiques: Actes du colloque de Corfou, 14–16 Mai 1992*. Paris: diffusé par Les Belles Lettres.

Dousougli, A. 1993. "Κοινότητα Στρογγύλης." *ArchDelt, Chronika B1* 49: 282–7.

Dousougli, A. 1998. "Μια αγροτική κατοικία στις ακτές του Αμβρακικού Κόλπου." *Archaiologia* 68: 74–8.

Dousougli A. and S. Morris 1994. "Ancient Towers on Leukas, Greece." In Doukellis and Mendoni (eds.) 1994: 215–25.

Drerup, H.1959. "Bildraum und Realraum in der römischen Architektur," *RM* 66: 145–74.

Drerup, H. 1990. "Die römische Villa." Reprint 1990 in *Die römische Villa*. Wege der Forschung 182. In Reutti (ed.): 116–49.

Drew-Bear, T. 1980. "An Act of Foundation at Hypaipa." *Chiron* 10: 509–36.

Drine, A. 2002. "Autour du lac El Bibèn: les sites d'El Mdeina et de Bou Garnin." *AfrRom* 14: 2001–13.

Drine, A., E. Fentress and R. Holod 2009. *An Island through Time: Jerba Studies. Volume 1. The Punic and Roman Periods. JRA* Supplementary series 71. Portsmouth, RI: Journal of Roman Archaeology.

Drinkwater, J. and H. Elton (eds.) 1992. *Fifth-Century Gaul: A Crisis of Identity?* Cambridge, UK, and New York: Cambridge University Press.

Drosines, G. (ed.) 1933. *Hemerologion tis Megalis Ellados*. Athens: Estia.

Druks, A. 1964. "Tiberias." *Hadashot Arkheologiyot* 12: 16. (Hebrew).

Du Prey, P. de la Ruffinière 1994. *The Villas of Pliny from Antiquity to Posterity*. Chicago, IL: Chicago University Press.

Dubois-Pélerin, E. 2008. *Le luxe privé à Rome et en Italie au Ier siècle après J.-C*. Naples: Centre Jean Bérard.

Duby, G. 1973. *Guerriers et paysans VII–XIIe siècle: Premier essor de l'économie européenne*. Paris: Gallimard.

Dunbabin, K.M.D. 1978. *Mosaics of Roman North Africa. Studies in Iconography and Patronage*. Oxford: Clarendon Press.

Dunbabin, K.M.D. 1991. "*Triclinium* and *Stibadium*." In Slater (ed.) 1991: 121–48.

Dunbabin, K.M.D. 1996. "Convivial Spaces: Dining and Entertainment in the Roman Villa." *JRA* 9: 66–80.

Dunbabin, K.M.D. 1998. "*Ut Graeco more biberetur*: Greeks and Romans on the Dining Couch." In Nielsen and Nielsen (eds.): 81–101.

Dunbabin, K.M.D. 1999. *Mosaics of the Greek and Roman World*. Cambridge: Cambridge University Press.

Dunbabin, K.M.D. 2003. *The Roman Banquet, Images of Conviviality*. Cambridge: Cambridge University Press.

Dunbabin, K.M.D. 2015. "Image, Myth, and Epic on Mosaics of the Late Roman West." In K. M. Coleman (ed.), *Images for Classicists*. Loeb classical monographs, 15, 39–65. Cambridge, MA, and London: Harvard University Department of the Classics.

Dunbabin, K.M.D. 2016. *Theater and Spectacle in the Art of the Roman Empire*. Ithaca and London: Cornell University Press.

Duncan-Jones, R. 1964. "The Purpose and Organisation of the Alimenta." *BSR* 32: 123–46.

Duncan-Jones, R. 1982. *The Economy of the Roman Empire. Quantitative Studies*. Cambridge and New York: Cambridge University Press.

Duval, N. 1978. "Comment reconnaître un palais impérial ou royal. Ravenne et Piazza Armerina." *Felix Ravenna* 115: 29–62.

Duval, N. 1980. "La répresentation des monuments dans l'antiquité tardive, à propos de deux livres récents." *BMon* 138: 77–95.

Duval, N. 1982. "Quelques remarques sur les 'églises-halles'." In *Aquileia nel IV Secolo [XII Settimana di studi aquileiesi, 30 aprile–5 maggio 1981]* vol. 2: 399–412. Udine: Arti grafiche friulane.

Duval, N. 1984. "Les maisons d'Apamée et l'architecture 'palatiale' de l'Antiquité Tardive." In Balty (ed.): 447–70.

Duval, N. 1985. "L'iconographie des 'villas africaines' et la vie rurale dans l'Afrique Romaine de l'Antiquité Tardive." In *Histoire et archéologie de l'Afrique du Nord: actes du IIIe colloque international réuni dans le cadre du 110e Congrès national des sociétes savantes, Montpellier, 1-15 avril 1985*, 163–76. Paris: C.T.H.S.

Duval, N. 1987. "Existe-t-il une 'structure palatiale' propre à l'antiquité tardive." In Lévy (ed.) 1987: 463–90.

Duval, N. 1991. "L'architecture cultuelle." In *Naissance des arts chrétiens: atlas des monuments paléochrétiens de la France. Atlas archéologiques de la France*: 186–219. Paris: Imprimerie nationale.

Duval, N. 1992. "Le palais de Milan parmi les résidences impériales du Bas Empire." In Sena Chiesa and Arslan (eds.): 137–46.

Duval, N. 1995. *Les premiers monuments chrétiens de la France*. Paris: Picard.

Duval, N. 1996. "Le plan centré dans l'architecture chrétienne: formes et fonctions (à propos de la rotonde de Carthage)." *CahÉtAnc* 31: 19–40.

Duval, N. (ed.) 1996. *Les premiers monuments chrétiens de la France*. Paris: Picard: Ministère de la culture et de la francophonie, Direction du patrimoine, Sous-direction de l'archéologie.

Duval, N. 1997a. "Les résidences impériales: leur rapport avec les problèmes de légitimité. Les partages de l'Empire et la chronologie des combinaisons dynastiques." In Paschoud and Szidat (eds.): 127–53.

Duval, N. 1997b, "Le lit semi-circulaire de repas: une invention d'Hélagabale? (Hel. 25, 1. 2–3)." In Bonamente and Rosen (eds.): 129–52.

Duval, N. 2002. "Le problème d'identification et de datation de Centcelles, près de Tarragone." *AnTard* 10: 443–59.

Duval, Y. (ed.) 1981. *Mosaïque romaine tardive. L'iconographie du temps: les programmes iconographique des maisons africaines*. Paris: Presses universitaires de France.

Dyson, S.L. 1983. *The Roman Villas of Buccino: Wesleyan University Excavations in Buccino, Italy 1969–1972*. Oxford: British Archaeological Reports.

Dyson, S.L. 2003. *The Roman Countryside*, London: Duckworth.

Džin, K. 1995. "Spomenički nalazi i projekt eko-arheološkog parka Vižula kod Medulina." *Histria Antiqua* 1: 73–8.

Džin, K. 2011. "Rimske vile i uvjeti stanovanja na pulskom ageru. Neki primjeri." *Histria Antiqua* 20: 91–107.

Early, R. (with contributions by J. DeLaine, M. Önal, Y. Yavaş) 2003. "Rescue Work by the Packard Humanities Institute: Interim Report, 2000." In *Zeugma: Interim Reports*. JRA supplement 51, 8–56. Portsmouth, RI: Journal of Roman Archaeology.

Ebhardt, B. 1865 (1962). *Vitruvius: die zehn Bücher der Architektur des Vitruv und ihre Herausgegeber seit 1484; mit einem Berzeichnis der vorhandenen Ausgaben und Erläuterungen nach der Sammlung solcher im Besitz des Verfassers*. Berlin: Burgverlag. (English trans. *The "Ten books of architecture" of Vitruvius and Their Editors since the 15th Century. With a Bibliography of the Editions*. Ossining, NY: W. Salloch.)

Ebbeler, J. 2009. "Tradition, Innovation, and Epistolary Mores in Late Antiquity." In Rousseau (eds.): 270–284.

Eck, W. 2003. *The Age of Augustus*. 2nd edn., trans. by D.L. Schneider. Malden, MA: Blackwell.

Eckert, A. 2010. "Aufklärung, Sklaverei und Abolition." *Geschichte und Gesellschaft. Sonderheft* 23: 243–62.

Eckstein, F. 1957. *Untersuchungen über die Stilleben aus Pompeji und Herculaneum*. Berlin: Gebr. Mann.

Eckstein, F. and E. Meyer 1960. "Eine *Villa rustica* bei Kalliani in Westarkadien." *MDAI* (A) 75: 9–67.

Edelstein, G. 1986. "En Yael." *Hadashot Arkheologiyot – Excavations and Surveys in Israel* 5: 30–3.

Edelstein, G. 1987. "En Yael, 1986." *IEJ* 37: 190–2.

Edelstein, G. 1990. "What's a Roman Villa Doing Outside Jerusalem?" *BARev* 16.6: 32–43.

Edmonson, J. and A. Keith (eds.) 2008. *Roman Dress and the Fabrics of Roman Culture*. Phoenix Supplementary Volumes 46. Toronto: University of Toronto Press.

Edwards, C. and G. Woolf (eds.) 2003. *Rome the Cosmopolis*. Cambridge: Cambridge University Press.

Edwards, D.R. and C.T. McCollough (eds.) 1997. *Archaeology and the Galilee: Texts and Contexts in the Graeco-Roman and Byzantine Periods*. South Florida Studies in the History of Judaism 143. Atlanta, GA: Scholars Press.

Egger, R. 1966. *Das Praetorium als Amtssitz und Quartier römischer Sitzenfunktionäre*. Wien: H. Bohlaus.

Ehrhardt, W. 1987. *Stilgeschichtliche Untersuchungen an römischen Wandmalereien von der späten Republik bis zur Zeit Neros*. Mainz-am-Rhein: P. von Zabern.

Ehrhardt, W. 1991. "Bild und Ausblick in Wandbemalungen Zweiten Stils." *Antike Kunst* 34: 28–65.

Eilers, C. 2002. *Roman Patrons of Greek Cities*. Oxford: Oxford University Press.

Ellis, S.P. 1985. "The End of the Roman House." *AJA* 92: 565–76.

Ellis, S.P. 1991. "Power, Architecture and Decor: How the Late Roman Aristocrat Appeared to His Guests." In Gazda (ed.): 117–34.

Ellis, S.P. 1995. "Classical Reception Rooms in Romano-British Houses." *Britannia* 26: 163–78.

Ellis, S.P. 1997. "Late-Antique Dining: Architecture, Furnishings and Behaviour." In Laurence and Wallace-Hadrill (eds.): 41–51.

Ellis, S.P. 2000. *Roman Housing*. London: Duckworth.

Ellis, S.P. 2007. "Late Antique Housing and the Uses of Residential Buildings: An Overview." In Lavan, Özgenel, and Sarantis (eds.): 1–22.

Elsner, J. 2007. *Roman Eyes. Visuality & Subjectivity in Art & Text*. Princeton, NJ, and Oxford: Princeton University Press.

Engels, F. 1850. "Der deutsche Bauernkrieg." *Neue Rheinische Zeitung. Politisch-ökonomische Revue 5 and 6*.

Ennabli, A. 1986a. "Mosaïque des thermes privés de Sidi Ghrib." In *30 ans au service du patrimoine. De la Carthage des Phéniciens à la Carthage du Bourguiba*, 183–5. Tunis: Ministère des Affaires Culturelles.

Ennabli, A. 1986b. "Les thermes du thiase marin de Sidi Ghrib (Tunisie)." *Monuments et Mémoires. Fondation Eugène Piot* 68: 1–59.

Ennabli, A. (ed.) 1992. *Pour sauver Carthage. Exploration et conservation de la cité punique, romaine et byzantine*. Paris: UNESCO and Tunis: Institut National d'Archéologie et d'Art.

Ennabli, A. 2009. "Die Villa von Sidi Ghrib." In Badisches Landesmuseum Karlsruhe 2009: 234–5.

Ennabli, A. and L. Neuru 1994. "Excavation of the Roman villa at Sidi Ghrib, Tunisia, 1985–1992." *Échos du Monde Classique/Classical Views* 38, n. s. 13: 207–20.

Ennabli, A. and H. Slim 1982. *Karthago. Die archäologischen Fundstätten*. Tunis: Cérès.

Ennaïfer, M. and N. Ben Lazreg 2005. "Les mosaïques des thermes de Nasr Allah (Tunisie)." In Morlier (ed.): 519–31.

Ergeç, R. 1998. "Rescue Excavations by the Gaziantep Museum." In Kennedy (ed.): 80–91.

Escacena, J.L. and A. Padilla 1992. *El poblamiento romano de las márgenes del antiguo estuario del Guadalquivir*. Écija: Editorial Gráfcias Sol.

Espérandieu, É. 1907–1929. *Recueil général des bas-reliefs, statues et bustes de la Gaule romaine*. Paris: Imprimerie nationale.

Esposito, D. 2007. "Pompei, Silla e la Villa dei Misteri." In Perrier (ed.): 441–65.

Esposito, D. 2009. *Le officine pittoriche di IV stile a Pompei: Dinamiche produttive ed economico-sociali. Studi della Soprintendenza Archeologica di Pompei*. Rome: "L'Erma" di Bretschneider.

Esposito, D. 2011a. "Il secondo stile nella villa dei Papiri di Ercolano." In La Torre and Torelli (eds.): 531–45.

Esposito, D. 2011b. "Su un possible *praedium* imperiale a Stabiae." *Oebalus* 6: 145–63.

Esteban Molina, J. 2007. *La villa romana y la necrópolis visigoda de Santa Lucía, Aguilafuente (Segovia). Nuevas aportaciones para su estudio*. Segovia: Ayuntamiento de Aguilafuente.

Étienne, R. 1980. "La comptabilité de Columelle." In *Les « dévaluations » à Rome. Epoque républicaine et impériale*. Volume 2. Actes du Colloque de Gdansk (19-21 octobre 1978), 121–8. Rome: École Française de Rome. (Publications de l'École française de Rome 37.2).

Étienne, R. and F. Mayet 2002. *Salaisons et sauce de poisson hispaniques. Trois clés pour l'économie de l'Hispanie romaine II*. Paris: Diffusion De Boccard.

Fabião, C. 2002. "Os chamados *Castella* do sudoeste. Arquitectura, cronologia e funções." *ArchEspArq* 75: 177–93.

Faedo, L. 1993. "Copia e il suo territorio in età romana." *AttiTaranto* 32: 431–55.

Fagan, G. 1999. *Bathing in Public in the Roman World*. Ann Arbor, MI: Michigan University Press.

Fant, C. 2007. "Real and Painted Marble in Pompeii." In Dobbins and Foss (eds.): 336–46.

Fantar, M. 1984. *Kerkouane. Cité punique de Cap Bon (Tunisie). Tome 1*. Tunis: Institut National d'Archéologie et d'Art.

Faravel, S. 2005. "Bilan des recherches sur les orgines de la pariosse en Aquitaine (IVe–Xe siècle)." In Delaplace (ed.): 150–8.

Farioli Campanati, R. (ed.) 1983. *III Colloquio internazionale sul mosaico antico, Ravenna 6–10 settembre 1980*. Ravenna: Edizioni del Girasole.

Farrar, L. 1998. *Ancient Roman Gardens*. Stroud: Sutton Publishing.

Fasolo, M. 2014. *Tyndaris e il suo territorio. Volume II. Carta archeologica di Tindari e materiale.* Rome: MediaGEO.

Favro, D. 2010. "From Pleasure, to 'Guilty Pleasure,' to Stimulation: Rebirthing the Villa of the Papyri." In Zarmakoupi (ed.): 181–93.

Favro, D. et al. (eds.) 2015. *Paradigm and Progeny: Roman Imperial Architecture and Its Legacy.* (JRA supplementary series 101. Portsmouth, RI: JRA.

Fedeli, P. 2005. "Le fonti letterarie." In *Tramonto della Magna Grecia. Atti Taranto* 44, 2004, 19–50. Taranto: Istituto per la storia e l'archeologia della Magna Grecia.

Fedeli, P. 2014. "Le biblioteche private nel mondo romano." In R. Meneghini and R. Rea (eds.), *La biblioteca infinita. I luoghi di sapere nel mondo antico*, 176–89. Milan: Electa.

Fejfer, J. 2008. *Roman Portraits in Context* (Image & Context 2). Berlin and New York: Walter de Gruyter.

Feletti Maj, B.M. 1958. *Iconografia romana imperiale da Severo Alessandro a M. Aurelio Carino.* Rome: "L'Erma" di Bretschneider.

Félibien des Avaux, J.-F. 1699. *Les plans et les descriptions de deux des plus belles maisons de campagne de Pline le jeune.* Paris.

Fendri, M. 1963. *Découverte archéologique dans la région de Sfax. Mosaique des Océans.* Tunis: Secretariat de l'État aux Affaires Culturelles et à l'Information and Institut National d'Archéologie et Arts.

Fendri, M. 1985. "Cités antiques et villas romaines de la région sfaxienne." *Africa* 9: 151–208.

Fentress, E. 1984. "Caesarian Reflections" (review of Leveau 1984). *Opus* 3: 487–93.

Fentress, E., D. Kennet and I. Valenti 1988. "A Sicilian Villa and its Landscape (contrada Mirabile, Mazara del Vallo)." *Opus* 5: 75–90.

Fentress, E. 1998. "The House of the Sicilian Greeks." In Frazer (ed.): 29–41.

Fentress, E. 2001. "Villas, Wine, and Kilns: The Landscape of Jerba in the Late Hellenistic Period." *JRA* 14.1: 249–68.

Fentress, E. 2003. "Stately Homes: Recent Work on Villas in Italy." *JRA* 16: 545–56.

Fentress, E. 2007. "Where Were North African *Nundinae* Held?" In Gosden et al. (eds.): 125–41.

Fentress, E. 2013. "Strangers in the City: Élite Communication in the Hellenistic Central Mediterranean." In Prag and Crawley Quinn (eds.): 157–78.

Fentress, E. and R.F. Docter 2008. "North Africa: Rural Settlement and Agricultural Production." In van Dommelen and Gómez Bellard (eds.): 101–28.

Fergola, L. 1984. *Oplontis e le sue ville.* Pompei: Flavius.

Fergola, L. 2014. "Villas and other Structures in the Area of Oplontis. Ville ed altri edifici nell'area Oplontina." In Clarke and Muntasser (eds.): 117–208.

Fergola, L. and P.G. Guzzo 2000. *Oplontis. La Villa di Poppea.* Milan: Motta.

Fergola, L. and M. Pagano 1998. *Oplontis: Le splendide ville romane di Torre Annunziata. Itinerario Archeologico Ragionato.* Torre del Greco: T & M.

Fernández Castro, M.C. 1982. *Villas romanas en España.* Madrid: Ministerio de Cultura.

Fernández Conde, F.J. 1971. *El Libro de los Testamentos de la Catedral de Oviedo.* Rome: Iglesia nacional española.

Fernández Galiano, D. 1992. "Cadmo y Harmonía. Imagen, Mito y Arqueología." *JRA* 5: 162–77.

Fernández Galiano, D. (ed.) 2001. *Carranque: centro de Hispania romana: Museo Arqueológico Regional, Alcalá de Henares, 27 de abril a 23 de septiembre de 2001.* Exhibition Catalogue. Alcalá de Henares: AACHE Ediciones.

Fernández Galiano, D. et al. 2001. "La más antigua basílica cristiana de Hispania." In Fernández Galiano (ed.): 71–80.

Fernández Ibáñez, C. and R. Bohigas Roldán (eds.) 2012. *Durii regione romanitas. Homenaje a Javier Cortes.* Santander-Palencia: Diputación Provincial de Palencia, Instituto de Prehistoria y Arqueología Sautuola.

Fernández Ochoa, C., V. García-Entero, and F. Gil Sendino (eds.) 2008. *Las villae tardorromanas en el occidente del Imperio: arquitectura y función. IV Coloquio Internacional de Arqueología en Gijón.* Gijón: Trea.

Fernández Ochoa, C. and L. Roldán Gómez 1991. "Arqueologia hispano-romana: Republica y Alto Imperio." In *Veinte años de Arqueología en España. Homenaje a Don Emeterio Cuadrado Díaz. Boletín Asociacion Espanol de Amigos Arqueologia* 30/31: 209–26. Madrid: Comunidad de Madrid, Consejería de Educación.

Feugere, M. (ed.) 1998. *Recherches sur l'économie du fer en Méditerranée nord-occidentale.* Monographies Instrumentum 4. Montagnac: Éditions Monique Mergoil.

Février, P.-A. 1974. "Permanences et héritages de l'antiquité dans la topographie des villes de l'Occident durant le haut Moyen-Age." In *Topografia urbana e vita cittadina nell'alto Medioevo in Occidente: settimana di studio 21, 26 aprile–1 maggio 1973*: 41–138. Spoleto: Centro di studi sull'alto medioevo.

Février, P.-A. 1981. "Villes et campagnes des Gaules sous l'Empire." *Ktema* 6: 359–72.

Février, P.-A. 1990. *Approches du Maghreb romain. Pouvoirs, différences et conflit.* Vol. II. Aix-en-Provence: Édisud.

Février, P.-A. 1996. "Valentine. *Villae* et lieux de culte." In Duval (ed.) 1996: 207–9.

Février, P.-A. and P. Leveau (eds.) 1982. *Villes et campagnes dans l'Empire romain: actes du colloque organisé à Aix-en-Provence par l'U.E.R. d'histoire, les 16 et 17 mai, 1980.* Aix-en-Provence: Université de Provence; Marseille: Diffusion J.Laffitte.

Fiches, J.-L. 1987. "L'espace rural antique dans le Sud-Est de la France: ambitions et réalités archéologiques." *AnnESC* 42: 219–38.

Fiches, J.-L. (ed.) 1996. *Le IIIe siècle en Gaule Narbonnaise, Actes de la table ronde du GDR 954, Aix-en-Provence, 15–16 septembre 1995.* Sophia-Antipolis: Éd. APDCA.

Fiches, J.-L., R. Plana-Mallart, and V. Revilla Calvo (eds.) 2013. *Paysages ruraux et territoires dans les cités de l'occident romain. Gallia et Hispania – Paisajes rurales y territorios en las ciudades del occidento romano. Gallia e Hispania. Actes du colloque International Ager IX, Barcelone, 25–27 mars 2010* (Collection "Mondes Anciens"). Montpellier: Presses Universitaires de la Méditerranée.

Filser, W., B. Fritsch, W. Kennedy, C. Klose, and R. Perrella 2017. "Surrounded by the Sea: Re-Investigating the *Villa Maritima* del Capo di Sorrento. Interim Report." *JRA* 30: 64–95.

Finley, M.I. 1958. Review of Boak 1955. *JRS* 48, 1156–64.

Finley, M.I. 1980. *Ancient Slavery and Modern Ideology.* London: Chatto and Windus.

Fiocchi Nicolai, V. 2007. "Il ruolo dell'evergetismo aristocratico nella costruzione degli edifici di culto cristiano nell'hinterland di Roma." In Brogiolo and Chavarría (eds): 107–26.

Fiocchi Nicolai, V. and S. Gelichi, 2001. "Battisteri e chiese rurali (IV–VII secolo)." In *L'edificio battesimale in Italia. Aspetti e problemi, Atti dell'VIII Congresso Nazionale di Archeologia Cristiana (Genova, Sarzana, Albenga, Finale Ligure, Ventimiglia, 21–26 settembre 1998)*: 303–84. Bordighera: Istituto internazionale di studi liguri.

Fiore Cavaliere, M.G. 1994. "Monachesimo prebenedettino e benedettino: note di topografia monastica." In Fiore Cavaliere (ed.): 1–24.

Fiore Cavaliere, M.G. (ed.) 1994. *Sublaqueum – Subiaco. Tra Nerone e S. Benedetto.* Rome: Quattro D.

Fiore Cavaliere, M.G. 1996. *Un ninfeo reiutilizzato. Scavi in un piccolo monastero di Subiaco, Soprintendenza Archeologica per il Lazio.* Rome: Soprintendenza Archeologica per il Lazio.

Fiore Cavaliere, M.G., Z. Mari, and A. Luttazzi. 1999. "Le villa di Nerone a Subiaco e la fondazione del monastero benedettino di S. Clemente." In Mari, Teresa Petrara, and Sperandio (eds.): 341–67.

Fiorentini, G. 1993–1994. "Attività di indagini archeologiche della Soprintendenza Beni Culturali e Ambientali di Agrigento." *Kokalos* 39–40: 717–33.

Fiorentini, G. 2006. *Villa romana di Durrueli presso Realmonte (Agrigento).* Agrigento: Regione Siciliana.

Fischer, M., O. Potchter, and Y. Jacob 1998 "Dwelling Houses in Ancient Israel: Methodological Considerations." *JRA* 11: 671–78.

Fish, J. 2011. "Is There an Epicurean in This Villa? Calpurnius Piso Caesoninus as Epicurean Statesman." Paper delivered at the annual meeting of the Archaeological Institute of America, San Antonio, TX, January 2011.

Fita, F. 1892. "Antigüedades romanas. Santa Colomba de Somoza." *Bull. Real Acad. Hist.* 21: 149–150.

Fittschen, K. 1976. "Zur Herkunft und Entstehung des 2. Stils – Probleme und Argumente." In Zanker (ed.): 539–63.

Fittschen, K. 1984. "Eine Büste des Kaisers Hadrian aus Milreu in Portugal. Zum Problem von Bildnisklitterungen." *MM* 25: 197–207.

Fittschen, K. 1993. "Bildnis des Kaisers Gallien aus Milreu. Zum Problem der Bildnistypologie." *MM* 34: 210–27.

Flickr photo www.flickr.com/photos/53144528@N04/5205911489/in/photostream/ (accessed August 8, 2011).

Flower, H.I. 1996. *Ancestor Masks and Aristocratic Power in Roman Culture.* Oxford: Clarendon Press.

Flower, H.I. (ed.) 2004. *The Cambridge Companion to the Roman Republic.* Cambridge: Cambridge University Press.

Flower, H.I. 2004 "Spectacle and Political Culture in the Roman Republic." In Flower (ed.): 334–7. Cambridge, UK: Cambridge University Press.

Flower, H. (ed.) 2014. *The Cambridge Companion to the Roman Republic.* 2nd rev. edn. Cambridge and New York: Cambridge University Press.

Foerster, G. 1977. "The Excavations at Tiberias." *Qadmoniot* 10: 87–91. (Hebrew).

Foletti, G. 1997. "Archeologia altomedievale nel canton Ticino." In *Archeologia della Regio Insubrica: dalla preistoria all'alto Medioevo (Atti del Convegno, Chiasso, 5-6 ottobre 1996)*, 113–80. Como: Associazione Archeologica Ticinese.

Fonseca, C.D., D. Adamesteanu, and F. D'Andria (eds.) 1986. *Casa, città e campagna nel tardoantico e nell'alto medioevo. Atti della XIII Settimana di studio della Fondazione CISAM.* Galatina: Congedo.

Font, G. 1994/5. "El mas ibèric de Can Pons (Arúbies)." *Tribuna d'Arqueologia*: 93–104. Barcelona: Generalitat de Catalunya, Departament de Cultura.

Fontaine, J. 1972. "Valeurs antiques et valeurs chrètiennes dans la spiritualité des grands propriètaires terriens a la fin du IVe siècle occidental." In Fontaine and Kannengiesser (eds.): 571–95.

Fontaine, J. and C. Kannengiesser (eds.) 1972. *Epektasis: Mélanges patristiques offerts au Cardinal Jean Daniélou.* Paris: Beauchesne.

Fontana, F. 1993. *La villa romana di Barcola. A proposito delle villae maritimae della Regio X.* Studi e richerche sulla Gallia Cisalpina 4. Rome: Quasar.

Fornell Muñoz, A. 1999. *Las Villae romanas de la Andalucía meridional y del Estrecho.* Jaén: Universidad de Jaén: Servicio de Publicaciones.

Fornell Muñoz, A. 2005. "Evolución de las *uillae* béticas durante la dinastía antonina." In Hernández Guerra, L. (ed.): 587–96.

Forsell, R. 1996. "The Roman Period." In *The Berbati-Limnes Archaeological Survey, 1988–1990.* In Wells and Runnels (eds.): 285–343.

Forsén J. and B. Forsén 2003. *The Asea Valley Survey. An Arcadian Mountain Valley from the Palaeolithic Period until Modern Times.* Acta Instituti Atheniensis Regni Sueciae. Stockholm: Svenska instituete i Athen; distributed by Paul Åströms Förlag.

Forster, E.S. and E.H. Heffner (eds. and trans.) 1955. *Columella on Agriculture,* 3 vols. Cambridge, MA: Harvard University Press.

Fortó, A., P. Martínez, and V. Muñoz 2008–11. "Assentaments al límit de la villa: Ca l'Estrada (Canovelles, Granollers)." In Revilla Calvo, González Pérez and Prevosti Monclús (eds.): 115–24.

Förtsch, R. 1989. "Ein Aurea-Aetas-Schema." *RM* 96: 333–45.

Förtsch, R. 1993. *Archäologischer Kommentar zu den Villenbriefen des jüngeren Plinius.* Mainz-am-Rhein: Philipp von Zabern.

Förtsch, R. 1995. "Villa und praetorium. Zur Luxusarchitektur in frühkaiserzeitlichen Legionslagern." *KölnJ* 28: 617–30.

Fortunati, M. and A. Ghiroldi 2007. "L'impianto termale della villa romana di Predore." In Fortunati and Keller (eds.): 634–38.

Fortunati, M. and A. Ghiroldi 2008. "Predore (BG). Area ex Lanza, Villa romana." *NSAL* 2006: 23–26.

Fortunati, M. and R.P. Keller (eds.) 2007. *Storia economica e sociale di Bergamo. I primi milleni: dalla Prestoria al Medioevo, II.* Bergamo: Fondazione per la storia economica e sociale di Bergamo, Istituto di studi e ricerche.

Foss, C. 1976. *Byzantine and Turkish Sardis.* Archaeological Exploration of Sardis monograph. Cambridge, MA: Harvard University Press.

Foss, P. 1997. "Watchful Lares: Roman Household Organization and the Rituals of Cooking and Eating." In Laurence and Wallace-Hadrill (eds.): 197–218.

Foucault, M. 1975. *Surveiller et punir: naissance de la prison.* Paris: Gallimard.

Foucault, M. 1984. *Histoire de la sexualité, vol. 2. L'usage des plaisirs.* Paris: Gallimard.

Fouet, G. 1969, re-issued 1984. *La villa gallo-romaine de Montmaurin (Haute-Garonne).* Supplément à Gallia 20. Paris: CNRS.

Fox, M. 2011. "Pompeii in Roberto Rossellini's Journey to Italy." In Hales and Paul (eds.): 286–300. Oxford: Oxford University Press.

Foxhall, L. 2007. *Olive Cultivation in Ancient Greece. Seeking the Ancient Economy.* Oxford: Oxford University Press.

Fracchia, H. and M. Gualtieri 1999. "Roman Lucania and the Upper Bradano Valley." *MAAR* 43–44: 295–343.

Fracchia, H. and M. Gualtieri 2011. "The Countryside of Regio II and Regio III (300 BC–14 AD)." In Colivicchi (ed.) 2011: 11–29.

Fracchia, H. and J.W. Hayes 2005. "A Sealed Late 2nd c. A D Pottery Deposit from Inland Basilicata." In Volpe and Turchiano (eds.) 2005: 145–72.

Franchi dell'Orto, L. (ed.) 1990. *Restaurare Pompei.* Milan: Sugarco Edizioni.

Franchi dell'Orto, L. (ed.) 1993. *Ercolano, 1738-1988: 250 anni di ricerca archeologica.* Rome: L'Erma di Bretschneider.

Franciosi, G. (ed.) 2002. *Ager Campanus. atti del convegno internazionale : la storia dell'Ager Campanus, i problemi della limitatio e sua lettura attuale : Real sito di S. Leucio, 8–9 giugno 2001.* Naples: Jovene.

Franciosi, G. 2002. "Il divieto della 'piscatio tinnaria': un'altra servitù prediale." *Revue internationale des droits de l'antiquité* 49: 102–7.

Francovich, R. and G. Noyé (eds.) 1994. *La storia dell'alto medioevo italiano alla luce dell'archeologia. Atti del convegno internazionale (Siena 2–6 dicembre 1992).* Florence: All'Insegna del Giglio.

Francovich, R. and R. Hodges 2003. *Villa to Village. The Transformation of the Roman Countryside in Italy, c. 400–1000.* Duckworth Debates in Archaeology. London: Duckworth.

Frank, T. 1933. *An Economic Survey of Ancient Rome, vol. 1. Rome and Italy of the Republic.* Baltimore, MD: Johns Hopkins University Press.

Frayn, J.M. 1979. *Subsistence Farming in Roman Italy.* London: Centaur Press Ltd.

Frayn, J.M. 1984. *Sheep-Rearing and the Wool Trade in Italy during the Roman Period.* Liverpool: Francis Cairns Publications.

Frazer, A. 1998. "Introduction." In Frazer (ed.): vii–x.

Frazer, A. (ed.) 1998. *The Roman Villa: Villa Urbana (First Williams Symposium on Classical Architecture held at the University of Pennsylvania, Philadelphia, April 21–22, 1990).* Philadelphia, PA: University of Pennsylvania Museum, University of Pennsylvania.

Freed, J. 2011. *Bringing Carthage Home. The Excavations of Nathan Davis, 1856–1859.* University of British

Columbia Studies in the Ancient World 2. Oxford: Oxbow Books.

Fremersdorf, F. 1933. *Der römische Gutshof Köln-Müngersdorf.* Römisch-Germanische Forschungen 6. Berlin and Leipzig: Walter de Gruyter.

Frendo, A.J. 1999. "A New Punic Inscription from Zejtun (Malta) and the Goddess Anat-Astarte." *Palestine Exploration Quarterly* 131: 24–35.

Freyberger, K.S. 1998. "Paläste und Wohnbauten in Syrien aus hellenistischer und römischer Zeit." In Aoyagi and Steingräber (eds.) 1998: 133–45.

Frézouls, E. 1980, "La vie rurale au Bas-Empire d'après l'ouvre de Palladius." *Ktema* 5, 193–210.

Frye, D. 2003. "Aristocratic Responses to Late Roman Urban Change: The Examples of Ausonius and Sidonius in Gaul." *CW* 96: 185–96.

Fuchs, W. 1963. *Der Schiffsfund von Mahdia.* Tübingen: Wasmuth.

Fuchs, W. 1979. *Die Skulptur der Griechen.* Munich: Hirmer Verlag.

Fumagalli, V. 1994. *Landscapes of Fear. Perceptions of Nature and the City in the Middle Ages.* Translated by S. Mitchell. Oxford: Oxford University Press.

Gabba, E. and Pasquinucci, M. 1979. *Strutture agrarie e allevamento transumante nell'Italia romana (III–I Sec. a. C.).* Pisa: Giardini.

Gabba, E. and A. Schiavone (eds.) 1989. In *Storia di Roma. Caratteri e Morfologie.* vol. 4. Turin: Einaudi.

Gabba, E. et al. 2003. *Misurare la terra: centuriazione e coloni nel mondo romano,* new and rev. edn. Modena: F. C. Panini.

Gabričević, B. 1973–4. "Bilješke uz prvi ilirski rat." *Radovi Filozofskog fakulteta u Zadru, Zadar* 12.5: 5–26.

Gaffney, C. and J. Gater 2003. *Revealing the Buried Past: Geophysics for Archaeologists.* Stroud, UK: Tempus.

Gaffney, V. and the Adriatic Islands Project team. 2006. "A game of numbers: rural settlement in Dalmatia and the Central Dalmatian Islands." In Davison, Gaffney, and Marin (eds.): 89–106.

Gaillard, J.-B. and M. Pasqualini 2010. "Fréjus, Capitou." *Bulletin Scientifique Régional,* Provence-Alpes-Côte d'Azur, 185–9.

Galand-Hallyn, P. (ed.) 2008. *La villa et l' univers familial dans l' Antiquité et à la Renaissance. Rome et ses renaissances.* Paris: Presses de l'Université Paris-Sorbonne.

Galand-Hallyn, P. and C. Lévy (eds.) 2008. *La villa et l' univers familial dans l' Antiquité et à la Renaissance:* Bonchamp-Lès-Laval: PUPS.

Galli, M. 2002. *Die Lebenswelt eines Sophisten: Untersuchungen zu den Bauten und Stiftungen des Herodes Atticus.* Mainz-am-Rhein: Philipp von Zabern.

Gallocchio, E. and P. Pensabene 2010. "Rinvestimenti musivi e marmorei dello *xystus* di Piazza Armerina alla luce dei nuovi scavi." In *AISCOM 2010,* 333–40.

Galor, K. 2000. "The Roman-Byzantine Dwelling in the Galilee and the Golan: 'House' or 'Apartment'?" In Holloway (ed.): 109–24.

Galor, K. and T. Waliszewski (eds.) 2007. *From Antioch to Alexandria: Recent Studies in Domestic Architecture.* Warsaw: Institute of Archaeology, University of Warsaw.

Gambaro, L., L. Gervasini, and S. Landi 2001. "Un edificio di epoca presillana al Varignano Vecchio." In "Atti della Giornata di Studio: Da Luna alla Diocesi (Luni 29 settembre 2001)." *Giornale Storico della Lunigiana* 49–51, 1998–2000: 67–111.

Gamberini, F. 1983. *Stylistic Theory and Practice in the Younger Pliny.* Altertumswissenschaftliche Texte und Studien XI. Hidlesheim: Olms-Weidmann.

Gambin, T. 2004. "Islands of the Middle Sea: An Archaeology of a Coastline." In De Maria and Turchetti (eds.): 127–47.

Ganschow, T. and M. Steinhart (eds.) 2005. "Otium." *Festschrift für Michael Strocka.* Remshalden: Bernhard Albert Greiner.

Garašanin, M. and D. Garašanin 1967. "Crna Gora u osvit pisane istorije." In *Historija Crne Gore* 1: 87–139.

García Merino, C. 2008. "Almenara de Adaja y las villas de la submeseta norte." In Fernández Ochoa, García-Entero, and Gil Sendino (eds.): 411–34.

García Merino, C. and M. Sánchez Simón 2004. "De nuevo acerca de la villa romana de Almenara de Adaja (Valladolid). Excavaciones de 1998 a 2002." *ArchEspArq* 77: 177–95.

García Merino, C. and M. Sánchez Simon 2010. "Abastecimiento de agua, saneamiento y drenaje en la villa romana de Almenara de Adaja (Valladolid)." *Saldvie* 10: 189–206.

García Merino, C. and M. Sánchez Simon 2012. "Historia de un planeamiento arquitectónico: un proyecto previo fallido, cambios y reformas en la planta de la villa tardorromana de Almenara de Adaja (Valladolid)." In Fernández Ibáñez and Bohigas Roldán (eds.) 2012: 343–50.

Garcia Vargas, E. and D. Florido del Corral 2010. "The Origin and Development of Tuna Fishing Nets (*Almadrabas*)." In Bekker-Nielsen and Bernal Casasola (eds.): 205–28.

García y Bellido, A. 1955. "Nombres de artistas en la España romana." *ArchEspArq* 28: 3–19.

García, M. and J.M. Puche 1999. "La vil·la romana del La Llosa (Cambrils, Baix Camp)." In Ruíz de Arbulo (ed.): 231–42.

Garcia, M., J.M. Macias, and I. Teixell 1999. "Necròpoli de la vil·la del Munts." In de Palol and Pladevall (eds.): 278–9.

García-Entero, V. 2003–4. "Algunos apuntes sobre el jardín doméstico en Hispania." *Anales de Prehistoria y Arqueología* 19–20: 55–70.

García-Entero, V. 2005. *Los balnea domésticos – ámbito rural y urbano – en la Hispania romana.* Anejos ArchEspArq 37. Madrid: Consejo Superior de Investigaciones Científicas Madrid.

García-Entero, V. 2005–6. "Las transformaciones de los balnea rurales domésticos durante la antigüedad tardía en Hispania (ss. IV–VI)." *CuPAUM* 31–32: 61–82.

García-Entero, V. 2006. "Los *balnea* de las *villae* tardoantiguas en *Hispania*." In Chavarría, Arce, and Brogiolo (eds.): 97–111.

García-Entero, V. and R. Castelo Ruano 2008. "Carranque, El Saucedo y las villae tardorromanas de la cuenca media del Tajo." In Fernández Ochoa, García-Entero, and Gil Sendino (eds.): 346–68.

García-Entero, V. et al. 2008. "La producción de vino en la Villa de Carranque (Toledo). Primeros resultados." In Blánquez Pérez and Celestino Pérez (eds.): 385–94.

Gargiulo, P. 2000. "Liternum: nuovi dati." In Gialanella (ed.): 115–17.

Gargiulo, P. (ed.) 2000. *Nova antiqua Phlegraea: nuovi tesori archeologici dai campi flegrei : guida alla mostra.* Milan and Naples: Electa Napoli and Soprintendenza archeologica di Napoli e Caserta.

Garmy, P. and L. Maurin 1996. *Enceintes romaines d'Aquitaine. Bordeaux, Dax, Périgueux, Bazas.* Documents d'archéologie française 53. Paris: Éditions de la Maison des Sciences de l'Homme.

Garnsey, P. 1968." Trajan's Alimenta: Some Problems." *Historia: Zeitschrift Für Alte Geschichte*, 17.3: 367–81.

Garnsey, P., K. Hopkins, and C.R. Whittaker (eds.) 1983. *Trade in the Ancient Economy.* London: Chatto & Windus.

Gasparri, C. 2002. "La decorazione scultorea del Ninfeo delle 'Grotte di Pilato' a Ponza." *Archeologia subacquea. Studi, ricerche e documenti* 3: 91–9.

Gasparri, C., G. Greco, and R. Pierobon (eds.) 2010. *Dall'immagine alla storia. Studi per ricordare Stefania Adamo Muscettola.* Pozzuoli: Naus.

Gasperini, L. 1996. "Ancora sul cippo di Arzaga (I.It. Brixia 817)." In Stella and Valvo (eds.): 183–9.

Gauckler, P. 1910. *Inventaire des mosaïques de la Gaule et de l'Afrique. II. Afrique Proconsulaire (Tunisie).* Paris: E. Leroux.

Gaudemet, J. 1979. *La formation du droit séculier et du droit de l'Église au VIᵉ et Vᵉ siècles*, 2nd rev. edn. Paris: Sirey.

Gauthier, N. and J.-Ch. Picard (eds.) 1986. *Topographie chrétienne des cités de la Gaule des origines au milieu du VIIIe siècle.* Paris: De Boccard.

Gazda, E.K. (ed.) 1991 (assisted by A.E. Haeckl). *Roman Art in the Private Sphere: New Perspectives on the Architecture and Decor of the Domus, Villa, and Insula.* Ann Arbor, MI: University of Michigan Press.

Gazda, E.K. and J.R. Clarke (eds.) 2016. *Leisure and Luxury in the Age of Nero. The Villas of Oplontis near Pompeii.* Kelsey Museum Publication 14. Ann Arbor, MI: Kelsey Museum of Archaeology.

Geertman, H. 1984. "Geometria e aritmetica in alcune case ad atrio pompeiane." *BABesch* 59: 31–52.

Geertman, H. and J.J. De Jong (eds.) 1989. Munus Non Ingratum. *Proceedings of the International Symposium on Vitruvius' De Architectura and the Hellenistic and Republican Architecture.* BaBesch supplement 2. Leiden: BABesch.

Geiger, J., H.M. Cotton, and G.D. Stiebel (eds.) *Israel's Land: Papers Presented to Israel Shatzman on his Jubilee.* Raʿanana and Jerusalem: The Open University of Israel and Israel Exploration Society.

Gelichi, S. (ed.) 1997. *Iº Congresso Nazionale di Archeologia Medievale. Auditorium del Centro studi della Cassa di risparmio di Pisa (ex Benedettine): Pisa, 29–31 maggio 1997.* Florence: All'Insegna del Giglio.

Gelichi, S. and N. Giordani (eds.) 1994. *Il tesoro nel pozzo. Pozzi-deposito e tesaurizzazioni nell'antica Emilia.* Modena: F.C. Panini, 1994.

Gell, A. 1998. *Art and Agency: Towards a New Anthropological Theory.* Oxford: Oxford University Press.

Genicot, L. 1990. *Rural Communities in the Medieval West.* Baltimore, MD: Johns Hopkins University Press.

Gentili, G. V. 1950. "Piazza Armerina. Grandiosa villa romana in contrada "Casale"." *NSc* ser.8, vol. 4: 291–335.

Gentili, G. V. 1959. *La Villa Erculia di Piazza Armerina. I mosaici figurati.* Rome: Edizioni mediterranee.

Gentili, G. V. 1962. *Musaici di Piazza Armerina. Le scene di caccia.* Milan: Officine Grafiche Ricordi.

Gentili, G. V. 1966. *The Imperial Villa of Piazza Armerina.* Guidebooks to the Museums, Galleries and Monuments of Italy 87. Rome: Istituto Poligrafico dello Stato.

Gentili, G. V. 1996. "Piazza Armerina e Faenza. Due mosaici con esaltazioni imperiali." *BdA* 98: 1–16.

Gentili, G. V. 1999. *La villa romana di Piazza Armerina. Palazzo Erculio*, 3 vols. Osimo: Fondazione Don Carlo.

George, M. 1997. *The Roman Domestic Architecture of Northern Italy.* BAR-IS 670. Oxford: Archaeopress.

George, M. 1998. "Elements of the Peristyle in Campanian Atria." *JRA* 11: 82–100.

George, M. 2002. "Review of J. T. Smith: Roman Villas: A Study in Social Structure." *Mouseion* 46 ser. 3.2: 278–80.

George, M. 2010. "Archaeology and Roman Slavery: Problems and Potential." In Heinen (ed.): 141–60.

George, M. 2013. "Introduction." In George (ed.): 3–18.

George, M. (ed.) 2013. *Roman Slavery and Roman Material Culture*. Toronto: University of Toronto Press.

Gerofoka, E., 2015. *Η αγροικία στη θέση Τρία Πλατάνια του νομού Πιερίας. Συμβολή στη Μελέτη της αρχαίας αγροικίας*. Thessaloniki: University Studio Press.

Gervasini, L. 2004. "Un insediamento presillano: il Varignano Vecchio (Portovenere, La Spezia)." In de Marinis and Spadea (eds.): 463–5.

Gervasini, L. and S. Landi 2001–2002. "Portovenere (SP). Zona archeologica del Varignano. Indagini archeologiche nel quartiere dei torchi oleari e nella zona residenziale della villa romana." *Rivista di Studi Liguri* 67–68: 47–190.

Getty, J.P. 1955. "A Journey from Corinth." In Le Vane and Getty: 286–329.

Getty, J.P. 1976. *As I See It: The Autobiography of J. Paul Getty*. New York: Prentice Hall (reprint Los Angeles, CA: Getty, 2003).

Ghalia, T. 2005. "La villa romaine de Demna, Wadi Arremel, et son environnement – Approche archéologique et projet de valorization." *Africa. Nouvelle Série. Séances Scientifiques III*: 53–86.

Ghalia, T. 2007. *Le Cap Bon. El Watan el Qibli. Le pays, l'histoire, les hommes*. Tunis: Centre de Publication Universitaire.

Ghalia, T., M. Bonifay, and C. Capelli 2005. "L'atelier de Sidi-Zahruni: mise en évidence d'une production d'amphores de l'Antiquité tardive sur le territoire de la cité de Neapolis (Nabeul, Tunisie)." In Gurt i Esparraguera, Buxeda i Garrigós, and Cau Ontiveros (eds.): 495–507.

Ghedini, F. 2005. "Il mare nella produzione musiva dell'Africa proconsolare." *Eidola* 2: 121–42.

Ghedini, F. et al. (eds.) 2005. *Lo Stretto di Messina nell'antichità*. Rome: Società Stretto di Messina.

Ghiandoni, O. 1995. "Il sarcofago asiatico di Melfi." *BdA* 89–90: 1–58.

Ghini, G. 1989. "Una statua di Dioniso con pantera proveniente dall'Ager Lanuvinus." *Documenta Albana* 2nd series, 11: 45–54.

Ghiroldi, A. 2002. "Toscolano Maderno (Bs), località Capra. Prosecuzione degli scavi nell'area della villa romana." *NSAL* 1999–2000: 141–3.

Giacopini, L., B.B. Marchesini, and L. Rustico 1994. *L'Itticoltura nell'Antichità*. Rome: Istituto Grafico Editoriale Romano.

Gialanella, C. (ed.) 2000. *Nova antiqua Phlegraea: nuovi tesori archeologici dai campi flegrei: guida alla mostra*. Milan and Naples: Electa Napoli and Soprintendenza Archeologica di Napoli e Caserta.

Giardina, A. (ed.) 1986. *Società romana e impero tardoantico*. 4 vols. Rome and Bari: Laterza.

Giardina, A. 1999a. "Considerazioni conclusive." In *Italia Meridionale Tardoantica*, 609–24.

Giardina, A. 1999b. "Esplosione del tardoantico." *Studi Storici* 40: 157–80.

Giardina, A. 2006. "Préface." In Quet (ed.): 12–18.

Giardina, A. 2007. "The Transition to Late Antiquity." In Scheidel, Morris, and Saller (eds.): 743–68.

Giardina, A. 2009 "Conclusioni." In Carlsen and Lo Cascio (eds.): 395–410.

Giardina, A. and A. Schiavone (eds.) 1981. *Società romana e produzione schiavistica*. 3 vols. Rome: Laterza.

Gibson, R.K. and R. Morello 2012. *Reading the Letters of Pliny the Younger. An Introduction*. Cambridge, UK, and New York: Cambridge University Press.

Gigante, M. (ed.) 1992. *Civiltà dei Campi Flegrei: Atti del convegno 1991*. Napoli: Giannini.

Ginouvès, R., R. Martin, F. Coarelli et al. 1985. *Dictionnaire méthodique de l'architecture grecque et romaine*, 3 vols. Athens and Rome: École française d'Athènes and École française de Rome.

Giorgi, E. 2002. "Ricerche e ricognizioni nel territorio." In De Maria and Gjongecaj (eds.): 121–31.

Giorgi, E. 2003. "Ricerche e ricognizioni nel territorio." In De Maria and Gjongecaj (eds.): 91–8.

Girardi Jurkić, V., K., Džin, and A. Paić 2011 "Ettinger Starčić, Z. 2010. Vižula kod Medulina. Rezidencijska maritimna vila: Istraživačka kampanja." *Histria Antiqua* 20, 489–503.

Giuffrida, C. and M. Cassia (eds.) 2016. *Silenziose rivoluzioni. La Sicilia dalla tarda antichità al primo medievo*. Testi e studi di storia antica 28. Catania and Rome: Edizioni del Prisma.

Gleason, K. 2014. "Wilhelmina Jashemski and Garden Archaeology at Oplontis." In Clarke and Muntasser (eds.): 929–1095.

Gleason, M. 2010. "Making Space for Bicultural Identity: Herodes Atticus Commemorates Regilla." In Whitmarsh (ed.): 125–62.

Glick, D. 2006. "A Salvage Excavation at 'Ein ez-Zeituna in Naḥal 'Iron." *'Atiqot* 51: 31–69.

Gnirs, A. 1908. "Istrische Beispiele für Formen dre antik-römischen villa rustica." *Jahrbuch für Altertumskunde, Wien* 2: 124–43.

Gnirs, A. 1915. "Forschungen über antiken villenbau in Südistrien." *Jahreshefte des Österreichischen Archäologischen Instituts* 18: 99–164.

Goette, H.R. 1994. "Ἀγρόκτημα κλασικῶν χρόνων στην Σούριζα (Λαυρεωτική)." In Doukellis and Mendoni (eds.): 133–46.

Goette, H.R. and T.M. Weber 2004. *Marathon: Siedlungskammer und Schlachtfeld – Sommerfrische und olympische Wettkampfstätte.* Mainz-am-Rhein: Philipp von Zabern.

Goffredo, R. (ed.) 2001. *Aufidus. Paesaggi della Valle dell'Ofanto.* Bari: Edipuglia.

Goffredo, R. 2010. "Persistence and Change in Settlement Patterns in the Ofanto Valley (Apulia)." *JRA* 23: 7–33.

Gómez Bellard, C. (ed.) 2003. *Ecohistoria del paisaje agrario. La agricultura fenicio-punica en el Mediterráneo.* Valencia: Univeristat de València.

Gonzalès, A. and Guillaumin, J.-Y. (eds.) 2006. *Autour des "libri coloniarum": Colonisation et colonies dans le monde romain. Actes du Colloque International (Besançon, 16–18 octobre 2003).* Besançon: Presses Univ. de Franche-Comté.

González Fernández, J. (ed.) 2000. *Trajano Emperador de Roma.* Roma: L'Erma di Bretschneider.

Goodchild, R. 1951. "Roman Sites on the Tarhuna Plateau of Tripolitania." *PBSR* 19: 43–77 (= Goodchild 1976: 72–106).

Goodchild, R. 1954. *Tabula Imperii Romani. Sheet H. I. 33 Lepcis Magna.* London: Society of Antiquaries.

Goodchild, R. 1976. *Libyan Studies. Select Papers of the Late R. G. Goodchild*, J. Reynolds (ed.) London: Paul Elek.

Goodman, M. 1983. *State and Society in Roman Galilee A.D. 132–212.* Totowa, NJ: Rowman and Allanheld.

Goodman, P.J. 2007. *The Roman City and Its Periphery from Rome to Gaul.* Abingdon, UK, and New York: Routledge.

Gorges, J.-G. 1979. *Les villas hispano-romaines: inventaire et problématique archéologiques.* Talence: Université de Bordeaux III and Paris: De Boccard.

Gorges, J.-G. 2008. "L'architecture des *villae* romaines tard-ives: la création et le développement du modèle tétrarchique." In Fernández Ochoa, García-Entero, and Gil Sendino (eds.): 17–25.

Gorges, J.-G. and F.G. Rodríguez Martín (eds.) 1999. *Économie et territoire en Lusitanie romaine* (Collection de la Casa Velázquez 65). Madrid: Casa de Velázquez.

Gorges, J.-G. and M. Salinas de Frías (eds.) 1994. *Les Campagnes de Lusitanie romaine. Occupation du sol et habitats. Table Ronde Internationale, Salamanque 1993.* Coll. Casa Velázquez 47. Madrid: Casa de Velázquez.

Gosden, C. 2001. "Making Sense: Archaeology and Aesthetics." *World Archaeology* 33: 163–7.

Gosden, C. et al. (eds.) 2007. *Communities and Connections: Essays in Honour of Barry Cunliffe.* Oxford: Oxford University Press.

Gouda, T. 2011. "*Der Romanisierungsprozess auf der Iberischen Halbinsel aus der Perspektive der iberischen Kulturen.*" Antiquitates – Archäologische Forschungsergebnisse 54. Hamburg: Dr. Kovac.

Goudineau, Chr. 1979. *Les fouilles de la Maison au Dauphin. Recherches sur la romanisation de Vaison-la-Romaine.* Supplément à *Gallia* 37. 2 vols. Paris: CNRS.

Goulet, C. C. 2001. "The 'Zebra Stripe' Design: An Investigation of Roman Wall Painting in the Periphery." *RStPomp* 12–13: 53–94.

Graen, D. 2004. "*Sepultus in villa.* Bestattet in der Villa: drei Zentralbauten in Portugal zeugen vom Grabprunk der Spaetantike." *AntW* 35: 65–74.

Graen, D. 2005. "Two Roman Mausoleums at Quinta de Marim (Olhão): Preliminary Results of the Excavations in 2002 and 2003." *Revista Portuguesa de Arqueologia* 8.1: 257–78.

Graham, J.W. 1966. "Origins and Interrelations of the Greek House and the Roman House." *Phoenix* 20: 3–31.

Grahame, M. 1997. "Public and Private in the Roman House: The *Casa del Fauno.*" In Laurence and Wallace-Hadrill (eds.): 137–64.

Graindor, P. 1930. *Hérode Atticus et sa famille: un milliardaire antique.* Cairo: Imprimerie Misr, Société anonyme égyptienne.

Grassigli. G. 2000. "Il regno della villa. Alle origini della rappresentazione della villa tardo antica."*Ostraka* 9: 199–226.

Grassigli, G.L. 1995. "La villa e il contesto produttivo nel paesaggio della Cisalpina." In Quilici and Quilici Gigli (eds.): 221–40.

Gravina, A. (ed.) 2006. *Atti 26°Convegno Nazionale sulla Preistoria, Protostoria e Storia della Daunia.* San Severo: Cromografica Dotoli.

Greco, C. 2009. "Attività della Soprintendenza per i Beni Archeologici della Basilicata." *AttiTaranto* 48: 787–824.

Green, R.P.H. 1991. *The Works of Ausonius.* Oxford: Oxford University Press.

Greenberg, R., O. Tal, and T. Daʿadli 2017. *Bet Yeraḥ, Vol. III: Hellenistic Philoteria and Islamic al-Ṣinnabra* (IAA Reports 61). Jerusalem: Israel Antiquities Authority.

Greene, K. 1986. *The Archaeology of the Roman Economy.* London: B.T. Batsford.

Gregory, T.E. (ed.) 1993. *The Corinthia in the Roman Period.* JRA Supplement 8. Ann Arbor, MI: Journal of Roman Archaeology.

Grelle, F. 1993. *Canosa romana.* Rome: "L'Erma" di Bretschneider.

Grelle, F. and M. Silvestrini 2001. "Lane apule e tessuti canosini." In Pani (ed.): 91–136.

Grenier, J.-C. 2000. "Il 'Serapeo' e il 'Canopo': un "Egitto' monumentale e un 'Mediterraneo.'" In *Adriano. Architettura e progetto*, 73–5. Milan: Electa.

Griesbach, J. 2005. "Villa e mausoleo: mutamenti nel concetto della memoria nel suburbio romano." In Santillo Frizell and Klynne (eds.): 113–23.

Griffin, J. 1976. "Augustan Poetry and the Life of Luxury." *JRS* 66: 87–105.

Grig, L. 2004. *Making Martyrs in Late Antiquity*. London: Duckworth.

Grimal, P. 1943 *Les jardins romains à la fin de la République et aux deux premiers siècles de l'Empire: essais sur le naturalisme romain*. BÉFAR 155. Paris: De Boccard.

Gros, P. 1996–2001. *L'architecture romaine: du début du IIIe siècle av. J.-C. à la fin du Haut-Empire*, 2 vols. Paris: Picard.

Gros, P. 1998. "Ville et 'non-villes': les ambiguïtés dans la hiérarchie juridique et de l'aménagement urban." In Gros (ed.): 11–25.

Gros, P. (ed.) 1998. *Villes et campagnes en Gaule romaine*. Paris: Éditions du CTHS.

Gros, P. 2001. *L'architecture romaine du début du IIIe siècle av. J.-C. à la fin du Haut-Empire*, vol 2: Maisons, palais, villas et tombeaux. Paris: Picard.

Gros, P. 2002. Review of Carafa 1998. *RA* 33: 138–40.

Gros, P. 2006. *Vitruve et la tradition des traités d'architecture: fabrica et ratiocinatio: recueil d'études*. Rome: École française de Rome.

Gros, P. 2015. "La posterité provinciale des sanctuaires 'urbains' du culte impériale: nature et signification de leurs citations architecturales et plastiques." In Favro, D. et al. (eds.): 181–200.

Grossmann, E. 2001. *Maritime Tel Michal and Apollonia: Results of the Underwater Survey 1989–1996*. Oxford: Archaeopress.

Gsell, S. 1901a. *Les monuments antiques de l'Algérie*. Tome premier. Paris: Albert Fontemoing Éditeur.

Gsell, S. 1901b. *Les monuments antiques de l'Algérie*. Tome second. Paris: Albert Fontemoing Éditeur.

Gsell, S. (ed.) 1911. *Atlas archéologique de l'Algérie. Édition spéciale des cartes au 200,000e du Service Géographique de l'Armée, avec un texte explicatif*. Algiers and Paris: Jourdan.

Gsell, S. 1912. *Exploration scientifique de l'Algérie pendant les années 1840–1845. Archéologie. Texte explicatif des planches de Ad. H. Al. Delamare*. Paris: E. Leroux Éditeur.

Gualtieri, M. (ed.) forthcoming. *L'alto Bradano in età romana: le villae di Oppido Lucano*. Collection du Centre Jean Bérard. Rome and Naples: Centre Jean Bérard.

Gualtieri, M. 2000. "*Figlinae, domi nobiles* ed approvvigionamento di laterizi nell'Italia centro-meridionale: due casi di studio." In Boucheron, Broise, and Thébert (eds.): 329–40.

Gualtieri, M. 2003. *La Lucania romana. Cultura e Società nella documentazione archeologica*. Quaderni di Ostraka, Vol. 8. Naples: Loffredo.

Gualtieri, M. 2008a. "The Water Supply System of a Senatorial Estate in Southern Italy." In Hermon (ed.): 67–76.

Gualtieri, M. 2008b. "Lucanian landscapes in the Age of Romanization." In De Ligt and Northwood (eds.): 387–412.

Gualtieri, M. 2009a. "A Mosaic of Aiòn and the Seasons from Lucania and Its 3rd c. A.D. Context." *JRA* 22: 275–85 and 289–90.

Gualtieri, M. 2009b *Villae* e uso del territorio nell' Alto Bradano (*Regio III*) fra tarda repubblica e primo impero." In Carlsen and Lo Cascio (eds.): 341–68.

Gualtieri, M., M. Salvatore, and A. Small (eds.) 1983. *Lo Scavo di S. Giovanni di Ruoti ed il periodo tardantico in Basilicata: Atti del Tavola Rotonda, Roma 4 luglio 1981*. Bari: Adriatica.

Guardia, M. 1992. *Los mosaicos de la Antigüedad tardía en Hispania. Estudios de Iconografía*. Barcelona: PPU.

Guardia Pons, M. 1992. *Los Mosaicos de la Antigüedad Tardía en Hispania*. Barcelona: PPU.

Guarducci, M. 1981. "Camerae fulgentes." In *Letterature comparate. Problemi e metodo. Studi in onore di Ettore Paratore*, 799–817. Bologna: Pàtron Editore.

Gugole J. 2006. "La villa gallo-romaine de Séviac à Montréal-du-Gers (Gers), architecture de la partie résidentielle." In Réchin (ed.) 2006: 79–121.

Gui, I., N. Duval, and J.-P. Gaillet 1992. *Basiliques chrétiennes d'Afrique du Nord. I – Inventaire des monuments de l'Algérie* (Collection des Études Augustiniennes, Série Antiquité 129). Paris: Institut d'études augustiniennes.

Guidobaldi, F. 1997. "I *sectilia pavimenta* della villa romana di Durrueli presso Agrigento." In *AISCOM 1997*, 247–58.

Guidobaldi, M.P. ed. 2008. *Ercolano, tre secoli di scoperte*. Milan: Electa.

Guidobaldi, M.P. and D. Esposito 2009. "Le nuove ricerche archeologiche nella villa dei Papiri di Ercolano." *CronErcol* 39: 333–72.

Guidobaldi, M.P. and D. Esposito 2010. "New Archaeological Research at the Villa of the Papyri at Herculaneum." In Zarmakoupi (ed.): 21–62.

Guidobaldi, M.P., D. Esposito, and E. Formisano 2009. "L'*insula* I, l'*insula* nord-occidentale e la Villa dei Papiri di Ercolano: una sintesi delle conoscenze alla luce delle recenti indagini archeologiche." *Vesuviana* 1: 43–182.

Guidoboni, E. (ed.) 1989. *I terremoti prima del Mille in Italia e nell'area mediterranea. Storia, archeologia, sismologia.* Bologna: Edizioni SGA Storia–Geofisica–Ambiente.

Guidoboni, E. 1994. *Catalogue of Ancient Earthquakes in the Mediterranean Area up to the 10th Century.* Rome: Istituto Nazionale di Geofisica.

Guijarro, S. 1997. "The Family in First-Century Galilee." In Moxnes (ed.): 42–65.

Gurt i Esparraguera, J.Ma., J. Buxeda i Garrigós, and M.A. Cau Ontiveros (eds.) 2005. *LRCW1, Late Roman Coarse Wares, Cooking Wares and Amphorae in the Mediterranean: Archaeology and Archaeometry.* BAR-IS 1340. Oxford: Archaeopress.

Gurt i Esparraguera, J.M. and A. Ribera i Lacomba (eds.) 2005. *VI Reunió d'Arqueologia Cristiana Hispànica: les ciutats tardoantigues d'Hispania: cristianització i topografia: València, 8, 9 i 10 de maig de 2003.* Barcelona: Institut d'Estudis Catalans.

Gusi, F. 1999. "Treballs de consolidació a la vil·la romana de Benicató (Nules, la Plana Baixa)." *Cuadernos Prehist Arqu Cast.* 20: 369–74.

Gusi, F. and C. Olaria 1977. "La villa roman de Benicató, Nules Castellón." *Cuadernos Prehist Arqu Cast.* 4: 101–144.

Guttmann, A. 1954. "The Patriarch Judah I: His Birth and His Death." *Hebrew Union College Annual* 25: 239–61.

Guzzardi, L. 1997–98. "L'attività della Soprintendenza ai Beni Culturali e Ambientali di Enna nel settore archeologico: 1996–1997." *Kokalos* 43–44: 291–309.

Guzzardi, L. 2014. "Nuove scoperte nel Siracusano." In Pensabene and Sfameni (eds.): 29–36.

Guzzo, P.G. 2000. *Il gabinetto segreto nel Museo Archeologico di Napoli.* Naples: Electa.

Guzzo P.G., G. Bonifacio, and A.M. Sodo (eds.) 2007. *Stabiae – at the Heart of the Roman Empire.* Castellamare di Stabia: Nicola Longobardi Editori.

Guzzo P.G., G. Bonifacio, and A.M. Sodo (eds.) 2009. *Stabiae, cuore dell'Impero Romano.* Castellamare di Stabia: Nicola Longobardi Editori.

Guzzo, P.G. and M.P. Guidobaldi (eds.) 2008. *Nuove ricerche archeologiche nell'area vesuviana (scavi 2003–2006). Atti del Convegno Internazionale, Roma 1–3 febbraio 2007.* Rome: "L'Erma" di Bretschneider.

Hadidi, A. (ed.) 1985. *Studies in the History and Archaeology of Jordan,* vol. 2. Amman: Department of Antiquities.

Haldimann, M.-A., J.-B. Humbert, and M. Martiniani-Reber (eds.) 2007. *Gaza à la croisée des civilisations: contexte archéologique et historique.* Geneva: Musées d'Art et d'Histoire.

Hales, S. 2003. *The Roman House and Social Identity.* Cambridge: Cambridge Univeristy Press.

Hales, S. and J. Paul (eds.) 2011. *Pompeii in the Public Imagination from Its Rediscovery to Today.* Oxford: Oxford University Press.

Hall, E. and R. Wyles. 2008. *New Directions in Ancient Pantomime.* Oxford: Oxford University Press.

Hallebeek, J. 1987. "Legal Problems Concerning a Draught of Tunny." *The Legal History Review* 55.1–2: 39–48.

Halsall, G. 1995. *Settlement and Social Organization: The Merovingian Region of Metz.* Cambridge, UK: Cambridge University Press.

Hannestad, N. 2007. "Late Antique Mythological Sculpture. In Search of a Chronology." In Alto Bauer and Witschel (eds.): 275–307.

Hanoune, R. 1990. "Le dossier des xenia et la mosaïque." In Balmelle and Guimier-Sorbets (eds.): 7–13.

Hanson, R.P.C. 1970. "The Church in Fifth-Century Gaul. Evidence from Sidonius Apollinaris." *JEH* 21, 1–10.

Harreither, R. et al. (eds.) 2006. *Acta Congressus Internationalis XIV Archaeologiae Christianae.* Vatican City and Vienna: Pontificio Istituto di Archeologia Cristiana and Österreichische Akademie der Wissenschaften.

Harries, J.D. 1992. "Sidonius Apollinars, Rome and the Barbarians: A Climate of Treason?" In Drinkwater and Elton (eds.): 298–308.

Harries, J.D. 1996. "Sidonius Apollinaris and the Frontiers of *Romanitas.*" In Mathisen and Sivan (eds.): 31–44.

Harries, J.D. 1999. *Law and Empire in Late Antiquity.* Cambridge: Cambridge University Press.

Harris, W.V. (ed.) 1999. *The Transformations of Urbs Roma in Late Antiquity.* JRA Supplementary series 33. Portsmouth, RI: JRA.

Harrison, G.W.M. 1993. *The Romans and Crete.* Amsterdam: Adolf M. Hakkert.

Hatzfeld, J. 1919. *Les trafiquants italiens dans l'Orient hellénique.* Paris: De Boccard.

Hauschild, T. 1969. "Das Mausoleum bei Las Vegas de Puebla Nueva." *MM* 10: 296–316.

Hauschild, T. 1972. "Untersuchungen in der Märtyrerkirche von Marialba (Prov. Leon) und im Mausoleum von las Vegas de Pueblanueva (Prov. Toledo)." In *Actas del VIII Congreso Internacional de Arqueología Cristiana,* vol. 1, 327–32. Barcelona: Consejo Superior de Investigaciones Científicas.

Hauschild, T. 1978. "Das Mausoleum von Las Vegas de Pueblanueva (Prov. Toledo). Grabungen in den Jahren 1971/1974." *MM* 19: 307–39.

Hayden, B.J. 2004. *Reports on the Vrokastro Area, Eastern Crete: The Settlement History of the Vrokastro Area and Related Studies.* University Museum Monograph 119, vol. 2. Philadelphia, PA: University of Pennsylvania.

Haynes, D.E.L. 1955. *An Archaeological and Historical Guide to the Pre-Islamic Antiquities of Tripolitania*. Tripoli: Antiquities Department of Tripolitania.

Hays, K.M. 1998. *Architecture Theory since 1968*. Cambridge, MA, and London: MIT Press.

Heather, P. 1991. "The Emergence of the Visigothic Kingdom." In Drinkwater and Elton (eds.): 84–94.

Heijmans, M. 2006. "Les habitations urbaines en Gaule méridionale durant l'Antiquité tardive." *Gallia* 63: 1–170.

Heinen, H. (ed.) 2010. *Antike Sklaverei: Rückblick und Ausblick: neue Beiträge zur Forschungsgeschichte und zur Erschliessung der archäologischen Zeugnisse*. Stuttgart: Steiner.

Heinen, H. 2010. "Aufstieg und Niedergang der sowjetischen Sklavereiforschung. Eine Studie zur Verbindung von Politik und Wissenschaft." In Heinen (ed.): 95–138.

Heinzelmann, M. 1993. "Villa d'après les œuvres de Grégoire de Tours." In Magnou-Nortier (ed.): 45–70.

Heitland, W.E. 1921. Agricola; *a Study of Agriculture and Rustic Life in the Greco-Roman World from the Point of View of Labour*. Cambridge, UK: Cambridge University Press.

Hekster, O. 2002. *Commodus, an Emperor at the Crossroads*. Amsterdam: Gieben.

Hekster, O., G. de Klein, and D. Slootjes (eds.) 2007. *Crises and the Roman Empire. Proceedings of the Seventh Workshop of the International Network Impact of Empire Nijmegen, June 20–24, 2006*. Leyden: Brill.

Heleno, M. 1962. "A 'Villa' lusitano-romana de Torre de Palma (Monforte)." *ArqPort* 4: 313–38.

Hellenkemper Salies, G. (ed.) 1994. *Das Wrack: Der Antike Schiffsfund von Mahdia*. Kataloge Des Rheinischen Landesmuseums Bonn 1. Köln: Rheinland Verlag.

Hemelrijk, H. 2015. *Hidden Lives, Public Personae: Women and Civic Life in the Roman West*. Oxford: Oxford University Press.

Henderson, J. 2004. *Morals and Villas in Seneca's Letters*. Oxford: Oxford University Press.

Hermon, H. (ed.) 2008. *Vers une gestion intégrée de l'eau dans l'empire romain: actes du Colloque international, Université Laval, octobre 2006*. Rome: "L'Erma" di Bretschneider.

Hernández Guerra, L. (ed.) 2005. *La Hispania de los Antoninos (98–180): actas del II Congreso Internacional de Historia Antigua: Valladolid, 10, 11 y 12 de noviembre de 2004*. Valladolid: Universidad de Valladolid, Secretariado de Publicaciones e Intercambio Editorial.

Herr, L.G. with W.C. Trenchard 1996. *Published Pottery of Palestine*. Atlanta, GA: Scholars Press.

Herrmann-Otto, E. 2010. "Das Projekt 'Forschungen zur antiken Sklaverei' an der Akademie der Wissenschaften und der Literatur, Mainz." In Heinen (ed.): 61–76.

Herz, P. and G. Waldherr (eds.) 2001. *Landwirtschaft im Imperium Romanum*. Pharos 14. St. Katharinen: Scripta Mercaturae.

Heurgon, J. 1976. "L'agronome cathaginois Magon et ses traducteurs en latin et en grec." *CRAI* 120.3: 441–56.

Hezser, C. 1997. *The Social Structure of the Rabbinic Movement in Roman Palestine*. Tübingen: Mohr Siebeck.

Hidalgo, R. 2002. "De edificio imperial a complejo de culto: la ocupación cristiana del palacio de Cercadilla." In Vaquerizo (ed.): 343–72.

Hidalgo, R. and A. Ventura 1994. "Sobre la cronología e interpretación del palacio de Cercadilla en Corduba." *Chiron* 24: 221–40.

Hidalgo Prieto, R. (ed.) 2017. *Las villas romanas de la Bética*, 2 vols. Granada: Universidad de Granada.

Higginbotham, J. A. 1997. *Piscinae: Artificial Fishponds in Roman Italy*. Chapel Hill, NC, and London: North Carolina University Press.

Hillier, B. and J. Hanson 1984. *The Social Logic of Space*. Cambridge, UK: Cambridge University Press.

Hingley, R. 1990. "Domestic Organisation and Gender Relations in Iron Age and Romano-British Households." In Samson (ed.): 125–47.

Hinks, R.P. 1933. *Catalogue of the Greek, Etruscan and Roman Paintings and Mosaics in the British Museum*. London: British Museum.

Hinz, H. (ed.) 1970. *Germania Romana III: Römisches Leben auf germanischem Boden*. Gymnasium, Beiheft 7. Heidelberg: C. Winter.

Hinz, H. 1970. "Zur römischen Besiedlung in der Kölner Buch." In Hinz (ed.): 62–9.

Hirsch, J. 2007. "Odysseys of Life and Death in the Bay of Naples: Roberto Rossellini's *Voyage in Italy* and Jean-Luc Godard's *Contempt*." In Seydl and Coates (eds.): 271–89.

Hirschfeld, Y. (ed.) 1988. *Tiberias: From Its Foundation until the Muslim Conquest* (Idan 11). Jerusalem: Yad Izhak Ben-Zvi. (Hebrew).

Hirschfeld, Y. 1991. "Excavations at Tiberias Reveal Remains of Church and Possibly Theater." *Biblical Archaeologist* 54: 170–1.

Hirschfeld, Y. 1992. *A Guide to Antiquity Sites in Tiberias*. Jerusalem: Israel Antiquities Authority.

Hirschfeld, Y. 1993. s.v. "Tiberias." In *NEAEHL*, vol. 4: 1464–70. Jerusalem: Israel Exploration Society and Carta.

Hirschfeld, Y. 1995. *The Palestinian Dwelling in the Roman-Byzantine Period*. Jerusalem: Franciscan Printing Press and Israel Exploration Society.

Hirschfeld, Y. 1997. "Farms and Villages in Byzantine Palestine." *DOP* 51: 33–71.

Hirschfeld, Y. 1999. s.v. "Habitat." In Bowersock, Brown, and Graber (eds.): 258–72.

Hirschfeld, Y. 2004. *Excavations at Tiberias, 1989–1994* (IAA Reports 22). Jerusalem: Israel Antiquities Authority.

Hirschfeld, Y. and R. Birger-Calderon 1991. "Early Roman and Byzantine Estates near Caesarea." *IEJ* 41: 81–111.

Hirschfeld, Y. and K. Galor. 2007. "New Excavations in Roman, Byzantine, and Early Islamic Tiberias." In Zangenberg, Attridge, and Martin (eds.): 207–29.

Hirschfeld, Y. and R. Reich 1988. "The City Plan of Tiberias in the Roman-Byzantine Period." In Hirschfeld (ed.): 111–18.

Hitchner, R.B. 1988. "The Kasserine archaeological survey 1982–86." *AntAfr* 24: 7–41.

Hitchner, R.B. 1989. "The Organization of Rural Settlement in the Cillium-Thelepte Region (Kasserine, Central Tunisia)." *AfrRom* 6: 387–402.

Hitchner, R.B. 1990 (with contributions by S. Ellis, A. Graham, D. Mattingly, and L. Neuru). "The Kasserine Archaeological Survey 1987." *AntAfr* 26: 231–59.

Hitchner, R.B. 1992–3. "The Kasserine archaeological survey, 1982–1985." *Africa* 11–12: 158–98.

Hjort Lange, C. 2009. *Res Publica Constituta: Actium, Apollo and the Accomplishment of the Triumviral Assignment.* Leiden: Brill.

Hodge, A.T. (ed.) 1991. *Future Currents in Aqueduct Studies.* Leeds: Francis Cairns.

Hodges, R., W. Bowden, and K. Lako (eds.) 2004. *Byzantine Butrint. Excavations and Surveys 1994–99.* Oxford: Oxbow Books.

Hodgkin, T. 1885. *Italy and Her Invaders, vol. 3: The Ostrogothic Invasion, 476–535.* Oxford: Clarendon Press.

Hoepfner, W. (ed.) *Antike Bibliotheken.* Mainz-am-Rhein: Philipp von Zabern.

Holden, A. 2002. "The Cultivation of Upper-Class *Otium*: Two Aquileian 'Oratory' Pavements Reconsidered." *Studies in Iconography* 23: 29–54.

Holloway, R. Ross (ed.) 2000. *Miscellanea Mediterranea.* Providence, RI: Center for Old World Archaeology and Art, Brown University.

Holum, K.G., A. Raban, and J. Patrich (eds.) 1999. *Caesarea Papers, vol. 2: Herod's Temple, The Provincial Governor's Praetorium and Granaries, the Later Harbor, A Gold Coin Hoard, and Other Studies. JRA* supplement 35. Portsmouth, RI: JRA.

Honoré, T. 1998. *Law in the Crisis of Empire 379–455 AD. The Theodosian Dynasty and Its Quaestors.* Oxford: Clarendon Press and New York: Oxford University Press.

Hopkins, K. 1978. *Conquerors and Slaves.* Cambridge, UK: Cambridge University Press.

Hopkins, K. 1983. "Introduction." In Garnsey, Hopkins, and Whittaker (eds.) 1983: i–xxvii.

Horden, P. and N. Purcell 2000. *The Corrupting Sea. A Study of Mediterranean History.* Oxford, UK and Malden, MA: Blackwell.

Hornung, S. 2008. *Luxus auf dem Lande. Die römische Palastvilla von Bad Kreuznach.* Bad Kreuznach: Museum Press.

Horster, M. and C. Reitz (eds.) 2005. *Wissensvermittlung in dichterischer Gestalt.* Stuttgart: Franz Steiner.

Houston, G.W. 2013. "The Non-Philodemus Book Collection in the Villa of the Papyri." In König, Oikonomopoulou, and Woolf (eds.): 183–208.

Howard, S. 1978. *The Lansdowne Herakles.* Malibu, CA: J. Paul Getty Museum.

Howe, T.N. 2004. "Powerhouses: The Seaside Villas of Campania in the Power Culture of Rome." In *In Stabiano. Exploring the Ancient Seaside Villas of the Roman Elite.* Exh. cat. National Museum of Natural History, Washington, DC, April 26–October 24, 2004, 15–24. Castellammare di Stabia: Nicola Longobardi Editore.

Howe, T.N., K. Gleason, and I. Sutherland 2011. "Stabiae, Villa Arianna: scavi e studi nel giardino del Grande Peristilio, 2007–2011." *RivStPomp* 22: 205–9.

Humbert, J.-B. 2000. *Gaza méditerranéenne: histoire et archéologie en Palestine.* Paris: Errance.

Humphrey, J.H. 1986. *Roman Circuses. Arenas for Chariot Racing.* London: B. T. Batsford Ltd.

Hunt, J.D. (ed.) 1992. *The Pastoral Landscape.* Washington, DC: National Gallery of Art.

Huskinson, J. 1974. "Some Pagan Mythological Figures and Their Significance in Early Christian Art." *PBSR* 42: 68–86.

Huskinson, J.M. 1982. Concordia Apostolorum. *Christian Proganganda at Rome in the Fourth and Fiifth Centuries. A Study in Early Christian Iconography and Iconology.* BAR-IS 148. Oxford: Archaeopress.

Icard Gianolio, N. 1997. *s.v.* "Tritones." In *LIMC* 8.1, 73–85. Zürich: Artemis.

Icard Gianolio, N. and A.V. Szabados, 1992. *s.v.* "Nereides." In *LIMC* 6.1, 785–824.

Isaac, B. 1992. *The Limits of Empire: The Roman Army in the East*, rev.ed. Oxford: Oxford UP.

Isaac, B. 1998. "Milestones in Judaea, from Vespasian to Constantine." In Isaac (ed.): 48–68, postscript 69–75.

Isaac, B. (ed.) 1998. *The Near East under Roman Rule: Selected Papers.* Leiden and New York: Brill.

Isaac, B. and Gichon, M. 1998. "A Flavian Inscription from Jerusalem." In Isaac (ed.): 76–85, postscript 86.

Isaac, B. and Roll, I. 1998. "A Milestone of A.D. 69 from Judaea: The Elder Trajan and Vespasian." In Isaac (ed.): 36–44, postscript 45.

Isager, J. (ed.) 2001. *Foundation and Destruction: Nikopolis and Northwestern Greece: The Archaeological Evidence for the City Destructions, the Foundation of Nikopolis and the Synoecism*. Athens: The Danish Institute at Athens/Aarhus University Press.

Isla, A. 2001. "*Villa, villula* y *castellum*. Problemas de terminología rural en época visigoda." *Arqueología y Territorio medieval* 8: 9–19.

Jacobi, G. 1943. "Galeata (Forlì). Scavi in loc. Saetta." *NSc* 1943: 204–12.

Jacono, L. 1924. 'Nettuno. *Piscinae in litore constructae.*" *NSc* 1924: 333–40.

Jacques, F. 1993. "L'origine du domaine de la Villa Magna Variana id est Mappalia Siga: une hypothèse." *AntAfr* 29: 63–9.

Jacques, P. 2006. "Nouvelles données sur l'habitat rural antique en Lot-et-Garonne." In Réchin (ed.): 79–121.

Jannet, M. and Ch. Sapin (eds.) 1996. *Guillaume de Volpiano et l'architecture des rotondes, Actes du colloque, Musée archéologique de Dijon, 1993*. Dijon: Musée archéologique de Dijon.

Jashemski, W.F. 1979a. "The Garden of Hercules at Pompeii (II.viii.6): The Discovery of a Commercial Flower Garden." *AJA* 83: 403–11.

Jashemski, W.F. 1979b. *The Gardens of Pompeii, Herculaneum and the Villas Destroyed by Vesuvius*, 2 vols. New Rochelle, NY: Aristide D. Caratzas.

Jashemski, W.F. 1981. "The Campanian Peristyle Garden." In Jashemski and MacDougall (eds.): 29–48. Washington, DC: Dumbarton Oaks.

Jashemski, W.F. (ed.) 1987. *Ancient Roman Gardens*. Dumbarton Oaks Colloquium on the History of Landscape 10. Washington, DC: Dumbarton Oaks.

Jashemski, W.F. 1993. *The Gardens of Pompeii. Herculaneum and the Villas Destroyed by Vesuvius*, vol. 2. *Appendices*. New Rochelle, NY: Aristide D. Caratzas.

Jashemski, W.F. 2007. "Gardens." In Dobbins and Foss (eds.): 487–98.

Jashemski, W.F. and E.B. MacDougall (eds.) 1981. *Ancient Roman Gardens*. Washington, DC: Dumbarton Oaks.

Jashemski, W.F. and F.G. Meyer. 2002. *The Natural History of Pompeii*. Cambridge, UK: Cambridge University Press.

Jastrzebowska, E. 1979. "Les scènes de banquet dans les peintures et sculptures chrétiennes des IIIe et IVe siècles." *Recherches Augustiniennes* 14: 3–90.

Jesnick, I.J. 1997. *The Image of Orpheus in Roman Mosaic: An Exploration of the Figure of Orpheus in Graeco-Roman Art and Culture with Special Reference to Its Expression in the Medium of Mosaic in Late Antiquity*. BAR-IS 671. Oxford: Archaeopress.

Jiménez, J.L. and J.M. Burriel 2007. "L'Horta Vella (Bétera, Valencia)." *Sagvntvm* 39: 193–8.

Jiménez, J.L. et al. 2005. "L'Horta Vella (Bétera, València), de vil·la altimperial a establiment rural visigòtic." In Gurt i Esparraguera and A. Ribera i Lacomba (eds.): 305–15.

Jiménez, J.L. et al. 2008. "La fase tardorromana de l'Horta Vella (Bétera, Valencia)." In Fernández Ochoa, García-Entero, and Gil Sendino (eds.): 629–38.

Jiménez Díez, A. 2008. "*Imagines Hibridae. Una aproximación postcolonialista al estudio de las necrópolis de la Bética.*" Madrid: CSIC.

Jodin, A. 1967. *Les établissements du Roi Juba II aux Îles Purpuraires (Mogador)*. Tangiers: Éditions marocaines et internationales.

Johannowsky, W. 1986. "Minori. La villa romana." In Johannowsky, Laforgia, Romito, and Sampaolo (eds.): 78–86.

Johannowsky, W., E. Laforgia, M. Romito, and V. Sampaolo (eds.) 1986. *Le ville romane dell'età imperiale*. Naples: Società Editrice Napoletana.

Johnson, D. 1912. "The Manuscripts of Pliny's Letters." *Classical Philology* 7: 66–75.

Johnson, L.L. 1984. The Hellenistic and Roman Library: studies pertaining to their architectural form. Unpublished Ph.D. dissertation, Brown University.

Johnson, M.J. 2009. *The Roman Imperial Mausolea in Late Antiquity*. Cambridge, UK: Cambridge University Press.

Johnson, S. 1983a. *Late Roman Fortifications*. New York: Barnes and Noble.

Johnson, S. 1983b. "Late Roman Urban Defenses in Europe." In Maloney and Hobley (eds.): 69–76.

Jolivet, V. et al. (eds.) 2009. *Suburbium II. Il Suburbio di Roma dalla fine dell'età monarchica alla nascita del sistema delle ville, (V–II secolo a.C.). Atti del Convegno 16 settembre, 3 dicembre 2004 e 16–17 febbraio 2005*. CÉFR 419. Rome: École française de Rome.

Jones, A.H.M. 1956. "Review of Boak 1955." *Economic History Review* 9, 379–81.

Jones, A.H.M. 1958. "The Roman Colonate." *Past and Present* 13: 1–13.

Jones, A.H.M. 1964. *The Later Roman Empire, 284–602. A Social, Economic and Administrative Survey*, 3 vols. Oxford: Blackwell.

Jones, C.P. 1970. "A Leading Family from Roman Thespiae." *HSCP* 74: 223–55.

Jones, C.P. 1991. "Dinner Theater." In Slater (ed.): 185–98.

Jongman, W. 2002. "Beneficial Symbols. *Alimenta* and the Infantilization of the Roman Citizen." In Jongman and Kleijwegt (eds.): 47–80.

Jongman, W. 2003. "Slavery and the Growth of Rome." In Edwards and Woolf (eds.): 100–22.

Jongman, W. and M. Kleijwegt (eds.) 2002. *After the Past: Essays in Ancient History in Honour of H.W. Pleket.* Leiden and Boston: Brill.

Jongmann, W.M. 2007. "The Loss of Innocence. Pompeian Society and Economy Between Past and Present." In Dobbins and Foss (eds.): 499–517.

Joshel, S.R. 1992. *Work, Identity, and Legal Status at Rome : A Study of the Occupational Inscriptions.* Norman, OK: University of Oklahoma Press.

Joshel, S.R. 2010. *Slavery in the Roman World.* Cambridge, UK, and New York: Cambridge University Press.

Joshel, S.R. 2013. "Geographies of Slave Containment and Movement." In George (ed.): 99–128.

Joshel. S.R. and S. Murnaghan (eds.) 1998. *Women and Slaves in Greco-Roman Culture: Differential Equations.* New York: Routledge.

Joshel, S.R. and L.H. Petersen 2014. *The Material Life of Roman Slaves.* Cambridge, UK, and New York: Cambridge University Press.

Joshel, S.R. and L.H. Petersen 2016. "Thinking about Roman Slaves at Villa A." In Gazda and Clarke (eds.): 148–59.

Juan, E. and J.V. Lerma 2000. "La villa áulica del 'Pla de Nadal' (Riba-Roja de Túria)." In Ribera i Lacomba and Abad Casal (eds.): 135–42.

Juan, E. and I. Pastor 1989. "Los visigodos en Valencia: Pla de Nadal: ¿una villa áulica?" *Boletín de Arqueología Medieval* 3: 137–79.

Junker, K. 1996. "Antike Stilleben," in König and Schön (eds.): 93–105.

Junker, K. 2003. "Täuschend echt. Stilleben in der römischen Wandmalerei," *AntW* 34: 471–89.

Justice, S. 1994. *Writing and Rebellion: England in 1381.* Berkeley: University of California Press.

Kah, D. and P. Scholz (eds.) 2004. *Das Hellenistische Gymnasion.* Wissenskultur und Gesellschaftlicher Wandel 8. Berlin: Akademie Verlag.

Kahane, A., L. Murray Threipland, and J.B. Ward-Perkins 1968. *The Ager Veientanus North and East of Rome.* PBSR 36. London: British School at Rome.

Kähler, H. 1973. *Die Villa des Maxentius bei Piazza Armerina.* Monumenta Artis Romanae 12. Berlin: Gebr. Mann Verlag.

Kahrstedt, U. 1950. "Die Territorien von Patrai und Nikopolis in der Kaiserzeit." *Historia:* 549–61.

Kaiser, T. 1995. "Archaeology and Ideology in South-East Europe." In Kohl and Fawcett (eds.): 99–119.

Kallintzi K. and M. Chryssaphi 2007. "Κτηριακό συγκρότημα της ύστερης αρχαιότητας στη θέση Μόλος Αβδήρων: πρώτη παρουσίαση." *AErgoMak* 21: 455–70.

Kallintzi K. and M. Chryssaphi 2010. "Κεραμική της Ύστερης Αρχαιότητας από τα Άβδηρα." In Papanikola-Bakrizti and Kousoulakou (eds.): 386–401.

Kallipolites, B. G. 1961–2. "Ανασκαφή ρωμαϊκής επαύλεως εν Κεφαλληνία." *ArchDelt, Meletai* 17 A: 1–31.

Kandler, M. and G. Wlach (eds.) 1998. *100 Jahre Österreichisches Archäologisches Institut 1898–1998.* Sonderschriften des Österreichischen Archäologischen Institutes 31. Vienna: Phoibos.

Kaplan, J. 1993. s.v. "Yavneh-Yam." In *NEAEHL*, vol. 4: 1504–6.

Karametrou-Mentesidi, G. and D. Theodorou 2009. "Από την Έρευνα στο φράγμα Ιλαρίωνα (Αλιάκμων): Η ανασκαφή στο Μέγα Άη Γιώργη και Άγιο Κωνσταντίνο Δήμητρας Γρεβενών." *AErgoMak* 1 (2009): 109–31.

Karatzeni, V. 2001. "Epirus in the Roman Era." In Isager (ed.): 163–79.

Karydas, N. 2009. "Παλαιοχριστιανικές οικίες με τρικλίνιο στη Θεσσαλονίκη μέρος II: δέκα χρόνια μετά." In Adam-Veleni and Tzanavari (eds.): 127–41.

Katsadima, I. and A. Angeli 2001. "Two Architectural Assemblages of the Roman Era along the Coast of Southern Epirus." In Isager (ed.): 91–107.

Kazanski, M. and J. Lapart 1995. "Quelques documents du Ve siècle ap. J.-C. attribuables aux Wisigoths découverts en Aquitaine." *Aquitania* 13: 193–202.

Keay, S. 2003. "Recent Archaeological Work in Roman Iberia (1990–2002)." *JRS* 93: 146–211.

Keay, S. et al. 2005. *Portus: An Archaeological Survey of the Port of Imperial Rome.* Archaeological Monographs of the British School at Rome 15. London: British School at Rome.

Kehoe, D.P. 1988. *The Economics of Agriculture on Roman Imperial Estates in North Africa.* Hypomnemata 89. Göttingen: Vandenhoeck & Ruprecht.

Kellum, B. A. 1994. "The Construction of Landscape in Augustan Rome: The Garden Room at the Villa *ad Gallinas*." *AB* 76: 211–24.

Kelly, G. 2004. "Ammianus and the Great Tsunami." *JRS* 94: 141–67.

Kennedy, G.A. 2003. *Progymnasmata: Greek Textbooks of Prose Composition and Rhetoric.* Atlanta, GA: Society of Biblical Literature.

Kennedy, R. (ed.) 1998. *The Twin Towns of Zeugma on the Euphrates. Rescue Work and Historical Studies.* JRA Supplement 27. Portsmouth RI: JRA.

Kenrick, P. 2009. *Libya Archaeological Guides: Tripolitania.* London: Silphium Press.

Kenrick, P. 2013a. *Libya Archaeological Guides: Cyrenaica.* London: Silphium Press.

Kenrick, P. 2013b. "Ancient Sites in Rural Cyrenaica: A Partial Update." *LibSt* 44: 57–72.

Kent, J.P.C. and K.S. Painter 1977. *Wealth of the Roman World. Gold and Silver AD 300–700*, London: Trustees of the British Museum.

Keppie, L. 2000. *Legions and Veterans. Roman Army Papers, 1971–2000*. Stuttgart: Franz Steiner.

Kereković, D. (ed.) 2009. *Time, GIS and Future* (Hrvatski Informatički Zbor – GIS Forum, University of Silesia). Zagreb: Nacionalna knjižnica.

Khanoussi, M. 1988. "*Spectaculum pugilum et gymnasium.* Compte rendu d'un spectacle de jeux athlétiques et de pugilat, figuré sur une mosaïque de la région de Gafsa (Tunisie)." *CRAI* 132: 543–61.

Khanoussi, M. (ed.) 2003. *L'Afrique du Nord antique et médiévale. VIIIe Colloque International sur l'Histoire et l'Archéologie de l'Afrique du Nord, Tabarka, 8–13 mai 2000*. Tunis: Institut National du Patrimoine.

Khanoussi, M. 2003 (with M. Nasr). "La Vénus de Gafsa." In Bejaoui (ed.): 129–46.

Kiilerich, B. 2001. "Ducks, Dolphins and Portraits Medallions: Framing the Achilles Mosaic at Pedrosa de la Vega (Palencia)." *Acta ad archaeologiam et artium historiam pertinentia* 15: 245–67.

Kilić-Matić, A. 2004. "A Contribution to the Study of Building Techniques and Structures At Roman Villae Rusticae on the Coast of the Roman Provinces of Dalmatia." *Opuscula Archaeologica* 28: 91–109.

Kirigin, B. 2006: *Pharos: The Parian Settlement in Dalmatia. A study of a Greek colony in the Adriatic*. BAR-IS 1561. Oxford: Archaeopress.

Kirigin, B., I. Schrunk, V. Begović, M. Petrić and M. Ugarković 2010. "Istraživanje rimske vile u Solinama na otoku Sv. Klement (Pakleni otoci), Hvar (Investigation of a Roman villa in Soline on the island of St. Clement (Pakleni Islands), Hvar)." *Annales Instituti Archaeologici* 6: 53–8.

Knüvener, P. 2002. "Private Bibliotheken in Pompeji und Herculaneum." In Hoepfner (ed.): 81–5.

Koch, H. 1951. *Vom Nachleben des Vitruv*. Baden-Baden: Verlag für Kunst und Wissenschaft.

Kochavi, M. 1989. *Aphek-Antipatris: Five Thousand Years of History*. Tel Aviv: Hakibbutz Hameuchad. (Hebrew).

Kohl, P.L. and C. Fawcett Kaiser (eds.) 1995. *Nationalism, Politics, and the Practice of Archaeology*. Cambridge: Cambridge University Press.

Kolendo, J. 1986. "Les grands domaines en Tripolitaine d'après l'Itinéraire Antonin." In *Histoire et archéologie de l'Afrique du Nord : actes du IIIe colloque international réuni dans le cadre du 110e Congrès national des sociétes savantes, Montpellier, 1-15 avril 1985*, 149–62. Paris: C.T.H.S.

Koloski-Ostrow, A.O. 2007. "The City Baths in Pompeii and Herculaneum." In Dobbins and Foss (eds.): 224–56.

Kondoleon, C. (ed.) 2000. *Antioch. The Lost Ancient City*. Princeton, NJ: Princeton University Press in association with the Worcester Art Museum.

Kondoleon, C. 2000. "Mosaics of Antioch." In Kondoleon (ed.): 62–77.

König, E. and C. Schön (eds.) 1996. *Stilleben. Geschichte der klassischen Bildgattungen in Quellentexten und Kommentaren*, vol. 5. Berlin: Reimer.

König, J., K. Oikonomopoulou and G. Woolf (eds.) 2013. *Ancient Libraries*. Cambridge: Cambridge University Press.

Koppel, E.M. 2000. "Informe preliminar sobre la decoración escultórica de la villa romana de 'Els Munts' (Altafulla, Tarragona)." *MM* 41: 380–93.

Koppel, E.M. and I. Rodà 2008. "La escultura de las villae de la zona del noreste hispánico: los ejemplos de Tarragona y Tossa de Mar." In Fernández Ochoa, García-Entero, and Gil Sendino (eds.): 99–131.

Kosso, C. 1996. "A Late Roman Complex at Palaiochora Near Karystos in Southern Euboia, Greece." *Classical Views* 40: 201–30.

Kotula, T. 1988. "*Modicam terram habes, id est villam.* Sur le notion de *villa* chez Saint Augustin." *AfrRom* 5: 339–44.

Koukouvou, A. 1999. "Η ανασκαφική έρευνα στον άξονα της Εγνατίας οδού. Νομός Ημαθίας." *AErgoMak* 13: 567–78.

Koumanoudes, S.A. 1872. *Prakt*: 3–16.

Krause, C. 1977. "Grundformen des griechischen Pastashauses." *AA* 92: 164–79.

Krause, C. 2003. *Villa Jovis. Die Residenz des Tiberius auf Capri*. Mainz-am-Rhein: Philipp von Zabern.

Krauss, S. 1910. *Talmudische Archäologie*, vol. 1. Leipzig: Fock.

Krischen, F. 1943. "Der Theodoric Palast bei Galeata." *AA* 1943: 459–72.

Kubelik, M. 1977. *Die Villa im Veneto : zur typologischen Entwicklung im Quattrocento*. Munich: Süddeutscher Verlag.

Kurtz, D. et al. (eds.) 2008. *Essays in Classical Archaeology for Eleni Hatzivassiliou 1977–2007*. Oxford: The Beazley Archive and Archaeopress.

Kuttner, A. 1998. "Prospects of Patronage: Realism and Romanitas in the Architectural Vistas of the 2nd Style." In Frazer (ed.): 93–107.

Kuttner, A. 2004. "Roman Art during the Republic." In Flower (ed.): 294–321.

Kyriakopoulou, E. 2010. "Οι απόγονοι του Θεοχαράκη Ρέντη από την ιστορική οικογένεια της Κορίνθου." *Peloponnesiaka, Supplement* 29: 285–332.

Kyrtatas, D.J. 2011. "Slavery and Economy in the Greek World." In Bradley and Cartledge (eds.) vol. 1: 91–111.

Ladstätter, S. and V. Scheibelreiter (eds.) 2010. *Städtisches Wohnen im östlichen Mittelmeerraum. 4. Jh. v. – 1. Jh. n. Chr. Akten des Kolloquiums von 24.–27. 10. 2007 an der Österreichischen Akademie der Wissenschaften.* Vienna: Verlag der Österreichischen Akademie der Wissenschaften.

La Rocca, E. 2008. *Lo spazio negato. Il paesaggio nella cultura artistica greca e romana.* Milan: Electa.

La Torre, G. F. 1994. "*Gela sive Philosophianis (It. Antonini 88.2)*: contributo per la storia di un centro interno della Sicilia romana." *QuadMess* 9: 99–139.

La Torre, G. F. 2011. "Origine e sviluppo dei sistemi di decorazione parietale nella Sicilia ellenistica." In La Torre and Torelli (eds.): 255–77.

La Torre, G.F. and M. Torelli (eds.) 2011. *Pittura ellenistica in Italia e in Sicilia: linguaggi e tradizioni. Atti del convegno di studi, Messina, 24–25 settembre 2009.* Rome: G. Bretschneider.

Lafon, X. 1981a. "A propos des «villae» républicaines. Quelques notes sur les programmes décoratifs et les commanditaires." In *L'art décoratif à Rome à la fin de la république et au début du principat. Table ronde organisée par l'École française de Rome (Rome, 10–11 mai 1979)*: 151–72. CÉFR 55. Paris and Rome: De Boccard and "L'Erma" di Bretschneider.

Lafon, X. 1981b. "À propos des villas de la zone de Sperlonga et le développement de la villa maritima sur le littoral tyrrhénien à l'époque républicaine." *MÉFRA* 93: 297–353.

Lafon, X. 1989. "À propos de Saint Ulrich: villas et lieux de culte dans la Gaule du nord-est." In *Aspects de la religion celtique et gallo-romaine dans le nord-est de la Gaule, à la lumière des découvertes récentes [Actes de la Rencontre archéologique de Saint-Dié-des-Vosges organisée par la Société philomatique vosgienne, 7–8–9 octobre 1988, en hommage au professeur Jean-Jacques Hatt]*, 1–14. Saint-Dié-des-Vosges: La Société.

Lafon X. 1990. "Marina di S. Nicola. Il complesso archeologico." *Bolletino di Archeologia* 4: 15–29.

Lafon, X. 1994. "Les villas de l'Italie impériale." In *L'Italie d'Auguste à Dioclétien. Actes du colloque international organisé par l'École française de Rome, l'École des hautes études en sciences sociales, le Dipartimento di scienze storiche, archeologiche dell'antichità di Roma La Sapienza et le Dipartimento di scienze dell'antichità dell'università di Trieste.* CÉFR 198, 219–26. Paris and Rome: De Boccard and "L'Erma" di Bretschneider.

Lafon, X. 2001. *Villa maritima. Recherches sur les villas littorales de l'Italie romaine (IIIe siècle av. J.–C. /IIIe siècle ap. J.-C.).* BÉFAR 307. Rome: École française de Rome.

Lafon, X. 2007. "Die römische Villa und ihre funktionalen und symbolischen Aspekte." In Petit and Santoro (eds.): 189–94.

Lafon, X. 2009. "La Villa de Split et sa place dans l'évolution de la villa maritime romaine." In Cambi, Belamarić, and Marasović (eds.): 295–306.

Lafon, X. et al. 1985. "La terrasse de Punta Tresino (Agropoli)." *MÉFRA* 97: 47–134.

L'Afrique dans l'Occident Romain (Ier siècle av. J.C.–IVe siècle ap. J.C.): Actes du colloque organisé par l'École française de Rome sous le patronage de l'Institut national d'archéologie et d'art de Tunis (Rome, 3–5 décembre 1987). CÉFR 134. Rome: École française de Rome.

Lagóstena Barrios, P. 2001. *La producción de salsas y conservas de pescado en la Hispania romana (II a. C.–VI d. C.)* (Coll. Instrumenta 11). Barcelona: Publ. Univ. de Barcelona.

Laken, L. 2003. "Zebra Patterns in Campanian Wall Painting: A Matter of Function." *BaBesch* 78: 167–89.

Laming, A. (ed.) 1952. *La découverte du passé.* Paris: Picard.

Lancha, J. 1989. "Le rinceau aux médaillons de la mosaïque d'Achille (Pedrosa de la Vega): essai d'interprétation." In *Mosaicos romanos. Actas de la I Mesa redonda hispano-francesa sobre mosaicos romanos habida en Madrid en 1985. Manuel Fernández-Galiano in memoriam*: 169–77. Madrid: Ministerio de Cultura.

Lancha, J. and P. André 2000. *A Villa de Torre de Palma. Corpus dos Mosaicos Romanos de Portugal II.* Conventus Pacensis 1. Lisbon: Instituto Português de Museus.

Landwehr, C. 1985. *Die antiken Gipsabgüsse aus Baiae: griechische Bronzestatuen in Abgüssen römischer Zeit.* Berlin: Mann.

Lane, E. 1962. "An unpublished inscription from Laconia." *Hesperia* 9: 396–98.

Lapart, J. 1987. "L'ensemble haut-médiéval du site de Séviac." In *De l'âge du fer aux temps barbares. Dix ans de recherches archéologiques en Midi-Pyrénées*: 139–44. Toulouse: Le Musée.

Lapart, J. and J.-L. Paillet 1996. "Montréal-du-Gers. Lieu-dit Séviac." In Duval (ed.): vol. 2, 160–7.

Lapart, J. and C. Petit. 1993. *Carte archéologique de la Gaule 32, Le Gers.* Paris: Académie des inscriptions et belles lettres.

Lapatin, K. 2005. *Guide to the Getty Villa.* Los Angeles, CA: Getty.

Lapatin, K. 2010. "Recreating the Villa of the Papyri in Malibu." In Zarmakoupi (ed.): 129–138.

Lapatin, K. 2011. "The Getty Villa: Art, Architecture, and Aristocratic Self-Fashioning in the Mid-Twentieth Century." In Hales and Paul (eds.): 270–85.

Lapyrionok, R.V. 2013. "Some Critical Notes on Peter Brunt's Reconstruction of the Conduct of the Roman Census." In Mehl, Makhlayuk, and Gabelko (eds.): 133–44.

Laseby, S.T. 1998. "Gregory's Cities: Urban Functions in Sixth-Century Gaul." In Wood (ed.): 239–70.

Lassus, J. 1938. "à Yakto." In Stillwell (ed.): 95–147.

Lauffray, J., J. Schreyeck, and N. Dupré 1973. "Les établissements et les villae gallo-romaines de Lalonquette (Pyrénées-Atlantiques)." Gallia 31: 123–55.

Launaro, A. 2011. Peasants and Slaves. The Rural Population of Roman Italy (200 BC to AD 100). Cambridge, UK: Cambridge University Press.

Laurence, R. 1994. Roman Pompeii. Space and Society. London: Routledge.

Laurence, R. and A. Wallace-Hadrill (eds.) 1997. Domestic Space in the Roman World: Pompeii and Beyond. JRA Supplement 22. Portsmouth, RI: JRA.

Laurenceau, N. and L. Maurin 1988. "Strucutures, caractères, étapes de l'occupation des origines au Bas-Empire." In Les fouilles de "Ma Maison", études sur Saintes antique. Aquitania 3rd supplément. Bordeaux: Éditions de la Fédération Aquitania.

Lauter, H. 1986. Die Architektur des Hellenismus. Darmstadt: Wissenschaftliche Buchgesellschaft.

Lauter, H. 1998. "Hellenistische Vorläufer der römischen villa." In Frazer (ed.) 1998: 21–7.

Lavan, L. 1999. "The residences of Late Antique governors: A Gazetter." AnTard 7: 135–64.

Lavan, L. (ed.) 2001. Recent Research in Late Antique Urbanism. JRA supplement 42. Portsmouth, RI: Journal of Roman Archaeology.

Lavan, L. and W. Bowden (eds.) 2003. Theory and Practice in Late Antique Archaeology. Late Antique Archaeology 1. Leiden: Brill.

Lavan, L., L. Özgenel, and A. Sarantis (eds.) 2007 (with the assistance of S. Ellis and Y. Marano). Housing in Late Antiquity. From Palaces to Shops. Late Antique Archaeology 3.2. Leiden and Boston, MA: Brill.

Lavan, L. et al. (eds.) 2007. Technology in Transition A.D. 300–650. Leiden and Boston, MA: Brill.

Lavin, I. 1962. "The House of the Lord. Aspects of the Role of Palace Triclinia in the Architecture of Late Antiquity and the Early Middle Ages." The Art Bulletin 44: 1–28.

Lavin, M.A. 1990. The Place of Narrative: Mural Decoration in Italian Churches, 431–1600. Chicago, IL: University of Chicago Press.

Le Roy, L., J. Galy, and Y. Zaaraoui 2009. "Vinassan, La Grangette, Saint-Félix." Bilan Scientifique Régional Languedoc-Roussillon: 57–8

Le Vane, E. and J.P. Getty 1955. Collectors Choice: The Chronicle of an Artistic Odyssey through Europe. London: W.H. Allen.

Leach, E.W. 1988. The Rhetoric of Space: Literary and Artistic Representations of Landscape in Republican and Augustan Rome. Princeton, NJ: Princeton University Press.

Leach, E.W. 1997. "Oecus on Ibycus: Investigating the Vocabulary of the Roman House." In Bon and Jones (eds.) 1997: 50–72.

Leach, E.W. 2003. "Otium as Luxuria: Economy of Status in the Younger Pliny's Letters." Arethusa 36: 147–65.

Leach, E.W. 2004. The Social Life of Painting in Ancient Rome and on the Bay of Naples. Cambridge, UK, and New York: Cambridge University Press.

Leacroft, H. and R. 1969. The Buildings of Ancient Rome. Leicester, UK, and New York: Brockhampton Press and W.R. Scott.

Leader-Newby, R. 2005 "Personifications and Paideia in Late Antique Mosaics from Greek East." In Stafford and Herrin (eds.): 231–46.

Leary, T.J. 2001. Martial Book XIII: The Xenia. London: Duckworth.

Leatham, J. and S. Hood 1958–9. "Sub-marine exploration in Crete, 1955." ABSA 53–54: 263–80.

Lentini, M. C. (ed.) 1998. Naxos a quarant'anni dall'inizio degli scavi. Giardini Naxos: Museo archeologico di Naxos.

Lenz, K.H. 1998. "Villae Rusticae: Zur Entstehung dieser Siedlungsform in den Nordwestprovinzen des römischen Reiches." Kölner Jahrbuch für Vor- und Frügeschichte 31: 49–70.

Leone, R. and U. Spigo (eds.) 2008. Tyndaris 1. Ricerche nel settore occidentale: campagne di scavo 1993–2004. Palermo: Regione Siciliana.

Lepetz, S. and V. Matterne (eds.) 2003. Cultivateurs, éleveurs et artisans dans les campagnes de Gaule romaine. Matières premières et produits transformés. Actes du VIe colloque AGER tenu à Compiègne (Oise) du 5 au 7 juin 2002. Revue archéologique de Picardie 1/2.

Leveau, P. 1982. "Une ville et ses campagnes: l'exemple de Caesarea de Maurétanie." In Leveau and Février (eds.): 77–90.

Leveau, P. 1983. "La ville antique et l'organisation de l'éspace rural: Villa, ville, village." AnnESC 38: 920–42.

Leveau, P. 1984. Caesarea de Maurétanie: une ville romaine et ses campagnes. CÉFR 70. Rome: École française de Rome.

Leveau, P. 1989. "L'organisation de l'espace rural en Maurétanie césarienne." In Dayron (ed.): 35–52.

Leveau, P. 1990. "L'organisation de l'espace agricole en Afrique à l'époque romaine." In L'Afrique dans l'occident: 129–41.

Leveau, P. 1993. "L'Afrique du Nord." In Leveau, Sillières, and Vallat (eds.): 155–200.

Leveau, P. 2002. "L'habitat rural dans la Provence antique : villa, vicus et mansio. Études de cas." *RANarb* 35: 59–92.

Leveau, P. and P.A. Février (eds.) 1982. *Villes et campagnes dans l'empire romain: Actes du colloque organisé à Aix-en-Provence les 16 et 17 mai 1980.* Aix-en-Provence: Université de Provence.

Leveau, P., P. Sillières, and J.-P. Vallat 1993. *Campagnes de la Méditerranée romaine: occident.* Paris: Hachette.

Levi, D. 1947. *Antioch Mosaic Pavements*, 2 vols. Princeton, NJ: Princeton University Press.

Levine, L.I. 1989. *The Rabbinic Class of Roman Palestine in Late Antiquity.* Jerusalem and New York: Yad Izhak Ben-Zvi and Jewish Theological Seminary.

Levine, L.I. (ed.) 1992. *The Galilee in Late Antiquity.* New York and Jerusalem: Jewish Theological Seminary.

Levine, L.I. 1998. *Judaism and Hellenism in Antiquity, Conflict or Confluence?* Seattle, WA: University of Washington Press.

Lévy, E. (ed.) 1987. *Le système palatial en Orient, en Grèce et à Rome. Actes du Colloque de Strasbourg, 19–22 juin 1985.* Leiden: E.J. Brill.

Lewis, J.P. 2013. "Did Varro Think That Slaves Were Talking Tools?" *Mnemosyne* 66: 634–648.

Lewit, T. 2003. "'Vanishing villas': What Happened to Élite Rural Habitation in the West in the 5th–6th c.?" *JRA* 16.1: 260–74.

Lewit, T. 2004. *Villas, Farms and the Late Roman Rural Economy (Third to Fifth Centuries AD)* (BAR-IS 568), rev. edn. of Lewit, T. 1991. *Agricultural Production in the Roman Economy, A.D. 200–400.* BAR-IS 568. Oxford: Archaeopress.

Lézine, A. 1968. *Carthage. Utique. Études d'architecture et d'urbanisme.* Paris: Éditions du CNRS.

L'Huillier, M.-C. 1992. *L'Empire des mots: orateurs gaulois et empereurs romains, 3e et 4e siècles.* Paris: Diffusion Les Belles Lettres.

Lichtenberger, A. 2011. "Zur Vorbildfunktion der Bauten Herodes des Großen in Palästina." In Deines, Herzer, and Niebuhr (eds.): 133–64.

Liebeschuetz, W. 1995. "Pagan Mythology in the Christian Empire." *International Journal of the Classical Tradition* 2.2: 193–208.

Lienhard, J.T. 1977. *Paulinus of Nola and Early Western Monasticism.* Cologne: P. Hanstein.

Lindhagen, A. 2009. "The Transport Amphoras Lamboglia 2 and Dressel 6A: A Central Dalmatian Origin?" *JRA* 22.1: 83–108.

Ling, R. 1977. "Studius and the Beginnings of Roman Landscape Painting." *JRS* 67: 1–16.

Ling, R. 1991. *Roman Painting.* Cambridge, UK: Cambridge University Press.

Ling, R. 1998. *Ancient Mosaics.* Princeton, NJ: Princeton University Press.

Linke, B. and M. Stemmler (eds.) 2000. *Mos maiorum: Untersuchungen zu den Formen der Identitätsstiftung und Stabilisierung in der Römischen Republik.* Stuttgart: Steiner.

Lintott, A. 1994. "Political History, 146–95 BC." In Crook, Lintott, and Rawson (eds.): 40–103.

Lintott, A. 1999. *The Constitution of the Roman Republic.* Oxford and New York: Clarendon Press.

Lippolis, E. 1997. *Fra Taranto e Roma. Società e cultura urbana in Puglia tra Annibale e l'età imperiale.* Taranto: Scorpione.

Lippolis, E. 2006. "Aristocrazia romana e italica nelle ville della Regio II." In Ortalli (ed.) 2006: 43–84.

Lippolis, I.B. 2001. *La domus tardoantica: forme e rappresentazioni dello spazio domestico nelle città del Mediterraneo.* Imola: University Press Bologna.

Littlewood, A.R. 1987. "Ancient Literary Evidence for Pleasure Gardens. In MacDougall (ed.): 7–30.

Ljapoustina, E.V. 1992. "La structure économique et sociale de la villa gallo-romaine." *ActaArchHung* 33: 301–5.

Llinàs, J. et al. 2008. "Pla de l'Horta (Sarrià de Ter, Girona): una necrópolis con inhumaciones visigodas en la Tarraconense oriental." *ArchEspArq* 81: 289–304.

L'Orange, H. P. 1952. "È un palazzo di Massimiano Erculeo che gli scavi di Piazza Armerina portano alla luce?" *Symbolae Osloenses* 29: 114–28.

Lo Cascio, E. (ed.) 1997. *Terre, proprietari e contadini dell'impero romano. Dall'affitto agrario al colonato tardoantico.* Rome: La Nuova Italia Scientifica.

Lo Cascio, E. 1999. "Popolazione e risorse agricole nell'Italia del II secolo a.C." In Vera (ed.): 217–45.

Lo Cascio, E. 2000. "Alimenta Italiae." In González Fernández (ed.): 287–312.

Lo Cascio, E. (ed.) 2000. *Mercati permanenti e mercati periodici nel mondo romano: atti degli Incontri capresi di storia dell'economia antica, Capri 13–15 ottobre 1997.* Bari: Edipuglia.

Lo Cascio, E. 2003. "L'economia dell'Italia romana nelle testimonianze di Plinio." In Castagna and Lefèvre (eds.): 281–302.

Lo Cascio, E. 2004 "Il rapporto uomini-terra nel paesaggio dell'Italia romana" *Index* 32, 107–21.

Lo Cascio, E. and A. Storchi Marino (eds.) 2001. *Modalità insediative e strutture agrarie nell'Italia meridionale in età romana.* Bari: Edipuglia.

Locatelli, D. 2002. "La ripresa delle indagini archeologiche nella villa di San Pawl Milqi a Malta." In Amadasi Guzzo, Liverani, and Matthiae (eds.): 295–318.

Locatelli, D. 2005–6. "Nuove ricerche a San Pawl Milqi: i primi risultati." In Rossignani, M.P. "La ripresa delle indagini della Missione Archeologica Italiana a Malta. Nuovi dati dal santuario di Tas-Silg e dalla villa di San Pawl Milqi." *RendPontAcc* 78: 257–73.

Lohmann, H. 1994. "'Ein Älter Schafstall' in neuem licht: die Ruinen von Palaia Kopraisia bei Legrena (Attika)." In Doukellis and Mendoni (eds.): 81–132.

Lolos, Y. 1997. "The Hadrianic Aqueduct of Corinth (with an Appendix on the Roman Aqueducts in Greece)." *Hesperia* 66: 271–314.

Lolos, Y. 2009. "Η οινοπαραγωγή στην Κορινθία κατά την αρχαιότητα (Κόρινθος, Σικυών Κλεωναί)." In Pikoulas (ed.) 2009: 115–32.

Longepierre, S. forthcoming. "Etudes des meules de la villa de Masseria Ciccotti (Oppido Lucano, Basilicate) et de ses environs." In *L'alto Bradano in età romana: le villae di Oppido Lucano*, Collection du Centre Jean Bérard. In M. Gualtieri (ed.). Rome and Naples: Centre Jean Bérard.

Longerstay, M. 1988. "Nouvelles fouilles à Tabarka (antique Tabarca)." *Africa* 10: 220–53.

Lopes, Mª. da Conceição and R. Alfenim 1994. "La villa romaine de Monte da Cegonha." *DossArch* 198: 64–7.

López Mullor, A. et al. 2001. *Les excavacions de 1985–1989 i 1992 a la vil·la romana dels Ametllers, Tossa (Selva)*. Barcelona: Institut d'Estudis Catalans.

Lorenz, R. 1966. "Die Anfänge des abendländischen Mönchtums im 4 Jahrhundert." *Zeitschrift für Kirchengeschichte* 77: 1–61.

Lot, F. 1927. *La fin du monde antique et le début du Moyen Âge*. Paris: Renaissance du livre. (English transl.: *The End of the Ancient World and the Beginning of the Middle Ages*. London 1931: Kegan Paul.)

Loukopoulou, L.D. 1996. "The Fortunes of the Roman Conventus of Chalcidice." In Rizakis (ed.): 143–8.

Lozano Santa, J. 1794. *Historia Antigua y Moderna de Jumilla*. Murcia: [s.n.].

Lucas, M.R. and V. Viñas 1977. "La villa romana de Aguilafuente (Segovia)." In *Segovia. Symposium de Arqueología romana. (Segovia, Septiembre de 1974)*: 239–55. Barcelona: Universidad, Instituto de Arqueología y Prehistoria.

Lugli, G. 1962–1963. "Contributo alla storia edilizia della villa romana di Piazza Armerina." *Rivista del Istituto Nazionale d'Archeologia e Storia dell'Arte* n.s. 11–12: 28–82.

Luraghi, N. 2008. *The Ancient Messenians: Constructions of Ethnicity and Memory*. Cambridge, UK, and New York: Cambridge University Press.

Luschin, E. M. 2002. *Cryptoporticus. Zur Entwicklungsgeschichte eines multifunktionalen Baukörpers*. Wien: Österreichisches Archäologisches Institut Wien.

Lymberopoulou. A. (ed.) 2011. *Images of the Byzantine World: Visions, Messages and Meanings. Studies presented to Leslie Brubaker*. Farnham, UK, and Burlington, VT: Ashgate Publishing.

MacDonald, W.L. 1965. *The Architecture of the Roman Empire*. New Haven, CT: Yale University Press.

MacDonald, W.L. and J.A. Pinto 1995. *Hadrian's Villa and its legacy*. New Haven, CT, and London: Yale University Press.

MacDougall, E.B. (ed.) 1987. *Ancient Roman Villa Gardens*. Dumbarton Oaks Colloquium on the History of Landscape Architecture 10. Washington, DC: Dumbarton Oaks.

MacMullen, R. 1963. *Soldier and Civilian in the Later Roman Empire*. Cambridge, MA: Harvard University Press.

MacMullen, R. 1970. "Market Days in the Roman Empire." *Phoenix* 24: 333–41.

MacMullen, R. 1976. "Two Notes on Imperial Properties." *Athenaeum* 34: 19–36.

Madsen, J.M. 2003. "Signs of Prosperity in Roman Villas in South Italy during the Third Century." *AnalRom* 29: 29–53.

Magnou-Nortier, E. (ed.) 1993. *Aux sources de la gestion publique. I. Enquête lexicographique sur fundus, villa, domus, mansus*. Lille: Septentrion Presses Universitaires.

Maguire, E., H. Maguire, and M. Duncan-Flowers 1989 (with contributions by A. Gonosová and B. Oehlschlager-Garvey). *Art and Holy Powers in the Early Christian House*. Urbana, IL: Krannert Art Museum, University of Illinois at Urbana-Champaign: Illinois University Press.

Maia, M. 1986. "Os castella do sul de Portugal." *MM* 27: 195–223.

Maier, C.S. 2006. *Among Empires. American Ascendency and Its Predecessors*. Cambridge, MA, and London: Harvard University Press.

Maiuri, A. 1931. *La villa dei Misterii*. Rome: Istituto Poligrafico dello Stato.

Maiuri, A. 1942. "Un decreto onorario di M. Nonio scoperto recentemente a Ercolano." *RendLinc* ser. 7–8: 1–26.

Maiuri, A. 1947. *La Villa dei Misteri*, 2nd edn. (1st edn. 1931). Rome: Libreria dello Stato.

Maiuri, A. 1955. "Le vicende dei monumenti antichi della costa amalfitana e sorrentina alla luce delle recenti alluvioni." *RendNap* 39: 87–98.

Maiuri, A. 1958. *Ercolano, I nuovi scavi (1927–1958)*. Rome: Istituto poligrafico dello Stato, Libreria della Stato.

Malacrino, C. 2007. "Il Monumento di Ottaviano a Nicopoli e l'opera reticolata in Grecia: diffusione, caratteristiche, significato." In Zachos (ed.): 371–91.

Malandrino, C. 1980. *Oplontis*. Naples: Loffredo.

Maloney, S.J. and M. da Luz Huffstot 2002. "Torre de Palma. Fact or Fiction?" *ArqPort* IV 20: 135–46.

Maloney, S.J. and J.R. Hale 1996. "The Villa of Torre de Palma (Alto Alentejo)." *JRA* 9: 275–94.

Maloney, J. and B. Hobley (eds.) 1983. *Roman Urban Defenses in the West*. London: Council for British Archaeology.

Maloney, S. and Å. Ringbom 1998. "14C dating of mortars at Torre de Palma, Portugal." Paper read at V Reunió de Arqueología Cristiana Hispánica, 2000, at Cartagena.

Manacorda, D. 1981. "Produzione agricola, produzione ceramica e proprietari nell'ager Cosanus nel I a.C." In A. Giardina and Schiavone (eds.): *Società romana e produzione schivistica. Vol 2: Merci, mercati e scambi nel Mediterraneo*, 3–54. Bari: Laterza.

Manacorda, D. 1995. "Sulla proprietà della terra nella *Calabria* romana tra Repubblica e Impero." In *Du latifundium au latifondo: un héritage de Rome, une création médiévale ou moderne?: actes de la table ronde internationale du CNRS organisée à l'Université Michel de Montaigne-Bordeaux III les 17–19 décembre 1992*, 143–89. Paris: De Boccard.

Mancheño y Olivares, M. 1901. *Antigüedades del partido judicial de Arcos de la Frontera*. Arcos de la Frontera: Impr. de "El Arcobricense."

Manganaro, G. 1982. "Die Villa von Piazza Armerina, Residenz des kaiserlichen Prokurators, und ein mit ihr verbundenes Emporium von Henna." In Papenfuss and Strocka (eds.): 493–513.

Manganaro Perrone, G. 2005. "Note storiche e epigrafiche per la villa (*praetorium*) del Casale di Piazza Armerina." *Sicilia Antiqua* 2: 173–91.

Mansuelli, G.A. 1957. "La villa romana nell'Italia settentrionale." *PP* 12: 444–558.

Mansuelli, G.A. 1958. *Le ville del mondo romano*. Milan: Pleion.

Mansuelli, G.A. 1971. "La villa nell'organizzazione romana." In *La villa romana: giornata di studi, Russi 10 maggio 1970*, 15–28. Faenza: F.lli Lega.

Mar, R. and G. Verde. 2008. "Las villas romanas tardoantiguas: cuestiones de tipología arquitectónica." In Fernández Ochoa, García-Entero, and Gil Sendino (eds.): 49–83.

Mar, R. et al. 1996. "El conjunto paleocristiano del Francolí en Tarragona. Nuevas aportaciones." *Antiquité Tardive* 4: 320–4.

Marasco 2014. "A Historical Account of Archaeological Discoveries in the Region of Torre Annunziata. La storia dell scoperte archeologiche nella zona di Torre Annunziata." In Clarke and Muntasser (eds.): 209–661.

Marchesi, I. 2008. *The Art of Pliny's Letters. A Poetics of Allusion in the Private Correspondence*. Cambridge, UK: Cambridge University Press.

Marchetti, P. 2010. "L'épigraphie argienne et l'oligarchie locale du haute-empire." In Rizakis and Lepenioti (eds.): 43–57.

Marchi, M.L. 2004. "Fondi, latifondi e proprietà imperiali nell'*Ager Venusinus*." *Agri centuriati: an international journal of landscape archaeology* 1: 129–56.

Margaritis, E. 2003, "Archaeobotanical Data." in Adam-Veleni, Poulaki, and Tzanavari (eds.): 61–70.

Mari, Z., M.T. Petrara, and M Sperandio (eds.) 1999. *Il Lazio tra antichità e medioevo. Studi in memoria di Jean Coste*. Rome: Quasar.

Marin, E. 2004. *Augusteum Narone. Splitska siesta naronskih careva*. Exhibition catalogue, Galerija umjetnina Split. Split: Galerija umjetnina.

Marinis, R.C. de and G. Spadea (eds.) 2004. *I Liguri. Un antico popolo europeo tra Alpi e Mediterraneo*. Milan: Skira.

Marki, E. and S. Akrivopoulou 2003. "Ανασκφή αγρέπαυλης στο Παλαιόκαστρο Ωραιοκάστρου." *AErgoMak* 17: 283–98.

Marlière, E. 2002. *L'outre et le tonneau dans l'Occident romain*. Monographies Instrumentum 22. Montagnac: Éditions Monique Mergoil.

Marrou, H. I. 1965. *Histoire de l'education dans l'antiquité*. Paris: Éditions du Seuil.

Martí Solano, J. 1995. "Informe de la excavación de urgencia en el pantano del Gudalcacín, Cádiz." In *Anuario Arqueológoco de Andalucía* 1992 III: 107–11. Cadiz: Junta de Andalucía.

Martín, A. and J. Alemany 1996.–7 "La vil·la romana de Sant Amanç (Rajadell, Bages)." *Tribuna d'Arqueologia*: 117–29.

Martin, G. and M.D. Serres 1970. *La factoria pesquera de Punta de l'Arenal y otros restos romanos de Javea (Alicante)*. Serie de trabajo varios 38. Valencia: Servicio de Investigación Prehistórica. Diputación Provincial de Valencia.

Martin, R. 1971. *Recherches sur les agronomes latins et leurs conceptions économiques et sociales*. Paris: Les Belles Lettres.

Martin, R. (ed.) 1976. *Traité d'agriculture. Palladius; texte établi, traduit et commenté par René Martin*. Paris: Les Belles Lettres.

Martinez, J.L. 2007. "Les styles praxitélisant aux époques hellénistique et romaine." *Praxitèle*: 295–311.

Martinez Melon, J.I. 2006. "El vocabulario de los asentamientos rurales (siglos I–IX d.C.). Evolución de la terminología." In Chavarría, Arce, and Brogiolo (eds.): 113–32.

Martínez Melón, J.I. 2008. "Aproximación al territorio de la diócesis de *Astigi* (Écija, Sevilla) en la Antigüedad Tardía." *Pyrenae* 39.1: 115–28.

Marvin, M. 1993. "Copying in Roman Sculpture: The Replica Series." In D'Ambra (ed.): 161–88.

Marvin, M. 2008. *The Language of the Muses: The Dialogue between Roman and Greek Sculpture*. Los Angeles, CA: Getty.

Marzano, A. 2005. "Country Villas in Roman Central Italy: Reassessing the Evidence." In Aubert and Várhelyi (eds.): 241–62.

Marzano, A. 2007. *Roman Villas in Central Italy. A Social and Economic History.* Columbia Studies in the Classical Tradition 30. Leiden and Boston, MA: E.J. Brill.

Marzano, A. 2008. "Non solo vino campano. La *pastio villatica* e una rivalutazione della navigazione nell'antichità." *Oebalus* 3: 251–66.

Marzano, A. 2010. "Le ville marittime dell'Italia romana tra *amoenitas* e *fructus.*" *Amoenitas* 1: 21–34.

Marzano, A. 2013a. *Harvesting the Sea. The Exploitation of Marine Resource in the Roman Mediterranean.* Oxford Studies in the Roman Economy. Oxford, UK: Oxford University Press.

Marzano, A. 2013b. "Agricultural Production in the Hinterland of Rome: Wine and Olive Oil." In Bowman and Wilson (eds.) 2013: 85–106.

Marzano, A. 2013c. "Capital Investment and Agriculture: Multi-Press Facilities from Gaul, the Iberian Peninsula, and the Black Sea Region." In Bowman and Wilson (eds.): 107–41.

Marzano, A. 2015. "Villas as Instigators and Indicators of Economic Growth." In P. Erdkamp and K. Verboven (eds.): *Structure and Performance in the Roman Economy: Models, Methods and Case Studies.* Collection Latomus 350, 197–221. Bruxelles: Latomus.

Marzano, A. and G. Brizzi 2009. "Costly Display or Economic Investment? A Quantitative Approach to the Study of Roman Marine Aquaculture." *JRA* 22: 215–30.

Mas, C. and M.A. Cau 2011. "From Roman to Byzantine: The Rural Occupation of Eastern Mallorca (Balearic Islands)." *Journal of Mediterranean Archaeology* 24.2: 191–217.

Massari, G. and E. Roffia 1985. "La villa tardoromana di Palazzo Pignano (Cremona)." In Pontiroli (ed.): 185–227.

Mastino, A. (ed.) 1993. *L'Africa romana, Atti del IX convegno di studio (Nuoro, 13–15 dicembre 1991).* Sassari: Gallizzi.

Mastrodonato V. 1999–2000. "Una residenza imperiale nel suburbio di Roma: La villa di Lucio Vero in località Aquatraversa." *ArchClass* 51: 157–235.

Mastrolorenzo, G. et al. 2002. "The 472 AD Pollena Eruption of Somma-Vesuvius (Italy) and Its enviroMental Impact at the End of the Roman Empire." *Journal of Volcanology and Geothermal Research* 113: 19–36.

Masturzo, N. 1997. "Haleg al-Karuba (Silin): Remains of a Coastal Villa." *LibAnt* n.s. 3: 216–17.

Mathisen, R.W. 1992. "Fifth-Century Visitors to Italy: Business or Pleasure?" In Drinkwater and Elton (eds.): 228–38.

Mathisen, R.W. 1993. *Roman Aristocrats in Barbarian Gaul: Strategies for Survival in an Age of Transition.* Austin, TX: Texas University Press.

Mathisen, R.W. and H.S. Sivan (eds.) 1996. *Shifting Frontiers in Late Antiquity: papers from the First Interdisciplinary Conferences on Late Antiquity, the University of Kansas, March, 1995.* Brookfield, VT: Variorum.

Matijašić, R. 1982. "Roman Rural Architecture in the Territory of *Colonia Iulia Pola.*" *AJA* 86.1: 53–64.

Matijašic, R. 1998. *Gospodarstvo antičke Istre.* Pula: Zavičajna naklada "Žakan Juri."

Matijašić, R. 2007. "Impianti antichi per olio e vino in contesto urbano in Istria." *Histria Antiqua* 15: 13–26.

Matoug, J.M. 1995 "Excavation at the Site of the Roman Villa of Wadi Zennad (Khoms)." *LibAnt* n.s. 1: 155.

Matthews, J. 1990. *Western Aristocracies and Imperial Court, A.D. 364–425,* second edn. Oxford: Clarendon Press, 1990.

Mattingly, D.J. 1988a. "Megalithic Madness and Measurement. Or How Many Olives Could an Olive Press Press?" *OJA* 7: 177–95.

Mattingly, D.J. 1988b. "The Olive Boom. Oil Surpluses, Wealth and Power in Roman Tripolitania." *LibSt* 19: 21–41.

Mattingly, D.J. 1988c. "Oil for Export? A Comparison of Libyan, Spanish and Tunisian Olive Oil Production in the Roman Empire." *JRA* 1: 49–56.

Mattingly, D.J. 1995. *Tripolitania.* London: B. T. Batsford Ltd.

Mattingly, D.J. 1998. "Landscapes of Imperialism in Roman Tripolitania." *AfrRom* 12: 163–79.

Mattingly, D.J. and G.S. Aldrete 2000. "The Feeding of Imperial Rome: The Mechanics of the Food Supply System." In Coulston and Dodge (eds.): 142–65.

Mattingly, D.J. and J.W. Hayes 1992. "Nador and Fortified Farms in north Africa." (Review of Anselmino et al. 1989). *JRA* 5: 408–18.

Mattusch, C.C. 1995. "Two Bronze Herms: Questions of Mass Production in Antiquity." *Art Journal* 54: 53–9.

Mattusch, C.C. 1996. *Classical Bronzes: The Art and Craft of Greek and Roman Statuary.* Ithaca, NY, and London: Cornell University Press.

Mattusch, C.C. 2005. (with H. Lie) *The Villa dei Papiri at Herculaneum. Life and Afterlife of a Sculpture Collection.* Los Angeles, CA: Getty.

Mattusch, C.C. 2010. "Programming Sculpture: Collection and Display in the Villa of the Papyri." In Zarmakoupi (ed.): 78–88.

Mattusch, C.C. 2011. *Letter and Report on the Discoveries at Herculaneum. Introduction, Translation, and Commentary by Carol C. Mattusch.* Los Angeles, CA: Getty.

Mattusch, C.C. (ed.) 2013. *Rediscovering the Ancient World on the Bay of Naples, 1710–1890*. Studies in the History of Art 79. Symposium papers 56. New Haven, CT: Yale University Press.

Mattusch, C.C., A.A. Donohue, and A. Brauer (eds.) 2006. *Proceedings of the XVIth International Congress of Classical Archaeology, Boston, August 23–26, 2003. Common Ground: Archaeology, Art, Science, and Humanities*. Oxford: Oxbow Books.

Mau, A. 1968 (1884). *Pompeji in seinen Gebäuden, Alterthümern und Kunstwerken*, with drawings by J. Overbeck, repr. of rev. 4th edn. (Leipzig: W. Engelmann 1856, 1884). Rome: "L'Erma" di Breitschneider.

Mau, A. 1982. *Pompeii: Its Life and Art*, trans. F.W. Kelsey, rev. and corrected edn. New Rochelle, NY: Caratzas Brothers.

Maufras, O. and L. Fabre 1998. "Une forge tardive (fin IVe–Ve s.) sur le site de la Ramière (Roquemaure, Gard)." In Feugere (ed.): 210–21.

Mauné, S. 1998. Les campagnes de la cité de Béziers dans l'antiquité: (partie nord-orientale) (IIE s. av. J.-C.-VIe s. ap. J.-C.). Montagnac: M. Mergoil.

Mauné, S. 2003. "La villa gallo-romaine de Vareilles à Paulhan (Hérault, fouilles de l'autoroute A75): un centre domanial du Haut-Empire spécialisé dans la viticulture." In Lepetz and Matterne (eds.): 309–38.

Mauné, S., V. Forest, and M. Picon 1998. *Les campagnes de la cité de Béziers dans l'Antiquité : partie nord-orientale (IIe s. av. J.-C.-VIe s. ap. J.-C.)*. Montagnac: M. Mergoil.

Maurin, L. 1978. *Saintes antique des origines à la fin du VIe siècle après Jésus-Christ*. Saintes: Société d'archéologie et d'histoire de la Charente-Maritime: Musée archéologique.

Mawer, C.F. 1995. *Evidence for Christianity in Roman Britain. The Small Finds*. BAR-BS 243. Oxford: Tempus Reparatum.

Mayer, J.W. 2005. *Imus ad villam. Studien zur Villeggiatur im stadtrömischen Suburbium in der späten Republik und frühen Kaiserzeit*. Geographica Historica 20. Stuttgart: Franz Steiner.

Mayer, R. 2005. "Creating a Literature of Information in Rome." In Horster and Reitz (eds.): 227–41.

Mayer i Olivé, M. and I. Rodà de Llanza (eds.) 1998. *Ciudades Antiguas del Mediterráneo*. Barcelona-Madrid: Lunwerg.

Mayoral Herrera, V. and S. Celestino Pérez (eds.) 2010. *Los paisajes rurales de la romanización. Arquitectura y explotación del territorio*. Colección Simposia 1. Madrid: La Ergastula.

Mazzoleni, D. 2004. *Domus: Wall Painting in the Roman House, Essay and Texts on the Sites by U. Pappalardo, Photographs by L. Roman*. Los Angeles, CA: Getty.

McCallum, M. and J. vanderLeest 2011. "A Roman Imperial Estate at San Felice (Bari): Cultural Interaction in Roman Puglia." Paper presented at the Archaeological Institute of America annual meeting, San Antonio, TX.

McCane, B.R. 2009. "Tomb." In Sakenfeld (ed.): vol. 5: S-Z, 618–23.

McCracken, G. 1935. "Cicero's Tusculan Villa." *Classical Journal* 30: 261–77.

McCracken, G. 1942. "The Villa and Tomb of Lucullus at Tusculum." *Journal of Archaeology* 46.3: 325–40.

McEwen, I.K. 1995. "Housing Fame: In the Tuscan Villa of Piny the Younger." *Res: Anthropology and Aesthetics* 27: 11–24.

McKay, A.G. 1975. *Houses, Villas and Palaces in the Roman World*. Ithaca, NY: Cornell University Press.

McKeown, N. 2010. "Inventing Slaveries: Switching the Argument." In Heinen (ed.): 39–59.

Meates, G.W. (ed.) 1979. *The Roman Villa at Lullingstone, Kent. Volume 1. The Site*. Monograph Series of the Kent Archaeological Society. Maidstone, Kent, UK: Kent Archaeological Society.

Meates, G.W. (ed.) 1987. *The Roman Villa at Lullingstone, Kent. Volume II: The Wall Paintings and Finds*. Monograph Series of the Kent Archaeological Society, 3. Maidstone, Kent, UK: Kent Archaeological Society.

Mee, C. and Cavanaugh, W. 2005. "Land Tenure and Rural Residence in Laconia." In Cavanaugh, W., C. Mee, P. James, N. Brodie, and T. Carter (eds.): 5–14.

Mehl, A., A.V. Makhlayuk, and O. Gabelko (ed.) 2013. *Ruthenia Classica Aetatis Novae: A Collection of Works by Russian Scholars in Ancient Greek and Roman History*. Stuttgart: Franz Steiner.

Meli, G. (ed.) 2004. *Apparati musivi antichi nell'area del Mediterraneo. Conservazione programmata e recupero. Contributi analitici alla carta del rischio. Atti del I Convegno Internazionale di Studi 'La materia e i segni della storia', Piazza Armerina, 9–13 aprile*. Quaderni di Palazzo Montalbo 4. Palermo: Regione Siciliana.

Meli, G. 2010–2011. "Studi recenti sulla Villa del Casale: gli interventi della Sapienza – Università di Roma. I. Recenti interventi di restauro alla Villa Romana del Casale." *RendPontAcc* 83: 129–40.

Meli, G. 2014. "Presentazione dei risultati del restauro e degli interventi della musealizzazzione." In Pensabene and Sfameni (eds.): 19–24.

Meloni, L. 2008. "Le Nundinae nel Nord Africa: produzione, merci e scambi nell'economia dei vici." *L'Africa romana. Le ricchezze dell'Africa: risorse, produzioni, scambi: atti del XVII Convegno di studio, 14–17 dicembre 2006,*

Sevilla, vol. 4 (Collana del Dipartimento di Storia dell'Università degli studi di Sassari. N. S. 35.4): 2533–2545. Rome: Carocci Editore.

Ménétret, C. 1895–1896. "Ruines d'El-Akbia (Commune mixte d'El-Milia)." *Recueil des notices et mémoires de la Société Archéologique du Département de Constantine* 30: 218–24.

Mercando, L. (ed.) 1998. *Archeologia in Piemonte II, L'età romana.* Turin: U. Allemandi.

Merlin, A. 1915. *Inventaire des mosaïques de la Gaule et de l'Afrique. Tome II (supplément). Afrique Proconsulaire (Tunisie).* Paris: E. Leroux.

Merlin, A. 1921. "La mosaïque de Seigneur Julius à Carthage." *BCTH* 1921: 95–114.

Merrony, M. 2005. "Sensational Mosaic from the Wadi Lebda Roman Villa, Libya." *Minerva* 16.4 (July/August 2005): 4.

Mertens, J. (ed.) 1995. *Herdonia. Scoperta di una città.* Bari: Edipuglia.

Méthy, N. 2007. *Les lettres de Pline le Jeune. Une représentation de l'homme.* Paris: Presses de l'Université Paris-Sorbonne.

Métraux, G.P.R. 1998. "Villa rustica alimentaria et annonaria." In Frazer (ed.): 1–19.

Métraux, G.P.R. 1999/2000. "Ancient Housing: 'Oikos' and 'Domus' in Greece and Rome." *JSAH* 58: 392–405.

Métraux, G.P.R. 2006. "Consumers' Choices: The Arts in the Age of Late Roman 'Mechanical' Reproduction." In D'Ambra and Métraux (eds.): 135–51.

Métraux, G.P.R. 2008. "Prudery and *Chic* in Late Antique Clothing." In Edmonson and Keith (eds.): 271–93.

Métraux, G.P.R. 2014. "Some Other Literary Villas of Roman Antiquity besides Pliny's." In Reeve (ed.): 27–40.

Métraux, G.P.R. 2015a. "Masonry and Memory in Hadrian's Architecture and Architectural Rhetoric." In Favro et al. (eds.): 139–49.

Métraux, G.P.R. 2015b. "Some Other Literary Villas of Roman Antiquity besides Pliny's." In Reeve (ed.): 27–40.

Meyer, K.E. 1999. "Axial Peristyle Houses in the Western Empire." *JRA* 12: 101–21.

Mezquíriz, M.A. 2008. "Arellano y las villas tardorromanas del valle del Ebro." In Fernández Ochoa, García-Entero, and Gil Sendino (eds.): 392–410.

Mezquíriz Irujo, Mª. Á. 2003. *La villa romana de Arellano.* Pamplona: Fondo de Publicaciones del Gobierno de Navarra.

Michaelis, A. 1854. *Ancient Marbles in Great Britain.* Cambridge: The University Press.

Michel, D. 1980. "Pompejanische Gartenmalereien." In Cahn and Simon (eds.): 373–404.

Mielsch, H. 1987. *Die römische Villa: Architektur und Lebensform.* Munich: C.H. Beck.

Mielsch, H. 1999. *La villa romana.* Florence: Giunti.

Mielsch, H. 2001. *Römische Wandmalerei.* Stuttgart: Theiss Verlag.

Milella, A. 2007. "L'assetto cultuale della Roma carolingia – Le strutture assistenziali." In Bonacasa Carra and Vitale (eds.): 393–7.

Millar, F. 1998. *The Crowd in the Late Republic.* Ann Arbor, MI: University of Michigan Press.

Miller, S.G. 1972. "A Mosaic Floor from a Roman Villa at Anaploga." *Hesperia* 41: 332–54.

Millet, M. 1992. "Roman Towns and Their Territories: An Archaeological Perspective." In Rich and Wallace-Hadrill (eds.): 173–93.

Millett, M. 1990. *The Romanization of Britain.* Cambridge, UK: Cambridge University Press.

Milson, D. 2006. "Design Analysis of the Peristyle Building from 'Ein ez-Zeituna." *'Atiqot* 51: 71–5.

Mingazzini, P. 1931. "Positano (prov. di Salerno). Resti di villa romana presso la Marina." *NSc* 1931: 356–9.

Mingazzini, P. and F. Pfister 1946. *Formae Italiae. Regio I. Latium et Campania, vol. II. Surrentum.* Florence: Sansoni.

Miniero Forte, P. 1989. *Stabiae. Pitture e stucchi delle ville romane.* Naples: Electa.

Miniero, P. 2007. "La villa romana tardo-repubblicana nel Castello Aragonese di Baia." In B. Perrier (ed.), *Villas, maisons, sanctuaires et tombeaux tardo-républicains: découvertes et relectures récentes : actes du colloque international de Saint-Romain-en-Gal en l'honneur d'Anna Gallina Zevi : Vienne, Saint-Romain-en-Gal, 8-10 février 2007,* 157–76. Rome: Quasar.

Mirabella Roberti, M. 1965. "Una basilica paleocristiana a Palazzo Pignano." *InsFulc* 4: 79–90.

Mirabella Roberti, M. 1968. "Ancora sulla 'Rotonda' di Palazzo Pignano." *InsFulc* 7: 85–94.

Mitchell, J. 2004. "The Archaeology of Pilgrimage in Late Antique Albania: The Basilica of the Forty Martyrs." In Bowden, Lavan, and Machado (eds.) 145–86.

Moesch, V. 2008. "La Villa dei Papiri." In Borriello, Guidobaldi, and Guzzo (eds.): 70–9.

Moesch, V. 2009. *La Villa dei Papiri.* Naples: Electa.

Mohr, P. (ed.) 1895. *C. Sollius Apollinaris Sidonius.* Leipzig: In aedibus B.G. Teubneri.

Momigliano, A. 1994. "M.I. Rostovtzeff." In Bowersock and Cornell (eds.): 32–43.

Momigliano, A. and A. Schiavone (eds.) 1989. *Storia di Roma, 4. Caratteri e morfologie.* Turin: Einaudi.

Mommsen, Th. 1900, "Praetorium." *Hermes* 1900: 437–42.

Monacchi, D. 1983. "Colle Plinio: Relazione della campagna 1979." In *Ville e insediamenti rustici d'età romana in Umbria*, 11–44. Perugia: Umbra.

Mondelor, R. 1984–85. "Mosaicos ornamentales de la villa romana de Marbella." *Mainake* 6.8: 117–26.

Monfrin, F. 1998. "La christianisation de l'éspace et du temps. A. L'établissement matériel de l'Église aux Ve et VIe siècles." In Pietri (ed.): 959–1014.

Monterroso Checa, A. 2010. *Theatrum Pompei : forma y arquitectura de la génesis del modelo teatral de Roma.* Madrid: Consejo Superior de Investigaciones Científicas.

Moore, M.B. and G. Köpcke (eds.) 1979. *Studies in Classical Art and Archaeology: A Tribute to Peter Heinrich von Blanckenhagen.* New York: Augustin Publisher.

Moorman, E.M. (ed.) 1993. *Functional and Spatial Analysis of Wall Painting. Proceedings of the Fifth International Congress on Ancient Wall Painting, Amsterdam 8–12 September 1992.* Leiden: BaBesch.

Moorman, E.M. 2013. "Literary Evocations of Herculaneum in the Nineteenth Century." In Mattusch (ed.): 189–204.

Moormann, E. 2010. "The Wall Paintings in the Villa of the Papyri: Old and New Finds." In Zarmakoupi (ed.): 63–78.

Moret, P. 1999. "Casas fuertes romanas en la Bética y la Lusitânia." In Gorges and Germán Rodríguez Martín (eds.): 55–89.

Moret, P. and T. Chapa Brunet (eds.) 2004. *Torres, atalayas y casas fortificadas. Explotación y control del territorio en Hispania (s. III a. de C.–s. I d. de C.).* Jaén: Universidad de Jaén.

Morgan, T. 1998. *Literate Education in the Hellenistic and Roman Worlds.* Cambridge, UK: Cambridge University Press.

Morley, N. 1996. *Metropolis and Hinterland: The City of Rome and the Italian Economy 200BC–AD200.* Cambridge, UK: Cambridge University Press.

Morley, N. 2001 "The Transformation of Italy, 225–28BC." *JRS* 91: 50–62.

Morlier, H. (ed.) *La mosaique gréco-romaine IX*, vol. 1. CÉFR 352. Rome: École française de Rome.

Morris, I. 2011. "Archaeology and Greek Slavery." In Bradley and Cartledge (eds.): 176–93.

Morris, S.P. and J. Papadopoulos 2005. "Greek Towers and Slaves: An Archaeology of Exploitation." *AJA* 109: 155–225.

Morvillez, É. 1995. "Les salles de réception triconques dans l'architecture domestique de l'Antiquité tardive en Occident." *Histoire de l'Art* 31: 15–26.

Morvillez, É. 1996. "Sur les installations de lits de table en sigma dans l'architecture domestique du Haut-Empire et Bas-Empire." *Pallas* 44: 119–58.

Morvillez, É. 2004. "La fontaine du Seigneur Julius à Carthage." In Balmelle, Chevalier, and Ripoll (eds.): 47–55.

Morvillez, É. 2006. "Les mosaïques des bains d'Oued Athménia (Algérie): les calques conservés à la Médiathèque de l'Architecture et du Patrimoine." *BullSocNatAntFr* 2006: 304–21.

Morvillez, É. 2007. "À propos de l'architecture domestique d'Antioche, de Daphné et Séleucie." In Galor and Waliszewski (eds.): 51–77.

Morvillez, E. 2008. "Les sigmas-fontaines dans l'antiquité tardive." In Vössing (ed.): 37–53.

Morvillez, E. 2013. "Sur la fameuse villa de Pompéanus à Oued Athménia, près de Constantine." In Blondeau et al. (eds.): 111–18.

Mouritsen, H. 1998. "The Town Council of Canusium and the Town Councils of Roman Italy." *Chiron* 28: 229–54.

Mouritsen, H. 2001. *Plebs and Politics in the Late Roman Republic.* Cambridge, UK, and New York: Cambridge University Press.

Moxnes, H. (ed.) 1997. *Constructing Early Christian Families.* London: Routledge.

Mratschek, S. 2001. "*Multis enim notissima est sanctitas loci*: Paulinus and the Gradual Rise of Nola as a Center of Christian Hospitality." *JECS* 9: 511–53.

Mukai, T. et al. 2010. "Nota preliminare sui materiali ceramici rinvenuti nel corso delle campagne di scavo 2002–2007 nella 'Villa di Augusto' a Somma Vesuviana." *Amoenitas* 1: 221–35.

Müller, C. and C. Hasenohr (eds.) 2002. *Les Italiens dans le monde grec: IIe siècle av. J.-C. – 1er siècle ap. J.-C.: circulation, activités, integration. Actes de la table ronde, École Normale Supérieure, Paris 14–16 Mai 1998.* BCH Supplement 41. Paris: Ecole française d'Athènes.

Mulvin, L. 2002. *Late Roman Villas in the Danube-Balkan Region.* BAR-IS 1064. Oxford: Archaeopress.

Mulvin, L. 2004. "Late Roman Villa Plans: The Danube-Balkan Region." In Bowden, Lavan, and Machado (eds.): 377–410.

Mundell Mango, M. and A. Bennett 1994. *The Sevso Treasure, Part One. JRA* Supplementary series 12. Ann Arbor, MI: Journal of Roman Archaeology.

Munro, B. 2012. "Recycling, Demand for Materials, and Landownweship at Villas in Italy and the Western Provinces in Late Antiquity." *JRA* 25: 351–70.

Munzi, M. 2010. "Il territorio di Leptis Magna. Insediamenti rurali, strutture produttive e rapporti con la città." In I. Tantillo and F. Bigi (eds.), *Leptis Magna. Una città e le sue iscrizioni in epoca tardoromana*, 45–80. Cassino: Edizioni dell'Università degli Studi di Cassino.

Munzi, M. and F. Felici 2008. "La villa del wadi er-Rasaf (*Leptis Magna*): stratigrafia e contesti." *AfrRom* 17: 2317–38.

Munzi, M. et al. 2008. "Il territorio di *Leptis Magna*: ricognizioni tra Ras el-Mergheb e Ras el-Hamman (2007)." *AfrRom* 18: 725–48.

Murray, O. (ed.) 1990. *Sympotica: A Symposium on the Symposion*, Oxford: Clarendon Press.

Museum Annual Report. *Annual Report of the Working of the Museum Department*, Malta.

Musso, L. (ed.) 1997. "Missione archeologica dell'Università di Roma Tre a Lepcis Magna." *LibAnt* n.s. 3: 257–94.

Musso, L., G. Matug and S. Sandri 2015. "Leptis Magna, il mosaico delle terme dell'uadi Lebda: contesto, iconografia, valorizzazione." In *XII Colloquio AIEMA. Venezia, 11–15 settembre 2012. Atti*, G. Trovabene (ed.): 305–17. Paris: AIEMA and Verona: Scripta edizioni.

Mustilli, D. 1956. "La villa pseudo-urbana ercolanese." *RendNap* n.s. 31: 77–97.

Muth, S. 1999a. *Erleben von Raum. Zur Funktion Mythologische Mosaikbilder in der Roemische kaiserzeitliche Wohnarkitektur*. Palilia 6. Heidelberg: Deutsches Archaeologisches Institut.

Muth, S. 1999b. "Bildkomposition und Raumstruktur. Zum Mosaik der 'Großen Jagd' von Piazza Armerina in seinem raumfunktionalen Kontext." *RM* 106: 189–212.

Myers, E.M. (ed.) 1997. *The Oxford Encyclopedia of Archaeology in the Near East*. Oxford: Oxford University Press.

Mylius, H. 1928. "Zu den Rekonstruktionen des Hauptgebäudes im gallorömischen Bauernhof bei Mayen." *BJb* 133: 141–52.

Mylonas, G.E. and D. Raymond (eds.) 1953. *Studies Presented to David Moore Robinson on His Seventieth Birthday*, vol. 2. St.Louis, MO: Washington University.

Mynors, R. (ed.) 1937. *Cassiodori Senatoris Institutiones*. Oxford: The Clarendon Press.

Mynors, R. (ed.) 1963. *C. Plini Caecili Secundi: Epistularum libri decem*. Oxford: Clarendon Press.

Nagy, R.M. et al. (eds.) 1996. *Sepphoris in Galilee: Crosscurrents of Culture*. Raleigh, NC: North Carolina Museum of Art.

Napoli, J. (ed.) 2008. *Ressources et activités maritimes des peuples de l'Antiquité. Actes du colloque international de Boulogne-sur-Mer , 12, 13 et 14 mai 2005 organisé par le Centre de recherche en histoire atlantique et littorale, C.R.A.H.E.L.* Les Cahiers du Littoral, série 2.6. Boulogne-sur-Mer: Université du Littoral Côte d'Opale.

Navarro, R. 1999. "Vil·la Fortunatus." In de Palol and Pladevall (eds.): 146–50.

Neal, D. 1991. *Lullingstone Roman Villa*. London: English Heritage.

Neira Jiménez, L. 1994. "Mosaicos romanos con nereidas y tritones. Su relacion con el ambiente arquitectònico en el Norte de Africa y en Hispania." *AfrRom* 10: 1259–78.

Nercessian, A. 1990. *s.v.* "Ino." In *LIMC* 5.1, 657–61. Zürich: Artemis.

Netzer, E. 1975a. "The Hasmonean and Herodian Winter Palaces at Jerusalem." *IEJ* 25: 89–100.

Netzer, E. 1975b. "Winter Palace Jericho." *IEJ* 25: 89–100.

Netzer, E. 1990. "Architecture in Palaestina Prior to and during the Days of King Herod the Great." In *Akten des XIII internationalen Kongresses für klassische Archäologie*: 37–50. Mainz-am-Rhein: Philipp von Zabern.

Netzer, E. 2001a. *Hasmonean and Herodian Palaces at Jericho, Final Report of the 1973–1987 Excavations, vol. I, Stratigraphy and Architecture*. Jerusalem: Israel Exploration Society.

Netzer, E. 2001b. *Palaces of the Hasmoneans and Herod the Great*. Jerusalem: Israel Exploration Society.

Netzer, E. 2011. "In search of Herod's Tomb," *BARev* 2011 (1), www.baslibrary.org/biblical-archaeology-review/37/1/7 (accessed February 26, 2011).

Netzer, E., Y. Kalman, R. Porath, and R. Cachy-Laureys 2010. "Preliminary Report on Herod's Mausoleum and Theatre with a Royal Box at Herodium." *JRA* 23, 84–108.

Netzer, E. and Z. Weiss 1994. *Zippori*. Jerusalem: Israel Exploration Society.

Neudecker, R. 1988. *Die Skulpturenausstattung der römischen Villen in Italien* Beiträge zur Erschließung hellenistischer und kaiserzeitlicher Skulptur und Architektur 9. Mainz-am-Rhein: Philipp von Zabern.

Neudecker, R. 1998. "The Roman Villa as a Locus of Art Collections." In Frazer (ed.): 77–91.

Neuerburg, N. 1975. *Herculaneum to Malibu: A Companion to the Visit of the J. Paul Getty Museum Building: A Descriptive and Explanatory Guide to the Re-Created Ancient Roman Villa of the Papyri Built at the Wishes of J. Paul Getty in Malibu, California, 1970–1974*. Malibu, CA: The Museum.

Neuru, L. and A. Ennabli 1993. "Recent Excavations at Sidi Ghrib, 1993." *Archaeological News* 18: 27–31.

Nevitt, L. 2008. "Castles in the Air? The Julius Mosaic as Evidence for Élite Country Housing in Late Roman North Africa." *AfrRom* 17: 745–58.

Newby, Z. 2005. *Greek Athletics in the Roman world*. Oxford: Oxford University Press.

Nielsen, I. 1993. *Thermai et Balnea. The Architecture and Cultural history of Roman Public Baths*. Aarhus: Aarhus University Press.

Nielsen, I. 1999. *Hellenistic Palaces: Tradition and Renewal*. Aarhus: Aarhus University Press.

Nielsen, I. (ed.) 2001. *The Royal Palace Institution in the First Millennium BC: Regional Development and Cultural Interchange between East and West.* Athens: The Danish Institute at Athens.

Nielsen, I. and H. S. Nielsen (eds.) 2001. *Meals in a Social Context: Aspects on the Communal Meal in the Hellenistic and Roman World.* Aarhus: Aarhus University Press.

Niemann, G. and A. Conze 1910 (2005). *Der Palast Diokletians in Spalato.* Reprint by K.K. Österreichisches archäologisches Institut; im Auftrage des K.K. Ministeriums für Kultus und Unterricht aufgenommen und beschrieben von George Niemann. Split: Knjizevni Krug Split.

Nikšić, G. 2009. "Dioklecijanova palača – od projekta do izvedbe/Diocletian's Palace – from Design to Execution." In Cambi, N., J. Belamarić, and T. Marasović (eds.): 117–34.

Nisard, D. 1844. *Les Agronomes Latins, Caton, Varron, Columelle, Palladius.* Paris: Dubochet.

Nixon, C.E.V. and B.S. Rodgers 1994. *In Praise of Later Roman Emperors. The Panegyrici Latini: Introduction, Translation, and Historical Commentary, with the Latin Text of R.A.B. Mynors. Panegyrici Latini. English & Latin.* Berkeley, CA: University of California Press.

Noble, T.F.X. 1984. *The Republic of St. Peter: The Birth of the Papal State, 680–825.* Philadelphia, PA: University of Pennysylvania Press.

Nogales Basarrate, T., A.R. Carvalho, and M.J. Almeida 2004. "El programa decorativo de la Quinta das Longas (Elvas, Portugal): un modelo excepcional de las *uillae* de la *Lusitania*." In Nogales Basarrate and Gonçalves Jorge (eds.): 103–56.

Nogales Basarrate, T. and M. L. Creus 1999. "Escultura de villae en el territorio emeritense. Nuevas aportaciones." In Gorges and Germán Rodríguez Martín (eds.): 499–523.

Nogales Basarrate, T. and L. Gonçalves Jorge (eds.) 2004. *Actas de la IV Reunión sobre Escultura Romana en Hispania.* Madrid: Ministerio de Cultura.

Noguera Celdrán, J.M. (ed.) 2010. *Poblamiento rural romano en el Sureste de Hispania. 15 Años después.* Murcia: Universidad de Murcia, Servicio de Publicaciones.

Noguera Celdrán, J.M. and J.A. Antolinos Marín 2010. "La villa de Los Cipreses: un modelo para el análisis del poblamiento rural romano en La Lanura de Jumilla (Murcia)." In Noguera Celdrán (ed.): 351–412.

Nolla i Brufau, J. M. (ed.) 2008. *The Countryside in the 3rd Century. From Septimius Severus to the Tetrachy* (Studies on the rural world in the Roman period 3). Girona: Universitat de Girona, Institut de Recerca Històrica.

Nolla, J.M. J., Sagrera, P. Verrié, and D. Vivó 1993. *Els mosaics de Can Pau Birol.* Girona: Ajuntament de Girona.

Nordh, A. 1949. *Libellus de regionibus Urbis.* Acta Instituti Romani Regni Sueciae 8:3. Lund: C.W.K. Gleerup.

Novak, B. 1901. *Fouille d'une villa romaine publiée sous les auspices de l'Association Historique pour l'Étude de l'Afrique du Nord.* Paris: E. Leroux.

Novello, M. 2007. *Scelte tematiche e committenza nelle abitazioni dell'Africa Proconsolare.* Pisa and Rome: F. Serra.

Novello, M. and M. Salvadori 2004. "Natura umanizzata e natura selvaggia nei mosaici dell'Africa romana: dallo spazio del giardino ai limiti esterni della tenuta." *AfrRom* 15: 853–75.

Noy, D. 2001. "The Sixth Hour is Mealtime for Scholars: Jewish Meals in the Roman World." In Nielsen and Nielsen (eds.): 134–44.

Noyé, G. 1999. "I centri del Bruzio tra IV e VII secolo." In *Italia Meridionale Tardoantica*: 431–70.

Oelmann, F. 1916. "Die römische Villa bei Blankenheim in der Eifel." *BJb* 123: 210–26.

Oelmann, F. 1928. "Ein gallorömischer Bauernhof bei Mayen." *BJb* 133: 51–140.

Oepen, A. 2011. *Villa und christlicher Kult auf der Iberischen Halbinsel in Spätantike und Westgotenzeit.* Wiesbaden: Reichert Verlag.

Oettel, A. 1996. *Fundcontexte römischer Vesuvvillen im Gebiet um Pompeji: die Grabungen von 1894 bis 1908.* Mainz-am-Rhein: Philipp von Zabern.

Oikonomakou, M. 2001–2004. "Νέα Μάκρη. Μρεξίζα." *ArchDelt* 56–59: 388.

Oikonomakou, M. 2005. "Νέα εθρήματα από τον Μαραθώνα και την Νέα Μάκρη." In *Αττική 2004: Ανασκαφές, Ευρήματα, Νέα Μουσεία,* V. Vasilopoulou (ed.): 41–3. Athens: B' Ephorate of Prehistoric and Classical Antiquities.

Oleson, J.P. 2008. *Oxford Handbook of Engineering and Technology in the Classical World.* Oxford, UK: Oxford University Press.

Oleson, J.P. and R. Stein 2007. "Comment on a Recent Article Concerning the Hydraulic System of the Roman Wreck at Grado, Gorizia." *IJNA* 36.2: 415–16.

Olesti, O. 1997. "El origen de las villas romanas en Cataluña." *ArchEspArq* 70: 71–90.

Oliver, G.J. 2001. "Regions and Micro-Regions: Grain for Rhamnous." In Archibald et al. (eds.): 137–56.

Oliver, J. 1971. "Epaminondas of Acraephia." *Greek, Roman, and Byzantine Studies* 12: 221–37.

Oppenheimer, A. 1991. *Galilee in the Mishnaic Period.* Jerusalem: Zalman Shazar Center. (Hebrew).

Oroz Arizcuren, F.J. 1999. "Miscelánea hispánica." In Villar and Beltrán (eds.): 499–534.

Orr, D.G. 1978. "Roman Domestic Religion: The Evidence of the Household Shrines." *ANRW* II.16.2: 1557–91.

Orrery, John Boyle, Fifth Earl of, 1751. *The Letters of Pliny the Younger, with Observations on Each Letter*, 2 vols. London: Printed by J. Bettenham for P. Vaillant.

Ørsted, P. 1992. "Town and Country in Roman Tunisia: A Preliminary Report on the Tuniso-Danish Survey Project in the Oued R'mel Basin in and around Ancient Segermes." *JRA* 5: 69–96.

Ørsted, P. et al. (eds.) 2000. *Africa Pronconsularis: Regional Studies in the Segermes Valley of Northern Tunisia*. Volume III. Århus: Århus University Press.

Ortalli, J. 1994. "Insediamento rurale in Emilia centrale." In Gelichi and Giordani (eds.): 169–214.

Ortalli, J. 1996 "La fine delle ville romane: esperienze locali e problemi generali." In Brogiolo (ed.): 9–18.

Ortalli, J. (ed.) 2006. *Vivere in villa. Le qualità delle residenze agresti in età romana; Atti del convegno, Ferrara, gennaio 2003*. Florence: Le Lettere.

Ortalli, J. and M. Hinzelmann (eds.) 2003. *Abitare in città. La Cisalpina tra impero e medioevo*. Wiesbaden: Reichert.

Osanna, M. 2008. "L'attività archeologica in Basilicata nel 2007." *AttiTaranto* 47: 911–44.

Osborne, R. 2004. "Demography and Survey." In Alcock and Cherry (eds.): 163–72.

Ouzoulias, P. et al. (eds.) 2001. *Les campagnes de la Gaule à la fin de l'Antiquité; Actes du colloque Montpellier, 11–14 mars 1998*. Antibes: Éditions APDCA.

Owens, E.J. 1996. "Residential Districts." In Barton (ed.): 7–32.

Oxé, A. 1933. *Arretinische Reliefgefässe vom Rhein*. Frankfurt: Habelt.

Özgenel, L. 2007. "Public Use and Privacy in Late Antique Houses in Asia Minor: The Architecture of Spatial Control." In Lavan, Özgenel, and Sarantis (eds.): 239–81.

Pace, B. 1955. *I mosaici di Piazza Armerina*. Rome: Gherardo Casini Editore.

Pachetère, F.G. de la 1920. *La Table hypothécaire de Veleia. Étude sur la propriété foncière dans l'Apennin de Plaisance*. Bibliothèque de l'École des hautes études, sciences historiques et philologiques 228. Paris: E. de Boccard.

Padoa-Schioppa, A. 2005. *Il diritto nella storia d'Europa. Vol. I. Il medioevo*, 2nd rev. edn. Padua: CEDAM.

Padró, P., M. Prevosti, M. Roca, and J. Sanmartí (eds.) 1993. *Homenatge a M. Tarradell*. Estudis Universitaris Catalans. Barcelona: Curial Edicions Catalanes.

Pagano, M. 1998. "La scoperta di Ercolano." In G. Cafasso, J. Ehrard, G.P. Migliaccio, and L. Vallet (eds.): 47–74.

Pagé, M.-M. 2012. *Empereurs et aristocrates bienfaiteurs : autour de l'inauguration des alimenta dans le monde municipal italien (fin Ier siècle - début IVe siècle)*. Québec: Presses de l'Université Laval.

Painter, K.S. 1965. "Excavation of the Roman Villa at Hinton St. Mary, Dorset, 1965." *Proceedings of the Dorset Natural History and Archaeological Society* 87: 102–3.

Painter, K.S. (ed.) 1980. *Roman Villas in Italy* (British Museum Occasional Paper 24). London: British Museum.

Palahí, L. and J.M. Nolla 2010. Felix Turissa. *La vil·la romana dels Atmetllers i el seu fundus (Tossa de Mar, la Selva)* (Documenta 12). Tarragona: Institut Català d'Arqueologia Clàssica.

Palahí Grimal, L. and J.M. Nolla i Brufau 2010: *Felix Turissa. La vil·la romana dels Ametllers i el seu fundus (Tossa de Mar, la Selva)* (Documenta 12). Tarragona: Institut Català d'Arqueologia Clàssica.

Pallas, D. 1955. "Ανασκαφή ρωμαϊκής επαύλεως παρά την Κόρινθον." *Prakt* 1955: 201–16.

Palmer, R.E.A. 1980. "Customs on Market Goods Imported into the City of Rome." In D'Arms and Kopff (eds.): 217–34.

Panagiotakis, N.P. (ed.) 1987. *Κρήτη Ιστορία και Πολιτισμός τ. Α΄. (Σύνδεσμος Τοπικών Ενώσεων Δήμων και Κοινοτήτων Κρήτης)*. Iraklion, Crete.

Pancrazzi, O. and S. Ducci (eds.) 1996. *Ville e giardini nell'Elba romana*. Florence: Octavo.

Pandermalis, D. 1976. "Beobachtungen zur Fassadenarchitektur und Aussichtsveranda im hellenistischen Makedonien." In Zanker (ed.): 387–97.

Pani, M. (ed.) 2001. *Epigrafia e territorio, politica e società* (Temi di antichità romane 6). Bari: Adriatica; Edipuglia.

Pantò, G. 2003. "Chiese rurali della diocesi di Vercelli." In Brogiolo (ed.) 2003: 87–107.

Panvini, R. 1997. "Considerazioni sui mosaici della villa ellenistica di Gela." In *AISCOM 1997*, 159–64.

Panzram, S. 2002. *Stadtbild und Elite. Tarraco, Corduba und Augusta Emerita zwischen Republik und Spätantike*. Historia Einzelschriften 161. Stuttgart: Franz Steiner.

Panzram, S. (ed.) 2014. *Städte in Spanien – Moderne Urbanität seit 2000 Jahren*. Mainz: Nünnerich-Asums Verlag.

Papachatzis, N. 1980. *Pausaniou Ellados Periegesis. Achaika-Arkadika*, vol. 4. Athens: Ekdotiki Athenon.

Papadakis, N. 1979. "Μακρύς Γιαλός Σητείας." *ArchDelt, Chronika* B2 34: 406–9.

Papadakis, N. 1980. "Μακρύς Γιαλός." *ArchDelt, Chronika* B2 45: 524–5.

Papaioannou, M. 2003. Domestic Architecture of Roman Greece. Unpublished Ph.D. dissertation. University of British Columbia, Vancouver, British Columbia.

Papaioannou, M. 2007. "The Roman *Domus* in the Greek World." In Westgate, Fischer, and Whitley (eds.): 350–61.

Papaioannou, M. 2010a. "The Evolution of the *Atrium* House: A Cosmopolitan Dwelling in Roman

Greece." In Ladstätter and Scheibelreiter (eds.): 81–115.

Papaioannou, M. 2010b. "East meets West: The Pottery evidence from Abdera," *Meetings between Cultures in the Ancient Mediterranean*, Proceedings of the International Congress of Classical Archaeology. *Bollettino di Archeologia on Line*, Volume Speciale C/C9/5: 53–65, available at:www.bollettinodiarcheologiaonline.beni culturali.it/documenti/generale/5_PAPAIOAN NOU.pdf.

Papaioannou, M. 2015. "Review of R. J. Sweetman: The Mosaics of Roman Crete. Art Archaeology and Social Change." *JRS* 105: 361–2.

Papaioannou, M., 2016. "A Synoecism of Cultures in Roman Greece." In Alcock, Egri, and Frakes (eds.): 31–45.

Papanikola-Bakrizti, D. and V. Kousoulakou (eds.) 2010. *Κεραμική της Ύστερης Αρχαιότητας από τον ελλαδικό χώρο (3ος-7ος αι. μ. Χ.)*, Επιστημονική συνάντηση, Θεσσαλονίκη, 12–16 Νοεμβρίου 2006. Thessaloniki: Archaeological Institute of Macedonian and Thracian Studies.

Papenfuss, D. and V. M. Strocka (eds.) 1982. *Palast und Hütte. Beiträge zum Bauen und Wohnen im Altertum von Archäologen, Vor- und Frühgeschichtlern. Tagungsbeiträge Symposium Alexander von Humboldt-Stiftung, Berlin 25.–30. November 1979*. Mainz-am-Rhein: Philipp von Zabern.

Papi, E. 1999. "'Ad delenimenta vitiorum' (Tac. *Agr.* 21). Il *balneum* nelle dimore di Roma dall'età repubblicana al I secolo d.C." *MÉFRA* 111.2: 695–728.

Pappalardo, U. 1997. "Nuove testimonianze su Marco Nonio Balbo ad Ercolano." *RM* 104: 415–33.

Pappalardo, U. 2007, "Le ville romane nel Golfo di Napoli." In Ciardiello (ed.): 17–46.

Parlasca, K. 1959. *Die römischen Mosaiken in Deutschland*. Römisch-Germanische Forschungen 23. Berlin: Walter de Gruyter.

Parrish, D. 1981. "Annus-Aion in Roman Mosaics." In Duval (ed.) : 11–25.

Parrish, D. 1985. "The Date of the Mosaics from Zliten." *AntAfr* 21: 137–58.

Parrish, D. 1995. "The Mosaic of Aion and the Seasons from Haidra (Tunisia): An Interpretation of its Meaning and Its Importance." *AnTard* 3: 167–91.

Parslow, C.C. 1995. *Rediscovering Antiquity: Karl Weber and the Excavation of Herculaneum, Pompeii, and Stabiae*. Cambridge, UK: Cambridge University Press.

Paschoud, F. and J. Szidat (eds.) 1997. *Usurpationen in der Spätantike: Akten des Kolloquiums "Staatsstreich und Staatlichkeit," 6–10 März 1996*. Stuttgart: Steiner.

Pasqui, A. 1897. "La villa pompeiana della Pisanella presso Boscoreale." *MonAnt* 7: 397–554.

Passi Pitcher, L. 1990. "Il complesso di Palazzo Pignano." In *Milano capitale dell'Impero romano 286–402 d C.* Milan: Silvana.

Pastor, M., F.E. Tendero Fernández, and P. Torregrosa Giménez 1999. "Avance del registro arqueológico de la villa romana 'Casa Ferrer I' (Partida La Condomina, Alicante)." In XXIV *Congreso Nacional de Arqueología – Cartagena*, IV: 475–9. Murcia: Instituto de Patriomonio Histórico.

Patlagean, E. 1977. *Pauvreté économique et pauvreté sociale à Byzance, 4e–7e siècles*. Civilisations et société 48. Paris: Mouton.

Patrich, J. 1996. "Warehouses and Granaries in Caesarea Maritima." In Raban and Holum (eds.): 146–73.

Patrich J. 1999. "The Warehouse Complex and the Governor's Palace (Areas KK, CC and CC, May 1993–December 1995)." In Holum, Raban, and Patrich (eds.): 71–107.

Patterson, J.R. 2000. *Political Life in the City of Rome*. London: Bristol Classical.

Patterson, J.R. 2006. *Landscapes and Cities. Rural Settlement and Civic Transformation in Early Imperial Italy*. Oxford and New York: Oxford University Press.

Patterson, H. and F. Coarelli (eds.) 2008. *Mercator Placidissimus. The Tiber Valley in Antiquity. New Research in the Upper and Middle River Valley*. Rome: Quasar.

Patterson, H., H. Di Giuseppe, and Witcher, R. 2004. "Three South Etrurian 'Crises': First Results of the Tiber Valley Project." *PBSR* 72: 1–36.

Pavan, M. 1958. *Ricerche sulla provincia Romana di Dalmazia*. Istituto Veneto di Scienze, Lettere ed Arti. Memorie. Classe di scienze morali e lettere 32. Venice: Istituto veneto di scienze, lettere ed arti.

Pavis d'Escurac, H. 1974. "Pour une étude sociale de l'*Apologie* d'Apulée." *AntAfr* 8: 89–101.

Payne Knight, R. 1816. *Report of the Select Committee of the House of Commons on the Earl of Elgin's Collection*. London.

Peacock, D.P.S. and Williams, D.F. (1986) *Amphorae and the Roman Economy. An Introductory Guide*. Longman Archaeology Series. London and New York: Longman.

Pedišić, I. and E. Podrug 2008. "Roman Brick Workshop Stamps from the Collection of the Šibenik City Museum." *Opuscula Archaeologica : Papers of the Department of Archaeology, Filozofski fakultet u Zagrebu* 31 (2007): 81–141.

Pejranni Baricco, L. 2003. "Chiese rurali in Piemonte tra V e VI secolo." In Brogiolo (ed.): 57–85.

Pelagatti, P. and G. Voza (eds.) 1973. *Archeologia nella Sicilia sud-orientale*. Naples: Centre Jean Bérard.

Pelagatti, P. 1998. "Dalle perlustrazioni di Paolo Orsi e Antonio Salinas alle ricerche recenti." In Lentini (ed.): 39–69.

Pellecuer, C. (ed.) 1996a. Formes de l'habitat rural en Gaule Narbonnaise 3. Juan-les-Pins: Editions APDCA.

Pellecuer, C. 1996b. "Villa et domaine." In Fiches (ed.): 277–91.

Pellecuer, C. 2000. La villa des Près-Bas (Loupian, Hérault) dans son environnement. Contribution à l'étude des villae et de l'économie domaniale en Narbonnaise. 2 vols. [Thèse de Doctorat Nouveau Régime]. Aix-en-Provence: Université Aix-Marseille I.

Pellecuer, C. and H. Pomarèdes 2001. "Crise, survie ou adaptation de la villa romaine en Narbonnaise Première? Contributions des récentes recherches de terrain en Languedoc-Roussillon." In Ouzoulias et al. (eds.) 2001: 503–32.

Pember, C. 1947. "The Country House of a Roman Man of Letters: The Lost Villa of the Younger Pliny." Illustrated London News 211: 220–1.

Penã, J. T. et al. (eds.) 1998. Carthage Papers. The Early Colony's Economy, Water Supply, a Public Bath and the Mobilization of State Oil. JRA Supplementary Series 28. Portsmouth, RI: Journal of Roman Archaeology.

Peña Cervantes, Y. 2010. Torcularia. La producción de vino y aceite en Hispania. Documenta 14. Tarragona: Institut Català d'Arqueologia Clàssica.

Pensabene, P. 2009. "Mosaici della Villa Romana del Casale: distribuzione, programmi iconografici, maestranze." In M. C. Lentini (ed.), Mosaici mediterranei, 87–116. Caltanissetta: Paruzzo Editore.

Pensabene, P. (ed.) 2010. Piazza Armerina. Villa del Casale e la Sicilia tra tardoantico e medioevo. Studia Archaeologica 175. Rome: L'Erma di Bretschneider.

Pensabene, P. 2010–2011. "Studi recenti sulla Villa del Casale: gli interventi della Sapienza – Università di Roma. II. La villa del Casale tra tardo antico e medioevo alla luce dei nuovi dati archeologici: funzioni, decorazioni e trasformazioni." RendPontAcc 83: 141–226.

Pensabene, P. 2013a. I marmi nella Roma antica. Rome: Carocci Editore.

Pensabene, P. 2013b. "Villa di Piazza Armerina: intervento della Sapienza–Università di Roma." In Rizzo (ed.): 31–99.

Pensabene, P. 2014. "Nuove scoperte alla Villa del Casale di Piazza Armerina: magazzini, terme e fornaci." In Pensabene and Sfameni (eds.): 9–18.

Pensabene, P. 2016. "Il contributo degli scavi 2004–2014 alla storia della Villa Casale di Piazza Armerina tra il IV e XII secolo." In Giuffrida and Cassia (eds.): 223–72.

Pensabene, P. and C. Bonanno (eds.) 2008. L'insediamento medievale sulla Villa del Casale di Piazza Armerina. Nuove acquisizioni sulla storia della villa e risultati degli scavi 2004–2005. Galatina: Congedo Editore.

Pensabene, P. et al. 2009. "Villa del Casale di Piazza Armerina: nuovi scavi." Fasti On Line Documents and Research 2009: 1–10 [www.fastionline.org/docs/FOLDER-it-2009-158.pdf]

Pensabene, P. and P.D. Di Vita, P. D. (eds.) 2008. Marmi colorati e marmi ritrovati della Villa Romana del Casale. Catalogo mostra archeologica. Piazza Armerina: Città di Piazza Armerina, Assessorato Aree Archeologiche.

Pensabene, P. and E. Gallocchio 2011a. "The Villa del Casale of Piazza Armerina." Expedition 53.2: 29–37.

Pensabene, P. and E. Gallocchio 2011b. "I mosaici delle terme della Villa del Casale: antichi restauri e nuove considerazioni sui proprietari." In AISCOM 2011, 15–24.

Pensabene, P. and P. Barresi. 2017. "Una rilettura della decorazione musiva del triconco della villa del Casale a Piazza Armerina." In AISCOM 2017: 117–29.

Pensabene, P. and C. Sfameni (eds.) 2006. Iblatasah Placea Piazza. L'insediamento medievale sulla Villa del Casale. Nuovi e vecchi scavi. Catalogo Mostra Archeologica, Piazza Armerina, 8 agosto 2006–31 gennaio 2007. Palermo: Regione Siciliana.

Pensabene, P. and C. Sfameni (eds.) 2014. La Villa restaurata e i nuovi studi sull'edilizia residenziale tardoantica. Atti del Convegno internazionale del Centro interuniversitario di Studi sull'Edilizia abitativa tardoantica nel Mediterraneo (CISEM) (Piazza Armerina, 7–10 novembre 2012). Bari: Edipuglia.

Penttinen, A. 1996. "The Berbati-Limnes Archaeological Survey: The Classical and Hellenistic Periods." In Wells and Runnels (eds.), 229–83.

Percival, J. 1976. The Roman Villa: A Historical Introduction. Berkeley, CA, and London: University of California Press and Batsford.

Percival, J. 1992. "The Fifth-Century Villa: New Life or Death Postponed?" In Drinkwater and Elton (eds.): 156–64.

Percival, J. 1996. "Saints, Ghosts and the Afterlife of the Roman Villa." L'antiquité classique 65: 161–73.

Percival, J. 1997. "Villas and Monasteries in Late Roman Gaul." JEH 48.1: 1–21.

Perelli, L. 1982. Il movimento popolare nell'ultimo secolo della Repubblica. Turin: G.B. Paravia.

Pérez Mínguez, R. 2006. Aspectos del mundo rural romano en el territorio comprendido entre los ríos Turia y Palancia. Servicio de Investigación Prehistórica, Serie de Trabajos Varios 106. Valencia: Diputación Provincial de Valencia.

Pergola, P. (ed.) 1999. Alle origini della parrocchia rurale (IV–VII sec.). Sussidi allo Studio delle antichità cristiane 12. Vatican City: Pontificio Istituto di Archeologia Cristiana.

Pernice, E. 1938. Pavimente und figürliche Mosaiken. Die Hellenistische Kunst in Pompeji 6. Berlin: Walter de Gruyter.

Perrier, B. (ed.) 2007. *Villas, maisons, sanctuaires et tombeaux tardo-républicains : découvertes et relectures récents (Actes du colloque international de Saint-Romain-en-Gal en l'honneur d'Anna Gallina Zevi. Vienne-Saint-Romain-en-Gal, 8–10 février 2007)*. Rome: Quasar.

Perring, D. 1991. "Spatial Organization and Social Change in Roman Towns." In Rich and Wallace-Hadrill (eds.): 273–93. London: Routledge.

Perring, D. 2003. "'Gnosticism' in Fourth-Century Britain: The Frampton Mosaics Reconsidered." *Britannia* 34: 97–127.

Perrotta, A. et al. 2006. "Burial of Emperor Augustus' Villa at Somma Vesuviana (Italy) by Post-79 AD Vesuvius Eruptions and Reworked (Lahars and Stream Flow) Deposits." *Journal of Volcanology and Geothermal Research* 158: 445–66.

Perry, E. E. 2001. "Iconography and the Dynamics of Patronage. A Sarcophagus from the Family of Herodes Atticus." *Hesperia* 70: 461–92.

Pesando, F. 1987. *Oikos e ktesis: la casa greca in età classica* (Pubblicazioni degli istituti di storia della Facoltà di lettere e filosofia). Rome: Quasar.

Pesando, F. 1996. Domus. *Edilizia privata et società pomepiana fra III e I secolo a.C.* Ministero per i beni culturali ed ambientali. Soprintendenza Archeologia di Pompei. Mongrafie 12. Rome: "L'Erma" di Bretschneider.

Pesando, F. and M. Stefanile. 2016. "Sperlonga. Le attività di archeologia subacquea dell'Università di Napoli 'L'Orientale' nella villa di Tiberio." *Newsletter di Archeologia CISA* 7: 205–21.

Pesavento Mattioli, S. and M-B. Carre (eds.) 2009. *Olio e pesce in epoca romana : produzione e commercio nelle regioni dell'Alto Adriatico. Atti del convegno (Padova 16 febbraio 2007)*. Rome: Edizioni Quasar.

Pessoa, M. 1995. "Villa romana do Rabaçal Penela (Coimbra-Portugal). Notas para o estudo da arquitectura e mosaicos." In *IV Reunió d'Arqueologia Cristiana Hispànica, Lisboa, 28–20 de setembre, 1–2 d'octubre de 1992*, 471–91. Barcelona: Institut d'Estudis Catalans.

Peters, W.J.T. 1963. *Landscape in Romano-Campanian Mural Painting*. Assen: Van Gorcum.

Petit, J.-P. and S. Santoro (eds.) 2007. *Leben im römischen Europa: Von Pompeji nach Bliesheim-Reinheim*. Paris: Editions Errance.

Petrakos, B. 1995. *Ο Μαραθών*. Βιβλιοθήκη της εν Αθήναις Αρχαιολογικής Εταιρείας, αρ. 146, Athens: The Archaeological Society at Athens.

Petrakos, B. 1996. *Marathon*. (Archaeological Society at Athens Library [B.A.E.]; no. 155). Athens: The Archaeological Society at Athens.

Petrakos, B. 2002. "Το κτήμα του Ηρόδου στον Μαραθώνα." *Praktika tis Akademias Athenon* 77: 83–90.

Petrakos, B 2010. "Οι πρώτες ελληνικές αρχαιολογικές έρευνες στην Κόρινθο και την περιοχή της." In *Πρακτικά του Η' Διεθνούς Συνεδρίου Πελοποννησιακών Σπουδών: Κόρινθος, 26–28 Σεπτεμβρίου 2008: αφιέρωμα στην αιώνια Κόρινθο*. Peloponnesiaka, Supplement 29: 39–46. Athens: Society for Peloponnesian Studies.

Petropoulos, M. 1991. "Η Αιτωλοακαρνανία κατά τη ρωμαϊκή περίοδο." In *Μνημειακή κληρονομία και ιστορία της Αιτωλοακαρνανίας. Proceedings of the Archaeological and Historical Conference on Aitoloakranania, Agrinion, 21–23 October 1988*, 93–125. Agrinion: Municipality of Agrinion.

Petropoulos, M. 1994. "Αγροικίες της Πατραϊκής." In Doukellis and Mendoni (eds.): 405–24.

Petropoulos, M. 1997. "Μιντιλόγλι, θέση Βάκρου." *ArchDelt, Meletai A* 52: 287–8.

Petropoulos, M. 1999. *Τα εργαστήρια των ρωμαϊκών λυχναριών της Πάτρας και το Λυχνομαντείο*. Athens: Tameio Archaiologikōn Porōn kai Apallotriōseōn.

Petropoulos, M. 2014. "Μόνιμες εγκαταστάσεις και κινητά σκεύη για την αγροτική παραγωγή στις ρωμαϊκές αγροικίες της Πάτρας." In Rizakis and Touratsoglou (eds.): 154–75.

Petropoulos, M. and A. D. Rizakis 1994. "Settlement Patterns and Landscape in the Coastal Area of Patras." *JRA* 7: 183–207.

Petsas, Ph. 1963a. "Αρχαιότητες και μνημεία Δυτικής Μακεδονίας: Ανασκαφή Ναούσης." *ArchDelt* 18: 213–15.

Petsas, Ph. 1963b. "Ανασκαφαί Ναούσης." *Prakt* 1963: 59–79.

Petsas, Ph. 1963c. "Λευκαδία Ναούσης." *Ergon* 10: 44–9.

Petsas, Ph. 1965. "Ανασκαφαί Ναούσης." *Prakt* 1964: 36–46.

Petsas, Ph. 1966a. "Νάουσα." *Ergon* 13: 22–5.

Petsas, Ph. 1966b. "Ανασκαφαί Ναούσης." *Prakt* 1966: 30–8.

Petsas, Ph. 1971. "Νέα λατινική επιγραφή εκ Πατρών." *AAA* 4: 112–15.

Pettineo, A. (ed.). 2008. *Dall'Aleso al Serravalle. 7 comuni, un'identità*. Motta d'Affermo: Comune di Motta d'Affermo.

Peyras, J. 1975. "Le *fundus Aufidianus*: étude d'un grand domaine romain de la région de Mateur (Tunisie du Nord)." *AntAfr* 9: 181–222.

Peyras, J. 1991. *Le Tell nord-est tunisien dans l'antiquité: essai de monographie régionale*. Paris: Éditions du CNRS.

Phaklaris, P. B. 1990. *Αρχαία Κυνουρία. Ανθρώπινη Δραστηριότητα και Περιβάλλον*. Athens: Archaeological Receipts Fund.

Philadelpheus, A. 1918. "Αρχαία Έπαυλις μετά Νυμφαίου εν Λεχαίῳ της Κορινθίας." *ArchDelt* 4: 125–35.

Philadelpheus, A. 1931–2. "Ἀνασκαφαί Ἡραίας." *ArchDelt* 14: 57–70.

Philipp, K.J. 2014. *Karl Friedrich Schinkel: Späte Projekte / Late Project.* Stuttgart: Axel Menges.

Picado Pérez, Y. 2001. "Nuevos datos para el conocimiento del área periurbana de Mérida en época altoimperial: La villa de Carrión. Intervención arqueológica realizada en el trazado de la Autovía de la Plata (tramo Mérida-Almendralejo Sur)." *Mérida, Excavavaciones arqueológicas* 7: 231–46.

Picard, G.-C. 1951. "Les vicissitudes de *C. Bruttius Praesens.*" *Karthago* 2: 91–9.

Picard, G.-C. 1985. "La villa du taureau à Silin (Tripolitaine)." *CRAI* 1985: 227–41.

Picard, G.-C. 1986. "Banlieues de villes dans l'Afrique romaine." In *Histoire et archéologie de l'Afrique du Nord: actes du IIIe colloque international réuni dans le cadre du 110e Congrès national des sociétes savantes, Montpellier, 1-15 avril 1985*, 143–8. Paris: C.T.H.S.

Picard, G.-C. 1987. "Les thermes de Sidi Ghrib (Tunisie) publiés récemment par M. Abdelmagid Ennabli." *Bulletin de la Société nationale des antiquaires de France* 1987: 44–51.

Picard, G.-C. 1990. "Mosaïques et société dans l'Afrique romaine. Les mosaïques d'El Alia (Tunisie)." In *L'Afrique dans l'occident*, 3–14.

Piccarreta, F. 1977. *Forma Italiae. Astura,* I.13. Florence: L.S. Olschki.

Piccirillo, M. 1985. "Rural Settlements in Byzantine Jordan." In Hadidi (ed.): 257–61.

Piccirillo, M. 1993. *The Mosaics of Jordan.* Amman: American Center of Oriental Research.

Piétri, C. 1961. "*Concordia apolostolum et renovatio urbis.* Culte des martyrs et propagande pontificale." *MÉFRA* 73: 275–322.

Piétri, L. (ed.) 1998. *Histoire du christianisme, vol. 3. Les églises d'orient et d'occident.* Paris: Desclée.

Piétri, L. 2002. "Évergétisme chrétien et fondations privées dans l'Italie de l'antiquité tardive." In Carrié and Lizzi Testa (eds.) 2002: 253–63.

Piétri, L. 2005. "Les *oratoria in agro proprio* dans la Gaule de l'antiquité tardive: un aspect des rapports entre potentes et évêques." In Delaplace (ed.) 2005: 235–42.

Piganiol, A. 1954 "Les documents annexes du cadastre d'Orange." *CRAI* 98: 302–10.

Piganiol, A. 1962. *Les documents cadastraux de la colonie romaine d'Orange.* 16th supplément à Gallia. Paris: CNRS.

Piganiol, A. et al. (eds.) 1960. *Atlas des centuriations romaines de Tunisie,* 2nd edn. Paris: Institut géographique national.

Pikoulas, Y.A. 1988. *Η Νότια Μεγαλοπολίτικη χώρα από τον 8° π.χ. ως τον 4° μ.Χ. αιώνα.* Athens: Horos.

Pikoulas, Y.A. 1995. "Η Ἄμπελος και ο οίνος στην Πελοπόννησο κατά την αρχαιότητα," *Peloponnesiaka* 21: 269–88.

Pikoulas, Y.A. 2009. "Ἀμπελόεσσα Πελοπόννησος: αρχαιογνωστική επισκόπηση." In Pikoulas (ed.): 53–66.

Pikoulas, Y.A. (ed.) 2009. *Οίνον ιστορώ IX : πολυστάφυλος Πελοπόννησος: επιστημονικό συμπόσιο.* Athens: ΕΝΟΑΠ, Nemea.

Pilo, C. 2006. "La villa di Capo Soprano a Gela." In M. Osanna, M. and M. Torelli (eds.), *Sicilia ellenistica, consuetudo italica: alle origini dell'architettura ellenistica d'Occidente*, 153–66. Rome: Edizioni dell'Ateneo.

Pinon, P. and M. Culot (eds.) 1982. *La Laurentine et l'invention de la villa romaine.* Paris: Moniteur.

Piro, S. 2009. "Introduction to Geophysics for Archaeology." In Campana and Piro (eds.) 2009: 27–66.

Pistilli, G. 2003. " Guarini, Guarino (Guarino Veronese, Varino." In *Dizionario biografico degli Italiani.* vol. 60, 357–69. Rome: Istituto della Enciclopedia Italiana.

Pleket, H.W. 1983. "Urban Elites and Business in the Greek Part of the Roman Empire." In Garnsey, Hopkins, and Whittaker (eds.): 131–44.

Pliakou, G. 2001. "Leukas in the Roman period." In Isager (ed.) 2001:147–61.

Plommer, H. 1973. *Vitruvius and Later Roman Building Manuals.* Cambridge: Cambridge University Press.

Poehler, E., M. Flohr, and K. Cole (eds.) 2011. *Art, Industry and Infrastructure in Roman Pompeii.* Oxford: Oxbow Books.

Polci, B. 2003. "Some Aspects of the Transformation of the Roman Domus Between Late Antiquity and the Early Middle Ages." In Lavan and Bowden (eds.): 79–112.

Pomarèdes, H. 1996. "Nîmes, Saint-André-de-Codols." In Pellecuer (ed.): 101–26.

Pomarèdes, H. and J.-Y. Breuil 2006. "Nîmes, réflexions sur l'origine et la romanisation du peuplement périurbain." In *Studies of the rural world in the Roman period 1, [actes de la talble ronde : El mon rural d'època romana. Ritmes et cicles de la romanitzacio del Camp. Table-ronde, Banyoles (Espagne), 5 novembre 2005]*, 115–30. Girona: Universitat de Girona, Grup de Recerca Arqueològica del Pla del Estany.

Pomeroy, S.B. 2007. *The Murder of Regilla: A Case of Domestic Violence in Antiquity.* Cambridge, MA: Harvard University Press.

Ponsich, M. 1964. "Exploitations agricoles romaines de la région de Tangier," *Bulletin d'archéologique marocaine* 5: 235–52.

Ponsich, M. 1970. *Recherches archéologiques à Tanger et dans sa région.* Paris: CNRS.

Ponsich, M. and M. Tarradell 1965. *Garum et industries antiques de salaison dans la Méditerranée occidentale*. Paris: Presses universitaires de France.

Pontiroli, G. (ed.) 1985. *Cremona Romana, Atti del congresso storico archeologico per il 2200 anno di fondazione di Cremona (Cremona, 30–31 maggio, 1982)*. Cremona: Libreria del convegno editrice.

Posac, C. 1972. "La villa romana de Río Verde." *NAHisp* 1: 82–115.

Postrioti, G. 2006. "L'occupazione in età romana della collina di S. Mercurio a Canne della Battaglia." In Gravina (ed.) 2006: 345–58.

Potter, T.W. 1979. *The Changing Landscape of South Etruria*. London: Elek.

Potter, T.W. 1980. "Villas in South Etruria: Some Comments and Contexts." In Painter (ed.): 73–81.

Potter, T.W. 1992. "Towns and Territories in Southern Etruria." In Rich and Wallace-Hadrill (eds.): 194–213.

Potter, T.W. and A.C. King (eds.) 1997. *Excavations at the Mola di Monte Gelato. A Roman and Medieval Settlement in South Etruria*. Archaeological Monographs of the British School at Rome 11. Rome: British School at Rome.

Poulaki, E. 2003. "Country Houses in the Areas of Phila-Heraklion and Leivithra, on Macedonian Olympus." In Adam-Veleni, Poulaki, and Tzanavari (eds.) 2003: 51–62.

Poulle, A. 1878. "Les bains de Pompeianus," *Recueil des notices et mémoires de la Société archéologique du Département de Constantine* 19 [publ. 1879]: 431–57.

Prag, J. R. W. and J. Crawley Quinn (eds.) 2013. *The Hellenistic West*. Cambridge: Cambridge University Press.

Preka-Alexandri, K. 1994. "Νομός Θεσπρωτίας." *ArchDelt, Chronika* B1, 49: 424–32.

Preka-Alexandri, K. 1995. "Ανασκαφικές εργασίες: Νομός Θεσπρωτίας." *ArchDelt, Chronika* B1, 50: 440–8.

Prevosti, M. 1987/8. "La vil·la romana de Torre Llauder (Mataró)." *Tribuna d'Arqueologia*: 125–32. Barcelona: Generalitat de Catalunya, Departament de Cultura.

Prevosti, M. 1993. *Torre Llauder. Mataró vil·la romana. Guies de yaciment*. Barcelona: Departament de Cultura de la Generalitat de Catalunya.

Prevosti, M. and J. Guitart i Duran (eds.) 2010: *Ager Tarraconensis 1. Aspectes històrics i marc natural – Historical aspects and natural settings*. Documenta 16. Tarragona: Institut Català d'Arqueologia Clàssica.

Prevosti, M., J. López Vilar, and J. Guitart i Duran (eds.) 2013. *Ager Tarraconensis 5. Paisatge, poblament, cultura material i història. Actes del Simposi internacional/ Landscape, Settlement, Material Culture and History Proceedings of the International Symposium*. Documenta 16. Tarragona: Institut Català d'Arqueologia Clàssica.

Prevosti i Monclús, M. and A. Martín i Olivares (eds.) 2009. *El vi tarraconense i laietà: ahir i avui. Actes del simpòsium*. Documenta 7. Tarragona: Institut Català d'Arqueologia Clàssica.

Prevot, F. (ed.) 2000. *Romanité et cité chrétienne, permanences et mutations, intégration et exclusion du Ier au VIe siècle, Mélanges en l'honneur d'Yvette Duval*. Paris: De Boccard.

Pritchett, K.W. 1989. *Studies in Ancient Topography, Part VI*. Berkeley, CA: University of California Press.

Prosperi, M. 1979. "Oplontis suburbio di Pompei. Della Tabula Peutingeriana." *Antiqua* 4: 21–6.

Prusac, M. 2007. *South of the Naro, North of the Drilo, from the Karst to the Sea. Cultural Identities in South Dalmatia 500 BC–Ad 500*. Acta Humaniora 312. Oslo: Unipub forlag.

Pucci, G. 1989. "Le inscrizioni di M. Cincius Hilarianus." In Anselmino et al. (eds.): 111–17.

Puerta, C., M.A. Elvira, and T. Artigas 1994. "La colección de esculturas hallada en Valdetorres de Jarama." *ArchEspArq* 67: 179–200.

Pugliese Carratelli, G. (ed.) 1991. *Storia e civiltà della Campania. L'Evo antico*. Naples: Electa.

Puig i Verdaguer, F. 1999. "Casa del Carrer del Bisbe Caçador (Barcelona)." In de Palol and Pladevall (eds.) 1999: 87–9.

Purcell, N. 1985. "Wine and Wealth in Roman Italy." *JRS* 75: 1–19.

Purcell, N. 1987a. "Tomb and Suburb." In von Hesberg and Zanker (eds.): 25–41.

Purcell, N. 1987b. "Town in Country and Country in Town." In MacDougall (ed.): 185–203.

Purcell, N. 1988. "Review of Tchernia 1986 and Carandini et al. (eds.) 1985." *JRS* 78: 194–8.

Purcell, N. 1993. "Forum Romanum, The Republican Period." *LTUR* 2: 329.

Purcell, N. 1995. "The Roman Villa and the Landscape of Production." In Cornell and Lomas (eds.): 151–79.

Purcell, N. 1996. "The Roman Garden as a Domestic Building." In Barton (ed.): 121–51.

Purpura, G. 2007. "'*Servitus thynnos non piscandi*' (D. 8, 4, 13 pr.)." In D'Ippolito (ed.): vol. 3, 2161–73.

Purpura, G. 2008. "'*Liberum mare*', acque territoriali e riserve di pesca nel mondo antico." In Napoli (ed.): 533–54.

Quenemoen, C. and R. Ulrich (eds.) 2013. *Blackwell Companion to Roman Architecture*. Malden, MA: Wiley-Blackwell.

Quet, M.-H. (ed.) 2006. *La "crise" de l'Empire romain de Marc Aurèle à Constantin : mutations, continuités, ruptures*. Paris: Presses de l'Université Paris-Sorbonne.

Queyrel, F. 1992. "Antonia Minor à Chiragan (Martres-Tolosane, Haute-Garonne)." *RANarb* 25: 69–81.

Quilici, L. and S. Qulici Gigli 1978. "Ville dell'agro cosano con fronte a torrette." *RIA-SA* 1:11–64.

Quilici, L. and S. Quilici Gigli 1984. "Attività estrattiva dello zolfo nella zona tra Ardea ed Anzio." *Quaderni del Centro di studio per l'archeologia etrusco-italica* 8: 229–49.

Quilici, L. and S. Quilici Gigli (eds.) 1995. *Agricoltura e commerci nell'Italia antica*. Atlante tematico di topografia antica suppl. I. Rome: "L'Erma" di Bretschneider.

Quirós Castillo, J.A. (ed.) 2009. *The Archaeology of Early Medieval Villages in Europe*. Documentos de arqueología e historia 1. Bilbao: Universidad del País Vasco, Servicio Editorial.

Quirós Castillo, J.A. 2009. "Early Medieval Villages in Spain in the Light of European Experience. New Approaches in Peasant Archaeology." In Quirós Castillo (ed.): 13–26.

Raban, A. and K.G. Holum (eds.) 1996. *Caesarea Maritima: A Retrospective after Two Millennia*. Leiden and New York: Brill.

Rada y Delgado, J. de D. de la 1875. "Mosaico romano de la Quinta de los Carabancheles, propiedad de la Excma. Sra. Condesa de Montijo." *Museo Español de Antigüedades* 4: 413–18.

Radice, B. (ed.) 1969. *Pliny Letters and Panygyricus*. (2 vols.) Cambridge, MA: Harvard University Press.

Raeder, J. 1983. *Die statuarische Ausstattung der Villa Hadriana bei Tivoli*. Frankfurt-am-Main; Bern: Lang.

Rakob, F. 1976. "Hellenismus in Mittelitalien. Bautypen und Bautechnik." In Zanker (ed.): 366–86.

Ramón, E. 2007. "La vil·la romana de la Llosa (Cambrils, Baix Camp)." In Remolà (ed.) 2007: 153–70.

Raper, R.A. 1977. "The Analysis of the Urban Structure at Pompeii: A Sociological Examination of the Land Use." In Clarke (ed.): 189–221.

Rascón, S., A. Méndez and P. Díaz 1991. "La reocupación del mosaico del auriga victorioso en la villa romana de El Val (Alcalá de Henares). Un estudio de microespacio." *Arqueología, Paleontología y Etnografía* 1: 181–200.

Rathbone, D.W. 1981. "The Development of Agriculture in the 'Ager Cosanus' during the Roman Republic: Problems of Evidence and Interpretation." *JRS* 71: 10–23.

Rathbone, D.W. 1983. "The Slave Mode of Production in Italy." *JRS* 73: 160–8.

Rebillard. É. and C. Sotinel (eds.) 1998. *L'évêque dans la cité du IVe au Ve siècle: image et autorité. Actes de la table ronde organisée par l'Istituto patristico Augustinianum et l'École française de Rome: Rome, 1er et 2 décembre 1995*. Rome: École française de Rome.

Rebuffat, R. 1986. "Recherches sur le basin du Sebou," *CRAI* 1986: 633–61.

Rebuffat, R., E. Lenoir, and A. Akerraz 1985. "Plaine et montagne en Tingitane méridionale," In *Histoire et archéologie de l'Afrique du Nord: actes du IIIe Colloque international réuni dans le cadre du 110e Congrès National des Sociétés Savantes, Montpellier 1–5 avril 1985*. 219–55. Paris: C.T.H.S.

Réchin, F. 2006. "Faut-il refouiller une villa ? Sondages archéologiques récentes sur la villa de l'Arribèra deus Gleisiars à Lalonquette (Pyrénées-Atlantiques)." In Réchin (ed.): 131–63.

Réchin, F. (ed.) 2006. *Nouveaux regards sur les villae d'Aquitaine : bâtiments de vie et d'exploitation, domaines et postérités médiévales*. Archéologie de Pyrénées occidentales et des Landes Hors Série n°2. Pau: Université de Pau,

Reeve, M. (ed.) 2014. *Tributes to Pierre Du Prey: Architecture and the Classical Tradition from Pliny to Posterity*. New York: Harvey Miller.

Regueras Grande, F. 2007. "Villas romanas del Duero: Historia y patrimonio." *Brigecio: revista de estudios de Benavente y sus tierras* 17: 11–59.

Regueras Grande, F. 2010. "Mosaicos de la Villa Astur-Romana de Camarzana de Tera (Zamora)." *Espacio, Tiempo y Forma, Serie II, Historia Antigua* 23: 477–525.

Reich, R. and Billig, Y. 2003. "Another Flavian Inscription near the Temple Mount of Jerusalem." *'Atiqot* 44: 243–7.

Reinhardt, E.G. et al. 2006. "The Tsunami of 13 December A.D. 115 and the Destruction of Herod the Great's Harbor at Caesarea Maritima, Israel." *Geology* 34: 1061–4.

Reisner, G.A. et al. 1924. *Harvard Excavations at Samaria 1908–1910*. Cambridge, MA: Harvard University Press.

Remesal Rodríguez, J. 2001. "Politik und Landwirtschaft im Imperium Romanum am Beispiel der Baetica." In Herz and Waldherr (eds.): 235–55.

Remolà, J.A. (ed.) 2007. *El territori de Tarraco: vil·les romanes del Camp de Tarragona*. Col·lecció Forum 13. Tarragona: Museu Nacional Arqueològic de Tarragona.

Remolà Vallverdú, J.-A. 2003. "Les vil·les romanes del Moro (Torredembarra)." *Butlletí Arqueològic* 25: 57–87.

Remolà Vallverdú, J.A. and M. Pérez Martínez 2013. "Centcelles y el *praetorium* del *comes Hispaniarum* Asterio en Tarraco." *ArchEspArq* 86.2013, 161–86.

Renfrew, C. and P. Bahn 2012. *Archaeology: Theories, Methods, and Practice*, 6th edn.: London and New York: Thames & Hudson.

Reutti, F. (ed.) 1990. *Die römische Villa*. Weg der Forschung 182. Darmstadt: Wissenschaftliche Buchgesellschaft.

Reutti, F. 2006. s.v. "Villa." *In Reallexikon der Germanischen Altertumskunde*, H. Beck, D. Geuenich and H. Steuer (eds.): 2nd edn., vol. 32., 375–87. Berlin and New York: Walter de Gruyter.

Revilla Calvo, V. 2004. "El poblamiento rural en el noreste de Hispania entre los siglos II a.C. y I d.C.: Organización y dinámicas culturales y socioeconómicas – Rural Settlement at Northeasthern Hispania between the 2nd Century BC and the 1st Century AD: Cultural and Socioeconomic Dynamics and Organization." In Moret and Chapa (eds.): 175–202.

Revilla Calvo, V. 2008. "La Villa y la organización del espacio rural en el litoral central de Cataluna: Implantación y evolución de un sistema de poblamiento." In Revilla, González and Prevosti (eds.): 99–123.

Revilla Calvo, V. 2010. "Hábitat rural y territorio en Hispania Citerior." In Noguera Celdrán (ed.): 25–70.

Revilla Calvo, V., J.R. González Pérez and M. Prevosti Monclús (eds.) 2008–11: *Les vil·les romanes a la Tarraconensis. Implantació, evolució i transformació. Estat actual de la investgació del món rural en època romana – Lleida 2007*. Museu d'Arqueologia de Catalunya Monografies 10, 2 vol. Barcelona: Museu d'Arqueologia de Catalunya.

Reyerson, K.L. (ed.) 2005. *Medieval Narbonne*. Aldershot, UK, and Burlington, VT: Ashgate.

Reynolds, L.D. and N.G. Wilson 1968. *Scribes and Scholars: A Guide to the Transmission of Greek and Latin Literature*. Oxford: Oxford University Press.

Reynolds, P. 1993. *Settlement and Pottery in the Vinalopó Valley (Alicante, Spain): AD 400–700*. BAR-IS 588. Oxford: Tempus Reparatum.

Reynolds, P. 2004. "The Roman Pottery from the Triconch Palace." In Hodges, Bowden, and Lako (eds.): 224–69.

Reynolds, P. 2010. *Hispania and the Roman Mediterranean, AD 100–700: Ceramics and Trade*. London: Duckworth Publishing.

Ribera i Lacomba, A. and L. Abad Casal (eds.) 2000. *Los orígenes del cristianismo en Valencia y su entorno*. Valencia: Ajuntament de València.

Ricaud, L. 1914. *Sulpice-Sévère et sa villa de Primuliac à Saint-Séver-de-Rustan*. Tarbes: Imp. Lesbordes.

Ricci, A. 2005. "Palladio e la villa di Passolombardo. Note e suggestioni da una ricerca in corso." *Annali del Dipartimento di Storia* 1: 169–87.

Rich, J.W. 2007. "Tiberius Gracchus, Land and Manpower." In Hekster, de Klein, and Slootjes (eds.): 155–66.

Rich, J. and A. Wallace-Hadrill (eds.) 1991. *City and Country in the Ancient World*. London: Routledge.

Richardson, L. 1988. "Water Triclinia and Biclinia in Pompeii." In R. Curtis (ed.): 305–12.

Richardson, L., Jr. 1977. "The Libraries of Pompeii." *Archaeology* 30: 394–402.

Richardson, L., Jr. 2000. *A Catalogue of Identifiable Figure Painters of Pompeii, Herculaneum and Stabiae*. Baltimore, MD, and London: Johns Hopkins University Press.

Richardson, P. 2004. "Towards a Typology of Levantine/ Palestinian Houses." *Journal for the Study of the New Testament* 27.1: 47–68.

Richmond, I. 1969. "The Plans of Roman Villas in Britain." In Rivet (ed.): 49–70.

Riera, S. and J.M. Palet 2005. "Aportaciones de la Palinología a la historia del paisaje mediterráneo: estudio de los sistemas de terrazas en las Sierras Litorales Catalanas desde la perspectiva de la Arqueología Ambiental y del Paisaje." In Riera and Julià (eds.): 55–74.

Riera, S. and R. Julià (eds.) 2005. *Transdisciplinary approach to a 8,000-yr history of land uses, 1st Workshop of Catalan Network of Cultural Landscapes and Environmental History*. Monografies del Seminari d'Estudis i Recerques Prehistòriques 5. Barcelona: Seminari d'Estudis i Recerques Prehistòriques.

Rife, J.L. 2008. "The Burial of Herodes Atticus: Élite Identity, Urban Society, and Public Memory in Roman Greece." *JHS* 128: 92–127.

Riggsby, A. 1998. "Self and Community in the Younger Pliny." *Arethusa* 31.1: 75–97.

Rind, M. 2009. *Römische Villen in Nordafrika. Untersuchungen zu Architektur und Wirtschaftsweise*. BAR-IS 2012. Oxford: Archaeopress.

Ripoll, G. 1999. "Bronzes d'indumentària personal." In de Palol and Pladevall (eds.) 1999: 305–9.

Ripoll, G. 2010. "The Archaeological Characterisation of the Visigothic Kingdom of Toledo: The Question of Visigothic Cemetaries." In Becher and Dick (eds.): 161–79.

Ripoll, G. and J. Arce 2000. "The Transformation and End of Roman *Villae* in the West (Fourth-Seventh Centuries). Problems and Perspectives." In Brogiolo, Gauthier, and Christie (eds.): 63–114.

Ripoll, G. and M. Darder 1994. "*Frena equorum*. Guarniciones de frenos de caballos en la antigüedad tardía hispánica." *Espacio, Tiempo y Forma I*, 7: 277–356.

Ripoll, G. and I. Velázquez 1999. "Origen y desarrollo de las parrochiae en la Hispania de la antigüedad tardía." In Pergola (ed.): 101–65.

Ripoll, G. et al. 2012. "La arquitectura religiosa hispánica del siglo IV al X y el proyecto del *Corpus Architecturae Religiosae Europeae* – CARE-Hispania." *Hortus Artium Medievalium* 18.1: 45–73.

Rivet, A.L.F. (ed.) 1969. *The Roman Villa in Britain*. London: Routledge & Kegan Paul.

Rizakis, A.D. (ed.) 1996. *Roman Onomastics in the Greek East. Social and Politcal Aspects, Proceedings of the International Colloquium Organized by the Finnish Institute and the Centre for Greek and Roman Antiquity, Athens, 7–9 September 1993, Meletemata 21*. Athens: Centre for Greek and Roman Antiquity, NHRF.

Rizakis, A.D. 1997. "Roman Colonies in the Province of Achaia." In Alcock (ed.): 15–36.

Rizakis, A.D. 1998. *Achaïe II : La cité de Patras: épigraphie et histoire, Meletemata 25*, Athens: Centre for Greek and Roman Antiquity, NHRF.

Rizakis, A.D. 2002. "Italian Elements among Roman Knights and Senators from Old Greece." In Müller and Hasenohr (eds.): 101–7.

Rizakis, A.D. 2010. "Peloponnesian Cities under Roman Rule: The New Political Geography and Its Economic and Social Repercussions." In Rizakis and Lepenioti (eds.) 2010: 1–18.

Rizakis, A.D. and C.E. Lepeniotis (eds.) 2010. *Roman Peloponnesos III. Society, Economy, and Culture under the Roman Empire: Continuity and Innovation, Meletemata 63*, Athens: Centre for Greek and Roman Antiquity, NHRF.

Rizakis, A.D. and I.P. Touratsoglou (eds.) 2013, Villae Rusticae. *Family and Market-Oriented Farms in Greece Under Roman Rule. Proceedings of the International Conference held at Patrai (Archaeological Museum), 23–24 April 2010, Co-Organized by the 6th Ephorate of Prehistoric and Classical Antiquities of Patrai and the Institute for Greek and Roman Antiquity. Meletemata 68*. Paris and Athens: De Boccard and National Hellenic Research Foundation.

Rizakis, A.D., S. Zoumbaki, and M. Kantirea (eds.) 2001. *Roman Peloponnese I: Roman Personal Names in Their Social Context (Achaia, Arcadia, Argolis, Corinthia and Eleia) Meletemata 31*. Athens: Centre for Greek and RomanAntiquity, NHRF.

Rizza, G. (ed.) 1988. *La Villa Romana del Casale di Piazza Armerina. Atti della IV Riunione Scientifica della Scuola di Perfezionamento in Archeologia Classica dell'Università di Catania (Piazza Armerina, 28 settembre – 1 ottobre 1983)*. Cronache di Archeologia 23 for 1984, publ. 1988. Catania: Università di Catania, Ist. di Archeologia.

Rizzo, F. P. (ed.) 2013. *La villa del Casale e oltre. Territorio, popolamento, economia nella Sicilia centrale tra Tarda Antichità e Alto Medioevo. Atti delle Giornate di Studio (Piazza Armerina 30 settembre–1 ottobre 2010)*. Seia 15–16 [2010–2011, publ. 2013]. Macerata: eum.

Rizzo, M. S. 2014. "Agrigento e il suo territorio in età tardormana e bizantina: primi dati da recenti ricerche." *Sicilia Antiqua* 11: 399–418.

Rizzo, M. S. and L. Zambito 2007. "Novità epigrafiche siciliane. I bolli di contrada Cignana (Naro, AG)." *ZPE* 162: 271–7.

Rizzo, M. S. and L. Zambito 2012. "La cultura materiale di un villaggio di età bizantina nella Sicilia centro meridionale: apporti dall'Oriente e dall'Africa a Cignana (Naro, Agrigento)." *AfrRom* 19: 3051–64.

Rodà, I. 1994. "Iconografía y epigrafía en dos mosaicos hispanos: las villae de Tossa y de Dueñas." In *VI Coloquio Internacional sobre mosaico antiguo, Palencia-Mérida octubre 1990*, 35–42. Guadalajara: Asociación Española del Mosaico.

Rodgers, R.H. 1975. *An Introduction to Palladius*. University of London, Institute of Classical Studies, Bulletin Supplement 35. London: Institute of Classical Studies.

Rodgers, R.H. (ed.) 1975. *Palladii Rutilii Tauri Aemiliani Opus agriculturae : De veterinaria medicina; De insitione*. Leipzig: Teubner.

Rodgers, Z. (ed.) 2007. *Making History: Josephus and Historical Method*. Leiden: E.J. Brill.

Rodríguez Hernández, J. 1975. *La villa romana en España*. Salamanca: Tesis-Universidad de Salamanca, unpublished.

Rodríguez Martín, F.G. 1995. "La villa romana de Torre Águila (Barbaño-Badajoz)." *JRA* 8: 313–16.

Rodríguez Martín, F.G. 1999. "Los asentamientos rurales romanos y su posible distribución en la ceunca media del Guadiana." In Gorges and Rodríguez Martín (eds.): 121–34.

Rodríguez Oliva, P. 1979. "Hallazgos arqueologicos en Torrox-Costa en el s. XVIII." *Jábega* 26: 39–42. Malaga: Diputación provincial de Málaga.

Roffia, E. (ed.) 1997. *Ville romane sul lago di Garda*. Brescia: Soprintendenza archeologica della Lombardia.

Roffia E. 2013. "*Suburbanae aut maritimae suptuosae villae.*" In *Storia dell'architettura nel Veneto: L'Età Romana e Tardoantica*, P. Basso and G. Cavalieri Mannasse (eds.): 118–35, Venice: Marsilio.

Roffia, E. and B. Portulano 1997. "La villa romana in località Capra a Toscolano." In Roffia (ed.): 217–37.

Rogers, R.H. (ed.) 1975. *Palladii Rutillii Tauri Aemiliani viri inlustris opus agriculturae, de veterinaria medicina, de insitione*. Leipzig: Teubner.

Roig, J. 2009. "Asentamientos y poblados tardoantiguos y altomedievales en Cataluña (siglos VI al X)." In Quirós (ed.): 207–51.

Rolandi, G., R. Munno, and I. Postiglione, I. 2004. " The A.D. 472 Eruption of the Somma Volcano." *Journal of Volcanology and Geothermal Research* 129: 291–319.

Rolandi, G., A. Paone, M. De Lascio, and G. Stefani 2008. "The 79 A.D. Eruption of Somma: The Relationship between the Date of the Eruption and the Southeast

Tephra Dispersion." *Journal of Volcanology and Geothermal Research* 169: 87–98.

Roll, I. 1996. "Roman Roads to Caesarea Maritima." In Raban and Holum (eds.): 549–58.

Roll, I. 1999. "Introduction; History of the Site, Its Research and Excavations." In Roll and Tal (eds.): 1–62.

Roll, I. and O. Tal 1999. *Apollonia-Arsuf: Final Report of the Excavations, I. The Persian and Hellenistic Periods (with Appendices on the Chalcolithic and Iron Age II Remains).* Tel Aviv: Emery and Claire Yass Publications in Archaeology of the Institute of Archaeology, Tel Aviv University.

Roll, I. and O. Tal. 2008. "A Villa of the Early Roman Period at Apollonia-Arsuf." *IEJ* 58: 132–49.

Romanelli, P. 1970. *Topografia e archeologia dell'Africa romana. Enciclopedia Classica, Sezione III.10.* Turin: Società Editrice Internazionale.

Romano, D.G. 1993. "Post-146 B.C. Land Use in Corinth, and Planning of the Roman Colony of 44 B.C." In Gregory (ed.): 9–30.

Romano, D.G. 2010. "Romanization in the Corinthia: Urban and Rural Developments." In Rizakis and Lepenioti (eds.): 165–72.

Romero Pérez, M. 1998. "Resultados de la primera fase de la intervención arqueológica en la villa de La estación (Antequera, Málaga)." In *Comercio y comerciantes en la Historia Antigua de Málaga (siglo VIII a.C. – año 711 d.C)*, 603–26. Malaga: Diputación de Málaga.

Romizzi, L. 2001. *Ville d'otium dell'Italia antica (II sec. a.C.–I sec. d.C.).* Napoli: Edizioni scientifiche italiane.

Romizzi, L. 2003. "La villa romana in Italia nella tarda antichità: un'analisi strutturale." *Ostraka* 13: 43–87.

Rosafio, P. 2009. "Plauto e le origini della villa." In Carlsen and Lo Cascio (eds.): 129–40.

Roselaar, S.T. 2010. *Public Land in the Roman Republic: A Social and Economic History of the Ager Publicus in Italy, 396–89 BC.* Oxford: Oxford University Press.

Rosselló Mesquida, M. 2005. "El territorium de Valentia a l'antiguitat tardana." In Gurt Esparraguera and Ribera i Lacomba (eds.): 279–304.

Rosenblum, M. 1961. *Luxorius. A Latin Poet among the Vandals.* New York and London: Columbia University Press.

Rosenstein, N. 2008. "Aristocrats and Agriculture in the Middle and Late Republic." *JRS* 98: 1–26.

Rosselló, V. M. 2004. "Els vivers de peix." In De Maria and Turchetti (eds.): 247–69.

Rossi, F. 1996. "I casi di Pontevico, Nuvolento e Breno." In Brogiolo (ed.): 35–41.

Rossiter, J.J. 1989. "Roman Villas of the Greek East and the Villa in Gregory of Nyssa, *Ep.*20." *JRA* 2: 101–10.

Rossiter, J.J. 1990. "Villas vandales: le *suburbium* de Carthage au début du VIe siècle de nôtre ère," in

Histoire et archéologie de l'Afrique du Nord. Actes du IVe Colloque International réuni dans le cadre du 113e Congrès national des Sociétés savants (Strasbourg, 5–9 avril 1988). Tome I. Carthage et son territoire dans l'antiquité: 221–7. Paris: Éditions du CTHS.

Rossiter, J.J. 1991. "Convivium and Villa in Late Antiquity." In Slater (ed.): 199–214.

Rossiter, J.J. 1992. "*Stabula equorum*: Evidence for Race-Horse Stables in Roman Africa." In *Afrique du Nord antique et médiévale: spectacles, vie portuaire, religions. Ve Colloque International sur l'histoire et l'archéologie de l'Afrique du Nord, Avignon 1990*: 41–7. Paris: Éditions du CTHS.

Rossiter, J.J. 1993. "Two Suburban Sites at Carthage: Preliminary Investigations, 1991–92." *Echos du monde antique/Classical views* 37: 301–11.

Rossiter, J.J. 1997. s.v. "Villa." In *The Oxford Encyclopedia of Archaeology in the Near East*, E. M. Meyers (ed.): Vol. V, 300–1. Oxford: Oxford University Press.

Rossiter, J.J. 1998. "A Roman Bath-House at Bir el Jebbana: Preliminary Report on the Excavations (1994–1997)," in Penã et al. (eds.): 103–15.

Rossiter, J.J. 2000. "Interpreting Roman villas. Review of J. T. Smith: *Roman Villas: A Study in Social Structure.*" *JRA* 13: 572–7.

Rossiter, J.J. 2005. "Re-Placing Scorpianus: Mosaics from Old and New Excavations at Bir el Jebbana, Carthage." In Morlier (ed.): 554–65.

Rossiter, J.J. 2007a. "*Domus* and *Villa*: Late Antique Housing in Carthage and Its Territory." In Lavan, Özgenel, and Sarantis (eds.): 367–92.

Rossiter, J.J. 2007b. "Wine-Making after Pliny: Viticulture and Farming Technology in Late Antique Italy." In Lavan, Zanini, and Sarantis (eds.): 93–118.

Rostovtzeff, M.I. 1911. "Die hellenistisch-römische Architekturlandschaft." *RM* 26: 1–185.

Rostovtzeff, M.I. 1926 (1957). *The Social and Economic History of the Roman Empire* (2nd edition, rev. by P.M. Fraser). Oxford: Clarendon Press.

Rosucci, A. 1987. "La villa romana denominata 'Casa del diavolo' in agro di Lavello." In *Studi Storici della Basilicata*: 47–82. Bari: Edipuglia.

Roth, U. 2007. *Thinking Tools. Agricultural Slavery between Evidence and Models.* London: University of London Institute of Classical Studies.

Rothaus, R.M. 1994. "Urban Space, Agricultural Space and Villas in Late Roman Corinth." In Doukellis and Mendoni (eds.): 391–6.

Roueché, Ch. and K.T. Erim 1982. "Sculptors from Aphrodisias: Some New Inscriptions." *PBSR* 50: 102–15.

Roure, A. et al. 1988. *La vil·la romana de Vilauba (Camós). Estudi d'un assentament rural (campanyes de 1979–85).*

Sèrie monogràfica 8. Girona: Centre d'Investigacions Arqueològiques de Girona.

Rousseau, P. (ed.) 2009 (with the assistance of J. Raithell). *Blackwell Companion to Late Antiquity*. Chichester, UK, and Malden, MA: Wiley-Blackwell.

Rowland, I.D. 2014. *From Pompeii: The Afterlife of a Roman Town*. Cambridge, MA, and London: Belknap Press of Harvard University.

Roy, J. 2010. "Roman Arkadia." In Rizakis and Lepenioti (eds.): 59–73.

Roymans, N. and T. Derks (eds.) 2011. *Villa Landscapes in the Roman North: Economy, Culture, and Lifestyles*. Amsterdam: Amsterdam University Press.

Ruffo, F. 2010. *La Campania antica, appunti di storia e di topografia: Parte I – dal Massico-Roccamonfina al Somma-Vesuvio*. Naples: Denaro Libri.

Ruggiero, M. 1881. *Degli scavi di Stabiae dal MDCCXLIX al MDCCLXXXII*. Naples: Tipografia dell'Academia reale delle scienze, Napoli.

Ruggiero, M. 1888. *Degli scavi di antichità nelle province di terraferma dell'antico regno di Napoli dal 1743 al 1876: Documenti raccolti e pubblicati da Michele Ruggiero*. Naples: V. Morano.

Ruíz de Arbulo, J. (ed.) 1999. *Tàrraco 99: Arqueologia d'una capital provincial romana*. Tarragona: Universitat Rovira i Virgili.

Rupp, D.W. 2011. "Field Work of the Canadian Institute in Greece, 2009." *Mouseion*, ser. 3, Vol. 11.1: 1–24.

Russell, J. 1968. "The Origin and Development of Republican Forums." *Phoenix* 22: 304–36.

Russell, K.W. 1985. "The Earthquake Chronology of Palestine and Northwest Arabia from the 2nd through the Mid-8th Century A.D." *BASOR* 260: 37–59.

Russo, A. 1992 "Mancamasone - complesso rurale." In *Da Leukania a Lucania: la Lucania centro-orientale fra Pirro e i Giulio-Claudii. Venosa, Castello Pirro del Balzo, 8 novembre 1992-31 marzo 1993*, L. De Lachenal (ed.): 30–2, Rome: Istituto Poligrafico e Zecca dello Stato.

Russo, F. 2010. "L'insula sud-orientale del cosidetto 'impianto urbano' di Stabiae. Nuovi dati dalla recente campagna di scavo (2009)." *Oebalus* 5: 177–93.

Russo, A. et al. 2007. "Dalla villa dei *Bruttii Praesentes* alla proprietà imperiale. Il complesso archeologico di Marsicovetere-Barricelle (PZ)." *Siris* 8: 81–119.

Rutledge, H. 1960. Herodes Atticus, World Citizen, AD 101–177. Unpublished Ph.D. dissertation, Ohio University, Columbus, OH.

Sabbatini, G. 2001. *Ager Venusinus I (Forma Italiae 40)*. Florence: L.S. Olschki.

Sabbione, C. (ed.) 2007. *La villa romana di Palazzi di Casignana. Guida archeologica*. Gioiosa Ionica: Corab.

Saboureux de la Bonnetrie, J.-Ch. 1771–1775. *Libri de re rustica*, 6 vols. Paris: Silvestre. (Republished in D. Nisard *Les Agronomes Latins, Caton, Varron, Columelle, Palladius*. 1844. Paris: Dubochet.)

Sabrié, M. and R. Sabrié (eds.) 2004. *Le Clos de la Lombarde à Narbonne. Espaces publics et privés du secteur nord-est*. Montagnac: Monique Mergoil.

Sabrié, M. et al. 2011. *La maison au Grand Triclinium du Clos de la Lombarde à Narbonne*. Montagnac: M. Mergoil.

Sackett, L.H. 1992. *Knossos: From Greek City to Roman Colony: Excavations at the Unexplored Mansion II*. London: Thames and Hudson.

Sadeq, M. 2007. "Le développement urbain de Gaza." In Haldimann, Humbert, and Martiniani-Reber (eds.): 221–31.

Safrai, S. 1958. "Beth She'arim in the Talmudic Literature," *ErIsr* 5: 206–12. (Hebrew).

Safrai, S. 1975. "The Nesiut in the Second and Third Centuries and Its Chronological Problems." In *Proceedings of the Sixth World Congress of Jewish Studies* 2: 51–7. Jerusalem: World Congress of Jewish Studies. (Hebrew).

Sagona, C. 2002. *The Archaeology of Punic Malta*. Ancient Near Eastern Studies Supplement 9. Leuven: Peeters.

Said-Zammit, George A. 1997. *Population, Land Use and Settlement on Punic Malta. A Contextual Analysis of Burial Evidence*. BAR-IS 682. Oxford: Archaeopress.

Sakellariou, M.B. ed. 1990. *Poikila, Meletemata*, vol. 10. Athens: Centre for Greek and Roman Antiquity, NHRF.

Sakenfeld, K.D. (ed.) 2009. *The New Interpreter's Dictionary of the Bible*, vol. 5 Nashville, TN: Abingdon Press.

Salvatore, M. (ed.) 1991. *Il museo archeologico nazionale di Venosa*. Potenza: IEM editrice.

Salway, P. 1967. "Villa and Town in Roman Britain." *Proceedings of the Cambridge Philological Society* 193: 35–6.

Salway, P. 1981. *Roman Britain*. Oxford, UK, and New York: Oxford University Press.

Salway, P. 1997. *A History of Roman Britain*. Oxford and New York: Oxford University Press.

Salza Prina Ricotti, E. 1970-1. "Le ville marittime di Silin (Leptis Magna)." *RendPontAcc* 43: 135–63.

Salza Prina Ricotti, E. 1972. "Ville marittime residenziali nel Nord Africa," *Colloqui del Sodalizio* 2 (for 1968–70): 21–32. Rome: De Luca Editore.

Salza Prina Ricotti, E. 1972–3. "I porti della zona di Leptis Magna," *RendPontAcc* 45: 75–103.

Samson, R. 1987. "The Merovingian Nobleman's House. Castle or Villa?" *Journal of Medieval History* 13: 287–315.

Samson, R. (ed.) 1990. *The Social Archaeology of Houses.* Edinburgh: Edinburgh University Press.

Sanders, I.F. 1982. *Roman Crete: An Archaeological Survey and Gazetteer of Late Hellenistic, Roman, and Early Byzantine Crete.* Warminster, UK: Aris & Phillips.

Sanesi Mastrocinque, L. 1984. "Insediamento romano di Corte Cavanella (Loreo)." In *Misurare la terra 4. Il caso veneto*, 109–16.

Sanesi Mastrocinque, L., S. Bonomi, M. D'abruzzo, and A. Toniolo. 1986. "L'insediamento romano di Corte Cavanella di Loreo." In *L'antico Polesine. Testimonianze archeologiche*, 237–57.

Sangineto, A. B. 2001. "Trasformazioni o crisi nei Bruttii tra II a.C. e VII d.C.?" In Lo Cascio and Storchi Marino (eds.): 203–46.

Santangeli, R. 2011. *Edilizia residenziale in Italia nell'altomedioevo.* Rome: Carocci editore.

Santillo Frizell, B. and A. Klynne (eds.) 2005. *Roman Villas around the Urbs: Interaction with Landscape and Environment. Proceedings of a Conference at the Swedish Institute in Rome, September 17–18, 2004.* Rome: The Swedish Institute in Rome.

Sarnowski, T. 1978. *Les représentations de villas sur les mosaïques africaines tardives.* Archiwum Filologiczne 37. Wroclaw, Warsaw, Kraków and Gdansk: Polskiej Akademii Nauk.

Sauron, G. 2000. *L'histoire végétalisée: ornement et politique à Rome.* Paris: Picard.

Sauron, G. 2007. *La pittura allegorica a Pompei: Lo sguardo di Cicerone.* Lucca: Jaca Book.

Savino, E. 2004. "A proposito del numero e della cronologia delle eruzioni vesuviane tra il V e il VI sec. d.C." In Senatore (ed.): 511–21.

Scagliarini Corlàita, D. 1997. "Le ville romane dell'Italia settentrionale." In Roffia (ed.): 53–81.

Scagliarini Corlàita, D. 2003. "Domus, villae, palatia.convergenze e divergenze nelle tipologie architettoniche." In Ortalli and Hinzelmann (eds.): 153–72.

Scagliarini Corlàita, D. 2008. "*Villa e domus: otium, negotium, officium* in campagna e in città." In Bertelli, Malnati, and Montevecchi (eds.): 33–8.

Scarpone, G. 2010–2011. "Studi recenti sulla Villa del Casale: gli interventi della Sapienza – Università di Roma. IV. Nuovi contesti ceramici di età romana dalla Villa del Casale." *RendPontAcc* 83: 255–62.

Schefold, K. 1975. "Der Zweite Stil als Zeugnis alexandrinischer Architektur." In Andreae and Kyrieleis (eds.): 53–9.

Scheidel, W. 1994. "Grain Cultivation in the Villa Economy of Roman Italy." In Carlsen, Ørsted, and Skydsgaard (eds.): 159–66.

Schinkel, K.F. 1841. *Architektonishes Album*, No. 7, Berlin.

Schmidt, A. 2009 "Electrical and Magnetic Methods in Archaeological Prospection." In Campana and Piro (eds.): 67–82.

Schmiedt, G. 1972. *Il livello antico del Mar Tirreno. Testimonianze dei resti archeologici.* Florence: L.S. Olschki.

Schneider, K. 1995. *Villa und Natur. Eine Studie zur römischen Oberschichtkultur im letzten vor- und ersten nachchristlichen Jahrhundert.* Quellen und Forschungen zur Antiken Welt 18. Munich: Herbert Utz Verlag.

Schneider, L. 1983. *Die Domäne als Weltbild. Wirkungsstrukturen der spätantiken Bildersprache.* Wiesbaden: Franz Steiner.

Schneider, L. 2001. "*Oppida* et *castra* tardo-antiques à propos des établissements de hauteur de la Gaule méditerranéenne." In Ouzoulias et al. (eds.): 443–8.

Schneider, P.I. and U. Wulf-Rheidt (eds.) 2010. *Licht – Konzepte in der vormodernen Architektur.* Wiesbaden: Steiner.

Schoonhoven, A. 2006. *Metrology and Meaning in Pompeii. The Urban Arrangement of Regio VI.* Studi della Soprintendenza Archeologica di Pompei 20. Rome: "L'Erma" di Bretschneider.

Schörle, K. and V. Leitch 2012. "Report on the Preliminary Season of the Lepcis Magna Coastal Survey." *LibSt* 43: 149–54.

Schrunk, I and V. Begović 2000. "Roman Estates on the Island of Brioni, Istria." *JRA* 13: 252–76.

Schwalb, H. 1902. *Römische Villa bei Pola.* Schriften der Balkan-Komission, Antiquarische Abteilung 2. Vienna: Österreichische Akademie der Wissenschaften.

Schwartz, J. 1966. "La fin du Sérapeum d'Aléxandrie." In *Essays in Honor of C. Bradford Welles.* American Studies in Papyrology 1, 97–111. New Haven, CT: The American Society of Papyrologists.

Scott, S. 1997. "The Power of Images in the Late-Roman House." In Laurence and Wallace-Hadrill (eds.): 53–67.

Scott, S. 2000. *Art and Society in Fourth-Century Britain: Villa Mosaics in Context.* Oxford: Oxford University School of Archaeology.

Scott, S. 2004. "Elites, Exhibitionism and the Society of the Late Roman Villa." In Christie (ed.): 39–66.

Scranton, R.L., J.W. Shaw, and L. Ibrahim 1978. *Kenchreai, Eastern Port of Corinth 1. Topography and Architecture.* Leiden: Brill.

Scully, V.J. 1962. *The Earth, the Temple, and the Gods: Greek Sacred Architecture.* New Haven, CT: Yale University Press.

Seelinger, R.A. 1998. "The Dionysiac Context of the Cult of Melikertes/Palaimon at the Isthmian Sanctuary of Poseidon." *Maia* n.s. 50.2: 271–80.

Sehili, S. 2008. "Henchir El Begar, centre du *Saltus Beguensis*, étude archéologique et historique." In Bejaoui (ed.): 85–106.

Sena Chiesa, G. and E.A. Arslan (eds.) 1992. Felix Temporis Reparatio. *Atti del convegno archeologico internazionale Milano capitale dell'impero Romano, Milano, 8–11 Marzo, 1990*. Milan: Edizioni ET.

Senatore, F. (ed.) 2004. *Pompei, Capri e la Penisola Sorrentina. Atti del quinto ciclo di conferenze di geologia, storia e archeologia. Pompei, Anacapri, Scafati, Castellammare di Stabia, ottobre 2002–aprile 2003*. Capri: Oebalus.

Sengoku-Haga, K. and M Aoyagi 2010. "Due statue marmoree dalla 'Villa di Augusto' a Somma Vesuviana: il Dioniso e la Peplophoros." *Amoenitas* 1: 237–52.

Senseney, J. 2011. "Adrift Toward Empire; The Lost Porticus Octavia in Rome and the Origins of the Imperial Fora." *JSAH* 70: 422–42.

Serra Rafols, J. de C. 1943. "La villa Fortunatus de Fraga." *Ampurias* 5: 6–35.

Serra Rafols, J. de C. 1952. *La villa romana de la Dehesa de 'La Cocosa.'* Badajoz: Institución de Servicios Culturales.

Serrano Ramos, E., A. Atencia Paez, and A. de Luque Moraño 1985. "Memoria de las excavaciones del yacimiento arqueoloógico de 'El Tesorillo' (Teba, Málaga)." *NAHisp* 26: 117–162.

Serrano Ramos, E. and P. Rodriguez Oliva 1975. "El Mosaico de Bellerofonte de la Villa de Puerta Oscura." *Jábega* 9: 57–61.

Seston, W. 1966. "Les murs, les portes et les tours des enceintes urbaines et le problème des *res sanctae* en droit romain." In Chevallier (ed.), vol 3: 1489–98.

Settis, S. 1982. "Neue Forschungen und Untersuchungen zur *villa* von Piazza Armerina." In Papenfuss and Strocka (eds.): 515–34.

Settis, S. and F. Donati. 2002. *Le pareti ingannevoli: la Villa di Livia e la pittura di giardino*. Milan: Electa.

Seydl, J. and V.C.G. Coates (eds.) 2007. *Antiquity Recovered: The Legacy of Pompeii and Herculaneum*. Los Angeles, CA: Getty.

Sfameni, C. 2004. "Residential Villas in Late Antique Italy." In Bowden, Lavan, and Machado (eds.): 335–75.

Sfameni, C. 2005a. "Le *villae-praetoria*: I casi di S.Giovanni di Ruoti e di Quote San Francesco." In Volpe and Turchiano (eds.): 609–22.

Sfameni, C. 2005b. "Fattorie e ville: il versante siciliano." In Ghedini et al. (eds.): 401–20.

Sfameni, C. 2006. *Ville residenziali nell'Italia tardo antica*. Munera 25. Studi Storici sulla Tarda Antichità. Bari: Edipuglia.

Sfameni, C. 2009. "La scultura 'ritrovata': riflessioni sull'arredo scultureo della villa di Piazza Armerina e di altre residenze tardoantiche." *Sicilia Antiqua* 6: 153–72.

Shackleton Bailey, D.R. (ed.) 1993. *Martial. Epigrams*, vol. 3. Cambridge, MA, and London: Harvard University Press.

Shear, T.L. 1930. *The Roman Villa*. Cambridge, MA: American School of Classical Studies at Athens, Harvard University Press.

Shelton, K. 1981. *The Esquiline Treasure*. London: British Museum Publications Ltd.

Sherwin-White, A.N. 1966. *The Letters of Pliny: A Historical and Social Commentary*. Oxford: Oxford University Press.

Shipley, G. 2002. "The Survey Area in the Hellenistic and Roman Periods." In Cavanagh et al. (eds.): 257–337.

Shochat, Y. 1980. *Recruitment and the Programme of Tiberius Gracchus*. Brussels: Latomus, Revue d'études latines.

Sider, D. 2005. *The Library of the Villa dei Papiri at Herculaneum*. Los Angeles, CA: Getty.

Sider, D. 2010. "The Books of the Villa of the Papyri." In Zarmakoupi (ed.): 115–27.

Sillières, P. 1994. "Les premiers établissements romains de la région de Vila de Frades (Vidigueira, Portugal)." In Gorges and Salinas de Frías (eds.): 89–98.

Silvestrini, M. 2003. "Les biens-fonds des élites en Italie du Sud." *Histoire et Sociétés Rurales* 19: 51–65.

Silvestrini, M., T. Spagnuolo Vigorita, and G. Volpe (eds.) 2006. *Studi in onore di Francesco Grelle*. Bari: Edipuglia.

Simonotti, F. 2009. "Toscolano Maderno (Bs), località Capra. Villa romana. Indagini archeologiche nel settore B." *NSAL* 2007: 78–81.

Simpson, C. J. 2003. "The 'Bikini Girls' of Piazza Armerina and Prudentius' *Psychomachia*: Narrative and Allegory." In P. Defosse (ed.), *Hommages à Carl Deroux IV. Archéologie et Histoire de l'Art, Religion*. Collection Latomus 277, 219–28. Brussels: Société d'Études Latines de Bruxelles.

Sintes, C. 2010. *Libye antique. Un rêve de marbre*. Paris: Imprimerie Nationale Éditions.

Sirago, V.A. 1987. *Puglia e Sud Italia nelle 'Variae' di Cassiodoro*. Bari: Levante Editori.

Sivan, H.S. 1992. "Town and Country in Late Antique Gaul: The Example of Bordeaux." In Drinkwater and Elton (eds.): 132–43.

Škegro, A. 1999. *Gospodarstvo rimske provincije Dalmacije*. Zagreb: Sveučilište u Zagrebu (University of Zagreb), Studia Croatica.

Slater, W.J. (ed.) 1991. *Dining in a Classical Context*. Ann Arbor, MI: University of Michigan Press.

Slater, W.J. 1993. "Three Problems in the History of Drama." *Phoenix* 47: 189–212.

Slater, W.J. 1994. "Pantomime Riots." *Classical Antiquity* 13.1: 120–44.

Slim, H. et al. 2004. *Le littoral de la Tunisie. Études géoarcheologique et historique*. Études d'antiquités africaines. Paris: CNRS.

Small, A.M. 1980. "San Giovanni di Ruoti: Some Problems in the Interpretation of the Structures." In Painter (ed.): 119–40.

Small, A.M. 1999. "L'occupazione del territorio in età romana." In Adamesteanu (ed.): vol.1, 559–600.

Small, A.M. 2003. "New Evidence from Tile-Stamps for Imperial Estates near Gravina and the Topography of Imperial Estates in South-East Italy." *JRA* 16: 178–99.

Small, A.M. and R.J. Buck 1994. *The Excavations of San Giovanni di Ruoti, vol. 1: The Villas and Their Environment*. Toronto: University of Toronto Press.

Smith, J.T. 1997. *Roman Villas. A Study in Social Structure*. London and New York: Routledge.

Smith, C. (ed.) 2013. *The Cambridge Ancient History, New Edition. Plates to Volumes VII Part 2 and VIII. The Rise of Rome to 133 BC*. Cambridge: Cambridge University Press.

Sodini, J.-P. 1993. "Habitat de l'Antiquité tardive." *Topoi* 5: 151–218.

Sodini, J.-P. 1997. "Habitat de l'antiquité tardive (2)." *Topoi* 7: 435–577.

Sokoloff, M. 1990. *A Dictionary of Jewish Palestinian Aramaic of the Byzantine Period*. Ramat Gan: Bar Ilan University Press.

Solier, Y. (ed.) 1986 (avec le concours de M. Janon et la contribution de R. Sabrié). *Narbonne, Aude: les monuments antiques et médiévaux, le Musée archéologique et le Musée Lapidaire*. Guides archéologiques de la France 8. Paris: Ministère de la culture et de la communication: Imprimerie nationale.

Solier, Y. (ed.) 1991. *La Basilique paléochrétienne du Clos de la Lombarde à Narbonne : cadre archéologique, vestiges et mobiliers*. Paris: Éditions du Centre national de la recherche scientifique: Diffusion, Presses du CNRS.

Solin, H. 2003 *Die griechischen Personnamen in Rom: ein Namenbuch*. 2nd edn. Berlin and New York: Walter de Gruyter.

Sollman, M.A. 1953. "Cui bono?" In Mylonas and Raymond (eds.): 1239–46.

Sommella, P. 1991. "Città e territorio nella Campania antica." In Pugliese Carratelli (ed.): 151–91.

Sommer, M. 2015. "'A vast scene of confusion': Die Krise des 3. Jahrhunderts in der Forschung." In Babusiaux and Kolb (eds.): 15–30.

Soraci, C. 2011. *Sicilia frumentaria. Il grano siciliano e l' annona di Roma*. Rome: L'Erma di Bretschneider.

Soraci, C. 2013. *Patrimonia sparsa per orbem. Melania e Pinano tra errabondaggio ascetico e carità eversiva*. Acireale and Rome: Bonanno Editore.

Soricelli, G. 2002. "Divisioni agrarie romane e occupazione del territorio nella piana nocerino-sarnese." In Franciosi (ed.): 123–29.

Soteriades, G. 1927. "Η Τετράπολις του Μαραθώνος και το Ηράκλειον του Ηροδότου" *Epistimoniki Epetiris tis Philosophikis Scholis tou Panepistimiou Thessalonikis*, 1: 117–50.

Soteriades, G. 1932. "Ανασκαφαί Μαραθώνος." *Prakt* 1932: 28–43.

Soteriades, G. 1933a. "Ανασκαφή Μαραθώνος." *Prakt* 1933: 31–46.

Soteriades, G. 1933b. "Ο Δισεκατομμυριούχος των αρχαίων Αθηνών Ηρώδης Αττικός." In Drosines (ed.): 517–58.

Soteriades, G. 1935. "Έρευναι και Ανασκαφαί εν Μαραθώνι." *Prakt* 1935: 84–158.

Sotinel, C. 1998. "Le personnel épiscopal." In Rebillard and Sotinel (eds.): 105–24.

Sotomayor, M. 2006a. "La iconografía de Centcelles. Enigmas sin resolver." *Pyrenae* 37.1: 143–73.

Sotomayor, M. 2006b. "Centcelles sigue siendo un enigma." *Pyrenae* 37.2: 143–7.

Soustal, P. 2004. "The Historical Sources for Butrint in the Middle Ages." In Hodges, Bowden, and Lako (eds.): 20–6.

Spadea, R. (ed.) 1989. *Da Skylletion a Scolacium. Il parco archeologico della Roccelletta*. Rome and Reggio Calabria: Gangemi.

Spagnolo Garzoli, G. 1998. "Il popolamento rurale in età romana." In Mercando (ed.): 67–88.

Spanu, M. 2015. "Opus caementicium in Asia Minor: its introduction and development." In Favro et al. (eds.): 27–36.

Spawforth, A.J.S. 1996. "Roman Corinth: The Formation of a Colonial Elite" In Rizakis (ed.): 167–82.

Spawforth, A.J.S. 2002. "Italian Elements among Roman Knights and Senators." In Müller and Hesenohr (eds.): 101–7.

Spencer, D. 2011. *Roman Landscape: Culture and Identity*. New Surveys in Classics 39. Cambridge, UK: Cambridge University Press.

Spigo, U. (ed.). 2004. *Archeologia a Capo d'Orlando. Studi per l'Antiquarium*. Milazzo: Rebus Edizioni.

Sposito, A. (ed.). 1995. *Natura e arteficio nell'iconografia ennese. Architettura, arte e ambiente nelle fonti letterarie-artistiche dal V sec. a.C. al sec. VII. d.C*. Palermo: Dipartimento di Progetto e Costruzione Edilizia, Università di Palermo.

Spyropoulos, G. 2001. *Drei Meisterwerke der griechischen Plastik aus der Villa des Herodes Atticus zu Eva Loukou*. Frankfurt-am-Main: Peter Lang.

Spyropoulos, G. 2006a. *Η Έπαυλη του Ηρώδη Αττικού στην Εύα Λουκού Κυνουρίας*. Athens: Olkos.

Spyropoulos, G. 2006b. Νεκρόδειπνα, ηρωϊκά άναγλυφα και ο ναός-ηρώο του Αντίνοου στην έπαυλη του Ηρώδη Αττικού [μέρος πρώτο]. Sparta: Γιώργος Σπυρόπουλος.

Spyropoulos, G. 2012. "Η βίλα του Ηρώδη Αττικού στην Εύα /Λουκού Κυνουρίας." In Vlahopoulos (ed.): 292–5.

Spyropoulos, T. and G. Spyropoulos 1996. The *Villa of Herodes Atticus at Eva (Loukou) in Arcadia*, unpublished manuscript. British School at Athens Library.

Spyropoulos, T. and G. Spyropoulos 2003. "Prächtige Villa, Refugium und Musenstätte. Die Villa des Herodes Atticus im arkadischen Eua." *AntW* 34: 463–70.

Stacey, D. 2004. *Excavations at Tiberias, 1973–1974: The Early Islamic Periods*. IAA Reports 21. Jerusalem: Israel Antiquities Authority.

Stafford, E. and J. Herrin (eds.) 2005. *Personification in the Greek World: From Antiquity to Byzantium*. Aldershot, UK, and Burlington, VT: Ashgate.

Stambaugh, J.E. 1988. *The Ancient Roman City*. Baltimore, MD, and London: Johns Hopkins University Press.

Stavropoulou-Gatse, M. and G.Z. Alexopoulou 2013. "Αγροικίες της Πάτρας και της Χώρας της." In Rizakis and Touratsoglou (eds.): 88–153.

Steger, B. 2017. *Piazza Armerina. La villa romaine du Casale en Sicile*. Paris: Picard.

Stein, P. 1999. *Roman Law in European History*. Cambridge and New York: Cambridge University Press.

Steinhauer, G. 2009. *Marathon and the Archaeological Museum*. Athens: John S. Latsis Public Benefit Foundation and EFG Eurobank Ergasias S.A.

Steinhauer, G. 2010. "C. Iulius Eurycles and the Spartan dynasty of the Euryclids." In Rizakis and Lepenioti (eds.): 75–87.

Stein-Hölkeskamp, E. 2005. *Das römische Gastmahl: Eine Kulturgeschichte*. Munich: C.H. Beck.

Stella, C. and A. Valvo (eds.) 1996. *Studi in onore di Albino Garzetti*. Brescia: Ateneo di Brescia.

Stemberger, G. 2000. *Jews and Christians in the Holy Land: Palestine in the Fourth Century*. Edinburgh: T & T Clark.

Stenico, A. 1966. *La Ceramica Arretina II*. Milan: Cisalpino.

Stern, E. ed. 2008. *The New Encyclopedia of Archaeological Excavations in the Holy Land*, vol. 5 (Supplementary Volume). Jerusalem, New York, and Toronto: Israel Exploration Society & Carta; Simon & Schuster.

Stewart, A. 2017. "14. Statue of the Lansdowne Herakles," in E. Angelicoussis, *Reconstructing the Lansdowne Collection of Classical Marbles*. Munich: Hirmer, vol. II, 119–125.

Stewart, A.F. 1977. "To Entertain an Emperor: Sperlonga, Laokoon and Tiberius at the Dinner-Table." *JRS* 67: 76–90.

Stewart, D. 2010. "The Rural Roman Peloponnese: Continuity and Change." In Rizakis and Lepenioti (eds.): 217–33.

Stier, F.W.L. 1867. *Architektonische Erfindungen von Wilhelm Stier. Entwurf zu dem laurentinischen Landsitze des Plinius*. 1 vol. and atlas, Berlin.

Stierlin, H. 1996. *The Roman Empire. Vol. 1. From the Etruscans to the Decline of the Roman Empire*. Cologne: Taschen.

Stikas, E.G. 1957. "Ανασκαφή ρωμαϊκού νυμφαίου και παλαιοχηριστιανικής κρήνης παρά το Λέχαιον Κορινθίας." *Prakt* 1957: 89–94.

Stikas, E.G. 1959. "Ανασκαφή Λευκαδίων, Ναούσης." *Prakt* 1957: 85–9.

Stillwell, R. (ed.) 1938. *Antioch-on-the-Orontes, vol. 2: The Excavations 1933–36*. Princeton, NJ: Princeton University Press.

Stillwell, R. 1941. *Antioch-on-the-Orontes, vol. 3. The Excavations 1937–1939*. Princeton, NJ: Department of Art and Archaeology.

Stirling, L.M. 1994. "Mythological Statuary in Late Antiquity: A Case Study of Villa Decoration in Southwest Gaul." Ph.D. diss., University of Michigan.

Stirling, L.M. 2005. *The Learned Collector: Mythological Statuettes and Classical Taste in Late Antique Gaul*. Ann Arbor, MI: Michigan University Press.

Stirling, L.M. 2007. "Statuary Collecting and Display in the Late Antique Villas of Gaul and Spain: A Comparative Study." In Alto Bauer and Witschel (eds.): 307–21.

Stockton, D. 1979. *The Gracchi*. Oxford and New York: Oxford University Press.

Stout, S.E. (ed.) 1962. *Plinius Epistulae: A Critical Edition*. Bloomington: Indiana University Press.

Strange, J.F. 1992. "Six Campaigns at Sepphoris: The University of South Florida Excavations, 1983–1989." In Levine (ed.): 339–55.

Strange, J.F., T.R.W. Longstaff, and D.E. Groh 2006. *Excavations at Sepphoris, vol. 1. University of South Florida Probes in the Citadel and Villa*. Leiden: E. J. Brill.

Strauch, D. 1996. *Römische Politik und griechische Tradtition: Die Umgestaltung Nordwest-Griechenlands unter römische Herrschaft*. Quellen und Forschungen zur Antiken Welt 2. Munich: Tuduv.

Strauss, L. 1970. *Xenophon's Socratic Discourse: An Interpretation of the Oeconomicus*. Ithaca, NY, and London: Cornell University Press.

Stronach, D. 1978. *Pasargadae: A Report on the Excavations Conducted by the British Institute of Persian Studies from 1961 to 1963*. Oxford: Clarendon Press.

Strong, D. E. 1966. *Greek and Roman Gold and Silver Plate*. London: Methuen.

Strong, D. and D. Brown (eds.) 1976. *Roman Crafts*. London: Duckworth.

Stucky, R.A. and I. Jucker (eds.) 1980. *Eikones: Studien zum griechischen und römischen Bildnis: Hans Jucker zum sechzigsten Geburtstag gewidmet*. Bern: Francke.

Suić, M. 1960. "Arheološka Istrazivanja u Mulinama na o Ugljanu." *Ljetopis* 64: 230–49.

Sweetman, R.J. (ed.) 2011. *Roman Colonies in the First Century of their Foundation*. Oxford: Oxbow.

Sweetman, R.J. 2013. *The Mosaics of Roman Crete. Art, Archaeology and Social Change*. Cambridge, UK, and New York: Cambridge University Press.

Swift, E. 2009. *Style and Function in Roman Decoration*. Farnham, UK, and Burlington, VT: Ashgate Publishing Ltd.

Swoboda, K. 1924. *Römische und romanische Paläste*. 2nd edn. Vienna: Schroll.

Syme, R. 1982–3. "Spaniards at Tivoli." *AncSoc* 13–14: 341–63.

Tal, O. 2017. "Hellenistic Philoteria in Its Architectural and Historical Contexts." In Greenberg, Tal, and Da'adli: 97–121.

Talbert, R.J.A. (ed.) 2000. *The Barrington Atlas of the Greek and Roman World*. Princeton, NJ, and Oxford: Princeton University Press.

Talgam, R. and Z. Weiss 2004. *The Mosaics in the House of Dionysos at Sepphoris: Excavated by E. M. Meyers, E. Netzer and C. L. Meyers*. Qedem 44. Jerusalem: Institute of Archaeology, Hebrew University.

Tamm, B. 1973. "Some Notes on Roman Houses." *Opuscula Romana. Annual of the Swedish Institute in Rome* 9: 53–60.

Tanzer, H. 1924. *The Villas of Pliny the Younger*. New York: G.E. Stechert.

Taracena Aguirre, B. 1944. "Construcciones rurales en la Hispania romana." *Investigación y Progreso* 15: 333–47.

Taracena Aguirre, B. 1949. "La villa romana de Liédena." *Príncipe de Viana* 37: 353–82.

Tarradell, M. 1968. "Población y propiedad rural en el este peninsular durante el Bajo Imperio." In *Actas del IIIo Congreso español de Estudios Clásicos II*: 164–9. Madrid: Sociedad Española de Estudios Clásicos.

Tarrats, F. and J.A. Remolà 2007. "La vil·la romana dels Munts (Altafulla, Tarragonès)." In Remolà (ed.): 95–117.

Tarrats Bou, F. et al. 2000. "Nuevas actuaciones en el área residencial de la villa romana de 'Els Munts' (Altafulla, Ager Tarraconensis). Estudio preliminar." *MM* 41: 358–78.

Tassaux, F. 1982. "Laecanii. Recherches sur une famille sénatoriale d'Istrie." *MÉFRA* 94.1: 227–69.

Tassaux, F. 2003. "Élites locales, élites centrales. Approche économique et sociale des grands propriétaires au nord de l'Italie romaine (Brescia et Istrie)." *Histoire & Sociétés Rurales* 19.1: 91–120.

Tassaux, F. 2009. "Fullonicae, huileries ou ateliers de salaisons? Interrogations sur quelques sites istriens." In Pesavento Mattioli and Carre (eds.): 101–11.

Tassaux, F., R. Matijašić, and V. Kovačić. 2001. *Loron (Croatie), un grand centre de production d'amphores à huile istriennes (Ier-IVe s. p.C.)*. Ausonius-Mémoires 6. Bordeaux: Ausonius-Publications.

Tchalenko, G. 1953. *Villages antiques de la Syrie du nord*, vol. 1. Paris: P. Geuthner.

Tchernia, A. 1983. "Italian Wine in Gaul at the End of the Republic." In Garnsey, Hopkins, and Whittaker (eds.): 87–104.

Teichner, F. 1997. "Die römischen Villen von Milreu (Algarve/Portugal). Ein Beitrag zur Romanisierung der südlichen Provinz Lusitania." *MM* 38: 106–62.

Teichner, F. 2006. "Romanisierung und keltische Resistenz? Die 'kleinen' Städte im Nordwesten Hispaniens." In Walde and Kainrath (eds.) 2006: 202–16.

Teichner, F. 2008. *Zwischen Land und Meer – Entre tierra y mar. Studien zur Architektur und Wirtschaftsweise ländlicher Siedlungen im Süden der römischen Provinz Lusitanien*. Stvdia Lvsitana 3. Mérida: Museo Nacional de Arte Romana.

Teichner, F. 2010/11. "La producción de aceite y vino en la villa romana de Milreu (Estói): el éxito del modelo catoniano en la Lusitania." In *Actas del Coloquio internacional. De vino et oleo hispaniae – Áreas de producción y precesos recnológicos del vino y aceite en la Hispania Romana. Murcia 2011. AnMurcia* 25–26: 401–14.

Teichner, F. 2011. "*Nam primum tibi mater Hispania est, terries omnibus terra felicior*. Spätantike Großvillen und Residenzen auf der Iberischen Halbinsel." In von Bülow and Zabehlicky (eds.) 2011: 293–308.

Teichner, F. 2013. "El territorium de Ossonoba (Lusitania): la economía agrícola de la villa classica versus la economia 'martima'." In Fiches, Plana-Mallart, and Revilla Calvo (eds.): 131–42.

Teichner, F. 2014a. "Von Exportschlagern und Cash Crops." In Panzram (ed.): 81–92. Mainz: Nünnerich-Asums Verlag.

Teichner, F. 2014b. "Mensch, Umwelt, Wirtschaft: zum Landschaftsbezug wirtschaftlichen Handelns im antiken Hispanien." In *LEGE ARTIS. Festschrift für Hans-Markus von Kaenel (Frankfurter Arch. Schr.)*: 39–54. Bonn: Habel Verlag.

Teichner, F. 2016. "Loci sepulcri in agro – La evidencia del Projecto VRB." In Hidalgo (ed.): 551–74.

Teichner, F. 2017a. "O estabelecimento portuário do Cerro da Vila (Vilamoura): de aglomerado romano a aldeia islâmica." In *Catálogo de exposição "Loulé – Território, Memória e Identidade"*: 168–81. Belem: Museu Nacional de Arqueologia.

Teichner, F. 2017b. "Cerro Cerro da Vila: A Rural Commercial Harbour beyond the Pillars of Hercules." In Campos Carrasco (ed.): 403–35.

Teichner, F. in press. "»Quinta da Abicada« – a Roman villa maritima on the distant shores of the mare externum." In *Praetoria longe lateque lucentia. Zbornik radova posvećen Vlasti Begović povodom 65. obljetnice života. = Papers in honour of Vlasta Begovic* (forthcoming). Zagreb: Serta Instituti Archaeologici, Institut za arheologiju Zagreb.

Teichner, F. et al. 2010. "Castelinho dos Mouros (Alcoutim). Um castelo da epoca repubblicana." In *Actas do Encontro de Arqueologia do Algarve 2009. XELB X. Actas do 7° Encontro de Arqueologia do Algarve, Silves- 22, 13 e 24 Outubro 2009*: 215–34. Silves: Câmara Municipal de Silves.

Teichner, F. et al. 2012. "O Castelinho dos Mouros (Alcoutim): Um edificio republicano do Baixo Guadiana, no peródo de fundação da Lusitânia romana." In: Los paisajes agrarios de la romanización, arquitectura y explotación del territorio II. *ArchEspArch* 70: 45–64.

Teichner, F. et al. 2015. "O caso do edifício republicano do Castelinho dos Mouros – Alcoutim. Um exemplo de arquitetura Mediterrânica no baixo Guadiana? In *Conferência Internacional Arquitetura Tradicional no Mediterrâneo occidental = Arquitetura Tradicional no Mediterrâneo Ocidental: 1° Congresso Internacional = Traditional Architecture in the Western Mediterranean: 1st International Conference*, 60–63. Lisboa: Argumentum; Mértola: Campo Arqueológico.

Teichner, F. et al. 2017 "The Castelinho das Mouros (Alcoutim) and the 'Casas fuertes' of South Portugal." In *Roman Frontier Studies – Newcastle 2009. Proceedings of the XXI International congress of Roman Frontier Studies (Limes Congress)*, N. Hogdson, P. Bidwell and J. Schachtmann (eds.): 200–6. Oxford: Archaeopress.

Teichner, F. and A. Neville 2000. "Christianization, Romanization and Islamicization in Southern Lusitania." *Antiquity* 74.283: 33–4.

Teichner, F. and Y. Peña Cervantes 2012. "Archäologisches zur Herstellung von Olivenöl und Wein in Hispanien – Ein Forschungsbericht. *BJb* 210/211: 95–178.

Teichner, F. and L. Pons Pujol 2008. "Roman Amphora Trade across the Straits of Gibraltar: An Ancient 'Anti-Economic Practice'?" *OJA* 27: 303–14.

Teichner, F. and T. Schierl 2009. "Zur Akkulturation des Westens der Iberischen Halbinsel am Beginn der römischen Kaiserzeit: das Beispiel des Monte da Nora (Terrugem, Portugal)." In *Limes XX – Estudios sobre la frontera romana*. Anejos de Gladius 13, 63–75. Madrid: CSIC.

Teichner, F. and T. Schierl 2010. "Asentamientos rurales en el sur de la Lusitania entre la fase tardo-republicana y el inicio de la época imperial romana." In Mayoral Herrera and Celestino Pérez (eds.): 89–114.

Teichner, F. and M. Ugarković 2012. "Zeugnisse einer römischen Villa maritima auf der Insel des Heiligen Clemens, Dalmatien." *Germania* 90: 97–126.

Teichner, F. and A. Wienkemeier. In press. "Cerro da Vila (Portogallo) – un porto di un centro per la produzione di purpura e garum nella provincia romana Lusitania." In *Atti Congresso Livorno. Porti antichi e retroterra produttivi* (in press).

Teja, R. and C. Pérez González (eds.) 1997. *Congreso Internacional La Hispania de Teodosio*, vol. 2. Salamanca: Universidad SEK and Junta de Castilla y León.

Terpstra, T., L. Toniolo, and P. Gardelli 2011. "Campagna di scavo APAHA 2011 a Villa San Marco di Stabiae: relazione preliminare sull'indagine archeologica." *RStPomp* 22: 199–205.

Terrenato, N. 2001. "The Auditorium Site in Rome and the Origins of the Villa." *JRA* 14: 5–31.

Terrenato, N. 2012. "The Enigma of "Catonian" Villas: The *De agri cultura* in the Context of Second-Century BC Italian Architecture." In Becker and Terrenato (eds.): 69–93.

Testaguzza, O. 1970. *Portus: illustrazione dei porti di Claudio e Traiano e della città di Porto a Fiumicino*. Rome: Julia.

Thébert, Y. 1987. "Private Life and Domestic Architecture in Roman Africa." In Veyne (ed.): 315–409.

Thébert, Y. 2000. "Transport à grand distance et magasinage de briques dans l'Empire romain. Quelques remarques sur les relations entre production et consummation." In *La brique antique et médiévale. Production et commercialization d'un matérieu*. CÉFR 272, 341–56. Rome: École française de Rome.

Thébert, Y. 2003. *Thermes romains d'Afrique du Nord et leur contexte méditerranéen. Études d'histoire et archéologie*. BÉFAR 315. Rome: École française de Rome.

Themelis, P. 1999. "Ανασκαφή Μεσσήνης." *Prakt* 154: 69–111.

Themelis, P. 2010. "The Economy and Society of Messenia under Roman Rule." In Rizakis and Lepenioti (eds.): 89–110.

Thibaut, J.-B. 1922. "L'Hebdomon de Constantinople." *Échos d'Orient* 21: 31–44.

Thirion, J. 1955. "Orphée magicien dans la mosaïque romaine. À propos d'une nouvelle mosaïque d'Orphée découverte dans la region de Sfax," *MÉFR* 67: 149–79.

Thomas, C. (ed.) 1966. *Rural Settlement in Roman Britain.* CBA Research Report 7. London: Council for British Archaeology.

Thomas, M. L. and J. R. Clarke 2007. "The Oplontis Project 2005–6: Observations on the Construction History of Villa A at Torre Annunziata." *JRA* 20: 223–32.

Thomas, M.L. and J. R. Clarke 2009. "Evidence of Demolition and Remodeling at Villa A at Oplontis (Villa of Poppaea) after A.D. 45." *JRA* 22: 355–64.

Thomas, R. and A.I. Wilson, 1994. "Water Supply for Roman Farms in Latium and South Etruria." *PBSR* 62: 139–96.

Thompson, D.J. 2011. "Slavery in the Hellenistic World." In Bradley and Cartledge (eds.): 194–213.

Thonemann, P. 2011. *The Maeander Valley. A Historical Geography from Antiquity to Byzantium.* Cambridge, UK: Cambridge University Press.

Tigano, G. (ed.) 2008. *Terme Vigilatore – S. Biagio. Nuove ricerche nella villa romana (2003–2005).* Palermo: Regione Siciliana.

Tigano, G., L. Borrello and A. L. Lionetti 2008. *Terme Vigilatore – S. Biagio. Villa romana. Introduzione alla visita.* Palermo: Regione Siciliana.

Tobin, J. 1997. *Herodes Attikos and the City of Athens.* Amsterdam: J. C. Gieben.

Tocco Sciarelli, G. (ed.) 1983. *Baia, il Ninfeo imperiale sommerso di Punta Epitaffio.* Naples: Banca sannitica/Arte Tipografica.

Todisco, E. 2001. "Una *vallis immunis* nell'agro bresciano." *ZPE* 134: 239–50.

Tomasello, F. 1992. "L'edificio termale di Misterbianco. Problemi di metodologia progettuale antica." *Cronache di Archeologia* 31: 117–22.

Tombrägel, M. 2012. *Die republikanischen Otiumvillen von Tivoli.* Wiesbaden: Reichert Verlag.

Toniolo, A. 1987. "L'insediamento di S. Basilio di Ariano Polesine." In *Il Veneto in età romana II*, 303–8.

Torelli, M. 1991. "La fondazione di Venosa nel quadro della romanizzazione dell'Italia meridionale." In Salvatore (ed.): 18–26.

Torelli, M. 2012. "The Early Villa: Roman Contributions to the Development of a Greek Prototype." In Becker and Terrenato (eds.): 8–31.

Touratsoglou, I. 2010. "Coin Production and Coin Circulation in the Roman Peloponnesos." In Rizakis and Lepenioti (eds.): 235–51.

Toutain, J. 1892. "Fouilles et explorations à Tabarka et aux environs," *BCTH* 1892: 175–209.

Toynbee, J. 1964. "A New Roman Mosaic Pavement Found in Dorset." *JRS* 54.1:7–14.

Toynbee, J. 1967. "Pagan Motifs and Practices in Christian Art and Ritual in Roman Britain." In Barley and Hanson (eds.): 177–92.

Treggiari, S. 1999. "The Upper-Class House as Symbol and Focus of Emotion in Cicero." *JRA* 12: 33–56.

Tremoleda, J. et al. 1995. "Recent Work on Villas around Ampurias, Gerona, Iluro, and Barcelona (NE Spain)." *JRA* 8: 271–307.

Trillmich, W. 1974. "Ein Bildnis der Agrippina minor von Milreu (Portugal)." *MM* 15: 184–202.

Trombley, F.R. 2001. *Hellenic Religion and Christianization. c. 370–529.* 2 vols. 2nd edn. Leiden: Brill.

Trout, D.E. 1996. "Town, Countryside, and Christianization at Paulinus' Nola." In Mathisen and Sivan (eds.): 175–86.

Trout, D.E. 1999. *Paulinus of Nola: Life, Letters, and Poems.* Berkeley, CA: University of California Press.

True, M. and J. Podany (eds.) 1990. *Marble: Art Historical and Scientific Perspectives on Ancient Sculptures.* Malibu, CA: J. Paul Getty Museum.

True, M. and J. Silvetti 2005. *The Getty Villa.* Los Angeles, CA: Getty.

Tsafrir, Y. and G. Foerster 1997. "Urbanism at Scythopolis-Bet Shean in the Fourth to Seventh Centuries." *DOP* 51: 85–146.

Tsigarida, E. B. and N. Hadad 1993. "Ανασκφική έρευνα στη Βεργίνα, 1993. Ελληνιστικό κτήριο με εξώστη." *AErgoMak* 7: 69–76.

Tsougarakis, D. 1987. "Ρωμαϊκή Κρήτη (1ος αι. π.Χ. – 5ος αι. μ.Χ.)." In Panagiotakis (ed.) 1987: 287–336.

Tuplin, C. 1996. *Achaemenid Studies.* Historia Einzelschriften 99. Stuttgart: Franz Steiner.

Turković, T. 2011. "The Late Antique 'Palace' in Polače Bay (Mljet) – Tetrarchic 'Palace'?" *Hortus Artium Medievalium* 17: 211–33.

Tybout, Rolf A. 1979. "Oplontis." *Hermeneus* 51: 263–83.

Tybout, R.A. 1989. *Aedificorum figurae. Untersuchungen zu den Architekturdarstellungen des frühen zweiten Stils.* Amsterdam: Gieben.

Tzanavari, K. 2003a. "Lete, a City in Ancient Mygdonia." In Adam-Veleni, Poulaki, and Tzanavari (eds.): 71–90.

Tzanavari, K. 2003b. "Roman Period." In Adam-Veleni, Poulaki, and Tzanavari (eds.): 44–9.

Tzanavari, K. 2003c. "The Economic Structure. Roman Period." In Adam-Veleni, Poulaki, and Tzanavari (eds.): 134–7.

Tzanavari, K. and K. Philes 2000. "Αγροτικές εγκαταστάσεις στη χώρα τις αρχαίας Λητής." *AErgoMak* 14: 153–68.

Ulrich, R. 1993. "The Building of the Forum Iulium." *AJA* 97: 49–80.

University of Southampton 2005. Roman Amphorae: a digital resource: www.archaeologydataservice.ac.uk /archives/view/amphora_ahrb_2005/index.cfm (accessed March 2014).

Urso, G. (ed.) 2002. *Hispania terris omnibus felicior. Premesse ed esiti di un processo di integrazione. Atti del convegno internazionale, Cividale del Friuli, 27–29 settembre 2001.* Pisa: ETS.

Valero Tévar, M.A. 2009. "La *villa* de Noheda: esplendor tardoimperial." *Revista Memorias* 15: 53–8.

Valero Tévar, M.A. 2010. "La *villa* romana de Noheda: Avance de los primeros resultados." *Informes sobre Patrimonio Histórico de Castilla-La Mancha* 1, 5–19.

Valero Tévar, M.A. 2013. "The Late-Antique Villa at Noheda (Villar de Domingo García) near Cuenca and Its Mosaics." *JRA* 25: 307–30.

Valero Tévar, M.A. 2014. "Les images de *ludi* sur la mosaïque de la *villa* romaine de Noheda (Villar de Domingo García- Cuenca)." *Nikephoros* 24: 103–26.

Valero Tévar, M.A. in press. Los mosaicos de la villa romana de Noheda (Villar de Domingo García-Cuenca). Contexto Arqueológico y análisis interpretativo. Cuenca: Diputación Provincial de Cuenca.

Valeva, J. 1998. "*Villae* in the Roman Provinces Thracia, Moesia Inferior and Dacia." In Aoyagi and Steingräber (eds.): 115–32.

van Dommelen, P. and C. Gómez Bellard (eds.) 2008. *Rural Landscapes of the Punic World.* London and Oakville, CT: Equinox Publishing Ltd.

van Krimpen-Winckel, L.M. 2009. *Ordinatio et dispositio. Design and Meaning in Pompeian Private Architecture* (University of Leiden, unpublished doctoral thesis).

Van Nijf, O.M. 1997. *The Civic World of Professional Associations.* Amsterdam: J.C. Gieben.

Van Ossel, P. 1992. *Etablissements ruraux de l'Antiquité tardive dans le nord de la Gaule.* Supplément à Gallia 51. Paris: CNRS.

Vanderpool, E. 1970. "Some Attic Inscriptions." *Hesperia* 39: 40–6.

Vaquerizo, D. ed. 2002. *Espacios y usos funerarios en el Occidente romano. Actas del Congreso Internacional celebrado en la Facultad de Filosofía y Letras de la Universidad de Córdoba (5–9 junio, 2001).* Córdoba: Universidad de Córdoba.

Vaquerizo, D. 2008. "La *villa* romana de El Ruedo (Almedinilla, Córdoba), paradigma de asentamiento rural en Baetica." In Fernández Ochoa, García-Entero, and Gil Sendino (eds.): 261–83.

Vaquerizo, D. and J.M. Noguera 1997. *La villa de El Ruedo, Almedinilla (Córdoba). Decoración escultórica e interpretación.* Murcia: Diputación de Córdoba, Universidad de Córdoba and Universidad de Murcia.

Vaquerizo Gil, D. and J.M. Carrillo Diaz-Pines 1995. "The Roman Villa of El Ruedo (Almedinilla, Cordòba)." *JRA* 8: 121–54.

Vaquerizo Gil, D. and J.M. Noguera Celdrán 1991. *La villa romana de El Ruedo (Almedinilla, Córdoba). Decoración escultórica e interpretación.* Murcia: Universidad de Murcia Servicio de publicaciones.

Varone, A. 2014. "Le iscrizioni graffite di Stabiae alla luce di nuovi rinvenimenti." *RendPontAcc* (serie III) 86: 375–428.

Vars, C. 1896. *Rusicade et Stora. Philippeville dans l'antiquité.* Constantine: Imprimerie à vapeur Émile Ivarle.

Vasilopoulou, V. (ed.) 2005. *Αττική 2004, Ανασκαφές Ευρύματα, Νέα Μουσεία.* Athens: B' Ephorate of Prehistoric and Classical Antiquities, Ministry of Culture.

Vassallo, S. 1993–1994. "Saggi nella fattoria ellenistico-romana in Contrada S. Luca." *Kokalos* 39–40: 1273–9.

Vassallo, S. 1997. "Rinvenimento di mosaici nella villa di Settefrati." *In AISCOM 1997, 63–9.*

Vassallo, S. 2009. "La *villa rustica* di Contrada San Luca (Castronovo di Sicilia)." In C. Ampolo (ed.), *Immagine e immagini della Sicilia e di altre isole del Mediterraneo antico,* 671–7 Pisa: Edizioni della Normale.

Vaz Pinto, I. and C. Viegas 1994. "Les thermes de la villa romaine de Tourega." *DossArch* 198: 60–3.

Vella, N.C., et al. 2017. "A view from the countryside: the nature of the late Punic and early Roman activity at the Żejtun villa site, Malta." *Rivista di Studi Fenici* 45 (forthcoming).

Vera, D. 1983. "Strutture agrarie e strutture patrimoniali nella tarda antichità: l'aristocrazia romana fra agricoltura e commercio." *Opus* 2.2: 489–533.

Vera, D. 1986. "Simmaco e le sue proprietà: struttura e funzionamento di un aristocratico del quarto secolo D.C." In Bowersock et al. (eds.): 231–70.

Vera, D. 1995. "Dalla '*villa perfecta*'alla villa di Palladio. Sulle trasformazioni del sistema agrario in Italia fra Principato e Dominato." *Athenaeum* 83: 189–211 and 331–56.

Vera, D. 1998. "Le forme del lavoro rurale: aspetti della trasformazione dell'Europa romana fra tarda antichità e alto medioevo." In *Olio e vino nell'Alto Medioevo, Atti della LIV Settimana di studio della Fondazione CISAM (Spoleto, 20–26 aprile 2006):* 293–338. Spoleto: Fondazione CISAM.

Vera, D. 1999a. "I silenzi di Palladio e l'Italia: *osservazioni sull'ultimo agronomo romano.*" *AnTard* 7: 283–97.

Vera, D. 1999b. "*Massa fundorum.* Forme della grande proprietà e poteri della città in Italia fra Costantino e Gregorio Magno." *MÉFRA* 111: 991–1025.

Vera, D. (ed.) 1999. *Demografia, sistemi agrari, regimi alimentari nel mondo antico.* Bari: Edipuglia.

Vera, D. 2001. "Sulla (ri)organizzazione agraria dell'Italia meridionale in età imperiale." In Lo Cascio and Storchi Marino (eds.): 613–34.

Vera, D. 2005. "I paesaggi rurali del meridione tardoantico: bilancio consuntivo e preventivo." In Volpe and Turchiano (eds.): 31–3.

Verde, G. 2008. "La ricostruzione del sectile dell'abside della basilica." In Pensabene and Di Vita (eds.) 25–29.

Veyne, P. 1957. "La Table des Ligures Baebiani et l'institution alimentaire de Trajan." *MÉFRA* 69: 81–135.

Veyne, P. 1958. "La Table des Ligures Baebiani et l'institution alimentaire de Trajan." *MÉFRA* 70: 177–241.

Veyne, P. (ed.) 1987. *A History of Private Life, vol. 1: From Pagan Rome to Byzantium*. Cambridge, MA: Belknap for Harvard University Press.

Verzár-Bass, M. 1986. "Le trasformazioni agrarie tra Adriatico nord-orientale e Norico." in Giardina (ed.), vol. 3: 647–883.

Vidal Gonzàlez, P. 2003. "Ecologia y paisaje fenicio-púnico de la isla de Malta." In Gómez Bellard (ed.): 255–70.

Vigil-Escalera, A. 2009. "Las aldeas altomedivales madrileñas y su proceso formativo." In Quirós Castillo (ed.): 315–39.

Vikela, E. and R. Vollkommer 1992. *s.v.* "Melikertes." In *LIMC* 6.1, 437–44.

Vilella, J. 1996. "Las cartas del epistolario de Q. Aurelio Símaco enviadas a Hispania." In *Spania. Estudis d'Antiguitat Tardana oferts en homenatge al professor Pere de Palol i Salellas*, 283–93. Barcelona: Publicacions de l'Abadia de Montserrat.

Villar, F. and F. Beltrán (eds.) 1999. *Pueblos, lenguas y escrituras de la Hispania Prerromana*. Acta Salmanticensia, Estudios Filológicos 273. Salamanca: Universidad de Salamanca.

Villedieu, F. (ed.) 2001. *Il Giardino dei Cesari: dai palazzo antichi alla Vigna Barberini, sul Monte Palatino, Scavi dell'École Française de Rome 1985–1999, guida alla mostra*. Rome: Quasar.

Villedieu, F. 2001. "I giardini del tempio." In Villedieu (ed.): 94–6.

Villeneuve, F. 1985. "L'économie rurale et la vie des campagnes dans le Hauran antique." In Dentzer (ed.): 63–136.

Villicich, R. 2009. "I dati archeologici." In Villicich, R. and M.L. Carra, "La villa di Teodorico a Galeata (FC): nuovi dati dalle campagne di scavo 2006–2008." *Ocnus: quaderni della Scuola di specializzazione in archeologia* 17: 184–6.

Violante, C. 1982. "Le strutture organizzative della cura d'anime nelle campagne dell'Italia centrosettentrionale." In *Cristianizzazione ed organizzazione ecclesiastica delle campagne nell'alto medioevo: espansione e resistenze*:

963–1158. Spoleto: Presso la sede del Centro italiano di studi sull'Alto Medioevo.

Vismara, C. 1998. "La villa romana nelle province africane." In Aoyagi and Steingräber (eds.) 1998: 146–54.

Vitti, M. 1993. "Υλικά και τρόποι δόμησης στη Μακεδονία." In *Ancient Macedonia V: papers read at the Fifth International Symposium held in Thessaloniki, October 10–15, 1989: Manolis Andronikos, in memoriam*. Institute for Balkan Studies Series 240: 1693–1719. Thessaloniki: Institute for Balkan Studies.

Vlahopoulos, A.G. (ed.) 2012. *Archaiologia Peloponnesos*. Athens: Melissa.

Vogt, J. 1972. *Sklaverei und Humanität: Studien z. antiken Sklaverei u. ihrer Erforschung*, 2nd rev. edn. Wiesbaden: Steiner. (English transl.: *Ancient Slavery and the Ideal of Man*, trans. by T. Wiedemann. 1974. Oxford: Blackwell.)

Vogt, J. and H. Bellen 1983. *Bibliographie zur antiken Sklaverei*. Bochum: Norbert Brockmeyer.

Volpe, G. 1995 "Fattorie e ville. Il caso di Posta Crusta." In Mertens (ed.) 1995: 311–18.

Volpe, G. 2006. "*Stibadium* e *convivium* in una villa tardoantica (Faragola-Ascoli Satriano)." In Silvestrini, Spagnuolo Vigorita, and Volpe (eds.) 2006: 319–49.

Volpe, G. 2007. "Il ruolo dei vescovi nei processi di trasformazione del paesaggio urbano e rurale." In Brogiolo and Chavarría Arnau (eds.): 85–106.

Volpe, G. and M. Turchiano (eds.) 2005. *Paesaggi e insediamenti rurali in Italia meridionale fra Tardoantico e Altomedioevo, Atti del 1° Seminario sul Tardoantico e l'Altomedioevo in Italia Meridionale (Foggia 12–14 febbraio 2004)*. Bari: Edipuglia.

Volpe, G. and M. Turchiano (eds.) 2009. *Faragola 1. Un insediamento nella valle del Carapelle, ricerche e studi*. Insulae Diomedeae 12. Bari: Edipuglia.

Volpe, G. and M. Turchiano (eds.) 2010. *Faragola di Ascoli Satriano. Guida agli scavi archeologici*. Foggia: Claudio Grenzi Editore.

Volpe, R. 2000. "Il Suburbio." In Carandini, A. (ed.): 183–210.

Volpe, R. 2009. "Vino, vigneti ed anfore in Roma repubblicana." In Jolivet et al. (eds.) 2009: 369–81.

Volpe, R. 2012. "Republican Villas in the *Suburbium* of Rome." In Becker and Terrenato (eds.) 94–110.

Von Boeselager, D. 1983. *Antike Mosaiken in Sizilien*. Rome: Giorgio Bretschneider.

von Bülow, G. and H. Zabehlicky (eds.) 2011. *Bruckneudorf und Gamzigrad – Spätantike Paläste und Großvillen im Donau-Balkan-Raum. Akten des Internationalen Kolloquiums in Bruckneudorf vom 15. bis 18. Oktober 2008*,

Kolloquien zur Vor- und Frühgeschichte Band 15 = Sonderschriften des Österreichischen Archäologischen Instituts Band 45. Bonn: Habelt.

von Hesberg, H. and P. Zanker (eds.) 1987. *Römische Gräberstrassen. Selbstdarstellung, Status, Standard; Kolloquium in München vom 28. bis 30. Okotober 1985.* Munich: Verlag der Bayerischen Akademie der Wissenschaften: in Kommission bei der Ch.H. Beck.

Vorster, H. 1998. "La villa come museo." In Aoyagi and Steingräber (eds.): 166–76.

Vössing, K. (ed.) 2008. *Das römische Bankett im Spiegel der Altertumswissenschaften, Internationales Kolloquium 5./6. Oktober 2005 Schloß Mickeln Düsseldorf.* Stuttgart: Franz Steiner.

Voza, G. 1972–1973. "Intervento." *Kokalos* 18–19: 186–92.

Voza, G. 1973. "Mosaici della "Villa del Tellaro"." In Pelagatti and Voza (eds.): 175–9.

Voza, G. 1976–1977. "L'attività della Soprintendenza alle Antichità della Sicilia Orientale. Parte II." *Kokalos* 22–23: 551–85.

Voza, G. 1980–1981. "L'attività della Soprintendenza alle Antichità della Sicilia Orientale. Parte I." *Kokalos* 26–27: 674–93.

Voza, G. 1982a. "Le ville romane del Tellaro e di Patti in Sicilia e il problema dei rapporti con l'Africa." In *150-Jahr-Feier, Deutsches Archäologisches Institut Rom. Ansprachen und Vorträge (4.–7. Dezember 1979),* 202–9. Mainz-am-Rhein: Philipp von Zabern.

Voza, G. 1982b. "L'attività della Soprintendenza ai Beni Archeologici della Sicilia Orientale dal 1976 al 1982," *Beni Culturali e Ambientali Sicilia* 3.1–4: 93–137.

Voza, G. 1983. "Aspetti e problemi dei nuovi monumenti d'arte musiva in Sicilia." In Fariolo Campanati (ed.): 5–18.

Voza, G. 1984–1985. "Attività della Soprintendenza alle Antichità di Siracusa nel quadrennio 1980–1984." *Kokalos* 30–31: 657–78.

Voza, G. 1989. "I crolli nella villa romana di Patti Marina." In Guidoboni (ed.): 496–501.

Voza, G. 2003. *I mosaici del Tellaro. Lusso e cultura della Sicilia sud-orientale.* Syracuse: Erre Produzioni.

Voza, G. 2008a. "Rinasce la villa del Tellaro." *Kalós* 20.1–2: 4–11.

Voza, G. 2008b. *La villa del Tellaro.* Palermo: Regione Siciliana and Syracuse: Erre Produzioni.

Wacker, C. 1996. *Das Gymnasion in Olympia. Geschichte und Funktion.* Würzburg: Ergon Verlag.

Wahl, J. 1985. "Castelo da Lousa. Ein Wehrgehöft caesarisch-augusteischer Zeit." *MM* 26: 150–76.

Walde, E. and B. Kainrath (eds.) 2006. *Die Selbstdarstellung der römischen Gesellschaft in den Provinzen im Spiegel der Steindenkmäler. Akten des IX. Internationalen Kolloquiums über provinzialrömisches Kunstschaffen – Innsbruck 2005* (IKARUS 2). Innsbruck: Universitätsverlag.

Waldstein, C. and L. Shoobridge 1908. *Herculaneum Past Present and Future.* London: Macmillan.

Wallace-Hadrill, A. 1988. "The Social Structure of the Roman House." *PBSR* 56: 43–97.

Wallace-Hadrill, A. 1990. "Greek Arches and Roman Honours: The Language of Power at Rome." *Proceedings of the Cambridge Philological Society* 36: 143–81.

Wallace-Hadrill, A. (ed.) 1990. *Patronage in Ancient Society.* London and New York: Routledge.

Wallace-Hadrill, A. 1994. *Houses and Society in Pompeii and Herculaneum.* Princeton, NJ: Princeton University Press.

Wallace-Hadrill, A. 1997. "Rethinking the Roman *Atrium* House." In Laurence and Wallace-Hadrill (eds.): 219–40.

Wallace-Hadrill, A. 1998. "Horti and Hellenization." In Cima and La Rocca (eds.): 1–12.

Wallace-Hadrill, A. 1998. "The Villa as Cultural Symbol." In Frazer (ed.): 43–53.

Wallace-Hadrill, A. 2008. *Rome's Cultural Revolution.* Cambridge, UK: Cambridge University Press.

Wallace-Hadrill, J.M. 1962. *The Barbarian West A.D. 400–1000. The Early Middle Ages.* 2nd rev. edn. New York: Harper & Row.

Walsh, P.G. (ed.) and trans. 1966. *Paulinus of Nola. Letters of St. Paulinus of Nola.* Westminster, MD: Newmann Press.

Walters, H.B. 1908. *Catalogue of the Roman Pottery in the Departments of Antiquities.* London: British Museum.

Ward-Perkins, J.B. 1955. "Notes on Southern Etruria and the Ager Veientanus." *PBSR* 23: 44–72.

Ward-Perkins, J.B. 1981. *Roman Imperial Architecture,* Harmondsworth, UK, and New York: Penguin Books.

Ward-Perkins, J.B. and J.M.C. Toynbee 1949. "The Hunting Baths at Lepcis Magna." *Archaeologia* 93: 165–95.

Warland, R. 2002. "Die Kuppelmosaiken von Centcelles als Bildprogram spätantiker Privatrepräsentation." In Arce (ed.): 21–35.

Watters, M. 2009. "The Complementary Nature of Geophysical Survey Methods." In Campana and Piro (eds.): 183–200.

Webb, R. 1999. "Ekphrasis Ancient and Modern: The Invention of a Genre." *Word and Image* 15: 7–18.

Weber, K. 1758 (1888). Report Dated "Portici, April 23, 1758." In Ruggiero, M. 1888. *Degli scavi di antichità nelle Province di Terraferma dell'antico Regno di Napoli dal 1743 al 1876,* 453–54. Naples: V. Morano.

Weber, M. 1891 (2008). *Die römische Agrargeschichte in ihrer Bedeutung für das Staats- und Privatrecht*. Stuttgart: F. Enke. (English transl.: 2008. *Roman Agrarian History*, transl. by R.I. Frank. Claremont, CA: Regina Books.)

Webster, L. and M. Brown (eds.) 1997. *The Transformation of the Roman World, AD 400–900*. London: British Museum Press.

Weiss, Z. 2001a. "Between Paganism and Judaism: Toward an Identification of the 'Dionysiac Building' Residents at Roman Sepphoris." *Cathedra* 99: 7–26. (Hebrew).

Weiss, Z. 2001b. "Zippori – 2000." *Hadashot Arkheologiyot–Excavations and Surveys in Israel* 113: 25–7.

Weiss, Z. 2002. "Zippori – 2001." *Hadashot Arkheologiyot–Excavations and Surveys in Israel* 114: 23–4.

Weiss, Z. 2003. "The House of Orpheus: Another Late Roman Mansion in Sepphoris." *Qadmoniot* 126: 94–101. (Hebrew).

Weiss, Z. 2005. "Sepphoris (Sippori), 2005." *IEJ* 55: 219–27.

Weiss, Z. 2007a. "Josephus and Archaeology on the Cities of the Galilee." In Rodgers (ed.): 387–414.

Weiss, Z. 2007b. "Private Architecture in the Public Sphere: Urban Dwellings in Roman and Byzantine Sepphoris." In Galor and Waliszewski (eds.): 125–36.

Weiss, Z. 2008. s.v. "Sepphoris." In *NEAEHL*, E. Stern (ed.): 5, 2029–35. Jerusalem: Israel Exploration Society.

Weiss, Z. and E. Netzer 1997a. "The Hebrew University Excavations at Sepphoris." *Qadmoniot* 113: 2–21. (Hebrew).

Weiss, Z. and E. Netzer 1997b. "Architectural Development of Sepphoris during the Roman and Byzantine periods." In Edwards and McCollough (eds.): 117–30.

Welch, K. 2007. *The Roman Amphitheater. From Its Origins to the Colosseum*. Cambridge, UK: Cambridge University Press.

Wells, B. and C. Runnels (eds.) 1996. *The Berbati-Limnes Archaeological Survey, 1988–1990*. Jonsered: P. Åströms.

Wells, B. and C. Runnels 1996. "Some Concluding Remarks." In Wells and Runnels (eds.): 453–57.

Wesenberg, B. 1993. "Zum integrierten Stilleben in der Wanddekoration des zweiten pompejanischen Stils." in Moormann (ed.): 160–7.

Westfall, C.W. 2007. "Urban Planning, Roads, Streets and Neighborhoods." In Dobbins and Foss (eds.): 129–39.

Westgate, R., N. Fischer and J. Whitley (eds.) 2007. *Building Communities, House, Settlement and Society in the Aegean and Beyond, Proceedings of the International Conference on Aegean Housing at Cardiff, April 17–21, 2001*. British School at Athens Studies 15. London: British School at Athens.

White, K.D. 1965. "The Productivity of Labour in Roman Agriculture." *Antiquity* 39: 102–7.

White, K.D. 1967. "*Latifundia*. A Critical Review of the Evidence." *Bulletin of the Institute of Classical Studies of the University of London* 14: 62–79.

White, K.D. 1970. *Roman Farming*. Ithaca, NY: Cornell University Press.

Whitehouse, D.B 1983. "Ruoti, Pottery and Pigs." In Gualtieri, Salvatore, and Small (eds.): 107–9.

Whitmarsh, T. (ed.) 2010. *Local Knowledge and Microidentities in the Imperial Greek World. Greek Culture in the Roman World*. Cambridge, UK: Cambridge University Press.

Whittaker, C.R. and P. Garnsey 1998. "Rural Life in the Later Roman Empire." In Cameron, A. and Garnsey, P. (eds.), *The Cambridge Ancient History*, 2nd edn., vol. 13: 277–311.

Wickham, C. 2005. *Framing the Early Middle Ages: Europe and the Mediterranean, 400–800*. Oxford and New York: Oxford University Press.

Wickham, C. 2009. *The Inheritance of Rome. Illuminating the Dark Ages, 400–1000*. London: Penguin Books.

Widrig, W.M. 1980. "Two Sites on the Ancient Via Gabina." In Painter (ed.) 1980: 119–40.

Widrig, W.M. 2009. *The Via Gabina villas: sites 10, 11, and 13*. Houston, TX: Rice University Press.

Wightman, E. 1970. *Roman Trier and the Treveri*. London: Rupert Hart-Davis.

Wikander, O. 1991. "Water Mills and Aqueducts." In Hodge (ed.): 141–8.

Wilkes, J.J. 1969. *Dalmatia*. London: Routledge and K. Paul.

Wilkes, J.J. 1992. *The Illyrians*. Oxford: Blackwell.

Williams-Goldhagen, S. and R. Legault (eds.) 2000. *Anxious Modernisms: Experimentation in Postwar Architectural Culture*. Montréal and Cambridge, MA: Canadian Centre for Architecture and MIT Press.

Wilson, A.I. 1999. "Deliveries *Extra Urbem*: Aqueducts and the Countryside." *JRA* 12: 314–31.

Wilson, A.I. 2003. "The Archaeology of the Roman *Fullonica*." *JRA* 16: 442–6.

Wilson, A.I. 2004. "Tuscan Landscapes: Surveying the Albegna Valley. Review of: Andrea Carandini and Franco Cambi (eds.), with MariaGrazia Celuzza and Elizabeth Fentress. *Paesaggi d'Etruria. Valle dell'Albegna, Valle d'Oro, Valle del Chiarone, Valle del Tafone* (Edizioni di Storia e Letteratura, Roma 2002)." *JRA* 17.2: 569–76.

Wilson, R.J.A. 1983a. *Piazza Armerina*. London: Granada and Austin, TX: University of Texas Press.

Wilson, R.J.A. 1983b. "Luxury Retreat, Fourth-Century Style: a Millionaire Aristocrat in Late Roman Sicily." *Opus* 2: 537–52.

Wilson, R.J.A. 1988. "Piazza Armerina and the Senatorial Aristocracy in Late Roman Sicily." In Rizza (ed.): 170–82.

Wilson, R.J.A. 1990. *Sicily under the Roman Empire. The Archaeology of a Roman Province 36 BC – AD 535.* Warminster, UK: Aris and Phillips.

Wilson, R.J.A. 1996a. "Rural Life in Roman Sicily: Excavation at Castagna and Campanaio." In Wilson (ed.): 24–41.

Wilson, R.J.A. 1996b. "Archaeology in Sicily 1988–95." *Archaeological Reports for 1995–1996*: 59–123. London: Society for the Promotion of Hellenic Studies.

Wilson, R.J.A. (ed.) 1996. *From River Trent to Raqqa. Nottingham University Archaeological Fieldwork in Britain, Europe and the Middle East, 1991–1995.* Nottingham: Department of Archaeology, University of Nottingham.

Wilson, R.J.A. 2000. "Rural Settlement in Hellenistic and Roman Sicily: Excavations at Campanaio (AG), 1994–1998." *PBSR* 68: 337–69.

Wilson, R.J.A. 2001–2002. "Chiese paleocristiane in Sicilia: problemi e prospettive." *Kokalos* 47–48: 145–68.

Wilson, R.J.A. 2004. "On the Identification of the Figure in the South Apse of the Great Hunt Corridor at Piazza Armerina." *Sicilia Antiqua* 1: 153–70.

Wilson, R.J.A. 2008a. "Sublime Silin: A Luxury Roman Villa on the Libyan Coastline." *Minerva* 19.4: 45–9.

Wilson, R.J.A. 2008b. "Vivere in Villa: Rural Residences of the Roman Rich in Italy. Review of A. Marzano. *Roman Villas in Central Italy. A Social and Economic History* and C. Sfameni, *Ville Residenziale nell' Italia tardoantica.*" *JRA* 21: 479–88.

Wilson, R.J.A. 2009. "Aithiopia." *LIMC. Supplementband* 2009.1, 38–9. Düsseldorf: Artemis Verlag.

Wilson, R.J.A. 2011. "The Fourth-Century Villa at Piazza Armerina (Sicily) in its Wider Imperial Context: A Review of Some Aspects of Recent Research." In von Bülow and Zabehlicky (eds.): 55–87.

Wilson, R.J.A. 2013a. "Hellenistic Sicily, c. 270–100 BC." In Prag and Crawley Quinn (eds.): 79–119.

Wilson, R.J.A. 2013b. "Sicily c. 300 BC – 133 BC," in Smith (ed): 156–96.

Wilson, R.J.A. 2013c. "Carthage and her Neighbours." In Smith (ed.): 197–241.

Wilson, R.J.A. 2014a. "La villa romana di Gerace: primi risultati della ricerca geofisica." In Pensabene and Sfameni (eds.): 95–101.

Wilson, R.J.A. 2014b. "Considerazioni conclusive," in Pensabene and Sfameni (eds.): 691–702.

Wilson, R.J.A. 2014c. "La villa tardoromana di Caddeddi sul fiume Tellaro (SR) e i suoi mosaici." In Pensabene and Sfameni (eds.): 37–46.

Wilson, R.J.A. 2014d. "Tile-Stamps of Philippianus in Late Roman Sicily: A Talking *signum* or Evidence for Horse-raising?" *JRA* 27: 472–86.

Wilson, R.J.A. 2015a. "On the Personification in the Hunt Mosaic at the Roman Villa of Caddeddi on the Tellaro, Sicily." *Mosaic* 42: 23–35.

Wilson, R.J.A. 2015b. "UBC Excavations of the Roman Villa at Gerace (EN), Sicily: Results of the 2013 Season." *Mouseion*[3] 12: 175–230.

Wilson, R.J.A. 2015c. "Scavi alla villa romana di Gerace (EN): risultati della campagna 2013." *Sicilia Antiqua* 12: 115–48.

Wilson, R.J.A. 2016. *Caddeddi on the Tellaro: a Late Roman Villa in Sicily and its Mosaics.* Bulletin Antieke Beschaving Supplementary volume 28. Leiden, Paris and Bristol, CT: Peeters.

Wilson, R.J.A. 2017. "UBC excavations of the Roman villa at Gerace, Sicily: results of the 2015 season." *Mouseion*[3] 14: 253–316.

Wilson, R.J.A. forthcoming a. Review of Steger 2017. *BMCR*, forthcoming.

Wilson, R.J.A. forthcoming b. "UBC Excavations of the Roman Villa at Gerace, Sicily: Results of the 2016 Season." *Mouseion*[3] 15: forthcoming.

Winckelmann J.J. 2011. *Letter and Report on the Discoveries at Herculaneum. Introduction, Translation, and Commentary by Carol C. Mattusch.* Los Angeles, CA: Getty.

Winter, T. 2006. "The Glass Vessels from 'Ein ez-Zeituna in Naḥal 'Iron." *'Atiqot* 51: 77–84.

Winterling, A. "Die römische Republik im Werk Max Webers. Rekonstruktion – Kritik – AkWitualität." *Historische Zeitschrift* 273.3: 595–635.

Wiseman, J. 2006. "The Early Churches and the Christian Community in Stobi, Macedonia." In Harreither et al. (eds.): 795–803.

Wiseman, T.P. 1971. *New Men in the Roman Senate, 139 B.C.–A.D. 14.* London: Oxford University Press.

Wiseman, T.P. 1987. "*Conspicui postes tectaque digna deo*: The Public Image of Aristocratic and Imperial Houses in the Late Republic and Early Empire." In *L'Urbs: espace urbain et histoire (Ier siècle av. J.-C. - IIIe siècle ap. J.-C.). Actes du colloque international de Rome (8-12 mai 1985)*, 393–413. Rome: École Française de Rome.

Wissowa, G. 1912. *Religion und Kultus der Römer, Handbuch der klassischen AltertumsWissenschaft, 5.4.* Munich: C.H. Beck.

Witcher, R. 2006. "Broken Pots and Meaningless Dots? Surveying the Rural Landscapes of Roman Italy." *PBSR* 74: 39–72.

Witschel, Chr. 2009. "Hispania en el siglo III." In Andreu Pintado, Cabrero Piquero, and Rodà de Llanza (eds.): 473–503.

Witten, A. 2006. *Handbook of Geophysics and Archaeology.* London: Equinox Publishing.

Witts, P. 2000. "Mosaics and Room Function: The Evidence from Some Fourth-Century Romano-British Villas." *Britannia* 31: 291–324.

Wocjik, M.R. 1979–1980. "La 'Villa dei Papiri' di Ercolano. Programma decorativo e problemi di committenza." *AnnPerugia* 17: 359–68.

Wood, I.N. 1979. "Early Merovingian Devotion in Town and Country." In Baker (ed.): 61–76.

Wood, I.N. (ed.) 1998. *Franks and Alamanni in the Merovingian Period. An Ethnographic Perspective.* Rochester, NY: Boydell Press.

Woolf, G. 1997. "The Roman Urbanization of the East." In Alcock (ed.): 1–14.

Wrede, H. 1972. *Die spätantike Hermengalerie von Welschbillig; Untersuchung zur Kunsttradition im 4. Jahrhundert n. Chr. und zur allgemeinen Bedeutung des antiken Hermenmals.* Römisch-Germanische Forschungen 32. Berlin: Walter de Gruyter.

Wrede, H. 1986. *Die antike Herme.* Mainz am Rhein: P. von Zabern.

Wright, G.R.H. 2000. *Ancient Building Technology*, 3 vols in 5. Leiden and Boston: Brill.

Wulff, F. 2008. "La cuestión de la romanización." In Alvar Ezquerra (ed.) 2008: 351–64.

Yacoub, M. 2002. *Splendeurs des mosaïques de Tunisie.* 2nd edn. Tunis: Agence Nationale du Patrimoine.

Yeo, C.A. 1951–2. "The Economics of Roman and American Slavery." *FinanzArchiv / Public Finance Analysis* n.s. 13.3: 445–85.

Yücel, E. 2014. *Great Palace Mosaic Museum.* Istanbul: Bilkent Kültür Girişimi Publications.

Yerkes, S.R. 2000. "Vitruvius' monstra." *JRA* 13, 234–51.

Zabehlicky, H. 1998. "Bruckneudorf." In Kandler and Wlach (eds.): 137–9.

Zabehlicky, H. 2002. "Das Hinterland von Carnuntum und die Villa von Bruckneudorf." *Anodos* 1: 227–30.

Zabehlicky, H. 2004. "Zum Abschluß der Grabungen im Hauptgebäude der Villa von Bruckneudorf." *Jahreshefte des Österreichen archäolischen Instituts in Wien* 73: 305–25.

Zaccaria Ruggiu, A. 1995. *Spazio privato e spazio pubblico nella città romana.* Rome: École française de Rome–Palais Farnèse.

Zaccaria Ruggiu, A. 2003. *More regio vivere: il banchetto aristocratico e la casa romana di età arcaica.* Rome: Quasar.

Zachos, K. 1993. "Καθαρισμοί – Στερεώσεις -Αποτυπώσεις Μνημείων. Νομός Πρέβεζας." *ArchDelt, Chronika B1* 48: 300–1.

Zachos, K. (ed.) 2007. *Nicopolis B. Proceedings of the Second International Nicopolis Symposium (11–15 September 2002 (I).* Preveza: Actia Nicopolis Foundation.

Zammit, T. 1908. *Guide to the Roman Villa Museum at Rabat, Malta.* Malta: Government Printing Office.

Zammit, T. 1930a. *The "Roman Villa" Museum at Rabat – Malta.* 3rd edition. Malta: Empire Press.

Zammit, T. 1930b. "Roman Villa and Thermae at Ghain Tuffieha – Malta." *Bulletin of the Museum at Rabat* I: 56–64.

Zangenberg, J.K., H.W. Attridge, and D.B. Martin (eds.) 2007. *Religion, Ethnicity and Identity in Ancient Galilee.* Tübingen: Mohr Siebeck.

Zaninović, M. 1995. "Villae rusticae u pejzažu otoka i obale antičke Dalmacije." *Histria Antiqua* 1: 86–96.

Zanker, P. (ed.) 1976. *Hellenismus in Mittelitalien: Kolloquium in Göttingen vom 5. bis 9. Juni 1974.* Göttingen: Vandenhoeck und Ruprecht.

Zanker, P. 1979 (1990). "Die Villa als Vorbild des späten pompejanischen Wohngeschmacks." *JdI* 94: 460–523, reprint 1990 in *Die römische Villa (Weg der Forschung* 182), F. Reutti (ed.): 150–71. Darmstadt: Wissenschaftliche Buchgesellschaft.

Zanker, P. 1990. *The Power of Images in the Age of Augustus*, translated by A. Shapiro. Ann Arbor, MI: The University of Michigan Press.

Zanker, P. 1998. *Pompeii. Public and Private Life.* Cambridge MA: Harvard University Press.

Zannier, M.-P. 2007. *Paysages du grand domaine et normes agronomiques de Caton à Pline l'Ancien.* (Ph. D. dissertation, Université du Maine. HAL Id: tel-00256683, available at www.tel.archives-ouvertes.fr).

Zarmakoupi, M. 2006. "The Roman Villa and its Physical and Cultural Landscapes from the Late Republic to the Early Empire: Issues of Typology." In Mattusch, Donohue, and Brauer (eds.): 245–8.

Zarmakoupi, M. 2007. Villae Expolitae: Aspects of the Architecture and Culture of Roman Country Houses on the Bay of Naples (C. 100 BCE–79 CE). 2 vols. D. Phil. thesis. Oxford: Oxford University.

Zarmakoupi, M. 2008. "Designing the Landscapes of the Villa of Livia at Prima Porta." In Kurtz et al. (eds.): 269–76.

Zarmakoupi, M. (ed.) 2010. *The Villa of the Papyri at Herculaneum. Archaeology, Reception and Digital Reconstruction.* Berlin and New York: Walter de Gruyter.

Zarmakoupi, M. 2010a. "The Architectural Design of Roman Luxury Villas around the Bay of Naples (circa 100 BCE–79 CE)." *Amoenitas* 1: 33–41.

Zarmakoupi, M. 2010b. "Light Concepts in Roman Luxury Villa Architecture." In Schneider and Wulf-Rheidt (eds.): 158–72.

Zarmakoupi, M. 2010c. "The Architectural Design of the Peristylium-Garden in Early Roman Luxury Villas." In Ladstätter and Scheibelreiter (eds.) 2010: 621–31.

Zarmakoupi, M. 2011. "*Porticus* and *Cryptoporticus* in Luxury Villa Architecture." In Poehler, Flohr, and Cole (eds.): 50–61.

Zarmakoupi, M. 2014a. "The Villa Culture of Roman Greece." In Rizakis and Touratsoglou (eds.): 772–81.

Zarmakoupi, M. 2014b. *Designing for Luxury on the Bay of Naples Villas and Landscapes (c. 100 BCE–79 CE).* (Oxford Studies in Ancient Culture and Representation [OSACR]). Oxford and New York: Oxford University Press.

Zerbini, L. 2006. "Il piacere di vivere in villa: testimonianze letterarie." In Ortalli (ed.): 11–18.

Zevi, F. 1982. "Urbanistica e architettura." In de Franciscis (ed.) 1982: 353–65.

Zevi, F. 1994. "Preface." In De Caro 1994: 5–132.

Zevi, F. 1996. "Pompei dalla città sannitica alla colonia sillana: per un'interpretazione dei dati archeologici." In Cébeillac-Gervasoni (ed.) 1996: 125–38.

Zevi, F. 2001. "Conclusioni." In Lo Cascio and Storchi Marino (eds.): 637–54.

Zevi, F. 2006. "Ville di Roma ... qualche appunto." In Ortalli (ed.): 1–6.

Zinzi, Emilia. 1994. *Studi sui luoghi cassiodorei in Calabria.* Soveria Mannelli (Catanzaro): Rubbettino.

Živkov, S. 2009. "Varia Diocletianea." In Cambi, Belamarić, and Marasović (eds.): 501–27.

Zori, N. 1966. "The House of Kyrios Leontis at Beth Shean." *IEJ* 16: 123–34.

Zucca, R. 1993. "Un'iscrizione monumentale dall'Oristanese." In Mastino (eds.) 1993: 595–636.

INDEX LOCORUM

Note: All references to these citations appear in the Endnotes

Acta Sanctorum, MAII, die XV, III, 471–474: 193
AE
 1954.58: 140
 1955.122: 140
 1959.271: 299
 1971.47: 316
 1977.298: 193
 1993.1756: 299
 2003.1810: 316
Agnellus, *Liber Pontificalis Ecclesia Ravennatis*, 94:
 193
Ant. Lib., *Met.*, 9: 451
App., B Civ.: 35
App., Mith.70–77 (=12.10–11 Loeb): 423
Apul.
 Apol.
 56.5: 298
 87.6: 298
 93.4: 298
Asc., *Scaurus*: 114
Athenaeus
 1.31: 363
 3.73B = Pylarchus FGrH 81 F 65: 362
August.
 Conf., 9.3.5: 192
 De civ D., 22.8: 463
 Enar. in Ps., 132.6: 421
 Ep.
 66.1: 298
 108.18: 421
 185.15: 421
 Ord.. 1.1.2: 305
 Serm.
 137.11.14: 298
 345.2: 298
Aur. Victor, *Caes.*, 12.4: 32
Auson.
 Ep., 23.90–95: 421
 Ephemeris, 2.2: 463
 Mos.
 210: 156

283–286: 424
337–48: 420

B Bava Batra, 8a: 326
B Bava Metzia, 85a: 327
B Berakhot
 43a: 326
 57b: 326
B 'Eruvin
 85b–86a: 326
 85b–86a: 326
B Ketubot
 103b: 326
 104a: 327
B Nedarim, 51a: 326
B Sanhedrin, 38a: 326
B Shabbat, 25b: 327

Cass. Dio
 23 (fragm. 73): 252
 48.38: 113
 56.29.2: 153
 56.46.3: 153
 73.4.5–6: 174
Cassiod.
 Inst., 1.29: 463
 Var.
 2.22.3–5: 192
 2.29: 193
 2.39.5: 194
 2.39.7–8: 194
 2.39.9–10: 194
 4, 50: 154
 11.14.3: 192
 12.22: 397
 12.22.5: 192
Cato
 Agr.
 1.1–7: 94
 1.1.1: 419
 1.1.7: 55

1.3: 34
1.6: 55
1.7: 34
2.7: 419
4.1: 34
4.1–2: 55
10–22: 265
12.2: 253
14.1–5: 34
16: 138
38: 138
52: 363
praef. 4: 55
Catullus, 44.1–9: 114
Ceas., *BCiv.*, 3.102: 356
Cic.
 Arch., 22: 424
 Att.
 1.10: 373
 1.13: 115, 118, 356
 1.16: 356
 1.19.6: 138
 1.5, 2.6: 395
 2.1: 356, 370
 2.1.11: 356
 2.14: 39
 2.20: 356
 2.9.1: 138
 3.14: 360
 3.7: 362
 4.17: 114
 5.2: 39
 5.2.2: 39, 94, 115
 7.5.3: 118
 8.13.12: 118
 10.7.3: 118
 12.32.2: 94
 12.36: 39, 118
 12.40.3: 118
 13.45.3: 39
 13.52: 113, 118

INDEX TOPOGRAPHICUM

Note: Page numbers in Bold refer to Maps and those in Italics to Figures.

INDEX VERBORUM